2006

Photographer's Market®

Donna Poehner, Editor

Erika Kruse O'Connell, Assistant Editor

WRITER'S DIGEST BOOKS
CINCINNATI, OH

If you are an editor, art director, creative director, art publisher or gallery director and would like to be considered for a listing in the next edition of *Photographer's Market*, send your request for a questionnaire to *Photographer's Market*, 4700 East Galbraith Road, Cincinnati OH 45236, or e-mail photomarket@fwpubs.com.

Managing Editor, Writer's Digest Market Books: Alice Pope
Supervisory Editor, Writer's Digest Market Books: Donna Poehner

Writer's Market website: www.writersmarket.com
Writer's Digest Books website: www.writersdigest.com

International Standard Serial Number 0147-247X
International Standard Book Number 1-58297-395-4

Cover design by Kelly Kofron
Interior design by Clare Finney
Production coordinated by Robin Richie

Attention Booksellers: This is an annual directory of F + W Publications.
Return deadline for this edition is December 31, 2006.

Contents

© Dennis Frates

GETTING STARTED

© Nevada Wier

ARTICLES & INFORMATION

Running Your Business

Nevada Wier

Marketing

© 2006 Chris E. Helsey

MARKETS

© Natalie Behring/OnAsia.com

RESOURCES

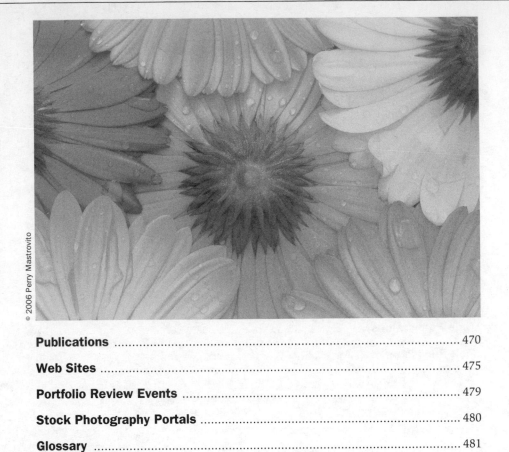

© 2006 Perry Mastrovito

INDEXES

From the Editor

What doesn't help you, hurts you. That might sound harsh, but that is the advice Jay Maisel delivered repeatedly to photographers in his Color, Light and Gesture workshop in Santa Fe last summer. I know because I was one of those photographers. Maisel was referring to those things that we unconsciously (and sometimes consciously) include in our photographs that don't really add anything to the photograph: a piece of washed-out sky or a wayward branch, for example. The photographer didn't really *want* them there; he just didn't work hard enough to compose a better shot—one without these distracting elements. Worse yet, maybe he hadn't even noticed them in the viewfinder. And maybe even worse, the photographer didn't know such elements were distracting. To Maisel, however, ignorance was no excuse. If a bland sky clouded the corners of your photo, or uninspiring foliage filled the foreground, Maisel would invariably ask: "Why did you put that in there? Did you *know* you were putting it in?" If something was not helping the overall impact of the photo, it was hurting it, Maisel insisted.

Of course, Maisel gave us other advice as well. "Carry your camera with you everywhere you go." "Trust your intuition." "Embrace failure." "Learn to think." "Take the pictures *you* want, or else you're a technician and craftsman, not an artist." Good advice, all of it. But as provocative and inspiring as those nuggets were, *what doesn't help you, hurts you* had the most staying power for me in the weeks after the workshop. It appealed to the minimalist in my soul and became my new mantra. I began thinking of how the mantra could be applied to all aspects of photography. Think about the possibilities: When you promote yourself to prospective clients, are you making the most of that opportunity by showing only your best work? (Another piece of advice from Jay Maisel: "No one will know you shoot well, if you don't edit well.") Do you show work that the client needs? Are you constantly shooting and improving your skills and building your portfolio? All these things will help you. So if you're doing them, keep doing them! *Photographer's Market* is designed to help you, the photographer, help yourself. So make the most of the information and advice you'll find in these pages.

Donna Poehner

Donna Poehner
photomarket@fwpubs.com
www.writersdigest.com

P.S. Tell us about yourself. Fill out our reader survey on the following page, and you will be eligible to win a free copy of the next edition of *Photographer's Market*.

Enter our drawing for a

free copy of the next edition

Reader Survey:
Tell us about yourself!

1. How often do you purchase *Photographer's Market?*

- ◯ every year
- ◯ every other year
- ◯ This is my first edition

2. What type of photography do you do?

3. Do you have suggestions for improving *Photographer's Market?*

4. Would you like to see an online version of *Photographer's Market?*

- ◯ Yes
- ◯ No

Name: _____

Address: _____

City: _____ State: _____ Zip: _____

Phone: _____ E-mail: _____

Web site: _____

Fax to Donna Poehner: (513)531-2686; mail to Photographer's Market, 4700 East
Galbraith Road, Cincinnati, OH 45236; or e-mail photomarket@fwpubs.com.

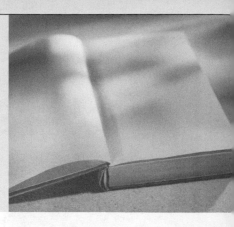

How to Use This Book

T he first thing you'll notice about most of the listings in this book is the group of symbols that appears before the name of each company. Scanning the listings for symbols can help you quickly locate markets that meet certain criteria. (You'll find a quick-reference key to the symbols on the front and back inside covers of the book.) Here's what each symbol stands for:

N This photo buyer is new to this edition of the book.

▼ This photo buyer is located in Canada.

⊕ This photo buyer is located outside the U.S. and Canada.

A This photo buyer uses only images created on assignment.

S This photo buyer uses only stock images.

▣ This photo buyer accepts submissions in digital format.

▨ This photo buyer uses film or other audiovisual media.

Complaint Procedure

Important

If you feel you have not been treated fairly by a listing in *Photographer's Market*, we advise you to take the following steps:

- First, try to contact the listing. Sometimes one phone call or a letter can quickly clear up the matter.

- Document all your correspondence with the listing. When you write to us with a complaint, provide the details of your submission, the date of your first contact with the listing, and the nature of your subsequent correspondence.

- We will enter your letter into our files.

- The number and severity of complaints will be considered in our decision whether to delete the listing from the next edition.

Getting Started

Frequently Asked Questions

Important

1 How do companies get listed in the book?
No company pays to be included—all listings are free. Every company has to fill out a detailed questionnaire about their photo needs. All questionnaires are screened to make sure the companies meet our requirements. Each year we contact every company in the book and have them update their information.

2 Why aren't other companies I know about listed in this book?
We may have sent these companies a questionnaire, but they never returned it. Or if they did return a questionnaire, we may have decided not to include them based on our requirements.

3 I sent some slides to a company that stated they were open to reviewing the type of work I do, but I have not heard from them yet, and they have not returned my slides. What should I do?
At the time we contacted the company they were open to receiving such submissions. However, things can change. It's a good idea to call any company listed in this book to check on their policy before sending them anything. Perhaps they have not had time to review your submission yet. If the listing states that they respond to queries in one month, and more than a month has passed, you can send a brief e-mail or make a quick phone call to the company to inquire about the status of your submission. Some companies receive a large volume of submissions, so sometimes you must be patient. Never send originals when you are querying—always send dupes (duplicate slides). If for any reason your slides are never returned to you, you will not have lost forever the opportunity to sell an important image. It is a good idea to include a SASE (self-addressed stamped envelope) with your submissions, even if the listing does not specifically request that you do so. This may facilitate getting your work back.

4 A company says they want to publish my photographs, but first they will need a fee from me. Is this a standard business practice?
No, it is not a standard business practice. You should never have to pay to have your photos reviewed or to have your photos accepted for publication. If you suspect that a company may not be reputable, do some research before you submit anything or pay their fees. The exception to this rule is contests. It is not unusual for some contests listed in this book to have entry fees (usually minimal—between five and twenty dollars).

PAY SCALE

We asked photo buyers to indicate their general pay scale based on what they typically pay for a single image. Their answers are signified by a series of dollar signs before each listing. Scanning for dollar signs can help you quickly identify which markets pay at the top of the scale. However, not every photo buyer answered this question, so don't mistake a missing dollar sign as an

Getting Started

indication of low fees. Also keep in mind that many photo buyers are willing to negotiate.

$ Pays $1-150

$ $ Pays $151-750

$ $ $ Pays $751-1,500

$ $ $ $ Pays more than $1,500

OPENNESS

We also asked photo buyers to indicate their level of openness to freelance photography. Looking for these symbols can help you identify buyers who are willing to work with newcomers as well as prestigious buyers who only publish top-notch photography.

○ Encourages beginning or unpublished photographers to submit work for consideration; publishes new photographers. May pay only in copies or have a low pay rate.

◑ Accepts outstanding work from beginning and established photographers; expects a high level of professionalism from all photographers who make contact.

◐ Hard to break into; publishes mostly previously published photographers. May pay at the top of the scale.

⊘ Closed to unsolicited submissions.

SUBHEADS

Each listing is broken down into sections to make it easier to locate specific information. In the first section of each listing you'll find mailing addresses, phone numbers, e-mail and Web site addresses, and the name of the person you should contact. You'll also find general information about photo buyers, including when their business was established and their publishing philosophy. Each listing will include one or more of the following subheads:

Needs. Here you'll find specific subjects each photo buyer is seeking. You can find an index of these subjects starting on page 507 to help you narrow your search. You'll also find the average number of freelance photos a buyer uses each year, which will help you gauge your chances of publication.

Audiovisual Needs. If you create images for media such as filmstrips or overhead transparencies, or you shoot videotape or motion picture film, look here for photo buyers' specific needs in these areas.

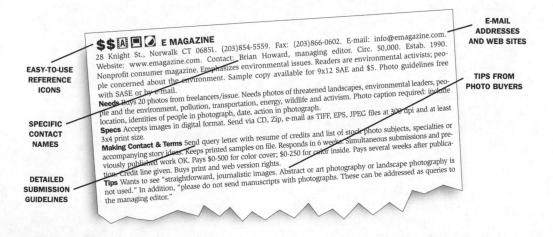

Specs. Look here to learn in what format a buyer wants to receive accepted work. Make sure you can provide your images in that format before you send samples.

Exhibits. This subhead appears only in the Galleries section of the book. Like the Needs subhead, you'll find information here about the specific subjects and types of photography a gallery shows.

Making Contact & Terms. When you're ready to make contact with a photo buyer, look here to find out exactly what they want to see in your submission. You'll also find what the buyer usually pays and what rights they expect in exchange. In the Stock section, this subhead is divided into two parts, Payment & Terms and Making Contact, because this information is often lengthy and complicated.

Handles. This subhead appears only in the Photo Representatives section. Some reps also represent illustrators, fine artists, stylists, make-up artists, etc., in addition to photographers. The term ''handles'' refers to the various types of ''talent'' they represent.

Tips. Look here for advice and information directly from photo buyers in their own words.

10 Steps to Selling Your Work

If this is your first edition of *Photographer's Market*, you're probably feeling a little overwhelmed by all the information in this book. Before you start flipping through the listings, read the 10 steps below to learn how to get the most out of this book and your selling efforts.

1. Be honest with yourself. Are the photographs you make of the same quality as those you see published in magazines and newspapers? If the answer is yes, you may be able to sell your photos.

2. Get someone else to be honest with you. Do you know a professional photographer who would critique your work for you? Other ways to get opinions about your work: join a local camera club or other photo organization; attend a stock seminar led by a professional photographer; attend a regional or national photo conference.

- You'll find workshop and seminar listings beginning on page 439.
- You'll find a list of photographic organizations on page 467.
- Check your local camera store for information about camera and slide clubs in your area.

3. Get Organized. Create a list of subjects you have photographed and organize your images into subject groups. Make sure you can quickly find specific images and keep track of any sample images you send out. You can use database software on your home computer to help you keep track of your images. (See page 28 for more information.)

Other Resources:

- *Photo Portfolio Success* by John Kaplan, Writer's Digest Books.
- *The Photographer's Market Guide to Photo Submission and Portfolio Formats* by Michael Willins, Writer's Digest Books.
- *Sell and Re-Sell Your Photos* by Rohn Engh, Writer's Digest Books.
- *Sellphotos.com* by Rohn Engh, Writer's Digest Books.

4. Consider the format. Are your pictures color snapshots, b&w prints, color slides or digital captures? The format of your work will determine, in part, which markets you can approach. Always check the listings in this book for specific format information.

- **b&w prints**—galleries, art fairs, private collectors, literary/art magazines, trade magazines, newspapers, some book publishers.
- **color prints**—newsletters, very small trade or club magazines.
- **large color prints**—galleries, art fairs, private collectors.
- **color slides** (35mm)—most magazines, newspapers, some greeting card and calendar publishers, some book publishers, textbook publishers, stock agencies.
- **color transparencies** ($2\frac{1}{4} \times 2\frac{1}{4}$ and 4×5)—magazines, book publishers, calendar publishers, ad agencies, stock agencies.

• **digital**—newspapers, magazines, stock agencies, ad agencies. All listings that accept digital work are marked with a ▣ symbol.

5. Do you want to sell stock images or accept assignments? A stock image is any photograph you create on your own and then sell to a publisher. An assignment is a photograph created at the request of a specific buyer. Many of the listings in *Photographer's Market* are interested in both stock and assignment work.

 • Listings that are only interested in stock photography are marked with a ⓢ symbol.
 • Listings that are only interested in assignment photography are marked with a Ⓐ symbol.

6. Start researching. Generate a list of the publishers that might buy your images— check the newsstand, go to the library, read the listings in this book. Don't forget to look at greeting cards, stationery, calendars and CD covers. Anything you see with a photograph on it, from a billboard advertisement to a cereal box, is a potential market.

 • See page 5 for instructions about how to read the listings in this book.
 • If you shoot a specific subject, check the subject index on page 507 to simplify your search.

7. Send for guidelines. Do you know exactly how the publisher you choose wants to be approached? Check the listings in this book first. If you don't know the format, subject and number of images a publisher wants in a submission, you should send a short letter with a self-addressed, stamped envelope (SASE) asking those questions. You could also check the publisher's Web site or make a quick call to the receptionist to find the answers.

8. Check out the market. Get in the habit of reading industry magazines.

 • You'll find a list of useful magazines on page 470.

9. Prepare yourself. Before you send your first submission, make sure you know how to respond when a publisher agrees to buy your work.

Pay Rates:

Most magazines and newspapers will tell you what they pay, and you can accept or decline. However, you should make yourself familiar with typical pay rates. Ask other photographers what they charge—preferably ones you know well or who are not in direct competition with you. Many will be willing to tell you to prevent you from devaluing the market by undercharging. (See page 17 for more information.)

 Other Resources:

 • *Pricing Photography: The Complete Guide to Assignment and Stock Prices* by Michal Heron and David MacTavish, Allworth Press.
 • *fotoQuote*, a software package that is updated each year to list typical stock photo and assignment prices, (800)679-0202, www.cradoc.com.
 • *Negotiating Stock Photo Prices* by Jim Pickerell, 110 Frederick Ave., Suite A, Rockville MD 20850, (301)251-0720.

Copyright:

You should always include a copyright notice on any slide, print or digital image you send out. While you automatically own the copyright to your work the instant it is created, the notice affords extra protection. The proper format for a copyright notice includes the word or symbol for copyright, the date and your name: © 2006 Donna Poehner. To fully protect your copyright and recover damages from infringers, you must register your copyright with the Copyright Office in Washington. (See page 28 for more information.)

Rights:

In most cases, you will not actually be selling your photographs, but rather, the rights to publish them. If a publisher wants to buy your images outright, you will lose the right to resell those images in any form or even display them in your portfolio. Most publishers will buy one-time rights and/or first rights. (See page 30 for more information.)

Other Resources:

- *Legal Guide for the Visual Artist* by Tad Crawford, Allworth Press.

Contracts:

Formal contract or not, you should always agree to any terms of sale in writing. This could be as simple as sending a follow-up letter restating the agreement and asking for confirmation, once you agree to terms over the phone. You should always keep copies of any correspondence in case of a future dispute or misunderstanding. (See page 15 for more information.)

Other Resources:

- *Business and Legal Forms for Photographers* by Tad Crawford, Allworth Press.

10. Prepare your submission. The number one rule when mailing submissions is: "Follow the directions." Always address letters to specific photo buyers. Always include a SASE of sufficient size and with sufficient postage for your work to be safely returned to you. Never send originals when you are first approaching a potential buyer. Try to include something in your submission that the potential buyer can keep on file, such as a tearsheet and your résumé. In fact, photo buyers *prefer* that you send something they don't have to return to you. Plus, it saves you the time and expense of preparing a SASE. (See page 12 for more information.)

Other Resources:

- *The Photographer's Market Guide to Photo Submission and Portfolio Formats* by Michael Willins, Writer's Digest Books.
- *Photo Portfolio Success* by John Kaplan, Writer's Digest Books.

Running Your Business

Photography is an art that requires a host of skills, some which can be learned and some which are innate. To make money from your photography, the one skill you can't do without is a knowledge of business. Thankfully, this skill can be learned. What you'll find on the following pages are the basics of running a photography business. We'll cover:

SUBMITTING YOUR WORK

Editors, art directors and other photo buyers are busy people. Many only spend 10 percent of their work time actually choosing photographs for publication. The rest of their time is spent making and returning phone calls, arranging shoots, coordinating production and a host of other unglamorous tasks that make publication possible. They want to discover new talent, and you may even have the exact image they are looking for, but if you don't follow a market's submission instructions to the letter, you have little chance of acceptance.

To learn the dos and don'ts of photography submissions, read each market's listing carefully and make sure to send only what they ask for. Don't send prints if they only want slides. Don't send color if they only want black & white. Send for guidelines whenever they are available to get the most complete and up-to-date submission advice. When in doubt, follow these ten rules when sending your work to a potential buyer:

1. Don't forget your SASE—Always include a self-addressed, stamped envelope whether you want your submission back or not. Make sure your SASE is big enough, has enough packaging, and has enough postage to ensure the safe return of your work.

2. Don't over-package—Never make a submission difficult to open and file. Don't tape down all the loose corners. Don't send anything too large to fit in a standard file.

3. Don't send originals—Try not to send things you must have back. *Never*, ever send originals unsolicited.

4. Label everything—Put a label directly on the slide mount or print you are submitting.

Include your name, address and phone number, as well as the name or number of the image. Your slides and prints will almost certainly get separated from your letter.

5. Do your research—Always research the places to which you want to sell your work. Request sample issues of magazines, visit galleries, examine ads, look at Web sites, etc. Make sure your work is appropriate before you send it out. A blind mailing is a waste of postage and a waste of time for both you and the art buyer.

6. Follow directions—Always request submission guidelines. Include a SASE for reply. Follow *all* the directions exactly, even if you think they're silly.

7. Include a business letter—Always include a cover letter, no more than one page, that lets the potential buyer know you are familiar with their company, what your photography background is (briefly), and where you've sold work before (if it pertains to what you're trying to do now).

8. Send to a person, not a title—Send submissions to a specific person at a company. When you address a cover letter to Dear Sir or Madam, it shows you know nothing about the company you want to buy your work.

9. Don't forget to follow through—Follow up major submissions with postcard samples several times a year.

10. Have something to leave behind—If you're lucky enough to score a portfolio review, always have a sample of your work to leave with the art director. Make it small enough to fit in a file but big enough not to get lost. Always include your contact information directly on the leave-behind.

DIGITAL SUBMISSION GUIDELINES

Digital images can come from scanned slides, negatives or prints, or from digital cameras. Today, almost every publisher of photographs will accept digital images. Some still accept "analog" images (slides and prints) as well as digital images, but some accept *only* digital images. And, of course, there are those who still do not accept digital images at all, but their number is decreasing.

Previews

Photo buyers need to see a preview of an image before they can decide if it will fit their needs. In the past, photographers mailed slides or prints to prospective photo buyers so they could review them, determine their quality, and decide whether or not the subject matter was something they could use. Or photographers sent a self-promotion mailer, often a post-card with one or more representative images of the their work. Today, preview images can be e-mailed to prospective photo buyers, or they can be viewed on a photographer's Web site. This eliminates the hassle and expense of sending slides through the mail and wondering if you'll ever get them back.

The important thing about digital preview images is size. They should be no larger than 3 by 5 inches at 72 dpi. E-mailing larger files to someone who just wants a peek at your work could greatly inconvenience them if they have to wait a long time for the files to open or if their e-mail system cannot handle larger files. If photo buyers are interested in using your photographs, they will definitely want a larger, high-resolution file later, but don't overload their systems and their patience in the beginning with large files. Another option is sending a CD with preview images. This is not as efficient as e-mail or a Web site since the photo buyer has to put the CD in the computer and view the images one by one. If you do this, be sure to also include a printout of thumbnail images: If the photo buyer does not have time to put the CD in the computer and view the images, she can at least glance at the printed thumbnails. CDs and DVDs are probably best reserved for high-resolution photos you know the photo buyer wants and has requested from you.

Articles & Information

Starting a Business

For More Info

To learn more about starting a business:

- Take a course at a local college. Many community colleges offer short-term evening and weekend courses on topics like creating a business plan or finding financial assistance to start a small business.

- Contact the Small Business Administration at (800)827-5722 or check out their Web site at www.sba.gov. "The U.S. Small Business Administration was created by Congress in 1953 to help America's entrepreneurs form successful small enterprises. Today, SBA's program offices in every state offer financing, training and advocacy for small firms."

- Contact the Small Business Development Center at (202)205-6766. The SBDC offers free or low-cost advice, seminars and workshops for small business owners.

- Read a book. Try *The Business of Commercial Photography* by Ira Wexler (Amphoto Books) or *The Business of Studio Photography* by Edward R. Lilley (Allworth Press). The business section of your local library will also have many general books about starting a small business.

Size and Quality

Size and quality might be the two most important aspects of your digital submission. If the quality is not there, photo buyers will not be interested in buying your image regardless of its subject matter. Find out what the photo buyer needs. If you scan your slides or prints, make sure your scanning quality is excellent: no dirt, dust or scratches. If the file size is too small, they will not be able to do much with it either. While each photo buyer may have different needs, there are some general guidelines to follow. Often digital images that are destined for print media need to be 300 dpi and the same size as the final, printed image will be (or preferably a little larger). For example, for a full-page photo in a magazine, the digital file might be 8 by 10 inches at 300 dpi. However, always check with the photo buyer who will ultimately be publishing the photo. Many magazines, book publishers, and stock photo agencies post digital submission guidelines on their Web sites or will provide copies to photographers if they ask. Photo buyers should be happy to inform photographers of their digital guidelines since they don't want to end up with images they won't be able to use due to poor quality.

Note: Most of the listings in this book that accept digital images state the dpi they require for final submissions. See subhead "Specs" in each listing.

Formats

When you know that a photo buyer is definitely going to use your photos, you will then need to submit a high-resolution digital file (as opposed to the low-resolution 72-dpi JPEGs used for previews). Photo buyers often ask for digital images to be saved as JPEGs or TIFFs. Again, make sure you know what format they prefer. Some photo buyers will want you to send them a CD or DVD with the high-resolution images saved on it. Most photo buyers appreciate having a printout of thumbnail images to review in addition to the CD. Some may allow you

to e-mail images directly to them, but keep in mind that anything larger than 9 megabytes is usually too large to e-mail. Get the permission of the photo buyer before you attempt to send anything that large via e-mail.

Another option is FTP (file transfer protocol). It allows files to be transferred over the Internet from one computer to another.

Note: Most of the listings in this book that accept digital images state the format they require for final digital submissions. See subhead "Specs" in each listing.

Color space
Another thing you'll need to find out from the photo buyer is what color space they want photos to be saved in. RGB (red, green, blue) is a very common one. You might also encounter CMYK (cyan, magenta, yellow, and black). Grayscale is for photos that will be printed without any color (black & white). Again, check with the photo buyer to find out what color space they require.

USING ESSENTIAL BUSINESS FORMS
Using carefully crafted business forms will not only make you look more professional in the eyes of your clients; it will make bills easier to collect while protecting your copyright. Forms from delivery memos to invoices can be created on a home computer with minimal design skills and printed in duplicate at most quick-print centers. When producing detailed contracts, remember that proper wording is imperative. You want to protect your copyright and, at the same time, be fair to clients. Therefore, it's a good idea to have a lawyer examine your forms before using them.

Forms for Photographers

For More Info

To learn more about forms for photographers, try the following:

- EP (Editorial Photographers), www.editorialphoto.com.

- *The Photographer's Market Guide to Photo Submission and Portfolio Formats* by Michael Willins (Writer's Digest Books).

- *Business and Legal Forms for Photographers* by Tad Crawford (Allworth Press).

- *Legal Guide for the Visual Artist* by Tad Crawford (Allworth Press).

- *ASMP Professional Business Practices in Photography* (Allworth Press).

- The American Society of Media Photographers offers traveling business seminars that cover issues from forms to pricing to collecting unpaid bills. Write to them at 14 Washington Rd., Suite 502, Princeton Junction NJ 08550, for a schedule of upcoming business seminars.

- The Volunteer Lawyers for the Arts, 1 E. 53rd St., 6th Floor, New York NY 10022, (212)319-2910. The VLA is a nonprofit organization, based in New York City, dedicated to providing all artists, including photographers, with sound legal advice.

The following forms are useful when selling stock photography, as well as when shooting on assignment:

Delivery Memo

This document should be mailed to potential clients along with a cover letter when any submission is made. A delivery memo provides an accurate count of the images that are enclosed, and it provides rules for usage. The front of the form should include a description of the images or assignment, the kind of media in which the images can be used, the price for such usage, and the terms and conditions of paying for that usage. Ask clients to sign and return a copy of this form if they agree to the terms you've spelled out.

Terms & Conditions

This form often appears on the back of the delivery memo, but be aware that conditions on the front of a form have more legal weight than those on the back. Your terms and conditions should outline in detail all aspects of usage for an assignment or stock image. Include copyright information, client liability, and a sales agreement. Also be sure to include conditions covering the alteration of your images, transfer of rights, and digital storage. The more specific your terms and conditions are to the individual client, the more legally binding they will be. If you own a computer and can create forms yourself, seriously consider altering your standard contract to suit each assignment or other photography sale.

Invoice

This is the form you want to send more than any of the others, because mailing it means you have made a sale. The invoice should provide clients with your mailing address, an explanation of usage, and the amount due. Be sure to include a reasonable due date for payment, usually 30 days. You should also include your business tax identification number or social security number.

Model/Property Releases

Get into the habit of obtaining releases from anyone you photograph. They increase the sales potential for images and can protect you from liability. A model release is a short form, signed by the person(s) in a photo, that allows you to sell the image for commercial purposes. The property release does the same thing for photos of personal property. When photographing children, remember that a parent or guardian must sign before the release is legally binding. In exchange for signed releases, some photographers give their subjects copies of the photos; others pay the models. You may choose the system that works best for you, but keep in mind that a legally binding contract must involve consideration, the exchange of something of value. Once you obtain a release, keep it in a permanent file. (You'll find a sample property release on page 17 and a sample model release on page 18.)

You do not need a release if the image is being sold editorially. However, some magazine editors are beginning to require such forms in order to protect themselves, especially when an image is used as a photo illustration instead of as a straight documentary shot. You *always* need a release for advertising purposes or for purposes of trade and promotion. In works of art, you only need a release if the subject is recognizable. When traveling in a foreign country, it is a good idea to carry releases written in that country's language. To translate releases into a foreign language, check with an embassy or a college language professor.

STOCK LIST

Some market listings in this book ask for a stock list, so it is a good idea to have one on hand. Your stock list should be as detailed and specific as possible. Include all the subjects

PROPERTY RELEASE

In consideration of $_____ and/or _____, receipt of which is acknowledged, I being the legal owner of or having the right to permit the taking and use of photographs of certain property designated as _____, do hereby give _____, his/her assigns, licensees, and legal representatives the irrevocable right to use this image in all forms and media and in all manners, including composite or distorted representations, for advertising, trade, or any other lawful purposes, and I waive any rights to inspect or approve the finished product, including written copy that may be created in connection therewith.

Short description of photographs: _____

Additional information: _____

I am of full age. I have read this release and fully understand its contents.

Please Print:

Name _____

Address _____

City _____ State _____ Zip Code _____

Sample property release

you have in your photo files, breaking them into logical categories and subcategories. On page 19 is a sample stock list that shows how you might categorize your stock images to create a list that will be easy for photo buyers to skim. It only hints at what a stock list might include. Create a list that reflects your unique collection of images.

CHARGING FOR YOUR WORK

No matter how many books you read about what photos are worth and how much you should charge, no one can set your fees for you, and if you let someone try you'll be setting yourself up for financial ruin. Figuring out what to charge for your work is a complex task that will require a lot of time and effort. But the more time you spend finding out how much you need to charge, the more successful you'll be at targeting your work to the right markets and getting the money you need to keep your business, and your life, going.

Keep in mind that what you charge for an image may be completely different from what a photographer down the street charges. There is nothing wrong with this if you've calculated your prices carefully. Perhaps the photographer works in a basement on old equipment and you have a brand new, state-of-the-art studio. You'd better be charging more. Why the disparity? For one thing, you've got a much higher overhead, the continuing costs of running your

MODEL RELEASE

In consideration of $ _____ and/or _____,
receipt of which is acknowledged, I, _____, do
hereby give _____, his/her assigns, licensees, and
legal representatives the irrevocable right to use my image in all forms and
media and in all manners, including composite or distorted representations, for
advertising, trade, or any other lawful purposes, and I waive any rights to in-
spect or approve the finished product, including written copy that may be cre-
ated in connection therewith. The following name may be used in reference to
these photographs:

My real name, or _____

Short description of photographs: _____

Additional information: _____

Please print:

Name _____

Address _____

City _____ State _____ Zip code _____

Country _____

CONSENT

(If model is under the age of 18) I am the parent or guardian of the minor named
above and have the legal authority to execute the above release. I approve the
foregoing and waive any rights in the premises.

Please print:

Name _____

Address _____

City _____ State _____ Zip code _____

Country _____

Signature _____

Witness _____ Date _____

Sample model release

STOCK LIST

INSECTS

Ants

Aphids

Bees

Beetles

Butterflies

Grasshoppers

Moths

Termites

Wasps

PROFESSIONS

Bee Keeper

Biologist

Firefighter

Nurse

Police Officer

Truck Driver

Waitress

Welder

LANDMARKS

Asia

 Angkor Wat

 Great Wall of China

Europe

 Big Ben

 Eiffel Tower

 Louvre

 Stonehenge

United States

 Empire State Building

 Grand Canyon

 Liberty Bell

 Mt. Rushmore

 Statue of Liberty

TRANSPORTATION

Airplanes and helicopters

Roads

 Country roads

 Dirt roads

 Interstate highways

 Two-lane highways

WEATHER

Clouds

 Cumulus

 Cirrus

 Nimbus

 Stratus

Flooding

Lightning

Snow and Blizzards

Storm Chasers

Rainbows

Tornadoes

Tornado Damage

Sample stock list

business. You're also probably delivering a higher-quality product and are more able to meet client requests quickly. So how do you determine just how much you need to charge in order to make ends meet?

Setting your break-even rate

All photographers, before negotiating assignments, should consider their break-even rate, the amount of money they need to make in order to keep their studios open. To arrive at the actual price you'll quote to a client, you should add onto your base rate things like usage, your experience, how quickly you can deliver the image, and what kind of prices the market will bear.

Start by estimating your business expenses. These expenses may include rent (office, studio, darkroom), gas and electric, insurance (equipment), phone, fax, Internet service, office supplies, postage, stationery, self-promotions/portfolio, photo equipment, computer, staff salaries, taxes. Expenses like film and processing will be charged to your clients.

Next, figure your personal expenses, which will include food, clothing, medical, car and home insurance, gas, repairs and other car expenses, entertainment, retirement savings and investments, etc.

Before you divide your annual expenses by the 365 days in the year, remember you won't be shooting billable assignments every day. A better way to calculate your base fee is by billable weeks. Assume that at least one day a week is going to be spent conducting office business and marketing your work. This amounts to approximately 10 weeks. Add in days for vacation and sick time, perhaps three weeks, and add another week for workshops and seminars. This totals 14 weeks of nonbillable time and 38 billable weeks throughout the year.

Now estimate the number of assignments/sales you expect to complete each week and multiply that number by 38. This will give you a total for your yearly assignments/sales. Finally, divide the total overhead and administrative expenses by the total number of assignments. This will give you an average price per assignment, your break-even or base rate.

As an example, let's say your expenses come to $65,000 per year (this includes $35,000 of personal expenses). If you complete two assignments each week for 38 weeks, your average price per assignment must be about $855. This is what you should charge to break even on each job. But, don't forget, you want to make money.

Establishing usage fees

Too often, photographers shortchange themselves in negotiations because they do not understand how the images in question will be used. Instead, they allow clients to set prices and prefer to accept lower fees rather than lose sales. Unfortunately, those photographers who shortchange themselves are actually bringing down prices throughout the industry. Clients realize if they shop around they can find photographers willing to shoot assignments at very low rates.

There are ways to combat low prices, however. First, educate yourself about a client's line of work. This type of professionalism helps during negotiations because it shows buyers that you are serious about your work. The added knowledge also gives you an advantage when negotiating fees because photographers are not expected to understand a client's profession.

For example, if most of your clients are in the advertising field, acquire advertising rate cards for magazines so you know what a client pays for ad space. You can also find print ad rates in the Standard Rate and Data Service directory at the library. Knowing what a client is willing to pay for ad space and considering the importance of your image to the ad will give you a better idea of what the image is really worth to the client.

For editorial assignments, fees may be more difficult to negotiate because most magazines have set page rates. They may make exceptions, however, if you have experience or if the assignment is particularly difficult or time-consuming. If a magazine's page rate is still too low to meet your break-even price, consider asking for extra tearsheets and copies of the issue in which your work appears. These pieces can be used in your portfolio and as mailers, and the savings they represent in printing costs may make up for the discrepancy between the page rate and your break-even price.

There are still more ways to negotiate sales. Some clients, such as gift and paper product manufacturers, prefer to pay royalties each time a product is sold. Special markets, such as galleries and stock agencies, typically charge photographers a commission of 20 to 50 percent for displaying or representing their images. In these markets, payment on sales comes from the purchase of prints by gallery patrons, or from fees on the "rental" of photos by clients of stock agencies. Pricing formulas should be developed by looking at your costs and the current price levels in those markets, as well as on the basis of submission fees, commissions and other administrative costs charged to you.

Bidding for jobs

As you build your business, you will likely encounter another aspect of pricing and negotiating that can be very difficult. Like it or not, clients often ask photographers to supply bids for jobs. In some cases, the bidding process is merely procedural and the assignment will go to the photographer who can best complete it. In other instances, the photographer who submits the lowest bid will earn the job. When asked to submit a bid, it is imperative that you find out which bidding process is being used. Putting together an accurate estimate takes time, and you do not want to waste your efforts if your bid is being sought merely to meet some budget quota.

If you decide to bid on a job, it's important to consider your costs carefully. You do not want to bid too much on projects and repeatedly get turned down, but you also don't want to bid too low and forfeit income. When a potential client calls to ask for a bid, consider these dos and don'ts:

1. Always keep a list of questions by the telephone so you can refer to it when bids are requested. The answers to the questions should give you a solid understanding of the project and help you reach a price estimate.
2. Never quote a price during the initial conversation, even if the caller pushes for a "ballpark figure." An on-the-spot estimate can only hurt you in the negotiating process.
3. Immediately find out what the client intends to do with the photos, and ask who will own copyrights to the images after they are produced. It is important to note that many clients believe if they hire you for a job they'll own all the rights to the images you create. If they insist on buying all rights, make sure the price they pay is worth the complete loss of the images.
4. If it is an annual project, ask who completed the job last time, then contact that photographer to see what he or she charged.
5. Find out who you are bidding against and contact those people to make sure you received the same information about the job. While agreeing to charge the same price is illegal, sharing information about reaching a price is not.
6. Talk to photographers *not* bidding on the project and ask them what they would charge.
7. Finally, consider all aspects of the shoot, including preparation time, fees for assistants and stylists, rental equipment and other materials costs. Don't leave anything out.

Pricing Information

For More Info

Where to find more information about pricing:

- *Pricing Photography: The Complete Guide to Assignment and Stock Prices* by Michal Heron and David MacTavish (Allworth Press).

- *ASMP Professional Business Practices in Photography* (Allworth Press).

- *fotoQuote*, www.fotoquote.com, a software package produced by the Cradoc Corporation, is a customizable, annually updated database of stock photo prices for markets from ad agencies to calendar companies. The software also includes negotiating advice and scripted telephone conversations. Call (800)679-0202 for ordering information.

- Stock Photo Price Calculator, a website that suggests fees for advertising, corporate and editorial stock, http://photographersindex.com/stockprice.htm.

- EP (Editorial Photographers), www.editorialphoto.com.

FIGURING SMALL BUSINESS TAXES

Whether you make occasional sales from your work or you derive your entire income from your photography skills, it is a good idea to consult with a tax professional. If you are just starting out, an accountant can give you solid advice about organizing your financial records. If you are an established professional, an accountant can double-check your system and maybe find a few extra deductions. When consulting with a tax professional, it is best to see someone who is familiar with the needs and concerns of small business people, particularly photographers. You can also conduct your own tax research by contacting the Internal Revenue Service.

Self-employment tax

As a freelancer it's important to be aware of tax rates on self-employment income. All income you receive over $400 without taxes being taken out by an employer qualifies as self-employment income. Normally, when you are employed by someone else, the employer shares responsibility for the taxes due. However, when you are self-employed, you must pay the entire amount yourself.

Freelancers frequently overlook self-employment taxes and fail to set aside a sufficient amount of money. They also tend to forget state and local taxes. If the volume of your photo sales reaches a point where it becomes a substantial percentage of your income, then you are required to pay estimated tax on a quarterly basis. This requires you to project the amount of money you expect to generate in a three-month period. However burdensome this may be in the short run, it works to your advantage in that you plan for and stay current with the various taxes you are required to pay. Read IRS publications #533 (Self-Employment Tax) and #505 (Tax Withholding and Estimated Tax).

Deductions

Many deductions can be claimed by self-employed photographers. It's in your best interest to be aware of them. Examples of 100-percent-deductible claims include production costs of

résumés, business cards and brochures; photographer's rep commissions; membership dues; costs of purchasing portfolio materials; education/business-related magazines and books; insurance; and legal and professional services.

Additional deductions can be taken if your office or studio is home-based. The catch here is that your work area must be used only on a professional basis; your office can't double as a family room after hours. The IRS also wants to see evidence that you use the work space on a regular basis via established business hours and proof that you've actively marketed your work. If you can satisfy these criteria, then a percentage of mortgage interests, real estate taxes, rent, maintencance costs, utilities and homeowner's insurance, plus office furniture and equipment, can be claimed on your tax form at year's end.

In the past, to qualify for a home-office deduction, the space you worked in had to be "the most important, consequential, or influential location" you used to conduct your business. This meant that if you had a separate studio location for shooting but did scheduling, billing and record keeping in your home office, you could not claim a deduction. However, as of 1999, your home office will qualify for a deduction if you "use it exclusively and regularly for administrative or management activities of your trade or business and you have no other fixed location where you conduct substantial administrative or management activities of your trade or business." Read IRS publication #587, Business Use of Your Home, for more details.

If you are working out of your home, keep separate records and bank accounts for personal and business finances, as well as a separate business phone. Since the IRS can audit tax records as far back as seven years, it's vital to keep all paperwork related to your business. This includes invoices, vouchers, expenditures and sales receipts, canceled checks, deposit slips, register tapes and business ledger entries for this period. The burden of proof will be on you if the IRS questions any deductions claimed. To maintain professional status in the eyes of the IRS, you will need to show a profit for three years out of a five-year period.

Tax Information

For More Info

To learn more about taxes, contact the IRS. There are free booklets available that provide specific information, such as allowable deductions and tax rate structure:

- Self-Employment Tax, #533

- Tax Guide for Small Businesses, #334

- Travel, Entertainment and Gift Expenses, #463

- Tax Withholding and Estimated Tax, #505

- Business Expenses, #535

- Accounting Periods and Methods, #538

- Business Use of Your Home, #587

- Guide to Free Tax Services, #910

To order any of these booklets, phone the IRS at (800)829-3676. IRS forms and publications, as well as answers to questions and links to help, are available on the Internet at www.irs.gov.

Sales tax

Sales taxes are complicated and need special consideration. For instance, if you work in more than one state, use models or work with reps in one or more states, or work in one state and store equipment in another, you may be required to pay sales tax in each of the states that apply. In particular, if you work with an out-of-state stock photo agency that has clients over a wide geographic area, you should explore your tax liability with a tax professional.

As with all taxes, sales taxes must be reported and paid on a timely basis to avoid audits and/or penalties. In regard to sales tax, you should:

- Always register your business at the tax offices with jurisdiction in your city and state.
- Always charge and collect sales tax on the full amount of the invoice, unless an exemption applies.
- If an exemption applies because of resale, you must provide a copy of the customer's resale certificate.
- If an exemption applies because of other conditions, such as selling one-time reproduction rights or working for a tax-exempt, nonprofit organization, you must also provide documentation.

SHOWCASING YOUR TALENT

There are basically three ways to acquaint photo buyers with your work: through the mail, over the Internet or in person. No one way is better or more effective than another. They each serve an individual function and should be used in concert to increase your visibility and, with a little luck, your sales.

Self-promotions

When you are just starting to get your name out there and want to begin generating assignments and stock sales, it's time to design a self-promotion campaign. This is your chance to do your best, most creative work and package it in an unforgettable way to get the attention of busy photo buyers. Self-promotions traditionally are samples printed on card stock and sent through the mail to potential clients. If the image you choose is strong and you carefully target your mailing, a traditional self-promotion can work.

But don't be afraid to go out on a limb here. You want to show just how amazing and

Ideas for Great Self-Promotions

For More Info

Where to find ideas for great self-promotions:

- *HOW* magazine's self-promotion annual (October issue).
- *Self-Promotion Online* by Ilise Benun (North Light Books).
- *Photo District News* magazine's self-promotion issue (April).
- *The Photographer's Guide to Marketing & Self-Promotion* by Maria Piscopo (Allworth Press).
- *Marketing Guidebook for Photographers* by Mary Virginia Swanson, available at www.mvswanson.com or (520)742-6311.

creative you are, and you want the photo buyer to hang onto your sample for as long as possible. Why not make it impossible to throw away? Instead of a simple postcard, maybe you could send a small, usable notepad with one of your images at the top, or a calendar the photo buyer can hang up and use all year. If you target your mailing carefully, this kind of special promotion needn't be expensive.

If you're worried that a single image can't do justice to your unique style, you have two options. One way to get multiple images in front of photo buyers without sending an overwhelming package is to design a campaign of promotions that builds from a single image to a small group of related photos. Make the images tell a story and indicate that there are more to follow. If you are computer savvy, the other way to showcase a sampling of your work is to point photo buyers to an online portfolio of your best work. Send a single sample that includes your Internet address, and ask buyers to take a look.

Portfolio presentations

Once you've actually made contact with potential buyers and piqued their interest, they'll want to see a larger selection of your work—your portfolio. Once again, there's more than one way to get this sampling of images in front of buyers. Portfolios can be digital—stored on a disk or CD-ROM, or posted on the Internet. They can take the form of a large box or binder and require a special visit and presentation by you. Or they can come in a small binder and be sent through the mail. Whichever way(s) you choose to showcase your best work, you should always have more than one portfolio, and each should be customized for potential clients.

Keep in mind that your portfolios should contain your best work (dupes only). Never put originals in anything that will be out of your hands for more than a few minutes. Also, don't include more than twenty images. If you try to show too many pieces you'll overwhelm the buyer, and any image that is less than your best will detract from the impact of your strongest work. Finally, be sure to show only work a buyer is likely to use. It won't do any good to show a shoe manufacturer your shots of farm animals or a clothing company your food pictures. For more detailed information on the various types of portfolios and how to select which photos to include and which ones to leave out, see *Photo Portfolio Success* by John Kaplan (Writer's Digest Books).

Do you need a résumé?

Some of the listings in this book say to submit a résumé with samples. If you are a freelancer, a résumé may not always be necessary. Sometimes a stock list or a list of your clients may suffice, and may be all the photo buyer is really looking for. If you do include a résumé, limit the details to your photographic experience and credits. If you are applying for a position teaching photography or for a full-time photography position at a studio, corporation, newspaper, etc., you will need the résumé. Galleries that want to show your work may also want to see a résumé, but, again, confine the details of your life to significant photographic achievements.

ORGANIZING AND LABELING YOUR IMAGES

It will be very difficult for you to make sales of your work if you aren't able to locate a particular image in your files when a buyer needs it. It is imperative that you find a way to organize your images—a way that can adapt to a growing file of images. There are probably as many ways to catalog photographs as there are photographers. However, most photographers begin by placing their photographs into large, general categories such as landscapes, wildlife, countries, cities, etc. They then break these down further into subcategories. If you specialize in a particular subject—birds, for instance—you may want to break the bird category down further into cardinal, eagle, robin, osprey, etc. Find a coding system that works for your

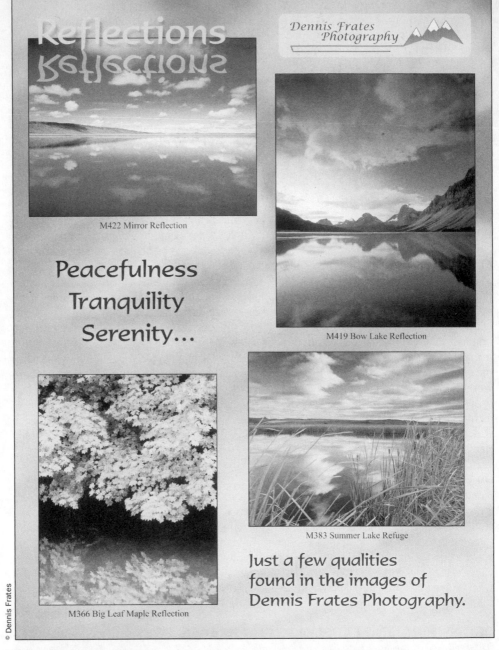

© Dennis Frates

Reflections

Dennis Frates Photography

M422 Mirror Reflection

M419 Bow Lake Reflection

Peacefulness
Tranquility
Serenity...

M366 Big Leaf Maple Reflection

M383 Summer Lake Refuge

Just a few qualities
found in the images of
Dennis Frates Photography.

Sample Self-Promo (front)

This self-promotion piece was not cheap to produce, but Dennis Frates says it has paid off handsomely. After mailing the piece, Frates was contacted by a calendar company to supply all the images for a calendar on reflections, and it has led to other sales as well. Frates used a design firm to produce this promo piece but says that when first starting out, photographers can create good self-promo pieces on their inkjet printers. Frates recommends setting aside money for self-promotion. ''You have to spend money to make money,'' he says.

Articles & Information

M470 Vermillion Wilderness Pond

Reflections

S87 Bandon Sunset

V181 Passion Tendril

H138 Moraine Lake Canoe

Stunning photographs from around the Western US and Canada including:

Mountains
Seascapes
Farmland
Rivers
Lakes
Waterfalls
Flowers
Trees
Gardens

Seasons
Clouds
Covered Bridges
Lighthouses
Roads/Paths in Nature
People in Nature
Patterns in Nature
Fly Fishing
Travel Locations

Visit our website for a complete, searchable catalog of images. Or request a free CD for your files containing the same catalog.

Dennis Frates Photography
24743 Bellfountain Road
Monroe, OR 97456
Toll Free: (866) 657-2717
Fax: (541) 847-6050
Web: www.FratesPhoto.com
Email: dennis@FratesPhoto.com

Sample Self-Promo (back)

particular set of photographs. For example, nature and travel photographer William Manning says, "I might have slide pages for Washington, DC (WDC), Kentucky (KY), or Italy (ITY). I divide my mammal subcategory into African wildlife (AWL), North American wildlife (NAW), zoo animals (ZOO)."

After you figure out a coding system that works for you, find a method for captioning your slides. Captions with complete information often prompt sales: Photo editors appreciate having as much information as possible. Always remember to include your name and copyright symbol © on each photo. Computer software can make this job a lot easier. Programs such as Emblazon (www.planettools.com), formerly CaptionWriter, allow photographers to easily create and print labels for their slides.

The computer also makes managing your photo files much easier. Programs such as FotoBiz (www.fotobiz.net) and StockView (www.hindsightltd.com) are popular with freelance and stock photographers. FotoBiz has an image log and is capable of creating labels. FotoBiz can also track your images and allows you to create documents such as delivery memos, invoices, etc. StockView also tracks your images, has labeling options, and can create business documents.

Image Organization and Storage

For More Info

To learn more about selecting, organizing, labeling and storing images, see:

- *The Photographer's Travel Guide* by William Manning (Writer's Digest Books).
- *The Photographer's Market Guide to Photo Submission and Portfolio Formats* by Michael Willins (Writer's Digest Books).
- *Photo Portfolio Success* by John Kaplan (Writer's Digest Books).
- *Sell & Re-Sell Your Photos* by Rohn Engh, 5th edition (Writer's Digest Books).

PROTECTING YOUR COPYRIGHT

What makes copyright so important to a photographer? First of all, there's the moral issue. Simply put, stealing someone's work is wrong. By registering your photos with the Copyright Office in Washington, DC, you are safeguarding against theft. You're making sure that if someone illegally uses one of your images they can be held accountable. By failing to register your work, it is often more costly to pursue a lawsuit than it is to ignore the fact that the image was stolen.

This brings us to issue number two: money. You should consider theft of your images a loss of income. After all, the person stealing one of your photos used it for a project—their project or someone else's. That's a lost sale for which you will never be paid.

The importance of registration

There is one major misconception about copyright: Many photographers don't realize that once you create a photo it becomes yours. You (or your heirs) own the copyright, regardless of whether you register it for the duration of your lifetime plus seventy years.

The fact that an image is automatically copyrighted does not mean that it shouldn't be

registered. Quite the contrary. You cannot even file a copyright infringement suit until you've registered your work. Also, without timely registration of your images, you can only recover actual damages—money lost as a result of sales by the infringer plus any profits the infringer earned. For example, recovering $2,000 for an ad sale can be minimal when weighed against the expense of hiring a copyright attorney. Often this deters photographers from filing lawsuits if they haven't registered their work. They know that the attorney's fees will be more than the actual damages recovered, and, therefore, infringers go unpunished.

Registration allows you to recover certain damages to which you otherwise would not be legally entitled. For instance, attorney fees and court costs can be recovered. So too can statutory damages—awards based on how deliberate and harmful the infringement was. Statutory damages can run as high as $100,000. These are the fees that make registration so important.

In order to recover these fees, there are rules regarding registration that you must follow. The rules have to do with the timeliness of your registration in relation to the infringement:

- **Unpublished images** must be registered before the infringement takes place.
- **Published Images** must be registered within three months of the first date of publication or before the infringement began.

The process of registering your work is simple. Contact the Register of Copyrights, Library of Congress, Washington, DC 20559, (202)707-9100, and ask for Form VA (works of visual art). Registration costs $30, but you can register photographs in large quantities for that fee. For bulk registration, your images must be organized under one title, for example, "The works of John Photographer, 1990-1995."

The copyright notice

Another way to protect your copyright is to mark each image with a copyright notice. This informs everyone reviewing your work that you own the copyright. It may seem basic, but in court this can be very important. In a lawsuit, one avenue of defense for an infringer is "innocent infringement"—basically the "I-didn't-know" argument. By placing a copyright notice on your images, you negate this defense for an infringer.

The copyright notice basically consists of three elements: the symbol, the year of first publication, and the copyright holder's name. Here's an example of a copyright notice for an image published in 1999: © 1999 John Q. Photographer. Instead of the symbol ©, you can use the word "Copyright" or simply "Copr." However, most foreign countries prefer © as a common designation.

Also consider adding the notation "All rights reserved" after your copyright notice. This phrase is not necessary in the U.S. since all rights are automatically reserved, but it is recommended in other parts of the world.

Know your rights

The digital era is making copyright protection more difficult. Often images are manipulated so much that it becomes nearly impossible to recognize the original version. As this technology grows, more and more clients will want digital versions of your photos. Don't be alarmed, just be careful. Your clients don't want to steal your work. They often need digital versions to conduct color separations or place artwork for printers.

So, when you negotiate the usage of your work, consider adding a phrase to your contract that limits the rights of buyers who want digital versions of your photos. You might want them to guarantee that images will be removed from their computer files once the work appears in print. You might say it's okay to perform limited digital manipulation, and then specify what

Protecting Your Copyright

For More Info

How to learn more about protecting your copyright:

- Call the Copyright Office at (202)707-3000 or check out their Web site, http://lcweb.loc.gov/copyright, for forms and answers to frequently asked questions.

- The *SPAR Do-It-Yourself Startup Kit* includes sample forms, explanations and checklists of all terms and questions that photographers should ask themselves when negotiating jobs and pricing, (212)779-7464.

- EP (Editorial Photographers), www.editorialphoto.com.

- *Legal Guide for the Visual Artist* by Tad Crawford, Allworth Press.

can be done. The important thing is to discuss what the client intends to do and spell it out in writing.

It's essential not only to know your rights under the Copyright Law, but also to make sure that every photo buyer you deal with understands them. The following list of typical image rights should help you in your dealings with clients:

- **One-time rights.** These photos are "leased" or "licensed" on a one-time basis; one fee is paid for one use.
- **First rights.** This is generally the same as purchase of one-time rights, though the photo buyer is paying a bit more for the privilege of being the first to use the image. He may use it only once unless other rights are negotiated.
- **Serial rights.** The photographer has sold the right to use the photo in a periodical. This shouldn't be confused with using the photo in "installments." Most magazines will want to be sure the photo won't be running in a competing publication.
- **Exclusive rights.** Exclusive rights guarantee the buyer's exclusive right to use the photo in his particular market or for a particular product. A greeting card company, for example, may purchase these rights to an image with the stipulation that it not be sold to a competing company for a certain time period. The photographer, however, may retain rights to sell the image to other markets. Conditions should always be put in writing to avoid any misunderstandings.
- **Electronic rights.** These rights allow a buyer to place your work on electronic media such as CD-ROMs or Web sites. Often these rights are requested with print rights.
- **Promotion rights.** Such rights allow a publisher to use a photo for promotion of a publication in which the photo appears. The photographer should be paid for promotional use in addition to the rights first sold to reproduce the image. Another form of this—agency promotion rights—is common among stock photo agencies. Likewise, the terms of this need to be negotiated separately.
- **Work for hire.** Under the Copyright Act of 1976, section 101, a "work for hire" is defined as: "(1) a work prepared by an employee within the scope of his or her employment; or (2) a work . . . specially ordered or commissioned for use as a contribution to a collective, as part of a motion picture or audiovisual work or as a supplementary work . . . if the parties expressly agree in a written instrument signed by them that the work shall be considered a work made for hire."

- **All rights.** This involves selling or assigning all rights to a photo for a specified period of time. This differs from work for hire, which always means the photographer permanently surrenders all rights to a photo and any claims to royalties or other future compensation. Terms for all rights—including time period of usage and compensation—should only be negotiated and confirmed in a written agreement with the client.

It is understandable for a client not to want a photo to appear in a competitor's ad. Skillful negotiation usually can result in an agreement between the photographer and the client that says the image(s) will not be sold to a competitor, but could be sold to other industries, possibly offering regional exclusivity for a stated time period.

Articles & Information

Nevada Wier

*The Joys and Challenges
of Travel Photography*

© Brenda Pfeiffer

by Brenda Pfeiffer

As a travel photographer, I'm at the mercy of whatever conditions are thrown my way. So when I find myself in a tropical paradise during a drenching downpour or at a resplendent festival at high noon, I have to be a master and magician of light," says Nevada Wier, award-winning travel photographer who specializes in photographing the remote cultures of the world. Wier's journeys have taken her to Southeast Asia, India, China, Nepal, Africa, New Zealand, Central Asia, Mongolia, South America and other regions of the globe.

Having always loved the outdoors, Wier wanted to make a living working in it, so she became an Outward Bound guide. Photography was still just a hobby when in 1978 the Outward Bound program asked her to be a guide in Nepal and to run their trekking program. Eventually, studying foreign cultures and capturing them on film became more important than guiding, and Wier made the natural career progression from travel guide to travel photographer.

Wier has written two books: *Land of Nine Dragons: Vietnam Today* (Abbeville Press, 1992), photography from contemporary Vietnam and winner of the Lowell Thomas Best Travel Book of 1992 award; and *Adventure Travel Photography* (Amphoto, 1993), a how-to travel photography book. She has contributed photos to three other books: *A Day in the Life of Thailand* (Collins, 1995), *Planet Vegas* (Collins, 1995) and *Mother Earth* (Sierra Club Editions, 2002).

Wier works on expanding her travel photography business by continuing to travel and create new images to meet the demands for her travel stock photography. When she's not creating photographs for publication, you will find her teaching aspiring travel photographers. Leading photo tours and travel photography workshops is a regular part of her annual schedule.

At a travel photography workshop in Santa Fe, New Mexico, Wier talked candidly about what it takes to be a travel photographer, the travel photography profession, and how to succeed in the business.

Packing for the Road

Since Wier photographs in a wide variety of circumstances—while hiking, on camel safaris, in cities, rain and shine, hot and cold—she is prepared for everything. She is even prepared

BRENDA PFEIFFER is a freelance writer and photographer living in San Diego, CA. Her photographs have won awards and have been used in advertising, magazines, on Web sites, and exhibited in galleries.

Nevada Wier's Tools of the Trade

Tips

Wardrobe and Luggage: Keep it light, keep it simple, keep it minimal. Have a good pair of shoes. Don't buy heavy luggage. Use the duffel-type luggage, to avoid the heavier frames. Wier buys Eaglecreek brand.

Gear: Wier travels with film and digital. She has a compact digital camera as well as a professional digital camera. For digital, she carries several back-up solutions. In addition to compact flash cards and downloading photos onto a hard drive, she uses memory sticks and external storage devices (digital wallet, pocket drive, compact discs, etc). She uses Sandisk Ultra II and Extreme compact flash cards for durability and speed.

Flash: The arrival of TTL-balanced fill-flash has helped Wier overcome the tyranny of bad light and the limited contrast range of film. Don't think of using flash only when it's dark outside. Used subtly, flash minimizes unwanted shadows, brightens dark scenes, and highlights areas of interest while preserving the ambient light.

Model Releases: In this day and age, it is vital to travel with model releases. If you travel in countries outside the United States, you need model releases in languages such as Spanish, French and German.

for that dreaded missed connection and the possibility that her bag won't show up for the job. The concept of traveling light is wishful thinking for serious photographers. Nothing is easy about shouldering pounds of high-tech equipment and film for the ride. Because new luggage regulations have forced photographers to be extra careful, Wier packs two carry-on bags specifically with bag loss in mind—one for gear and one for film and computer. "With this gear, I can step off the plane and start photographing most situations. I have the most important equipment with me—the backup is all in the checked luggage," she says.

She counsels: "Be thorough, but tailor your gear sensibly to your own needs. Most people (I hope) do not travel with three camera bodies, two flashes, seven lenses, two tripods and a plethora of filters, batteries and cans of Dust-Off as I do. Traveling light means compromising on gear, but when your camera bag is too heavy, your enthusiasm for photography wanes. Choose your camera bag carefully."

Photographing People

The biggest struggle for most photographers is approaching people to photograph them. Many photographers think people don't want to be approached, so they hold back. However, Wier has found that people across the globe are pretty much the same: They tend to like the interaction with photographers. Even if you don't speak the same language, you can still communicate in a universal nonverbal language. She suggests that when you approach people, give them several opportunities to tell you no. Show them the camera, bring the camera to your shoulder, then bring the camera to shooting position. If the person still is making eye contact with you, assume that you have their permission to take their photograph.

Wier's motto is "Move in slowly and work quickly." As you meet the person and develop a relationship, you are moving in slowly. But as soon as you decide that you want to take a picture, you have to do it fast. If you spend too much time concentrating on your camera,

© Nevada Wier

Nevada Wier has been working on a long-term project photographing Kirghiz nomads who live in the Pamir Mountains of western China. This shot of men playing buzkashi (a kind of horse polo with the skin of a goat as the ''ball'') is part of that project. She wanted a more dramatic photograph than one she would get by standing on the sidelines, so she stood on a rock in the middle of the field with a 200mm lens. ''It was quite exciting (frightening at moments) and resulted in a more dramatic image,'' she says. ''It was also extremely dusty. I was cleaning my camera for days, but I never worry about my gear if I want to get a better photograph.''

you will lose the person. ''The camera should ideally become an extension of your arm,'' Wier says.

 ''When I first started traveling and photographing over 20 years ago I felt uncomfortable, even guilty. Photographing someone I did not know made me feel intrusive, so I stood back with a telephoto lens to discreetly photograph—or so I thought. I know now that people were usually aware of me and probably even more annoyed that I was surreptitiously taking

Nevada Wier's Tips and Tricks

Tips

- Tape a tissue over the camera flash to reduce the power, or use an 81A gel over the flash to warm the flash tone. Both these techniques will give fill-flash pictures a more natural look. You can even apply ketchup or wine to the flash unit to add color to the flash output.

- When shooting for travel stock, it is important to try all angles, all light settings and shoot at all times of the day. Try handholding in low light. Try the shot with and without fill flash.

- Try a 20mm lens or even a macro lens to get a different perspective.

photographs. I did get some great images, but there was an empty feeling; I was a voyeur, a passive observer and not an active participant in the situation," says Wier.

"I began using wider-angle lenses and thus coming in closer to people. I was forced to be direct and communicate in some manner, whether it was verbal or nonverbal. I discovered that 90 percent of the people in the world enjoy being photographed: It just depends on how you approach them. You have to be in a good mood, open, sincere and possessed of an almost Zen-like beginner's mind."

Wier believes that the photographer has to feel comfortable photographing a person in order for the person to feel comfortable being photographed. "I sincerely believe that photographing someone is a compliment. It's a sign that you find the person interesting," she says. "If you have the attitude that the act of selecting a subject to photograph is a compliment, then you open the door to more opportunity. I think the successful photographers are the ones who consistently are allowed to penetrate into the intimate parts of people's lives."

With digital, people like to see themselves immediately. Wier says that if you do take a person's photograph, as a courtesy, you need to send them a copy. "Always follow through on your promise," she says, "in order to make it easier for the next photographer who comes along."

The business of travel photography

The travel photography business is not easy. The pressure of creating new, fresh images combined with the challenge of worldwide travel requires hard work and long hours. "It's difficult to make a living as a full-time travel photographer," says Wier. While she doesn't

"I have been to this beautiful old, wooden bridge outside Mandalay many times. It is always easy to get a lovely shot here, but I wanted one that would stand out from the usual sunset shot," says Nevada Wier. So she rented a boat to shoot from the middle of the lake, trying many perspectives and using various optical lengths. "I was primarily captivated by the silhouettes on the bridge, so I waited for the right confluence of people. I want to see a lot of great shots when I'm editing and have one that jumps out as special. That is how I felt about this image—the way the people and their bicycles are sliced by the bridge pilings in exact proportion."

want to discourage anyone from pursuing travel photography, she does want emerging travel photographers to be realistic about creating a formula for success. She recommends that photographers diversify: "Do a variety of things, such as books, cards, stock photography, speculation, personal projects. The travel photography market is not the same as it used to be."

Wier believes having a good business sense is vital for success. In fact, most of being a successful travel photographer is being a good businessperson. She warns that the business side of a photography career usually takes up more time and energy than the travel. Wier's advice is to keep your day job, find a market for your work, and hire for your business and marketing needs.

She also suggests that photographers research the changing needs and demands of travel editors. The hottest locations for travel stock photography right now are the United States, Canada, Mexico and Europe, but photographers need to verify the actual needs of the publications for which they hope to work. She also recommends moving beyond travel magazines to trade magazines, where photographers might find fresh markets for their travel photos.

It takes a particular type of person to enjoy the lifestyle of a travel photographer, make a business out of it and, most importantly, have an eye and an instinct for capturing those special moments. Wier says it also helps to develop a personal balance of working with people and enjoying the time spent working alone. And in the digital age, it also helps to know computers and technology. Wier sums it up: "I think photography is hard, but it's one of those lifelong pursuits that I still find challenging."

Marketing

New Ideas for an Effective Marketing Mix

by Leslie Burns-Dell'Acqua

It used to be that photographers had a fairly limited number of marketing options, most of which required long-range planning and fairly hefty budgets. Today, there are many new tools available which, when added to the marketing mix, can be very effective and have strong return on investment (ROI), without breaking the bank. While you shouldn't get rid of all the more traditional tools, at least not yet, some of these new options can make a significant positive impact on your business's bottom line.

Web sites

The first of these tools is the photographer's Web site. This one is practically a no-brainer—it's absolutely essential and should be on the top of your list of marketing tools. While the physical portfolio used to be a photographer's most important tool, today it's the Web site (but don't throw out that book, yet!).

While you can spend a large sum on a site, it certainly isn't necessary and, regardless, it's going to have a great ROI. Spend the paltry sum (usually $30 or so) to register your own domain name (keep the name simple—like *joephotographer.com*) and get on the Web.

The greatest cost you will encounter is the original design and programming of your site, but the ROI makes it worth it. Don't cut corners here and try to do it yourself—hire a professional for the initial design and/or programming. Some photographers try to do everything themselves, but if you are not a designer, don't pretend to be one. Unless you've been trained in design, you'll actually end up losing money if you turn off potential clients because your site looks unprofessional or is buggy. Besides, there are many ways to save money with a real designer—do some photography in trade, hire a student designer (many are very good), or trade a prominent credit line and/or link on your site for a discount.

After the initial design, you should be able to update and maintain your site yourself. Take lessons if you need to, but learn the skills to be able to do this. An outdated site is just as bad as an outdated portfolio.

A photographer's Web site needs to focus on the images, so keep it simple. Avoid things like Flash (unless you have an optional HTML version as well), music, sound effects (especially shutter noises!) and obscure navigation. You want your potential clients to be able to get in, see your work, and be able to contact you—quickly and easily.

LESLIE BURNS-DELL'ACQUA, formerly a photographer's and artist's representative, helps photographers, illustrators, designers and writers improve their marketing and business strategies. She is the owner of Burns Auto Parts—Consultants, in San Diego, CA.

Tracking Your Marketing Efforts

Tips

Tracking your marketing efforts will help you make sure you're spending your budget effectively. While it's often difficult to gauge the effectiveness of a print ad, almost everything online can be tracked. Most hosting services provide a log, and on it you can see that someone clicked to your site via your AltPick.com ad, for example. Check your log regularly.

Here's a little tracking tip for those of you with multiple e-mail accounts: Use different e-mail addresses for different tools. For example, use info@photographer.com on your print promos, and use contact@photographer.com on your e-mail promos and wb@photographer.com for your Workbook.com online ad. If you get an e-mail from a client, you'll know right away what tool got them to contact you! Then, the next year, you can make sure to keep what's been working for you.

The sites that get the best reviews from clients are self-directed by the user (no slideshows) and have thumbnails (to click for larger images) and clickable arrows (allowing user to go back and forth or click to other images). Between 25-100 images is a good ballpark figure. Remember, it is better to have 25 great images than 50 "good enough" ones.

The well-liked sites also have easy-to-find full contact information. Many photographers' sites have beautiful images, but no phone number! Include your contact information on every page, or have a separate page listing your name, complete mailing address, phone number(s) and linked e-mail address. Also put a link to that page on every page of your site.

There is a lot of discussion about using Flash to protect your images and also having copyright agreements that require the user to sign-in. These are both bad ideas. If someone wants to steal your images, neither of these tools will stop them. The agreement may add a tiny bit to your side if you go after someone who swiped an image, but it's not necessary and turns off many legitimate clients. I suggest putting a notice at the bottom of each page, which states clearly that the images are copyrighted and may not be used, downloaded, or in any way reproduced without your permission.

A quick note about Search Engine Optimization (SEO): It may or may not be important for you to consider. If you are a wedding photographer who wants more local business, then you will want to pop at or near the top of a search on sites like Google. However, if you are looking to attract advertising clients, they will generally not be using tools like Google to find photographers, and you'll waste time and money worrying about SEO. Most editorial clients will not be searching through Google either, unless, of course, they already know your name and are looking for your site.

Just because you have a fabulous site doesn't mean you'll get more (or better) business. You still have to drive clients to that site. Without a full marketing plan that uses a mix of tools, any one tool will probably not make a significant change in your business. So, how do you get traffic to your site? Through other marketing tools like e-mail promos, sourcebook ads (especially online sourcebooks, such as www.blackbook.com or www.altpick.com), and the good old traditional postal mail campaign.

Postal and e-mail campaigns

Yes, those postcards really are effective. In a 2004 interview in *PDN Online*, William Nabers, photo editor of *Fortune*, was quoted as saying, "I can't tell you how important [print promos]

are. It's how we hire people here. It's how you capture our interest." So don't discount those "old fashioned" promos!

The key word is "campaign." Make sure you have a cohesive mail campaign that matches your Web site in tone and design. Most importantly, make sure it has a call to action, such as "Check out our online portfolio at www.photographer.com!" Postal mail promos should go out no less often than quarterly, and can go out as often as monthly before hitting overkill.

In between mailings, e-mail promos are another alternative for your marketing plan. An e-mail promo should reflect your print promos, which reflect your Web site. However, e-mail promos are still getting mixed reviews because many photographers are putting large images and/or too many images in them. E-mail promos act as a little nudge to the client, so limit their contents to one or two *very small* images.

Still, many companies immediately filter unsolicited e-mails with attachments to the spam folder or directly to the trash: They never even make it to your targets' inboxes. And don't think embedding the image in the text of the e-mail will make it any better—technically that is still an attachment, and the e-mail won't get through. HTML-programmed e-mails are also often filtered out.

So *how* to get seen? The best option for e-mail promos is to send clients a simple text-based e-mail first, telling them you will be sending e-mail promos in the future with embedded/attached images. That way your recipients can add you to their "do not filter out" list. This e-mail should also include an option for the recipient to opt out of all future e-mail campaigns. That's very important—some people do not want e-mail promos at all and giving them the chance to opt out builds trust with these clients. Make sure you respect that trust.

For those targets who just can't accept attachments but want to be included on your e-mail list, another option is to post the promo to a special Web page on your site and include a direct link to that page in your e-mail promo. In fact, this method is very popular and effective.

One important detail: Remember to put the recipients in the BCC (blind carbon copy) address field. Doing so will prevent everyone on your list from seeing the huge list of people you are sending to. It's incredibly annoying to receive an e-mail message with a screen full of names before you even get to the message itself.

Networking

Tips

Of course, none of your tools are going to work for you if you don't have a good understanding of your market. Networking with your target market is a great way to get your name out there and to understand your clients' needs and wants. For example, if you shoot architecture, go to American Institute of Architects (AIA) meetings; if you shoot weddings, go to wedding shows and wedding planner conventions. The better you understand your clients, the more effective you can be in marketing to them and servicing them.

Online ads

Another tool to consider is the online sourcebook. While print sourcebooks like *Workbook* and the *Black Book* are losing favor with clients and thus becoming generally unattractive marketing tools, their Web sites are growing in popularity (see www.workbook.com and

www.blackbook.com). Buying an online sourcebook ad is often a very effective use of your marketing budget. Usually you can build a small online portfolio on their site and get links to your own site and e-mail. Once again, make sure your online ads match your print and e-mail promos, which match your Web site. Even if you can't afford an ad, many of these online sourcebooks offer free listings. Take advantage of those freebies!

PhotoServe (from *Photo District News*) and Find a Photographer listings from the Advertising Photographers of America (APA) and the American Society of Media Photographers (ASMP) are also paying off well for many photographers. In addition to the useful information you can get from being a member of ASMP or APA, your membership can also lead to more work. In fact, there have been multiple reports of photographers earning more than their annual dues in one month with these listings.

Print portfolios

Your print portfolio is still a very important tool and shouldn't be ignored. While more and more projects are being awarded via a review of photographers' Web sites, the best-paying projects usually require a print portfolio review. Again, make sure your portfolio matches your Web site. The worst thing you can do is have a potential client call in your book because of what they see on your Web site (or any other marketing tool) and get a portfolio that doesn't show the same vision. Kiss of death. Seriously.

In the end, all of these steps and tools will improve your business and its bottom line. There's only one more step you should always keep in mind: keep shooting. Self-assignments often result in great work, a clarified vision, and fresh, wonderful material for all your marketing tools.

Consumer Publications

Research is the key to selling any kind of photography. If you want your work to appear in a consumer publication, you're in luck. Magazines are the easiest market to research because they're available on newsstands and at the library and at your doctor's office and . . . you get the picture. So, do your homework. Before you send your query or cover letter and samples, and before you drop off your portfolio on the prescribed day, look at a copy of the magazine. The library is an especially helpful place when searching for sample copies because they're free and there will be at least a year's worth of back issues right on the shelf.

Once you've read a few issues and feel confident your work is appropriate for a particular magazine, it's time to hit the keyboard. Most first submissions take the form of a query or cover letter and samples. So what kind of letter do you send? That depends on what kind of work you're selling. If you simply want to let an editor know you are available for assignments or have a list of stock images appropriate for the publication, send a cover letter, a short business letter that introduces you and your work and tells the editor why your photos are right for the magazine. If you have an idea for a photo essay or plan to provide the text and photos for an article, you should send a query letter, a 1- to 1½-page letter explaining your story or essay idea and why you're qualified to shoot it. (You'll find a sample query letter on the next page.)

Both kinds of letters can include a brief list of publication credits and any other relevant information about yourself. Both also should be accompanied by a sample of your work—a tearsheet, a slide or a printed piece, but never an original negative. Be sure your sample photo is of something the magazine might publish. It will be difficult for the editor of a mountain biking magazine to appreciate your skills if you send a sample of your fashion work.

If your letter piques the interest of an editor, he or she may want to see more. If you live near the editorial office, you can schedule an appointment to show your portfolio in person. Or you can inquire about the drop-off policy—many magazines have a day or two each week when artists can leave their portfolios for art directors. If you're in Wichita and the magazine is in New York, you'll have to send your portfolio through the mail. Consider using FedEx or UPS; both have tracking services that can locate your book if it gets waylaid on its journey. If the publication accepts images in a digital format (most do these days), you can send more samples of your work via e-mail or on a CD—whatever the publication prefers. Make sure you ask first. If you have a Web site, you can provide the photo buyer with the link.

To make your search for markets easier, consult the subject index in the back of this book. The index is divided into topics, and markets are listed according to the types of photographs they want to see. Consumer Publications is the largest section in this book, so take a look at the Subject Index on page 507 before you tackle it.

Sample Query Letter

February 6, 2006

Alicia Pope
2984 Hall Avenue
Cincinnati, OH 45206
e-mail: amp@shoot.net

Connie Albright
Coastal Life
1234 Main Street
Cape Hatteras, NC 27954

Dear Ms. Albright:

I enjoy reading *Coastal Life*, and I'm always impressed with the originality of the articles and photography. The feature on restored lighthouses in the June 2004 edition was spectacular.

I have traveled to many regions along the eastern seaboard and have photographed in several locations along the coast. I have enclosed samples of my work, including 20 slides of lighthouses, sea gulls, sand castles, as well as people enjoying the seaside at all times of the year. I have included vertical shots that would lend themselves to use on the cover. I have also included tearsheets from past assignments with *Nature Photographer*. You may keep the tearsheets on file, but I have enclosed a SASE for the return of the slides when you are done reviewing them.

If you feel any of these images would be appropriate for an upcoming edition of *Coastal Life*, please contact me by phone or e-mail. If you would like to see more of my coast life images, I will be happy to send more.

I look forward to hearing from you in the near future.

Sincerely,

Alicia Pope

Side annotations:

You may also include your Web site in your contact information.

Make sure to address letter to the current photo contact.

Show that you are familiar with the magazine.

Briefly explain your reason for querying.

Enclose copies of relevant work or direct them to your Web site. Never send originals.

Always include a self-addressed, stamped envelope for the magazine's reply.

Consumer Publications

$ ▣ ☑ ⑤ AAA MIDWEST TRAVELER

Auto Club of Missouri, 12901 N. Forty Dr., St. Louis MO 63141. (314)523-7350. Fax: (314)523-6982. E-mail: dreinhardt@aaamissouri.com. Website: www.aaatravelermags.com. **Contact:** Deborah Reinhardt, managing editor. Circ. 470,000. Bimonthly. Emphasizes travel and driving safety. Readers are members of the Auto Club of Missouri. Sample copy and photo guidelines free with SASE (use large manila envelope) or via website.

Needs Buys 3-5 photos/issue. ''We use four-color photos inside to accompany specific articles. Our magazine covers topics of general interest, historical (of Midwest regional interest), profile, travel, car care and driving tips. Our covers are full-color photos mainly corresponding to an article inside. Except for cover shots, we use freelance photos only to accompany specific articles.'' Model release preferred. Photo captions required.

Specs Accepts images in digital format. Send via Zip as TIFF files.

Making Contact & Terms Send query letter with résumé of credits and list of stock photo subjects. Does not keep samples on file; include SASE for return of material. Responds in 1 month. Simultaneous submissions and previously published work OK. Pays $400 for color cover; $75-200 for color inside. **Pays on acceptance.** Credit line given. Buys first, second and electronic rights.

Tips ''Send an 8½×11 SASE for sample copies and study the type of covers and inside work we use. Photo needs driven by an editoral calendar/schedule. Write to request a copy and include SASE.''

$ $ ▣ ACROSS THE BOARD MAGAZINE

The Conference Board, 845 Third Ave., New York NY 10022-6679. (212)339-0455. E-mail: spiezio@confere nce-board.org or atb@conference-board.org. **Contact:** Serena Spiezio, creative director. Circ. 30,000. Estab. 1976. General interest business magazine with 6 monthly issues. Readers are senior executives in large corporations.

Needs Uses 10-15 photos/issue, some supplied by freelancers. Wide range of needs, including location portraits, industrial, workplace, social topics, environmental topics, government and corporate projects, foreign business (especially east and west Europe and Asia).

Specs Accepts digital images.

Making Contact and Terms Query *by e-mail only*; place the word ''Photo'' in the subject line. Cannot return material. ''No phone queries please. We pay $125-400 for inside, up to $1,500 for cover or $400/day for assignments. We buy one-time rights.''

Tips ''Our style is journalistic, and we are assigning photographers who are able to deliver high-quality photographs with an inimitable style. We are interested in running full photo features with business topics from the U.S. or worldwide. If you are working on a project, e-mail. Interested in any **business**-related stories.''

ADVENTURE CYCLIST

Box 8308, Missoula MT 59807. (406)721-1776. Fax: (406)721-8754. E-mail: editor@adventurecycling.org. Website: www.adventurecycling.org/mag. **Contact:** Mike Deme, editor. Circ. 40,000. Estab. 1974. Publication of Adventure Cycling Association. Magazine published 9 times/year. Emphasizes bicycle touring. Sample copy and photo guidelines free with 9×12 SAE and 4 first-class stamps. Guidelines also available online.

Needs Covers. Model release preferred. Photo captions required.

Making Contact & Terms Submit portfolio for review. Responds in 6-9 weeks. Simultaneous submissions and previously published work OK. Payment negotiable. Pays on publication. Credit line given. Buys one-time rights.

$ ▣ ◯ AFTER FIVE MAGAZINE

P.O. Box 492905, Redding CA 96049. (800)637-3540. Fax: (530)335-5335. Website: www.after5online.com. **Contact:** Craig Harrington, publisher. Monthly tabloid. Emphasizes news, arts and entertainment. Circ. 32,000. Estab. 1986.

Needs Buys 1-2 photos from freelancers/issue; 2-24 photos/year. Needs scenic photos of northern California. Also wants regional images of wildlife, rural, adventure, automobiles, entertainment, events, health/fitness, hobbies, humor, performing arts, sports, travel. Model release preferred. Photo captions preferred.

Specs Accepts images in digital format. Send via CD, e-mail, Jaz, Zip as TIFF, JPEG, EPS files at 150 dpi.

Making Contact & Terms Provide résumé, business card, brochure, flier or tearsheets to be kept on file for possible future assignments. Responds in 2 weeks. Previously published work OK. Pays $60 for b&w or color cover; $20 for b&w or color inside. Pays on publication. Credit line given. Buys one-time rights.

Tips "Need photographs of subjects north of Sacramento to Oregon-California border, plus southern Oregon. Query first."

N $ AIM MAGAZINE

P.O. Box 1174, Maywood IL 60153. E-mail: apiladoone@aol.com. Website: www.aimmagazine.org. **Contact:** Myron Apilado, editor. Circ. 7,000. Estab. 1974. Quarterly magazine dedicated to promoting racial harmony and peace. Readers are high school and college students, as well as those interested in social change. Sample copy available for $5 with 9 × 12 SAE and 6 first-class stamps.

Needs Uses 10 photos/issue; 40 photos/year. Needs "ghetto pictures, pictures of people deserving recognition, etc." Needs photos of "integrated schools with high achievement." Model release required.

Specs Uses b&w prints.

Making Contact & Terms Send unsolicited photos by mail for consideration; include SASE. Responds in 1 month. Simultaneous submissions OK. Pays $25-50 for b&w cover; $5-10 for b&w inside. **Pays on acceptance.** Credit line given. Buys one-time rights.

Tips Looks for "positive contributions and social and educational development."

$ ☐ ☑ ALABAMA LIVING

P.O. Box 244014, Montgomery AL 36124. (334)215-2732. Fax: (334)215-2733. E-mail: dgates@areapower.c om. Website: www.alabamaliving.com. **Contact:** Darryl Gates, editor. Circ. 375,000. Estab. 1948. Publication of the Alabama Rural Electric Association. Monthly magazine. Emphasizes rural and suburban lifestyles. Readers are older males and females living in small towns and suburban areas. Sample copy free with 9 × 12 SAE and 4 first-class stamps.

Needs Buys 1-3 photos from freelancers/issue; 12-36 photos/year. Needs photos of babies/children/teens, nature/wildlife, gardening, rural, agriculture, humor, southern region, some scenic and Alabama specific; anything dealing with the electric power industry. Special photo needs include vertical scenic cover shots. Photo captions preferred; include place and date.

Specs Accepts images in digital format. Send via CD, Zip as EPS, JPEG files at 400 dpi.

Making Contact & Terms Send query letter with stock list or transparencies ("dupes are fine") in negative sleeves. Keeps samples on file; include SASE for return of material. Responds in 1 month. Simultaneous submissions and previously published work OK "if previously published out-of-state." Pays $75-200 for color cover; $50 for color inside; $60-75 for photo/text package. **Pays on acceptance**. Credit line given. Buys one-time rights; negotiable.

$ ☐ ALASKA: Exploring Life on The Last Frontier

301 Arctic Slope Ave., Suite 300, Anchorage AK 99518. (907)272-6070. Website: www.alaskamagazine.com. **Contact:** Donna Rae Thompson, editorial assistant. Circ. 183,000. Estab. 1935. Monthly magazine. Readers are people interested in Alaska. Sample copy available for $4. Photo guidelines free with SASE or on website.

Needs Buys 500 photos/year, supplied mainly by freelancers. Photo captions required.

Making Contact & Terms Send carefully edited, captioned submission of 35mm, 2¼ × 2¼ or 4 × 5 transparencies. Include SASE for return of material. Also accepts images in digital format; check guidelines before submitting. Responds in 1 month. Pays $50 maximum for b&w photos; $75-500 for color photos; $300 maximum/day; $2,000 maximum/complete job; $300 maximum/full page; $500 maximum/cover. Buys limited rights, First North American serial rights and electronic rights.

Tips "Each issue of *Alaska* features a 4- to 6-page photo feature. We're looking for themes and photos to show the best of Alaska. We want sharp, artistically composed pictures. Cover photo always relates to stories inside the issue."

☐ ☑ ALTERNATIVES JOURNAL: Canadian Environmental Ideas and Action

Faculty of Environmental Studies, University of Waterloo, Waterloo ON N2L 3G1 Canada. (519)888-4545. Fax: (519)746-0292. E-mail: mruby@fes.uwaterloo.ca. Website: www.alternativesjournal.ca. **Contact:** Marcia Ruby, production coordinator. Circ. 5,000. Estab. 1971. Bimonthly magazine. Emphasizes environmental issues. Readers are activists, academics, professionals, policy makers. Sample copy free with 9 × 12 SAE and 2 first-class stamps.

● "*Alternatives* is a nonprofit organization whose contributors are all volunteer. We are able to give a small honorarium to artists and photographers. This in no way should reflect the value of the work. It symbolizes our thanks for their contribution to *Alternatives*."

Needs Buys 4-8 photos from freelancers/issue; 48-96 photos/year. Subjects vary widely depending on theme

of each issue. "We need action shots of people involved in environmental issues." Upcoming themes: climate change, waste, aid and art. Reviews photos with or without a ms. Photo captions preferred; include who, when, where, environmental significance of shot.

Specs Accepts images in digital format. Send via CD, e-mail as JPEG files at 300 dpi.

Making Contact & Terms "E-mail your Web address/electronic portfolio." Simultaneous submissions and previously published work OK. Pays on publication. Buys one-time rights; negotiable.

Tips "*Alternatives* covers Canadian and global environmental issues. Strong action photos or topical environmental issues are needed—preferably with people. We also print animal shots. We look for positive solutions to problems and prefer to illustrate the solutions rather than the problems. Freelancers need a good background understanding of environmental issues. You need to know the significance of your subject before you can powerfully present its visual perspective."

$ ▣ ◯ AMC OUTDOORS

Appalachian Mountain Club, 4 Joy St., Boston MA 02108. (617)523-0655. Fax: (617)523-0722. E-mail: amcpub lications@outdoors.org. Website: www.outdoors.org. **Contact:** Photo Editor. Circ. 70,000. Estab. 1908. Magazine published 10 times/year (monthly except double issues in January/February and July/August). "Our 94,000 members do more than just read about the outdoors; they get out and play. More than just another regional magazine, *AMC Outdoors* provides information on hundreds of AMC-sponsored adventure and education programs. With award-winning editorial, advice on Northeast destinations and trip planning, recommendations and reviews of the latest gear, AMC chapter news and more, *AMC Outdoors* is the primary source of information about the Northeast outdoors for most of our members." Photo guidelines free with SASE.

Needs Buys 6-12 photos from freelancers/issue; 100 photos/year. Needs photos of adventure, environmental, landscapes/scenics, wildlife, health/fitness/beauty, sports, travel. Other specifc photo needs: people active outdoors. "We seek powerful outdoor images from the Northeast U.S., or non-location-specific action shots (hiking, skiing, snowshoeing, paddling, etc.) Our needs vary from issue to issue, based on content, but are often tied to the season."

Specs Uses color prints or 35mm slides. Accepts images in digital format. Send via CD, Zip, e-mail as TIFF, JPEG files at 250-300 dpi. Lower resolution OK for review of digital photos.

Making Contact & Terms Previously published work OK. Pays $300 (negotiable) for color cover; $50-100 (negotiable) for color inside. Pays on publication. Credit line given. Buys one-time rights.

Tips "We do not run images from other parts of the U.S. or from outside the U.S. unless the landscape background is 'generic.' Most of our readers live and play in the Northeast, are intimately familiar with the region in which they live, and enjoy seeing the area and activities reflected in living color in the pages of their magazines."

$ ▣ AMERICAN ANGLER, The Magazine of Fly Fishing and Fly Tying

Morris Communications, 160 Benmont Ave., Bennington VT 05201. (802)447-1518. Fax: (802)447-2471. Website: www.americanangler.com. **Contact:** Phil Monahan. Circ. 63,500. Estab. 1978. Bimonthly consumer magazine covering "fly fishing only. More how-to than where-to, but we need shots from all over. More domestic than foreign. More trout, salmon, and steelhead than bass or saltwater." Sample copy available for $6 and 9×12 SAE with $2.62 first-class postage or Priority Mail Flat Rate Envelope with $3.85. Photo guidelines available on website.

Needs Buys 10 photos from freelancers/issue; 60 photos/year. "Most of our photos come from writers of articles." Wants photos that convey "the spirit, essence and exhilaration of fly fishing. Always need good fish-behavioral stuff—spawning, rising, riseforms, etc." Photo captions required.

Specs Prefers slides or digital images via CD or e-mail at 300 dpi; must be very sharp with good contrast.

Making Contact & Terms Send query letter with samples, brochure, stock photo list, tearsheets. Provide résumé, business card, self-promotion piece or tearsheets to be kept on file for possible future assignments. Portfolio review by prior arrangement. Query deadline: 6-10 months prior to cover date. Submission deadline: 5 months prior to cover date. Responds in 6 weeks to queries; 1 month to samples. Simultaneous submissions and previously published work OK—"but only for inside 'editorial' use—not for covers, prominent feature openers, etc." Pays $600 for color cover; $30-350 for color inside. Pays on publication. Credit line given. Buys one-time rights, first rights for covers.

Tips "We are sick of the same old shots: grip and grin, angler casting, angler with bent rod, fish being released. Sure, we need them, but there's a lot more to fly fishing. Don't send us photos that look exactly like the ones you see in most fishing magazines. Think like a storyteller. Let me know where the photos were taken, at what time of year, and anything else that's pertinent to a fly fisher."

$▣ AMERICAN ARCHAEOLOGY

The Archaeological Conservancy, 5301 Central NE #902, Albuquerque NM 87108. (505)266-9668. Fax: (505)266-0311. E-mail: tacmag@nm.net. Website: www.americanarchaeology.org. **Contact:** Vicki Singer, art director. Circ. 35,000. Estab. 1997. Quarterly consumer magazine. Sample copies available.

Specs Uses 35mm, 2¼×2¼, 4×5 transparencies. Accepts images in digital format. Send via CD at 300 dpi or higher.

Making Contact & Terms Send query letter with résumé, photocopies and tearsheets. Provide résumé, business card, self-promotion piece to be kept on file for possible future assignments. Responds in 2 months to queries. Previously published work OK. Pays $50 and up for occasional stock images; assigns work by project, pay varies; negotiable. **Pays on acceptance.** Credit line given. Buys one-time rights.

Tips "Study our magazine. Include accurate and detailed captions."

$AMERICAN FITNESS

15250 Ventura Blvd., Suite 200, Sherman Oaks CA 91403. (818)905-0040. **Contact:** Meg Jordan, editor. Circ. 42,000. Estab. 1983. Publication of the Aerobics and Fitness Association of America. Publishes 6 issues/year. Emphasizes exercise, fitness, health, sports nutrition, aerobic sports. Readers are fitness professionals, 75% college educated, 66% female, majority between ages 20-45. Sample copy available for $3.50.

Needs Buys 20-40 photos from freelancers/issue; 120-240 photos/year. Assigns 90% of work. Needs action photography of runners, aerobic classes, swimmers, bicyclists, speedwalkers, in-liners, volleyball players, etc. Also needs food choices, babies/children/teens, celebrities, couples, multicultural, families, parents, senior fitness, people enjoying recreation, cities/urban, rural, adventure, entertainment, events, hobbies, humor, performing arts, sports, travel, medicine, product shots/still life, science. Interested in alternative process, fashion/glamour, seasonal. Model release required.

Specs Uses b&w prints; 35mm, 2¼×2¼ transparencies.

Making Contact & Terms Send query letter with samples, list of stock photo subjects; include SASE for return of material. Responds in 2 weeks. Simultaneous submissions and previously published work OK. Pays $10-35 for b&w or color photo; $50 for text/photo package. Pays 4-6 weeks after publication. Credit line given. Buys first North American serial rights.

Tips Over-40 sports leagues, youth fitness, family fitness and senior fitness are hot trends. Wants high-quality, professional photos of people participating in high-energy activities—anything that conveys the essence of a fabulous fitness lifestyle. Also accepts highly stylized studio shots to run as lead artwork for feature stories. "Since we don't have a big art budget, freelancers usually submit spin-off projects from their larger photo assignments."

$▣ ◪ AMERICAN FORESTS MAGAZINE

734 15th St. NW, 8th Floor, Washington DC 20005. (202)737-1944, ext. 203. Fax: (202)737-2457. E-mail: mrobbins@amfor.org. Website: www.americanforests.org. **Contact:** Michelle Robbins, editor. Circ. 25,000. Estab. 1895. Quarterly publication of American Forests. Emphasizes use, enjoyment and management of forests and other natural resources. Readers are "people from all walks of life, from rural to urban settings, whose main common denominator is an abiding love for trees, forests or forestry." Sample copy and photo guidelines free with magazine-sized envelope and 7 first-class stamps.

Needs Buys 32 photos from freelancers/issue; 128 photos/year. Needs woods scenics, wildlife, woods use/management, and urban forestry shots. Photo captions required; include who, what, where, when and why.

Specs Uses 35mm or larger. Accepts images in digital format. Send via CD as TIFF files at 300 dpi.

Making Contact & Terms "We regularly review portfolios from photographers to look for potential images for upcoming magazines or to find new photographers to work with." Send query letter with résumé of credits. Include SASE for return of material. Responds in 4 months. Pays $400 for color cover; $75-100 for b&w inside; $90-200 for color inside; $250-2,000 for text/photo package. **Pays on acceptance**. Credit line given. Buys one-time rights.

Tips Seeing trend away from "static woods scenics, toward more people and action shots." In samples wants to see "overall sharpness, unusual conformation, shots that accurately portray the highlights and 'outsideness' of outdoor scenes."

$▣ ⑤ THE AMERICAN GARDENER

American Horticultural Society, 7931 E. Boulevard Dr., Alexandria VA 22308-1300. (703)768-5700. Fax: (703)768-7533. E-mail: editor@ahs.org. Website: www.ahs.org. **Contact:** Mary Yee, managing editor. Circ. 34,000. Estab. 1922. Bimonthly magazine. Sample copy available for $5. Photo guidelines free with SASE.

Needs Uses 35-50 photos/issue. Needs photos of plants, gardens, landscapes. Reviews photos with or without ms. Photo captions required; include complete botanical names of plants including genus, species and botanical variety or cultivar.

Specs Prefers color, 35mm slides and 4×5 transparencies. Accepts images in digital format. Send via CD, Zip as EPS, TIFF files at 300 dpi with a preferred canvas size of at least 3×5 inches.

Making Contact & Terms Send query letter with samples, stock list. Photographer will be contacted for portfolio review if interested. Does not keep samples on file; include SASE for return of material. Pays $300 maximum for color cover; $40-125 for color inside. Pays on publication. Credit line given. Buys one-time North American and non-exclusive rights.

Tips ''Lists of plant species for which photographs are needed are sent out to a selected list of photographers approximately 10 weeks before publication. We currently have about 20 photographers on that list. Most of them have photo libraries representing thousands of species. Before adding photographers to our list, we need to determine both the quality and quantity of their collections. Therefore, we ask all photographers to submit both some samples of their slides (these will be returned immediately if sent with a SASE) and a list indicating the types and number of plants in their collection. After reviewing both, we may decide to add the photographer to our photo call for a trial period of 6 issues (1 year).''

$ ▣ AMERICAN HUNTER

11250 Waples Mill Rd., Fairfax VA 22030-9400. (703)267-1336. Fax: (703)267-3971. E-mail: publications@nra hq.org. Website: www.nrapublications.org. **Contact:** J. Scott Olmsted, editor-in-chief. Circ. 1.4 million. Publication of the National Rifle Association. Monthly magazine. Sample copy and photo guidelines free with 9×12 SAE.

Needs Uses wildlife shots and hunting action scenes. Photos purchased with or without accompanying ms. Seeks general hunting stories on North American game. Model release required ''for every recognizable human face in a photo.'' Photo captions preferred.

Specs Uses 35mm color transparencies. Accepts images in digital format. Vertical format required for cover. Send via CD as TIFF, GIF, JPEG files at 300 dpi.

Making Contact & Terms Send material by mail for consideration; include SASE for return of material. Responds in 3 months. Pays $75-450/transparency; $450-600 for color cover; $300-800 for text/photo package. Pays on publication. Credit line given. Buys one-time rights.

Tips ''Most successful photographers maintain a file in our offices so editors can select photos to fill holes when needed. We keep files on most North American big game, small game, waterfowl, upland birds, and some exotics. We need live hunting shots as well as profiles and portraits in all settings. Many times there is not enough time to call photographers for special needs. This practice puts your name in front of the editors more often and increases the chances of sales.''

$ ▣ AMERICAN MOTORCYCLIST

13515 Yarmouth Dr., Pickerington OH 43147. (614)856-1900. Fax: (614)856-1920. E-mail: ama@ama-cycle.o rg. Website: www.amadirectlink.com. **Contact:** Bill Wood, director of communications. Managing Editor: Bill Parsons. Circ. 245,000. Monthly magazine of the American Motorcyclist Association. For ''enthusiastic motorcyclists, investing considerable time in road riding or competition sides of the sport. We are interested in people involved in, and events dealing with, all aspects of motorcycling.'' Sample copy and photo guidelines available for $1.50.

Needs Buys 10-20 photos/issue. Subjects include: travel, technical, sports, humorous, photo essay/feature and celebrity/personality. Photo captions preferred.

Specs Uses 5×7 or 8×10 semigloss prints; transparencies. Accepts images in digital format. Send via CD as TIFF, GIF, JPEG files at 300 dpi.

Making Contact & Terms Send query letter with samples to be kept on file for possible future assignments. Responds in 3 weeks. Pays $50-150/photo; $50-150/slide; $250 minimum for cover. Also buys photos in photo/text packages according to same rate; pays $8/column inch minimum for story. Pays on publication. Buys first North American serial rights.

Tips ''The cover shot is tied in with the main story or theme of that issue and generally needs to be with accompanying manuscript. Show us experience in motorcycling photography and suggest your ability to meet our editorial needs and complement our philosophy.''

$ ▣ ◩ ⒮ AMERICAN TURF MONTHLY

747 Middle Neck Rd., Suite 103, Great Neck NY 11024. (516)773-4075. Fax: (516)773-2944. E-mail: editor@a mericanturf.com. Website: www.americanturf.com. **Contact:** James Corbett, editor-in-chief. Circ. 30,000.

Estab. 1946. Monthly magazine covering Thoroughbred horse racing, especially aimed at horseplayers and handicappers.

Needs Buys 10 photos from freelancers/issue; 120 photos/year. Needs photos of celebrities, racing action, horses, owners, trainers, jockeys. Reviews photos with or without ms. Photo captions preferred; include who, what, where.

Specs Uses glossy color prints. Accepts images in digital format. Send via CD, floppy disk, Zip as TIFF, JPEG files at 300 dpi.

Making Contact & Terms Send query letter with CD, prints. Provide business card to be kept on file for possible future assignments. Responds only if interested; send nonreturnable samples. Pays $150 minimum for color cover; $25 minimum for b&w or color inside. Pays on publication. Credit line given. Buys all rights.

Tips Like horses and horse racing.

▣ ANCHOR NEWS

75 Maritime Dr., Manitowoc WI 54220. (920)684-0218. Fax: (920)684-0219. E-mail: museum@WisconsinMar itime.org. Website: www.WisconsinMaritime.org. **Contact:** Sarah Spude-Olson, marketing specialist. Circ. 1,900. Publication of the Wisconsin Maritime Museum. Quarterly magazine. Emphasizes Great Lakes maritime history. Readers include learned and lay readers interested in Great Lakes history. Sample copy available for 9×12 SAE and $1 postage. Photo guidelines free with SASE.

Needs Uses 8-10 photos/issue; infrequently supplied by freelance photographers. Needs historic/nostalgic, personal experience and general interest articles on Great Lakes maritime topics. How-to and technical pieces and model ships and shipbuilding are OK. Special needs include historic photography or photos that show current historic trends of the Great Lakes. Photos of waterfront development, bulk carriers, sailors, recreational boating, etc. Model release required. Photo captions required.

Specs Accepts images in digital format. Send via CD, Zip, e-mail as TIFF, JPEG files.

Making Contact & Terms Send 4×5 or 8×10 glossy b&w prints by mail for consideration; include SASE for return of material. Simultaneous submissions and previously published work OK. Pays in copies on publication. Credit line given. Buys first North American serial rights.

Tips ''Besides historic photographs, I see a growing interest in underwater archaeology, especially on the Great Lakes, and underwater exploration—also on the Great Lakes. Sharp, clear photographs are a must. Our publication deals with a wide variety of subjects; however, we take a historical slant with our publication. Therefore photos should be related to a historical topic in some respect. Also, there are current trends in Great Lakes shipping. A query is most helpful. This will let the photographer know exactly what we are looking for and will help save a lot of time and wasted effort.''

ⓝ $ANTIETAM REVIEW

41 S. Potomac St., Hagerstown MD 21740-5512. (310)791-3132. Fax: (240)420-1754. E-mail: antietamreview @washingtoncountyarts.com. (For queries/inquiries only—electronic submissions not accepted.) Website: www.washingtoncountyarts.com. **Contact:** Mary Jo Vincent, managing editor. Annual literary magazine covering fiction (short stories), poetry and b&w photography which have not been previously published. Estab. 1982. Circ. 1,000. Sample copy available for $6.30 (back issue) or $8.40 (current issue).

Making Contact & Terms Guidelines available upon request with #10 SASE or via website. Pays $25 per photo published and 2 contributor's copies.

APERTURE

547 West 27th St., 4th Floor, New York NY 10001. (212)505-5555. E-mail: info@aperture.org. Website: www.aperture.org. **Contact:** Michael Famighetti, managing editor. Circ. 30,000. Quarterly. Emphasizes fine art and contemporary photography, as well as social reportage. Readers include photographers, artists, collectors, writers.

Needs Uses about 60 photos/issue; biannual portfolio review. Model release required. Photo captions required.

Making Contact & Terms Submit portfolio for review in January and July; include SASE for return of material. Responds in 2 months. No payment. Credit line given.

Tips ''We are a nonprofit foundation. Do not send portfolios outside of January and July.''

$▣ ☑ APPALACHIAN TRAIL JOURNEYS

(formerly *Appalachian Trailway News*), Box 807, 799 Washington St., Harpers Ferry WV 25425. (304)535-6331. Fax: (304)535-2667. E-mail: kmallow@appalachiantrail.org. Website: www.appalachiantrail.org. **Con-**

tact: Marty Bartels, director of marketing & communications. Circ. 35,000. Estab. 2005. Bimonthly publication of the Appalachian Trail Conservancy. Uses only photos related to the Appalachian Trail. Readers are conservationists, hikers. Photo guidelines available on website.

Needs Buys 4-5 photos from freelancers/issue in addition to 2- to 4-page "Vistas" spread each issue; 50-60 photos/year. Most frequent need is for candids of people enjoying the trail. Photo captions and release required.

Specs Uses 5×7 or larger glossy b&w prints or 35mm transparencies. Accepts images in digital format at 300 dpi.

Making Contact & Terms Send query letter with ideas by mail, e-mail. Duplicate slides preferred over originals for query. Responds in 3 weeks. Simultaneous submissions and previously published work OK. **Pays on publication.** Pays $250 for cover; variable for inside. Credit line given. Rights negotiable.

$▣ ◭ AQUARIUM FISH MAGAZINE

P.O. Box 6050, Mission Viejo CA 92690. Fax: (949)855-3045. E-mail: aquariumfish@fancypubs.com. Website: www.aquariumfish.com. **Contact:** Patricia Knight, managing editor. Estab. 1988. Monthly magazine. Emphasizes aquarium fish. Readers are both genders, all ages. Photo guidelines free with SASE, on website or by e-mail.

Needs Buys 30 photos from freelancers/issue; 360 photos/year. Needs photos of aquariums and fish, freshwater and saltwater; ponds.

Specs Uses 35mm slides, transparencies; original prints are preferred. Accepts digital images—"but digital image guidelines must be strictly followed for submissions to be considered."

Making Contact & Terms Send slides, transparencies, original prints (no laser printouts) or CDs (no DVDs) by mail for consideration; include SASE for return of material. Pays $200 for color cover; $15-150 for color inside. Pays on publication. Credit line given. Buys first North American serial rights.

$▣ ◭ ARTEMIS MAGAZINE, Science and Fiction for a Space-Faring Age

LRC Publications, 1380 E. 17th St., Suite 201, Brooklyn NY 11230-6011. (718)375-3862. Website: www.lrcpublications.com. **Contact:** Ian Randal Strock, editor. Circ. 4,000. Estab. 2000. Quarterly magazine emphasizing science and fiction with a predeliction for the moon and near-earth space. Sample copy available for $5 and 9×12 SAE with $1.21 first-class postage. Photo guidelines free with SASE or via website.

* **Currently not accepting submissions. Submissions will be sent back unopened while on hiatus seeking additional funding.**

Needs Buys very few photos from freelancers/issue. Needs photos of environment, landscapes/scenics, adventure, entertainment, hobbies, humor, sports, travel, business concepts, military, political, science, technology/computers. Reviews photos with or without ms. Photo captions preferred.

Specs Uses color and/or b&w prints. Accepts images in digital format. Send via CD as TIFF, GIF, JPEG files at 300 dpi.

Making Contact & Terms Send query letter with prints, photocopies, tearsheets. Keeps samples on file. Responds only if interested; send nonreturnable samples. Previously published work OK. Pays $100 minimum for color cover; $25 minimum for b&w or color inside. **Pays on acceptance.** Credit line given. Buys one-time rights.

Tips "We haven't published much photography (other than NASA images), but we're open to seeing and running more. We're publishing in an all-glossy format, so we're much more open to photos."

$▣ ◭ Ⓐ ▩ ASCENT MAGAZINE, yoga for an inspired life

Timeless Books, 837 Rue Gilford, Montreal QC H2J 1P1 Canada. (514)499-3999. Fax: (514)499-3904. E-mail: design@ascentmagazine.com. Website: www.ascentmagazine.com. **Contact:** Joe Ollmann, designer. Circ. 7,500. Estab. 1999. Quarterly consumer magazine. Focuses on the personal transformational and spiritual aspects of yoga and meditation. The writing is intimate and literary, with a focus on the living aspects of spiritual inquiry. Sample copy available for $8. Photo guidelines available via e-mail.

Needs Buys 12 photos from freelancers/issue; 48 photos/year. Interested in alternative process, avant garde, documentary, fine art. Other specific photo needs: yoga, meditation. Reviews photos with or without ms. Model release required; property release preferred. Photo captions preferred; include title, artist, date.

Specs Uses glossy color and/or b&w prints. Accepts images in digital format. Send via CD, e-mail as TIFF, JPEG files at 300 dpi.

Making Contact & Terms Send query letter with résumé, self-promotion piece to be kept on file for possible future assignments. Responds in 2 months to queries; 2 months to portfolios. Previously published work OK.

Pays $150-250 for b&w cover; $300-800 for color cover; $50-200 for b&w inside. Pays on publication. Credit line given. Buys first rights; negotiable.

Tips Prefers classic and abstract black & white. Should be literate and willing to work with content.

$⬛🅰 ATLANTA HOMES & LIFESTYLES

1100 Johnson Ferry Rd. NE, Suite 595, Atlanta GA 30342. (404)252-6670. Website: www.atlantahomesmag.com. **Contact:** Clinton Ross Smith, editor. Creative Director: Gill Autrey. Circ. 34,000. Estab. 1983. Magazine published 8 times/year. Covers residential design (home and garden); food, wine and entertaining; people, lifestyle subjects in the Metro Atlanta area. Sample copy available for $3.95.

Needs Needs photos of homes (interior/exterior), people, decorating ideas, products, gardens. Model/property release required. Photo captions preferred.

Specs Uses 35mm, 2¼×2¼, 4×5 transparencies.

Making Contact & Terms Contact creative director to review portfolio. Provide résumé, business card, brochure, flier or tearsheets to be kept on file for possible future assignments. Responds in 2 months. Simultaneous submissions and previously published work OK. Pays $150-750/job. **Pays on acceptance**. Credit line given. Buys one-time rights.

$⬛ ATLANTA PARENT

2346 Perimeter Park Dr., Atlanta GA 30341. (770)454-7599. Fax: (770)454-7699. E-mail: rmintz@atlantaparent.com. Website: www.atlantaparent.com. **Contact:** Robin Mintz, general manager. Circ. 110,000. Estab. 1983. Monthly magazine. Emphasizes parents, families, children, babies. Readers are parents with children ages 0-18. Sample copy available for $3.

Needs Needs professional-quality photos of babies, children involved in seasonal activities, parents with kids and teenagers. Also needs photos showing racial diversity. Model/property release required.

Specs Accepts images in digital format. Send via CD, e-mail as TIFF, EPS, JPEG files at 300 dpi.

Making Contact & Terms Send query letter with samples via e-mail. Keeps samples on file for future consideration. Simultaneous submissions and previously published work OK. Pays after publication. Credit line given.

$⬛ ◯ AUTO RESTORER

P.O. Box 6050, Mission Viejo CA 92690. (949)855-8822, ext. 3412. Fax: (949)855-3045. E-mail: tkade@fancypubs.com. Website: www.autorestorermagazine.com. **Contact:** Ted Kade, editor. Circ. 60,000. Estab. 1989. Monthly magazine. Emphasizes restoration of collector cars and trucks. Readers are male (98%), professional/technical/managerial, ages 35-65.

Needs Buys 47 photos from freelancers/issue; 564 photos/year. Needs photos of auto restoration projects and restored cars. Reviews photos with accompanying ms only. Model/property release preferred. Photo captions required; include year, make and model of car; identification of people in photo.

Specs Prefers transparencies, mostly 35mm, 2¼×2¼. Accepts images in high-resolution digital format. Send via CD at 240 dpi with minimum width of 5 inches.

Making Contact & Terms Submit inquiry and portfolio for review. Provide résumé, business card, brochure, flier or tearsheets to be kept on file for possible future assignments. Responds in 1 month. Simultaneous submissions OK. Pays $50 for b&w cover; $35 for b&w inside. Pays on publication. Credit line given. Buys first North American serial rights; negotiable.

Tips Looks for "technically proficient or dramatic photos of various automotive subjects, auto portraits, detail shots, action photos, good angles, composition and lighting. We're also looking for photos to illustrate how-to articles such as how to repair a damaged fender or how to repair a carburetor."

🅽 ◉ BABYTALK

530 Fifth Ave., 3rd Floor, New York NY 10036. (212)522-8793. Fax: (212)522-8770. E-mail: nancy_smith@timeinc.com. Website: www.babytalk.com. **Contact:** Nancy Smith, art director. Estab. 1937. *Babytalk* is a monthly consumer magazine with a non-newsstand circulation of 2 million for new mothers and pregnant women. It is distributed via subscription and through physicians' offices and retail outlets. Sample copies available upon request.

Making Contact & Terms Send query letter and printed samples; include URL for your website. After introductory mailing, send follow-up postcard every 3 months. Samples are kept on file. Responds only if interested. Portfolios not required. **Pays on acceptance.** Buys one-time rights, reprint rights, all rights, electronic rights. Finds freelancers through agents, artists' submissions, word of mouth and sourcebooks.

Tips "Please no calls or e-mails. Postcards or mailers are best. We don't look at portfolios unless we request them. Websites listed on mailers are great."

$ $▣ ◱ BACKPACKER MAGAZINE

135 North 6th St., Emmaus PA 18098. (610)967-8371. Fax: (610)967-8181. E-mail: jackie.ney@rodale.com. Website: www.backpacker.com. **Contact:** Jackie Ney, photo editor. Photo Assistant: Genny Wright (genny.wright@rodale.com; (610)967-7754). Magazine published 9 times/year. Readers are male and female, ages 35-45. Photo guidelines available via website or free with SASE marked Attn: Guidelines.

Needs Buys 80 photos from freelancers/issue; 720 photos/year. Needs transparencies of people backpacking, camping, landscapes/scenics. Reviews photos with or without ms. Model/property release required.

Specs Accepts images in digital format. Send via CD, Zip, e-mail as JPEG files at 72 dpi for review (300 dpi needed to print).

Making Contact & Terms Send query letter with résumé of credits, photo list and example of work to be kept on file. Sometimes considers simultaneous submissions and previously published work. Pays $500-1,000 for color cover; $100-600 for color inside. Pays on publication. Credit line given. Rights negotiable.

Ⓝ $ $▣ ◱ Ⓢ BACKYARD LIVING

Reiman Media Group, Inc., 5400 S. 60th St., Greendale WI 53129. Fax: (414)423-8436. E-mail: photocoordinator@reimanpub.com. Website: www.backyardlivingmagazine.com. **Contact:** Trudi Bellin, photo coordinator. Estab. 2004. Bimonthly magazine. Readers are ages 30-60, 60% female, 40% male. Readers enjoy gardening, outside entertaining and weekend projects. Heavy interest in "amateur" gardening of both vegetables and flowers, backyard dining and grilling for family and friends as well as folks engaged in quick weekend projects such as building a dog house. *Backyard Living* is a fun, useful hands-on magazine that helps readers quickly and easily create and enjoy the backyard of their dreams. Sample copy available for $2.

Needs Buys 25 photos from freelancers/issue; 150 photos/year. Needs photos of backyard gardening (both flowers and vegetables), outdoor entertaining in private yards and weekend home projects. Covers should include "human element" so that it looks like a backyard setting. Also include vacant space or selective focus for type to read clearly. Particular needs: backyard makeovers (befores and afters); backyard entertaining; gardening features with how-tos.

Specs Prefers color transparencies, all sizes. Accepts images in digital format. Send via lightboxes, CD/DVD with printed thumbnails and caption sheet, or e-mail if first review selection is small (12 images or less).

Making Contact & Terms Send query letter with résumé of credits, stock list. Send unsolicited photos by mail for consideration. Keep samples on file (tearsheets; no dupes); include SASE for return of material. Responds in 3 months for first review. Simultaneous submissions and previously published work OK. Buys stock only. Pays $300 for cover; $200 for back cover; $100-300 for inside. Pays on publication. Credit line given. Buys one-time rights. Purchases "work for hire." Also wants electronic rights for all printed photographs.

Tips "We want lifestyle images; action is welcome. Study our magazine thoroughly—those who can supply what we need can expect to be regular contributors. Very interested in photos of people involved in typical backyard activities. *Backyard Living* is an opportunity to see your photos used large and beautiful, in all their glory. Design is outstanding, making your work portfolio-quality."

$▣ ◯ BALLOON LIFE

P.O. Box 7, Litchfield CT 06759. (860)567-2061. E-mail: mick_murphy@balloonlife.com. Website: www.balloonlife.com. **Contact:** Mick Murphy, editor. Circ. 4,000. Estab. 1986. Monthly magazine. Emphasizes sport ballooning. Readers are sport balloon enthusiasts. Sample copy free with 9×12 SAE and 6 first-class stamps. Photo guidelines free with SASE.

Needs Rarely buys stock. Query first about the magazine's anticipated stock needs; include stock list. Assignments are occasionally made to shoot either specific events, flights, or subjects. Model/property release preferred. Photo captions preferred.

Specs Uses 35mm transparencies and color or b&w prints. Accepts images in digital format. Send via CD, Zip, e-mail as TIFF, JPEG files at 300 dpi.

Making Contact & Terms Send b&w or color prints or 35mm transparencies by mail for consideration. Responds in 1 month. Simultaneous submissions and previously published work OK. Pays $50 for b&w or color cover; $15 for b&w or color inside. Pays on publication. Credit line given. Buys one-time and first North American serial rights.

Tips "Generally, photographs should be accompanied by a story. Cover the basics first—good exposure,

sharp focus, color saturation, etc. Then get creative with framing and content. Often we look for one single photograph that tells readers all they need to know about a specific flight or event. We're evolving our coverage of balloon events into more than just 'pretty balloons in the sky.' I'm looking for photographers who can go the next step and capture the people, moments in time, unusual happenings, etc., that make an event unique. Query first with interest in the sport, access to people and events, experience shooting balloons or other outdoor special events.''

$ BALTIMORE

1000 Lancaster St., Suite 400, Baltimore MD 21202. (410)752-4200. Fax: (410)625-0280. E-mail: wamanda@b altimoremagazine.net. Website: www.baltimoremagazine.net. **Contact:** Amanda Laine White-Iseli, art director. Assistant Art Director: Andrea Prebish. Director of Photography: David Colwell. Circ. 50,000. Estab. 1907. Monthly magazine for Baltimore region. Readers are educated Baltimore denizens, ages 35-60. Sample copy available for $3.95 with 9×12 SASE.

Needs Buys 30-50 photos from freelancers/issue; 360-600 photos/year. Needs photos of lifestyle, profile, news, food, etc. Special photo needs include photo essays about Baltimore. Model release required. Photo captions required; include name, age, neighborhood, reason/circumstances of photo.

Making Contact & Terms Provide résumé, business card, brochure, flier or tearsheets to be kept on file for possible future assignments. Include SASE with photo essays. Responds in 1 month. Pays $100-350/day. Pays 30 days past invoice. Credit line given. Buys first North American serial rights; negotiable.

🎨 BASEBALL

2660 Petersborough St., Herndon VA 20171. E-mail: shannonaswriter@yahoo.com. Quarterly magazine covering baseball. Photo guidelines available by e-mail request.

Needs Wants photos of baseball scenes featuring children and teens; photos of celebrities, couples, multicultural, families, parents, environmental, landscapes/scenics, wildlife, agriculture—as related to the sport of baseball. Interested in alternative process, avant garde, documentary, fine art, historical/vintage, seasonal. Reviews photos with or without ms.

Specs Uses glossy or matte color and/or b&w prints.

Making Contact & Terms Send query letter via e-mail. ''If possible, please do not include photographs in files if they are sent through e-mail. A disk with your photographs sent to *Baseball* is acceptable. If you plan to send a disk, photographs or portfolio, please send an e-mail stating this.'' Provide résumé, business card, self-promotion piece to be kept on file for possible future assignments. Responds within 1 month to queries; 1 week to portfolios. Simultaneous submissions and previously published work OK. **Pays on acceptance.** Credit line given. Buys one-time, first rights; negotiable.

📷 📁 💾 BC OUTDOORS: HUNTING & SHOOTING

OP Publishing Ltd., 1080 Howe St., Suite 900, Vancouver BC V6Z 2T1 Canada. (604)606-4644. Fax: (604)687-1925. E-mail: clumsdon@oppublishing.com. Website: www.oppublishing.com. **Contact:** Chris Lumsdon, editor. Circ. 35,000. Estab. 1945. Emphasizes hunting, RV camping, wildlife and management issues in British Columbia only. Published 2 times/year. Sample copy available for $4.95 (Canadian).

Needs Buys 30-35 photos from freelancers/issue; 60-70 photos/year. ''Hunting, canoeing and camping. Family oriented. By far, most photos accompany manuscripts. We are always on the lookout for good covers—wildlife, recreational activities, people in the outdoors—of British Columbia, vertical and square format. Photos with manuscripts must, of course, illustrate the story. There should, as far as possible, be something happening. Photos generally dominate lead spread of each story. They are used in everything from double-page bleeds to thumbnails. Column needs basically supplied inhouse.'' Model/property release preferred. Photo captions or at least full identification required.

Making Contact & Terms Send by mail for consideration actual 5×7 or 8×10 color prints; 35mm, 2¼×2¼, 4×5 or 8×10 color transparencies; color contact sheet. If color negative, send jumbo prints, then negatives only on request. Or e-mail high-resolution electronic images. Send query letter with list of stock photo subjects. Include SASE or IRC. Pays in Canadian currency. Simultaneous submissions not acceptable if competitor. Editor determines payments. Pays on publication. Credit line given. Buys one-time rights inside; with covers ''we retain the right for subsequent promotional use.''

📷 📁 💾 BC OUTDOORS: SPORT FISHING & OUTDOOR ADVENTURE

OP Publishing Ltd., 1080 Howe St., Suite 900, Vancouver BC V6Z 2T1 Canada. (604)606-4644. Fax: (604)687-1925. E-mail: clumsdon@oppublishing.com. Website: www.oppulibhisn.com. **Contact:** Chris Lumsdon, edi-

tor. Circ. 35,000. Estab. 1945. Emphasizes fishing, both fresh water and salt. Published 6 times/year. Sample copy available for $4.95 (Canadian).

Needs Buys 30-35 photos from freelancers/issue; 180-210 photos/year. "Fishing (in our territory) is a big need—people in the act of catching or releasing fish. Family oriented. By far, most photos accompany manuscripts. We are always on the lookout for good covers—fishing, wildlife, recreational activities, people in the outdoors—of British Columbia, vertical and square format. Photos with manuscripts must, of course, illustrate the story. There should, as far as possible, be something happening. Photos generally dominate lead spread of each story. They are used in everything from double-page bleeds to thumbnails. Column needs basically supplied inhouse." Model/property release preferred. Photo captions or at least full identification required.

Making Contact & Terms Send by mail for consideration actual 5×7 or 8×10 color prints; 35mm, 2¼×2¼, 4×5 or 8×10 color transparencies; color contact sheet. Or e-mail high-resolution electronic images. If color negative, send jumbo prints, then negatives only on request. Send query letter with list of stock photo subjects. Include SASE or IRC. Pays in Canadian currency. Simultaneous submissions not acceptable if competitor. Editor determines payments. Pays on publication. Credit line given. Buys one-time rights inside; with covers "we retain the right for subsequent promotional use."

$ 🖥 📷 THE BEAR DELUXE MAGAZINE

Orlo, P.O. Box 10342, Portland OR 97296. (503)242-1047. E-mail: bear@orlo.org. Website: www.orlo.org. **Contact:** Thomas Cobb or Kristen Rogers, art directors. Circ. 20,000. Estab. 1993. Quarterly magazine. "We use the arts to focus on environmental themes." Sample copy available for $3. Photo guidelines available for SASE.

Needs Buys 10 photos from freelancers/issue; 40 photos/year. Needs photos of environmental, landscapes/scenics, wildlife, adventure, political. Reviews photos with or without ms. Model release required (as needed); property release preferred. Photo captions preferred; include place, year, photographer, names of subjects.

Specs Uses 8×10 matte b&w prints. Accepts images in digital format. Send via CD, Zip, or low-res e-mail files.

Making Contact & Terms Send query letter with résumé, slides, prints, photocopies. Portfolio may be dropped off by appointment. Provide résumé, self-promotion piece to be kept on file for possible future assignments. Responds in 6 months to queries; 2 months to portfolios. Only returns materials if appropriate SASE included. Not liable for submitted materials. Simultaneous submissions and previously published work OK as long as it is noted as such. Pays $200 for b&w cover; $30-50 for b&w inside. Pays approximately 3 weeks after publication. Credit line given. Buys one-time rights; negotiable.

Tips "Read the magazine. We want unique and unexpected photos, not your traditional nature or landscape stuff."

$ 🖥 ◯ BIBLE ADVOCATE

P.O. Box 33677, Denver CO 80233. E-mail: bibleadvocate@cog7.org. Website: www.cog7.org/BA/. **Contact:** Sherri Langton. Circ. 13,500. Estab. 1863. Publication of the Church of God (Seventh Day). Magazine published 8 times/year. Gives a voice for the Bible and represents the Church of God. Sample copy free with 9×12 SAE and 3 first-class stamps.

Needs Needs photos of people, especially Hispanics and other ethnic groups, social issues, churches, congregations worshiping in church and being involved in church activities, Israel. Photo captions preferred; include name, place.

Specs Accepts images in digital format. Send via CD, Zip, e-mail as TIFF, JPEG files at 300 dpi.

Making Contact & Terms Submit portfolio for review; include SASE for return of material. "Digital work is easiest for us to access. E-mail is preferred." Responds as needed. Simultaneous submissions and previously published work OK. Pays $25-50 for color cover; $10-35 for color inside. Rights negotiable.

Tips "Because of our limited budget, we don't purchase many freelance photos. We prefer to buy CDs of freelance work to save money. Please, *no scenics*. We really need people shots."

$ 🖥 BIRD TIMES

Pet Publishing, Inc., 7-L Dundas Circle, Greensboro NC 27407-1645. (336)292-4047. Fax: (336)292-4272. E-mail: editorial@petpublishing.com. Website: www.birdtimes.com. **Contact:** Rita Davis, executive editor. Bimonthly magazine. Emphasizes pet birds, birds in aviculture, plus some feature coverage of birds in nature. Sample copy available for $5 and 9×12 SASE. Photo guidelines free with SASE.

Needs Needs photos of pet birds. Special needs arise with story schedule. Common pet birds are always in demand (cockatiels, parakeets, etc.) Photo captions required; include common and scientific name of bird; additional description as needed. "Accuracy in labeling is essential."

Specs Prefers digital images. Send full-size submissions at 266 dpi on CD-ROM.

Making Contact & Terms Send unsolicited photos by mail for consideration; include SASE for return of material. "Please send duplicates. We cannot assume liability for originals." Pays $100 for color cover; $20 for color inside. Pays on publication. Buys all rights; negotiable.

Tips "We are looking for pet birds primarily, but we frequently look for photos of some of the more exotic breeds, and we look for good composition (indoor or outdoor). Photos must be professional and of publication quality—in focus and with proper contrast. We work regularly with a few excellent freelancers, but are always on the lookout for new contributors. Images we think we might be able to use will be scanned into our CD-ROM file and the slides returned to the photographer."

$⬛ Ⓢ BIRD WATCHER'S DIGEST

149 Acme St., Marietta OH 45750. (740)373-5285. E-mail: editor@birdwatchersdigest.com. Website: www.bir dwatchersdigest.com. **Contact:** Bill Thompson III, editor. Circ. 99,000. Bimonthly; digest size. Emphasizes birds and bird watchers. Readers are bird watchers/birders (backyard and field, veterans and novices). Sample copy available for $3.99. Photo guidelines available via website.

Needs Buys 25-35 photos from freelancers/issue; 150-210 photos/year. Needs photos of North American species.

Making Contact & Terms Send query letter with list of stock photo subjects, samples, SASE. Responds in 2 months. **Work previously published in other bird publications should not be submitted.** Pays $75 for color inside. Pays on publication. Credit line given. Buys one-time rights.

Tips "Query with slides to be considered for photograph want-list. Send a sample of at least 20 slides for consideration. Sample will be reviewed and responded to in 8 weeks."

$⬛ ⬛ ⬛ BIRD WATCHING MAGAZINE

EMAP Active Ltd., Bretton Court, Bretton, Peterborough PE3 8DZ United Kingdom. (44)(733)264666. Fax: (44)(733)465376. E-mail: sue.begg@emap.com. Website: www.birdwatching.co.uk. Circ. 22,000. Estab. 1986. Monthly hobby magazine for bird watchers. Sample copy free for SAE with first-class postage/IRC.

Needs Needs photos of "wild birds photographed in the wild, mainly in action or showing interesting aspects of behavior. Also stunning landscape pictures in birding areas and images of people with binoculars, telescopes, etc." Also considers travel, hobby and gardening shots related to bird watching. Reviews photos with or without ms. Photo captions preferred.

Specs Uses 35mm, $2\frac{1}{4} \times 2\frac{1}{4}$ transparencies. Accepts images in digital format. Send via CD, e-mail as TIFF, EPS, JPEG files at 200 dpi.

Making Contact & Terms Provide résumé, business card, self-promotion piece or tearsheets to be kept on file for possible future assignments. Returns unsolicited material if SASE enclosed. Responds in 1 month. Simultaneous submissions OK. Pays £70-100 for color cover; £15-120 for color inside. Pays on publication. Buys one-time rights.

Tips "All photos are held on file here in the office once they have been selected. They are returned when used or a request for their return is made. Make sure all slides are well labeled: bird, name, date, place taken, photographer's name and address. Send sample of images to show full range of subject and photographic techniques."

Ⓝ $ $⬛ ⬛ BIRDER'S WORLD

Kalmbach Publishing Co., 21027 Crossroads Circle, Waukesha WI 53187-1612. (262)796-8776, ext. 426. E-mail: emastroianni@birdersworld.com. Website: www.birdersworld.com. **Contact:** Ernie Mastroianni, photo editor. Circ. 55,000. Estab. 1987. Bimonthly consumer magazine. "Our readers are avid bird watchers, ornithologists and those interested in wildlife." Sample copy available for 9×12 SAE with first-class postage. Photo guidelines available on website.

Needs Buys 30 photos from freelancers/issue; 180 photos/year. Interested in landscapes/scenics, wildlife, hobbies, travel. Reviews photos with or without a manuscript. Photo captions should include species of bird, date and place.

Specs Accepts images in digital format. Send via CD as TIFF or JPEG files at 300 dpi.

Making Contact & Terms Send query letter with slides, transparencies or full-resolution digital images in JPEG format on CD to be kept on file for possible future assignments. Responds in 1 week to queries; 1

month to portfolios. Previously published work OK. Pays $250 minimum for color cover; $100 minimum for color inside; $125 for full page; $200 for spread. Pays on publication. Credit line given. Buys one-time rights.

Tips "Our contributors are well-established wildlife photographers who submit photographs in response to an e-mail want list. To be considered for placement on the want list, submit a portfolio of 20-40 transparencies of full-resolution digital images on a CD with complete captions. We need images of birds in their natural habitat. We generally do not publish pictures of pets or birds in captivity. If an image is digitally altered or a composite, please tell us. We also publish our readers' best photos in our Gallery section, but we do not pay for images in that section. I like to see complete captions. Tell me the species name and the date and place where a photo was taken."

$ $⬛ ⬛ ⬚ Ⓢ BIRDS & BLOOMS

Reiman Media Group, Inc., 5400 S. 60th St., Greendale WI 53129. Fax: (414)423-8463. E-mail: photocoordinat or@reimanpub.com. Website: www.birdsandblooms.com. **Contact:** Trudi Bellin, photo coordinator. Estab. 1994. Bimonthly magazine. Celebrates "the beauty in your own backyard." Readers are male and female, ages 30-50 (majority), who prefer to spend their spare time in their "outdoor living room." Heavy interest in "amateur" gardening, backyard bird watching and bird feeding. Sample copy available for $2.

• *Birds & Blooms EXTRA* is published in the months between regular issues. Content and guidelines are the same.

Needs Buys 45 photos from freelancers/issue; 250 photos/year. Needs photos of gardening, rural birding, landscapes, hobbies and seasonal.

Specs Prefers color transparencies, all sizes. Accepts images in digital format. Send via lightboxes, CD/DVD with printed thumbnails and caption sheet, or e-mail if first review selection is small (12 images or less).

Making Contact & Terms Send query letter with résumé of credits, stock list. Send unsolicited photos by mail for consideration. Keeps samples on file (tearsheets; no dupes); include SASE for return of material. Responds in 3 months for first review. Simultaneous submissions and previously published work OK. Buys stock only. Pays $100-300 for inside; $300 for cover; $200 for back cover. Pays on publication. Credit line given. Buys one-time rights. "Magazine generates an annual book; you can count on most images appearing again in the annual at a re-use rate."

Tips "Technical quality is extremely important; focus must be sharp (no soft focus), and colors must be vivid so they 'pop off the page.' Study our magazine thoroughly—we have a continuing need for sharp, colorful images, and those who can supply what we need can expect to be regular contributors. Very interested in photos of people involved in typical backyard activities."

⬛ ◯ Ⓐ ⬚ BLACKFLASH

Buffalo Berry Press, P.O. Box 7381, Station Main, Saskatoon SK S7K 4J3 Canada. (306)374-5115. E-mail: editor@blackflash.ca. Website: www.blackflash.ca. **Contact:** Lissa Robinson and Diana Savage, co-editing managers. Circ. 1,700. Estab. 1983. Canadian journal of photo-based and electronic arts published 3 times/ year.

Needs Looking for contemporary fine art photography and electronic arts practitioners. Reviews photos with or without ms.

Specs Accepts images in digital format. Send via CD, Zip, e-mail as TIFF, EPS, BMP, JPEG files at 300 dpi.

Making Contact & Terms Send query letter with résumé, slides, transparencies. Does not keep samples on file; cannot return material. Simultaneous submissions OK. Pays when copy has been proofed and edited. Credit line given. Buys one-time rights.

Tips "We need alternative and interesting contemporary photography. Understand our mandate and read our magazine prior to submitting."

⬚ BLIND SPOT PHOTOGRAPHY MAGAZINE

210 11th Ave., 10th Floor, New York NY 10001. (212)633-1317. Fax: (212)627-9364. E-mail: editors@blindspo t.com. Website: www.blindspot.com. **Contact:** Editors. Circ. 20,000. Estab. 1992. Triannual magazine. Emphasizes fine art photography. Readers are creative designers, curators, collectors, photographers, ad firms, publishers, students and media. Sample copy available for $14.

• Although this publication does not pay, the image quality inside is superb. It is worth submitting here just to get copies of an attractive publication.

Making Contact & Terms E-mail for permission to submit. No longer accepts unsolicited submissions.

Trudi Bellin

Reiman Publications' photo coordinator
offers advice on preparing submissions

I f you're searching for a strong market to publish your scenic photos, Reiman Publications just might be the perfect place to start. Over the last 40 years, the company has grown from a basement project in Roy Reiman's home to a powerhouse of rural-focused products and publications. The Wisconsin-based family of companies publishes more than a dozen consumer magazines, with a combined circulation of over 16 million and growing. Many of their magazines are listed in the Consumer Publications section of this book. Six of them rank among the top 100 in national circulation, and one (*Taste of Home*) is the largest food magazine in the world.

In addition to publishing magazines, Reiman operates its own mail order Country Store, offering a wide variety of country-oriented products, calendars and best-selling books, including cookbooks, scenic photo books, nostalgia books and more. If your stock list includes rural American scenery, wildlife, gardening, food and backyard entertaining, Reiman Publications offers a wealth of opportunity for getting your photos published and seen by millions of people across the country.

Keep in mind, however, that *no one* will see your photos if you don't follow instructions when submitting them for consideration. Editors won't even give your submission a second glance if it doesn't conform to their guidelines. Trudi Bellin, photo coordinator for Reiman Publications, stresses the importance of well-prepared submissions. "Photographers who can supply what we need can expect to be regular contributors," she says. The best way to deliver what a publication needs is to review past issues, study submission guidelines, and submit photos with appropriate subject matter. If you don't take the time to learn about the publications you submit to, why should they bother getting to know you and your work? According to Bellin, a submission "speaks volumes" about a photographer, and it's up to you to decide what your submissions will say about you. Here, she offers further insight into how to make a positive first impression.

As Reiman Publications' photo coordinator, for which publications are you responsible?

I am the photo coordinator for the company and all of its publications. We publish *Backyard Living*, *Birds & Blooms*, *Birds & Blooms EXTRA*, *Cooking for Two*, *Country*, *Country EXTRA*, *Country Discoveries*, *Country Woman*, *Farm & Ranch Living*, *Light & Tasty*, *Quick Cooking*, *Reminisce*, *Reminisce EXTRA* and *Taste of Home* magazines, plus books and calendars.

What kinds of books and calendars do you publish?

We prepare wall calendars (the number fluctuates; for 2006 it will be 17) and book-style daily planners (two). The calendars are offshoots of themes within our magazines, such as

Old Iron, Country Scenics, Hummingbirds, etc., or themes that appeal to our audience, such as puppies, covered bridges, waterfalls, etc.

We publish a growing number of cookbooks based on themes from our cooking magazines and annuals of these magazines. We also publish books drawn from the themes in our non-food magazines as well as newsstand specials and bookazines on a range of themes from baking to gardening.

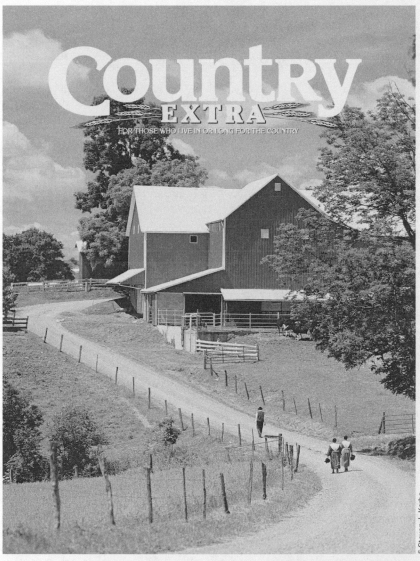

Country Extra is one of the magazines published by Reiman Publications. Ohio photographer Steven Korba took this cover shot in Amish country near Charm, Ohio.

What does a photo coordinator do? What are your primary responsibilities?

The photo coordinator for Reiman Publications makes sure there is a steady stream of photos arriving for review, is the go-to person for photo needs and research, and is the in-house source on photo rights and photo ordering.

My chief responsibility is to ensure we have a steady stream of incoming photo submissions for our creative teams. I place most of the company's orders for professional rights-managed and royalty-free photography. I assist the staff in locating photos. I negotiate rates and make sure image use complies with contracts, payments are issued, submissions are properly handled, that sort of thing.

Is there a different creative team for each magazine?

Yes, there is one team per project. However, we all wear many hats. For example, the *Farm & Ranch Living* editor also quarterbacked the Old Iron calendar; the *Birds & Blooms* editor is also the editor for the annual book project.

How do you make sure there is a steady stream of photos arriving for the creative teams to review?

We request seasonal submissions "on spec" from regular and new contributors. I work with some editors to prepare wants lists, but most prefer to see selections based strictly on season and relative to their magazine's theme.

A creative team member may directly ask me for help in finding a photo, or I'll detect a search struggle and offer to help. Asking the right questions up front saves a lot of time in the search. Spending precious minutes and sometimes hours gathering shots of Bryce Canyon, cattle grazing, or dandelions can be a waste if you find out later the season had to be winter, or the breed Guernsey, or the weed washed and ready for culinary use. Budgets also have to be determined, which can greatly influence the search. Working with more than a dozen creative teams makes life interesting.

How many submissions do you receive per month for all of your publications?

This number varies *greatly*, but on average we receive 100 submissions of conventional photos per month (about 5,000 images). We also handle CDs and e-mailed photos.

Do you prefer to receive prints or electronic images?

Our preference is for slides or transparencies. We have better quality control on photo reproduction from originals. However, if the photographer has honed his/her digital skills, uses professional-grade equipment, and can supply us with high-res scans for publication, we can usually get together on a photo need. Our creative teams specify if they are willing to work with digital photos, and I pass that word along to the suppliers I contact.

How do you find photographers who are right for your publications?

When I joined the company 15 years go, many suppliers were already regular contributors. They are as loyal as our readers for perhaps the same reason—the quality of our products. When I'm adding to our supplier list, I look over promotional literature, consider staff recommendations, eyeball photos in other publications, consult stock resource materials, and conduct online searches. Fortunately, some folks find us; they submit on spec and are often an excellent fit.

What are some of the most important qualities you look for in a photographer?

Experience or, if new, a knowledge of how to proceed. I truly appreciate the prepared photographers. The ones who first request guidelines, study our publications, then gather

a submission based on their understanding of our needs are far more likely to make a positive impression. Any submission that targets the correct season (seasonal submissions are our preference) and comes with well-organized paperwork and properly identified photos makes our job easier. A submission speaks volumes about the photographer; I don't need a personal conversation to learn if the supplier is experienced, new, organized or talented. All this is revealed when we open the submission package.

What are some of the most important qualities you look for in photographs for your magazines?

Subject matter, then quality, and then originality. If the subject isn't appropriate for us, there's no point in reviewing. If the subject is right on, quality drives the decision whether to publish. We want sharp focus and colors we can make pop. Some photographers make us want to make room for their work because the subject they suggest or their "view" of the topic is so compelling and such a good fit for one of our publications, we can't ignore it.

Do you get many submissions that are just not right for your publications? If so, what could these photographers do differently to succeed?

Definitely—too moody, wrong season, inappropriate subjects. Photographers should do their homework first. A blind submission to a company they know nothing about won't make a good first impression. Be familiar with our publications before making contact (buy some newsstand issues, subscribe, page through our titles at the local library, or visit our Web site). Share a short bio and succinct stock list when requesting photo guidelines. If photographers take the time to go that extra mile and pay attention to submission details, they'll get noticed in a good way.

Do you have anything to add—any final words of advice for aspiring photographers?

Pay attention to detail. Investigate how to gather a basic submission of 20-60 images on a given theme and package it for safe delivery and return. Tightly edit the submission, and be patient. Excellent work speaks volumes. Give us time to do our job—making you look as good as you are.

—*Erika Kruse O'Connell*

$▣ ☑ BLUE RIDGE COUNTRY

P.O. Box 21535, Roanoke VA 24018. (540)989-6138. Fax: (540)989-7603. E-mail: photos@leisurepublishing.com. Website: www.blueridgecountry.com. **Contact:** Cara Ellen Modisett, editor. Circ. 75,000. Estab. 1988. Bimonthly magazine. Emphasizes outdoor scenics, recreation, travel destinations in 9-state Blue Ridge Mountain region. Photo guidelines available for SASE or via website.

Needs Buys 10-15 photos from freelancers/issue; 60-90 photos/year. Needs photos of travel, scenics and wildlife. Seeking more scenics with people in them. Model release preferred. Photo captions required.

Specs Uses 35mm, 2¼×2¼, 4×5 transparencies. Accepts images in digital format. Send via CD at 300 dpi; low-res images okay for initial review, but accepted images must be high-res.

Making Contact & Terms Send query letter with list of stock photo subjects, samples and SASE. Responds in 2 months. Pays $100-150 for color cover; $25-100 for color inside. Pays on publication. Credit line given. Buys one-time rights.

$▣ ◯ ⑤ BOROUGH NEWS MAGAZINE

2941 N. Front St., Harrisburg PA 17110. (717)236-9526. Fax: (717)236-8164. E-mail: caccurti@boroughs.org. Website: www.boroughs.org. **Contact:** Courtney Accurti, editor. Circ. 6,000. Estab. 2001. Monthly magazine of Pennsylvania State Association of Boroughs. Emphasizes borough government in Pennsylvania. Readers are officials in municipalities in Pennsylvania. Sample copy free with 9×12 SAE and 5 first-class stamps.

Needs Number of photos/issue varies with inside copy. Needs "color photos of scenics (Pennsylvania), local government activities, Pennsylvania landmarks, ecology for cover photos only; authors of articles supply

their own photos.'' Special photo needs include street and road maintenance work; wetlands scenic. Model release preferred. Photo captions preferred; include identification of place and/or subject.

Specs Uses color prints and 35mm transparencies. Accepts images in digital format. Send via CD, Zip, e-mail as TIFF, EPS, JPEG, PSD files at 300 dpi.

Making Contact & Terms Send query letter with résumé of credits and list of stock photo subjects. Send unsolicited photos by mail for consideration; include SASE for return of material. Provide résumé, business card, brochure, flier or tearsheets to be kept on file for possible future assignments. Responds in 1 month. Pays $30 for color cover. Pays on publication. Buys one-time rights.

Tips ''We're looking for a variety of scenic shots of Pennsylvania for front covers of the magazine, especially special issues such as engineering, street/road maintenance, downtown revitalization, technology, tourism & historic preservation, public safety and economic development, and recreation.''

$ BOWHUNTER

6405 Flank Dr., Harrisburg PA 17112. (717)657-9555. E-mail: bowhunter@cowles.com. Website: www.bowhunter.com. **Contact:** Mark Olszewski, art director. Editor: Dwight Schuh. Publisher: Jeff Waring. Circ. 180,067. Estab. 1971. Published 9 times/year. Emphasizes bow and arrow hunting. Sample copy available for $2. Submission guidelines free with SASE.

Needs Buys 50-75 photos/year. Wants scenic (showing bowhunting) and wildlife (big and small game of North America) photos. ''No cute animal shots or poses. We want informative, entertaining bowhunting adventure, how-to and where-to-go articles.'' Reviews photos with or without ms.

Specs Uses 5×7, 8×10 glossy b&w and/or color prints, both vertical and horizontal format; 35mm and $2^{1}/_{4} \times 2^{1}/_{4}$ transparencies; vertical format preferred for cover.

Making Contact & Terms Send query letter with samples, SASE. Responds in 2 weeks to queries; 6 weeks to samples. Pays $50-125 for b&w inside; $75-300 for color inside; $600 for cover, ''occasionally more if photo warrants it.'' **Pays on acceptance.** Credit line given. Buys one-time publication rights.

Tips ''Know bowhunting and/or wildlife and study several copies of our magazine before submitting any material. We're looking for better quality, and we're using more color on inside pages. Most purchased photos are of big game animals. Hunting scenes are second. In b&w we look for sharp, realistic light, good contrast. Color must be sharp; early or late light is best. We avoid anything that looks staged; we want natural settings, quality animals. Send only your best, and, if at all possible, let us hold those we indicate interest in. Very little is taken on assignment; most comes from our files or is part of the manuscript package. If your work is in our files, it will probably be used. Some digital photography may be accepted—inquire by phone before submitting!''

BOYS' LIFE

Boy Scouts of America Magazine Division, 1325 W. Walnut Hill Lane, Irving TX 75038. (972)580-2358. Fax: (972)580-2079. Website: www.boyslife.org. **Contact:** Photo Editor. Circ. 1.4 million. Estab. 1911. Monthly magazine. General interest youth publication. Readers are primarily boys, ages 8-18. Photo guidelines free with SASE.

 • Boy Scouts of America Magazine Division also publishes *Scouting* magazine.

Needs ''Most photographs are from specific assignments that freelance photojournalists shoot for *Boys' Life*. We license some stock monthly, mostly from PACA member agencies. Stock licensed is usually historic, nature, or science.''

Making Contact & Terms Interested in all photographers, ''but do not send unsolicited images.'' Send query letter with list of credits. Pays $500 base editorial day rate against placement fees. **Pays on acceptance.** Buys one-time rights.

Tips ''Learn and read our publications before submitting anything.''

▣ ◖ BRANCHES

Uccelli Press, P.O. Box 85394, Seattle WA 98145-1394. E-mail: editor@uccellipress.com. Website: www.branchesquarterly.com and www.uccellipress.com. **Contact:** Toni La Ree Bennett, editor. Estab. 2001. Quarterly online literary/fine art journal combining each verbal piece with a visual. Most verbal pieces are poetry. Needs evocative, daring, expressionistic, earthy, ethereal, truthful images. See website for examples. Sample copy available for $8 and 9×12 SAE with $1.29 first-class postage or $10 with no envelope. Photo guidelines available for SASE or online.

Needs Uses 25 photos from freelancers/issue; 100 photos/year. Needs photos of multicultural, families, disasters, environmental, landscapes/scenics, wildlife, architecture, cities/urban, rural, performing arts,

travel. Interested in alternative process, avant garde, documentary, fine art, historical/vintage, seasonal. Reviews photos with or without ms. Model/property release preferred. Photo captions preferred; include year photo was taken, location.

Specs Accepts images in digital format. Send as JPEG files at 72 dpi, approximately 768×512 pixels.

Making Contact & Terms Send query letter or e-mail with résumé, prints, or web URL to view images. Occasionally keeps samples on file if editor likes the photographer's style; include SASE for return of material. Responds in 6 weeks to queries and portfolios. Simultaneous submissions and previously published work OK. Pays nothing for online journal; $25 minimum for cover of *Best of Branches* annual print version. Pays on publication. Credit line given. Buys one-time rights, first rights, right to archive electronically online and possibly reprint in annual anthology.

Tips "See website for examples of how I use art/photos together and what kind of images I run. Give me a link to your website where I could look at a body of work all at once. I am getting a lot of queries from professional photographers with impressive résumés and prices quoted for picture usage. But at this time, we are not able to pay for images used in the online version of *Branches*, as it does not generate income. If a work is published in *Branches* and consequently chosen to be in the annual print anthology *Best of Branches*, the artist/photographer will receive $25. Uccelli Press also publishes books and may, on occasion, be looking for book covers. Please visit the press website for up-to-date information and click on 'For Artists/Photographers.'"

N ○ ✉ BRIARPATCH

2138 McIntyre St., Regina SK S4P 2R7 Canada. (306)525-2949. Fax: (306)565-3430. E-mail: briarpatch.mag@sasktel.net. Website: www.briarpatchmagazine.com. **Contact:** Dave Mitchell, editor. Circ. 2,000. Estab. 1973. Magazine published 8 times/year. Emphasizes Canadian and international politics, labor, environment, women, peace. Readers are left-wing political activists. Sample copy available for $3.99 plus shipping.

Needs Buys 15-30 photos from freelancers/issue; 150-300 photos/year. Needs photos of Canadian and international politics, labor, environment, women, peace and personalities. Model/property release preferred. Photo captions preferred; include name of person(s) in photo, etc.

Specs Minimum 3×5 color or b&w prints.

Making Contact & Terms Send query letter with stock list. Send unsolicited photos by mail for consideration. "Do not send slides!" Provide résumé, business card, brochure, flier or tearsheets to be kept on file for possible future assignments. Keeps samples on file; include SASE for return of material. Responds in 1 month. Simultaneous submissions and previously published work OK. "We cannot pay photographers for their work since we do not pay any of our contributors (writers, illustrators). We rely on volunteer submissions. When we publish photos, etc., we send photographer 5 free copies of magazine." Credit line given. Buys one-time rights.

Tips "We keep photos on file and send free magazines when they are published."

$ ✉ BRIDAL GUIDES

2660 Petersborough St., Herndon VA 20171. E-mail: BridalGuides@yahoo.com. Estab. 1998. Quarterly. Photo guidelines available by e-mail request.

Needs Buys 12 photos from freelancers/issue; 48-72 photos/year. Needs photos of babies/children/teens, celebrities, couples, multicultural, families, parents, cities/urban, environmental, landscapes/scenics, wildlife, architecture, gardening, interiors/decorating, pets, religious, rural, adventure, entertainment, events, food/drink, health/fitness, performing arts, travel, agriculture—as related to weddings. Interested in alternative process, avant garde, documentary, fashion/glamour, fine art, historical/vintage, seasonal. Wants photos of weddings "and those who make it all happen, both behind and in front of the scene." Reviews photos with or without ms. Model/property release preferred.

Specs Uses glossy or matte color and/or b&w prints.

Making Contact & Terms Send query letter via e-mail. "If possible, please do not include photographs in files if they are sent through e-mail. A disk with your photographs sent to *Bridal Guides* is acceptable. If you plan to send a disk, photographs or portfolio, please send an e-mail stating this." Provide résumé, business card or self-promotion piece to be kept on file for possible future assignments. Responds within 1 month to queries; 1 week to portfolios. Simultaneous submissions and previously published work OK. **Pays on acceptance.** Credit line given. Buys one-time rights, first rights; negotiable.

$ ▣ THE BRIDGE BULLETIN

American Contract Bridge League, 2990 Airways Blvd., Memphis TN 38116-3847. (901)332-5586. Fax: (901)398-7754. E-mail: acbl@acbl.org. Website: www.acbl.org. Circ. 154,000. Estab. 1937. Monthly association magazine for tournament/duplicate bridge players. Sample copies available.

Needs Buys 4-5 photos/year. Reviews photos with or without ms.

Specs Prefers high-res digital images, color only.

Making Contact & Terms Query by phone. Responds only if interested; send nonreturnable samples. Previously published work OK. Pays $100 or more for suitable work. Pays on publication. Credit line given. Buys all rights.

Tips Photos must relate to bridge. Call first.

$ BUSINESS IN BROWARD

500 SE 17th St., Suite 101, Ft. Lauderdale FL 33316. (954)763-3338. Fax: (954)763-4481. E-mail: sfbiz@mindspring.com. **Contact:** Sherry Friedlander, publisher. Circ. 20,000. Estab. 1986. Magazine published 6 times/year. Emphasizes business. Readers are male and female executives, ages 30-65. Sample copy available for $4.

Needs Buys 22-30 photos from freelancers/issue; 176-240 photos/year. Needs photos of local sports, people, ports, activities and festivals. Model/property release required. Photo captions required.

Making Contact & Terms Contact through rep or submit portfolio for review. Responds in 2 weeks. Previously published work OK. Pays $150 for color cover; $75 for color inside. Pays on publication. Buys one-time rights; negotiable.

Tips "Know the area we service."

$ ▣ CALIFORNIA WILD

California Academy of Sciences, 875 Howard St., San Francisco CA 94103. (415)321-8189. Fax: (415)321-8625. E-mail: sschneider@calacademy.org. Website: www.calacademy.org/calwild. **Contact:** Susan Schneider, art director. Circ. 15,000. Estab. 1948. Quarterly magazine of the California Academy of Sciences. Emphasizes natural history and culture of California, the western US, the Pacific and Pacific Rim countries; and Academy of Sciences news. Sample copy available for $1.50 with SASE. Photo guidelines available for SASE or on website.

Needs Buys 25 photos from freelancers/issue; 100 photos/year. Needs scenics of habitat as well as detailed photos of individual species that convey biological information; wildlife, habitat, ecology, conservation and geology. "Scientific accuracy in identifying species is essential. We do extensive photo searches for every story." Current needs listed at www.AGPix.com. Model release preferred. "Caption information is essential, as captions are generally staff written."

Specs Uses color prints; 35mm, $2\frac{1}{4} \times 2\frac{1}{4}$ or 4×5 transparencies; originals or quality dupes preferred. Accepts images in digital format (high-res, 300 dpi minimum at size of reproduction).

Making Contact & Terms Send query letter with list of stock photo subjects. "Consult www.AGPix.com and call us first." Responds in 6 weeks. Pays $250 for color cover; $90-150 for color inside; $50-90 for b&w inside; $400-1,200 for photo/text packages, depending on length of text and number of photos. Pays on panel selection. Credit line given. Buys one-time rights.

Tips "*California Wild* has a reputation for high-quality photo reproduction and favorable layouts, but photographers must be meticulous about identifying what they shoot. Refer to our submission guidelines at www.AGPix.com, which lists all our needs. Usually feature articles about places, animals or plants require photos. Send a query letter with photos to Editor Kathleen Wong."

$ CALLIOPE: Exploring World History

Cobblestone Publishing, 30 Grove St., Suite C, Peterborough NH 03458. (603)924-7209. Fax: (603)924-7380. E-mail: cfbakeriii@meganet.net. Website: www.cobblestonepub.com. **Contact:** Rosalie Baker, editor. Circ. 12,000. Estab. 1990. Magazine published 9 times/year, September through May. Emphasis on non-United States history. Readers are children ages 10-14. Sample copy available for $4.95 with 9×12 or larger SAE and 5 first-class stamps. Photo guidelines available on website or free with SASE.

Needs Needs contemporary shots of historical locations, buildings, artifacts, historical reenactments and costumes. Reviews photos with or without accompanying ms. Model/property release preferred.

Specs Uses b&w and/or color prints; 35mm transparencies.

Making Contact & Terms Send query letter with stock photo list. Provide résumé, business card, brochure, flier or tearsheets to be kept on file for possible future assignments. Responds within 5 months. Simultaneous

submissions and previously published work OK. Pays $15-100 for inside; cover (color) photo payment negotiated. Pays on publication. Credit line given. Buys one-time rights; negotiable.

Tips "Given our young audience, we like to have pictures that include people, both young and old. Pictures must be dynamic to make history appealing. Submissions must relate to themes in each issue."

$▣ CALYPSO LOG

710 Settlers Landing Rd., Hampton VA 23669. (757)722-9300. Fax: (757)722-8185. E-mail: cousteau@cousteausociety.org. **Contact:** Clark Lee Merriam, American section editor. Circ. 50,000. Quarterly publication of The Cousteau Society. Emphasizes expedition activities of The Cousteau Society; educational/science articles; environmental activities. Readers are members of The Cousteau Society. Sample copy available for $2 with 9×12 SAE and $1 postage. Photo guidelines free with SASE.

Needs Uses 10-14 photos/issue; 1-2 supplied by freelancers; 2-3 photos/issue from freelance stock.

Specs Uses color prints; 35mm and 2¼×2¼ transparencies (duplicates only). Accepts images in digital format. Send via CD at 300 dpi or higher.

Making Contact & Terms Query with samples, list of stock photo subjects, SASE. Responds in 5 weeks. Previously published work OK. Pays $75-200/color photo. Pays on publication. Buys one-time rights and "translation rights for our French publication."

Tips Looks for sharp, clear, good composition and color; unusual animals or views of environmental features. Prefers transparencies over prints. "We look for ecological stories, food chain, prey-predator interaction and impact of people on environment. Please request a copy of our publication to familiarize yourself with our style, content and tone, and then send samples that best represent underwater and environmental photography."

$▣ ⊘ ◪ CANADA LUTHERAN

302-393 Portage Ave., Winnipeg MB R3B 3H6 Canada. (204)984-9172. Fax: (204)984-9185. E-mail: canaluth@elcic.ca. Website: www.elcic.ca/clweb. **Contact:** Trina Gallop, manager of communications. Circ. 14,000. Estab. 1986. Monthly publication of Evangelical Lutheran Church in Canada. Emphasizes faith/religious content; Lutheran denomination. Readers are members of the Evangelical Lutheran Church in Canada. Sample copy available for $5 Canadian (includes postage).

Needs Buys 1-2 photos from freelancers/issue; 12-24 photos/year. Needs photos of people (in worship/work/play etc.). Canadian sources preferred.

Specs Accepts images in digital format. Send via CD, e mail as JPEG files at 300 dpi minimum.

Making Contact & Terms Send sample prints and photo CDs by mail (include SASE for return of material) or send low-resolution images by e-mail. Pays $75-125 for color cover; $15-50 for b&w inside. Prices are in Canadian dollars. Pays on publication. Credit line given. Buys one-time rights.

Tips "Give us many photos that show your range. We prefer to keep them on file for at least 1 year. We have a short-term turnaround and turn to our file on a monthly basis to illustrate articles or cover concepts. Changing technology speeds up the turnaround time considerably when assessing images, yet forces publishers to think farther in advance to be able to achieve promised cost savings. U.S. photographers—send via U.S. mail. We sometimes get wrongly charged duty at the border when shipping via couriers."

$⊘ Ⓐ ◪ CANADIAN HOMES & COTTAGES

2650 Meadowvale Blvd., Unit #4, Mississauga ON L5N 6M5 Canada. (905)567-1440. Fax: (905)567-1442. E-mail: editorial@homesandcottages.com. Website: www.homesandcottages.com. **Contact:** Steve Chester, managing editor. Circ. 79,099. Canada's largest building and renovating magazine; published 6 times/year. Photo guidelines free with SASE.

Needs Needs photos of landscapes/scenics, architecture, interiors/decorating.

Making Contact & Terms Does not keep samples on file; cannot return material. Responds only if interested; send nonreturnable samples. **Pays on acceptance.** Credit line given.

$▣ ⊘ Ⓐ ◪ CANADIAN RODEO NEWS

2116 27th Ave. NE, #223, Calgary AB T2E 7A6 Canada. (403)250-7292. Fax: (403)250-6926. E-mail: editor@rodeocanada.com. Website: www.rodeocanada.com. **Contact:** Darell Hartlen, editor. Circ. 4,000. Estab. 1964. Monthly tabloid. Promotes professional rodeo in Canada. Readers are male and female rodeo contestants and fans—all ages.

Needs Wants photos of professional rodeo action or profiles.

Specs Uses color and/or b&w prints. Accepts images in digital format. Send via CD or e-mail as JPEG or TIFF files at 300 dpi.

Making Contact & Terms Send low-resolution unsolicited photos by e-mail for consideration. Phone to confirm if photos are usable. Keeps samples on file. Simultaneous submissions and previously published work OK. Pays $25 for color cover; $15 for b&w or color inside. Pays on publication. Credit line given. Rights negotiable.

Tips "Photos must be from or pertain to professional rodeo in Canada. Phone to confirm if subject/material is suitable before submitting. *CRN* is very specific in subject."

☒ $☒ CANADIAN YACHTING

49 Bathhurst St., Suite 201, Toronto ON M5V 2P2 Canada. (416)703-7167. Fax: (416)703-1330. E-mail: eakerr @kerrwil.com. Website: www.cymagazine.ca. **Contact:** Elizabeth A. Kerr, publisher. Circ. 31,000. Estab. 1976. Bimonthly magazine. Emphasizes sailing (and powerboats). Readers are mostly male, highly educated, high income, well read. Sample copy free with 9×12 SASE.

Needs Buys 28 photos from freelancers/issue; 168 photos/year. Needs photos of all sailing/boating-related (keelboats, dinghies, racing, cruising, etc.). Model/property release preferred. Photo captions preferred.

Making Contact & Terms Submit portfolio for review or query with SASE, stock photo list and transparencies. Responds in 1 month. Simultaneous submissions and previously published work OK. Pays $150-350 for color cover; $30-70 for b&w or color inside. Pays on publication. Buys one-time rights.

$☐ ☑ ☒ CANOE & KAYAK

P.O. Box 3146, Kirkland WA 98083-3146. (425)827-6363. Fax: (425)827-1893. E-mail: photos@canoekayak.c om. Website: www.canoekayak.com. **Contact:** Art Director. Circ. 63,000. Estab. 1973. Bimonthly magazine. Emphasizes a variety of paddle sports, as well as how-to material and articles about equipment. For upscale canoe and kayak enthusiasts at all levels of ability. Also publishes special projects. Sample copy free with 9×12 SASE.

Needs Buys 25 photos from freelancers/issue; 150 photos/year. Canoeing, kayaking, ocean touring, canoe sailing, fishing when compatible to the main activity, canoe camping but not rafting. No photos showing disregard for the environment, be it river or land; no photos showing gasoline-powered, multi-hp engines; no photos showing unskilled persons taking extraordinary risks to life, etc. Accompanying manuscripts for "editorial coverage striving for balanced representation of all interests in today's paddling activity. Those interests include paddling adventures (both close to home and far away), camping, fishing, flatwater, white-water, ocean kayaking, poling, sailing, outdoor photography, how-to projects, instruction and historical perspective. Regular columns feature paddling techniques, conservation topics, safety, interviews, equipment reviews, book/movie reviews, new products and letters from readers." Photos only occasionally purchased without accompanying ms. Model release preferred "when potential for litigation." Property release required. Photo captions preferred.

Specs Uses 5×7, 8×10 glossy b&w prints; 35mm, 2¼×2¼, 4×5 transparencies; color transparencies for cover; vertical format preferred. Accepts images in digital format. Send via CD, Zip as TIFF, EPS, JPEG files at 300 dpi.

Making Contact & Terms Interested in reviewing work from newer, lesser-known photographers. Query or send material. "Let me know those areas in which you have particularly strong expertise and/or photofile material. Send best samples only and make sure they relate to the magazine's emphasis and/or focus. (If you don't know what that is, pick up a recent issue before sending me unusable material.) We will review dupes for consideration only. Originals required for publication. Also, if you have something in the works or extraordinary photo subject matter of interest to our audience, let me know! It would be helpful to me if those with substantial reserves would supply indexes by subject matter." Include SASE for return of material. Responds in 1 month. Simultaneous submissions and previously published work OK, in noncompeting publications. Pays $500-700 for color cover; $75-200 for b&w inside; $75-350 for color inside. Pays on publication. Credit line given. Buys one-time rights, first serial rights and exclusive rights.

Tips "We have a highly specialized subject, and readers don't want just any photo of the activity. We're particularly interested in photos showing paddlers' *faces*; the faces of people having a good time. We're after anything that highlights the paddling activity as a lifestyle and the urge to be outdoors." All photos should be "as natural as possible with authentic subjects. We receive a lot of submissions from photographers to whom canoeing and kayaking are quite novel activities. These photos are often clichéd and uninteresting. So consider the quality of your work carefully before submission if you are not familiar with the sport. We are always in search of fresh ways of looking at our sport. All paddlers must be wearing life vests/PFDs."

$▣ ◨ CAPE COD LIFE INCLUDING MARTHA'S VINEYARD AND NANTUCKET

270 Communication Way, #6A, Hyannis MA 02601-1883. (508)775-9800. Fax: (508)775-9801. E-mail: pconra d@capecodlife.com. Website: www.capecodlife.com. **Contact:** Pam Conrad, art director. Publisher: Brian F. Shortsleeve. Circ. 45,000. Estab. 1979. Bimonthly magazine. Emphasizes Cape Cod lifestyle. Also publishes *Cape Cod Dream* and *Cape Cod and Island Home*. "Readers are 55% female, 45% male, upper income, second home, vacation homeowners." Sample copy available for $4.95. Photo guidelines free with SASE.

Needs Buys 30 photos from freelancers/issue; 180 photos/year. Needs "photos of Cape and Island scenes, people, places; general interest of this area." Subjects include boating and beaches, celebrities, families, environmental, landscapes/scenics, wildlife, architecture, gardening, interiors/decorating, rural, adventure, events, travel. Interested in fine art, historical/vintage, seasonal. Reviews photos with or without a ms. Model release required; property release preferred. Photo captions required; include location.

Specs Uses 35mm, $2\frac{1}{4} \times 2\frac{1}{4}$, 4×5 transparencies. Accepts images in digital format. Send via Zip, floppy disk, e-mail as TIFF files at 300 dpi.

Making Contact & Terms Submit portfolio for review. "Photographers should not drop by unannounced. We prefer photographers to mail portfolio, then follow up with a phone call 1 to 2 weeks later." Send unsolicited photos by mail for consideration. Keeps samples on file. Simultaneous submissions and previously published work OK. Pays $225 for color cover; $25-175 for b&w or color inside, depending on size. Pays 30 days after publication. Credit line given. Buys one-time rights; reprint rights for *Cape Cod Life* reprints; negotiable.

Tips "Write for photo guidelines. Mail photos to the attention of our art director, Pam Conrad. Photographers who do not have images of Cape Cod, Martha's Vineyard, Nantucket or the Elizabeth Islands should not submit." Looks for "clear, somewhat graphic slides. Show us scenes we've seen hundreds of times with a different twist and elements of surprise. Photographers should have a familiarity with the magazine and the region first. Prior to submitting, photographers should send a SASE to receive our guidelines. They can then submit works (via mail) and follow up with a brief phone call. We love to see images by professional-calibre photographers who are new to us, and prefer it if the photographer can leave images with us at least 2 months, if possible."

$ THE CAPE ROCK

Southeast Missouri State University, Cape Girardeau MO 63701. (573)651-2500. E-mail: hhecht@semo.edu. Website: http://cstl-cla.semo.edu/hhecht. **Contact:** Harvey Hecht, editor-in-chief. Circ. 1,000. Estab. 1964. Semiannual. Emphasizes poetry and poets for libraries and interested persons. Photo guidelines available on website.

Needs 12 photos (at least 10 must be "portrait format") per issue; 24 photos/year. "We feature a single photographer each issue. Submit 25-30 thematically organized b&w glossies (at least 5×7), or send 5 pictures with plan for complete issue. We favor a series that conveys a sense of place. Seasons are a consideration, too: we have spring and fall issues. Photos must have a sense of place; e.g., an issue featuring Chicago might show buildings or other landmarks, people of the city (no nudes), travel or scenic. No how-to or products. Sample issues and guidelines provide all information a photographer needs to decide whether to submit to us." Model release not required, "but photographer is liable." Photo captions not required, "but photographer should indicate where series was shot."

Making Contact & Terms Send query letter with list of stock photo subjects, actual b&w photos, or submit portfolio by mail for review; include SASE for return of material. Response time varies. Pays $100 and 10 copies of publication. Credit line given. Buys "all rights, but will release rights to photographer on request." **Tips** "We don't give assignments, but we look for a unified package put together by the photographer. We may request additional or alternative photos when accepting a package."

$◨ ⬚ THE CAPILANO REVIEW

2055 Purcell Way, North Vancouver BC V7J 3H5 Canada. (604)984-1712. E-mail: tcr@capcollege.bc.ca. Website: www.capcollege.bc.ca/about/publications/cap-review/tcr/index.html. **Contact:** Editor. Circ. 900. Estab. 1972. Member of Canadian Magazine Publishers Association and B.C. Association of Magazine Publishers. Visual and literary arts magazine published 3 times/year. Sample copy available for $9.

Needs Publishes an 8- to 16-page visual section by 1 or 2 artists/issue. Interested in "work that is new in concept and in execution."

Making Contact & Terms Send an artist statement and list of exhibitions. Submit a group of photos with SASE (with Canadian postage or IRCs). "We do NOT accept submissions via e-mail or on disk." Pays $50

for cover and $50/page to maximum of $200 Canadian. Additional payment for electronic rights; negotiable. Pays on publication. Credit line given. Buys first North American serial rights only.

Tips "Read the magazine before submitting. *TCR* is an avant garde literary and visual arts publication that wants innovative work. We've previously published photography by Barrie Jones, Roy Kiyooka, Robert Keziere, Laiwan, and Colin Browne."

$ CAREER FOCUS

7300 W. 110th St., 7th Floor, Overland Park KS 66210. (913)317-2888. E-mail: editorial@careerfocusmagazine .com. Website: www.careerfocusmagazine.com. **Contact:** N. Michelle Paige. Circ. 250,000. Estab. 1988. Bi-monthly magazine. Emphasizes career development. Readers are male and female African-American and Hispanic professionals, ages 21-45. Sample copy free with 9 × 12 SAE and 4 first-class stamps. Photo guidelines free with SASE.

Needs Uses approximately 40 photos/issue. Needs technology photos and shots of personalities; career people in computer, science, teaching, finance, engineering, law, law enforcement, government, hi-tech, leisure. Model release preferred. Photo captions required; include name, date, place, why.

Making Contact & Terms Send query letter by e-mail with résumé of credits and list of stock photo subjects. Keeps samples on file. Simultaneous submissions and previously published work OK. Responds in 1 month. Pays $10-50 for color photos; $5-25 for b&w photos. Pays on publication. Credit line given. Buys one-time rights.

Tips "Freelancer must be familiar with our magazine to be able to submit appropriate manuscripts and photos."

$ $ $ CAREERS AND COLLEGES MAGAZINE

2 LAN Dr., Suite 100, Westford MA 01886. (978)842-2770. Fax: (978)692-2304. E-mail: jaynepenn@alloyeduc ation.com. Website: www.careersandcolleges.com. **Contact:** Jayne Pennington, managing director. Circ. 750,000. Estab. 1980. Magazine published 4 times during school term. Emphasizes college and career choices for teens. Readers are high school juniors and seniors, male and female, ages 16-19. Sample copy available for $2.50 with 9 × 12 SAE and 5 first-class stamps.

Needs Buys photos from freelancers; 12 + photos/year. Uses minimum 4 photos/issue; 80% supplied by freelancers. Photo subjects: teen situations, study or career related; some profiles. Model release preferred; property release required. Photo captions preferred.

Making Contact & Terms Send tearsheets and promo cards. Submit portfolio for review or submit URL. Please call for appointment. Keeps samples on file. Responds within 3 weeks. Pays $800-1,000 for color cover; $350-450 for color inside; $600-800/color page rate. Work-for-hire basis. **Pays on acceptance**. Credit line given. Buys one-time rights; negotiable.

Tips "Must work well with teen subjects; hip, fresh style, not too corny. Promo cards or packets work best; business cards are not needed unless they contain your photography."

$ $ CARIBBEAN TRAVEL AND LIFE MAGAZINE

460 N. Orlando Ave., Suite 200, Winter Park FL 32789. (407)571-4704. E-mail: zach.stovall@worldpub.net. Website: www.caribbeantravelmag.com. **Contact:** Zach Stovall, photo services. Circ. 150,000. Estab. 1985. Published 9 times/year. Emphasizes travel, culture and recreation in islands of Caribbean, Bahamas and Bermuda. Readers are male and female frequent Caribbean travelers, ages 32-52. Sample copy available for $4.95. Photo guidelines available via website or free with SASE.

Needs Uses about 100 photos/issue; 90% supplied by freelance photographers: 10% assignment and 90% freelance stock. "We combine scenics with people shots. Where applicable, we show interiors, food shots, resorts, water sports, cultural events, shopping and wildlife/underwater shots. We want images that show intimacy between people and place. Provide thorough caption information. Don't submit stock that is mediocre."

Specs Uses 4-color photography.

Making Contact & Terms Query by mail or e-mail with list of stock photo subjects and tearsheets. Responds in 3 weeks. Pays $1,000 for color cover; $450/spread; $325/full + page; $275/full page; $200/¹/₂ + page; $150/¹/₂ page; $120/¹/₃page; $90/¹/₄ page or less. Pays after publication. Buys one-time rights. Does not pay shipping, research or holding fees.

Tips Seeing trend toward "fewer but larger photos with more impact and drama. We are looking for particularly strong images of color and style, beautiful island scenics and people shots—images that are powerful enough to make the reader want to travel to the region; photos that show people doing things in the destina-

tions we cover; originality in approach, composition, subject matter. Good composition, lighting and creative flair. Images that are evocative of a place, creating story mood. Good use of people. Submit stock photography for specific story needs; if good enough can lead to possible assignments. Let us know exactly what coverage you have on a stock list so we can contact you when certain photo needs arise."

$ ▣ ◿ CAT FANCY

Fancy Publications, a division of BowTie Inc., P.O. Box 6050, Mission Viejo CA 92690.(949)855-8822. Fax: (949)855-0654. E-mail: smeyer@bowtieinc.com. Website: www.catfancy.com. **Contact:** Sandy Meyer, managing editor. Estab. 1965. Monthly magazine. Readers are "men and women of all ages interested in all aspects of cat ownership." Photo guidelines and needs free with SASE or via website.

Needs Buys 20-30 photos from freelancers/issue; 240-360 photos/year. Editorial "lifestyle" shots of cats in beautiful, modern homes; cats with attractive people (all ages); cat behavior (good and bad, single and in groups); cat and kitten care (grooming, vet visits, feeding, etc.); high-quality portraits of CFA- or TICA-registered cats and kittens. Model releases required.

Specs Accepts images in digital format; 35mm or $2\frac{1}{4}\times2\frac{1}{4}$ color transparencies preferred. If digital, send via CD, Zip as TIFF or EPS files at 300 dpi (3×5 inches minimum). Please include color contact sheets (thumbnails with image names) for digital submissions. Include SASE.

Making Contact & Terms Obtain photo guidelines before submitting photos. Pays $200 maximum for color cover; $35-100 for b&w inside; $25-100 for color inside. Credit line given. Buys first North American serial rights.

Tips Sharp, focused color transparencies or digital images only (no prints). Do not send scans of prints or negatives. Indoor cats preferred. Send SASE for list of specific photo needs.

$ ▣ CATS & KITTENS

Pet Publishing, Inc., 7-L Dundas Circle, Greensboro NC 27407. (336)292-4047. Fax: (336)292-4272. E-mail: editorial@petpublishing.com. Website: www.catsandkittens.com. **Contact:** Rita Davis, executive editor. Bi-monthly magazine about cats. "Articles include breed profiles, stories on special cats, cats in art and popular culture, and much more." Sample copy available for $5 and 9×12 SASE. Photo guidelines free with SASE.

Needs Photos of various registered cat breeds, posed and unposed, interacting with other cats and with people. Photo captions required; include breed name, additional description as needed.

Specs Transparencies or slides preferred. Images may be scanned full-size at 266 dpi on CD-ROM for submission.

Making Contact & Terms Send unsolicited photos by mail for consideration, "but please include SASE if you want them returned. Please send duplicates. We cannot assume liability for unsolicited originals." Pays $150 for color cover; $25-50 for color inside. Pays on publication. Buys all rights; negotiable.

Tips "We seek good composition (indoor or outdoor). Photos must be professional and of publication quality—good focus and contrast. We work regularly with a few excellent freelancers, but are always seeking new contributors. Images we think we might be able to use will be scanned into our CD-ROM file and the originals returned to the photographer."

⬚ $ CHARISMA MAGAZINE

600 Rinehart Rd., Lake Mary FL 32746. (407)333-0600. E-mail: joe.deleon@strang.com. Website: www.strang.com. **Contact:** Joe Deleon, magazine design director. Circ. 200,000. Monthly magazine. Emphasizes Christians. General readership. Sample copy available for $2.50.

Needs Buys 3-4 photos from freelancers/issue; 36-48 photos/year. Needs editorial photos—appropriate for each article. Model release required. Photo captions preferred.

Specs Uses color 35mm, $2\frac{1}{4}\times2\frac{1}{4}$, 4×5 or 8×10 transparencies.

Making Contact & Terms Send unsolicited photos by mail for consideration. Provide brochure, flier or tearsheets to be kept on file for possible future assignments. Simultaneous submissions and previously published work OK. Cannot return material. Responds ASAP. Pays $500 for color cover; $150 for b&w inside; $50-150/hour or $400-750/day. Pays on publication. Credit line given. Buys all rights; negotiable.

Tips In portfolio or samples, looking for "good color and composition with great technical ability."

$ ◿ ⬚ THE CHATTAHOOCHEE REVIEW

Georgia Perimeter College, 2101 Womack Rd., Dunwoody GA 30338-4497. Website: www.chattahoochee-review.org. **Contact:** Marc Fitten, editor. Circ. 1,200. Estab. 1979. Quarterly literary magazine. "*The Chattahoochee Review* is a 25-year veteran showcasing works by new and established writers particular to the

southeast United States and from around the world." Sample copy available for $6. Photo guidelines available for #10 SASE.

Needs Buys 5-10 photos from freelancers/issue; 20-40 photos/year. Reviews photos with or without ms. Property release preferred. Photo captions preferred; include title, photographer's name.

Specs Uses glossy or matte color and/or b&w prints. Contact editor for complete details.

Making Contact & Terms Send query letter with slides, prints or photocopies. Does not keep samples on file; include SASE for return of material. Responds in 1 month to queries. Pays $25 for b&w or color inside. Pays on publication. Credit line given.

Tips "Become familiar with our journal and the types of things we regularly publish."

$ $ 🖳 CHESAPEAKE BAY MAGAZINE: Boating At Its Best

Chesapeake Bay Communications, Inc., 1819 Bay Ridge Ave., Annapolis MD 21403. (410)263-2662, ext. 15. Fax: (410)267-6924. E-mail: kashley@cbmag.net. Website: www.cbmmag.net. **Contact:** Karen Ashley, art director. Circ. 45,000. Estab. 1972. Monthly. Emphasizes boating—Chesapeake Bay only. Readers are "people who use Chesapeake Bay for recreation." Sample copy available for SASE.

● *Chesapeake Bay* is CD-ROM-equipped and does corrections and manipulates photos inhouse.

Needs Buys 27 photos from freelancers/issue; 324 photos/year. Needs photos that are Chesapeake Bay related (must); vertical powerboat shots are badly needed (color). Special needs include "vertical 4-color slides showing boats and people on Bay."

Specs Uses 35mm, $2^1/_4 \times 2^1/_4$, 4×5, 8×10 transparencies. Accepts images in digital format. Send via CD at 300 dpi (a proof sheet would be helpful).

Making Contact & Terms Interested in reviewing work from newer, lesser-known photographers. Send query letter with samples or list of stock photo subjects. Responds in 3 weeks. Simultaneous submissions OK. Pays $400 for color cover; $75-250 for color inside, depending on size; $150-1,000 for photo/text package. Pays on publication. Credit line given. Buys one-time rights.

Tips "We prefer Kodachrome over Ektachrome. Looking for: boating, bay and water-oriented subject matter. Qualities and abilities include: fresh ideas, clarity, exciting angles and true color. We're using larger photos— more double-page spreads. Photos should be able to hold up to that degree of enlargement. When photographing boats on the Bay, keep safety in mind. People hanging off the boat, drinking, women 'perched' on the bow are a no-no!"

$ 🖳 CHESS LIFE

3068 Rt. 9W, Suite 200, New Windsor NY 12553. (845)562-8350. Fax: (845)236-4852. E-mail: artwork@uschess.org. Website: www.uschess.org. **Contact:** Glenn Petersen, editor. Senior Art Director: Kathleen Merz. Circ. 70,000. Estab. 1939. Monthly publication of the US Chess Federation. *Chess Life* covers news of all major national and international tournaments; historical articles, personality profiles, columns of instruction, occasional fiction, humor for the devoted fan of chess. Sample copy and photo guidelines free.

Needs Uses about 15 photos/issue; 7-8 supplied by freelancers. Needs "news photos from events around the country; shots for personality profiles." Special needs include "Spot Light" section. Model release preferred. Photo captions preferred.

Specs Accepts prints or high-resolution digital images.

Making Contact & Terms Query with samples. Provide business card and tearsheets to be kept on file for possible future assignments. Responds in "1 month, depending on when the deadline crunch occurs." Simultaneous submissions and previously published work OK. Pays $150-300/b&w or color cover; $25 for b&w inside; $35 for color inside; $15-30/hour; $150-250/day. Pays on publication. Buys one-time rights; "we occasionally purchase all rights for stock mug shots." Credit line given.

Tips Using "more color, and more illustrative photography. The photographer's name, address and date of the shoot should appear on the back of all photos. Also, name of person(s) in photograph and event should be identified." Looks for "clear images, good composition and contrast with a fresh approach to interest the viewer. Increasing emphasis on strong portraits of chess personalities, especially Americans. Tournament photographs of winning players and key games are in high demand."

$ 🖳 🖉 🖾 CHICKADEE MAGAZINE

49 Front St. E., 2nd Floor, Toronto ON M5E 1B3 Canada. (416)340-2700. Fax: (416)946-1679. E-mail: apilas@owl.on.ca. Website: www.owlkids.com. **Contact:** Angela Pilas Magee, photo researcher. Circ. 92,000. Estab. 1979. Published 10 times/year. A discovery magazine for children ages 6-9. Sample copy available for $4.95 with 9×12 SAE and $1.50 money order to cover postage. Photo guidelines available for SAE or by e-mail.

● *chickaDEE* has received Magazine of the Year, Parents' Choice, Silver Honor, Canadian Children's Book Centre Choice and several Distinguished Achievement awards from the Association of Educational Publishers.

Needs Buys 1-2 photos from freelancers/issue; 10-20 photos/year. Needs "crisp, bright shots" of children, multicultural, environmental, landscapes/scenics, wildlife, cities/urban, pets, adventure, events, hobbies, humor, performing arts, sports, travel, science, technology, animals in their natural habitat. Interested in documentary, seasonal. Model/property release required. Photo captions required.

Specs Uses images in any hard-copy format. Accepts images in digital format. Send via CD, e-mail as TIFF, JPEG files at 75 dpi; 300 dpi required for publication.

Making Contact & Terms Request photo package before sending photos for review. Responds in 3 months. Previously published work OK. Pays $550 Canadian for 2-page spread; $300 Canadian for color page; text/photo package negotiated separately. **Pays on acceptance.** Credit line given. Buys one-time rights.

N $ CHILDREN'S DIGEST

P.O. Box 567, Indianapolis IN 46206. (317)636-8881, ext. 220. Fax: (317)684-8094. Website: www.childrensdigest.mag.org. **Contact:** Penny Rasdall, photo editor. Circ. 75,000. Estab. 1950. Magazine published 6 times/year. Emphasizes health and fitness. Readers are preteens—kids ages 10-13. Sample copy available for $1.25. Photo guidelines free with SASE.

Needs "We have featured photos of health and fitness, wildlife, children in other countries, adults in different jobs, how-to projects." *Reviews photos with accompanying ms only.* Model release preferred.

Specs Uses 35mm transparencies. "We prefer images in digital format. Send via e-mail or CD at at least 300 dpi."

Making Contact & Terms Send complete manuscript and photos on speculation. Include SASE. Responds in 10 weeks. Pays $70-275 for color cover; $35-70 for b&w inside; $70-155 for color inside. Pays on publication. Buys North American serial rights.

$ CHIRP MAGAZINE

49 Front St. E., 2nd Floor, Toronto ON M5E 1B3 Canada. (416)340-2700. Fax: (416)946-1679. E-mail: apilas@owl.on.ca. Website: www.owlkids.com. **Contact:** Angela Pilas-Magee, photo researcher. Circ. 85,000. Estab. 1997. Published 10 times/year. A discovery magazine for children ages 3-6. Sample copy available for $4.95 with 9×12 SAE and $1.50 money order to cover postage. Photo guidelines available for SAE or by e-mail.

● *Chirp* has received Best New Magazine of the Year, Parents' Choice, Canadian Children's Book Centre Choice and Distinguished Achievement awards from the Association of Educational Publishers.

Needs Buys at least 2 photos from freelancers/issue; 10-20 photos/year. Needs "crisp, bright shots" of children ages 5-8, multicultural, environmental, landscapes/scenics, wildlife, cities/urban, pets, adventure, events, hobbies, humor, performing arts, animals in their natural habitat. Interested in documentary, seasonal. Model/property release required. Photo captions required.

Specs Uses images in any hard-copy format. Accepts images in digital format. Send via CD, e-mail as TIFF, JPEG files at 75 dpi; 300 dpi required for publication.

Making Contact & Terms Request photo package before sending photos for review. Responds in 3 months. Previously published work OK. Pays $300 Canadian for color page; text/photo package negotiated separately. **Pays on acceptance.** Credit line given. Buys one-time rights.

$ THE CHRONICLE OF THE HORSE

P.O. Box 46, Middleburg VA 20118. (540)687-6341. Fax: (540)687-3937. E-mail: results@chronofhorse.com. Website: www.chronofhorse.com. **Contact:** John Strassburger, editor. Circ. 23,000. Estab. 1937. Weekly magazine. Emphasizes English horse sports. Readers range from young to old. "Average reader is a college-educated female, middle-aged, well-off financially." Sample copy available for $2. Photo guidelines free with SASE or on website.

Needs Buys 10-20 photos from freelancers/issue. Needs photos from competitive events (horse shows, dressage, steeplechase, etc.) to go with news story or to accompany personality profile. "A few stand alone. Must be cute, beautiful or newsworthy. Reproduced in b&w." Prefers purchasing photos with accompanying ms. Photo captions required with every subject identified.

Specs Uses b&w and/or color prints, slides (reproduced b&w). Accepts images in digital format at 300 dpi.

Making Contact & Terms Send query letter by mail or e-mail. Responds in 6 weeks. Pays $30 base rate. Pays on publication. Buys one-time rights. Credit line given. Prefers first North American rights.

Tips "We do not want to see portfolio or samples. Contact us first, preferably by letter; include SASE for reply. Know horse sports."

$ ▣ ⬚ CHRONOGRAM

Luminary Publishing, 314 Wall St., Kingston NY 12401. (845)334-8600. Fax: (845)334-8610. E-mail: dperry@chronogram.com. Website: www.chronogram.com. **Contact:** David Perry, art director. Circ. 15,000. Estab. 1993. Monthly arts, events, philosophy, literary magazine. Sample copy available for $1. Photo guidelines available on website.

Needs Buys 16 photos from freelancers/issue; 192 photos/year. Interested in alternative process, avant garde, fashion/glamour, fine art, historical/vintage, artistic representations of anything. "Striking, minimalistic and good! Great covers!" Reviews photos with or without ms. Model/property release preferred. Photo captions required; include title, date, artist, medium.

Specs Prefers images in digital format. Send via CD as TIFF files at 300 dpi or larger at printed size. Also uses glossy or matte color and/or b&w prints no larger than 8½×14; 35mm, 4×5 transparencies.

Making Contact & Terms Send query letter with résumé, slides, prints, transparencies. Provide self-promotion piece to be kept on file for possible future assignments. Responds only if interested; send nonreturnable samples or SASE for returns. Pays $300 maximum for b&w inside. Pays 1 month after publication. Credit line given. Buys one-time rights; negotiable.

Tips "Colorful, edgy, great art! Include SASE with package. See our website—look at the back issues and our covers—submit one for consideration!"

$ $ ▣ ⬚ CLEVELAND MAGAZINE

Great Lakes Publishing, 1422 Euclid Ave., #730, Cleveland OH 44115. (216)771-2833. Fax: (216)781-6318. E-mail: sluzewski@clevelandmagazine.com. Website: www.clevelandmagazine.com. **Contact:** Gary Sluzewski, design director. Circ. 50,000. Estab. 1972. Monthly consumer magazine. General interest to upscale audience.

Needs Buys 50 photos from freelancers/issue; 600 photos/year. Needs photos of people (babies/children/teens, celebrities, couples, multicultural, parents, families, senior citizens), environmental, landscapes/scenics, architecture, education, gardening, interiors/decorating, adventure, entertainment, events, food/drink, health/fitness, hobbies, humor, performing arts, sports, travel, business concepts, industry, medicine, political, product shots/still life, technology/computers. Interested in documentary, fashion/glamour, seasonal. Reviews photos with or without ms. Model release required for portraits; property release required for individual homes. Photo captions required; include names, date, location, event, phone.

Specs Uses color and b&w prints; 35mm, 2¼×2¼, 4×5, 8×10 transparencies. Prefers images in digital format. Send via CD, e-mail as TIFF, JPEG files at 300 dpi.

Making Contact & Terms Provide business card, self-promotion piece or tearsheets to be kept on file for possible future assignments. To show portfolio, photographer should follow up with call. Portfolio should include "only your best, favorite work." Keeps samples on file. Responds only if interested; send nonreturnable samples. Simultaneous submissions and previously published work OK. Pays $300-700 for color cover; $100-300 for b&w inside; $100-600 for color inside. Pays on publication. Credit line given. Buys one-time publication, electronic and promotional rights.

Tips "Ninety percent of our work is people. Send sample. Follow up with phone call. Make appointment for portfolio review. Arrange the work you want to show me ahead of time and be professional, instead of telling me you just threw this together."

$ ▣ ⬚ COBBLESTONE: Discover American History

Cobblestone Publishing, 30 Grove St., Suite C, Peterborough NH 03458. (603)924-7209. Fax: (603)924-7380. Website: www.cobblestonepub.com. **Contact:** Meg Chorlian, editor. Circ. 29,000. Estab. 1980. Publishes 9 issues/year, September-May. Emphasizes American history; each issue covers a specific theme. Readers are children ages 8-14, parents, teachers. Sample copy available for $4.95 and 9×12 SAE with 5 first-class stamps. Photo guidelines free with SASE.

Needs Buys 10-20 photos from freelancers/issue; 90-180 photos/year. Needs photos of children, multicultural, landscapes/scenics, architecture, cities/urban, agriculture, industry, military. Interested in fine art, historical/vintage, reenacters. "We need photographs related to our specific themes (each issue is theme-related) and urge photographers to request our themes list." Model release required. Photo captions preferred.

Specs Uses 8×10 glossy prints; 35mm, 2¼×2¼ transparencies. Accepts images in digital format. Send via CD, SyQuest, Zip as TIFF files at 300 dpi, saved at 8×10 size.

Making Contact & Terms Send query letter with samples or list of stock photo subjects; include SASE for return of material. "Photos must pertain to themes, and reporting dates depend on how far ahead of the issue the photographer submits photos. We work on issues 6 months ahead of publication." Simultaneous submissions and previously published work OK. Pays $150-300 for color cover; $10-50 for b&w inside; $10-100 for color inside (payment depends on size of photo). Pays on publication. Credit line given. Buys one-time rights.

Tips "Most photos are of historical subjects, but contemporary color images of, for example, a Civil War battlefield, are great to balance with historical images. However, the amount varies with each monthly theme. Please review our theme list and submit related images."

$▤ ☑ COLLECTIBLE AUTOMOBILE

Publications International Ltd., 7373 N. Cicero Ave., Lincolnwood IL 60712. (847)583-4525. E-mail: bhawk@ pubint.com. Website: www.collectibleautomobile.com. **Contact:** Ben Hawk, acquisitions editor. Estab. 1984. Bimonthly magazine. "*CA* is an upscale, full-color automotive history magazine. We strive to feature the best photography of accurately restored or pristine original factory stock autos." Sample copy available for $8 and 10½×14 SAE with $3.50 first-class postage. Photo guidelines available for #10 SASE.

Needs "We require full photo shoots for any auto photo assignment. This requires 2-3 rolls of 35mm, 2-3 rolls of 2¼×2¼, and/or 4-8 4×5 exposures. Complete exterior views, interior and engine views, and close-up detail shots of the subject vehicle are required."

Specs Uses 35mm, 2¼×2¼, 4×5 transparencies. Accepts images in digital format (discuss file parameters with the acquisitions editor).

Making Contact & Terms Send query letter with transparencies and stock list. Provide business card to be kept on file for possible future assignments. Responds only if interested; send nonreturnable samples. Previously published work OK. Pays $300 bonus if image is used as cover photo; $250-275 plus mileage and film costs for standard auto shoot. **Pays on acceptance**. Photography is credited on an article-by-article basis in an "Acknowledgments" section at the front of the magazine. Buys all rights.

Tips "Read our magazine for good examples of the types of backgrounds, shot angles and overall quality that we are looking for."

$ COLLECTOR CAR & TRUCK MARKET GUIDE

12 Williams St., Suite 1, North Grafton MA 01536-1559. (508)839-6707. Fax: (508)839-6266. E-mail: vmr@vm rintl.com. Website: www.vmrintl.com. **Contact:** Kelly Hulitzky, production director. Circ. 30,000. Estab. 1994. Bimonthly magazine. Emphasizes old cars and trucks. Readers are primarily males, ages 30-60.

Needs Buys 3 photos from freelancers/issue; 18 photos/year. Needs photos of old cars and trucks. Model/property release required. Photo captions required; include year, make and model.

Making Contact & Terms Provide résumé, business card, brochure, flier or tearsheets to be kept on file for possible future assignments. Responds in 1 month. Previously published work OK. Pays $100 for color cover. Pays net 30 days. Buys one-time rights.

$ COLLEGE PREVIEW

7300 W. 110th St., 7th Floor, Overland Park KS 66210. (913)317-2888. E-mail: editorial@CollegePreviewMaga zine.com. Website: www.CollegePreviewMagazine.com. **Contact:** N. Michelle Paige, editor. Circ. 600,000. Bimonthly magazine. Emphasizes college and college-bound African-American and Hispanic students. Readers are African-American, Hispanic, ages 16-24. Sample copy free with 9×12 SAE and 4 first-class stamps.

Needs Uses 30 photos/issue. Needs photos of students in class, at work, in interesting careers, on campus. Special photo needs include computers, military, law and law enforcement, business, aerospace and aviation, health care. Model/property release required. Photo captions required; include name, age, location, subject.

Making Contact & Terms Send query letter with résumé of credits. Simultaneous submissions and previously published work OK. Pays $10-50 for color photos; $5-25 for b&w inside. Pays on publication. Buys first North American serial rights.

$▤ ⒶCOMPANY MAGAZINE

P.O. Box 60790, Chicago IL 60660-0790. (773)761-9432. Fax: (773)761-9443. E-mail: editor@companymagazi ne.org. Website: www.companymagazine.org. **Contact:** Martin McHugh, editor. Circ. 114,000. Estab. 1983. Published by the Jesuits (Society of Jesus). Quarterly magazine. Emphasizes Jesuit works/ministries and the people involved in them. Sample copy available for 9×12 SAE.

Needs Needs photos and photo-stories of Jesuit and allied ministries and projects. Reviews photos with or without a ms. Photo captions required.

Specs Accepts images in digital format. Send via CD, Zip, e-mail "at screen resolution as long as higher-res is available."

Making Contact & Terms Query with samples; include SASE for return of material. Provide résumé, business card, brochure, flier or tearsheets to be kept on file for possible future assignments. Responds in 1 month. Pays $50-100 for individual photos; $300 for color cover; up to $750 for photo story. Pays on publication. Credit line given. Buys one-time rights; negotiable.

Tips "Avoid large-group, 'smile-at-camera' photos. We are interested in people/activity photographs that tell a story about Jesuit ministries."

$ ▣ ⊘ COMPLETE WOMAN

875 N. Michigan Ave., Suite 3434, Chicago IL 60611-1901. (312)266-8680. **Contact:** Scott Oldham, art director. Estab. 1980. Bimonthly magazine. General interest magazine for women. Readers are "females, ages 21-40, from all walks of life."

Needs Uses 50-60 photos/issue; 300 photos/year. Needs high-contrast shots of attractive women, how-to beauty shots, celebrities, couples, health/fitness/beauty, business concepts. Interested in fashion/glamour. Model release required.

Specs Uses color transparencies (slide and large-format). Accepts images in digital format. Send via CD as TIFF, JPEG files at 300 dpi.

Making Contact & Terms Portfolio may be dropped off and picked up by appointment only. Provide résumé, business card, brochure, flier or tearsheets to be kept on file for possible future assignments. Send color prints and transparencies. "Each print/transparency should have its own protective sleeve. Do not write or make heavy pen impressions on back of prints; Identification marks will show through, affecting reproduction." Responds in 1 month. Simultaneous submissions and previously published work OK. Pays $75-150 for color inside. Pays on publication. Credit line given. Buys one-time rights.

Tips "We use photography that is beautiful and flattering, with good contrast and professional lighting. Models should be attractive, ages 18-28, and sexy. We're always looking for nice couple shots."

CONDÉ NAST TRAVELER

Condé Nast Publications, Inc., 4 Times Square, 14th floor, New York NY 10036. (212)286-2860. Fax: (212)286-5931. *Condé Nast Traveler* provides the experienced traveler with an array of diverse travel experiences encompassing art, architecture, fashion, culture, cuisine and shopping. This magazine has very specific needs and contacts a stock agency when seeking photos.

$ ⊿ CONFRONTATION MAGAZINE

English Dept., C.W. Post Campus of Long Island University, 720 Northern Blvd., Brookville NY 11548. (516)299-2391. Fax: (516)299-2735. E-mail: martin.tucker@liu.edu. **Contact:** Martin Tucker, editor. Circ. 2,000. Estab. 1968. Semiannual literary magazine. Readers are college-educated lay people interested in literature. Sample copy available for $3.

Needs Reviews photos with or without a ms. Photo captions preferred.

Making Contact & Terms Send query letter with résumé of credits, stock list. Responds in 1 month. Simultaneous submissions OK. Pays $100-300 for b&w or color cover; $40-100 for b&w inside; $50-100 for color inside. Pays on publication. Credit line given. Buys first North American serial rights; negotiable.

THE CONNECTION PUBLICATION OF NJ, INC.

P.O. Box 2120, Teaneck NJ 07666-1520. (201)801-0771. Fax: (201)692-1655. E-mail: theconnection@elsolme dia.com. **Contact:** Editor. Weekly tabloid. Readers are male and female executives, ages 18-62. Circ. 41,000. Estab. 1982. Sample copy available for $1.50 with 9×12 SAE.

Needs Uses 12 photos/issue; 4 supplied by freelancers. Needs photos of personalities. Reviews photos with accompanying ms only. Photo captions required.

Specs Uses b&w prints.

Making Contact & Terms Send unsolicited photos by mail for consideration. Keeps samples on file. Responds in 2 weeks. Previously published work OK. Payment negotiable. Pays on publication. Buys one-time rights; negotiable. Credit line given.

Tips "Work with us on price."

$▣ ○ ⑤ CONSCIENCE

1436 U St. NW, #301, Washington DC 20009. (202)986-6093. E-mail: conscience@catholicsforchoice.org. Website: www.catholicsforchoice.org. **Contact:** David Nolan, editor. Circ. 12,500. Quarterly news journal of Catholic opinion. Sample copies available.

Needs Buys up to 25 photos/year. Needs photos of multicultural, religious, Catholic-related news. Reviews photos with or without ms. Model/property release preferred. Photo captions preferred; include title, subject, photographer's name.

Specs Uses glossy color and/or b&w prints. Accepts high-res images in digital format. Send as TIFF, JPEG files.

Making Contact & Terms Send query letter with tearsheets. Responds only if interested; send nonreturnable samples. Simultaneous submissions and previously published work OK. Pays $300 maximum for color cover; $50 maximum for b&w inside. Pays on publication. Credit line given.

▣ CONTEMPORARY BRIDE MAGAZINE

North East Publishing, Inc., 4475 S. Clinton Ave., Suite 201, South Plainfield NJ 07080. (908)561-6010. Fax: (908)755-7864. E-mail: sales@contemporarybride.com. Website: www.contemporarybride.com. **Contact:** Linda Paris, editor. Circ. 120,000. Estab. 1994. Biannual. Bridal magazine with 80-page wedding planner; 4-color publication with editorial, calendars, check-off lists and advertisers. Sample copy available for first-class postage.

Needs Needs photos of travel destinations, fashion, bridal events. Reviews photos with accompanying ms only. Model/property release preferred. Photo captions preferred; include photo credits.

Specs Accepts images in digital format. Send as high-res files at 300 dpi.

Making Contact & Terms Send query letter with samples. Art director will contact photographer for portfolio review if interested. Provide b&w and/or color prints, disc. Keeps samples on file; cannot return material. Responds only if interested; send nonreturnable samples. Simultaneous submissions and previously published work OK. Payment negotiable. Buys all rights, electronic rights.

Tips "Digital images preferred with a creative eye for all wedding-related photos. Give us the *best* presentation."

$○ ⑤ CONTINENTAL NEWSTIME

501 W. Broadway, Plaza A, PMB #265, San Diego CA 92101-3802. (858)492-8696. E-mail: ContinentalNewsService@yahoo.com. Website: www.ContinentalNewsService.com. **Contact:** Gary P. Salamone, editor-in-chief. Estab. 1987. Twice monthly general-interest magazine of news and commentary on US national and world news, with travel columns, entertainment features, humor pieces, comic strips, general humor panels, and editorial cartoons. Covers the unreported and under-reported national (US) and international news. Sample copy available for $6.

Needs Buys variable number of photos from freelancers. Needs photos of celebrities, public figures, multicultural, disasters, environmental, wildlife, architecture, cities/urban, adventure, entertainment, events, performing arts, sports, travel, agriculture, industry, medicine, military, political, science, technology; US and foreign government officials/cabinet ministers and newsworthy events, breaking/unreported/under-reported news. Interested in documentary, historical/vintage, seasonal. Reviews photos with or without ms. Model/property release required. Photo captions required.

Specs Uses 8×10 color and/or b&w prints.

Making Contact & Terms Send query letter with résumé, photocopies, tearsheets, stock list. Provide résumé to be kept on file for possible future assignments. Responds only if interested; send nonreturnable samples. Simultaneous submissions OK. Pays $10 minimum for b&w cover. Pays on publication. Credit line given. Buys one-time rights.

Tips "Read our magazine to develop a better feel for our photo applications/uses and to satisfy our stated photo needs."

Ⓝ ▣ CONVERGENCE

955 Plaza Drive, San Jose CA 95125. (408)515-9204. E-mail: editor@converegence-journal.com. Website: www.convergence-journal.com. **Contact:** Lara Gularte, editor. Circ. 400. Estab. 2003. Quarterly. *Convergence* seeks to unify the literary and visual arts and draw new interpretations on the written word by pairing poems and flash fiction with complementary art.

Needs Ethnic/multicultural, experimental, feminist, gay/lesbian.

Making Contact & Terms Send up to 6 JPEGs of your work via e-mail. Include full name, address, phone number and preferred e-mail address with submission. Acquires electronic rights.

Tips "Working with a common theme has a greater chance of being accepted."

COSMOPOLITAN

Hearst Corporation, Magazine Division, 224 W. 57th St., 8th Floor, New York NY 10019. (212)649-2000. *Cosmopolitan* targets young women for whom beauty, fashion, fitness, career, relationships and personal growth are top priorities. It includes articles and columns on nutrition and food, travel, personal finance, home/lifestyle and celebrities. Query before submitting.

$ $回 ☑ 匽 COUNTRY

Reiman Media Group, Inc., 5400 S. 60th St., Greendale WI 53129. Fax: (414)423-8463. E-mail: photocoordinat or@reimanpub.com. Website: www.country-magazine.com. **Contact:** Trudi Bellin, photo coordinator. Estab. 1987. Bimonthly magazine. "For those who live in or long for the country." Readers are rural-oriented, male and female. "*Country* is supported entirely by subscriptions and accepts no outside advertising." Sample copy available for $2. Photo guidelines free with SASE.

 • *Country EXTRA* is published in the months between regular issues. Content and guidelines are the same.

Needs Buys 46 photos from freelancers/issue; 275 photos/year. Needs photos of families, senior citizens, gardening, travel, agriculture, country scenics, animals, rural and small-town folk at work or wholesome play. Interested in historical/vintage, seasonal. Photo captions preferred; include season, location.

Specs Prefers color transparencies, all sizes. Accepts images in digital format. Send via lightboxes, CD/DVD with printed thumbnails and caption sheet, or e-mail if first review selection is small (12 images or less).

Making Contact & Terms Send query letter with résumé of credits, stock list. Send unsolicited photos by mail for consideration. Keeps samples on file (tearsheets; no dupes); include SASE for return of material. Responds in 3 months. Previously published work OK. Buys stock only. Pays $300 for color cover; $200 for back cover; $100-300 for color inside. Pays on publication. Credit line given. Buys one-time rights.

Tips "Technical quality is extremely important; focus must be sharp (no soft focus), and colors must be vivid so they 'pop off the page.' Study our magazine thoroughly—we have a continuing need for sharp, colorful images, especially those taken along the backroads of rural America. Photographers who can supply what we need can expect to be regular contributors. Submissions are on spec. Limit them to one season."

$ $回 ☑ 匽 COUNTRY DISCOVERIES, Your Guide to Great Backroads Travel

Reiman Media Group, Inc., 5400 S. 60th St., Greendale WI 53129. Fax: (414)423-8463. E-mail: photocoordinat or@reimanpub.com. Website: www.countrydiscoveries.com. **Contact:** Trudi Bellin, photo coordinator. Estab. 1999. Bimonthly consumer magazine. Supported entirely by subscriptions and accepts no outside advertising. Readers are males and females over age 40. Sample copy available for $2. Photo guidelines available for SASE.

Needs Buys 20 photos from freelancers/issue; 115 photos/year. Needs people-populated travel lifestyle photos; photos of lesser-known North American travel destinations and unique attractions and festivals. Photo/text spreads are 1-9 pages. Buys about 25 photos/issue from freelancers for these pages; 150 photos/year. Features include "Prettiest Drive Around" (people, scenery, long drive), "Fun Day in the City" (medium-to-large cities), "Let's Hit the Road to. . . " (North American long weekend destination). Photo captions required.

Specs Prefers color transparencies, all sizes. Accepts images in digital format. Send via lightboxes, CD/DVD with printed thumbnails and caption sheet, or e-mail if first review selection is small (12 images or less).

Making Contact & Terms Send query letter with résumé of credits, stock list. Send unsolicited photos by mail for consideration. Keeps samples on file (tearsheets; no dupes); include SASE for return of material. Responds in 3 months to queries. Simultaneous submissions and previously published work OK. Buys stock only. Pays $300 for color cover; $200 for back cover; $100-300 for color inside; $150-750 for photo/text package. Pays on publication. Credit line given. Buys one-time rights.

Tips "Technical quality is extremely important; focus must be sharp (no soft focus), and colors must be vivid so they 'pop off the page.' Study our magazine thoroughly—we have a continuing need for sharp, colorful images; those who can supply what we need can expect to be regular contributors. Very interested in photos that include people. Interested in photos that highlight interesting small towns, 2-day road trips, 4-day getaways, unique celebrations and events, unusual attractions, quirky museums, neat factory tours, the fun side of medium-to-large cities, and historic inns and B&Bs."

$ $ □ COUNTRY WOMAN

Reiman Media Group, Inc., 5400 S. 60th St., Greendale WI 53129. E-mail: editors@countrywomanmagazine.com. Website: www.countrywomanmagazine.com. **Contact:** Marilyn Kruse, managing editor. Bimonthly consumer magazine. Supported entirely by subscriptions and accepts no outside advertising. Emphasizes rural life and a special quality of living to which country women can relate; at work or play, in sharing problems, etc. Sample copy available for $2. Photo guidelines free with SASE.

Needs Uses 75-100 photos/issue; most supplied by readers, rather than freelance photographers. "Covers are usually supplied by professional photographers; they are often seasonal in nature and generaly feature a good-looking country woman (mid-range to close up, shown within her business setting or with a hobby, craft or others; static pose or active)." Photos purchased with or without accompanying ms. Also interested

Canadian photographer L. Diane Lackie licensed this image for use on the cover of *Country Woman*. She says perseverance is key to getting published in magazines such as *Country Woman*. "Do not take initial rejection personally. Magazines' needs are constantly changing," she says. "Try to provide what editors call the 'wow' factor. Usually that means unusual subjects shot in a novel fashion with bright, vibrant colors that 'sing.' "

© L. Diane Lackie

Consumer Publications

in unique or well-designed country homes and interiors. Some work assigned for interiors. Works 6 months in advance. "No poor-quality color prints, posed photos, etc." Photo captions required.

Specs Prefers color transparencies, all sizes. Accepts images in digital format. Send via lightboxes, CD/DVD with printed thumbnails and caption sheet, or e-mail if first review selection is small (12 images or less).

Making Contact & Terms Send material by mail for consideration; include SASE. Provide brochure, calling card, letter of inquiry, price list, résumé and samples to be kept on file for possible future assignments. Responds in 3 months. Previously published work OK. Pays $300-800 for text/photo package depending on quality of photos and number used; $300 minimum for front cover; $200 minimum for back cover; $100-300 for partial page inside, depending on size. No b&w photos used. **Pays on acceptance**. Buys one-time rights.

Tips Prefers to see "rural scenics, in various seasons; include a variety of country women—from traditional farm and ranch women to the new baby-boomer, rural retiree; slides appropriately simple for use with poems or as accents to inspirational, reflective essays, etc."

⊠ $COUSTEAU KIDS

(formerly *The Dolphin Log*), 710 Settlers Landing Rd., Hampton VA 23669. (757)722-9300. Fax: (757)722-8185. E-mail: cousteau@cousteausociety.com. Website: www.cousteaukids.org. **Contact:** Melissa Norkin, editor. Circ. 80,000. Estab. 1981. Publication of The Cousteau Society, Inc., a nonprofit organization. Bimonthly magazine. Emphasizes "ocean and water-related subject matter for children ages 8 to 12." Sample copy available for $2.50 with 9×12 SAE and 3 first-class stamps. Photo guidelines free with SASE.

Needs Uses about 20 photos/issue; 2-6 supplied by freelancers; 10% stock. Needs "selections of images of individual creatures or subjects, such as architects and builders of the sea, how sea animals eat, the smallest and largest things in the sea, the different forms of tails in sea animals, resemblances of sea creatures to other things. Also excellent potential for cover shots or images which elicit curiosity, humor or interest." No aquarium shots. Model release required if person is recognizable. Photo captions preferred; include when, where and, if possible, scientifically accurate identification of animal.

Making Contact & Terms Query with samples or list of stock photos. Send 35mm, 4×5 transparencies or b&w contact sheets by mail for consideration. Send duplicates only. Include SASE. Responds in 1 month. Simultaneous and previously published submissions OK. Pays $50-200/color photo. Pays on publication. Buys one-time rights and worldwide translation rights. Credit line given.

Tips Prefers to see "rich color, sharp focus and interesting action of water-related subjects" in samples. "No assignments are made. A large amount is staff-shot. However, we use a fair amount of freelance photography, usually pulled from our files, approximately 45-50%. Stock photos purchased only when an author's sources are insufficient or we have need for a shot not in file. These are most often hard-to-find creatures of the sea." To break in, "send a good submission of dupes in keeping with our magazine's tone/content; be flexible in allowing us to hold slides for consideration."

$⊡ ⬀ CRC PRODUCT SERVICES

2850 Kalamazoo Ave. SE, Grand Rapids MI 49560. (616)246-0780. Fax: (616)246-0803. Website: www.crcna.org/proservices. **Contact:** Dean Heetderks, art acquisition. Publishes numerous magazines with various formats. Emphasizes living the Christian life. Readers are Christians, ages 35-85. Photo guidelines available on website.

Needs Buys 6-8 photos from freelancers/issue. Needs photos of people, holidays and concepts. Reviews photos with or without a ms. Special photo needs include real people doing real activities: couples, families. Model/property release required. Photo captions preferred.

Specs Uses any color or b&w prints; 35mm, 2¼×2¼, 4×5, 8×10 transparencies. Accepts images in digital format.

Making Contact & Terms Provide résumé, business card, brochure, flier or tearsheets to be kept on file for possible future assignments. Cannot return material. Simultaneous submissions and previously published work OK. Pays $300-600 for color cover; $200-400 for b&w cover; $200-300 for b&w or color inside. **Pays on acceptance.** Buys one-time and electronic rights.

$⊡ ◻ CRUISING WORLD MAGAZINE

55 Hammarlund Way, Middletown RI 02842. (401)845-5100. Fax: (401)845-5180. Website: www.cruisingworld.com. **Contact:** William Roche, art director. Circ. 156,000. Estab. 1974. Emphasizes sailboat maintenance, sailing instruction and personal experience. For people interested in cruising under sail. Sample copy free for 9×12 SAE.

Needs Buys 25 photos/year. Needs "shots of cruising sailboats and their crews anywhere in the world. Shots

of ideal cruising scenes. No identifiable racing shots, please.'' Also wants exotic images of cruising sailboats, people enjoying sailing, tropical images, different perspectives of sailing, good composition, bright colors. For covers, photos ''must be of a cruising sailboat with strong human interest, and can be located anywhere in the world.'' Prefers vertical format. Allow space at top of photo for insertion of logo. Model release preferred; property release required. Photo captions required; include location, body of water, make and model of boat.

Specs Prefers images in digital format via CD. Accepts 35mm color transparencies for cover; 35mm color slides for inside only with ms.

Making Contact & Terms ''Submit original 35mm slides. *No* duplicates. Most of our editorial is supplied by author. We look for good color balance, very sharp focus, the ability to capture sailing, good composition and action. Always looking for *cover shots*.'' Responds in 2 months. Pays $600 for color cover; $50-300 for color inside. Pays on publication. Credit line given. Buys all rights, but may reassign to photographer after publication; first North American serial rights; or one-time rights.

$ ▣ ◿ CYCLE CALIFORNIA! MAGAZINE

1702-L Meridian Ave., #289, San Jose CA 95125. (888)292-5323. Fax: (408)292-3005. E-mail: bmack@cyclecal ifornia.com. Website: www.cyclecalifornia.com. **Contact:** Bob Mack, publisher. Circ. 26,500. Estab. 1995. Monthly magazine providing readers with a comprehensive source of bicycling information, emphasizing the bicycling life in northern California and Nevada; promotes bicycling in all its facets. Sample copy available for 9×12 SAE with 83¢ first-class postage. Photo guidelines available for 37¢ SASE.

Needs Buys 3-5 photos from freelancers/issue; 45 photos/year. Needs photos of recreational bicycling, bicycle racing, triathalons, bicycle touring and adventure racing. Cover photos must be vertical format, color. All cyclists must be wearing a helmet. Reviews photos with or without ms. Model release required; property release preferred. Photo captions preferred; include when and where photo is taken; if an event, include name, date and location of event; for nonevent photos, location is important.

Specs Uses 4×6 matte color and/or b&w prints; 35mm transparencies; high-resolution TIFF images.

Making Contact & Terms Send query letter with slides, prints or CD/disk. Does not keep samples on file; include SASE for return of material. Responds in 3 weeks. Simultaneous submissions OK. Pays $125 for color cover; $25 for b&w inside; $50 for color inside. Payment negotiable for website usage. Pays on publication. Credit line given. Buys one-time rights, first rights.

Tips ''We are looking for photographic images that depict the fun of bicycle riding. Your submissions should show people enjoying the sport. Read the magazine to get a feel for what we do. Label images so we can tell what description goes with which image.''

$ ▣ ◯ Ⓢ DAKOTA OUTDOORS

P.O. Box 669, Pierre SD 57501. (605)224-7301. Fax: (605)224-9210. E-mail: office@capjournal.com. Website: www.dakotashop.com/do. **Contact:** Rachel Engbrecht, managing editor. Circ. 8,000. Estab. 1978. Monthly magazine. Emphasizes hunting and fishing in the Dakotas. Readers are sportsmen interested in hunting and fishing, ages 35-45. Sample copy available for 9×12 SAE and 3 first-class stamps. Photo guidelines free with SASE.

Needs Uses 15-20 photos/issue; 8-10 supplied by freelancers. Needs photos of hunting and fishing. Reviews photos with or without ms. Special photo needs include: scenic shots of sportsmen, wildlife, fish. Model/ property release required. Photo captions preferred.

Specs Uses 3×5 b&w prints; 35mm b&w transparencies. Accepts images in digital format. Send via Zip, e-mail as EPS, JPEG files.

Making Contact & Terms Send query letter with samples. Keeps samples on file; include SASE for return of material. Responds in 3 weeks. Pays $20-75 for b&w cover; $10-50 for b&w inside; payment negotiable. Pays on publication. Credit line given. Usually buys one-time rights; negotiable.

Tips ''We want good-quality outdoor shots, good lighting, identifiable faces, etc.—photos shot in the Dakotas. Use some imagination and make your photo help tell a story. Photos with accompanying story are accepted.''

◿ DANCE

2660 Petersborogh St., Herndon VA 20171. E-mail: shannonaswriter@yahoo.com. Quarterly publication featuring international dancers.

Needs Needs photos of babies/children/teens, celebrities, couples, multicultural, families, parents, senior citizens, environmental, landscapes/scenics, wildlife, architecture, cities/urban, gardening, interiors/decorating, pets, religious, rural, performing arts, agriculture, product shots/still life—as related to international

dance. Interested in alternative process, avant garde, documentary, fashion/glamour, fine art, historical/vintage, seasonal. Reviews photos with or without ms. Model/property release preferred.

Specs Uses glossy or matte color and/or b&w prints.

Making Contact & Terms Send query letter via e-mail. Provide résumé, business card, self-promotion piece to be kept on file for possible future assignments. Responds within 1 month to queries; 1 week to portfolios. Simultaneous submissions and previously published work OK. **Pays on acceptance.** Credit line given. Buys one-time rights, first rights; negotiable.

$ ▣ DEER AND DEER HUNTING

700 E. State St., Iola WI 54990. (715)445-2214. Website: www.deeranddeerhunting.com. **Contact:** Daniel Schmidt, editor. Circ. 200,000. Estab. 1977. Magazine published 9 times/year. Emphasizes white-tailed deer and deer hunting. Readers are "a cross-section of American deer hunters—bow, gun, camera." Sample copy and photo guidelines free with 9 × 12 SAE with 7 first-class stamps. Photo guidelines also available on website.

Needs Buys 20 photos from freelancers/issue; 180 photos/year. Needs photos of deer in natural settings. Model release preferred. Photo captions preferred.

Specs Accepts images in digital format. Send contact sheet.

Making Contact & Terms Send query letter with résumé of credits and samples. "If we judge your photos as being usable, we like to hold them in our file. Send originals—include SASE if you want them returned." Responds in 2 weeks. Simultaneous submissions and previously published work OK. Pays $600 for color cover; $50 for b&w inside; $75-250 for color inside. Pays within 10 days of publication. Credit line given. Buys one-time rights.

Tips Prefers to see "adequate selection of 8 × 10 b&w glossy prints and 35mm color transparencies; action shots of whitetail deer only, as opposed to portraits. We also need photos of deer hunters in action. We are currently using almost all color—very little b&w. Submit a limited number of quality photos rather than a multitude of marginal photos. Include your name on all entries. Cover shots must have room for masthead."

$ ▣ DOG & KENNEL

Pet Publishing, Inc., 7-L Dundas Circle, Greensboro NC 27407. (336)292-4047. Fax: (336)292-4272. E-mail: editorial@petpublishing.com. Website: www.dogandkennel.com. **Contact:** Rita Davis, executive editor. Bimonthly magazine about dogs. "Articles include breed profiles, stories about special dogs, dogs in art and popular culture, etc." Sample copy available for $5 and 9 × 12 SASE. Photo guidelines free with SASE.

Needs Photos of dogs—posed, candid and interacting with other dogs and people. Photo captions required; include the breed name and additional description as needed.

Specs Transparencies or slides preferred. Images may be scanned full-size at 266 dpi on CD-ROM for submission.

Making Contact & Terms Send unsolicited material by mail for consideration, "but please include SASE if you want it returned. Please send duplicates. We cannot assume liability for unsolicited originals." Pays $150 for color cover; $25-50 for color inside. Pays on publication. Buys all rights; negotiable.

Tips "We seek good composition (indoor or outdoor). Photos must be professional and of publication quality—good focus and contrast. We work regularly with a few excellent freelancers, but are always seeking new contributors. Images we think we might be able to use will be scanned into our CD-ROM file and the originals returned to the photographer."

$ ▣ ◪ DOG FANCY

Fancy Publications, a division of BowTie, Inc., P.O. Box 6050, Mission Viejo CA 92690. (949)855-8822. Fax: (949)855-3045. E-mail: ashirreffs@bowtieinc.com. Website: www.dogfancy.com. **Contact:** Annie Shirreffs, associate editor. Circ. 268,000. Estab. 1970. Monthly consumer magazine. Readers are "men and women of all ages interested in all aspects of dog ownership." Sample copy available for $5.50. Photo guidelines free with SASE or via website.

Needs Buys 40-60 photos from freelancers/issue; 490-720 photos/year. Three specific breeds featured in each issue. Prefers "photographs that show the various physical and mental attributes of the breed. Include both environmental and action photographs. Dogs must be well groomed and, if purebred, good examples of their breed. By good example, we mean a dog that has achieved some recognition on the show circuit and is owned by a serious breeder or exhibitor. We also have a need for good-quality, interesting photographs of any breed or mixed breed in any and all canine situations (dogs with veterinarians; dogs eating, drinking, playing, swimming, etc.) for use with feature articles." Shots should have natural background, style and

setting, avoiding stylized studio backgrounds. Model release required. Slides should be labeled with photographer's name and breed of dog.

Specs Uses high-density 35mm slides for inside. Accepts images in digital format. Send via CD, Jaz, Zip as TIFF, EPS files at 300 dpi, 5 inches minimum size.

Making Contact & Terms Send by mail for consideration actual 35mm photos or slides. Address submission to ''Photo Editors.'' Present a professional package: 35mm slides in sleeves, labeled, numbered or otherwise identified. Pays $300 for color cover; $25-100 for color inside; $200 for 4-color centerspreads. Credit line given. Buys first North American print rights and non-exclusive rights to use in electronic media.

Tips ''Nothing but sharp, high-contrast shots. Send SASE for list of photography needs. We're looking more and more for good-quality photo/text packages that present an interesting subject both editorially and visually. Bad writing can be fixed, but we can't do a thing with bad photos. Subjects should be in interesting poses or settings with good lighting, good backgrounds and foregrounds, etc. We are very concerned with sharpness and reproducibility; the best shot in the world won't work if it's fuzzy, and it's amazing how many are. Submit a variety of subjects—there's always a chance we'll find something special we like.''

ⓝ $ $◨ ▧ DOGS IN CANADA

Apex Publishing Ltd., 89 Skyway Ave., Suite 200, Etobicoke ON M9W 6R4 Canada. (416)798-9778. Fax: (416)798-9671. E-mail: photos@dogsincanada.com. Website: www.dogsincanada.com. **Contact:** Bill Whitehead, art director. Circ. 41,769. Estab. 1889. Monthly consumer magazine. ''*Dogs in Canada* magazine is a reliable and authoritative source of information about dogs. Our mix of editorial content and photography must satisfy a diverse readership, including breed fanciers and those who simply have a beloved family pet. Photography is of central importance.'' Sample copy available for $4.95 and 8 × 10 SAE with postage. Request photo guildelines via e-mail.

Needs Buys 10-30 photos/year. Needs photos from any catagory as long as there is a dog in the shot. Reviews photos with or without a ms. Model/property release preferred. Photo captions preferred; include breed of dog.

Specs Uses 5 × 7 and 8 × 10 glossy color prints; 35mm, 2¼ × 2¼, 4 × 5 transparencies. Accepts images in digital format. Send via CD as TIFF or ESP files at 300 dpi.

Making Contact & Terms E-mail query letter with link to photographer's website and JPEG samples at 72 dpi. Send query letter with slides, prints. Provide résumé, business card, self-promotion piece to be kept on file for possible future assignments. Responds only if interested; send nonreturnable samples. Considers previously published work. Pays $80-600 for b&w or color cover; $50-300 for b&w or color inside. Pays net 30 days. Credit line given. Buys first rights, electronic rights.

Tips ''Well-composed, high-quality photographs are expected. What really catches our eye is a creative approach to photography. Purebred dogs preferred.''

▣ ◨ DOUBLETAKE/POINTS OF ENTRY

(formerly *Doubletake Magazine*), Dept. of English, Christopher Newport University, 1 University Place, Newport News VA 23606. E-mail: photoeditor@doubletakecommunity.org. Website: www.doubletakecommunity.org. **Contact:** Photo Editor. Circ. 20,000. Estab. 2005. Biannual magazine covering all writing (fiction, nonfiction and poetry) and photography, mostly documentary. General interest, ages 18 and over. Sample copy available for $12. Photo guidelines free with SASE and on website.

Needs Uses photos on approximately half of the pages (50+ pages/issue); 95% supplied by freelancers. Needs completed photo essays. ''We also accept works in progress. We are interested in work that is in the broad photojournalistic/humanistic tradition.'' Model release preferred for children. Photo captions preferred.

Specs Accepts images in digital format. Send via e-mail as low-resolution JPEG files (10-20 images). Upon acceptance, high-resolution (2,700 dpi) images on disk will be required. Also accepts print portfolios.

Making Contact & Terms Call for an appointment to drop off portfolio. ''We prefer to review prints or good photocopies/laser printouts, no more than 40, with artist's statement. We have an ongoing review process. We do not keep samples from every photographer.'' Responds in 3 months. Simultaneous submissions OK. ''We are unable to pay fees for published work. We do offer two complimentary copies of the magazine upon publication.'' Credit line given. Buys one-time rights.

$▣ ◯ ⓢ DOVETAIL, A Journal by and for Jewish/Christian Families

Dovetail Institute for Interfaith Family Resources, 775 Simon Greenwell Lane, Boston KY 40107-8524. (502)549-5499 or (800)530-1596. Fax: (502)549-3543. E-mail: di-ifr@bardstown.com. Website: www.dovetai

linstitute.org. **Contact:** Mary Rosenbaum, editor. Circ. 800. Estab. 1992. Bimonthly association magazine for Jews and Christians who are intermarried. Covers all positive interfaith options. (Occasionally treats other religious mixes, e.g., Christian/Muslim.) Suspending print version; PDF sample version available online.

Needs Very seldom buys photos from freelancers. Needs photos of babies/children/teens, couples, multicultural, families, parents, religious. Interested in seasonal. Reviews photos with or without ms. Model/property release required. Photo captions preferred; include names, place, date, occasion.

Specs Uses maximum 4×5 b&w prints. Accepts images in digital format. Send via CD, Zip, e-mail as TIFF files at 1,200 dpi.

Making Contact & Terms Send query letter with photocopies, stock list. Does not keep samples on file; cannot return material. Responds only if interested; send nonreturnable samples. Simultaneous submissions and previously published work OK. Pays $25-50 for b&w. Pays on publication. Credit line given. Buys one-time rights.

Tips ''Pictures must relate to interfaith theme. We have no use for generic single-faith religious scenes, objects or people. Take a look at our publication first.''

⋈ $⊟ DOWN BEAT MAGAZINE

102 N. Haven Rd., Elmhurst IL 60126. (630)941-2030. Fax: (630)941-3210. E-mail: jasonk@downbeat.com. Website: www.downbeat.com. **Contact:** Jason Koransky, editor. Circ. 90,000. Estab. 1934. Monthly. Emphasizes jazz musicians. Sample copy available for SASE.

Needs Buys 20 photos from freelancers/issue; 240 photos/year. Needs photos of live music performers/posed musicians/equipment, ''primarily jazz and blues.'' Photo captions preferred.

Specs Accepts images in digital format. *Do not send unsoliciated high-resolution images via e-mail!*

Making Contact & Terms Send 8×10 b&w prints; 35mm, 2¼×2¼, 4×5, 8×10 transparencies; b&w or color contact sheets by mail. Unsolicited samples will not be returned unless accompanied by SASE. Provide résumé, business card, brochure, flier or tearsheets to be kept on file for possible future assignments. Responds only when needed. Simultaneous submissions and previously published work OK. Pays $50 for b&w photos; $75 for color photos. Credit line given. Buys one-time rights.

Tips ''We prefer live shots and interesting candids to studio work.''

$ $⊟ DUCKS UNLIMITED

One Waterfowl Way, Memphis TN 38120. (901)758-3825. E-mail: jhoffman@ducks.org. Website: www.ducks.org. **Contact:** John Hoffman, photo editor. Circ. 580,000. Estab. 1937. Bimonthly magazine. Association publication of Ducks Unlimited, a nonprofit organization. Emphasizes waterfowl hunting and conservation. Readers are professional males, ages 40-50. Sample copy available for $3. Photo guidelines available free via website, e-mail or with SASE.

Needs Buys 84 photos from freelancers/issue; 504 photos/year. Needs images of wild ducks and geese, waterfowling and scenic wetlands. Special photo needs include dynamic shots of waterfowl interacting in natural habitat.

Specs Accepts images in digital format. Send via CD as TIFF, JPEG, EPS files at 300 dpi; include thumbnail sheet.

Making Contact & Terms Send only top-quality portfolio of not more than 40 transparencies (35mm or larger) with SASE for consideration. Responds in 1 month. Previously published work OK, if noted. Pays $100 for thumbnails; $125 for quarter page or less; $150 for images less than half page; $185 for half page; $240 for full page; $400 for 2-page spread; $850 for cover. **Pays on acceptance.** Credit line given. Buys one-time rights ''plus permission to reprint in our Mexican and Canadian publications.''

$⊟ ∅ ⊠ E MAGAZINE

28 Knight St., Norwalk CT 06851. (203)854-5559. Fax: (203)866-0602. E-mail: info@emagazine.com. Website: www.emagazine.com. **Contact:** Brian Howard, managing editor. Circ. 50,000. Estab. 1990. Nonprofit consumer magazine. Emphasizes environmental issues. Readers are environmental activists; people concerned about the environment. Sample copy available for 9×12 SAE and $5. Photo guidelines free with SASE or by e-mail.

Needs Buys 20 photos from freelancers/issue. Needs photos of threatened landscapes, environmental leaders, people and the environment, pollution, transportation, energy, wildlife and activism. Photo captions required; include location, identities of people in photograph, date, action in photograph.

Specs Accepts images in digital format. Send via CD, Zip, e-mail as TIFF, EPS, JPEG files at 300 dpi and at least 3×4 print size.

Making Contact & Terms Send query letter with résumé of credits and list of stock photo subjects, specialties or accompanying story ideas. Keeps printed samples on file. Responds in 6 weeks. Simultaneous submissions and previously published work OK. Pays $0-500 for color cover; $0-250 for color inside. Pays several weeks after publication. Credit line given. Buys print and Web version rights.

Tips Wants to see "straightforward, journalistic images. Abstract or art photography or landscape photography is not used." In addition, "please do not send manuscripts with photographs. These can be addressed as queries to the managing editor."

$EASYRIDERS MAGAZINE

P.O. Box 3000, Agoura Hills CA 91376-3000. (818)889-8740. Fax: (818)889-1252. Website: www.easyriders.com. **Contact:** Dave Nichols, editorial director. Estab. 1971. Monthly. Emphasizes "motorcycles (Harley-Davidsons in particular), motorcycle women, bikers having fun." Readers are "adult men who own, or desire to own, custom motorcycles—the individualist—a rugged guy who enjoys riding a custom motorcycle and all the good times derived from it." Free sample copy. Photo guidelines free with SASE.

Needs Uses about 60 photos/issue; "the majority" supplied by freelance photographers; 70% assigned. Needs photos of "motorcycle riding (rugged chopper riders), motorcycle women, good times had by bikers, etc." Model release required. Also interested in technical articles relating to Harley-Davidsons.

Making Contact & Terms Send b&w prints, color prints, 35mm transparencies by mail for consideration. Include SASE. Call for appointment for portfolio review. Responds in 3 months. Pays $30-100 for b&w photos; $40-250 for color photos; $30-1,700 for complete package. Other terms for bike features with models to satisfaction of editors. Pays 30 days after publication. Credit line given. Buys all rights. All material must be exclusive.

Tips Trend is toward "more action photos, bikes being photographed by photographers on bikes to create a feeling of motion." In samples, wants photos "clear, in-focus, eye-catching and showing some emotion. Read magazine before making submissions. Be critical of your own work. Check for sharpness. Also, label photos/slides clearly with name and address."

N $ $ $⊡ 18EIGHTEEN

The SCORE Group, 1629 NW 84th Ave., Miami FL 33126. (305)662-5959. Fax: (305)662-5952. E-mail: model@scoregroup.com. Website: www.18eighteen.com. **Contact:** P. Wall. Monthly men's magazine featuring models ages 18-21. Sample copy available for $8. Photo guidelines available; inquire via e-mail.

Needs Model release required as well as copies of 2 forms of ID from the model, one of them being a photo ID.

Specs Uses 35mm transparencies (100 ASA or less) or larger-format transparencies. Accepts images in digital format. Inquire about digital guidelines.

Making Contact & Terms "Please do not send individual photos except for test shots." Include SASE for return of material. Responds in 1 month to queries. Pays $1,250-1,800 for color sets of 100-200 transparencies for inside. Pays on publication. Buys first rights in North America with a reprint option, electronic rights and nonexclusive worldwide publishing rights.

$ $⊘ ⑤ THE ELKS MAGAZINE

425 W. Diversey Pkwy., Chicago IL 60614-6196. (773)755-4894. Fax: (773)755-4792. E-mail: annai@elks.org. Website: www.elks.org/elksmag. **Contact:** Anna L. Idol, managing editor. Circ. 1 million. Estab. 1922. Magazine published 10 times/year whose mission is to provide news of Elks to all 1 million members. "In addition, we have general interest articles. Themes: Americana; history; wholesome, family info; sports; industries; adventure; technology. We do not cover religion, politics, controversial issues." Sample copy free.

Needs Buys 7 cover photos/year. "Photographs of Elks in action are particularly welcome." Reviews photos with or without ms. Photo captions required; include location of photo.

Specs Uses 35mm, 2¼×2¼, 4×5, 8×10 transparencies.

Making Contact & Terms Send query letter with samples. Does not keep samples on file; include SASE for return of material. Responds in 2 months to queries. Simultaneous submissions OK. Pays $475 for color cover. Pays on publication. Credit line given. Buys one-time rights.

Tips "Please send your slides or transparencies. We will review them as soon as possible and return those we will not be publishing. Artistry and technical excellence are as important as subject matter."

$ $⊡ ⊘ ENTREPRENEUR

2445 McCabe Way, Suite 400, Irvine CA 92614. (949)261-2325. E-mail: rolson@entrepreneur.com. Website: www.entrepreneur.com. **Contact:** Richard R. Olson, design director. Circ. 575,000. Estab. 1977. Monthly magazine emphasizing business. Readers are existing and aspiring small business owners.

Needs Uses about 30 photos/issue; many supplied by freelance photographers; 60% on assignment; 40% from stock. Needs "people at work: home office, business situations. I want to see colorful shots in all formats and styles." Model/property release preferred. Photo captions required; include names of subjects.

Specs Accepts images in digital format. Send via Zip, CD, e-mail as TIFF, EPS, JPEG files at 300 dpi.

Making Contact & Terms Provide résumé, business card, brochure, flier or tearsheets to be kept on file for possible future assignments; "follow up for response." Pays $425-700 for b&w cover; $800-1,200 for color cover; $150-275 for b&w inside; $150-600 for color inside. Pays "depending on photo shoot, per hour or per day. We pay $450 per day plus up to $250 for expenses for assignments." **Pays on acceptance.** Credit line given. Buys one-time rights; negotiable.

Tips "I am looking for photographers who use the environment creatively; I do not like blank walls for backgrounds. Lighting is also important. I prefer medium-format for most shoots. I think photographers are going back to the basics—a good, clean shot, different angles and bright colors. I also like gelled lighting. I prefer examples of your work—promo cards and tearsheets—along with business cards and résumés."

$▣ ◯ ⊕ EOS MAGAZINE

Robert Scott Publishing Ltd., The Old Barn, Ball Lane, Tackley, Kidlington, Oxfordshire OX5 3AG United Kingdom. (44)(186)933-1741. Fax: (44)(186)933-1641. E-mail: editorial@eos-magazine.com. Website: www. eos-magazine.com. **Contact:** Angela August, editor. Circ. 20,000. Estab. 1993. Quarterly consumer magazine for all users of Canon EOS cameras. Photo guidelines free.

Needs Buys 100 photos from freelancers/issue; 400 photos/year. Needs photos showing use of or techniques possible with EOS cameras and accessories. Reviews photos with or without ms. Model release preferred. Photo captions required; include technical details of photo equipment and techniques used.

Specs Accepts images in digital format exclusively.

Making Contact & Terms Send query letter with samples. Keeps samples on file; include SASE for return of material. Responds in 1 week to queries; 2 weeks to samples. Simultaneous submissions and previously published work OK. Pays $175 for color cover; $15-45 for color inside. Pays on publication. Credit line given. Buys one-time rights.

Tips "Request our 'Notes for Contributors' leaflet."

$▣ ✐ Ⓢ ⤮ EVENT

Douglas College, Box 2503, New Westminster BC V3L 5B2 Canada. (604)527-5293. Fax: (604)527-5095. E-mail: event@douglas.bc.ca. Website: http://event.douglas.bc.ca. **Contact:** Ian Cockfield, managing editor. Circ. 1,300. Magazine published every 4 months. Emphasizes literature (short stories, reviews, poetry, creative nonfiction). Sample copy available for $5.

Needs Buys 3 photos/year intended for cover art. Documentary, fine art, human interest, nature, special effects/experimental, still life, travel or "any subject suitable for the cover of a literary magazine, particularly images that are self-sufficient and do not lead the reader to expect further artwork within the journal." Wants any "non-applied" photography, or photography not intended for conventional commercial purposes. Needs excellent quality. "No unoriginal, commonplace or hackneyed work."

Specs Uses color and/or b&w prints or slides. Any smooth finish OK. Accepts images in digital format. Send via CD, SyQuest, floppy disk, Jaz, Zip, e-mail as TIFF, PDF, EPS files at 300 dpi/150 lpi.

Making Contact & Terms Send material by mail with SAE and IRC or Canadian stamps for consideration. Simultaneous submissions OK. Pays $150 on publication. Credit line given. Buys one-time rights.

Tips "We prefer work that appears as a sequence: thematically, chronologically, stylistically. Individual items will only be selected for publication if such a sequence can be developed. Photos should preferably be composed for vertical, small-format (6×9). Please send no more than 10 images to *Event* along with a SASE (Canadian postage or International Reply Coupons only) for return of work."

$▣ ✐ Ⓢ FACES: People, Places, and Cultures

Cobblestone Publishing, 30 Grove St., Suite C, Peterborough NH 03458. (603)924-7209. Fax: (603)924-7380. Website: www.cobblestonepub.com. **Contact:** Elizabeth Crooker Carpentiere, editor. Circ. 13,500. Estab. 1984. Magazine published 9 times/year, September-May. Emphasizes cultural anthropology for young people ages 8-14. Sample copy available; see website. Photo guidelines and themes available via website or free with SASE.

Needs Uses about 30-35 photos/issue; about 75% supplied by freelancers. "Photos (color) for text must relate to themes; cover photos (color) should also relate to themes." Send SASE for themes. Photos purchased with or without accompanying ms. Model release preferred. Photo captions preferred.

Making Contact & Terms Query with stock photo list and/or samples. Responds in 1 month. Simultaneous submissions and previously published work OK. Pays $200-350 for color cover; $25-100 color inside. Pays on publication. Buys one-time rights. Credit line given.

Tips "Photographers should request our theme list. Most of the photographs we use are of people from other cultures. We look for an ability to capture people in action—at work or play. We primarily need photos showing people, young and old, taking part in ceremonies, rituals, customs and with artifacts and architecture particular to a given culture. Appropriate scenics and animal pictures are also needed. All submissions must relate to a specific future theme."

$▣ ✐ ✥ FAITH TODAY

Evangelical Fellowship of Canada, MIP Box 3745, Markham ON L3R 0Y4 Canada. (905)479-6071, ext 255. Fax: (905)479-4742. E-mail: FTeditor@efc-canada.com. Website: www.faithtoday.ca. **Contact:** Bill Fledderus, senior editor. Circ. 18,000. Estab. 1984. Bimonthly consumer publication. Sample copy free for SAE.

Needs Buys 3 photos from freelancers/issue; 18 photos/year. Needs photos of multicultural, families, senior citizens, education, religious. Interested in historical/vintage. Also looking for scenes of church life: people praying, singing, etc. Reviews photos with or without ms. Model/property release preferred. Photo captions required.

Specs Uses color prints. Accepts images in digital format. Send via e-mail as TIFF, EPS, JPEG files at 266 dpi.

Making Contact & Terms Send query letter with photocopies, stock list. Does not keep samples on file; include SASE for return of material. Responds only if interested; send nonreturnable samples. Simultaneous submissions and previously published work OK. Pays $25-400 for color cover; $25-150 for color inside. Pays on publication. Credit line given "if requested." Buys one-time rights.

Tips "Our website does not adequately represent our use of photos but does list sample articles, so you can see the kind of topics we cover. We also commission illustrations and welcome queries on that."

© 2006 Oscar C. Williams

Faith Today published Oscar Williams' photo of a boy going fishing with his great-grandfather. This image could be used to portray concepts such as love, patience, instruction and generations.

$▣ FAMILY MOTOR COACHING

8291 Clough Pike, Cincinnati OH 45244. (513)474-3622. Fax: (513)388-5286. E-mail: magazine@fmca.com. Website: www.fmca.com. **Contact:** Robbin Gould, editor. Art Director: Guy Kasselmann. Circ. 140,000. Estab. 1963. Monthly publication of the Family Motor Coach Association. Emphasizes motor homes. Readers are members of national association of motor home owners. Sample copy available for $3.99 ($5 if paying by credit card). Writer's/photographer's guidelines free with SASE or via e-mail.

Needs Buys 55-60 photos from freelancers/issue; 660-720 photos/year. Each issue includes varied subject matter—primarily needs photos depicting motorhome travel, travel with scenic shots, couples, families, senior citizens, hobbies and how-to material. Photos purchased with accompanying ms only. Model release preferred. Photo captions required.

Specs Accepts images in digital format. Send via CD as EPS, TIFF files at 300 dpi.

Making Contact & Terms Send query letter with résumé of credits, samples, contact sheets; include SASE for return of material. Responds in 3 months. Pays $100 for color cover; $25-100 for b&w and color inside. $125-500 for text/photo package. **Pays on acceptance.** Credit line given if requested. Prefers first North American rights, but will consider one-time rights on photos *only*.

Tips Photographers are "welcome to submit brochures or copies of their work. We'll keep them in mind should a freelance photography need arise."

$ $☐ 🖳 ☑ 🅂 FARM & RANCH LIVING

Reiman Media Group, Inc., 5400 S. 60th St., Greendale WI 53129. Fax: (414)423-8463. E-mail: photocoordinator@reimanpub.com. Website: www.farmandranchliving.com. **Contact:** Trudi Bellin, photo coordinator. Estab. 1978. Bimonthly magazine. Supported entirely by subscriptions and accepts no outside advertising. "Concentrates on farming and ranching as a way of life." Readers are full-time farmers and ranchers. Sample copy available for $2. Photo guidelines free with SASE.

Needs Buys 25 photos from freelancers/issue; 150 photos/year. Needs photos of beautiful or warmhearted agricultural scenes, lifestyle images of farmers and ranchers (riding, gardening, restoring tractors, handling livestock, hobbies, pets, etc.). Looks for everything from colorful close-ups of produce to panoramic vistas of crops and pastures in a scenic environment. Especially interested in great seasonal shots of agriculture: harvests, feeding cattle in winter, planting, mowing hay. "Shots that are creative, pretty, idyllic or have a warmhearted human interest quality have the best chance of being used." Photo captions preferred; include season and location, and identify subject (type of crop, livestock, etc.).

Specs Prefers color transparencies, all sizes. Accepts images in digital format. Send via lightboxes, CD/DVD with printed thumbnails and caption sheet, or e-mail if first review selection is small (12 images or less).

Making Contact & Terms Send query letter with samples or list of stock photo subjects; include SASE for return of material. "We review one season at a time; we work one season in advance." Responds in 3 months. Previously published work OK. Buys stock only. Pays $300 for color cover; $200 for back cover; $100-300 for inside. Pays on publication. Buys one-time rights.

Tips "Technical quality is extremely important; focus must be sharp (no soft focus), and colors must be vivid so they 'pop off the page.' Study our magazine thoroughly. We have a continuing need for sharp, colorful images. Those who supply what we need can expect to be regular contributors."

$☐ FELLOWSHIP

P.O. Box 271, Nyack NY 10960. (845)358-4601. Fax: (845)358-3278. E-mail: editor@forusa.org. Website: www.forusa.org. **Contact:** Ethan Vesely-Flad, editor. Circ. 8,500. Estab. 1935. Publication of the Fellowship of Reconciliation; 36-page magazine published 6 times/year. Emphasizes peace-making, social justice, nonviolent social change. Readers are people interested in peace, justice, nonviolence and spirituality. Sample copy available for $4.50.

Needs Buys 9 photos from freelancers/issue; 54 photos/year. Needs stock photos of people, civil disobedience, demonstrations—Middle East, Latin America, Caribbean, prisons, anti-nuclear, children, gay/lesbian, the former Soviet Union. Other needs include landscapes/scenics, disasters, environmental, wildlife, religious, humor. Interested in fine art; b&w only. Photo captions required.

Making Contact & Terms Provide résumé, business card, brochure, flier or tearsheets to be kept on file for possible future assignments. "Call on specs." Responds in 3 weeks. Simultaneous submissions and previously published work OK. Pays $60 for color cover; $15 for b&w inside. Pays on publication. Credit line given. Buys one-time rights.

Tips "You must want to make a contribution to peace movements. Money is simply token."

$🖳 ☑ FIELD & STREAM

2 Park Ave., New York NY 10016. (212)779-5364. Fax: (212)779-5114. Website: www.fieldandstream.com. **Contact:** Amy Berkley, photo editor. Circ. 1.5 million (11 issues/year). This is a broad-based service magazine. The editorial content ranges from very basic "how it's done" filler stories that tell in pictures and words how an outdoor technique is accomplished or device is made, to feature articles of penetrating depth about national conservation, game management and resource management issues; also recreational hunting, fishing, travel, nature and outdoor equipment. Photo guidelines available.

Needs Photos using action and a variety of subjects and angles in color and occasionally b&w. "We are always looking for cover photographs, in color, vertical or horizontal. Remember: a cover picture must have room for cover lines." Also looking for interesting photo essay ideas related to hunting and fishing. Query photo editor by mail. Needs photo information regarding subjects, the area, the nature of the activity and the point the picture makes. First Shots: these photos appear every month (2/issue). Prime space, 2-page spread. One of a kind, dramatic, impactful images, capturing the action and excitement of hunting and fishing. Great beauty shots. Unique wildlife images. See recent issues. "Please do not submit images without reviewing past issues and having a strong understanding of our audience."

Specs Uses 35mm slides. Will also consider large-format photography. Accepts images in digital format. Send via CD, e-mail as JPEG files at 300 dpi.

Making Contact & Terms Submit photos by registered mail. Send slides in 8½×11 plastic sheets, and pack

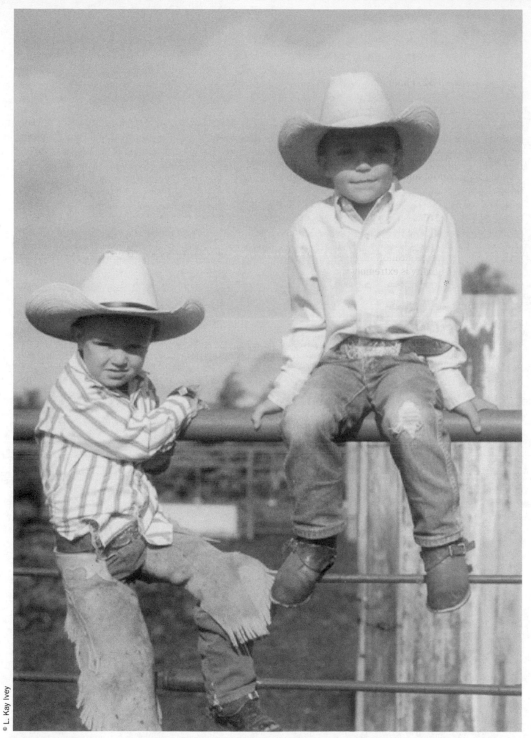

© L. Kay Ivey

Kay Ivey's image of two little cowboys on a Texas ranch appeared on the cover of *Farm & Ranch Living*. Ivey advises photographers to request guidelines from publishers, submit images that fit their needs and make a neat, well-organized presentation. ''Send only really good, crisp images with a short, concise cover letter,'' she says.

slides and/or prints between cardboard. Include SASE for return of material. Drop portfolios at receptionist's desk, ninth floor. Buys first North American serial rights.

$ ▣ ◯ FIFTY SOMETHING MAGAZINE

1168 Beachview Dr., Willoughby OH 44094. (440)951-2468. Fax: (440)951-1015. E-mail: linde@apk.net. **Contact:** Linda Lindeman deCarlo, publisher. Circ. 10,000. Estab. 1990. Quarterly consumer magazine targeted to the 50-and-better reader. Sample copy available for 9×12 SAE with $1.35 first-class postage. Photo guidelines available for #10 SASE.

Needs Buys 2 photos from freelancers/issue; 8 photos/year. Needs photos of celebrities, couples, families, parents, senior citizens, disasters, environmental, landscapes/scenics, architecture, gardening, interiors/decorating, pets, rural, medicine, military, political, product shots/still life, adventure, entertainment, events, health/fitness/beauty, hobbies, humor, sports, travel. Interested in alternative process, avant garde, documentary, fashion/glamour, fine art, historical/vintage, seasonal. Reviews photos with or without ms. Model/property release preferred. Photo captions preferred.

Specs Uses 4×6 glossy color and/or b&w prints; 35mm, 8×10 transparencies. Accepts images in digital format. Send via CD as TIFF, EPS, JPEG files at 300 dpi.

Making Contact & Terms Send query letter with résumé, slides, prints, photocopies, tearsheets, transparencies, stock list. Provide résumé, business card, self-promotion piece to be kept on file for possible future assignments. Responds in 2 months. Simultaneous submissions and previously published work OK. Pays $10-100. Pays on publication. Credit line given. Buys one-time rights.

Tips "Looking for photos that are clear and colorful. Need material for historical and nostalgic features. Anything that is directed toward the over-50 reader."

$ Ⓢ FINESCALE MODELER

21027 Crossroads Circle, P.O. Box 1612, Waukesha WI 53187-1612. (262)796-8776. Fax: (262)796-1383. E-mail: editor@finescale.com. Website: www.finescale.com. **Contact:** Mark Thompson, editor. Circ. 60,000. Published 10 times/year. Emphasizes "how-to information for hobbyists who build non-operating scale models." Readers are "adult and juvenile hobbyists who build non-operating model aircraft, ships, tanks and military vehicles, cars and figures." Sample copy available for $4.95. Photo guidelines free with SASE or on website.

Needs Buys 10 photos from freelancers/issue; 100 photos/year. Needs "in-progress how-to photos illustrating a specific modeling technique; photos of full-size aircraft, cars, trucks, tanks and ships." Model release required. Photo captions required.

Making Contact & Terms Provide résumé, business card, brochure, flier or tearsheets to be kept on file for possible future assignments. "Phone calls are OK." Responds in 2 months. "Will sometimes accept previously published work if copyright is clear." Pays $25 minimum for color cover; $8 minimum for inside; $50/page; $50-500 for text/photo package. **Pays for photos on publication, for text/photo package on acceptance.** Credit line given. Buys all rights.

Tips Looking for "sharp color prints or slides of model aircraft, ships, cars, trucks, tanks, figures and science-fiction subjects. In addition to photographic talent, must have comprehensive knowledge of objects photographed and provide complete caption material. Freelance photographers should provide a catalog stating subject, date, place, format, conditions of sale and desired credit line before attempting to sell us photos. We're most likely to purchase color photos of outstanding models of all types for our regular feature, 'Showcase.'"

$ ▣ ◐ 540 RIDER

TMB Publications, P.O. Box 1156, Lake Oswego OR 97035. (503)236-2524. Fax: (503)620-3800. E-mail: dan.kesterson@verizon.net. Website: www.540rider.com. **Contact:** Dan Kesterson, publisher. Circ. 100,000. Estab. 2002. Quarterly consumer magazine. Emphasizes action sports for youth: snowboarding, skateboarding and other board sports. Features high school teams, results, events, training, and kids that just like to ride. Sample copy available for 8×10 SAE and 75¢ first-class postage. Photo guidelines available by e-mail request or on website.

Needs Buys 10-20 photos from freelancers/issue; 40-80 photos/year. Needs photos of sports. Reviews photos with or without ms. Model/property release preferred. Photo captions preferred.

Specs Uses glossy color or b&w prints; 35mm, 2¼×2¼ transparencies. Accepts images in digital format. Send via CD as TIFF files.

Making Contact & Terms Send query letter with prints; e-mail is better. Provide self-promotion piece to

be kept on file for possible future assignments. Responds only if interested; send nonreturnable samples. Simultaneous submissions OK. Pays $25 minimum for b&w and color covers and inside photos. Pays on publication. Credit line given. Buys all rights.

Tips "Send an e-mail ahead of time to discuss. Send us stuff that even you don't like, because we just might like it."

▣ FLY FISHERMAN

Primedia Magazines, Inc., 6405 Flank Dr., Harrisburg PA 17112. (717)657-9555. Fax: (717)657-9552. Website: www.flyfisherman.com. **Contact:** John Randolph, editor/publisher. Managing Editor: Jay Nichols. Circ. 130,000. Magazine published 6 times/year. Emphasizes all types of fly fishing for readers who are "97.8% male, 83% college-educated, 98% married; average household income is $138,000, and 49% are managers or professionals; 68% keep their copies for future reference and spend 33 days/year fishing." Sample copy available via website or for $4.95 with 9×12 SAE and 4 first-class stamps. Photo guidelines available via website or free with SASE.

Needs Buys 36 photos from freelancers/issue; 216 photos/year. Needs shots of "fly fishing and all related areas—scenics, fish, insects, how-to." Photo captions required.

Making Contact & Terms Send 35mm, 2¼×2¼, 4×5 or 8×10 color transparencies by mail with SASE for consideration. Accepts color digital images on CD or via e-mail for submissions. Responds in 6 weeks. Payment negotiable. Pays on publication. Credit line given. Buys one-time or all rights.

Ⓝ $ $🄼 Ⓢ FLY ROD & REEL: The Excitement of Fly-Fishing

P.O. Box 370, Camden ME 04843. (207)594-9544. Fax: (207)594-5144. E-mail: pguernsey@flyrodreel.com. Website: www.flyrodreel.com. **Contact:** Paul Guernsey, editor-in-chief. Circ. 61,941. Estab. 1979. Magazine published bimonthly. Emphasizes fly-fishing. Readers are primarily fly-fishers ages 30-60. Sample copy and photo guidelines free with SASE; photo guidelines also available via e-mail.

Needs Buys 15-20 photos from freelancers/issue; 90-120 photos/year. Needs "photos of fish, scenics (preferrably with anglers in shot), equipment." Photo captions preferred; include location, name of model (if applicable).

Specs Uses 35mm slides; 2¼×2¼, 4×5 transparencies.

Making Contact & Terms Send query letter with list of stock photo subjects. Send unsolicited photos by mail for consideration; include SASE for return of material. Provide résumé, business card, brochure, flier or tearsheets to be kept on file for possible future assignments. Responds in 1 month. Pays $500-650 for color cover photo; $75 for b&w inside; $75-200 for color inside. Pays on publication. Credit line given. Buys one-time rights.

Tips "Photos should avoid appearance of being too 'staged.' We look for bright color (especially on covers), and unusual, visually appealing settings. Trout and salmon are preferred for covers. Also looking for saltwater fly-fishing subjects. Ask for guidelines, then send 20 to 40 shots showing breadth of work."

$ $ FOOD & WINE

American Express Publishing Corporation, 1120 Avenue of the Americas, New York NY 10036. (212)382-5600. Website: www.foodandwine.com. **Contact:** Fredrika Stjarne, photo editor. Circ. 950,000. Estab. 1978. Monthly. Emphasizes food and wine. Readers are an "upscale audience who cook, entertain, dine out and travel stylishly."

Needs Uses about 25-30 photos/issue; 85% freelance photography on assignment basis; 15% freelance stock. "We look for editorial reportage specialists who do restaurants, food on location, and travel photography." Model release required. Photo captions required.

Making Contact & Terms Drop off portfolio on Wednesday (attn: Lisa Kim). Call for pickup. Submit fliers, tearsheets, etc., to be kept on file for possible future assignments and stock usage. Pays $450/color page; $100-450 for color photos. **Pays on acceptance**. Credit line given. Buys one-time world rights.

$ $🄰 FORTUNE

Rockefeller Center, Time-Life Bldg., 1271 Avenue of the Americas, New York NY 10020. (212)522-3803. Fax: (212)467-1213. E-mail: scott_thode@fortunemail.com. Website: www.fortune.com. **Contact:** Scott Thode, deputy picture editor. Emphasizes analysis of news in the business world for management personnel.

Making Contact & Terms Picture Editor reviews photographers' portfolios on an overnight drop-off basis. Photos purchased on assignment only. Day rate on assignment (against space rate): $400; page rate for space: $400; minimum for b&w or color usage: $200. Pays extra for electronic rights.

⊞ $▣○ 4-WHEEL ATV ACTION

Hi-Torque Publications, 25233 Anza Dr., Valencia CA 91355. (661)295-1910. Fax: (661)295-1278. E-mail: atv@hi-torque.com. Website: www.4wheelatv.com. **Contact:** Joe Kosch, editor. Circ. 65,000. Estab. 1986. Monthly consumer magazine emphasizing all-terrain vehicles and anything closely related to them.

Needs Buys 4 photos from freelancers/issue; 50 photos/year. Needs photos of adventure, events, hobbies, sports. "We are interested only in ATVs and very closely related ride-on machines with more than two wheels—no cars, trucks, buggies or motocycles. We're looking for scenic riding areas with ATVs in every shot, plus unusual or great looking ATVs." Reviews photos with or without ms. Model/property release preferred. Photo captions preferred; include location, names.

Specs Uses 8×10 glossy color prints; 35mm transparencies. Accepts images in digital format. Send via Zip, e-mail as JPEG files at 300 dpi.

Making Contact & Terms Send query letter with photocopies or e-mail JPEGs. Does not keep samples on file; cannot return material. Responds only if interested; send nonreturnable samples. Simultaneous submissions and previously published work OK. Pays $50-100 for color cover; $15-25 for color inside. Credit line given. Buys one-time rights, first rights; negotiable.

Tips "*4-Wheel ATV Action* offers a good opportunity for amateur but serious photographers to get a credit line in a national publication."

$▣ ◐ Ⓢ ⊕ FRANCE MAGAZINE

Archant House, Oriel Rd., Cheltenham, Gloucestershire GL50 1BB United Kingdom. (44)(124)221-6050. Fax: (44)(124)221-6076. E-mail: editorial@francemag.com. Website: www.francemag.com. **Contact:** Susan Bozzard, art editor. Circ. 45,000. Estab. 1990. Monthly magazine about France. Readers are male and female, ages 45 and over; people who holiday in France.

Needs Needs photos of France and French subjects: people, places, customs, curiosities, produce, towns, cities, countryside. Photo captions required; include location and as much information as is practical.

Specs Uses 35mm, medium-format transparencies; high-quality digital.

Making Contact & Terms "E-mail in the first instance with lists of subjects and/or low-res JPEG files. Will request transparencies or high-res as necessary." Pays £100 for color cover; £50/color full page; £25/quarter page. Pays following publication. Buys one-time rights. Credit line given.

$▣ ○ FT. MYERS MAGAZINE

15880 Summerlin Rd., Suite 189, Ft. Myers FL 33908. E-mail: ftmyers@optonline.net. **Contact:** Andrew Elias, director. Circ. 20,000. Estab. 2002. Magazine published every 2 months for southwest Florida focusing on local and national arts and lifestyle. *Ft. Myers Magazine* is targeted at successful, educated and active residents of southwest Florida, ages 20-60, as well as guests at the best hotels and resorts on the Gulf Coast. Media columns and features include: books, music, video, films, theater, Internet, software (news, previews, reviews, interviews, profiles). Lifestyle columns and features include: art & design, house & garden, food & drink, sports & recreation, health & fitness, travel & leisure, science & technology (news, previews, reviews, interviews, profiles). Sample copy available for $3 including postage & handling.

Needs Buys 3-6 photos from freelancers/year. Needs photos of celebrities, architecture, gardening, interiors/decorating, medicine, product shots/still life, environmental, landscapes/scenics, wildlife, entertainment, events, food & drink, health/fitness/beauty, performing arts, sports, travel. Interested in alternative process, avant garde, documentary, fashion/glamour, fine art, historical/vintage. Also needs beaches, beach scenes/sunsets over beaches, boating/fishing, palm trees. Reviews photos with or without ms. Model release required. Photo captions preferred; include description of image and photo credit.

Specs Uses 4×5, 8×10 glossy or matte color and/or b&w prints; 35mm, 2×2, 4×5, 8×10 transparencies ("all are acceptable, but we prefer prints or digital"). Accepts images in digital format. Send via CD, floppy disk, Zip, e-mail (preferred) as TIFF, EPS, PICT, JPEG, PDF files (prefers TIFF or JPEG) at 300-600 dpi.

Making Contact & Terms Send query letter via e-mail with digital images and stock list. Provide résumé, business card, self-promotion piece to be kept on file. Responds only if interested; send nonreturnable samples. Simultaneous submissions and previously published work OK. Pays $100 for b&w or color cover; $25-100 for b&w or color inside. Pays on publication. Credit line given. Buys one-time rights.

$ FUR-FISH-GAME

A.R. Harding Publishing, 2878 E. Main St., Columbus OH 43212. **Contact:** Mitch Cox, editor. Monthly outdoor magazine emphasizing hunting, trapping, fishing and camping.

Needs Buys 4 photos from freelancers/issue; 50 photos/year. Needs photos of freshwater fish, wildlife,

wilderness and rural scenes. Reviews photos with or without ms. Photo captions required; include subject.
Specs Uses color and/or b&w prints; 35mm transparencies.
Making Contact & Terms Send query letter "and nothing more." Does not keep samples on file; include SASE for return of material. Responds in 1 month to queries. Simultaneous submissions and previously published work OK. Pays $25 minimum for b&w and color inside. Pays on publication. Credit line given. Buys one-time rights.

$ $ GALLERY MAGAZINE

401 Park Ave. S., New York NY 10016-8802. (212)779-8900. Fax: (212)725-7215. E-mail: michellet@ggn.net. Website: www.gallerymagazine.com. **Contact:** Michelle Talich, photo editor. Editorial Director: C.S. O'Brien. Art Director: Mark DeMaio. Estab. 1972. Emphasizes men's interests. Readers are male, collegiate, middle class. Photo guidelines free with SASE.
Needs Buys 20 photos from freelancers/issue. Needs photos of nude women and celebrities, plus sports, adventure, popular arts and investigative journalism pieces. Model release with photo ID required.
Making Contact & Terms Send at least 200 35mm transparencies by mail with SASE for consideration. "We need several days for examination of photos." Responds in 1 month. Pays $85-120/photo. Girl sets: pays $1,500-2,500; cover extra. Pays extra for electronic usage of images. Buys first North American serial rights plus nonexclusive international rights. Also operates Girl Next Door contest: $250 entry photo; $2,500 monthly winner; $25,000 yearly winner (must be amateur!). Photographer: entry photo receives 1-year free subscription; monthly winner $500; yearly winner $2,500. Send *by mail* for contest information.
Tips In photographer's samples, wants to see "beautiful models and excellent composition. Avoid soft focus! Send complete layout."

$ 🖥 🖉 GAME & FISH MAGAZINES

2250 Newmarket Pkwy., Suite 110, Marietta GA 30067. (770)953-9222, ext. 2029. Fax: (770)933-9510. E-mail: ronald.sinfelt@primedia.com. Website: www.gameandfish.about.com. **Contact:** Ron Sinfelt, photo editor. Editorial Director: Ken Dunwoody. Combined circ. 576,000. Estab. 1975. Publishes 31 different monthly outdoors magazines: *Alabama Game & Fish, Arkansas Sportsman, California Game & Fish, Florida Game & Fish, Georgia Sportsman, Great Plains Game & Fish, Illinois Game & Fish, Indiana Game & Fish, Iowa Game & Fish, Kentucky Game & Fish, Louisiana Game & Fish, Michigan Sportsman, Mid-Atlantic Game & Fish, Minnesota Sportsman, Mississippi Game & Fish, Missouri Game & Fish, New England Game & Fish, New York Game & Fish, North Carolina Game & Fish, Ohio Game & Fish, Oklahoma Game & Fish, Pennsylvania Game & Fish, Rocky Mountain Game & Fish, South Carolina Game & Fish, Tennessee Sportsman, Texas Sportsman, Virginia Game & Fish, Washington-Oregon Game & Fish, West Virginia Game & Fish, Wisconsin Sportsman,* and *North American Whitetail.* All magazines (except *Whitetail*) are for experienced fishermen and hunters and provide information about where, when and how to enjoy the best hunting and fishing in their particular state or region, as well as articles about game and fish management, conservation and environmental issues. Sample copy available for $3.50 with 10×12 SAE. Photo guidelines and current needs list free with SASE.
Needs 50% of photos supplied by freelance photographers; 5% assigned. Needs photos of live game animals/birds in natural environment and hunting scenes; also underwater game fish photos and fishing scenes. Photo captions required; include species identification and location. Number slides/prints.
Specs Accepts images in digital format. Send via CD at 300 ppi with output of 8×12 inches.
Making Contact & Terms Send 5×7, 8×10 glossy b&w prints or 35mm transparencies (preferably Fujichrome, Kodachrome) with SASE for consideration. Responds in 1 month. Simultaneous submissions not accepted. Pays $250 for color cover; $25 for b&w inside; $75 for color inside. Pays 60 days prior to publication. Tearsheet provided. Credit line given. Buys one-time rights.
Tips "Study the photos that we are publishing before sending submission. We'll return photos we don't expect to use and hold remainder in-house so they're available for monthly photo selections. Please do not send dupes. Photos will be returned upon publication or at photographer's request."

$ $ 🖥 🖉 GARDENING HOW-TO

North American Media Group, 12301 Whitewater Dr., Minnetonka MN 55317. (952)936-9333. E-mail: lsamoilenko@namginc.com. Website: www.gardeningclub.com. **Contact:** Lisa Samoilenko, art director. Circ. 600,000. Estab. 1996. Association magazine published 6 times/year. A multi-subject gardening magazine for the avid home gardener, from beginner to expert. Readers are 78% female and average age of 51. Sample copies available.
Needs Buys 50 photos from freelancers/issue; 300 photos/year. Needs photos of gardening. Assignment

work shooting specific gardens around the country. Reviews photos with or without ms. Model/property release preferred. Photo captions preferred.

Specs Uses 35mm, 2¼×2¼, 4×5, 8×10 transparencies. Prefers images in digital format. Send via CD as TIFF, EPS, JPEG files at 300 dpi.

Making Contact & Terms Contact through rep. Provide self-promotion piece to be kept on file for possible future assignments. Responds only if interested; send nonreturnable samples. Previously published work OK. Pays $750 for b&w cover; payment for inside depends on size. **Pays on acceptance.** Credit line given. Buys one-time rights, first rights, electronic rights; negotiable.

Tips "Looking for tack-sharp, colorful general gardening photos and will send specific wants if interested in your work. Send a complete list of photos along with slides or CD in package."

$ GENRE

333 7th Ave., 14th Floor, New York NY 10001. (212)594-8181. Fax: (212)594-8263. E-mail: genre@genremaga zine.com. Website: www.genremagazine.com. **Contact:** John Mok, art director. Deputy Director: Chris Ciompi. Circ. 65,000. Estab. 1990. Monthly. Emphasizes gay life. Readers are gay men, ages 24-35. Sample copy available for $5.

Needs Uses 40 photos/issue. Needs photos of celebrities, couples, multicultural, entertainment, events, political. Interested in fashion/glamour. Model/property release required. Photo captions preferred.

Making Contact & Terms Provide résumé, business card, brochure, flier or tearsheets to be kept of file for possible future assignments. Responds only if interested. Pays on publication. Credit line given. Buys all rights; negotiable.

$ ▣ ◪ GEORGIA BACKROADS

Legacy Communications, Inc., P.O. Box 127, Roswell GA 30077-0127. (770)642-5569. E-mail: georgiabackroa ds@georgiahistory.ws. Website: www.georgiahistory.ws. **Contact:** Dan Roper, editor and publisher. Circ. 18,861. Estab. 1984. Quarterly magazine emphasizing travel, history, and lifestyle articles on topics related to the state of Georgia and its scenic and historic attractions. *Georgia Backroads* is the state's leading travel and history magazine. Sample copy available for $4.98 and 9×12 SAE with $2 first-class postage.

> • **Address and phone numbers were in process of changing at press time. Please consult website for updated contact information in Rome, GA.**

Needs Buys 25 photos from freelancers/issue; 100 photos/year. Needs photos of celebrities, disasters, landscapes/scenics, wildlife, rural, adventure, entertainment, travel. Interested in historical/vintage, seasonal. Reviews photos with or without ms. Model/property release required. Photo captions required.

Specs Uses 5×7 glossy prints; 35mm transparencies. Accepts images in digital format. Send via CD, Zip, e-mail as TIFF, EPS, JPEG files.

Making Contact & Terms Send query letter with photocopies, stock list. Does not keep samples on file. Responds in 1 month to queries. Responds only if interested; send nonreturnable samples. Pays $100-250 for color cover; $5-15 for inside. Pays on publication. Credit line given. Buys all rights; negotiable.

Ⓝ $ $◪ GEORGIA STRAIGHT

1770 Burrard St., 2nd Floor, Vancouver BC V6J 3G7 Canada. (604)730-7000. Fax: (604)730-7010. E-mail: photos@straight.com. Website: www.straight.com. **Contact:** Ian Hanington, editor. Circ. 117,000. Estab. 1967. Weekly tabloid. Emphasizes entertainment. Readers are generally well-educated people, ages 20-45. Sample copy free with 10×12 SASE.

Needs Buys 7 photos from freelancers/issue; 364 photos/year. Needs photos of entertainment events and personalities. Photo captions preferred.

Making Contact & Terms Send query letter with list of stock photo subjects. Provide résumé, business card, brochure, flier or tearsheets to be kept on file for possible future assignments. Responds in 1 month. Simultaneous submissions and previously published work OK. Include SASE for return of work. Pays $250-300 for cover; $100-200 for inside. Pays on publication. Credit line given. Buys one-time rights.

Tips "Almost all needs are for in-Vancouver assigned photos, except for high-quality portraits of film stars. We rarely use unsolicited photos, except for Vancouver photos for our content page."

$ ▣ ◯ GERMAN LIFE MAGAZINE

1068 National Hwy., LaVale MD 21502. (301)729-6190. Fax: (301)729-1720. E-mail: mslider@germanlife.c om. Website: www.germanlife.com. **Contact:** Mark Slider, editor. Circ. 40,000. Estab. 1994. Bimonthly maga-

zine focusing on history, culture, and travel relating to German-speaking Europe and German-American heritage. Sample copy available for $5.95.

Needs Limited number of photos purchased separate from text articles.

Specs Queries welcome for specs.

Making Contact & Terms Payment varies. Pays on publication. Credit line given. Buys one-time rights.

$ $🖳 ☑ GIRLFRIENDS MAGAZINE

HAF Enterprises, 3415 Cesar Chavez, Suite 101, San Francisco CA 94110. (415)648-9464. Fax: (415)648-4705. E-mail: stefani@girlfriendsmag.com. Website: www.girlfriendsmag.com. **Contact:** Stefani Barber, assistant editor. Circ. 75,000. Estab. 1994. Monthly, glossy national magazine focused on culture, politics, and entertainment from a lesbian perspective. Sample copy available for $4.95 and 9×12 SAE with $1.50 first-class postage. Photo guidelines free.

Needs Needs photos of celebrities, couples, families, landscapes/scenics, entertainment, health/fitness, performing arts, sports, travel. Interested in erotic, fashion glamour, fine art, historical/vintage. Reviews photos with or without ms. Model release required; property release preferred. Photo captions preferred; include name of models, contact information.

Specs Uses 8×10 glossy color prints; 35mm, 2¼×2¼ transparencies. Accepts images in digital format. Send via CD, Zip, e-mail as EPS, JPEG files at 300 dpi.

Making Contact & Terms Send query letter with samples. Provide résumé, business card, self-promotion piece or tearsheets to be kept on file for possible future assignments. Art director will contact photographer for portfolio review if interested. Portfolio should include color. Keeps samples on file; include SASE for return of material. Responds in 2 months. Simultaneous submissions OK. Pays $500-850 for b&w cover; $750-1,000 for color cover; $50-600 for b&w inside; $50-800 for color inside. Pays on publication. Credit line given. Buys one-time rights.

Tips "Read our magazine to see what type of photos we use. We're looking to increase our stock photography library of women. We like colorful, catchy photos, beautifully composed, with models who are diverse in age, size and ethnicity."

$🅰 GIRLS LIFE MAGAZINE/GIRLSLIFE.COM

4517 Harford Rd., Baltimore MD 21214. (410)426-9600. Fax: (410)254-0991. E-mail: kasey@girlslife.com. Website: www.girlslife.com. **Contact:** Kasey Simcoe, online editor. Estab. 1994. Readers are preteen girls (ages 10-15). Emphasizes advice, relationships, school, current news issues, entertainment, quizzes, fashion and beauty pertaining to preteen girls.

Needs Buys 65 photos from freelancers/issue. Submit seasonal material 3 months in advance.

Specs Uses 5×8, 8½×11 color and/or b&w prints; 35mm, 4×5 transparencies.

Making Contact & Terms Send query letter with stock list. Works on assignment only. Keeps samples on file. Responds in 3 weeks. Simultaneous submissions and previously published work OK. Pays on usage. Credit line given.

$🖳 GO BOATING MAGAZINE

17782 Cowan, Suite A, Irvine CA 92614. (949)660-6150. Fax: (949)660-6172. E-mail: editorial@goboatingame rica.com. Website: www.goboatingamerica.com. **Contact:** Mike Telleria, editor. Circ. 100,000. Estab. 1997. Consumer magazine for active families that own power boats from 16-34 feet in length. Published 8 times/year. Contains articles on cruising and fishing destinations, new boats and marine electronics, safety, navigation, seamanship, maintenance how-to, consumer guides to boating services, marine news and product buyer guides. Sample copy available for $5. Photo guidelines free with SASE.

Needs Buys 25 photos from freelancers/issue; 150 photos/year. Needs photos of cruising destinations, boating events, seamanship, boat repair procedures and various marine products. "We are always in search of photos depicting families having fun in small power boats (16 to 34 feet)." Reviews photos with or without ms. Model release required. Photo captions preferred; include place, date, people's names, and any special circumstances.

Specs Uses 35mm, 2¼×2¼ color transparencies. Accepts high-res images in digital format. Send via CD at 300 dpi, 4×5 minimum.

Making Contact & Terms Send query letter with stock photo list. Provide résumé, business card, self-promotion piece or tearsheets to be kept on file for possible future assignments. Editor or publisher will contact photographer for portfolio review if interested. Responds in 2 months to queries. Simultaneous submissions and previously published work OK. Pays $250 maximum for color cover; $50-200 for color inside. Pays on

publication. Credit line given. Buys first North American, second rights and reprint rights for one year via print and electronic media.

Tips "When submitting work, label each slide with your name, address, daytime phone number, and include Social Security Number on a photo delivery memo. Submit photos with SASE. All photos will be returned within 60 days."

$ $ 🖥 ✐ GOLF TIPS

12121 Wilshire Blvd., #1200, Los Angeles CA 90025. (310)820-1500. Fax: (310)826-5008. E-mail: wkeating@ wernerpublishing.com. Website: www.golftipsmag.com. **Contact:** Warren Keating, art director. Circ. 300,000. Estab. 1986. Magazine published 9 times/year. Readers are "hardcore golf enthusiasts." Sample copy free with SASE.

Needs Buys 40 photos from freelancers/issue; 360 photos/year. Needs photos of golf instruction (usually pre-arranged, on-course), equipment; health/fitness, travel. Interested in alternative process, documentary, fashion/glamour. Reviews photos with accompanying ms only. Model/property release preferred. Photo captions required.

Specs Uses prints; 35mm, $2\frac{1}{4} \times 2\frac{1}{4}$, 4×5, 8×10 transparencies. Accepts images in digital format. Send via Zip as TIFF files at 300 dpi.

Making Contact & Terms Send query letter with résumé of credits. Submit portfolio for review. Cannot return material. Responds in 1 month. Pays $500-1,000 for b&w or color cover; $100-300 for b&w inside; $150-450 for color inside. Pays on publication. Buys one-time rights; negotiable.

🅰 GOOD HOUSEKEEPING

Hearst Corporation Magazine Division, 959 Eighth Ave., New York NY 10019-3795. (212)649-2000. Fax: (212)265-3307. Website: www.goodhousekeeping.com. **Contact:** Marilu Lopez, design director. *Good Housekeeping* articles focus on food, fitness, beauty and childcare, drawing upon the resources of the Good Housekeeping Institute. Editorial includes human interest stories and articles that focus on social issues, money management, health news and travel. Photos purchased mainly on assignment. Query before submitting.

● **During renovations, temporary address through June 2006 is 250 West 55th St., New York NY 10019; consult website for address updates.**

🖥 ◯ 🔀 GOSPEL HERALD

4904 King St., Beamsville ON L0R 1B6 Canada. (905)563-7503. E-mail: info@gospelherald.org. Website: www.gospelherald.org. **Contact:** Wayne Turner, co-editor. Managing Editor: Max Craddock. Circ. 1,300. Estab. 1936. Monthly consumer magazine. Emphasizes Christianity. Readers are primarily members of the Churches of Christ. Sample copy free with SASE.

Needs Uses 2-3 photos/issue. Needs photos of babies/children/teens, families, parents, landscapes/scenics, wildlife, seasonal, especially those relating to readership—moral, religious and nature themes.

Specs Uses b&w, any size and any format. Accepts images in digital format. Send via CD, floppy disk, Zip, e-mail as JPEG files.

Making Contact & Terms Send unsolicited photos by mail for consideration. Payment not given, but photographer receives credit line.

Tips "We have never paid for photos. Because of the purpose of our magazine, both photos and stories are accepted on a volunteer basis."

$ $ GRAND RAPIDS FAMILY MAGAZINE

549 Ottawa NW, Grand Rapids MI 49503. (616)459-4545. Fax: (616)459-4800. **Contact:** Carole Valade, editor. Circ. 30,000. Estab. 1989. Monthly magazine. Sample copy available for $2. Photo guidelines free with SASE.

Needs Buys 20-50 photos from freelancers/issue; 240-600 photos/year. *Only using in-state photographers— west Michigan region.* Needs photos of families, children, education, infants, play, etc. Model/property release required. Photo captions preferred; include who, what, where, when.

Making Contact & Terms Send query letter with résumé of credits, stock list. Sometimes keeps samples on file; include SASE for return of material. Responds in 1 month, only if interested. Simultaneous submissions and previously published work OK. Pays $200 minimum for color cover; $35-75 for b&w inside; $40-200 for color inside. Pays on publication. Credit line given. Buys one-time rights, all rights; negotiable.

Tips "We are not interested in 'clip art' variety photos. We want the honesty of photojournalism, photos that speak to the heart, that tell a story, that add to the story told."

$ ▣ GRAND RAPIDS MAGAZINE

549 Ottawa Ave. NW, Grand Rapids MI 49503-1444. (616)459-4545. Fax: (616)459-4800. **Contact:** John H. Zwarensteyn, publisher. Editor: Carol Valade. Design & Production Manager: Scott Sommerfeld. Estab. 1964. Monthly magazine. Emphasizes community-related material of metro Grand Rapids area and western Michigan; local action and local people.

Needs Needs photos of animals, nature, scenic, travel, sport, fashion/beauty, photo essay/photo feature, fine art, documentary, human interest, celebrity/personality, humorous, wildlife, vibrant people shots and special effects/experimental. Wants on a regular basis western Michigan photo essays and travel-photo essays of any area in Michigan. Model release required. Photo captions required.

Specs Uses $2^1/4 \times 2^1/4$, 4×5 color transparencies for cover, vertical format required. "High-quality digital also acceptable."

Making Contact & Terms Freelance photos assigned and accepted. Send material by mail for consideration; include SASE for return. Prefers images in digital format. Send CD at at least 300 dpi. Provide business card to be kept on file for possible future assignments; "only people on file with us are those we have met and personally reviewed." Arrange a personal interview to show portfolio. Responds in 3 weeks. Pays $35-100 for color photos; $100 minimum for cover. Buys one-time rights, exclusive product rights, all rights; negotiable.

Tips "Most photography is by our local freelance photographers, so freelancers should sell us on the unique nature of what they have to offer."

$ ▣ ◔ Ⓢ GRIT MAGAZINE

1503 SW 42nd St., Topeka KS 66609. (785)274-4300. Fax: (785)274-4305. E-mail: grit@grit.com. Website: www.grit.com. **Contact:** Editor-in-Chief. Circ. 90,000. Estab. 1882. Monthly magazine. Emphasizes "family-oriented material which is helpful, inspiring or uplifting. Readership is national." Sample copy available for $4.

Needs Buys "hundreds" of photos/year with accompanying stories or articles; 90% from freelancers. Needs on a regular basis "photos of all subjects, provided they have up-beat themes that are so good they surprise us. Need *short*, unusual stories—heartwarming, nostalgic, inspirational, off-beat, humorous—or human interest with b&w or color photos. Be certain pictures are well composed, properly exposed and pin sharp. No cheesecake. No pictures that cannot be shown to any member of the family. No pictures that are out of focus or over- or under-exposed. No ribbon-cutting, check-passing or hand-shaking pictures. We use 35mm and up." Story subjects include babies/children/teens, couples, multicultural, families, parents, senior citizens, environmental, landscapes/scenics, wildlife, education, gardening, pets, religious, rural, adventure, events, health/fitness, hobbies, humor, travel. Interested in historical/vintage, seasonal. Reviews photos with accompanying ms. Photo captions required. "Single b&w photo or color slide that stands alone must be accompanied by 50-100 words of meaningful caption information."

Specs Prefers color slides or prints. Accepts images in digital format. Send via CD, Zip as JPEG files at 300 dpi.

Making Contact & Terms Study magazine. Send material by mail with SASE for consideration. Responds ASAP. Pays $50 for color cover; $15-25 for color inside; $5-15 for b&w inside. Uses much more color than b&w. Pays on publication. Buys shared rights; negotiable.

Tips "Send samples and slides for review."

$ $ ▣ ◔ Ⓢ GUEST INFORMANT

21200 Erwin St., Woodland Hills CA 91367. (818)716-7484. Fax: (818)716-7583. E-mail: allison.white@guestinformant.com or karen.maze@guestinformant.com. Website: www.guestinformant.com. **Contact:** Allison White or Karen Maze. Quarterly and annual city guide books. Emphasizes city-specific photos for use in guide books distributed in upscale hotel rooms in approximately 30 U.S. cities.

Needs "We review people-oriented, city-specific stock photography that is innovative and on the cutting edge." Needs photos of couples, multicultural, landscapes/scenics, wildlife, architecture, cities/urban, events, food/drink, travel. Interested in fine art, historical/vintage, seasonal. Photo captions required; include city, location, event, etc.

Specs Uses transparencies. Accepts images in digital format. Send via CD.

Making Contact & Terms Send query letter via e-mail. Provide promo, business card and list of cities covered. Send transparencies with a delivery memo stating the number and format of transparencies you are sending. All transparencies must be clearly marked with photographer's name and caption information. They should be submitted in slide pages with similar images grouped together. To submit portfolio for review, "call first."

Pays $250-450 for color cover; $100-200 for color inside. 50% reuse rate. Pays on publication, which is about 60 days from initial submission. Credit line given.

Tips Contact photo editors via e-mail for guidelines and submission schedule before sending your work.

$ $▣ ☑ GUIDEPOSTS

16 E. 34th St., 21st Floor, New York NY 10016. (212)251-8124. Fax: (212)684-1311. Website: www.guideposts .com. **Contact:** Candice Smilow, photo editor. Circ. 2.6 million. Estab. 1945. Monthly magazine. Emphasizes tested methods for developing courage, strength and positive attitudes through faith in God. Free sample copy and photo guidelines with 6×9 SAE and 3 first-class stamps.

Needs Uses 90% assignment, 10% stock on a story-by-story basis. Photos are mostly environmental portraiture, editorial reportage. Stock can be scenic, sports, fine art, mixed variety. Model release required.

Specs Uses 35mm, 2¼×2¼ transparencies; vertical for cover, horizontal or vertical for inside. Accepts images in digital format. Send via CD at 300 dpi.

Making Contact & Terms Send photos or arrange a personal interview. Responds in 1 month. Simultaneous submissions OK. Pays by job or on a per-photo basis; $800 minimum for color cover; $150-400 for color inside; $450/day; negotiable. **Pays on acceptance.** Credit line given. Buys one-time rights.

Tips "I'm looking for photographs that show people in their environment; straight portraiture and people interacting. We're trying to appear more contemporary. We want to attract a younger audience and yet maintain a homey feel. For stock—scenics; graphic images in color. *Guideposts* is an 'inspirational' magazine. NO violence, nudity, sex. No more than 40 images at a time. Write first and ask for a sample issue; this will give you a better idea of what we're looking for. I will review transparencies on a light box."

▣ ☑ GUITAR ONE

Future Network USA, 149 5th Ave., 9th Floor, New York NY 10010-6987. (646)723-5400. E-mail: jimmyhubba rd@guitarworld.com. Website: www.futurenetworkusa.com. **Contact:** Jimmy Hubbard, photo editor. Circ. 150,000. Consumer magazine for guitar players and enthusiasts.

Needs Buys 20 photos from freelancers/issue; 240 photos/year. Needs photos of guitarists. Reviews photos with or without ms. Property release preferred. Photo captions preferred.

Specs Uses glossy or matte color and/or b&w prints; 35mm, 2¼×2¼ transparencies. Accepts images in digital format. Send via e-mail as TIFF, EPS, JPEG files at 300 dpi.

Making Contact & Terms Send query letter with slides, prints, photocopies, tearsheets. Keeps samples on file. Responds in 2 weeks to queries. Previously published work OK. Pay rates vary by size. **Pays on acceptance.** Credit line given. Buys one-time rights.

$ $▣ ☑ HADASSAH MAGAZINE

50 W. 58th St., New York NY 10019. (212)451-6284. Fax: (212)451-6257. E-mail: lfinkelshteyn@hadassah.o rg. **Contact:** Leah Finkelshteyn, associate editor. Circ. 300,000. Monthly magazine of the Hadassah Women's Zionist Organization of America. Emphasizes Jewish life, Israel. Readers are 85% females who travel and are interested in Jewish affairs, average age 59. Photo guidelines free with SASE.

Needs Uses 10 photos/issue; most supplied by freelancers. Needs photos of travel, Israel and general Jewish life. Photo captions preferred; include where, when, who and credit line.

Specs Accepts images in digital format. Send via CD as JPEG files at 300 dpi.

Making Contact & Terms Submit portfolio for review. Send unsolicited photos by mail for consideration. Keeps samples on file; include SASE for return of material. Responds in 3 months. Pays $450 for color cover; $125-175 for ¼ page color inside. Pays on publication. Credit line given. Buys one-time rights.

Tips "We frequently need travel photos, especially of places of Jewish interest."

$ $▣ HARPER'S MAGAZINE

Harper's Magazine Foundation, 666 Broadway, 11th Floor, New York NY 10012. (212)420-5720. Fax: (212)228-5889. E-mail: alyssa@harpers.org. Website: www.harpers.org. **Contact:** Alyssa Coppelman, assistant art director. Circ. 250,000. Estab. 1850. Monthly literary magazine. "The nation's oldest continually published magazine providing fiction, satire, political criticism, social criticism, essays."

Needs Buys 8-10 photos from freelancers/issue; 120 photos/year. Needs photos of human rights issues, environmental, political. Interested in alternative process, avant garde, documentary, fine art, historical/ vintage. Model/property release preferred.

Specs Uses any format. Accepts images in digital format. Send via CD, Zip, e-mail as TIFF, EPS, JPEG files at 300 dpi.

Making Contact & Terms Send query letter with résumé, slides, prints, photocopies, tearsheets, transparencies. Portfolio may be dropped off last Wednesday of the month. Provide self-promotion piece to be kept on file for possible future assignments. Responds in 1 week. Pays $200-800 for b&w, color cover; $250-400 for b&w, color inside. Pays on publication. Credit line given. Buys one-time rights; negotiable.

Tips *"Harper's* is geared more toward fine art photos or artist's portfolios than to 'traditional' photo usages. For instance, we never do fashion, food, travel (unless it's for political commentary), lifestyles or celebrity profiles. A good understanding of the magazine is crucial for photo submissions. We consider all styles and like experimental or non-traditional work. Please don't confuse us with *Harper's Bazaar!"*

▣ ◑ HEALING LIFESTYLES & SPAS MAGAZINE

JLD Publications, 899 Water St., Indiana PA 15701. (202)441-9557. E-mail: melissa@healinglifestyles.com. Website: www.healinglifestyles.com. **Contact:** Melissa B. Williams, editor-in-chief. Circ. 50,000. Estab. 1997. Bimonthly consumer magazine focusing on spas, retreats, therapies, food and beauty geared towards a mostly female audience, offering a more holistic and alternative approach to healthy living. Sample copies available. Photo guidelines available for SASE or via website.

Needs Buys 3 photos from freelancers/issue; 6-12 photos/year. Needs photos of multicultural, environmental, landscapes/scenics, adventure, health/fitness/beauty, food, yoga, travel. Reviews photos with or without ms. Model/property release preferred. Photo captions required; include subject, location, etc.

Specs Uses 35mm or large-format transparencies. Accepts images in digital format. Send via CD, Zip, e-mail as TIFF, EPS, JPEG files at 300 dpi.

Making Contact & Terms Send query letter with résumé, prints, tearsheets. Provide résumé, business card, self-promotion piece to be kept on file for possible future assignments. Responds in 1 month. Responds only if interested; send nonreturnable samples. Simultaneous submissions OK. Pays on assignment. Credit line given. Buys one-time rights.

Tips "We strongly prefer digital submissions, but will accept all formats. We're looking for something other than the typical resort/spa shots—everything from at-home spa treatments to far-off, exotic locations. We're also looking for reliable lifestyle photographers who can shoot yoga-inspired shots, healthy cuisine, ingredients, and spa modalities in an interesting and enlightening way."

Ⓝ ⊕ HERITAGE RAILWAY MAGAZINE

P.O. Box 43, Horncastle, Lincolnshire LN9 6LR United Kingdom. (44)(507)529300. Fax: (44)(507)529301. E-mail: robinjones@mortons.co.uk. Website: www.heritagerailway.co.uk. **Contact:** Mr. Robin Jones. Circ. 15,000. Monthly leisure magazine emphasizing preserved railways; covering heritage steam, diesel and electric trains with over 30 pages of news in each issue.

Needs Interested in railway preservation. Reviews photos with or without ms. Photo captions required.

Specs Uses glossy or matte color and b&w prints; 35mm, 2¼×2¼, 4×5, 8×10 transparencies. No digital images accepted.

Making Contact & Terms Send query letter with slides, prints, transparencies. Does not keep samples on file; include SASE for return of material. Responds in 1 month to queries. Simultaneous submissions OK. Buys one-time rights.

Tips "Contributions should be topical, preferably taken in the previous month. Label clearly all submissions and include a SAE."

$ HIGHLIGHTS FOR CHILDREN

803 Church St., Honesdale PA 18431. (570)253-1080. Website: www.highlights.com. **Contact:** Cindy Faber Smith, art director. Circ. around 2.5 million. Monthly magazine for children ages 2-12. Sample copy free.

 • *Highlights* is currently expanding photographic needs.

Needs Buys 100 or more photos annually. "We will consider outstanding photo essays on subjects of high interest to children." Reviews photos with accompanying ms. Wants no single photos without captions or accompanying ms.

Specs Prefers transparencies.

Making Contact & Terms Send photo essays with SASE for consideration. Responds in 7 weeks. Pays $30 minimum for b&w photos; $50 minimum for color photos. Pays $100 minimum for ms. Buys all rights.

Tips "Tell a story that is exciting to children. We also need mystery photos, puzzles that use photography/collage, special effects, anything unusual that will visually and mentally challenge children."

$ $ 📺 🖉 🇸🇮 HIGHWAYS, The Official Publication of The Good Sam Club

Affinity Group Inc., 2575 Vista Del Mar Dr., Ventura CA 93001-3920. (805)667-4003. Fax: (805)667-4454. E-mail: sfrankel@affinitygroup.com. Website: www.goodsamclub.com/highways. **Contact:** Stacey Frankel, art director. Circ. 975,000. Estab. 1966. Consumer magazine published 12 times/year. Sample copy free with 8½×11 SAE.

Specs Accepts images in digital format. Send via CD or e-mail at 300 dpi.

Making Contact & Terms Art director will contact photographer for portfolio review if interested. Pays $500 for cover; $75-350 for inside. Buys one-time rights.

$ 📺 🖉 HOME EDUCATION MAGAZINE

P.O. Box 1083, Tonasket WA 98855. (509)486-1351. Website: www.homeedmag.com. **Contact:** Helen Hegener, managing editor. Circ. 40,000. Estab. 1983. Bimonthly magazine. Emphasizes homeschooling. Readership includes parents, educators, researchers, media, etc.—anyone interested in homeschooling. Sample copy available for $6.50. Photo guidelines free with SASE or via e-mail.

Needs Number of photos used/issue varies based on availability; 50% supplied by freelance photographers. Needs photos of babies/children/teens, multicultural, families, parents, senior citizens, education. Special photo needs include homeschool personalities and leaders. Model/property release preferred. Photo captions preferred.

Specs Uses color and b&w prints in normal print size. "Enlargements not necessary." Accepts images in digital format. Send via CD, Zip, e-mail as TIFF files at 300 dpi.

Making Contact & Terms Send unsolicited color and b&w prints by mail with SASE for consideration. Responds in 1 month. Pays $100 for color cover; $12.50 for b&w or color inside; $50-150 for photo/text package. Pays on publication. Credit line given. Buys first North American serial rights.

Tips In photographer's samples, wants to see "sharp, clear photos of children doing things alone, in groups, or with parents. Know what we're about! We get too many submissions that are simply irrelevant to our publication."

$ $ HOOF BEATS

750 Michigan Ave., Columbus OH 43215. (614)224-2291. Fax: (614)222-6791. E-mail: hoofbeats@ustrotting.com. Website: www.ustrotting.com. **Contact:** Nicole Kraft, executive editor. Art Director/Production Manager: Gena Gallagher. Circ. 13,500. Estab. 1933. Monthly publication of the US Trotting Association. Emphasizes harness racing. Readers are participants in the sport of harness racing. Sample copy free.

Needs Buys 6 photos from freelancers/issue; 72 photos/year. Needs "artistic or striking photos that feature harness horses for covers; other photos on specific horses and drivers by assignment only."

Making Contact & Terms Send query letter with samples; include SASE for return of material. Responds in 3 weeks. Simultaneous submissions OK. Pays $150 minimum for color cover; $25-150 for b&w inside; $50-200 for color inside; freelance assignments negotiable. Pays on publication. Credit line given if requested. Buys one-time rights.

Tips "We look for photos with unique perspective and that display unusual techniques or use of light. Send query letter first. Know the publication and its needs before submitting. Be sure to shoot pictures of harness horses only, not thoroughbred or riding horses. We always need good night racing action or creative photography."

$ $ 📺 🖉 HORIZONS MAGAZINE

P.O. Box 1091, Bismarck ND 58502. (701)335-4458. Fax: (701)223-4645. E-mail: ndhorizons@btinet.net. Website: www.ndhorizons.com. **Contact:** Andrea W. Collin, editor. Estab. 1971. Quality regional magazine. Photos used in magazines, audiovisual, calendars.

Needs Buys 50 photos/year; offers 25 assignments/year. Needs scenics of North Dakota events, places and people. Also needs wildlife, cities/urban, rural, adventure, entertainment, events, hobbies, performing arts, travel, agriculture, industry. Interested in historical/vintage, seasonal. Model/property release preferred. Photo captions preferred.

Specs Uses 8×10 glossy color prints; 35mm, 2¼×2¼, 4×5 transparencies. Accepts images in digital format. Send via CD, Zip as TIFF, EPS files at 600 dpi.

Making Contact & Terms Send query letter with samples, stock list, SASE. Does not keep samples on file; include SASE for return of material. Responds in 2 weeks. Pays by the project, varies ($300-500); negotiable. Pays on usage. Credit line given. Buys one-time rights; negotiable.

Tips ''Know North Dakota events, places. Have strong quality of composition and light. Query by mail, e-mail with samples and stock list.''

$ HORSE ILLUSTRATED

Fancy Publications, a division of BowTie Inc., P.O. Box 6050, Mission Viejo CA 92690. (949)855-8822. Fax: (949)855-3045. E-mail: horseillustrated@bowtieinc.com. Website: www.horseillustrated.com. **Contact:** Moira C. Harris, editor. Circ. 220,000. Readers are ''primarily adult horsewomen, ages 18-40, who ride and show mostly for pleasure, and who are very concerned about the well being of their horses.'' Sample copy available for $4.50. Photo guidelines free with SASE.

Needs Buys 30-50 photos from freelancers/issue. Needs stock photos of riding and horse care. ''Photos must reflect safe, responsible horsekeeping practices. We prefer all riders to wear protective helmets; prefer people to be shown only in action shots (riding, grooming, treating, etc.). We like all riders—especially those jumping—to be wearing protective headgear.''

Specs ''We generally use color transparencies.'' Prefers 35mm, $2\frac{1}{4} \times 2\frac{1}{4}$ color transparencies.

Making Contact & Terms Send by mail for consideration. Responds in 2 months. Pays $200 for color cover; $60-200 for color inside; $100-350 for text/photo package. Credit line given. Buys one-time rights.

Tips ''Nothing but sharp, high-contrast shots. Looks for clear, sharp color shots of horse care and training. Healthy horses, safe riding and care atmosphere is standard in our publication. Send SASE for a list of photography needs, photo guidelines and to submit work.''

$ ▣ ✇ ⑤ HUNGER MOUNTAIN: The Vermont College Journal of Arts & Letters

Vermont College/Union Institute & University, 36 College St., Montpelier VT 05602. E-mail: hungermtn@tui.edu. Website: www.hungermtn.org. **Contact:** Caroline Mercurio, managing editor. Estab. 2002. Biannual literary magazine. Sample copy available for $10. Photo guidelines free with SASE.

Needs Buys no more than 10 photos/year. Interested in avant garde, documentary, fine art, seasonal. Reviews photos with or without ms.

Specs Accepts slides or images in digital format. Send via CD/disk, or send website link via e-mail; do not send e-mail attachments.

Making Contact & Terms Send query letter with résumé, slides, prints, tearsheets. Does not keep samples on file; include SASE for return of material. Responds in 3 months to queries and portfolios. Simultaneous submissions OK. Cover negotiable; $30-45 for b&w or color inside. Pays on publication. Credit line given. Buys first rights.

Tips Fine art photography—no journalistic/media work. Particularly interested in b&w. ''Keep in mind that we only publish twice per year with a minimal amount of artwork. Considering publication of a special edition of all b&w photos.''

$ ✇ ⑤ IDEALS MAGAZINE

Ideals Publications, 535 Metroplex Dr., Suite 250, Nashville TN 37211. (615)333-0478. Fax: (615)781-1447. Website: www.idealsbooks.com. **Contact:** Marjorie Lloyd, editor. Circ. 200,000. Estab. 1944. Magazine published 6 times/year. Emphasizes an idealized, nostalgic look at America through poetry and short prose, using ''seasonal themes—bright flowers and scenics for Thanksgiving, Christmas, Easter, Mother's Day, Friendship and Country—all thematically related material. Average reader has a college degree.'' Sample copy available for $4. Photo guidelines free with SASE or available on website.

Needs Buys 40 photos from freelancers/issue; 240 photos/year. Needs photos of ''bright, colorful flowers, scenics, still life, children, pets, home interiors; subject-related shots depending on issue.'' Model/property release required. No research fees.

Specs Prefers medium- to large-format transparencies; no 35mm.

Making Contact & Terms Submit tearsheets to be kept on file. No color copies. Will send photo needs list if interested. Do not submit unsolicited photos or transparencies. Keeps samples on file. Simultaneous submissions and previously published work OK. Payment negotiable. Pays on publication. Credit line given. Buys one-time rights.

Tips ''We want to see *sharp* shots. No mood shots, please. No filters. We suggest the photographer study several recent issues of *Ideals* magazine for a better understanding of our requirements.''

$ $ ▣ ◯ IN THE WIND: If It's Out There, It's In Here

Paisano Publications, LLC, P.O. Box 3000, Agoura Hills CA 91376-3000. (818)889-8740. Fax: (818)889-1252. E-mail: photos@easyriders.net. Website: www.easyriders.com. **Contact:** Kim Peterson, editor. Circ. 65,000.

Estab. 1978. Quarterly consumer magazine displaying the exhilaration of riding American-made V-twins (primarily Harley-Davidson) street motorcycles, the people who enjoy them, and the fun involved. Motto: "If It's Out There, It's In Here." Photo guidelines free with SASE.

Needs Needs photos of celebrities, couples, landscapes/scenics, adventure, events, travel. Interested in erotic, historical/vintage. Other specific photo needs: Action photos of people—men or women—riding Harley-Davidson motorcycles. Ideally, with no helmets, full-frame without wheels cropped off on the bikes. No children. Reviews photos with or without ms. Model release required on posed and nude photos.

Specs Uses 4×6, 5×7, 8×10 glossy color and/or b&w prints; 35mm transparencies. Accepts images in digital format. Send via CD, e-mail as TIFF, JPEG files at 300 dpi, 5×7 size.

Making Contact & Terms Send query letter with slides, prints, transparencies. Does not keep samples on file; include SASE for return of material. Responds in 6 weeks to queries; 3 months to portfolios. Responds only if interested; send nonreturnable samples. Pays $30-200 for b&w cover; $30-200 for color cover; $30-500 for b&w inside; $30-500 for color inside; inset photos usually not paid extra. Assignment photography for features pays up to $1,500 for bike and model. Pays on publication. Credit line given. Buys all rights; negotiable.

Tips "Get familiar with the magazine. Shoot sharp, in-focus pictures. Fresh views and angles of bikes and the biker lifestyle. Send self-addressed, stamped envelopes for return of material. Label each photo with name, address and caption information, i.e., where and when picture was taken."

Ⓝ $⊡ INDIANAPOLIS BUSINESS JOURNAL

41 E. Washington St., Suite 200, Indianapolis IN 46204. (317)634-6200. Fax: (317)263-5060. E-mail: rjerstad@ibj.com. Website: www.ibj.com. **Contact:** Robin Jerstad, picture editor. Circ. 17,000. Estab. 1980. Weekly newspaper/monthly magazine. Emphasizes Indianapolis business. Readers are male, ages 28 and up, middle management to CEOs.

Needs Buys 3-4 photos from freelancers/issue. Needs portraits of business people. Model release preferred. Photo captions required; include who, what, when and where.

Specs Accepts images in digital format. Send via CD, e-mail, floppy disk, SyQuest as EPS, TIFF files at 170 dpi.

Making Contact & Terms Send query letter with résumé and credits, stock photo list. Cannot return material. Responds in 3 weeks. Simultaneous submissions and previously published work OK. Pays $50-75 for color inside; $25-50 for b&w inside. Pays on publication. Credit line given. Buys one-time rights. Offers internships for photographers during the summer.

Tips "We generally use local freelancers (when we need them). Rarely do we have needs outside the Indianapolis area."

$ $⊡ INDIANAPOLIS MONTHLY

40 Monument Circle, Suite 100, Indianapolis IN 46204. (317)237-9288. Website: www.indianapolismonthly.com. **Contact:** Michael McCormick, art director. Monthly. Emphasizes regional/Indianapolis. Readers are upscale, well-educated. Circ. 50,000. Sample copy available for $4.95 and 9×12 SASE.

Needs Buys 10-12 photos from freelancers/issue; 120-144 photos/year. Needs seasonal, human interest, humorous, regional; subjects must be Indiana- or Indianapolis-related. Model release preferred. Photo captions preferred.

Specs Uses 5×7 or 8×10 glossy b&w prints; 35mm, $2\frac{1}{4} \times 2\frac{1}{4}$ transparencies. Accepts images in digital format. Send via CD, e-mail as TIFF, EPS, JPEG files at 300 dpi.

Making Contact & Terms Send query letter with samples, SASE. Responds in 1 month. Previously published work on occasion OK, if different market. Pays $300-1,200 for color cover; $75-300 for b&w inside; $75-350 for color inside. Pays on publication. Credit line given. Buys first North American serial rights.

Tips "Read publication. Send photos similar to those you see published. If we do nothing like what you are considering, we probably don't want to. We are always interested in photo essay queries (Indiana-specific)."

$⊡ INSIDE TRIATHLON

1830 N. 55th St., Boulder CO 80301-2700. (303)440-0601. Fax: (303)443-9919. Website: www.insidetriathlon.com. **Contact:** Don Karle, director of photography. Paid circ. 40,000. The journal of triathlons.

Needs Looking for action and feature shots that show the emotion of triathlons, not just finish-line photos with the winner's arms in the air. Reviews photos with or without a ms. Uses news, features, profiles. Photo captions required; include identification of subjects.

Specs Uses digital files, negatives and transparencies.

Making Contact & Terms Send samples of work or tearsheets with assignment proposal. Send query letter first, before ms. Responds in 3 weeks. Pays $325 for color cover; $24-72 for b&w inside; $48-300 for color inside. Pays on publication. Credit line given. Buys one-time rights.

Tips "Photos must be timely."

Ⓝ $ $⊘ INSIDE TV

TV Guide, 1211 6th Ave., 4th Floor, New York NY 10036. Website: www.insidetv.com. **Contact:** C. Tiffany Lee, photo editor. Circ. 300,000. Estab. 2005. Weekly celebrity magazine designed for TV enthusiasts. Emphasizes fashion, beauty, celebrity gossip, TV listings and latest TV news. Photo guildelines available via e-mail.

Needs Needs photos of celebrities, fashion/glamour. Reviews photos with or without ms. Photo captions required.

Specs Accepts images in digital format. Send via Zip or e-mail as TIFF or JPEG files at 300 dpi.

Making Contact & Terms E-mail query letter with link to photographer's website or JPEG samples at 72 dpi. Portfolio may be dropped off every Tuesday. Provide self-promotion piece to be kept on file for possible future assignments. Responds only if interested; send nonreturnable samples. Previously published work OK. Pays $250 minimum for color cover; $175 minimum for color inside. Pays on publication. Credit line given. Buys one-time rights or all rights; negotiable.

$ $⊘ INSIGHT MAGAZINE

Review and Herald Publishing Assoc., 55 W. Oak Ridge Dr., Hagerstown MD 21740-7390. (301)393-3000. Fax: (301)393-4055. E-mail: insight@rhpa.org. Website: www.insightmagazine.org. **Contact:** Jason Diggs, art director. Circ. 20,000. Estab. 1970. Weekly Seventh-Day Adventist teen magazine. "We print teens' true stories about God's involvement in their lives. All stories, if illustrated by a photo, must uphold moral and church organization standards while capturing a hip, teen style." Sample copy free.

Needs "Send query letter with photo samples so we can evaluate style." Model/property release required. Photo captions preferred; include who, what, where, when.

Making Contact & Terms Send query letter with samples. Provide résumé, business card, self-promotion piece or tearsheets to be kept on file for possible future assignments. Responds only if interested; send nonreturnable samples. Simultaneous submissions and previously published work OK. Pays $200-300 for color cover; $200-400 for color inside. Pays 30-45 days after receiving invoice and contract. Credit line given. Buys first rights.

▣ ◌ INSTINCT MAGAZINE

Instinct Publishing, 11440 Ventura Blvd., Suite 200, Studio City CA 91604. (818)286-0071. Fax: (818)286-0077. E-mail: jriggs@instinctmag.com. Website: www.instinctmag.com. **Contact:** Jonathan Riggs, photo editor. Circ. 75,000. Estab. 1997. Monthly gay men's magazine. "*Instinct* is geared towards a gay male audience. The slant of the magazine is humor mingled with entertainment, travel, and health & fitness." Sample copies available. Photo guidelines available via website.

Needs Buys 50-75 photos from freelancers/issue; 500-750 photos/year. Needs photos of celebrities, couples, cities/urban, entertainment, health/fitness, humor, travel. Interested in lifestyle, fashion/glamour. High emphasis on humorous and fashion photography. Reviews photos with or without a ms. Model release required; property release preferred. Photo captions preferred.

Specs Uses 8×10 glossy color prints; 2¼×2¼ transparencies. Accepts images in digital format. Send via CD, Jaz, Zip as TIFF files at least 300 dpi.

Making Contact & Terms Portfolio may be dropped off every weekday. Provide résumé, business card, self-promotion piece to be kept on file for possible future assignments. Responds in 2 weeks. Simultaneous submissions OK. Payment negotiable. Pays on publication. Credit line given.

Tips "Definitely read the magazine. Keep our editor updated about the progress or any problems with the shoot."

$▣ ⊘ THE IOWAN MAGAZINE

218 Sixth Ave., Suite 610, Des Moines IA 50309. (515)246-0402. Fax: (515)282-0125. E-mail: iowan@thepioneergroup.com. Website: www.iowan.com. **Contact:** Abbie Hansen, editor. Associate Editor: Callie Dunbar. Circ. 25,000. Estab. 1952. Bimonthly magazine. Emphasizes "Iowa—its people, places, events, nature and history." Readers are over age 30, college-educated, middle-to-upper income. Sample copy available for $4.50 with 9×12 SAE and 8 first-class stamps. Photo guidelines free with SASE or via website.

Needs Buys 20 photos from freelancers/issue; 120 photos/year. Needs "Iowa scenics—all seasons." Also

needs environmental, landscape/scenics, wildlife, architecture, rural, entertainment, events, performing arts, travel. Interested in historical/vintage, seasonal. Model/property release preferred. Photo captions required. **Specs** Uses 35mm, $2^{1}/_{4} \times 2^{1}/_{4}$, 4×5 color transparencies. Accepts images in digital format. Send via Zip as EPS files at 300 dpi.
Making Contact & Terms Send color 35mm, $2^{1}/_{4} \times 2^{1}/_{4}$ or 4×5 transparencies by mail with SASE for consideration. Responds in 1 month. Pays $25-50 for b&w photos; $50-200 for color photos; $200-500/day. Pays on publication. Credit line given. Buys one-time rights; negotiable.

$ $ ▣ ✐ ISLANDS MAGAZINE

World Publications, 6267 Carpinteria Ave., Suite 200, Carpinteria CA 93013. (805)745-7126. Fax: (805)745-7102. E-mail: vmathew@islands.com. Website: www.islands.com. **Contact:** Viju Mathew, photography coordinator. Circ. 200,000. Bimonthly. Emphasizes travel.
Needs Buys 50 photos from freelancers/issue; 400 photos/year. Needs photos of travel. Reviews photos with or without ms. Model/property release preferred. Photo captions required; include name, phone, address, subject information.
Specs Uses color 35mm, $2^{1}/_{4} \times 2^{1}/_{4}$, 4×5, 8×10 transparencies. Accepts images in digital format. Send via CD, e-mail as JPEG files at 300 dpi.
Making Contact & Terms Send query letter with tearsheets. Provide résumé, business card, self-promotion piece or tearsheets to be kept on file for possible future assignments. To show portfolio, photographer should follow up with call. Portfolio should include b&w and/or color prints, slides, tearsheets, transparencies. Keeps samples on file. Simultaneous submissions OK. Pays $600-1,000 for color cover; $100-350 for inside. Pays 30 days after publication. Credit line given. Buys one-time rights.

$ ▣ ✐ ITALIAN AMERICA

219 E St. NE, Washington DC 20002. (202)547-2900. Fax: (202)547-0121. E-mail: kcafiero@osia.org. Website: www.osia.org. **Contact:** Kylie Cafiero, communications manager. Circ. 65,000. Estab. 1996. Quarterly. "*Italian America* is the official publication of the Order Sons of Italy in America, the nation's oldest and largest organization of American men and women of Italian heritage. *Italian America* strives to provide timely information about OSIA, while reporting on individuals, institutions, issues and events of current or historical significance in the Italian-American community." Sample copy and photo guidelines free.
Needs Buys 5-10 photos from freelancers/issue; 25 photos/year. Needs photos of travel, history, personalities; anything Italian or Italian-American. Reviews photos with or without ms. Special photo needs include travel in Italy. Model release preferred. Photo captions required.
Specs Prefers 35mm, 4×5, 8×10 transparencies. Accepts images in digital format. Send via CD, floppy disk, e-mail as TIFF, EPS, PICT, BMP, GIF, JPEG files at 400 dpi.
Making Contact & Terms Send query letter with tearsheets. Provide résumé, business card, self-promotion piece or tearsheets to be kept on file for possible future assignments. Art director will contact photographer for portfolio review if interested. Portfolio should include color tearsheets. Responds only if interested; send nonreturnable samples. Simultaneous submissions OK. Pays $250 for b&w or color cover; $50-250 for b&w or color inside. Pays on publication. Credit line given. Buys one-time rights.

$ ✐ ITE JOURNAL

1099 14th St. NW, Suite 300W, Washington DC 20005-3438. (202)289-0222. Fax: (202)289-7722. E-mail: ite_staff@ite.org. Website: www.ite.org. **Contact:** Managing Editor. Circ. 17,000. Estab. 1930. Monthly journal of the Institute of Transportation Engineers. Emphasizes surface transportation, including streets, highways and transit. Readers are transportation engineers and professionals.
Needs One photo used for cover illustration per issue. Needs "shots of streets, highways, traffic, transit systems. No airports, airplanes, or bridges." Also considers landscapes, cities, rural, automobiles, travel, industry, technology, historical/vintage. Model release required. Photo captions preferred; include location, name or number of road or highway, and details.
Making Contact & Terms Send query letter with list of stock photo subjects. Send 35mm slides or $2^{1}/_{4} \times 2^{1}/_{4}$ transparencies by mail for consideration. Provide résumé, business card, brochure, flier or tearsheets to be kept on file for possible future assignments. "Send originals; no dupes, please." Simultaneous submissions and previously published work OK. Pays $200 for color cover. Pays on publication. Credit line given. Buys multiple-use rights.
Tips "Send a package to me in the mail; package should include samples in the form of slides and/or transparencies."

While researching possible markets for her photographs of Italy, Joy Brown discovered *Italian America*. She submitted some samples of her work, and this image appeared on the magazine's cover.

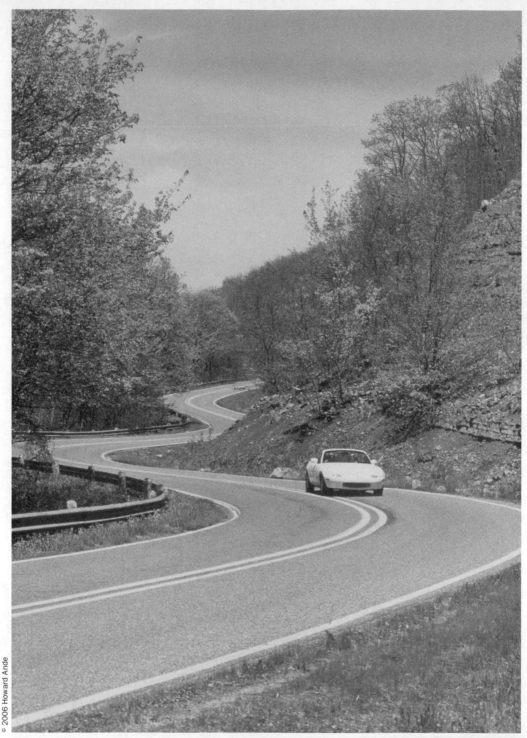

The editor of *ITE Journal* was looking for graphic, interesting images of highways and roads. Howard Ande submitted this photograph of a winding Arkansas road, and it was published on the journal's cover. Ande says photographers must be flexible to succeed: "Provide the client with what *they* want, not what *you* feel is a good image."

$ $ ▣ JEWISH ACTION, The Magazine of the Orthodox Union

11 Broadway, 14th Floor, New York NY 10004. (212)613-8146. Fax: (212)613-0646. E-mail: ja@ou.org. Website: www.ou.org/publications/ja. **Contact:** Nechama Carmel, editor. Circ. 20,000. Estab. 1986. Quarterly magazine with adult Orthodox Jewish readership. Sample copy available for $5 or on website.

Needs Buys 30 photos/year. Needs photos of Jewish lifestyle, landscapes and travel photos of Israel, and occasional photo essays of Jewish life. Reviews photos with or without ms. Model/property release preferred. Photo captions required; include description of activity, where taken, when.

Specs Uses color and/or b&w prints. Accepts images in digital format. Send CD, Jaz, Zip as TIFF, GIF, JPEG files.

Making Contact & Terms Send query letter with samples, brochure or stock photo list. Keeps samples on file. Responds in 2 months. Simultaneous submissions OK. Pays $250 maximum for b&w cover; $400 maximum for color cover; $100 maximum for b&w inside; $150 maximum for color inside. Pays within 6 weeks of publication. Credit line given. Buys one-time rights.

Tips "Be aware that models must be clothed in keeping with Orthodox laws of modesty. Make sure to include identifying details. Don't send work depicting religion in general. We are specifically Orthodox Jewish."

$ $ ▣ JOURNAL OF ASIAN MARTIAL ARTS

Via Media Publishing Co., 821 W. 24th St., Erie PA 16502-2523. (814)455-9517. E-mail: info@goviamedia.com. Website: www.goviamedia.com. **Contact:** Michael DeMarco, editor-in-chief. Circ. 10,000. Estab. 1991. "An indexed, notch-bound quarterly magazine exemplifying the highest standards in writing and graphics available on the subject. Comprehensive, mature, and eye-catching. Covers all historical and cultural aspects of Asian martial arts." Sample copy available for $10. Photo guidelines free with SASE.

Needs Buys 120 photos from freelancers/issue; 480 photos/year. Needs photos of health/fitness, sports, action shots; technical sequences of martial arts; photos that capture the philosophy and aesthetics of Asian martial traditions. Interested in alternative process, avant garde, digital, documentary, fine art, historical/vintage. Model release preferred for photos taken of subjects not in public demonstration; property release preferred. Photo captions preferred; include short description, photographer's name, year taken.

Specs Uses color and/or b&w prints; 35mm, 2¼×2¼, 4×5, 8×10 transparencies. Accepts images in digital format. Send via CD, Zip as TIFF files at 300 dpi.

Making Contact & Terms Send query letter with samples, stock list. Provide résumé, business card, self-promotion piece or tearsheets to be kept on file for possible future assignments. Art director will contact photographer for portfolio review if interested. Keeps samples on file. Responds in 2 months. Previously published work OK. Pays $100-500 for color cover; $10-100 for b&w inside. Credit line given. Buys first rights and reprint rights.

Tips "Read the journal. We are unlike any other martial arts magazine and would like photography to compliment the text portion, which is sophisticated with the flavor of traditional Asian aesthetics. When submitting work, be well organized and include a SASE."

$ $ JUNIOR SCHOLASTIC

557 Broadway, New York NY 10012. (212)343-4557. Fax: (212)343-6333. Website: www.juniorscholastic.com. **Contact:** Larry Schwartz, photo editor. Circ. 589,000. Biweekly educational school magazine. Emphasizes middle school social studies (grades 6-8): world and national news, US and world history, geography, how people live around the world. Sample copy available for $1.75 with 9×12 SAE.

Needs Uses 20 photos/issue. Needs photos of young people ages 11-14; non-travel photos of life in other countries; US news events. Reviews photos with accompanying ms only. Photo captions required.

Making Contact & Terms Arrange a personal interview to show portfolio. "Please do not send samples—only stock list or photocopies of photos. No calls, please." Simultaneous submissions OK. Pays $500 for color cover; $175 for b&w or color inside. Pays on publication. Credit line given. Buys one-time rights.

Tips Prefers to see young teenagers, in US and foreign countries; especially interested in "personal interviews with teenagers worldwide with photos."

$ $ ▣ JUVENILE DIABETES RESEARCH FOUNDATION INTERNATIONAL

120 Wall St., New York NY 10005. (800)533-2873. Fax: (212)785-9595. E-mail: info@jdrf.org. Website: www.jdrf.org. **Contact:** Jonathan Stenger. Estab. 1970. Produces 4-color, 48-page quarterly magazine to deliver research information to a lay audience.

Needs Buys 60 photos/year; offers 20 freelance assignments/year. Needs photos of babies/children/teens, families, events, food/drink, health/fitness, medicine, product shots/still life, science. Needs "mostly por-

traits of people, but always with some environmental aspect.'' Reviews stock photos. Model release preferred. Photo captions preferred.

Specs Uses $2^1/_4 \times 2^1/_4$ transparencies. Accepts images in digital format. Send via CD, Zip as TIFF, EPS, JPEG files at 300 dpi.

Making Contact & Terms Send query letter with samples. Provide résumé, business card, brochure, flier or tearsheets to be kept on file for possible future assignments. Cannot return material. Responds as needed. Pays $500 for color photos; $500-700 per day. Also pays by the job—payment ''depends on how many days, shots, cities, etc.'' Credit line given. Buys nonexclusive perpetual rights.

Tips Looks for ''a style consistent with commercial magazine photography—upbeat, warm, personal, but with a sophisticated edge. Call and ask for samples of our publications before submitting any of your own samples so you will have an idea of what we are looking for in photography. Nonprofit groups have seemingly come to depend more and more on photography to get their messages across. The business seems to be using a variety of freelancers, as opposed to a single in-house photographer.''

$ $⊘ KANSAS!

1000 SW Jackson St., Suite 100, Topeka KS 66612-1354. (785)296-3479. Fax: (785)296-6988. Website: www.kansmag.com. **Contact:** Nancy Kauk, editor. Circ. 40,000. Estab. 1945. Quarterly magazine. Emphasizes Kansas travel, scenery, arts, recreation and people. Sample copy free. Photo guidelines available via website.

Needs Buys 60-80 photos from freelancers/year. Animal, human interest, nature, seasonal, rural, photo essay/photo feature, scenic, sport, travel and wildlife, all from Kansas. No b&w, nudes, still life or fashion photos. Reviews photos with or without a ms. Model/property release preferred. Photo captions required; include subject and specific location.

Specs Uses 35mm, $2^1/_4 \times 2^1/_4$ or 4×5 transparencies.

Making Contact & Terms Send material by mail for consideration. Transparencies must be identified by location and photographer's name on the mount. Photos are returned after use. Previously published work OK. Pays $300 for color cover; varies for color inside. **Pays on acceptance.** Credit line given. Buys one-time rights.

Tips Kansas-oriented material only. Prefers Kansas photographers. ''Follow guidelines, submission dates specifically. Shoot a lot of seasonal scenics.''

$⊘ KASHRUS MAGAZINE, The Guide for the Kosher Consumer

P.O. Box 204, Parkville Station, Brooklyn NY 11204. (718)336-8544. Website: www.kashrusmagazine.com. **Contact:** Rabbi Yosef Wikler, editor. Circ. 10,000. Bimonthly. Emphasizes kosher food and food technology, travel (Israel-desirable), catering, weddings, remodeling, humor. Readers are kosher food consumers, vegetarians and food producers. Sample copy available for $2.

Needs Buys 3-5 photos from freelancers/issue; 18-30 photos/year. Needs photos of babies/children/teens, environmental, landscapes, interiors, Jewish, rural, food/drink, humor, travel, product shots, technology/computers. Interested in seasonal, nature photos and Jewish holidays. Model release preferred. Photo captions preferred.

Specs Uses $2^1/_4 \times 2^1/_4$, $3^1/_2 \times 3^1/_2$ or $7^1/_2 \times 7^1/_2$ matte b&w and color prints.

Making Contact & Terms Send unsolicited photos by mail with SASE for consideration. Provide business card, brochure, flier or tearsheets to be kept on file for possible future assignments. Responds in 1 week. Simultaneous submissions and previously published work OK. Pays $40-75 for b&w cover; $50-100 for color cover; $25-50 for b&w inside; $75-200/job; $50-200 for text for photo package. Pays part on acceptance, part on publication. Buys one-time rights, first North American serial rights, all rights; negotiable.

Tips ''Seriously in need of new photo sources, but *call first* to see if your work is appropriate before submitting samples.''

$▣ ◯ KENTUCKY MONTHLY

213 St. Clair St., P.O. Box 559, Frankfort KY 40601-0559. (502)227-0053. Fax: (502)227-5009. E-mail: membry @kentuckymonthly.com. Website: www.kentuckymonthly.com. **Contact:** Michael Embry, editor. Circ. 40,000. Estab. 1998. Monthly magazine focusing on Kentucky and/or Kentucky-related stories. Sample copy available for $3.

Needs Buys 3 photos from freelancers/issue; 36 photos/year. Needs photos of celebrities, wildlife, entertainment, sports. Interested in fashion/glamour. Reviews photos with or without ms. Model release required. Photo captions preferred.

Specs Uses glossy prints; 35mm transparencies. Accepts images in digital format. Send via CD, e-mail at 300 dpi.

Making Contact & Terms Send query letter. Provide self-promotion piece to be kept on file for possible future assignments. Responds in 1 month to queries. Simultaneous submissions OK. Pays $25 minimum for inside. Pays the 15th of the following month. Credit line given. Buys one-time rights.

$ $▣ ◉ KNOWATLANTA, The Premier Relocation Guide

New South Publishing, 1303 Hightower Trail, Suite 101, Atlanta GA 30350. (770)650-1102. Fax: (770)650-2848. E-mail: editor1@knowatlanta.com. Website: www.knowatlanta.com. **Contact:** Editor-in-Chief. Circ. 48,000. Estab. 1986. Quarterly magazine serving as a relocation guide to the Atlanta metro area with a corporate audience. Photography reflects regional and local material as well as corporate-style imagery.

Needs Buys more than 10 photos from freelancers/issue; more than 40 photos/year. Needs photos of cities/urban, events, performing arts, business concepts, medicine, technology/computers. Reviews photos with or without ms. Model release required; property release preferred. Photo captions preferred.

Specs Uses 8×10 glossy color prints; 35mm, 2¼×2¼ transparencies. Accepts images in digital format. Send via CD, Zip, e-mail as TIFF, EPS, JPEG files at 300 dpi.

Making Contact & Terms Send query letter with photocopies. Provide résumé, business card, self-promotion piece to be kept on file for possible future assignments. Responds only if interested; send nonreturnable samples. Pays $600 maximum for color cover; $300 maximum for color inside. Pays on publication. Credit line given. Buys first rights.

Tips "Think like our readers. What would they want to know about or see in this magazine? Try to represent the relocated person if using subjects in photography."

$▣ ◯ Ⓐ LACROSSE MAGAZINE

113 W. University Pkwy., Baltimore MD 21210. (410)235-6882. Fax: (410)366-6735. E-mail: pkrome@uslacrosse.org. Website: www.uslacrosse.org. **Contact:** Paul Krome, editor. Circ. 160,000. Estab. 1978. Publication of US Lacrosse. Monthly magazine during lacrosse season (March, April, May, June); bimonthly off-season (July/August, September/October, November/December, January/February). Emphasizes sport of lacrosse. Readers are male and female lacrosse enthusiasts of all ages. Sample copy free with general information pack.

Needs Buys 15-30 photos from freelancers/issue; 120-240 photos/year. Needs lacrosse action shots. Photo captions required; include rosters with numbers for identification.

Specs Uses 4×6 glossy color and b&w prints. Accepts images in digital format. Send via CD, e-mail.

Making Contact & Terms Send unsolicited photos by mail with SASE for consideration. Provide résumé, business card, brochure, flier or tearsheets to be kept on file for possible future assignments. Responds in 3 weeks. Simultaneous submissions and previously published work OK. Pays $100 for color cover; $50 for b&w or color inside. Pays on publication. Credit line given. Buys one-time rights.

$ $LADIES HOME JOURNAL

125 Park Ave., New York NY 10017. (212)455-1033. Fax: (212)455-1313. Website: www.lhj.com. **Contact:** Sabrina Regan, photo associate. Circ. 6 million. Monthly magazine. Features women's issues. Readership consists of women with children and working women in 30s age group.

Needs Uses 90 photos/issue; 100% supplied by freelancers. Needs photos of children, celebrities and women's lifestyles/situations. Reviews photos only without ms. Model release and photo captions preferred.

Making Contact & Terms Provide résumé, business card, brochure, flier or tearsheet to be kept on file for possible assignment. "Do not send slides or original work; send only promo cards or disks." Responds in 3 weeks. Pays $500/page. **Pays on acceptance.** Credit line given. Buys one-time rights.

$▣ ◉ LAKE COUNTRY JOURNAL

Evergreen Press, P.O. Box 465, Brainerd MN 56401. (218)828-6424. Fax: (218)825-7816. E-mail: jessica@lakecountryjournal.com. Website: www.lakecountryjournal.com. **Contact:** Jessica Meihack, assistant art director. Estab. 1996. Bimonthly regional consumer magazine focused on north-central area of Minnesota. Sample copy and photo guidelines available for $5 and 9×12 SAE.

Needs Buys 35 photos from freelancers/issue; 210 photos/year. Needs photos of babies/children/teens, couples, multicultural, families, senior citizens, environmental, landscapes, wildlife, architecture, gardening, decorating, rural, entertainment, events, food/drink, health/fitness/beauty, hobbies, humor, sports, agriculture, medicine. Interested in documentary, fine art, historical/vintage, seasonal. Also Minnesota outdoors.

Reviews photos with or without ms. Model release preferred. Photo captions preferred; include who, where, when.

Specs Uses 35mm, $2\frac{1}{4}\times2\frac{1}{4}$, 4×5, 8×10 transparencies. Accepts images in digital format. Send via CD, DVD as TIFF, EPS files at 300 dpi.

Making Contact & Terms Send query letter with résumé, slides, prints, tearsheets, transparencies, stock list. Provide résumé, business card or self-promotion piece to be kept on file for possible future assignments. Responds in 3 weeks to queries. Previously published work OK. Pays $180 for cover; $35-150 for inside. Pays on publication. Credit line given. Buys one-time rights; negotiable.

$▣ ☑ LAKE SUPERIOR MAGAZINE

Lake Superior Port Cities, Inc., P.O. Box 16417, Duluth MN 55816-0417. (218)722-5002. Fax: (218)722-4096. E-mail: edit@lakesuperior.com. Website: www.lakesuperior.com. **Contact:** Konnie LeMay, editor. Circ. 20,000. Estab. 1979. Bimonthly magazine. "Beautiful picture magazine about Lake Superior." Readers are male and female, ages 35-55, highly educated, upper-middle and upper-management level through working. Sample copy available for $3.95 with 9×12 SAE and 5 first-class stamps. Photo guidelines free with SASE or by e-mail.

Needs Buys 21 photos from freelancers/issue; 126 photos/year. Also buys photos for calendars and books. Needs photos of landscapes/scenics, travel, wildlife, personalities, boats, underwater, all photos Lake Superior-related. Photo captions preferred.

Specs Uses 5×7, 8×10 glossy b&w and color-corrected prints; 35mm, $2\frac{1}{4}\times2\frac{1}{4}$, 4×5, 8×10 transparencies. Accepts images in digital format. Send via CD.

Making Contact & Terms Send unsolicited photos by mail with SASE for consideration. Provide résumé, business card, brochure, flier or tearsheets to be kept on file for possible future assignments. Responds in 2 months. Simultaneous submissions OK. Pays $150 for color cover; $50 for b&w or color inside. Pays on publication. Credit line given. Buys first North American serial rights; reserves second rights for future use.

Tips "Be aware of the focus of our publication—Lake Superior. Photo features concern only that. Features with text can be related. We are known for our fine color photography and reproduction. It has to be 'tops.' We try to use images large; therefore, detail quality and resolution must be good. We look for unique outlook on subject, not just snapshots. Must communicate emotionally. Some photographers send material we can keep in-house and refer to, and these will often get used."

$ LAKELAND BOATING MAGAZINE

727 South Dearborn St., Suite 812, Chicago IL 60605. (312)276-0610. Fax: (312)276-0619. E-mail: lb@omeara-brown.com. Website: www.lakelandboating.com. **Contact:** Matthew Wright, editor. Circ. 60,000. Estab. 1945. Monthly magazine. Emphasizes powerboating in the Great Lakes. Readers are affluent professionals, predominantly men over age 35.

Needs Needs shots of particular Great Lakes ports and waterfront communities. Model release preferred. Photo captions preferred.

Making Contact & Terms Send query letter with list of stock photo subjects. Provide résumé, business card, brochure, flier or tearsheets to be kept on file for possible future assignments. Pays $25-100 for photos. Pays on publication. Credit line given.

$ $ ▣ ☑ Ⓐ THE LION

Lions Clubs International, 300 W. 22nd St., Oak Brook IL 60523-8842. (630)571-5466. Fax: (630)571-1685. E-mail: rkleinfe@lionsclubs.org. Website: www.lionsclubs.org. **Contact:** Robert Kleinfelder, editor. Circ. 490,000. Estab. 1918. Monthly magazine for members of the Lions Club and their families. Emphasizes Lions Club service projects. Sample copy and photo guidelines free.

Needs Uses 50-60 photos/issue. Needs photos of Lions Club service or fundraising projects. "All photos must be as candid as possible, showing an activity in progress. Please, no award presentations, meetings, speeches, etc. Generally, photos are purchased with manuscript (300-1,500 words) and used as a photo story. We seldom purchase photos separately." Model release preferred for young or disabled children. Photo captions required.

Specs Uses 5×7, 8×10 glossy color prints; 35mm transparencies; also accepts digital images via e-mail.

Making Contact & Terms Works with freelancers on assignment only. Provide résumé to be kept on file for possible future assignments. Query first with résumé of credits or story idea. Responds in 2 weeks. Pays $150-600 for text/photo package. "Must accompany story on the service or fundraising project of the The Lions Club." **Pays on acceptance**. Buys all rights; negotiable.

Tips "Query on specific project and photos to accompany manuscript."

$▣ ☑ THE LIVING CHURCH

P.O. Box 514036, Milwaukee WI 53203. (414)276-5420. Fax: (414)276-7483. E-mail: tlc@livingchurch.org. Website: www.livingchurch.org. **Contact:** John Schuessler, managing editor. Circ. 9,500. Estab. 1878. Weekly magazine. Emphasizes news of interest to members of the Episcopal Church. Readers are clergy and lay members of the Episcopal Church, predominantly ages 35-70. Sample copies available.

Needs Uses 6-12 photos from freelancers/year. Needs photos to illustrate news articles. Needs stock photos—churches, scenic, people in various settings. Photo captions preferred.

Specs Uses 5×7 or larger glossy color or b&w prints. Accepts images in digital format. Send as TIFF files at 300 dpi.

Making Contact & Terms Send unsolicited photos by mail with SASE for consideration. Responds in 1 month. Pays $25-50 for color or b&w cover; $10-25 for color or b&w inside. Pays on publication.

$ $☑ LOG HOME LIVING

4125 Lafayette Center Dr., Suite 100, Chantilly VA 20151. (703)222-9411. Fax: (703)222-3209. E-mail: dbaxley @homebuyerpubs.com. Website: www.loghomeliving.com. **Contact:** Dave Baxley, photo editor. Circ. 120,000. Estab. 1989. Monthly magazine. Emphasizes planning, building and buying a log home. Sample copy available for $4. Photo guidelines available on website.

Needs Buys 90 photos from freelancers/issue; 120 photos/year. Needs photos of homes—living room, dining room, kitchen, bedroom, bathroom, exterior, portrait of owners, design/decor—tile sunrooms, furniture, fireplaces, lighting, porch and deck, doors. Close-up shots of details (roof trusses, log stairs, railings, dormers, porches, window/door treatments) are appreciated. Model release required.

Specs Prefers to use 4×5 color transparencies/Kodachrome or Ektachrome color slides; smaller color transparencies and 35mm color prints also acceptable.

Making Contact & Terms Send unsolicited photos by mail for consideration. Keeps samples on file. Responds only if interested. Previously published work OK. Pays $2,000 maximum for color feature. Cover shot submissions also accepted; fee varies, negotiable. **Pays on acceptance.** Credit line given. Buys first World-one-time stock serial rights, negotiable.

Tips "Send photos of log homes, both interiors and exteriors."

$▣ LOYOLA MAGAZINE

820 N. Michigan, Suite 1500, Chicago IL 60611. (312)915-7666. Fax: (312)915-6815. Website: www.luc.edu/ loyolamagazine/. **Contact:** Nicole LeDuc, associate director of alumni relations and special events. Circ. 110,000. Estab. 1971. Loyola University Alumni magazine published 3 times/year. Emphasizes issues related to Loyola University Chicago. Readers are Loyola University Chicago alumni—professionals, ages 22 and up. Sample copy available for 9×12 SAE and 3 first-class stamps.

Needs Buys 20 photos from freelancers/issue; 60 photos/year. Needs Loyola-related or Loyola alumni-related photos only. Model release preferred. Photo captions preferred.

Specs Uses 8×10 b&w and/or color prints; 35mm, 2¼×2¼ transparencies. Accepts high-resolution digital images. Query before submitting.

Making Contact & Terms Best to query by mail before making any submissions. If interested, will ask for résumé, business card, brochure, flier or tearsheets to be kept on file for possible future assignments. Responds in 3 months. Simultaneous submissions and previously published work OK. Pays $250/assignment; $400 half-day rate; $800 full-day rate. **Pays on acceptance.** Credit line given.

Tips "Send us information, but don't call."

$ $▣ ☑ THE LUTHERAN

8765 W. Higgins Rd., Chicago IL 60631. (773)380-2540. Fax: (773)380-2751. E-mail: michael.watson@theluth eran.org. Website: www.thelutheran.org. **Contact:** Michael Watson, art director. Circ. 300,000. Estab. 1988. Monthly publication of Evangelical Lutheran Church in America.

Needs Buys 10-15 photos from freelancers/issue; 120-180 photos/year. Needs current news, mood shots. Subjects include babies/children/teens, couples, multicultural, families, parents, senior citizens, disasters, landscapes/scenics, cities/urban, education, religious. Interested in fine art, seasonal. "We usually assign work with exception of 'Reflections' section." Model release required. Photo captions preferred.

Specs Accepts images in digital format. Send via CD or e-mail as TIFF or JPEG files at 300 dpi.

Making Contact & Terms Send query letter with list of stock photo subjects. Provide résumé, brochure, flier or tearsheets to be kept on file for possible future assignments. Pays $300-500 for color cover; $175-300 for color inside; $300 for half day; $600 for full day. Pays on publication. Credit line given. Buys one-time rights.

Tips Trend toward "more dramatic lighting; careful composition." In portfolio or samples, wants to see "candid shots of people active in church life, preferably Lutheran. Church-only photos have little chance of publication. Submit sharp, well-composed photos with borders for cropping. Send printed or duplicate samples to be kept on file; no originals. If we like your style, we will call you when we have a job in your area."

$LUTHERAN FORUM

P.O. Box 327, Delhi NY 13753. (607)746-7511. Website: www.alpb.org. **Contact:** Ronald Bagnall, editor. Circ. 3,500. Quarterly. Emphasizes "Lutheran concerns, both within the church and in relation to the wider society, for the leadership of Lutheran churches in North America."

Needs Uses cover photos occasionally. "While subject matter varies, we are generally looking for photos that include people, and that have a symbolic dimension. We use *few* purely 'scenic' photos. Photos of religious activities, such as worship, are often useful, but should not be 'cliches'—types of photos that are seen again and again." Photo captions "may be helpful."

Making Contact & Terms Send query letter with list of stock photo subjects. Responds in 2 months. Simultaneous submissions and previously published work OK. Pays $15-25 for b&w photos. Pays on publication. Credit line given. Buys one-time rights.

▣ THE MAGAZINE ANTIQUES

575 Broadway, New York NY 10012. (212)941-2800. Fax: (212)941-2819. **Contact:** Allison E. Ledes, editor. Circ. 60,000. Estab. 1922. Monthly magazine. Emphasizes art, antiques, architecture. Readers are male and female collectors, curators, academics, interior designers, ages 40-70. Sample copy available for $10.50.

Needs Buys 24-48 photos from freelancers/issue; 288-576 photos/year. Needs photos of interiors, architectural exteriors, objects. Reviews photos with or without ms.

Specs Uses 8×10 glossy prints; 4×5 transparencies; JPEGs at 300 dpi.

Making Contact & Terms Submit portfolio for review; phone ahead to arrange drop-off. Does not keep samples on file; include SASE for return of material. Responds in 6 weeks. Previously published work OK. Payment negotiable. Pays on publication. Credit line given. Buys one-time rights; negotiable.

$ $▣ MARLIN MAGAZINE

P.O. Box 8500, Winter Park FL 32790. (407)628-4802. Fax: (407)628-7061. E-mail: editor@marlinmag.com. Website: www.marlinmag.com. **Contact:** David Ferrell, editor. Circ. 45,000 (paid). Estab. 1981. Magazine published 8 times/year. Emphasizes offshore big game fishing for billfish, tuna and other large pelagics. Readers are 94% male, 75% married, average age 43, very affluent businessmen. Sample copy free with 8×10 SASE. Photo guidelines free with SASE or on website.

Needs Buys 45 photos from freelancers/issue; 270 photos/year. Needs photos of fish/action shots, scenics and how-to. Special photo needs include big game fishing action and scenics (marinas, landmarks etc.). Model release preferred. Photo captions preferred.

Specs Uses 35mm transparencies. Also accepts high-resolution images on CD or Zip.

Making Contact & Terms Contract required. Send unsolicited photos by mail with SASE for consideration. Responds in 1 month. Simultaneous submissions OK, with notification. Pays $1,000 for color cover; $100-300 for color inside. Pays on publication. Buys first North American rights.

Tips "Send in sample material with SASE. No phone call necessary."

$ $▣ ○ METROSOURCE MAGAZINE

MetroSource Publishing, 180 Varick St., #504, New York NY 10014. (212)691-5127. Fax: (212)741-2978. E-mail: rwalsh@metrosource.com. **Contact:** Richard Walsh, editor. Designer: Sara Burke. Circ. 125,000. Estab. 1990. Upscale, gay men's luxury lifestyle magazine published 6 times/year covering fashion, travel, profiles, interiors, film, art. Sample copies free.

Needs Buys 10-15 photos from freelancers/issue; 50 photos/year. Needs photos of celebrities, architecture, interiors/decorating, adventure, food/drink, health/fitness, travel, product shots/still life. Interested in erotic, fashion/glamour, seasonal. Also needs still life drink shots for spirits section. Reviews photos with or without ms. Model/property release preferred. Photo captions preferred.

Specs Uses 8×10, glossy or matte color and/or b&w prints; 2¼×2¼, 4×5 transparencies. Prefers images in digital format. Send via CD, Zip, e-mail as TIFF, EPS, JPEG files at 300 dpi.

Making Contact & Terms Send query letter with self-promo cards. Please call first for portfolio drop-off. Provide self-promotion piece to be kept on file for possible future assignments. Responds only if interested;

send nonreturnable samples. Simultaneous submissions and previously published work OK. Pays $500-800 for cover; $0-300 for inside. Pays on publication. Credit line given. Buys one-time rights.

Tips "We work with creative established and newly-established photographers. Our budgets vary depending on the importance of story. Have an e-mail address on card so I can see more photos or whole portfolio online."

$⊡▣▢ MICHIGAN OUT-OF-DOORS

P.O. Box 30235, Lansing MI 48909. (517)346-6483. Fax: (517)371-1505. E-mail: magazine@mucc.org. Website: www.mucc.org. **Contact:** Dennis C. Knickerbocker, editor. Circ. 80,000. Estab. 1947. Monthly magazine for people interested in "outdoor recreation, especially hunting and fishing; conservation; environmental affairs." Sample copy available for $3.50; editorial guidelines free.

Needs Buys 6-12 photos from freelancers/issue; 72-144 photos/year. Needs photos of animals/wildlife, nature, scenics, sports (hunting, fishing, backpacking, camping, cross-country skiing, and other forms of noncompetitive outdoor recreation). Materials must have a Michigan slant. Photo captions preferred.

Making Contact & Terms Send any size glossy b&w prints; 35mm or $2\frac{1}{4} \times 2\frac{1}{4}$ color transparencies; high-definition digital images. Include SASE for return of material. Responds in 1 month. Pays $175 for cover; $20 minimum for b&w inside; $40 for color inside. Credit line given. Buys first North American serial rights.

Tips Submit seasonal material 6 months in advance. Wants to see "new approaches to subject matter."

$⊡▣▢▣ MINNESOTA GOLFER

Minnesota Golf Association, 6550 York Ave. S., Suite 211, Edina MN 55435. (952)927-4643. Fax: (952)927-9642. E-mail: editor@mngolf.org. Website: www.mngolf.org. **Contact:** W.P. Ryan, editor. Circ. 60,000. Estab. 1970. Bimonthly association magazine covering Minnesota golf scene. Sample copies available.

Needs Works on assignment only. Buys 25 photos from freelancers/issue; 150 photos/year. Needs photos of golf, golfers, and golf courses only. Will accept exceptional photography that tells a story or takes specific point of view. Reviews photos with or without ms. Model/property release required. Photo captions required; include date, location, names and hometowns of all subjects.

Specs Uses 5×7 or 8×10 glossy color and/or b&w prints; 35mm, $2\frac{1}{4} \times 2\frac{1}{4}$, 4×5 transparencies. Accepts images in digital format. Send via CD, e-mail as JPEG files.

Making Contact & Terms Send query letter with slides, prints. Portfolios may be dropped off every Monday. Provide business card or self-promotion piece to be kept on file for possible future assignments. Responds only if interested; send nonreturnable samples. Pays on publication. Credit line given. Buys one time rights. Will negotiate one-time or all rights, depending on needs of the magazine and the MGA.

Tips "We use beautiful golf course photography to promote the game and Minnesota courses to our readers. We expect all submissions to be technically correct in terms of lighting, exposure, and color. We are interested in photos that portray the game and golf courses in new, unexpected ways. For assignments, submit work with invoice and all expenses. For unsolicited work, please include contact, fee, and rights terms submitted with photos; include captions where necessary. Artist agreement available upon request."

$⊡▣○ MISSOURI LIFE

Missouri Life, Inc., P.O. Box 421, Fayette MO 65248-0421. (660)248-3489. Fax: (660)248-2310. E-mail: info@missourilife.com. Website: www.missourilife.com. **Contact:** Martha Everett, managing editor. Circ. 20,000. Estab. 1973. Bimonthly consumer magazine. "*Missouri Life* celebrates Missouri people and places, past and present, and the unique qualities of our great state with interesting stories and bold, colorful photography." Sample copy available for $4.50 and SASE with $2.44 first-class postage. Photo guidelines available on website.

Needs Buys 80 photos from freelancers/issue; more than 500 photos/year. Needs photos of environmental, seasonal, landscapes/scenics, wildlife, architecture, cities/urban, rural, adventure, historical sites, entertainment, events, hobbies, performing arts, travel. Reviews photos with or without ms. Model/property release required. Photo captions required; include location, names and detailed identification (including any title and hometown) of subjects.

Specs Uses 4×6 or larger glossy color and/or b&w prints, slides, transparencies. Accepts images in high-resolution digital format (minimum 300 dpi at 8×10). Send via e-mail, CD, Zip as EPS, JPEG, TIFF files.

Making Contact & Terms Send query letter with résumé, stock list. Provide self-promotion piece to be kept on file for possible future assignments. Responds in 1 month. Pays $100-150 for color cover; $50 for color inside. Pays on publication. Credit line given. Buys first rights, nonexclusive rights, limited rights.

Tips "Be familiar with our magazine and the state of Missouri. Provide well-labeled images with detailed caption and credit information."

$ MODERN DRUMMER MAGAZINE

12 Old Bridge Rd., Cedar Grove NJ 07009. (973)239-4140. Fax: (973)239-7139. Editor: Ron Spagnardi. **Contact:** Scott Bienstock, art director. Circ. 100,000. Magazine published 12 times/year. For drummers at all levels of ability: students, semiprofessionals and professionals. Sample copy available for $4.99.

Needs Buys 100-150 photos annually. Needs celebrity/personality, product shots, action photos of professional drummers and photos dealing with "all aspects of the art and the instrument."

Making Contact & Terms Send query letter with b&w contact sheet, b&w negatives, 5×7 or 8×10 glossy b&w prints, 35mm, 2¼×2¼, 8×10 color transparencies. Include SASE. Previously published work OK. Pays $200 for cover; $15-75 for b&w inside; $30-150 for color inside. Pays on publication. Credit line given. Buys all rights.

$ MONTANA MAGAZINE

Far County Press, P.O. Box 5630, Helena MT 59630. (406)443-2842. Fax: (406)443-5480. Website: www.mont anamagazine.com. **Contact:** Mary Alice Chester, photo librarian. Circ. 120,000. Bimonthly consumer magazine. *Montana Magazine* subscribers include lifelong residents, first-time visitors, and "wanna-be" Montanans from around the nation and the world. Publishes articles on Montana recreation, contemporary issues, people, natural history, cities, small towns, humor, wildlife, real-life adventure, nostalgia, geography, history, byways and infrequently explored countryside, made-in-Montana products, local businesses and environment. Photo guidelines available on website and by request with SASE.

Needs Buys majority of photos from freelancers. Needs photos of wildlife, cities/urban. Interested in seasonal. Community scenes, scenic panoramas and intimate close-ups that showcase Montana. Subject matter is limited to Montana and Yellowstone National Park. Humorous or nostalgic images for "Glimpses" page. Model/property release preferred. Photo captions required.

Specs Uses 35mm transparencies. Accepts reproduction-grade dupes and professional prints.

Making Contact & Terms Send query letter with slides. Does not keep samples on file; include SASE for return of material. Pays $250 maximum for color cover. Pays $50-175 for color inside. Credit line given. Buys one-time rights.

Tips "Editorial calendar available on request with SASE."

$ $ ▣ MOUNTAIN LIVING

7009 S. Potomac St., Centennial CO 80112. (303)397-7600. Fax: (303)397-7619. E-mail: lshowell@mountainli ving.com. Website: www.mountainliving.com. **Contact:** Loneta Showell, art director. Circ. 35,000. Estab. 1994. Bimonthly magazine. Emphasizes shelter, lifestyle.

Needs Buys 50-75 photos from freelancers/issue; 600-900 photos/year. Needs photos of home interiors, architecture. Reviews photos with accompanying ms only. Model/property release required. Photo captions preferred.

Specs Uses 35mm, 2¼×2¼ transparencies. Accepts images in digital format. Send via CD as TIFF files at 300 dpi.

Making Contact & Terms Submit portfolio for review. Send query letter with stock list. Provide résumé, business card, brochure, flier or tearsheets to be kept on file for possible future assignments. Responds in 6 weeks. Pays $500-600/day; $0-600 for color inside. **Pays on acceptance**. Credit line given. Buys one-time and first North American serial rights as well as rights to use photos on the *Mountain Living* website and in promotional materials; negotiable.

$ Ⓐ MULTINATIONAL MONITOR

P.O. Box 19405, Washington DC 20036. (202)387-8030. Fax: (202)234-5176. E-mail: monitor@essential.org. Website: www.multinationalmonitor.org. **Contact:** Robert Weissman, editor. Circ. 10,000. Estab. 1978. Bimonthly magazine. "We are a political-economic magazine covering operations of multinational corporations." Emphasizes multinational corporate activity. Readers are in business, academia, and many are activists. Sample copy free with 9×12 SAE.

Needs Uses 12 photos/issue; number of photos supplied by freelancers varies. "We need photos of industry, people, cities, technology, agriculture and many other business-related subjects." Also uses photos of medicine, military, political, science. Photo captions required; include location, your name and description of subject matter.

Making Contact & Terms Send query letter with list of stock photo subjects, SASE. Responds in 3 weeks. Pays $75 for b&w cover; $35 for b&w inside. Pays on publication. Credit line given. Buys one-time rights.

⬛ $ $⬛ ⬛ MUSCLEMAG INTERNATIONAL

5775 McLaughlin Rd., Mississauga ON L5R 3P7 Canada. Website: www.emusclemag.com. Contact: Editor. Circ. 300,000. Estab. 1974. Monthly magazine. Emphasizes male and female physical development and fitness. Sample copy available for $6.

Needs Buys 3,000 photos/year; 50% assigned; 50% stock. Needs celebrity/personality, fashion/beauty, glamour, swimsuit, how-to, human interest, humorous, special effects/experimental and spot news. "We require action exercise photos of bodybuilders and fitness enthusiasts training with sweat and strain." Wants on a regular basis "different" pics of top names, bodybuilders or film stars famous for their physique (i.e., Schwarzenegger, The Hulk, etc.). No photos of mediocre bodybuilders. "They have to be among the top 100 in the world or top film stars exercising." Photos purchased with accompanying ms. Photo captions preferred.

Specs Uses 8×10 glossy b&w prints; 35mm, 2¼×2¼ or 4×5 transparencies; vertical format preferred for cover.

Making Contact & Terms Send material by mail for consideration; send $3 for return postage. Send query letter with contact sheet. Responds in 1 month. Pays $85-100/hour; $500-700/day and $1,000-3,000/complete package. Pays $20-50/b&w photo; $25-500/color photo; $1,000/cover photo; $85-300/accompanying ms. **Pays on acceptance.** Credit line given. Buys all rights.

Tips "We would like to see photographers take up the challenge of making exercise photos look like exercise motion. In samples we want to see sharp, color-balanced, attractive subjects, no grain, artistic eye. Someone who can glamorize bodybuilding on film. To break in get serious: read, ask questions, learn, experiment and try, try again. Keep trying for improvement—don't kid yourself that you are a good photographer when you don't even understand half the attachments on your camera. Immerse yourself in photography. Study the best; study how they use light, props, backgrounds, angles. Current biggest demand is for swimsuit-type photos of fitness men and women (splashing in waves, playing/posing in sand, etc.). Shots must be sexually attractive."

$⬛ ⬛ ⬛ ⬛ MUSHING: The Magazine of Dog-Powered Sports

P.O. Box 246, 3875 Geist Rd., Suite E, Fairbanks AK 99709. (917)929-6118. E-mail: editor@mushing.com. Website: www.mushing.com. **Contact:** Mary Haley, managing editor. Circ. 6,000. Estab. 1987. Bimonthly magazine. Readers are dog drivers, mushing enthusiasts, dog lovers, outdoor specialists, innovators, and sled dog history lovers. Sample copy available for $5 in US. Photo guidelines free with SASE.

Needs Uses 20 photos/issue; most supplied by freelancers. Needs action photos: all-season and wilderness; still and close-up photos: specific focus (sledding, carting, dog care, equipment, etc). Special photo needs include skijoring, feeding, caring for dogs, summer carting or packing, 1- to 3-dog-sledding, and kids mushing. Model release preferred. Photo captions preferred.

Specs Accepts images in digital format. Send via CD, Zip, e-mail as JPEG files at 300 dpi.

Making Contact & Terms Send unsolicited photos by mail for consideration. Responds in 6 months. Pays $175 maximum for color cover; $15-40 for b&w inside; $40-50 for color inside. Pays $10 extra for 1 year of electronic use rights on the Web. Pays within 60 days after publication. Credit line given. Buys first serial rights and second reprint rights.

Tips Wants to see work that shows "the total mushing adventure/lifestyle from environment to dog house." To break in, one's work must show "simplicity, balance and harmony. Strive for unique, provocative shots that lure readers and publishers. Send 10-40 images for review. Allow for 2-6 months' review time for at least a screened selection of these."

$⬛ ⬛ ⬛ MUZZLE BLASTS

P.O. Box 67, Friendship IN 47021. (812)667-5131. Fax: (812)667-5137. E-mail: mblastdop@seidata.com. Website: www.nmlra.org. **Contact:** Terri Trowbridge, director of publications. Circ. 20,000. Estab. 1939. Publication of the National Muzzle Loading Rifle Association. Monthly magazine emphasizing muzzleloading. Sample copy free. Photo guidelines free with SASE.

Needs Interested in muzzleloading, muzzleloading hunting, primitive camping. "Ours is a specialized association magazine. We buy some big-game wildlife photos but are more interested in photos featuring muzzleloaders, hunting, powder horns and accoutrements." Model/property release required. Photo captions preferred.

Specs Prefers to use 3×5 color transparencies; sharply contrasting 35mm color slides acceptable. Accepts images in digital format. Send via CD, floppy disk, Zip as TIFF, EPS files at 300 dpi.

Making Contact & Terms Send query letter with stock list. Keeps samples on file; include SASE for return of material. Responds in 2 weeks. Simultaneous submissions OK. Pays $300 for color cover; $25-50 for b&w inside. Pays on publication. Credit line given. Buys one-time rights.

$ ▣ ⊘ NA'AMAT WOMAN

350 Fifth Ave., Suite 4700, New York NY 10018. (212)563-5222. Fax: (212)563-5710. E-mail: judith@naamat. org. Website: www.naamat.org. **Contact:** Judith A. Sokoloff, editor. Circ. 20,000. Estab. 1926. Published 4 times/year. Organization magazine focusing on issues of concern to contemporary Jewish families and women. Sample copy free with SAE and $1.26 first-class postage.

Needs Buys 5-10 photos from freelancers/issue; 50 photos/year. Needs photos of Jewish themes, Israel, women, babies/children/teens, families, parents, senior citizens, landscapes/scenics, architecture, religious, travel. Interested in documentary, fine art, historical/vintage, seasonal. Reviews photos with or without a ms. Photo captions preferred.

Specs Uses color and/or b&w prints. "Can use color prints, but magazine is b&w except for cover." Accepts images in digital format. Contact editor before sending.

Making Contact & Terms Provide résumé, business card, self-promotion piece or tearsheets to be kept on file for possible future assignments. Art director will contact photographer for portfolio review if interested. Keeps samples on file; include SASE for return of material. Responds in 6 weeks. Pays $250 maximum for b&w cover; $35-75 for b&w inside. Pays on publication. Credit line given. Buys one-time, first rights.

◉ ⊘ NATIONAL GEOGRAPHIC

National Geographic Society, 1145 17th St. NW, Washington DC 20036. Website: www.nationalgeographic.c om. **Contact:** Susan Smith, deputy director of photography & illustration. Director of Photography & Illustration: David Griffin. Circ. 7 million. Publication of the National Geographic Society. Monthly.

- This is a premiere market that demands photographic excellence. *National Geographic* does not accept unsolicited work from freelance photographers. Photography internships and faculty fellowships are available. Contact Susan Smith, deputy director of photography and illustration, for application information.

$ $ ⑤ ⊘ NATIONAL PARKS MAGAZINE

National Parks Conservation Association, 1300 19th St. NW, Suite 300, Washington DC 20036. (800)628-7275. E-mail: nyin@npca.org. Website: www.npca.org. **Contact:** Nicole Yin, communications coordinator. Circ. 300,000. Estab. 1919. Quarterly magazine. Emphasizes the preservation of national parks and wildlife. Sample copy available for $3.

Making Contact & Terms "We are not currently accepting unsolicited photographs from freelancers. We only accept images from our established corps of photographers. Less than 1 percent of our image needs are generated from unsolicited photographs, yet we receive dozens of submissions every week. Our limited staffing and even more limited time make it incredibly difficult to keep up with the inflow of images. Hopefully, as we continue to grow, we will eventually be able to lift this moratorium. Photographers are welcome to send postcards or other simple promotional materials that we do not have to return or respond to." Pays $525 for full-bleed color covers; $150-350 for color inside. Pays on publication. Buys one-time rights.

Tips "When searching for photos, we frequently use www.AGPix.com to find photographers who fit our needs. If you're interested in breaking into the magazine, we suggest setting up a profile and posting your absolute best parks images there."

$ $ $ ▣ ⊘ NATIONAL WILDLIFE

Photo Submissions, NW Publications, 11100 Wildlife Center Dr., Reston VA 20190-5362. E-mail: photoguide @nwf.org. Website: www.nwf.org/nationalwildlife. **Contact:** John Nuhn, photo director; Jill Stanley, photo associate. Circ. 650,000. Estab. 1962. Bimonthly magazine. Emphasizes wildlife, nature, environment and conservation. Readers are people who enjoy viewing high-quality wildlife and nature images from around the world, and who are interested in knowing more about the natural world and man's interrelationship with animals and environment. Sample copy available for $3; send to National Wildlife Federation Membership Services (same address). Photo guidelines available by e-mail.

Needs Buys 45 photos from freelancers/issue; 270 photos/year. Photo needs include worldwide photos of wildlife, wild plants, nature-related how-to, conservation practices. Subject needs include single photos for various uses (primarily wildlife but also plants, scenics). Photo captions required.

Specs Accepts scanned or digital images for unsolicited submissions via e-mail, and will accept digital prints of such images for review. See below.

Making Contact & Terms "Study the magazine, and ask for and follow photo guidelines before submitting. No unsolicited submissions from photographers whose work has not been previously published or considered for use in our magazine. Instead, send nonreturnable samples (tearsheets, digital prints, or photocopies) to Photo Queries (same address). If nonreturnable samples are acceptable, send 35mm or larger transparencies (magazine is 100% color) for consideration." Responds in 1 month. Previously published work OK. Pays $1,250 for cover; $150-925 for inside; text/photo package negotiable. **Pays on acceptance.** Credit line given. Buys one-time rights with limited promotion rights and possible web edition rights.

Tips "The annual photo contest is an excellent way to introduce your photography. The contest is open to amateur photographers. Rules are updated each year and printed along with the winning photos in the December/January issue and on PhotoZone through the magazine's website. Rules and online submission forms are also available on the website. Photographers sending unsolicited work must think editorially. For us to accept individual photographs, they must be striking images that make a statement and could be used as a 'final frame' or back cover. We're much more inclined to consider well-thought-out story proposals with professional-quality photos, photo essays, or a zeroed-in focus of photographs that have a potential story that we could assign to a writer."

$ ▣ ◿ NATIVE PEOPLES MAGAZINE

5333 N. Seventh St., Suite C-224, Phoenix AZ 85014. (602)265-4855. Fax: (602)265-3113. E-mail: editorial@nativepeoples.com. Website: www.nativepeoples.com. **Contact:** Hilary Wallace, art director. Circ. 50,000. Estab. 1987. Bimonthly magazine. Dedicated to the sensitive protrayal of the arts and lifeways of the Native peoples of the Americas. Photo guidelines free with SASE or via website.

Needs Buys 50-60 photos from freelancers/issue; 300-360 photos/year. Needs Native American lifeways photos (babies/children/teens, celebrities, couples, multicultural, families, parents, senior citizens, events). Also uses photos of entertainment, performing arts, travel. Interested in fine art. Model/property release preferred. Photo captions preferred; include names, location and circumstances.

Specs Uses transparencies, all formats. Accepts images in digital format. Send via CD, Zip, e-mail as TIFF, JPEG, EPS files at 300 dpi.

Making Contact & Terms Submit portfolio for review. Send unsolicited photos by mail for consideration; include SASE for return of material. Responds in 1 month. Pays $250 for color cover; $45-150 for color or b&w inside. Pays on publication. Buys one-time rights.

Tips "Send samples, or, if in the area, arrange a visit with the editors."

$ $ NATURAL HISTORY MAGAZINE

36 W. 25th St., 5th Floor, New York NY 10010. (646)356-6500. Fax: (646)356-6511. E-mail: nhmag@nhmag.com. Website: www.nhmag.com. **Contact:** Steve Black, art director. Circ. 250,000. Magazine printed 10 times/year. For primarily well-educated people with interests in the sciences. Free photo guidelines.

Needs Buys 400-450 photos/year. Animal behavior, photo essay, documentary, plant and landscape. "We are interested in photoessays that give an in-depth look at plants, animals, or people and that are visually superior. We are also looking for photos for our photographic feature, 'The Natural Moment.' This feature focuses on images that are both visually arresting and behaviorally interesting." Photos used must relate to the social or natural sciences with an ecological framework. Accurate, detailed captions required.

Specs Uses 8×10 glossy, matte and semigloss b&w prints; 35mm, $2\frac{1}{4} \times 2\frac{1}{4}$, 4×5, 6×7, 8×10 color transparencies. Covers are always related to an article in the issue.

Making Contact & Terms Send query letter with résumé of credits. "We prefer that you come in and show us your portfolio, if and when you are in New York. Please don't send us any photographs without a query first, describing the work you would like to send. No submission should exceed 30 original transparencies or negatives. However, please let us know if you have additional images that we might consider. Potential liability for submissions that exceed 30 originals shall be no more than $100 per slide." Responds in 2 weeks. Previously published work OK but must be indicated on delivery memo. Pays (for color and b&w) $400-600 for cover; $350-500 for spread; $300-400 for oversize; $250-350 for full-page; $200-300 for ¾ page; $175-250 for less than ¼ page. Pays $50 for usage on contents page. Pays on publication. Credit line given. Buys one-time rights.

Tips "Study the magazine—we are more interested in ideas than individual photos."

$ ▣ ☑ ⓢ NATURE FRIEND, Helping Children Explore the Wonders of God's Creation

Carlisle Press, 2673 TR421, Sugarcreek OH 44681. (330)852-1900. Fax: (330)852-3285. **Contact:** Marvin Wengerd, editor. Circ. 12,000. Estab. 1982. Monthly children's magazine. Sample copy available for $2 first-class postage.

Needs Buys 6 photos from freelancers/issue; 72 photos/year. Needs photos of wildlife, closeup wildlife, wildlife interacting with each other. Reviews photos with or without ms. Model/property release preferred. Photo captions preferred.

Specs Uses $2\frac{1}{4} \times 2\frac{1}{4}$, 4×5 transparencies and slides. Accepts images in digital format. Send via CD or DVD as TIFF files at 300 dpi at 8×10 size; provide color thumbnails when submitting photos on CD.

Making Contact & Terms Send query letter with slides, transparencies. "Most of our photographers send their new work for us to keep on file for possible use." Responds in 1 month to queries; 2 weeks to portfolios. Simultaneous submissions and previously published work OK. Pays $75 for front cover; $50 for back cover; $75 for centerfold; $20-30 for inside. Pays on publication. Credit line given. Buys one-time rights.

Tips "We're always looking for wild animals doing something unusual (e.g., unusual pose, interacting with one another, or freak occurences)."

$ ▣ NATURE PHOTOGRAPHER

P.O. Box 220, Lubec ME 04652. (207)733-4201. Fax: (207)733-4202. E-mail: nature_photographer@yahoo.com. Website: www.naturephotographermag.com. **Contact:** Helen Longest-Saccone, editor-in-chief/photo editor. Circ. 35,000. Estab. 1990. Quarterly 4-color, high-quality magazine. Emphasizes "conservation-oriented, low-impact nature photography" with strong how-to focus. Readers are male and female nature photographers of all ages. Sample copy available for 10×13 SAE with 6 first-class stamps.

• *Nature Photographer* charges $78/year to be a "field contributor."

Needs Buys 90-120 photos from freelancers/issue; 400 photos/year. Needs nature shots of "all types—abstracts, animals/wildlife, flowers, plants, scenics, environmental images, etc. Shots must be in natural settings; no set-ups, zoo or captive animal shots accepted." Reviews photos (slides or digital images on CD) with or without ms 4 times/year: May (for fall issue); August (for winter issue); November (for spring issue); and January (for summer issue). Photo captions required; include description of subject, location, type of equipment, how photographed. "This information published with photos."

Making Contact & Terms Contact by e-mail or with SASE for guidelines before submitting images. Prefers to see 35mm transparencies or CD of digital images. "Send digital images via CD; please do not e-mail digital images." Does not keep samples on file; include SASE for return of material. Responds within 4 months, according to deadline. Simultaneous submissions and previously published work OK. Pays $100 for color cover; $20 for b&w inside; $25-40 for color inside; $75-150 for photo/text package. Pays on publication. Credit line given. Buys one-time rights.

Tips Recommends working with "the best lens you can afford and slow-speed slide film; or, if shooting digital, using the RAW mode." Suggests editing with a $4 \times$ or $8 \times$ lupe (magnifier) on a light board to check for sharpness, color saturation, etc. "Color prints are not normally used for publication in our magazine."

$ ▣ ◯ NATURIST LIFE INTERNATIONAL

260 Carmel Rd., Westfield VT 05874. (603)455-7368. E-mail: info@naturistlifemag.com or editor@naturistlifemag.com. Website: www.naturistlife.com. **Contact:** Tom Caldwell, editor-in-chief. Circ. 2,000. Estab. 1987. Quarterly electronic magazine. Emphasizes nudism. Readers are male and female nudists, ages 30-80. Sample copy of paperback issue available for $3. Photo guidelines free with SASE.

• *Naturist Life* holds yearly Vermont Naturist Photo Safaris organized to shoot nudes in nature.

Needs Buys 36 photos from freelancers/issue; 144 photos/year. Needs photos depicting family-oriented nudist/naturist work, recreational activity and travel. Reviews photos with or without ms. Model release required (including Internet use) for recognizable nude subjects. Photo captions preferred.

Specs Uses digital images submitted on CD; 8×10 glossy color and/or b&w prints; 35mm, $2\frac{1}{4} \times 2\frac{1}{4}$, 4×5, 8×10 (preferred) transparencies.

Making Contact & Terms Send query letter with résumé of credits. Send unsolicited photos by mail for consideration; include SASE for return of material. Provide résumé, business card, brochure, flier or tearsheets to be kept on file for possible future assignments. Responds in 2 weeks. Pays $50 for color cover; $10-25 for others. Pays on publication. Credit line given. "Prefer to own all rights but sometimes agree to one-time publication rights."

Tips "The ideal *NLI* photo shows ordinary-looking people of all ages doing everyday activities, in the joy of nudism. We do not want 'cheesecake' glamour images or anything that emphasizes the erotic."

$ $ NEW MEXICO MAGAZINE

495 Old Santa Fe Trail, Santa Fe NM 87501. (505)827-7447. Fax: (505)827-6496. E-mail: photos@nmmagazine .com. Website: www.nmmagazine.com. **Contact:** Steve Larese, photo editor. Circ. 123,000. Monthly magazine. For affluent people ages 35-65 interested in the Southwest or who have lived in or visited New Mexico. Sample copy available for $3.95 with 9×12 SAE and 3 first-class stamps. Photo guidelines available on website.

Needs Buys 10 photos from freelancers/issue; 120 photos/year. Needs New Mexico photos only—landscapes, people, events, architecture, etc. "Most work is done on assignment in relation to a story, but we welcome photo essay suggestions from photographers. Cover photos usually relate to the main feature in the magazine." Model release preferred. Photo captions required; include who, what, where.

Specs Uses transparencies.

Making Contact & Terms Submit portfolio to Steve Larese; include SASE for return of material. Pays $450/day; $300 for color or b&w cover; $60-100 for color or b&w stock. Pays on publication. Credit line given. Buys one-time rights.

Tips Prefers transparencies submitted in plastic pocketed sheets. Interested in different viewpoints, styles not necessarily obligated to straight scenic. "All material must be taken in New Mexico. Representative work suggested. If photographers have a preference about what they want to do or where they're going, we would like to see that in their work. Transparencies or dupes are best for review and handling purposes."

$◻ NEW YORK STATE CONSERVATIONIST MAGAZINE

Editorial Office, NYSDEC, 625 Broadway, 2nd Floor, Albany NY 12233-4205. (518)402-8047. Fax: (518)402-8050. Website: www.dec.state.ny.us. **Contact:** Photo Editor. Circ. 100,000. Estab. 1946. Bimonthly nonprofit, New York State government publication. Emphasizes natural history, environmental, and outdoor interests pertinent to New York State. Sample copy available for $3.50. Photo guidelines free with SASE.

Needs Uses 40 photos/issue; 80% supplied by freelance photographers. Needs wildlife shots, people in the environment, outdoor recreation, forest and land management, fisheries and fisheries management, environmental subjects. Also needs landscapes/scenics, cities, travel, historical/vintage, seasonal. Model release preferred. Photo captions required.

Making Contact & Terms Send 35mm, $2\frac{1}{4} \times 2\frac{1}{4}$, 4×5 or 8×10 transparencies by mail for consideration, or submit portfolio for review. Provide résumé, business card, brochure, flier or tearsheets to be kept on file for possible future assignments. Responds in 3 weeks. Simultaneous submissions and previously published work OK. Pays $50 for cover photos; $15 for b&w or color inside. Pays on publication. Buys one-time rights.

Tips Looks for "artistic interpretation of nature and the environment; unusual ways of picturing environmental subjects (even pollution, oil spills, trash, air pollution, etc.); wildlife and fishing subjects at all seasons. Try for unique composition, lighting. Technical excellence a must."

NEWSWEEK

Newsweek, Inc., 251 W. 57th St., New York NY 10019-6999. (212)445-4000. Website: www.newsweek.com. Circ. 3,180,000. *Newsweek* reports the week's developments on the newsfront of the world and the nation through news, commentary and analysis. News is divided into National Affairs; International; Business; Society; Science & Technology; and Arts & Entertainment. Relevant visuals, including photos, accompany most of the articles. Query before submitting.

$◫ ◻ NEWWITCH, not your mother's broomstick

BBI Media, Inc., P.O. Box 641, Point Arena CA 95468-0641. (707)882-2052. Fax: (707)882-2793. E-mail: m_editor@newwitch.com. Website: www.newwitch.com. **Contact:** Anne Niven, editor-in-chief. Circ. 15,000. Estab. 2002. Quarterly consumer magazine. "*newWitch* aims to break the stereotypes about wicca being boring—we are hip, active and irreverent." Sample copy and photo guidelines available for SAE.

Needs Buys 10 photos from freelancers/issue; 40 photos/year. Needs photos of couples, multicultural, cities/urban, religious (pagan), adventure, health/fitness/beauty, performing arts, travel. Interested in alternative process, avant garde, seasonal. Reviews photos with or without ms. Model release preferred.

Specs Uses 5×7 or larger matte color or b&w prints. Accepts images in digital format. Send via CD, Zip, e-mail as TIFF, JPEG files at 400 dpi.

Making Contact & Terms "Request a sample copy (we send them free!) first, to see if our style and subject matter meet your interests." Provide self-promotion piece to be kept on file for possible future assignments. Responds in 10 weeks to queries; 1 month to portfolios. Responds only if interested; send nonreturnable samples. Simultaneous submissions and previously published work OK. Pays $100-200 for color cover; $10-

100 for b&w inside. Pays on publication. Credit line given. Buys one-time rights, all rights; negotiable.

Tips "You should be aware of pagan/wiccan culture (you do *not* need to be a witch). We like contemporary, edgy work and extreme closeups, mostly of people ages 18-34."

Ⓝ $Ⓔ Ⓞ Ⓢ NORTH & SOUTH, The Official Magazine of the Civil War Society

31718 Old Ranch Park Lane, Auberry CA 93602. Website: www.northandsouthmagazine.com. **Contact:** Keith Poulter, publisher. Circ. 30,000. Estab. 1997. Consumer magazine published 7 times /year. *North & South* provides "fresh and accurate history of the Civil War." Sample copy available for $4.95.

Needs Needs photos of Civil War sites. Reviews photos with or without ms. Photo captions required.

Specs Uses glossy color prints. Accepts images in digital format. Send as TIFF files.

Making Contact & Terms Send query letter with résumé. Does not keep samples on file; include SASE for return of material. Pays $50 maximum for color inside. Pays on publication. Credit line given. Buys one-time rights.

$Ⓔ Ⓞ NORTH AMERICAN WHITETAIL MAGAZINE

P.O. Box 741, Marietta GA 30061. (770)953-9222. Fax: (770)933-9510. E-mail: ronald.sinfelt@primedia.com. Website: www.northamericanwhitetail.com. **Contact:** Ron Sinfelt, photo editor. Circ. 130,000. Estab. 1982. Published 8 times/year (July-February) by Primedia. Emphasizes trophy whitetail deer hunting. Sample copy available for $3. Photo guidelines free with SASE.

Needs Buys 8 photos from freelancers/issue; 64 photos/year. Needs photos of large, live whitetail deer, hunter posing with or approaching downed trophy deer, or hunter posing with mounted head. Also uses photos of deer habitats and signs. Model release preferred. Photo captions preferred; include when and where scene was photographed.

Specs Accepts images in digital format. Send via CD at 300 pppi with output of 8×12 inches. Uses 8×10 b&w prints; 35mm transparencies.

Making Contact & Terms Send query letter with résumé of credits and list of stock photo subjects. Will return unsolicited material in 1 month if accompanied by SASE. Simultaneous submissions not accepted. Pays $400 for color cover; $25 for b&w inside; $75 for color inside. Tearsheets provided. Pays 60 days prior to publication. Credit line given. Buys one-time rights.

Tips "In samples we look for extremely sharp, well-composed photos of whitetailed deer in natural settings. We also use photos depicting deer hunting scenes. Please study the photos we are using before making submission. We'll return photos we don't expect to use and hold the remainder for potential use. Please do not send dupes. Use an 8×10 envelope to ensure sharpness of images, and put name and identifying number on all slides and prints. Photos returned at time of publication or at photographer's request."

$Ⓔ NORTH CAROLINA LITERARY REVIEW

East Carolina University, Greenville NC 27858-4353. (252)328-1537. Fax: (252)328-4889. E-mail: BauerM@mail.ecu.edu. Website: www.ecu.edu/nclr. **Contact:** Margaret Bauer, editor. Circ. 750. Estab. 1992. Annual literary magazine. *NCLR* publishes poetry, fiction and nonfiction by (and interviews with) NC writers, and articles and essays about NC literature, history, and culture. Photographs must be NC-related. Sample copy available for $15. Photo guidelines available for SASE or on website.

Needs Buys 3-6 photos from freelancers/issue. Model/property release preferred. Photo captions preferred.

Specs Uses b&w prints; 4×5 transparencies. Accepts images in digital format. Send via Zip as TIFF, GIF files at 300 dpi.

Making Contact & Terms Send query letter. Portfolios may be dropped off. Provide résumé, business card, self-promotion piece to be kept on file for possible future assignments. Send nonreturnable samples or include SASE for return of material. Responds in 2 months to queries. Pays $50-200 for b&w cover; $25-100 for b&w inside. Pays on publication. Credit line given. Buys first rights.

Tips "Look at our publication—1998-present back issues. See our website."

$Ⓔ NORTHERN WOODLANDS MAGAZINE, a new way of looking at the forest

P.O. Box 471, 1776 Center Rd., Corinth VT 05039-9900. (802)439-6292. Fax: (802)439-6296. E-mail: mail@northernwoodlands.org. Website: www.northernwoodlands.org. **Contact:** Anne Margolis, assistant editor. Circ. 15,000. Estab. 1994. Quarterly consumer magazine created to inspire landowners' sense of stewardship by increasing their awareness of the natural history and the principles of conservation and forestry that are directly related to their land; to encourage loggers, foresters, and purchasers of raw materials to continually raise the standards by which they utilize the forest's resources; to increase the public's awareness and

appreciation of the social, economic, and environmental benefits of a working forest; to raise the level of discussion about environmental and natural resource issues; and to educate a new generation of forest stewards. Sample copy available for $5.

Needs Buys 10-50 photos from freelancers/year. Needs photos of forestry, environmental, landscapes/scenics, wildlife, rural, adventure, travel, agriculture, science. Interested in historical/vintage, seasonal. Other specific photo needs: vertical format, photos specific to assignments in northern New England and upstate New York. Reviews photos with or without ms. Model release preferred. Photo captions required.

Specs Uses glossy or matte color and b&w prints; 35mm, $2\frac{1}{4} \times 2\frac{1}{4}$ transparencies. Accepts images in digital format. Send via CD, Zip, e-mail as TIFF, EPS files at 300 dpi minimum. No e-mails larger than 1 MB.

Making Contact & Terms Send query letter with slides. Provide self-promotion piece to be kept on file for possible future assignments. Responds only if interested; send nonreturnable samples. Previously published work OK. Pays $150 for color cover; $35-75 for b&w inside. "We might pay upon receipt or as late as publication." Credit line given. Buys one-time rights.

Tips "Read our magazine or go to our website for samples of the current issue. We're always looking for high-quality cover photos on a seasonal theme. Vertical format for covers is essential. Also, note that our title goes up top, so photos with some blank space up top are best. Please remember that not all good photographs make good covers—we like to have a subject, lots of color, and we don't mind people. Anything covering the woods and people of Vermont, New Hampshire, Maine, northern Massachusetts or northern New York is great. Unusual subjects, and ones we haven't run before (we've run lots of birds, moose, large mammals, and horse-loggers), get our attention. For inside photos we already have stories and are usually looking for regional photographers willing to shoot a subject theme."

$ NORTHWEST TRAVEL MAGAZINE

4969 Hwy. 101 N., Suite 2, Florence OR 97439. (800)348-8401. Fax: (541)997-1124. E-mail: barb@ohwy.com. Website: www.northwestmagazines.com. **Contact:** Barbara Grano, photo editor. Circ. 50,000. Estab. 1991. Bimonthly consumer magazine emphasizing travel in Oregon, Washington, Idaho, western Montana, and British Columbia, Canada. Readers are middle-class, middle-age. Sample copy available for $6. Photo guidelines free with SASE or on website.

Needs Buys 3-5 photos from freelancers/issue; 18-30 photos/year. Wants seasonal scenics. Model release required. Photo captions required; include specific location and description. "Label all slides and transparencies with captions and photographer's name."

Specs Uses 35mm, 2×2, 4×5 positive transparencies. "Do not e-mail images."

Making Contact & Terms Send query letter with transparencies. Does not keep samples on file; include SASE for return of material. Responds in 1 month. Pays $350 for color cover; $100 for calendar usage; $25-50 for b&w inside; $25-100 for color inside; $100-250 for photo/text package. Credit line given. Buys one-time rights.

Tips "Use slide film that can be enlarged without graininess (50-100 ASA). Don't use color filters. Send 20-40 slides. Protect slides with sleeves put in plastic holders. Don't send in little boxes. We work about 3 months ahead, so send spring images in winter, summer images in spring, etc."

$ 🖳 ☑ 🆂 NORTHWOODS JOURNAL, a magazine for writers

Conservatory of American Letters, P.O. Box 298, Thomaston ME 04861. (207)354-0998. Fax: (207)354-8953. E-mail: cal@americanletters.org. Website: www.americanletters.org. **Contact:** Robert Olmsted, editor. Circ. 250-300. Estab. 1992. Quarterly literary magazine. "We are a magazine for writers—a showcase, not a how-to." Sample copy available for $6.50 and 6×9 SAE with 83¢ postage.

Needs Buys 1 photo from freelancers/issue; at least 6 photos/year. Needs photos of landscapes/scenics, wildlife, rural. Reviews photos with or without ms. Model release required.

Specs Uses 5×7 glossy color and/or b&w prints. Accepts images in digital format. Send via CD, floppy disk as TIFF, BMP, JPEG files.

Making Contact & Terms Send query letter with prints. Does not keep samples on file; include SASE for return of material. Responds in 1 week to queries. Pays $5-20 for b&w cover; $20-50 for color cover. **Pays on acceptance**. Credit line given. Buys one-time rights.

Tips "We're a small, tough market. We buy a seasonal color cover photo for each issue of the magazine, and occasional color covers for books. Our subject matter usually does not suggest interior photos."

$ 🖳 ☑ NOW & THEN, The Appalachian Magazine

Center for Appalachian Studies & Services, 807 University Pkwy., Box 70556 ETSU, Johnson City TN 37614-1707. (423)439-7865. Fax: (423)439-7870. E-mail: nowandthen@mail.etsu.edu. Website: http://cass.etsu.

edu/n&t. **Contact:** Nancy Fischman, managing editor. Circ. 1,000. Estab. 1985. Literary magazine published 3 times/year. *Now & Then* tells the story of Appalachia, the mountain region that extends from northern Mississippi to southern New York state. The magazine presents a fresh, revealing picture of life in Appalachia, past and present, with engaging articles, personal essays, fiction, poetry and photography. Sample copy available for $7. Photo guidelines free with SASE.

Needs Buys 1-3 photos from freelancers/issue; 3-9 photos/year. Needs photos of environmental, landscapes/scenics, architecture, cities/urban, rural, adventure, performing arts, travel, agriculture, political, disasters. Interested in documentary, fine art, historical/vintage. Photographs must relate to theme of issue. Themes are posted on the website or available with guidelines. Vertical-format color best for front covers. "We like to publish photo essays based on the magazine's theme." Reviews photos with or without ms. Model/property release preferred. Photo captions preferred; include where the photo was taken, identify places/people.

Specs Uses 5×7 or 8×10 glossy color or b&w prints; 35mm, $2^{1}/_{4}\times2^{1}/_{4}$, 4×5, 8×10 transparencies. Accepts images in digital format. Send via CD, Zip, e-mail as TIFF, EPS, JPEG files at 600 dpi.

Making Contact & Terms Send query letter with résumé, photocopies. Provide self-promotion piece to be kept on file for possible future assignments. Responds only if interested; send nonreturnable samples. Simultaneous submissions OK. Pays $100 maximum for color cover; $25 for b&w inside. Pays on publication. Credit line given. Buys one-time rights; negotiable.

Tips "Know what our upcoming themes are. Keep in mind we cover only the Appalachian region. (See the website for a definition of the region). Plus know our technical needs."

$ ▣ ODYSSEY: Adventures in Science

Cobblestone Publishing, 30 Grove St., Suite C, Peterborough NH 03458. (603)924-7209. Fax: (603)924-7380. E-mail: blindstrom@cobblestone.mv.com. Website: www.odysseymagazine.com. **Contact:** Elizabeth Lindstrom, senior editor. Circ. 21,000. Estab. 1979. Monthly magazine, September-May. Emphasis on science and technology. Readers are children, ages 10-16. Sample copy available for $4.95 with 9×12 or larger SAE and 5 first-class stamps. Photo guidelines and theme list free with SASE or on website.

Needs Uses 30-35 photos/issue. Needs photos of babies/children/teens, science, technology. Reviews photos with or without ms. Model/property release required. Photo captions preferred.

Specs Uses color prints or transparencies. Accepts images in digital format.

Making Contact & Terms Send query letter with stock list. Send unsolicited photos by mail with SASE for consideration. Provide résumé, business card, brochure, flier or tearsheets to be kept on file for possible future assignments. Responds in 1 month. Payment negotiable for color cover and other photos; pays $25-100 for color inside. Pays on publication. Credit line given. Buys one-time and all rights; negotiable.

Tips "We like photos that include kids in reader-age range and plenty of action. Each issue is devoted to a single theme. Photos should relate to those themes. It is best to request theme list before submitting."

$ $ ▣ OFFSHORE

Offshore Communications, Inc., 500 Victory Rd., Marina Bay, North Quincy MA 02171. (617)221-1400. Fax: (617)847-1871. E-mail: editors@offshoremag.net. Website: www.offshoremag.net. **Contact:** Dave Dauer, director of creative services. Monthly magazine. Focuses on recreational boating in the Northeast region, from Maine to New Jersey. Sample copy free with 9×12 SASE.

Needs Buys 35-50 photos from freelancers/issue; 420-600 photos/year. Needs photos of recreational boats and boating activities. Boats covered are mostly 20-50 feet; mostly power, but some sail, too. Especially looking for inside back page photos of a whimsical, humorous, or poignant nature, or that say "Goodbye" (all nautically themed)—New Jersey to Maine. Photo captions required; include location.

Specs Cover photos should be vertical format and have strong graphics and/or color. Accepts slides only.

Making Contact & Terms "Please call before sending photos." Simlultaneous submissions and previously published work OK. Pays $400 for color cover; $75-250 for color inside. Pays on publication. Credit line given. Buys one-time rights.

$ $ ▣ ▣ OKLAHOMA TODAY

120 N. Robinson, Suite 600, Oklahoma City OK 73102. (405)230-8450. E-mail: brooke@oklahomatoday.com. Website: www.oklahomatoday.com. **Contact:** Brooke Adcox, associate editor. Circ. 45,000. Estab. 1956. Bimonthly magazine. "We cover all aspects of Oklahoma, from history to people profiles, but we emphasize travel." Readers are "Oklahomans, whether they live in-state or are exiles; studies show them to be above

average in education and income." Sample copy available for $4.95. Photo guidelines free with SASE or on website.

Needs Buys 45 photos from freelancers/issue; 270 photos/year. Needs photos of "Oklahoma subjects only; the greatest number are used to illustrate a specific story on a person, place or thing in the state. We are also interested in stock scenics of the state." Other areas of focus are adventure—sport/travel, reenactment, historical and cultural activities. Model release required. Photo captions required.

Specs Uses 8×10 glossy b&w prints; 35mm, $2\frac{1}{4} \times 2\frac{1}{4}$, 4×5, 8×10 transparencies. Accepts images in digital format. Send via CD or e-mail.

Making Contact & Terms Send query letter with samples; include SASE for return of material. Responds in 2 months. Simultaneous submissions and previously published work OK (on occasion). Pays $50-150 for b&w photos; $50-250 for color photos; $125-1,000/job. Pays on publication. Buys one-time rights with a 4-month from publication exclusive, plus right to reproduce photo in promotions for magazine without additional payment with credit line.

Tips To break in, "read the magazine. Subjects are normally activities or scenics (mostly the latter). I would like good composition and very good lighting. I look for photographs that evoke a sense of place, look extraordinary and say something only a good photographer could say about the image. Look at what Ansel Adams and Eliot Porter did and what Muench and others are producing, and send me that kind of quality. We want the best photographs available, and we give them the space and play such quality warrants."

◼ 🖉 ONBOARD MEDIA

960 Alton Rd., Miami Beach FL 33139. (305)673-0400. Fax: (305)674-9396. E-mail: beth@onboard.com; sirena@onboard.com; bonnieb@onboard.com. **Contact:** Beth Wood, Sirena Andras and Bonnie Bennett, co-art directors. Circ. 792,184. Estab. 1990. Ninety annual and quarterly publications. Emphasize travel in the Caribbean, Europe, Mexican Riviera, Bahamas, Alaska, Las Vegas. Custom publications reach cruise vacationers and vacation/resort audience. Photo guidelines free with SASE.

Needs Needs photos of scenics, nature, prominent landmarks based in Caribbean, Mexican Riviera, Bahamas, Alaska, Europe and Las Vegas. Model/property release required. Photo captions required; include where the photo was taken and explain the subject matter. Credit line information requested.

Specs Uses 35mm, $2\frac{1}{4} \times 2\frac{1}{4}$, 4×5, 8×10 transparencies. Prefers images in digital format. Send via CD at 300 dpi.

Making Contact & Terms Send query letter with stock list. Provide résumé, business card, brochure, flier or tearsheets to be kept on file for possible future assignments. Keeps samples on file. Responds in 3 weeks. Previously published work OK. Rates negotiable per project. Pays on publication. Credit line given.

$🖉 ONE

CNEWA, 1011 First Ave., New York NY 10022-4195. (212)826-1480. Fax: (212)826-8979. E-mail: cnewa@cnewa.org. Website: www.cnewa.org. **Contact:** Michael Lacivita, executive editor. Circ. 90,000. Estab. 1974. Bimonthly magazine. Official publication of Catholic Near East Welfare Association, "a papal agency for humanitarian and pastoral support." *ONE* informs Americans about the traditions, faiths, cultures and religious communities of the Middle East, Northeast Africa, India and Eastern Europe. Sample copy and photo guidelines available for $6\frac{1}{2} \times 9\frac{1}{2}$ SASE.

Needs 60% of photos supplied by freelancers. Prefers to work with writer/photographer team. Looking for evocative photos of people—not posed—involved in activities: work, play, worship. Liturgical shots also welcome. Extensive captions required if text is not available.

Making Contact & Terms Send query letter first. "Please do not send an inventory; rather, send a letter explaining your ideas." Include $6\frac{1}{2} \times 9\frac{1}{2}$ SASE. Responds in 3 weeks; acknowledges receipt of material immediately. Simultaneous submissions and previously published work OK, "but neither is preferred. If previously published, please tell us when and where." Pays $75-100 for b&w cover; $150-200 for color cover; $50-100 for b&w inside; $75-175 for color inside. Pays on publication. Credit line given. "Credits appear on page 3 with masthead and table of contents." Buys first North American serial rights.

Tips "Stories should weave current lifestyles with issues and needs. Avoid political subjects; stick with ordinary people. Photo essays are welcome. Write requesting sample issue and guidelines, then send query. We rarely use stock photos but have used articles and photos submitted by single photojournalist or writer/photographer team."

$ $◼ 🖉 📷 ONTARIO OUT OF DOORS MAGAZINE

One Mount Pleasant Rd., Isabella Tower, Toronto ON M4Y 2Y5 Canada. (416)764-1652 or (800)487-0843. Fax: (416)764-1751. E-mail: tamas.pal@ood.rogers.com. Website: www.OntarioOutOfDoors.com. **Contact:**

Tamas Pal, art director. Circ. 90,000. Estab. 1968. Monthly magazine. Emphasizes hunting and fishing in Ontario. Readers are males, ages 20-65. Sample copy and photo guidelines free with SAE, IRC.

Needs Buys 15 photos from freelancers/issue; 180 photos/year. Needs photos of game and fish species sought in Ontario; also scenics and portraits with anglers or hunters. Background must be similar to or Ontario-related. Model/property release required for photos used in advertising. Photo captions preferred.

Specs Uses b&w prints; 35mm transparencies. Accepts images in digital format. Send via CD, Zip as TIFF, EPS, PICT, GIF, JPEG files at 300 dpi.

Making Contact & Terms Send query letter with list of stock photo subjects. Keeps samples on file. Responds in 1 month. Previously published work OK. Pays $400-700 for color cover; $35-75 for b&w inside; $75-300 for color inside. Pays on publication. Credit line given. Buys one-time rights.

Tips ''Photographers should call, write or e-mail me with their interest and send in sample files for my viewing. Always looking for images for upcoming issues. May hold photos for future use.''

$ OREGON COAST MAGAZINE

4969 Hwy. 101 N., Suite 2, Florence OR 97439. (800)348-8401. Fax: (541)997-1124. E-mail: barb@ohwy.com. Website: www.northwestmagazines.com. **Contact:** Barbara Grano, photo editor. Circ. 50,000. Estab. 1982. Bimonthly magazine. Emphasizes Oregon coast life. Readers are middle-class, middle-aged. Sample copy available for $6, including postage. Photo guidelines available for SASE or on website.

Needs Buys 3-5 photos from freelancers/issue; 18-30 photos/year. Needs scenics. Especially needs photos of typical subjects—waves, beaches, lighthouses—but from a different angle. Needs mostly vertical format. Model release required. Photo captions required; include specific location and description. ''Label all slides and transparencies with captions and photographer's name.''

Making Contact & Terms Send unsolicited 35mm, 2×2, 4×5 positive transparencies by mail for consideration; SASE or return postage required. ''Do not e-mail images.'' Responds in 1 month. Pays $350 for color cover; $100 for calendar usage; $25-50 for b&w inside; $25-100 for color inside; $100-250 for photo/text package. Credit line given. Buys one-time rights.

Tips ''Send only the very best. Use only slide film that can be enlarged without graininess. Don't use color filters. An appropriate submission would be 20-40 slides. Protect slides with sleeves—put in plastic holders. Don't send in little boxes.''

$ $ ▣ ◯ OUTDOOR AMERICA

Izaak Walton League of America, 707 Conservation Lane, Gaithersburg MD 20878-2983. (301)548-0150. Fax: (301)548-9409. E-mail: oa@iwla.org. Website: www.iwla.org/oa. **Contact:** Jason McGarvey, editorial director. Art Director: Jay Clark. Circ. 40,000. Estab. 1922. Published quarterly. Covers environmental topics, from clean air and water to public lands, fisheries and wildlife. Also focuses on outdoor recreation issues. Topics include the Upper Mississippi River, energy efficiency, farm conservation, stream water quality, responsible outdoor behavior, hunting- and fishing-oriented conservation issues, sustainable resource use, and wetlands protection. It also covers conservation-related accomplishments of the League's membership and reports on major state and federal natural resources/environmental legislation.

Needs Needs vertical wildlife photos or shots of anglers or hunters for cover. Reviews photos with or without a ms. Model release required. Photo captions preferred; include date taken, model info, location and species.

Specs Uses 35mm, 6×9 transparencies or negatives. Accepts images in digital format. Send via CD, Zip, e-mail as TIFF, EPS, PICT, JPEG files at 300 dpi.

Making Contact & Terms Send query letter with résumé, stock list. ''Tearsheets and nonreturnable samples only. Not responsible for return of unsolicited material.'' Simultaneous submissions and previously published work OK. Pays $500 for cover; $50-500 for inside. **Pays on acceptance.** Credit line given. Buys one-time rights.

Tips ''We prefer the unusual shot—new perspectives on familiar objects or subjects. We occasionally assign work. Approximately one half of the magazine's photos are from freelance sources.''

$ $ ▣ ◑ ⊠ OUTDOOR CANADA

25 Sheppard Ave. W, Suite 100, Toronto ON M2N 6S7 Canada. (416)218-3697. Fax: (416)227-8296. E-mail: rbiron@outdoorcanada.ca. Website: www.outdoorcanada.ca. **Contact:** Robert Biron, art director. Circ. 100,000. Estab. 1972. Magazine published 8 times/year. Photo guidelines free with SASE (or SAE and IRC) or via e-mail or website.

Needs Buys 200-300 photos/year. Needs photos of wildlife; fishing, hunting, ice-fishing; action shots. ''Canadian content ONLY.'' Photo captions required; include identification of fish, bird or animal.

Making Contact & Terms "Send a well edited selection of transparencies with return postage for consideration. E-mail/CD portfolios also accepted. Digital images accepted pending equipment." Responds in 1 month. Pays $550 for cover; $75-400 for color inside, depending on size used (all payable in Canadian funds). Pays on publication. Buys one-time rights.

$ $⊡ OUTDOOR LIFE MAGAZINE

Time 4 Media, 2 Park Ave., 10th Floor, New York NY 10016. E-mail: cherie.cincilla@time4.com. Website: www.outdoorlife.com. **Contact:** Cherie Cincilla, photo editor. Circ. 750,000. Monthly. Emphasizes hunting, fishing and shooting. Readers are "outdoor enthusiasts of all ages." Sample copy "not for individual requests." Photo guidelines available for SASE.

Needs Buys 100 photos from freelancers/issue; 1,000-2,000 photos/year. Needs photos of "all species of wildlife and game fish, especially in action and in natural habitat; how-to and where-to." Interested in historical/vintage hunting and fishing photos. Photo captions preferred.

Specs Prefers 35mm slides. Accepts images in digital format. Send via CD, e-mail as JPEG files at 100 dpi, 3×5 size.

Making Contact & Terms Send 35mm or 2¼×2¼ transparencies by certified mail with SASE for consideration. Prefers dupes. Responds in 1 month. Pays $1,000 minimum for color cover; $100-850 for color inside. Rates are negotiable. Pays on publication. Credit line given. Buys one-time rights.

Tips "Print name and address clearly on each photo to ensure return; send in 8×10 plastic sleeves. Multiple subjects encouraged. E-mail examples and list of specific animal species and habitats. All of our images are hunting and fishing related. We are about adventure (hunting & fishing!) and 'how-to!' Query first with SASE; will not accept, view or hold artist's work without first receiving a signed copy of our waiver of liability."

⊡ ◯ ⑤ OUTDOORS MAGAZINE, For the Better Hunter, Angler & Trapper

Elk Publishing, Inc., 531 Main St., Colchester VT 05446. (802)879-2013. Fax: (802)879-2015. E-mail: managingeditor@outdoorsmagazine.net. Website: www.outdoorsmagazine.net. **Contact:** James Ehlers, publisher. Circ. 14,000. Estab. 1996. Monthly consumer magazine emphasizing New England hunting, fishing and wildlife issues. Photo guidelines available.

Needs Buys 6 photos from freelancers/issue; 50 photos/year. Needs photos of wildlife, sports. Reviews photos with or without ms. Model/property release preferred. Photo captions required.

Specs Uses 5×7 color and/or b&w prints; 35mm transparencies. Accepts images in digital format. Send via CD as TIFF files at 300 dpi.

Making Contact & Terms Send query letter with stock list. Provide résumé to be kept on file for possible future assignments. Responds in 3 months to queries. Previously published work OK. Payment negotiated. Pays on publication. Credit line given. Buys one-time rights.

Tips "It definitely helps to look at a copy. We have use for many different levels of quality. Do not call every other day."

$⊡ ◯ ⊠ OUTPOST MAGAZINE

Outpost Incorporated, 474 Adelaide St. E., Lower Level, Toronto ON M5A 1N6 Canada. (416)972-6635. Fax: (416)972-6645. E-mail: info@outpostmagazine.com. Website: www.outpostmagazine.com. **Contact:** Christopher Frey, editor-in-chief. Bimonthly consumer travel magazine. Sample copy available for $6. Photo guidelines available on website.

Needs Needs photos of multicultural, environmental, landscapes/scenics, wildlife, architecture, cities/urban, rural, adventure, events, food/drink, travel, medicine. Interested in documentary, regional, seasonal. Reviews photos with or without a ms. Photo captions preferred; include location, description of scene, year.

Specs Uses glossy or matte color or b&w prints; 35mm, 2¼×2¼ transparencies. Accepts images in digital format. Send via CD, floppy disk, Zip, e-mail as TIFF, JPEG files at 100 dpi.

Making Contact & Terms Send query letter with résumé, slides, prints, photocopies, tearsheets, transparencies. Portfolio may be dropped off Monday-Saturday. Does not keep samples on file; include SASE for return of material. Responds in 2 months to queries; 1 month to portfolios. Simultaneous submissions and previously published work OK. Pays 30-60 days after publication. Credit line given. Buys one-time rights, electronic rights.

$⊡ OVER THE BACK FENCE

5572 Brecksville Rd., Suite 100, Independence OH 44131. (216)674-0220. Fax: (216)674-0221. E-mail: rca_publishing@pantherpress.com. Website: www.pantherpublishing.com. **Contact:** Rocky Alten, creative director.

Estab. 1994. Quarterly magazine. "*Over the Back Fence* is a regional magazine serving southern and central Ohio. We are looking for photos of interesting people, events and history of our area." Sample copy available for $4. Photo guidelines free with SASE.

Needs Buys 50 photos from freelancers/issue; 200 photos/year. Needs photos of scenics, attractions, food (specific to each issue), historical locations in region (call for specific counties). Model release required for identifiable people. Photo captions preferred; include location, description, names, date of photo (year), and if previously published, where and when.

Making Contact & Terms Send query letter with stock list and résumé of credits. Provide résumé, business card, brochure, flier or tearsheets to be kept on file for possible future assignments. Responds in 3 months. Simultaneous submissions and previously published work OK, "but you must identify photos used in other publications." Pays $100 for color cover; $25-100 for b&w or color inside. "We pay mileage fees to photographers on assignments. Request our photographer's rates and guidelines for specifics." Pays on publication. Credit line given "except in the case of ads, where it may or may not appear." Buys one-time rights.

Tips "We are looking for sharp, colorful images and prefer using digital files or color transparencies over color prints when possible. Nostalgic and historical photos are usually in black & white."

$ $▣ ◲ ⬚ OWL MAGAZINE

49 Front St. E., 2nd Floor, Toronto ON M5G 1B3 Canada. (416)340-2700. Fax: (416)340-9769. E-mail: apilas@owl.on.ca. Website: www.owlkids.com. **Contact:** Angela Pilas-Magee, photo researcher. Circ. 80,000. Estab. 1976. Published 10 times/year. A discovery magazine for children ages 9-13. Sample copy available for $4.95 and 9×12 SAE with $1.50 money order for postage. Photo guidelines free with SAE or via e-mail.

Needs Buys 5 photos from freelancers/issue; 40 photos/year. Needs photos of children ages 12-14, cities/urban, travel, extreme weather, landscapes/scenics, wildlife, science, technology, environmental, pop culture, multicultural, events, pets, adventure, hobbies, humor, sports and extreme sports. Interested in documentary, seasonal. Model/property release required. Photo captions required. Will buy story packages.

Specs Uses images in any hard-copy format. Accepts images in digital format. Send via CD, e-mail as TIFF, JPEG files at 72 dpi. "For publication, we require 300 dpi."

Making Contact & Terms Request photo guidelines package before sending photos for review. "We prefer promotional brochures but will accept up to 20 slides for review if accompanied by payment for return courier/mail. We accept no responsibility for unsolicited material." Keeps samples on file. Responds in 3 months. Previously published work OK. Pays $650 Canadian for color cover; $550 Canadian for color inside. **Pays on acceptance**. Credit line given. Buys one-time rights.

Tips "Photos should be sharply focused with good lighting, and engaging for kids. We are always on the lookout for humorous, action-packed shots; eye-catching, sports, animals, bloopers, etc. Photos with a 'wow' impact. Become familiar with the magazine—study back issues."

$ $⬚ OXYGEN

MuscleMag International Corp. (USA), 5775 McLaughlin Rd., Mississauga ON L5R 3P7 Canada. (905)507-3545. Fax: (905)507-2372. E-mail: editorial@oxygenmag.com. Website: www.oxygenmag.com. **Contact:** Robert Kennedy, editor-in-chief. Circ. 250,000. Estab. 1997. Monthly magazine. Emphasizes exercise and nutrition for women. Readers are women, ages 15-40. Sample copy available for $5.

Needs Buys 720 photos from freelancers/issue. Needs photos of women weight training and exercising aerobically. Model release required. Photo captions preferred; include names of subjects.

Specs Uses 35mm, 2¼×2¼ transparencies. Occasional prints acceptable.

Making Contact & Terms Send unsolicited photos by mail for consideration. Does not keep samples on file; include SASE for return of material. Responds in 3 weeks. Pays $200-400/hour; $800-1,500/day; $500-1,500/job; $500-2,000 for color cover; $35-50 for color or b&w inside. **Pays on acceptance**. Credit line given. Buys all rights.

Tips "We are looking for attractive, fit women working out on step machines, joggers, rowers, treadmills; with free weights; running for fitness; jumping, climbing. Professional pictures only, please. We particularly welcome photos of female celebrities who are into fitness; higher payments are made for these."

$⬚ ◲ 🅐 ⬚ PACIFIC YACHTING MAGAZINE

1080 Howe St., Vancouver BC V6Z 2T1 Canada. (604)606-4644. Fax: (604)687-1925. E-mail: editorial@pacificyachting.com. Website: www.pacificyachting.com. **Contact:** Peter A. Robson, editor. Circ. 20,000. Estab. 1968. Monthly magazine. Emphasizes boating on West Coast. Readers are male, ages 35-60; boaters, power and sail. Sample copy available for $5.95 Canadian plus postage.

Needs Buys 75 photos from freelancers/issue; 900 photos/year. Needs photos of landscapes/scenics, adventure, sports. Interested in historical/vintage, seasonal. "All should be boating related." Reviews photos with accompanying ms only. "Always looking for covers; must be shot in British Columbia."

Making Contact & Terms Keeps samples on file. Simultaneous submissions and previously published work OK. Pays $300 Canadian for color cover. Payment negotiable. Credit line given. Buys one-time rights.

$▤ ☑ PADDLER MAGAZINE

Paddlesport Publishing, Inc., P.O. Box 775450, Steamboat Springs CO 80477. (970)879-1450. Fax: (970)870-1404. E-mail: eugene@paddlermagazine.com. Website: www.paddlermagazine.com. **Contact:** Eugene Buchanan, editor. Circ. 65,000. Estab. 1990. Bimonthly magazine. Emphasizes kayaking, rafting, canoeing and sea kayaking. Sample copy available for $3.50. Photo guidelines free with SASE.

Needs Buys 27-45 photos from freelancers/issue; 162-270 photos/year. Needs photos of scenics and action. Model/property release preferred. Photo captions preferred; include location.

Specs Uses 35mm transparencies. Accepts images in digital format. Send via CD, Zip, floppy disk, e-mail as TIFF, EPS, JPEG files at 300 dpi. Digital submissions should be accompanied by a printed proof sheet.

Making Contact & Terms Send query letter with stock list. Send unsolicited photos by mail with SASE for consideration. Keeps samples on file. Responds in 2 months. Pays $250-350 for color cover; $50 for inset color cover; $150 for color full page inside. Pays on publication. Credit line given. Buys first North American serial rights; negotiable.

Tips "Send dupes and let us keep them on file."

$▤ PENNSYLVANIA

P.O. Box 755, Camp Hill PA 17011. (717)697-4660. E-mail: PaMag@aol.com. Website: www.pa-mag.com. **Contact:** Matthew K. Holliday, editor. Circ. 30,000. Bimonthly. Emphasizes history, travel and contemporary topics. Readers are 40-70 years old, professional and retired; average income is $59,000. Sample copy available for $2.95. Photo guidelines free with SASE or via e-mail.

Needs Uses about 40 photos/issue; most supplied by freelancers. Needs include travel and scenic. All photos must be taken in Pennsylvania. Reviews photos with or without accompanying ms. Photo captions required.

Making Contact & Terms Send query letter with samples. Send digital submissions of 3.1 MP or higher (OK on CD-ROM with accompanying printout with image file references); 5×7 and larger color prints; 35mm and 2¼×2¼ transparencies (duplicates only, no originals) by mail for consideration; include SASE for return of material. Responds in 1 month. Simultaneous submissions and previously published work OK with notification. Pays $100-125 for color cover; $25 for color inside; $50-500 for text/photo package. Credit line given. Buys one-time, first rights.

Tips Look at several past issues and review guidelines before submitting.

$ $▤ PENNSYLVANIA ANGLER & BOATER

P.O. Box 67000, Harrisburg PA 17106-7000. (717)705-7844. Fax: (717)705-7831. E-mail: amichaels@state.pa.us. Website: www.fish.state.pa.us. **Contact:** Art Michaels, editor. Bimonthly. "*Pennsylvania Angler & Boater* is the Keystone State's official fishing and boating magazine, published by the Pennsylvania Fish & Boat Commission." Readers are "anglers and boaters in Pennsylvania." Sample copy and photo guidelines free for 9×12 SAE and 9 oz. postage, or via website.

Needs Buys 4 photos from freelancers/issue; 24 photos/year. Needs "action fishing and boating shots." Model release required. Photo captions required.

Making Contact & Terms "Don't submit without first considering contributor guidelines, available on website. Then send query letter with résumé of credits. Send 35mm or larger transparencies by mail for consideration; include SASE for return of material. Send low-res images on CD; we'll later request high-res images of those shots that interest us." Responds in several weeks. Pays $400 maximum for color cover; $30 minimum for color inside; $50-300 for text/photo package. Pays between acceptance and publication. Credit line given.

$▤ PENNSYLVANIA GAME NEWS

2001 Elmerton Ave., Harrisburg PA 17110-9797. (717)787-3745. **Contact:** Bob Mitchell, editor. Circ. 120,000. Monthly magazine published by the Pennsylvania Game Commission. Readers are people interested in hunting, wildlife management and conservation in Pennsylvania. Sample copy available for 9×12 SASE. Editorial guidelines free.

Needs Considers photos of "any outdoor subject (Pennsylvania locale), except fishing and boating." Reviews photos with accompanying ms only.

Making Contact & Terms Send prints or slides. "No negatives, please." Include SASE for return of material. Will accept electronic images via CD only (no e-mail). Will also view photographer's website if available. Responds in 2 months. Pays $40-300. **Pays on acceptance**.

PENTHOUSE

2 Penn Plaza, Suite 1125, New York NY 10121. (212)702-6000. Fax: (212)702-6262. Monthly magazine for the sophisticated male. Editorial scope ranges from outspoken contemporary comment to photography essays of beautiful women. Features interviews with personalities, sociological studies, humor, travel, food and wines, and fashion and grooming for men. **Query before submitting**.

$ $▣ ☑ PERSIMMON HILL MAGAZINE

1700 NE 63rd St., Oklahoma City OK 73111. (405)478-6404. Fax: (405)478-4714. E-mail: editor@nationalcow boymuseum.org. Website: www.nationalcowboymuseum.org. **Contact:** M.J. Van Deventer, editor. Circ. 15,000. Estab. 1970. Quarterly publication of the National Cowboy and Western Heritage Museum. Emphasizes the West, both historical and contemporary views. Has diverse international audience with an interest in preservation of the West. Sample copy available for $10.50 and 9×12 SAE with 10 first-class stamps. Photo guidelines free with SASE or on website.

- This magazine has received Outstanding Publication honors from the Oklahoma Museums Association, the International Association of Business Communicators, Ad Club and Public Relations Society of America.

Needs Buys 65 photos from freelancers/issue; 260 photos/year. "Photos must pertain to specific articles unless it is a photo essay on the West." Western subjects include celebrities, couples, families, landscapes, wildlife, architecture, interiors/decorating, rural, adventure, entertainment, events, hobbies, travel. Interested in documentary, fine art, historical/vintage, seasonal. Model release required for children's photos. Photo captions required; include location, names of people, action. Proper credit is required if photos are historic.

Specs Accepts images in digital format. Send via CD.

Making Contact & Terms Submit portfolio for review by mail, directly to the editor, or with a personal visit to the editor. Responds in 6 weeks. Pays $100-150 for b&w cover; $150-500 for color cover; $25-100 for b&w inside; $50-150 for color inside. Credit line given. Buys first North American serial rights.

Tips "Make certain your photographs are high quality and have a story to tell. We are using more contemporary portraits of things that are currently happening in the West and using fewer historical photographs. Work must be high quality, original, innovative. Photographers can best present their work in a portfolio format and should keep in mind that we like to feature photo essays on the West in each issue. Study the magazine to understand its purpose. Show only the work that would be beneficial to us or pertain to the traditional Western subjects we cover."

$☑ Ⓐ PETERSEN'S PHOTOGRAPHIC

6420 Wilshire Blvd., #LL, Los Angeles CA 90048-5515. E-mail: ron.leach@primedia.com. Website: www.phot ographic.com. **Contact:** Ron Leach, editor. Circ. 200,000. Estab. 1972. Monthly magazine. Emphasizes photography. Sample copies available on newsstands. Photo guidelines free with SASE.

Needs All queries, outlines and manuscripts must be accompanied by a selection of images that would illustrate the article. Possible subjects include babies/children/teens, couples, families, parents, landscapes/scenics, wildlife, architecture, cities/urban, pets, adventure, sports, travel. Interested in fashion/glamour, fine art, seasonal.

Making Contact & Terms All queries and manuscripts must be accompanied by sample photos for the article; include SASE for return of material. Responds in 2 months. Previously published work OK. Pays $50-150 for b&w or color inside. Pays on publication. Credit line given. Buys one-time rights.

Tips "Typically we only purchase photos as part of an editorial manuscript/photo package. We need images that are visually exciting and technically flawless. The articles mostly cover the theme 'We Show You How.' Send great photographs with an explanation of how to create them. Submissions must be by mail."

$▣ ☑ Ⓐ ▣ PHOTO LIFE

Apex Publications, One Dundas St. W., Suite 2500, P.O. Box 84, Toronto ON M5G 1Z3 Canada. (800)905-7468. Fax: (800)664-2739. Website: www.photolife.com. **Contact:** Anita Dammer, editor. Circ. 55,000. Magazine

© 2006 Perry Mastrovito

Perry Mastrovito submitted 20 images with the theme of "patterns and textures" to *Photo Life* magazine. Four of the images were published as a group on the "Readers' Gallery" page. This image of dewy petals was one of the four. Although Mastrovito received no monetary payment for use of the images, *Photo Life* gave him several free copies of the magazine as well as an ample supply of tearsheets, which Mastrovito will use to further promote his work.

published 6 times/year. Readers are amateur, advanced amateur and professional photographers. Sample copy free with SASE. Photo guidelines available on website.

Needs Buys 70 photos from freelancers/issue; 420 photos/year. Needs landscape/wildlife shots, fashion, scenics, b&w images and so on. Priority is given to Canadian photographers.

Specs Accepts images in digital format. Send via SyQuest, CD, Zip at 300 dpi.

Making Contact & Terms Send query letter with résumé of credits, SASE. Responds in 1 month. Pays on publication. Buys first North American serial rights and one-time rights.

Tips "Looking for good writers to cover any subject of interest to the amateur and advanced photographer. Fine art photos should be striking, innovative. General stock and outdoor photos should be presented with a strong technical theme."

$ ▣ ▨ PHOTO TECHNIQUES

Preston Publications, 6600 W. Touhy Ave., Niles IL 60714. (847)647-2900. Fax: (847)647-1155. E-mail: slewis @phototechmag.com. Website: www.phototechmag.com. **Contact:** Scott Lewis, editor. Circ. 30,000. Estab. 1979. Bimonthly magazine for advanced traditional and digital photographers. Sample copy available for $5. Photo guidelines free with SAE or available on website.

Needs Publishes expert technical articles about photography. Needs photos of rural, landscapes/scenics, "but if extensively photographed by others, ask yourself if your photo is sufficiently different." Also "some urban or portrait if it fits theme of article." Especially needs digital ink system testing and coloring and alternative processes articles. Reviews photos with or without ms. Photo captions required; include technical data.

Specs Uses any and all formats.

Making Contact & Terms E-mail queries work best. Send article or portfolio for review. Portfolio should include b&w and/or color prints, slides or transparencies. Keeps samples on file; include SASE for return of

material. "Prefer that work not have been previously published in any competing photography magazine; small, scholarly, or local publication OK." Pays $300 for color cover; $100-150 per page. Pays on publication. Credit line given. Buys one-time rights.

Tips "We need people to be familiar with our magazine before submitting/querying; however, we receive surprisingly few portfolios and are interested in seeing more. We are most interested in non-big-name photographers. Include return postage/packaging. Also, we much prefer complete, finished submissions; when people ask, 'Would you be interested in...?', often the answer is simply, 'We don't know! Let us see it.' Most of our articles are written by practicing photographers and use their work as illustrations."

N PHOTOGRAPHER'S FORUM MAGAZINE

Serbin Communications, 813 Reddick St., Santa Barbara CA 93103. (805)963-0439 or (800)876-6425. Fax: (805)965-0496. E-mail: admin@serbin.com. Website: www.serbin.com. Quarterly magazine for the serious student and emerging professional photographer. Includes feature articles on historic and comtemporary photographers, interviews, book reviews, workshop listings, new products.

N $ $ PINK MAGAZINE

(formerly *The Pink Pages*), 5412 N. Clark St., Suite 220, Chicago IL 60640. (773)769-6328 or (877)769-7465. Fax: (773)769-8424. E-mail: editorial@pinkmag.com. Website: www.pinkmag.com. **Contact:** David Cohen, publisher. Circ. 200,000. Estab. 1990. Quarterly gay and lesbian lifestyle magazine. Sample copy free.

Needs Buys 6-10 photos from freelancers/issue; 40 photos/year. Needs photos of fashion stories. Reviews photos with or without ms. Model/property release required. Photo captions required; include description of clothes, designer name, model's name, etc.

Specs Uses 8×10 matte color and/or b&w prints.

Making Contact & Terms Send query letter with samples, tearsheets. Provide résumé, business card, self-promotion piece or tearsheets to be kept on file for possible future assignments. To show portfolio, photographer should follow-up with call and/or letter after initial query. Art director will contact photographer for portfolio review if interested. Portfolio should include b&w and/or color prints or tearsheets. Keeps samples on file. Responds only if interested; send nonreturnable samples. Pays $100-300 for cover; $25-300 for inside. Pays on publication. Credit line given. Buys first rights or all rights. "Usually whatever we print—we keep all rights."

Tips "We need fast workers with quick turnaround. Photographer needs to be organized and time efficient, as well as friendly, trusty and responsible. Needs to have good ideas, too. We like to publish alternative lifestyles. Like to see action fashion photography."

$ ▤ ⊘ ⊕ PLANET: The Welsh Internationalist

P.O. Box 44, Aberystwyth, Ceredigion SY23 3ZZ United Kingdom. (44)(1970)611255. Fax: (44)(1970)611197. E-mail: planet.enquiries@planetmagazine.org.uk. Website: www.planetmagazine.org.uk. **Contact:** John Barnie, editor. Circ. 1,400. Estab. 1970. Bimonthly cultural magazine devoted to Welsh culture, current affairs, the arts, the environment, but set in broader international context. Audience based mostly in Wales. Sample copy available for $8 and 25.5×17.5 cm SAE with 96P first-class postage.

Needs Wants photos of environmental, performing arts, sports, agriculture, industry, political, science. Interested in fine art, historical/vintage. Reviews photos with or without ms. Model/property release preferred. Photo captions required; include subject, copyright holder.

Specs Uses glossy color and/or b&w prints; 4×5 transparencies. Accepts images in digital format. Send as JPEG files at 300 dpi.

Making Contact & Terms Send query letter with résumé, slides, prints, photocopies. Does not keep samples on file; include SASE for return of material. Responds in 1 month to queries. Simultaneous submissions and previously published work OK. Pays £30 minimum. Pays on publication. Credit line given. Buys first rights.

Tips "Read the magazine first to get an idea of the kind of areas we cover so incompatible/unsuitable material is not submitted."

$ $ PLAYBOY

680 N. Lake Shore Dr., Suite 1500, Chicago IL 60611. (312)751-8000. Fax: (312)587-9046. Website: www.play boy.com. **Contact:** Gary Cole, photography director. Circ. 3.15 million, US Edition; 5 million worldwide. Estab. 1954. Monthly magazine. Readers are 75% male and 25% female, ages 18-70; come from all economic, ethnic and regional backgrounds.

• This is a premiere market that demands photographic excellence. *Playboy* does not use freelance photographers per se, but if you send images they like, they may use your work and/or pay a finder's fee.

Needs Uses 50 photos/issue. Needs photos of glamour, fashion, merchandise, travel, food and personalities. Model release required. Models must be 18 years or older.

Specs Uses 35mm, $2\frac{1}{4} \times 2\frac{1}{4}$, 4×5, 8×10 color transparencies.

Making Contact & Terms Contact through rep. Submit portfolio for review. Send query letter with résumé of credits. Provide résumé, business card, brochure, flier or tearsheets to be kept on file for possible future assignments. Pays $300 minimum/job. **Pays on acceptance**. Buys all rights.

Tips "Lighting and attention to detail is most important when photographing women, especially the ability to use strobes indoors. Refer to magazine for style and quality guidelines."

▣ PLAYBOY'S SPECIAL EDITIONS

680 N. Lakeshore Dr., Suite 1500, Chicago IL 60611. (312)373-2273. Fax: (312)751-2818. E-mail: specialeditions@playboy.com. Website: www.playboyse.com. Circ. 300,000. Estab. 1984. Bimonthly magazine and 18 newsstand specials for male sophisticates (24 issues/year). Photo guidelines available on website.

Needs Needs photos of beautiful women. Model/property release required. Models must be 18 years or older. Photo captions required.

Specs Uses 35mm, $2\frac{1}{4} \times 2\frac{1}{4}$ tranparencies; Kodachrome film. Accepts images in digital format. Send via e-mail.

Making Contact & Terms Send query letter with samples. Does not keep samples on file; include SASE for return of material. Responds in 2 months. Pays on publication. Credit line given. Buys one-time rights or all rights.

$ PLAYERS MAGAZINE

8060 Melrose Ave., Los Angeles CA 90046. (323)653-8060. Fax: (323)655-9452. E-mail: info@psiemail.com. **Contact:** Danny Sate, editor. Monthly magazine. Emphasizes black adults. Readers are black men over age 18. Sample copy and photo guidelines free with SASE.

Needs Number of photos/issue varies; all supplied by freelancers. Needs photos of various editorial shots and female pictorials. Reviews photos purchased with accompanying ms only. Model release and 2 photo IDs required for pictorial sets. Models must be 18 or older. Property release preferred for pictorial sets. Photo captions required.

Making Contact & Terms Submit portfolio for review. Send 35mm, $2\frac{1}{4} \times 2\frac{1}{4}$ transparencies. Keeps samples on file. Responds in 2 weeks. Simultaneous submissions and/or previously published work OK. Pays $200-250 for color cover; $100-150 for color inside. Pays on publication. Credit line given. Buys first North American serial and all rights; negotiable.

Tips "We're interested in innovative, creative, cutting-edge work, and we're not afraid to experiment."

$ ▣ Ⓐ PN MAGAZINE

2111 E. Highland Ave., Suite 180, Phoenix AZ 85016-4702. (602)224-0500. Fax: (602)224-0507. E-mail: susan@pnnews.com. Website: www.pn-magazine.com. **Contact:** Susan Robbins, director of art & production. Circ. 28,000. Estab. 1946. Monthly magazine. Emphasizes all aspects of living for people with spinal-cord injuries or diseases. Readers are primarily well-educated males, ages 40-55, who use wheelchairs for mobility. Sample copy free with 9×12 SASE and 7 first-class stamps.

Needs Buys 3-5 photos from freelancers/year. Articles/photos must deal with accessibility or some aspect of wheelchair living. "We do not accept photos that do not accompany manuscript." Model/property release preferred. Photo captions required; include who, what, when, where.

Specs Accepts images in digital format. Send via CD, Zip, e-mail as TIFF, EPS, GIF, JPEG files at 300 dpi, size 4×6.

Making Contact & Terms Provide résumé, business card, brochure, flier or tearsheets to be kept on file for possible future assignments. "OK to call regarding possible future assignments in your locale." Keeps samples on file. Responds in 1 month. Simultaneous submissions and previously published work OK. Pays $25-200 for color cover; $10-25 for b&w or color inside; $50-200 for photo/text package; other forms of payment negotiable. Pays on publication. Credit line given. Buys one-time, all, electronic rights; negotiable.

Tips "Feature a person in a wheelchair in photos whenever possible. Person should preferably be involved in some activity."

▣ POETS & WRITERS MAGAZINE

72 Spring St., New York NY 10012. (212)226-3586. Fax: (212)226-3963. E-mail: editor@pw.org. Website: www.pw.org/mag. Circ. 60,000. Estab. 1987. Bimonthly literary trade magazine. "Designed for poets, fiction writers and creative nonfiction writers. We supply our readers with information about the publishing industry, conferences and workshop opportunities, grants and awards available to writers, as well as interviews with contemporary authors."

Needs Needs photos of contemporary writers: poets, fiction writers, writers of creative nonfiction. Photo captions required.

Specs Uses b&w prints. Accepts images in digital format.

Making Contact & Terms Provide résumé, business card, self-promotion piece or tearsheets to be kept on file for possible future assignments. Managing editor will contact photographer for portfolio review if interested. Pays on publication. Credit line given.

Tips "We seek black & white photographs to accompany articles and profiles. We'd be pleased to have photographers' lists of author photos."

$ $ POLO PLAYERS EDITION MAGAZINE

3500 Fairlane Farms Rd., #9, Wellington FL 33414. (561)793-9524. Fax: (561)793-9576. Website: www.polopl ayersedition.com. **Contact:** Gwen Rizzo, editor. Circ. 7,000. Estab. 1975. Monthly magazine. Emphasizes the sport of polo and its lifestyle. Readers are primarily male; average age is 40; 90% of readers are at professional/managerial levels, including CEOs and presidents. Sample copy free with 10×13 SASE. Photo guidelines free with SASE.

Needs Buys 35 photos from freelancers/issue; 420 photos/year. Needs photos of polo action, portraits, travel, party/social and scenics. Most polo action is assigned, but freelance needs range from dynamic action photos to spectator fashion to social events. Photographers may write and obtain an editorial calendar for the year, listing planned features/photo needs. Photo captions preferred; include subjects and names.

Making Contact & Terms Send query letter with list of stock photo subjects. Provide résumé, business card, brochure, flier or tearsheets to be kept on file for possible future assignments. Responds in 2 weeks. Simultaneous submissions and previously published work OK "in some instances." Pays $25-150 for b&w photo, $30-300 for color photo, $150 for half day, $300 for full day, $200-500 for complete package. Pays on publication. Credit line given. Buys one-time or all rights; negotiable.

Tips Wants to see tight focus on subject matter and ability to capture drama of polo. "In assigning action photography, we look for close-ups that show the dramatic interaction of two or more players rather than a single player. On the sidelines, we encourage photographers to capture emotions of game, pony picket lines, etc." Sees trend toward "more use of quality b&w images." To break in, "send samples of work, preferably polo action photography."

$ ▣ ◖ POPULAR PHOTOGRAPHY & IMAGING

P.O. Box 1247, Teaneck NJ 07666. (201)836-0024. E-mail: rlazaroff@aol.com. Website: www.popularphotogr aphy.com. **Contact:** Bob Lazaroff, contributing editor. Circ. 450,000. Estab. 1937. Monthly magazine. Readers are male and female photographers, amateurs to professionals of all ages. Photo guidelines free with SASE.

Needs Uses amateur and professional photos for monthly contest feature, Your Best Shot.

Making Contact & Terms Send up to 5 photos per month. Send prints, slides or CDs by mail to Your Best Shot at the address above; include SASE for return of material (material held up to 12 weeks). E-mail JPEGs (100K max size) to yourbestshot@gmail.com. Pays prize money for contest: $300 (1st), $200 (2nd), $100 (3rd), and honorable mention. **Pays on acceptance**.

$ ▣ ◖ POPULAR SCIENCE MAGAZINE

Time 4 Media, Two Park Ave., 9th Floor, New York NY 10016. (212)779-5345. Fax: (212)779-5103. E-mail: kris.lamanna@time4.com. Website: www.popsci.com. **Contact:** Kris LaManna, picture editor. Circ. 1.55 million. Estab. 1872. World's largest monthly science and technology magazine.

Needs Buys 10 photos from freelancers/issue; 120 photos/year. Needs photos of environmental, adventure, automobiles, hobbies, travel, industry, medicine, military, product shots/still life, science, technology/computers. Interested in alternative process, documentary. Reviews photos by request only with or without ms. Photo captions required.

Specs Uses 8×10 glossy prints; 35mm, 2¼×2¼, 4×5, 8×10 transparencies. Accepts images in digital format. Send as TIFF, JPEG files at 300 dpi.

Making Contact & Terms Send query letter with tearsheets. Provide self-promotion piece to be kept on file for possible future assignments. Responds only if interested; send nonreturnable samples. Day rate is $500 plus expenses. **Pays on acceptance.** Credit line given. Buys one-time rights.

Tips "Understand our style; read the magazine on a regular basis. Submissions should be neat and clean."

$▣ ○ Ⓢ 🔀 PRAIRIE JOURNAL, A Magazine of Canadian Literature

P.O. Box 61203, Brentwood PO, Calgary AB T2L 2K6 Canada. E-mail: prairiejournal@yahoo.com. Website: www.geocities.com/prairiejournal. Circ. 600. Estab. 1983. Literary magazine published twice/year. Features mainly poetry and artwork. Sample copy available for $6 and 7×8½ SAE. Photo guidelines available for SAE and IRC.

Needs Buys 4 photos/year. Needs literary only, artistic.

Specs Uses b&w prints. Accepts images in digital format. Send via e-mail if your query is successful.

Making Contact & Terms Send query letter with photocopies only (no originals) by mail. Provide self-promotion piece to be kept on file. Responds in 6 months. Responds only if interested; send nonreturnable samples. Pays $10-50 for b&w cover or inside. Pays on publication. Credit line given. Buys first rights.

Tips "Black & white literary, artistic work preferred; not commercial. We especially like newcomers. Read our publication or check out our website. You need to own copyright for your work and have permission to reproduce it. We are open to subjects that would be suitable for a literary arts magazine containing poetry, fiction, reviews, interviews. We do not commission but choose from your samples."

$ $▣ ☑ Ⓢ PRECISION SHOOTING

222 McKee St., Manchester CT 06040-4800. (860)645-8776. Fax: (860)643-8215. Website: www.precisionshooting.com. **Contact:** Dave Brennan, editor. Circ. 17,000. Estab. 1956. Monthly consumer magazine. Masthead motto declares "dealing exclusively with the topic of extreme rifle accuracy." Sample copy available gratis—call editor.

Needs Buys 1 photo from freelancers/issue; 12 photos/year. Needs rifle-related photos, hobbies. Reviews photos with or without ms. "Cover photos are all we buy. Inside the magazine photos are provided by the authors with their manuscripts."

Specs Uses glossy color prints; 35mm, 4×5 transparencies. Accepts images in digital format. Send via Zip as TIFF files.

Making Contact & Terms Send query letter with prints. Does not keep samples on file; include SASE for return of material. Responds in 1 week to queries. Simultaneous submissions OK. Pays $300 for color cover. Pays on publication. Credit line given. Buys first rights; negotiable.

Tips "We do not overprint verbal trivia on our covers. It is a great place for a quality photograph to shine. We pride ourselves on being artistic; we are not a newsstand publication."

Ⓝ $🔀 PRESBYTERIAN RECORD

50 Wynford Dr., Toronto ON M3C 1J7 Canada. (416)441-1111. Fax: (416)441-2825. E-mail: pcrecord@presbyterian.ca. Website: www.presbyterianrecord.ca. **Contact:** Rev. David Harris, editor. Circ. 50,000. Estab. 1875. Monthly magazine. Emphasizes subjects related to The Presbyterian Church in Canada, ecumenical themes and theological perspectives for church-oriented family audience. Free sample copy and photo guidelines with 9×12 SAE and $1 Canadian postage (minimum) or IRC.

Needs Religious themes related to features published. No formal poses, food, nude studies, alcoholic beverages, church buildings, empty churches or sports. Reviews photos with or without ms. Photo captions preferred.

Specs Uses 8×10, 4×5 glossy b&w and/or color prints; 35mm transparencies. Vertical format used on cover.

Making Contact & Terms Send photos by mail; include SAE, IRCs for return of work. Responds in 1 month. Simultaneous submissions and previously published work OK. Pays $15-35 for b&w prints; $60 minimum for cover; $30-60 for text/photo package. Pays on publication. Credit line given. Buys one-time rights; negotiable.

Tips "Unusual photographs related to subject needs are welcome."

☑ PRIMAVERA

Box 37-7547, Chicago IL 60637. **Contact:** Ruth Young, co-editor. Annual literary/visual arts magazine. "We publish original fiction, poetry, drawings, paintings and photographs that deal with women's experiences." Sample copy available for $5. Photo guidelines free with SASE.

Needs Buys 2-12 photos from freelancers/issue. Needs photos of babies/children/teens, couples, multicul-

tural, families, parents, senior citizens, environmental, landscapes/scenics, wildlife, architecture, gardening, interiors/decorating, rural.

Specs Uses b&w prints.

Making Contact & Terms Send unsolicited photos or photocopies by mail for consideration; include SASE for return of material. Responds in 1 month. Payment is 2 contributor's copies (volume in which photography appears). Pays on publication. Credit line given. Buys one-time rights.

PRINCETON ALUMNI WEEKLY

194 Nassau St., Princeton NJ 08542. (609)258-4722. Website: www.princeton.edu/paw. **Contact:** Marianne Nelson, art director. Circ. 58,000. Biweekly. Emphasizes Princeton University and higher education. Readers are alumni, faculty, students, staff and friends of Princeton University. Sample copy available for $2 with 9×12 SAE and 2 first-class stamps.

Needs Assigns local and out-of-state photographers as well as purchases stock. Needs photos of "people, campus scenes; subjects vary greatly with content of each issue."

Making Contact & Terms Arrange a personal interview to show portfolio. Provide sample card to be kept on file for possible future assignments. Payment varies according to usage, size, etc. Pays on publication. Buys one-time rights.

$⬤ 🅐 THE PROGRESSIVE

409 E. Main St., Madison WI 53703. (608)257-4626. Website: www.progressive.org. **Contact:** Nick Jehlen, art director. Circ. 50,000. Estab. 1909. Monthly political magazine. "Grassroots publication from a left perspective, interested in foreign and domestic issues of peace and social justice." Photo guidelines free and on website.

Needs Buys 5-10 photos from freelancers/issue; 50-100 photos/year. Looking for images documenting the human condition and the social/political environments of contemporary society. Special photo needs include "labor activities, environmental issues and political movements." Photo captions required; include name, place, date, credit information.

Making Contact & Terms Send query letter with photocopies; include SASE. Provide stock list to be kept on file for possible future assignments. Art director will contact photographer for portfolio review if interested. Responds once every month. Simultaneous submissions and previously published work OK. Pays $50-150 for b&w inside. Pays on publication. Credit line given. Buys one-time rights. All material returned with SASE.

Tips "Most of the photos we publish are of political actions. Interesting and well-composed photos of creative actions are the most likely to be published. We also use 2-3 short photo essays on political or social subjects per year." For detailed photo information, see website at www.art.progressive.org.

$ $🖻 PSYCHOLOGY TODAY

Sussex Publishers, 115 E. 23rd St., 9th Floor, New York NY 10010. (212)260-7210. Fax: (212)260-7566. E-mail: claudia@psychologytoday.com. Website: www.psychologytoday.com. **Contact:** Claudia. Estab. 1992. Bimonthly magazine. Readers are male and female, highly educated, active professionals. Photo guidelines free with SASE.

Needs Uses 19-25 photos/issue; supplied by freelancers and stock agencies. Needs photos of humor, photo montage, symbolic, environmental, portraits, conceptual. Model/property release preferred.

Specs Accepts image in digital format. Send via CD, Jaz as JPEG files.

Making Contact & Terms Submit portfolio for review. Send promo card. Keeps samples on file. Cannot return material. Responds only if interested. Payment for assignments negotiable; for stock, pays $200-450.

$🖻 🖉 🅐 RACQUETBALL MAGAZINE

1685 W. Uintah, Colorado Springs CO 80904-2906. (719)635-5396. Fax: (719)635-0685. E-mail: jhiser@usra.org. Website: www.usaracquetball.com. **Contact:** Jim Hiser, executive director. Circ. 30,000. Estab. 1990. Bimonthly magazine of USA Racquetball. Emphasizes racquetball. Sample copy available for $4.50. Photo guidelines available.

Needs Buys 6-12 photos from freelancers/issue; 36-72 photos/year. Needs photos of action racquetball. Model/property release preferred. Photo captions required.

Specs Accepts images in digital format. Send via CD as EPS files at 900 dpi.

Making Contact & Terms Provide résumé, business card, brochure, flier or tearsheets to be kept on file for possible future assignments. Responds in 1 month. Previously published work OK. Pays $200 for color cover; $3-5 for b&w inside; $25-75 for color inside. Pays on publication. Credit line given. Buys all rights; negotiable.

$ ▣ ◩ Ⓐ RAILMODEL JOURNAL

2403 Champa St., Denver CO 80205. (303)296-1600. Website: www.railmodeljournal.com. Circ. 15,000. Estab. 1990. Monthly magazine for experienced model railroaders who wish to recreate specific locomotives, cars, structures and complete scenes. Sample copy available for $6.95.

Needs Buys 50 photos from freelancers/issue; 600 photos/year. Needs photos of hobbies. Interested in documentary, historical/vintage. Reviews photos with accompanying manuscripts only. Model release required. Photo captions required.

Specs Uses 4×5 glossy prints; 35mm transparencies. Accepts images in digital format. Send via floppy disk, CD as TIFF files at 300 dpi.

Making Contact & Terms Send query letter with slides, prints, transparencies. Does not keep samples on file; include SASE for return of material. Responds in 2 months to queries. Pays $100 minimum for cover; $15 minimum for b&w inside; $80 minimum for color inside. Pays on publication. Credit line given. Buys one-time rights.

Tips "Depth of field critical. Models must look real. Need step-by-step how-to sequences. ID each slide or print."

$ $ $ ◙ RANGER RICK

11100 Wildlife Center Dr., Reston VA 20190-5362. (703)438-6525. Fax: (703)438-6094. E-mail: mcelhinney@nwf.org. Website: www.nwf.org/rangerrick. **Contact:** Susan McElhinney, photo editor. Circ. 600,000. Estab. 1967. Monthly educational magazine published by the National Wildlife Federation for children ages 7-12. Photo guidelines free with SASE.

Needs Needs photos of children, multicultural, environmental, wildlife, adventure, science.

Specs Uses transparencies; dupes OK for first edit.

Making Contact & Terms Send nonreturnable printed samples or website address. *Ranger Rick* space rates: $300 (quarter page) to $1,000 (cover).

Tips "Seeking experienced photographers with substantial publishing history only."

▣ ◯ RECREATION PUBLICATIONS INC.

4090 S. McCarran Blvd., Suite E, Reno NV 89502. (775)353-5100. Fax: (775)353-5111. E-mail: don.abbott@yachtsforsale.com. Website: www.yachtsforsale.com. **Contact:** Don Abbott, publisher. Circ. 25,000. Estab. 1965. Monthly slick that emphasizes recreational boating for boat owners of northern California. Sample copy available for $3.

Needs Buys 5-10 photos/issue; 60-120 photos/year. Wants sport photos; power and sail (boating and recreation in northern California); spot news (about boating); travel (of interest to boaters). Seeks manuscripts about power boats and sailboats, boating personalities, locales, piers, harbors, and how-tos in northern California. Photos purchased with or without accompanying ms. Model release required. Photo captions preferred.

Specs Uses any size glossy color prints. Uses color slides for cover. Vertical (preferred) or horizontal format.

Making Contact & Terms "We would love to give a newcomer a chance at a cover." Send material by mail with SASE for consideration; or e-mail to don.abbott@yachtsforsale.com. Accepts images in digital format. Send via CD at 300 dpi. Responds in 1 month. Simultaneous submissions or previously published work OK but must be exclusive in Bay Area (nonduplicated). Pay varies. Pays on publication. Credit line given. Buys one-time rights.

Tips Prefers to see action color slides, water scenes. "We do not use photos as stand-alones; they must illustrate a story. The exception is cover photos, which must have a Bay Area application—power, sail or combination; vertical format with uncluttered upper area especially welcome."

REFORM JUDAISM

633 Third Ave., 7th Floor, New York NY 10017-6778. (212)650-4240. E-mail: rjmagazine@urj.org. Website: www.reformjudaismmag.org. **Contact:** Joy Weinberg, managing editor. Circ. 305,000. Estab. 1972. Quarterly magazine. Publication of the Union for Reform Judaism. Offers insightful, incisive coverage of the challenges faced by contemporary Jews. Readers are members of Reform congregations in North America. Sample copy available for $3.50.

Needs Buys 3 photos from freelancers/issue; 12 photos/year. Needs photos relating to Jewish life or Jewish issues, Israel, politics. Model release required. Photo captions required.

Making Contact & Terms Provide résumé, business card, brochure, flier or tearsheets to be kept on file for possible future assignments. Responds in 1 month. Simultaneous submissions and previously published work

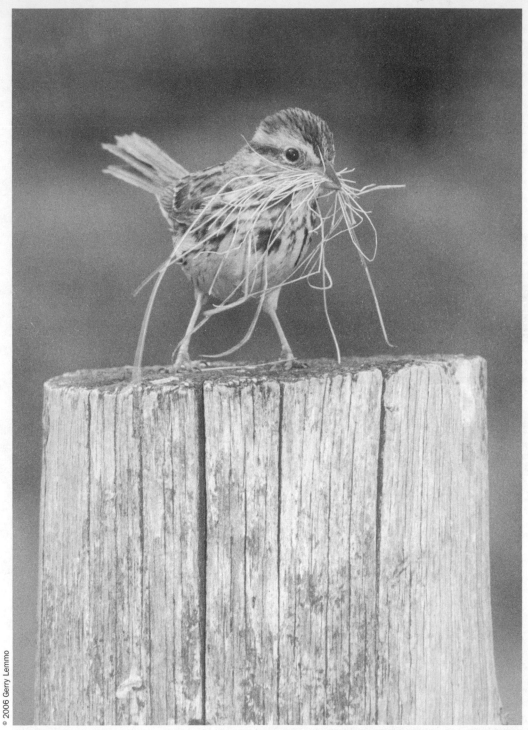

Gerry Lemmo sent 20 slides on speculation to *Ranger Rick*. The editor chose this image because it is cute and represents spring. "Knowing how and where to find wildlife subjects—their habitats and preferences—can help a lot in capturing them on film or digitally," says Lemmo.

OK. Include self-addressed, stamped postcard for response. Pays on publication. Credit line given. Buys one-time rights, first North American serial rights.

Tips Wants to see "excellent photography: artistic, creative, evocative pictures that involve the reader."

$ ▣ ⬜ ⑤ REMINISCE

Reiman Media Group, Inc., 5400 S. 60th St., Greendale WI 53129. Fax: (414)423-8463. E-mail: photocoordinat or@reimanpub.com. Website: www.reminisce.com. **Contact:** Trudi Bellin, photo coordinator. Estab. 1990. Bimonthly magazine. "The magazine that brings back the good times." Readers are male and female, interested in nostalgia, ages 55 and over. "*Reminisce* is supported entirely by subscriptions and accepts no outside advertising." Sample copy available for $2. Photo guidelines free with SASE.

- *Reminisce EXTRA* is published in the months between regular issues. Content and guidelines are the same.

Needs Buys 20 photos from freelancers/issue; 120 photos/year. Needs good-quality b&w and color vintage photography; has occasional use for high-quality color shots of memorabilia. Photo captions preferred; include season, location.

Specs Accepts images in digital format. Send via lightboxes, CD/DVD with printed thumbnails and caption sheet, or e-mail if first review selection is small (12 images or less). Will preview sharp photocopies to judge possible use; or color transparencies/b&w prints.

Making Contact & Terms Send query letter with list of stock photo subjects. Send unsolicited photos by mail for consideration. Submit seasonally. Keeps samples on file (tearsheets; no dupes); include SASE for return of material. Responds in 3 months. Previously published work OK. Buys stock only. Pays $150-300 for cover; $50-150 for inside. Pays on publication. Credit line given. Buys one-time rights, occasionally needs electronic rights.

Tips "We are continually in need of authentic color taken in the 1940s, 1950s and 1960s, and b&w stock photos. Technical quality is extremely important; focus must be sharp (no soft focus); we can work with faded color on vintage photos. Study our magazine thoroughly—we have a continuing need for vintage color and b&w images, and those who can supply what we need can expect to be regular contributors."

$ ▣ ⬜ THE REPORTER

Women's American ORT, 250 Park Ave. S., Suite 600, New York NY 10003. (212)505-7700. Fax: (212)674-3057. E-mail: dasher@waort.org. Website: www.waort.org. **Contact:** Dana Asher, director of marketing. Circ. 50,000. Estab. 1966. National semiannual magazine for contemporary Jewish women who are active, informed and involved. "We focus on issues of education, Jewish life and culture worldwide, Israel, travel, technology, public policy issues, literature and the arts." Sample copy available for 9×12 SAE with 2 first-class stamps.

Needs Buys 4 photos/year. Needs photos of education, religious, humor, technology/computers. Interested in documentary, historical/vintage. Reviews photos with or without ms. Model release preferred. Photo captions required; include ID of people, location, year.

Specs Uses 4×6 glossy color and/or b&w prints. Prefers images in digital format. Send via CD, e-mail as TIFF, JPEG files at 300 dpi.

Making Contact & Terms Send query letter with prints, photocopies, tearsheets. Provide résumé, business card or self-promotion piece to be kept on file for possible future assignments. Responds only if interested; send nonreturnable samples. Pays $40-200. Pays on publication. Credit line given. Buys all rights; negotiable.

Tips Women's issues, especially Jewish women's issues, get quick attention.

$ ▣ ⬜ RHODE ISLAND MONTHLY

Belo Corp., 280 Kinsley Ave., Providence RI 02903-1017. (401)277-8174. Fax: (401)277-8080. Website: www.r imonthly.com. **Contact:** Ellen Dessloch, art director. Circ. 40,000. Estab. 1988. Monthly regional publication for and about Rhode Island.

Needs Buys 15 photos from freelancers/issue; 200 photos/year. "Almost all photos have a local slant. Portraits, photo essays, food, lifestyle, home, issues."

Specs Uses glossy b&w prints; 35 mm, $2^{1}/_{4} \times 2^{1}/_{4}$, 4×5 transparencies. Accepts images in digital format.

Making Contact & Terms Send query letter with tearsheets, transparencies. Portfolio may be dropped off. Provide self-promotion piece to be kept on file for possible future assignments. Will return anything with SASE. Responds in 2 weeks. Pays "about a month after invoice is submitted." Credit line given. Buys one-time rights.

Tips ''Freelancers should be familiar with *Rhode Island Monthly* and should be able to demonstrate their proficiency in the medium before any work is assigned.''

$☐ ◌ Ⓐ THE ROANOKER

P.O. Box 21535, Roanoke VA 24018. (540)989-6138. Fax: (540)989-7603. E-mail: photos@leisurepublishing.com. Website: www.theroanoker.com. **Contact:** Kurt Rheinheimer, editor. Circ. 14,000. Estab. 1974. Bimonthly. Emphasizes Roanoke region and western Virginia. Readers are upper-income, educated people interested in their community. Sample copy available for $3.

Needs Buys 30 photos from freelancers/issue; 180 photos/year. Needs photos of couples, multicultural, families, parents, senior citizens, architecture, cities/urban, education, interiors/decorating, entertainment, events, food/drink, health/fitness/beauty, performing arts, sports, travel, business concepts, medicine, technology/computers, seasonal. Needs ''travel and scenic photos in western Virginia; color photo essays on life in western Virginia.'' Model/property release preferred. Photo captions required.

Making Contact & Terms Send any size glossy color prints and transparencies (preferred) by mail with SASE for consideration. Accepts images in digital format. Send via CD, Zip, e-mail as TIFF, EPS, GIF, JPEG files at 300 dpi, minimum print size 4×6 with cutlines and thumbnails. Responds in 1 month. Simultaneous submissions and previously published work OK. Pays $100-150 for color cover; $15-25 for b&w inside; $25-100 for color inside; $100/day. Pays on publication. Credit line given. Rights purchased vary; negotiable.

ROCKFORD REVIEW

P.O. Box 858, Rockford IL 61105. Website: http://writersguild1.tripod.com. **Contact:** David Ross, editor. Circ. 750. Estab. 1982. Association publication of Rockford Writers' Guild. Published twice/year (summer and winter). Emphasizes poetry and prose of all types. Readers are of all stages and ages who share an interest in quality writing and art. Sample copy available for $9.

- This publication is literary in nature and publishes very few photographs. However, the photos on the cover tend to be experimental (e.g., solarized images, photograms, etc.).

Needs Uses 1-5 photos/issue; all supplied by freelancers. Needs photos of scenics and personalities. Model/property release preferred. Photo captions preferred; include when and where, and biography.

Specs Uses 8×10 or 5×7 glossy b&w prints.

Making Contact & Terms Send unsolicited photos by mail for consideration. Does not keep samples on file; include SASE for return of material. Responds in 6 weeks. Simultaneous submissions OK. Payment is one copy of magazine, but work is eligible for *Review*'s $25 Editor's Choice prize. Pays on publication. Credit line given. Buys first North American serial rights.

Tips ''Experimental work with a literary magazine in mind will be carefully considered. Avoid the 'news' approach.''

$☐ ◌ ROLLING STONE

1290 Avenue of the Americas, 2nd Floor, New York NY 10104-0295. (212)484-1616. Fax: (212)767-8203. Website: www.rollingstone.com. **Contact:** Jodi Peckman, director of photography. Circ. 1,254,148. Estab. 1967. Biweekly consumer magazine geared towards young adults interested in news of popular music, politics and culture. Contents emphasize film, CD reviews, music groups, celebrities, fashion. Photo guidelines available on website.

Needs Needs photos of celebrities, political, entertainment, events. Interested in alternative process, avant garde, documentary, fashion/glamour.

Specs Accepts images in digital format. Send as TIFF, JPEG files at 300 dpi.

Making Contact & Terms Portfolio may be dropped off every Wednesday and picked up on Friday afternoon. Provide business card, self-promotion piece to be kept on file for possible future assignments. Responds only if interested; send nonreturnable samples.

Tips ''It's not about a photographer's experience, it's about a photographer's talent and eye. Lots of photographers have years of professional experience but their work isn't for us. Others might not have years of experience, but they have this amazing eye.''

$ ROMANTIC HOMES

Y-Visionary Publishing, LP, 265 S. Anita Dr., Suite 120, Orange CA 92868-3310. (714)939-9991. Fax: (714)939-9909. Website: www.romantichomes.com. **Contact:** Hillary Black, visuals editor. Circ. 140,000. Estab. 1983. Monthly magazine for women who want to create a warm, intimate and casually elegant home. Provides

how-to advice, along with information on furniture, floor and window coverings, artwork, travel, etc. Sample copy available for SASE.

Needs Buys 20-30 photos from freelancers/issue; 240-360 photos/year. Needs photos of gardening, interiors/decorating, travel. Reviews photos with accompanying ms only. Model/property release required. Photo captions preferred.

Specs Uses $2^1/_4 \times 2^1/_4$ transparencies.

Making Contact & Terms Send query letter with transparencies, stock list. Provide self-promotion piece to be kept on file for possible future assignments. Responds in 3 weeks. Simultaneous submissions OK. **Pays on acceptance**. Credit line given. Buys all rights; negotiable.

Ⓝ ▣ THE ROTARIAN

1560 Sherman Ave., Evanston IL 60201. (847)866-3000. Fax: (847)866-9732. E-mail: lawrende@rotaryintl.org. Website: www.rotary.org. **Contact:** Deborah Lawrence, creative director, or Alyce Henson, photo editor. Circ. 500,000. Estab. 1911. Monthly organization magazine for Rotarian business and professional men and women and their families. "Dedicated to business and professional ethics, community life, and international understanding and goodwill." Sample copy and photo guidelines free with SASE.

Needs Buys 5 photos from freelancers/issue; 60 photos/year. "Our greatest needs are for assigned location photography that is specific to Rotary, i.e. humanitarian projects, fundraisers, conventions. Photo captions essential."

Specs Uses 35mm, $2^1/_4 \times 2^1/_4$, 4×5 transparencies. Accepts digital images at 300 dpi, 24MB files.

Making Contact & Terms Send query e-mail with résumé of credits, fee schedule and link to website. Creative director will contact photographer for portfolio review if interested. Portfolio should include color slides, tearsheets and transparencies. Keeps samples on file. Include SASE for return of material. Responds in 3 weeks. Simultaneous submissions and previously published work OK. Payment negotiable. **Pays on acceptance**. Credit line given. Buys one-time rights; occasionally all rights; negotiable.

Tips "We prefer high-resolution digital images in most cases. The key words for the freelance photographer to keep in mind are *internationality* and *variety*. Study the magazine. Read the kinds of articles we publish. Think how your photographs could illustrate such articles in a dramatic, storytelling way. Key submissions are general interest, art-of-living material."

$▣ ◯ Ⓐ RUGBY MAGAZINE

459 Columbus Ave., Suite 1200, New York NY 10024. (212)787-1160. Fax: (212)787-1161. E-mail: rugbymag@aol.com. Website: www.rugbymag.com. **Contact:** Ed Hagerty, publisher. Circ. 10,000. Estab. 1975. Magazine published 12 times/year. Emphasizes rugby matches. Readers are male and female, wealthy, well-educated, ages 16-60. Sample copy available for $4 with $1.25 postage.

Needs Uses 20 photos/issue, mostly supplied by freelancers. Needs rugby action shots. Reviews photos with accompanying ms only.

Specs Uses color or b&w prints. Accepts images in digital format. Send as high-res JPEG or TIFF files at 300 dpi.

Making Contact & Terms Send unsolicited photos by mail with SASE for consideration. Provide résumé, business card, brochure, flier or tearsheets to be kept on file for possible future assignments. Responds in 2 weeks. Simultaneous submissions and previously published work OK. "We only pay when we assign a photographer. Rates are very low, but our magazine is a good place to get some exposure." Pays on publication. Credit line given. Buys one-time rights.

$▣ RURAL HERITAGE

281 Dean Ridge Lane, Gainesboro TN 38562-5039. (931)268-0655. E-mail: editor@ruralheritage.com. Website: www.ruralheritage.com. **Contact:** Gail Damerow, editor. Circ. 8,000. Estab. 1976. Bimonthly journal in support of modern-day farming and logging with draft animals (horses, mules, oxen). Sample copy available for $8 ($10 outside the US).

Needs "Quality photographs of draft animals working in harness."

Specs "For covers we use color vertical shots, 5×7 glossy (color or 35mm slide), or high-quality digital. Digital images must be original (not resized, cropped, etc.) high-resolution files from a digital camera; scans unacceptable."

Making Contact & Terms Send query letter with samples. "Please include SASE for the return of your material, and put your name and address on the back of each piece." Pays $100 for color cover; $10-25 for b&w inside. Also provides 2 copies of issue in which work appears. Pays on publication.

Tips "Animals usually look better from the side than from the front. We like to see all the animal's body parts, including hooves, ears and tail. For animals in harness, we want to see the entire implement or vehicle. We prefer action shots (plowing, harvesting hay, etc.). Watch out for shadows across animals and people. Please include the name of any human handlers involved, the farm, the town (or county), state, and the animals' names (if possible) and breeds. You'll find current guidelines in the business office of our website."

$☐ RUSSIAN LIFE MAGAZINE

P.O. Box 567, Montpelier VT 05601. (802)223-4955. E-mail: editors@russianlife.net. Website: www.russianlife.net. **Contact:** Paul Richardson, publisher. Estab. 1956. Bimonthly magazine.
Needs Uses 25-35 photos/issue. Offers 10-15 freelance assignments/year. Needs photojournalism related to Russian culture, art and history. Model/property release preferred.
Making Contact & Terms Works with local freelancers only. Send query letter with samples. Send 35mm, 2¼×2¼, 4×5, 8×10 transparencies; 35mm film; digital format. Include SASE "or material will not be returned." Responds in 1 month. Pays $20-50 (color photo with accompanying story), depending on placement in magazine. Pays on publication. Credit line given. Buys one-time and electronic rights.

$ $☐ ☑ SAIL MAGAZINE

98 N. Washington St., 2nd Floor, Boston MA 02114. (617)720-8600. Fax: (617)723-0912. E-mail: sailmail@primediasi.com. Website: www.sailmagazine.com. **Contact:** Elizabeth B. Wrightson, photo editor. Circ. 200,000. Estab. 1970. Monthly magazine. Emphasizes all aspects of sailing. Readers are managers and professionals, average age 44. Photo guidelines free with SASE and on website.
Needs Buys 20 photos from freelancers/issue; 240 photos/year. "We are particularly interested in photos for our 'Under Sail' section. Photos for this section should be original 35mm transparencies only and should humorously depict some aspect of sailing." Vertical cover shots also needed. Photo captions preferred.
Specs Accepts images in digital format. Send via CD, Zip as TIFF files at 300 dpi. Accepts all forms of transparencies and prints with negatives.
Making Contact & Terms Send unsolicited 35mm and 2¼×2¼ transparencies by mail with SASE for consideration. Pays $700 for color cover; $25-800 for color inside; also negotiates prices on a per day, per hour and per job basis. Pays on publication. Credit line given. Buys one-time North American rights.

$ $☐ ☑ SAILING WORLD

55 Hammarlund Way, Middletown RI 02842. (401)845-5147. Fax: (401)845-5180. Website: www.sailingworld.com. **Contact:** Dave Reed, managing editor. Associate Art Director: Joan Westman. Circ. 65,000. Estab. 1962. Monthly magazine. Emphasizes performance sailing and racing for upper-income sailors. Readers are males ages 35-45, females ages 25-35 who are interested in sailing. Sample copy available for $7. Photo guidelines available on website.
Needs Needs photos of adventure, health/fitness, humor, sports. "We will send an updated e-mail listing our photo needs on request." Freelance photography in a given issue: 20% assignment and 80% freelance stock. Covers most sailing races.
Specs Uses 35mm for covers; vertical and square (slightly horizontal) formats; digital 300-dpi 5×7 JPEGs.
Making Contact & Terms Responds in 1 month. Pays $650 for cover; $75-400 for inside. Pays on publication. Credit line given. Buys first North American serial rights.
Tips "We look for photos that are unusual in composition, lighting and/or color that feature performance sailing at its most exciting. We would like to emphasize speed, skill, fun and action. Photos must be of high quality. We prefer Fuji Velvia film. We have a format that allows us to feature work of exceptional quality. A knowledge of sailing and experience with on-the-water photography is a requirement. Please call with specific questions or interests. We cover current events and generally only use photos taken in the past 30-60 days."

$☐ ☑ SANDLAPPER MAGAZINE

P.O. Box 1108, Lexington SC 29071. Fax: (803)359-0629. E-mail: aida@sandlapper.org. Website: www.sandlapper.org. **Contact:** Aida Rogers, managing editor. Estab. 1989. Quarterly magazine. Emphasizes South Carolina topics *only*.
Needs Uses about 10 photographers/issue. Needs photos of anything related to South Carolina in any style, "as long as they're not in bad taste." Model release preferred. Photo captions required; include places and people.
Specs Uses 8×10 color and b&w prints; 35mm, 2¼×2¼, 4×5, 8×10 transparencies. Accepts images in

digital format. Send via CD, Zip as TIFF, JPEG files at 300 dpi. Do not format exclusively for PC. RGB preferred. Submit low-resolution and high-resolution files, and label them as such. Please call or e-mail Elaine Gillespie with any questions about digital submissions: (803)779-2126; elaine@thegillespieagency.com.

Making Contact & Terms Send query letter with samples. Keeps samples on file; include SASE for return of material. Responds in 1 month. Pays $100 for color cover; $50-100 for color inside. Pays 1 month *after* publication. Credit line given. Buys first rights plus right to reprint.

Tips "Looking for any South Carolina topic—scenics, people, action, mood, etc."

SANTA BARBARA MAGAZINE

25 E. De la Guerra St, Santa Barbara CA 93101. (805)965-5999. Fax: (805)965-7627. Website: www.sbmag.com. **Contact:** Jennifer Smith Hale, publisher. Art Director: Alisa Baur. Editor: Wendy Janson. Circ. 40,000. Estab. 1975. Bimonthly magazine. Emphasizes Santa Barbara community and culture. Sample copy available for $4.95 with 9×12 SASE.

Needs Buys 64-80 photos from freelancers/issue; 384-480 photos/year. Needs portrait, environmental, architectural, travel, celebrity, et al. Reviews photos with accompanying ms only. Model release required. Photo captions preferred.

Making Contact & Terms Provide résumé, business card, brochure, flier or tearsheets to be kept on file for possible future assignments; "portfolio drop-off 24 hours." Cannot return unsolicited material. Pays $75-250 for b&w or color. Pays on publication. Credit line given. Buys first North American serial rights.

Tips Prefers to see strong personal style and excellent technical ability. "Work needs to be oriented to our market. Know our magazine and its orientation before contacting me."

$ SCHOLASTIC MAGAZINES

568 Broadway, New York NY 10012. (212)343-7147. Fax: (212)343-7799. E-mail: sdiamond@scholastic.com. Website: www.scholastic.com. **Contact:** Steven Diamond, executive director of photography. Estab. 1920. Publication of magazine varies from weekly to monthly. "We publish 27 titles on topics from current events, science, math, fine art, literature and social studies. Interested in featuring high-quality, well-composed images of students of all ages and all ethnic backgrounds."

Needs Needs photos of various subjects depending upon educational topics planned for academic year. Model release required. Photo captions required. "Images must be interesting, bright and lively!"

Specs Accepts images in digital format. Send via CD, e-mail.

Making Contact & Terms Send query letter with résumé, business card, brochure, flier or tearsheets to be kept on file for possible future assignments. Material cannot be returned. Previously published work OK. Pays on publication.

Tips Especially interested in good photography of all ages of student population.

$$ SCIENTIFIC AMERICAN

415 Madison Ave., New York NY 10017. (212)451-8891. Fax: (212)755-1976. E-mail: eharrison@sciam.com. Website: www.sciam.com. **Contact:** Emily Harrison, photography editor. Circ. 900,000. Estab. 1854. Emphasizes science technology and people involved in science. Readers are mostly male, ages 15-55.

Needs Buys 100 photos from freelancers/issue. Needs photos of science and technology, personalities, photojournalism and how-to shots; especially "amazing science photos." Model release required; property release preferred. Photo captions required.

Making Contact & Terms Arrange personal interview to show portfolio. "Do not send unsolicited photos." Provide résumé, business card, brochure, flier or tearsheets to be kept on file for possible future assignments. Cannot return material. Responds in 1 month. Pays $600/day; $1,000 for color cover. Pays on publication. Credit line given. Buys one-time rights and world rights.

Tips Wants to see strong natural and artificial lighting, location portraits and location shooting. "Send business cards and promotional pieces frequently when dealing with magazine editors. Find a niche."

SCOUTING MAGAZINE

Boy Scouts of America Magazine Division, 1325 W. Walnut Hill Lane, Irving TX 75038. (972)580-2358. Fax: (972)580-2079. Website: www.scoutingmagazine.org. **Contact:** Photo Editor. Circ. 1 million. Published 6 times/year. Magazine for adults within the Scouting movement.

• Boy Scouts of America Magazine Division also publishes *Boys' Life* magazine.

Needs Assigns 90% of photos; uses 10% from stock. Needs photos dealing with success and/or personal interest of leaders in Scouting. Photo captions required.

Making Contact & Terms Send written query with ideas. Pays $500 base editorial day rate against placement fees. **Pays on acceptance.** Buys one-time rights.

Tips Study the magazine carefully.

$ ▣ ○ SEA, America's Western Boating Magazine

17782 Cowan, Irvine CA 92614. (949)660-6150. Fax: (949)660-6172. E-mail: editorial@goboatingamerica.com. Website: www.goboatingamerica.com. **Contact:** Holly Simpson, managing editor. Associate Editor and Publisher: Jeff Fleming. Circ. 60,000. Monthly magazine. Emphasizes "recreational boating in 13 western states (including some coverage of Mexico and British Columbia) for owners of recreational power boats." Sample copy and photo guidelines free with 10×13 SAE.

Needs Uses about 50-75 photos/issue; most supplied by freelancers; 10% assignment; 90% requested from freelancers, existing photo files, or submitted unsolicited. Needs "people enjoying boating activity (families, parents, senior citizens) and scenic shots (travel, regional); shots that include parts or all of a boat are preferred." Special needs include "vertical-format shots involving power boats for cover consideration." Photos should have West Coast angle. Model release required. Photo captions required.

Specs Accepts images in digital format. Send via CD, SyQuest, floppy disk, Zip, e-mail as TIFF, EPS, JPEG files at 266 dpi.

Making Contact & Terms Send query letter with samples; include SASE for return of material. Responds in 1 month. Pays $250 for color cover; inside photo rate varies according to size published (range is $50-200 for color). Pays on publication. Credit line given. Buys one-time North American rights and retains reprint rights via print and electronic media.

Tips "We are looking for sharp color transparencies with good composition showing pleasure boats in action, and people having fun aboard boats in a West Coast location. Digital shots are preferred; they must be at least 5 inches wide and a minimum of 300 dpi. We also use studio shots of marine products and do personality profiles. Black & white also accepted, for a limited number of stories. Color preferred. Send samples of work with a query letter and a résumé or clips of previously published photos. No phone calls, please; *Sea* does not pay for shipping; will hold photos up to 6 weeks."

Ⓝ $ $▣ ⊘ Ⓐ SEATTLE HOMES AND LIFESTYLES

Wiesner Publishing, 1221 E. Pike St., Suite 305, Seattle WA 98122. (206)322-6699. Fax: (206)322-2799. E-mail: swilliams@seattlehomesmag.com. Website: www.seattlehomesmag.com. **Contact:** Shawn Williams, art director. Circ. 30,000. Estab. 1996. Magazine published 8 times/year. Emphasizes home design, gardens, architecture, lifestyles (profiles, food, wine). Sample copy available for $3.95 and SAE.

Needs Buys 35-60 photos from freelancers/issue; 200 photos/year. Needs photos of architecture, interior design, gardening, entertainment, events, food/drink. Interested in fine art, seasonal. All work is commissioned specifically for magazine. Model release required. Photo captions required. "Do not send photos without querying first."

Specs Uses 35mm, 2¼×2¼, 4×5 transparencies. Accepts images in digital format.

Making Contact & Terms Send query letter with résumé, photocopies, tearsheets. Provide self-promotion piece to be kept on file for possible future assignments. Responds only if interested; send nonreturnable samples. Payment varies by assignment, $140-450, depending on number of photos and complexity of project. **Pays on acceptance**. Credit line given. Buys one-time rights, first rights; includes Web usage for one year.

Tips "We primarily use experienced architectural and interior photographers for home-design stories; garden photographers and portrait photographers for profiles and occasional celebrity profiles. Photographers must be in Seattle area."

Ⓐ SEVENTEEN MAGAZINE

1440 Broadway, 13th Floor, New York NY 10018. (917)934-6500. Website: www.seventeen.com. *Seventeen* is a young women's fashion and beauty magazine. Tailored to young women in their teens and early 20s, *Seventeen* covers fashion, beauty, health, fitness, food, cars, college, careers, talent, entertainment, fiction, plus crucial personal and global issues. Photos usually by assignment only. **Query before submitting**.

$▣ ⊘ SHARING THE VICTORY

Fellowship of Christian Athletes, 8701 Leeds Rd., Kansas City MO 64129. (816)921-0909. Fax: (816)921-8755. E-mail: stv@fca.org. Website: www.fca.org. **Contact:** Jill Ewert, managing editor. Circ. 80,000. Estab. 1982. Monthly association magazine featuring stories and testimonials of prominent athletes and coaches in sports

who proclaim a relationship with Jesus Christ. Sample copy available for $1 and 9×12 SAE. Photo guidelines not available.

Needs Needs photos of sports. "We buy photos of persons being featured in our magazine. We don't buy photos without story being suggested first." Reviews photos with accompanying ms only. "All submitted stories must be connected to the FCA Ministry." Model release preferred; property release required. Photo captions preferred.

Specs Uses glossy or matte color prints; 35mm, 2¼×2¼ transparencies. Accepts images in digital format. Send via CD, Zip, e-mail as TIFF, JPEG files at 300 dpi.

Making Contact & Terms Contact through e-mail with a list of types of sports photographs in stock. **Do not send samples**. Simultaneous submissions OK. Pays $150 maximum for color cover; $100 maximum for color inside. Pays on publication. Credit line given. Buys one-time rights.

Tips "We would like to increase our supply of photographers who can do contract work."

$▣ ◙ SHINE BRIGHTLY

P.O. Box 7259, Grand Rapids MI 49510. (616)241-5616. Fax: (616)241-5558. E-mail: christina@gemsgc.org. Website: www.gemsgc.org. **Contact:** Christina Malone, managing editor. Circ. 15,500. Estab. 1970. Monthly publication of GEMS Girls' Club. Emphasizes "girls ages 9-14 in action. The magazine is a Christian girls' publication geared to the needs and activities of girls in the above age group." Sample copy and photo guidelines available for $1 with 9×12 SASE. "Also available is a theme update listing all the themes of the magazine for one year."

Needs Uses about 5-6 photos/issue. Needs "photos suitable for illustrating stories and articles: photos of babies/children/teens, multicultural, religious, girls aged 9-14 from multicultural backgrounds, close-up shots with eye contact." Model/property release preferred.

Specs Uses 5×7 glossy color prints. Accepts images in digital format. Send via Zip, CD as TIFF, BMP files at 300 dpi.

Making Contact & Terms Send 5×7 glossy color prints by mail (include SASE), electronic images by CD only (no e-mail) for consideration. Will view photographer's website if available. Responds in 2 months. Simultaneous submissions OK. Pays $50-75 for cover, $35 for color inside. Pays on publication. Credit line given. Buys one-time rights.

Tips "Make the photos simple. We prefer to get a spec sheet or CDs rather than photos, and we'd really like to hold photos sent to us on speculation until publication. We select those we might use and send others back. Freelancers should write for our annual theme update and try to get photos to fit the theme of each issue." Recommends that photographers "be concerned about current trends in fashions and hair styles, and realize that all girls don't belong to 'families.' Please, no slides, no negatives and no e-mail submissions."

◙ SHOTS

P.O. Box 27755, Minneapolis MN 55427-0755. E-mail: shotsmag@juno.com. Website: www.shotsmag.com. **Contact:** Russell Joslin, editor/publisher. Circ. 3,000. Quarterly fine art photography magazine. "*Shots* publishes b&w fine art photography by photographers with an innate passion for personal, creative work." Sample copy available for $5. Photo guidelines free with SASE or on website.

Needs Fine art photography of all types accepted (but not bought). Reviews photos with or without ms. Model/property release preferred. Photo captions preferred.

Specs Uses 8×10 b&w prints.

Making Contact & Terms Send query letter with prints. There is a $12 submission fee for nonsubscribers (free for subscribers). Include SASE for return of material. Responds in 3 months. Credit line given. Does not buy photographs/rights.

$$▣ ◙ SHOWBOATS INTERNATIONAL

910 SE 17th St., Suite 400, Ft. Lauderdale FL 33316. (954)525-8626. Fax: (954)525-7954. (Art department located at 29160 Heathercliff Rd., Suite 200, Malibu CA 90265; (310)589-7700.) E-mail: info@showboats.com. Website: www.showboats.com. **Contact:** Jill Bobrow, editor. Circ. 60,000. Estab. 1981. Publishes 8 issues/ year with annual charter issue. Emphasizes primarily large yachts (80 feet or over). Readers are mostly male, 40-plus years of age, incomes above $1 million, international. Sample copy available for $7.

● This publication has received 20 Florida Magazine Association Awards plus two Ozzies since 1989.

Needs Buys 72-120 photos from freelancers/issue; 432-720 photos/year. Needs photos of very large yachts and exotic destinations. "Almost all shots are commissioned by us." Color photography only. Model/property release required. Photo captions preferred.

Specs Accepts images in digital format. Send via CD, e-mail (high resolution).

Making Contact & Terms Arrange personal interview to show portfolio. Send query letter with résumé of credits, business card, brochure, flier or tearsheets to be kept on file for possible future assignments. Responds in 3 weeks. Previously published work OK, however, exclusivity is important. Pays $500 for color cover; $125-375 color page rate; $800-1,000/day. Pays on publication. Credit line given. Buys first serial rights, all rights; negotiable.

Tips Looking for excellent control of lighting; extreme depth of focus; well-saturated transparencies. Prefers to work with photographers who can supply both exteriors and beautiful, architectural-quality interiors. "Don't send pictures that need any excuses. The larger the format, the better. Send samples. Exotic location shots should include yachts."

$ ▣ ◪ SKATING

20 First St., Colorado Springs CO 80906-3697. (719)635-5200. Fax: (719)635-9548. E-mail: skatingmagazine@ usfigureskating.org. Website: www.usfigureskating.org. **Contact:** Editor. Circ. 45,000. Estab. 1923. Magazine published 10 times/year. Publication of The United States Figure Skating Association. Emphasizes competitive figure skating. Readers are primarily active skaters, coaches, officials and girls who spend up to 15 hours per week skating. Sample copy available for $3.

Needs Buys 22 photos from freelancers/issue; 220 photos/year. Needs sports action shots of national and world-class figure skaters; casual, off-ice shots of skating personalities, children on the ice, learning to skate in structured classes; and synchronized skating shots. Model/property release required. Photo captions preferred; include who, what, when, where.

Specs Uses $3\frac{1}{2} \times 5$, 4×6, 5×7 glossy color prints; 35mm transparencies. Prefers images in digital format. Send via CD, Zip, e-mail as TIFF files at 300 dpi.

Making Contact & Terms Send unsolicited photos by mail for consideration. Keeps samples on file. Cannot return material. Responds in 1 month. Pays $50 maximum for color cover; $15 for b&w inside; $25 for color inside. Pays on publication. Credit line given. Buys one-time rights; negotiable.

Tips "We look for a mix of full-body action shots of skaters in dramatic skating poses and tight, close-up or detail shots that reveal the intensity of being a competitor. Shooting in ice arenas can be tricky. Flash units are prohibited during skating competitions; therefore, photographers need fast, zoom lenses that will provide the proper exposure, as well as stop the action. I am always open to excellent-quality on-ice or off-ice photos of U.S. competitive skaters. I am looking for more off-ice, personality-driven photos. Also in need of good photos detailing synchronized skating—an up-and-coming discipline. I have very few good file photos of synchro and will most likely make use of quality close-up photos."

$ $ ▣ ◪ SKI CANADA

117 Indian Rd., Toronto ON M6R 2V5 Canada. (416)538-2293. Fax: (416)538-2475. E-mail: mac@skicanadam ag.com. Website: http://travel.canoe.ca/SkiCanada/home.html. **Contact:** Iain MacMillan, editor. Magazine published monthly, September-February. Readership is 65% male, ages 25-44, with high income. Circ. 50,000. Sample copy free with SASE.

Needs Buys 80 photos from freelancers/issue; 480 photos/year. Needs photos of skiing—travel (within Canada and abroad), new school, competition, equipment, instruction, news and trends. Photo captions preferred.

Specs Uses 35mm color transparencies. Accepts images in digital format. Send via e-mail.

Making Contact & Terms Send unsolicited photos by mail for consideration; include SASE for return of material. Provide résumé, business card, brochure, flier or tearsheets to be kept on file for possible future assignments. Responds in 1 month. Simultaneous submissions OK. Pays $400 for cover; $50-200 for inside. Pays within 30 days of publication. Credit line given.

Tips "Please see http://travel.canoe.ca/SkiCanada/mediakit.html#editorial for the annual editorial lineup."

▣ ◯ SKIPPING STONES: A Multicultural Children's Magazine

P.O. Box 3939, Eugene OR 97403. (541)342-4956. E-mail: skipping@efn.org. Website: www.skippingstones.o rg. **Contact:** Arun N. Toké, managing editor. Circ. 2,500. Estab. 1988. Nonprofit, noncommercial magazine published 5 times/year. Emphasizes multicultural and ecological issues. Readers are youth ages 8-16, their parents and teachers, schools and libraries. Sample copy available for $6 (including postage). Photo guidelines free with SASE.

Needs Buys 10-15 photos from freelancers/issue; 50 photos/year. Needs photos of animals, wildlife, children

ages 8-16, cultural celebrations, international, travel, school/home life in other countries or cultures. Model release preferred. Photo captions preferred; include site, year, names of people in photo.

Specs Uses 4×6, 5×7 glossy color and/or b&w prints. Accepts images in digital format. Send via CD as TIFF, JPEG files at 300 dpi.

Making Contact & Terms Send unsolicited photos by mail for consideration. Keeps samples on file; include SASE for return of material. Responds in 4 months. Simultaneous submissions OK. Pays in contributor's copies; "we're a labor of love." For photo essays, "we provide 5-10 copies to contributors. Additional copies at a 25% discount." Credit line given. Buys first North American serial rights and nonexclusive reprint rights; negotiable.

Tips "We publish b&w inside; color on cover. Should you send color photos, choose the ones with good contrast that can translate well into b&w photos. We are seeking meaningful, humanistic, and realistic photographs."

⊘ SMITHSONIAN

MRC 951, P.O. Box 37012, Washington DC 20012-7012. (202)275-2000. Fax: (202)275-1972. Website: www.smithsonianmag.si.edu. *Smithsonian* magazine chronicles the arts, environment, sciences and popular culture of the times for today's well-rounded individuals with diverse, general interests, providing its readers with information and knowledge in an entertaining way. **Does not accept unsolicited photos or portfolios. Call or query before submitting.**

$⊘ SOAPS IN DEPTH

Bauer Publishing, 270 Sylvan Ave., Englewood Cliffs NJ 07632. (201)569-6699. Fax: (201)569-4031. E-mail: soapsindepth@bauerpublishing.com. **Contact:** Lois, administrative assistant. Weekly magazine emphasizing soap operas.

Needs Wants photos of celebrities.

$ $▣ Ⓢ SOUTHERN BOATING

Southern Boating & Yachting, Inc., 330 N. Andrews Ave., Ft. Lauderdale FL 33301. (954)522-5515. Fax: (954)522-2260. E-mail: bill@southernboating.com. Website: www.southernboating.com. **Contact:** Bill Lindsey, executive editor. Circ. 40,000. Estab. 1972. Monthly magazine. Emphasizes "boating (mostly power, but also sail) in the southeastern U.S., Bahamas and the Caribbean." Readers are "concentrated in 30-50 age group, male and female, affluent—executives mostly." Sample copy available for $5.

Needs Number of photos/issue varies; all supplied by freelancers. Seeks "boating lifestyle" cover shots. Buys stock only. No "assigned covers." Model release preferred. Photo captions required.

Specs Accepts images in digital format. Send via CD, floppy disk, e-mail as JPEG, TIFF files at 300 dpi minimum.

Making Contact & Terms Send query letter with list of stock photo subjects, SASE. Response time varies. Simultaneous submissions and previously published work OK. Pays $400 minimum for color cover; $50 minimum for color inside; $200-500 for photo/text package. Pays within 30 days of publication. Credit line given. Buys one-time print and electronic/website rights.

Tips "We want lifestyle shots of saltwater cruising, fishing or just relaxing on the water. Lifestyle shots are actively sought."

$▣ Ⓢ SPECIALIVING

P.O. Box 1000, Bloomington IL 61702. (309)820-9277. E-mail: gareeb@aol.com. Website: www.speciaLiving.com. **Contact:** Betty Garee, publisher. Circ. 12,000. Estab. 2001. Quarterly consumer magazine for physically disabled people. Travel, home modifications, products, info, inspiration. Sample copy available for $3.50.

Needs Any events/settings that involve physically disabled people (who use wheelchairs), not developmentally disabled. Reviews photos with or without ms. Model release preferred. Photo captions required.

Specs Uses glossy or matte color and/or b&w prints. Accepts images in digital format. Send via CD, Zip, e-mail as TIFF, JPEG files at 300 dpi.

Making Contact & Terms Send query letter with prints. Does not keep samples on file; include SASE for return of material. Responds in 3 weeks. Simultaneous submissions and previously published work OK. Pays $50 minimum for b&w cover; $100 maximum for color cover; $10 minimum for b&w or color inside. Pays on publication. Credit line given. Buys one-time rights.

Tips "Need good-quality photos of someone in a wheelchair involved in an activity. Need caption and where I can contact subject to get story if wanted."

$ 🖳 ☑ SPEEDWAY ILLUSTRATED

Performance Media LLC, 107 Elm St., Salisbury MA 01952. (978)465-9099. Fax: (978)465-9033. E-mail: thanke @speedwayillustrated.com. Website: www.speedwayillustrated.com. **Contact:** Tim Hanke, managing editor. Circ. 125,000. Estab. 2000. Monthly auto racing magazine that specializes in stock cars. Sample copies and photo guidelines available.

Needs Buys 75 photos from freelancers/issue; 1,000 photos/year. Needs photos of automobiles, entertainment, events, humor, sports. Reviews photos with or without ms. Model release required. Photo captions required.

Specs Prefers images in digital format. Send via CD-ROM at high resolution.

Making Contact & Terms Send query letter and CD-ROM with photos and captions. Provide business card to be kept on file for possible future assignments. Responds in 1 week to queries. Pays $250 minimum for color cover; $40 for inside. Pays on publication. Credit line given. Buys first rights.

Tips "Send only your best stuff."

🅽 $ 🖳 ◯ SPFX: SPECIAL EFFECTS MAGAZINE

181 Robinson St., Teaneck NJ 07666. (201)833-5153. E-mail: thedeadlyspawn@aol.com. Website: www.dead lyspawn.net/spfxmagazine.html. **Contact:** Ted A. Bohus, editor. Circ. 6,000-10,000. Estab. 1978. Biannual film magazine emphasizing science fiction, fantasy and horror films past, present and future. Includes feature articles, interviews and rare photos. Sample copy available for $5. Photo guidelines free.

Needs Needs film stills and film personalities. Reviews photos with or without ms. Special photo needs include rare film photos. Model/property release preferred. Photo captions preferred.

Specs Uses any size prints. Accepts images in digital format. Send via floppy disk, CD, Jaz, Zip, e-mail as TIFF, EPS files at 300 dpi.

Making Contact & Terms Send query letter with samples. Provide résumé, business card, self-promotion piece or tearsheets to be kept on file for possible future assignments. To show portfolio, photographer should follow up with letter after initial query. Art director will contact photographer for portfolio review if interested. Portfolio should include b&w and/or color, prints, tearsheets, slides, transparencies or thumbnails. Responds only if interested; send nonreturnable samples. Previously published work OK. Pays $150-200 for color cover; $10-50 for b&w and color inside. Pays on publication. Credit line given.

$ $ $ 🖳 ☑ SPORT FISHING

P.O. Box 8500, Winter Park FL 32790. (407)628-5662. Fax: (407)628-7061. E-mail: editor@sportfishingmag.c om. Website: www.sportfishingmag.com. **Contact:** Ted Lund, managing editor. Circ. 150,000 (paid). Estab. 1986. Publishes 9 issues/year. Emphasizes saltwater sport fishing. Readers are upscale boat owners and affluent fishermen. Sample copy available for $2.50, 9×12 SAE and 6 first-class stamps. Photo guidelines available via website, e-mail or with SASE.

Needs Buys 37 photos from freelancers/issue; 333 photos/year. Needs photos of saltwater fish and fishing—especially good action shots. "We are working more from stock—good opportunities for extra sales on any given assignment." Model release preferred; releases needed for subjects (under "unusual" circumstances) in photo.

Specs Uses 35mm, $2\frac{1}{4} \times 2\frac{1}{4}$, 4×5 transparencies. "Fuji Velvia 50 or Fuji Provia 100 preferred." Accepts images in digital format. E-mail for information on submitting.

Making Contact & Terms Send query letter with samples. Send unsolicited photos by mail for consideration. Provide résumé, business card, brochure, flier or tearsheets to be kept on file for possible future assignments. Responds in 3 weeks. Pays $1,000 for cover; $75-400 for inside. Buys one-time rights unless otherwise agreed upon.

Tips "Tack-sharp focus critical; avoid 'kill' shots of big game fish, sharks; avoid bloody fish in/at the boat. The best guideline is the magazine itself. Know your market. Get used to shooting on, in, or under water. Most of our needs are found there. If you have first-rate photos and questions, e-mail us."

SPORTS ILLUSTRATED

AOL/Time Warner, Time Life Building, 135 W. 50th St., New York NY 10020. (212)522-1212. Website: www.si.com. **Contact:** Photo Editor. *Sports Illustrated* reports and interprets the world of sports, recreation and active leisure. It previews, analyzes and comments on major games and events, as well as those noteworthy for character and spirit alone. In addition, the magazine has articles on such subjects as fashion, physical fitness and conservation. **Query before submitting.**

$ ▣ SPORTSCAR

16842 Von Karman Ave., Suite 125, Irvine CA 92606. (949)417-6700. Fax: (949)417-6115. E-mail: sportscar@r acer.com. Website: www.sportscarmag.com. **Contact:** Richard James, editor. Circ. 50,000. Estab. 1944. Monthly magazine of the Sports Car Club of America. Emphasizes sports car racing and competition activities. Sample copy available for $2.95.

Needs Uses 75-100 photos/issue; 75% from assignment and 25% from freelance stock. Needs action photos from competitive events, personality portraits and technical photos.

Making Contact & Terms Send query letter with résumé of credits, or send 5×7 color or b&w glossy/borders prints or 35mm or 2¼×2¼ transparencies by mail with SASE for consideration. Will accept electronic submissions on CD. Provide résumé, business card, brochure, flier or tearsheets to be kept on file for possible future assignments. Responds in 1 month. Simultaneous submissions OK. Pays $250-400 for color cover; $25-100 for color inside; $10 for b&w inside. Negotiates all other rates. Pays on publication. Credit line given. Buys first North American serial rights.

Tips To break in with this or any magazine, "always send only the absolute best work; try to accommodate the specific needs of your clients. Have a relevant subject, strong action, crystal-sharp focus, proper contrast and exposure. We need good candid personality photos of key competitors and officials."

$ ▣ ◡ Ⓐ SPRINGFIELD! MAGAZINE

Springfield Communications, Inc., P.O. Box 4749, Springfield MO 65808. (417)831-1600. E-mail: pub@sgfma g.com. **Contact:** Bob Glazier, editor. Circ. 10,000. Estab. 1979. Monthly consumer magazine. "We concentrate on the glorious past, exciting future and thrilling present of the Queen City of the Ozarks—Springfield, Missouri. (Extremely provincial!)" Sample copy available for $5.50 and $3 SAE.

Needs Buys 20-25 photos from freelancers/issue; 300 photos/year. Needs photos of babies/children/teens, couples, families, parents, landscapes/scenics, wildlife, education, gardening, humor, travel, computers, medicine, science. Interested in documentary, erotic, fashion/glamour, historical/vintage, seasonal. Other specific photo needs: "We want local personalities in the Queen City of the Ozarks only." Reviews photos with accompanying ms only. Model release required. Photo captions required.

Specs Uses 4×6 or 5×7 glossy color prints. Accepts images in digital format. Send via Zip. "No e-mail submissions, please."

Making Contact & Terms Send query letter with résumé, prints, tearsheets. Provide résumé, business card, self-promotion piece to be kept on file for possible future assignments. Responds in 3 weeks to queries; 6 weeks to portfolios. Responds only if interested; send nonreturnable samples. Pays $100 for color cover; $10 for b&w inside; $20 for color inside. Pays on publication. Credit line given. Buys first rights.

$ ▣ ◯ STICKMAN REVIEW, An Online Literary Journal

2890 N. Fairview Dr., Flagstaff AZ 86004. (928)913-0869. E-mail: art@stickmanreview.com. Website: www.st ickmanreview.com. **Contact:** Anthony Brown, editor. Estab. 2001. Biannual literary magazine publishing fiction, poetry, essays and art for a literary audience. Sample copies available on website.

Needs Buys 2 photos from freelancers/issue; 4 photos/year. Interested in alternative process, avant garde, documentary, erotic, fine art. Reviews photos with or without ms.

Specs Accepts images in digital format. Send via e-mail as TIFF, EPS, JPEG files at 72 dpi.

Making Contact & Terms Contact through e-mail only. Does not keep samples on file; cannot return material. Responds in 1 month to queries; 2 months to portfolios. Simultaneous submissions OK. Pays $25-50. **Pays on acceptance.** Credit line given. Buys electronic rights.

Tips "Please check out the magazine on our website. We are open to anything, so long as its intent is artistic expression."

Ⓝ $ ◨ SUB-TERRAIN MAGAZINE

P.O. Box 3008, MPO, Vancouver BC V6B 3X5 Canada. (604)876-8710. Fax: (604)879-2667. E-mail: subter@po rtal.ca. Website: www.subterrain.ca. **Contact:** Brian Kaufman, managing editor. Estab. 1988. Literary magazine published 3 times/year.

Needs Uses "many" unsolicited photos. Needs "artistic" photos. Photo captions preferred.

Specs Uses color and/or b&w prints.

Making Contact & Terms Submit portfolio for review. Send unsolicited photos by mail for consideration. Keeps samples on file "sometimes." Responds in 6 months. Simultaneous submissions OK. Pays $10-30/ photo (solicited material only). Also pays in contributor's copies. Pays on publication. Credit line given. Buys one-time rights.

Consumer Publications

$ ▣ ☑ THE SUN

107 N. Roberson St., Chapel Hill NC 27516. (919)942-5282. Fax: (919)932-3101. E-mail: info@thesunmagazin e.org. Website: www.thesunmagazine.org. **Contact:** Art Director. Circ. 70,000. Estab. 1974. Monthly literary magazine featuring personal essays, interviews, poems, short stories, photos and photo essays. Sample copy available for $5. Photo guidelines free with SASE or on website.

Needs Buys 10-30 photos/issue; 200-300 photos/year. Needs photos of babies/children/teens, couples, multicultural, families, parents, senior citizens, environmental, landscapes/scenics, cities/urban, education, religious, rural, travel, agriculture, political. Interested in alternative process, documentary, fine art. Model/property release strongly preferred.

Specs Uses 4×5 to 11×17 glossy or matte b&w prints. Slides are not accepted, and color photos are discouraged. "We cannot review images via e-mail or website. If you are submitting digital images, please send high-quality digital prints first. If we accept your images for publication, we will request the image files on CD or DVD media (Mac or PC) in uncompressed TIFF grayscale format at 300 dpi or greater."

Making Contact & Terms Send query letter with prints. Portfolio may be dropped off Monday-Friday. Does not keep samples on file; include SASE for return of material. Responds in 3 months. Simultaneous submissions and previously published work OK. "Submit no more than 30 of your best b&w prints. Please do not e-mail images." Pays $300 for b&w cover; $50-150 for b&w inside. Pays on publication. Credit line given. Buys one-time rights.

Tips "We're looking for artful and sensitive photographs that aren't overly sentimental. We use many photographs of people—though generally not portrait style. We're open to unusual work. Read the magazine to get a sense of what we're about. Send the best possible prints of your work. Our submission rate is extremely high; please be patient after sending us your work. Send return postage and secure return packaging."

Ⓝ ▣ ☑ Ⓐ SURFACE MAGAZINE: American Avant Garde

1663 Mission St., Suite 700, San Francisco CA 9410 3. (415) 575-3100. Fax: (415) 575-3105. E-mail: surfacemag @surfacemag.com. Website: www.surfacemag.com. Circ. 112,000. Estab. 1994. Consumer magazine published 8 times/year.

Needs Buys 200 photos from freelancers/issue; 1,600 photos/year. Needs photos of environmental, landscapes/scenics, architecture, cities/urban, interiors/decorating, events, food/drink, humor, performing arts, travel, product shots/still life, science, technology. Interested in avant garde, fashion/glamour, fine art, seasonal.

Specs Uses 11×17 glossy matte prints; 35mm, $2\frac{1}{4} \times 2\frac{1}{4}$, 4×5, 8×10 transparencies. Accepts images in digital format. Send via CD, Zip as TIFF, JPEG files at 300 dpi.

Making Contact & Terms Contact through rep or send query letter with prints, photocopies, tearsheets. Provide self-promotion piece to be kept on file for possible future assignments. "Portfolios are reviewed on Friday each week. Submitted portfolios must be clearly labelled and include a shipping account number or postage for return. Please call for more details." Responds only if interested; send nonreturnable samples. Simultaneous submissions OK. Credit line given.

$ $ ▣ ☑ SURFING MAGAZINE

P.O. Box 73250, San Clemente CA 92673. (949)492-7873. Fax: (949)498-6485. E-mail: flame@primedia.com. Website: www.surfingthemag.com. **Contact:** Larry Moore, photo editor. Circ. 180,000. Monthly magazine. Emphasizes "surfing action and related aspects of beach lifestyle. Travel to new surfing areas covered as well. Average age of readers is 17 with 95% being male. Nearly all drawn to publication due to high-quality, action-packed photographs." Sample copy available for legal-size SAE and 9 first-class stamps. Photo guidelines free with SASE or via e-mail.

Needs Buys an average of 10 photos from freelancers/issue. Needs "in-tight, front-lit surfing action photos, as well as travel-related scenics. Beach lifestyle photos always in demand."

Specs Uses 35mm transparencies. Accepts digital images via CD; please contact for digital requirements before submitting digital images.

Making Contact & Terms Send samples by mail for consideration; include SASE for return of material. Responds in 1 month. Pays $750-1,000 for color cover; $25-330 for color inside; $600 for color poster photo. Pays on publication. Credit line given. Buys one-time rights.

Tips Prefers to see "well-exposed, sharp images showing both the ability to capture peak action, as well as beach scenes depicting the surfing lifestyle. Color, lighting, composition and proper film usage are important. Ask for our photo guidelines prior to making any film/camera/lens choices."

$ $▣ ☑ TASTE FOR LIFE, Nutritional Solutions You Can Trust

86 Elm St., Peterborough NH 03458-1009. (603)924-7271. Fax: (603)924-7344. E-mail: tmackay@tasteforlife.c om. Website: www.tasteforlife.com. **Contact:** Ellen Klempner-Beguin, creative director. Art Director: Tim MacKay. Circ. 250,000. Estab. 1998. Monthly consumer magazine. *"Taste for Life* is a national publication catering to the natural product and health food industry and its consumers. Our mission is to provide authoritative information on nutrition, fitness and choices for healthy living." Sample copies available.

Needs Buys 2-5 photos from freelancers/issue; 24-60 photos/year. Needs photos of gardening, food/drink, health/fitness. Wants photos of herbs, medicinal plants, organic farming, aromatherapy, alternative healthcare. Reviews photos with accompanying manuscripts only. Model and property release required. Photo captions required; include plant species, in the case of herbs.

Specs Prefers images in digital format. Send via CD, DVD as TIFF, EPS files at least 300 dpi.

Making Contact & Terms Send query letter with résumé, photocopies, tearsheets, stock list. Provide résumé, business card, self-promotion piece to be kept on file for possible future assignments. Responds only if interested. Include SASE if samples need to be returned. Simultaneous submissions and previously published work OK. Pays $400-600 for color cover; $100-300 for color inside. Pays extra for electronic usage of photos. Pays on publication. Credit line given. Buys one-time rights. Will negotiate with a photographer unwilling to sell all rights.

Tips "Photos should portray healthy people doing healthy things everywhere, all the time. In the case of herbal photography, stunning detailed images showing fruit, leaves, flowers, etc., are preferred. All images should be good enough to be covers."

▣ ◌ TEEN LIGHT: The Teen 2 Teen Christian Magazine

We-eee! Writers' Ministries, Inc., 6118 Bend of River Rd., Dunn NC 28334. Phone/fax: (910)980-1126. E-mail: publisher@teenlight.org. Website: www.teenlight.org and www.writershelper.org. **Contact:** Annette Dammer, publisher. Circ. 3,000. Estab. 2001. Quarterly Christian teen-to-teen literary magazine. *"Teen Light* is totally teen-authored. Between our online and print audience, we are blessed to serve many. We help teens learn to write and to share their love of God in the process. Our only goal is to help teens help each other. If you'd like to be a part of that, we'd be honored to look at your work." Sample copy available for $1.75 and return address or 2 first-class stamps and return address. Photo guidelines free with SASE.

Needs Needs photos of babies/children/teens, couples, multicultural, families, parents, senior citizens, landscapes/scenics, wildlife, education, gardening, interiors/decorating, pets, religious, rural, entertainment, events, health/fitness/beauty, hobbies, humor, performing arts, sports, travel, product shots/still life, science, technology/computers. Interested in documentary, fashion/glamour, fine art, historical/vintage, seasonal. Anything thought-provoking that will spark a writer. Nature, odd shapes, anything that can be used as a "writer's prompt." Reviews photos with or without ms. Model release/photo captions required.

Specs Uses 8×10 and smaller matte color and b&w prints. Accepts images in digital format. Send via CD, floppy disk, ZIP, or e-mail attachment as JPEG or GIF files at 200 dpi (72 dpi OK if for website only).

Making Contact & Terms Send short query in e-mail with 72-dpi image attached. Does not keep samples on file; include SASE for return of material. Responds in 6 weeks. Simultaneous submissions and previously published work OK. "We all volunteer, but we offer free copies, free writer's classes, and may offer advertising space and Web links as well on individual consideration/basis." Credit line given. Buys one-time rights.

Tips "If you have a heart for teens, we welcome your work. We keep it clean, honest, and encouraging. Our photos do end up in b&w, but it's a nice look. Great place to get clips and help America's teens grow. Check us out online or order a sample copy. Focus on God's beauty and take chances."

$▣ ◌ Ⓐ TENNIS WEEK

15 Elm Place, Rye NY 10580. (914)967-4890. Fax: (914)967-8178. E-mail: tennisweek@tennisweek.com. Website: www.tennisweek.com. **Contact:** Eugene L. Scott, publisher. Managing Editor: Andre Christopher. Circ. 110,000. Published 11 times/year. Readers are "tennis fanatics." Sample copy available for $4 (current issue); $5 back issue.

Needs Uses about 16 photos/issue. Needs photos of "off-court color, beach scenes with pros, social scenes with players, etc." Emphasizes originality. Subject identification required.

Specs Uses b&w and/or color prints. Accepts images in digital format. Send via CD, e-mail as EPS files at 300 dpi.

Making Contact & Terms Send actual 8×10 or 5×7 b&w photos by mail for consideration. Send portfolio via mail or CD-ROM. Responds in 2 weeks. Pays barter. Pays on publication. Rights purchased on a work-for-hire basis.

$ ▣ TEXAS GARDENER MAGAZINE

P.O. Box 9005, Waco TX 76714-9005. (254)848-9393. Fax: (254)848-9779. E-mail: info@texasgardener.com. Website: www.texasgardener.com. **Contact:** Chris S. Corby, editor/publisher. Circ. 25,000. Bimonthly. Emphasizes gardening. Readers are "51% male, 49% female, home gardeners, 98% Texas residents." Sample copy available for $4.

Needs Buys 18-27 photos from freelancers/issue; 108-162 photos/year. Needs "color photos of gardening activities in Texas." Special needs include "cover photos shot in vertical format. Must be taken in Texas." Model release preferred. Photo captions required.

Specs Prefers high-resolution digital images. Send via e-mail as JPEG files at 300 dpi.

Making Contact & Terms Send query letter with samples, SASE. Responds in 3 weeks. Pays $100-200 for color cover; $25-100 for color inside. Pays on publication. Credit line given. Buys one-time rights.

Tips "Provide complete information on photos. For example, if you submit a photo of watermelons growing in a garden, we need to know what variety they are and when and where the picture was taken."

$ $ ▣ TEXAS HIGHWAYS

P.O. Box 141009, Austin TX 78714. (512)486-5870. Fax: (512)486-5879. E-mail: mmurph1@dot.state.tx.us. Website: www.texashighways.com. **Contact:** Michael A. Murphy, photo editor. Circ. 275,000. Monthly. "*Texas Highways* interprets scenic, recreational, historical, cultural and ethnic treasures of the state and preserves the best of Texas heritage. Its purpose is to educate and entertain, to encourage recreational travel to and within the state, and to tell the Texas story to readers around the world." Readers are ages 45 and over (majority); $24,000 to $60,000/year salary bracket with a college education. Photo guidelines available on website.

Needs Buys 30-35 photos from freelancers/issue; 360-420 photos/year. Needs "travel and scenic photos in Texas only." Special needs include "fall, winter, spring and summer scenic shots and wildflower shots (Texas only)." Photo captions required; include location, names, addresses and other useful information.

Specs "We take only color originals, 35mm or larger transparencies. No negatives or prints." Accepts images in digital format. Consult guidelines before submitting.

Making Contact & Terms Send query letter with samples, SASE. Provide business card and tearsheets to be kept on file for possible future assignments. Responds in 1 month. Simultaneous submissions OK. Pays $400 for color cover; $60-170 for color inside. Pays $15 extra for electronic usage. Pays on publication. Credit line given. Buys one-time rights.

Tips "Know our magazine and format. We accept only high-quality, professional-level work—no snapshots. Interested in a photographer's ability to edit own material and the breadth of a photographer's work. Look at 3-4 months of the magazine. Query not just for photos but with ideas for new/unusual topics."

Ⓝ $ ▣ ○ Ⓢ TEXAS POETRY JOURNAL

P.O. Box 90635, Austin TX 78709-0635. (512)779-6202. E-mail: editor@texaspoetryjournal.com. Website: www.texaspoetryjournal.com. **Contact:** Steven Ray Smith, editor. Circ. 500. Estab. 2004. Semiannual literary magazine. "Texas Poetry Journal publishes poetry, interviews with poets, criticism for a general audience, and black and white photography." Sample copy available for $7.50. Photo guidelines available on website.

Needs Buys 4 photos from freelancers/issue; 8 photos/year. Interested in documentary, fine art. Reviews photos with or without a ms. Model release required. Property release preferred.

Specs Uses 4×6 glossy b&w prints. Accepts images in digital format. Send via CD, Zip or e-mail as TIFF, EPS or JPEG files at 300 dpi.

Making Contact & Terms E-mail query letter with link to photographer's website, JPEG samples at 72 dpi. Send query letter with prints. Does not keep samples on file; include SASE for return of material. Responds in 8 weeks to queries. Simultaneous submissions OK. Pays $20 maximum for b&w cover. Pays $10 maximum for b&w inside. Pays on publication. Credit line given. Buys one-time rights, electronic rights.

Tips "We need work that helps our journal say, 'Poetry is fun, accessible, understandable and easy.' Photos that invite the reader to keep reading are the ones we will buy. Like our poems, we want our photos to be poetic too!"

$ ▣ ○ THEMA

THEMA Literary Society, P.O. Box 8747, Metairie LA 70011-8747. (504)887-1263. E-mail: thema@cox.net. Website: http://members.cox.net/thema. **Contact:** Virginia Howard, manager/editor. Circ. 300. Estab. 1988. Literary magazine published 3 times/year emphasizing theme-related short stories, poetry and art. Sample copy available for $8.

Needs Photo must relate to one of *THEMA*'s upcoming themes (indicate the target theme on submission of photo). For example: Just Describe Them to Me (11/1/2005); Rage Over a Lost Penny (3/1/2006); The Perfect Cup of Coffee (7/1/2006); Written in Stone (11/1/2006). Reviews photos with or without ms. Model/property release preferred. Photo captions preferred.

Specs Uses 5×7 glossy color and/or b&w prints. Accepts images in digital format. Send via Zip as TIFF files at 200 dpi.

Making Contact & Terms Send query letter with prints, photocopies. Does not keep samples on file; include SASE for return of material. Responds in 1 week to queries; 3 months to portfolios. Simultaneous submissions and previously published work OK. Pays $25 for cover; $10 for b&w inside. **Pays on acceptance.** Credit line given. Buys one-time rights.

Tips "Submit only work that relates to one of *THEMA*'s upcoming themes."

$▣ TIKKUN

2342 Shattack Ave., #1200, Berkeley CA 94704. (510)644-1200. Fax: (510)644-1255. E-mail: magazine@tikkun.org. Website: www.tikkun.org. **Contact:** Liz Winer, assistant editor. Circ. 25,000. Estab. 1986. Bimonthly journal. Publication is a political, social and cultural Jewish critique. Readers are 60% Jewish, white professional, middle-class, literary people ages 30-60.

Needs Uses 15 photos/issue; 30% supplied by freelancers. Needs political, social commentary; Middle Eastern; US photos. Reviews photos with or without ms.

Specs Uses b&w and color prints. Accepts images in digital format for Mac (Photoshop EPS). Send via CD.

Making Contact & Terms Send prints or good photocopies. Keeps samples on file; include SASE for return of material. Response time varies. "Turnaround is 4 months, unless artist specifies other." Previously published work OK. Pays $50 for b&w inside. Pays on publication. Credit line given. Buys all rights; negotiable.

Tips "Look at our magazine and suggest how your photos can enhance our articles and subject material. Send samples."

TIME

Time Inc., Time/Life Building, 1271 Avenue of the Americas, New York NY 10020. (212)522-1212. Website: www.time.com. *TIME* is edited to report and analyze a complete and compelling picture of the world, including national and world affairs, news of business, science, society and the arts, and the people who make the news. **Query before submitting**.

$▣ ◯ 🌐 TIMES OF THE ISLANDS: The International Magazine of the Turks & Caicos Islands

Times Publications Ltd., Southwinds Plaza, Box 234, Providenciales, Turks & Caicos Islands, British West Indies. (649)946-4788. E-mail: timespub@tciway.tc. Website: www.timespub.tc. **Contact:** Kathy Borsuk, editor. Circ. 10,000. Estab. 1988. Quarterly magazine focusing on in-depth topics specifically related to Turks & Caicos Islands. Targeted beyond mass tourists to homeowners/investors/developers and others with strong interest in learning about these islands. Sample copy available for $6. Photo guidelines available for #10 SAE and on website.

Needs Buys 2 photos from freelancers/issue; 10 photos/year. Needs photos of environmental, landscapes/scenics, wildlife, architecture, adventure, travel. Interested in historical/vintage. Also scuba diving, islands in TCI beyond main island of Providenciales. Reviews photos with or without ms. Photo captions required; include specific location, names of any people.

Specs Uses 8×10 (max) glossy or matte color and/or b&w prints; 35mm transparencies. Accepts images in digital format. Send via CD, floppy disk, Zip, e-mail as TIFF, EPS, JPEG files at 300 dpi.

Making Contact & Terms Send query letter with slides, prints, photocopies, tearsheets. Provide business card, self-promotion piece to be kept on file for possible future assignments. Responds in 6 weeks to queries. Simultaneous submissions and previously published work OK. Pays $100-300 for color cover; $10-50 for inside. Pays on publication. Credit line given. Buys one-time rights; negotiable.

Tips "Subject/photo should be unique and really stand out. Most of our photography is done in-house or by manuscript writers (submitted with manuscript). Better chance with photos taken on out-islands, beyond tourist center Providenciales. Make sure photo is specific to Turks & Caicos and location/subject accurately identified."

◯ TODAY'S PHOTOGRAPHER INTERNATIONAL

P.O. Box 777, Lewisville NC 27023. Fax: (336)945-3711. Website: www.aipress.com. **Contact:** Vonda H. Blackburn, photography editor. Circ. 78,000. Estab. 1986. Bimonthly magazine. Emphasizes making money

with photography. Readers are 90% male photographers. Sample copy available for 9×12 SASE. Photo guidelines free with SASE.

Needs Buys 40 photos from freelancers/issue; 240 photos/year. Model release required. Photo captions preferred.

Making Contact & Terms Send 35mm, 2¼×2¼, 4×5, 8×10 b&w and/or color prints or transparencies by mail for consideration; include SASE for return of material. Responds at end of the quarter. Simultaneous submissions and previously published work OK. Payment negotiable. Credit line given. Buys one-time rights, per contract.

Tips Wants to see "consistently fine-quality photographs and good captions or other associated information. Present a portfolio that is easy to evaluate—keep it simple and informative. Be aware of deadlines. Submit early."

$ ▣ ⬤ TRACK & FIELD NEWS

2570 El Camino Real, Suite 606, Mountain View CA 94040. (650)948-8417. Fax: (650)948-9445. E-mail: edit@trackandfieldnews.com. Website: www.trackandfieldnews.com. **Contact:** Jon Hendershott, associate editor (features/photography). Circ. 25,000. Estab. 1948. Monthly magazine. Emphasizes national and world-class track and field competition and participants at those levels for athletes, coaches, administrators and fans. Sample copy free with 9×12 SASE. Photo guidelines free.

Needs Buys 10-15 photos from freelancers/issue; 120-180 photos/year. Wants, on a regular basis, photos of national-class athletes, men and women, preferably in action. "We are always looking for quality pictures of track and field action, as well as offbeat and different feature photos. We always prefer to hear from a photographer before he/she covers a specific meet. We also welcome shots from road and cross-country races for both men and women. Any photos may eventually be used to illustrate news stories in *T&FN*, feature stories in *T&FN*, or may be used in our other publications (books, technical journals, etc.). Any such editorial use will be paid for, regardless of whether material is used directly in *T&FN*. About all we don't want to see are pictures taken with someone's Instamatic or Polaroid. No shots of someone's child or grandparent running. Professional work only." Photo captions required; include subject name, meet date/name.

Specs Prefers images in digital format. Send via CD, e-mail at 300 dpi.

Making Contact & Terms Send query letter with samples, SASE. Responds in 10-14 days. Pays $175 for color cover; $25 for b&w inside; $60 for color inside ($100 for interior color, full page; $175 for interior 2-page poster/spread). Payment is made monthly. Credit line given. Buys one-time rights.

Tips "No photographer is going to get rich via *T&FN*. We can offer a credit line, nominal payment and, in some cases, credentials to major track and field meets to enable on-the-field shooting. Also, we can offer the chance for competent photographers to shoot major competitions and competitors up close, as well as being the most highly regarded publication in the track world as a forum to display a photographer's talents."

$ $ ▣ ⬤ TRAIL RUNNER, The Magazine of Running Adventure

Big Stone Publishing, 1101 Village Rd., UL-4D, Carbondale CO 81623. (970)704-1442. Fax: (970)963-4965. E-mail: dclifford@bigstonepub.com. Website: www.trailrunnermag.com. **Contact:** David Clifford, photo editor. Circ. 57,000. Estab. 1999. Bimonthly magazine. The nation's only 4-color glossy magazine covering all aspects of trail running. Sample copy available for 9×12 SAE with $1.65 postage. Photo guidelines available for SASE.

Needs Buys 50-75 photos from freelancers/issue; 300-500 photos/year. Needs photos of landscapes/scenics, adventure, health/fitness, sports, travel. Interested in anything related to running on trails and the outdoors. Reviews photos with or without ms. Model/property release required. Photo captions preferred.

Specs Uses glossy color prints; 35mm transparencies. Accepts images in digital format. Send via CD, e-mail as TIFF files at 600 dpi.

Making Contact & Terms Send query letter with slides, stock list. Contact photo editor for appointment to drop off portfolio. Provide résumé, business card or self-promotion piece to be kept on file for possible future assignments. Responds in 3 weeks. Simultaneous submissions OK. Pays $50-300 for b&w cover; $500 for color cover; $50-200 for b&w inside; $50-250 for color inside; $350 for spread (color). Pays 30 days from date of publication. Credit line given. Buys one-time rights, first rights; negotiable.

Tips "Read our magazine. Stay away from model shots, or at least those with make-up and spandex clothing. No waving or smiling at the camera."

$ $ ▣ ⬤ TRAILER BOATS MAGAZINE

Ehlert Publishing, Inc., 20700 Belshaw Ave., Carson CA 90746. (310)537-6322. Fax: (310)537-8735. Website: www.trailerboats.com. **Contact:** Ron Eldridge, editor. Circ. 110,000. Estab. 1971. Monthly magazine. "We are

the only magazine devoted exclusively to trailerable boats and related activities'' for owners and prospective owners. Sample copy available for $1.25.

Needs Uses 15 photos/issue with ms. 95-100% of freelance photography comes from assignment; 0-5% from stock. Scenic (with ms), how-to, travel (with ms). For accompanying ms, need articles related to trailer boat activities. Photos purchased with or without accompanying ms. ''Photos must relate to trailer boat activities. No long list of stock photos or subject matter not related to editorial content.'' Photo captions preferred; include location of travel pictures.

Specs Uses transparencies. Accepts images in digital format. Send as EPS, TIFF, PIC at 300 dpi.

Making Contact & Terms Query or send photos or contact sheet by mail with SASE for consideration. Responds in 1 month. Pays per text/photo package or on a per-photo basis. Pays $500 for cover; $25-200 for color inside. **Pays on acceptance.** Credit line given.

Tips ''Shoot with imagination and a variety of angles. Don't be afraid to 'set up' a photo that looks natural. Think in terms of complete feature stories: photos and manuscripts. It is rare that we publish freelance photos without accompanying manuscripts.''

$▣ ◯ TRANSITIONS ABROAD

P.O. Box 745, Bennington VT 05201. (802)442-4827. E-mail: editor@transitionsabroad.com. Website: www.transitionsabroad.com. **Contact:** Sherry Schwarz, editor. Circ. 12,000. Estab. 1977. Bimonthly magazine. Emphasizes educational and special interest travel abroad. Readers are people interested in cultural travel and learning, living, or working abroad; all ages, both sexes. Sample copy available for $6.95. Photo guidelines available on website.

Needs Buys 10 photos from freelancers/issue; 60 photos/year. Needs photos in international settings of people of other countries. Each issue has an area focus: January/February—Asia and the Pacific Rim; March/April—Western Europe; May/June—Latin America; July/August—worldwide; September/October—Eastern Europe, Middle East, newly independent states; November/December—Mediterranean Basin and Africa. Photo captions preferred.

Specs Uses b&w and color inside. Accepts images in digital format. Send via CD, Zip, e-mail as TIFF files at 300 dpi. Prefers e-mail previews as JPEGs.

Making Contact & Terms Send unsolicited 3×4 b&w or color prints by mail with SASE for consideration. Responds in 6 weeks. Simultaneous submissions and previously published work OK. Pays $125-150 for color cover; $25-50 for inside. Pays on publication. Credit line given. Buys one-time rights.

Tips In freelance photographer's samples, wants to see ''mostly people in action shots—people of other countries; close-ups preferred for cover. We use very few landscapes or abstract shots. Send b&w or color prints by mail or samples by e-mail.''

$▨ TRAVEL + LEISURE

1120 Avenue of the Americas, 10th Floor, New York NY 10036. (212)382-5600. Fax: (212)382-5877. Website: www.travelandleisure.com. **Contact:** Photo Department. Circ. 1.2 million. Monthly magazine. Emphasizes travel destinations, resorts, dining and entertainment.

Needs Nature, still life, scenic, sport and travel. Does not accept unsolicited photos. Model release required. Photo captions required.

Specs Uses 8×10 semigloss b&w prints; 35mm, 2¼×2¼, 4×5, 8×10 transparencies; vertical format required for cover.

Making Contact & Terms ''If mailing a portfolio, include a self-addressed stamped package for its safe return. You may also send it by messenger Monday through Friday between 11 a.m. and 5 p.m. We accept work in book form exclusively—no transparencies, loose prints, nor scans on CD, disk or e-mail. Send photocopies or photo prints, not originals, as we are not responsible for lost or damaged images in unsolicited portfolios. We do not meet with photographers if we haven't seen their book. However, please include a promo card in your portfolio with contact information, so we may get in touch with you if necessary.''

$▣ ◪ ⑤ TRAVEL NATURALLY: nude recreation

Internaturally, Inc., P.O. Box 317-W, Newfoundland NJ 07435-0317. (973)697-3552. Fax: (973)697-8313. E-mail: naturally@internaturally.com. Website: www.internaturally.com. **Contact:** Bernard Loibl, editor. Circ. 35,000. Estab. 1981. Quarterly publication that focuses on ''family nude recreation and travel.'' Sample copy available for $9.50. Photo guidelines free with SASE.

Needs Needs photos of nude or clothing-optional travel and events. Reviews photos with accompanying ms only. Model/property release required.

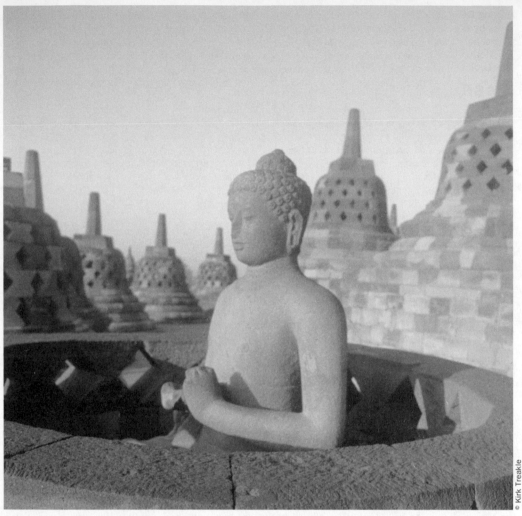

© Kirk Treakle

Transitions Abroad is geared toward people who are interested in living, studying or working abroad. Kirk Treakle sent this image, taken at the Borobudur Buddhist stupa in southeast Java, along with several other travel images to *Transitions Abroad*. It was published in the March/April 2003 edition of the magazine.

Specs Uses glossy or matte color prints; 2¼ × 2¼ transparencies. Accepts images in digital format. Send via CD or e-mail as JPEG files at 300 dpi.

Making Contact & Terms Send query letter with prints. Does not keep samples on file. Responds only if interested; send nonreturnable samples. Simultaneous submissions and previously published work OK. Pays $150-200 for color cover; $25-70 for color inside. Pays on publication. Buys one-time rights.

Tips "We are looking for quality articles with photos of upscale nudist resorts from around the world. We encourage photography at all clothes-free events by courteous and considerate photographers."

Ⓝ $▣ ⊕ TRAVELLER

45-49 Brompton Rd., London SW3 1DE United Kingdom. (44)(207)589-0500. Fax: (44)(207)581-8476. E-mail: traveller@wexas.com. Website: www.traveller.org.uk. **Contact:** Jonathan Lorie, editor. Circ. 35,000. Quarterly. Readers are predominantly male, professional, ages 35 and older. Sample copy available for £2.50. **Needs** Uses 30 photos/issue; all supplied by freelancers. Needs photos of travel, wildlife, tribes. Reviews photos with or without ms. Photo captions preferred.

Making Contact & Terms Send at least 20 original color slides or b&w prints. Or send at least 20 low-res scans by e-mail or CD (include printout of thumbnails); high-res (300 dpi) scans will be required for final publication. Does not keep samples on file; include SASE for return of material. Responds in 3 months. Pays £150 for color cover; £80 for full page; £50 for other sizes. Pays on publication. Buys one-time rights.
Tips Look at guidelines for contributors on website.

▧ $ $▤ ◌ TRICYCLE: The Buddhist Review

The Buddhist Ray, Inc., 92 Vandam St., New York NY 10013. (212)645-1143. Fax: (212)645-1493. E-mail: editorial@tricycle.com. Website: www.tricycle.com. **Contact:** Alexandra Kaloyanides, associate editor. Circ. 60,000. Estab. 1991. Quarterly nonprofit magazine devoted to the exploration of Buddhism, literature and the arts.
Needs Buys 30 photos from freelancers/issue; 120 photos/year. Reviews photos with or without ms. Model/property release preferred. Photo captions preferred.
Specs Uses glossy b&w and color prints; 35mm transparencies. Accepts images in digital format. Send via CD, Zip, e-mail as TIFF, EPS, BMP, GIF, JPEG files at 300 dpi.
Making Contact & Terms Send query letter with tearsheets. Provide business card, self-promotion piece to be kept on file for possible future assignments. Responds in 3 months to queries. Simultaneous submissions OK. Pays $700 maximum for color cover; $250 maximum for b&w inside. Pays on publication. Credit line given. Buys one-time rights.
Tips "Read the magazine to get a sense of the kind of work we publish. We don't only use Buddhist art; we select artwork depending on the content of the piece."

$ $▤ TURKEY & TURKEY HUNTING

F + W Publications, 700 E. State St., Iola WI 54990-0001. (715)445-2214. Fax: (715)445-4087. E-mail: jim.schlender@fwpubs.com. Website: www.turkeyandturkeyhunting.com. **Contact:** Jim Schlender. Circ. 50,000. Estab. 1983. Magazine published 6 times/year. Provides features and news about wild turkeys and turkey hunting. Photo guidelines available on website.
Needs Buys 150 photos/year. Needs action photos of wild turkeys and hunter interaction scenes. Reviews photos with or without ms.
Specs Uses 35mm transparencies and high-res digital images.
Making Contact & Terms Send query letter with samples; include SASE for return of material. Responds in 3 months to queries. Pays $300 minimum for color cover; $75 minimum for b&w inside; $75-200 for color inside. Pays on publication. Credit line given. Buys one-time rights.

$ $▤ TURKEY CALL

P.O. Box 530, Parcel services: 770 Augusta Rd., Edgefield SC 29824. (803)637-3106. Fax: (803)637-0034. E-mail: turkeycall@nwtf.net. Website: www.nwtf.org. **Contact:** Jason Gilbertson, editor. Publisher: National Wild Turkey Federation, Inc. (nonprofit). Circ. 200,000. Estab. 1973. Bimonthly magazine for members of the National Wild Turkey Federation—people interested in conserving the American wild turkey. Sample copy available for $3 with 9×12 SASE. Photo guidelines free with SASE or on website.
Needs Buys at least 50 photos/year. Needs photos of "wild turkeys, wild turkey hunting, wild turkey management techniques (planting food, trapping for relocation, releasing), wild turkey habitat." Photo captions required.
Specs Uses color transparencies, any format; prefers originals, 35mm accepted. Accepts images in digital format. Send via CD at 300 dpi with thumbnail page.
Making Contact & Terms Send copyrighted photos to editor for consideration; include SASE. Responds in 6 weeks. Pays $400 for cover; $200 maximum for color inside. **Pays on acceptance.** Credit line given. Buys one-time rights.
Tips Wants no "poorly posed or restaged shots, mounted turkeys representing live birds, domestic turkeys representing wild birds or typical hunter-with-dead-bird shots. Photos of dead turkeys in a tasteful hunt setting are considered. Keep the acceptance agreement/liability language to a minimum. It scares off editors and art directors." Sees a trend developing regarding serious amateurs who are successfully competing with pros. "Newer equipment is partly the reason. In good light and steady hands, full auto is producing good results. I still encourage tripods, however, at every opportunity."

▣ TV GUIDE

News America Publications, Inc., 1211 Avenue of the Americas, 4th Floor, New York NY 10036. (212)852-7500. Fax: (212)852-7470. Website: www.tvguide.com. **Contact:** Photo Editor. *TV Guide* watches television

with an eye for how TV programming affects and reflects society. It looks at the shows and the stars, and covers the medium's impact on news, sports, politics, literature, the arts, science and social issues through reports, profiles, features and commentaries.

Making Contact & Terms Works only with celebrity freelance photographers. "Photos are for one-time publication use. Mail self-promo cards to photo editor at above address. No calls, please."

▨ ▣ ◯ ⑤ UP AND UNDER: The QND Review

93 S. Main St., Medford NJ 08055. (609)953-7568. E-mail: qndpoets@yahoo.com. Website: www.quickanddirtypoets.com. **Contact:** Rachel Bunting, editor. Circ. 100. Estab. 2005. Annual literary magazine. "A literary journal with an eclectic mix of poetry: sex, death, politics, IKEA, Mars, food and jug handles, alongside a smorgasbord of other topics covered in such diverse forms as the sonnet, villanelle, haiku and free verse." Sample copy available for $7 and SAE.

Needs Acquires 8 photos from freelancers/issue; 8 photos/year. Interested in architecture, cities/urban, rural, landscapes/scenics, avant garde, fine art, historical/vintage. Reviews photos with or without a ms.

Specs Uses 8×10 or smaller b&w prints. Accepts digital images in Windows format. Send via e-mail as GIF or JPEG files.

Making Contact & Terms Send query letter with prints. Does not keep samples on file; include SASE for return of material. Responds in 2-3 months to queries. Simultaneous submissions OK. Pays 1 copy on publication. Credit line sometimes given, depending on space allowance in the journal. Acquires one-time rights.

Tips "This is predominantly a poetry journal, and we choose photographs to complement the poems, so we prefer unusual artistic images whether they are landscapes, buildings or art. Include a short (3- to 5-line) bio."

$ $▣ ◪ ▧ UP HERE

P.O. Box 1350, Yellowknife NT X1A 2N9 Canada. (867)766-6710. Fax: (867)873-9876. E-mail: jake@uphere.ca. Website: www.uphere.ca. **Contact:** Jake Kennedy, editor. Circ. 35,000. Estab. 1984. Magazine published 8 times/year. Emphasizes Canada's north. Readers are educated, affluent, men and women ages 30 to 60. Sample copy available for $3.50 plus GST and 9×12 SAE. Photo guidelines free with SASE. If coming from US, include international postage coupon instead of American stamps (which cannot be used in Canada).

Needs Buys 18-27 photos from freelancers/issue; 144-216 photos/year. Needs photos of environmental, landscapes/scenics, wildlife, adventure, performing arts. Interested in documentary, seasonal. Purchases photos with or without accompanying ms. Photo captions required.

Specs Uses color transparencies, not prints, labeled with the photographer's name, address, phone number and caption. Occasionally accepts images in digital format. Send via CD, e-mail, Syquest, Zip.

Making Contact & Terms Provide résumé, business card, brochure, flier or tearsheets to be kept on file for possible future assignments. Include SASE for return of material. Responds in 2 months. Pays $250-350 for color cover; $40-150 for color inside. Pays on publication. Credit line given. Buys one-time rights.

Tips "We are a *people* magazine. We need stories that are uniquely Northern (people, places, etc.). Few scenics as such. We approach local freelancers for given subjects, but routinely complete commissioned photography with images from stock sources. Please let us know about Northern images you have." Wants to see "sharp, clear photos, good color and composition. We always need verticals to consider for the cover, but they usually tie in with an article inside."

◪ VANITY FAIR

Condé Nast Building, 4 Times Square, New York NY 10036. (212)286-2860. Fax: (212)286-7787 or (212)286-6787. Website: www.vanityfair.com. **Contact:** Susan White, photography director. Monthly magazine.

Needs 50% of photos supplied by freelancers. Needs portraits. Model/property release required for everyone. Photo captions required for photographer, styles, hair, makeup, etc.

Making Contact & Terms Contact through rep or submit portfolio for review. Provide résumé, business card, brochure, flier or tearsheets to be kept on file for possible future assignments. Responds in 2 weeks. Payment negotiable. Pays on publication.

Tips "We solicit material after a portfolio drop. So, really we don't want unsolicited material."

▨ $ $◪ VERMONT LIFE

6 Baldwin St., Montpelier VT 05602. **Contact:** Tom Slayton, editor. Circ. 75,000. Estab. 1946. Quarterly magazine. Emphasizes life in Vermont: its people, traditions, way of life, farming, industry, and the physical

beauty of the landscape for "Vermonters, ex-Vermonters, and would-be Vermonters." Sample copy available for $6 with 9×12 SAE. Photo guidelines free.

Needs Buys 27 photos from freelancers/issue; 108 photos/year. Wants (on a regular basis) scenic views of Vermont, seasonal (winter, spring, summer, autumn) submitted 6 months prior to the actual season, animal, human interest, humorous, nature, landscapes/scenics, wildlife, gardening, sports, photo essay/photo feature, still life, travel. Interested in documentary. "We are using fewer, larger photos and are especially interested in good shots of wildlife, Vermont scenics." No photos in poor taste, clichés, or photos of places other than Vermont. Model/property release preferred. Photo captions required.

Specs Uses 35mm, 2¼×2¼ color transparencies.

Making Contact & Terms Send query letter with SASE. Responds in 3 weeks. Simultaneous submissions OK. Pays $500 minimum for color cover; $75-250 for b&w or color inside; $400-800/job. Pays on publication. Credit line given. Buys one-time rights; negotiable.

Tips "We look for clarity of focus; use of low-grain, true film (Kodachrome or Fujichrome are best); unusual composition or subject."

$ ◻ VERMONT MAGAZINE

P.O. Box 800, 31A John Graham Court, Middlebury VT 05753. (802)388-8480. Fax: (802)388-8485. E-mail: editor@vermontmagazine.com. Website: www.vermontmagazine.com. **Contact:** Joe Healy, editor-in-chief. Circ. 35,000. Estab. 1989. Bimonthly magazine. Emphasizes all facets of Vermont culture, business, sports, restaurants, real estate, people, crafts, art, architecture, etc. Readers are people interested in Vermont, including residents, tourists and second home owners. Sample copy available for $4.95 with 9×12 SAE and 5 first-class stamps. Photo guidelines free with SASE.

Needs Buys 10 photos from freelancers/issue; 60 photos/year. Needs animal/wildlife shots, travel, Vermont scenics, how-to, products and architecture. Special photo needs include Vermont activities such as skiing, ice skating, biking, hiking, etc. Model release preferred. Photo captions required.

Making Contact & Terms Send query letter with résumé of credits, samples, SASE. Send 8×10 b&w prints or 35mm or larger transparencies by mail for consideration. Submit portfolio for review. Provide tearsheets to be kept on file for possible future assignments. Responds in 2 months. Previously published work OK, depending on "how it was previously published." Pays $300 for color cover; $150 color page rate; $50-150 for color or b&w inside; $250/day. Pays on publication. Credit line given. Buys one-time rights and first North American serial rights; negotiable.

Tips In portfolio or samples, wants to see tearsheets of published work and at least 40 35mm transparencies. Explain your areas of expertise. Looking for creative solutions to illustrate regional activities, profiles and lifestyles. "We would like to see more illustrative photography/fine art photography where it applies to the articles and departments we produce."

$ $ ◫ ◯ VILLAGE PROFILE

VillageProfile.com, Inc., 33 N. Geneva St., Elgin IL 60120. (847)468-6800. Fax: (847)468-9751. Website: www.villageprofile.com. **Contact:** Juli Schatz, vice president/production. Circ. 5-15,000 per publication; average 240 projects/year. Estab. 1988. Publication offering community profiles, chamber membership directories, maps. *"Village Profile* has published community guides, chamber membership directories, maps, atlases and builder brochures in 45 states. Community guides depict the town(s) served by the chamber with 'quality of life' text and photos, using a brochure style rather than a news or documentary look." Sample copy available for 10×13 SAE. Photo guidelines free with SASE.

Needs Buys 50 photos from freelancers/issue; 5,000 photos/year. Needs photos of babies/children/teens, multicultural, families, parents, senior citizens, cities/urban, food/drink, health/fitness/beauty, business concepts, industry, medicine, technology/computers. Interested in historical/vintage, seasonal. Points of interest specific to the community(s) being profiled. Reviews photos with or without ms. Model/property release preferred. Photo captions required.

Specs Uses up to 8×10 glossy prints; 35mm, 2¼×2¼ transparencies. Accepts images in digital format. Send via Zip as TIFF files at 300 dpi.

Making Contact & Terms Send query letter with photocopies, tearsheets, stock list, locale/travel ability. Provide résumé, business card, self-promotion piece to be kept on file for possible future assignments. Responds in 1 week to queries. Previously published work OK. Pays $500 minimum/project; negotiates higher rates for multiple-community projects. **Pays on acceptance.** Credit line given. Buys all rights.

Tips "We want photographs of, and specific to, the community/region covered by the *Profile*, but we always need fresh stock photos of people involved in healthcare, shopping/dining, recreation, education and busi-

ness to use as fillers. E-mail anytime to find out if we're doing a project in your neighborhood. Do NOT query with or send samples or tearsheets of scenics, landscapes, wildlife, nature—see stock needs list above. We only purchase stock images in batches if the price is comparable to stock photo CDs available on the market—don't expect $100 per image.''

$ ▣ ☑ Ⓐ VIPER MAGAZINE, The Quarterly Magazine for Dodge Viper Enthusiasts

J.R. Thompson Company, 26970 Haggerty Rd., Farmington Hills MI 48331. (248)553-4566. Fax: (248)553-2138. E-mail: jrt@jrthompson.com. Website: www.vipermagazine.com. **Contact:** Mark Gianotta, editor-in-chief. Circ. 15,000. Estab. 1992. Quarterly magazine published by and for the enthusiasts of the Dodge Viper sports car. Sample copy available for $6. Photo guidelines free.

Needs Buys 3-10 photos from freelancers/issue; 12-40 photos/year. Needs photos of ''All Viper, only Viper—unless the shot includes another car suffering indignity at the Viper's hands.'' Reviews photos with or without a ms. ''Can always use fresh pro outlooks on racing or pro/amateur series.'' Model release required; property release preferred for anything not shot in the public domain or in a ''news'' context. Photo captions required; include names and what's happening.

Specs 35mm slides preferred. Uses any size color prints; $2\frac{1}{4} \times 2\frac{1}{4}$, 4×5, 8×10 transparencies. Accepts images in digital format.

Making Contact & Terms Send query letter with samples, brochure, stock list or tearsheets. Provide résumé, business card, self-promotion piece or tearsheets to be kept on file for possible future assignments. Keeps samples on file; include SASE for return of material. Responds in 1 month to queries; 2-3 weeks to samples. Simultaneous submissions and previously published work OK. Payment varies. **Pays on acceptance.** Credit line given. Buys all rights; negotiable.

Tips ''Know what we want—we don't have time to train anyone. That said, unpublished pro-grade work will probably find a good home here. Send first-class work—not outtakes; have patience; and don't waste our time—or yours. Would like to see less 'buff-book' art and more of a 'fashion' edge.''

$ $ ▣ ☑ VISTA

1201 Brickell Ave., Suite 360, Miami FL 33131. (305)416-4644. Fax: (305)416-4344. E-mail: vistamag@earthlink.net. Website: www.vistamagazine.com. **Contact:** Peter Ekstein, art director. Circ. 1 million. Estab. 1985. Monthly newspaper insert. Emphasizes Hispanic life in the US. Readers are Hispanic-Americans of all ages. Sample copies available.

Needs Buys 10-50 photos from freelancers/issue; 120-600 photos/year. Needs photos mostly of personalities (celebrities, multicultural, families, events). Reviews photos with accompanying ms only. Special photo needs include events in Hispanic-American communities. Model/property release preferred. Photo captions required.

Specs Accepts images in digital format. Send via CD, e-mail, Zip, Jaz (1GB) as TIFF, EPS files at 300 dpi.

Making Contact & Terms Provide résumé, business card, brochure, flier or tearsheets to be kept on file for possible future assignments. Keeps samples on file. Responds in 3 weeks. Previously published work OK. Pays $500 for color cover; $75 for b&w inside; $150 for color inside; day assignments are negotiated. Pays 25% extra for Web usage. Pays on publication. Credit line given. Buys one-time rights.

Tips ''Build a file of personalities and events. Hispanics are America's fastest-growing minority.''

$ ▣ ☑ Ⓢ THE WAR CRY

The Salvation Army, 615 Slaters Lane, Alexandria VA 22314. (703)684-5500. Fax: (703)684-5539. E-mail: war_cry@usn.salvationarmy.org. Website: www.warcry.com or www.salpubs.com. **Contact:** Photo Editor. Managing Editor: Jeff McDonald. Circ. 500,000. Official national publication of The Salvation Army, published biweekly and online. Emphasizes the inspirational. Pluralistic readership reaching all socioeconomic strata and including distribution in institutions. Photo guidelines/theme list available on request or via website.

Needs Uses about 10 photos/issue. Needs ''inspirational, scenic, holiday-observance photos—any that depict Christian truths, Christmas, Easter, and other observances in the Christian calendar—and conceptual photos that match our themes (write for theme list).''

Specs Uses color prints and slides. Accepts images in digital format. Send via CD as TIFF, EPS, JPEG files at 300 dpi, 5×7 or larger.

Making Contact & Terms Send color prints or slides by mail with SASE for consideration. Responds in 4-6 weeks. Simultaneous submissions and previously published work OK (tell when/where appeared). Pays $50-250 per photo. **Pays on acceptance.** Buys first and reprint rights.

Tips "Write for themes. Get a copy of our publication first. We are moving away from posed or common stock photography, and looking for originality."

▣ WASHINGTON TRAILS

2019 3rd Ave., Suite 100, Seattle WA 98121-2430. (206)625-1367. E-mail: editor@wta.org. Website: www.wta .org. **Contact:** Andrew Engelson, editor. Circ. 6,000. Estab. 1966. Publication of the Washington Trails Association. Published 10 times/year. Emphasizes "backpacking, hiking, cross-country skiing, all nonmotorized trail use, outdoor equipment and minimum-impact camping techniques." Readers are "people active in outdoor activities, primarily backpacking; residents of the Pacific Northwest, mostly Washington; age group: 9-90; family-oriented; interested in wilderness preservation, trail maintenance." Photo guidelines free with SASE or on website.

Needs Uses 10-15 photos from volunteers/issue; 100-150 photos/year. Needs "wilderness/scenic; people involved in hiking, backpacking, canoeing, skiing, wildlife; outdoor equipment photos, all with Pacific Northwest emphasis." Photo captions required.

Making Contact & Terms Send JPEGs by e-mail, or 5×7 or 8×10 glossy b&w prints by mail for consideration; include SASE for return of material. Responds in 1-2 months. Simultaneous submissions and previously published work OK. No payment for photos. A 1-year subscription offered for use of color cover shot. Credit line given.

Tips "We are a b&w publication and prefer using b&w originals for the best reproduction. Photos must have a Pacific Northwest slant. Photos that meet our cover specifications are always of interest to us. Familiarity with our magazine would greatly aid the photographer in submitting material to us. Contributing to *Washington Trails* won't help pay your bills, but sharing your photos with other backpackers and skiers has its own rewards."

$ ▣ 🅐 THE WATER SKIER

1251 Holy Cow Rd., Polk City FL 33868-8200. (863)324-4341. Fax: (863)325-8259. E-mail: satkinson@usawat erski.org. Website: www.usawaterski.org. **Contact:** Scott Atkinson, editor. Circ. 28,000. Estab. 1950. Magazine published 9 times/year. Publication of USA Water Ski. Emphasizes water skiing. Readers are male and female professionals, ages 20-45. Sample copy available for $3.50. Photo guidelines available.

Needs Buys 1-5 photos from freelancers/issue; 9-45 photos/year. Needs photos of sports action. Model/ property release required. Photo captions required.

Making Contact & Terms Call first. Pays $50-150 for color photos. Pays on publication. Credit line given. Buys all rights.

$ $ WATERSKI MAGAZINE

460 N. Orlando Ave., Suite 200, Winter Park FL 32789. (407)628-4802. Fax: (407)628-7061. Website: www.wa terskimag.com. **Contact:** Shawn Jenkins, senior editor. Circ. 105,000. Estab. 1978. Published 8 times/year. Emphasizes water skiing instruction, lifestyle, competition, travel. Readers are 36-year-old males, average household income $65,000. Sample copy available for $2.95. Photo guidelines free with SASE.

Needs Buys 20 photos from freelancers/issue; 160 photos/year. Needs photos of instruction, travel, personality. Model/property release preferred. Photo captions preferred; include person, trick described.

Making Contact & Terms Query with good samples, SASE. Keeps samples on file. Responds within 2 months. Pays $200-500/day; $500 for color cover; $50-75 for b&w inside; $75-300 for color inside; $150/color page rate; $50-75/b&w page rate. Pays on publication. Credit line given. Buys first North American serial rights.

Tips "Clean, clear, tight images. Plenty of vibrant action, colorful travel scenics and personality. Must be able to shoot action photography. Looking for photographers in other geographic regions for diverse coverage."

$ ▣ ▢ WATERWAY GUIDE

326 First St., Suite 400, Annapolis MD 21403. (443)482-9377. Fax: (443)482-9422. Website: www.waterwaygu ide.com. **Contact:** Jack Dozier, publisher. Circ. 30,000. Estab. 1947. Cruising guides with 4 annual regional editions. Emphasizes recreational boating. Readers are men and women ages 25-65, management or professional, with average income $138,000. Sample copy available for $39.95 and $3 shipping. Photo guidelines free with SASE.

Needs Buys 10-15 photos from freelancers/issue. Needs aerial photos of waterways. Expects to use more coastal shots from Maine to the Bahamas; also, Hudson River, Great Lakes, Lake Champlain and Gulf of Mexico. Model release required. Photo captions required.

Specs Accepts images in digital format. Send as EPS, TIFF files.

Making Contact & Terms Send unsolicited photos by mail with SASE for consideration. Responds in 4 months. Pay varies; negotiable. Pays on publication. Credit line given. Must sign contract for copyright purposes.

$ ▣ ○ ⚏ WAVELENGTH PADDLING MAGAZINE

2735 North Rd., Gabriola Island BC V0R 1X7 Canada. (250)247-8858. E-mail: alan@wavelengthmagazine.com. Website: www.wavelengthmagazine.com. **Contact:** Alan Wilson, editor. Circ. 60,000. Estab. 1991. Bimonthly magazine. For sample copy, see downloadable PDF version on website.

Needs Buys 10 photos from freelancers/issue; 60 photos/year. Needs kayaking shots. Should have sea kayak in them. Reviews photos with or without ms. Model/property release preferred. Photo captions preferred.

Specs Prefers digital submissions, but only after query. Send as low-res for assessment. Duplicate prints/slides acceptable but returned only if accompanied by adequate Canadian postage.

Making Contact & Terms Send query letter. Provide business card or self-promotion piece to be kept on file for possible future assignments. Responds in 2 months to queries. Absolutely no simultaneous submissions or previously published work accepted. Pays $100-200 for color cover; $25-50 for inside. Pays on publication. Credit line given. Buys one-time print rights including electronic archive rights.

Tips "Look at free downloadable version on website and include kayak in picture wherever possible. Always need vertical shots for cover!"

$ ▣ ○ ☑ WEST SUBURBAN LIVING MAGAZINE

C² Publishing, Inc., 775 Church Rd., Elmhurst IL 60126. (630)834-4994. Fax: (630)834-4996. **Contact:** Chuck Cozette, editor. Circ. 25,000. Estab. 1995. Bimonthly regional magazine serving the western suburbs of Chicago. Sample copies available.

Needs Needs photos of babies/children/teens, couples, families, senior citizens, landscapes/scenics, architecture, gardening, interiors/decorating, entertainment, events, food/drink, health/fitness/beauty, performing arts, travel. Interested in seasonal. Model release required. Photo captions required. Limited to Chicago area freelance photographers.

Specs Uses glossy color and/or b&w prints; 35mm, 2¼×2¼, 4×5, 8×10 transparencies. Accepts images in digital format. Send via CD, Zip as TIFF files at 300 dpi.

Making Contact & Terms Responds only if interested; send nonreturnable samples. Simultaneous submissions and previously published work OK. Credit line given. Buys one-time rights, first rights, all rights; negotiable.

$ WESTERN HORSEMAN

P.O. Box 7980, Colorado Springs CO 80933. (719)633-5524. Fax: (719)473-0997. E-mail: edit@westernhorseman.com. Website: www.westernhorseman.com. **Contact:** A.J. Mangum, editor. Circ. 211,000. Estab. 1936. Monthly magazine. Readers are active participants in western horse activities, including pleasure riders, ranchers, breeders and riding club members.

Needs Articles and photos must have a strong horse angle, slanted towards the western rider—rodeos, shows, ranching, stable plans, training. "We do not buy single photographs/slides; they must be accompanied by an article. The exception: We buy 35mm color slides for our annual cowboy calendar. Slides must depict ranch cowboys/cowgirls at work." Model/property release preferred. Photo captions required; include name of subject, date, location.

Specs "For color, we prefer 35mm slides. For b&w, either 5×7 or 8×10 glossies. We can sometimes use color prints if they are of excellent quality."

Making Contact & Terms Submit material by mail for consideration. Pays $30/b&w photo; $50-75/color photo; $400-800 maximum for articles. For the calendar, pays $125-225/slide. "We buy manuscripts and photos as a package." Payment for 1,500 words with b&w photos: $100-600. Buys one-time rights; negotiable.

Tips "In all prints, photos and slides, subjects must be dressed appropriately. Baseball caps, T-shirts, tank tops, shorts, tennis shoes, bare feet, etc., are unacceptable."

$ ▣ ○ ⑤ WESTERN NEW YORK FAMILY MAGAZINE

Western New York Family, Inc., 3147 Delaware Ave., Buffalo NY 14217. (716)836-3486. Fax: (716)836-3680. E-mail: feedback@wnyfamilymagazine.com. Website: www.wnyfamilymagazine.com. **Contact:** Michele Miller, editor/publisher. Circ. 26,500. Estab. 1984. Monthly regional parenting magazine (printed on newsprint stock) focusing on the needs and interests of young, growing families with children ages 0-14 years. Sample copy available for $2.50 and SASE.

Needs Buys 3 photos from freelancers/issue; 36 photos/year. Needs photos of babies/children/teens, families, education. "We are especially interested in increasing our supply of photos that include non-Caucasian children and families." Reviews photos with or without ms. Model release preferred.

Specs Uses 8×10 color prints for covers (vertical format); 5×7 maximum b&w prints for inside (both horizontal and vertical formats). Cannot use transparencies. Accepts images in digital format. Send via CD, e-mail at 300 dpi. "If you e-mail as a query, 72-dpi JPEG is fine to see if there's interest."

Making Contact & Terms Send query letter with prints, photocopies. "E-mailed low-res files with query work well!" Does not keep samples on file; cannot return material. Responds only if interested; send nonreturnable samples. Simultaneous submissions OK. Pays $50-100 for color cover; $20 for b&w inside. Pays on publication. Credit line given. Buys one-time rights.

$ $□ ☑ WESTERN OUTDOORS, The Magazine of Western Sportfishing

Western Outdoors Publications, P.O. Box 73370, San Clemente CA 92673. (949)366-0030. Fax: (949)366-0804. E-mail: woutdoors@aol.com. **Contact:** Lew Carpenter, editor. Circ. 100,000. Estab. 1961. Magazine published 9 times/year. Emphasizes fishing and boating for Far West states. Sample copy free. Editorial and photo guidelines free with SASE.

Needs Uses 80-85 photos/issue; 70% supplied by freelancers; 80% comes from assignments, 25% from stock. Needs photos of fishing in California, Oregon, Washington, Baja. "We are moving toward 100% 4-color books, meaning we are buying only color photography. A special subject need will be photos of boat-related fishing, particularly small and trailerable boats and trout fishing cover photos." Most photos purchased with accompanying ms. Model/property release preferred for women and men in brief attire. Photo captions required.

Specs Uses 35mm transparencies. Accepts images in digital format.

Making Contact & Terms Query or send photos with SASE for consideration. Responds in 3 weeks. Pays $50-150 for color inside; $300-400 for color cover; $400-600 for text/photo package. **Pays on acceptance**. Buys one-time rights for photos only; first North American serial rights for articles; electronic rights are negotiable.

Tips "Submissions should be of interest to Western fishermen, and should include a 1,120- to 1,500-word manuscript; a Trip Facts Box (where to stay, costs, special information); photos; captions; and a map of the area. Emphasis is on fishing how-to, somewhere-to-go. Submit seasonal material 6 months in advance. Query only; no unsolicited manuscripts. Make your photos tell the story, and don't depend on captions to explain what is pictured. Avoid 'photographic cliches' such as 'dead fish with man.' Get action shots, live fish. In fishing, we seek individual action or underwater shots. For cover photos, use vertical format composed with action entering picture from right; leave enough left-hand margin for cover blurbs, space at top of frame for magazine logo. Add human element to scenics to lend scale. Get to know the magazine and its editors. Ask for the year's editorial schedule (available through advertising department), and offer cover photos to match the theme of an issue. In samples, looks for color saturation, pleasing use of color components; originality; creativity; attractiveness of human subjects, as well as fish; above all—sharp, sharp, sharp focus! Send duplicated transparencies as samples, but be prepared to provide originals."

$□ ◯ WHOLE LIFE TIMES

Dragonfly Media, Whole World Communications, Inc., 21225 Pacific Coast Hwy., #B, Malibu CA 90265. (310)317-4200. Fax: (310)317-4206. E-mail: editor@wholelifetimes.com. Website: www.wholelifetimes.com. Circ. 58,000. Estab. 1979. Local southern California magazine on alternative health, personal growth, environment, progressive politics, spirituality, social justice, food. Readers are 65% female, educated and active, mostly ages 35-55. "Our approach is option-oriented, holistic, entertaining." Sample copy available for $4 or on website.

Needs Buys 4-5 photos from freelancers/issue; 50 photos/year. Sometimes needs photos related to local environmental issues, food, celebrities in alignment with our mission, progressive local politicians, social or political commentary cartoons, unusual beauty shots. Also seeking local photographers with unusual, edgy style. Cover is in color. Interior is b&w and color. Reviews photos with or without ms. Model release required; ownership release required. "Almost all photos are by local assignment."

Specs Uses 8×10 glossy or matte color and/or b&w prints; 35mm, 2¼×2¼, 4×5, 8×10 transparencies. Prefers images in digital format. Send via e-mail, CD as TIFF, EPS, JPEG files at 300 dpi.

Making Contact & Terms Send query letter with nonreturnable prints, photocopies, tearsheets, stock list. Provide business card to be kept on file for possible future assignments. Responds only if interested; send nonreturnable samples. Simultaneous submissions and previously published work OK. Fees are negotiated

for assignments. Stock usage fees comparable to online fees. Pays 30 days after publication. Credit line given. Buys one-time rights.

Tips "Our readers are sophisticated but not trendy. For more info on our niche, see www.culturalcreatives.com. Prefer vertical images for cover and require space for cover lines and masthead. Payscale is moderate. Great opportunity for exposure and expanding portfolio through our well-established, nationally recognized niche publication in business for 27 years. Send only your best work!"

$ $☐ WINE & SPIRITS

2 W. 32nd St., Suite 601, New York NY 10001. (212)695-4660, ext. 15. Fax: (212)695-2920. E-mail: elenab@wineandspiritsmagazine.com. Website: www.wineandspiritsmagazine.com. **Contact:** Elena Beffarabova, art director. Circ. 70,000. Estab. 1985. Bimonthly magazine. Emphasizes wine. Readers are male, ages 39-60, married, parents, $70,000-plus income, wine consumers. Sample copy available for $4; September and November special issues $6.50.

Needs Buys 0-30 photos from freelancers/issue; 0-180 photos/year. Needs photos of food, wine, travel, people. Photo captions preferred; include date, location.

Specs Accepts images in digital format. Send via SyQuest, Zip at 266 dpi.

Making Contact & Terms Submit portfolio for review. Provide résumé, business card, brochure, flier or tearsheets to be kept on file for possible future assignments. Responds in 2 weeks, if interested. Simultaneous submissions OK. Pays $200-1,000/job. Pays on publication. Credit line given. Buys one-time rights.

$☐ WISCONSIN OUTDOOR JOURNAL

F + W Publications, 700 E. State St., Iola WI 54990-0001. (715)445-2214. Fax: (715)445-4087. E-mail: paul.wait@fwpubs.com. Website: www.wisoutdoorjournal.com. **Contact:** Paul Wait, editor. Circ. 28,000. Estab. 1987. An in-state publication for hunters and anglers published 8 times/year. *WOJ* covers Wisconsin outdoors through how-to features, informational articles, regional field reports, historical features and features on Wisconsin flora, fauna and geography. Sample copy available for 9×12 SAE. Photo guidelines available on website or with SASE.

Needs Buys 20 photos from freelancers/issue; 160 photos/year. Needs photos of environmental, landscapes/scenics, wildlife. Reviews photos with or without ms. Model/property release preferred. Photo captions preferred.

Making Contact & Terms Query before submitting samples. Keeps samples on file. Pays $25-150 for b&w inside; $40-200 for color inside. Pays on publication. Credit line given. Buys one-time rights.

Tips "Become familiar with the magazine. Because we're seasonal, emphasis is on fishing during warm weather, hunting in the fall, and ice fishing in the winter."

$☐ WISCONSIN SNOWMOBILE NEWS

P.O. Box 182, Rio WI 53960-0182. (920)992-6370. Fax: (920)992-6369. E-mail: wisnow@centurytel.net. Website: www.awsc.org/magazine.htm. **Contact:** Cathy Hanson, editor. Circ. 35,000. Estab. 1969. Magazine published 7 times/year. Official publication of the Association of Wisconsin Snowmobile Clubs. Emphasizes snowmobiling. Sample copy free with 9×12 SAE and 4 first-class stamps.

Needs Buys very few stand-alone photos from freelancers. "Most photos are purchased in conjunction with a story (photo/text) package. Photos need to be Midwest region only!" Needs photos of family-oriented snowmobile action, posed snowmobiles, travel, new products. Model/property release preferred. Photo captions preferred; include where, what, when.

Specs Uses 8×10 glossy color and/or b&w prints; 35mm, 2¼×2¼, 4×5, 8×10 transparencies. Electronic files accepted at 300 dpi.

Making Contact & Terms Submit portfolio for review. Send unsolicited photos by mail for consideration; include SASE for return of material. Provide résumé, business card, brochure, flier or tearsheets to be kept on file for possible future assignments. Responds in 2 weeks. Simultaneous submissions and previously published work OK. Pays $10-50 for color photos. Pays on publication. Credit line given. Buys one-time rights, all rights; negotiable.

$☐ ◔ WITH, The Magazine for Radical Christian Youth

P.O. Box 347, Newton KS 67114. (620)367-8432. Fax: (620)367-8218. E-mail: carold@mennoniteusa.org. Website: www.withonline.org. **Contact:** Carol Duerksen, editor. Circ. 6,200. Estab. 1968. 4-color magazine published 6 times/year. Emphasizes "Christian values in lifestyle, vocational decision making, and conflict

resolution for U.S. and Canadian high school students." Sample copy free with 9×12 SAE and 4 first-class stamps. Photo guidelines free with SASE.

Needs Buys 0-2 photos from freelancers/issue. Buys 90% of freelance photography from assignment; 10% from stock. Documentary (related to concerns of high school youth "interacting with each other, with family and in school environment; intergenerational"); head shot; photo essay/photo feature; scenic; human interest; humorous. Particularly interested in action shots of teens, especially of ethnic minorities. "We use some mood shots and a few nature photos." Prefers candids over posed model photos. Few religious shots, e.g., crosses, steeples, etc. Photos purchased with or without accompanying ms and on assignment. For accompanying manuscripts, wants issues involving youth—school, peers, family, hobbies, sports, community involvement, sex, dating, drugs, self-identity, values, religion, etc. Model release preferred.

Specs Uses 8×10 glossy prints. Accepts images in digital format. Send via CD at 300 dpi.

Making Contact & Terms Send material by mail with SASE for consideration. Responds in 2 months. Simultaneous submissions and previously published work OK. Pays 6¢/word for text/photo packages, or on a per-photo basis. **Pays on acceptance.** Credit line given. Buys one-time rights.

Tips "Candid shots of youth doing ordinary daily activities and mood shots are what we generally use. Photos dealing with social problems are also often needed. Needs to relate to teenagers—either include them in photos or subjects they relate to; using a lot of 'nontraditional' roles, also more ethnic and cultural diversity. Use models who are average-looking, not obvious model-types. Teenagers have enough self-esteem problems without seeing 'perfect' teens in photos."

$⬚ WOODENBOAT MAGAZINE

P.O. Box 78, Brooklin ME 04616. (207)359-4651. Fax: (207)359-8920. E-mail: matt@woodenboat.com. Website: www.woodenboat.com. **Contact:** Matthew P. Murphy, editor. Circ. 90,000. Estab. 1974. Bimonthly magazine. Emphasizes wooden boats. Sample copy available for $5.99. Photo guidelines free with SASE.

Needs Buys 95-118 photos from freelancers/issue; 570-708 photos/year. Needs photos of wooden boats: in use, under construction, maintenance, how-to. "We rarely, if ever, use unsolicited photographs that are not part of a proposed feature article." Photo captions required; include identifying information, name and address of photographer on each image.

Making Contact & Terms Send query letter with stock list. Keeps samples on file; include SASE for return of material. Responds in 2 months. Simultaneous submissions and previously published work OK with notification. Pays $350 for color cover; $15-75 for b&w inside; $25-125 for color inside. Pays on publication. Credit line given. Buys first world serial rights.

$ $⬚ WOODMEN MAGAZINE

1700 Farnam St., Omaha NE 68102. (402)342-1890. Fax: (402)271-7269. E-mail: service@woodmen.com. Website: www.woodmen.com. **Contact:** Billie Jo Foust, editor. Circ. 480,000. Estab. 1890. Bimonthly magazine. Official publication for Woodmen of the World/Omaha Woodmen Life Insurance Society. Emphasizes American family life. Sample copy and photo guidelines free.

Needs Buys 10-12 photos/year. Needs photos of the following themes: historic, family, insurance, photo essay/photo feature, scenic, human interest, humorous and health. Model release required. Photo captions preferred.

Specs Uses 8×10 glossy b&w prints on occasion; 35mm, $2^1\!/_4 \times 2^1\!/_4$, 4×5 transparencies; for cover: 4×5 transparencies, vertical format preferred. Accepts images in digital format. Send high-res scans via CD.

Making Contact & Terms Send material by mail with SASE for consideration. Responds in 1 month. Previously published work OK. Pays $250 minimum for color inside; $500-600 for cover. **Pays on acceptance.** Credit line given on request. Buys one-time rights.

Tips "Submit good, sharp pictures that will reproduce well."

⬚ ◯ WORLD SPORTS & ENTERTAINMENT

Franklin Publishing Company, 2723 Steamboat Circle, Arlington TX 76006. (817)548-1124. E-mail: luotto@comcast.net. Website: www.franklinpublishing.net. **Contact:** Dr. Ludwig Otto, publisher. Circ. 1,000. Estab. 1988. Quarterly trade and literary magazine; peer-reviewed, academic journal. Photo guidelines available on website.

Needs Needs photos of entertainment, sports. Reviews photos with or without ms. Photo captions required.

Specs Uses glossy or matte color and/or b&w prints. Accepts images in digital format. Send via e-mail.

Making Contact & Terms Responds in 3 weeks. Simultaneous submissions and previously published work OK.

$ $ ▣ ☑ WRITER'S DIGEST

F + W Publications, 4700 E. Galbraith Rd., Cincinnati OH 45236. (513)531-2690, ext. 1483. Fax: (513)891-7153. E-mail: tari.clidence@fwpubs.com. Website: www.writersdigest.com. **Contact:** Tari Clidence, art director, writing magazines. Editor: Kristin Godsey. Circ. 175,000. Estab. 1920. Monthly consumer magazine. "Our readers write fiction, nonfiction, plays and scripts. They're interested in improving their writing skills and the ability to sell their work, and finding new outlets for their talents." Photo guidelines free with SASE or by e-mail.

Needs Buys about 1-2 photos from freelancers/issue; about 12-14 photos/year. Needs photos of education, hobbies, writing life, business concepts, product shots/still life. Other specific photo needs: photographers to shoot authors on location for magazine cover. Model/property release required. Photo captions required; include your copyright notice.

Specs Uses 8×10 color and/or digital (resizable) images. Accepts images in digital format if hired. Send via CD, Zip as TIFF, EPS, JPEG files at 300 dpi (at hire).

Making Contact & Terms Provide business card, self-promotion piece to be kept on file for possible future assignments. Keeps samples on file. Responds only if interested; send nonreturnable samples. Pays $0-1,000 for color cover; $0-600 for b&w inside. Pays when billed/invoiced. Credit line given. Buys one-time rights.

Tips "Please don't submit/re-submit frequently. We keep samples on file and will contact you if interested. Submissions are considered for other Writer's Digest publications as well. For stock photography, please include pricing/sizes of b&w usage if available."

Ⓝ ◯ THE WYOMING COMPANION MAGAZINE

Box 1111, Laramie WI 82073-1111. (307)760-9649. Fax: (307)755-6366. E-mail: editor@wyomingcompanion. com. Website: www.wyomingcompanion.com. **Contact:** Mick McLean, editor. Online magazine.

Needs Photos should be related to the State of Wyoming: scenics, recreation, people, Yellowstone and the Tetons, sunsets.

Making Contact & Terms Photographers retain copyright.

Tips "Photographers should see website for more information."

Ⓝ YACHTING MAGAZINE

Time4Media, a division of Time, Inc., 18 Marshall St., Suite 114, South Norwalk CT 06854-2237. (203)299-5900. Fax: (203)299-5901. Website: www.yachtingnet.com. **Contact:** David Pollard, art director. Circ. 132,000. Estab. 1907. Monthly magazine addressing the interests of both sail and powerboat owners, with the emphasis on high-end vessels. Includes boating events, boating-related products, gear and how-to.

Making Contact & Terms Send query letter with tearsheets. Provide self-promotion piece to be kept on file for possible future assignments. Responds only if interested; send nonreturnable samples. Pays on publication. Buys first rights.

Tips "Read the magazine, and have a presentable portfolio."

$ $ ☑ YANKEE MAGAZINE

1121 Main St., Dublin NH 03444. (603)563-8111. Fax: (603)563-8252. Website: www.yankeemagazine.com. **Contact:** Heather Marcus, photo editor. Circ. 500,000. Estab. 1935. Monthly magazine. Emphasizes general interest within New England, with national distribution. Readers are of all ages and backgrounds; majority are actually outside of New England. Sample copy available for $1.95. Photo guidelines free with SASE.

Needs Buys 56-80 photos from freelancers/issue; 672-960 photos/year. Needs photos of landscapes/scenics, wildlife, gardening, interiors/decorating. "Always looking for outstanding photo essays or portfolios shot in New England." Model/property release preferred. Photo captions required; include name, locale, pertinent details.

Making Contact & Terms Submit portfolio for review. Keeps samples on file; include SASE for return of material. Responds in 1 month. Simultaneous submissions and previously published work OK. Pays $800-1,000 for color cover; $150-700 for color inside. Credit line given. Buys one-time rights; negotiable.

Tips "Submit only top-notch work. Submit the work you love. Prefer to see focused portfolio, even of personal work, over general 'I can do everything' type of books."

$ $ ▣ ◯ YOGA JOURNAL

475 Sansome St., Suite 850, San Francisco CA 94111. (415)591-0555. Fax: (415)591-0733. Website: www.yoga journal.com. **Contact:** Charli Ornett, art director. Circ. 300,000. Estab. 1975. Bimonthly magazine. Emphasizes yoga, holistic health, bodywork and massage, meditation, and Eastern spirituality. Readers are female,

college educated, median income ($74,000) and median age (47). Sample copy available for $5.

Needs Uses 20-30 photos/issue; 1-5 supplied by freelancers. Needs photos of travel, editorial by assignment. Special photo needs include botanicals, foreign landscapes. Model release preferred. Photo captions preferred; include name of person, location.

Specs Uses 35mm, $2\frac{1}{4} \times 2\frac{1}{4}$, 4×5, 8×10 transparencies and prints. Accepts images in digital format. Send via CD or Zip as TIFF, EPS files at 300 dpi.

Making Contact & Terms "Do not send unsolicited original art." Provide samples or tearsheets for files. Keeps samples on file. Responds in 1 month only if interested. Pays $150 maximum for b&w inside; $400 maximum for color inside. **Pays on acceptance.** Buys one-time rights.

Tips Seeking electronic files or printed samples sent by mail.

$◧ YOUTH RUNNER MAGAZINE

P.O. Box 1156, Lake Oswego OR 97035. (503)236-2524. Fax: (503)620-3800. E-mail: dank@youthrunner.com. Website: www.youthrunner.com. **Contact:** Dan Kesterson, editor. Circ. 100,000. Estab. 1996. Quarterly magazine. Emphasizes track, cross country and road racing for young athletes, ages 8-18. Photo guidelines available on website.

Needs Uses 30-50 photos/issue. Needs action shots from track, cross country and indoor meets. Model release preferred; property release required. Photo captions preferred.

Specs Accepts images in digital format only. Send via e-mail or CD.

Making Contact & Terms Send unsolicited photos by e-mail for consideration. Responds to e-mail submissions immediately. Simultaneous submissions OK. Pays $25 minimum. Credit line given. Buys electronic rights, all rights.

Newspapers & Newsletters

When working with newspapers, always remember that time is of the essence. Newspapers have various deadlines for each of their sections. An interesting feature or news photo has a better chance of getting in the next edition if the subject is timely and has local appeal. Most of the markets in this section are interested in regional coverage. Find publications near you and contact editors to get an understanding of their deadline schedules.

More and more newspapers are accepting submissions in digital format. In fact, most newspapers prefer digital images. However, if you submit to a newspaper that still uses film, ask the editors if they prefer certain types of film or if they want color slides or black & white prints. Many smaller newspapers do not have the capability to run color images, so black & white prints are preferred. However, color slides can be converted to black and white. Editors who have the option of running color or black & white photos often prefer color film because of its versatility.

Although most newspapers rely on staff photographers, some hire freelancers as stringers for certain stories. Act professionally and build an editor's confidence in you by supplying innovative images. For example, don't get caught in the trap of shooting "grip-and-grin" photos when a corporation executive is handing over a check to a nonprofit organization. Turn the scene into an interesting portrait. Capture some spontaneous interaction between the recipient and the donor. By planning ahead you can be creative.

When you receive assignments, think about the image before you snap your first photo. If you are scheduled to meet someone at a specific location, arrive early and scout around. Find a proper setting or locate some props to use in the shoot. Do whatever you can to show the editor you are willing to make that extra effort.

Always try to retain resale rights to shots of major news events. High news value means high resale value, and strong news photos can be resold repeatedly. If you have an image with national appeal, search for larger markets, possibly through the wire services. You also may find buyers among national news magazines such as *Time* or *Newsweek*.

While most newspapers offer low payment for images, they are willing to negotiate if the image will have a major impact. Front-page artwork often sells newspapers, so don't underestimate the worth of your images.

$ $🖼 AMERICAN SPORTS NETWORK

Box 6100, Rosemead CA 91770. (626)292-2200. Website: www.fitnessamerica.com or www.musclemania.com. **Contact:** Louis Zwick, president. Associate Producer: Ron Harris. Circ. 873,007. Publishes 4 newspapers covering "general collegiate, amateur and professional sports, i.e., football, baseball, basketball, wrestling, boxing, powerlifting and bodybuilding, fitness, health contests, etc." Also publishes special bodybuilder annual calendar, collegiate and professional football pre-season and post-season editions.

Needs Buys 10-80 photos from freelancers/issue for various publications. Needs "sport action, hard-hitting contact, emotion-filled photos." Model release preferred. Photo captions preferred.

Audiovisual Needs Uses film and video.

Making Contact & Terms Send 8×10 glossy b&w prints, 4×5 transparencies, video demo reel, or film work by mail for consideration. Include SASE for return of material. Provide résumé, business card, brochure, flier or tearsheets to be kept on file for possible future assignments. Responds in 1 week. Simultaneous submissions and previously published work OK. Pays $1,400 for color cover; $400 for b&w inside; negotiates rates by the job and hour. Pays on publication. Buys first North American serial rights.

🅐 ▣ ◯ AQUARIUS

1035 Green St., Roswell GA 30075. (770)641-9055. Fax: (770)641-8502. E-mail: aquarius-editor@mindspring.com. Website: www.aquarius-atlanta.com. **Contact:** Gloria Parker, publisher. Circ. 50,000. Estab. 1991. Monthly newspaper. Emphasizes "New Age, metaphysical, holistic health, alternative religion; environmental audience primarily middle-aged, college-educated, computer-literate, open to exploring new ideas." Sample copy available for SASE.

Needs "We use photos of authors, musicians, and photos that relate to our articles, but we have no budget to pay photographers at this time. We offer byline in paper, website, and copies." Needs photos of New Age and holistic health, celebrities, multicultural, environmental, religious, adventure, entertainment, events, health/fitness, performing arts, travel, medicine, technology, alternative healing processes. Interested in coverage on environmental issues, genetically altered foods, photos of "anything from Sufi Dancers to Zen Masters." Model/property release required. Photo captions required; include photographer's name, subject's name, and description of content.

Specs Uses color and b&w prints; 4×5 transparencies. Accepts images in digital format. Send via Zip, e-mail as JPEG files at 300 dpi.

Making Contact & Terms Send query letter with photocopies and/or tearsheets, or e-mail samples with cover letter. Provide résumé, business card or self-promotion piece to be kept on file for possible future assignments. Pays in copies, byline with contact info (phone number, e-mail address published if photographer agrees).

$ ◯ ARCHEAOLOGY

2660 Petersborough St., Herndon VA 20171. E-mail: shannonaswriter@yahoo.com. Estab. 1998. Quarterly magazine. Photo guidelines available by e-mail request.

Needs Buys 12 photos from freelancers/issue; 48-72 photos/year. Needs photos of babies/children/teens, celebrities, couples, multicultural, families, parents, disasters, environmental, landscapes/scenics, wildlife, architecture, cities/urban, education, gardening, interiors/decorating, pets, religious, rural, adventure, events, food/drink, sports, travel, agriculture, medicine, military, political, product shots/still life, science, technology—as related to archaeology. Interested in alternative process, avant garde, documentary, fashion/glamour, fine art, historical/vintage, seasonal. Wants photos of archaeology sites and excavations in progress. "Would like photographs of artifacts and Paleobiology." Reviews photos with or without ms. Model/property release preferred.

Specs Uses glossy or matte color and/or b&w prints.

Making Contact & Terms Send query letter via e-mail. "If possible, please do not include photographs in files if they are sent through e-mail. A disk with your photographs sent to *Archeaology* is acceptable." Provide résumé, business card or self-promotion piece to be kept on file for possible future assignments. Responds within 1 month to queries; 1 week to portfolios. Simultaneous submissions and previously published work OK. **Pays on acceptance.** Credit line given. Buys one-time rights, first rights; negotiable.

$ ⑤ ▣ CAPPER'S

1503 SW 42nd St., Topeka KS 66609-1265. (800)678-5779, ext. 4348. Fax: (800)274-4305. E-mail: cappers@cappers.com. Website: www.cappers.com. **Contact:** Andrea Skalland, editor. Circ. 120,000. Estab. 1879. Bi-

weekly tabloid. Emphasizes human-interest subjects. Readers are "mostly Midwesterners in small towns and on rural routes." Sample copy available for $1.95.

Needs Buys 1-3 photos from freelancers/issue; 26-72 photos/year. "We make no photo assignments. We select freelance photos with specific issues in mind." Needs photos of "human-interest activities, nature (scenic), etc., in bright primary colors. We often use photos tied to the season, a holiday, or an upcoming event of general interest." Photo captions required.

Specs Uses 35mm color slides or larger transparencies. Accepts images in digital format. Send via CD; "Images should be at least 6 inches wide, with a resolution of no less than 300 dpi. Include a hard-copy sheet of thumbnails."

Making Contact & Terms "Send for guidelines and a sample copy. Study the types of photos in the publication, then send a sheet of 10-20 samples with caption material for our consideration. Although we do most of our business by mail, a phone number is helpful in case we need more caption information. Phone calls to try to sell us on your photos don't really help." Reporting time varies. Pays $40 for color cover photo; $10-30 for color inside; $5-15 for b&w inside. Pays on publication. Credit line given. Buys shared rights.

Tips "Generally, we're looking for photos of everyday people doing everyday activities. If the photographer can present this in a pleasing manner, these are the photos we're most likely to use. Seasonal shots are appropriate for *Capper's*, but they should be natural, not posed. We steer clear of dark, mood shots; they don't reproduce well on newsprint. Most of our readers are small-town or rural Midwesterners, so we're looking for photos with which they can identify. Although our format is tabloid, we don't use celebrity shots and won't devote an area much larger than 5×6 to one photo."

$ⓈＥⓏ FISHING AND HUNTING NEWS

P.O. Box 19000, Seattle WA 98109. (206)624-3845. Fax: (206)695-8512. E-mail: staff@fishingandhuntingnews.com. Website: www.fhnews.com. **Contact:** John Marsh, managing editor. Published 24 times/year. Emphasizes fishing and hunting locations, how-to material and new products for hunters and fishermen. Circ. 90,000. Sample copy and photo guidelines free.

Needs Buys 300 or more photos/year. Needs photos of wildlife—fish/game with successful fishermen and hunters. Model release required. Photo captions required.

Specs Uses slide-size transparencies and snapshot-size b&w and prints. Accepts images in digital format. Send via CD, e-mail at 300 dpi.

Making Contact & Terms Send samples of work with SASE for consideration. Responds in 4 weeks. Pays $50 for color cover; $10 for b&w inside; $10 for color inside. Pays on publication. Credit line given. Buys all rights, but may reassign to photographer after publication.

Tips Looking for fresh, timely approaches to fishing and hunting subjects. Query for details of special issues and topics. "We need newsy photos with a fresh approach. Looking for near-deadline photos from Michigan, New York, Pennsylvania, New Jersey, Ohio, Illinois, Wisconsin, Oregon, California, Utah, Idaho, Wyoming, Montana, Colorado and Washington (sportsmen with fish or game)."

Ⓐ Ｅ Ⓩ THE LOG NEWSPAPER

4918 North Harbor Dr., Suite 201, San Diego CA 92106. (619)226-6140, ext. 11. Fax: (619)226-1037. E-mail: editor@thelognewspaper.com. Website: www.thelog.com. **Contact:** Mike Harris, editor. Circ. 65,000. Estab. 1971. Biweekly newspaper. Emphasizes recreational boating.

Needs Buys 15-18 photos from freelancers/issue; 390-468 photos/year. Needs photos of marine-related, historic sailing vessels, sailing/boating in general. Photo captions required; include location, name and type of boat, owner's name, race description if applicable.

Specs Uses 4×6 or 8×10 glossy color or b&w prints; 35mm transparencies. Accepts images in digital format. Send via e-mail as TIFF, EPS, JPEG files at 250 dpi or greater.

Making Contact & Terms Send query with SASE. Responds in 1 week. Simultaneous submissions and previously published work OK. Pays $75 for color cover; $25 for color inside. Pays on publication. Credit line given. Buys all rights; negotiable.

Tips "We want timely and newsworthy photographs! We always need photographs of people enjoying boating, especially power boating. Ninety-five percent of our images are of West Coast or Arizona subjects."

$MILL CREEK VIEW

16212 Bothell-Everett Hwy., Suite F-313, Mill Creek WA 98012-1219. (425)357-0549. Fax: (425)357-1639. **Contact:** F.J. Fillbrook, publisher. Newspaper.

Needs Photos for news articles and features. Photo captions required.

Specs Uses b&w and color prints.
Making Contact & Terms Submit portfolio for review. Send unsolicited photos by mail for consideration. Provide résumé, business card, brochure, flier or tearsheets to be kept on file for possible future assignments. Keeps samples on file; include SASE for return of material. Responds in 1 month. Pays $10-25 for photos. Pays on publication. Credit line given.

$NATIONAL MASTERS NEWS

P.O. Box 50098, Eugene OR 97405. (541)343-7716. Fax: (541)345-2436. E-mail: natmanews@aol.com. Website: www.nationalmastersnews.com. **Contact:** Suzy Hess, publisher; Jerry Wojcik, editor. Circ. 8,000. Estab. 1977. Monthly tabloid. Official world and US publication for Masters (ages 30 and over)—track and field, long distance running, and race walking. Sample copy free with 9×12 SASE.
Needs Uses 25 photos/issue; 30% assigned and 70% from freelance stock. Needs photos of Masters athletes (men and women over age 30) competing in track and field events, long distance running races or racewalking competitions. Photo captions required.
Making Contact & Terms Send any size matte or glossy b&w prints by mail for consideration; include SASE for return of material. Responds in 1 month. Simultaneous submissions and previously published work OK. Pays $25 for cover; $8 for inside. Pays on publication. Credit line given. Buys one-time rights.

$ THE NEW YORK TIMES ON THE WEB

The New York Times, 500 7th Ave., New York NY 10018. E-mail: brentm@nytimes.com. Website: www.nytimes.com. **Contact:** Brent Murray, producer. Circ. 1.3 million. Daily newspaper. "Covers breaking news and general interest." Sample copy available for SAE or on website.
Needs Needs photos of celebrities, architecture, cities/urban, gardening, interiors/decorating, industry, medicine, military, political, product shots/still life, science, technology/computers, disasters, environmental, landscapes/scenics, wildlife, automobiles, entertainment, events, food/drink, health/fitness/beauty, hobbies, performing arts, sports, travel, alternative process, avant garde, documentary, fashion/glamour, fine art, breaking news. Model release/photo captions required.
Specs Accepts images in digital format. Send via CD or e-mail as TIFF or JPEG files.
Making Contact & Terms E-mail query letter with link to photographer's website. Provide business card, self-promotion piece to be kept on file for possible future assignments. Responds in 1-2 weeks to queries. Simultaneous submissions OK. Pays on publication. Credit line given. Buys one-time rights and electronic rights.

$PACKER REPORT

2121 S. Oneida St., Green Bay WI 54304. (920)497-7225. Fax: (920)497-7227. E-mail: packrepted@aol.com. Website: www.packerreport.com. **Contact:** Todd Korth, editor. Circ. 30,000. Estab. 1973. Weekly tabloid. Emphasizes Green Bay Packer football. Readers are 94% male, all occupations, all ages. Sample copy free with SASE and 3 first-class stamps.
Needs Freelance writers for packerreport.com website.
Making Contact & Terms Send query letter with résumé of credits. Provide résumé, business card, brochure, flier or tearsheets to be kept on file for possible future assignments. Does not keep samples on file; include SASE for return of material. Responds in 1 month. Simultaneous submissions and previously published work OK. Pays $50 for color cover; $20 for b&w or color inside. Pays on publication. Credit line given. Buys one-time rights; negotiable.

$ STREETPEOPLE'S WEEKLY NEWS (Homeless Editorial)

P.O. Box 270942, Dallas TX 75227-0942. E-mail: sw_n@ctelcom.net. **Contact:** Lon G. Dorsey, Jr., publisher. Estab. 1990. Newspaper. Sample copy available by sending $5 to cover immediate handling (same day as received) and postage. Includes photo guidelines package now required. "Also contains information about our homeless television show and photo gallery."
● *SWN* wishes to establish relationships with professionals interested in homeless issues.
Needs Needs photos of babies/children/teens, celebrities, couples, multicultural, families, parents, senior citizens, cities/urban, education, pets, religious, rural, events, food/drink, health/fitness, hobbies, humor, political, technology/computers. Interested in alternative process, documentary, fine art, historical/vintage, seasonal. Subjects include: photojournalism on homeless or street people. Model/property release required. "All photos *must* be accompanied by *signed* model releases." Photo captions required.
Specs Accepts images in digital format. Send via CD, e-mail as GIF, JPEG files.

Making Contact & Terms "Hundreds of photographers are needed to show national state of America's homeless." Send unsolicited photos by mail for consideration with SASE for return. Responds promptly. Pays $15-450 for cover; $15-150 for inside. Pays extra for electronic usage (negotiable). Pays on acceptance or publication. Credit line sometimes given. Buys all rights; negotiable.

Tips In freelancer's samples, wants to see "professionalism, clarity of purpose, without sex or negative atmosphere which could harm purpose of paper." The trend is toward "kinder, gentler situations, the 'let's help our fellows' attitude." To break in, "find out what we're about so we don't waste time with exhaustive explanations. We're interested in all homeless situations. Inquiries not answered without SASE. All persons interested in providing photography should get registered with us. Now using 'Registered photographers and Interns of *SWN*' for publishing and upcoming Internet worldwide awards competition. Info regarding competition is outlined in *SWN*'s photo guidelines package. Photographers not registered will not be considered due to the continuous sending of improper materials, inadequate information, wasted hours of screening matter, etc. If you don't wish to register with us, please don't send anything for consideration. You'll find that many professional pubs are going this way to reduce the materials management pressures which have increased. We are trying something else new—salespeople who are also photographers. So, if you have a marketing/sales background with a photo kicker, contact us!"

$⊕▢⃟ THE SUNDAY POST

D.C. Thomson & Co. Ltd., 2 Albert Square, Dundee DD1 9QJ Scotland. (44)(138)222-3131. Fax: (44)(138)220-1064. E-mail: mail@sundaypost.com. Website: www.sundaypost.com. **Contact:** Alan Morrison, picture editor. Circ. 497,800. Estab. 1919. Weekly family newspaper.

Needs Needs photos of babies/children/teens, families, disasters, sports, business concepts. Other specific needs: news pictures from the UK, especially Scotland. Reviews photos with accompanying ms only. Model/property release preferred. Photo captions required; include contact details, subjects, date.

Specs Accepts images in digital format. Send via e-mail as TIFF, EPS, JPEG files at "minimum 5MB open."

Making Contact & Terms Send query letter with tearsheets, stock list. Does not keep samples on file; include SASE for return of material. Responds in 2 weeks to queries. Simultaneous submissions OK. Pays $125-150 for b&w or color cover; $100-125 for b&w or color inside. Pays on publication. Credit line not given. Buys all rights; negotiable.

Tips "Offer pictures by e-mail before sending. Make sure the daily papers aren't running the story first."

$📷▢⃟ THE WESTERN PRODUCER

P.O. Box 2500, Saskatoon SK S7K 2C4 Canada. (306)665-3544. Fax: (306)934-2401. E-mail: newsroom@producer.com. Website: www.producer.com. **Contact:** Terry Fries, news editor. Editor: Barb Glen. Circ. 70,000. Estab. 1923. Weekly newspaper. Emphasizes agriculture and rural living in western Canada. Photo guidelines free with SASE.

Needs Buys 5-8 photos from freelancers/issue; 260-416 photos/year. Needs photos of farm families, environmental, gardening, science, livestock, nature, human interest, scenic, rural, agriculture, day-to-day rural life and small communities. Interested in documentary. Model/property release preferred. Photo captions required; include person's name, location, and description of activity.

Specs Accepts images in digital format. Send via CD, Zip, e-mail as TIFF, EPS, PICT files at 300 dpi.

Making Contact & Terms Send material by mail or e-mail for consideration to the attention of the news editor; include SASE for return of material if sending by mail. Previously published work OK, "but let us know." Pays $75-150 for b&w or color cover; $60-80 for b&w or color inside; $50-250 for text/photo package. Pays on publication. Credit line given. Buys one-time rights.

Tips Needs current photos of farm and agricultural news. "Don't waste postage on abandoned, derelict farm buildings or sunset photos. We want modern scenes with life in them—people or animals, preferably both." Also seeks items on agriculture, rural western Canada, history and contemporary life in rural western Canada.

Trade Publications

Most trade publications are directed toward the business community in an effort to keep readers abreast of the ever-changing trends and events in their specific professions. For photographers, shooting for these professions can be financially rewarding and can serve as a stepping stone toward acquiring future jobs.

As often happens with this category, the number of trade publications produced increases or decreases as professions develop or deteriorate. In recent years, for example, magazines involving new technology have flourished as the technology continues to grow and change.

Trade publication readers are usually very knowledgeable about their businesses or professions. The editors and photo editors, too, are often experts in their particular fields. So, with both the readers and the publications' staffs, you are dealing with a much more discriminating audience. To be taken seriously, your photos must not be merely technically good pictures, but also should communicate a solid understanding of the subject and reveal greater insights.

In particular, photographers who can communicate their knowledge in both verbal and visual form will often find their work more in demand. If you have such expertise, you may wish to query about submitting a photo/text package that highlights a unique aspect of working in that particular profession or that deals with a current issue of interest to that field.

Many photos purchased by these publications come from stock—both freelance inventories and stock photo agencies. Generally, these publications are more conservative with their freelance budgets and use stock as an economical alternative. For this reason, listings in this section will often advise sending a stock list as an initial method of contact. (See sample stock list on page 19.) Some of the more established publications with larger circulations and advertising bases will sometimes offer assignments as they become familiar with a particular photographer's work. For the most part, though, stock remains the primary means of breaking in and doing business with this market.

$ $ ▣ ◖ ABA BANKING JOURNAL

345 Hudson St., New York NY 10014. **Contact:** Wendy Williams, creative director. Art Director: Phil Desiere. Circ. 30,000. Estab. 1909. Monthly magazine. Emphasizes "how to manage a bank better. Bankers read it to find out how to keep up with changes in regulations, lending practices, investments, technology, marketing and what other bankers are doing to increase community standing."

Needs Buys 12-24 photos/year; freelance photography is 20% assigned, 80% from stock. Personality, and occasionally photos of unusual bank displays or equipment. "We need candid photos of various bankers who are subjects of articles." Photos purchased with accompanying ms or on assignment.

Specs Uses 35mm transparencies. Accepts images in digital format. Send via CD, e-mail as TIFF, JPEG files at 300 dpi.

Making Contact & Terms Send query letter with samples, postcards; include SASE for return of material. Responds in 1 month. Pays $200-500/photo. **Pays on acceptance**. Credit line given. Buys one-time rights.

Tips "Send postcard. We hire by location, city."

$ $ ▣ ☑ ⑤ AFTERMARKET BUSINESS

Advanstar Communications, 7500 Old Oak Blvd., Cleveland OH 44130. (440)891-2604. Fax: (440)891-2675. E-mail: cmiller@advanstar.com. Website: www.aftermarketbusiness.com. **Contact:** Stephanie Parker, senior graphic designer. Circ. 40,439. Estab. 1936. Monthly trade magazine. "*Aftermarket Business* is a monthly tabloid-sized magazine, written for corporate executives and key decision-makers responsible for buying automotive products (parts, accessories, chemicals) and other services sold at retail to consumers and professional installers. It's the oldest continuously published business magazine covering the retail automotive aftermarket today and is the only publication dedicated to the specialized needs of this industry." Sample copies available. Call (888)527-7008 for rates.

Needs Buys 0-1 photo from freelancers/issue; 12-15 photos/year. Needs photos of automobiles, product shots/still life. "Review our editorial calendar to see what articles are being written. We use lots of conceptual material." Model/property release preferred.

Specs Uses 35mm, 2¼×2¼ transparencies. Prefers images in digital format. Send via CD, Zip, e-mail as TIFF, JPEG files at 300 dpi.

Making Contact & Terms Send query letter with slides, transparencies, stock list. Provide business card or self-promotion piece to be kept on file for possible future assignments. Responds only if interested; send nonreturnable samples. Pay negotiable. Pays on publication. Credit line given. "Corporate policy requires all freelancers to sign a print and online usage contract for stories and photos." Usually buys one-time rights.

Tips "We can't stress enough the importance of knowing our audience. We are not a magazine aimed at car dealers. Our readers are auto parts distributors. Looking through sample copies will show you a lot about what we need. Show us a variety of stock and lots of it. Send only dupes."

$ $ ▣ ☑ ⑤ AIR LINE PILOT

535 Herndon Pkwy., Box 20172, Herndon VA 22070. (703)481-4460. Fax: (703)464-2114. E-mail: magazine@ alpa.org. Website: www.alpa.org. **Contact:** Pete Janhunen, publications manager. Circ. 72,000. Estab. 1932. Publication of Air Line Pilots Association. 10 issues/year. Emphasizes news and feature stories for airline pilots. Photo guidelines available on website.

Needs Buys 3-4 photos from freelancers/issue; 18-24 photos/year. Needs dramatic 35mm transparencies, prints or high-resolution IBM-compatible images on disk or CD of commercial aircraft, pilots and co-pilots performing work-related activities in or near their aircraft. "Pilots must be ALPA members in good standing. Our editorial staff can verify status." Special needs include dramatic images technically and aesthetically suitable for full-page magazine covers. Especially needs vertical composition scenes. Model release required. Photo captions required; include aircraft type, airline, location of photo/scene, description of action, date, identification of people and which airline they work for.

Specs Accepts images in digital format. Send via CD, SyQuest, ZIP, e-mail. "Final digital cover images must be 300 dpi at 8¼×11. Submissions should be larger to allow cropping."

Making Contact & Terms Send query letter with samples. Send unsolicited photos by mail with SASE for consideration. "Currently use 2 local outside vendors for assignment photography. Occasionally need professional 'news' photographer for location work. Most freelance work is on speculative basis only." Simultaneous submissions and previously published work OK. Pays $450 for cover; $25-100 for b&w inside; $75-300 for color inside. **Pays on acceptance.** Buys all internal rights. Will accept e-mail of "low-resolution" images for review purposes. Can accept large e-mail files if required.

Tips In photographer's samples, wants to see "strong composition, poster-like quality and high technical quality. Photos compete with text for space, so they need to be very interesting to be published. Be sure to provide brief but accurate caption information and send only professional-quality work. Cover images should show airline pilots at work or in the airport going to work. For covers, please shoot vertical images. Check website for criteria and requirements. Send samples of slides to be returned upon review. Make appointment to show portfolio."

$AMERICAN BEE JOURNAL

51 S. Second St., Hamilton IL 62341. (217)847-3324. Fax: (217)847-3660. E-mail: abj@dadant.com. Website: www.dadant.com/journal. **Contact:** Joe M. Graham, editor. Circ. 13,000. Estab. 1861. Monthly trade magazine. Emphasizes beekeeping for hobby and professional beekeepers. Sample copy free with SASE.

Needs Buys 1-2 photos from freelancers/issue; 12-24 photos/year. Needs photos of beekeeping and related topics, beehive products, honey and cooking with honey. Special needs include color photos of seasonal beekeeping scenes. Model release preferred. Photo captions preferred.

Making Contact & Terms Send query letter with samples. Send 5×7 or 8½×11 b&w and/or color prints by mail for consideration; include SASE for return of material. Responds in 2 weeks. Pays $75 for color cover; $10 for inside. Pays on publication. Credit line given. Buys all rights.

$AMERICAN CHAMBER OF COMMERCE EXECUTIVES

4875 Eisenhower Ave., Suite 250, Alexandria VA 22304-4850. (703)998-0072. Fax: (703)212-9512. **Contact:** Greg Roth, communications manager. Circ. 5,000. Monthly trade newsletter. Emphasizes chambers of commerce. Readers are chamber professionals (male and female) interested in developing chambers and securing their professional place. Sample copy free.

Needs Buys 0-5 photos from freelancers/issue; 0-60 photos/year. Special photo needs include conference brochures and artwork provided by local freelancers of chamber executives throughout the country. Model release required. Photo captions preferred.

Making Contact & Terms Send query letter with stock list. Provide résumé, business card, brochure, flier or tearsheets to be kept on file for possible future assignments. Send 4×6 matte b&w prints. Keeps samples on file. Responds in 2 weeks. Pays $10-50/hour. **Pays on acceptance.** Buys all rights.

$▣ ⊘ 🅰 AMERICAN POWER BOAT ASSOCIATION

17640 E. Nine Mile Rd., Box 377, Eastpointe MI 48021-0377. (586)773-9700. Fax: (586)773-6490. E-mail: tana@apba-racing.com. Website: www.apba-racing.com. **Contact:** Tana Moore, publications editor. Estab. 1903. Sanctioning body for US power boat racing; monthly magazine. Majority of assignments made on annual basis. Photos used in monthly magazine, brochures, audiovisual presentations, press releases, programs and website.

Needs Needs photos of adventure, events. Interested in documentary, historical/vintage. Power boat racing—action and candid. Photo captions required.

Specs Uses 5×7 and larger b&w and color prints. Accepts images in digital format. Send via CD, Zip, e-mail as TIFF, EPS, PICT, JPEG files at 300 dpi.

Making Contact & Terms Initial personal contact preferred. Suggests initial contact by phone, possibly to be followed by evaluating samples. Provide business card to be kept on file for possible future assignments. Responds in 2 weeks when needed. Payment varies. Standard is $25 for color cover; $15 for b&w or color inside. Credit line given. Buys one-time rights; negotiable. Photo usage must be invoiced by photographer within the month incurred.

Tips Prefers to see selection of shots of power boats in action or pit shots, candids, etc., (all identified). Must show ability to produce clear color action shots of racing events. "Send a few samples with introduction letter, especially if related to boat racing."

$▣ ⊘ ANIMAL SHELTERING

Humane Society of the US, 2100 L St. NW, Washington DC 20037. (202)452-1100. Fax: (301)258-3081. E-mail: asm@hsus.org. Website: www.animalsheltering.org. **Contact:** Kate Antoniades, editorial assistant/staff writer. Circ. 7,500. Estab. 1978. Bimonthly magazine. Emphasizes animal protection. Readers are animal control and shelter workers, men and women, all ages. Sample copy free.

Needs Buys about 7-10 photos from freelancers/issue; 50 photos/year. Needs photos of domestic animals interacting with animal control and shelter workers; animals in shelters, including farm animals and wildlife;

general public visiting shelters and adopting animals; humane society work, functions, and equipment. Model release required for cover photos only. Photo captions preferred.

Specs Accepts color images in digital or print format. Send via CD, floppy disk, Zip, e-mail as TIFF, BMP, JPEG files.

Making Contact & Terms Provide samples of work to be kept on file for possible future assignments; include SASE for return of material. Responds in 1 month. Pays $150 for cover; $75 for inside. Pays on publication. Credit line given. Buys one-time rights.

Tips "We almost always need good photos of people working with animals in an animal shelter or in the field. We do not use photos of individual dogs, cats and other companion animals as often as we use photos of people working to protect, rescue or care for dogs, cats and other companion animals."

$⬜ APPALOOSA JOURNAL

Appaloosa Horse Club, 2720 W. Pullman Rd., Moscow ID 83843. (208)882-5578. Fax: (208)882-8150. E-mail: journal@appaloosa.com. Website: www.appaloosajournal.com. **Contact:** Diane Rice, editor. Circ. 22,000. Estab. 1946. Monthly association magazine. "*Appaloosa Journal* is the official publication of the Appaloosa Horse Club. We are dedicated to educating and entertaining Appaloosa enthusiasts from around the world." Readers are Appaloosa owners, breeders and trainers, child through adult. Complimentary sample copies available. Photo guidelines free with SASE.

Needs Buys 3 photos from freelancers/issue; 36 photos/year. Needs photos for cover, and to accompany features and articles. Specifically wants photographs of Appaloosas (high-quality horses), especially in winter scenes. Model release required. Photo captions required.

Specs Uses glossy color prints; 35 mm transparencies.

Making Contact & Terms Send query letter with résumé, slides, prints. Keeps samples on file. Responds only if interested; send nonreturnable samples. Simultaneous submissions OK. Pays $200 for color cover; $25 minimum for color inside. **Pays on acceptance**. Credit line given. Buys first rights.

Tips "The Appaloosa Horse Club is a not-for-profit organization. Serious inquiries within specified budget only." In photographer's samples, wants to see "high-quality color photos of world-class, characteristic Appaloosa horses with people in appropriate outdoor environments. Send a letter introducing yourself and briefly explaining your work. If you have inflexible preset fees, be upfront and include that information. Be patient. We are located at the headquarters; although an image might not work for the magazine, it might work for other printed materials. Work has a better chance of being used if allowed to keep on file. If work must be returned promptly, please specify. Otherwise, we will keep it for other departments' consideration."

$ $⬜ ⬜ ⬜ ARCHITECTURAL WRITING

770 Broadway, New York NY 10003. (646)654-4472. Fax: (646)654-4480. E-mail: jmarsland@vnubusinesspublications.com. **Contact:** Jonathan Marsland, art director. Circ. 35,000. Estab. 1981. Monthly magazine. Emphasizes corporate space planning, real estate and office furnishings. Readers are executive-level management. Sample copy free.

Needs Buys 3-5 photos from freelancers/issue; 36-60 photos/year. Needs photos of executive-level decision makers photographed in their corporate environments.

Specs Accepts images in digital format. Send via CD, Zip, e-mail as TIFF, JPEG files at 300 dpi.

Making Contact & Terms Arrange personal interview to show portfolio. Keeps samples on file. Cannot return material. Responds in 1-2 weeks. Simultaneous submissions OK. Pays $400-600 for color cover; $150-250 for color inside; $700-900/day. **Pays on acceptance.** Credit line given. Buys one-time rights.

Tips Looking for "a strong combination of architecture and portraiture."

$ $⬜ ARMY MAGAZINE

2425 Wilson Blvd., Arlington VA 22201. (703)841-4300. Fax: (703)841-3505. **Contact:** Paul Bartels, art director. Circ. 100,000. Monthly magazine of the U.S. Army. Emphasizes military events, topics, history (specifically U.S. Army related). Readers are male/female military personnel—active and retired; defense industries. Sample copy free with 8×10 SASE.

Needs Buys 2-8 photos from freelancers/issue; 24-96 photos/year. Needs photos of Army events, news events, famous people and politicans, military technology. Model release required. Photo captions required.

Specs Uses 5×7 to 8×10 *reflective* (color or b&w) prints or 300-dpi Photoshop files in JPEG, EPS or TIFF format.

Making Contact & Terms Send query letter with résumé of credits. Send unsolicited photos by mail for consideration; include SASE for return of material. Provide résumé, business card, brochure, flier or tearsheets

to be kept on file for possible future assignments. Responds in 3 weeks. Pays $100-400 b&w cover; $125-600 for color cover; $50 for b&w inside; $75-250 for color inside; $75-200 b&w page rate; $100-400 color page rate. Pays on publication. Buys one-time rights; negotiable.

$▣ ◯ ⑤ ASIAN ENTERPRISE

Asian Business Ventures, Inc., P.O. Box 2135, Walnut CA 91788-2135. (909)860-3316. Fax: (909)860-7054. E-mail: almag@asianenterprise.com. Website: www.asianenterprise.com. **Contact:** Gelly Borromeo, publisher. Circ. 100,000. Estab. 1993. Monthly trade magazine. "Largest Asian American small business focus magazine in U.S." Sample copy available for SAE with first-class postage.

Needs Buys 3-5 photos from freelancers/issue; 36-60 photos/year. Needs photos of multicultural, business concepts, senior citizens, environmental, architecture, cities/urban, education, travel, military, political, technology/computers. Reviews photos with or without a ms. Model/property release required.

Specs Uses 4×6 matte b&w prints. Accepts images in digital format. Send via Zip as TIFF, JPEG files.

Making Contact & Terms Send query letter with prints. Provide self-promotion piece to be kept on file for possible future assignments. Responds only if interested; send nonreturnable samples. Simultaneous submissions OK. Pays $50-200 for color cover; $25-100 for b&w inside. Pays on publication. Credit line given. Buys one-time rights.

$ $ ATHLETIC BUSINESS

Athletic Business Publications Inc., 4130 Lien Rd., Madison WI 53704. (608)249-0186. Fax: (608)249-1153. E-mail: kay@athleticbusiness.com. Website: www.athleticbusiness.com. **Contact:** Kay Lum, Cathy Liewen or Scott Mauer, art directors. Circ. 40,000. Estab. 1977. Monthly magazine. Emphasizes athletics, fitness and recreation. "Readers are athletic, park and recreational directors and club managers, ages 30-65." Sample copy available for $8.

Needs Buys 2-3 photos from freelancers/issue; 24-36 photos/year. Needs photos of sporting shots, athletic equipment, recreational parks and club interiors. Model/property release preferred. Photo captions preferred.

Making Contact & Terms "Feel free to send any promotional literature, but do not send anything that needs to be returned (e.g., slides, prints) unless we asked for it." Simultaneous submissions and previously published work OK "but should be explained." Pays $400 for color cover (negotiable); $200 for color inside. Pays on publication. Credit line given. Buys all rights; negotiable.

Tips Wants to see ability with subject, high quality and reasonable price. To break in, "shoot a quality and creative shot from more than one angle."

$ AUTOMATED BUILDER

1445 Donlon St. #16, Ventura CA 93003. (805)642-9735. Fax: (805)642-8820. E-mail: info@automatedbuilder. com. Website: www.automatedbuilder.com. **Contact:** Don Carlson, editor and publisher. Circ. 26,000. Estab. 1964. Monthly. Emphasizes home and apartment construction. Readers are "factory and site builders and dealers of all types of homes, apartments and commercial buildings." Sample copy free with SASE.

Needs Buys 4-8 photos from freelancers/issue; 48-96 photos/year. Needs in-plant and job site construction photos and photos of completed homes and apartments. Reviews photos purchased with accompanying ms only. Photo captions required.

Making Contact & Terms "Call to discuss story and photo ideas." Send 3×5 color prints; 35mm or $2^{1}/_{4} \times 2^{1}/_{4}$ transparencies by mail with SASE for consideration. Will consider dramatic, preferably vertical cover photos. Responds in 2 weeks. Pays $300 for text/photo package; $150 for cover. Credit line given "if desired." Buys first time reproduction rights.

Tips "Study sample copy. Query editor by phone on story ideas related to industrialized housing industry."

▣ AUTOMOTIVE NEWS

Crain Communications, 1155 Gratiot Ave., Detroit MI 48207. (313)446-6000. Fax: (313)446-0383. Website: www.autonews.com. Circ. 77,000. Estab. 1926. Weekly tabloid. Emphasizes the global automotive industry. Readers are automotive industry executives, including people in manufacturing and retail. Sample copies available.

Needs Buys 5 photos from freelancers/issue; 260 photos/year. Needs photos of automotive executives (environmental portraits), auto plants, new vehicles, auto dealer features. Photo captions required; include identification of individuals and event details.

Specs Uses 8×10 color prints; 35mm, $2^{1}/_{4} \times 2^{1}/_{4}$, 4×5 transparencies. Accepts images in digital format. Send as JPEG files at 300 dpi (at least 6″ wide).

Making Contact & Terms Send unsolicited photos by mail with SASE for consideration. Provide résumé, business card, brochure, flier or tearsheets to be kept on file for possible future assignments. Keeps samples on file. Responds in 2 weeks. Simultaneous submissions and previously published work OK. Pays on publication. Credit line given. Buys one-time rights, possible secondary rights for other Crain publications.

$$□ ☑ AVIONICS MAGAZINE

4 Choke Cherry Rd., 2nd floor, Rockville MD 20854. (301)354-2000. Fax: (301)340-8741. **Contact:** David Jensen, editor-in-chief. Senior Editor: Charlotte Adams. Circ. 24,000. Estab. 1978. Monthly magazine. Emphasizes aviation electronics. Readers are avionics and air traffic management engineers, technicians, executives. Sample copy free with 9×12 SASE.

Needs Buys 1-2 photos from freelancers/issue; 12-24 photos/year. Needs photos of travel, business concepts, industry, technology, aviation. Interested in alternative process, avant garde. Reviews photos with or without ms. Photo captions required.

Specs Uses 8½×11 glossy color prints; 35mm, 2¼×2¼, 4×5, 8×10 transparencies. Accepts images in digital format. Send via CD, Zip, e-mail (high resolution only).

Making Contact & Terms Send unsolicited photos by mail with SASE for consideration. Provide résumé, business card, brochure, flier or tearsheets to be kept on file for possible future assignments. Simultaneous submissions OK. Responds in 2 months. Pays $200-500 for color cover. **Pays on acceptance.** Credit line given. Rights negotiable.

$□ BALLINGER PUBLISHING

P.O. Box 12665, Pensacola FL 32591-2665. (850)433-1166. Fax: (850)435-9174. E-mail: shannon@ballingerpublishing.com. Website: www.ballingerpublishing.com. **Contact:** Malcom Ballinger. Circ. 15,000. Estab. 1990. Bimonthly magazines. Emphasize business, lifestyle. Readers are executives, ages 35-54, with average annual income of $80,000. Sample copy available for $1.

Needs Buys 20 photos from freelancers/issue; 120 photos/year. Needs photos of Florida topics: technology, government, ecology, global trade, finance, travel, regional and life shots. Model/property release required. Photo captions preferred.

Specs Uses 5×7 b&w and/or color prints; 35mm. Prefers images in digital format. Send via CD, floppy disk, Zip as TIFF, EPS files at 300 dpi.

Making Contact & Terms Send unsolicited photos by mail for consideration; include SASE for return of material. Provide résumé, business card, brochure, flier or tearsheets to be kept on file for possible future assignments. Responds in 3 weeks. Pays $100-200 for color cover; $75 for b&w inside; $100/color page. Pays on publication. Buys one-time rights.

BARTENDER MAGAZINE

P.O. Box 158, Liberty Corner NJ 07938. (908)766-6006. Fax: (908)766-6607. E-mail: barmag@aol.com. Website: www.bartender.com. **Contact:** Todd Thomas, art director. Circ. 150,000. Estab. 1979. Magazine published 4 times/year. *Bartender Magazine* serves full-service drinking establishments (full-service means able to serve liquor, beer and wine). "We serve single locations including individual restaurants, hotels, motels, bars, taverns, lounges and all other full-service on-premises licensees." Sample copy available for $2.50.

Needs Number of photos/issue varies; number supplied by freelancers varies. Needs photos of liquor-related topics, drinks, bars/bartenders. Reviews photos with or without ms. Model/property release required. Photo captions preferred.

Making Contact & Terms Provide résumé, business card, brochure, flier or tearsheets to be kept on file for possible future assignments; include SASE for return of material. Previously published work OK. Payment negotiable. Pays on publication. Credit line given. Buys all rights; negotiable.

$$□ ☑ BEDTIMES, Business Journal for the Sleep Products Industries

501 Wythe St., Alexandria VA 22314. (703)683-8371. Fax: (703)683-4503. E-mail: jpalm@sleepproducts.org. **Contact:** Julie Palm, editor. Estab. 1917. Monthly association magazine; 40% of readership is overseas. Audience is manufacturers and suppliers in bedding industry. Sample copies available.

Needs Needs head shots, events, product shots/still life, conventions, shows, annual meetings. Reviews photos with or without a ms. Photo captions required; include correct spelling of name, title, company, return address for photos.

Specs Prefers digital images sent as JPEGs via e-mail. Accepts glossy prints.

Making Contact & Terms Send query letter with résumé, photocopies. Responds in 3 weeks to queries.

Simultaneous submissions and previously published work may be OK—depends on type of assignment. Pays $500-1,000 for color cover; $100-400 for b&w or color inside. Pays on publication. Credit line given. Buys one-time rights; negotiable.

Tips "Like to see variations of standard 'mug shot' so they don't all look like something for a prison line-up. Identify people in the picture. Use interesting angles. We'd like to get contacts from all over the U.S. (near major cities) who are available for occasional assignments."

$ ▣ ◯ Ⓐ BEE CULTURE: The Magazine of American Beekeeping

A.I. Root, 623 W. Liberty St., Medina OH 44256-6677. (800)289-7668, ext. 3214 or (330)725-6677, ext. 3214. E-mail: kim@beeculture.com. Website: www.beeculture.com. **Contact:** Kim Flottum, editor. Circ. 12,000. Estab. 1873. Monthly trade magazine emphasizing beekeeping industry—how-to, politics, news and events. Sample copies available. Photo guidelines available on website.

Needs Buys 1-2 photos from freelancers/issue; 6-8 photos/year. Needs photos of wildlife, gardening, agriculture, science. Reviews photos with or without ms. Model release required. Photo captions preferred.

Specs Uses 5×7 glossy or matte color prints; 35mm, $2\frac{1}{4}\times2\frac{1}{4}$, 4×5, 8×10 transparencies. Accepts images in digital format. Send via CD, e-mail as TIFF, EPS, JPEG files at 300 dpi.

Making Contact & Terms Send query letter with photocopies. Does not keep samples on file; include SASE for return of material. "E-mail contact preferred. Send low-res samples electronically for examination." Responds in 2 weeks to queries. Payment negotiable. **Pays on acceptance.** Credit line given. Buys first rights.

Tips "Read 2-3 issues for layout and topics. Think in vertical!"

Ⓝ ▣ BEEF TODAY

FarmJournal Media, 222 S. Jefferson St., Mexico MO 65265. (573)581-9643. Fax: (573)581-9646. E-mail: beeftoday@farmjournal.com. Website: www.agweb.com. **Contact:** Anna McBrayer, art director. Circ. 220,000. Monthly magazine. Emphasizes American agriculture. Readers are active farmers, ranchers or agribusiness people. Sample copy and photo guidelines free with SASE.

Needs Buys 15-20 photos from freelancers/issue; 180-240 photos/year. "We use studio type portraiture (environmental portraits), technical, details, scenics." Wants photos of environmental, landscapes/scenics, rural, agriculture. Model release preferred. Photo captions required.

Making Contact & Terms Arrange a personal interview to show portfolio. Send query letter with résumé of credits along with business card, brochure, flier or tearsheets to be kept on file for possible future assignments. DO NOT SEND ORIGINALS. Accepts images in digital format. Send via CD or e-mail as TIFF, EPS, JPEG files. Responds in 2 weeks. Simultaneous submissions OK. Payment negotiable. "We pay a cover bonus." **Pays on acceptance.** Credit line given. Buys one-time rights.

Tips In portfolio or samples, likes to see "about 20 slides showing photographer's use of lighting and ability to work with people. Know your intended market. Familiarize yourself with the magazine and keep abreast of how photos are used in the general magazine field."

$ $ BEVERAGE DYNAMICS

Adams Beverage Group, 17 High St., 2nd Floor, Norwalk CT 06851. (203)855-8499. Fax: (203)855-7605. Website: www.beveragenet.net. **Contact:** Richard Brandes, editor. Art Director: Adam Lane. Circ. 67,000. Quarterly. Emphasizes distilled spirits, wine and beer, and all varieties of non-alcoholic beverages (soft drinks, bottled water, juices, etc.). Readers are national—retailers (liquor stores, supermarkets, etc.), wholesalers, distillers, vintners, brewers, ad agencies and media.

Needs Uses 30-50 photos/issue. Needs photos of retailers, products, concepts and profiles. Special needs include good retail environments, interesting store settings, special effect photos. Model/property release required. Photo captions required.

Making Contact & Terms Send query letter with samples and list of stock photo subjects. Provide business card to be kept on file for possible future assignments. Keeps samples on file; send nonreturnable samples, slides, tearsheets, etc. Responds in 2 weeks. Simultaneous submissions OK. Pays $550-750 for color cover; $450-950/job. Pays on publication. Credit line given. Buys one-time rights or all rights.

Tips "We're looking for good location photographers who can style their own photo shoots or have staff stylists. It also helps if they are resourceful with props."

$ ▣ ◳ BOXOFFICE

155 S. El Molino Ave., Suite 100, Pasadena CA 91101. (626)396-0250. Fax: (626)396-0248. E-mail: kimw@box office.com. Website: www.boxoffice.com. **Contact:** Kim Williamson, editor-in-chief. Circ. 6,000. Estab. 1920. Monthly trade magazine. Sample copy available for $10.

Needs Photo needs are very specific. "All photos must be of movie theaters and management." Reviews photos with accompanying ms only. Photo captions required.

Specs Uses 4×5, 8×10 glossy color and/or b&w prints; 35mm, 2¼×2¼, 4×5 transparencies. Accepts images in digital format. Send via CD, Zip as TIFF files at 300 dpi.

Making Contact & Terms Send query letter with résumé, tearsheets. Does not keep samples on file; cannot return material. Responds in 1 month to queries. Responds only if interested; send nonreturnable samples. Previously published work OK. Pays $10/printed photo. Pays on publication. Credit line sometimes given. Buys one-time print rights and all electronic rights.

$ $ 🖾 BUSINESS NH MAGAZINE

670 N. Commercial St., Suite 110, Manchester NH 03101. (603)626-6354. Fax: (603)626-6359. E-mail: producti on@businessnhmagazine.com. Website: www.businessnhmagazine.com. **Contact:** Holly Kennedy, graphic designer. Circ. 14,600. Estab. 1984. Monthly magazine. Emphasizes business. Readers are male and female top management, average age 45. Sample copy free with 9×12 SAE and 5 first-class stamps.

Needs Uses 3-6 photos/issue. Needs photos of couples, families, rural, entertainment, food/drink, health/ fitness, performing arts, travel, business concepts, industry, science, technology/computers. Model/property release preferred. Photo captions required; include names, locations, contact phone number.

Specs Accepts images in digital format. Send via CD, Zip as TIFF, JPEG files at 300 dpi.

Making Contact & Terms Arrange personal interview to show portfolio. Provide résumé, business card, brochure, flier or tearsheets to be kept on file for possible future assignments. Responds in 3 weeks. Pays $450 for color cover; $100 for color or b&w inside. Pays on publication. Credit line given. Buys one-time rights. Offers internships for photographers.

Tips Looks for "people in environment shots, interesting lighting, lots of creative interpretations, a definite personal style. If you're just starting out and want excellent statewide exposure to the leading executives in New Hampshire, you should talk to us. Send letter and samples, then arrange for a portfolio showing."

$ 🖾 CANADIAN GUERNSEY JOURNAL

RR 5, Guelph ON N1H 6J2 Canada. (519)836-2141. E-mail: info@guernseycanada.ca. Website: www.guernse ycanada.ca. **Contact:** V.M. Macdonald, editor. Circ. 500. Estab. 1927. Bimonthly magazine of the Canadian Guernsey Association. Emphasizes dairy cattle, purebred and grade guernseys. Readers are dairy farmers. Sample copy available for $5.

Needs Buys 1 photo from freelancers/issue; 6 photos/year. Needs photos of guernsey cattle; posed, informal, scenes. Photo captions preferred.

Making Contact & Terms Contact through rep. Keeps samples on file. Responds in 2 weeks. Previously published work OK. Pays $10 for b&w inside. Pays on publication. Credit line given. Rights negotiable.

🖾 CATHOLIC LIBRARY WORLD

100 North St., Suite 224, Pittsfield MA 01201-5109. (413)443-2CLA. Fax: (413)442-2252. E-mail: cla@cathla.o rg. Website: www.cathla.org/cathlibworld.html. **Contact:** Jean R. Bostley, SSJ, executive director. Circ. 1,100. Estab. 1929. Quarterly magazine of the Catholic Library Association. Emphasizes libraries and librari-ans (community/school libraries; academic/research librarians; archivists). Readers are librarians who be-long to the Catholic Library Association; other subscribers are generally employed in Catholic institutions or academic settings. Sample copy available for $15.

Needs Uses 2-5 photos/issue. Needs photos of authors of children's books, and librarians who have done something to contribute to the community at large. Special photo needs include photos of annual conferences. Model release preferred for photos of authors. Photo captions preferred.

Specs Uses 5×7 b&w prints. Accepts images in digital format. Send via CD, Zip as PDF files at 1,200 dpi.

Making Contact & Terms Send b&w prints; include SASE for return of material. Deadlines: January 15, April 15, July 15, September 15. Responds in 2 weeks. Credit line given. Acquires one-time rights.

🖾 🖉 CHEF, The Professional Magazine for Chefs

Talcott Communications Corp., 20 W. Kinzie St., 12th Floor, Chicago IL 60610. (312)849-2220. Fax: (312)849-2174. E-mail: chef@talcott.com. Website: www.chefmagazine.com. **Contact:** Robert J. Benes, senior editor. Circ. 40,000. Estab. 1956. Trade magazine. "We are a food magazine for chefs. Our focus is to help chefs enhance the bottom lines of their businesses through food preparation, presentation, and marketing the menu."

Needs Buys 1-2 photos from freelancers/issue. Needs photos of food/drink. Other specific photo needs:

chefs, establishments. Reviews photos with or without a ms. Model/property release preferred. Photo captions preferred.

Specs Uses 8×10 glossy color prints; 35mm, 2¼×2¼, 4×5, 8×10 transparencies. Accepts images in digital format. Send via CD, Jaz, Zip as TIFF, EPS, JPEG files at 300 dpi.

Making Contact & Terms Send query letter with résumé, photocopies, tearsheets, stock list. Provide résumé, business card or self-promotion piece to be kept on file for possible future assignments. Responds in 1 month to queries; 3 months to portfolios. Previously published work OK. Pays on publication. Credit line given. Buys one-time rights (prefers one-time rights to include electronic).

$ CHILDHOOD EDUCATION

The Olney Professional Bldg., 17904 Georgia Ave., Suite 215, Olney MD 20832. (301)570-2111. **Contact:** Anne Bauer, director of publications/editor. Assistant Editor: Bruce Herzig. Circ. 15,000. Estab. 1924. Publication for the Association for Childhood Education International. Bimonthly journal. Emphasizes the education of children from infancy through early adolescence. Readers include teachers, administrators, day-care workers, parents, psychologists, student teachers, etc. Sample copy free with 9×12 SAE and $1.44 postage. Photo guidelines free with SASE.

Needs Uses 5-10 photos/issue; 2-3 supplied by freelance photographers. Uses freelancers mostly for covers. Subject matter includes children, infancy-14 years, in groups or alone, in or out of the classroom, at play, in study groups; boys and girls of all races and in all cities and countries. Wants close ups of children, unposed. Reviews photos with or without accompanying ms. Special needs include photos of minority children; photos of children from different ethnic groups together in one shot; boys and girls together. Model release required.

Specs Uses 8×10 glossy b&w and color prints and color transparencies.

Making Contact & Terms Send unsolicited photos by mail with SASE for consideration. Responds in 1 month. Simultaneous submissions and previously published work are discouraged but negotiable. Pays $75-100 for color cover; $25-50 for b&w inside. Pays on publication. Credit line given. Buys one-time rights.

Tips "Send pictures of unposed children, please."

$ ▣ ◑ ⑤ CIVITAN MAGAZINE

P.O. Box 130744, Birmingham AL 35213-0744. (205)591-8910. Fax: (205)592-6307. E-mail: wellborn@civitan .org. Website: www.civitan.org. **Contact:** Dorothy Wellborn, editor. Circ. 27,000. Estab. 1920. Bimonthly magazine. Publication of Civitan International. Emphasizes work with mental retardation/developmental disabilities. Readers are men and women, college age to retirement, usually managers or owners of businesses. Sample copy free with 9×12 SASE and 2 first-class stamps.

Needs Buys 1-2 photos from freelancers/issue; 6-12 photos/year. Always looking for good cover shots (multicultural, travel, scenic and how-to), babies/children/teens, families, religious, disasters, environmental, landscapes/scenics. Model release required. Photo captions preferred.

Specs Accepts images in digital format. Send via CD, Jaz, Zip as TIFF files at 300 dpi.

Making Contact & Terms Send sample of unsolicited 2¼×2¼ or 4×5 transparencies by mail for consideration. Provide résumé, business card, brochure, flier or tearsheets to be kept on file for possible future assignments. Responds in 1 month. Simultaneous submissions and previously published work OK. Pays $50-200 for color cover; $20 for color inside. **Pays on acceptance.** Buys one-time rights.

$ ▣ CLASSICAL SINGER

P.O. Box 1710, Draper UT 84020. (801)254-1025. Fax: (801)254-3139. E-mail: layout@classicalsinger.com. **Contact:** Art Director. Circ. 9,000. Estab. 1988. Glossy monthly trade magazine for classical singers. Sample copy free.

Needs Looking for photos in opera or classical singing. E-mail for calendar and ideas. Photo captions preferred; include where, when, who.

Specs Uses b&w and color prints or high-res digital photos.

Making Contact & Terms Responds in 1 month to queries. Simultaneous submissions and previously published work OK. Pays honorarium plus 10 copies. Pays on publication. Credit line given. Buys one-time rights. Photo may be used in a reprint of an article on paper or website.

Tips "Our publication is expanding rapidly. We want to make insightful photographs a big part of that expansion."

$ CLAVIER

200 Northfield Rd., Northfield IL 60093. (847)446-5000. Fax: (847)446-6263. **Contact:** Judy Nelson, editor. Circ. 13,000. Estab. 1962. Magazine published 10 times/year. Readers are piano and organ teachers. Sample copy available for $2.

Needs Human interest photos of keyboard instrument students and teachers. Special needs include synthe-sizer photos and children performing.

Specs Uses glossy b&w and/or color prints. For cover: Kodachrome glossy color prints or 35mm transparencies. Vertical format preferred. Photos should enlarge to $8^{3}/_{4} \times 11^{3}/_{4}$ without grain.

Making Contact & Terms Send material by mail with SASE for consideration. Responds in 1 month. Pays $225 for color cover; $10-25 for b&w inside. Pays on publication. Credit line given. Buys all rights.

Tips "We look for sharply focused photographs that show action, and for clear color that is bright and true. We need photographs of children and teachers involved in learning music at the piano. We prefer shots that show them deeply involved in their work rather than posed shots. Very little is taken on specific assignment except for the cover. Authors usually include article photographs with their manuscripts. We purchase only one or two items from stock each year."

$◙ CLEANING & MAINTENANCE MANAGEMENT MAGAZINE

13 Century Hill Dr., Latham NY 12110. (518)783-1281. Fax: (518)783-1386. E-mail: lbrin@ntpinc.com. Web-site: www.cmmonline.com. **Contact:** Lisa Brin, executive editor. Circ. 42,000. Estab. 1963. Monthly. Emphasizes management of cleaning/custodial/housekeeping operations for commercial buildings, schools, hospitals, shopping malls, airports, etc. Readers are middle- to upper-level managers of in-house cleaning/custodial departments, and managers/owners of contract cleaning companies. Sample copy free (limited) with SASE.

Needs Uses 10-15 photos/issue. Needs photos of cleaning personnel working on carpets, hardwood floors, tile, windows, restrooms, large buildings, etc. Model release preferred. Photo captions required.

Making Contact & Terms Provide résumé, business card, brochure, flier or tearsheets to be kept on file for possible future assignments. "Send query letter with specific ideas for photos related to our field." Responds in 1-2 weeks. Simultaneous submissions and previously published work OK. Pays $25 for b&w inside. Credit line given. Rights negotiable.

Tips "Query first and shoot what the publication needs."

◙ COMMERCIAL CARRIER JOURNAL

3200 Rice Mine Rd. NE, Tuscaloosa AL 35406. (800)633-5953. Fax: (205)750-8070. **Contact:** Paul Richards, editor. Circ. 105,000. Estab. 1911. Monthly magazine. Emphasizes truck and bus fleet maintenance operations and management.

Needs Spot news (of truck accidents, Teamster activities and highway scenes involving trucks). Photos purchased with or without accompanying ms, or on assignment. Model release required. Detailed captions required.

Specs For color photos, uses prints and slides. For covers, uses medium-format transparencies (vertical only).

Making Contact & Terms Does not accept unsolicited phots. Query first; send material by mail with SASE for consideration. Responds in 3 months. Pays on a per-job or per-photo basis. **Pays on acceptance.** Credit line given. Buys all rights.

Tips Needs accompanying features on truck fleets and news features involving trucking companies.

CONSTRUCTION EQUIPMENT GUIDE

470 Maryland Dr., Ft. Washington PA 19034. (215)885-2900 or (800)523-2200. Fax: (215)885-2910. E-mail: editorial@cegltd.com. Website: www.constructionequipmentguide.com. **Contact:** Editor. Circ. 120,000. Estab. 1957. Biweekly trade newspaper. Emphasizes construction equipment industry, including projects ongoing throughout the country. Readers are males and females of all ages; many are construction executives, contractors, dealers and manufacturers. Free sample copy.

Needs Buys 35 photos from freelancers/issue; 910 photos/year. Needs photos of construction job sites and special event coverage illustrating new equipment applications and interesting projects. Call to inquire about special photo needs for coming year. Model/property release preferred. Photo captions required for subject identification.

Making Contact & Terms Send any size matte or glossy b&w prints by mail with SASE for consideration. Provide résumé, business card, brochure, flier or tearsheets to be kept on file for possible future assignments. Responds in 3 weeks. Payment negotiable. Pays on publication. Credit line given. Buys all rights; negotiable.

$ $▣ CONVENIENCE STORE DECISIONS

Penton Media, Two Greenwood Square, Suite 410, 3331 Street Rd., Bensalem PA 19020. (215)638-6273. Fax: (215)245-4060. E-mail: jgordon@penton.com. Website: www.c-storedecisions.com. **Contact:** Bill Donahue, editor. Circ. 41,000. Estab. 1990. Monthly trade magazine. Sample copies available.

Needs Buys 24-36 photos from freelancers/year. Needs photos of food/drink, business concepts, product shots/still life, retail. Convenience stores—transactions, customers, employees. Gasoline/petroleum outlets—customers pumping gas, etc. Newsworthy photos dealing with convenience stores and gas stations. Reviews photos with or without ms. Photo captions preferred.

Specs Uses any print format, but prefers digital images in TIFF, EPS or JPEG format via CD or e-mail at 300 dpi.

Making Contact & Terms Send query letter with photocopies, stock list. Provide business card or self-promotion piece to be kept on file for possible future assignments. Simultaneous submissions and previously published work OK. Pays $300-800 for color cover; $100-600 for color inside. Pays on publication. Credit line given. Buys one-time rights, electronic rights; negotiable.

Tips "We have numerous opportunities for spec jobs in various markets across the country. We also have a great need for spot photo/illustration that relates to our audience (convenience store operators and petroleum marketers). We will do a lot of volume with the right photographer. Consider our audience."

$ $☑ COTTON GROWER MAGAZINE

Meister Media Worlwide, 65 Germantown Court, Suite 202, Cordova TN 38018. (901)756-8822. Fax: (901)756-8879. Website: www.meisternet.com. **Contact:** Frank Giles, senior editor. Circ. 45,000. Estab. 1999. Monthly trade magazine. Emphasizes "cotton production; for cotton farmers." Sample copies and photo guidelines available.

Needs Buys 1 photo from freelancers/issue; 12 photos/year. Needs photos of agriculture. "Our main photo needs are cover shots of growers. We write cover stories on each issue."

Specs Uses 35mm glossy prints.

Making Contact & Terms Send query letter with slides, prints, tearsheets. Responds in 1 week. Pays $100-350 for color cover. **Pays on acceptance.** Credit line given. Buys all rights.

Tips Most photography hired is for cover shots of cotton growers.

$ ▣ ◯ Ⓐ CRANBERRIES

P.O. Box 113, Allendale MI 49401. (616)443-3678. E-mail: cranmag@yahoo.com. **Contact:** Greg Brown, publisher/editor. Circ. 1,000. Monthly, but December/January is a combined issue. Emphasizes cranberry growing, processing, marketing and research. Readers are "primarily cranberry growers but include anybody associated with the field." Sample copy available for $3.

Needs Buys 3 photos from freelancers/issue; 25 photos/year. Needs "portraits of growers, harvesting, manufacturing—anything associated with cranberries." Photo captions required.

Specs Uses prints. Accepts images in digital format. Send via CD as JPEG, TIFF files.

Making Contact & Terms Send 4×5 or 8×10 b&w or color glossy prints by mail with SASE for consideration; "simply query about prospective jobs." Simultaneous submissions and previously published work OK. Pays $50-95 for color cover; $15-30 for b&w inside; $35-100 for text/photo package. Pays on publication. Credit line given. Buys one-time rights.

Tips "Learn about the field."

$ $CROPLIFE

37733 Euclid Ave., Willoughby OH 44094. (440)602-9142. Fax: (440)942-0662. E-mail: paul@croplife.com. Website: www.croplife.com. **Contact:** Paul Schrimpp, senior editor. Circ. 24,500. Estab. 1894. Monthly magazine. Serves the agricultural distribution channel delivering fertilizer, chemicals, and seed from manufacturer to farmer. Sample copy and photo guidelines free with 9×12 SASE.

Needs Buys 6-7 photos/year; 5-30% supplied by freelancers. Needs photos of agricultural chemical and fertilizer application scenes (of commercial—not farmer—applicators), people shots of distribution channel executives and managers. Model release preferred. Photo captions required.

Specs Uses 8×10 glossy b&w and color prints; 35mm slides, transparencies.

Making Contact & Terms Send query letter first with résumé of credits. Responds in 3 weeks. Simultaneous submissions and previously published work OK. Pays $150-300 for color cover; $150-250 for color inside. **Pays on acceptance.** Buys one-time rights.

Tips "E-mail is the best way to approach us with your work. Experience and expertise is best."

Ⓝ $ $DAIRY TODAY

FarmJournal Media, 1818 Market St., 31st Floor, Philadelphia PA 19103. (215)557-8900. Fax: (215)568-3989. E-mail: dairytoday@farmjournal.com. Website: www.agweb.com. **Contact:** Joe Tenerelli, art director. Circ.

50,000. Monthly magazine. Emphasizes American agriculture. Readers are active farmers, ranchers or agribusiness people. Sample copy and photo guidelines free with SASE.

Needs Buys 5-10 photos from freelancers/issue; 60-120 photos/year. ''We use studio-type portraiture (environmental portraits), technical, details, scenics.'' Wants photos of environmental, landscapes/scenics, agriculture, business concepts. Model release preferred. Photo captions required.

Making Contact & Terms Arrange a personal interview to show portfolio. Send query letter with résumé of credits along with business card, brochure, flier or tearsheets to be kept on file for possible future assignments. ''Portfolios may be submitted via CD-ROM or floppy disk.'' DO NOT SEND ORIGINALS. Responds in 2 weeks. Simultaneous submissions OK. Pays $75-400 for color photo; $200-400/day. ''We pay a cover bonus.'' **Pays on acceptance.** Credit line given, except in advertorials. Buys one-time rights.

Tips In portfolio or samples, likes to see ''about 40 slides showing photographer's use of lighting and ability to work with people. Know your intended market. Familiarize yourself with the magazine and keep abreast of how photos are used in the general magazine field.''

$ ▣ ◪ DANCE TEACHER

Lifestyle Media, Inc., 110 William St., 23rd Floor, New York NY 10038. (646)459-4800. Fax: (646)459-4900. E-mail: jtu@lifestylemedia.com. Website: www.dance-teacher.com. **Contact:** Jeni Tu, managing editor. Circ. 12,000. Estab. 1979. Monthly magazine. Emphasizes dance, business, health and education. Readers are dance instructors and other related professionals, ages 15-90. Sample copy free with 9×12 SASE. Photo guidelines free with SASE.

Needs Buys 20 photos from freelancers/issue; 240 photos/year. Needs photos of action shots (teaching, etc.). Reviews photos with accompanying ms only. Model release required for minors and celebrities. Photo captions preferred; include date and location.

Specs Accepts digital images via SyQuest, Zip, floppy disk, e-mail; call art director for requirements.

Making Contact & Terms Provide résumé, business card, brochure, flier or tearsheets to be kept on file for possible future assignments. Pays $50 minimum for color cover; $20-125 for b&w inside; $20-150 for color inside. Pays on publication. Credit line given. Buys one-time rights plus publicity rights; negotiable.

Ⓝ ▣ DENTAL ECONOMICS

Box 3408, Tulsa OK 74101. (918)831-9804. Fax: (918)831-9804. **Contact:** Dr. Joe Blaes, editor. Circ. 109,000. Monthly magazine. Emphasizes dental practice administration—how to handle staff, patients and bookkeeping, and how to handle personal finances for dentists. Sample copy and photo guidelines free with SASE.

Needs ''Our articles relate to the business side of a practice: scheduling, collections, consultation, malpractice, peer review, closed panels, capitation, associates, group practice, office design, etc.'' Also uses profiles of dentists.

Specs Uses digital images; 8×10 b&w glossy prints; 35mm, $2^{1}/_{4} \times 2^{1}/_{4}$ transparencies.

Making Contact & Terms Send material by mail for consideration; include SASE. Responds in 5-6 weeks. Credit line given. Buys all rights but may reassign to photographer after publication.

Tips ''Write and think from the viewpoint of the dentist—not as a consumer or patient. If you know of a dentist with an unusual or very visual hobby, tell us about it. We'll help you write the article to accompany your photos. Query, please.''

$ $ ▣ ◯ EL RESTAURANTE MEXICANO

Maiden Name Press, P.O. Box 2249, Oak Park IL 60303. (708)445-9454. Fax: (708)445-9477. E-mail: kfurore@restmex.com. Website: www.restmex.com. **Contact:** Kathy Furore, editor. Circ. 27,000. Estab. 1997. Bimonthly trade magazine for restaurants that serve Mexican, Tex-Mex, Southwestern and Latin cuisine. Sample copies available.

Needs Buys at least 1 photo from freelancers/issue; at least 6 photos/year. Needs photos of food/drink. Reviews photos with or without ms.

Specs Uses 35mm transparencies. Accepts images in digital format. Send via e-mail as TIFF, JPEG files of at least 300 dpi.

Making Contact & Terms Send query letter with slides, prints, photocopies, tearsheets, transparencies or stock list. Provide résumé, business card, self-promotion piece to be kept on file for possible future assignments. Responds in 2 months to queries. Previously published work OK. Pays $450 maximum for color cover; $125 maximum for color inside. Pays on publication. Credit line given. Buys all rights; negotiable.

Tips ''We look for outstanding food photography; the more creatively styled, the better.''

$ $▣ ☑ ELECTRIC PERSPECTIVES

701 Pennsylvania Ave. NW, Washington DC 20004. (202)508-5714. Fax: (202)508-5759. E-mail: eblume@eei. org. **Contact:** Eric Blume, editor/publisher. Circ. 20,000. Estab. 1976. Bimonthly magazine of the Edison Electric Institute. Emphasizes issues and subjects related to investor-owned electric utilities. Sample copy available on request.

Needs Needs photos relating to the business and operational life of electric utilities—from customer service to engineering, from executive to blue collar. Model release required. Photo captions preferred.

Specs Uses 8×10 glossy color prints; 35mm, $2\frac{1}{4} \times 2\frac{1}{4}$, 4×5 transparencies. Accepts images in digital format. Send via Zip, e-mail as TIFF, JPEG files at 300 dpi and scanned at a large size, at least 4×5.

Making Contact & Terms Send query letter with stock list or send unsolicited photos by mail for consideration. Provide résumé, business card, brochure, flier or tearsheets to be kept on file for possible future assignments. Keeps samples on file; include SASE for return of material. Pays $300-500 for color cover; $100-300 for color inside; $200-350 color page rate; $750-1,500 for photo/text package. Pays on publication. Buys one-time rights; negotiable (for reprints).

Tips "We're interested in annual-report-quality images in particular. Quality and creativity are often more important than subject."

$ ▣ ELECTRICAL APPARATUS

Barks Publications, Inc., 400 N. Michigan Ave., Chicago IL 60611-4198. (312)321-9440. **Contact:** Elsie Dickson, associate publisher. Circ. 17,000. Monthly magazine. Emphasizes industrial electrical machinery maintenance and repair for the electrical aftermarket. Readers are "persons engaged in the application, maintenance and servicing of industrial and commercial electrical and electronic equipment." Sample copies available.

Needs "Assigned materials only. We welcome innovative industrial photography, but most of our material is staff-prepared." Photos purchased with accompanying ms or on assignment. Model release required "when requested." Photo captions preferred.

Making Contact & Terms Send query letter with résumé of credits. Contact sheet or contact sheet with negatives OK; include SASE for return of material. Responds in 3 weeks. Pays $25-100 for b&w or color. Pays on publication. Credit line given. Buys all rights, but exceptions are occasionally made.

$ $▣ ☑ EMS MAGAZINE: The Journal of Emergency Care, Rescue and Transportation

Summer Communications, Inc., 7626 Densmore Ave., Van Nuys CA 91406-2042. (800)224-4367. Fax: (818)786-9246. E-mail: nancy.perry@cygnuspub.com. Website: www.emsmagazine.com. **Contact:** Nancy Perry, managing editor. Circ. 53,000. Estab. 1972. Monthly magazine emphasizing emergency medical services—prehospital care; aimed at EMTs and paramedics. Sample copies available.

Needs Buys 5 photos from freelancers/issue; 70 photos/year. Needs photos of disasters, medicine, military, ambulance photos, accident scenes. Reviews photos with or without ms. Model release preferred. Photo captions preferred.

Specs Uses 5×7 matte color prints; 35mm transparencies. Accepts images in digital format. Send via CD, floppy disk, e-mail as TIFF, JPEG files at 300 dpi.

Making Contact & Terms Send query letter with résumé, prints, stock list. Does not keep samples on file; include SASE for return of material. Responds in 3 weeks. Pays $200-500 for color cover; $25-50 for color inside. Pays on publication. Credit line given. Buys one-time rights.

Ⓝ $ $▣ FARM JOURNAL

FarmJournal Media, 1818 Market St., 31st Floor, Philadelphia PA 19103-3654. (215)557-8900. Fax: (215)568-8959. E-mail: farmjournal@farmjournal.com. Website: www.agweb.com. **Contact:** Joe Tenerelli, art director. Circ. 600,000. Estab. 1877. Monthly magazine. Emphasizes the business of agriculture: "Good farmers want to know what their peers are doing and how to make money marketing their products." Free sample copy upon request.

- *Farm Journal* has received the Best Use of Photos/Design from the American Agricultural Editors' Association (AAEA).

Needs Freelancers supply 60% of the photos. Photos having to do with the basics of raising, harvesting and marketing of all the farm commodities, farm animals and international farming. People-oriented shots are encouraged. Also uses human interest and interview photos. All photos must relate to agriculture. Photos purchased with or without accompanying ms. Model release required. Photo captions required.

Specs Uses glossy or semigloss color and/or b&w prints; 35mm, $2\frac{1}{4} \times 2\frac{1}{4}$ transparencies; all sizes for covers. Accepts images in digital format. Send via CD as TIFF, EPS, JPEG files at 300 dpi.

Making Contact & Terms Arrange a personal interview or send photos by mail. Provide calling card and samples to be kept on file for possible future assignments. Responds in 1 month. Simultaneous submissions OK. Pays by assignment or photo. Pays $200-400/job; $400-1,200 for color cover; $100-300 for b&w inside; $150-500 for color inside. Cover bonus. **Pays on acceptance.** Credit line given. Buys one-time rights; negotiable.

Tips "Be original and take time to see with the camera. Be selective. Look at use of light—available or strobed—and use of color. I look for an easy rapport between photographer and subject. Take as many different angles of subject as possible. Use fill where needed. Send nonreturnable samples of agriculture-related photos only. We are always looking for photographers located in the midwest and other areas of the country where farming is a way of life."

$ ⒶＥ FIRE CHIEF

330 N. Wabash Ave., Suite 2300, Chicago IL 60611. (312)595-1080. Fax: (312)595-0295. Website: www.firechief.com. **Contact:** Kevin Daniels, editor. Circ. 53,000. Estab. 1956. Monthly magazine. Emphasizes fire department management and operations. Readers are primarily fire officers and predominantly chiefs of departments. Sample copy free. Photo guidelines free with SASE.

Needs Uses photos of fire and emergency response.

Specs Accepts images in digital format. Send via CD, Zip as TIFF, EPS files at highest possible resolution.

Making Contact & Terms Send any glossy color prints; 35mm, $2\frac{1}{4} \times 2\frac{1}{4}$ transparencies by mail for consideration. Keeps samples on file. Responds in 1 month. Pays $50-100 for color inside. Pays on publication. Buys first serial rights; negotiable.

Tips "Most photographs are part of a feature story; however, we do buy some for other use. Cover photos must include an officer in the picture—white, yellow or red helmet—in an action scene,fire, accident, incident, etc."

Ｎ $Ｅ ⊘ FIRE ENGINEERING

21-00 Route 208 South, Fairlawn NJ 07410. (973)251-5040. Fax: (973)251-5065. E-mail: dianef@pennwell.com. **Contact:** Diane Feldman, managing editor. Estab. 1877. Training magazine for firefighters. Photo guidelines free.

Needs Uses 400 photos/year. Needs action photos of disasters, firefighting, EMS, public safety, fire investigation and prevention, rescue. Photo captions required; include date, what is happening, location and fire department contact.

Specs Uses prints; 35mm transparencies. Accepts images in digital format. Send via CD as JPEG files at 300 dpi.

Making Contact & Terms Send unsolicited photos by mail for consideration. Responds in 3 months. Pays $300 for color cover; $35-150 for color inside. Pays on publication. Credit line given. Rights negotiable.

Tips "Firefighters must be doing something. Our focus is on training and learning lessons from photos."

$Ｅ ⊘ FIRE-RESCUE MAGAZINE

Jems Communications, P.O. Box 469012, Escondido CA 92046-9745. (800)266-5367. Fax: (619)699-6396. E-mail: m.garrido@elsevier.com. Website: www.jems.com/firerescue. **Contact:** Michelle Garrido, editor. Circ. 50,000. Estab. 1997. Monthly. Emphasizes techniques, equipment, action stories of fire and rescue incidents. Editorial slant: "Read it today, use it tomorrow." Sample copy free with 9×12 SAE and 7 first-class stamps. Photo guidelines free with SASE.

Needs Uses 50-75 photos/issue; 25-50 supplied by freelancers. Needs photos of disasters, emergency medical services, rescue scenes, transport, injured victims, equipment and personnel, training, earthquake rescue operations. Special photo needs include strong color shots showing newsworthy rescue operations, including a unique or difficult firefighting, rescue/extrication, treatment, transport, personnel, etc.; b&w showing same. Photo captions required.

Specs Prefers slides/transparencies. Accepts images in digital format. Send via Zip, e-mail, Jaz, floppy disk, SyQuest, CD as TIFF, EPS, JPEG files at 300 dpi.

Making Contact & Terms Send query letter with 5×7 or larger glossy color prints or color contact sheets. Pays $200 for cover; $20-125 for color inside; $10-100 for b&w inside. Pays on publication. Credit line given. Buys one-time rights.

Tips Looks for "photographs that show firefighters in action, using proper techniques and wearing the proper equipment. Submit timely photographs that show the technical aspects of firefighting and rescue. Tight shots/close-ups preferred."

$ $▣ ✐ ⑤ FIREHOUSE MAGAZINE

3 Huntington Quadrangle, Suite 301N, Melville NY 11747. (631)845-2700. Fax: (631)845-7218. Website: www.firehouse.com. **Contact:** Harvey Eisner, editor-in-chief. Circ. 110,000. Estab. 1976. Monthly. Emphasizes "firefighting—notable fires, techniques, dramatic fires and rescues, etc." Readers are "paid and volunteer firefighters, EMTs." Sample copy available for $5 with 9×12 SASE and 7 first-class stamps. Photo guidelines free with SASE.

Needs Buys 20 photos from freelancers/issue; 240 photos/year. Needs photos of fires, terrorism, firefighter training, natural disasters, highway incidents, hazardous materials, dramatic rescues. Model release preferred.

Specs Uses 3×5, 5×7, 8×10 matte or glossy b&w or color prints; 35mm transparencies. Accepts images in digital format. Send via CD, e-mail as TIFF, EPS, JPEG files at 300 dpi.

Making Contact & Terms "Photos must not be more than 30 days old." Include SASE. "Photos cannot be returned without SASE." Responds ASAP. Pays up to $300 for color cover; $20-100 for b&w inside; $20-200 for color inside. Pays on publication. Credit line given. Buys one-time rights.

Tips "Mostly we are looking for action-packed photos—the more fire, the better the shot. Show firefighters in full gear; do not show spectators. Fire safety is a big concern. Much of our photo work is freelance. Try to be in the right place at the right time as the fire occurs. Be sure that photos are clear, in focus, and show firefighters/EMTs at work. *Firehouse* encourages submissions of high-quality action photos that relate to the firefighting/EMS field. Please understand that while we encourage first-time photographers, a minimum waiting period of 3-6 months is not unusual. Although we are capable of receiving photos over the Internet, please be advised that there are color variations. Include captions. Photographers must include a SASE, and we cannot guarantee the return of unsolicited photos. Mark name and address on the back of each photo."

$ $▣ ✐ FLEET EXECUTIVE, The Magazine for Vehicle Management

NAFA, 100 Wood Ave. S., Suite 310, Iselin NJ 08830. (732)494-8100. Fax: (732)494-6789. E-mail: cmcloughlin @nafa.org. Website: www.nafa.org. **Contact:** Carolann McCloughlin, managing editor. Circ. 4,500. Estab. 1957. Official magazine of the National Association of Fleet Administrators, Inc., published 8 times/year. Sample copy available for $4. Photo guidelines available.

Needs Needs photos of automobiles, business concepts, technology/computers. Interested in historical/vintage. Assignments include photo coverage of association members' work environments and vehicle fleets. Reviews photos with or without ms. Model/property release preferred. Photo captions preferred.

Specs Uses color prints. Accepts images in digital format. Send via CD, Zip, e-mail as TIFF files at 300 dpi.

Making Contact & Terms Provide business card or self-promotion piece to be kept on file for possible future assignments. Responds only if interested; send nonreturnable samples. **Pays on acceptance.** Buys all rights; negotiable.

Tips "Research publication so samples are on target with magazine's needs."

$ $▣ ✐ ⒜ ▣ FLORAL MANAGEMENT MAGAZINE

1601 Duke St., Alexandria VA 22314. (703)836-8700. Fax: (800)208-0078. E-mail: ckohler@safnow.org or kpenn@safnow.org. **Contact:** Cathy Kohler or Kate Penn. Estab. 1894. National trade association magazine representing growers, wholesalers and retailers of flowers and plants. Photos used in magazine and promotional materials.

Needs Offers 15-20 assignments/year. Needs photos of floral business owners, employees on location, and retail environmental portraits. Reviews stock photos. Model release required. Photo captions preferred.

Audiovisual Needs Uses slides (with graphics) for convention slide shows.

Specs Uses b&w prints; transparencies. Accepts images in digital format. Send via CD, Zip as TIFF files.

Making Contact & Terms Send query letter with samples. Provide résumé, business card, brochure, flier or tearsheets to be kept on file for possible future assignments. Responds in 1 week. Pays $150-600 for color cover; $75-150/hour; $125-250/job; $75-500 for color inside. Credit line given. Buys one-time rights.

Tips "We shoot a lot of tightly composed, dramatic shots of people, so we look for these skills. We also welcome input from the photographer on the concept of the shot. Our readers, as business owners, like to see photos of other business owners. Therefore, people photography, on location, is particularly popular." Photographers should approach magazine "via letter of introduction and sample. We'll keep name in file and use if we have a shoot near photographer's location."

$ FOOD DISTRIBUTION MAGAZINE

P.O. Box 811768, Boca Raton FL 33481. (561)994-1118. Fax: (561)994-1610. **Contact:** Ken Whitacre, editor. Circ. 35,000. Estab. 1959. Monthly magazine. Emphasizes gourmet and specialty foods. Readers are male and female food-industry executives, ages 30-60. Sample copy available for $5.

Needs Buys 3 photos from freelancers/issue; 36 photos/year. Needs photos of food: prepared food shots, products on store shelves. Reviews photos with accompanying ms only. Model release required for models only. Photo captions preferred; include photographer's name, subject.

Making Contact & Terms Send any size color prints or slides and 4×5 transparencies by mail with SASE for consideration. Responds in 2 weeks. Simultaneous submissions OK. Pays $100 minimum for color cover; $50 minimum for color inside. Pays on publication. Credit line given. Buys all rights.

$ GENERAL AVIATION NEWS

P.O. Box 39099, Lakewood WA 98439-0099. (253)471-9888. Fax: (253)471-9911. E-mail: janice@GeneralAviationNews.com. Website: www.GeneralAviationNews.com. **Contact:** Janice Wood, editor. Circ. 50,000. Estab. 1949. Biweekly tabloid. Emphasizes aviation. Readers are pilots, airplane owners and aviation professionals. Sample copy available for $3.50. Photo guidelines free with SASE.

Needs Photo captions preferred.

Making Contact & Terms Send query letter with résumé of credits. Do *not* send unsolicited prints; contact editor first. Does not keep samples on file; include SASE for return of material. Responds in 1 month. Fee varies according to subject, how/where photo is used. Pays on publication. Credit line given. Buys one-time rights.

Tips Wants to see "sharp photos of planes with good color; airshows not generally used."

GEOTECHNICAL FABRICS REPORT

1801 County Rd. B.W., Roseville MN 55113. (651)222-2508 or (800)225-4324. Fax: (651)225-6966. **Contact:** Chris Kelsey, editor. Circ. 18,000. Estab. 1983. Published 9 times/year. Emphasizes geosynthetics in civil engineering applications. Readers are civil engineers, professors and consulting engineers. Sample copies available.

Needs Uses 10-15 photos/issue; various number supplied by freelancers. Needs photos of finished applications using geosynthetics, photos of the application process. Reviews photos with accompanying ms only. Model release required. Photo captions required; include project, type of geosynthetics used and location.

Making Contact & Terms Send any size color prints or slides by mail with SASE for consideration. Keeps samples on file. Responds in 1 month. Simultaneous submissions OK. Payment negotiable. Credit line given. Buys all rights; negotiable.

Tips "Contact manufacturers in the geosynthetics industry and offer your services. We will provide a list, if needed. There is no cash payment from our magazine. Manufacturers may pay freelancers."

$ $ $ ▣ ▨ GOVERNMENT TECHNOLOGY

e-Republic, 100 Blue Ravine Rd., Folsom CA 95630. (916)932-1300. E-mail: gperez@govtech.net. Website: www.govtech.net. **Contact:** Gerardo Perez, creative director. Circ. 60,000. Estab. 2001. Monthly trade magazine.

Needs Buys 2 photos from freelancers/issue; 20 photos/year. Needs photos of celebrities, disasters, environmental, political, technology/computers. Reviews photos with accompanying ms only. Model release required; property release preferred. Photo captions required.

Specs Uses 8×10 matte b&w prints; 35mm, 2¼×2¼ transparencies. Accepts images in digital format. Send via CD, Zip, e-mail as TIFF, JPEG files at 300 dpi.

Making Contact & Terms Send query letter with résumé, prints, tearsheets. Portfolio may be dropped off every Monday. Provide business card, self-promotion piece to be kept on file for possible future assignments. Responds only if interested; send nonreturnable samples. Simultaneous submissions and previously published work OK. Pays $600-900 for b&w cover; $600-1,200 for color cover; $600-800 for b&w or color inside. Pays on publication. Credit line not given. Buys one-time rights, electronic rights.

Tips "See some of the layout of the magazine; read a little of it."

$ ▣ GRAIN JOURNAL

3065 Pershing Court, Decatur IL 62526. (217)877-9660. Fax: (217)877-6647. E-mail: ed@grainnet.com. Website: www.grainnet.com. **Contact:** Ed Zdrojewski, editor. Circ. 11,303. Bimonthly. Emphasizes grain industry.

Readers are "elevator managers primarily, as well as suppliers and others in the industry." Sample copy free with 10×12 SAE and 3 first-class stamps.

Needs Uses about 1-2 photos/issue. "We need photos concerning industry practices and activities. We look for clear, high-quality images without a lot of extraneous material." Photo captions preferred.

Specs Accepts images in digital format. Send via e-mail, floppy disk, Zip.

Making Contact & Terms Send query letter with samples and list of stock photo subjects. Responds in 1 week. Pays $100 for color cover; $30 for b&w inside. Pays on publication. Credit line given. Buys all rights; negotiable.

$ THE GREYHOUND REVIEW

P.O. Box 543, Abilene KS 67410. (785)263-4660. **Contact:** Gary Guccione or Tim Horan. Circ. 3,006. Monthly publication of the National Greyhound Association. Emphasizes Greyhound racing and breeding. Readers are Greyhound owners and breeders. Sample copy free with SAE and 11 first-class stamps.

Needs Buys 1 photo from freelancers/issue; 12 photos/year. Needs "anything pertinent to the Greyhound that would be of interest to Greyhound owners." Photo captions required.

Making Contact & Terms Query first. After response, send b&w or color prints and contact sheets by mail for consideration. Provide résumé, business card, brochure, flier or tearsheets to be kept on file for possible future assignments. Can return unsolicited material if requested; include SASE for return of material. Responds in 1 month. Simultaneous submissions and previously published work OK. Pays $85 for color cover; $25-100 for color inside. **Pays on acceptance.** Credit line given. Buys one-time and North American rights.

Tips "We look for human-interest or action photos involving Greyhounds. No muzzles, please, unless the Greyhound is actually racing. When submitting photos for our cover, make sure there's plenty of cropping space on all margins around your photo's subject; full breeds on our cover are preferred."

$ $ ▣ HEARTH AND HOME

P.O. Box 1288, Laconia NH 03247. (603)528-4285. Fax: (603)527-3404. E-mail: production@villagewest.com. **Contact:** Production. Circ. 18,500. Monthly magazine. Emphasizes news and industry trends for specialty retailers and manufacturers of solid fuel and gas appliances, barbeque grills, hearth accessories and casual furnishings. Sample copy available for $5.

Needs Buys 3 photos from freelancers/issue; 36 photos/year. Needs "shots of fireplace and patio furnishings stores (preferably a combination store), retail displays, wood heat installations, fireplaces, wood stoves, lawn and garden shots (installation as well as final design), gas grills, gas fireplaces, indoor/outdoor gas installation, outdoor room shots emphasizing BBQs, furniture, and outdoor fireplaces. Assignments available for interviews, conferences, and out-of-state stories." Model release required. Photo captions preferred.

Specs Uses glossy color prints; transparencies. Also accepts digital images with color proof; high-res, 300 dpi preferred.

Making Contact & Terms Contact before submitting material. Responds in 2 weeks. Simultaneous and photocopied submissions OK. Pays $50-300 for color photos; $250-1,200/job. Pays within 30 days. Credit line given. Buys various rights.

Tips "Call first and ask what we need. We're *always* on the lookout for material."

$ $ ▣ ◩ ▧ HEATING PLUMBING AIR CONDITIONING (HPAC) MAGAZINE

Rogers Media, Inc., 1 Mount Pleasant Rd., Toronto ON M4Y 2Y5 Canada. (416)764-2000. Fax: (416)764-1746. E-mail: bruce.meacock@hpacmag.rogers.com. **Contact:** Bruce Meacock, publisher. Circ. 17,000. Estab. 1927. Bimonthly magazine plus annual buyers guide. Emphasizes heating, plumbing, air conditioning, refrigeration. Readers are predominantly male mechanical contractors ages 30-60. Sample copy available for $4.

Needs Buys 5-10 photos from freelancers/issue; 30-60 photos/year. Needs photos of mechanical contractors at work, site shots, product shots. Model/property release preferred. Photo captions preferred.

Specs Uses 4×6 glossy/semi-matte color and/or b&w prints; 35mm transparencies. Accepts images in digital format. Send via CD, SyQuest, floppy disk, Jaz, Zip, e-mail as TIFF, JPEG files.

Making Contact & Terms Send unsolicited photos by mail for consideration. Cannot return material. Responds in 1 month. Simultaneous submissions and previously published work OK. Pays $400 for b&w or color cover; $50-200 for b&w or color inside. Pays on publication. Credit line given. Buys one-time rights; negotiable.

$HEREFORD WORLD

AHA, P.O. Box 014059, Kansas City MO 64101. (816)842-3757. Fax: (816)842-6931. E-mail: hworld@hereford .org. Website: www.herefordworld.org. **Contact:** Amy Cowan, communications coordinator. Circ. 10,000. "We also publish a commercial edition with a circulation of 25,000." Estab. 1947. Monthly association magazine. Emphasizes Hereford cattle for registered breeders, commercial cattle breeders and agribusinessmen in related fields.

Specs Uses b&w and color prints.

Making Contact & Terms Query. Responds in 2 weeks. Pays $5 for b&w print; $100 for color print. Pays on publication.

Tips Wants to see "Hereford cattle in quantities, in seasonal and/or scenic settings."

$▣ ◯ HOME LIGHTING & ACCESSORIES

1011 Clifton Ave., Clifton NJ 07013. (973)779-1600. Fax: (973)779-3242. Website: www.homelighting.com. **Contact:** Linda Longo, editor-in-chief. Circ. 12,000. Estab. 1923. Monthly magazine. Emphasizes outdoor and interior lighting. Readers are small business owners, specifically lighting showrooms and furniture stores. Sample copy available for $6.

Needs Buys 10 photos from freelancers/issue; 120 photos/year. Needs photos of lighting applications that are unusual—either landscape or interior application shots for residential or some commercial and retail stores. Reviews photos with accompanying ms only. Model/property release preferred. Photo captions required; include location and relevant names of people or store.

Specs Uses 5×7, 8×10 color prints; 4×5 transparencies. Accepts digital images on CD-ROM.

Making Contact & Terms Send query letter with résumé of credits. Provide résumé, business card, brochure, flier or tearsheets to be kept on file for possible future assignments. Responds in 1 month. Simultaneous submissions and previously published work OK. Pays $150 for color cover; $90 for color inside. Pays on publication. Credit line given. Buys one-time rights.

$▣ ◨ Ⓢ THE HORSE

P.O. Box 919003, Lexington KY 40591-9003. (859)276-6890. Fax: (859)276-4450. E-mail: mreca@thehorse.c om. Website: www.thehorse.com. **Contact:** Marcella Reca, staff writer. Circ. 43,700. Estab. 1995. Monthly magazine. Emphasizes equine health. Readers are equine veterinarians, hands-on horse owners, trainers and barn managers. Sample copy free with large SASE. Photo guidelines free with SASE and on website at www.thehorse.com/freelance_info.asp.

Needs Buys 20-30 photos from freelancers/issue; 240-360 photos/year. Needs generic horse shots, horse health such as farrier and veterinarian shots. "We use all breeds and all disciplines." Model/property release preferred. Photo captions preferred.

Specs Uses color transparencies. Accepts images in digital format. Send via CD, floppy disk, Zip, e-mail as TIFF, EPS, JPEG files at 300 dpi (4×6).

Making Contact & Terms Send unsolicited photos by mail for consideration. Keeps samples on file. Previously published work OK. Pays $350 for color cover; $35-115 for color inside. Pays on publication. Buys one-time rights.

Tips "Please include name, address, and phone number of photographer; date images were sent; whether images may be kept on file or should be returned; date by which images should be returned; number of images sent. Usually 10-20 samples is adequate. Do not submit originals."

$ $▣ ◨ IEEE SPECTRUM

3 Park Ave., 17th Floor, New York NY 10016. (212)419-7569. Fax: (212)419-7570. Website: www.spectrum.ie ee.org. **Contact:** Randi Silberman, photo editor. Circ. 380,000. Monthly magazine of the Institute of Electrical and Electronics Engineers, Inc. (IEEE). Emphasizes electrical and electronics field and high technology. Readers are male/female; educated; age range: 20-65.

Need Uses 20-30 photos/issue. Purchases stock photos in following areas: technology, energy, medicine, military, sciences and business concepts. Hires assignment photographers for location shots and portraiture, as well as product shots. Model/property release required. Photo captions required.

Specs Accepts images in digital format. Send via CD as TIFF, JPEG files at 300 dpi.

Making Contact & Terms Provide promos or tearsheets to be kept on file for possible future assignments. Pays $1,200 for color cover; $250-800 for inside. **Pays on acceptance.** Credit line given. Buys one-time rights.

Tips Wants photographers who are consistent, have an ability to shoot color and b&w, display a unique vision, and are receptive to their subjects. "As our subject matter is varied, *Spectrum* uses a variety of imagemakers."

$ ▣ ☑ IGA GROCERGRAM

1301 Carolina St., Greensboro NC 27401. (336)383-5443. Fax: (336)383-5792. E-mail: tina.miller@paceco.com. Website: www.iga.com. **Contact:** Flontina Miller, editor. Circ. 18,000. Estab. 1926. Monthly magazine of the Independent Grocers Alliance. Emphasizes food industry. Readers are IGA retailers. Sample copy available upon request.

Needs Needs in-store shots, food (appetite appeal). Prefers shots of IGA stores. Model/property release required. Photo captions required.

Specs Accepts images in digital format. Send as TIFF files at 350 dpi.

Making Contact & Terms Send unsolicited 35mm transparencies by mail for consideration. Provide résumé, business card, brochure, flier or tearsheets to be kept on file for possible future assignments. Keeps samples on file. Responds in 3 weeks. Simultaneous submissions and previously published work OK. Pay negotiable. **Pays on acceptance**. Credit line given. Buys one-time rights.

$ ▣ ☑ INDOOR COMFORT NEWS

454 W. Broadway, Glendale CA 91204. (818)551-1555. Fax: (818)551-1115. E-mail: g.rivera@ihaci.org. Website: www.ihaci.org. **Contact:** Gilbert Rivera. Circ. 20,000. Estab. 1955. Monthly magazine of the Institute of Heating and Air Conditioning Industries. Emphasizes news, features, updates, special sections on CFC's, Indoor Air Quality, Legal. Readers are predominantly male—ages 25-65, HVAC/R/SM contractors, wholesalers, manufacturers and distributors. Sample copy free with 10×13 SAE and 10 first-class stamps.

Needs Interested in photos with stories of topical projects, retrofits, or renovations that are of interest to the heating, venting, and air conditioning industry. Property release required. Photo captions required; include what it is, where and what is unique about it.

Specs Uses 3×5 glossy color and b&w prints.

Making Contact & Terms Send unsolicited photos by mail for consideration. Provide résumé, business card, brochure, flier or tearsheets to be kept on file for possible future assignments. Keeps samples on file. Responds in 1-2 weeks. Payment negotiable. Credit line given.

Tips Looks for West Coast material—projects and activities with quality photos of interest to the HVAC industry. ''Familiarize yourself with the magazine and industry before submitting photos.''

$ ▣ ☑ JOURNAL OF ADVENTIST EDUCATION

General Conference of Seventh-day Adventists, 12501 Old Columbia Pike, Silver Spring MD 20904-6600. (301)680-5075. Fax: (301)622-9627. E-mail: rumbleb@gc.adventist.org. Website: http://education.gc.adventist.org/jae. **Contact:** Beverly J. Rumble, editor. Circ. 11,000. Estab. 1939. Professional journal for teachers published 5 times/year. Deals with procedures, philosophy, and subject matter of Christian education; is the official professional organ of the Department of Education covering elementary, secondary, and higher education for all Seventh-day Adventist educational personnel; also official organ of the Association of Seventh-day Adventist educators.

Needs Buys 5-15 photos from freelancers/issue; up to 75 photos/year. Needs photos of children/teens, multicultural, parents, education, religious, health/fitness, technology/computers with people, committees, offices, school photos of teachers, students, parents, activities at all levels. Reviews photos with or without ms. Model release preferred. Photo captions preferred.

Specs Uses b&w prints; 35mm, 2¼×2¼, 4×5 transparencies. Accepts images in digital format. Send via Zip, e-mail as TIFF, GIF, JPEG files at 300 dpi.

Making Contact & Terms Send query letter with prints, photocopies, transparencies. Provide self-promotion piece to be kept on file for possible future assignments. Responds in 1 month to queries. Simultaneous submissions and previously published work OK. Pays $100-350 for color cover; $35-50 for b&w inside; $50-100 for color inside. Willing to negotiate on electronic usage of photos. Pays on publication. Credit line given. Buys one-time rights.

Tips ''Get good-quality people shots—close-ups, verticals especially; use interesting props in classroom shots; include teacher and students together, teachers in groups, parents and teachers, cooperative learning and multiage, multicultural children. Pay attention to backgrounds (not too busy) and understand the need for high-res photos!''

$ ▣ ◯ ⒮ JOURNAL OF CHRISTIAN NURSING

InterVarsity Christian Fellowship, P.O. Box 7895, Madison WI 53707-7895. (608)846-8560. Fax: (608)274-7882. E-mail: jcn.me@intervarsity.org. Website: www.intervarsity.org/ncf/jcn. **Contact:** Cathy Walker, managing editor. Circ. 8,000. Quarterly professional journal for nurses. Sample copy available for $6.50.

Needs Buys 5 photos from freelancers/issue; 20 photos/year. Needs photos of multicultural, families, medicine. Reviews photos with or without ms. Model release preferred.

Specs Accepts images in digital format. Send as JPEG files at 300 dpi.

Making Contact & Terms Send query letter with tearsheets. Provide self-promotion piece to be kept on file for possible future assignments. Responds only if interested; send nonreturnable samples. Previously published work OK. Pays $400 maximum for color cover; $125 maximum for b&w inside. **Pays on acceptance**. Credit line given. Buys one-time rights.

Tips "Work must reflect the daily life/work of those in the nursing profession. We want nurses at work, hospital/clinical scenes not doctors."

$ $□ ◨ JOURNAL OF PROPERTY MANAGEMENT
430 N. Michigan Ave., Chicago IL 60611-4090. (312)329-6058. Fax: (312)410-7958. E-mail: adruckman@irem.org. Website: www.irem.org. **Contact:** Managing Editor. Circ. 18,000. Estab. 1934. Bimonthly magazine of the Institute of Real Estate Management. Readers are mid- and upper-level managers of investment real estate. Sample copy free with SASE.

Needs Buys 3 photos from freelancers/issue; 18 photos/year. Needs photos of architecture, cities/urban (apartments, condos, offices, shopping centers, industrial), building operations and office interaction. Model/property release preferred.

Specs Accepts images in digital format. Send via CD, floppy disk, SyQuest, Zip as TIFF, EPS files at 266 dpi.

Making Contact & Terms Contact managing editor for detailed submission guidelines.

$ JOURNAL OF PSYCHOACTIVE DRUGS
Haight-Ashbury Publications, 612 Clayton St., San Francisco CA 94117. (415)565-1904. Fax: (415)864-6162. **Contact:** Richard B. Seymour, editor. Circ. 1,400. Estab. 1967. Quarterly. Emphasizes "psychoactive substances (both legal and illegal)." Readers are "professionals (primarily health) in the drug abuse treatment field."

Needs Uses 1 photo/issue; supplied by freelancers. Needs "full-color abstract, surreal, avant garde or computer graphics."

Making Contact & Terms Send query letter with 4×6 color prints or 35mm slides. Include SASE for return of material. Responds in 2 weeks. Simultaneous submissions and previously published work OK. Pays $50 for color cover. Pays on publication. Credit line given. Buys one-time rights.

$ $□ ◨ JUDICATURE
2700 University Ave., Des Moines IA 50311. (773)973-0145. Fax: (773)338-9687. E-mail: drichert@ajs.org. Website: www.ajs.org. **Contact:** David Richert, editor. Circ. 6,000. Estab. 1917. Bimonthly publication of the American Judicature Society. Emphasizes courts, administration of justice. Readers are judges, lawyers, professors, citizens interested in improving the administration of justice. Sample copy free with 9×12 SAE and 6 first-class stamps.

Needs Buys 1-2 photos from freelancers/issue; 6-12 photos/year. Needs photos relating to courts, the law. "Actual or posed courtroom shots are always needed." Interested in fine art, historical/vintage. Model/property release preferred. Photo captions preferred.

Specs Uses b&w and/or color prints. Accepts images in digital format. Send via CD, Zip, e-mail as JPEG files at 600 dpi.

Making Contact & Terms Send 5×7 glossy b&w prints or slides by mail for consideration; include SASE for return of material. Provide résumé, business card, brochure, flier or tearsheets to be kept on file for possible future assignments. Responds in 2 weeks. Simultaneous submissions and previously published work OK. Pays $250 for b&w cover; $350 for color cover; $125-250 for b&w inside; $125-300 for color inside. Pays on publication. Credit line given. Buys one-time rights.

KITCHEN & BATH BUSINESS
770 Broadway, New York NY 10003. (646)654-4406. Fax: (646)654-4417. E-mail: lmurphy@kbbonline.com. Website: www.kbbonline.com. **Contact:** Lee Ann Murphy. Circ. 52,000. Estab. 1955. Monthly magazine. Emphasizes kitchen and bath design, sales and products. Readers are male and female kitchen and bath dealers, designers, builders, architects, manufacturers, distributors and home center personnel. Sample copy free with 9×12 SASE.

Needs Buys 4-8 photos from freelancers/issue; 48-96 photos/year. Needs kitchen and bath installation shots and project shots of never-before-published kitchens and baths. Reviews photos with accompanying ms

only. Photo captions preferred; include relevant information about the kitchen or bath—remodel or new construction, designer's name and phone number.

Making Contact & Terms Send any size color and/or b&w prints by mail for consideration. Keeps samples on file. Responds in 3 weeks. Simultaneous submissions OK. Payment negotiable. Pays on publication. Buys one-time rights.

$ LAND LINE MAGAZINE

1 NW Ooida Dr., Grain Valley MO 64029. (816)229-5791. Fax: (816)443-2227. E-mail: information@landline mag.com. Website: www.landlinemag.com. **Contact:** Sandi Soendker, managing editor. Circ. 110,000. Estab. 1975. Bimonthly magazine. Publication of Owner-Operator Independent Drivers Association. Emphasizes trucking. Readers are male and female independent truckers with an average age of 44. Sample copy available for $2.

Needs Uses 18-20 photos/issue; 50% supplied by freelancers. Needs photos of trucks, highways, truck stops, truckers, etc. "We prefer to have truck owners/operators in photos." Reviews photos with or without ms. Model/property release preferred for company trucks, drivers. Photo captions preferred.

Specs Uses glossy color or b&w prints; $2\frac{1}{4} \times 2\frac{1}{4}$ transparencies.

Making Contact & Terms Provide résumé, business card, brochure, flier or tearsheets to be kept on file for possible future assignments. Previously published work OK. Pays $100 for color cover; $50 for b&w cover; $50 for color inside; $30 for b&w inside. Credit line given. Buys one-time rights.

$ LANDSCAPE ARCHITECTURE

636 Eye St. NW, Washington DC 20001. (202)898-2444. E-mail: jroth@asla.org. Website: www.asla.org. **Contact:** Jeff Roth, art director. Circ. 35,000. Estab. 1910. Monthly magazine of the American Society of Landscape Architects. Emphasizes "landscape architecture, urban design, parks and recreation, architecture, sculpture" for professional planners and designers. Sample copy available for $7. Photo guidelines free with SASE.

Needs Buys 35-50 photos from freelancers/issue; 410-600 photos/year. Needs photos of landscape and architecture-related subjects as described above. Special needs include aerial photography and environmental portraits. Model release required. Credit, caption information required.

Making Contact & Terms Send query letter with samples or list of stock photo subjects. Provide brochure, flier or tearsheets to be kept on file for possible future assignments. Reporting time varies. Previously published work OK. Pays $400/day. Pays on publication. Credit line given. Buys one-time rights.

Tips "We take an editorial approach to photographing our subjects."

$ ▣ ⬚ LAW AND ORDER MAGAZINE

Hendon Publishing, 130 Waukegan Rd., Deerfield IL 60015. (847)444-3300. Fax: (847)444-3333. Website: www.hendonpub.com/lawmag/. **Contact:** Ed Sanow, editorial director. Circ. 35,000. Estab. 1953. Monthly magazine published for police department administrative personnel. The articles are designed with management of the department in mind and are how-to in nature. Sample copy free. Photo guidelines available on website.

Needs Buys 10 photos from freelancers/issue; 120 photos/year. Needs photos of uniformed police, crime, technology, weapons, vehicles. Special photo needs include police using technology—laptop computers, etc. Reviews photos with or without ms. Model release required for any police department personnel. Property release required. Photo captions required; include name and department of subject, identify products used.

Specs Uses color prints, matte or glossy, 4×6 minimum; 35mm, 4×5 transparencies. Accepts digital submissions, 600 dpi; send as TIFF, EPS, JPG or PDF files in PC format.

Making Contact & Terms Send query letter with stock list. Art director will contact photographer for portfolio review if interested. Portfolio should include color prints, slides, transparencies. Keeps samples on file; include SASE for return of material. Responds in 3 weeks to queries; 2 weeks to samples. Simultaneous submissions OK. Pays $300 for color cover; $25 for color inside. Pays after publication. Buys all rights; negotiable.

Tips "Read the magazine. Get a feel for what we cover. We like work that is dramatic and creative. Police are moving quickly into the high-tech arena. We are interested in photos of that. Police officers during training activities are also desirable."

$ ⬚ Ⓐ ⬚ THE MANITOBA TEACHER

191 Harcourt St., Winnipeg MB R3J 3H2 Canada. (204)888-7961. Fax: (204)831-0877. E-mail: rjob@mbteach. org. Website: www.mbteach.org. **Contact:** Raman Job, communications officer/managing editor. Circ.

Trade Publications

17,000. Publication of The Manitoba Teachers' Society. Published 7 times/year. Emphasizes education in Manitoba—emphasis on teachers' interests. Readers are teachers and others in education. Sample copy free with 10×12 SAE and Canadian stamps.

Needs Buys 3 photos from freelancers/issue; 21 photos/year. Needs action shots of students and teachers in education-related settings. Model release required.

Making Contact & Terms Send 8×10 glossy b&w prints by mail for consideration; include SASE for return of material. Submit portfolio for review. Provide résumé, business card, brochure, flier or tearsheets to be kept on file for possible future assignments. Responds in 1 month. Pays $40/photo for single use.

Tips "Always submit action shots directly related to major subject matter of publication and interests of readership."

$ $⬛ MARKETING & TECHNOLOGY GROUP

1415 N. Dayton, Chicago IL 60622. (312)274-2216. Fax: (312)266-3363. E-mail: qburns@meatingplace.com. **Contact:** Queenie Burns, vice president, design & production. Circ. 18,000. Estab. 1993. Publishes 3 magazines: *Carnetec*, *Meat Marketing & Technology* and *Poultry Marketing & Technology*. Emphasizes meat and poultry processing. Readers are predominantly male, ages 35-65, generally conservative. Sample copy available for $4.

Needs Buys 1-3 photos from freelancers/issue. Needs photos of food, processing plant tours, product shots, illustrative/conceptual. Model/property release preferred. Photo captions preferred.

Making Contact & Terms Provide résumé, business card, brochure, flier or tearsheets to be kept on file for possible future assignments. Submit portfolio for review. Keeps samples on file. Responds in 1 month. Simultaneous submissions and previously published work OK. Payment negotiable. Pays on publication. Credit line given.

Tips "Work quickly and meet deadlines. Follow directions when given; and when none are given, be creative while using your best judgment."

$⬛ ⬛ ⬛ MEETINGS AND INCENTIVE TRAVEL

Rogers Media, 1 Mount Pleasant Rd., 7th Floor, Toronto ON M4Y 2Y5 Canada. (416)764-1634. Fax: (416)764-1419. E-mail: dave.curcio@mtg.rogers.com. Website: www.meetingscanada.com. **Contact:** David Curcio, creative services and design manager. Circ. 10,500. Estab. 1970. Bimonthly trade magazine emphasizing meetings and travel.

Needs Buys 1-5 photos from freelancers/issue; 7-30 photos/year. Needs photos of environmental, landscapes/scenics, cities/urban, interiors/decorating, events, food/drink, travel, business concepts, technology/computers. Reviews photos with or without ms. Model/property release required. Photo captions required; include location and date.

Specs Uses 8×12 prints depending on shoot and size of photo in magazine. Accepts images in digital format. Send via CD as TIFF files at 300 dpi.

Making Contact & Terms Contact through rep or send query letter with tearsheets. Portfolio may be dropped off every Tuesday. Provide résumé, business card, self-promotion piece to be kept on file for possible future assignments. Responds only if interested; send nonreturnable samples. Simultaneous submissions and previously published work OK. Payment depends on many factors. Credit line given. Buys one-time rights.

Tips "Send samples to keep on file."

⬛ ⬛ MIDWEST FOODSERVICE NEWS

8205-F Estates Pkwy., Plain City OH 43064. (614)873-1120, ext. 23. Fax: (614)873-1650. E-mail: editorial@MidwestFoodServiceNews.com. Website: www.MidwestFoodServiceNews.com. Circ. 27,000. Estab. 1976. Monthly magazine. "National publication with a regional focus and a local flair. Each edition contains state and national news, plus articles of local interest, to foster an informative dialogue between foodservice operators, their suppliers and associated businesses." Sample copy available for $3.95 with $2 first-class postge.

Needs Buys 5 or more photos from freelancers/issue; approximately 100 photos/year. Needs photos of celebrities, cities/urban, food/drink, travel, product shots/still life, photos from the restaurant and hospitality industry and foodservice companies (i.e., chefs, restaurant kitchens, dining areas, chef celebrities, etc.). Interested in historical/vintage. Reviews photos with or without ms. Model/property release required. Photo captions preferred; include description of photo plus all the names, etc., and photo credit.

Specs Uses 5×7 to 8×10 glossy color and/or b&w prints; 35mm, 2¼×2¼, 4×5, 8×10 transparencies.

Accepts images in digital format. Send via CD, floppy disk, Zip, e-mail as TIFF, EPS, BMP, GIF, JPEG files at 300-800 dpi.

Making Contact & Terms Send query letter with slides, prints, transparencies. Provide self-promotion piece to be kept on file for possible future assignments. Responds only if interested; send nonreturnable samples. Simultaneous submissions OK. Pay is based on experience. Pays on publication. Credit line given. Buys first rights.

$▣ MILITARY OFFICER MAGAZINE

201 N. Washington St., Alexandria VA 22314. (800)234-6622. Fax: (703)838-8179. Website: www.moaa.org. **Contact:** Jill Akers, photo editor. Circ. 400,000. Estab. 1945. Monthly publication of the Military Officers Association of America. Represents the interests of military officers from the 7 uniformed services: military history (particularly Vietnam and Korea), travel, health, second-career job opportunities, military family lifestyle and current military/political affairs. Readers are officers or warrant officers from the Army, Navy, Air Force, Marine Corps, Coast Guard, Public Health Service and NOAA.

Needs Buys 8 photos from freelancers/issue; 96 photos/year. "We're always looking for good color slides of active-duty military people and healthy, active mature adults with a young 50s look—our readers are 55-65."

Specs Uses original 35mm, $2\frac{1}{4} \times 2\frac{1}{4}$ or 4×5 transparencies. Accepts images in digital format.

Making Contact & Terms Send query letter with list of stock photo subjects. Provide résumé, brochure, flier to be kept on file. "Do *not* send original photos unless requested to do so." Payment negotiated. "Photo rates vary with size and position." Pays on publication. Credit line given. Buys one-time rights.

$▣ ◪ MODERN BAKING

2700 S. River Rd., Suite 303, Des Plaines IL 60018. (847)299-4430. Fax: (847)296-1968. Website: http://modernbaking.bakery-net.com. **Contact:** Heather Brown, executive editor. Circ. 27,000. Estab. 1987. Monthly. Emphasizes on-premise baking in supermarkets, food service establishments and retail bakeries. Readers are owners, managers and operators. Sample copy available for 9×12 SAE with 10 first-class stamps.

Needs Buys 1-2 photos from freelancers/issue; 12-24 photos/year. Needs on-location photography in above-described facilities. Model/property release preferred. Photo captions required; include company name, location, contact name and telephone number.

Specs Accepts images in digital format. Send via CD, Zip as TIFF, EPS, JPEG files at 300 dpi.

Making Contact & Terms Provide résumé, business card, brochure, flier or tearsheets to be kept on file for possible future assignments. Responds in 2 weeks. Pays $50 minimum; negotiable. **Pays on acceptance.** Credit line given. Buys all rights; negotiable.

Tips Prefers to see "photos that would indicate person's ability to handle on-location, industrial photography."

$ $▣ ◪ NAILPRO

7628 Densmore Ave., Van Nuys CA 91406-2042. (818)782-7328. Fax: (818)782-7450. E-mail: jmills@creativeage.com. Website: www.nailpro.com. **Contact:** Jodi Mills, executive editor. Circ. 65,000. Estab. 1990. Monthly magazine publishd by Creative Age Publications. Emphasizes topics for professional manicurists and nail salon owners. Readers are females of all ages. Sample copy available for $2 with 9×12 SASE.

Needs Buys 10-12 photos from freelancers/issue; 120-144 photos/year. Needs photos of beautiful nails illustrating all kinds of nail extensions and enhancements; photographs showing process of creating and decorating nails, both natural and artificial. Also needs salon interiors, health/fitness, fashion/glamour. Model release required. Photo captions required; identify people and process if applicable.

Specs Accepts images in digital format. Send via Zip, e-mail as TIFF, EPS files at 300 dpi or better.

Making Contact & Terms Send query letter; responds only if interested. Call for portfolio review. "Art directors are rarely available, but photographers can leave materials and pick up later (or leave nonreturnable samples)." Send color prints; 35mm, $2\frac{1}{4} \times 2\frac{1}{4}$, 4×5 transparencies. Keeps samples on file. Responds in 1 month. Previously published work OK. Pays $500 for color cover; $50-250 for color inside. **Pays on acceptance.** Credit line given. Buys one-time rights.

Tips "Talk to the person in charge of choosing art about photo needs for the next issue and try to satisfy that immediate need; that often leads to assignments. Submit samples and portfolios with letter stating specialties or strong points."

$ ▣ NAILS MAGAZINE

Bobit Publishing, 3520 Challenger St., Torrance CA 90503. (310)533-2400. Fax: (310)533-2507. E-mail: daniell e.parisi@bobit.com. Website: www.nailsmag.com. **Contact:** Danielle Parisi, art director. Circ. 60,000. Estab. 1982. Monthly trade publication for nail technicians and beauty salon owners. Sample copies available.

Needs Buys up to 10 photos from freelancers/issue. Needs photos of celebrities, buildings, historical/vintage. Other specific photo needs: salon interiors, product shots, celebrity nail photos. Reviews photos with or without a ms. Model release required. Photo captions preferred.

Specs Uses 35mm transparencies. Accepts images in digital format. Send via CD, SyQuest, Zip as TIFF, EPS files at 266 dpi.

Making Contact & Terms Send query letter with résumé, slides, prints. Keep samples on file. Responds in 1 month on queries. **Pays on acceptance.** Credit line sometimes given if it's requested. Buys all rights.

$ $ THE NATIONAL NOTARY

9350 DeSoto Ave., Box 2402, Chatsworth CA 91313-2402. (818)739-4000. **Contact:** Chuck Faerber, editor. Circ. 260,000. Bimonthly. Emphasizes "Notaries Public and notarization—goal is to impart knowledge, understanding and unity among notaries nationwide and internationally." Readers are employed primarily in the following areas: law, government, finance and real estate. Sample copy available for $5.

Needs Buys 10 photos from freelancers/issue; 60 photos/year. "Photo subject depends on accompanying story/theme; some product shots used." Reviews photos with accompanying ms only. Model release required.

Making Contact & Terms Send query letter with samples. Provide business card, tearsheets, résumé or samples to be kept on file for possible future assignments. Prefers to see prints as samples. Cannot return material. Responds in 6 weeks. Previously published work OK. Pays $25-300 depending on job. Pays on publication. Credit line given "with editor's approval of quality." Buys all rights.

Tips "Since photography is often the art of a story, the photographer must understand the story to be able to produce the most useful photographs."

THE NATIONAL RURAL LETTER CARRIER

1630 Duke St., 4th Floor, Alexandria VA 22314-3465. (703)684-5545. **Contact:** Kathleen O'Connor, managing editor. Circ. 98,000. Monthly magazine. Emphasizes Federal legislation and issues affecting rural letter carriers and the activities of the membership for rural carriers and their spouses and postal management.

• This magazine uses a limited number of photos in each issue, usually only a cover photograph.

Needs Unusual mailboxes. Photos purchased with accompanying ms. Photo captions required.

Specs Uses 8×10 glossy b&w or color prints, vertical format necessary for cover.

Making Contact & Terms Send material by mail for consideration. Previously published work OK. Pays on publication. Credit line given.

Tips "Please submit sharp and clear photos."

$ ▣ ◪ ⑤ NAVAL HISTORY

US Naval Institute, 291 Wood Rd., Annapolis MD 21402. (410)295-1071. Fax: (410)295-1049. E-mail: jtill@us ni.org. Website: www.navalinstitute.org. **Contact:** Photo Editor. Circ. 50,000. Estab. 1873. Bimonthly association publication. Emphasizes Navy, Marine Corps, Coast Guard. Readers are male and female naval officers, enlisted, retirees, civilians. Photo guidelines free with SASE.

Needs Needs 40 photos from freelancers/issue; 240 photos/year. Needs photos of foreign and US Naval, Coast Guard and Marine Corps vessels, industry, military, personnel and aircraft. Interested in historical/vintage. Photo captions required.

Specs Uses 8×10 glossy or matte b&w and/or color prints (color preferred); transparencies. Accepts images in digital format. Send via CD, floppy disk, Zip, e-mail as JPEG files at 300 dpi.

Making Contact & Terms Send unsolicited photos by mail for consideration; include SASE for return of material. Responds in 1 month. Simultaneous submissions and previously published work OK. Pays $200 for color cover; $50 for color inside. Pays on publication. Credit line given. Buys one-time and electronic rights.

$ NEVADA FARM BUREAU AGRICULTURE AND LIVESTOCK JOURNAL

2165 Green Vista Dr., Suite 205, Sparks NV 89431. (775)674-4000. **Contact:** John Corbin. Circ. 7,200. Monthly tabloid. Emphasizes Nevada agriculture. Readers are primarily Nevada Farm Bureau members and their

families; men, women and youth of various ages. Members are farmers and ranchers. Sample copy free with 10×13 SAE with 3 first-class stamps.

Needs Uses 5 photos/issue; 30% occasionally supplied by freelancers. Needs photos of Nevada agriculture people, scenes and events. Model release preferred. Photo captions required.

Making Contact & Terms Send 3×5 and larger b&w prints, any format and finish, by mail with SASE for consideration. Responds in 1 week. Pays $10 for b&w cover; $5 for b&w inside. **Pays on acceptance.** Credit line given. Buys one-time rights.

Tips In portfolio or samples, wants to see: "newsworthiness, 50%; good composition, 20%; interesting action, 20%; photo contrast/resolution, 10%. Try for new angles on stock shots: awards, speakers, etc. We like 'Great Basin' agricultural scenery such as cows on the rangelands and high desert cropping. We pay little, but we offer credits for your résumé."

$ $◩ NEW HOLLAND NEWS

CNH America LLC, P.O. Box 1895, New Holland PA 17557-0903. (717)355-1121. Fax: (717)355-1826. E-mail: comments@newholland.com. Website: www.newholland.com/na. **Contact:** Gary Martin, editor. Full-color magazine to inform and entertain successful farmers and ranchers. Published 8 times/year. Sample copy available for 9×12 SAE with first-class postage.

Needs Buys 10 photos from freelancers/issue; 80 photos/year. Uses photos of farm production and farm animals. For covers, North American agriculture at its scenic best—no equipment. Reviews photos with or without a ms. Model/property release required. Photo captions required; include where, what crop, animal, etc., who, why—as necessary.

Specs Uses glossy or matte color and/or b&w prints; 35mm, 2¼×2¼, 4×5 transparencies.

Making Contact & Terms Send query letter with slides, prints, transparencies. Provide business card, self-promotion piece to be kept on file for possible future assignments. Responds in 1 month. Previously published work OK. Pays $500 for color cover; $150-300 for color inside. **Pays on acceptance**. Credit line given. Buys one-time rights, first rights.

Tips "Demonstrate a genuine appreciation for agriculture in your work. Don't be afraid to get dirty. Include meaningful captions."

$◩ NEWS PHOTOGRAPHER

National Press Photographers Assn., 3200 Croasdaile Dr., Suite 306, Durham NC 27705. (919)383-7246. Fax: (919)383-7261. E-mail: magazine@nppa.org. Website: www.nppa.org. **Contact:** Donald Winslow, editor. Circ. 11,000. Estab. 1946. Monthly magazine of the National Press Photographers Association, Inc. Emphasizes photojournalism and news photography. Readers are newspaper, magazine and television freelancers and photojournalists. Sample copy free with 9×12 SAE and 9 first-class stamps.

Needs Uses 50 photos/issue. Needs photos of photojournalists at work; photos that illustrate problems of photojournalists. Special photo needs include photojournalists at work, assaulted, arrested; groups of news photographers at work; problems and accomplishments of news photographers. Photo captions required.

Specs Uses glossy b&w and/or color prints; 35mm, 2¼×2¼ transparencies or negatives. Accepts images in digital format. Send via CD, floppy disk, Zip, e-mail as JPEG files at 266 dpi. "Prints (silver image or thermal) are always acceptable."

Making Contact & Terms Provide résumé, business card, brochure, flier or tearsheets to be kept on file for possible future assignments; make contact by telephone. Responds in 3 weeks. Simultaneous submissions and previously published work OK. Pays $50-300 for photo/text package. **Pays on acceptance**. Credit line given. Buys one-time rights.

NFPA JOURNAL

1 Batterymarch Park, Quincy MA 02169. E-mail: NFPAJournal@nfpa.org. Website: ww.nfpa.org. **Contact:** David Yount, art director. Circ. 69,000. Bimonthly magazine of the National Fire Protection Association. Emphasizes fire and life safety information. Readers are fire professionals, engineers, architects, building code officials, ages 20-65. Sample copy free with 9×12 SAE or via e-mail.

Needs Buys 5-7 photos from freelancers/issue; 30-42 photos/year. Needs photos of fires and fire-related incidents. Model release preferred. Photo captions preferred.

Making Contact & Terms Send query letter with list of stock photo subjects. Provide résumé, business card, brochure, flier or tearsheets to be kept on file for possible future assignments. Send color prints and 35mm transparencies in 3-ring slide sleeve with date. Responds in 3 weeks. Payment negotiated. Pays on publication. Credit line given.

Tips "Send cover letter, 35mm color slides, preferably with manuscripts and photo captions."

$ ▣ ◑ 9-1-1 MAGAZINE

18201 Weston Place, Tustin CA 92780. (714)544-7776. E-mail: editor@9-1-1magazine.com. Website: www.9-1-1magazine.com. **Contact:** Randall Larson, editor. Circ. 18,000. Estab. 1988. Published 9 times/year. Emphasizes public safety communications for police, fire, paramedic, dispatch, medical, etc. Readers are ages 20-65. Sample copy free with 9×12 SASE and 7 first-class stamps. Photo guidelines free with SASE.

Needs Buys 20-30 photos from freelancers/issue; 270 photos/year. "From the Field" department photos are needed of incidents involving public safety communications showing proper techniques and attire. Subjects include rescue, traffic, communications, training, stress, media relations, crime prevention, etc. Model release preferred. Photo captions preferred; if possible include incident location by city and state, agencies involved, incident details.

Specs Uses color prints; 35mm, 2¼×2¼, 4×5, 8×10 transparencies. Accepts images in digital format. Send via CD, Zip, e-mail as TIFF, JPEG files at 300 dpi.

Making Contact & Terms Send query letter with list of stock photo subjects. "Prefer original images versus stock content." Send unsolicited photos by mail for consideration; include SASE for return of material. Responds in 3 weeks. Pays $300 for color cover; $50 for b&w inside; $50 for color inside, ¼ page or less; $75 for color inside, ½ page; $100 for color inside, full page. Pays on publication. Credit line given. Buys one-time rights.

Tips "We need photos for unillustrated cover stories and features appearing in each issue. Calendar available. Assignments possible. Emphasis is on interesting composition, clarity and uniqueness of image."

$ ▣ OHIO TAVERN NEWS

580 S. High St., Suite 316, Columbus OH 43215. (614)228-6397. Fax: (614)224-8649. E-mail: editor@ohiotavernnews.com. Website: www.ohiotavernnews.com. **Contact:** Chris Bailey, editor. Circ. 4,000. Estab. 1939. Tabloid newspaper. Emphasizes beverage alcohol/hospitality industries in Ohio. Readers are liquor permit

© 2005 Christy Whitehead, www.ChristyWhitehead.com.

Photographer/writer Christy Whitehead specializes in law enforcement photography. She captured this tense scene of riot police standing by as one protester tries to calm another for *9-1-1 Magazine*. She believes it is vital for trade photographers to understand their subject matter. "You really have to know something about the field. My father is a police officer and my brother a firefighter, so when I am writing a story or photographing officers, I generally know what is going on, or I can make a phone call to clarify," says Whitehead.

holders: restaurants, bars, distillers, vintners, wholesalers. Sample copy free with 9×12 SASE.

Needs Uses 1-4 photos/issue. Needs photos of people, places, products covering the beverage alcohol/hospitality industries in Ohio. Photo captions required; include who, what, where, when and why.

Specs Uses up to 8×10 glossy color and/or b&w prints. Accepts images in digital format. Send as JPEG, TIFF files.

Making Contact & Terms Send unsolicited photos by mail or e-mail for consideration. Keeps samples on file. Responds in 1 month. Simultaneous submissions OK. Pays $15/photo. Pays on publication. Credit line given. Buys one-time rights; negotiable.

$▣ OMM FABRICATOR

NOMMA, 532 Forest Pkwy., Suite A, Forest Park GA 30297. (404)363-4009. Fax: (404)363-2857. E-mail: rachel@nomma.org. Website: www.nomma.org. **Contact:** Rachel Squires Bailey, editor. Circ. 9,000. Estab. 1959. Bimonthly magazine of the National Ornamental & Miscellaneous Metals Association.

Needs Buys 3-4 photos from freelancers/issue; 18-24 photos/year. Needs photos of ornamental and miscellaneous metals network. Reviews photos with or without ms. Model release preferred. Photo captions preferred.

Specs Accepts images in digital format. Send via CD, floppy disk, Zip, e-mail as TIFF, JPEG files at 266 dpi.

Making Contact & Terms Send query letter with slides, prints, photocopies, tearsheets, transparencies, stock list. Provide self-promotion piece to be kept on file for possible future assignments. Responds in 1 week to queries. Simultaneous submissions and previously published work OK. Pays $50-125 for color inside. **Pays on acceptance.** Credit line given. Buys one-time rights.

$▨ THE ONTARIO TECHNOLOGIST

10 Four Seasons Place, Suite 404, Etobicoke ON M9B 6H7 Canada. (416)621-9621. Fax: (416)621-8694. E-mail: cmellor@oacett.org. Website: www.oacett.org. **Contact:** Colleen Mellor, editor-in-chief. Circ. 21,400. Bimonthly publication of the Ontario Association of Certified Engineering Technicians and Technologists. Emphasizes engineering and applied science technology. Sample copy free with SAE and IRC.

Needs Uses 10-12 photos/issue. Needs how-to photos—"building and installation of equipment; similar technical subjects." Model release preferred. Photo captions preferred.

Making Contact & Terms Prefers business card and brochure for files. Send 5×7 glossy b&w or color prints for consideration. Responds in 1 month. Previously published work OK. Pays $25 for b&w photos; $50 for color photos. Pays on publication. Credit line given. Buys one-time rights.

$ $ THE PARKING PROFESSIONAL

P.O. Box 7167, Fredericksburg VA 22404. (540)371-7535. Fax: (540)371-8022. E-mail: jackson@parking.org. Website: www.parking.org. **Contact:** Kim Jackson, editor. Circ. 10,000. Estab. 1984. Monthly magazine of the International Parking Institute. Emphasizes parking: public, private, institutional, etc. Readers are male and female public parking managers, ages 30-60. Sample copy free.

Needs Buys 4-5 photos from freelancers/issue; 48-60 photos/year. Model release required. Photo captions preferred; include location, purpose, type of operation.

Specs Uses 5×7, 8×10 color and/or b&w prints; 35mm, $2^{1}/_{4} \times 2^{1}/_{4}$, 4×5, 8×10 transparencies.

Making Contact & Terms Contact through rep. Arrange personal interview to show portfolio for review. Send query letter with résumé of credits. Provide résumé, business card, brochure, flier or tearsheets to be kept on file for possible future assignments. Responds in 2 weeks. Previously published work OK. Pays $100-300 for color cover; $25-100 for b&w or color inside; $100-500 for photo/text package. Pays on publication. Credit line given. Buys one-time, all rights; negotiable.

$ $▣ ⑤ PEDIATRIC ANNALS

6900 Grove Rd., Thorofare NJ 08086. (856)848-1000. E-mail: pedann@slackinc.com. Circ. 58,000. Monthly journal. Readers are practicing pediatricians. Sample copy free with SASE.

Needs Uses 5-7 photos/issue; primarily stock. Occasionally uses original photos of children in medical settings.

Specs Color photos preferred. Accepts images in digital format. Send as TIFF files at 300 dpi.

Making Contact & Terms Request editorial calendar for topic suggestions. E-mail query with link(s) to samples. Simultaneous submissions and previously published work OK. Pays $300-700 for cover. Pays on publication. Credit line given. Buys one-time North American rights including any and all subsidiary forms of publication, such as electronic media and promotional pieces.

$ ▣ ⬛ PET PRODUCT NEWS

P.O. Box 6050, Mission Viejo CA 92690. (949)855-8822. Fax: (949)855-3045. Website: www.petproductnews. com. **Contact:** Photo Editor. Monthly tabloid. Emphasizes pets and the pet retail business. Readers are pet store owners and managers. Sample copy available for $5. Photo guidelines available on website and free with SASE.

Needs Buys 16-50 photos from freelancers/issue; 192-600 photos/year. Needs photos of people interacting with pets, retailers interacting with customers and pets, pets doing "pet" things, pet stores and vets examining pets. Also needs wildlife, events, industry, product shots/still life. Interested in seasonal. Reviews photos with or without ms. Model/property release preferred. Enclose a shipment description with each set of photos detailing the type of animal, name of pet store, names of well-known subjects and any procedures being performed on an animal that are not self-explanatory.

Specs Accepts images in digital format. Send via floppy disk, CD, Zip, e-mail as TIFF, EPS, JPEG files at 300 dpi.

Making Contact & Terms "We cannot assume responsibility for submitted material, but care is taken with all work. Freelancers must include a self-addressed, stamped envelope for returned work." Send sharp 35mm color slides or prints by mail for consideration. Responds in 2 months. Previously published work OK. Pays $65 for color cover; $45 for color inside. Pays on publication. Photographer also receives 2 complimentary copies of issue in which their work appears. Credit line given; name and identification of subject must appear on each slide or photo. Buys one-time rights.

Tips Looks for "appropriate subjects, clarity and framing, sensitivity to the subject. No avant garde or special effects. We need clear, straight-forward photography. Definitely no 'staged' photos; keep it natural. Read the magazine before submission. We are a trade publication and need business-like, but not boring, photos that will add to our subjects."

$ $ ▣ ◯ Ⓢ PI MAGAZINE, Journal of Professional Investigators

4400 Rt. 9 S., Suite 1000, P.O. Box 7198, Freehold NJ 07728-7198. (732)308-3800. Fax: (732)308-3314. E-mail: info@pimagazine.com. Website: www.pimagazine.com. **Contact:** Jimmie Mesis, publisher. Circ. 10,000. Estab. 1987. Bimonthly trade magazine. "Our audience is 80% private investigators with the balance law enforcement, insurance investigators, and people with interest in becoming a PI. The magazine features educational articles about the profession. Serious conservative format." Sample copy available for $6.95 and SAE with $1.75 first-class postage.

Needs Buys 10 photos from freelancers/issue; 60-100 photos/year. Needs photos of technology/computers, law/crime. Reviews photos with or without ms. Model/property release required. Photo captions preferred.

Specs Accepts images in digital format. Send via CD, e-mail as TIFF, EPS files at highest dpi.

Making Contact & Terms Send query letter with tearsheets, stock list. Provide résumé, business card, self-promotion piece to be kept on file for possible future assignments. Responds only if interested; send nonreturnable samples. Simultaneous submissions OK. Pays $200-500 for color cover; $50-200 for color inside. Pays on publication. Credit line given. Buys all rights; negotiable.

$ ▣ ⬛ Ⓐ PILOT GETAWAYS

Airventure Publishing LLC, P.O. Box 550, Glendale CA 91209. (818)241-1890. E-mail: john@pilotgetaways.com. Website: www.pilotgetaways.com. **Contact:** John Kounis, editor. Circ. 25,000. Estab. 1998. Bimonthly magazine focusing on travel by private aircraft. Includes sections on backcountry, bush and mountain flying. Emphasizes backcountry aviation—flying, safety, education, new products, aviation advocacy, outdoor recreation and lifestyles. Readers are mid-life males, affluent. Sample copy available for $4.95.

Needs Uses assignment photos. Needs photos of adventure, travel, product shots/still life, technology/computers. Model release required. Photo captions required.

Specs Accepts medium-format and 35mm slides. Accepts images in digital format. Send via CD as TIFF files at 300 dpi.

Making Contact & Terms Provide résumé, business card, or tearsheets to be kept on file for possible future assignments; contact by e-mail. Responds in 1 month. Simultaneous submissions OK. Prefers previously unpublished work. Pays $135 for color cover. Pays 30 days after publication. Credit line given. Buys all rights; negotiable.

Tips "Exciting, fresh and unusual photos of airplanes used for recreation or operating in the mountains, backcountry and bush. Planes on skis, floats or tundra tires are of particular interest. Backcountry aerial landscapes. Outdoor backcountry recreation: skiing, hiking, fishing and motor sports. Affluent backcountry

lifestyles: homes, hangars and private airstrips. Query first. Don't send originals—color copies or low-resolution digital OK for evaluation."

$ ▣ PLANNING

American Planning Association, 122 S. Michigan Ave, Chicago IL 60603. (312)431-9100. E-mail: rsessions@planning.org. **Contact:** Sylvia Lewis, editor. Photo Editor: Richard Sessions. Circ. 35,000. Estab. 1972. Monthly magazine. "We focus on urban and regional planning, reaching most of the nation's professional planners and others interested in the topic." Sample copy and photo guidelines free with 10×13 SAE and 4 first-class stamps (do not send cash or checks).

Needs Buys 4-5 photos from freelancers/issue; 60 photos/year. Photos purchased with accompanying ms and on assignment. Photo essay/photo feature (architecture, neighborhoods, historic preservation, agriculture); scenic (mountains, wilderness, rivers, oceans, lakes); housing; and transportation (cars, railroads, trolleys, highways). "No cheesecake; no sentimental shots of dogs, children, etc. High artistic quality is very important. We publish high-quality nonfiction stories on city planning and land use. Ours is an association magazine but not a house organ, and we use the standard journalistic techniques: interviews, anecdotes, quotes. Topics include energy, the environment, housing, transportation, land use, agriculture, neighborhoods and urban affairs." Photo captions required.

Specs Uses 4-color prints; 35mm, 4×5 transparencies. Accepts images in digital format. Send via Zip, CD as TIFF, EPS, JPEG files at 300 dpi and around 5×7 in physical size.

Making Contact & Terms Send query letter with samples; include SASE for return of material. Responds in 1 month. Previously published work OK. Pays $50-100 for b&w photos; $50-200 for color photos; $350 maximum for cover; $200-600 for ms. Pays $25-75 for electronic use of images. Pays on publication. Credit line given.

Tips "Just let us know you exist. Eventually, we may be able to use your services. Send tearsheets or photocopies of your work, or a little self-promo piece. Subject lists are only minimally useful, as are website addresses. How the work looks is of paramount importance. Please don't send original slides or prints with the expectation of them being returned. Send something we can keep in our files."

$ PLASTICS NEWS

1725 Merriman Rd., Akron OH 44313. (330)836-9180. Fax: (330)836-2322. E-mail: editorial@plasticsnews.com. Website: www.plasticsnews.com. **Contact:** Don Loepp, managing editor. Circ. 60,000. Estab. 1989. Weekly tabloid. Emphasizes plastics industry business news. Readers are male and female executives of companies that manufacture a broad range of plastics products; suppliers and customers of the plastics processing industry. Sample copy available for $1.95.

Needs Buys 1-3 photos from freelancers/issue; 52-156 photos/year. Needs photos of technology related to use and manufacturing of plastic products. Model/property release preferred. Photo captions required.

Making Contact & Terms Send unsolicited photos by mail for consideration. Provide résumé, business card, brochure, flier or tearsheets to be kept on file for possible future assignments. Send query letter with stock list. Keeps samples on file; include SASE for return of material. Responds in 2 weeks. Simultaneous submissions and previously published work OK. Pays $125-175 for color cover; $100-150 for b&w inside; $125-175 for color inside. Pays on publication. Credit line given. Buys one-time and all rights.

$ $ ▣ ⬙ PLASTICS TECHNOLOGY

Gardner Publications, 29 W. 34th St., New York NY 10001. (646)827-4848. Fax: (646)827-4859. E-mail: mdelia@ptonline.com. Website: www.ptonline.com. **Contact:** Michael Delia, art director. Circ. 50,000. Estab. 1954. Monthly trade magazine. Sample copy available for first-class postage.

Needs Buys 1-3 photos from freelancers/issue. Needs photos of agriculture, business concepts, industry, science, technology. Model release required. Photo captions required.

Specs Uses 5×7 glossy color prints; 35mm, $2\frac{1}{4} \times 2\frac{1}{4}$, 4×5 transparencies. Accepts images in digital format. Send via CD, Zip, e-mail as TIFF, EPS, JPEG files at 300 dpi.

Making Contact & Terms Send query letter with résumé, photocopies, tearsheets. Provide business card, self-promotion piece to be kept on file for possible future assignments. Responds only if interested; send nonreturnable samples. Simultaneous submissions OK. Pays $1,000-1,300 for color cover; $300 minimum for color inside. Pays on publication. Credit line given. Buys one-time rights, all rights; negotiable.

$ POLICE AND SECURITY NEWS

DAYS Communications, Inc., 1208 Juniper St., Quakertown PA 18951. (215)538-1240. Fax: (215)538-1208. E-mail: amenear@policeandsecuritynews.com. Website: www.policeandsecuritynews.com. **Contact:** Al

Menear, associate publisher. Circ. 22,200. Estab. 1984. Bimonthly trade journal. *"Police and Security News* is edited for middle and upper management and top administration. Editorial content is a combination of articles and columns ranging from the latest in technology, innovative managerial concepts, training and industry news in the areas of both public law enforcement and private security." Sample copy free with 9½×10 SAE and $2.17 first-class postage.

Needs Buys 2 photos from freelancers/issue; 12 photos/year. Needs photos of law enforcement and security related. Reviews photos with or without a ms. Photo captions preferred.

Specs Uses color and b&w prints.

Making Contact & Terms Provide résumé, business card, self-promotion piece or tearsheets to be kept on file for possible future assignments. Art director will contact photographer for portfolio review if interested. Portfolio should include b&w and/or color prints or tearsheets. Keeps samples on file; include SASE for return of material. Simultaneous submissions and previously published work OK. Pays $10 for b&w inside. Pays on publication. Credit line given. Buys one-time rights; negotiable.

▣ ◿ POLICE MAGAZINE

3520 Challenger St., Torrance CA 90503. (310)533-2400. Fax: (310)533-2507. E-mail: info@policemag.com. Website: www.policemag.com. **Contact:** David Griffith, editor. Estab. 1976. Monthly. Emphasizes law enforcement. Readers are various members of the law enforcement community, especially police officers. Sample copies available. Photo guidelines free via e-mail.

Needs Uses in-house photos and freelance submissions. Needs law enforcement-related photos. Special needs include photos relating to daily police work, crime prevention, international law enforcement, police technology and humor. Model release required; property release preferred. Photo captions preferred.

Specs Uses color photos only. Accepts images in digital format. Send via e-mail or CD; no Zip files.

Making Contact & Terms Send contact sheet or samples by e-mail or mail for consideration. Simultaneous submissions OK. Payscale available in photographer's guidelines. Pays on publication. Buys all rights.

Tips "Send for our editorial calendar and submit photos based on our projected needs. If we like your work, we'll consider you for future assignments. A photographer we use must grasp the conceptual and the action shots."

$◻ POLICE TIMES/CHIEF OF POLICE

6350 Horizon Dr., Titusville FL 32780. (321)264-0911. Fax: (321)264-0033. E-mail: policeinfo@aphf.org. Website: www.aphf.org. **Contact:** Jim Gordon, executive editor. Circ. 50,000. Quarterly (*Police Times*) and bimonthly (*Chief of Police*) trade magazines. Readers are law enforcement officers at all levels. *Police Times* is the official journal of the American Federation of Police and Concerned Citizens. Sample copy available for $2.50. Photo guidelines free with SASE.

Needs Buys 60-90 photos/year. Needs photos of police officers in action, civilian volunteers working with the police, and group shots of police department personnel. Wants no photos that promote other associations. Police-oriented cartoons also accepted on spec. Model release preferred. Photo captions preferred.

Making Contact & Terms Send glossy b&w and color prints for consideration; include SASE for return of material. Responds in 3 weeks. Simultaneous submissions and previously published work OK. Pays $10-25 for b&w; $25-50 for color. **Pays on acceptance.** Credit line given if requested; editor's option. Buys all rights, but may reassign to photographer after publication; includes Internet publication rights.

Tips "We are open to new and unknowns in small communities where police are not given publicity."

$Ⓐ POWERLINE MAGAZINE

1650 S. Dixie Hwy., Suite 500, Boca Raton FL 33432. (561)750-5575. Fax: (561)395-8557. Website: www.egsa. org. **Contact:** Don Ferreira, editor. Trade magazine of Electrical Generating Systems Association. Photos also used for PR releases, brochures, newsletters, newspapers and annual reports.

Needs Buys 40-60 photos/year; gives 2 or 3 assignments/year. "Need cover photos, events, award presentations, groups at social and educational functions." Model release required. Property release preferred. Photo captions preferred; include identification of individuals only.

Specs Uses 5×7 glossy b&w and color prints; b&w and color contact sheets; b&w and color negatives.

Making Contact & Terms Provide résumé, business card, brochure, flier or tearsheets to be kept on file for possible future assignments. Solicits photos by assignment only. Reports as soon as selection of photographs is made. Payment negotiable. Buys all rights; negotiable.

Tips "Basically, a freelance photographer working with us should use a photojournalistic approach and have the ability to capture personality and a sense of action in fairly static situations. With those photographers

who are equipped, we often arrange for them to shoot couples, etc., at certain functions on spec, in lieu of a per-day or per-job fee.''

PRIMO RISTORANTE MAGAZINE

P.O. Box 73, Liberty Corner NJ 07938. (908)766-6006. Fax: (908)766-6607. **Contact:** Tod Thomas, art director. Circ. 50,000. Estab. 1994. Quarterly magazine for the Italian connoisseur and Italian restaurants with liquor licenses.

Needs Number of photos/issue varies; number supplied by freelancers varies. ''Think Italian!'' Reviews photos with or without ms. Model/property release required. Photo captions preferred.

Making Contact & Terms Provide résumé, business card, brochure, flier or tearsheets to be kept on file for possible future assignments. Previously published work OK. Payment negotiable. Pays on publication. Credit line given. Buys all rights; negotiable.

$ ▣ ◯ ⑤ PROCEEDINGS

U.S. Naval Institute, 291 Wood Rd., Annapolis MD 21402. (410)295-1071. Fax: (410)295-1049. E-mail: jwallace@usni.org. Website: www.navalinstitute.org. **Contact:** Jennifer Wallace, photo editor. Circ. 80,000. Monthly trade magazine dedicated to providing an open forum for national defense. Samples copy available for $3.95. Photo guidelines free with SASE.

Needs Buys 10 photos from freelancers/issue; 120 photos/year. Needs photos of industry, military, political. Model release preferred. Photo captions required; include time, location, subject matter, service represented, if necessary.

Specs Uses glossy color prints. Accepts images in digital format. Send via CD, Zip as TIFF, JPEG files at 300 dpi.

Making Contact & Terms Send query letter with résumé, prints. Does not keep samples on file; include SASE for return of material. Responds only if interested; send nonreturnable samples. Simultaneous submissions and previously published work OK. Pays $200 for color cover; $25-75 for color inside. Pays on publication. Credit line given. Buys one-time and sometimes electronic rights.

Tips ''We look for original work. The best place to get a feel for our imagery is to see our magazine or look at our website.''

$ ▣ Ⓐ PRODUCE MERCHANDISING

Vance Publishing Corp., 10901 W. 84th Terrace, Lenexa KS 66214. (913)438-8700. Fax: (913)438-0691. E-mail: eashby@producemerchandising.com. Website: www.thepacker.com/prodMerch/prodMerch-about.asp. **Contact:** Elizabeth Ashby, editor. Circ. 12,000. Estab. 1988. Monthly magazine. Emphasizes the fresh produce industry. Readers are male and female executives who oversee produce operations in US and Canadian supermarkets. Sample copies available.

Needs Buys 2-5 photos from freelancers/issue; 24-60 photos/year. Needs in-store shots, environmental portraits for cover photos or display pictures. Photo captions preferred; include subject's name, job title and company title—all verified and correctly spelled.

Specs Accepts images in digital format. Send via Zip as TIFF, JPEG files.

Making Contact & Terms Provide résumé, business card, brochure, flier or tearsheets to be kept on file for possible future assignments. Response time ''depends on when we will be in a specific photographer's area and have a need.'' Pays $500-750 for color cover transparencies; $25-50/color photo; $50-100/color roll inside. **Pays on acceptance.** Credit line given. Buys all rights.

Tips ''We seek photographers who serve as our on-site 'art director' to ensure art sketches come to life. Supermarket lighting (fluorescent) offers a technical challenge we can't avoid. The 'greening' effect must be diffused/eliminated.''

▣ Ⓐ ∅ PROFESSIONAL PHOTOGRAPHER

229 Peachtree St. NE, Suite 2200, International Tower, Atlanta GA 30303. (404)522-8600. Fax: (404)614-6406. E-mail: cbishopp@ppa.com. Website: www.ppmag.com. **Contact:** Cameron Bishopp, executive editor. Art Director: Debbie Todd. Circ. 26,000. Estab. 1907. Monthly. Emphasizes professional photography in the fields of portrait, wedding, commercial/advertising, sports, corporate and industrial. Readers include professional photographers and photographic services and educators. Approximately half the circulation is Professional Photographers of America members. Sample copy available for $5 postpaid. Photo guidelines free with SASE.

● PPA members submit material unpaid to promote their photo businesses and obtain recognition. Images sent to *Professional Photographer* should be technically perfect, and photographers should include information about how the photo was produced.

Needs Buys 25-30 photos from freelancers/issue; 300-360 photos/year. "We only accept material as illustration that relates directly to photographic articles showing professional studio, location, commercial and portrait techniques. A majority are supplied by Professional Photographers of America members." Reviews photos with accompanying ms only. "We always need commercial/advertising and industrial success stories. How to sell your photography to major accounts, unusual professional photo assignments. Also, photographer and studio application stories about the profitable use of electronic still imaging for customers and clients." Model release preferred. Photo captions required.

Specs Uses 8×10 unmounted glossy b&w and/or color prints; 35mm, 2¼×2¼, 4×5, 8×10 transparencies. Accepts images in digital format. Send via CD, e-mail , floppy disk, SyQuest, Zip, Jaz.

Making Contact & Terms Send query letter with résumé of credits. "We prefer a story query, or complete manuscript if writer feels subject fits our magazine. Photos will be part of manuscript package." Responds in 2 months. Credit line given.

$ $ 🖳 PROGRESSIVE RENTALS

1504 Robin Hood Trail, Austin TX 78703. (512)794-0095. Fax: (512)794-0097. E-mail: nferguson@aprovision. org. Website: www.aprovision.org. **Contact:** Neil Ferguson, art director. Circ. 6,000. Estab. 1983. Bimonthly magazine published by the Association of Progressive Rental Organizations. Emphasizes the rental-purchase industry. Readers are owners and managers of rental-purchase stores in North America, Canada, Great Britain and Australia.

Needs Buys 1-2 photos from freelancers/issue; 6-12 photos/year. Needs "strongly conceptual, cutting-edge photos that relate to editorial articles on business/management issues. Also looking for photographers to capture unique and creative environmental portraits of our members." Model/property release preferred.

Specs Prefers images in digital format.

Making Contact & Terms Provide brochure, flier or tearsheets to be kept on file for possible future assignments. Simultaneous submissions and previously published work OK. Pays $200-450/job; $350-450 for cover; $200-450 for inside. Pays on publication. Credit line given. Buys one-time and electronic rights.

Tips "Understand the industry and the specific editorial needs of the publication, i.e., don't send beautiful still life photography to a trade association publication."

🖳 🅐 PUBLIC POWER

2301 M. St. NW, 3rd Floor, Washington DC 20037-1484. (202)467-2948. Fax: (202)467-2910. E-mail: jlabella @appanet.org. Website: www.appanet.org. **Contact:** Jeanne LaBella, editor. Circ. 20,000. Bimonthly publication of the American Public Power Association. Emphasizes electric power provided by cities, towns and utility districts. Sample copy and photo guidelines free.

Needs "We buy photos on assignment only."

Making Contact & Terms Send query letter with samples. Provide résumé, business card, brochure, flier or tearsheets to be kept on file for possible future assignments. Prefers digital images; call art director (Robert Thomas) at (202)467-2983 to discuss. **Pays on acceptance.** Credit line given. Buys one-time rights.

$ $ 🖉 PURCHASING MAGAZINE

225 Wyman St., Waltham MA 02451. (617)964-3030. Fax: (781)734-8076. E-mail: mroach@reedbusiness.c om. Website: www.purchasing.com. **Contact:** Michael Roach, senior art director. Circ. 93,000. Estab. 1915. Bimonthly. Readers are management and purchasing professionals.

Needs Uses 0-10 photos/issue, most on assignment. Needs corporate photos and people shots. Model/property release preferred. Photo captions required.

Making Contact & Terms Arrange a personal interview to show portfolio. Provide résumé, business card, brochure, flier or tearsheets to be kept on file for possible future assignments. Cannot return material. Simultaneous submissions and previously published work OK. Pays $500-800 for b&w; $300-500 for color; $50-100/hour; $800/day; $1,200 for cover and reprints. **Pays on acceptance.** Credit line given. Buys all rights for all media including electronic media.

Tips In photographer's portfolio, looks for informal business portraits, corporate atmosphere.

$ $ 🖳 🖉 QSR, The Magazine of Quality and Speed for Restaurant Success

4905 Pine Cone Dr., Suite 2, Durham NC 27707. (919)489-1916. Fax: (919)489-4767. E-mail: mavery@journali stic.com. Website: www.qsrmagazine.com. **Contact:** Mitch Avery, production manager. Estab. 1997. Trade

magazine directed toward the business aspects of quick-service restaurants (fast food). "Our readership is primarily management level and above, usually franchisors and franchisees. Our goal is to cover the quick-service restaurant industry objectively, offering our readers the latest news and information pertinent to their business." Photo guidelines free.

Needs Buys 10-15 photos/year. Needs corporate identity portraits, images associated with fast food, general food images for feature illustration. Interested in alternative process, documentary. Reviews photos with or without ms. Model/property release preferred.

Specs Uses 8×10 color prints; 2¼×2¼, 4×5, 8×10 transparencies. Accepts images in digital format. Send via CD, Zip as TIFF, EPS files at 300 dpi.

Making Contact & Terms Send query letter with samples, brochure, stock list, tearsheets. Art director will contact photographer for portfolio review if interested. Portfolio should include slides and digital sample files. Keeps samples on file. Responds only if interested; send nonreturnable samples. Simultaneous submissions and previously published work OK. Pays $250-500 for color cover; $250-500 for color inside. Pays on publication. Publisher only interested in acquiring all rights unless otherwise specified.

Tips "Willingness to work with subject and magazine deadlines essential. Willingness to follow artistic guidelines necessary but should be able to rely on one's own eye. Our covers always feature quick-service restaurant executives with some sort of name recognition (i.e., a location shot with signage in the background, use of product props which display company logo)."

$ 🖥 🅿 QUICK FROZEN FOODS INTERNATIONAL

2125 Center Ave., Suite 305, Fort Lee NJ 07024-5898. (201)592-7007. Fax: (201)592-7171. Website: www.quic kfrozenfoods.com. **Contact:** John M. Saulnier, chief editor/publisher. Circ. 13,000. Quarterly magazine. Emphasizes retailing, marketing, processing, packaging and distribution of frozen foods around the world. Readers are international executives involved in the frozen food industry: manufacturers, distributors, retailers, brokers, importers/exporters, warehousemen, etc. Review copy available for $12.

Needs Buys 10-25 photos/year. Uses photos of agriculture, plant exterior shots, step-by-step in-plant processing shots, photos of retail store frozen food cases, head shots of industry executives, etc. Photo captions required.

Specs Uses 5×7 glossy b&w and/or color prints. Accepts digital images via CD at 300 dpi.

Making Contact & Terms Send query letter with résumé of credits. Responds in 1 month. Payment negotiable. Pays on publication. Buys all rights but may reassign to photographer after publication.

Tips A file of photographers' names is maintained; if an assignment comes up in an area close to a particular photographer, she/he may be contacted. "When submitting your name, inform us if you are capable of writing a story if needed."

$ THE RANGEFINDER

1312 Lincoln Blvd., Santa Monica CA 90401. (310)451-8506. Fax: (310)395-9058. E-mail: bhurter@rfpublishi ng.com. **Contact:** Bill Hurter, editor. Circ. 50,000. Estab. 1952. Monthly magazine. Emphasizes topics, developments and products of interest to the professional photographer. Readers are professionals in all phases of photography. Sample copy free with 11×14 SAE and 2 first-class stamps. Photo guidelines free with SASE.

Needs Buys very few photos from freelancers/issue. Needs all kinds of photos; almost always run in conjunction with articles. "We prefer photos accompanying 'how-to' or special interest stories from the photographer." No pictorials. Special needs include seasonal cover shots (vertical format only). Model release required; property release preferred. Photo captions preferred.

Making Contact & Terms Send query letter with résumé of credits. Keeps samples on file; include SASE for return of material. Responds in 1 month. Previously published work occasionally OK; give details. Pays $100 minimum/printed editorial page with illustrations. Covers submitted gratis. Pays on publication. Credit line given. Buys first North American serial rights; negotiable.

$ 🖥 READING TODAY

International Reading Association, 800 Barksdale Rd., P.O. Box 8139, Newark DE 19714-8139. (302)731-1600, ext. 250. Fax: (302)731-1057. E-mail: jmicklos@reading.org. Website: www.reading.org. **Contact:** John Micklos, Jr., editor. Circ. 85,000. Estab. 1983. Bimonthly newspaper of the International Reading Association. Emphasizes reading education. Readers are educators who belong to the International Reading Association. Sample copies available. Photo guidelines free with SASE.

Needs Buys 4 photos from freelancers/issue; 24 photos/year. Needs classroom shots and photos of people

of all ages reading in various settings. Reviews photos with or without ms. Model/property release preferred. Photo captions preferred; include names (if appropriate) and context of photo.

Specs Uses $3^{1}/_{2} \times 5$ or larger color and b&w prints. Accepts images in digital format. Send via CD, e-mail as JPEG files.

Making Contact & Terms Send query letter with résumé of credits and stock list. Send unsolicited photos by mail for consideration; include SASE for return of material. Responds in 1 month. Simultaneous submissions and previously published work OK. Pays $100 for editorial use. **Pays on acceptance.** Credit line given. Buys one-time rights for print use and rights to post editorially on the IRA website.

$ ▣ ⊘ RECOMMEND MAGAZINE

Worth International Media Group, 5979 NW 151st St., Suite 120, Miami Lakes FL 33014. (305)828-0123. Fax: (305)826-6950. E-mail: janet@recommend.com. Website: www.recommend.com; www.worthit.com. **Contact:** Janet Del Mastro, art director. Circ. 65,000. Estab. 1985. Monthly. Emphasizes travel. Readers are travel agents, meeting planners, hoteliers, ad agencies. Sample copy free with $8^{1}/_{2} \times 11$ SAE and 10 first-class stamps.

Needs Buys 16 photos from freelancers/issue; 192 photos/year. "Our publication divides the world into 7 regions. Every month we use travel destination-oriented photos of animals, cities, resorts and cruise lines; feature all types of travel photography from all over the world." Model/property release required. Photo captions preferred; identification required on every slide.

Specs Accepts images in digital format. Send via CD, Zip as TIFF, EPS files at 300 dpi minimum.

Making Contact & Terms "We prefer a résumé, stock list and sample card or tearsheets with photo review later." Simultaneous submissions and previously published work OK. Pays $75-150 for color cover; front cover less than 80 square inches, $50; $25-50 for color inside. Pays 30 days after publication. Credit line given. Buys one-time rights.

Tips Prefers to see high-res digital files, first generation high-quality.

$ ▣ ◯ REEVES JOURNAL

Business News Publishing Media, 23421 S. Pointe Dr., Suite 280, Laguna Hills CA 92653. (949)830-0881. Fax: (949)859-7845. E-mail: jack@reevesjournal.com. Website: www.reevesjournal.com. **Contact:** Jack Sweet, editor. Circ. 13,500. Estab. 1920. Monthly trade magazine. "Our focus is residential and commercial construction—mechanical (plumbing and HVAC) written to contractor reader. We blend business, mechanical and technical subject matter." Sample copy available for 8×11 SAE. Photo guidelines free with SASE.

Needs Buys 10 photos from freelancers/issue. Needs photos of construction, home building, commercial high rise, action photos of installers (plumbers, HVAC technicians). Reviews photos with or without ms. Model/property release preferred. Photo captions preferred; include name, position, company, description of what's going on.

Specs Uses 5×7, 8×10 glossy or matte color and/or b&w prints; 35mm, $2^{1}/_{4} \times 2^{1}/_{4}$ transparencies. Accepts images in digital format. Send via CD, Zip as TIFF, EPS, JPEG (preferred) files at more than 300 dpi.

Making Contact & Terms Send query letter with slides, prints, tearsheets, stock list. Does not keep samples on file; include SASE for return of material. Responds in 3 weeks to queries. Previously published work OK. Negotiable payment (cover, usually $150-300; inside, $50-75). Pays on publication. Credit line given. Rights negotiable.

Tips "Need to clearly show action of installer; shoot both horizontal and vertical, wide and tight. Give us a variety to work with. Caption needs to be thorough. Make sure you are tuned into the magazine's focus—plumbing and HVAC installation in residential, commercial applications. We're a western region publication."

$ ▣ ⊘ Ⓢ REFEREE

P.O. Box 161, Franksville WI 53126. (262)632-8855. Fax: (262)632-5460. E-mail: kzirbel@referee.com. Website: www.referee.com. **Contact:** Keith Zirbel, photo editor. Circ. 40,000. Estab. 1976. Monthly magazine. Readers are mostly male, ages 30-50. Sample copy free with 9×12 SAE and 5 first-class stamps. Photo guidelines free with SASE.

Needs Buys 37 photos from freelancers/issue; 444 photos/year. Needs action officiating shots—all sports. Photo needs are ongoing. Photo captions required.

Specs Prefers to use digital files (minimum 300 dpi submitted on CD only) and 35mm slides. Also uses color prints.

Making Contact & Terms Send unsolicited photos by mail for consideration. Responds in 2 weeks. Simultane-

ous submissions and previously published work OK. Pays $100 for color cover; $35 for color inside. Pays on publication. Credit line given. Rights purchased negotiable.

Tips "Prefers photos that bring out the uniqueness of being a sports official. Need photos primarily of officials at or above the high school level in baseball, football, basketball, softball and soccer in action. Other sports acceptable, but used less frequently. When at sporting events, take a few shots with the officials in mind, even though you may be on assignment for another reason. Don't be afraid to give it a try. We're receptive, always looking for new freelance contributors. We are constantly looking for pictures of officials/umpires. Our needs in this area have increased. Names and hometowns of officials are required."

▣ RELAY MAGAZINE
P.O. Box 10114, Tallahassee FL 32302-2114. (850)224-3314. **Contact:** Faye Howell, editor. Circ. 5,000. Estab. 1957. Bimonthly magazine of Florida Municipal Electric Association. Covers the energy, electric, utility and telecom industries in Florida. Sent to utility professionals, local elected officials, state and national legislators, and other state power associations.

Needs Number of photos/issue varies; various number supplied by freelancers. Needs photos of electric utilities in Florida (hurricane/storm damage to lines, utility workers, power plants, infrastructure, telecom, etc.); cityscapes of member utility cities. Model/property release preferred. Photo captions required.

Specs Uses 3×5, 4×6, 5×7, 8×10 b&w and/or color prints. Accepts images in digital format.

Making Contact & Terms Send query letter with description of photo or photocopy. Keeps samples on file. Simultaneous submissions and previously published work OK. Payment negotiable. Rates negotiable. Pays on use. Credit line given. Buys one-time rights, repeated use (stock); negotiable.

Tips "Must relate to our industry. Clarity and contrast important. Always query first."

$ $ ▣ ◿ RESTAURANT HOSPITALITY
Penton Media, 1300 E. Ninth St., Cleveland OH 44114. (216)931-9942. Fax: (216)696-0836. E-mail: croberto@penton.com. Website: www.restaurant-hospitality.com. **Contact:** Christopher Roberto, group creative director. Editor-in-Chief: Michael Sanson. Circ. 123,000. Estab. 1919. Monthly. Emphasizes "hands-on restaurant management ideas and strategies." Readers are "restaurant owners, chefs, food service chain executives."

Needs Buys 15 photos from freelancers/issue; 180 photos/year. Needs "on-location portraits, restaurant and food service interiors, and occasional food photos." Special needs include "subject-related photos; query first." Model release preferred. Photo captions preferred.

Specs Accepts images in digital format. Send via CD, Zip, e-mail as TIFF, EPS, JPEG files at 300 dpi.

Making Contact & Terms Send samples or list of stock photo subjects if available. Provide business card, samples or tearsheets to be kept on file for possible future assignments. Previously published work OK "if exclusive to foodservice press." Pays $350/half day; $150-450/job; includes normal expenses. Cover fees on per project basis. **Pays on acceptance.** Credit line given. Buys one-time rights plus reprint rights in all media.

Tips Send postcard samples including your Web address for online viewing of your work.

$ ▣ RETAILERS FORUM
383 E. Main St., Centerport NY 11721. (631)754-5000. Fax: (631)754-0630. E-mail: forumpublishing@aol.com. **Contact:** Martin Stevens, publisher. Circ. 70,000. Estab. 1981. Monthly magazine. Readers are entrepreneurs and retail store owners. Sample copy available for $7.50.

Needs Buys 3-6 photos from freelancers/issue; 36-72 photos/year. "We publish trade magazines for retail variety goods stores and flea market vendors. Items include jewelry, cosmetics, novelties, toys, etc. (five-and-dime-type goods). We are interested in creative and abstract impressions—not straight-on product shots. Humor a plus." Model/property release required.

Specs Uses color prints. Accepts images in digital format. Send via e-mail at 300 dpi.

Making Contact & Terms Send unsolicited photos by mail or e-mail for consideration. Does not keep samples on file; include SASE for return of material. Responds in 2 weeks. Simultaneous submissions and previously published work OK. Pays $100 for color cover; $50 for color inside. **Pays on acceptance.** Buys one-time rights.

$ ▣ Ⓢ THE SCHOOL ADMINISTRATOR
801 N. Quincy St., Arlington VA 22203. Website: www.aasa.org. **Contact:** Liz Griffin, managing editor. Circ. 22,000. Monthly magazine of the American Association of School Administrators. Emphasizes K-12 education. Readers are school district administrators including superintendents, ages 50-60. Sample copy available for $10.

Needs Uses 8-10 photos/issue. Needs classroom photos (K-12), photos of school principals, superintendents and school board members interacting with parents and students. Model/property release preferred for physically handicapped students. Photo captions required; include name of school, city, state, grade level of students, and general description of classroom activity.

Specs Uses 5×7, 8×10 matte or glossy color and/or b&w prints; slides. Accepts images in digital format. Send via Zip as TIFF, JPEG files at 300 dpi.

Making Contact & Terms Provide business card or tearsheets to be kept on file for possible future assignments. Send photocopy of color prints by mail for consideration. Photocopy of prints should include contact information including fax number. "Check our website for our editorial calendar. Familiarize yourself with topical nature and format of magazine before submitting prints." Work assigned is 3-4 months prior to publication date. Keeps samples on file; include SASE for return of material. Simultaneous submissions and previously published work OK. Pays $50-75 for inside photos. Credit line given. Buys one-time rights.

Tips "Prefer photos with interesting, animated faces and hand gestures. Always looking for the unusual human connection where the photographer's presence has not made subjects stilted. Also, check out our editorial calendar on our website. Please do not send e-mails of your work or website."

[N] SIGNCRAFT MAGAZINE

P.O. Box 60031, Fort Myers FL 33906. (239)939-4644 or (800)204-0204. Fax: (239)939-0607. E-mail: signcraft @signcraft.com. Website: www.signcraft.com. **Contact:** Tom McIltrot, editor. Circ. 14,000. Estab. 1980. Bimonthly magazine. Readers are sign makers and sign shop personnel. Sample copy available for $5. Photo guidelines free with SASE.

Needs Uses over 100 photos/issue; few at present supplied by freelancers. Uses photos of well-designed, effective signs. Photo captions preferred.

Specs Uses b&w and/or color prints; 35mm, 2¼×2¼ transparencies; b&w and/or color contact sheets.

Making Contact & Terms Send query letter with samples, SASE. Responds in 1 month. Previously published work possibly OK. Payment negotiable. Pays on publication. Credit line given. Buys first North American serial rights.

Tips "If you have some background or past experience with sign making, you may be able to provide photos for us."

[A] STRATEGIC FINANCE

10 Paragon Dr., Montvale NJ 07645. (201)573-9000. Fax: (201)474-1603. E-mail: mzisk@imanet.org. **Contact:** Mary Zisk, art director. Circ. 66,000. Estab. 1919. Monthly publication of the Institute of Management Accountants. Emphasizes management accounting and financial management. Readers are financial executives.

Needs Needs environmental portraits of executives through assignment only.

Specs Uses prints and transparencies.

Making Contact & Terms Provide tearsheets to be kept on file for possible future assignments. Pays $500/day plus expenses. **Pays on acceptance.** Credit line given. Buys one-time rights.

$ $ SUCCESSFUL MEETINGS

770 Broadway, New York NY 10003. (646)654-7348. Fax: (646)654-7367. **Contact:** Don Salkaln, art director. Circ. 70,000. Estab. 1955. Monthly. Emphasizes business group travel for all sorts of meetings. Readers are business and association executives who plan meetings, exhibits, conventions and incentive travel. Sample copy available for $10.

Needs Special needs include *good*, high-quality corporate portraits; conceptual, out-of-state shoots.

Making Contact & Terms Arrange a personal interview to show portfolio. Send query letter with résumé of credits and list of stock photo subjects. Responds in 2 weeks. Simultaneous submissions and previously published work OK "only if you let us know." Pays $500-750 for color cover; $50-150 for b&w inside; $75-200 for color inside; $150-250/b&w page; $200-300/color page; $50-100/hour; $175-350/½ day. **Pays on acceptance**. Credit line given. Buys one-time rights.

$ THOROUGHBRED TIMES

P.O. Box 8237, Lexington KY 40533. (859)260-9800. E-mail: photos@thoroughbredtimes.com. **Contact:** Mark Simon, editor. Circ. 22,000. Estab. 1985. Weekly tabloid news magazine. Emphasizes Thoroughbred breeding and racing. Readers are wide demographic range of industry professionals. No photo guidelines.

Needs Buys 7-12 photos from freelancers/issue; 364-624 photos/year. Looks for photos "only from desired

trade (Thoroughbred breeding and racing).'' Needs photos of specific subject features (personality, farm or business). Model release preferred. Photo captions preferred.

Making Contact & Terms Provide résumé, business card, brochure, flier or tearsheets to be kept on file for possible future assignments. Responds in 1 month. Previously published work OK. Pays $50 for b&w cover or inside; $50 for color; $250/day. Pays on publication. Credit line given. Buys one-time rights.

Ⓝ $ $◫ TOP PRODUCER

FarmJournal Media, 1818 Market St., 31st Floor, Philadelphia PA 19103. (215)557-8900. Fax: (215)568-3989. E-mail: TopProducer@farmjournal.com. Website: www.agweb.com. **Contact:** Joe Tenerelli, art director. Circ. 190,000. Monthly. Emphasizes American agriculture. Readers are active farmers, ranchers or agribusiness people. Sample copy and photo guidelines free with SASE.

Needs Buys 10-15 photos from freelancers/issue; 120-180 photos/year. ''We use studio-type portraiture (environmental portraits), technical, details and scenics.'' Model release preferred. Photo captions required.

Making Contact & Terms Arrange a personal interview to show portfolio. Send query letter with résumé of credits along with business card, brochure, flier or tearsheets to be kept on file for possible future assignments. Accepts images in digital format. Send via CD or e-mail as TIFF, EPS or JPEG files. ''Portfolios may be submitted via CD-ROM or floppy disk.'' DO NOT SEND ORIGINALS. Responds in 2 weeks. Simultaneous submissions and previously published work OK. Pays $75-400 for color photos; $200-400/day. Pays extra for electronic usage of images. ''We pay a cover bonus.'' **Pays on acceptance.** Credit line given. Buys one-time rights.

Tips In portfolio or samples, likes to see ''about 40 slides showing photographer's use of lighting and ability to work with people. Know your intended market. Familiarize yourself with the magazine and keep abreast of how photos are used in the general magazine field.''

◫ TRANSPORT TOPICS

2200 Mill Rd., Alexandria VA 22314. (703)838-1735. Fax: (703)548-3662. Website: www.ttnews.com. **Contact:** Jonathan Reiskin, associate news editor. Circ. 31,000. Estab. 1935. Weekly tabloid. Publication of the American Trucking Associations. Emphasizes the trucking industry. Readers are male executives, ages 35-65.

Needs Uses approximately 12 photos/issue; amount supplied by freelancers ''depends on need.'' Needs photos of truck transportation in all modes. Model/property release preferred. Photo captions preferred.

Making Contact & Terms Send unsolicited JPEGs by e-mail for consideration. Provide résumé, business card, brochure, flier or tearsheets to be kept on file for possible future assignments. Does not keep samples on file; include SASE for return of material. Responds in 1 month. Simultaneous submissions and previously published work OK. Payment negotiable. Pays standard ''market rate'' for color cover photo. **Pays on acceptance.** Credit line given. Buys one-time or permanent rights; negotiable.

Tips ''Trucks/trucking must be dominant element in the photograph—not an incidental part of an environmental scene.''

$ $◫ ◪ UNDERGROUND CONSTRUCTION

P.O. Box 941669, Houston TX 77094-8669. (281)558-6930. Fax: (281)558-7029. E-mail: rcarpenter@oildom.com. Website: www.undergroundconstructiononline.com. **Contact:** Robert Carpenter, editor. Circ. 37,000. Estab. 1945. Monthly. Emphasizes construction and rehabilitation of sewer, water, gas, telecom, electric and oil underground pipelines/conduit. Readers are contractors, utilities and engineers. Sample copy available for $3.

Needs ''Uses photos of underground construction and rehabilitation.''

Specs Uses high-resolution digital images (minimum 300 dpi), large-format negatives or transparencies.

Making Contact & Terms Queries preferred before sending photos. Generally responds within 30 days. Pays $100-400 for color cover; $50-250 for color inside. Buys one-time rights.

Tips ''Freelancers are competing with staff as well as complimentary photos supplied by equipment manufacturers. Subject matter must be unique, striking and/or off the beaten track. People on the job are always desirable.''

$ $◫ ◪ VETERINARY ECONOMICS

Advanstar Veterinary Healthcare Communications, 8033 Flint, Lenexa KS 66214. (913)492-4300. Fax: (913)492-4157. Website: www.vetecon.com. **Contact:** Alison Fulton, associate design director. Circ. 58,000.

Estab. 1960. Monthly trade magazine emphasizing practice management for veterinarians. Sample copies and photo guidelines available.

Needs Buys 1 photo from Internet and/or freelancers; 12 photos/year. Needs photos of business concepts and medicine. Reviews photos with or without ms. Model release required. Photo captions preferred.

Specs Uses matte color prints; 35mm transparencies. Accepts images in digital format. Send via CD, Zip, e-mail as TIFF, EPS, JPEG files at 300 dpi.

Making Contact & Terms Send query letter with tearsheets, stock list. Does not keep samples on file; include SASE for return of material. Pays $500 minimum for color cover. **Pays on acceptance**. Credit line given.

$ ▣ ○ WATER WELL JOURNAL

601 Dempsey Rd., Westerville OH 43081. (800)551-7379. Fax: (614)898-7786. E-mail: tplumley@ngwa.org. Website: www.ngwa.org. **Contact:** Thad Plumley, director of publications. Circ. 26,000. Estab. 1947. Monthly. Emphasizes construction of water wells, development of ground water resources and ground water cleanup. Readers are water well drilling contractors, manufacturers, suppliers, and ground water scientists. Sample copy available for $21 US, $36 foreign.

Needs Buys 1-3 freelance photos/issue plus cover photos; 12-36 photos/year. Needs photos of installations and how-to illustrations. Model release preferred. Photo captions required.

Specs Accepts images in digital format. Send via CD, floppy disk, Jaz, Zip as TIFF files at 300 dpi.

Making Contact & Terms Send query letter with samples. "We'll contact you." Pays $250 for color cover; $50 for b&w or color inside; "flat rate for assignment." Pays on publication. Credit line given. Buys all rights.

Tips "E-mail or send written inquiries; we'll reply if interested. Unsolicited materials will not be returned."

$ $ ▣ WINES & VINES

1800 Lincoln Ave., San Rafael CA 94901. (415)453-9700. Fax: (415)453-2517. E-mail: edit@winesandvines.com. Website: www.winesandvines.com. **Contact:** Jane Firstenfeld. Circ. 5,000. Estab. 1919. Monthly magazine. Emphasizes winemaking and marketing in the US and internationally for wine industry professionals, including winemakers, wine merchants and suppliers.

Needs Wants color cover subjects on a regular basis.

Specs Accepts images in digital format. Send via CD, Zip, e-mail as TIFF, or JPEG files at 400 dpi.

Making Contact & Terms Prefers e-mail query with link to portfolio; or send material by mail for consideration. Will e-mail if interested in reviewing photographer's portfolio. Provide business card to be kept on file for possible future assignments. Responds in 3 months. Previously published work considered. Pays $100-300 for color cover. Pays on publication. Credit line given. Buys one-time rights.

$ WISCONSIN ARCHITECT

321 S. Hamilton St., Madison WI 53703. (608)257-8477. **Contact:** Brenda Taylor, managing editor. Circ. 3,700. Estab. 1931. Bimonthly magazine of the American Institute of Architects Wisconsin. Emphasizes architecture. Readers are design/construction professionals.

Needs Uses approximately 35 photos/issue. "Photos are almost exclusively supplied by architects who are submitting projects for publication. Of these, approximately 65% are professional photographers hired by the architect."

Making Contact & Terms "Contact us through architects." Keeps samples on file. Responds in 1-2 weeks when interested. Simultaneous submissions and previously published work OK. Pays $50-100 for color cover when photo is specifically requested. Pays on publication. Credit line given. Rights negotiable.

$ WOMAN ENGINEER

Equal Opportunity Publications, Inc., 445 Broad Hollow Rd., Suite 425, Melville NY 11747. (631)421-9421, ext. 17. Fax: (631)421-0359. E-mail: LRusso@eop.com. Website: www.eop.com/we.html. **Contact:** Lana Russo, managing editor. Circ. 16,000. Estab. 1979. Published 3 times/year. Emphasizes career guidance for women engineers at the college and professional levels. Readers are college-age and professional women in engineering. Sample copy free with 9×12 SAE and 6 first-class stamps.

Needs Uses at least 1 photo/issue (cover); planning to use freelance work for covers and possibly editorial; most of the photos are submitted by freelance writers with their articles. Model release preferred. Photo captions required.

Making Contact & Terms Send query letter with list of stock photo subjects, or call to discuss current needs. Responds in 6 weeks. Simultaneous submissions OK. Pays $25 for color cover; $15 for b&w inside; $15 for color inside. Pays on publication. Credit line given. Buys one-time rights.

Tips "We are looking for strong, sharply focused photos or slides of women engineers. The photo should show a woman engineer at work, but the background should be uncluttered. The photo subject should be dressed and groomed in a professional manner. Cover photo should represent a professional woman engineer at work and convey a positive and professional image. Read our magazine, and find actual women engineers to photograph. We're not against using cover models, but we prefer cover subjects to be women engineers working in the field."

$ $ ▣ WOODSHOP NEWS, The News Magazine for Professional Woodworkers

Soundings Publications LLC, 10 Bokum Rd., Essex CT 06426. (860)767-8227. Fax: (860)767-0645. E-mail: editorial@woodshopnews.com. Website: www.woodshopnews.com. **Contact:** Editor. Circ. 70,000. Estab. 1986. Monthly trade magazine (tabloid format) covering all areas of professional woodworking. Sample copies available.

Needs Buys 12 sets of cover photos from freelancers/year. Needs photos of celebrities, architecture, interiors/decorating, industry, product shots/still life. Interested in documentary. "We assign our cover story, which is always a profile of a professional woodworker. These photo shoots are done in the subject's shop and feature working shots, portraits and photos of subject's finished work." Photo captions required; include description of activity contained in shots. Photo captions will be written in-house based on this information.
Specs Uses 35mm, $2\frac{1}{4} \times 2\frac{1}{4}$ transparencies. Accepts digital photos with prior arrangement.
Making Contact & Terms Send query letter with résumé, photocopies, tearsheets. Provide self-promotion piece to be kept on file for possible future assignments. Responds only if interested; send nonreturnable samples. Previously published work OK occasionally. Pays $600-800 for color cover. "Note: We want a cover photo 'package.' One shot makes the cover, others will be used inside with the cover story." **Pays on acceptance**. Credit line given. Buys one-time rights.
Tips "I need a list of photographers in every geographical region of the country—I never know where our next cover profile will be done, so I need to have options everywhere. Familiarity with woodworking is a definite plus. Listen to our instructions! We have very specific lighting and composition needs, but some photographers ignore instructions in favor of creating 'artsy' photos, which we do not use, or poorly lighted photos, which we cannot use."

Ⓝ WORKFORCE

Crain Communications, Inc., 4 Executive Circle, Suite 185, Irvine CA 92614. (949)255-5340. Fax: (949)221-8964. E-mail: ddeay@workforce.com. Website: www.workforce.com. **Contact:** Douglas Deay, art director. Circ. 50,000. Estab. 1921. Monthly magazine. Emphasizes human resources. Readers are male and female business leaders in the hiring profession, ages 30-65. Sample copies can be viewed in libraries.
Needs Buys 2-5 photos from freelancers/issue; 24-60 photos/year. "We purchase business, news stock and assign monthly cover shoots." Model release required; property release preferred. Photo captions preferred.
Making Contact & Terms Provide résumé, business card, brochure, flier or tearsheets to be kept on file for possible future assignments. Send query letter with stock list. Cannot return material. Responds in 1 month. Simultaneous submissions and previously published work OK. Payment negotiable. Pays on publication. Credit line given. Buys one-time rights.

$ ◻ WRITERS' JOURNAL, The Complete Writers' Magazine

Val-Tech Media, P.O. Box 394, Perham MN 56573. (218)346-7921. Fax: (218)346-7924. E-mail: writersjournal@ writersjournal.com. Website: www.writersjournal.com. **Contact:** John Ogroske, publisher. Circ. 26,000. Estab. 1980. Bimonthly trade magazine. Sample copy available for $5.
Needs Buys 1 photo from freelancers/issue; 6 photos/year. Needs photos of landscapes/scenics, wildlife, rural, travel. *Writers' Journal* offers 2 photography contests yearly. Send SASE for guidelines or visit website. Model release required. Photo title preferred.
Specs Uses 8×10 color prints; 35mm or larger transparencies
Making Contact & Terms Send query letter with tearsheets, stock list. Does not keep samples on file; include SASE for return of material. Responds in 2 months. Pays $50-60 for color cover. Pays on publication. Credit line given. Buys one-time rights.

Book Publishers

There are diverse needs for photography in the book publishing industry. Publishers need photos for the obvious (covers, jackets, text illustrations, and promotional materials), but now they may also need them for use on CD-ROMs and Web sites. Generally, though, publishers either buy individual or groups of photos for text illustration, or they publish entire books of photography.

Those in need of text illustration use photos for cover art and interiors of textbooks, travel books and nonfiction books. For illustration, photographs may be purchased from a stock agency or from a photographer's stock, or the publisher may make assignments. Publishers usually pay for photography used in book illustration or on covers on a per-image or per-project basis. Some pay photographers hourly or day rates, if on an assignment basis. No matter how payment is made, however, the competitive publishing market requires freelancers to remain flexible.

To approach book publishers for illustration jobs, send a cover letter with photographs or slides and a stock photo list with prices, if available. (See sample stock list on page 19.) If you have a Web site, provide a link to it. If you have published work, tearsheets are very helpful in showing publishers how your work translates to the printed page.

PHOTO BOOKS

Publishers who produce photography books usually publish books with a theme, featuring the work of one or several photographers. It is not always necessary to be well-known to publish your photographs as a book. What you do need, however, is a unique perspective, a salable idea and quality work.

For entire books, publishers may pay in one lump sum or with an advance plus royalties (a percentage of the book sales). When approaching a publisher for your own book of photographs, query first with a brief letter describing the project, and include sample photographs. If the publisher is interested in seeing the complete proposal, you can send additional information in one of two ways depending on the complexity of the project.

Prints placed in sequence in a protective box, along with an outline, will do for easy-to-describe, straightforward book projects. For more complex projects, you may want to create a book dummy. A dummy is basically a book model with photographs and text arranged as they will appear in finished book form. Book dummies show exactly how a book will look, including the sequence, size, format and layout of photographs and accompanying text. The quality of the dummy is important, but keep in mind that the expense can be prohibitive.

To find the right publisher for your work, first check the Subject Index on page 507 to help narrow your search, then read the appropriate listings carefully. Send for catalogs and

guidelines for those publishers that interest you. You may find guidelines on publishers' Web sites as well. Also, become familiar with your local bookstore or visit the site of an online bookstore such as Amazon.com. By examining the books already published, you can find those publishers who produce your type of work. Check for both large and small publishers. While smaller firms may not have as much money to spend, they are often more willing to take risks, especially on the work of new photographers. Keep in mind that photo books are expensive to produce and may have a limited market.

$ $ ▣ ◪ ⓢ A&B PUBLISHERS GROUP

Imprint: Upstream Publications, A&B Distributors Inc., 1000 Atlantic Ave., Brooklyn NY 11238. (718)783-7808. Fax: (718)783-7267. E-mail: ericgist2002@yahoo.com. Website: www.anbdonline.com. **Contact:** Eric Gist, production manager. Estab. 1992. Publishes hardcover, trade paperback and mass market paperback originals; trade paperback and mass market paperback reprints. Subjects include nutrition, cooking, health, healing. Photos used for text illustrations, promotional materials, book covers, dust jackets. Examples of recently published titles: *Master Teacher* (text illustrations); *A Taste of the Africa Table* (book cover).

Needs Buys 20-30 freelance photos/year. Needs photos of babies/children/teens, multicultural. Model release required. Photo captions preferred.

Specs Uses matte prints; 4×5 transparencies. Accepts images in digital format. Send via CD, Zip as TIFF, EPS files at 300 dpi.

Making Contact & Terms Send query letter with slides. Keeps samples on file. Responds in 2 months to queries; 1 month to portfolios. Simultaneous submissions and previously published work OK. Pays $250-750 for b&w cover; $350-900 for color cover; $125-750 for b&w inside; $250-900 for color inside.

$ $ ▣ ◪ ABSEY AND CO. INC.

23011 Northcrest Dr., Spring TX 77389. (888)412-2739. E-mail: AbseyandCo@aol.com. Website: www.absey. com. Estab. 1997. Publishes hardcover, trade paperback and mass market paperback originals. Subjects include young adult, poetry, educational material. Photos used for text illustrations, promotional materials, book covers, dust jackets. Examples of recently published titles: *Conclusions* (book cover); *Guide to Writing with Depth* (book cover); *Poetry After Lunch* (book cover); *Where I'm From* (book cover).

Needs Buys 5-50 freelance photos/year. Needs photos of babies/children/teens, multicultural, environmental, landscapes/scenics, wildlife, education, health/fitness, agriculture, product shots/still life. Interested in avant garde. Model/property release required. Photo captions required.

Specs Uses 3×5 glossy or matte color and/or b&w prints. Accepts images in digital format. Send as TIFF, EPS, GIF, JPEG files at 600 dpi.

Making Contact & Terms Send query letter with résumé, photocopies, tearsheets, stock list. Provide résumé or self-promotion piece to be kept on file for possible future assignments. Responds in 3 months if interested. Pays $50-1,000 for b&w or color cover; $25-100 for b&w inside; $25-150 for color inside. Pays on publication. Credit line given. Buys one-time rights; negotiable.

Tips Does not want "cutesy" photos.

▣ ACTION PUBLISHING

P.O. Box 391, Glendale CA 91209. (323)478-1667. Fax: (323)478-1767. Website: www.actionpublishing.com. **Contact:** Art Director. Estab. 1996. Subjects include children's books, fiction, nonfiction, art and photography.

Specs Uses all formats.

Making Contact & Terms Send promo piece. Pays by the project or per photo.

Tips "We use a small number of photos. Promo is kept on file for reference if potential interest. If book proposal, send query letter first with Web link to sample photos if available."

▣ Ⓐ AERIAL PHOTOGRAPHY SERVICES

2511 S. Tryon St., Charlotte NC 28203. (704)333-5143. Fax: (800)204-4910. E-mail: aps@aps-1.com. Website: www.aps-1.com. **Contact:** Joe Joseph, photography/lab manager. Estab. 1960. Publishes pictorial books, calendars, postcards, etc. Photos used for text illustrations, book covers, souvenirs. Examples of recently published titles: *Blue Ridge Parkway Calendar, Great Smoky Mountain Calendar, North Carolina Calendar, North Carolina Outer Banks Calendar,* all depicting the seasons of the year. Photo guidelines free with SASE.

Needs Buys 100 photos/year. Wants landscapes/scenics, mostly seasons (fall, winter, spring). Reviews stock photos. Model/property release preferred. Photo captions required; include location.

Book Publishers

Specs Uses 5×7, 8×10 matte color prints; 35mm, 2¼×2¼, 4×5 transparencies; c-41 120mm film mostly. Accepts images in digital format on CD.

Making Contact & Terms Send unsolicited photos by mail with SASE for consideration. Works with local freelancers on assignment only. Responds in 3 weeks. Simultaneous submissions OK. Payment negotiable. **Pays on acceptance**. Credit line given. Buys all rights; negotiable.

Tips Looking for "fresh looks; creative, dynamic, crisp images. We use a lot of nature photography, scenics of the Carolinas area including Tennessee and the mountains. We like to have a nice variety of the 4 seasons. We also look for good-quality chromes good enough for big reproduction. Only submit images that are very sharp and well exposed. For the fastest response time, please limit your submission to only the highest-quality transparencies. Seeing large-format photography the most (120mm-4×5). If you would like to submit images on a CD, that is acceptable too."

ALL ABOUT KIDS PUBLISHING

117 Bernal Rd. #70, PMB 405, San Jose CA 95119.(408)846-1833. E-mail: mail@aakp.com. Website: www.aakp.com. **Contact:** Linda L. Guevara, art acquisitions editor. Estab. 2000. Subjects include children's books including picture books and books for young readers: fiction, activity books, animal, concept , multicultural, nature/environment.

Needs Model/property release required.

Specs Uses 35mm transparencies.

Making Contact & Terms Submit portfolio, résumé, client list. Pays by the project, $500 minimum or royalty of 5% based on wholesale price. Not taking submissions until after December 31, 2005.

$ $▣ ◿ ALLYN AND BACON PUBLISHERS

75 Arlington St., Suite 300, Boston MA 02116. (617)848-7328. E-mail: larissa.tierney@ablongman.com. Website: www.ablongman.com. **Contact:** Larissa Tierney, photography director. Publishes college textbooks. Photos used for text illustrations, book covers. Examples of recently published titles: *Criminal Justice*; *Including Students with Special Needs*; *Social Psychology* (text illustrations and promotional materials).

Needs Offers 1 assignment plus 80 stock projects/year. Needs photos of babies/children/teens, celebrities, couples, multicultural, families, parents, senior citizens, disasters, education, special education, science, technology/computers. Interested in fine art, historical/vintage. Also uses multi-ethnic photos in education, health and fitness, people with disabilities, business, social sciences, and good abstracts. Reviews stock photos. Model/property release required.

Specs Uses b&w prints, any format; all transparencies. Accepts images in digital format. Send via CD, Zip, e-mail as TIFF, EPS, PICT, GIF, JPEG files at 72 dpi for review, 300 dpi for use.

Making Contact & Terms Provide self-promotion piece or tearsheets to be kept on file for possible future assignments. "Do not call or send stock lists." Cannot return samples. Responds in "24 hours to 4 months." Pays $100-250 for b&w cover; $100-600 for color cover; $100-200 for b&w inside; $100-250 for color inside. Pays on usage. Credit line given. Buys one-time rights; negotiable. Offers internships for photographers January-June.

Tips "Send tearsheets and promotion pieces. Need bright, strong, clean abstracts and unstaged, nicely lit people photos."

$▣ ◿ AMERICAN PLANNING ASSOCIATION

122 S. Michigan, Suite 1600, Chicago IL 60603. (312)431-9100. Fax: (312)431-9985. Website: www.planning.org. **Contact:** Richard Sessions, art director. Publishes planning and related subjects. Photos used for text illustrations, promotional materials, book covers, dust jackets. Examples of recently published titles: *Planning* (text illustrations, book cover); *PAS Reports* (text illustrations, book cover). Photo guidelines and sample available for $1 postage.

Needs Buys 100 photos/year; offers 8-10 freelance assignments/year. Needs planning-related photos. Photo captions required; include what's in the photo and credit information.

Specs Uses 35mm color slides; 5×7, 8×10 b&w prints. Accepts images in digital format. Send via CD, floppy disk, Zip, e-mail as TIFF, EPS, JPEG files at 300 dpi minimum; maximum quality, lowest compression.

Making Contact & Terms Provide résumé, business card, brochure, flier, tearsheets, promo pages or good photocopies to be kept on file for possible future assignments. "Do not send original work—slides, prints, whatever—with the expectation of it being returned." Responds in 2 weeks. Simultaneous submissions and previously published work OK. Pays $350 maximum for cover; $100-150 for b&w or color inside. **Pays on**

receipt of invoice. Credit line given. Buys one-time and electronic rights (CD-ROM and online).
Tips "Send a sample I can keep."

AMERICAN SCHOOL HEALTH ASSOCIATION

P.O. Box 708, Kent OH 44240. (330)678-1601. Fax: (330)678-4526. E-mail: treed@ashaweb.org. Website: www.ashaweb.org. **Contact:** Thomas M. Reed, director of editorial services. Estab. 1927. Publishes professional journals. Photos used for book covers.
Needs Looking for photos of school-age children. Model/property release required. Photo captions preferred; include photographer's full name and address.
Specs Uses 35mm transparencies.
Making Contact & Terms Send query letter with samples. Does not keep samples on file; include SASE for return of material. Responds as soon as possible. Simultaneous submissions and previously published work OK. Payment negotiable. Pays on publication. Credit line given. Buys one-time rights.

$ AMHERST MEDIA INC.

175 Rano St., Suite 200, Buffalo NY 14207. (716)874-4450. E-mail: submissions@amherstmedia.com. Website: www.amherstmedia.com. **Contact:** Craig Alesse, publisher. Estab. 1979. Publishes how-to photography books. Photos used for text illustrations, book covers. Examples of published titles: *The Freelance Photographer's Handbook*; *Wedding Photographer's Handbook* (Illustration); *Portrait Photographer's Handbook* (illustration).
Needs Buys 100 photos/year; offers 12 freelance assignments/year. Model/property release preferred. Photo captions preferred.
Specs Uses 5×7 prints; 35mm transparencies.
Making Contact & Terms Send query letter with résumé of credits. Does not keep samples on file; include SASE for return of material. Responds in 1 month. Simultaneous submissions OK. Pays $30-100 for b&w or color photos. Pays on publication. Credit line sometimes given depending on photographer. Rights negotiable.

$ $ ☑ Ⓐ APPALACHIAN MOUNTAIN CLUB BOOKS

5 Joy St., Boston MA 02108. (617)523-0636. Fax: (617)523-0722. Website: www.outdoors.org. **Contact:** Belinda Thresher, production manager. Estab. 1876. Publishes hardcover originals, trade paperback originals and reprints. Subjects include nature, outdoor, recreation, paddlesports, hiking/backpacking, skiing. Photos used for text illustrations, book covers. Examples of recently published titles: *Discover the White Mountains* (cover, text illustration); *Nature Walks* (cover, text illustration); *River Days* (cover, text illustration).
Needs Buys 10-15 freelance photos/year. Looking for photos of paddlesports, skiing and outdoor recreation. Model/property release required. Photo captions preferred; include where photo was taken, description of subject, author's name and phone number.
Specs Uses 3×5 glossy color and/or b&w prints; 35mm, 2¼×2¼ transparencies.
Making Contact & Terms Send query letter with brochure, stock list or tearsheets. Art director will contact photographer for portfolio review if interested. Portfolio should include b&w or color prints, tearsheets. Works with local freelancers on assignment only. Keeps samples on file; include SASE for return of material. Responds only if interested; send nonreturnable samples. Considers previously published work. Pays by the project, $100-400 for color cover; $50 for b&w inside. **Pays on acceptance**. Credit line given. Buys first North American serial rights.

$ $ Ⓐ ART DIRECTION BOOK CO., INC.

456 Glenbrook Rd., Stamford CT 06906. (203)353-1441 or (203)353-1355. Fax: (203)353-1371. **Contact:** Art Director. Estab. 1939. Publishes only books of advertising art, design, photography. Photos used for dust jackets.
Needs Buys 10 photos/year. Needs photos for advertising.
Making Contact & Terms Submit portfolio for review; include SASE for return of material. Responds in 1 month. Works on assignment only. Pays $200 minimum for b&w photos; $500 minimum for color photos. Credit line given. Buys one-time and all rights.

$ $ ▣ ☑ Ⓢ BEDFORD/ST. MARTIN'S

75 Arlington St., Boston MA 02116. (617)399-4000. Website: www.bedfordstmartins.com. **Contact:** Donna Lee Dennison, art director. Estab. 1981. Publishes college textbooks (English, communications, philosophy, music, history). Photos used for text illustrations, promotional materials, book covers. Examples of recently

published titles: *Stages of Drama, 5th Edition* (text illustration, book cover); *12 Plays* (book cover).

Needs Buys 12+ photos/year. "We use photographs editorially, tied to the subject matter of the book." Also wants artistic, abstract, conceptual photos; people—predominantly American, multicultural, cities/urban, education, performing arts, political, product shots/still life, business concepts, technology/computers. Interested in documentary, fine art, historical/vintage. Not interested in photos of children or religous subjects. Also uses product shots for promotional material. Reviews stock photos. Model/property release required.

Specs Uses 8×10 b&w and/or color prints; 35mm, 2¼×2¼, 4×5 transparencies. Prefers images in digital format. Send via CD, Zip as TIFF, EPS, JPEG files at 300 dpi.

Making Contact & Terms Send query letter with nonreturnable samples. Provide résumé, business card, brochure, flier or tearsheets to be kept on file for possible future assignments. Previously published work OK. Pays $50-1,000 for color or b&w cover. Credit line always included for covers, never on promo. Buys one-time rights and all rights in every media; depends on project; negotiable.

Tips "We want artistic, abstract, conceptual photos, computer-manipulated works, collages, etc., that are nonviolent and nonsexist. We like Web portfolios; we keep postcards, sample sheets on file if we like the style and/or subject matter."

$ ▣ Ⓢ BONUS BOOKS, INC.

1223 Wilshire Blvd., #597, Santa Monica CA 90403. (310)260-9400. Fax: (310)260-9494. E-mail: bb@bonusbooks.com. Website: www.bonusbooks.com. **Contact:** David Bell, operations manager. Estab.1980. Publishes adult trade: sports, gambling, self-help, how-to, biography; professional: broadcasting, fundraising, medical. Photos used for text illustrations, book covers. Examples of recently published titles: *Chicago the Beautiful* (text illustrations); *Quick Inspirations*.

Needs Buys 1 freelance photo/year; offers 1 assignment/year. Model release required; property release preferred. Photo captions required; include identification of location and objects or people.

Specs Uses 8×10 matte b&w prints; 35mm transparencies. Accepts images in digital format. Send via Zip, CD as TIFF, EPS files at 300 dpi.

Making Contact & Terms Send query letter with résumé of credits and samples. Provide résumé, business card, brochure, flier or tearsheets to be kept on file for possible future assignments. Buys stock photos only. Does not return unsolicited material. Responds in 1 month. Pays in contributor's copies and $150 maximum for color transparency. Credit line given if requested. Buys one-time rights.

Tips "Don't call. Send written query. In reviewing a portfolio, we look for composition, detail, high-quality prints, well-lit studio work. We are not interested in nature photography or greeting card-type photography."

▣ ⚑ BOSTON MILLS PRESS

132 Main St., Erin ON N0B 1T0 Canada. (519)833-2407. Fax: (519)833-2195. Website: www.bostonmillspress.com. **Contact:** John Denison, publisher. Estab. 1974. Publishes coffee table books, local guide books. Photos used for text illustrations, book covers and dust jackets. Examples of recently published titles: *Gift of Wings*; *Superior: Journey on an Inland Sea*.

Needs "We're looking for book-length ideas, *not* stock. We pay a royalty on books sold, plus advance."

Specs Uses 35mm transparencies. Accepts images in digital format.

Making Contact & Terms Send query letter with résumé of credits. Does not keep samples on file; include SAE/IRC for return of material. Responds in 3 weeks. Simultaneous submissions OK. Payment negotiated with contract. Credit line given.

Ⓝ BREAKAWAY BOOKS

P.O. Box 24, Halcottsville NY 12438-0024. E-mail: information@breakawaybooks.com. Website: breakawaybooks.com. Estab. 1994. Publishes hardcover originals, trade paperback originals and reprints. Subjects include sports—primarily running, cycling, swimming, triathlon, with periodic other sports. Also, a small sideline in wooden boats and homebuilt boats.

Needs Buys 10 freelance photos/year. Needs photos of adventure, sports.

Making Contact & Terms Send query letter. Does not keep samples on file; include SASE for return of material. Responds in 2 weeks. Simultaneous submissions OK. Credit line given.

$ $ ▣ Ⓐ BREWERS ASSOCIATION

(formerly Association of Brewers, Inc.), 736 Pearl St., Boulder CO 80302. (888)822-6273 (US and Canada only) or (303)447-0816. Fax: (303)447-2825. E-mail: kelli@aob.org. Website: www.beertown.org. **Contact:** Kelli McPhail, art director. Estab. 1978. Publishes beer how-to, cooking with beer, trade, hobby, brewing,

beer-related books. Photos used for text illustrations, promotional materials, books, magazines. Examples of published magazines: *Zymurgy* (front cover and inside); *The New Brewer* (front cover and inside). Examples of published book titles: *Sacred & Herbal Healing Beers* (front/back covers and inside); *Standards of Brewing* (front/back covers).

Needs Buys 15-30 photos/year; offers 10 freelance assignments/year. Needs photos of food/drink, beer, hobbies, humor, agriculture, business, industry, product shots/still life, science. Interested in alternative process, fine art, historical/vintage.

Specs Uses b&w prints; 35mm, $2\frac{1}{4} \times 2\frac{1}{4}$, 4×5 transparencies. Accepts images in digital format. Send via CD, Jaz, Zip, e-mail as TIFF, EPS, JPEG files at 300 dpi.

Making Contact & Terms Send query letter with nonreturnable samples. Provide résumé, business card, brochure, flier or tearsheets to be kept on file for possible future assignments. Simultaneous submissions and previously published work OK. Payment negotiable; all jobs done on a quote basis. Pays by the project, $700-800 for cover shots, $300-600 for inside shots. Pays 60 days after receipt of invoice. Preferably buys one-time usage rights; negotiable.

Tips "Send nonreturnable samples for us to keep in our files that depict whatever your specialty is, plus some samples of beer-related objects, equipment, events, people, etc."

▣ ⬚ BRISTOL FASHION PUBLISHING

Wescott Cove Publishing Company, P.O. Box 560989, Rockledge FL 32956-0989. E-mail: publisher@Wescott CovePublishing.com. Website: www.WescottCovePublishing.com. **Contact:** Will Standley, publisher. Publishes marine, how-to, adventure, reference and guide books. Photos used for text illustrations, book covers, calendars, other projects.

• Bristol Fashion Publishing and Wescott Cove Publishing Company are imprints of NetPV, Inc.

Specs Accepts images in digital format only.

Making Contact & Terms No calls. Send query letter with nonreturnable samples. "Please provide all contact information." Pays on publication. Credit line given. Buys worldwide book rights.

$ ▣ ⬚ CAPSTONE PRESS

151 Good Counsel Dr., Mankato MN 56002. (888)293-2609. Fax: (507)345-1872. E-mail: d.barton@capstonep ress.com. Website: www.capstonepress.com. **Contact:** Dede Barton. Estab. 1991. Publishes juvenile nonfiction and educational books. Subjects include animals, ethnic groups, vehicles, sports, history, scenics. Photos used for text illustrations, promotional materials, book covers. Examples of recently published titles: *BMX Racing*; *From Milk to Cheese*; *Taking Care of My Teeth*; *Tsunami*; *Animal Opposites*; *Under the Sea*; *Graphic Biographies and History* (covers and interior illustrations). Photo "wish lists" for projects are available after initial contact or reviewing of photographer's stock list.

Needs Buys 1,000-2,000 photos/year. "Our subject matter varies (usually 100 or more different subjects/year); editorial type imagery preferable although always looking for new ways to show an overused subject or title (fresh)." Model/property release preferred. Photo captions preferred; include "basic description; if people of color, state ethnic group; if scenic, state location and date of image."

Specs Uses various sizes color and/or b&w prints (if historical); 35mm, $2\frac{1}{4} \times 2\frac{1}{4}$, 4×5 transparencies. Accepts images in digital format for submissions as well as for use. Digital images must be at least 8×10 at 300 dpi for publishing quality (TIFF, EPS, or original camera file format preferred).

Making Contact & Terms Send query letter with stock list. Provide résumé, business card, brochure, flier or tearsheets to be kept on file for possible future assignments. Keeps samples on file. Responds in 6 months. Simultaneous submissions and previously published work OK. Pays $200 for cover; $75 for inside. Pays after publication. Credit line given. Buys one-time rights; North American rights negotiable. (Rights purchased may vary depending on the project.)

Tips "Be flexible. Book publishing usually takes at least 6 months. Capstone does not pay holding fees. Be prompt. The first photos in are considered for covers first."

▣ ⬚ [A] CENTERSTREAM PUBLICATION

P.O. Box 17878, Anaheim CA 92807. Phone/fax: (714)779-9390. E-mail: centerstrm@aol.com. **Contact:** Ron Middlebrook, owner. Estab. 1982. Publishes music history, biographies, DVDs, music instruction (all instruments). Photos used for text illustrations, book covers. Examples of published titles: *Dobro Techniques*; *History of Leedy Drums*; *History of National Guitars*; *Blues Dobro* (book cover); *Jazz Guitar Christmas* (book cover).

Needs Reviews stock photos of music. Model release preferred. Photo captions preferred.

Specs Uses color and/or b&w prints; 35mm, 2¼×2¼, 4×5 transparencies. Accepts images in digital format. Send via Zip as TIFF files.

Making Contact & Terms Send query letter with samples and stock list. Send unsolicited photos by mail for consideration. Provide résumé, business card, brochure, flier or tearsheets to be kept on file for possible future assignments. Works on assignment only. Responds in 1 month. Simultaneous submissions and previously published work OK. Payment negotiable. **Pays on receipt of invoice.** Credit line given. Buys all rights.

▣ CHARLESBRIDGE PUBLISHING

School Dept., 85 Main St., Watertown MA 02472. (617)926-0329. Fax: (617)926-5720. Website: www.charles bridge.com. **Contact:** Submissions Editor. Estab. 1978. Publishes hardcover and trade paperback originals, educational curricula, CD-ROMs. Subjects include natural science, astronomy, physical science, reading, writing. Photos used for book covers. Examples of recently published titles: *Insights: Reading Comprehension* (book cover); *Night Wonders* (book cover and interior). Photo guidelines available.

Needs Buys 4-5 freelance photos/year. Needs photos of babies/children/teens, multicultural, landscapes/ scenics, wildlife, science, astronomy. Photo captions preferred; include subject matter.

Specs Accepts images in digital format. Send via CD, Zip as EPS files at 350 dpi.

Making Contact & Terms Send query letter with résumé and photocopies. Provide résumé, self-promotion piece to be kept on file for possible future assignments. Responds only if interested; send nonreturnable samples. Simultaneous submissions and previously published work OK. Pays on publication. Credit line given. Buys one-time, first and all rights.

Tips "We use photos only for specific projects, mainly to illustrate covers. Please do not send samples via e-mail."

$▢ CHATHAM PRESS

Box A, Old Greenwich CT 06870. (203)622-1010. Fax: (203)862-4040. **Contact:** Roger Corbin, editor. Estab. 1971. Publishes New England- and ocean-related topics. Photos used for text illustrations, book covers, art, wall framing.

Needs Buys 25 photos/year; offers 5 freelance assignments/year, preferably New England- and ocean-related topics. Needs photos of architecture, gardening, cities/urban, automobiles, food/drink, health/fitness/ beauty, science. Interested in fashion/glamour, fine art, avant garde, documentary, historical/vintage. Model release preferred. Photo captions required.

Specs Uses b&w prints.

Making Contact & Terms Send query letter with samples; include SASE for return of material. Responds in 1 month. Payment negotiable. Credit line given. Buys all rights.

Tips To break in with this firm, "produce superb b&w photos. There must be an Ansel Adams-type of appeal that is instantaneous to the viewer!"

$▣ ▢ CHIVALRY BOOKSHELF

3305 Mayfair Lane, Highland Village TX 75077. (866)268-1495. E-mail: submissions@chivalrybookshelf.com. Website: www.chivalrybookshelf.com. **Contact:** Photo editor. Estab. 1996. Publishes hardcover originals and reprints, trade paperback originals and reprints, and mass market paperback originals. Subjects include history, art. Photos used for text illustrations, promotional materials, book covers, dust jackets. Examples of recently published titles: *The Swordsman's Companion* (text illustrations, book cover, dust jacket); *Arte of Defense* (text illustrations, promotional materials, book cover). Catalog free with #10 SASE. Photo guidelines available on website.

Needs Buys 50-100 freelance photos/year. Needs photos of military, product shots/still life, events, hobbies, sports. Interested in documentary, fine art, historical/vintage. Model/property release required. Photo captions preferred; include photographer, subject, context.

Specs Uses glossy b&w and/or color prints. Accepts images in digital format. Send via CD, e-mail as TIFF files at 600+ dpi.

Making Contact & Terms Send query letter with tearsheets. Provide résumé, business card, self-promotion piece to be kept on file for possible future assignments. Responds in 2-4 weeks. Pays on publication. Credit line given. Buys all rights; negotiable.

Tips "Most of our freelance work is done in conjunction with one of our authors, and hence our payment structure is dependent upon the project. For a how-to or martial arts work, for example, the author is responsible for negotiating with the photographer. For a cover or a still photograph, we would negotiate rates on a per-project basis. Chivalry Bookshelf does maintain a file of interested illustrators and photographers, al-

though this is not the primary route through which photographers are selected. The best option is to send a note to us or to one of our authors with examples of your work to see if we have an author in need of photo work. Look at several of our existing books to see what our style is like; we have a unique brand and are looking for potential talent who understands the content *and* photography."

$CLEANING CONSULTANT SERVICES

P.O. Box 1273, Seattle WA 98111. (206)682-9748. Fax: (206)622-6876. E-mail: wgriffin@cleaningconsultants. com. Website: www.cleaningconsultants.com. **Contact:** William R. Griffin, publisher. "We publish books on cleaning, maintenance and self-employment. Examples are related to janitorial, housekeeping, maid services, window washing, carpet cleaning and pressure washing, etc. We also publish a quarterly magazine for self-employed cleaners. For information and a free sample, visit www.cleaningbusiness.com." Photos used for text illustrations, promotional materials, book covers and all uses related to production and marketing of books.

Needs Buys 20-50 freelance photos/year; offers 5-15 freelance assignments/year. Needs photos of people doing cleaning work. "We are always looking for unique cleaning-related photos." Reviews stock, cleaning-related photos only. Model release preferred. Photo captions preferred.

Specs Uses 4×6, 5×7, 8×10 glossy color prints.

Making Contact & Terms Send query with résumé of credits, samples, list of stock photo subjects, or send unsolicited photos for consideration via e-mail. Provide résumé, business card, brochure, flier or tearsheets to be kept on file for possible future assignments. Responds in 3-4 weeks if interested. Simultaneous submissions and previously published work OK if not used in competitive publications. Pays $5-50/b&w photo; $5/color photo; $10-30/hour; $40-250/job; negotiable depending on specific project. Credit lines generally given. Buys all rights; depends on need and project.

Tips "We are especially interested in color photos of people doing cleaning work in USA and other countries for use on the covers of our publications. Be willing to work at reasonable rates. Selling 2 or 3 photos does not qualify you to earn top-of-the-line rates. We expect to use more photos, but they must be specific to our market, which is quite select. Don't send stock sample sheets that do not relate to our target audience. Send photos that fit our specific interest only. E-mail if you need more information or would like specific guidance."

$ $▣ CLEIS PRESS

P.O. Box 14697, San Francisco CA 94114. (415)575-4700. Fax: (415)575-4705. E-mail: fdelacoste@cleispress.c om. Website: www.cleispress.com. **Contact:** Frédérique Delacoste, art director. Estab. 1979. Publishes fiction, nonfiction, trade and gay/lesbian erotica. Photos used for book covers. Examples of recently published titles: *Best Gay Erotica 2005*; *Best Lesbian Erotica 2005*; *Best Women's Erotica 2005*.

Needs Buys 20 photos/year. Reviews stock photos.

Specs Uses color and/or b&w prints; 35mm transparencies.

Making Contact & Terms Query via e-mail only; provide résumé, business card, brochure, flier or tearsheets to be kept on file for possible future assignments. Works with local freelancers on assignment only. Keeps samples on file. Responds in 1 week. Pays $250-300/photo for all uses in conjunction with book. Pays on publication.

$ $▣ CONARI PRESS

Red Wheel/Weiser, LLC, 368 Congress St., Boston MA 02210. (617)542-1324. Fax: (617)482-9676. E-mail: info@redwheelweiser.com. Website: www.redwheelweiser.com. **Contact:** Kathleen Wilson Fivel, art director. Estab. 1987. Publishes hardcover and trade paperback originals and reprints. Subjects include women's studies, psychology, parenting, inspiration, home and relationships (all nonfiction titles). Photos used for text illustrations, book covers, dust jackets.

Needs Buys 5-10 freelance photos/year. Looking for artful photos; subject matter varies. Interested in reviewing stock photos of most anything except high-tech, corporate or industrial images. Model release required. Photo captions preferred; include photography copyright.

Specs Prefers images in digital format. Also uses color and/or b&w prints.

Making Contact & Terms Provide résumé, business card, self-promotion piece or tearsheets to be kept on file for possible future assignments. Art director will contact photographer for portfolio review if interested. Portfolio should include b&w or color prints, tearsheets, slides, transparencies or thumbnails. Keeps samples on file. Simultaneous submissions and previously published work OK. Pays by the project, $400-1,000 for color cover. Payment varies for color inside. Pays on publication. Credit line given on copyright page or back cover.

Tips "Review our website to make sure your work is appropriate."

$ $ ▣ ▢ ⊘ THE COUNTRYMAN PRESS

W.W. Norton & Co., Inc., P.O. Box 748, Mt. Tom Bldg., Woodstock VT 05091. (802)457-4826. Fax: (802)457-1678. E-mail: countrymanpress@wwnorton.com. Website: www.countrymanpress.com. **Contact:** Production Coordinator. Estab. 1973. Publishes hardcover originals, trade paperback originals and reprints. Subjects include travel, nature, hiking, biking, paddling, cooking, Northeast history, gardening and fishing. Examples of recently published titles: *The King Arthur Flour Baker's Companion* (book cover); *Vermont: An Explorer's Guide* (text illustrations, book cover). Catalog available for $6^3/_4 \times 10^1/_2$ envelope.

Needs Buys 25 freelance photos/year. Varies depending on need. Needs photos of environmental, landscapes/scenics, wildlife, architecture, gardening, rural, sports, travel. Interested in historical/vintage, seasonal. Model/property release preferred. Photo captions preferred; include location, state, season.

Specs Uses 4×6 glossy or matte color prints; 35mm, $2^1/_4 \times 2^1/_4$, 4×5, 8×10 transparencies. Accepts images in digital format. Send via CD, floppy disk, Zip as TIFF files at 350 dpi.

Making Contact & Terms Send query letter with résumé, slides, tearsheets, stock list. Provide résumé, business card, self-promotion piece to be kept on file for possible future assignments. Responds in 2 months, only if interested. Simultaneous submissions and previously pubished work OK. Pays $100-600 for color cover. Pays on publication. Credit line given. Buys all rights for life of edition (normally 2-7 years); negotiable.

Tips "Our catalog demonstrates the range of our titles and shows our emphasis on travel and the outdoors. Crisp focus, good lighting, and strong contrast are goals worth striving for in each shot. We prefer images that invite rather than challenge the viewer, yet also look for eye-catching content and composition."

$ ▣ ⊘ CRABTREE PUBLISHING COMPANY

PMB 16A, 350 Fifth Ave., Suite 3308, New York NY 10118. (800)387-7650. Fax: (800)355-7166. Website: www.crabtreebooks.com. **Contact:** Heather Fitzpatrick, production coordinator. Estab. 1978. Publishes juvenile nonfiction, library and trade—natural science, history, geography (including cultural geography), 18th- and 19th-century North America. Photos used for text illustrations, book covers. Examples of recently published titles: *Egypt: the Land* (text illustrations, cover); *Spanish Missions* (text illustrations, cover); *Baseball in Action* (text illustrations); *What is a Marsupial?* (text illustrations, cover).

Needs Buys 400-600 photos/year. Wants photos of babies/children/teens, cultural events around the world, animals (exotic and domestic) and historical reenactments. Model/property release required for children, photos of artwork, etc. Photo captions preferred; include place, name of subject, date photographed, animal behavior.

Specs Uses color prints; 35mm, $2^1/_4 \times 2^1/_4$, 4×5, 8×10 transparencies; high-resolution digital files (no JPEG compressed files).

Making Contact & Terms Does not accept unsolicited photos. Provide résumé, business card, brochure, flier or tearsheets to be kept on file for possible future assignments. Simultaneous submissions and previously published work OK. Pays $75-100 for color photos. Pays on publication. Credit line given. Buys non-exclusive rights.

Tips "Since our books are for younger readers, lively photos of children and animals are always excellent." Portfolio should be "diverse and encompass several subjects rather than just 1 or 2; depth of coverage of subject should be intense so that any publishing company could, conceivably, use all or many of a photographer's photos in a book on a particular subject."

$ ▣ ◯ THE CREATIVE COMPANY

Imprint: Creative Editions. 123 S. Broad St., Mankato MN 56001. (507)388-6273. Fax: (507)388-1364. E-mail: ccphotoeditor@hotmail.com. **Contact:** Photo Researcher. Estab. 1933. Publishes hardcover originals, textbooks for children. Subjects include animals, nature, geography, history, sports (professional and college), science, technology, biographies. Photos used for text illustrations, book covers. Examples of recently published titles: *Let's Investigate Wildlife* series (text illustrations, book cover); *Ovations* (biography) series (text illustrations, book cover). Catalog available for 9×12 SAE with $2 first-class postage. Photo guidelines free with SASE.

Needs Buys 2,000 stock photos/year. Needs photos of celebrities, disasters, environmental, landscapes/scenics, wildlife, architecture, cities/urban, gardening, pets, rural, adventure, automobiles, entertainment, health/fitness, hobbies, sports, travel, agriculture, industry, medicine, military, science, technology/computers. Other specific photo needs: NFL, NHL, NBA, Major League Baseball. Photo captions required; include photographer's or agent's name.

Specs Accepts images in digital format for Mac only. Send via CD as JPEG files.

Making Contact & Terms Send query letter with photocopies, tearsheets, stock list. Provide self-promotion

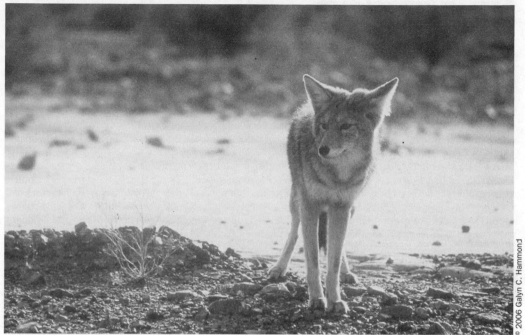

The Creative Company published Galyn Hammond's image of a coyote in Death Valley. It appeared on the cover of *Deserts: Gardens of Sand*, which was part of their "Caring for the Planet" series.

piece to be kept on file for possible future assignments. Responds in 1 month to queries. Simultaneous submissions and previously published work OK. Pays $100-150 for cover; $50-150 for inside. Projects with photos and text are considered as well. Pays on publication. Credit line given. Buys one-time rights and foreign publication rights as requested.

Tips "Inquiries must include nonreturnable samples. After establishing policies and terms, we keep photographers on file and contact as needed. All photographers who agree to our policies can be included on our e-mail list for specific, hard-to-find image needs. We rarely use b&w or photos of people unless the text requires it. Project proposals must be for a 4-, 6-, or 8-book series for children."

$ ▣ ◯ CREATIVE EDITIONS

The Creative Company, 123 S. Broad St., Mankato MN 56001. (507)388-6273. E-mail: ccphotoeditor@hotmail .com. **Contact:** Photo Researcher. Estab. 1989. Publishes hardcover originals. Subjects include photo essays, biography, poetry, stories designed for children. Photos used for text illustrations, book covers, dust jackets. Examples of recently published titles: *Little Red Riding Hood* (text illustrations, book cover, dust jacket); *Poe* (text illustrations, book cover, dust jacket). Catalog available.

Needs Looking for photo-illustrated documentaries or gift books. Must include some text. Publishes 5-10 books/year.

Specs Uses any size glossy or matte color and/or b&w prints. Accepts images in digital format for Mac only. Send via CD as JPEG files at 72 dpi minimum. High-res upon request only.

Making Contact & Terms Send query letter with publication credits and project proposal, prints, photocopies, tearsheets of previous publications, stock list for proposed project. Responds in 1 month to queries. Simultaneous submissions and previously published work OK. Advance to be negotiated. Credit line given. Buys world rights for the book; photos remain property of photographer.

Tips "Creative Editions publishes unique books for the book-lover. Emphasis is on aesthetics and quality. Completed manuscripts are more likely to be accepted than preliminary proposals. Please do not send slides or other valuable materials."

$ $ ▤ ⬛ CREATIVE HOMEOWNER

24 Park Way, Upper Saddle River NJ 07458. (201)934-7100, ext. 375. Fax: (201)934-7541. E-mail: robyn.popla sky@creativehomeowner.com. Website: www.creativehomeowner.com. **Contact:** Robyn Poplasky, photo researcher. Estab. 1975. Publishes soft cover originals, mass market paperback originals. Photos used for text illustrations, promotional materials, book covers. Examples of recently published titles: *The New Smart Approach to Home Decor*; *Design Ideas for Decks*; *The New Smart Approach to Window Decor*. Catalog available. Photo guidelines available for fax.

Needs Buys 1,000 freelance photos/year. Needs photos of environmental, landscapes/scenics, wildlife, architecture, some gardening, interiors/decorating, rural, agriculture, product shots/still life. Interested in fine art, historical/vintage, seasonal. Other needs include horticultural photography; close-ups of various cultivars and plants; interior and exterior design photography; garden beauty shots. Photo captions required; include photographer credit, designer credit, location, small description, if possible.

Specs Uses 35mm, 120, $2\frac{1}{4} \times 2\frac{1}{4}$, 4×5, 8×10 transparencies. Accepts images in digital format. Send via CD, Zip as TIFF, JPEG files at 300 dpi. Transparencies are preferred.

Making Contact & Terms Send query letter with résumé, photocopies, tearsheets, transparencies, stock list. Provide résumé, business card, self-promotion piece to be kept on file for possible future assignments. Responds in 2 weeks to queries. Simultaneous submissions and previously published work OK. Pays $800 for color cover; $100-150 for color inside; $200 for back cover. Pays on publication. Credit line given. Buys one-time rights.

Tips "Be able to pull submissions for fast delivery. Label and document all transparencies for easy in-office tracking and return."

CREATIVE WITH WORDS PUBLICATIONS

P.O. Box 223226, Carmel CA 93922. Fax: (831)655-8627. E-mail: cwpub@usa.net. Website: http://members.t ripod.com/CreativeWithWords. **Contact:** Brigitta Geltrich, editor. Estab. 1975. Publishes poetry and prose anthologies according to set themes. Black & white photos used for text illustrations, book covers. Photo guidelines free with SASE.

Needs Looking for theme-related b&w photos. Model/property release preferred.

Specs Uses any size b&w photos.

Making Contact & Terms Request theme list, then query with photos. "We will reduce to fit the page." Does not keep samples on file; include SASE for return of material. Responds 3 weeks after deadline if submitted for a specific theme. Payment negotiable. Pays on publication. Credit line given. Buys one-time rights.

▣ Ⓐ DOCKERY HOUSE PUBLISHING INC.

1720 Regal Row, Suite 112, Dallas TX 75235. (214)630-4300. Fax: (214)638-4049. E-mail: jwinchester@docker ypublishing.com. Website: www.dockerypublishing.com. **Contact:** Judith Winchester, creative director. Photos used for text illustrations, promotional materials, book covers, magazines. Example of recently published title: *Premiere Essentials* (travel, fashion, lifestyle, culture).

Needs Looking for lifestyle trends, people, travel, luxury goods. Needs vary. Reviews stock photos. Model release preferred.

Specs Uses all sizes and finishes of color and b&w prints; 35mm and digital.

Making Contact & Terms Send query letter with samples. Provide résumé, business card, brochure, flier or tearsheets to be kept on file for possible future assignments. Works on assignment only. Keeps samples on file. Cannot return material. Payment negotiable. Pays net 30 days. Buys all rights; negotiable.

$ ▣ ⬛ ⑤ DOWN THE SHORE PUBLISHING CORP.

P.O. Box 3100, Harvey Cedars NJ 08008. Fax: (609)597-0422. E-mail: info@down-the-shore.com. Website: www.down-the-shore.com. **Contact:** Raymond G. Fisk, publisher. Estab. 1984. Publishes regional calendars; seashore, coastal, and regional books (specific to the mid-Atlantic shore and New Jersey). Photos used for text illustrations, scenic calendars (New Jersey and mid-Atlantic only). Examples of recently published titles: *Great Storms of the Jersey Shore* (text illustrations); *NJ Lighthouse Calendar* (text illustrations, book cover); *Shore Stories* (text illustrations, dust jacket). Photo guidelines free with SASE or on website.

Needs Buys 30-50 photos/year. Needs scenic coastal shots, photos of beaches and New Jersey lighthouses (New Jersey and mid-Atlantic region). Interested in seasonal. Reviews stock photos. Model release required; property release preferred. Photo captions preferred; *specific location* identification essential.

Specs "We have a very limited use of prints." Prefers 35mm, $2\frac{1}{4} \times 2\frac{1}{4}$, 4×5 transparencies. Accepts digital submissions via high-resolution files on CD. Refer to guidelines before submitting.

Making Contact & Terms Send query letter with stock list. Provide résumé, business card, brochure, flier or tearsheets to be kept on file for possible future requests. Responds in 6 weeks. Previously published work OK. Pays $100-200 for b&w or color cover; $10-100 for b&w or color inside. Pays 90 days from publication. Credit line given. Buys one-time or book rights; negotiable.

Tips "We are looking for an honest depiction of familiar scenes from an unfamiliar and imaginative perspective. Images must be specific to our very regional needs. Limit your submissions to your best work. Edit your work very carefully."

▣ EASTERN PRESS, INC.

P.O. Box 881, Bloomington IN 47402. (812)339-3985. **Contact:** Don Lee, publisher. Estab. 1981. Publishes university-related Asian subjects: language, linguistics, literature, history, archaeology; teaching English as second language (TESL); teaching Korean as second language (TKSL); teaching Japanese as second language (TJSL); Chinese, Arabic. Photos used for text illustrations. Examples of recently published titles: *An Annotated Bibliography on South Asia*; *An Annotated Prehistoric Bibliography on South Asia*.

Needs Depends on situation; looking for higher academic. Captions for photos related to East Asia/Asian higher academic.

Specs Uses 6×9 book b&w prints.

Making Contact & Terms Provide résumé, business card, brochure, flier or tearsheets to be kept on file for possible future assignments. Keeps samples on file. Responds in 1 month. Payment negotiable. **Pays on acceptance.** Credit line sometimes given. Rights negotiable.

Tips Looking for "East Asian/Arabic textbook-related photos. However, it depends on type of book to be published. Send us a résumé and about 2 samples. We keep them on file. Photos on, for example, drama, literature or archaeology (Asian) will be good; also TESL."

$ ▣ ▣ ▣ ▣ ECW PRESS

2120 Queen St. E., Suite 200, Toronto ON M4E 1E2 Canada. (416)694-3348. Fax: (416)698-9906. E-mail: info@ecwpress.com. Website: www.ecwpress.com. **Contact:** Jack David, publisher. Estab. 1974. Publishes hardcover and trade paperback originals. Subjects include biography, sports, travel, fiction, poetry. Photos used for text illustrations, book covers, dust jackets. Examples of recently published titles: *Depp* (text illustrations); *Inside the West Wing* (text illustrations).

Needs Buys hundreds of freelance photos/year. Looking for color, b&w, fan/backstage, paparazzi, action, original, rarely used. Reviews stock photos. Property release required for entertainment or star shots. Photo captions required; include identification of all people.

Specs Accepts images in digital format. Send via CD as TIFF files at 300 dpi.

Making Contact & Terms Send query letter. Provide e-mail. To show portfolio, photographer should follow-up with letter after initial query. Does not keep samples on file; include SASE for return of material. Responds in 3 weeks. Pays by the project, $250-600 for color cover; $50-125 for color inside. Pays on publication. Credit line given. Buys one-time book rights (all markets).

Tips "We have many projects on the go. Query for projects needing illustrations. Please check our website before querying."

$ ▣ EMPIRE PUBLISHING SERVICE

Imprints: Gaslight, Empire, Empire Music & Percussion. P.O. Box 1344, Studio City CA 91614-0344. (818)784-8918. **Contact:** J. Cohen, art director. Estab. 1960. Publishes hardcover and trade paperback originals and reprints, textbooks. Subjects include entertainment, plays, health, Sherlock Holmes, music. Photos used for text illustrations, book covers. Examples of recently published titles: *Men's Costume Cut and Fashion, 17th Century* (text illustrations); *Scenery* (text illustrations).

Needs Needs photos of celebrities, entertainment, events, food/drink, health/fitness, performing arts. Interested in fashion/glamour, historical/vintage. Model release required. Photo captions required.

Specs Uses 8×10 glossy prints.

Making Contact & Terms Send query letter with résumé, samples. Provide résumé, business card to be kept on file for possible future assignments. Responds only if interested; send nonreturnable samples. Simultaneous submissions considered depending on subject and need. Pays on publication. Credit line given. Buys all rights.

Tips "Send appropriate samples of high-quality work only. Submit samples that can be kept on file and are representative of your work."

$FARCOUNTRY PRESS

Lee Enterprises, P.O. Box 5630, Helena MT 59604. (406)444-5100. Fax: (406)443-5480. E-mail: theresa.rush@ lee.net. Website: www.farcountrypress.com. **Contact:** Theresa Rush. Estab. 1973. Montana's largest book publisher. Regional book publisher specializing in geographical coffee table books. Premier publisher of Lewis and Clark titles, natural history and historical books, guidebooks and custom books of all kinds.

Needs Looking for photos that are clear with strong focus and color—scenics, wildlife, people, landscapes. Photo captions required; include name and address on mount. Package slides in individual protectors, then in sleeves.

Specs Uses 35mm, $2\frac{1}{4} \times 2\frac{1}{4}$, 4×5, 8×10 transparencies.

Making Contact & Terms Send query letter with stock list. "Do not send unsolicited transparencies." Reporting time depends on project. Simultaneous submissions and previously published work OK. Buys one-time rights.

Tips "We seek bright, heavily saturated colors. Focus must be razor sharp. Include strong seasonal looks, scenic panoramas, intimate close-ups. Of special note to *wildlife* photographers, specify shots taken in a captive situation (zoo or game farm). We identify shots taken in a captive situation."

$ $ FIFTH HOUSE PUBLISHERS

1511-1800 Fourth St. SW, Calgary AB T2S 2S5 Canada. (403)571-5230. Fax: (403)571-5235. E-mail: meaghan @hillsboro.ca. **Contact:** Meaghan Craven, managing editor. Estab. 1982. Publishes calendars, history, biography, Western Canadiana. Photos used for text illustrations, book covers, dust jackets and calendars. Examples of recently published titles: *The Canadian Weather Trivia Calendar*; *Wild Alberta*; *A World Within*.

Needs Buys 15-20 photos/year. Looking for photos of Canadian weather. Model/property release preferred. Photo captions required; include location and identification.

Making Contact & Terms Send query letter with samples and stock list. Keeps samples on file. Pays $300 Canadian/calendar image. Pays on publication. Credit line given. Buys one-time rights.

$ $ FINE EDGE PRODUCTIONS

14004 Biz Point Lane, Anacortes WA 98221. (360)299-8500. Fax: (360)299-0535. E-mail: editors@fineedge.c om. Website: www.fineedge.com. **Contact:** Mark Bunzel, general manager. Estab. 1986. Publishes outdoor guide and how-to books; custom topographic maps—mostly mountain biking and sailing. Publishes 6 new titles/year. Photos used for text illustrations, promotional materials, book covers. Examples of recently published titles: *Mountain Biking the Eastern Sierra's Best 100 Trails*; *Exploring the North Coast of British Columbia*; *Exploring the San Juan & Gulf Islands*. "Call to discuss" photo guidelines.

Needs Buys 200 photos/year; offers 1-2 freelance assignments/year. Looking for area-specific mountain biking (trail usage), Northwest cruising photos. Model release required. Photo captions preferred; include place and activity.

Specs Uses 3×5, 4×6 glossy b&w prints; color for covers.

Making Contact & Terms Send query letter with samples, SASE. Responds in 2 months. Simultaneous submissions and previously published work OK. Pays $10-50 for b&w photos; $150-500 for color photos. Pays on publication. Credit line given. Rights purchased vary.

Tips Looking for "photos which show activity in realistic (not artsy) fashion—want to show sizzle in sport. Increasing—now going from disc directly to film at printer."

FISHER HOUSE PUBLISHERS

E-mail: editor@fisherhouse.com. Website: www.fisherhouse.com. **Contact:** John R. Fisher, editor. Estab. 1991. Publishes textbooks, biographies, histories, government/politics, how-to. Photos used for text illustrations, book covers, dust jackets, and artwork in poetry books.

Needs Looking for photos of nature and human interest. Model release preferred. Photo captions preferred.

Specs Uses color and/or b&w prints.

Making Contact & Terms Send query e-mail with samples, stock list. Responds in 1 month. Simultaneous submissions and previously published work OK. Credit line given. Rights negotiable.

Tips "We prefer to work with beginning photographers who are building a portfolio."

FOCAL PRESS

30 Corporate Dr., Suite 400, Burlington MA 01803. (781)313-4794. Fax: (781)313-4880. E-mail: d.heppner@el sevier.com. Website: www.focalpress.com. **Contact:** Diane Heppner. Estab. 1938.

Needs "We publish professional reference titles, practical guides and student textbooks in all areas of media

and communications technology, including photography and digital imaging. We are always looking for new proposals for book ideas. Send e-mail for proposal guidelines.''

Making Contact & Terms Simultaneous submissions and previously published work OK. Buys all rights; negotiable.

$ ▣ ☑ Ⓢ FORT ROSS INC.

26 Arthur Place, Yonkers NY 10701-1703. (914)375-6448. Fax: (914)375-6439. E-mail: vladimir.kartsev@veri zon.net. Website: www.fortross.net. **Contact:** Vladimir Kartsev, executive director. Estab. 1992. Publishes hardcover reprints, trade paperback originals; offers photos to East European publishers and advertising agencies. Subjects include romance, science fiction, fantasy. Photos used for book covers. Examples of recently published titles: *Danielle Steel in Russian*; *Sex, Boys and You in Russian*.

Needs Buys 100 freelance photos/year. Needs photos of babies/children/teens, celebrities, couples, families, parents, landscapes/scenics, wildlife, cities/urban, automobiles, entertainment, food/drink, health/fitness. Interested in alternative process, fashion/glamour. Model release required. Photo captions preferred.

Specs Uses 4×5 transparencies. Accepts images in digital format. Send via CD, e-mail as JPEG files.

Making Contact & Terms Send query letter with photocopies. Provide self-promotion piece to be kept on file for possible future assignments. Responds only if interested. Simultaneous submissions and previously published work OK. Pays $50-120 for color images. **Pays on acceptance**. Credit line given. Buys one-time rights.

$ ▢ FORUM PUBLISHING CO.

Imprint: Retailers Forum. 383 E. Main St., Centerport NY 11721. (631)754-5000. Fax: (631)754-0630. E-mail: forumpublishing@aol.com. Website: www.forum123.com. **Contact:** Marti, art director. Estab. 1981. Publishes trade magazines and directories.

Needs Buys 24 freelance photos/year. Needs photos of humor, business concepts, industry, product shots/still life. Interested in seasonal. Other photo needs include humorous and creative use of products and merchandise. Model/property release preferred.

Specs Uses any size color prints; 4×5, 8×10 transparencies.

Making Contact & Terms Send query letter with prints. Does not keep samples on file; include SASE for return of material. Responds in 2 weeks to queries. Simultaneous submissions and previously published work OK. Works with local freelancers only. Pays $50-100 for color cover. **Pays on acceptance.** Credit line sometimes given. Buys one-time rights.

Tips ''We publish trade magazines and directories and are looking for creative pictures of products/merchandise. Call Marti for complete details.''

$ ▣ ☻ GRAPHIC ARTS CENTER PUBLISHING COMPANY

3019 NW Yeon, Portland OR 97210. (503)226-2402, ext. 306. Fax: (503)223-1410. E-mail: jeanb@gacpc.com. Website: www.gacpc.com. **Contact:** Jean Bond-Slaughter, editorial assistant. Publishes adult trade photo essay books and state, regional and recreational calendars. Examples of published titles: *Primal Forces*; *Cherokee*; *Oregon IV*; *Alaska's Native Ways*.

Needs Offers 5-10 photo-essay book contracts/year. Needs photos of environmental, landscapes/scenics, wildlife, gardening, adventure, food/drink, travel. Interested in fine art, historical/vintage, seasonal.

Specs Uses 35mm, 2¼×2¼ and 4×5 transparencies. Accepts images in digital format. Send via Jaz, Zip, CD.

Making Contact & Terms ''Contact the editorial assistant to receive permission to send in a submission. An unsolicited submission will be returned unopened with postage due.'' Once permission is granted, send bio, samples, 20-40 transparencies that are numbered, labeled with descriptions and verified in a delivery memo, and return postage or a completed FedEx form. Responds in up to 4 months. Payment varies based on project. Credit line given. Buys book rights.

Tips ''Photographers must be previously published and have a minimum of 5 years full-time professional experience to be considered. Call to present your book or calendar proposal before you send in a submission. Topics proposed must have strong market potential.''

▣ Ⓐ GREAT QUOTATIONS PUBLISHING CO.

8102 Lemont St., #300, Woodridge IL 60517. (630)390-3580. Fax: (630)390-3585. Estab. 1985. Publishes gift books. Examples of recently published titles: *Mother & Daughter*; *Motivational*.

Needs Buys 20-30 photos/year; offers 10 freelance assignments/year. Looking for inspirational or humorous.

Reviews stock photos of inspirational, humor, family. Subjects include parents, landscapes/scenics, education, health/fitness/beauty, hobbies, sports, product shots/still life. Interested in documentary, seasonal. Model/property release preferred.

Specs Uses color and/or b&w prints; 35mm, $2^{1}/_{4} \times 2^{1}/_{4}$, 4×5 transparencies. Accepts images in digital format. Send via CD.

Making Contact & Terms Provide résumé, business card, brochure, flier or tearsheets to be kept on file for possible future assignments. Works on assignment only. Keeps samples on file. "We prefer to maintain a file of photographers and contact them when appropriate assignments are available." Simultaneous submissions and previously published work OK. Payment negotiable. Pays on publication. "We will work with artist on rights to reach terms all agree on."

Tips "We intend to introduce 30 new books per year. Depending on the subject and book format, we may use photographers or incorporate a photo image in a book cover design. Unfortunately, we decide on new product quickly and need to go to our artist files to coordinate artwork with subject matter. Therefore, more material and variety of subjects on hand is most helpful to us."

$ ▣ ◩ GRYPHON HOUSE

P.O. Box 207, Beltsville MD 20704. (301)595-9500. Fax: (301)595-0051. E-mail: rosanna@ghbooks.com. Website: www.ghbooks.com. **Contact:** Rosanna Demps, art director. Estab. 1970. Publishes educational resource materials for teachers and parents of young children. Examples of recently published titles: *Innovations: The Comprehensive Infant Curriculum* (text illustrations); *125 Brain Games for Babies* (book cover).

Needs Looking for b&w and color photos of young children (from birth to 6 years.) Reviews stock photos. Model release required.

Specs Uses 5×7 glossy color (cover only) and b&w prints. Accepts images in digital format. Send via CD, Zip, e-mail as TIFF files at 300 dpi.

Making Contact & Terms Send query letter with samples and stock list. Keeps samples on file. Simultaneous submissions OK. Payment negotiable. **Pays on receipt of invoice**. Credit line given. Buys book rights.

$ ▣ ◪ GUERNICA EDITIONS, INC.

P.O. Box 117, Station P, Toronto ON M5S 2S6 Canada. Fax: (416)657-8885. Website: www.guernicaeditions.com. **Contact:** Antonio D'Alfonso, editor. Estab. 1978. Publishes adult trade (literary). Photos used for book covers. Examples of recently published titles: *Jane Urquhart: Essays on Her Works*, edited by Laura Ferri; *Linda Rogers: Essays on Her Works*, edited by Harold Rhenisch; *David Adams Richards: Essays on His Works*, edited by Tony Tremblay.

Needs Buys varying number of photos/year; "often" assigns work. Needs life events, including characters; houses. Photo captions required.

Specs Uses color and/or b&w prints. Accepts images in digital format. Send via CD, Zip as TIFF, GIF files at 300 dpi minimum.

Making Contact & Terms Send query letter with samples. Sometimes keeps samples on file. Cannot return material. Responds in 2 weeks. Pays $150 for cover. Pays on publication. Credit line given. Buys book rights. "Photo rights go to photographers. All we need is the right to reproduce the work."

Tips "Look at what we do. Send some samples. If we like them, we'll write back."

HANCOCK HOUSE PUBLISHERS

1431 Harrison Ave., Blaine WA 98230-5005. (800)938-1114. Fax: (800)983-2262. E-mail: david@hancockwildlife.org. Website: www.hancockwildlife.org. **Contact:** David Hancock, president. Estab. 1968. Publishes trade books. Photos used for text illustrations, promotions, book covers. Examples of recently published titles: *Meet the Sasquatch* by Chris Murhydd (over 500 color images); *Alaska in the Wake of the North Star* by Loel Schuler; *Pheasants of the World* (350 color photos).

Needs Needs photos of birds/nature. Reviews stock photos. Model release preferred. Photo captions preferred.

Making Contact & Terms Send query letter with samples, SASE. Responds in 1 month. Simultaneous submissions and previously published work OK. Payment negotiable. Credit line given. Buys nonexclusive rights.

$ $ ▣ ◉ HARMONY HOUSE PUBLISHERS

1008 Kent Rd., Goshen KY 40026. (502)228-2010. **Contact:** William Strode, owner. Estab. 1984. Publishes photographic books on specific subjects. Photos used for text illustrations, promotional materials, book covers, dust jackets. Examples of recently published titles: *The Crystal Coast—North Carolina's Treasure*

Book Publishers

by the Sea (text illustrations, promotional materials, book cover, dust jacket); *Keeneland: Reflections on Thoroughbred Traditions*; *Notre Dame: Footfalls In Time*.

Needs Number of freelance photos purchased varies. Assigns 30 shoots each year. Photo captions required.

Specs Uses 35mm, 2¼×2¼, 4×5, 8×10 transparencies. Accepts images in digital format. Send via Zip or CD.

Making Contact & Terms Send query letter with résumé of credits along with business card, brochure, flier or tearsheets to be kept on file for possible future assignments. Send samples or stock list. Submit portfolio for review. Works on assignment mostly. Simultaneous submissions and previously published work OK. Payment negotiable. Credit line given. Buys one-time and book rights.

Tips To break in, "send book ideas to William Strode, with good photographs to show work."

$ ☑ Ⓢ HIPPOCRENE BOOKS INC.

171 Madison Ave., New York NY 10016. Fax: (212)779-9338. E-mail: hippocrene.books@verizon.net. Website: www.hippocrenebooks.com. **Contact:** Managing Editor. Estab. 1970. Publishes hardcover and trade paperback originals and reprints. Subjects include foreign language dictionaries and study guides, international ethnic cookbooks, travel, bilingual international love poetry, Polish interest, Russian interest, Judaica. Photos used for book covers, dust jackets. Examples of recently published titles: *Japanese Home Cooking* (dust jacket); *Icelandic Food & Cookery* (dust jacket); *Swahili Dictionary & Phrasebook* (book cover).

Needs Buys 3 freelance photos/year. Needs photos of ethnic food, travel destinations/sites. Photo captions preferred.

Making Contact & Terms Send query letter by mail with samples, brochure, stock list, tearsheets. Responds only if interested; send nonreturnable samples. Simultaneous submissions and previously published work OK. Pays $100-250 for color cover; $20-75 for b&w inside. Credit line given. Buys all rights.

Tips "We only use color photographs on covers. We want colorful, eye-catching work."

$ $ ▣ ☑ HOLT, RINEHART AND WINSTON

10801 N. MoPac Expressway, Bldg. 3, Austin TX 78759-5415. (512)721-7000. Fax: (800)269-5232. E-mail: HoltInfo@hrw.com. Website: www.hrw.com. **Contact:** Curtis Riker, director of image acquisitions. Photo Research Manager: Jeannie Taylor. Publishes textbooks in multiple formats. "The Photo Research Department of the HRW School Division in Austin obtains photographs for textbooks in subject areas taught in secondary schools." Photos are used for text illustrations, promotional materials and book covers.

Needs Uses 6,500+ photos/year. Wants photos that illustrate content for mathematics, sciences, social studies, world languages, and language arts. Model/property release preferred. Photo captions required; include scientific explanation, location and/or other detailed information.

Specs Prefers images in digital format. Send via CD or broadband transmission.

Making Contact & Terms Send a query letter with a sample of work (nonreturnable photocopies, tearsheets, printed promos) and a list of subjects in stock. Self-promotion pieces kept on file for future reference. Include promotional website link if available. "Do not call!" Will respond only if interested. Payment negotiable depending on format and number of uses. Credit line given.

Tips "Our book image programs yield an emphasis on rights-managed stock imagery, with a focus on teens and a balanced ethnic mix. Though we commission assignment photography, we maintain an in-house studio with two full-time photographers. We are interested in natural-looking, uncluttered photographs labeled with exact descriptions, that are technically correct and include no evidence of liqor, drugs, cigarettes or brand names."

$ ▣ ☑ HOWELL PRESS, INC.

1713-2D Allied Lane, Charlottesville VA 22903. Fax: (888)971-7204. E-mail: rhowell@howellpress.com. Website: www.howellpress.com. **Contact:** Ross A. Howell, Jr., president. Estab. 1985. Publishes illustrated books. Examples of recently published titles: *The Corner: A History of Student Life at the University of Virginia*; *Virginia Wines and Wineries*; *Milestones of Flight*; *Lewis and Clark: The Maps of Exploration 1507-1814* (photos used for illustrations, jackets and promotions for all books). Photo guidelines available on website.

Needs Needs photos of aviation, military history, maritime history, motor sports, cookbooks, transportation, regional (Mid-Atlantic and Southeastern US), quilts and crafts. Model/property release preferred. Photo captions required; clearly identify subjects.

Specs Uses b&w and color prints; transparencies. Accepts images in digital format. Send via CD, Zip, e-mail as TIFF, GIF, JPEG files.

Making Contact & Terms Send query letter. Keeps samples on file; include SASE for return of material.

Responds in 1 month. Simultaneous submissions and previously published work OK. Payment negotiable. Buys one-time rights.

Tips "We work individually with photographers on book-length projects. Photographers who wish to be considered for assignments or have proposals for book projects should submit a written query." When submitting work, please "provide a brief outline of project, including cost predictions and target market. Be specific in terms of numbers and marketing suggestions."

$ 🖳 HUMAN KINETICS PUBLISHERS

1607 N. Market, Champaign IL 61820. (217)351-5076. E-mail: danw@hkusa.com. Website: www.hkusa.com. **Contact:** Dan Wendt. Estab. 1979. Publishes hardcover originals, trade paperback originals, textbooks and CD-ROMs. Subjects include sports, fitness, physical activity. Photos used for text illustrations, promotional materials, book covers. Examples of recently published titles: *Serious Tennis* (text illustrations, book cover); *Beach Volleyball* (text illustrations, book cover). Photo guidelines available by e-mail only.

Needs Buys 2,000 freelance photos/year. Needs photos of babies/children/teens, multicultural, families, education, events, food/drink, health/fitness, performing arts, sports, medicine, military, product shots/still life. All photos purchased must show some sort of sport, physical activity, health and fitness. Model release preferred.

Specs Prefers images in digital format. Send via CD, Zip as TIFF, JPEG files at 300 dpi at 9×12 inches; will accept 5×7 color prints, 35mm transparencies.

Making Contact & Terms Send query letter and URL via e-mail to view samples. Responds only if interested. Simultaneous submissions and previously pubished work OK. Pays $250-500 for b&w or color cover; $75-100 for b&w or color inside. Pays extra for electronic usage of photos. Pays on publication. Credit line given. Buys one-time rights. Prefers world rights, all languages, for one edition; negotiable.

Tips "Go to Borders or Barnes & Noble and look at our books in the sport and fitness section. We want and need peak action, emotion, and razor-sharp images for future projects. The pay is low, but there is opportunity for exposure and steady income to those with patience and access to a variety of sports and physical education settings. We have a high demand for quality shots of youths engaged in physical education classes at all age groups. We place great emphasis on images that display diversity and technical quality. Do not contact us if you charge research or holding fees. Do not contact us for progress reports. Will call if selection is made or return images. Typically, we hold images 4 to 6 months. If you can't live without the images that long, don't contact us. Don't be discouraged if you don't make a sale in the first 6 months. We work with over 200 agencies and photographers. Photographers should check to see if techniques demonstrated in photos are correct with a local authority. Most technical photos and submitted work are rejected on content, not quality."

🌐 Ⓐ HYPERION BOOKS FOR CHILDREN

114 Fifth Ave., New York NY 10011. (212)633-4400. Website: www.hyperionchildrensbooks.com. **Contact:** Susan Feakins. Subjects include children's books, including picture books and books for young readers: adventure, animals, history, multicultural, sports. Catalog available for 9×12 SAE with 3 first-class stamps.

Needs Needs photos of multicultural.

Making Contact & Terms Provide résumé, business card, self-promotion piece to be kept on file for possible future assignments. Pays royalty based on retail price of book or a flat fee.

Tips Publishes photo essays and photo concept books.

INAUDIO

100 Weems Lane, Winchester VA 22601. (888)578-5797. Fax: (888)749-5722. E-mail: jlangenfeld@inaudio.biz. Website: www.inaudio.biz. **Contact:** Joseph Langenfeld, president. Estab. 1992. Publishes audiobooks (literature). Photos used for promotional materials, book covers and dust jackets. Examples of recently published titles: *Classic Poe* (cover) and *The Eyes* (cover).

Needs Reviews stock photos of authors' portraits and book-related scenes. Model/property release preferred.

Specs Uses 8×10 prints.

Making Contact & Terms Send query letter with stock list, SASE. Responds in 3 weeks. Previously published work OK. Payment negotiable. Pays on publication. Credit line given. Buys book rights.

$ $🖳 Ⓞ Ⓐ INNER TRADITIONS/BEAR & COMPANY

1 Park St., Rochester VT 05767. (802)767-3174. Fax: (802)767-3726. E-mail: peri@innertraditions.com. Website: www.innertraditions.com. **Contact:** Peri Champine, art director. Estab. 1975. Publishes adult trade: New Age, health, self-help, esoteric philosophy. Photos used for text illustrations, book covers. Examples of re-

cently published titles: *Tibetan Sacred Dance* (cover, interior); *Tutankhamun Prophecies* (cover); *Animal Voices* (cover, interior).

Needs Buys 10-50 photos/year; offers 5-10 freelance assignments/year. Needs photos of babies/children/teens, multicultural, families, parents, religious, alternative medicine, environmental, landscapes/scenics. Interested in fine art, historical/vintage. Reviews stock photos. Model/property release required. Photo captions preferred.

Specs Uses 35mm, 4×5 transparencies. Accepts images in digital format. Send via CD, Jaz, Zip as TIFF, EPS, JPEG files at 300 dpi.

Making Contact & Terms Provide résumé, business card, brochure, flier or tearsheets to be kept on file for possible future assignments. Works with freelancers on assignment only. Simultaneous submissions OK. Pays $150-600 for color cover; $50-200 for b&w and color inside. Pays on publication. Credit line given. Buys book rights; negotiable.

$ $▣ ⊘ Ⓐ JUDICATURE

2700 University Ave., Des Moines IA 50311. (773)973-0145. Fax: (773)338-9687. E-mail: drichert@ajs.org. **Contact:** David Richert, editor. Estab. 1917. Publishes legal journal, court and legal books. Photos used for text illustrations, cover of bimonthly journal.

Needs Buys 10-12 photos/year; rarely offers freelance assignments. Looking for photos relating to courts, the law. Reviews stock photos. Model/property release preferred. Photo captions preferred.

Specs Uses 5×7 color and/or b&w prints; 35mm transparencies. Accepts images in digital format.

Making Contact & Terms Send query letter with samples. Works on assignment only. Keeps samples on file. Responds in 2 weeks. Simultaneous submissions and previously published work OK. Pays $250-350 for cover; $125-300 for color inside; $125-250 for b&w inside. **Pays on receipt of invoice**. Credit line given. Buys one-time rights.

Ⓝ Ⓐ B. KLEIN PUBLICATIONS

P.O. Box 6578, Delray Beach FL 33482. (561)496-3316. Fax: (561)496-5546. **Contact:** Bernard Klein, president. Estab. 1953. Publishes adult trade, reference and who's who. Photos used for text illustrations, promotional materials, book covers, dust jackets. Examples of published titles: *1933 Chicago World's Fair*; *1939 NY World's Fair*; *Presidential Ancestors*.

Needs Reviews stock photos.

Making Contact & Terms Send query letter with résumé of credits and samples. Works on assignment only. Cannot return material. Responds in 2 weeks. Payment negotiable.

Tips "We have several books in the works that will need extensive photo work in the areas of history and celebrities."

⊘ 🌐 LANGENSCHEIDT PUBLISHERS, INC./APA PUBLICATIONS

58 Borough High St., London SE1 1XF United Kingdom. Fax: (44)(207)403-0286. E-mail: hilary1@insightguides.co.uk. Estab. 1969. Publishes trade paperback originals, mainly travel subjects. Photos used for text illustrations, book covers. Catalog available.

Needs Buys hundreds of freelance photos/year. Needs photos of travel. Model/property release required, where necessary.

Making Contact & Terms Send query letter with résumé, photocopies. Does not keep samples on file; cannot return material. Responds only if interested; send nonreturnable samples. Simultaneous submissions OK. Pays on publication. Credit line given. Buys one-time rights.

Tips "We look for spectacular color photographs relating to travel. See our guides for examples."

$ $▣ ⊘ LERNER PUBLISHING GROUP

241 First Ave. N., Minneapolis MN 55401. (612)332-3344. Fax: (612)332-7615. E-mail: bjohnson@igigraphics.com. Website: www.lernerbooks.com. **Contact:** Beth Johnson, photo research director. Estab. 1959. Publishes educational books for young people covering a wide range of subjects including animals, biography, history, geography, science and sports. Photos used for text illustrations, promotional materials, book covers. Examples of recently published titles: *Chattering Chipmunks* (text illustrations, book cover); *Ethiopia in Pictures* (text illustrations, book cover).

Needs Buys over 1,000 photos/year; occasionally offers assignments. Needs photos of children/teens, celebrities, multicultural, families, disasters, environmental, landscapes/scenics, wildlife, cities/urban, education, pets, rural, hobbies, sports, agriculture, industry, political, science, technology/computers. Model/property

© 2006 Elwin Trump

Elwin Trump almost threw out this slide when he first looked at it because it appeared to be out of focus (but it's not), and he could not imagine any use for it. He was wrong, however, because Lerner Publications used it in a children's book, *Things that Float and Things that Sink.* "I've sold thousands of photos to publishing companies, and I've learned to take photos that editors need. Ninety percent of what editors use is to illustrate a point or theme. Beauty is not the criteria; illustration is," says Trump.

release preferred when photos are of social issues (e.g., the homeless). Photo captions required; include who, where, what and when.

Specs Uses any size glossy color prints; 35mm, 2¼×2¼, 4×5 transparencies. Accepts images in digital format. Send via CD, SyQuest, floppy disk, Zip, e-mail, FTP link as TIFF, JPEG files at 300 dpi.

Making Contact & Terms Send query letter with detailed stock list by fax, e-mail or mail. Provide flier or tearsheets to be kept on file. "No calls, please." Cannot return material. Responds only if interested. Previously published work OK. Pays by the project, $125-500 for cover shots; $50-150 for inside shots. **Pays on receipt of invoice.** Credit line given. Buys one-time rights.

Tips Prefers crisp, clear images that can be used editorially. "Send in as detailed a stock list as you can, and be willing to negotiate pay."

LITTLE, BROWN & CO.

1271 Avenue of the Americas, New York NY 10020. (212)522-2428. Fax: (212)467-4502. **Contact:** Yasmeen Motiwalla, studio manager. Publishes adult trade. Photos used for book covers, dust jackets.

Needs Reviews stock photos. Model release required.

Making Contact & Terms Provide tearsheets to be kept on file for possible future assignments. "Samples should be nonreturnable." Response time varies. Payment negotiable. Credit line given. Buys one-time rights.

$ LUCENT BOOKS

15822 Bernardo Center Dr., Suite C, San Diego CA 92127. (858)485-7424. Fax: (858)485-9549. Website: www.lucentbooks.com. **Contact:** Brian Staples, production manager. Estab. 1987. Publishes juvenile nonfiction—social issues, biographies and histories. Photos used for text illustrations and book covers. Examples of recently published titles: *The Death Penalty* (text illustrations); *Teen Smoking* (text illustrations).

Needs Buys hundreds of photos/year, including many historical and biographical images, as well as controversial topics such as euthanasia. Needs celebrities, teens, disasters, environmental, wildlife, education. Interested in documentary, historical/vintage. Reviews stock photos. Model/property release required; photo captions required.

Specs Uses 5×7, 8½×11 b&w prints. Accepts images in digital format. Send via CD, SyQuest, Zip, e-mail at 266 dpi.

Making Contact & Terms Send query letter with résumé of credits and samples. Provide résumé, business card, brochure, flier or tearsheets to be kept on file for possible future assignments. Keeps samples on file. Will contact if interested. Simultaneous submissions and previously published work OK. Pays $100-300 for color cover; $50-100 for b&w inside. Credit lines given on request.

$ ▣ ◪ MAISONNEUVE PRESS

Institute for Advanced Cultural Studies, P.O. Box 2980, Washington DC 20013-2980. (301)277-7505. Fax: (301)277-2467. E-mail: editors@maisonneuvepress.com. Website: www.maisonneuvepress.com. **Contact:** Robert Merrill, editor. Estab. 1986. Publishes hardcover and trade paperback originals, trade paperback reprints. Photos used for text illustrations, book covers, dust jackets. Examples of recently published titles: *Our Forest Legacy* (text illustrations, promotional materials, book cover, dust jacket); *Crisis Cinema* (text illustrations, promotional materials, book cover, dust jacket). Catalog free. Photo guidelines free with SASE.

Needs Buys 25 freelance photos/year. Needs photos of military, political. Interested in documentary, fine art, historical/vintage. Model/property release preferred. Photo captions required; include photographer's name, date, description of contents, permission or copyright.

Specs Uses 5×7 b&w prints. Accepts images in digital format. Send via CD, Zip, e-mail as TIFF files at the best resolution you have. "Color for book covers only."

Making Contact & Terms Send query letter with résumé, prints, photocopies. Keeps samples on file. Responds only if interested; send nonreturnable samples. Simultaneous submissions OK. Pays $50-150 for b&w or color cover; $10-70 for b&w inside. **Pays on acceptance.** Credit line given. Buys one-time rights.

Tips "Look at our catalog. Query via e-mail. Especially interested in documentary photos. Mostly use photos to illustrate text—ask what texts we're working on. Send thumbnails via e-mail attachment."

$ $ $ ▣ ◪ MCGRAW-HILL

1333 Burr Ridge Pkwy., Floors 2-5, Burr Ridge IL 60527. (630)789-4000. Fax: (630)789-6594. E-mail: gino_cies lik@mcgraw-hill.com. Website: www.mhhe.com. Publishes hardcover originals, textbooks, CD-ROMs. Photos used for book covers.

Needs Buys 20 freelance photos/year. Needs photos of business concepts, industry, technology/computers.

Specs Uses 8×10 glossy prints; 35mm, 2¼×2¼, 4×5 transparencies. Accepts images in digital format. Send via CD.

Making Contact & Terms Contact through rep. Provide business card, self-promotion piece to be kept on file for possible future assignments. Responds only if interested. Previously published work OK. Pays $650-1,000 for b&w cover; $650-1,500 for color cover. Pays extra for electronic usage of photos. Pays on publication. Credit line given. Buys one-time rights.

$ $ ▣ ◪ MILKWEED EDITIONS

1011 Washington Ave. S., Suite 300, Minneapolis MN 55415. (612)332-3192. Fax: (612)215-2550. Website: www.milkweed.org. Estab. 1980. Publishes hardcover originals and trade paperback originals. Subjects include literary fiction, literary nonfiction, poetry, children's fiction. Photos used for book covers and dust jackets. Examples of recently published titles: *Ordinary Wolves*; *Firekeeper*. Catalog available for $1.50. Photo guidelines available for first-class postage.

Needs Buys 6-8 freelance photos/year. Needs photos of environmental, landscapes/scenics, wildlife, people, stock, art, multicultural.

Specs Uses any size glossy or matte color and/or b&w prints; 2¼×2¼, 4×5 transparencies. Accepts images in digital format. Send via CD, Zip, e-mail as TIFF, EPS, JPEG files at 300 dpi.

Making Contact & Terms Send query letter with résumé, business card, self-promotion piece to be kept on file for possible future assignments. Responds only if interested; send nonreturnable samples. Simultaneous submissions OK. Pays $300-800 for b&w or color cover; by the project, $800 maximum for cover/inside shots. Credit line given. Buys one-time rights.

Book Publishers

$ ▣ Ⓢ MITCHELL LANE PUBLISHERS, INC.

P.O. Box 196, Hockessin DE 19707. (302)234-9426. Fax: (302)234-4742. E-mail: mitchelllane@comcast.net. Website: www.mitchelllane.com. **Contact:** Barbara Mitchell, publisher. Estab. 1993. Publishes hardcover originals for library market. Subjects include biography for children and young adults. Photos used for text illustrations, book covers. Examples of recently published titles: *Latino Entrepreneurs* (book cover); *Jonas Salk and the Polio Vaccine* (text illustrations, book cover).

Needs Photo captions required.

Specs Accepts images in digital format. Send via CD as TIFF, JPEG files at 300 dpi.

Making Contact & Terms Send query letter with stock list (stock photo agencies only). Does not keep samples on file; cannot return material. Responds only if interested. Pays on publication. Credit line given. Buys one-time rights.

$ ▣ MUSEUM OF NORTHERN ARIZONA

3101 N. Fort Valley Rd., Flagstaff AZ 86001. (928)774-5213. Fax: (928)779-1527. E-mail: publications@mna. mus.az.us. Website: www.musnaz.org. **Contact:** Dianne Rechel, editor. Estab. 1928. Subjects include biology, geology, archaeology, anthropology and history. Photos used for *Plateau: Land and Peolpe of the Colorado Plateua* magazine, published twice/year (May, October).

Needs Buys approximately 80 photos/year. Biology, geology, history, archaeology and anthropology—subjects on the Colorado Plateau. Reviews stock photos. Photo captions preferred; include location, description and context.

Specs Uses 8×10 glossy b&w prints; 35mm, 2¼×2¼, 4×5 and 8×10 transparencies. Prefers 2¼×2¼ transparencies or larger. Possibly accepts images in digital format. Submit via Zip disk.

Making Contact & Terms Send query letter with samples, SASE. Responds in 1 month. Simultaneous submissions and previously published work OK. Pays $55-250/color photo; $55-250/b&w photo. Credit line given. Buys one-time and all rights; negotiable. Offers internships for photographers. Contact Photo Archivist: Tony Marinella.

Tips Wants to see top-quality, natural history work. To break in, send only pre-edited photos.

$ $ MUSIC SALES CORP.

257 Park Ave. S., 20th Floor, New York NY 10010. (212)254-2100. Fax: (212)254-2013. E-mail: de@musicsale s.com. Website: www.musicsales.com. **Contact:** Daniel Earley. Publishes instructional music books, song collections and books on music. Photos used for covers and/or interiors. Examples of recently published titles: *Bob Dylan: Time Out of Mind*; *Paul Simon: Songs from the Capeman*; *AC/DC: Bonfire*.

Needs Buys 200 photos/year. Present model release on acceptance of photo. Photo captions required.

Specs Uses 8×10 glossy prints; 35mm, 2×2, 5×7 transparencies.

Making Contact & Terms Send query letter first with résumé of credits. Provide business card, brochure, flier or tearsheet to be kept on file for possible future assignments. Responds in 2 months. Simultaneous submissions and previously published work OK. Pays $75-100 for b&w photos; $250-750 for color photos.

Tips In samples, wants to see "the ability to capture the artist in motion with a sharp eye for framing the shot well. Portraits must reveal what makes the artist unique. We need rock, jazz, classical—onstage and impromptu shots. Please send us an inventory list of available stock photos of musicians. We rarely send photographers on assignment and buy mostly from material on hand." Send "business card and tearsheets or prints stamped 'proof' across them. Due to the nature of record releases and concert events, we never know exactly when we may need a photo. We keep photos on permanent file for possible future use."

$ ▣ Ⓓ Ⓢ NEW LEAF PRESS, INC.

Box 726, Green Forest AR 72638. (870)438-5288. Fax: (870)438-5120. Website: www.newleafpress.net. **Contact:** Brent Spurlock, art director. Publishes Christian adult trade, gifts, devotions and homeschool. Photos used for book covers, book interiors and catalogs. Example of recently published title: *The Hand That Paints the Sky*.

Needs Buys 5 freelance photos/year. Needs photos of landscapes, dramatic outdoor scenes, "anything that could have an inspirational theme." Reviews stock photos. Model release required. Photo captions preferred.

Specs Uses 35mm slides and transparencies. Accepts images in digital format. Send via CD, Jaz, Zip, e-mail as TIFF, EPS files at 300 dpi.

Making Contact & Terms Send query letter with copies of samples and list of stock photo subjects. "Not responsible for submitted slides and photos from queries. Please send copies, no originals unless requested." Does not assign work. Responds in 2-3 months. Simultaneous submissions and previously published work

OK. Pays $50-100 for b&w photos; $100-175 for color photos. Credit line given. Buys one-time and book rights.

Tips "In order to contribute to the company, send color copies of quality, crisp photos. Trend in book publishing is toward much greater use of photography."

$ ▢ ◪ Ⓢ NICOLAS-HAYS INC.

P.O. Box 1126, Berwick ME 03901. (207)363-4393, ext. 12. Fax: (207)698-1042. E-mail: info@nicolashays.com. Website: www.nicolashays.com. **Contact:** Valerie Cooper, managing editor. Estab. 1976. Publishes trade paperback originals and reprints. Subjects include Eastern philosophy, Jungian psychology, New Age how-to. Photos used for book covers. Example of recently published title: *A Call to Compassion: Bringing Buddhist Practices of the Heart into the Soul of Psychology* (book cover). Catalog available upon request.

Needs Buys 1 freelance photo/year. Needs photos of landscapes/scenics.

Specs Uses color prints; 35mm, $2^1/_4 \times 2^1/_4$, 4×5 transparencies. Accepts images in digital format.

Making Contact & Terms Send query letter with photocopies, tearsheets. Provide self-promotion piece to be kept on file for possible future assignments. Responds only if interested; send nonreturnable samples. Simultaneous submissions and previously pubished work OK. Pays $100-200 for color cover. **Pays on acceptance**. Credit line given. Buys one-time rights.

Tips "We are a small company and do not use many photos. We keep landscapes/seascapes on hand— images need to be inspirational."

NORTHLAND PUBLISHING

P.O. Box 1389, Flagstaff AZ 86002. (928)774-5251. Fax: (928)774-0592. E-mail: info@northlandpub.com. Website: www.northlandpub.com. **Contact:** David Jenney, publisher. Estab. 1958. "Northland specializes in nonfiction titles with American West and Southwest themes, including Native American arts, crafts and culture; regional cookery; interior design and architecture; and site-specific visual tour books." Photos used for text illustrations, promotional materials, book covers, dust jackets. Examples of recently published photography-driven titles: *San Diego* (cover/interior); *Napa Valley and Sonoma* (cover/interior); *The Desert Home* (cover/interior).

Needs Buys 1,000 stock photos/year. "Looking for photographers in the region for occasional assignments." Model/property release required. Photo captions required.

Specs Uses $2^1/_4 \times 2^1/_4$, 4×5 transparencies.

Making Contact & Terms Send query letter with samples. Keeps samples on file. Previously published work OK. Payment negotiable. Pays within 30 days of invoice. Credit line given. Buys non-exclusive lifetime and all rights.

Tips "Often we look for site- or subject-specific images but occasionally publish a new book with an idea from a photographer."

$ ▢ Ⓢ W.W. NORTON AND COMPANY

500 Fifth Ave., New York NY 10110. (212)790-4362. Fax: (212)869-0856. Website: www.wwnorton.com. **Contact:** Neil Ryder Hoos, manager, photo permissions. Estab. 1923. Photos used for text illustrations, book covers, dust jackets. Examples of recently published titles: *Inventing America*; *We the People*; *Earth: Portrait of a Planet*; *Microbiology*.

Needs Variable. Photo captions preferred.

Specs Accepts images in all formats; digital images at a minimum of 300 dpi for reproduction and archival work.

Making Contact & Terms Send stock list. Do not enclose SASE. Simultaneous submissions and previously published work OK. Responds as needed. Payment negotiable. Credit line given. Buys one-time rights; many images are also used in print and Web-based ancillaries; negotiable.

Tips "Competitive pricing and minimal charges for electronic rights are a must."

$ ▢ Ⓢ ◪ THE OLIVER PRESS

Charlotte Square, 5707 W. 36th St., Minneapolis MN 55416-2510. (952)926-8981. Fax: (952)926-8965. e-mail queries@oliverpress.com. Website: www.oliverpress.com. **Contact:** Charles Helgesen, photo editor. Estab. 1991. Publishes history books and collective biographies for the school and library market. Photos used for text illustrations, promotional materials, book covers. Example of published titles: *You Are the Explorer* (text illustrations).

Needs Needs photos of people in the public eye: politicians, business people, activists, etc. Also wants photos

of lancscapes/scenics, agriculture, travel, business concepts, industry, medicine, military, political, product shots/still life, science, technology/computers. Interested in historical/vintage. Reviews stock photos. Photo captions required; include the name of the person photographed, the year, and the place/event at which the picture was taken.

Specs Uses 8×10 glossy b&w and/or color prints. Accepts images in digital format. "We will give specifics at time of purchase."

Making Contact & Terms Send query letter with stock list. Keeps samples on file. Responds in 1 month. Simultaneous submissions and previously published work OK. Pays $35-50 for b&w photo; $50-75 for color cover. Pays on publication. Credit line given. Buys book rights, including the right to use photos in publicity materials; negotiable.

Tips "We generally use historical societies, museums, and libraries as photo sources and only rarely use freelancers; when we do, it is for very specific needs. Please do not send us unsolicited photos. Instead, send a résumé and cover letter describing the major subjects you have photographed in the past. We will keep the information on file and contact you if the need arises."

$ $🖬 🖉 🄰 OUR SUNDAY VISITOR, INC.

200 Noll Plaza, Huntington IN 46750. (260)356-8400 or (800)348-2440. E-mail: booksed@osv.com. Website: www.osv.com. **Contact:** Troy Lefevre, design editor. Estab. 1912. Publishes religious (Catholic) periodicals, books and educational materials. Photos used for text illustrations, promotional materials, book covers, dust jackets. Examples of recently published titles: *Treasury of Catholic Stories* (color on cover); *Parenting with Grace* (color on cover); *What is Catholicism* (color on cover).

Needs Buys 75-100 photos/year; offers 25-50 freelance assignments/year. Interested in family settings, "anything related to Catholic Church." Reviews stock photos. Model/property release required. Photo captions preferred.

Specs Uses 8×10 glossy color and/or b&w prints; 35mm transparencies. Accepts images in digital format. Send via e-mail at 300 dpi.

Making Contact & Terms Send query letter with samples. Works with freelancers on assignment only. Keeps samples on file. Responds in 1 month. Pays $150-300 for b&w cover; $300-400 for color cover; $25-150 for b&w, color inside. **Pays on acceptance, receipt of invoice.** Credit line given. Buys one-time rights.

$🖉 🄰 RICHARD C. OWEN PUBLISHERS, INC.

P.O. Box 585, Katonah NY 10536. (914)232-3903. Fax: (914)232-3977. **Contact:** Amy Haggblom, editor (professional books); Janice Boland, editor (children's books). Publishes picture/storybook fiction and nonfiction for 5- to 7-year-olds; author autobiographies for 7- to 10-year-olds; professional books for educators. Photos used for text illustrations, promotional materials, book covers. Examples of recently published titles: *Maker of Things* (text illustrations, book cover); *Springs* (text illustrations, book cover).

Needs Number of photos bought annually varies; offers 3-10 freelance assignments/year. Needs unposed people shots and nature photos that suggest storyline. "For children's books, must be child-appealing with rich, bright colors and scenes, no distortions or special effects. For professional books, similar, but often of classroom scenes, including teachers. Nothing posed; should look natural and realistic." Reviews stock photos of children involved with books and classroom activities, ranging from kindergarten to sixth grade. Also wants photos of babies/children/teens, multicultural, families, environmental, landscapes/scenics, wildlife, architecture, cities/urban, pets, adventure, automobiles, sports, travel, science. Interested in documentary. (All must be of interest to children ages 5-9.) Model release required for children and adults. Children (under the age of 21) must have signature of legal guardian. Property release preferred. Photo captions required; include "any information we would need for acknowledgments, including if special permission was needed to use a location."

Specs "For materials that are to be used, we need 35mm mounted transparencies or high-definition color prints. We usually use full-color photos."

Making Contact & Terms Submit copies of samples by mail for review. Provide brochure, flier or tearsheets to be kept on file for possible future assignments; no slides or disks. Include a brief cover letter with name, address, and daytime phone number, and indicate *Photographer's Market* as a source for correspondence. Works with freelancers on assignment only. "For samples, we like to see any size color prints (or color copies)." Keeps samples on file "if appropriate to our needs." Responds in 1 month. Simultaneous submissions OK. Pays $10-100 for color cover; $10-100 for color inside; $250-800 for multiple photo projects. "Each job has its own payment rate and arrangements." **Pays on acceptance.** Credit line sometimes given, depending on the project. "Photographers' credits appear in children's books and in professional books, but not in

promotional materials for books or company.'' For children's books, publisher retains ownership, possession and world rights, which apply to first and all subsequent editions of a particular title and to all promotional materials. ''After a project, (children's books) photos can be used by photographer for portfolio.''

Tips Wants to see ''real people in natural, real life situations. No distortion or special effects. Bright, clear images with jewel tones and rich colors. Keep in mind what would appeal to children. Be familiar with what the publishing company has already done. Listen to the needs of the company. Send tearsheets, color photocopies with a mailer. No slides, please.''

$🖵 PAULIST PRESS

997 Macarthur Blvd., Mahwah NJ 07430. (201)825-7300. Fax: (201)825-8345. Website: www.paulistpress.c om. **Contact:** Paul McMahon, managing editor. Estab. 1865. Publishes hardcover and trade paperback originals, trade paperback reprints, textbooks, CD-ROMs, video, audio, bookmarks, pamphlets. Subjects include Catholic, religious. Photos used for text illustrations, book covers, dust jackets. Examples of recently published titles: *The Spiritual Traveler: New York City* (text illustrations); *The Spiritual Traveler: England, Scotland, Wales* (text illustrations). Catalog available; request via phone. Photo guidelines available.

Needs Buys 50-100 freelance photos/year. Needs photos of religious. ''Mainly images concerning religious pilgrimage—not limited to Catholic images. Cathedrals, artwork, world sites such as the Hagia Sophia, Benares, India, etc.'' Photo captions preferred.

Specs Uses color and/or b&w prints; 35mm transparencies. Accepts images in digital format. Send via CD, e-mail at minimum 800 dpi.

Making Contact & Terms Contact through rep. Provide business card, self-promotion piece to be kept on file for possible future assignments. Simultaneous submissions and previously published work OK. Pays $50-100/image. Credit line given. Buys one-time or all rights.

Tips ''Images are fairly standard, almost 'stock,' but will consider creative/abstract work for certain projects.''

$ $🖵 ⊘ 🆂 PELICAN PUBLISHING CO.

1000 Burmaster St., Gretna LA 70053. (504)368-1175. Fax: (504)368-1195. E-mail: tcallaway@pelicanpub.c om. Website: www.pelicanpub.com. **Contact:** Terry Callaway, production manager. Publishes adult trade, juvenile, textbooks, how-to, cooking, fiction, travel, science and art books; also religious inspirational and business motivational. Photos used for book covers. Examples of published titles: *Maverick Berlin*; *Coffee Book*; *Maverick Guide to Hawaii*.

Needs Buys 8 photos/year; offers 3 freelance assignments/year. Needs photos of travel (international), cooking/food, business concepts, nature/inspirational. Reviews royalty-free stock photos of travel subjects, people, nature, etc. Model/property release required. Photo captions required.

Specs Uses 8×10 glossy color prints; 35mm, 4×5 transparencies. Accepts images in digital format. Send via CD as TIFF files at 300 dpi or higher.

Making Contact & Terms Send query letter with stock list. Provide résumé, business card, brochure, flier or tearsheets to be kept on file for possible future assignments. Responds as needed. Pays $100-500 for color photos; negotiable with option for books as payment. **Pays on acceptance.** Credit line given. Buys one-time and book rights; negotiable.

$🖵 ◯ PHOTOGRAPHER'S MARKET

4700 E. Galbraith Rd., Cincinnati OH 45236. (513)531-2690, ext. 1226. Fax: (513)531-2686. E-mail: photomark et@fwpubs.com. **Contact:** Donna Poehner, editor. Photo guidelines free with SASE or via e-mail.

Needs Publishes 30-35 photos/year. Uses general subject matter. Photos must be work sold to markets listed in *Photographer's Market*. Photos are used to illustrate the various types of images being sold to photo buyers listed in the book. ''We receive many photos for our Publications section. Your chances of getting published are better if you can supply images for sections other than Publications. We're especially looking for images to include in the Advertising, Design & Related Markets section and the Book Publishers section.'' Look through this book for examples.

Specs Uses color and b&w (b&w preferred) prints, any size and format (5×7 or 8×10 preferred). Also uses tearsheets and transparencies, all sizes, color and b&w. Accepts images in digital format. Send via e-mail or CD as TIFF or JPEG files, 5×7 at 300 dpi; saved as grayscale, not RGB.

Making Contact & Terms ''Submit photos in winter and spring to ensure sufficient time to review them before our early-summer deadline. Be sure to include SASE for return of material. All photos are judged according to subject uniqueness as well as technical quality and composition. Photos are held and reviewed at close of deadline.'' Simultaneous submissions OK. *Work must be previously published.* Pays $75 plus

complimentary copy of book. Pays when book goes to printer (September). Book forwarded in November upon arrival from printer. Credit line given. Buys second reprint and promotional rights.

Tips "Send photos with brief cover letter describing the background of the sale. If sending more than one photo, make sure that photos are clearly identified. Slides should be enclosed in plastic slide sleeves, and prints should be reinforced with cardboard. Cannot return material if SASE is not included. Tearsheets will be considered disposable unless SASE is provided and return is requested. Because photos are printed in b&w on newsprint stock, some photos (especially color shots) may not reproduce well. Photos should have strong contrast and not too much fine detail that might be lost when printed. Be able to communicate via e-mail."

$ ▣ ☑ ⑤ PLAYERS PRESS INC.

P.O. Box 1132, Studio City CA 91614. **Contact:** David Cole, vice president. Estab. 1965. Publishes entertainment books including theater, film and television. Photos used for text illustrations, promotional materials, book covers, dust jackets. Examples of recently published titles: *Women's Wear for the 1930s* (text illustrations); *Period Costume for Stage & Screen* (text illustrations).

Needs Buys 50-1,000 photos/year. Needs photos of entertainers, actors, directors, theaters, productions, actors in period costumes, scenic designs and clowns. Reviews stock photos. Model release required for actors, directors, productions/personalities. Photo captions preferred for names of principals and project/production.

Specs Uses 8×10 glossy or matte b&w prints; 5×7 glossy color prints; 35mm, $2^{1}/_{4} \times 2^{1}/_{4}$ transparencies. Accepts images in digital format. Send via Zip as TIFF files at 600 dpi.

Making Contact & Terms Send query letter with list of stock photo subjects. Send unsolicited photos by mail for consideration; include SASE for return of material. Responds in 3 weeks. Simultaneous submissions and previously published work OK. Pays $1-100 for b&w cover; $1-500 for color cover; by the project, $10-100 for cover shots; $1-50 for b&w and color inside; by the project, $10-100 for inside shots. Credit line sometimes given, depending on book. Buys all rights; negotiable in "rare cases."

Tips Wants to see "photos relevant to the entertainment industry. Do not telephone; submit only what we ask for."

▣ ☑ PRAKKEN PUBLICATIONS, INC.

832 Phoenix Dr., P.O. Box 8623, Ann Arbor MI 48107. (734)975-2800. Fax: (734)975-2787. Website: http://techdirections.com or http://eddigest.com. **Contact:** Sharon K. Miller, production & design manager. Estab. 1934. Publishes *The Education Digest* (magazine), *Tech Directions* (magazine for technology and vocational/technical educators), text and reference books for technology and vocational/technical education. Photos used for text illustrations, promotional materials, book covers, magazine covers and posters. No photo guidelines available.

Needs Wants photos of education "in action," especially technology and vocational-technical education; prominent historical figures, technology/computers, industry. Photo captions required; include scene location, activity.

Specs Uses all media; any size. Accepts images in digital format. Send via CD, Jaz, Zip as TIFF, EPS, JPEG files at 300 dpi.

Making Contact & Terms Send query letter with samples. Send unsolicited photos by mail for consideration. Keeps samples on file. Payment negotiable. Methods of payment to be arranged. Credit line given. Rights negotiable.

Tips Wants to see "high-quality action shots in tech/voc-ed classrooms" when reviewing portfolios. Send inquiry with relevant samples to be kept on file. "We buy very few freelance photographs but would be delighted to see something relevant."

$ ☑ PROSTAR PUBLICATIONS INC.

3 Church Circle, Suite 109, Annapolis MD 21401. (800)481-6277. E-mail: editor@prostarpublications.com. Website: www.prostarpublications.com. **Contact:** Diana Hunter, associate editor. Estab. 1991. Publishes how-to, nonfiction. Photos used for book covers. Photo guidelines free with SASE.

Needs Buys less than 100 photos/year; offers very few freelance assignments/year. Reviews stock photos of nautical (sport). Model/property release required. Photo captions required.

Specs Uses color and/or b&w prints.

Making Contact & Terms Send query letter with stock list. Does not keep samples on file; include SASE for

return of material. Responds in 1 month. Simultaneous submissions and previously published work OK. Pays $10-50 for color or b&w photos. Pays on publication. Credit line given. Buys book rights; negotiable.

$ $▣ ☑ ⑤ REIMAN MEDIA GROUP, INC.

5400 S. 60th St., Greendale WI 53129. Fax: (414)423-8463. E-mail: tbellin@reimanpub.com. Website: www.re imanpub.com. **Contact:** Trudi Bellin, photo coordinator. Estab. 1965. Publishes consumer-cooking, people-interest, country themes. Examples of recently published titles: *Taste of Home's Weeknight Cooking Made Easy, Brides' Complete Guide to Country Cooking, The Best of Birds & Blooms 2005*.

Needs Buys 350 photos/year. Looking for food-related images showing at-home entertaining for all seasons, family dinners, couples cooking and dining, pot lucks, table settings, food as gifts; people and backyard beauty shots. Reviews stock photos of families, senior citizens, couples (30s-60s age range), social groups, rural, scenics, birds, flowers and flower gardens. "Conservative audience means few photos published with wine, liquor or smoking elements." Model/property release required. Photo captions preferred; include season, location.

Specs Uses color transparencies, any size. Accepts images in digital format. Send via lightboxes or e-mail as JPEG files at 300 dpi. "CDs/DVDs must come with printed thumbnails and caption sheets."

Making Contact & Terms Send query letter with résumé of credits and stock list. Send unsolicited photos by mail for consideration. Keeps samples on file ("tearsheets; no duplicates"); include SASE for return of material. Responds in 3 months for first review. Simultaneous submissions and previously published work OK. Pays $300 for color cover; $100-300 for color inside. Pays on publication. Credit line given. Buys one-time rights.

Tips "Study our publications first. Keep our conservative audience in mind. Send well-composed and well-framed photos that are sharp and colorful. All images received on spec."

$ $▣ ☑ RUNNING PRESS BOOK PUBLISHERS

The Perseus Books Group, 125 S. 22nd St., Philadelphia PA 19103-4399. (215)567-5080. Fax: (215)567-4636. Website: www.runningpress.com. **Contact:** Sue Oyama, photo editor. Estab. 1972. Publishes hardcover originals, trade paperback originals. Subjects include adult and children's nonfiction; cooking; photo pictorials on every imaginable subject; kits; miniature editions. Photos used for text illustrations, promotional materials, book covers, dust jackets. Examples of recently published titles: *Garden Proverbs; Silent Moments; Lennon Revealed*. Catalog available for SASE.

Needs Buys a few hundred freelance photos/year. Needs photos for gift books and photos of wine, food, lifestyle, landscapes/scenics, wildlife, architecture, cities/urban, gardening, interiors/decorating, rural, hobbies, performing arts, travel. Interested in fine art, folk art, historical/vintage, seasonal. Model/property release preferred. Photo captions preferred; include exact locations, names of pertinent items or buildings, names and dates for antiques or special items of interest.

Specs Uses b&w prints; medium- and large-format transparencies. Accepts images in digital format. Send via CD as TIFF, EPS files at 300 dpi.

Making Contact & Terms Send stock list and provide business card, self-promotion piece to be kept on file for possible future assignments. Do not send original art. Responds only if interested. Simultaneous submissions and previously published work OK. Pays $300-500 for color cover; $100-250 for inside. Pays on publication. Credit line given. Credits listed on separate copyright or credit pages. Buys one-time rights.

Tips "Look at our catalog on the website."

$▣ ☑ ⑤ SCHOLASTIC LIBRARY PUBLISHING

(formerly Grolier, Educational), 90 Sherman Turnpike, Danbury CT 06816. (800)243-7256. Fax: (203)797-3344. **Contact:** Cindy Joyce, director of photo research. Estab. 1829. Publishes 7 encyclopedias plus specialty reference sets in print and online versions. Photos used for text illustrations, website. Examples of published titles: *The New Book of Knowledge* and *Encyclopedia Americana*.

Needs Buys 5,000 images/year. Needs excellent-quality editorial photographs of all subjects A-Z and current events worldwide. All images must have clear captions and specific dates and locations, and natural history subjects should carry Latin identification.

Specs Uses 8×10 glossy b&w and/or color prints; 35mm, 4×5, 8×10 (reproduction-quality dupes preferred) transparencies. Accepts images in digital format. Send via photo CD, floppy disk, Zip as JPEG files at 300 dpi.

Making Contact & Terms Send query letter, stock lists and printed examples of work. Cannot return unsolicited material and does not send guidelines. Include SASE only if you want material returned. Pricing to be

discussed if/when you are contacted to submit images for specific project. Please note, encyclopedias are printed every year, but rights are requested for continuous usage until a major revision of the article in which an image is used.

Tips "Send subject lists and small selection of samples. Printed samples *only*, please. In reviewing samples, we consider the quality of the photographs, range of subjects, and editorial approach. Keep in touch, but don't overdo it."

$ ▣ ○ SENTIENT PUBLICATIONS, LLC

1113 Spruce St., Boulder CO 80302. (303)443-2188. Fax: (303)381-2538. E-mail: cshaw@sentientpublications. com. Website: www.sentientpublications.com. **Contact:** Connie Shaw, editor. Estab. 2001. Publishes trade paperback originals and reprints. Subjects include education, ecology, spirituality, travel, publishing, psychology. Photos used for book covers. Examples of recently published titles: *Radical Optimism*; *The Happy Child*. Catalog free with #10 SASE.

Needs Buys 8 freelance photos/year. Needs photos of babies/children/teens, landscape/scenics, religious. Interested in avant garde.

Specs Accepts images in digital format. Send via e-mail as TIFF files at 300 dpi.

Making Contact & Terms Send query letter with résumé, prints, photocopies, stock list. Provide self-promotion piece to be kept on file for possible future assignments. Responds only if interested; send nonreturnable samples. Simultaneous submissions and previously published work OK. Pays $100 maximum color cover. Pays on publication. Credit line given. Buys one-time rights.

Tips "Look at our website for the kind of cover art we need."

$ SILVER MOON PRESS

160 Fifth Ave., Suite 622, New York NY 10010. (212)242-6499. Fax: (212)242-6799. Website: www.silvermoonpress.com. **Contact:** David Katz, publisher. Managing Editor: Hope Killcoyne. Estab. 1991. Publishes juvenile fiction and general nonfiction. Photos used for text illustrations, book covers, dust jackets. Examples of recently published titles: *Leo Politi: Artist of the Angels* by Ann Stalcup; *The War Between the States* by David Rubel.

Needs Buys 5-10 photos/year; offers 1 freelance assignment/year. Looking for general-children, subject-specific photos and American historical fiction photos. Reviews general stock photos. Photo captions preferred.

Making Contact & Terms Provide résumé, business card, brochure, flier or tearsheets to be kept on file for possible future assignments. Keeps samples on file. Responds in 1 month. Simultaneous submissions and previously published work OK. Pays $25-100 for b&w photos. Pays on publication. Credit line given. Buys all rights; negotiable.

$ ▣ ○ Ⓢ SMART APPLE MEDIA

123 S. Broad St., Mankato MN 56001. (507)388-6273. Fax: (507)388-1364. E-mail: ccphotoeditor@hotmail.com. **Contact:** Photo Researcher. Estab. 1994. Publishes hardcover originals and textbooks. Subjects include science, nature, technology, hobbies, geography, animals, space, climate/weather, ecology. Photos used for text illustrations, book covers. Examples of recently published titles: *Habitats* Series (text illustrations, book cover); *In Time of Need* Series (text illustrations, book cover).

Needs Buys 2,000 stock photos/year. Needs photos of disasters, environmental, landscape/scenics, wildlife, architecture, cities/urban, education, pets, rural, adventure, automobiles, entertainment, events, food/drink, health/fitness, hobbies, sports, travel, agriculture, industry, medicine, military, science, technology/computers. Photo captions required; include name of photographer or agency.

Specs Uses 35mm. Accepts images in digital format for Mac only. Send via CD as JPEG files.

Making Contact & Terms Send query letter with photocopies, tearsheets, stock list. Provide self-promotion piece to be kept on file for possible future assignments. Simultaneous submissions and previously published work OK. Pays $150 for b&w and color cover; $50-150 for b&w and color inside. Pays on publication. Credit line given. Buys one-time rights.

$ $ ▣ THE SPEECH BIN INC.

1965 25th Ave., Vero Beach FL 32960. (772)770-0007. Fax: (772)770-0006. E-mail: photos@speechbin.com. **Contact:** Jan J. Binney, senior editor. Estab. 1984. Publishes textbooks and instructional materials for speech-language pathologists, occupational and physical therapists, audiologists and special educators. Photos used

for book covers, instructional materials, catalogs. Example of recently published title: *Talking Time* (cover). Catalog available for $1.43 first-class postage and 9×12 SAE.

Needs Mostly photos of scenics. Also needs events and travel. Model release required.

Specs Uses any size prints. Accepts images in digital format. Send as TIFF files at a high resolution (300 dpi).

Making Contact & Terms Send query letter with photocopies, tearsheets, transparencies, stock list. Does not keep samples on file; include SASE for return of material. Works on assignment; also purchases stock photos from time to time. Responds in 2 months. Previously published work OK. Pays on publication. Credit line given. Buys one-time rights.

Tips "When presenting your work, select brightly colored, eye-catching photos. We like unusual and very colorful seasonal scenics."

$ $▣ STONE BRIDGE PRESS

P.O. Box 8208, Berkeley CA 94707. (510)524-8732. Fax: (510)524-8711. E-mail: sbp@stonebridge.com. Website: www.stonebridge.com. **Contact:** Peter Goodman, publisher. Estab. 1989. Publishes hardcover and trade paperback originals. Subjects include Japanese culture, travel, business. Photos used for text illustrations, book covers, dust jackets. Examples of recently published titles: *Cruising the Anime City* (text illlustrations, book cover); *Shinto* (text illustrations, book cover). Catalog available for SAE with 75¢ postage.

Needs Buys 2-3 freelance photos/year. Needs photos of travel. Only Japan-themed photos. Model/property release required. Photo captions required.

Specs Accepts images in digital format. Send via CD as TIFF files at 300 dpi.

Making Contact & Terms Send query letter with résumé, photocopies, tearsheets. Does not keep samples on file; cannot return material. Responds in 1 month. Responds if interested; send nonreturnable samples. Simultaneous submissions and previously published work OK. Pays $300 for b&w cover; $500 for color cover. Pays on publication. Credit line given. Buys all rights for all editions.

Tips "Don't waste money sending us inappropriate materials. Japan-related *only*."

$ $▣ Ⓐ STRANG COMMUNICATIONS COMPANY

600 Rinehart Rd., Lake Mary FL 32746. (407)333-0600. E-mail: bill.johnson@strang.com. Website: www.strang.com. **Contact:** Bill Johnson, marketing design director. Estab. 1975. Publishes religious magazines and books for Sunday School and general readership as well as gift books and children's books. Photos used for text illustrations, promotional materials, book covers, dust jackets. Examples of recently published titles: *Charisma Magazine*; *New Man Magazine*; *Ministries Today Magazine*; *Vida Cristiana* (all editorial, cover).

Needs Buys 75-100 photos/year; offers 75-100 freelance assignments/year. Needs photos of people, environmental portraits, situations. Reviews stock photos. Model/property release preferred for all subjects. Photo captions preferred; include who, what, when, where.

Specs Uses 8×10 prints; 35mm, 2¼×2¼, 4×5 transparencies. Accepts images in digital format for Mac (PhotoShop). Send via CD, e-mail.

Making Contact & Terms Arrange personal interview to show portfolio or call and arrange to send portfolio. Send query letter with samples. Provide résumé, business card, brochure, flier or tearsheets to be kept on file for possible future assignments. Works with freelancers on assignment only. Keeps samples on file. Simultaneous submissions and previously published work OK. Pays $5-75 for b&w photos; $50-550 for color photos; negotiable with each photographer. Pays on publication and receipt of invoice. Credit line given. Buys one-time, first-time, book, electronic and all rights; negotiable.

Ⓐ Ⓐ TILBURY HOUSE, PUBLISHERS

2 Mechanic St., #3, Gardiner ME 04345. (207)582-1899. Fax: (207)582-8227. E-mail: tilbury@tilburyhouse.com. Website: www.tilburyhouse.com. **Contact:** Jennifer Bunting, publisher. Subjects include children's books; Maine; ships, boats and canoes. Photos used for text illustrations, book covers. Example of recently published titles: *Sea Soup: Zooplankton* (text illustrations, book cover) by Bill Curtsinger. Catalog available for 6×9 SAE with 55¢ first-class postage.

Making Contact & Terms Pays by the project, or royalties based on book's wholesale price.

$▣ TRAILS MEDIA GROUP, INC.

P.O. Box 317, Black Earth WI 52513. E-mail: kcampbell@wistrails.com. Website: www.wistrails.com. **Contact:** Kathie Campbell, creative director. Estab. 1960. Publishes nonfiction, guide books and various magazines. "Check our website for examples of our products." Photo guidelines free with SASE.

Needs Buys many photos and gives large number of freelance assignments/year. Needs photos of Wisconsin

and the Midwest—nature and historic scenes and activities. Photo captions preferred; include location information and name clearly marked on each photo.

Specs Uses any size transparencies and electronic files.

Making Contact & Terms Send query letter with samples, stock list. Provide résumé to be kept on file for possible future assignments. Responds within 2 months. Simultaneous submissions and previously published work OK. Credit line given. Buys one-time rights.

Tips "See our products and know the types of photos we use."

$⬚ TRAKKER MAPS INC.

8350 Parkline Blvd., Orlando FL 32809. (703)750-0510. Fax: (703)750-3092. E-mail: personnel@trakkermaps. com. Website: www.trakkermaps.com. **Contact:** Oscar Darias, production manager. Estab. 1980. Publishes street atlases and folding maps of Florida and Florida's major cities. Photos used for covers of folding maps and atlas books. Example of recently published titles: *Florida Folding Map* (cover illustration).

Needs Buys 3 photos/year. Looking for photos that illustrate the lifestyle/atmosphere of a city or region (beach, swamp, skyline, etc.). Reviews stock photos of Florida cities.

Specs Uses color prints; 35mm, $2^1/_4 \times 2^1/_4$ transparencies; digital.

Making Contact & Terms Provide résumé, business card, brochure, flier or tearsheets to be kept on file for possible future assignments. Responds in 1 month. Simultaneous submissions and previously published work OK. Pays $150-300 for color photos. **Pays on receipt of invoice**. Credit line sometimes given depending upon request of photographer. Buys all rights.

Tips "We want to see clarity at $4 \times 4^1/_2$ (always vertical) and 6×8 (always horizontal); colors that complement our red-and-yellow cover style; subjects that give a sense of place for Florida's beautiful cities; scenes that draw customers to them and make them want to visit those cities and, naturally, buy one of our maps or atlases to help them navigate. Have patience. We buy few freelance photos, but we do buy them. Let your photos do your talking; don't hassle us. *Listen* to what we ask for. We want eye-grabbing shots that *say* the name of the city. For example, a photo of a polo match on the cover of the West Palm Beach folding map says 'West Palm Beach' better than a photo of palm trees or flamingos."

⬚ ⬚ Ⓐ TRICYCLE PRESS

Ten Speed Press, P.O. Box 7123, Berkeley CA 94707. (510)559-1629. Fax: (510)559-1637. Website: www.tenspeed.com. **Contact:** Nicole Geiger, publisher. Estab. 1993. Publishes children's books, including board books, picture books, and books for middle readers. Photos used for text illustrations and book covers. Example of recently published title: *Busy Doggies* (photography by Beverly Sparks).

Needs Needs photos of children, multicultural, wildlife, performing arts, science.

Specs Uses 35mm transparencies; also accepts images in digital format.

Making Contact & Terms Responds only if interested; send nonreturnable samples. Pays royalties of $7^1/_2$-$8^1/_2$%, based on net receipts.

Tips "Tricycle Press is looking for something outside the mainstream; books that encourage children to look at the world from a different angle. Like its parent company, Ten Speed Press, Tricycle Press is known for its quirky, offbeat books. We publish high-quality trade books."

⬚ ⬚ TRUTH CONSCIOUSNESS/DESERT ASHRAM

3403 W. Sweetwater Dr., Tucson AZ 85745-9301. E-mail: images@truthconsciousness.org (text messages only). Website: www.truthconsciousness.org. **Contact:** Sita Stuhlmiller. Estab. 1974. Publishes books; a periodical: *Light of Consciousness, A Journal of Spiritual Awakening*; and a large-format wall calendar: *Prayer/Meditation*. Example of recently published title: *Retreat into Eternity* (text illustrations).

Needs Buys/assigns about 60 photos/year. "Wants universal spirituality, all traditions that in some way illustrate or evoke upliftment, reverence, devotion or other spiritual qualities. Needs photos of people and ceremonies of all religious traditions in prayer and/or meditation from around the world. Most often chosen are photos with the faces of people showing deep feeling." Art used relates to or supports a particular article. Also wants: babies/children/teens, couples, multicultual, famlies, parents, senior citizens, landscapes/scenics, wildlife, gardening, religious, rural. Interested in fine art. Model release preferred. Photo captions preferred.

Specs Accepts images in digital format for Mac in Photoshop. Send via CD or e-mail at 300 dpi, 150 linescreen.

Making Contact & Terms Send b&w and color slides, cards, prints; include SASE for return of material. Payment negotiable; prefers gratis except for calendar photos. Credit line given; also, artist's name/address/phone (if wished).

TUTTLE PUBLISHING

A member of Periplus Editions, Airport Business Park, 364 Innovation Dr., North Clarenton VT 05759-9436. (800)526-2778. Fax: (802)786-6946. E-mail: info@tuttlepublishing.com. Website: www.tuttlepublishing.com. Estab. 1953 in Japan; 1991 in US. Publishes hardcover and trade paperback originals and reprints. Subjects include cooking, martial arts, interior design, architecture, Eastern religion and philosophy, spirituality. Photos used for text illustrations, promotional materials, book covers, dust jackets. Examples of recently published titles: *Food of Jamaica* (text illustrations); *Shunju: New Japanese Cuisine* (text illustrations); *Contemporary Asian Bedrooms* (cover).

Needs Buys 50 freelance photos/year. Model/property release preferred. Photo captions required; include location, description and some additional information (color).

Specs Uses 35mm, $2^{1}/_{4} \times 2^{1}/_{4}$, 4×5, 8×10 transparencies.

Making Contact & Terms Provide résumé, business card, self-promotion piece or tearsheets to be kept on file for possible future assignments. ''No calls, please.'' Art director will contact photographer for portfolio review if interested. Portfolio should include color tearsheets. Responds only if interested; send nonreturnable samples. Simultaneous submissions and previously published work OK. Payment varies. Buys one-time rights, all rights.

Tips ''For our regional cookbooks, we look for exciting photos that reveal insider familiarity with the place. We are always looking for new interpretations of 'East meets West.' ''

$ $ $▣ ☑ TYNDALE HOUSE PUBLISHERS

351 Executive Dr., Carol Stream IL 60188. Website: www.tyndale.com. **Contact:** Talinda Iverson, art buyer. Estab. 1962. Publishes hardcover and trade paperback originals. Subjects include Christian content. Photos used for promotional materials, book covers, dust jackets. Examples of recently published titles: *The Rising* (book cover); *Red Rock Mysteries*—Youth Fiction Series. Photo guidelines free with #10 SASE.

Needs Buys 5-20 freelance photos/year. Needs photos of babies/children/teens, couples, multicultural, families, parents, senior citizens, landscapes/scenics, cities/urban, gardening, religious, rural, adventure, entertainment. Model/property release required.

Specs Accepts images in digital format.

Making Contact & Terms Send query letter with prints, tearsheets. Provide self-promotion piece to be kept on file for possible future assignments. Responds only if interested; send nonreturnable samples. Simultaneous submissions OK. Pays by the project, $200-1,750 for cover shots; $100-500 for inside shots. **Pays on acceptance.** Credit line given.

Tips ''We don't have portfolio viewings. Negotiations are different for every project. Have every piece submitted with legible contact information.''

$▣ ☑ Ⓐ VICTORY PRODUCTIONS

55 Linden St., Worcester MA 01609. (508)755-0051. Fax: (508)755-0025. E-mail: susan.littlewood@victoryprd.com. Website: www.victoryprd.com. **Contact:** Susan Littlewood. Publishes children's books. Examples of recently published titles: *OPDCA Readers* (text illustrations); *Ecos del Pasado* (text illustrations); *Enciclopedia Puertorriquena* (text illustrations).

Needs Needs a wide variety of photographs. ''We do a lot of production for library reference and educational companies.'' Model/property release required.

Specs Accepts images in digital format. Send via CD, e-mail, floppy disk, Jaz, SyQuest, Zip as TIFF, GIF, JPEG files.

Making Contact & Terms Provide résumé, business card, brochure, flier or tearsheets to be kept on file for possible future assignments. Works on assignment only. Keeps samples on file. Responds in 1-2 weeks. Payment negotiable; varies by project. Credit line usually given, depending upon project. Rights negotiable.

VINTAGE BOOKS

Random House, 1745 Broadway, 20-2, New York NY 10019. (212)572-2444. Fax: (212)572-2662. **Contact:** John Gall, art director. Publishes trade paperback reprints; fiction. Photos used for book covers. Examples of recently published titles: *Selected Stories* by Alice Munro (cover); *The Fight* by Norman Mailer (cover); *Bad Boy* by Thompson (cover).

Needs Buys 100 freelance photos/year. Model/property release required. Photo captions preferred.

Making Contact & Terms Send query letter with samples, stock list. Portfolios may be dropped off every Wednesday. Keeps samples on file. Responds only if interested; send nonreturnable samples. Pays by the

Mary McClean

Freelance art researcher finds
photos for book covers

Browse the aisles of any bookstore these days, and you might be surprised at the wide use of photographs on book covers and jackets. Book publishers have become very creative in their use of photographs: Capturing the shopper's attention with an evocative visual is their goal. If you've ever wondered how to get your images published on a book cover, read on. Mary McClean is a freelance art researcher who works in-house at Vintage/Knopf three days a week, and also freelances for almost all the major U.S. trade book publishers. Her task is to find images for book covers and jackets. While her clients rely on her to find all types of art for their projects, a large proportion of the art she seeks is photography, both old and new. Here she shares her knowledge of how book publishers select images for covers and jackets; what makes a strong book cover image; and how photographers can get their work in front of book publishing decision-makers.

Describe the process of selecting photographs for book covers and jackets.
Either a designer or an art director will ask me for some sort of image for a particular title, based on what they've gleaned from various cover meetings with editors and marketing people. Usually their brief to me is quite concise. I'll have a look around and bring in what I can; they'll try to work with it, and it goes on from there. There could be many phases of re-working a concept (or finding new concepts) before anything actually gets approved by all parties concerned. And things get rejected for all sorts of reasons; you absolutely can't have an ego investment if you do this kind of work. I don't often have to read the book, just listen to what the take is that they want on the cover. Sometimes if I read it myself, I get my own ideas, which may not be at all like the approach they've decided they want to take!

What sources do you use to find photos for book jackets and covers? Do you make assignments or just look at stock images?
A little of everything. I rarely assign photography, although sometimes photographers are nice enough to undertake projects on speculation. I mostly work with photographers whose work I know or I've seen over the years, or I look in stock. I also go to the galleries, and I do portfolio reviews to meet new photographers. I get the fine-art photography magazines; I look at lots and lots of photo books.

Is there a particular style of photography that you or your clients prefer?
Styles come and go. Certain photographic approaches are more in favor at certain times, perhaps. For example, Polaroid transfers, which were the hot thing when I first started doing this over a decade ago, have been so completely out of favor for so long that they

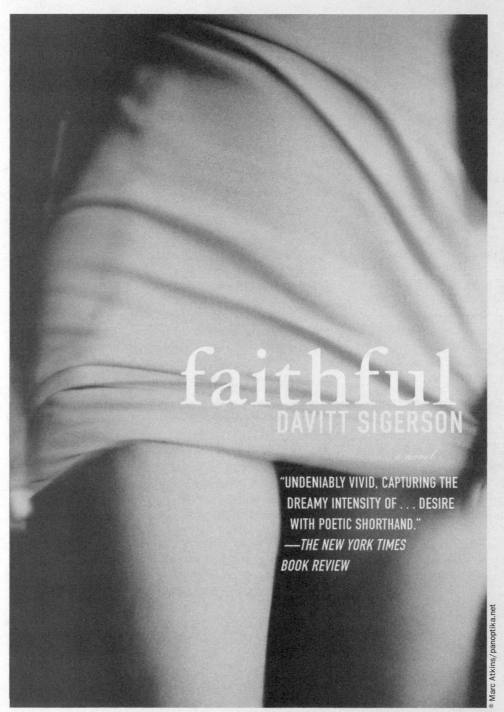

faithful

DAVITT SIGERSON

a novel

"UNDENIABLY VIVID, CAPTURING THE
DREAMY INTENSITY OF . . . DESIRE
WITH POETIC SHORTHAND."
—*THE NEW YORK TIMES
BOOK REVIEW*

© Marc Atkins/panoptika.net

Mary McClean found this image by Marc Atkins on his Web site, www.panoptika.net. It fit the criteria of a good book cover image: a strong graphic impact, some open space for type, and a bit of mystery.

are probably about to become the Next New Thing. Color is very popular now for covers, whereas a few years ago everything was 'fine-art' black & white. Also, different art directors and designers have different styles that they prefer, which you become acquainted with little by little as you work for them.

Do you see trends in the types of photos being used on book covers? Should photographers try to keep up with trends or just do the type of work they like and follow their own vision?

Trends, like styles, come and go. Photographers should definitely follow their own vision, but if they're really interested in doing book covers, then I recommend going to bookstores and taking an in-depth look at what's being used (both on hardback and paperback trade books). Doing that will give the photographer a better orientation than anything.

What makes a strong image for a book cover?

An image that has a strong graphic impact, as well as what I call 'breathing room'—i.e., some open space. Images that are too dense, cluttered or textural not only don't leave room for type, but they tend to contain too much information of their own. A cover image needs to be a bit spare, to hold a bit of mystery. It needs to have room for the viewer to enter in and wonder what that book might contain, and be seduced enough by it to take it all the way to the cash register.

What is the best way for photographers to let you know about their work?

I prefer receiving self-promos in the mail (as opposed to e-mail) that show a representative selection of the photographer's work with a minimum of fuss: I don't need their resumé, or a long explanation of what they were trying to do. I just need to see the work, and if I think it might be appropriate for my purposes I will keep it. When people send me things by e-mail, it's a bit of a problem, as the e-mail box is always overflowing, and often there's just not time to open lots of files and look at them. Of course, people also visit in person to show their portfolios, but I'd advise them to save themselves the trouble, because if we receive something in the mail that looks interesting, we will call that photographer and ask them to come in. We may not call right away, but it could happen down the line.

You've served as a portfolio reviewer at Review Santa Fe and Powerhouse Books. Are portfolio review events valuable experiences for most photographers? Have you found photographers whose work you wanted to use at these reviews?

A portfolio review event is without question a valuable experience for photographers, especially if the review is well organized. Photographers need to be able to know who the reviewers are well in advance, and target which ones they really want to see, and then do everything they can to see those people. But I always warn photographers not to go to these events expecting to come away with a book contract or a gallery show! That is pretty unlikely. They should just go in hopes of meeting a wide range of good people and getting useful insight into their work and possible markets for it. I absolutely have found work at reviews that I've used subsequently— some wonderful discoveries.

—*Donna Poehner*

project, per use negotiation. Pays on publication. Credit line given. Buys one-time and first North American serial rights.

Tips "Show what you love. Include samples with name, address and phone number."

$ ▣ ⋰ VISITOR'S CHOICE MAGAZINE

1155 W. Pender St., Suite 500, Vancouver BC V6E 2P4 Canada. (604)608-5180. Fax: (604)608-5181. E-mail: sackerman@telus.net. Website: www.visitorschoice.com. **Contact:** Shelley Ackerman, art director. Estab. 1977. Publishes full-color visitor guides for 16 communities throughout British Columbia. Photos used for text illustrations, book covers, websites. Photo guidelines available via e-mail upon request.

Needs Looking for photos of attractions, mountains, lakes, views, lifestyle, architecture, festivals, people, sports and recreation, specific to British Columbia region. Specifically looking for "people shots." Model release required; property release preferred. Photo captions required; "detailed but brief."

Specs Uses color prints; 35mm transparencies. Prefers images in digital format.

Making Contact & Terms Send query letter with samples; include SASE for return of material. Works with Canadian photographers. Keeps digital images on file. Responds in 3 weeks. Previously published work OK. Pays $65/color photo for unlimited use of photos purchased. Pays in 30-60 days. Credit line given.

Tips "Please submit photos that are relevant to our needs only. Photos should be specific, clear, artistic, colorful."

$ ▣ ◨ VOYAGEUR PRESS

123 N. Second St., Stillwater MN 55082. Fax: (651)430-2211. E-mail: mlabarre@voyageurpress.com. Website: www.voyageurpress.com. **Contact:** Mary LaBarre, stock photography coordinator. Estab. 1972. Publishes adult trade books, hardcover originals and reprints. Subjects include regional history, nature, popular culture, travel, wildlife, Americana, collectibles, lighthouses, quilts, tractors, barns and farms. Photos used for text illustrations, book covers, dust jackets, calendars. Examples of recently published titles: *Ghost Towns of the Pacific Northwest*, *Baseball . . . The Perfect Game*, *For the Love of Knitting* and *Minnesota Quilts* (text illustrations, book covers, dust jackets). Photo guidelines free with SASE.

Needs Buys 500 photos/year. Wildlife and Americana; also wants environmental, landscapes/scenics, cities/urban, gardening, rural, hobbies, humor, travel, farm equipment, agricultural. Interested in fine art, historical/vintage, seasonal. "Artistic angle is crucial—books often emphasize high-quality photos." Model release required. Photo captions preferred; include location, species, "interesting nuggets," depending on situation.

Specs Uses 35mm, $2\frac{1}{4} \times 2\frac{1}{4}$, 4×5, some 8×10 transparencies. Accepts images in digital format for review only; prefers transparencies for production. Send via CD, Zip, e-mail as TIFF, BMP, GIF, JPEG files at 300 dpi.

Making Contact & Terms Provide résumé of credits, samples, brochure, detailed stock list or tearsheets to be kept on file for possible future assignments. Cannot return material. Responds only if interested; send nonreturnable samples. Simultaneous submissions OK. Pays $300 for cover; $75-175 for inside. Pays on publication. Credit line given, but photographer's website will not be listed. Buys all rights; negotiable.

Tips "We are often looking for specific material (crocodile in the Florida Keys; farm scenics in the Midwest; wolf research in Yellowstone), so subject matter is important. However, outstanding color and angles and interesting patterns and perspectives are strongly preferred whenever possible. If you have the capability and stock to put together an entire book, your chances with us are much better. Though we use some freelance material, we publish many more single-photographer works. Include detailed captioning info on the mounts."

$ $ $ WARNER BOOKS

1271 Avenue of the Americas, 9th Floor, New York NY 10020. (212)522-2842. Fax: (212)522-7993. **Contact:** Anne Twomey, creative director. Publishes "everything but textbooks." Photos used for book covers and dust jackets.

Needs Buys approximately 100 freelance photos/year; offers approximately 30 assignments/year. Needs photos of landscapes, people, food still life, women and couples. Reviews stock photos. Model release required. Photo captions preferred.

Specs Uses color prints/transparencies; also some b&w and hand-tinting.

Making Contact & Terms Provide brochure, flier or tearsheets to be kept on file for possible future assignments. Cannot return unsolicited material. Simultaneous submissions and previously published work OK. Pays $800 minimum for color photos; $1,200 minimum/job. Credit line given. Buys one-time rights.

Tips "Printed and published work (color copies are OK, too) are very helpful. Do not call; we do not remember names—we remember samples. Be persistent."

$ ▣ ☑ ⑤ WAVELAND PRESS, INC.

4180 IL Rt. 83, Suite 101, Long Grove IL 60047-9580. (847)634-0081. Fax: (847)634-9501. E-mail: info@wavel and.com. Website: www.waveland.com. **Contact:** Jan Weissman, photo editor. Estab. 1975. Publishes college textbooks. Photos used for text illustrations, book covers. Examples of recently published titles: *Our Global Environment*, Fifth Edition (text illustrations); *2005 Anthropology Catalog* (book cover).

Needs Number of photos purchased varies depending on type of project and subject matter. Subject matter should relate to college disciplines: criminal justice, anthropology, speech/communication, sociology, archaeology, etc. Needs photos of multicultural, disasters, environmental, cities/urban, education, religious, rural, health/fitness, agriculture, political, technology. Interested in fine art, historical/vintage. Model/property release required. Photo captions preferred.

Specs Uses 5×7, 8×10 glossy b&w prints. Accepts images in digital format. Send via CD, Zip, e-mail as TIFF, EPS, JPEG files at 300 dpi.

Making Contact & Terms Send query letter with stock list. Provide résumé, business card, brochure, flier or tearsheets to be kept on file for possible future assignments. Responds in 1 month. Simultaneous submissions and previously published work OK. Pays $50-200 for cover; $25-100 for color or b&w inside. Pays on publication. Credit line given. Buys one-time and book rights.

Tips "Mail stock list and price list."

$ ▣ ○ ⑤ ⬙ WEIGL EDUCATIONAL PUBLISHERS LIMITED

6325 10th St. SE, Calgary AB T2H 2Z9 Canada. (403)233-7747. Fax: (403)233-7769. E-mail: annalise.bekkering @weigl.com. Website: www.weigl.com. **Contact:** Photo Research Department. Estab. 1979. Publishes textbooks, library and multimedia resources. Subjects include social studies, biography, life skills, environment/ science studies, multicultural, language arts, geography. Photos used for text illustrations, book covers. Examples of recently published titles: *Land Mammals* (text illustrations, book cover); *Fossils* (text illustrations, book cover).

Needs Buys 2,000 photos/year. Needs photos of social issues and events, politics, celebrities, technology, people gatherings, multicultural, architecture, cities/urban, religious, rural, agriculture, disasters, environment, science, performing arts, life skills, landscape, wildlife, industry, medicine, biography and people doing daily activities. Interested in historical/vintage, seasonal. Model/property release required. Photo captions required.

Specs Uses 5×7, 3×5, 4×6, 8×10 color prints (b&w for historical only); 35mm, $2\frac{1}{4} \times 2\frac{1}{4}$ transparencies. Accepts images in digital format. Send via CD, e-mail, FTP as TIFF files at 350 dpi.

Making Contact & Terms Send query letter with stock list. Provide tearsheets to be kept on file for possible future assignments. "Tearsheets or samples that don't have to be returned are best. We get in touch when we actually need photos." Simultaneous submissions and previously published work OK. Pays $0-150 for color cover; $0-50 for color inside. Credit line given (photo credits as appendix). Buys one-time, book and all rights; negotiable.

Tips Needs "clear, well-framed shots that don't look posed. Action, expression, multicultural representation are important, but above all, educational value is sought. People must know what they are looking at. Please keep notes on what is taking place, where and when. As an educational publisher, our books use specific examples as well as general illustrations."

$ $ ▣ ☑ WILLOW CREEK PRESS

P.O. Box 147, Minocqua WI 54548. (715)358-7010. Fax: (715)358-2807. E-mail: info@willowcreekpress.com. Website: www.willowcreekpress.com. **Contact:** Art Director. Estab. 1986. Publishes hardcover, paperback and trade paperback originals; hardcover and paperback reprints; calendars and greeting cards. Subjects include pets, outdoor sports, gardening, cooking, birding, wildlife. Photos used for text illustrations, promotional materials, book covers, dust jackets, calendars and greeting cards. Examples of recently published titles: *Cat Rules* (text illustrations, promotional materials, book cover, dust jacket); *What Dogs Teach Us* (text illustrations, promotional materials, book cover, dust jacket). Catalog free with #10 SASE. Photo guidelines free with #10 SASE or on website.

Needs Buys 2,000 freelance photos/year. Needs photos of gardening, pets, outdoors, recreation, landscapes/ scenics, wildlife. Model/property release required. Photo captions preferred.

Specs Uses 35mm transparencies. Accepts images in digital format. Send via CD. "We prefer slides; there is usually not enough time to review a CD."

Making Contact & Terms Send query letter with sample of work. Provide self-promotion piece to be kept on file. Responds only if interested. "If you send slides, we will return them if a SASE is included." Simultaneous submissions and previously published work OK. Pays by the project. Pays on publication. Credit line given. Buys one-time rights.

Tips "CDs are hard to browse as quickly as a slide sheet or prints. Slides or transparencies are best, as the quality can be assessed immediately. Be patient. Communicate through e-mail."

$ ▣ ◪ ▨ WILSHIRE BOOK COMPANY

12015 Sherman Rd., North Hollywood CA 91605-3781. (818)765-8579. Fax: (818)765-2922. E-mail: mpowers @mpowers.com. Website: www.mpowers.com. **Contact:** Melvin Powers, president. Estab. 1947. Publishes trade paperback originals and reprints. Photos used for book covers. Catalog available for 1 first-class stamp.

Needs Needs photos of horses. Model release required.

Specs Uses 35mm, $2^{1}/_{4} \times 2^{1}/_{4}$, 4×5 transparencies. Accepts images in digital format. Send via floppy disk, e-mail.

Making Contact & Terms Send query letter with slides, prints, transparencies. Portfolio may be dropped off Monday through Friday. Does not keep samples on file; include SASE for return of material. Responds in 6 weeks. Simultaneous submissions and previously published work OK. Pays $100-150 for color cover. **Pays on acceptance**. Credit line given. Buys one-time rights.

Greeting Cards, Posters

& Related Products

The greeting card industry takes in close to $7.5 billion per year—80 percent through the giants American Greetings and Hallmark Cards. Naturally, these big companies are difficult to break into, but there is plenty of opportunity to license your images to smaller companies.

There are more than 2,000 greeting card companies in the United States, many of which produce low-priced cards that fill a niche in the market, focusing on anything from the cute to the risqué to seasonal topics. A number of listings in this section produce items like calendars, mugs and posters, as well as greeting cards.

Before approaching greeting card, poster or calendar companies, it's important to research the industry to see what's being bought and sold. Start by checking out card, gift and specialty stores that carry greeting cards and posters. Pay attention to the selections of calendars, especially the large seasonal displays during December. Studying what you see on store shelves will give you an idea of what types of photos are marketable.

Greetings etc., published by Edgell Publications, is a trade publication for marketers, publishers, designers, and retailers of greeting cards. The magazine offers industry news and information on trends, new products, and trade shows. Look for the magazine at your library; call (973)895-3300, ext. 234 to subscribe, or visit their Web site: www.edgellcommunications. com/Greetings/. Also, the National Stationery Show (www.nationalstationeryshow.com) is a large trade show held every year in New York City. It is the main event of the greeting card industry.

APPROACHING THE MARKET

After your initial research, query companies you are interested in working with and send a stock photo list. (See sample stock list on page 19.) You can help narrow your search by consulting the Subject Index on page 507. Check the index for companies interested in the subjects you shoot.

Since these companies receive large volumes of submissions, they often appreciate knowing what is available rather than actually receiving samples. This kind of query can lead to future sales even if your stock inventory doesn't meet their immediate needs. Buyers know they can request additional submissions as their needs change. Some listings in this section advise sending quality samples along with your query while others specifically request only a list. As you plan your queries, follow the instructions to establish a good rapport with companies from the start.

Some larger companies have staff photographers for routine assignments but also look for freelance images. Usually, this is in the form of stock, and images are especially desirable

if they are of unusual subject matter or remote scenic areas for which assignments—even to staff shooters—would be too costly. Freelancers are usually offered assignments once they have established track records and demonstrated a flair for certain techniques, subject matter or locations. Smaller companies are more receptive to working with freelancers, though they are less likely to assign work because of smaller budgets for photography.

The pay in this market can be quite lucrative if you provide the right image at the right time for a client in need of it, or if you develop a working relationship with one or a few of the better-paying markets. You should be aware, though, that one reason for higher rates of payment in this market is that these companies may want to buy all rights to images. But with changes in the copyright law, many companies are more willing to negotiate sales that specify all rights for limited time periods or exclusive product rights rather than complete surrender of copyright. Some companies pay royalties, which means you will earn the money over a period of time based on the sales of the product.

$ $▣ ◩ ADVANCED GRAPHICS

447 E. Channel Rd., Benicia CA 94510. (707)745-5062. Fax: (707)745-5320. E-mail: licensing@advancedgraph ics.com. Website: www.advancedgraphics.com. **Contact:** Steve Hoagland, vice president of licensing and sales. Estab. 1984. Specializes in life-size standups and cardboard displays, decorations and party supplies.
Needs Buys 20 images/year; number supplied by freelancers varies. Needs photos of celebrities (movie and TV stars, entertainers), babies/children/teens, couples, multicultural, families, parents, senior citizens, wildlife. Interested in seasonal. Reviews stock photos.
Specs Uses 4×5, 8×10 transparencies. Accepts images in digital format. Send via CD, Jaz, Zip, e-mail.
Making Contact & Terms Send query letter with stock list. Keeps samples on file. Responds in 1 month. Pays $400 maximum/image; royalties of 7-10%. Simultaneous submissions and previously published work OK. **Pays on acceptance.** Credit line given. Buys exclusive product rights; negotiable.
Tips "We specialize in publishing life-size standups which are cardboard displays of celebrities. Any pictures we use must show the entire person, head to toe. We must also obtain a license for each image that we use from the celebrity pictured or from that celebrity's estate. The image should be vertical and not too wide."

▣ ◰ ART IN MOTION

2000 Brigantine Dr., Coquitlam BC V3K 7B5 Canada. (604)525-3900 or (800)663-1308. Fax: (604)525-6166 or (877)525-6166. E-mail: artistrelations@artinmotion.com. Website: www.artinmotion.com. **Contact:** Artist Relations. Specializes in open edition reproductions, framing prints, wall decor and licensing.
Needs "We are publishers of fine art reproductions, specializing in the decorative and gallery market. With photography, we often look for alternative techniques such as hand coloring, polaroid transfer, or any process that gives the photograph a unique look."
Specs Accepts unzipped digital images sent via e-mail as JPEG files at 72 dpi.
Making Contact & Terms Submit portfolio for review. Pays royalties of 10%. Royalties paid monthly. "Art In Motion covers all associated costs to reproduce and promote your artwork."
Tips Contact "via e-mail, or direct us to your website; also send slides or color copies of your work (all submissions will be returned)."

▣ ARTVISIONS℠ FINE ART LICENSING

Avidre, Inc., 12117 SE 26th St., Bellevue WA 98005-4118. E-mail: art@artvisions.com. Website: www.artvisio ns.com. **Contact:** Neil Miller, president. Estab. 1993. "ArtVisions provides a broad variety of fine art and photography to licensees worldwide. ArtVisions' website is one of the most popular fine art licensing sites on the Internet—high rankings in Google and other search engines." Specializes in licensing for all markets, including wallcoverings, puzzles, calendars, home décor, dinnerware, giftware, gift wrap, collectibles, home furnishing, children's furnishings, textiles, kitchen accessories, comfort mats, mugs, posters, games, greeting cards, stationery products and limited edition prints.
Making Contact & Terms "There is a one-time set-up fee, paid from your royalty earnings. Commission to ArtVisions is 50%. We prefer that your original work be 4×5, or no smaller than 2¼ square format. First preference for submittal is via e-mail containing a link to a website where your art can be seen. Second preference is via e-mail with a few small samples attached as JPEGs. Third preference is for slides/photos/

tearsheets or brochures via mail, with SASE for return. Always label your materials. We will not respond to mail inquiries that do not include examples of your art.''

Tips ''We do not buy art; we are licensing agents for fine artists and a few very special photographers. Our income is derived from commission from licensing fees we generate for you, so we are very careful about selecting artists for our service. To gain an idea of the type of art we seek, please view our website. Animals, children, people, and pretty places should be generic, rather than readily identifiable (this also prevents potential copyright issues and problems caused by not having personal releases for use of a 'likeness').''

$ $ 🖾 ☑ AVANTI PRESS INC.

6 W. 18 St., 6th Floor, New York NY 10011. (212)414-1025. E-mail: artsubmissions@avantipress.com. Website: www.avantipress.com. **Contact:** Art Submissions. Estab. 1980. Specializes in photographic greeting cards. Photo guidelines free with SASE or on website.

Needs Buys approximately 200 images/year; all are supplied by freelancers. Interested in humorous, narrative, colorful, simple, to-the-point photos of babies, children (4 years old and younger), mature adults, animals (in humorous situations) and exceptional florals. Has specific deadlines for seasonal material. Does NOT want travel, sunsets, landscapes, nudes, high-tech. Reviews stock photos. Model/property release required.

Specs Will work with all mediums and formats. Accepts images in digital format. Send via CD as TIFF, JPEG files.

Making Contact & Terms Request guidelines for submission with SASE or visit website. DO NOT submit original material. Pays on license. Credit line given. Buys 5-year worldwide, exclusive card rights.

🖾 ☑ BENTLEY PUBLISHING GROUP

1410 Lesnick Lane, Walnut Creek CA 94597. (925)935-3186. Fax: (925)935-0213. E-mail: info@bentleypublishinggroup.com. Website: www.bentleypublishinggroup.com. **Contact:** Liz Driscoll, product development coordinator. Estab. 1986. Publishes posters.

Needs Interested in figurative, architecture, cities, urban, gardening, interiors/decorating, rural, food/drink, travel—b&w, color or handtinted photography. Interested in alternative process, avant garde, fine art, historical/vintage. Reviews stock photos and slides. Model/property release required. Include location, date, subject matter or special information.

Specs Mainly uses 16×20, 22×28, 18×24, 24×30, 24×36 color and/or b&w prints; 4×5 transparencies from high-quality photos. Accepts images in digital format. Send via CD as TIFF or JPEG files.

Making Contact & Terms Submit photos or slides for review; include SASE for return of material. ''Do not call.'' Responds in 6 weeks. Simultaneous submissions and previously published work OK. Pays royalties quarterly based upon sales, 10%, plus 50 free posters. Buys exclusive product rights.

Tips ''Send photos/slides with SASE and wait about 6 weeks for response. If we notice something that has been sent may have an immediate need, we will contact photographer soon. Don't call.''

$ 🖾 ☑ �8️ BLUE SKY PUBLISHING

Spectrum Press, P.O. Box 19974, Boulder CO 80308-2974. (303)530-4654. E-mail: BSPinfo@blueskypublishing.net. Website: www.blueskypublishing.net. Estab. 1989. Specializes in fine art and photographic greeting cards.

Needs Buys 12-24 images/year; all are supplied by freelancers. Interested in Rocky Mountain winter landscapes, dramatic winter scenes featuring wildlife in mountain settings, winter scenes from the Southwest, unique and creative Christmas still life images, and scenes that express the warmth and romance of the holidays. Submit seasonal material December-April. Reviews stock photos. Model/property release preferred.

Specs Uses 35mm, 4×5 (preferred) transparencies. Accepts images in digital format.

Making Contact & Terms Submit 24-48 of your best images for review. Provide résumé, business card, self-promotion piece or tearsheets to be kept on file for possible future assignments. ''We try to respond within 1 month, but it could take 2 months.'' Simultaneous submissions and previously published work OK. Pays $150 advance against royalties of 3%. **Pays on acceptance.** Buys exclusive product rights for 5 years; negotiable.

Tips ''Due to the volume of calls we receive from photographers, we ask that you refrain from calling regarding the status of your submission. We will contact you within 2 months to request more samples of your work if we are interested. We do not return unsolicited samples.''

▣ ✐ Ⓐ BON ART/ARTIQUE/ART RESOURCES INT., LTD.

281 Fields Lane, Brewster NY 10509. (845)277-8888. Fax: (845)277-8602. E-mail: robin@fineartpublishers.com. Website: www.fineartpublishers.com. **Contact:** Robin Bonnist, vice president. Estab. 1980. Specializes in posters and open edition fine art prints.

Needs Buys 50 images/year. Needs photos of landscapes/scenics, wildlife, architecture, cities/urban, gardening, interiors/decorating, rural, adventure, health/fitness, extreme sports. Interested in fine art, cutting edge b&w, sepia photography. Model release required. Photo captions preferred.

Specs Uses 35mm, 4×5, 8×10 transparencies. Accepts images in digital format. Send via CD, floppy disk, Zip, e-mail as TIFF, JPEG files at 300 dpi.

Making Contact & Terms Send unsolicited photos by mail with SASE for consideration. Works on assignment only. Responds in 1 month. Simultaneous submissions and previously published work OK. Pays advance against royalties—specific dollar amount is subjective to project. Pays on publication. Credit line given if required. Buys all rights; exclusive reproduction rights.

Tips "Send us new and exciting material; subject matter with universal appeal. Submit color copies, slides, transparencies, actual photos of your work; if we feel the subject matter is relevant to the projects we are currently working on, we'll contact you."

▣ ✐ THE BOREALIS PRESS

P.O. Box 230, Surry Rd. at Wharf, Surry ME 04684. (207)667-3700 or (800)669-6845. Fax. (207)667-9649. E-mail: info@borealispress.net. Website: www.borealispress.net. **Contact:** David Williams or Mark Baldwin. Estab. 1989. Specializes in greeting cards, magnets and "other products for thoughtful people." Photo guidelines available for SASE.

Needs Buys more than 100 images/year; 90% are supplied by freelancers. Needs photos of humor, babies/children/teens, couples, families, parents, senior citizens, adventure, events, hobbies. Interested in documentary, historical/vintage, seasonal. Photos must tell a story. Model/property release preferred.

Specs Uses 5×7 to 8×10 prints; 35mm, 2¼×2¼, 4×5, 8×10 transparencies. Accepts images in digital format. Send via CD, Zip as EPS files at 400 dpi.

Making Contact & Terms Send query letter with slides, prints, photocopies, SASE. "Photographer's name must be on every image submitted." Responds in 2 weeks to queries; 3 weeks to portfolios. Previously published work OK. Pays by the project, royalties. **Pays on acceptance**, receipt of contract. Credit line given.

Tips "Photos should have some sort of story, in the loosest sense. They can be in any form. We do *not* want multiple submissions to other card companies. Include SASE, and put your name on every image you submit."

$ ▣ ✐ Ⓢ BRISTOL GIFT CO., INC.

P.O. Box 425, Washingtonville NY 10992. (845)496-2821. Fax: (845)496-2859. E-mail: bristol6@frontiernet.net. Website: http://bristolgift.net. **Contact:** Matthew Ropiecki, president. Estab. 1988. Specializes in gifts.

Needs Interested in religious, nature, still life. Submit seasonal material 6 months in advance. Reviews stock photos. Model/property release preferred.

Specs Uses 4×5, 8×10 color prints; 4×5 transparencies. Accepts images in digital format. Send via CD, floppy disk, Zip, e-mail as TIFF, JPEG files.

Making Contact & Terms Send query letter with samples. Keeps samples on file. Responds in 1 month. Previously published work OK. Pays $50-200/image. Buys exclusive product rights.

Ⓝ ▣ ☒ CANADIAN ART PRINTS

110-6311 Westminster Hwy., Richmond BC V7C 4V4 Canada. (604)276-4551. Fax: (604)276-4552. E-mail: thanus@canadianartprints.com. Website: www.canadianartprints.com. **Contact:** Theresa Hanus, artist relations coordinator. Specializes in open edition prints and art cards.

Needs Other specific photo needs: florals, botanicals, European landmarks (e.g., Eiffel Tower), street scenes, café scenes, vintage themes, coastal or beach themes.

Specs Uses 11×14 glossy or matte color and/or b&w prints; 35mm, 2¼×2¼, 4×5, 8×10 transparencies. Accepts images in digital format. Send via CD.

Making Contact & Terms Send query letter with résumé, slides, prints, photocopies, tearsheets, transparencies. Provide résumé, business card, self-promotion piece to be kept on file for possible future assignments. Responds in 2 months to queries.

$ ▣ ◯ CENTRIC CORPORATION

6712 Melrose Ave., Los Angeles CA 90038. (323)936-2100. Fax: (323)936-2101. E-mail: centric@juno.com. Website: www.centriccorp.com. **Contact:** Sammy Okdot, president. Estab. 1986. Specializes in gift products: gifts, t-shirts, clocks, watches, pens, mugs, frames.

Needs Needs photos of celebrities, environmental, wildlife, humor. Interested in humor, nature and thought-provoking images. Submit seasonal material 5 months in advance. Reviews stock photos.

Specs Uses 8×12 color and/or b&w prints; 35mm transparencies. Accepts images in digital format. Send via CD as JPEG files.

Making Contact & Terms Submit portfolio for review or query with résumé of credits. Provide résumé, business card, self-promotion piece or tearsheets to be kept on file for possible future assignments. Responds in 2 weeks. Works mainly with local freelancers. Pays by the job; negotiable. **Pays on acceptance.** Rights negotiable.

$☐ ⑤ THE CHATSWORTH COLLECTION

51 Bartlett Ave., Pittsfield MA 01201. (413)443-0973. Fax: (413)445-5014. E-mail: mark@chatsworthcollectio n.com. Website: www.chatsworthcollection.com. **Contact:** Mark Brown, art director. Estab. 1950. Specializes in greeting cards, stationery.

Needs Buys 80 images/year; 2-3 are supplied by freelancers. Needs photos of babies/children/teens, couples, multicultural, families, parents, senior citizens. Other specific photo needs: "We use photos only for our sample holiday photocards. We need good 'family' pictures. We will reprint ourselves. Will pay small fee for one-time use." Submit seasonal material 8 months in advance. Model/property release required.

Specs Uses 4×6 prints.

Making Contact & Terms Send query letter with slides, prints, photocopies, tearsheets. Does not keep samples on file; include SASE for return of material. Responds only if interested; send nonreturnable samples. Simultaneous submissions and previously published work OK. Pays on publication. Credit line given. Buys one-time rights.

$▣ COMSTOCK CARDS

600 S. Rock Blvd., Suite 15, Reno NV 89502. (775)856-9400. Fax: (775)856-9406. E-mail: info@comstockcards .com. Website: www.comstockcards.com. **Contact:** Andy Howard, production assistant. Estab. 1986. Specializes in greeting cards, invitations, notepads, games, gift wrap. Photo guidelines free with SASE.

Needs Buys/assigns 30-40 images/year; all are supplied by freelancers. Wants wild, outrageous and shocking adult humor; seductive images of men or women. Definitely does not want to see traditional, sweet, cute, animals or scenics. "If it's appropriate to show your mother, we don't want it!" Frontal nudity in both men and women is OK and now being accepted as long as it is professionally done—no snapshot from home. Submit seasonal material 10 months in advance. Model/property release required. Photo captions preferred.

Specs Uses 5×7 color prints; 35mm, $2\frac{1}{4} \times 2\frac{1}{4}$ color transparencies. Accepts images in digital format.

Making Contact & Terms Send query letter with samples, tearsheets, SASE. Responds in 2 months. Pays $50-150 for color photos. Pays on publication. Buys all rights; negotiable.

Tips "Submit with SASE if you want material returned."

$▣ ⊘ ⑤ CONCORD LITHO

92 Old Turnpike Rd., Concord NH 03301. (603)225-3328 or (800)258-3662. Fax: (603)225-5503. E-mail: info@concordlitho.com. Website: www.concordlitho.com. **Contact:** Art Librarian. Estab. 1958. Specializes in bookmarks, greeting cards, calendars, postcards, stationery and gift wrap. Photo guidelines free with SASE.

Needs Buys 150 images/year; 50% are supplied by freelancers. Rarely offers assignments. Needs photos of nature, seasonal, domestic animals, dogs and cats, religious, inspirational, florals and scenics. Also considers babies/children, multicultural, families, gardening, rural, business concepts, fine art. Submit seasonal material minimum 6-8 months in advance. Does not want nudes, comedy or humorous—nothing wild or contemporary. Model/property release required for historical/nostalgia, homes and gardens, dogs and cats. Photo captions preferred; include accurate information pertaining to image (location, dates, species, etc.).

Specs Uses 8×10 satin color prints; 35mm, $2\frac{1}{4} \times 2\frac{1}{4}$, 4×5, 8×10 transparencies. Accepts images in digital format. Send via CD, e-mail as TIFF, EPS, PICT, GIF, JPEG files at 300 dpi.

Making Contact & Terms Submit samples/dupes for review along with stock list. Keeps samples/dupes on file. Response time may be as long as 6 months. Simultaneous submissions and previously published work OK. Pays by the project, $50-800. Pays on usage. Credit line sometimes given depending upon client and/or product. Buys one-time rights.

Tips "Send nonreturnable samples/color copies demonstrating skill and creativity, along with a complete-as-possible stock list. No phone calls, please."

DELJOU ART GROUP

1616 Huber St., Atlanta GA 30318. (404)350-7190. Fax: (404)350-7195. E-mail: submit@deljouartgroup.com. Website: www.deljou.com. **Contact:** Daniel Deljou, president. Estab. 1980. Specializes in wall decor, fine art.

Needs All images supplied by freelancers. Specializes in artistic images for reproduction for high-end art market. Work sold through art galleries as photos or prints. Needs nature photos. Reviews stock photos of graphics, b&w photos.

Specs Uses color and/or b&w prints; 35mm, 2¼×2¼, 4×5, 8×10 transparencies.

Making Contact & Terms Submit portfolio for review; include SASE for return of material. Also send portfolio via e-mail. Responds in 1 month. Simultaneous submissions and previously published work OK. Pays royalties on sales. Credit line sometimes given depending upon the product. Rights negotiable.

Tips "Abstract-looking photographs OK. Hand-colored b&w photographs needed."

▣ DESIGN DESIGN, INC.

P.O. Box 2266, Grand Rapids MI 49501. (616)774-2448. Fax: (616)774-4020. **Contact:** Tom Vituj, creative director. Estab. 1986. Specializes in greeting cards and paper-related product development.

Needs Licenses stock images from freelancers and assigns work. Specializes in humorous topics. Submit seasonal material 1 year in advance. Model/property release required.

Specs Uses 35mm transparencies. Accepts images in digital format. Send via Zip.

Making Contact & Terms Submit portfolio for review. Provide résumé, business card, self-promotion piece or tearsheets to be kept on file for possible future assignments. Do not send original work. Pays royalties. Pays upon sales. Credit line given.

$ $ $▣ ◿ DLM STUDIO

2563 Princeton Rd., Cleveland Heights OH 44118. (216)881-8888, ext. 100. Fax: (216)274-9308. E-mail: pat@dlmstudio.com. Website: www.dlmstudio.com. **Contact:** Pat Walker, owner. Estab. 1984. Specializes in CD-ROMs, decorations, housewares, posters, wallpaper, murals. Photo guidelines available.

Needs Buys 100 images/year; 50% are supplied by freelancers. Needs photos of architecture, interiors/decorating, religious. Interested in fine art, historical/vintage. Model release preferred. Photo captions preferred.

Specs Uses 9×12 matte prints; 35mm, 8×10 transparencies. Accepts images in digital format. Send via CD, Zip as TIFF files at 300 dpi.

Making Contact & Terms Send query letter with résumé, prints, photocopies. Portfolio may be dropped off every Monday. Provide résumé, business card, self-promotion piece to be kept on file for possible future assignments. Responds in 2 months to queries; 1 month to portfolios. Responds only if interested; send nonreturnable samples. Simultaneous submissions and previously published work OK. Pays by the project, $200-1,500/image; negotiable for licensing of existing room photography—residential or commercial. **Pays on receipt of invoice.** Credit line sometimes given depending upon relationship and previous success. Buys one-time rights "for our industry only;" negotiable.

Tips Uses photographs for advertising, catalogs, sample books, online.

▣ Ⓐ DODO GRAPHICS INC.

P.O. Box 585, Plattsburgh NY 12901. (518)561-7294. Fax: (518)561-6720. **Contact:** Frank How, president. Estab. 1979. Specializes in posters and framing prints.

Needs Buys 50-100 images/year; 100% are supplied by freelancers. Offers 25-50 assignments/year. Needs all subjects. Submit seasonal material 3 months in advance. Reviews stock photos. Model/property release preferred. Photo captions preferred.

Specs Uses color and/or b&w prints; 35mm, 4×5 transparencies; CD-ROMs.

Making Contact & Terms Submit portfolio for review. Send query letter with samples and stock list or CD-ROMs. Works on assignment only. Keeps samples on file. Responds in 1 month. Simultaneous submissions OK. Payment negotiable. **Pays on acceptance.** Credit line given. Buys all rights; negotiable.

$▣ ◿ Ⓢ DYNAMIC GRAPHICS

6000 Forest Park Dr., Peoria IL 61614. (309)687-0261. Fax: (309)688-8515. E-mail: mistic@dgusa.com. Website: www.dgusa.com. **Contact:** Jim Mistic, content director. Estab. 1964. Specializes in monthly photo and illustration services on CD and Internet. Photo guidelines available at www.liquidelibrary.com or free with SASE.

Greeting Cards

Needs Buys 1,200 or more images/year; 100% are supplied by freelancers. Interested in holiday and seasonal, retail and model-released people photos. Submit seasonal material 6 months in advance. Not interested in copyrighted material (logos, etc.). Subjects include babies/children/teens, couples, multicultural, families, parents, senior citizens, environmental, wildlife, architecture, cities/urban, education, gardening, pets, religious holidays, adventure, automobiles, food/drink, health/fitness/beauty, hobbies, humor, sports, travel, agriculture, business concepts, industry, medicine, military, political, product shots/still life, science, technology/computers. Model/property release required for all identifiable people and private property.

Specs Uses 35mm, $2^1/_4 \times 2^1/_4$ transparencies. Accepts images in digital format. Send via CD, DVD, Jaz, Zip as JPEG files at 300 dpi, RGB, 30-50MB minimum.

Making Contact & Terms ''Send an intro letter with samples of your work via mail or e-mail with a request for guidelines.'' Content director will contact photographer for portfolio review if interested. Portfolio should include color slides, transparencies or digital files. Does not keep samples on file; include SASE for return of material. Responds in 3 weeks to queries; 1 month to samples. Pays by the project, $100-125/image. **Pays on receipt of invoice.** Credit line not given. Buys 5-year exclusive license—converts to nonexclusive after.

Tips ''Stock-quality photos are an important part of our monthly services, and we have a constant need for high-quality, fresh and innovative images.''

▣ ⊘ ⑤ FOTOFOLIO, INC.

561 Broadway, New York NY 10012. (212)226-0923. Fax: (212)226-0072. e-mail submissions@fotofolio.com. Website: www.fotofolio.com. **Contact:** Editorial Department. Estab. 1976. Specializes in greeting cards, postcards, postcard books, books, posters, stationery, T-shirts, notecards. ''Fotofolio's line of over 5,000 images comprises the complete history of photography and includes the work of virtually every major photographer, from past masters such as Walker Evans, Berenice Abbott, Brassai, Philippe Halsman and Paul Strand to contemporary artists including William Wegman, Richard Avedon, Andres Serrano, Cindy Sherman, Herb Ritts and Sandy Skoglund.'' Photo guidelines free with SASE.

Needs Needs photos of babies/children/teens, celebrities, couples, multicultural, families, parents, senior citizens, cities/urban, pets, automobiles, entertainment, events, humor, performing arts, travel. Interested in alternative process, avant garde, fashion/glamour, fine art, historical/vintage. Specializes in humorous, seasonal material. Submit seasonal material 9 months in advance. Reviews stock photos. Photo captions required; include name, date and title.

Specs Uses up to 11×14 color and/or b&w prints; 35mm, $2^1/_4 \times 2^1/_4$, 4×5, 8×10 transparencies. Accepts images in digital format. Send link to website.

Making Contact & Terms Send for guidelines. Do not submit original materials. Does not keep samples on file. Responds only if interested. Simultaneous submissions and previously published work OK. Pays royalties. Pays on usage. Credit line given. Buys exclusive product rights (only for that item—e.g., postcard rights).

▣ FRONT LINE ART PUBLISHING

The Art Publishing Group, 165 Chubb Ave., Lyndhurst NJ 07071. (800)760-3058. E-mail: frontline@theartpublishinggroup.com. Website: www.frontlineartpublishing.com. **Contact:** Artist Submissions. Specializes in posters, prints.

Needs Chooses 100-150 images/year; all are supplied by freelancers. Interested in ''dramatic,'' sports, landscaping, animals, contemporary, b&w, hand-tinted and decorative images. Reviews stock photos of sports and scenic. Model release required. Photo captions preferred.

Specs Uses color and/or b&w prints; 35mm, $2^1/_4 \times 2^1/_4$, 4×5, 8×10 transparencies. Accepts images in digital format. Send JPEG files for review to submitart@theartpublishinggroup.com.

Making Contact & Terms Send query letter with samples, brochure, stock list, tearsheets. Art director will contact photographer for portfolio review if interested. Portfolio should include b&w and color, prints, tearsheets, slides, transparencies or thumbnails. Include SASE for return of unsolicited material. Responds in 1 month to queries. Pays on publication. Credit line given. Rights negotiable.

$ $▣ ⊘ ⑤ GALLANT GREETINGS CORP.

P.O. Box 308, Franklin Park IL 60131. (847)671-6500. Fax: (847)233-2499. E-mail: joanlackouitz@gallantgreetings.com. Website: www.gallantgreetings.com. **Contact:** Joan Lackouitz, vice president, product development. Estab. 1966. Specializes in greeting cards.

Needs Buys vertical images; all are supplied by freelancers. Needs photos of landscapes/scenics, wildlife, gardening, pets, religious, automobiles, humor, sports, travel, product shots/still life. Interested in alternative

process, avant garde, fine art. Submit seasonal material 1 year in advance. Model release required. Photo captions preferred.

Specs Accepts images in digital format. Send via CD, e-mail as TIFF files at 300 dpi.

Making Contact & Terms Send query letter with photocopies. Provide self-promotion piece to be kept on file for possible future assignments. Responds in 3 weeks. Send nonreturnable samples. Pays by the project, approximately $300/image. **Pays on receipt of invoice**. Buys US greeting card rights; negotiable.

▣ ◯ Ⓢ GANGO EDITIONS

351 NW 12th Ave., Portland OR 97209. (503)223-9694. Fax: (503)223-0925. E-mail: jackie@gangoeditions.com. Website: www.gangoeditions.com. **Contact:** Jackie Gango. Estab. 1977. Specializes in reproductions.

Needs Buys 50 images from freelancers/year. Interested in fine art.

Specs Uses any size matte prints; 4×5 transparencies. Accepts images in digital format. Send via CD, e-mail.

Making Contact & Terms Send query letter with slides. Does not keep samples on file; include SASE for return of material. Responds in 2 months. Pays royalties.

Tips "We use fine art photographs. To be competitive in our market, the work must be unique, not commercial looking. We publish transfer and manipulated work."

▣ ◑ ⊕ GB POSTERS LTD.

1 Russell St., Kelham Island, Sheffield S3 8RW United Kingdom. (44)(0114)292-0088. Fax: (44)(0114)272-9599. E-mail: heather@gbposters.com. Website: www.gbposters.com. **Contact:** Heather Fenwick, licensing assistant. Estab. 1985. Specializes in posters, postcards, and special edition prints.

Needs Needs photos of celebrities, multicultural, disasters, environmental, landscapes/scenics, wildlife, cities/urban, rural, adventure, automobiles, entertainment, humor, performing arts, sports, travel. Interested in avant garde, fashion/glamour, fine art. Model/property release required.

Specs Uses A4 or larger glossy or matte color and/or b&w prints. Accepts images in digital format. Send via CD, Jaz, Zip as TIFF, PICT, BMP, GIF, JPEG, EPS files at 300 dpi minimum.

Making Contact & Terms Send query letter with slides, prints, photocopies, transparencies, stock list. Provide self-promotion piece to be kept on file for possible future assignments. Responds "as soon as possible." Simultaneous submissions and previously published work OK. Payment negotiable. Credit line given depending upon agreement stipulation. Rights negotiable.

Tips "When sending in material, make sure your personal details (i.e., name, address, contact number, etc.) are included."

Ⓝ ◑ Ⓐ GRAPHIC ARTS CENTER PUBLISHING CO.

P.O. Box 10306, Portland OR 97296-0306. (503)226-2402, ext. 306. Fax: (503)223-1410. Website: www.gacpc.com. "We are an independent book packager/producer."

Needs Photos of environment, regional, landscapes/scenics. "We only publish regionally focused books and calendars." Photo captions required.

Specs Contact the editorial assistant at the phone number above to receive permission to send in a submission. Upon acceptance, send bio, samples, 20-40 transparencies that are numbered, labeled with descriptions and verified in a delivery memo, return postage or a filled-out FedEx form. Responds in up to 4 months. Uses transparencies of any format, 35mm, 2¼×2¼, 4×5, but must be tack sharp and possess high reproductive quality; or submit equivalent digital files. "Our books/calendars usually represent one photographer. We use only full-time, professional photographers and/or well-established photographic businesses. New calendar/book proposals must have large market appeal and/or have corporate sale possibilities as well as fit our company's present focus."

$◑ RAYMOND L. GREENBERG ART PUBLISHING

116 Costa Rd., Highland NY 12528-2400. (845)469-6699. Website: www.raymondlgreenberg.com. **Contact:** Ray Greenberg, owner. Estab. 1995. Specializes in posters. Photo guidelines free with SASE.

Needs Buys 100 images/year; all are supplied by freelancers. Needs photos of yoga and spiritual themes; Black ethnic images. Interested in fine art. Submit seasonal material 7 months in advance. Reviews stock photos. Model release preferred. Photo captions preferred.

Specs Uses 35mm, 2¼×2¼, 4×5, 8×10 transparencies.

Making Contact & Terms Send query letter with samples, brochure, stock list, tearsheets. Provide résumé, business card, self-promotion piece or tearsheets to be kept on file for possible future assignments. Art director will contact photographer for portfolio review if interested. Responds in 3 weeks to queries; 6 weeks

© 2006 Howard Ande

After consulting the Web site of Graphic Arts Center Publishing Co., Howard Ande followed their guidelines for submission. This image, which comes from Ande's extensive stock file on Chicago, was used in a calendar. "Calendar and postcard companies want readily identifiable images of a particular city or area with a few unusual shots included. Try to shoot the area's icon in a different way to make it interesting. Try different angles, different times of day, different lighting situations," he advises.

to samples. Pays by the project, $50-200/image, or pays advance of $50-100 plus royalties of 5-10%. **Pays on acceptance.** Credit line sometimes given depending on photographer's needs. Buys all rights; negotiable. **Tips** "Be patient in awaiting answers on acceptance of submissions."

▣ HEALTHY PLANET PRODUCTS PUBLISHING, INC.
51 Moraga Way, Suite 204, Orinda CA 94563. (800)426-6210, ext. 102. E-mail: graphics@healthyplanet.com. Website: www.healthyplanet.com. **Contact:** Photo Submissions. Specializes in greeting cards and gift products such as magnets, journals, gift bags and address books. Photo guidelines available on website.

Needs "We have expanded several of our Healthy Planet lines. Our National Wildlife Federation line of wildlife and wilderness cards are a new line for us, and we continue to look for more shots to expand this line. Wildlife in pairs, interacting in a nonthreatening manner are popular, as well as dramatic shots of man in nature. Non-West Coast shots are always in demand, as well as nonsnow images that could be used in our Christmas line. Our underwater line, Marine Mammal Center, is comprised of only sea-related shots. The Center for the Reproduction of Endangered Species line of cards and gifts features images of baby animals. Vibrant colors are a real plus. Sea mammals are very popular." Submit seasonal material 1 year in advance; all-year-round review; "include return postage."

Specs Uses 35 mm, 2¼×2¼, 4×5 transparencies. Accepts images in digital format. Send via e-mail, CD as TIFF files at 300 dpi minimum (CMYK).

Making Contact & Terms Submit digital images as specified above, or send transparencies by mail. Include SASE for return. "Due to insurance requirements, we cannot accept responsibility for original transparencies, so we encourage you to submit duplicates. Should we select a shot from your original submission for further review, we will at that time request the original and accept responsibility for that original up to $1,500 per transparency." Responds in 6 weeks. Simultaneous submissions and previously published work OK. Buys 3-year, worldwide greeting card rights, which include online sales of greeting cards; separate fees for other rights. "We do not pay research fees." Buys exclusive product rights. Credit line given.

Greeting Cards

Tips "Please limit submissions for our Healthy Planet line to your best 200-250 shots. A portion of the proceeds from the sales of our lines goes to environmentally conscious organizations."

🖼 ⊘ ⑤ IMAGE CONNECTION AMERICA, INC.

456 Penn St., Yeadon PA 19050. (610)626-7770. Fax: (610)626-2778. E-mail: sales@imageconnection.biz. **Contact:** Michael Markowicz, president. Estab. 1988. Specializes in postcards, posters, bookmarks, calendars, giftwrap, greeting cards.

Needs Wants contemporary photos of babies/children/teens, celebrities, families, pets, entertainment, humor. Interested in alternative process, avant garde, documentary, erotic, fashion/glamour, fine art, historical/vintage. Model release required. Photo captions preferred.

Specs Uses 8×10 b&w prints; 35mm transparencies. Accepts images in digital format. Send via floppy disk, Zip as TIFF, EPS, PICT files.

Making Contact & Terms Send query letter with samples and SASE. Payment negotiable. Pays quarterly or monthly on sales. Credit line given. Buys exclusive product rights; negotiable.

🖼 ⊘ ⑤ IMPACT PHOTOGRAPHICS

4961 Windplay Dr., El Dorado Hills CA 95762. (916)939-9333. Fax: (916)939-9334. Website: www.impactpho tographics.com. Estab. 1975. Specializes in calendars, postcards, magnets, bookmarks, mugs, CD-ROMs, posters, books for the tourist industry. Photo guidelines and fee schedule free with SASE.

- This company sells to specific tourist destinations; their products are not sold nationally. They need material that will be sold for at least a 5-year period.

Needs Buys stock. Buys 3,000 photos/year. Needs photos of wildlife, scenics, US travel destinations, national parks, theme parks and animals. Submit seasonal material 4-5 months in advance. Model/property release required. Photo captions preferred.

Impact Photographics used Russell Anderson's photo of cherry blossoms as a postcard. Anderson warns photographers not to become discouraged if they do not make sales right away. "For every photograph that is published, there are hundreds upon hundreds that were not chosen. Even with those odds, photo buyers are always looking for fresh, new images," he says.

Specs Uses 35mm, 2¼×2¼, 4×5, 8×10 transparencies. Accepts images in digital format. Send via CD, Zip as TIFF, JPEG files at 350 dpi.

Making Contact & Terms "Must have submissions request before submitting samples. No unsolicited submissions." Send query letter with stock list. Provide business card, self-promotion piece or tearsheets to be kept on file for possible future assignments. Responds in 1 month. Simultaneous submissions and previously published work OK. Request fee schedule; rates vary by size. Pays on usage. Credit line and printed samples of work given. Buys one-time and nonexclusive product rights.

$ $▣ ☑ Ⓐ INSPIRATIONART & SCRIPTURE

P.O. Box 5550, Cedar Rapids IA 52406. (319)365-4350. Fax: (319)861-2103. E-mail: charles@inspirationart.com. Website: www.inspirationart.com. **Contact:** Charles Edwards. Estab. 1996. Specializes in Christian posters (all contain scripture and are geared toward teens and young adults). Photo guidelines free with SASE or on website.

Needs Buys 25-40 images/year; all are supplied by freelancers. Needs photos of babies/children/teens, celebrities, couples, multicultural, families, parents, senior citizens, cities/urban, gardening, pets, rural, adventure, events, food/drink, health/fitness, hobbies, humor, performing arts, sports, political, science, technology/computers. Interested in alternative process, avant garde, documentary, fashion/glamour, fine art, historical/vintage, seasonal. "All images must be able to work with scripture." Submit seasonal material 6 months in advance. Reviews stock photos. Model/property release required.

Specs Uses 35mm, 2¼×2¼, 4×5, 8×10 transparencies. Prefers 2¼×2¼ or 4×5 but can work with 35mm. ("We go up to 24×36.") Accepts images in digital format. Send via CD, SyQuest, floppy disk, Jaz, Zip, e-mail as TIFF, EPS, JPEG files.

Making Contact & Terms Send query letter with samples, SASE. Works with local freelancers on assignment only. Keeps samples on file. Responds in 4 months. Art acknowledgment is sent upon receipt. Pays by the project, $150-400/image; royalties of 5%. Pays on usage. Credit line given. Buys exclusive rights to use as a poster only.

Tips "Photographers interested in having their work published by InspirationArt & Scripture should consider obtaining a catalog of the type of work we do prior to sending submissions. Also, remember that we review art monthly; please allow 90 days for returns."

$ $▣ INTERCONTINENTAL LICENSING

176 Madison Ave., New York NY 10016. (212)683-5830. Fax: (212)779-8564. E-mail: intertg@intercontinental-ltd.com. Website: www.intercontinental-ltd.com. **Contact:** Thea Groene, creative director. Estab. 1967. Represents artists in 50 countries, with clients specializing in greeting cards, calendars, postcards, posters, art prints, stationery, gift wrap, giftware, decorations, mugs, school supplies, food tins, and puzzles. Sells reproduction rights of designs to publishers/manufacturers.

Needs Seeking a collection of 20-50 photos and/or digital images. Graphics, occasions (i.e., Christmas, baby, birthday, valentine/flowers, wedding), "soft-touch" romantic themes, flowers and still lifes, studio photography, animals (domestic, barnyard, wildlife). No nature, landscape. Accepts seasonal material any time. Model release preferred.

Specs Uses slides; 4×5, 8×10 transparencies. Accepts images in digital format.

Making Contact & Terms Send query letter with samples via CD or e-mail. Provide résumé, business card, brochure, flier or tearsheets to be kept on file for possible future assignments. Upon request, submit portfolio for review. Simultaneous submissions and previously published work OK. Pays on publication. Credit line not given. Buys one-time rights and exclusive product rights.

Tips In photographer's portfolio samples, wants to see "a neat presentation, perhaps thematic in arrangement. We don't buy much photography, but it pays to be persistent. Just keep sending samples until something catches my eye."

$ $▣ JILLSON & ROBERTS

3300 W. Castor St., Santa Anna CA 92704-3908. (714)424-0111. Fax: (714)424-0054. E-mail: shawn@jillsonroberts.com. Website: www.jillsonroberts.com. **Contact:** Shawn K. Doll, creative director. Estab. 1974. Specializes in gift wrap, totes, printed tissues, accessories. Photo guidelines free with SASE.

Needs Needs vary. Specializes in everyday and holiday products. Themes include babies, sports, pets, seasonal, weddings. Submit seasonal material 3-6 months in advance.

Making Contact & Terms Submit portfolio for review or query with samples. Provide résumé, business card,

self-promotion piece or tearsheets to be kept on file for possible future assignments. Responds in 3 weeks. Pays average flat fee of $250 or royalties.

Tips "Please follow our guidelines!"

$ $ 🖻 🖰 BRUCE MCGAW GRAPHICS, INC.

389 W. Nyack Rd., West Nyack NY 10994. (845)353-8600. Fax: (845)353-8907. E-mail: acquisitions@bmcgaw .com. Website: www.bmcgaw.com. **Contact:** Katy Murphy, product development manager. Estab. 1979. Specializes in posters, framing prints, wall decor.

Needs 250-300 images in a variety of media are licensed/year; 10-15% in photography. Interested in b&w: still life, floral, figurative, landscape. Color: landscape, still life, floral. Also considers celebrities, environmental, wildlife, architecture, rural, fine art, historical/vintage. Does not want images that are too esoteric or too commercial. Model/property release required for figures, personalities, images including logos or copyrighted symbols. Photo captions required; include artist's name, title of image, year taken. Not interested in stock photos.

Specs Uses color and/or b&w prints; 35mm, $2\frac{1}{4} \times 2\frac{1}{4}$, 4×5, 8×10 transparencies. Accepts images in digital format at 300 dpi.

Making Contact & Terms Submit portfolio for review. "Review is typically 2 weeks on portfolio drop-offs. Be certain to leave phone number for pick up." Provide résumé, business card, self-promotion piece or tearsheets to be kept on file for possible future assignments. "Do not send originals!" Responds in 1 month. Simultaneous submissions and previously published work OK. Pays royalties on sales. Pays quarterly following first sale and production expenses. Credit line given. Buys exclusive product rights for all wall decor.

Tips "Work must be accessible without being too commercial. Our posters/prints are sold to a mass audience worldwide who are buying art prints. Images that relate a story typically do well for us. The photographer should have some sort of unique style or look that separates him from the commercial market. It is important to take a look at our catalog or website before submitting work to get a sense of our aesthetic. You can view the catalog in any poster shop. We do not typically license traditional stock-type images—we are a decorative house appealing to a higher-end market. Send your best work (20-60 examples)."

$ $ 🖻 🖰 MODERNART EDITIONS

The Art Publishing Group, 165 Chubb Ave., Lyndhurst NJ 07071. (201)842-8500. E-mail: DebraLisovsky@the artpublishinggroup.com. Website: www.modernarteditions.com. **Contact:** Debra Lisovsky, publisher. Specializes in posters, wall decor, open edition fine art prints.

Needs Interested in b&w or sepia tone, seasonal, landscapes, seascapes, European scenes, floral still lifes, abstracts, cities, gardening, sports, fine art. Model/property release required.

Specs Uses 8×10 color and/or b&w prints; 35mm, $2\frac{1}{4} \times 2\frac{1}{4}$, 4×5 transparencies; 35mm slides. Accepts images in digital format. Send via e-mail as JPEG files.

Making Contact & Terms Submit portfolio for review. Keeps samples on file. Simultaneous submissions OK. Pays advance of $100-300 plus royalties of 10%. Pays on usage. Credit line given. Buys one-time, all, and exclusive product rights.

Tips "Submit 35mm slides for our review with SASE. We respond back to artist within 2 months."

🖻 🖰 NEW YORK GRAPHIC SOCIETY PUBLISHING GROUP

129 Glover Ave., Norwalk CT 06850-1311. (800)677-6947. Fax: (203)846-2105. E-mail: patty@nygs.com. Website: www.nygs.com. **Contact:** Patty Sechi, art director. Estab. 1925. Specializes in fine art reproductions, prints, posters.

Needs Buys 150 images/year; 125 are supplied by freelancers. "Looking for variety of images."

Specs Uses 4×5 transparencies. Accepts images in digital format. Send via Zip, e-mail.

Making Contact & Terms Send query letter with samples to Attn: Artist Submissions. Does not keep samples on file; include SASE for return of material. Responds in 1 month. Payment negotiable. Pays on usage. Credit line given. Buys exclusive product rights.

Tips "Submissions sent with cover letter, SASE, samples of work (prints, brochures, transparencies) are best. Images must be color correct."

$ $ 🖻 🖰 NORS GRAPHICS

P.O. Box 143, Woolwich ME 04579. (207)442-7237. Fax: (207)442-8904. E-mail: norsman@care2.com. Website: www.norsgear.com. **Contact:** Alexander Bridge, publisher. Estab. 1982. Specializes in posters, stationery products, greeting cards, limited edition prints, T-shirts.

Needs Buys 6 images/year; 50% are supplied by freelancers. Offers 2 assignments/year. Needs photos of sports. Interested in rowing/crew and sailing. Submit seasonal material 6-12 months in advance. Does not want only rowing photos. Reviews stock photos of sports. Model release required. Photo captions preferred.
Specs Uses 4×5 transparencies. Accepts images in digital format. Send via CD, Zip.
Making Contact & Terms Send query letter with samples. Keeps samples on file. Responds in 3 weeks. Pays by the project, $100-750/image plus royalties of 5-20%. Pays on usage. Credit line given. Buys all rights.

$ ▣ ◑ NOVA MEDIA INC.

1724 N. State St., Big Rapids MI 49307-9073. (231)796-4637. E-mail: trund@netonecom.net. Website: www.n ovamediainc.com. **Contact:** Thomas J. Rundquist, president. Estab. 1981. Specializes in CD-ROMs, CDs/ tapes, games, limited edition plates, posters, school supplies, T-shirts. Photo guidelines free with SASE.
Needs Buys 100 images/year; most are supplied by freelancers. Offers 20 assignments/year. Seeking art fantasy photos. Needs photos of babies/children/teens, celebrities, multicultural, families, landscapes/sce- nics, education, religious, rural, entertainment, health/fitness/beauty, military, political, technology/com- puters. Interested in documentary, erotic, fashion/glamour, fine art, historical/vintage. Submit seasonal ma- terial 2 months in advance. Reviews stock photos. Model release required. Photo captions preferred.
Specs Uses color and/or b&w prints. Accepts images in digital format. Send via CD, floppy disk as JPEG files.
Making Contact & Terms Send query letter with samples and SASE. Responds in 1 month. Simultaneous submissions and previously published work OK. Payment negotiable. Pays extra for electronic usage of photos. Pays on usage. Credit line given. Buys electronic rights; negotiable.
Tips "The most effective way to contact us is by e-mail or regular mail."

▣ PALM PRESS, INC.

1442A Walnut St., Berkeley CA 94709. (510)486-0502. Fax: (510)486-1158. E-mail: theresa@palmpressinc.c om. Website: www.palmpressinc.com. **Contact:** Theresa McCormick, assistant art director. Estab. 1980. Specializes in greeting cards. Photo guidelines available on website.
Needs Buys only photographic images from freelancers. Buys 200 images/year. Wants photos of humor, nostalgia; unusual, interesting, original b&w or color images for all occasions including Christmas and Valen- tine's Day. Submit seasonal material 1 year in advance. Model/property release required.
Specs Uses prints, slides, transparencies. Accepts images in digital format. Send via e-mail as small JPEG, TIFF files.
Making Contact & Terms "SASE must be included for work to be returned." Responds in 3-4 weeks. Pays royalties on sales. Credit line given.

▣ ◑ PAPER PRODUCTS DESIGN

60 Galli Dr., Novato CA 94949. (415)883-1888. Fax: (415)883-1999. E-mail: carol@paperproductsdesign.com. Estab. 1992. Specializes in napkins, plates, candles, porcelain.
Needs Buys 500 images/year; all are supplied by freelancers. Needs photos of babies/children/teens, architec- ture, gardening, pets, food/drink, humor, travel. Interested in avant garde, fashion/glamour, fine art, histori- cal/vintage, seasonal. Submit seasonal material 6 months in advance. Model release required. Photo captions preferred.
Specs Uses glossy color and/or b&w prints; 35mm, 2¼×2¼, 4×5, 8×10 transparencies. Accepts images in digital format. Send via Zip, e-mail at 350 dpi.
Making Contact & Terms Send query letter with photocopies, tearsheets. Responds in 1 month to queries, only if interested. Simultaneous submissions and previously published work OK.

▣ PORTAL PUBLICATIONS LTD.

201 Alameda del Prado, #200, Novato CA 94949. (800)227-1720 or (415)884-6200. Fax: (415)382-3377. Web- site: www.portalpub.com. **Contact:** Andrea Smith, senior art director. Estab. 1954. Specializes in greeting cards, calendars, posters, wall decor, and framed prints. Photo guidelines free with SASE.
Needs Gives up to 400 or more assignments/year. Contemporary photography (florals, landscapes, b&w and hand-tinted b&w); nostalgia, nature and wildlife, endangered species, humorous, animal photography, sce- nic, inspirational, tinted b&w children's photography, still life, garden themes and dance; sports, travel, food and youth-oriented popular icons such as celebrities, movie posters and cars. "Nothing too risqué." Reviews stock photos. Model release required. Photo captions preferred.

Making Contact & Terms "No submission will be considered without a signed guidelines form, available on our website at www.portalpub.com/contact/ArtistSubmissionForm.pdf."

Tips "Ours is an increasingly competitive business, so we look for the highest quality and most unique imagery that will appeal to our diverse market of customers."

$ ◪ ⑤ PORTFOLIO GRAPHICS, INC.

P.O. Box 17437, Salt Lake City UT 84117. (801)424-2574. E-mail: info@portfoliographics.com. Website: www.nygs.com. **Contact:** Kent Barton, creative director. Estab. 1986. Publishes and distributes open edition fine art prints and posters.

Needs Buys 100 images/year; nearly all are supplied by freelancers. Seeking creative, fashionable, and decorative art for commercial and designer markets. Clients include galleries, designers, poster distributors (worldwide), and framers. For posters, "keep in mind that we need decorative art that can be framed and hung in home or office." Submit seasonal material on an ongoing basis. Reviews stock photos. Photo captions preferred.

Specs Uses prints; 4×5 transparencies, digital files.

Making Contact & Terms Send photos, transparencies, tearsheets, or gallery booklets with SASE. Does not keep samples on file; must include SASE for return of material. Art director will contact photographer for portfolio review if interested. Responds in 3 months. Pays royalties of 10% on sales. Semi-annual royalties paid per pieces sold. Credit line given. Buys exclusive product rights license per piece.

Tips "We find artists through galleries, magazines, art exhibits, and submissions. We are looking for a variety of artists, styles and subjects that are fresh and unique."

$ $ ▣ ◪ POSTER PORTERS

P.O. Box 9241, Seattle WA 98109-9241. (206)286-0818 or (800)531-0818. Fax: (206)286-0820. E-mail: markwithposterporters@msn.com. Website: www.posterporters.com. **Contact:** Mark Simard, marketing director. Estab. 1982. Specializes in gifts, mugs, posters, stationery, T-shirts.

Needs Buys 20 images/year; 15 are supplied by freelancers. Mainly interested in the US West Coast—landscapes/scenics, mountains, lighthouses, cities, cats, fine art, b&w photo transfers.

Specs Accepts images either digitally or as fliers, slides, etc.

Making Contact & Terms Send query letter with samples, tearsheets. Keeps samples on file. Responds only if interested; send nonreturnable samples. Pays by the project, $350-700/image. Buys one-time rights; negotiable.

$ $ ▣ ◪ ⋮ POSTERS INTERNATIONAL

1200 Castlefield Ave., Toronto ON M6B 1G2 Canada. (416)789-7156. Fax: (416)789-7159. E-mail: info@postersinternational.net. Website: www.postersinternational.net. **Contact:** Mitch Ostapchuk, creative director. Estab. 1976. Specializes in posters/prints. Photo guidelines available.

Needs Buys 200 images/year. Needs photos of landscapes/scenics, architecture, cities/urban, rural, hobbies, sports, travel. Interested in alternative process, avant garde, fine art, historical/vintage. Interesting effects, Polaroids, painterly or hand-tinted submissions welcome. Submit seasonal material 2 months in advance. Model/property release preferred. Photo captions preferred; include date, title, artist, location.

Specs Uses 8×10 prints; 2¼×2¼, 4×5, 8×10 transparencies. Accepts images in digital format. Send via CD, Zip, e-mail as TIFF, JPEG files at 600 dipi.

Making Contact & Terms Send query letter with résumé, slides, prints, photocopies, tearsheets, transparencies, stock list. Provide business card, self-promotion piece to be kept on file for possible future assignments. Responds in 2 weeks to queries; 5 weeks to portfolios. Simultaneous submissions OK. Pays advance of $200 minimum/image plus royalties of 10% minimum. **Pays on acceptance**. Pays on publication. Buys worldwide rights for approximately 4-5 years to publish in poster form. Slides will be returned.

Tips "Keep all materials in contained unit. Provide easy access to contact information. Provide any information on previously published images. Submit a number of pieces. Develop a theme (we publish in series of 2, 4, 6, etc.). Black & white performs very well. Vintage is also a key genre; sepia great, too. Catalog is published with supplement 2 times/year. We show our images in our ads, supporting materials and website."

$ $ ◪ RECYCLED PAPER GREETINGS, INC.

Art Dept., 3636 N. Broadway, Chicago IL 60613-4488. (773)348-6410 or (800)777-9494. Website: www.recycled.com. **Contact:** Gretchen Hoffman, art director. Estab. 1971. Specializes in greeting cards. Photo guidelines available on website.

Needs Buys 200-400 images/year. Wants "primarily humorous photos for greeting cards. Unlikely subjects and offbeat themes have the best chance, but we'll consider all types. Text ideas required with all photo submissions." Needs photos of babies/children/teens, landscapes/scenics, wildlife, pets, humor. Interested in alternative process, fine art, historical/vintage, seasonal. Model release required.

Specs Uses b&w and/or color prints; b&w and/or color contact sheets. "Please do not submit slides, disks or original photos."

Making Contact & Terms Send for artists' guidelines or visit website. Include SASE with submissions for return of material. Responds in 2 months. Simultaneous submissions OK. Pays $250/b&w or color photo, some royalty contracts. **Pays on acceptance.** Credit line given. Buys card rights.

Tips Prefers to see "up to 10 samples of photographer's best work. Cards are printed in 5×7 format. Please include messages."

$ $▣ ☑ ⑤ REIMAN MEDIA GROUP, INC.

5400 S. 60th St., Greendale WI 53129. Fax: (414)423-8463. E-mail: tbellin@reimanpub.com. Website: www.reimanpub.com. **Contact:** Trudi Bellin, photo coordinator. Estab. 1965. Specializes in calendars and occasionally posters and cards. Photo guidelines free with SASE.

● Also publishes magazines, several of which are listed in the Consumer Publications section of this book.

Needs Buys more than 450 images/year; all are supplied by freelancers. Interested in humorous cow and pig photos as well as scenic North American country images including barns, churches, cabins, waterfalls and lighthouses. Needs photos of landscapes/scenics, gardening, rural, travel, agriculture. Also needs backyard and flower gardens; wild birds, song birds (especially cardinals), hummingbirds; North American scenics by season; kittens and puppies. Interested in seasonal. Unsolicited calendar work must arrive between September 1-15. No smoking, drinking, nudity. Reviews stock photos. Model/property release required. Photo captions required; include season, location; birds and flowers must include common and/or scientific names.

Specs Uses color transparencies, all sizes. Accepts images in digital format. Prefers you set up lightboxes for review, but accepts files via CD or DVD with printed thumbnails and caption sheets. Comp high-res files must be available. Published at 300 dpi.

Making Contact & Terms Send query letter with résumé of credits, stock list. Tearsheets are kept on file but not dupes. Responds in 3 months for first review. Simultaneous submissions and previously published work OK. Pays $25-400/image. Pays on publication. Credit line given. Buys one-time rights.

Tips "Contribute to the magazines first. Horizontal format is preferred for calendars. The subject of the calendar theme must be central to the photo composition. All projects look for technical quality. Focus has to be sharp (no soft focus), and colors must be vivid so they 'pop off the page.'"

$ $▣ ⑤ RIGHTS INTERNATIONAL GROUP

453 First St., Hoboken NJ 07030. (201)239-8118. Fax: (201)222-0694. E-mail: rhazaga@rightsinternational.com. Website: www.rightsinternational.com. **Contact:** Robert Hazaga, president. Estab. 1996. Licensing agency specializing in the representation of photographers and artists to manufacturers for licensing purposes. Manufacturers include greeting card, calendar, poster and home furnishing companies.

Needs Needs photos of architecture, entertainment, humor, travel, floral, coastal. Globally influenced—not specific to one culture. Moody feel. See website for up-to-date needs. Reviews stock photos. Model/property release required.

Specs Uses prints, slides, transparencies. Accepts images in digital format. Send via CD, e-mail as JPEG files.

Making Contact & Terms Submit portfolio for review. Keeps samples on file. Responds in 2 weeks. Simultaneous submissions and previously published work OK. Payment negotiable. Pays on license deal. Credit line given. Buys exclusive product rights.

$☑ ROSE PUBLISHING, INC.

4733 Torrance Blvd., #259, Torrance CA 90503. (310)370-7152. Fax: (310)370-7492. Website: www.rose-publishing.com. **Contact:** Jeff Shaw or Sergio Urquiza. Estab. 1991. Specializes in visual aids and reference charts for Sunday schools, Christian schools, churches, libraries.

Needs Buys 24 photos from freelancers/year. Needs photos of major religions and religious groups: headquarters, leaders, documents, symbols, history, statues. Bible lands: archaeology, Christianity, Israel, Turkey, Greece, Iraq, Iran, Egypt. Model release required. Photo captions required; include subject and location, any significant historical or archaeological information.

Specs "We prefer to flip through color photocopies that we can keep on file indefinitely. If we are interested in a particular photo, we will request a slide or scan."

Making Contact & Terms ''Send query letter with color photocopies (9 to a page is fine) of images in our interest area.'' Responds only if interested; send nonreturnable samples. Simultaneous submissions and previously published work OK. Pays on publication. Credit line given (name only). Buys all rights. ''When we produce a teaching aid, we need to have the option to release it in print or PowerPoint, other electronic media, or some other language.''

⊠ $⊟◌⊠⊕ SANGHAVI ENTERPRISES PVT. LTD.

D-24, M.I.D.C., Satpur, Nasik 422 007 India. (91)(253)235-0181. Fax: (91)(253)235-1381. E-mail: seplnsk@sa ncharnet.in. **Contact:** H.L. Sanghavi, managing director. Estab. 1974. Specializes in greeting cards, calendars, school supplies, stationery.

Needs Buys approximately 50 images/year. Needs photos of babies/children/teens, couples, landscapes/ scenics, wildlife, gardening, pets. Interested in erotic. No graphic illustrations. Submit seasonal material anytime throughout the year. Reviews stock photos.

Specs Uses any size color prints. Accepts images in digital format.

Making Contact & Terms Send query letter with samples. Responds in 1 month. Previously published work OK. Pays $30 maximum for color photos. Credit line given. Pays on publication.

Tips In photographer's samples, ''quality of photo is important. Prefer nonreturnable copies; no originals, please. Send us duplicate photos, not more than 10 for selection.''

⊟⊕ SANTORO GRAPHICS LTD.

Rotunda Point, 11 Hartfield Crescent, Wimbledon, London SW19 3RL United Kingdom. (44)(208)781-1100. Fax: (44)(208)781-1101. E-mail: elevy@santorographics.com. Website: www.santorographics.com and www .santoro.co.uk. **Contact:** Ellie Levy, art director's assistant. Specializes in greeting cards, gift stationery, giftwrap, party supplies, school supplies.

Needs Needs photos of babies/children, couples, people, pets, humor, unusual, retro and nostalgia. Interested in fine art. Wants ''humorous, cute and unusual images of animals and people. Do not submit seasonal material; we do not print it.''

Specs Uses glossy prints and 35mm transparencies. Accepts images in digital format. Send via CD or e-mail at 300 dpi.

Making Contact & Terms Send query letter with résumé, slides, prints, photocopies. Does not keep samples on file; include SASE for return of material. **Pays on receipt of invoice.** Credit line not given. Rights and fees determined by negotiation.

$ $⊟ ◪ SPENCER GIFTS, LLC

6826 Black Horse Pike, Egg Harbor Twp. NJ 08234-4197. (609)645-5526. Fax: (609)645-5797. E-mail: james.st evenson@spencergifts.com. Website: www.spencergifts.com. **Contact:** James Stevenson, senior graphic artist. Estab. 1965. Specializes in packaging design, full-color art, novelty gifts, brochure design, poster design, logo design, promotional P.O.P.

Needs Needs photos of babies/children/teens, couples, jewelry (gold, sterling silver, body jewelry—earrings, chains, etc.). Interested in fashion/glamour. Model/property release required. Photo captions preferred.

Specs Uses transparencies. Accepts images in digital format. Send via CD, DVD at 300 dpi.

Making Contact & Terms Send inquiry letter with photocopies. Portfolio may be dropped off any weekday, 9-5. Provide self-promotion piece to be kept on file for possible future assignments. Responds only if interested; send *only* nonreturnable samples. Pays by the project, $250-850/image. **Pays on receipt of invoice.** Buys all rights; negotiable. Will respond upon need of services.

NEIL SULIER PHOTOGRAPHY

PMB-55, 3735 Palomar Centre, Suite 150, Lexington KY 40513-1147. (859)621-5511 or (800)230-8199. E-mail: info@neilsulier.com. Website: www.neilsulier.com. **Contact:** Neil Sulier, president. Estab. 1969. Specializes in art prints, wedding and event photography.

Making Contact & Terms Does not accept stock photography images. Publishes fine-art prints only.

$ $⊟ SYRACUSE CULTURAL WORKERS

P.O. Box 6367, Syracuse NY 13217. (315)474-1132. Fax: (877)265-5399. E-mail: studio@syrculturalworkers.c om. Website: www.syrculturalworkers.com. **Contact:** Karen Kerney, art director. Publisher: Dik Cool. ''Syracuse Cultural Workers publishes and distributes peace and justice resources through their Tools For Change catalog. Produces posters, notecards, postcards, greeting cards, T-shirts, and calendars that are feminist,

progressive, radical, multicultural, lesbian/gay allied, racially inclusive, and honoring of elders and children.'' Photo guidelines available on website or free with SASE.

Needs Buys 15-25 freelance images/year. Needs photos of social content reflecting a consciousness of diversity, multiculturalism, community building, social justice, environment, liberation, etc. Interested in alternative process, documentary, historical/vintage. Model release preferred. Photo captions preferred.

Specs Uses any size transparencies. Accepts images in digital format. ''Send low-resolution images for review.''

Making Contact & Terms Send unsolicited photos by mail for consideration; include SASE for return of material. Responds in 4 months. Pays flat fee of $85-450; royalties 4-6% of gross sales. Credit line given. Buys one-time rights.

Tips ''We are interested in photos that reflect a consciousness of peace and social justice; that portray the experience of people of color, the disabled, elderly, gay/lesbian—must be progressive, feminist, nonsexist. Look at our catalog (available for $1 or on website) and understand our philosophy and politics. Send only what is appropriate and socially relevant. We are looking for positive, upbeat, and visionary work.''

$⊘ ⑤ ✉ TELDON PRINT MEDIA

A Division of Teldon International Inc., 3500 Viking Way, Richmond BC V6V 1N6 Canada. (604)273-4500, ext. 266. Fax: (604)272-9774. E-mail: photo@teldon.com. Website: www.teldon.com. **Contact:** Photo Editor. Estab. 1968. Publishes high-quality dated and nondated promotional products, including wall calendars, desk calendars, magnets, etc. Photo guidelines free with SAE (9×11) and IRCs or Canadian stamps—waiting list applies.

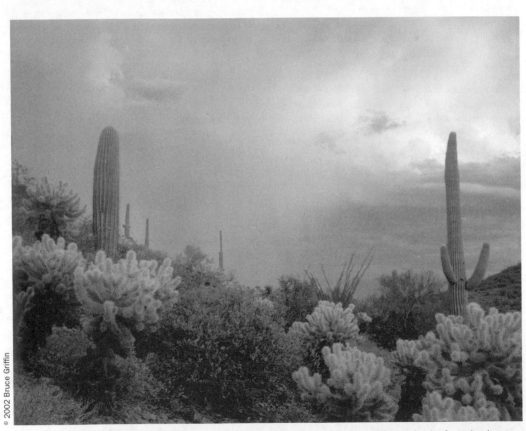

© 2002 Bruce Griffin

Teldon Print Media published Bruce Griffin's photo of a summer storm near Tucson in a calendar featuring images of Arizona. Teldon likes sharp images with color that is characteristic of the state being featured. Griffin says this shot is a classic for the region and its summer storm season. He adds, ''My bottom line is an appreciation of nature. I allow the time to work and execute well technically; the rest takes care of itself.''

Needs Buys over 1,000 images/year; 70% are supplied by freelancers. Needs photos of babies/children/teens, couples, multicultural, families, parents, senior citizens, wildlife (North American), architecture (exterior residential homes), gardening, interiors/decorating, adventure, sports, travel (world), motivational, inspirational, and landscape/scenic. Reviews stock photos. Model/property release required for trademarked buildings, residential houses, people. Photo captions required; include complete detailed description of destination, i.e., Robson Square, Vancouver, British Columbia, Canada (month picture taken also helpful).

Specs Uses 35mm, medium- and large-format (horizontal only) transparencies. "We make duplicates of what we think is possible material and return the originals within a given time frame. Originals are recalled once final selection has been made. We do not accept digital submissions at this time."

Making Contact & Terms Send query letter or e-mail. "No submissions accepted unless guidelines have been received and reviewed." Include SAE and IRCs for return of material. Responds in 1 month, depending on workload. Simultaneous submissions and previously published work OK. Works with freelancers and stock agencies. Pays $150 for one-time use. Pays in September of publication year. Credit line and complementary calendar copies given. Photos used for one-time use in calendars, North American rights, unlimited print runs.

Tips Send horizontal transparencies only; dramatic and colorful nature/scenic/wildlife shots. City shots to be no older than 1 year. "Examine our catalogs, flyers and website carefully, and you will see what we are looking for."

$ $▣ ⊘ ⑤ TIDE-MARK PRESS

P.O. Box 20, 176 Broad St., Windsor CT 06095. (860)683-4499, ext. 107. Fax: (860)683-4055. E-mail: heather@tide-mark.com. Website: www.tidemarkpress.com. **Contact:** Heather Carreiro, acquisitions editor. Estab. 1979. Specializes in calendars. Photo guidelines available on website or free with SASE.

Needs Buys 1,200 images/year; 800 are supplied by freelancers. Needs photos of landscapes/scenics, wildlife, architecture, gardening, interiors/decorating, pets, religious, adventure, automobiles, entertainment, events, food/drink, health/fitness, hobbies, humor, performing arts, sports, travel. Interested in fine art, historical/vintage. Needs complete calendar concepts that are unique but also have identifiable markets; groups of photos that could work as an entire calendar; ideas and approach must be visually appealing and innovative but also have a definable audience. No general nature or varied subjects without a single theme. Submit seasonal material 18 months in advance. Reviews stock photos. Model release preferred. Photo captions required.

Specs Uses 35mm, 2¼×2¼, 4×5, 8×10 transparencies. Accepts images in digital format. Send as EPS or JPEG files.

Making Contact & Terms "Offer specific topic suggestions that reflect specific strengths of your stock." Send query letter with sample images; include SASE for return of material. Editor will contact photographer for portfolio review if interested. Responds in 3 months. Pays $150-350/color image for photos; royalties on net sales if entire calendar supplied. Pays on publication or per agreement. Credit line given. Buys one-time rights.

Tips "We tend to be a niche publisher and rely on niche photographers to supply our needs. Ask for a copy of our guidelines and a copy of our catalog so that you will be familiar with our products. Then send a query letter of specific concepts for a calendar."

$ $▣ ⊘ VAGABOND CREATIONS, INC.

2560 Lance Dr., Dayton OH 45409. (937)298-1124. E-mail: vagabondcreations@sbcglobal.net. Website: www.vagabondcreations.com. **Contact:** George F. Stanley, Jr., president. Specializes in greeting cards.

Needs Buys 3 images/year. Interested in general Christmas scenes (nonreligious). Submit seasonal material 9 months in advance. Reviews stock photos.

Specs Uses 35mm transparencies. Accepts images in digital format.

Making Contact & Terms Send query letter with stock list, SASE. Responds in 1 week. Simultaneous submissions OK. Pays by the project, $200-250/image. **Pays on acceptance**. Buys all rights.

$▣ ⊘ WISCONSIN TRAILS

Trails Media Group, P.O. Box 317, Black Earth WI 53515. (608)767-8000. Fax: (608)767-5444. E-mail: info@wistrails.com. Website: www.wistrails.com. **Contact:** Kathie Campbell, creative director. Estab. 1960. Specializes in calendars (horizontal and vertical) portraying seasonal scenics, some books and activities from Wisconsin.

Chris Heisey

Civil War photographer
pursues his passion

C hris Heisey's passion for the Civil War was kindled in 1972 when, as a second grader, he visited the Gettysburg National Military Park for the first time. "I never forgot the immensity of the place," he says of the historic battlefield. Thirty-five years later, Heisey is known as America's most-published Civil War photographer and supplies all the images for Tide-Mark's Civil War calendar. His career as a Civil War photographer began in 1990 when Ken Burns' PBS Civil War series inspired him to get up at 4 o'clock on a September morning and head for Gettysburg, a half-hour drive from his home. "I shot a tremendous sunrise," he says. "I was hooked."

When Heisey first contacted Tide-Mark with a query letter and a few samples of his work, they had been publishing a Civil War calendar for a number of years with another photographer. Heisey told Tide-Mark he could improve the calendar by matching the photos to the seasons better: snow scenes for winter, and colorful explosions of foliage for fall. At that point, Heisey still had to build a substantial file of images. "I was honest with them up front," he says, "and our relationship has always been solid because they trust what I say."

According to Heisey, it is tough to break into the calendar market, but it can be done. He recommends sending high-quality inkjet prints to introduce your work to calendar publishers. "A few years ago I would have said send slides to a prospective publisher, but now I think sending prints or tearsheets works better," says Heisey. "I have found that sending digital modes such as CD, DVD or the like, is not well received yet. That will probably change in a few years as younger editors and new creative directors assume more control of the creative process."

Heisey believes snow scenes are a good way for photographers to distinguish themselves. "There's a level of dedication that is just intrinsically communicated with a winter image. It tells an editor that you show up when others don't, which is a good quality for a photographer to have, especially if you are going to do niche work," he says.

"A simple query letter and some samples of my work have worked many times," says Heisey, "but you still fail more than you succeed. You just have to handle rejection and move forward." Heisey recommends diversifying marketing efforts. In addition to creating all the images for Tide-Mark's calendar, he supplies calendar publisher Teldon International with a number of single images every year. Heisey also publishes his Civil War photos in markets that are not dedicated to the Civil War. For example, a bucolic scene of a battlefield may not be recognizable as a battlefield, and so may be used in many types of publications. Heisey's photos have been published in 85 different publications.

Although Heisey believes inkjet prints make an impressive presentation when first con-

tacting publishers, he still uses slide film when shooting for calendars. "Slide film will always be magic to me," he says. "I have never been one to send duplicate slides because they just don't pop like masters. So I try to create in-camera dupes as much as possible." Heisey says filters give his photographs their impact. "I have only six filters in my bag, mostly a variety of polarizers and neutral density filters, but these filters make my work." Heisey suggests experimenting with combinations of filters under various conditions. "The best way to learn is to get out and shoot and try," he says. "Experience is everything, especially when the weather is poor or the lighting is fluid." Heisey believes you don't need a lot of expensive equipment to make quality images for the calendar market. "Even in digital, you can do amazing things with a little more than $1,000," he says.

Heisey believes that great light is what makes a good calendar image. "If you shoot a scene with wonderful light, you have a chance to publish it as long as the composition and subject matter are average. Superior light will always rule the day," he says.

Combining writing with photography has been a satisfying aspect to publishing the Tide-Mark calendar. "The calendar is not only 13 images every year, it is also a historical writing opportunity," says Heisey. A 500-word essay accompanies each photo. For example, an image of barley ripening in a field at Gettysburg sparks an essay on the diets of the soldiers. In addition to the calendar, Heisey has also published a book, *Getttysburg: This Hallowed Ground*, with Tide-Mark Press. Heisey felt honored to provide the photographs that accompany the poetry of noted Civil War author Kent Gramm. Says Heisey, "I always tell my

© Chris Heisey

Chris Heisey believes snow and winter scenes show that the photographer is a go-getter, one who will be out shooting when others won't. Heisey shot "Pickett's Charge," featured in Tide-Mark's Civil War calendar, during an ice storm at Gettysburg.

"Rest in Peace" was shot in the Harrisburg Cemetery in Harrisburg, PA. Chris Heisey is fortunate to live within easy driving distance of many of the great Civil War battlefields of the east, including Gettysburg.

fellow photographers when I do public speaking to shoot for a book because someday it will be published." Gramm and Heisey have also recently collaborated on a book about Antietam.

Heisey says he still makes plenty of technical mistakes, but he rarely makes the mistake of not showing up. "Being there, 'getting off the bench,' as I call it, is so important to good photography," says Heisey. "Every year 2.5 million people visit Gettysburg. On a nice summer day, there are people everywhere with cameras and tripods. But on a snowy day when travel is hazardous or when the mercury dips to minus 10, I rarely see people out shooting. But I am there. I know I am feeding my niche by being there and showing up when others don't. Super Bowl Sunday at 6 p.m. is a wonderful time to shoot at Gettysburg. The place is empty. You are alone and your niche is working to provide a little income that will help some day down the road."

—Donna Poehner

selections in January for calendars, 6 months ahead for issues. Photo captions required.

Specs Uses 35mm, 2¼×2¼, 4×5 transparencies. Accepts images in digital format. Send via CD, Zip, Jaz as TIFF, EPS files at 300-1,250 dpi.

Making Contact & Terms Submit material by mail with SASE for consideration. Responds in 1 month. Simultaneous submissions OK "if we are informed, and if there's not a competitive market among them." Previously published work OK. Pays $50-100 for b&w photos; $50-200 for color photos. Buys one-time rights.

Tips "Be sure to inform us how you want materials returned and include proper postage. Calendar scenes must be horizontal to fit 8½×11 format, but we also want vertical formats for engagement calendars. See our magazine and books and be aware of our type of photography. Submit only Wisconsin scenes. Call for an appointment."

$ $▣ ⊘ ZOLAN FINE ARTS, LLC

70 Blackman Rd., Ridgefield CT 06877. (203)431-1629. Fax: (203)431-2629. E-mail: donaldz798@aol.com. Website: www.zolan.com. **Contact:** Jennifer Zolan, president/art director. Commercial and fine art business. Photos used for artist reference in oil paintings.

Needs Buys 16-24 images/year; assignments vary with need. Needs candid, heartwarming and endearing photos of children (ages 1-2) with high emotional appeal, capturing the magical moments of early childhood. Interested in seasonal. "We are looking for Caucasion, Hispanic, Asian, and African-American kids in the following scenes: boys in country scenes with John Deere tractors, boys on the farm, boys fishing/hunting, girls at the beach, boys playing sports, children with pets, little girls in gardens and English garden scenes, little girls as Angels." Reviews stock photos. Model release preferred.

Specs Uses any size color and/or b&w prints; 35mm, $2^{1}/_{4} \times 2^{1}/_{4}$, 4×5, 8×10 transparencies. Accepts images in digital format. Send via e-mail, CD, Zip as TIFF, EPS, PICT, GIF, JPEG files at 300 dpi.

Making Contact & Terms Send for photo guidelines by phone, mail, fax or e-mail. Does not keep samples on file; include SASE for return of material. Responds in 2 months to queries. Pays $100-1,000 depending on the extent of photo shoot and if backgrounds are part of the assignment shoot. **Pays on acceptance**.

Tips "Photos should have high emotional appeal and tell a story. Photos should look candid and natural. Call or write for free photo guidelines before submitting your work. We are happy to work with amateur and professional photographers. We are always looking for human interest types of photographs on early childhood, ages 1-2. Photos should evoke pleasant and happy memories of early childhood. Photographers can phone, write, e-mail or fax for guidelines before submitting their work. No submissions without receiving the guidelines."

Stock Photo Agencies

If you are unfamiliar with how stock agencies work, the concept is easy to understand. Stock agencies house large files of images from contracted photographers and market the photos to potential clients. In exchange for licensing the images, agencies typically extract a 50-percent commission from each use. The photographer receives the other 50 percent.

In recent years, the stock industry has witnessed enormous growth, with agencies popping up worldwide. Many of these agencies, large and small, are listed in this section. However, as more and more agencies compete for sales, there has been a trend toward partnerships among some small to mid-size agencies. In order to match the file content and financial strength of larger stock agencies, such as Corbis and Getty, small agencies have begun to combine efforts when putting out catalogs and other promotional materials.

Other agencies have been acquired by larger agencies and essentially turned into subsidiaries. Often these subsidiaries are strategically located to cover different portions of the world. Typically, smaller agencies are bought if they have images that fill a need for the parent company. For example, a small agency might specialize in animal photographs and be purchased by a larger agency that needs those images but doesn't want to search for individual wildlife photographers.

The stock industry is extremely competitive, and if you intend to sell stock through an agency, you must know how they work. Below is a checklist that can help you land a contract with an agency:

- Build a solid base of quality images before contacting any agency. If you send an agency 50-100 images, they are going to want more if they're interested. You must have enough quality images in your files to withstand the initial review and get a contract.
- Be prepared to supply new images on a regular basis. Most contracts stipulate that photographers must send additional submissions periodically—perhaps quarterly, monthly, or annually. Unless you are committed to shooting regularly, or unless you have amassed a gigantic collection of images, don't pursue a stock agency.
- Make sure all of your work is properly cataloged and identified with a file number. Start this process early so that you're prepared when agencies ask for this information. They'll need to know what is contained in each photograph so that the images can be properly keyworded on Web sites.
- Research those agencies that might be interested in your work. Smaller agencies tend to be more receptive to newcomers because they need to build their image files. When larger agencies seek new photographers, they usually want to see specific subjects in which photographers specialize. If you specialize in a certain subject area, be sure to

check out our Subject Index on page 507, which lists companies according to the types of images they need.

- Conduct reference checks on any agencies you plan to approach to make sure they conduct business in a professional manner. Talk to current clients and other contracted photographers to see if they are happy with the agency. Also, some stock agencies are run by photographers who market their own work through their own agencies. If you are interested in working with such an agency, be certain that your work will be given fair marketing treatment.
- Once you've selected a stock agency, contact them via e-mail or whatever means they have stipulated in their listing or on their Web site. Today, almost all stock agencies have Web sites and want images submitted in digital format. If the agency accepts slides, write a brief cover letter explaining that you are searching for an agency and that you would like to send some images for review. Wait to hear back from the agency before you send samples. Then send only duplicates for review so that important work won't get lost or damaged. Always include a SASE when sending samples by regular mail. It is best to send images in digital format; some agencies will only accept digital submissions.
- Finally, don't expect sales to roll in the minute a contract is signed. It usually takes a few years before initial sales are made.

SIGNING AN AGREEMENT

There are several points to consider when reviewing stock agency contracts. First, it's common practice among many agencies to charge photographers fees, such as catalog insertion rates or image duping fees. Don't be alarmed and think the agency is trying to cheat you when you see these clauses. Besides, it might be possible to reduce or eliminate these fees through negotiation.

Another important item in most contracts deals with exclusive rights to market your images. Some agencies require exclusivity to sales of images they are marketing for you. In other words, you can't market the same images they have on file. This prevents photographers from undercutting agencies on sales. Such clauses are fair to both sides as long as you can continue marketing images that are not in the agency's files.

An agency also may restrict your rights to sign with another stock agency. Usually such clauses are designed merely to keep you from signing with a competitor. Be certain your contract allows you to work with other agencies. This may mean limiting the area of distribution for each agency. For example, one agency may get to sell your work in the United States, while the other gets Europe. Or it could mean that one agency sells only to commercial clients, while the other handles editorial work.

Unfortunately, the struggles in the stock industry over royalty-free (RF) versus rights-managed (RM) imagery and unfavorable fee splits between agencies and photographers have followed us into the new millennium. Before you sign any agency contract, make sure you can live with the conditions, including 40/60 fee splits favoring the agency.

Finally, be certain you understand the term limitations of your contract. Some agreements renew automatically with each submission of images. Others renew automatically after a period of time unless you terminate your contract in writing. This might be a problem if you and your agency are at odds for any reason. So, be certain you understand the contractual language before signing anything.

REACHING CLIENTS

One thing to keep in mind when looking for a stock agent is how they plan to market your work. A combination of marketing methods seems the best way to attract buyers, and most large stock agencies are moving in that direction, offering catalogs, CDs and Web sites.

Stock Photo Agencies

But don't discount small, specialized agencies. Even if they don't have the marketing muscle of big companies, they do know their clients well and often offer personalized service and deep image files that can't be matched by more general agencies. If you specialize in regional or scientific imagery, you may want to consider a specialized agency.

MARKETING YOUR OWN STOCK

If you find the terms of traditional agencies unacceptable, there are alternatives available. Many photographers are turning to the Internet as a way to sell their stock images without an agent. Boston-based photographer Seth Resnick is one of a handful of shooters who are

Learn More About the Stock Industry

For More Info

There are numerous resources available for photographers who want to learn about the stock industry. Here are a few of the best.

- **PhotoSource International, (800)223-3860**, website: www.photo-source.com. Owned by author/photographer Rohn Engh, this company produces several newsletters that can be extremely useful for stock photographers. A few of these include *PhotoStockNotes*, *PhotoDaily*, *PhotoLetter* and *PhotoBulletin*. Engh's *Sellphotos.com* (Writer's Digest Books) is a comprehensive guide to selling editorial stock photography online. Recently revised *Sell & Re-Sell Your Photos* (Writer's Digest Books) tells how to sell stock to book and magazine publishers.

- **Selling Stock, (301)251-0720**, website: www.pickphoto.com. This newsletter is published by one of the photo industry's leading insiders, Jim Pickerell. He gives plenty of behind-the-scenes information about agencies and is a huge advocate for stock photographers.

- ***Negotiating Stock Photo Prices,*** **5th edition**, by Jim Pickerell and Cheryl Pickerell DiFrank, 110 Frederick Avenue, Suite A, Rockville MD 20850, (301)251-0720. This is the most comprehensive and authoritative book on selling stock photography.

- **The Picture Archive Council of America, (800)457-7222**, website: www.pacaoffice.org. Anyone researching an American agency should check to see if the agency is a member of this organization. PACA members are required to practice certain standards of professionalism in order to maintain membership.

- **British Association of Picture Libraries and Agencies, (44)(171)713-1780**, website: www.bapla.org.uk. This is PACA's counterpart in the United Kingdom and is a quick way to examine the track record of many foreign agencies.

- ***Photo District News***, website: www.pdn-pix.com. This monthly trade magazine for the photography industry frequently features articles on the latest trends in stock photography, and publishes an annual stock photography issue.

Stock Photo Agencies

doing very well selling their own stock. Check out his Web site at www.sethresnick.com. Your other option is to join with other photographers sharing space on the Web. Check out PhotoSource International at www.photosource.com and www.agpix.com.

If you want to market your own stock, it is not absolutely necessary that you have your own Web site, but it will help tremendously. Photo buyers often ''google'' the keyword they're searching for—that is, they use an Internet search engine, keying in the keyword plus ''photo.'' Many photo buyers from advertising firms to magazines, at one time or another, have found the big stock agencies either too unwieldy to deal with, or they simply did not have exactly what the photo buyer was looking for. Googling can lead a photo buyer straight to your site; be sure you have adequate contact information on your Web site so the photo buyer can contact you and possibly negotiate the use of your photos.

One of the best ways to get into stock is to sell outtakes from assignments. The use of stock images in advertising, design and editorial work has risen in the last five years. As the quality of stock images continues to improve, even more creatives will embrace stock as an inexpensive and effective means of incorporating art into their designs. Retaining the rights to your assignment work will provide income even when you are no longer able to work as a photographer.

AAA IMAGE MAKERS

2750 Pine St., Vancouver BC V6J 3G2 Canada. (604)688-3001. E-mail: sales@aaaimagemakers.com. Websites: www.aaaimagemakers.com, www.fineartprints.ca and www.prophotos.ca. **Contact:** Reimut Lieder, owner. Art Director: Silvia Waechter. Estab. 1981. Stock photography, art and illustration agency. Has 300,000 images on file. Clients include: advertising agencies,interior designers, public relations firms, audiovisual firms, businesses, book/encyclopedia publishers, magazine and textbook publishers, postcard, calendar and greeting card companies.

Needs Artwork, illustration and photography: model-released lifestyles, high-tech, medical, families, industry, computer-related subjects, active middle age and seniors, food, mixed ethnic groups, students, education, occupations, health and fitness, extreme and team sports, and office/business scenes.

Specs Accepts images only in digital format. Send via CD or DVD as TIFF or PSD files at minimum 20MB file size.

Payment & Terms Pays 50% commission for color and b&w photos. Average price per image (to clients): $60-40,000 for b&w and color photos. Enforces minimum prices. Offers volume discount to customers; terms specified in contributor's contract. Discount sales terms not negotiable. Works on contract basis only. Offers limited regional exclusivity, guaranteed subject exclusivity. Charges 50% catalog insertion fee ($8 Canadian). Statements issued quarterly. Payment made quarterly. Contributors allowed to review account records. Rights negotiated by client needs. Does not inform contributors or allow them to negotiate when client requests all rights. Model/property releases required. Photo captions required.

Making Contact Interested in receiving work from established, especially commercial, photographers and artists. Arrange personal interview to show portfolio or submit portfolio for review. Send query letter with résumé of credits, samples. Send e-mail with letter of inquiry, résumé, business card, flier, tearsheets or samples. Responds within 3 weeks.

Tips ''As we do not have submission minimums, be sure to edit your work ruthlessly. We expect quality work on a regular basis. Research your subject completely and submit early and often! We now also represent www.fineartprints.ca, a fine art giclée reproduction service, and www.prophotos.ca. Check them out, too!''

ACCENT ALASKA/KEN GRAHAM AGENCY

P.O. Box 272, Girdwood AK 99587. (907)783-2796. Fax: (907)783-3247. E-mail: info@accentalaska.com. Website: www.accentalaska.com. **Contact:** Ken Graham, owner. Estab. 1979. Stock agency. Has 300,000 photos in files. Clients include: advertising agencies, public relations firms, audiovisual firms, businesses, book publishers, magazine publishers, newspapers, calendar companies, greeting card companies, postcard publishers, CD-ROM encyclopedias.

Needs Wants modern stock images of Alaska, Antarctica, Hawaii and Pacific Northwest. ''Please do not submit material which we already have in our files.''

Specs Uses digital 6MP or greater; 35mm, 2¼×2¼, 4×5, 5×7, 617, 624, 4×10 transparencies. Send via CD, Zip, e-mail lightbox URL.

Payment & Terms Pays 50% commission for color photos. Negotiates fees at industry-standard prices. Works

with photographers on contract basis only. Offers nonexclusive contract. Payment made quarterly.

Making Contact "See our website contact page. Any material must include SASE for returns." Expects minimum initial submission of 60 images. Prefers online web gallery for initial review.

Tips "Realize we specialize in Alaska and the Northwest although we do accept images from Hawaii, Pacific, Antarctica and Europe. The bulk of our sales are Alaska-related. We are always interested in seeing submissions of sharp, colorful, and professional-quality images with model-released people when applicable. Do not want to see same material repeated in our library."

ACE STOCK LIMITED

Satellite House, 2 Salisbury Rd., Wimbledon, London SW19 4EZ United Kingdom. (44)(208)944-9944. Fax: (44)(208)944-9940. E-mail: info@acestock.com. Website: www.acestock.com. **Contact:** John Panton, director. Estab. 1980. Stock photo agency. Has approximately 300,000 photos in files; over 50,000 online. Clients include: ad agencies, audiovisual firms, businesses, book/encyclopedia publishers, magazine publishers, postcard companies, calendar companies, greeting card companies, design companies, direct mail companies.

Needs Photos of babies/children/teens, couples, multicultural, families, parents, senior citizens, environmental, landscapes/scenics, wildlife, pets, adventure, automobiles, food/drink, health/fitness, hobbies, humor, sports, travel, business concepts, industry, medicine, product shots/still life, science, technology/computers. Interested in alternative process, avant garde, documentary, fashion/glamour, seasonal.

Specs "Under duress will accept 35mm, 6×6 cm, 4×5, 8×10 transparencies. Prefer digital submissions saved as RGB, JPEG, Photoshop 98 color space, Quality High. Scanning resolutions for low-res at 72 dpi and high-res at 300 dpi with 30mb minimum size. Send via CD-ROM, or e-mail low-res samples."

Payment & Terms Pays 50% commission on net receipts. Average price per image (to clients): $400. Works with photographers on contract basis only. Offers limited regional exclusivity. Contracts renew automatically for 2 years with each submission. No charges for scanning. Charges $200/image for catalog insertion. Statements issued quarterly. Payment made quarterly. Photographers permitted to review sales records with 1-month written notice. Offers one-time rights, first rights or mostly non-exclusive rights. Informs photographers when client requests to buy all rights, but agency negotiates for photographer. Model/property release required for people and buildings. Photo captions required; include place, date and function. "Prefer data as IPTC-embedded within Photoshop File Info 'caption' for each scanned image."

Making Contact Send e-mail with low-res attachments or website link. Alternatively, arrange a personal interview to show portfolio or post 50 sample transparencies. Responds within 1 month. Photo guidelines sheet free with SASE. Online tips sheet for contracted photographers.

Tips Prefers to see "definitive cross-section of your collection that typifies your style and prowess. Must show originality, command of color, composition and general rules of stock photography. All people must be mid-Atlantic to sell in UK. No dupes. Scanning and image manipulation is all done in-house. We market primarily via online promos sent by e-mail. In addition, we distribute printed catalogs and CD-ROMs."

AERIAL ARCHIVES

Hangar 23, Box 470455, San Francisco CA 94147-0455. (415)771-2555. Fax: (707)769-7277. E-mail: herb@aerialarchives.com. Website: www.aerialarchives.com. **Contact:** Herb Lingl. Estab. 1989. Has 80,000 photos in files, plus 250 gigabytes of digital aerial imagery. Has 2,000 hours of film, video footage. Clients include: advertising agencies, public relations firms, audiovisual firms, businesses, book publishers, magazine publishers, newspapers, calendar companies.

Needs Aerial photography only.

Specs Uses 2¼×2¼, 4×5, 9×9 transparencies; 70mm, 5" and 9×9 (aerial film). Other media also accepted. Accepts images in digital format.

Payment & Terms Buys photos, film, videotape outright only in special situations where requested by submitting party. Pays on commission basis. Average price per image (to clients): $325. Enforces minimum prices. Offers volume discounts to customers. Photographers can choose not to sell images on discount terms. Works with photographers on contract basis only. Statements issued quarterly. Payment made monthly. Photographers allowed to review account records in cases of discrepancies only. Offers one-time rights, electronic media rights, agency promotion rights. Informs photographers and allows them to negotiate when client requests all rights. Property release preferred. Photo captions required; include date and location, and altitude if available.

Making Contact Send query letter with stock list. Provide résumé, business card, self-promotion piece to be kept on file. Expects minimum initial submission of 100 images with quarterly submissions of at least 50 images.

Responds only if interested; send nonreturnable samples. Photo guidelines sheet available via e-mail.

Tips "Supply complete captions with date and location; aerial photography only."

🖳 🌐 AFLO FOTO AGENCY

8F Sun Bldg., 5-13-12 Ginza, Chuo-ku, Tokyo 104-0061 Japan. (81)(3)5550-2120. Fax: (81)(3)3546-0258. E-mail: info@aflofoto.com. Website: www.aflofoto.com. Estab. 1980. Stock agency, picture library and news/feature syndicate. Member of the Picture Archive Council of America (PACA). Has 1 million photos in files. "We have other offices in Tokyo and Osaka." Clients include: advertising agencies, businesses, public relations firms, book publishers, magazine publishers.

Needs Wants photos of babies/children/teens, celebrities, couples, multicultural,families, parents, senior citizens, disasters, environmental, landscapes/scenics, wildlife, architecture, cities/urban, education, gardening, interiors/decorating, pets, religious, rural, adventure, automobiles, entertainment, events, food/drink, health/fitness, hobbies, humor, performing arts, sports, travel, agriculture, business concepts, industry, medicine, military, political, product shots/still life, science, technology/computers. Interested in alternative process, avant garde, documentary, erotic, fashion/glamour, fine art, historical/vintage, seasonal.

Specs Uses 35mm, $2^{1}/_{4} \times 2^{1}/_{4}$, 4×5, 8×10 transparencies. Accepts images in digital format. Send via CD, e-mail as TIFF, JPEG files. When making initial submission via e-mail, files should total less than 3MB.

Payment & Terms Pays 50% commission. Average price per image (to clients): $195 minimum for b&w photos; $250 minimum for color photos, film, videotape. Offers volume discounts to customers; terms specified in photographers' contracts. Photographers can choose not to sell images on discount terms. Works with photographers with or without a contract; negotiable. Contract type varies. Contracts renew automatically with additional submissions for 3 years. Statements issued quarterly. Payment made quarterly. Photographers allowed to review account records. Model/property release preferred. Photo captions required.

Making Contact Send query letter with transparencies, stock list. Provide self-promotion piece to be kept on file. Expects minimum initial submission of 100 images with quarterly submissions of at least 25 images. Responds in 2 weeks to samples. Photo guidelines sheet free with SASE. See website ("Contact Us") for more information.

🖳 🌐 AGE FOTOSTOCK

Buenaventura Muñoz 16, 08018 Barcelona Spain. (34)(93)300-2552. E-mail: age@agefotostock.com. Website: www.agefotostock.com. Estab. 1973. Stock agency. There is a branch office in Madrid and a subsidiary company in New York City, age fotostock america, inc. Photographers may submitt their images to Barcelona directly or through the New York office at: age fotostock america, inc., 594 Broadway, Suite 707, New York NY 10012-3257. Clients include: advertising agencies, businesses, newspapers, postcard publishers, public relations firms, book publishers, calendar companies, audiovisual firms, magazine publishers, greeting card companies.

Needs "We are a general stock agency and are constantly uploading images onto our website. Therefore, we constantly require creative new photos from all categories."

Specs Accepts all formats. Details available upon request.

Payment & Terms Pays 50% commission for all formats. Terms specified in photographer's contract. Works with photographers on contract basis only. Offers image exclusivity worldwide. Statements issued monthly. Payment made monthly. Photographers allowed to review account records. Model/property release required. Photo captions required.

Making Contact "Send query letter with résumé and 100 images for selection. Download the photographer's info pack from our website."

🖳 AGSTOCKUSA INC.

25315 Arriba Del Mundo Dr., Carmel CA 93923. (831)624-8600. Fax: (831)626-3260. E-mail: info@agstockus.com. Website: www.agstockusa.com. **Contact:** Ed Young, owner. Estab. 1996. Stock photo agency. Has 100,000 photos. Clients include: advertising agencies, graphic design firms, businesses, public relations firms, book/encyclopedia publishers, calendar companies, magazine publishers, greeting card companies.

Needs Photos should cover all aspects of agriculture worldwide: fruits, vegetables and grains in various growth stages; studio work, aerials; harvesting, processing, irrigation, insects, weeds, farm life, agricultural equipment, livestock, plant damage and plant disease.

Specs Uses 35mm, $2^{1}/_{4} \times 2^{1}/_{4}$, 4×5, 6×7, 6×17 transparencies. Accepts images in digital format. Send as high-res TIFF files.

Payment & Terms Pays 50% commission for color photos. Average price per image (to clients): $200-25,000

for color photos. Enforces minimum price of $200. Offers volume discounts to customers; inquire about specific terms. Photographers can choose not to sell images on discount terms. Works with photographers on contract basis only. Offers nonexclusive contract. Contracts renew automatically with additional submissions for 2 years. Charges 50% catalog insertion fee; 50% for production costs for direct mail and CD-ROM advertising. Statements issued monthly. Payment made monthly. Photographers allowed to review account records. Offers unlimited use and buyouts if photographer agrees to sale. Informs photographer when client requests all rights; final decision made by agency. Model/property release preferred. Photo captions required; include location of photo and all technical information (what, why, how, etc.).

Making Contact ''Review our website to determine if work meets our standards and requirements.'' Submit low-res JPEGs on CD for review. Call first. Keeps samples on file; include SASE for return of material. Expects minimum initial submission of 250 images. Responds in 3 weeks. Photo guidelines available on website. Agency newsletter distributed yearly to contributors under contract.

Tips ''Build up a good file (quantity and quality) of photos before approaching any agency. A portfolio of 16,000 images is currently displayed on our website. CD-ROM catalog with 7,600 images available to qualified photo buyers.''

AKM IMAGES, INC.

1747 Paddington Ave., Naperville IL 60563. E-mail: um83@yahoo.com. Website: www.akmimages.com. **Contact:** Annie-Ying Molander. Estab. 2002. Stock agency. Has over 10,000 photos in files. Clients include: advertising agencies, book publishers, magazine publishers, newspapers, calendar companies, greeting card companies, postcard publishers.

Needs Wants photos of agriculture, cities/urban, gardening, multicultural, religious, rural, landscapes/scenics, entertainment, wildlife, travel. ''We also need landscape and culture from Asian countries, Nordic countries (Sweden, Norway, Finland), Alaska, Greenland, Iceland. Also need culture about Sami, Lapplander, from Nordic countries and Native American.''

Specs Uses 4×6 glossy color prints; 35mm transperancies. Accepts images in digital format. Send via CD or floppy disk as JPEG or TIFF files at 300 dpi for PC Windows XP.

Payment/Terms Pays 50% commission for b&w photos; 50% commission for color photos. Average price per image (to clients): $25-75 for b&w photos; $50-150 for color photos. Offers volume discount to customers; terms specified in photographers' contracts. Photographers can choose not to sell images on discount terms. Discount sales terms not negotiable. Works with photographers with a contract. Offers nonexclusive contract. Contracts renew automatically with additional submissions. Statements of photographers' sales issued quarterly. Payment made quarterly. Photographers allowed to review account records in cases of discrepancies only. Offers one-time rights. Model/property release required. Photo captions required.

Making Contact Send query letter by e-mail with images and stock list. Does not keep samples on file; include SASE for return of material. Expects minimum initial submissions of 50 images. Responds in 1 month to samples. Photo submission guidelines available free with SASE or via e-mail.

ALASKA STOCK IMAGES

2505 Fairbanks St., Anchorage AK 99503. (907)276-1343. Fax: (907)258-7848. E-mail: info@alaskastock.com. Website: www.alaskastock.com. **Contact:** Jeff Schultz, owner. Stock photo agency. Member of the Picture Archive Council of America (PACA) and ASMP. Has 275,000 photos in files. Clients include: advertising agencies, businesses, newspapers, postcard publishers, book/encyclopedia publishers, calendar companies.

Needs Wants photos of everything related to Alaska, including babies/children/teens, couples, multicultural, families, parents, senior citizens involved in winter activities and outdoor recreation, wildlife, environmental, landscapes/scenics, cities/urban, pets, adventure, travel, industry. Interested in alternative process, avant garde, documentary (images which were or could have been shot in Alaska), historical/vintage, seasonal.

Specs Uses 35mm, 2¼×2¼, 4×5, 6×17 panoramic transperancies. Accepts images in digital format. Send via CD as JPEG files at 72 dpi for review purposes.

Payment & Terms Pays 40% commission for color and b&w photos; minimum use fee $125. No charges for catalog, dupes, etc. Offers volume discounts to customers; inquire about specific terms. Photographers can choose not to sell images on discount terms. Works with photographers on contract basis only. Offers nonexclusive contract; exclusive contract for images in promotions. Contracts renew automatically with additional submissions; nonexclusive for 3 years. Statements issued monthly. Payment made monthly. Photographers allowed to review account records. Offers negotiable rights. Informs photographer and negotiates rights for photographer when client requests all rights. Model/property release preferred for any people and recognizable personal objects (boats, homes, etc.). Photo captions required; include who, what, when, where.

Making Contact Send query letter with samples. Does not keep samples on file; include SASE for return of material. Expects minimum initial submission of 200 images with periodic submissions of 100-200 images 1-4 times/year. Responds in 3 weeks. Photo guidelines free on request. Market tips sheet distributed 2 times/year to those with contracts. "View our guidelines online at www.alaskastock.com/prospectivephotographers.asp."

Tips "E-mailed sample images should be sent in one file, not separate images."

ALLPIX PHOTO AGENCY

P.O. Box 803, Lod 71106 Israel. (972)(8)9248617. E-mail: gilhadny@zahav.net.il. Website: www.allpiximages.spotfolio.com. **Contact:** Gil Hadani or Ruth Regev, directors. Estab. 1995. Stock agency. Has 100,000 photos in files. Clients include: advertising agencies, public relations firms, businesses, book publishers, magazine publishers, newspapers.

Making Contact Send query letter with stock list. Does not keep samples on file; cannot return material.

THE ANCIENT ART & ARCHITECTURE COLLECTION, LTD.

410-420 Rayners Lane, Suite 1, Pinner, Middlesex, London HA5 5DY United Kingdom. (44)(208)429-3131. Fax: (44)(208)429-4646. E-mail: library@aaacollection.co.uk. Website: www.aaacollection.com. **Contact:** Michelle Williams. Picture library. Has 250,000 photos in files. Clients include: advertising agencies, book/encyclopedia publishers, magazine publishers, newspapers.

Needs Wants photos of ancient and medieval buildings, sculptures, objects, artifacts, religious, travel. Interested in fine art, historical/vintage.

Specs Uses 35mm, $2^1/_4 \times 2^1/_4$, 4×5 transparencies. Accepts images in digital format.

Payment & Terms Pays 50% commission for color photos. Average price per image (to clients): $80-180 for color photos. Works with photographers on contract basis only. Offers nonexclusive contract. Contracts renew automatically with additional submissions. Statements issued quarterly. Payment made quarterly. Photographers allowed to review account records. Offers one-time rights. Photo captions required.

Making Contact Send query letter with samples, stock list, SASE. Responds in 2 weeks.

Tips "Material must be suitable for our specialist requirements. We cover historical and archeological periods from 25,000 BC to the 19th century AD, worldwide. All civilizations, cultures, religions, objects and artifacts as well as art are includable. Pictures with tourists, cars, TV aerials, and other modern intrusions not accepted. Send us a submission of color transparencies by mail together with a list of other material that may be suitable for us."

ANDES PRESS AGENCY

26 Padbury Ct., London E2 7EH United Kingdom. (44)(207)613-5417. Fax: (44)(207)739-3159. E-mail: apa@andespressagency.com. Website: http://andespressagency.com. **Contact:** Val Baker. Picture library and news/feature syndicate. Has 300,000 photos in files. Clients include: magazine publishers, businesses, book publishers, non-governmental charities, newspapers.

Needs Wants photos of multicultural, senior citizens, disasters, environmental, landscapes/scenics, architecture, cities/urban, education, religious, rural, travel, agriculture, business, industry, political. "We have color and b&w photographs on social, political, and economic aspects of Latin America, Africa, Asia, and Britain, specializing in contemporary world religions."

Specs Uses 35mm and digital files.

Payment & Terms Pays 50% commission for b&w and color photos. General price range (to clients): £60-300 for color photos. Works with photographers on contract basis only. Offers nonexclusive contract. Contracts renew with additional submissions. Statements issued bimonthly. Payment made bimonthly. Offers one-time rights. "We never sell all rights; photographer has to negotiate if interested." Model/property release preferred. Photo captions required.

Making Contact Send query via e-mail. Do not send unsolicited images.

Tips "We want to see that the photographer has mastered one subject in depth. Also, we have a market for photo features as well as stock photos. Please write to us first via e-mail."

ANIMALS ANIMALS/EARTH SCENES

17 Railroad Ave., Chatham NY 12037. (518)392-5500. E-mail: info@animalsanimals.com. Website: www.animalsanimals.com. **Contact:** Nancy Carrizales. Member of Picture Archive Council of America (PACA). Has 1.5 million photos in files. Clients include: ad agencies, public relations firms, businesses, audiovisual firms,

book publishers, magazine publishers, encyclopedia publishers, newspapers, postcard companies, calendar companies, greeting card companies.

Needs "We specialize in nature photography." Wants photos of disasters, environmental, landscapes/scenics, wildlife, pets, travel, agriculture.

Specs Uses 35mm, $2\frac{1}{4} \times 2\frac{1}{4}$, 4×5 transparencies. Accepts images in digital format.

Payment & Terms Pays 50% commission. Works with photographers on contract basis only. Offers exclusive contract. Charges catalog insertion fee. Photographers allowed to review account records to verify sales figures "if requested and with proper notice and cause." Statements issued quarterly. Payment made quarterly. Offers one-time rights; other uses negotiable. Informs photographers and allows them to negotiate when client requests all rights. Model release required if used for advertising. Photo captions required; include Latin names ("they must be correct!").

Making Contact Send query for guidelines by mail or e-mail. Expects minimum initial submission of 200 images with quarterly submissions of at least 200 images. Include SASE for return of material.

Tips "First, pre-edit your material. Second, know your subject."

ANT PHOTO LIBRARY

112A Martin St., Suite 7, Brighton, Victoria 3186 Australia. (61)(3)9530-8999. Fax: (61)(3)9530-8299. E-mail: images@antphoto.com.au. Website: www.antphoto.com.au. **Contact:** Peter Crawley-Boevey. Estab. 1982. Has 170,000 photos in files, with 20,000 high-res files online. Clients include: advertising agencies, public relations firms, businesses, book publishers, magazine publishers, newspapers, calendar companies, greeting card companies, postcard publishers.

Needs Wants photos of "flora and fauna of Australia, Asia, Antarctica and Africa, and the environments in which they live."

Specs "Use digital camera files supplied as a minimum of 16-bit TIFF files from a minimun of 6 megapixal SLR quality digital camera. Full specs on our website."

Payment & Terms Pays 45% commission for color photos. Offers volume discounts to customers. Discount sales terms not negotiable. Works with photographers on contract basis only. Offers limited regional exclusivity. Statements issued quarterly. Payment made quarterly. Photographers allowed to review account records in cases of discrepancies only. Model release required. Photo captions required; include species, common name and scientific name on supplied Excel spreadsheet.

Making Contact Send e-mail. Include SASE for return of material. Expects minimum initial submission of 200 images with regular submissions of at least 100 images. Responds in 3 weeks to samples. Photo guidelines available on website. Market tips sheet "available to all photographers we represent."

Tips "Our clients come to us for images of all common and not-so-common wildlife species from around the world particularly. Good clean shots. Good lighting and very sharp."

ANTHRO-PHOTO FILE

33 Hurlbut St., Cambridge MA 02138. (617)868-4784. Fax: (617)497-7227. Website: www.anthrophoto.com. **Contact:** Nancy DeVore. Estab. 1969. Has 10,000 photos in files. Clients include: book publishers, magazine publishers.

Needs Wants photos of environmental, wildlife, social sciences.

Specs Uses b&w prints; 35mm transparencies.

Payment & Terms Pays 60% commission. Average price per image (to clients): $170 minimum for b&w photos; $200 minimum for color photos. Offers volume discounts to customers; discount terms negotiable. Works with photographers with contract. Contracts renew automatically. Statements issued annually. Payment made annually. Photographers allowed to review account records. Offers one-time rights. Informs photographers and allows them to negotiate when client requests all rights. Photo captions required.

Making Contact Send query letter with stock list. Keeps samples on file; include SASE for return of material.

Tips Photographers should call first.

(APL) ARGUS PHOTOLAND, LTD.

Room 2001-4 Progress Commercial Bldg., 9 Irving St., Causeway Bay, Hong Kong. (852)2890-6970. Fax: (852)2881-6979. E-mail: argus@argusphoto.com. Website: www.argusphoto.com. **Contact:** Lydia Li, photo editor. Estab. 1992. Stock photo agency. Has 500,000 photos in files. Has a branch office in Beijing. Clients include: advertising agencies, graphic houses, public relations firms, book/encyclopedia publishers, magazine publishers, postcard, greeting card, calendar and mural printing companies, and corporates.

Needs "We cover general subject matters with urgent needs of lifestyle images, concepts and ideas, business

and finance, science and technology, amenities and facilities, interiors, cityscapes and landscapes, Asian people, and sports images.''

Specs Accepts images in digital format. Send via CD/DVD/FTP download as 50- to 80-MB JPEGS at 300 dpi.

Payment & Terms Pays 50% commission. Average price per image (to clients): $200-6,000. Offers volume discounts to customers. Works with photographers on contract basis only. Contracts renew automatically with additional submissions. Statements/payment made quarterly. Informs photographers and allows them to negotiate when client requests all rights. Model/property release required. Photo captions required: include name of event(s), building(s), location(s) and geographical area. Submit portfolio for review. Expects minimum initial submission of 200 images.

🖳 🌐 A+E

9 Hochgernstr., Stein D-83371 Germany. Phone: (+49)8621-61833. Fax: (+49)8621-63875. E-mail: apluse@aol.com. Website: http://members.aol.com/AplusE. **Contact:** Elizabeth Pauli, director. Estab. 1987. Picture library. Has 30,000 photos in files. Clients include newspapers, postcard publishers, book publishers, calendar companies, magazine publishers.

Needs Wants photos of nature/landscapes/scenics, pets, ''only your best material.''

Specs Uses 35mm, $2^{1}/_{4} \times 2^{1}/_{4}$, 4×5 transparencies. Accepts images in digital format. Send via CD as JPEG files at 100 dpi for referencing purposes only.

Payment & Terms Pays 50% commission. Average price per image (to clients): $15-100 for b&w photos; $75-1,000 for color photos. Offers volume discounts to customers. Works with photographers on contract basis only. Offers nonexclusive contract. Subject exclusivity may be negotiated. Statements issued annually. Payment made annually. Photographers allowed to review account records in cases of discrepancies only. Offers one-time rights. Model/property release required. Photo captions preferred; include country, date, name of person, town, landmark, etc.

Making Contact Send query letter with your qualification, description of your equipment, transparencies or CD, stock list. Include SASE for return of material in Europe. Cannot return material outside Europe. Expects minimum initial submission of 100 images with annual submissions of at least 100 images. Responds in 1 month.

Tips ''Judge your work critically. Technically perfect photos only—sharp focus, high colors, creative views—are likely to attract a photo editor's attention.''

🖳 🗖 APPALIGHT

230 Griffith Run Rd., Spencer WV 25276. E-mail: wyro@appalight.com. Website: www.appalight.com. **Contact:** Chuck Wyrostok, director. Estab. 1988. Stock photo agency. Has over 30,000 photos in files. Clients include advertising agencies, public relations firms, businesses, book/encyclopedia publishers, magazine publishers, calendar companies, greeting card companies, graphic designers.

• This agency also markets images through the Photo Source Bank.

Needs General subject matter with emphasis on the people, natural history, culture, commerce, flora, fauna, and travel destinations of the Appalachian Mountain region and Eastern Shore of the United States. Wants photos of West Virginia, babies/children/teens, couples, multicultural, families, parents, senior citizens, disasters, environmental, landscapes, wildlife, cities/urban, education, gardening, pets, religious, rural, adventure, events, health/fitness, hobbies, humor, travel, agriculture, business concepts, industry, medicine, military, political, science, technology/computers. Interested in documentary, seasonal.

Specs Uses 8×10 glossy b&w prints; 35mm, $2^{1}/_{4} \times 2^{1}/_{4}$, 4×5 transparencies and digital images.

Payment & Terms Pays 50% commission for b&w, color photos. Works with photographers on nonexclusive contract basis only. Contracts renew automatically for 2-year period with additional submissions. Payment made quarterly. Photographers allowed to review account records during regular business hours or by appointment. Offers one-time rights, electronic media rights. Model release preferred. Photo captions required.

Making Contact AppaLight is not accepting submissions currently.

Tips ''We look for a solid blend of topnotch technical quality, style, content and impact. Images that portray metaphors applying to ideas, moods, business endeavors, risk-taking, teamwork and winning are especially desirable.''

🖳 🌐 ARCHIVO CRIOLLO

San Ignacio 1001, Quito Ecuador. (593)(2)2222-467. Fax: (593)(2)2231-447. E-mail: info@archivocriollo.com. Website: www.archivocriollo.com. **Contact:** Julian Larrea, agent. Estab. 1998. Picture library. Has 10,000

photos in files. Clients include: advertising agencies, businesses, newspapers, postcard publishers, calendar companies, magazine publishers, greeting card companies, travel agencies.

Needs Wants photos of multicultural, environmental, landscapes/scenics, wildlife, architecture, cities/urban, religious, rural, adventure, travel. Interested in alternative process, documentary, historical/vintage.

Specs Uses 35mm transparencies. Accepts images in digital format. Send via CD, Zip, e-mail as JPEG files at 72 dpi.

Payment & Terms Pays 50% commission for color photos. Average price per image (to clients): $50-150 for color photos; $450-750 for videotape. Enforces minimum prices. Offers volume discounts to customers; terms specified in photographers' contracts. Photographers can choose not to sell images on discount terms. Works with photographers with or without a contract; negotiable. Offers nonexclusive contract. Charges 50% sales fee. Payment made quarterly. Photographers allowed to review account records. Informs photographers and allows them to negotiate when client requests all rights. Photo captions preferred.

Making Contact Send query letter with stock list. Responds only if interested. Catalog available.

ART DIRECTORS & TRIP PHOTO LIBRARY

57 Burdon Lane, Cheam Surrey SM2 7BY United Kingdom. (44)(208)642-3593. Fax: (44)(208)395-7230. E-mail: images@artdirectors.co.uk. Website: www.artdirectors.co.uk. Estab. 1992. Stock agency. Has 1 million photos in files. Clients include: advertising agencies, businesses, newspapers, postcard publishers, public relations firms, book publishers, calendar companies, magazine publishers, greeting card companies.

Needs Wants photos of babies/children/teens, couples, multicultural, families, parents, senior citizens, disasters, environmental, landscapes/scenics, wildlife, architecture, cities/urban, education, gardening, interiors/decorating, pets, religious, rural, adventure, automobiles, entertainment, events, food/drink, health/fitness, hobbies, humor, performing arts, sports, travel, agriculture, business concepts, industry, medicine, military, political, product shots/still life, science, technology/computers. Interested in alternative process, avant garde, documentary, historical/vintage, seasonal.

Specs Uses 35mm, $2\frac{1}{4} \times 2\frac{1}{4}$, 4×5, 8×10 transparencies.

Payment & Terms Pays 50% commission for b&w or color photos. Average price per image (to clients): $65-1,000 for b&w or color photos. Enforces strict minimum prices. Offers volume discounts to customers. Discount sales terms not negotiable. Works with photographers on contract basis only. Offers nonexclusive contract. Statements issued quarterly. Payment made quarterly. Photographers allowed to review account records in cases of discrepancies only. Offers one-time rights, electronic media rights. Model/property release preferred. Photo captions required; include as much relevant information as possible.

Making Contact Contact through rep or send query letter with slides, transparencies. Does not keep samples on file; include SASE for return of material. Expects minimum initial submission of 50 images with periodic submissions of at least 50 images. Responds in 6 weeks to queries. Photo guidelines sheet free with SASE.

Tips ''Fully caption material and submit in chronological order.''

ART LICENSING INTERNATIONAL INC.

7350 S. Tamiami Trail, #227, Sarasota FL 34231. Estab. 1986. (941)966-8912. Fax: (941)966-8914. E-mail: artlicensing@comcast.net. Website: www.artlicensinginc.com, www.licensingcourse.com or www.out-of-the-blue.us. **Contact:** Michael Woodward, president. Creative Director: Maureen May. Estab. 1986. ''We represent artists, photographers and creators who wish to establish a licensing program for their work. We are particularly interested in photographic images that we can license internationally across a range of products such as posters, prints, greeting cards, stationery, calendars, etc.''

Needs Images must have commercial application for particular products. ''We prefer concepts that have a unique look or theme and that are distinctive from the generic designs produced in-house by publishers and manufacturers. Images for prints and posters must be in pairs or sets of 4 or more with a regard for trends and color palettes related to the home décor market. Creating art brands is our specialty.''

Payment & Terms ''Our general commission rate is 50% with no expenses to the photographer as long as the photographer provided high-resolution scans.''

Making Contact Send a CD/photocopies, e-mail JPEGS or details of your website. Send SASE if you want material returned. ''We require substantial portfolios of work that can generate good incomes, or concepts that have wide commerical appeal.''

ART RESOURCE

536 Broadway, 5th Floor, New York NY 10012. (212)505-8700. Fax: (212)505-2053. E-mail: requests@artres.c om. Website: www.artres.com. **Contact:** Diana Reeve, general manager. Estab. 1970. Stock photo agency

specializing in fine arts. Member of the Picture Archive Council of America (PACA). Has access to 3 million photos. Clients include: advertising agencies, public relations firms, audiovisual firms, businesses, book/encyclopedia publishers, magazine publishers, newspapers, postcard publishers, calendar companies, greeting card companies, all other publishing.

Needs Wants photos of painting, sculpture, architecture *only*.

Specs Uses 8×10 b&w prints; 35mm, 4×5, 8×10 transparencies.

Payment & Terms Pays 50% commission. Average price per image (to client): $185-10,000 for color photos. Negotiates fees below standard minimum prices. Offers volume discounts to customers; terms specified in photographer's contract. Discount sales terms not negotiable. Offers one-time rights, electronic media rights, agency promotion and other negotiated rights. Photo captions required.

Making Contact Send query letter with stock list.

Tips "We represent European fine art archives and museums in US and Europe but occasionally represent a photographer with a specialty in photographing fine art."

◪ ART SOURCE L.A., INC.

2801 Ocean Park Blvd., PMB 7, Santa Monica CA 90405. (310)452-4411. Fax: (310)452-0300. E-mail: info@artsourcela.com. Website: www.artsourcela.com. **Contact:** Patty Evert. Estab. 1984. Consultants. Has thousands of photos in files. Has a branch office in North Bethesda, Maryland. Clients include: businesses, hotels, corporations.

Needs Wants photos of landscapes/scenics, architecture, cities/urban, gardening, food/drink, sports, travel, business concepts, technology/computers. Interested in alternative process, avant garde, fine art, historical/vintage.

Specs Uses glossy or matte color and/or b&w prints; 35mm, 2¼×2¼, 4×5, 8×10 transparencies; Film. Accepts images in digital format. Send via CD, e-mail as TIFF, JPEG files at 150+ dpi.

Payment & Terms Commission percentage varies. Sometimes uses 800 of one image; depends on project. Please inquire. Negotiates fees below standard minimum prices. Offers volume discounts to customers. Photographers can choose not to sell images on discount terms. Works with photographers with or without contract; negotiable. Offers nonexclusive contract. Contracts renew automatically with additional submissions. Statements issued quarterly. Payment made quarterly. Photographers not allowed to review account records. "Photographers are given an accounting of client sold to, discounts and net pricing." Offers one-time rights. Model/property release preferred.

Making Contact Send query letter with résumé, slides, prints, tearsheets, transparencies. "Portfolio may be dropped off via FedEx or messenger to our address." Provide résumé, business card, self-promotion piece to be kept on file. Expects minimum initial submission of 20 images with annual submissions of at least 20 images. Responds in 6-8 weeks. Must include SASE for response.

Tips "Have a consistent body of work of excellent quality. Include résumé and SASE. Be patient."

◪ ⊕ ASIA IMAGES GROUP

15 Shaw Rd., #08-02, Teo Bldg., Singapore 367953. (65)6288-2119. Fax: (65)6288-2117. E-mail: info@asia-images.com. Website: www.asia-images.com. **Contact:** Alexander Mares-Manton, director. Estab. 2001. Stock agency. "We do commercial stock and both editorial and corporate assignments in Asia. We currently have 12,000 images, but are expanding that by about 1,000 images each month." Clients include: advertising agencies, corporations, public relations firms, book publishers, calendar companies, magazine publishers.

Needs Wants photos of babies/children/teens, couples, families, parents, senior citizens, health/fitness/beauty, science, technology. "We are only interested in seeing images about or from Asia."

Specs Accepts images in digital format. Send via CD as TIFF, JPEG files at 300 dpi. "We want to see 72-dpi JPEGs for editing and 300-dpi TIFF files for archiving and selling."

Payment & Terms "We have minimum prices that we stick to unless many sales are given to one photographer at the same time." Works with photographers on image-exclusive contract basis only. "We need worldwide exclusivity for the images we represent, but photographers are encouraged to work with other agencies with other images." Statements issued monthly. Payment made monthly. Photographers allowed to review account records. Offers one-time rights, electronic media rights. Model and property releases are required for all images.

Making Contact Send e-mail with 10-20 JPEGs of your best work. No minimum submissions. Responds only if interested; send nonreturnable samples.

Tips "Asia Images Group is a small niche agency specializing in images of Asia for both advertising and editorial clients worldwide. We are interested in working closely with a small group of photographers rather

than becoming too large to be personable. When submitting work, please send 10-20 JPEGs in an e-mail and tell us something about your work and your experience in Asia.''

◼ AURORA PHOTOS

(formerly Aurora & Quanta Productions), 20-36 Danforth St., Suite 216, Portland ME 04101. (207)828-8787. Fax: (207)828-5524. E-mail: info@auroraphotos.com. Website: www.auroraphotos.com. **Contact:** José Azel, owner. Estab. 1993. Stock agency, news/feature syndicate. Member of the Picture Archive Council of America (PACA). Has 500,000 photos in files. Clients include: advertising agencies, businesses, book publishers, magazine publishers, newspapers, calendar companies, postcard publishers.

Needs Wants photos of babies/children/teens, celebrities, couples, multicultural, families, parents, senior citizens, disasters, environmental, landscapes/scenics, wildlife, architecture, cities/urban, education, rural, adventure, events, sports, travel, agriculture, industry, military, political, science, technology/computers.

Specs Accepts digital submissions only; contact for specs.

Payment & Terms Pays 50% commission for film. Average price per image (to clients): $225 minimum-$30,000 maximum for film. Offers volume discounts to customers. Photographers can choose not to sell images on discount terms. Works with photographers on contract basis only. Statements issued quarterly. Payment made quarterly. Photographers allowed to review account records once/year. Offers one-time rights, electronic media rights. Model/property release required. Photo captions required.

Making Contact Send query letter with website address. Does not keep samples on file; does not return material. Responds in 1 month. Photo guidelines available on website.

Tips ''E-mail after viewing our website. List area of photo expertise/interest and forward a personal website address where photos can be found.''

◼ ◉ AUSCAPE INTERNATIONAL

8/44-48 Bowral St., Bowral NSW 2576 Australia. (61)(02)4861-6818. Fax: (61)(02)4861-6838. E-mail: auscape @auscape.com.au. Website: www.auscape.com.au. **Contact:** Sarah Tahourdin, director. Has 250,000 photos in files. Clients include: advertising agencies, book publishers, magazine publishers, newspapers, calendar companies, greeting card companies.

Needs Wants photos of environmental, landscapes/scenics, wildlife, pets, health/fitness, medicine.

Specs Uses 35mm, $2^1/_4 \times 2^1/_4$, 4×5, 8×10 transparencies. Accepts images in digital format. Send via CD or DVD as TIFF files at 300 dpi.

Payment & Terms Pays 50% commission for color photos. Enforces minimum prices. Offers volume discounts to customers. Works with photographers on contract basis only. Requires exclusive contract. Statements issued quarterly. Payment made quarterly. Photographers allowed to review account records. Offers one-time rights. Photo captions required; include scientific names, common names, locations.

Making Contact Does not keep samples on file. Expects minimum initial submission of 200 images with monthly submissions of at least 50 images. Responds in 3 weeks to samples. Photo guidelines sheet free.

Tips ''Send only informative, sharp, well-composed pictures. We are a specialist natural history agency and our clients mostly ask for pictures with content rather than empty but striking visual impact. There must be passion behind the images and a thorough knowledge of the subject.''

◼ ◉ AUSTRALIAN PICTURE LIBRARY

Level 2/21 Parraween St., Cremorne NSW 2090 Australia. (61)(2)9080-1000. Fax: (61)(2)9080-1001. E-mail: liaison@australianpicturelibrary.com.au. Website: www.australianpicturelibrary.com.au. **Contact:** Photo Editor. Estab. 1979. Stock photo agency and news/feature syndicate. Has over 1.5 million photos in files. Clients include: advertising agencies, public relations firms, audiovisual firms, businesses, book/encyclopedia publishers, magazine publishers, newspapers, postcard publishers, calendar companies, greeting card companies.

• APL represents the entire Corbis collection in Australia.

Needs Wants photos of Australia—babies/children/teens, celebrities, couples, multicultural, families, parents, senior citizens, disasters, environmental, landscapes/scenics, wildlife, architecture, cities/urban, education, gardening, interiors/decorating, pets, religious, rural, adventure, entertainment, food/drink, health/fitness, humor, sports, travel, agriculture, business concepts, medicine, military, political, science, technology/computers. Interested in alternative process, avant garde, fashion/glamour, fine art, historical/vintage.

Specs Uses 35mm and large-format transparencies. Accepts images in digital format. Contact for details.

Payment & Terms Pays 50% commission. Offers volume discounts to customers. Works with photographers on contract basis only. Offers exclusive contract. Statements issued quarterly. Payment made quarterly.

Offers one-time rights. Informs photographers and allows them to negotiate when client requests all rights. Model/property release required. Photo captions required.

Making Contact Submit portfolio for review. Expects minimum initial submission of "enough high-quality material for us to select a minimum of 200 images," with yearly submissions of at least 400 images. Responds in 1 month. Photo guidelines free with SASE or on website. Catalog available. Market tips sheet distributed quarterly to agency photographers.

Tips Looks for formats larger than 35mm in travel, landscapes and scenics with excellent quality. "There must be a need within the library that doesn't conflict with existing photographers too greatly." Visit website and review guidelines before submitting.

THE BERGMAN COLLECTION

Division of Project Masters, Inc., P.O. Box AG, Princeton NJ 08542-0872. (609)921-0749. Fax: (609)921-6216. E-mail: information@pmiprinceton.com. Website: http://pmiprinceton.com. **Contact:** Victoria B. Bergman, vice president. Estab. 1980 (Collection established in the 1930s.) Stock agency. Has 20,000 photos in files. Clients include: advertising agencies, book publishers, audiovisual firms, magazine publishers.

Needs "Specializes in medical, technical and scientific stock images of high quality and accuracy."

Specs Uses color and/or b&w prints; 35mm, $2\frac{1}{4} \times 2\frac{1}{4}$ transparencies. Accepts images in digital format. Send via CD, floppy disk, Zip, e-mail as TIFF, BMP, JPEG files.

Payment & Terms Pays on commission basis. Works with photographers on contract basis only. Offers one-time rights. Model/property release required. Photo captions required; must be medically, technically, scientifically accurate.

Making Contact "Do not send unsolicited images. Call, write, fax or e-mail to be added to our database of photographers able to supply, on an as-needed basis, specialized images not already in the collection. Include a description of the field of medicine, technology or science in which you have images. We contact photographers when a specific need arises."

Tips "Our needs are for very specific images that usually will have been taken by specialists in the field as part of their own research or professional practice. A good number of the images placed by The Bergman Collection have come from photographers in our database."

BIOLOGICAL PHOTO SERVICE AND TERRAPHOTOGRAPHICS

P.O. Box 490, Moss Beach CA 94038. (650)359-6219. E-mail: bpsterra@pacbell.net. Website: www.agpix.com/biologicalphoto. **Contact:** Carl W. May, photo agent. Stock photo agency. Estab. 1980. Has 70,000 photos in files. Clients include: ad agencies, businesses, book/encyclopedia publishers, magazine publishers.

Needs All subjects in the pure and applied life and earth sciences. Stock photographers must be scientists. Subject needs include: electron micrographs of all sorts; biotechnology; modern medical imaging; marine and freshwater biology; diverse invertebrates; organisms used in research; tropical biology; and land and water conservation. All aspects of general and pathogenic microbiology, normal human biology, petrology, volcanology, seismology, paleontology, mining, petroleum industry, alternative energy sources, meteorology and the basic medical sciences, including anatomy, histology, medical microbiology, human embryology and human genetics.

Specs Uses 4×5 through 11×14 glossy, high-contrast b&w prints for EM's; 35mm, $2\frac{1}{4} \times 2\frac{1}{4}$, 4×5, 8×10 transparencies. "Dupes acceptable for rare and unusual subjects, but we prefer originals." Accepts images in digital format as 50-100 MB TIFF files.

Payment & Terms Pays 50% commission for b&w and color photos. General price range (for clients): $75-500, sometimes higher for advertising uses. Works with photographers with or without a contract, but only as an exclusive agency. Statements issued quarterly. Payment made quarterly; "one month after end of quarter." Photographers allowed to review account records to verify sales figures "by appointment at any time." Offers only rights-managed uses of all kinds; negotiable. Informs photographers and allows them veto authority when client requests a buyout. Model/property release required for photos used in advertising and other commercial areas. Thorough scientific photo captions required; include complete identification of subject and location.

Making Contact Interested in receiving work from newer, lesser-known scientific and medical photographers if they have the proper background. Send query letter with stock list, résumé of scientific and photographic background; include SASE for return of material. Responds in 2 weeks. Photo guidelines free with query, résumé and SASE. Tips sheet distributed intermittently to stock photographers only. "Non-scientists should not apply."

Tips "When samples are requested, we look for proper exposure, maximum depth of field, adequate visual

information and composition, and adequate technical and general information in captions." Requests fresh light and electron micrographs of biological and geological textbook subjects; applied biology and geology such as biotechnology, agriculture, industrial microbiology, medical research, mineral exploration; biological and geological careers; field research. "We avoid excessive overlap among our photographer/scientists. We are experiencing an ever-growing demand for photos covering environmental problems of all sorts—local to global, domestic and foreign. Tropical biology, marine biology, medical research, biodiversity, volcanic eruptions, and forestry are hot subjects. Our 3 greatest problems with potential photographers are: 1) inadequate captions; 2) inadequate quantities of *fresh* and *diverse* photos; 3) poor sharpness/depth of field/grain/composition in photos."

▣ ● THE ANTHONY BLAKE PHOTO LIBRARY LTD.

20 Blades Court, Deodar Rd., London SW15 2NU United Kingdom. (44)(208)877-1123. Fax: (44)(208)877-9787. E-mail: info@abpl.co.uk. Website: www.abpl.co.uk. **Contact:** Anna Weller. Estab. 1980. Has 200,000 photos in files. Clients include: advertising agencies, businesses, book publishers, magazine publishers, newspapers, calendar companies, greeting card companies.

Needs Wants photos of food/drink. Other photo needs include people eating/drinking, vineyards (around the world).

Specs Uses 35mm, $2^{1}/_{4} \times 2^{1}/_{4}$, 4×5, 8×10 transparencies. Accepts images in digital format. Send via CD or e-mail.

Payment & Terms Pays 50% commission. Average price per image (to clients): $75-1,000 for film. Negotiates fees below standard minimum prices occasionally for bulk use. Offers volume discounts to customers. Discount sales terms not negotiable. Works with photographers on contract basis only. Guaranteed subject exclusivity (within files). Contracts renew automatically with additional submissions. Statements issued quarterly. Photographers allowed to review account records in cases of discrepancies only. Offers one-time rights. Informs photographers and allows them to negotiate when client requests all rights. Model release preferred. Photo captions preferred.

Making Contact Call first. Send slides, tearsheets, transparencies. Does not keep samples on file; include SASE for return of material. Expects minimum initial submission of 150 images. Responds in 1 month to samples. Photo guidelines available on website.

▣ ● BLUEBOX GMBH

Flerrentwiete 82, D22559 Hamburg Germany. (49)(408)816-7661. Fax: (49)(408)816-7665. E-mail: info@pictures.de. Website: www.picturefinder.com. Estab. 1996. Stock agency. Member of BVPA. Has 45,000 digitized photos in files. Clients include: advertising agencies, businesses, newspapers, postcard publishers, public relations firms, book publishers, calendar companies, magazine publishers.

Needs Wants photos of babies/children/teens, couples, families, parents, senior citizens, environmental, landscapes/scenics, wildlife, architecture, cities/urban, gardening, pets, rural, adventure, food/drink, health/fitness, performing arts, sports, travel, agriculture, business concepts, industry, product shots/still life, science, technology/computers. Interested in alternative process, avant garde, fine art, seasonal. Needs creative images of high technical quality on all subjects for European and worldwide use.

Specs Uses 35mm, $2^{1}/_{4} \times 2^{1}/_{4}$, 4×5, 8×10 transparencies or "digital camera images starting from 8 megapixel (TIFF format). Selected images will be digitized into high-res scans and returned to photographer."

Payment & Terms Does not buy film outright. Pays 50% commission for photos, film and videotape. Average price per image (to clients): $60-$4,500 for b&w photos; $60-8,000 for color photos. Offers volume discounts to customers; up to 20%. Discount sales terms not negotiable. Works with photographers on contract basis only. Offers exclusivity for the specific picture. Contracts last minimum 3 years. No costs are charged to photographers. Statements issued quarterly. Payment made quarterly. Photographers allowed to review account records in cases of discrepancies only. Offers one-time rights, electronic media rights, agency promotion rights. Informs photographers and allows them to negotiate when a client requests all rights. Model release required; property release preferred. Photo captions required; include place, country, name of celebrations, plants, animals, etc., including scientific name.

Making Contact Contact by e-mail, phone or mail. Expects minimum initial submission of 30 images; maximum 300 slides.

Tips "We like to see creative and professional photography with good technical quality. Submission should be packed carefully, and photographers shouldn't use glass slides when sending transparencies."

◼ THE BRIDGEMAN ART LIBRARY

65 E. 93rd St., New York NY 10128. (212)828-1238. Fax: (212)828-1255. E-mail: newyork@bridgemanart.c om. Website: www.bridgemanart.com. **Contact:** Ed Whitley. Estab. 1972. Member of the Picture Archive Council of America (PACA). Has 250,000 photos in files. Has branch offices in London, Paris and Berlin. Clients include: advertising agencies, public relations firms, audiovisual firms, businesses, book publishers, magazine publishers, newspapers, calendar companies, greeting card companies, postcard publishers.
Needs Interested in fine art.
Specs Uses 4×5, 8×10 transparencies and 50MB+ digital files.
Payment & Terms Pays 50% commission for color photos. Enforces minimum prices. Offers volume discounts to customers; terms specified in photographers' contracts. Discount sales terms not negotiable. Works with photographers on contract basis only. Charges 100% duping fee. Statements issued quarterly. Photographers allowed to review account records. Offers one-time rights, electronic media rights, agency promotion rights.
Making Contact Send query letter with photocopies, stock list. Does not keep samples on file; include SASE for return of material. Expects minimum initial submission of 20 images. Responds only if interested; send nonreturnable samples. Catalog available.

CALIFORNIA VIEWS/MR. PAT HATHAWAY HISTORICAL PHOTO COLLECTION

469 Pacific St., Monterey CA 93940-2702. (831)373-3811. E-mail: hathaway@caviews.com. Website: www.ca views.com. **Contact:** Mr. Pat Hathaway, photo archivist. Estab. 1970. Picture library; historical collection. Has 80,000 b&w images; 10,000 35mm color images in files. Clients include: advertising agencies, public relations firms, audiovisual firms, book/encyclopedia publishers, magazine publishers, museums, postcard companies, calendar companies, television companies, interior decorators, film companies.
Needs Historical photos of California from 1855 to today, including disasters, landscapes/scenics, rural, agricultural, automobiles, travel, military, portraits, John Steinbeck and Edward F. Rickets.
Payment & Terms Payment negotiable. Offers volume discounts to customers.
Making Contact "We accept donations of California photographic material in order to maintain our position as one of California's largest archives. Please do not send unsolicited images." Does not keep samples on file; cannot return material.

◼ ◷ ⊕ CAMERA PRESS LTD.

21 Queen Elizabeth St., London SE1 2PD United Kingdom. (44)(207)278-1300 or (44)(207)940-9123. Fax: (44)(207)278-5126. E-mail: editorial@camerapress.com or j.wald@camerapress.com. Website: www.camer apress.com. **Contact:** Jacqui Ann Wald, editor. Quality syndication service and picture library. Clients include: advertising agencies, public relations firms, audiovisual firms, book/encyclopedia publishers, maga zine publishers, newspapers, postcard companies, calendar companies, greeting card companies and TV stations. Clients principally press but also advertising, publishers, etc.
 • Camera Press has a fully operational electronic picture desk to receive/send digital images via modem/ ISDN lines, FTP.
Needs Always looking for celebrities, world personalities (e.g., politics, sports, entertainment, arts, etc.), news/documentary, scientific, human interest, humor, women's features, stock. "All images now digitized."
Specs Accepts images in digital format as TIFF, JPEG files as long as they are a minimum of 300 dpi or 16MB.
Payment & Terms Standard payment term: 50% net commission. Statements issued every 2 months along with payments.
Tips "Camera Press, one of the oldest and most celebrated family-owned picture agencies, will celebrate its 60th anniversary in 2007. We represent some of the top names in the photographic world but also welcome emerging talents and gifted newcomers. We seek quality celebrity images; lively, colorful features which tell a story; and individual portraits of world personalities, both established and up-and-coming. Accurate cap tions are essential. Remember there is a big worldwide demand for premieres, openings and US celebrity-based events. Other needs include: scientific development and novelties; beauty, fashion, interiors, food and women's interests; humorous pictures featuring the weird, the wacky and the wonderful."

◩ ◷ CAMERIQUE INC. INTERNATIONAL

164 Regency Dr., Eagleville PA 19403. (888)272-4749. E-mail: camerique@earthlink.net. Website: www.cam erique.com. Representatives in Los Angeles, New York City, Montreal, Tokyo, Calgary, Buenos Aires, Rio de Janerio, Amsterdam, Hamburg, Barcelona, Athens, Rome, Lisbon and Hong Kong. **Contact:** Christopher C. Johnson, photo director. Estab. 1973. Has 1 million photos in files. Clients include: advertising agencies,

public relations firms, audiovisual firms, businesses, book/encyclopedia publishers, magazine publishers, newspapers, postcard companies, calendar companies, greeting card companies.

Needs Needs general stock photos, all categories. Emphasizes people, activities, all seasons. Always needs large-format color scenics from all over the world. No fashion shots.

Specs Uses 35mm, $2^1/_4 \times 2^1/_4$, 4×5 transparencies; b&w contact sheets; b&w negatives; "35mm accepted if of unusual interest or outstanding quality."

Payment & Terms Sometimes buys photos outright; pays $10-25/photo. Also pays 50-60% commission for b&w or color after sub-agent commissions. General price range (for clients): $300-500. Works with photographers on contract basis only. Offers nonexclusive contract. Contracts are valid "indefinitely until canceled in writing." Charges 50% catalog insertion fee; for advertising, CD and online services. Statements issued monthly. Payment made monthly; within 10 days of end of month. Photographers allowed to review account records. Offers one-time rights, electronic media and multi-rights. Informs photographers and allows them to negotiate when client requests all rights. Model/property release required for people, houses, pets. Photo captions required; include "date, place, technical detail and any descriptive information that would help to market photos."

Making Contact Send query letter with stock list. Send unsolicited photos by mail with SASE for consideration. "Send letter first; we'll send our questionnaire and spec sheet. You must include correct return postage for your material to be returned." Tips sheet distributed periodically to established contributors.

Tips Prefers to see "well-selected, edited color on a variety of subjects. Well-composed, well lit shots, featuring contemporary styles and clothes. Be creative, selective, professional and loyal. Communicate openly and often." Review guidelines on website before submitting.

▣ ▨ ⊕ CAPITAL PICTURES

85 Randolph Ave., London W9 1DL United Kingdom. (44)(207)286-2212. Fax: (44)(207)286-1218. E-mail: sales@capitalpictures.com. Website: www.capitalpictures.com. Picture library. Has 500,000 photos in files. Clients include: advertising agencies, book publishers, magazine publishers, newspapers.

Needs Specializes in high-quality photographs of famous people (politics, royalty, music, fashion, film and television).

Specs High-quality digital format only. Send via CD, e-mail as JPEG files.

Payment & Terms Pays 50% commission for b&w and color photos, film, videotape. "We have our own price guide but will negotiate competitive fees for large quantity usage or supply agreements." Offers volume discounts to customers. Discount sales terms negotiable. Works with photographers with or without a contract; negotiable, whatever is most appropriate. No charges—only 50% commission for sales. Statements issued monthly. Payment made monthly. Photographers allowed to review account records. Offers any rights they wish to purchase. Informs photographers and allows them to negotiate when client requests all rights "if we think it is appropriate." Photo captions preferred; include date, place, event, name of subject(s).

Making Contact Send query letter with samples. Agency will contact photographer for portfolio review if interested. Keeps samples on file. Expects minimum initial submission of 24 images with monthly submissions of at least 24 images. Responds in 1 month to queries. Market tips sheet not available.

▣ CATHOLIC NEWS SERVICE

3211 Fourth St. NE, Washington DC 20017-1100. (202)541-3251. Fax: (202)541-3255. E-mail: photos@catholicnews.com. Website: www.catholicnews.com. **Contact:** Nancy Wiechec, photos/graphics manager. Photo Associates: Bob Roller and Paul Haring. News service transmitting news, features, photos and graphics to Catholic newspapers and religious publishers.

Needs Timely news and feature photos related to the Catholic Church or Catholics, head shots of Catholic newsmakers or politicians, and other religions or religious activities, including those that illustrate spirituality. Also interested in photos of family life, modern lifestyles, teenagers, poverty, and active seniors.

Specs Prefers high-quality JPEG files, 8×10 at 200 dpi. If sample images are available online, send URL via e-mail; or send samples via CD.

Payment & Terms Pays $75 for unsolicited news or feature photos accepted for one-time editorial use in the CNS photo service. Include full caption information. Unsolicited photos can be submitted via e-mail for consideration. Some assignments made, mostly in large U.S. cities and abroad, to experienced photojournalists; inquire about assignment terms and rates.

Making Contact Query by mail or e-mail; include samples of work. Calls are fine, but be prepared to follow up with letter and samples.

Tips "See our website for an idea of the type and scope of news covered. No scenic, still life, or composite images."

⊞ CHARLTON PHOTOS, INC.

3605 Mountain Dr., Brookfield WI 53045. (262)781-9328. Fax: (262)781-9390. E-mail: jim@charltonphotos.com. Website: www.charltonphotos.com. **Contact:** James Charlton, director of research. Estab. 1981. Stock photo agency. Has 475,000 photos; 200 hours video. Clients include: ad agencies, public relations firms, audiovisual firms, businesses, book/encyclopedia publishers, magazine publishers, newspapers, calendar companies.

Needs "We handle photos of agriculture and pets."

Specs Uses color photos; 35mm, 2¼ transparencies, as well as digital.

Payment & Terms Pays 60/40% commission. Average price per image (to clients): $500-650 for color photos. Offers volume discounts to customers; terms specified in photographers' contracts. Works with photographers on contract basis only. Prefers exclusive contract, but negotiable based on subject matter submitted. Contracts renew automatically with additional submissons for 3 years minimum. Charges duping fee, 50% catalog insertion fee and materials fee. Statements issued monthly. Payment made monthly. Photographers allowed to review account records that relate to their work. Model/property release required for identifiable people and places. Photo captions required; include who, what, when, where.

Making Contact Query by phone before sending any material. Expects initial submission of 1,000 images. Responds in 2 weeks. Photo guidelines free with SASE. Market tips sheet distributed quarterly to contract freelance photographers; free with SASE.

Tips "Provide our agency with images we request by shooting a self-directed assignment each month. Visit our website."

⊞ CHINASTOCK

2506 Country Village, Ann Arbor MI 48103-6500. (734)996-1440. Fax: call for number. E-mail: decoxphoto@aol.com. Website: www.denniscox.com. **Contact:** Dennis Cox, director. Estab. 1993. Stock photo agency. Has 60,000 photos in files. Has branch office in Beijing, China. Clients include: advertising agencies, public relations firms, book/encyclopedia publishers, magazine publishers, newspapers, calendar companies.

Needs Handles only photos of China (including Hong Kong and Taiwan), including tourism. Wants photos of babies/children/teens, celebrities, couples, multicultural, families, parents, senior citizens, disasters, environmental, landscapes/scenics, wildlife, architecture, cities/urban, education, gardening, pets, religious, rural, automobiles, entertainment, events, food/drink, health/fitness/beauty, performing arts, sports, travel, agriculture, industry, medicine, military, political, science, technology/computers, cultural relics. Interested in documentary, historical/vintage. Needs hard-to-locate photos and exceptional images of tourism subjects.

Specs Uses 35mm, 2×2 transparencies, high-res digital files.

Payment & Terms Pays 50% commission for b&w and color photos. Average price per image (to clients): $125 minimum for b&w and color photos. Occasionally negotiates fees below standard minimum prices. "Prices are based on usage and take into consideration budget of client." Offers volume discounts to customers. Costs are deducted from resulting sales. Photographers can choose not to sell images on discount terms. Works with photographers with or without a signed contract. "Will negotiate contract to fit photographer's and agency's mutual needs." Payment made quarterly. Photographers allowed to review account records. Offers one-time rights and electronic media rights. Informs photographers and allows them to negotiate when client requests all rights. Model/property release preferred. Photo captions required; include where image was shot and what is taking place.

Making Contact Send query letter with stock list. "Let me know if you have unusual material." Keeps samples on file; include SASE for return of material. Agency is willing to accept 1 great photo and has no minimum submission requirements. Responds in 2 weeks. Market tips sheet available upon request.

Tips Agency "represents mostly veteran Chinese photographers and some special coverage by Americans. We're not interested in usual photos of major tourist sites. We have most of those covered. We need more photos of festivals, modern family life, joint ventures, and all aspects of Hong Kong and Taiwan."

⊞ BRUCE COLEMAN PHOTO LIBRARY

Bruce Coleman, Inc., 111 Brook St., 2nd Floor, Scarsdale NY 10583. (914)713-4821. Fax: (914)722-8347. E-mail: library@bciusa.com. Website: www.bciusa.com. **Contact:** Norman Owen Tomalin, photo director. Estab. 1970. Stock photo agency. Has more than 1.5 million photos in files. Clients include: advertising agencies, public relations firms, audiovisual firms, businesses, book/encyclopedia publishers, magazine pub-

lishers, newspapers, postcard publishers, calendar companies, greeting card companies, zoos (installations), TV.

Needs Wants photos of babies/children/teens, couples, multicultural, families, parents, senior citizens, disasters, environmental, landscapes/scenics, wildlife, architecture, cities/urban, pets, rural, adventure, hobbies, sports, travel, agricultural, business concepts, industry, product shots/still life, science, technology/computers.

Specs Accepts images in digital format.

Payment & Terms Pays 50% commission for color transparencies, digital files and b&w photos. Average price per image (to clients): $125 minimum for color and b&w photos. Contracts renew automatically for 5 years. Statements issued quarterly. Payment made quarterly. Does not allow photographer to review account records; any deductions are itemized. Offers one-time rights. Model/property release preferred for people, private property. Photo captions required; include location, species, genus name, Latin name, points of interest.

Making Contact Send query letter with résumé. Expects minimum initial submission of 200 images with annual submission of 2,000 images. Responds in 3 months to completed submission; 1-week acknowledgment. Photo guidelines free with SASE. Want lists distributed on website.

Tips "We look for strong dramatic angles, beautiful light, sharpness. We like photos that express moods/feelings and show us a unique eye/style. We like work to be properly captioned. Caption labels should be typed or computer generated and should contain all vital information regarding the photograph. We are asking for natural settings, dramatic use of light and/or angles. Photographs should not be contrived and should express strong feelings toward the subject. We advise photographers to shoot a lot of film, photograph what they really love, and follow our want lists."

▣ ⊕ EDUARDO COMESAÑA-AGENCIA DE PRENSA/BANCO FOTOGRAFICO

Av. Olleros 1850 4to. "F" C1426CRH Buenos Aires Argentina. (54)(11)4771-9418. Fax: (54)(11)4771-0080. E-mail: info@comesana.com. Website: www.comesana.com. **Contact:** Eduardo Comesaña, managing director. Estab. 1977. Stock agency, news/feature syndicate. Has 500,000 photos in files. Clients include: advertising agencies, businesses, newspapers, postcard publishers, book publishers, calendar companies, magazine publishers.

Needs Wants photos of babies/children/teens, celebrities, couples, families, parents, disasters, environmental, landscapes/scenics, wildlife, education, adventure, entertainment, events, health/fitness, humor, performing arts, travel, agriculture, business concepts, industry, medicine, political, science, technology/computers. Interested in documentary, fine art, historical/vintage.

Specs Accepts images in digital format only. Send via CD, DVD as TIFF or JPEG files at 300 dpi. By e-mail in JPEG format only.

Payment & Terms Pays 50% commission for b&w or color photos. Offers volume discounts to customers; terms specified in photographer's contracts. Photographers can choose not to sell images on discount terms. Works with photographers with or without a contract; negotiable. Offers limited regional exclusivity. Contracts renew automatically with additional submissions. Statements issued quarterly. Payment made quarterly. Photographers allowed to review account records in cases of discrepancies only. Offers one-time rights. Model release preferred; property release required.

Making Contact Send query letter with tearsheets, stock list. Provide self-promotion piece to be kept on file. Expects minimum initial submission of 200 images in low-res files with monthly submissions of at least 200 images. Responds only if interested; send nonreturnable samples.

CORBIS

902 Broadway, 3rd Floor, New York NY 10010. (212)777-6200. Fax: (212)533-4034. Website: www.corbis.com. Estab. 1991. Stock agency, picture library, news/feature syndicate. Member of the Picture Archive Council of America (PACA). Corbis also has offices in London, Paris, Dusseldorf, Tokyo, Seattle, Chicago and Los Angeles. Clients include: advertising agencies, businesses, newspapers, public relations firms, book publishers, calendar companies, audiovisual firms, magazine publishers, greeting card companies, businesses/corporations, media companies.

Making Contact "Please check the 'For Our Photographers' section of our website for current submission information."

▣ ⊕ SYLVIA CORDAIY LIBRARY LTD.

45 Rotherstone, Devizes, Wilshire SN10 2DD United Kingdom. (44)01380728327. Fax: (44)01380728328. E-mail: info@sylvia-cordaiy.com. Website: www.sylvia-cordaiy.com. Estab. 1990. Stock photo agency. Has

400,000 photos in files. Clients include: advertising agencies, public relations firms, audiovisual firms, businesses, book publishers, magazine publishers, newspapers, calendar companies, greeting card companies, postcard publishers.

Needs Wants photos of worldwide travel, wildlife, disasters, environmental issues. Specialist files include architecture, the polar regions, ancient civilizations, natural history, flora and fauna, livestock, domestic pets, veterinary, equestrian and marine biology, London and UK, transport railways, shipping, aircraft, aerial photography. Also interested in babies/children/teens, couples, multicultural, families, parents, senior citizens, architecture, cities/urban, education, gardening, pets, religious, rural, adventure, sports, travel, agriculture, industry, military, product shots/still life, science, technology/computers. Interested in documentary, historical/vintage, seasonal. Handles the Paul Kaye archive of 20,000 b&w prints.

Specs Uses 35mm, $2\frac{1}{4} \times 2\frac{1}{4}$, 4×5, 8×10 transparencies. Accepts images in digital format. Send via CD, floppy disk.

Payment & Terms Pays 50% commission for b&w and color photos. Pay "varies widely according to publisher and usage." Offers volume discounts to customers. Works with photographers with or without a contract, negotiable. Offers nonexclusive contract, limited regional exclusivity. Charges for return postage. Payment made monthly. Statements only issued with payments. Photographers allowed to review account records. Offers one-time rights, electronic media rights. Model release preferred. Photo captions required; include location and content of image.

Making Contact Send query letter with samples, stock list. Provide résumé, business card, self-promotion piece or tearsheets to be kept on file. Agency will contact photographer for portfolio review if interested. Portfolio should include transparencies. Keeps samples on file; include SASE for return of material. Expects minimum initial submission of 100 images. Responds in 2 weeks. Photo guidelines sheet free with SASE.

Tips "Send SASE, location of images list, and brief résumé of previous experience."

▣ CUSTOM MEDICAL STOCK PHOTO

The Custom Medical Bldg., 3660 W. Irving Park Rd., Chicago IL 60618. (773)267-3100. Fax: (773)267-6071. E-mail: info@cmsp.com. Website: www.cmsp.com. **Contact:** Mike Fisher and Henry Schleichkorn, medical archivists. Member of Picture Archive Council of America (PACA). Clients include: advertising agencies, magazines, journals, textbook publishers, design firms, audiovisual firms, hospitals, Web designers—all commercial and editorial markets that express interest in medical and scientific subject area.

Needs Wants photos of biomedical, scientific, healthcare environmentals and general biology for advertising illustrations, textbook and journal articles, annual reports, editorial use and patient education.

Specs "Accepting only digital submissions. Go online to www.cmsp.com/cmspweb/images for information about contacting us before submitting images, and image specifications."

Payment & Terms Pays per shot or commission. Per-shot rate depends on usage. Commission: 30-40% on domestic leases; 30% on foreign leases. Works with photographers on contract basis only. Offers guaranteed subject exclusivity contract. Contracts of 5-7 years. Royalty-free contract available. Administrative costs charged based on commission structure. Statements issued bimonthly. Payment made bimonthly. Credit line given if applicable, at client's discretion. Offers one-time, electronic media and agency promotion rights; other rights negotiable. Informs photographers but does not permit them to negotiate when a client requests all rights.

Making Contact Send query letter with list of stock photo subjects or check contributor website. Call for address and submission packet. "Do not send uncaptioned unsolicited photos by mail." Responds in 1 month on average. Photo guidelines available on website. Monthly want list available to contributors only. Model/property release required.

Tips "Our past want lists are a valuable guide to the types of images requested by our clients. Past want lists are available on the Web. Environmentals of researchers, hi-tech biomedicine, physicians, nurses and patients of all ages in situations from neonatal care to mature adults are requested frequently. Almost any image can qualify to be medical if it touches an area of life: breakfast, sports, etc. Trends also follow newsworthy events found on newswires. Photos should be good clean images that portray a single idea, whether it is biological, medical, scientific or conceptual. Photographers should possess the ability to recognize the newsworthiness of subjects. Put together a minimum of 10 images for submission. Contributing to our agency can be very profitable if a solid commitment can exist."

▣ DDB STOCK PHOTOGRAPHY, LLC

P.O. Box 80155, Baton Rouge LA 70898. (225)763-6235. Fax: (225)763-6894. E-mail: info@ddbstock.com. Website: www.ddbstock.com. **Contact:** Douglas D. Bryant, president. Estab. 1970. Stock photo agency. Mem-

ber of American Society of Picture Professionals. Currently represents 115 professional photographers. Has 500,000 photos in files. Clients include: travel industry, ad agencies, audiovisual firms, book/encyclopedia publishers, magazine publishers, CD-ROM publishers, large number of foreign publishers.

Needs Specializes in picture coverage of Latin America with emphasis on Mexico, Central America, South America, the Caribbean Basin and Louisiana. Eighty percent of picture rentals are for editorial usage. Important subjects include agriculture, anthropology/archeology, art, commerce and industry, crafts, education, festivals and ritual, geography, history, indigenous people and culture, museums, parks, political figures, religion, scenics, sports and recreation, subsistence, tourism, transportation, travel and urban centers. Also uses babies/children/teens, couples, multicultural, families, parents, senior citizens, architecture, rural, adventure, entertainment, events, food/drink, health/fitness, performing arts, business concepts, industry, medicine, military, science, technology/computers.

Specs Uses 35mm, $2\frac{1}{4} \times 2\frac{1}{4}$, 4×5, 8×10 transparencies. Accepts images in digital format. Send via CD as TIFF files at 2,800 dpi. ''Will review low-res digital subs from first-contact photographers.''

Payment & Terms Pays 50% commission for color photos; 30% on foreign sales through foreign agents. Payment rates: $200-18,000 for color photos. Average price per image (to clients): $250 for color photos. Offers volume discount to customers; terms specified in photographers' contracts. 3-year initial minumum holding period after which all slides can be demanded for return by photographer. Statements issued quarterly. Payment made quarterly. Does not allow photographers to review account records to verify sales figures. ''We are a small agency and do not have staff to oversee audits.'' Offers one-time, electronic media, world and all language rights. Model/property release preferred for ad set-up shots. Photo captions required; include location and detailed description. ''We have a geographic focus and need specific location info on captions.''

Making Contact Interested in receiving work from professional photographers who regularly visit Latin America. Send query letter with brochure, tearsheets, stock list. Expects minimum initial submission of 300 images with yearly submissions of at least 500 images. Responds in 6 weeks. Photo guidelines available on website. Tips sheet updated continually on website.

Tips ''Speak Spanish and spend 1 to 6 months shooting in Latin America every year. Follow our needs list closely. Shoot Fuji, Velvia or Provia transparency film and cover the broadest range of subjects and countries. We have an active duping and digitizing service where we provide European and Asian agencies with images they market in film and on CD. The Internet provides a great delivery mechanism for marketing stock photos and we have digitized and put up thousands on our website. We have 10,000 high-res downloadable TIFFs on our e-commerce site. Edit carefully. Eliminate any images with focus, framing or exposure problems. The market is far too competitive for average pictures and amateur photographers. Review guidelines for photographers on our website. Include coverage from at least 3 Latin American countries or 5 Caribbean Islands. No one-time vacation shots! Send only subjects in demand listed on website.''

▣ DESIGN CONCEPTIONS

112 Fourth Ave., New York NY 10003. (212)254-1688. Fax: (212)533-0760. **Contact:** Joel Gordon. Estab. 1970. Stock photo agency. Has 500,000 photos in files. Clients include: book/encyclopedia publishers, magazine publishers, advertising agencies.

Needs ''Real people.'' Also interested in children/teens, couples, families, parents, senior citizens, events, health/fitness, medicine, science, technology/computers. **Not interested in photos of nature.** Interested in documentary, fine art.

Specs Accepts images in digital format only. Send via CD as JPEG files (low-res for first review) with 1 PTC or meta data info.

Payment & Terms Pays 50% commission for photos. Average price per image (to clients): $200-250 minimum for b&w and color photos. Enforces minimum prices. Offers volume discounts to customers; terms specified in photographers' contracts. Works with photographers with or without a contract. Offers limited regional exclusivity, nonexclusive. Statements issued monthly. Payment made monthly. Photographers allowed to review account records. Offers one-time electronic media and agency promotion rights. Informs photographer when client requests all rights. Model/property release preferred. Photo captions preferred.

Making Contact Call first to explain range of files. Arrange personal interview to show portfolio or CD. Send query letter with samples.

Tips Looks for ''real people doing real, not set-up, things.''

▣ ⊕ DINODIA PHOTO LIBRARY

13-15 Vithoba Lane, Vithalwadi, Kalbadevi, Bombay 400 002 India. (91)(22)2240-4126. Fax: (91)(22)2240-1675. E-mail: jagdish@dinodia.com. Website: www.dinodia.com. **Contact:** Jagdish Agarwal, founder. Estab.

Dinodia Photo Library, based in Bombay, India, contains more than 500,000 images. This one, by Madhusudan Tawde, was used in a promotional calendar for Dinodia.

1987. Stock photo agency. Has 500,000 photos in files. Clients include: advertising agencies, public relations firms, audiovisual firms, businesses, book/encyclopedia publishers, magazine publishers, newspapers, postcard companies, calendar companies, greeting card companies.

Needs Wants photos of babies/children/teens, celebrities, couples, multicultural, families, parents, senior citizens, disasters, environment, landscapes/scenics, wildlife, architecture, cities/urban, education, gardening, interiors/decorating, pets, religious, rural, adventure, automobiles, entertainment, events, food/drink, health/fitness/beauty, hobbies, humor, performing arts, sports, travel, agriculture, business concepts, industry, medicine, military, political, product shots/still life, science, technology/computers. Interested in alternative process, avant garde, documentary, erotic, fashion/glamour, fine art, historical/vintage, seasonal.

Specs "At the moment we are only accepting digital. Initially it is better to send a few nonreturnable printed samples for our review."

Payment & Terms Pays 50% commission for b&w and color photos. General price range (to clients): US $50-600. Negotiates fees below stated minimum prices. Offers volume discounts to customers; inquire about specific terms. Discount sales terms not negotiable. Works with photographers on contract basis only. Offers limited regional exclusivity; "Prefer exclusive for India." Contracts renew automatically with additional submissions for 5 years. Statement issued monthly. Payment made monthly. Photographers permitted to review sales figures. Informs photographers and allows them to negotiate when client requests all rights. Offers one-time rights. Model release preferred. Photo captions required.

Making Contact Send query letter with résumé of credits, nonreturnable samples, stock list and SASE. Responds in 1 month. Photo guidelines free with SASE. Dinodia news distributed monthly to contracted photographers.

Tips "We look for style—maybe in color, composition, mood, subject matter, whatever—but the photos should have above-average appeal." Sees trend that "market is saturated with standard documentary-type photos. Buyers are looking more often for stock that appears to have been shot on assignment."

▣ DK STOCK, INC.

75 Maiden Lane, Suite 319, New York NY 10038. (212)405-1891. Fax: (212)405-1890. E-mail: david@dkstock. com. Website: www.dkstock.com. **Contact:** David Deas, photo editor. Estab. 2000. "A multicultural stock photo company based in New York City, and the first company to launch a fully searchable multiethnic website and publish an African-American stock photography catalog. Prior to launching DK Stock, its founders worked for years in the advertising industry as a creative team specializing in connecting clients to the $1.6 trillion ethnic market. This market is growing, and DK Stock's goal is to service it with model-released, well composed, professional imagery." Member of the Picture Archive Council of America (PACA). Has 10,000 photos in files. Clients include: advertising agencies, public relations firms, buisinesses, book publishers, magazine publishers, newspapers, calendar companies, greeting card companies.

Needs "Looking for contemporary lifestyle images that reflect the black and Hispanic diaspora." Wants photos of babies/children/teens, celebrities, couples, multicultural, families, parents, senior citizens, education, adventure, entertainment, health/fitness/beauty, hobbies, humor, performing arts, sports, travel, agriculture, business concepts, industry, medicine, military, political, science, technology/computers. Interested in historical/vintage. "Images should include models of Hispanics and/or people of African descent. Images of Caucasian models interacting with black and/or Hispanic people can also be submitted. Be creative, selective and current. Visit website to get an idea of the style and range of representative work. E-mail for a current copy of 'needs list.' "

Specs Uses 35mm, $2\frac{1}{4} \times 2\frac{1}{4}$, 4×5, 8×10 transparencies. Accepts images in digital format. Send via CD as TIFF files at 300 dpi, 50MB.

Payment & Terms Pays 50% commission for b&w or color photos. Average price per image (to clients): $100-15,000 for b&w photos or color photos. Enforces minimum prices. Offers volume discounts to customers; terms specified in photographers' contracts. Photographers can choose not to sell images on discount terms. Works with photographers on contract basis only. Offers nonexclusive contract. Contracts renew automatically with additional submissions for 5 years. Statements issued monthly. Payment made monthly. Photographers allowed to review account records. Model/property release required. Photo captions optional.

Making Contact Send query letter with slides, prints, photocopies, tearsheets, transparencies. Portfolio may be dropped off every Monday-Friday. Does not keep samples on file; include SASE for return of material. Expects minimum initial submission of 50 images with 5 times/year submissions of at least 25 images. Responds in 2 weeks to samples, portfolios. Photo guidelines free with SASE. Catalog free with SASE.

Tips "We love working with talented people. If you have 10 incredible images, let's begin a relationship. Also, we're always looking for new and upcoming talent as well as photographers who can contribute often. There is an increasing demand for lifestyle photos of multicultural people. Our clients are based in the Americas, Europe, Asia and Africa. Be creative, original and technically proficient."

▣ ▣ DRK PHOTO

100 Starlight Way, Sedona AZ 86351. (928)284-9808. Fax: (928)284-9096. Website: www.drkphoto.com. **Contact:** Daniel R. Krasemann, president. "We handle only the personal best of a select few photographers—not hundreds. This allows us to do a better job aggressively marketing the work of these photographers." Member of Picture Archive Council of America (PACA) and American Society of Picture Professionals (ASPP). Clients include: ad agencies; PR and AV firms; businesses; book, magazine, textbook and encyclopedia publishers; newspapers; postcard, calendar and greeting card companies; branches of the government; and nearly every facet of the publishing industry, both domestic and foreign.

Needs "Especially need marine and underwater coverage." Also interested in S.E.M.'s, African, European and Far East wildlife, and good rainforest coverage.

Specs Uses 35mm, $2\frac{1}{4} \times 2\frac{1}{4}$, 4×5 transparencies; high-res digital scans.

Payment & Terms Pays 50% commission for color photos. General price range (to clients): $100 "into thousands." Works with photographers on contract basis only. Offers nonexclusive contract. Contracts renew automatically. Statements issued quarterly. Payment made quarterly. Offers one-time rights; "other rights negotiable between agency/photographer and client." Model release preferred. Photo captions required.

Making Contact "With the exception of established professional photographers shooting enough volume to support an agency relationship, we are not soliciting open submissions at this time. Those professionals wishing to contact us in regards to representation should query with a brief letter of introduction and tearsheets."

▣ ▣ DW STOCK PICTURE LIBRARY (DWSPL)

108 Beecroft Rd., Beecroft, New South Wales 2119 Australia. (612)9869-0717. E-mail: info@dwpicture.com. au. Website: www.dwpicture.com.au. Estab. 1997. Has more than 200,000 photos on file and 30,000 online.

"Strengths include African wildlife, Australia, travel, horticulture, agriculture, people and lifestyles." Clients include: advertising agencies, designers, printers, book publishers, magazine publishers, calendar companies.

Needs Wants photos of babies/children/teens, families, parents, senior citizens, disasters, gardening, pets, rural, health/fitness, travel, industry.

Specs Accepts images in digital format. Send as low-res JPEG files via CD.

Payment & Terms Pays 50% commission. Average price per image (to clients): $200 for color photos. Enforces minimum prices. Offers volume discounts to customers. Works with photographers on contract basis only. Statements issued quarterly. Photographers allowed to review account records in cases of discrepancies only. Offers one-time rights. Model release preferred. Photo captions required.

Making Contact Send query letter with images; include SASE if sending by mail. Expects minimum initial submission of 200 images. Responds in 2 weeks to samples.

E & E PICTURE LIBRARY

Beggars Roost, Woolpack Hill, Brabourne Lees, Ashford, Kent TN25 6RR United Kingdom. E-mail: isobel@picture-library.freeserve.co.uk. Website: http://picture-library.mysite.wanadoo-members.co.uk. **Contact:** Isobel Sinden. Estab. 1998. Member of BAPLA (British Association of Picture Libraries and Agencies). Has 130,000 images on file. Clients include: advertisers/designers, businesses, book publishers, magazine publishers, newspapers, calendar/card companies, merchandising, TV.

Needs Religious/spiritual images worldwide, buildings, clergy, festivals, ceremony, objects, places, food, ritual, monks, nuns, stained glass, carvings symbols. Mormons, Shakers, all groups/sects, large or small. Biblelands. Death, burial, funerals, graves, gravediggers, green burial. Festivals. Curiosities, unusual oddities like follies, signs, symbols. Architecture, religious or secular, commemmorative, i.e., VIPs. Manuscripts and illustrations, old and new, linked with any of the subjects above. Interested in documentary, fine art, historical/vintage, seasonal.

Specs Uses 35mm, 2¼×2¼, 4×5 transparencies. Accepts images in digital format. Send via CD, JPEG files.

Payment & Terms Average price per image (to clients): $140-200 for color photos. Offers volume discounts to customers. Works with photographers on contract basis for 5 years, offering exclusive/nonexclusive contract renewable automatically with additional submissions. Offers one-time rights. Model release where necessary. Photo captions very important and must be accurate. Include what, where, any special features or connections, name, date (if possible), and religion.

Making Contact Send query letter with slides, tearsheets, transparencies/CD. Expects minimum initial submission of 40 images. Responds in 2 weeks. Photo guidelines sheet free with SASE or via e-mail.

Tips "Decide on subject matter. GET IN CLOSE and then closer. Exclude all extraneous objects. Fill the frame. Dynamic shots. Interesting angles, light. No shadows or miniscule objects far away. Tell us what is important about the picture. Don't get people in shot unless they have a role in the proceedings as in a festival or service, etc."

ECOSCENE

Empire Farm, Throop Rd., Templecombe Somerset BA8 0HR United Kingdom. (44)(196)337-1700. E-mail: sally@ecoscene.com. Website: www.ecoscene.com. **Contact:** Sally Morgan, director. Estab. 1988. Picture library. Has 80,000 photos in files. Clients include: advertising agencies, businesses, book/encyclopedia publishers, magazine publishers, newspapers, Internet, multimedia.

Needs Wants photos of disasters, environmental, wildlife, gardening, pets, rural, health/fitness, agriculture, medicine, science, pollution, industry, energy, indigenous peoples. Interested in seasonal.

Specs Accepts digital submissions only. Send via CD as TIFF files at 300 dpi.

Payment & Terms Pays 55% commission for color photos. Average price per image (to clients): $90 minimum for color photos. Negotiates fees below stated minimum prices, depending on quantity reproduced by a single client. Offers volume discounts to customers. Discount sales terms not negotiable. Works with photographers on contract basis only. Offers nonexclusive contract. Contracts renew automatically with additional submissions, 4 years minimum. Statements issued quarterly. Payment made quarterly. Offers one-time and electronic media rights. Informs photographers and allows them to negotiate when client requests all rights. Model/property release preferred. Photo captions required; include location, subject matter, and common and Latin names of wildlife and any behavior shown in pictures.

Making Contact Send query letter with résumé of credits. Digital submissions only. Keeps samples on file; include SASE for return of material. Expects minimum initial submission of 100 images with annual submissions of at least 100 images. Responds in 3 weeks. Photo guidelines free with SASE. Market tips sheets distributed quarterly to anybody who requests and to all contributors.

Tips Photographers should have a "neat presentation and accurate, informative captions. Images must be tightly edited with no fillers. Photographers must be critical of their own work and check out the website to see the type of image required. Sub-standard work is never accepted, whatever the subject matter. Enclose return postage."

ECOSTOCK PHOTOGRAPHY

Harper Studios, Inc., 5531 Airport Way S., Studio C, Seattle WA 98108. (206)764-4893 or (800)563-5485. E-mail: info@ecostock.com. Website: www.ecostock.com. **Contact:** Photo Editor. Estab. 1990. Stock agency. Has 18,000 photos in files. Clients include: advertising agencies, businesses, public relations firms, book publishers, magazine publishers.

Needs Wants photos of animals and wildlife, landscapes/scenics, environmental issues, outdoor recreation, gardening, adventure, sports, travel, agriculture, concepts. Also needs tourism, human interest, families, kids.

Specs Uses digital; 35mm, medium- and large-format transparencies.

Payment & Terms Pays 50% commission for b&w photos; 50% for color photos. Offers volume discounts to customers. Works with photographers on contract basis only. Offers image exclusive contract. Statements and payments are issued at time of receipt of payment. Photographers allowed to review account records in cases of discrepancies only. Offers one-time, electronic media and agency promotion rights. Model/property release required. Photo captions required; include common name, scientific name, where taken, when taken, behaviors, relative information.

Making Contact E-mail for guidelines. No phone calls please. Does not keep samples on file; include SASE for return of material. Expects minimum initial submission of 100 images. Responds in 6 weeks to portfolios. Photo guidelines sheet free with SASE.

Tips "Thorough and accurate caption information required. Need clean, in-focus, quality imagery. Use a quality loup when editing for submission. We want to see more conceptual imagery rather than common, everyday subject matter."

EDUCATIONAL IMAGES

24 Victoria St., Torpoint, Cornwall PL11 2HE United Kingdom. E-mail: enquiries@educationalimages.co.uk. Website: www.educationalimages.co.uk. Estab. 1998. Has 8,000 photos in files. Clients include: book publishers, magazine publishers.

Needs Wants photos of babies/children/teens, environmental, landscapes/scenics, wildlife, education, religious, travel, science, technology/computers. Interested in historical/vintage.

Specs Uses 4×6, 5×7, 8×10 glossy color and/or b&w prints; 35mm, $2^{1}/_{4}\times2^{1}/_{4}$ transparencies.

Payment & Terms Pays 50% commission for photos. Average price per image (to clients): $60-600 for b&w or color photos. Enforces minimum prices. Offers volume discounts to customers. Terms specified in photographer's contract. Discount sales terms not negotiable. Works with photographers on contract basis only. Offers nonexclusive contract. Photographers allowed to review account records. Offers one-time rights. Informs photographers and allows them to negotiate when client requests all rights. Model release preferred. Photo captions preferred.

Making Contact Send query letter with résumé, tearsheets. Provide résumé, self-promotion piece to be kept on file. Expects minimum initial submission of 50 images. Responds in 2 weeks. Photo guidelines sheet free with SASE. Market tips sheet available regularly for contracted photographers.

Tips "Check that it meets agency requirements before submission. Potential contributors from North America should make initial contact by e-mail. Do *not* send photos with U.S. stamps for return—they can't be used here."

ENGINE101.COM

Engine101 Inc., 89 Canterbury St., Saint John NB E2L 2C7 Canada. (506)657-6557. E-mail: artists@engine101.com. Website: www.engine101.com. **Contact:** Marc LeBlanc, account representative. Estab. 2003. Stock agency. Has 2,000 photos in files. Clients include: advertising agencies, audiovisual firms, businesses, newspapers, postcard publishers, public relations firms, book publishers, calendar companies, magazine publishers.

Needs Wants photos of babies/children/teens, celebrities, couples, multicultural, families, parents, senior citizens, architecture, cities/urban, education, gardening, interiors/decorating, pets, religious, rural, agriculture, science, business concepts, industry, medicine, military, political, product shots/still life, technology/computers, disasters, environmental, landscapes/scenics, wildlife, adventure, automobiles, entertainment,

events, food/drink, health/fitness/beauty, hobbies, humor, performing arts, sports, travel. Interested in alternative process, avant garde, documentary, fashion/glamour, fine art, historical/vintage.

Specs Accepts images in digital format. Send via CD as TIFF files at 8×12 at 300 dpi or greater.

Payment & Terms Pays 50% commission for b&w or color photos. Average price per image (to clients): $89.95-$499.95 (Canadian) for b&w or color photos. Enforces strict minimum prices. "We have set the prices; however, they are subject to change without notice. We do not offer discounts for large quantity purchases." Works with photographers on contract basis only. Offers nonexclusive contract. Contracts renew automatically with additional submissions. Statements issued monthly. Payment made monthly. Photographers allowed to review account records in cases of discrepancies only. Offers one-time rights; electronic media rights. Informs photographers and allows them to negotiate when client requests all rights. Model/property release required. Photo captions required; include location, city, state, country, full description, related keywords, date image was taken.

Making Contact Expects minimum initial submission of 30 images with a minimum of 100 images/year. Responds in 2 weeks to samples; 2 weeks to portfolios. Photo guidelines sheet free with SASE.

Tips "Submit digital images, 8×12 at 300 dpi or (preferably) greater, free of all dust and scratches, smooth color gradiations, low noise/pixelization, sharpness, color accuracy. We accept digital submissions from 6 megapixel or greater, digital SLR professional cameras, as well as scanned slides or scanned black-and-white negatives."

▣ ENVISION

27 Hoppin Rd., Newport RI 02840. (401)619-1500 or (800)524-8238. E-mail: envision@att.net. Website: www.envision-stock.com. **Contact:** Sue Pashko, director. Estab. 1987. Stock photo agency. Member of the Picture Archive Council of America (PACA). Has 200,000 photos in files. Clients include: advertising agencies, public relations firms, businesses, book/encyclopedia publishers, magazine publishers, newspapers, calendar and greeting card companies, graphic design firms.

Needs Wants professional-quality photos of food, commercial food processing, fine dining, crops, Third World lifestyles, European landmarks, tourists in Europe and Europe in winter looking lovely with snow, and anything on Africa and African-Americans. Also wants people, business, lifestyle and conceptual photos.

Specs Uses 35mm, $2^{1}/_{4} \times 2^{1}/_{4}$, 4×5, 8×10 transparencies. "We prefer large and medium formats." Accepts images in digital format. Send via CD as TIFF files at 300 dpi.

Payment & Terms Pays 50% commission for b&w and color photos and film. General price range (to clients): $100-25,000 for b&w photos; $200-25,000 for color photos. Works with photographers on contract basis only. Statements issued monthly. Payment made monthly. Offers one-time rights; "each sale individually negotiated—usually one-time rights." Model/property release required. Photo captions required.

Making Contact Arrange personal interview to show portfolio. Send query letter with résumé of credits "on company/professional stationery." Regular submissions are mandatory. Responds in 1 month.

Tips "Clients expect the very best in professional-quality material. Photos that are unique, taken with a very individual style. Demands for traditional subjects *but* with a different point of view; African- and Hispanic-American lifestyle photos are in great demand. We have a need for model-released, professional-quality photos of people with food—eating, cooking, growing, processing, etc."

▣ ▣ ESTOCK PHOTO, LLC

1170 Broadway, 9th Floor, New York NY 10001. (800)284-3399. Fax: (212)545-1185. E-mail: sales@estockphoto.com. Website: www.estockphoto.com. **Contact:** Laura Diez, president. Member of Picture Archive Council of America (PACA). Has over 1 million photos in files. Clients include: ad agencies, public relations and AV firms; business; book, magazine and encyclopedia publishers; newspapers, calendar and greeting card companies; textile firms; travel agencies and poster companies.

Needs Wants photos of travel, destination, people, lifestyles, business.

Specs Uses 35mm, medium-format, 4×5 transparencies. Accepts images in digital format.

Payment & Terms Price depends on quality and quantity. Usually pays 50% commission. General price range (to clients): $125-6,500. Works with photographers on contract basis only. Offers exclusive and limited regional exclusive contracts. Contracts renew automatically for 3 years. Offers to clients "any rights they want to have; payment is calculated accordingly." Statements issued bimonthly and quarterly. **Payment made bimonthly and quarterly.** Photographers allowed to review account records to verify their sales figures. Offers one-time and electronic media rights. Informs photographers and allows them to negotiate when client requests all rights; some conditions. Model release required; "depends on subject matter." Photo captions preferred.

Making Contact Send query letter with samples—"about 100 is the best way." Send query letter with list of stock photo subjects or submit portfolio for review. Response time depends; often the same day. Photo guidelines free with SASE.

Tips "Photos should show what the photographer is all about. They should show technical competence—photos that are sharp, well-composed, have impact; if color, they should show color."

■ ETHNO IMAGES, INC.

189 Third St., Suite A112, Oakland CA 94607. (510)433-0766. E-mail: admin@mail.ethnoimages.com. Website: www.ethnoimages.com. **Contact:** Troy A. Jones, CEO/president; T. Lynn Jones, COO. Estab. 1999. "The resource of choice for multicultural imagery." Has 50,000 photos in files. Clients are marketing professionals in the communications industry, including advertising agencies, public relations firms, book and magazine publishers and printing companies.

Needs Wants multicultural images representing lifestyles, families, teenagers, children, couples, celebrities, sports and business. "We specialize in ethnic images representing minorities and multicultural groups."

Specs Uses 35mm transparencies, "but digital is preferred." Send digital images via CD, Zip as TIFF, JPEG files at 300 dpi (at least 48MB).

Payment & Terms Pays 50% commission for b&w or color photos. Average price per image (to clients): $300. Enforces minimum prices. Offers volume discounts to customers. Works with photographers on contract and freelance basis. Offers nonexclusive contract. Payment made monthly. Model release required; property release preferred. Photo captions required.

Making Contact Send query letter with sample of multicultural images, CD-ROM or digital images. Provide business card and self-promotion piece to be kept on file. Photo guidelines sheet provided upon request. Market tips sheets available monthly.

Tips "Caption each image—multicultural images only—and provide contact information. Prefer initial submissions on CD-ROM in JPEG format. Call or e-mail."

■ ⊕ EUREKA-SLIDE

3 av Th. Frissen, Brussels B-1160 Belgium. (32)(02)372-2702. Fax: (32)(02)372-2707. E-mail: info@eurekaslide.com. Website: www.eurekaslide.com. **Contact:** Sylvie De Leu, director. Estab. 1985. Has 300,000 photos in files. Clients include: advertising agencies, businesses, newspapers, postcard publishers, public relations firms, book publishers, calendar companies, audiovisual firms, magazine publishers, greeting card companies.

Needs Wants photos of babies, children, couples, multicultural, families, parents, senior citizens, teens, disasters, environmental, landscapes/scenics, wildlife, architecture, beauty, cities/urban, education, gardening, interiors/decorating, pets, religious, rural, adventure, automobiles, entertainment, events, food/drink, health/fitness, hobbies, humor, performing arts, sports, travel, agriculture, buildings, business concepts, computers, industry, medicine, military, political product shots/still life, science, technology/computers. Interested in alternative process, avant garde, documentary.

Specs Uses 35mm, $2^1/_4 \times 2^1/_4$, 4×5 transparencies. Accepts images in digital format. Send via CD, Jaz as JPEG files at 300 dpi.

Payment & Terms Pays 50% commission for color photo. Average price per image (to clients): $150 minimum-$200 maximum for color photos. Enforces minimum prices. Offers volume discounts to customers; terms specified in photographer's contracts. Works with photographers on contract basis only. Offers limited regional exclusivity. Statements issued semiannually. Payment made semiannually. Photographers allowed to review account records in cases of discrepancies only. Model/property release required. Photo captions required.

Making Contact Contact through rep. Send query letter with résumé. Expects minimum initial submission of 50 images.

Tips "Before sending, call us."

Ⓝ ⊕ EYE UBIQUITOUS

65 Brighton Rd., Shoreham, West Sussex BN43 6RE United Kingdom. (440)(127)344-0113. Fax: (440)(127)344-0116. E-mail: library@eyeubiquitous.com. Website: www.eyeubiquitous.com. **Contact:** Paul Seheult, owner. Estab. 1988. Picture library. Has 300,000 photos in files. Clients include: ad agencies, public relations firms, businesses, book/encyclopedia publishers, magazine publishers, newspapers, television companies.

Needs Wants photos of worldwide social documentary and general stock.

Specs Uses 35mm, $2\frac{1}{4} \times 2\frac{1}{4}$, 4×5 transparencies; Fuji and Kodak film.

Payment & Terms Pays 50% commission. Offers volume discounts to customers; inquire about specific terms. Discount sales terms not negotiable. Works with photographers on contract basis only. Offers exclusive, limited regional exclusivity and nonexclusive contracts. Contracts renew automatically with additional submissions. Charges to photographers "discussed on an individual basis." Payment made quarterly. Photographers allowed to review account records. Buys one-time, electronic media and agency promotion rights; negotiable. Does not inform photographers or allow them to negotiate when client requests all rights. Model/property release preferred for people, "particularly Americans." Photo captions required; include where, what, why, who.

Making Contact Submit portfolio for review. Works with local freelancers only. Keeps samples on file. Include SASE for return. No minimum number of images expected in initial submission, but "the more the better." Responds as time allows. Photo guidelines free with SASE. Catalog free with SASE. Market tips sheet distributed to contributors "when we can"; free with SASE.

Tips "Find out how picture libraries operate. This is the same for all libraries worldwide. Amateurs can be very good photographers but very bad at understanding the industry after reading some irresponsible and misleading articles. Research the library requirements."

▣ 🌐 FAMOUS PICTURES & FEATURES AGENCY

13 Harwood Rd., London SW6 4QP United Kingdom. (44)(207)731-9333. Fax: (44)(207)731-9330. E-mail: info@famous.uk.com. Website: www.famous.uk.com. **Contact:** Rob Howard. Estab. 1985. Picture library, news/feature syndicate. Has more than 500,000 photos on database. Clients include: advertising agencies, book publishers, magazine publishers, newspapers, calendar companies, postcard publishers and poster publishers.

Needs Wants photos of music, film, TV personalities; international celebrities; live, studio, party shots (paparazzi) with stars of all types.

Specs Prefers images in digital format. Send via FTP or e-mail as JPEG files at 300 dpi or higher.

Payment & Terms Pays 50% commission for color photos. Offers volume discounts to customers. Photographers can choose not to sell images on discount terms. Works with photographers with or without a contract; contracts available for all photographers. Offers limited regional exclusivity. Statements issued monthly. Payment made monthly. Photographers allowed to review account records. Offers one-time rights. Photo captions preferred.

Making Contact E-mail, phone or write, provide samples. Provide résumé, business card, self promotion piece or tearsheets to be kept on file. Agency will contact photographer for portfolio review if interested. Keeps samples in online database. Will return material with SAE/IRC.

Tips "We are solely marketing images via computer networks. Our fully searchable archive of new and old pictures is online. Send details via e-mail for more information. When submitting work, please caption pictures correctly."

🌐 FFOTOGRAFF

10 Kyveilog St., Cardiff, Wales CF11 9JA United Kingdom. (44)(2920)236879. E-mail: ffotograff@easynet.co.uk. Website: www.ffotograff.com. **Contact:** Patricia Aithie, owner. Estab. 1988. Picture library. Has 200,000 photos in files. Clients include: businesses, book publishers, magazine publishers, newspapers.

Needs Wants photos of Middle and Far East countries, Africa and Central America, and the Worlds Islands—multicultural, environmental, landscapes/scenics, architecture, cities/urban, religious, agriculture.

Specs Uses 35mm, $2\frac{1}{4} \times 2\frac{1}{4}$ transparencies only.

Payment & Terms Pays 50% commission for color photos. Average price per image (to clients): $60-500 for color photos (transparencies only). Negotiates fees around market rate. Offers volume discounts to customers. Photographers can choose not to sell images on discount terms. Works with photographers on contract basis only. Offers nonexclusive contract. Contracts renew automatically with additional submissions "as long as the slides are kept by us." Statements issued when a sale is made. Offers one-time rights. Photo captions required.

Making Contact Contact by telephone or send query letter with résumé, slides; or "e-mail us with countries covered—color transparencies only, no JPEG files, please." Does not keep samples on file; include SAE/IRC for return of material. Responds in 2 weeks to samples.

Tips "Send interesting, correctly focused, well exposed transparencies that suit the specialization of the library. We are interested in images concerning Middle East and Far East countries, Australia, China, Africa

and Central America, and the Worlds Islands; general travel images, arts, architecture, culture, landscapes, people, cities, and everyday activities. Photographers with a UK address preferred.''

▣ ⊕ FIREPIX INTERNATIONAL

68 Arkles Lane, Liverpool, Merseyside L4 2SP United Kingdom. E-mail: info@firepix.com. Website: www.fire pix.com. **Contact:** Tony Myers. Estab. 1995. Picture library. Has 25,000 photos in files. Clients include: advertising agencies, businesses, newspapers, postcard publishers, public relations firms, book publishers, calendar companies, magazine publishers.

Needs Wants photos of disasters, firefighting, fire salvage, work of firefighters.

Specs Uses various sizes of glossy color and/or b&w prints; 35mm transparencies. Accepts images in digital format. Send via CD, floppy disk, Zip, e-mail as TIFF, GIF, JPEG files at any dpi.

Payment & Terms Pays 50% commission. Average price per image (to clients): $90. Works with photographers on contract basis only. Contracts renew automatically with additional submissions. Payment made within 2 weeks of receiving sale invoice. Photographers allowed to review account records. Offers one-time rights. Model release required. Photo captions required.

Making Contact Send query letter with slides. Keeps samples on file. Expects minimum initial submission of 20 images. Responds in 2 weeks to samples.

Tips ''Submit better quality images than existing library stock.''

▣ ◪ FIRST LIGHT ASSOCIATED PHOTOGRAPHERS

333 Adelaide St. W., 6th Floor, Toronto ON M5V 1R5 Canada. (416)597-8625. Fax: (416)597-2035. E-mail: info@firstlight.ca. Website: www.firstlight.ca. **Contact:** Anne Bastarache, director/photography. Estab. 1984. Stock agency, represents 40 international agencies and over 250 photographers. One million images available online. Clients include: advertising agencies, public relations firms, audiovisual firms, businesses, book/encyclopedia publishers, magazine publishers, newspapers, calendar companies.

Needs Wants commercial imagery in all categories. Special emphasis on model-released people, lifestyle, conceptual photography and business. ''Our broad files require variety of subjects.''

Specs ''For initial review submission we prefer low-res JPEG files on CD; for final submissions we require clean 50MB (minimum) high-res files. Can also send preview-sized files via e-mail.''

Payment & Terms Pays 45% commmission. Works on contract basis only, nonexclusive. Minimal scanning fee per image for images supplied as film. Statements issued monthly. Payment made monthly. Offers one-time rights. Informs photographers and allows them to negotiate when client requests all rights. Model release required. Photo captions required.

Making Contact Send query letter via e-mail.

Tips Wants to see ''tight, quality editing and description of goals and shooting plans.''

▣ FIRTH PHOTOBANK

420 Oak St. N., Suite 101, P.O. Box 99, Carver MN 55315. (952)361-6766. Fax: (952)361-0256. E-mail: bobfirth photo@earthlink.net. Website: http://firthphotobank.com. **Contact:** Bob Firth, owner. Stock photo agency. Has more than 1 million photos in files. Clients include: advertising agencies, book publishers, magazine publishers, calendar companies, greeting card companies, postcard publishers.

Needs Write for current guidelines.

Specs Uses $2\frac{1}{4}\times2\frac{1}{4}$, 4×5 transparencies, some 35mm. Accepts images in digital format. Send via CD, floppy disk, Zip as TIFF, EPS files.

Payment & Terms Pays 40% commission for b&w and color photos. Average price per image (to clients): $100-1,000 for b&w and color photos.

Making Contact Call or send query letter with brochure, stock list, tearsheets. Do not send images without prior approval. Do not send e-mails with images!

▣ ⊕ THE FLIGHT COLLECTION

Reed Business Information, Quadrant House, The Quadrant, Sutton, Surrey SM2 5AS United Kingdom. (44)(208)652-8888. Fax: (44)(208)652-8933. E-mail: qpl@rbi.co.uk. Website: www.theflightcollection.com. **Contact:** Kim Hearn. Estab. 1983. Has 1 million photos in files. Clients include: advertising agencies, public relations firms, audiovisual firms, businesses, book publishers, magazine publishers, newspapers, calendar companies, greeting card companies, postcard publishers.

Needs Wants photos of aviation.

Specs Uses 35mm, $2\frac{1}{4} \times 2\frac{1}{4}$, 4×5 transparencies. Accepts images in digital format. Send via CD as TIFF files at 300 dpi.

Payment & Terms Pays 50% commission for color photos. Average price per image (to clients): $50-150 for color photos. Enforces minimum prices. Offers volume discounts to customers. Discount sales terms not negotiable. Works with photographers on contract basis only. Offers nonexclusive contract. Contracts renew automatically with additional submissions, no specific time. Statements issued monthly. Payment made monthly. Offers one-time rights. Model/property release required. Photo captions required; include name, subject, location, date.

Making Contact Send query letter with résumé, transparencies. Does not keep samples on file; include SASE for return of material. Expects minimum initial submission of 50 images. Responds in 2 weeks to samples. Photo guidelines sheet free with SASE. Catalog free with SASE.

Tips "Caption slides properly. Provide a list of what's submitted."

▣ ⊕ FOCUS NEW ZEALAND PHOTO LIBRARY LTD.

Box 84-153, Westgate, Auckland 1250 New Zealand. (64)(9)4115416. Fax: (64)(9)4115417. E-mail: photos@focusnzphoto.co.nz. Website: www.focusnzphoto.co.nz. **Contact:** Brian Moorhead, director. Estab. 1985. Stock agency. Has 40,000 photos in files. Clients include: advertising agencies, businesses, newspapers, postcard publishers, public relations firms, book publishers, calendar companies, magazine publishers, greeting card companies, electronic graphics.

Needs Wants photos of babies/children/teens, couples, multicultural, families, parents, senior citizens, environmental, landscapes/scenics, architecture, cities/urban, education, rural, adventure, events, health/fitness/beauty, hobbies, performing arts, sports, travel, agriculture, business concepts, industry, science, technology/computers. Interested in seasonal. Also needs New Zealand, Australian and South Pacific images.

Specs Uses 35mm, medium-format and up to full-frame panoramic 6×17 transparencies. Accepts images in digital format, RGB, TIFF, 300 dpi, A4 minimum.

Payment & Terms Pays 50% commission. Offers volume discounts to customers. Discount sales terms not negotiable. Works with photographers on contract basis only. Offers nonexclusive contract. Statements issued quarterly. Payment made quarterly. Photographers allowed to review account records. Offers one-time, electronic media and agency promotion rights. Model/property release preferred. Photo captions required; include exact location, content, details, releases, date taken.

Making Contact Send query letter. Does not keep samples on file; include SASE for return of material. Expects minimum initial submission of 100 images with yearly submissions of at least 100-200 images. Responds in 3 weeks to samples. Photo guidelines sheet free with SASE or by e-mail. Catalog free on website. Market tips sheet available by mail or e-mail to contributors only.

Tips "Only submit original, well-composed, well-constructed, technically excellent work, fully captioned."

▣ FOLIO, INC.

5683 Columbia Pike, Suite 101, Falls Church VA 22041. (800)662-1992 or (703)820-4810. Fax: (703)820-4812. E-mail: info@foliophoto.com. Website: www.foliophoto.com. Estab. 1983. Stock agency. Has 275,000 photos in files. Clients include: advertising agencies, businesses, newspapers, postcard publishers, public relations firms, book publishers, calendar companies, magazine publishers, greeting card companies.

Needs Wants photos of babies/children/teens, couples, families, parents, senior citizens, disasters, environmental, landscapes/scenics, wildlife, education, pets, adventure, sports, travel, business concepts, political, technology/computers. Interested in seasonal.

Specs Uses 35mm. Accepts images in digital format. Send via CD, DVD. Contact for submission guidelines. "No e-mail attachments; links only."

Payment & Terms Pays 50% commission for b&w and color photos. Offers volume discounts to customers; terms specified in photographers' contracts. Photographers can choose not to sell images on discount terms. Works with photographers with or without a contract; negotiable. Offers limited regional exclusivity. Photographers allowed to review account records. Offers one-time rights, electronic media rights, agency promotion rights.

Making Contact Contact through rep. Send query letter with stock list. Does not keep samples on file; include SASE for return of material. Photo guidelines available on website. Market tips sheet available to contract photographers.

▣ FOODPIX

Picture Arts Corporation, 99 Pasadena Ave., South Pasadena CA 91030. (800)720-9755. E-mail: cheryl.lee@picturearts.com. Website: www.picturearts.com. **Contact:** Cheryl Lee. Estab. 1994. Stock agency. Member of

the Picture Archive Council of America (PACA). Has 33,000 photos in files. Clients include: advertising agencies, businesses, newspapers, book publishers, calendar companies, design firms, magazine publishers. **Needs** Wants food, beverage and lifestyle images.

Specs Uses 35mm, $2\frac{1}{4} \times 2\frac{1}{4}$, 4×5, 8×10 transparencies. Accepts images in digital format. Send via CD as JPEG files at 300 dpi for review. Submissions guidelines are available on the website.

Payment & Terms Enforces minimum prices. Offers volume discounts to customers; terms specified in photographers' contracts. Works with photographers on contract basis only. Offers exclusive contract only. Statements issued quarterly. Payment made quarterly. Offers one-time rights. Model/property release required. Photo captions required.

Making Contact Send query letter with tearsheets. Expects maximum initial submission of 50 images. Responds in 1 month. Catalog available.

Tips Review guidelines on website (www.picturearts.com/contributors.aspx) and complete the Online Submission Questionnaire and Submission Delivery Memo before submitting work.

◫ ⊕ FOTEX MEDIEN AGENTUR GMBH

Glashuettenstrasse 79, D-20357 Hamburg Germany. (49)(40)43214111. Fax: (49)(40)43214199. E-mail: fotex @fotex.de. Website: www.fotex.com. **Contact:** Mrs. Sabine von Johnn or Gabriele Dreschsler, International Relations. Estab. 1985. Stock agency. Has 1 million photos in files. Clients include: advertising agencies, businesses, newspapers, postcard publishers, public relations firms, book publishers, calendar companies, audiovisual firms, magazine publishers, greeting card companies, record companies.

Needs Wants photos of babies/children/teens, celebrities, couples, multicultural, families, parents, senior citizens, disasters, environmental, landscapes/scenics, wildlife, architecture, cities/urban, education, gardening, interiors/decorating, pets, religious, rural, adventure, automobiles, entertainment, events, food/drink, health/fitness/beauty, hobbies, humor, performing arts, sports, travel, agriculture, business concepts, industry, medicine, military, political, product shots/still life, science, technology/computers. Interested in alternative process, avant garde, documentary, erotic, fashion/glamour, fine art, historical/vintage, seasonal.

Specs Uses images in digital format. Send via CD/DVD, Zip, e-mail at 300 dpi. Accepts also 35mm, $2\frac{1}{4} \times 2\frac{1}{4}$, 4×5 transparencies.

Payment & Terms Buys photos outright. Pays 50% commission for color photos. Offers volume discounts to customers; terms specified in photographers' contracts. Discount sales terms not negotiable. Works with photographers on contract basis only. Offers exclusive contract, limited regional exclusivity, nonexclusive contract, guaranteed subject exclusivity. Statements issued monthly. Photographers allowed to review account records in cases of discrepancies only. Offers one-time, electronic media and agency promotion rights. Model release required; property release preferred. Photo captions required.

Making Contact Send query letter with CD/DVD/transparencies and stock list. Provide résumé, business card to be kept on file. Responds in 2 weeks to samples.

◫ ⊕ FOTO-PRESS TIMMERMANN

Speckweg 34A, D-91096 Moehrendorf Germany. (49)(9131)42801. Fax: (49)(9131)450528. E-mail: info@f-pt.com. Website: www.f-pt.com. **Contact:** Wolfgang Timmermann. Stock photo agency. Has 750,000 photos in files. Clients include: advertising agencies, audiovisual firms, businesses, book/encyclopedia publishers, magazine publishers, newspapers, calendar companies.

Needs Wants all themes: landscapes, countries, travel, tourism, towns, people, business, nature, babies/children/teens, couples, families, parents, senior citizens, adventure, entertainment, health/fitness/beauty, hobbies, industry, medicine, technology/computers. Interested in erotic, fine art, seasonal.

Specs Uses $2\frac{1}{4} \times 2\frac{1}{4}$, 4×5, 8×10 transparencies (no prints). Accepts images in digital format. Send via CD, Zip as TIFF files.

Payment & Terms Pays 50% commission for color photos. Works on nonexclusive contract basis (limited regional exclusivity). First period: 3 years; contract automatically renewed for 1 year. Photographers allowed to review account records. Statements issued quarterly. Payment made quarterly. Offers one-time rights. Informs photographers and allows them to negotiate when a client requests to buy all rights. Model/property release preferred. Photo captions required; include state, country, city, subject, etc.

Making Contact Send query letter with stock list. Send unsolicited photos by mail for consideration; include SAE/IRC for return of material. Responds in 1 month.

◫ ⊕ FOTOASIA.COM

11 Kalang Place, #06-09, Singapore 339155. (65)398-1383. Fax: (65)398-1393. E-mail: sales@fotoasia.com. Website: www.fotoasia.com. **Contact:** Winston Tan, managing director. Estab. 1999. Has 30,000 photos

online. Has branch offices in China, Malaysia. Clients include: advertising agencies, public relations firms, businesses, book publishers, magazine publishers, newspapers, calendar companies, greeting card companies, postcard publishers.

Needs Wants photos of babies/children/teens, celebrities, couples, multicultural, families, parents, senior citizens, landscapes/scenics, wildlife, architecture, cities/urban, education, gardening, interiors/decorating, pets, religious, rural, adventure, automobiles, entertainment, food/drink, health/fitness/beauty, hobbies, humor, performing arts, sports, travel, buildings, business concepts, industry, medicine, military, political, product shots/still life, science, technology/computers. All must be Asian images.

Specs Uses 35mm, 4×5 transparencies; 120 slides. Accepts images in digital format. Send via CD, Jaz, Zip, e-mail as JPEG files.

Payment & Terms Pays 50% commission for color photos. Average price per image (to clients): $30-180 for color photos. Negotiates fees below standard minimum prices. Offers volume discounts to customers. Terms specified in photographers' contracts. Discount sales terms not negotiable. Works with photographers with or without contract; negotiable. Contracts renew automatically with additional submissions for 3 years. Statements issued quarterly. Payment made quarterly. Photographers allowed to review account records. Offers agency promotion rights. Royalty-free. Model release required. Photo captions required; include place, race.

Making Contact Send query letter with tearsheets. Provide résumé, business card, self-promotion piece to be kept on file. Responds in 1 month. Photo guidelines sheet available online. Catalog available online.

Tips "Provide captions; clean (no fungus) slides; SASE for return of slides."

FOTOCONCEPT INC.

18020 SW 66th St., Ft. Lauderdale FL 33331. (954)680-1771. Fax: (954)680-8996. **Contact:** Aida Bertsch, vice president. Estab. 1985. Stock photo agency. Has 400,000 photos in files. Clients include: magazines, advertising agencies, newspapers, publishers.

Needs Wants general worldwide travel, medical and industrial.

Specs Uses 35mm, 2¼×2¼, 4×5 transparencies.

Payment & Terms Pays 50% commission for b&w or color photos. Average price per image (to clients): $175 minimum for b&w or color photos. Works with photographers on contract basis only. Offers nonexclusive contract. Contracts renew automatically with each submission for 1 year. Statements issued quarterly. Payment made quarterly. Photographers allowed to review account records to verify sales figures. Offers one-time rights. Model release required. Photo captions required.

Making Contact Send query letter with stock list. Responds in 1 month.

Tips Wants to see "clear, bright colors and graphic style. Looking for photographs with people of all ages with good composition, lighting and color in any material for stock use."

☐ ⊕ FOTOSCOPIO

Capital Federal, Buenos Aires Argentina. E-mail: info@fotoscopio.com. Website: www.fotoscopio.com. **Contact:** Gustavo Di Pace, director. Estab. 1999. Fotoscopio is a Latin American stock photo agency. Has 10,000 photos in files. Clients include: advertising agencies, businesses, postcard publishers, book publishers, calendar companies, magazine publishers, greeting card companies.

Needs Wants photos of Hispanic people, Latin American countries, babies/children/teens, celebrities, couples, multicultural, families, senior citizens, disasters, environmental, landscapes/scenics, wildlife, architecture, cities/urban, interiors/decorating, pets, religious, adventure, automobiles, entertainment, health/fitness/beauty, hobbies, sports, travel, agriculture, business concepts, industry, product shots/still life, technology/computers. Interested in documentary, fine art, historical/vintage.

Specs Uses 35mm, 2¼×2¼, 4×5, 8×10 transparencies. Accepts images in digital format. Send via CD, Zip, e-mail as JPEG files at 72 dpi.

Payment & Terms Average price per image (to clients): $50-300 for b&w photos; $50-800 for color photos. Negotiates fees below stated minimums. Offers volume discounts to customers; terms specified in photographer's contracts. Discount sales terms not negotiable. Works with photographers on contract basis only. Offers nonexclusive contract. Contracts renew automatically with additional submissions for 1 year. Statements issued and payment made whenever one yields rights of reproduction of his photography. Photographers allowed to review account records in cases of discrepancies only. Offers one-time and electronic media rights. Model release required; property release preferred. Photo captions preferred.

Making Contact Send query letter with résumé, slides, prints, photocopies, tearsheets, transparencies, stock

list. Provide résumé, business card, self-promotion piece to be kept on file. Expects minimum initial submission of 100 images. Responds in 1 month to samples. Photo guidelines sheet free with SASE.

▣ FUNDAMENTAL PHOTOGRAPHS

210 Forsyth St., New York NY 10002. (212)473-5770. Fax: (212)228-5059. E-mail: mail@fphoto.com. Website: www.fphoto.com. **Contact:** Kip Peticolas, partner. Estab. 1979. Stock photo agency. Applied for membership into the Picture Archive Council of America (PACA). Has 100,000 photos in files. Clients include: book/encyclopedia publishers, advertising agencies, corporate industrial.

Needs Wants photos of medicine, biology, environmental, industry, weather, disasters, science-related business concepts, agriculture, technology/computers.

Specs Uses 35mm and all large-format transparencies. Accepts images in digital format. Send as TIFF files at 300 dpi, 11×14 size.

Payment & Terms Pays 50% commission for b&w, color photos. General price range (to clients): $100-500 for b&w photos; $150-1,200 for color photos; depends on rights needed. Enforces strict minimum prices. Offers volume discount to customers. Works with photographers on contract basis only. Offers guaranteed subject exclusivity. Contracts renew automatically with additional submissions for 2 or 3 years. Charges $5/image scanning fee; can increase to $15 if corrective Photoshop work required. Statements issued and payment made quarterly for any sales during previous quarter. Photographers allowed to review account records with written request submitted 2 months in advance. Offers one-time and electronic media rights. Gets photographer's approval when client requests all rights; negotiation conducted by the agency. Model release required. Photo captions required; include date and location.

Making Contact Arrange a personal interview to show portfolio or make contact by e-mail and arrange for digital submission. Submit portfolio for review. Send query letter with résumé of credits, samples or list of stock photo subjects. Keeps samples on file; include SASE for return of material. Expects minimum initial submission of 100 images. Photo guidelines free with SASE. Tips sheet distributed. E-mail crucial for communicating current photo needs.

Tips "Our primary market is science textbooks. Photographers should research the type of illustration used and tailor submissions to show awareness of saleable material. We are looking for science subjects ranging from nature and rocks to industrials, medicine, chemistry and physics; macro photography, photomicrography, stroboscopic; well-lit still life shots are desirable. The biggest trend that affects us is the need for images that document new discoveries in sciences and ecology."

GAYSTOCKPHOTOGRAPHY.COM

Blue Door Productions, Inc., 515 Seabreeze Blvd., Suite 228, Ft. Lauderdale FL 33316. (954)713-8126. Fax: (954)713-8165. E-mail: info@gaystockphotography.com. Website: www.gaystockphotography.com. Estab. 1997. Stock agency and picture library. Has over 3,000 photos in files. Clients include: advertising agencies, businesses, newspapers, postcard publishers, book publishers, calendar companies, magazine publishers, greeting card companies.

Payment & Terms Average price per image (to clients): $50-5,000 for b&w and color photos or film. Offers volume discounts to customers. Offers one-time, electronic media, agency promotion and limited term rights. Model release required; property release preferred.

Making Contact Send query letter with stock list.

⊕ GEOSLIDES & GEO AERIAL PHOTOGRAPHY

4 Christian Fields, London SW16 3JZ United Kingdom. (44)(208)764-6292. Fax: (44)(115)981-9418. E-mail: geoslides@geo-group.co.uk. Website: www.geo-group.co.uk. **Contact:** John Douglas, marketing director. Estab. 1968. Picture library. Has approximately 100,000 photos in files. Clients include: advertising agencies, public relations firms, audiovisual firms, businesses, book/encyclopedia publishers, magazine publishers, newspapers, calendar companies, television.

Needs Accent on travel/geography and aerial (oblique) shots. Wants photos of disasters, environmental, landscapes/scenics, wildlife, architecture, rural, adventure, travel, agriculture, industry, medicine, military, political, product shots/still life, science, technology/computers. Interested in documentary, historical/vintage.

Specs Uses 35mm, $2^{1}/_{4} \times 2^{1}/_{4}$, 4×5 transparencies.

Payment & Terms Pays 50% commission for b&w or color photos. General price range (to clients) $75-750. Works with photographers with or without a contract; negotiable. Offers nonexclusive contract. Charges mailing costs. Statements issued monthly. Payment made upon receipt of client's fees. Offers one-time rights

and first rights. Does not inform photographers or allow them to negotiate when clients request all rights. Model release required. Photo captions required; include description of location, subject matter and sometimes the date.

Making Contact Send query letter or e-mail with résumé of credits, stock list; include SAE/IRC for return of material. Photo guidelines available for SAE/IRC. No samples until called for.

Tips Looks for "technical perfection, detailed captions, must fit our needs, especially location needs. Increasingly competitive on an international scale. Quality is important. Needs large stocks with frequent renewals." To break in, "build up a comprehensive (i.e., in subject or geographical area) collection of photographs which are well documented."

GETTY IMAGES

601 N. 34th St., Seattle WA 98103. (206)925-5000. Fax: (206)925-5001. Website: www.gettyimages.com. "Getty Images is the world's leading imagery company, creating and distributing the largest and most relevant collection of still and moving images to communication professionals around the globe and supporting their work with asset management services. From news and sports photography to contemporary and archival imagery, Getty Images' products are found each day in newspapers, magazines, advertising, films, television, books and websites. Gettyimages.com is the first place customers turn to search, purchase, download and manage powerful imagery. Seattle-headquartered Getty Images is a global company with customers in more than 100 countries."

Making Contact Please visit www.gettyimages.com/contributors and select the link "Interested in marketing your imagery through Getty Images?"

GLOBE PHOTOS, INC.

275 Seventh Ave., 14th Floor, New York NY 10001. (212)645-9292. Fax: (212)627-8932. E-mail: info@globeph otos.com. Website: www.globephotos.com **Contact:** Ray Whelan, Sr., general manager (celebrity photos). Estab. 1939. Stock photo agency. Member of the Picture Archive Council of America. Has 10 million photos. Clients include: ad agencies, public relations firms, audiovisual firms, businesses, book/encyclopedia publishers, magazine publishers, newspapers and calendar companies.

Needs General stock photography, celebrity photos and coverage of the entertainment industry.

Specs Uses 8×10 b&w prints; 35mm, $2\frac{1}{4} \times 2\frac{1}{4}$, 4×5, 8×10 transparencies. Prefers images in digital format.

Payment & Terms Pays 50% commission for b&w and color photos. Offers volume discounts to customers; inquire about specific terms. Discount sales terms not negotiable. Works on contract basis only. Offers nonexclusive and exclusive contracts. Contracts renew automatically with additional submissions for 3 years. Statements issued monthly, when there is sales activity in photographer's account. Payment made monthly. Photographers allowed to review account records once a year, after request in writing stating reasons. Offers one-time or electronic media rights and exclusivity upon negotiation. Model/property release required for recognizable people, commercial establishments and private homes.

Making Contact Arrange personal interview to show portfolio. Send query letter with résumé of credits, stock list. "Résumé or stock list appreciated but not required." Keeps samples on file. Expects minimum initial submission of 150-200 images (depends on medium). Responds in 3 weeks. Photo guidelines free with SASE. Market tips sheet distributed periodically to contributing photographers upon request.

Tips "We transmit images digitally via modem, e-mail and ISDN lines to affiliates and clients."

JOEL GORDON PHOTOGRAPHY

112 Fourth Ave., New York NY 10003. (212)254-1688. E-mail: joel.gordon@verizon.net. **Contact:** Joel Gordon, picture agent. Stock photo agency. Clients include: ad agencies, designers, textbook/encyclopedia publishers.

Specs "We now accept digital files only. Call for information. Will review low-res files only if they have IPTC or meta data info."

Payment & Terms Pays 50% commission for b&w and color images. Works with photographers with or without a contract. Offers nonexclusive contract. Payment made after client's check clears. Photographers allowed to review account records to verify sales figures. Informs photographers and allows them to negotiate when client requests all rights. Offers one-time, electronic media and agency promotion rights. Model/property release preferred. Photo captions preferred.

GEORGE HALL/CHECK SIX

426 Greenwood Beach, Tiburon CA 94920. (415)381-6363. Fax: (415)383-4935. E-mail: george@check-6.com. Website: www.check-6.com. **Contact:** George Hall, owner. Estab. 1980. Stock photo agency. Member of the

Picture Archive Council of America (PACA). Has 60,000 photos in files. Clients include advertising agencies, public relations firms, businesses, magazine publishers, calendar companies.
Needs All modern aviation and military.
Specs Uses 35mm, 2¼×2¼, 4×5 transparencies. Accepts images in digital format.
Payment & Terms Pays 50% commission for color photos. Average price per stock sale: $1,000. Has minimum price of $300 (some lower fees with large bulk sales, rare). Offers volume discounts to customers; terms specified in photographer's contract. Photographers can choose not to sell images on discount terms. Works with photographers on contract basis only. Offers nonexclusive contract. Payment made within 5 days of each payment receipt. Photographers allowed to review account records. Offers one-time and electronic media rights. Does not inform photographers or allow them to negotiate when client requests all rights. Model release preferred. Photo captions preferred; include basic description.
Making Contact Call or write with details, SASE. Responds in 3 days. Photo guidelines available.

▣ GEORGE HALL/CODE RED

426 Greenwood Beach, Tiburon CA 94920. (415)381-6363. Fax: (415)383-4935. E-mail: george@check-6.com. Website: www.code-red.com. **Contact:** George Hall, owner. Stock photo agency. Member of the Picture Archive Council of America (PACA). Has 5,000 photos in files. Clients include: advertising agencies, public relations firms, businesses, book/encyclopedia publishers, magazine publishers, calendar companies.
Needs Interested in firefighting, emergencies, disasters, hostile weather: hurricanes, quakes, floods, etc.
Specs Uses color prints; 35mm, 2¼×2¼, 4×5 transparencies. Accepts images in digital format.
Payment & Terms Pays 50% commission. Average price per image (to clients) $1,000. Enforces strict minimum prices of $300. Offers volume discounts to customers; terms specified in photographer's contract. Photographers can choose not to sell images on discount terms. Works with photographers on contract basis only. Offers nonexclusive contract. Payment made within 5 days of each payment receipt. Photographers allowed to review account records. Offers one-time rights. Does not inform photographers or allow them to negotiate when client requests all rights. Model release preferred. Photo captions required.
Making Contact Call or write with details, SASE. Responds in 3 days. Photo guidelines available.

▣ GRANT HEILMAN PHOTOGRAPHY, INC.

P.O. Box 317, Lititz PA 17543. (717)626-0296. Fax: (717)626-0971. E-mail: info@heilmanphoto.com. Website: www.heilmanphoto.com. **Contact:** Sonia Wasco, president. Estab. 1948. Member of the Picture Archive Council of America (PACA). Has one million photos in files. Now representing Photo Network Stock. Sub agents in Canada, Europe, England, Japan. Clients include: advertising agencies, public relations firms, businesses, book/textbook publishers, magazine publishers, calendar companies, greeting card companies, postcard publishers.
Needs Wants photos of environmental, landscapes/scenics, wildlife, gardening, pets, rural, agriculture, science, technology/computers. Interested in seasonal.
Specs Uses 35mm, 2¼×2¼, 4×5 transparencies. Accepts images in digital format. Send via CD, floppy disk, Jaz, Zip, e-mail as TIFF, EPS, PICT, JPEG files.
Payment & Terms Pays on commission basis. Enforces minimum prices. Offers volume discounts to customers. Works with photographers on contract basis only. Offers guaranteed subject exclusivity (within files). Contracts renew automatically with additional submissions per contract definition. Charges determined by contract. Statements issued quarterly. Payment made quarterly. Photographers allowed to review account records. Offers one-time rights, electronic media rights, agency promotion rights. Model/property release required. Photo captions required; include all known information.
Making Contact Send query letter with résumé, slides, prints, photocopies, tearsheets, transparencies, stock list. Provide résumé, business card, self-promotion piece to be kept on file. Expects minimum initial submission of 200 images.
Tips ''Make a professional presentation.''

⊕ HOLT STUDIOS

Coxes Farm, Branscombe, Seaton, Devon EX12 3BJ United Kingdom. (44)(1297)680569. Fax: (44)(1297)680478. E-mail: library@holt-studios.co.uk. Website: www.holt-studios.co.uk. **Contact:** Graham Everitt or Nigel Cattlin. Picture library. Has 130,000 photos in files. Clients include: advertising agencies, public relations firms, book publishers, magazines, newspapers, national and multinational industries, commercial customers.
Needs Wants photos of world agriculture, livestock, crops, crop production, horticulture and aquaculture;

crop protection including named species of weeds, pests, diseases and examples of abiotic disorders; general farming, people, agricultural and biological research and innovation. Also needs photos of gardens, gardening, environmental, landscapes/scenics, wildlife, rural, food/drink, named varieties of ornamental plants, clearly identified natural history subjects and examples of environmental issues.

Specs Uses all formats of transparencies, 35mm and larger.

Payment & Terms Pays 50% commission. Average price per image (to clients): $70 minimum. Offers nonexclusive contract. Contracts renew automatically with additional submissions for 3 years. Photographers allowed to review account records. Statements issued quarterly. Payment made quarterly. Offers one-time nonexclusive rights. Model release preferred. Photo captions required.

Making Contact Write, call or e-mail outlining the type and number of photographs being offered. Photo guidelines free with SAE. **Holt Studios is not seeking new photograph contributors at the present time.**

🖳 🌐 HORIZON INTERNATIONAL IMAGES LIMITED

Horizon House, Route de Picaterre, Alderney, Guernsey GY9 3UP British Channel Islands. (44)(1481)822587. Fax: (44)(1481)823880. E-mail: mail@hrzn.com. Website: www.hrzn.com. Estab. 1978. Stock photo agency. Horizon sells stock image use rights, both Rights Managed and Royalty Free, via catalogs, international agents and website.

Needs Subjects include Lifestyle (babies/children/teens, couples, multicultural, families, parents, seniors, adventure, entertainment, food/drink, health/fitness, humor, sports); Business (meetings, small business, big business); Environment (landscapes/scenics, plants, rural); Animals (farm, wildlife, pets); Travel (architecture, natural landmarks, festivals/traditional costume); Industry (medicine, science, technology/computers).

Specs Digital images (12 megapixel camera and above) and drum-scanned transparencies, fully detailed, all submitted via Horizon's www.e-picturelibrary.net website. Transparency scanning service available.

Payment & Terms Occasionally accepting new photographers on 50% sales commission. Optional subscription; "membership of E-Picture Library network allows photographers to create their own Web pages on the system and receive favorable percentage of sales. See full Terms and Conditions on website."

Making Contact Register on www.e-picturelibrary.net website (click "Join Now" on the task bar). Then submit via online submission system. Horizon sometimes purchases and commissions stock (is prepared to review assignment portfolios from photographers interested to produce images of model-released people on an assigned basis).

Tips "Terms & Conditions apply."

🖳 HORTICULTURAL PHOTOGRAPHY℠

337 Bedal Lane, Campbell CA 95008. (408)364-2015. Fax: (408)364-2016. E-mail: requests@horticulturalphoto.com. Website: www.horticulturalphoto.com. **Contact:** Robin M. Orans, owner. Estab. 1974. Picture library. Has 200,000 photos in files. Clients include: advertising agencies, public relations firms, businesses, book publishers, magazine publishers.

Needs Wants photos of flowers, plants with botanical identification, gardens, landscapes.

Specs Uses color slides; 35mm transparencies. Accepts images in digital format. Contact prior to sending images.

Payment & Terms Pays commission for images. Average price per image (to clients): $25-1,000 for color photos. Negotiates fees below stated minimums; depends on quantity. Offers volume discounts to customers. Discount sales terms not negotiable. Works with photographers on contract basis only; negotiable. Statements issued semiannually. Payment made semiannually. Photographers allowed to review account records in cases of discrepancies only. Offers one-time rights, electronic media rights and language rights. Photo captions required; include common and botanical names of plants, date taken, location.

Making Contact Contact through rep. Send e-mail with résumé, stock list. Does not keep samples on file. Expects minimum initial submission of 40 images with quarterly submissions of at least 100 images. Responds in 1 month to samples and portfolios. Photo guidelines available by e-mail or on website.

Tips "Send e-mail for guidelines."

🖼 🌐 I.C.P. INTERNATIONAL COLOUR PRESS

Piazza Vesuvio 19, Milano 20144 Italy. (39)(024)801-3106. Fax: (39)(024)819-5625. E-mail: icp@icponline.it. Website: www.icponline.it. **Contact:** Mr. Alessandro Marosa, marketing assistant. Estab. 1970. Stock photo agency. Clients include: advertising agencies, public relations firms, audiovisual firms, businesses, book/

encyclopedia publishers, magazine publishers, postcard publishers, calendar companies and greeting card companies.

Specs High-res digital (A3-A4, 300 dpi), keyworded (English and, if possible, Italian).

Payment & Terms Pays 50% commission for color photos. Offers volume discounts to customers; terms specified in photographer's contract. Discount sales terms not negotiable. Contracts renew automatically with additional submissions, for 3 years. Statements issued monthly. Payment made monthly. Photographers permitted to review account records to verify sales figures or deductions. Offers one-time, first and sectorial exclusive rights. Model/property release required. Photo captions required.

Making Contact Arrange personal interview to show portfolio. Send query letter with samples and stock list. Works on assignment only. No fixed minimum for initial submission. Responds in 3 weeks.

N E 🌐 IDARTA TRAVEL IMAGES

Idarta Limited, 522 The Greenhouse, Gibb Street, Birmingham B94AA United Kingdom. E-mail: sales@idartatravelimages.com. Website: www.idartatravelimages.com. Estab. 2003. Stock agency. Has 10,000 photos in files. Clients include: advertising agencies, businesses, book publishers, magazine publishers.

Needs Wants photos of travel.

Specs Accepts images in digital format. Send via CD as TIFF files at 300 dpi.

Payment & Terms Pays 70% commission for b&w photos; 70% for color photos; 70% for film. Average price per image (to clients): $40-1,000 for color photos. Negotiates fees below stated minimums. Offers volume discounts to customers. Terms specified in photographer's contracts. Discount sales terms not negotiable. Works with photographers on exclusive contract only. Contracts renew automatically with additional submissions for 1 year. Charges storage fees (see website). Statements issued quarterly. Payment made quarterly. Photographers allowed to review account records in cases of discrepancies only. Offers one-time rights. Model/property release required. Photo captions required.

Making Contact E-mail query letter with link to photographer's website. Does not keep samples on file; cannot return material. Expects minimum intitial submission of 100 images with annual submissions of at least 100 images. Responds in 1 week to samples.

📃 THE IMAGE FINDERS

2570 Superior Ave., 2nd Floor, Cleveland OH 44114. (216)781-7729. Fax: (216)443-1080. E-mail: imagefinders @sbcglobal.net. Website: http://agpix.com/theimagefinders. **Contact:** Jim Baron, owner. Estab. 1988. Stock photo agency. Has 300,000 photos in files. Clients include: advertising agencies, public relations firms, businesses, book/encyclopedia publishers, magazine publishers, calendar companies, greeting card companies.

Needs General stock agency. Always interested in good Ohio images. Also needs babies/children/teens, couples, multicultural, families, senior citizens, landscapes/scenics, wildlife, architecture, gardening, pets, automobiles, food/drink, sports, travel, agriculture, business concepts, industry, medicine, political, technology/computers. Interested in fashion/glamour, fine art, seasonal.

Specs Uses 35mm, $2\frac{1}{4} \times 2\frac{1}{4}$, 4×5, 6×7, 6×9 transparencies. Accepts digital images; see guidelines before submitting. Send via CD.

Payment & Terms Pays 50% commission for b&w and color photos. Average price per image (to clients): $50-500 for b&w photos; $50-2,000 for color photos. "This is a small agency and we will, on occasion, go below stated minimum prices." Offers volume discounts to customers; terms specified in photographers' contracts. Works with photographers on contract basis only. Contracts renew automatically with additional submissions for 2 years. Statements issued monthly if requested. Payment made monthly. Photographers allowed to review account records. Offers one-time rights; negotiable depending on what the client needs and will pay for. Informs photographers and allows them to negotiate when client requests all rights. "This is rare for us. I would inform photographer of what the client wants and work with photographer to strike the best deal." Model/property release preferred. Photo captions required; include location, city, state, country, type of plant or animal, etc.

Making Contact Send query letter with stock list or send e-mail with link to your website. Call before you send anything that you want returned. Expects minimum initial submission of 100 images with periodic submission of at least 100-500 images. Responds in 2 weeks. Photo guidelines free with SASE. Market tips sheet distributed 2-4 times/year to photographers under contract.

Tips Photographers must be willing to build their file of images. "We need more people images, industry, lifestyles, wildlife, travel, etc. Scenics and landscapes must be outstanding to be considered. Call first or e-mail. Submit at least 100 good images. Must have ability to produce more than 100-200 images per year."

▣ ⊕ IMAGES.DE DIGITAL PHOTO GMBH

Potsdamer Str. 96, Berlin 10785 Germany. (49)(30)59006950. Fax: (49)(30)59006959. E-mail: info@images. de. Website: www.images.de. **Contact:** Katja Herold. Estab. 1997. News/feature syndicate. Has 40,000 photos in files. Clients include: advertising agencies, newspapers, public relations firms, book publishers, magazine publishers.

Needs Wants photos of babies/children/teens, couples, multicultural, families, parents, senior citizens, environment, entertainment, events, food/drink, health/fitness, hobbies, travel, agriculture, business concepts, industry, medicine, political, science, technology/computers.

Specs Accepts images in digital format. Send via CD, Zip, e-mail.

Payment & Terms Pays 50% commission for b&w photos; 50% for color photos. Average price per image (to clients): $50-1,000 for b&w photos or color photos. Offers volume discounts to customers. Discount sales terms not negotiable. Works with photographers with or without a contract; negotiable. Offers limited regional exclusivity. Statements issued monthly. Payment made monthly. Photographers allowed to review account records in cases of discrepancies only. Offers one-time rights, electronic media rights. Informs photographers and allows them to negotiate when client requests all rights. Model release preferred; property release required. Photo captions required.

Making Contact Send query letter with slides, prints. Expects minimum initial submission of 200 images with monthly submissions of at least 50 images. Responds in 2 months to samples. Photo guidelines sheet free with SASE.

▣ IMAGESTATE

29 E. 19th St., 4th Floor, New York NY 10003. (800)821-9600. Fax: (212)358-9101. E-mail: aldeng@imagestate .com. Website: www.imagestate.com. **Contact**: Alden Gewitz, art director. Stock agency. Member of Picture Archive Council of America (PACA). Has more than 2 million photos in files. Clients include: advertising agencies, public relations firms, graphic designers, businesses, publishers, calendar companies, greeting card companies.

• In addition to newly created imagery, Imagestate owns the following outstanding image collections: Zephyr Images, Adventure Photo & Film, WestStock, International Stock, Images Colour Library, John Foxx, and the Pictor collections.

Needs Wants tightly edited, high-quality, current imagery for advertising and editorial clients.

Specs Uses digital images; 35mm, medium- and large-format transparencies; b&w prints.

Payment & Terms Pays 50% rights-managed commission; 20% royalty-fee commission. Works with photographers on contract basis only. Offers image exclusive contract. Statements issued monthly. Payments made monthly. Offers one-time rights; occasionally negotiates exclusive and unlimited use rights. "We notify photographers and work to settle on an acceptable fee when a client requests all rights." Model/property release required. Photo captions required; include description of subjects, locations and persons.

Making Contact Write or e-mail photo editors for a copy of current submission guidelines, or visit website.

Tips "We tell our content providers to always take note of the kinds of images our clients are using, by looking at current media and noting stylistic trends. We also tell them to stay true to their own style, but be flexible enough to try new ideas."

▣ INDEX STOCK IMAGERY, INC.

(formerly Stock Imagery, L.L.C.), 23 W. 18th St., 3rd Floor, New York NY 10011. (212)929-4644 or (800)690-6979. Fax: (212)633-1914. E-mail: editing@indexstock.com. Website: www.indexstock.com. **Contact:** New Artist Inquiries. Estab. 1981. Stock photo agency. Member of Picture Archive Council of America (PACA). "With representation in over 50 countries worldwide, our catalogs receive maximum exposure."

Needs Alternative processes and stylistically creative imagery of the highest quality.

Specs Transparencies and b&w prints only; no color prints, negatives or contact sheets. Accepts digital submissions.

Payment & Terms Pays 50% commission for image sales. "We have competitive prices, but under special circumstances we contact photographer prior to negotiations." Works on an image exclusive contract basis only. Statements and payments issued monthly. Photographers allowed to review account records. Offers one-time and electronic media rights. Informs photographer and allows them to negotiate when client requests all rights. Model/property release required. Photo captions required.

Making Contact "We are always willing to review new photographers' work. However, we prefer to see that the individual has a subject specialty or a stylistic signature that sets them apart in this highly competitive industry. Therefore, we ask that an initial submission be properly edited to demonstrate that they have a

high degree of vision, creativity and style that can be relied upon on a regular basis. Quite simply we are looking for technically superior, highly creative images.''

$ ▣ Ⓐ INTERNATIONAL PHOTO NEWS

Dept. PM, 2902 29th Way, West Palm Beach FL 33407. (561)683-9090. E-mail: jkravetz1@earthlink.net. **Contact:** Jay Kravetz, photo editor. News/feature syndicate. Has 50,000 photos in files. Clients include: newspapers, magazines, book publishers. Previous/current clients include: *Lake Worth Herald, S. Florida Entertainment Guide* and *Prime-Time*; all 3 need celebrity photos with story.

Needs Wants photos of celebrities, entertainment, events, health/fitness/beauty, performing arts, travel, politics, movies, music and television, at work or play. Interested in avant garde, fashion/glamour.

Specs Uses 5×7, 8×10 glossy b&w prints. Accepts images in digital format. Send via CD, Zip, e-mail as TIFF, JPEG files at 300 dpi.

Payment & Terms Pays $10 for b&w photos; $25 for color photos; 5-10% commission. Average price per image (to clients): $25-100 for b&w photos; $50-500 for color photos. Works with photographers on contract basis only. Offers nonexclusive contract. Contracts renew automatically with additional submissions; 1-year renewal. Photographers allowed to review account records. Statements issued monthly. Payment made monthly. Offers one-time rights. Model/property release preferred. Photo captions required.

Making Contact Send query letter with résumé of credits. Solicits photos by assignment only. Responds in 1 week.

Tips ''We use celebrity photographs to coincide with our syndicated columns. Must be approved by the celebrity.''

🌐 THE IRISH IMAGE COLLECTION

Ballydowane East, Bunmahon, Kilmacthomas, Co. Waterford Ireland. E-mail: info@theirishimagecollection. ie. Website: www.theirishimagecollection.ie. **Contact:** George Murday, picture editor. Stock photo agency and picture library. Has 50,000 photos in files. Clients include: advertising agencies, public relations firms, businesses, book/encyclopedia publishers, magazine publishers, newspapers and designers.

Needs Consideration is given only to Irish or Irish-connected subjects.

Specs Uses 35mm and all medium-format transparencies.

Payment & Terms Pays 40% commission for color photos. Average price per image (to client): $85-2,000. Works on contract basis only. Offers exclusive contracts and limited regional exclusivity. Contracts renew automatically with additional submissions. Statements issued quarterly. Payment made quarterly. Photographers allowed to review account records. Offers one-time and electronic media rights. Informs photographer when client requests all rights, but ''we take care of negotiations.'' Model release required. Photo captions required.

Making Contact Send query letter with list of stock photo subjects. Does not return unsolicited material. Expects minimum initial submission of 250 transparencies; 1,000 images annually. ''A return shipping fee is required: important that all similars are submitted together. We keep our contributor numbers down and the quantity and quality of submissions high. Send for information first by e-mail.'' Responds in 2 months.

Tips ''Our market is Ireland and the rest of the world. However, our continued sales of Irish-oriented pictures need to be kept supplied. Pictures of Irish-Americans in Irish bars, folk singing, Irish dancing, in Ireland or anywhere else would prove to be useful. They would be required to be beautifully lit, carefully composed and attractive, model-released people.''

Ⓝ ▣ 🌐 ISOPIX

(formerly Isopress Sénépart), Werkhuizenstraat 7-9 Rue des Ateliers, Brussels 1080 Belgium. (32)(2)420-30-50. Fax: (32)(2)420-41-22. E-mail: pmarnef@isopix.be. Website: www.isopix.be. **Contact:** Paul Marnef, director. Estab. 1984. News/feature syndicate. Has 5 million photos in files. Clients include: advertising agencies, public relations firms, businesses, book publishers, magazine publishers, newspapers, calendar companies, postcard publishers.

Needs Wants photos of babies/children/teens, celebrities, couples, families, parents, senior citizens, disasters, environmental, landscapes/scenics, wildlife, education, religious, events, food/drink, health/fitness, hobbies, humor, agriculture, business concepts, industry, medicine, science, technology/computers. Interested in alternative process, avant garde, documentary, fashion/glamour, fine art, historical/vintage, seasonal.

Specs Accepts images in digital format. Send via CD as TIFF, EPS, PICT, GIF, JPEG files.

Payment & Terms Pays 60-65% commission for b&w and color photos. Enforces strict minimum prices.

Offers volume discounts to customers. Discount sales terms not negotiable. Works with photographers with or without a contract; negotiable. Offers limited regional exclusivity. Contracts renew automatically with additional submissions. Statements issued monthly. Payment made monthly. Photographers allowed to review account records in cases of discrepancies only. Model/property release preferred. Photo captions required.

Making Contact Contact through rep. Does not keep samples on file; include SAE/IRC for return of material. Expects minimum initial submission of 1,000 images with quarterly submissions of at least 500 images.

🖵 🌐 ISRAELIMAGES.COM

Kammon, DN Bikat Bet Hakerem 20112 Israel. (972)(4)990-5783. E-mail israel@israelimages.com. Website: www.israelimages.com. **Contact:** Israel Talby, managing director. Estab. 1991. Has 450,000 photos in files. Clients include: advertising agencies, web designers, businesses, book publishers, magazine publishers, newspapers, calendar companies, greeting card and postcard publishers, multimedia producers, schools and universities, etc.

Needs ''We are interested in everything about Israel, Judaism (worldwide) and The Holy Land.''

Specs Uses digital material only, minimum accepted size 2000×3000 pixels. Send CD with low-res samples for review. ''When accepted, we need TIFF or JPEG files at 300 dpi, RGB, saved at quality '11' in Photoshop.''

Payment & Terms Average price per image (to clients): $50-3,000/picture. Negotiates fees below standard minimum against considerable volume that justifies it. Offers volume discounts to customers. Works with photographers on contract basis only. Offers limited regional exclusivity, nonexclusive contract. Contracts renew automatically with additional submissions. Statements issued quarterly. Payment made quarterly. Photographers allowed to review account records. Offers one-time rights, electronic media rights, agency promotion rights. Informs photographers and allows them to negotiate when a client requests all rights. Model/property release preferred. Photo captions required (what, who, when, where).

Making Contact Send query letter with CD or send low-res by e-mail. Expects minimum initial submission of 100 images. Responds in 2 weeks.

Tips ''We strongly encourage everyone to send us images to review. When sending material, a strong edit is a must. We don't like to get 100 pictures with 50 similars. Last, don't overload our e-mail with submissions. Make an e-mail query, or better yet, view our submission guidelines on the website.''

🖵 IVERSON SCIENCE PHOTOS

31 Boss Ave., Portsmouth NH 03801. (603)433-8484. Fax: (603)433-8484. E-mail: bruce.iverson@verizon.net. **Contact:** Bruce Iverson, owner. Estab. 1981. Stock photo agency. Clients include: advertising agencies, book/encyclopedia publishers, museums.

Needs Currently only interested in submission of scanning electron micrographs and transmission electron micrographs—all subjects.

Specs Uses all photographic formats and digital imagery.

Payment & Terms Pays 50% commission for b&w and color photos. Offers nonexclusive contract. Photographer paid within 1 month of agency's receipt of payment. Offers one-time rights. Photo captions required; include magnification and subject matter.

Making Contact ''Give us a call or e-mail first. Our subject matter is very specialized.'' Responds in 2 weeks.

Tips ''We are a specialist agency for science photos and technical images.''

JEROBOAM

120 27th St., San Francisco CA 94110. (415)824-8085. Fax: (415)824-8085 (call before faxing). E-mail: jeroboamster@gmail.com. **Contact:** Ellen Bunning, owner. Estab. 1972. Has 200,000 b&w photos, 200,000 color slides in files. Clients include: text and trade book, magazine and encyclopedia publishers, editorial (mostly textbooks).

Needs ''We want people interacting, relating photos, artistic/documentary/photojournalistic images, especially ethnic and handicapped. Images must have excellent print quality—contextually interesting and exciting and artistically stimulating.'' Wants photos of babies/children/teens, couples, multicultural, families, parents, senior citizens, disasters, environmental, cities/urban, education, gardening, pets, religious, rural, adventure, health/fitness, humor, performing arts, sports, travel, agriculture, industry, medicine, military, political, science, technology/computers. Interested in documentary, historical/vintage, seasonal. Needs shots of school, family, career and other living situations. Child development, growth and therapy, medical situations. No nature or studio shots.

Specs Uses 35mm transparencies.

Payment & Terms Works on consignment only; pays 50% commission. Average price per image (to clients): $150 minimum for b&w and color photos. Works with photographers without a signed contract. Statements issued monthly. Payment made monthly. Photographers allowed to review account records to verify sales figures. Offers one-time and electronic media rights. Informs photographers and allows them to negotiate when client requests all rights. Model/property release preferred for people in contexts of special education, sexuality, etc. Photo captions preferred; include "age of subject, location, etc."

Making Contact Call if in the Bay area; if not, query with samples and list of stock photo subjects; send material by mail for consideration or submit portfolio for review. "Let us know how long you've been shooting." Responds in 2 weeks.

Tips "The Jeroboam photographers have shot professionally a minimum of 5 years, have experienced some success in marketing their talent, and care about their craft excellence and their own creative vision. New trends are toward more intimate, action shots; more ethnic images needed."

🖥 🌐 KEYPHOTOS INTERNATIONAL

Keystone Press Agency Japan, #305 Sunheim, 1-34-11 Kamiuma, Setagaya-ku, Tokyo 154-0011 Japan. (81)(3)5779-3217. Fax: (81)(3)5779-3219. E-mail: info@keystone-tokyo.com. **Contact:** Hidetoshi Miyagi, director. Estab. 1960. Stock agency. Has 1 million photos in files. Clients include: advertising agencies, audiovisual firms, book publishers, magazine publishers, calendar companies, greeting card companies, postcard publishers.

Needs Wants photos of babies/children/teens, celebrities, couples, multicultural, families, parents, senior citizens, disasters, environmental, landscapes/scenics, wildlife, architecture, cities/urban, education, gardening, interiors/decorating, pets, religious, rural, adventure, automobiles, entertainment, events, food/drink, health/fitness/beauty, hobbies, humor, performing arts, sports, travel, agriculture, business concepts, industry, medicine, military, political, product shots/still life, science, technology/computers. Interested in alternative process, avant garde, computer graphics, documentary, erotic, fashion/glamour, fine art, historical/vintage, seasonal.

Specs Uses 35mm, $2^{1}/_{4} \times 2^{1}/_{4}$, 4×5 transparencies. Accepts images in digital format. Send via CD, e-mail as JPEG files at 72 dpi.

Payment & Terms Pays 50% commission for b&w and color photos. Average price per image (to clients): $185-750 for b&w photos; $220-1,100 for color photos. Negotiates fees below stated minimums. Offers volume discounts to customers; terms specified in photographer's contract. Discount sales terms not negotiable. Works with photographers on contract basis only. Offers nonexclusive contract. Contracts renew automatically with additional submissions for first 3 years. Statements issued monthly. Payment made quarterly. Photographers allowed to review account records in cases of discrepancies only. Offers one-time rights. Informs photographers and allows them to negotiate when client requests all rights. Model/property release required. Photo captions required.

Making Contact Send query letter with résumé, transparencies. Does not keep samples on file; include SAE/IRC for return of material. Responds in 3 weeks.

🖥 KEYSTONE PRESS AGENCY, INC.

1100 S. Pacific Coast Hwy., Suite 308, Laguna Beach CA 92651. (212)924-8123. E-mail: info@keystonepictures.com. **Contact:** Scott McKiernan, owner. Types of clients: book publishers, magazines, major newspapers.

Needs Subjects include photojournalism, entertainment, features, travel, stock, historical, assignments.

Specs Accepts digital images only. Exceptions made for clients that request slide or film.

Payment & Terms Pays 50% commission. Photo captions required.

🖥 🌐 KEYSTONE PRESSEDIENST GMBH

Kleine Reichenstr. 1, D-20457 Hamburg Germany. (49)(040)309-6333. Fax: (49)(040)324-036. E-mail: info@keypix.de. Website: www.keypix.de. **Contact:** Jessica Fortmann, editor. Stock photo agency, picture library and news/feature syndicate. Has 4 million photos in files. Clients include: ad agencies, public relations firms, audiovisual firms, businesses, book/encyclopedia publishers, magazine publishers, newspapers, postcard companies, calendar companies, greeting card companies, TV stations.

Needs Wants all subjects excluding sports events.

Specs Accepts images in digital format only. Send as RGB, JPEG, compressed, level 8 or better, 300 dpi, minimum $3,500 \times 2,500$ pixels; about 500 images on CD/DVD in good review quality ($1,024 \times 768$ or better) for initial submission; no sharpening, etc.

Payment & Terms Pays 40-50% commission for b&w and color photos. General price range: $30-1,000.

Works with photographers on contract basis only. Contracts renew automatically for 1 year. Does not charge duping, filing or catalog insertion fees. Payment made one month after photo is sold. Offers one-time and agency promotion rights. "We ask the photographer if client requests exclusive rights." Model release required. Photo captions required; include who, what, where, when and why.

Making Contact Send unsolicited photos by mail for consideration. "Contact us before first submission!" Works with local freelancers by assignment only. Responds in 2 weeks. Distributes a monthly tip sheet.

Tips Prefers to see "American way of life—people; cities; general features—human and animal; current events—political; show business; scenics from the USA—travel, tourism; personalities from politics and TV. An advantage of working with Keystone is our wide circle of clients and very close connections to all leading German photo users. We especially want to see skylines of all U.S. cities. Send only highest quality work."

▣ KIEFFER NATURE STOCK

4548 Beachcomber Court, Boulder CO 80301. (303)530-3357. Fax: (303)530-0274. E-mail: John@KiefferNatur eStock.com. Website: www.KiefferNatureStock.com. **Contact:** John Kieffer, president. Estab. 1986. Stock agency. Has 150,000 images on file. Clients include: advertising agencies, businesses, multimedia, greeting card and postcard publishers, book publishers, calendar companies, graphic design firms, magazine publishers.

Needs "Our photos show people of all ages participating in an active and healthy lifestyle." Wants photos of babies/children/teens, couples, multicultural, families, senior citizens, recreation, environmental, landscapes/scenics, wildlife, rural, adventure, health/fitness, sports, travel, agriculture.

Specs Prefers images in high-resolution digital format. Also accepts large-format film (6×7-cm and 4×5-inch); 35mm transparencies. Send low-resolution files via CD or e-mail in JPEG format at 72 dpi.

Payment & Terms Pays 50% commission for all imagery. Average price per image (to clients): $150-3,500 for all imagery. "I try to work with a buyer's budget." Offers volume discounts to customers. Offers nonexclusive contract. Payment made quarterly. Model release required; property release preferred. Photo captions required; include location, description.

Making Contact "First review our website. Then send a query letter via e-mail, and include a stock list or an active link to your website." Keeps samples on file. Responds in 3 weeks.

Tips "Call and speak with John Kieffer before submitting film, and include a FedEx account number for its safe return."

▣ RON KIMBALL STOCK

1960 Colony St., Mountain View CA 94043. (650)969-0682. Fax: (650)969-0485. E-mail: rk@ronkimballstock. com. Website: www.ronkimballstock.com. **Contact:** Javier Flores. Estab. 1970. Has 500,000 photos in files. Clients include: advertising agencies, businesses, newspapers, postcard publishers, public relations firms, book publishers, calendar companies, magazine publishers, greeting card companies.

Needs Wants photos of pets, landscapes/scenics, wildlife. Interested in seasonal.

Specs Uses 35mm, $2\frac{1}{4} \times 2\frac{1}{4}$, 4×5 transparencies. Accepts images in digital format. Send via e-mail as JPEG files.

Payment & Terms Pays 50% commission for color photos. Offers volume discounts to customers. Works with photographers with or without a contract; negotiable. Offers nonexclusive contract. Contracts renew automatically with additional submissions for 3 years. Statements issued quarterly. Payment made quarterly. Photographers allowed to review account records. Offers one-time rights, electronic media rights. Model release required. Photo captions required.

Making Contact Send query letter with tearsheets, transparencies, stock list. Provide self-promotion piece to be kept on file. Expects minimum initial submission of 250 images with quarterly submissions of at least 200 images. Responds only if interested, send nonreturnable samples. Photo guidelines sheet free with SASE. Catalog free with SASE.

▣ JOAN KRAMER AND ASSOCIATES, INC.

10490 Wilshire Blvd., Suite 1701, Los Angeles CA 90024. (310)446-1866. Fax: (310)446-1856. E-mail: ekeeeek @earthlink.net. Website: www.home.earthlink.net/ ~ ekeeeek. **Contact:** Joan Kramer, president. Member of Picture Archive Council of America (PACA). Has 1 million photos in files. Clients include: ad agencies, magazines, recording companies, photo researchers, book publishers, greeting card companies, promotional companies, AV producers.

Needs "We use any and all subjects! Stock slides must be of professional quality." Subjects on file include: travel, cities, personalities, animals, flowers, lifestyles, underwater, scenics, sports and couples.

Specs Uses 8×10 glossy b&w prints; any size transparencies.
Payment & Terms Pays 50% commission. Offers all rights. Model release required.
Making Contact Send query letter or call to arrange an appointment. Do not send photos before calling.

▣ ⊕ LAND OF THE BIBLE PHOTO ARCHIVE

P.O. Box 8441, Jerusalem 91084 Israel. (972)(2)566-2167. Fax: (972)(2)566-3451. E-mail: radovan@netvision
.net.il. Website: www.biblelandpictures.com. **Contact:** Zev Radovan. Estab. 1975. Picture library. Has 50,000
photos in files. Clients include: book publishers, magazine publishers, newspapers, calendar companies,
postcard publishers.
Needs Wants photos of museum objects, archaeological sites. Also multicultural, landscapes/scenics, archi-
tecture, religious, travel. Interested in documentary, fine art, historical/vintage.
Specs Uses high resolution digital system.
Payment & Terms Average price per image (to clients): $80-700 for b&w, color photos. Offers volume dis-
counts to customers; terms specified in photographers' contracts.
Tips "Our archives contain tens of thousands of color slides covering a wide range of subjects: historical and
archaeological sites, aerial and close-up views, museum objects, mosaics, coins, inscriptions, the myriad
ethnic and religious groups individually portrayed in their daily activities, colorful ceremonies, etc. Upon
request, we accept assignments for in-field photography."

▣ ⊕ LEBRECHT MUSIC & ARTS PHOTO LIBRARY

58-B Carlton Hill, London NW8 0ES United Kingdom. E-mail: pictures@lebrecht.co.uk. Website: www.lebrec
ht.co.uk. **Contact:** Ms. E. Lebrecht. Estab. 1992. Has 80,000 photos in files. Clients include: book publishers,
magazine publishers, newspapers, calendar companies, film production companies, greeting card companies,
public relations firms, advertising agencies.
Needs Wants photos of arts personalities, performing arts, instruments, musicians, dance (ballet, contempo-
rary and folk), orchestras, opera, concert halls, jazz, blues, rock, authors, artists, theatre, comedy, art and
artists. Interested in historical/vintage.
Specs Digital format preferred.
Payment & Terms Pays 50% commission for b&w, color photos and illustration. Offers volume discounts to
customers. Works with photographers on contract basis only. Offers limited regional exclusivity. Statements
issued quarterly. Offers one-time rights. Informs photographers and allows them to negotiate when a client
requests all rights. Model release required. Photo captions required; include who is in photo, place, location,
date.
Making Contact Send e-mail.

$ LIGHTWAVE

170 Lowell St., Arlington MA 02174. (781)646-1747. E-mail: paul@lightwavephoto.com. Website: www.light
wavephoto.com. **Contact:** Paul Light. Has 250,000 photos in files. Clients include: advertising agencies,
textbook publishers.
Needs Wants candid photos of people in school, work and leisure activities.
Specs Uses color transparencies.
Payment & Terms Pays $210/photo; 50% commission. Works with photographers on contract basis only.
Offers nonexclusive contract. Contracts renew automatically each year. Statements issued annually. Payment
made "after each usage." Offers one-time rights. Informs photographers and allows them to negotiate when
client requests all rights. Model/property release preferred. Photo captions preferred.
Making Contact "Create a small website and send us the URL."
Tips "Photographers should enjoy photographing people in everyday activities. Work should be carefully
edited before submission. Shoot constantly and watch what is being published. We are looking for photogra-
phers who can photograph daily life with compassion and originality."

▣ ⊕ LINEAIR FOTOARCHIEF, B.V.

van der Helllaan 6, Arnhem 6824 HT Netherlands. (31)(26)4456713. Fax: (31)(26)3511123. E-mail: info@line
airfoto.nl. Website: www.lineairfoto.nl. **Contact:** Ron Giling, manager. Estab. 1990. Stock photo agency.
Has 750,000 photos in files. Clients include advertising agencies, public relations firms, book/encyclopedia
publishers, magazine publishers. Library specializes in images from Asia, Africa, Latin America, Eastern
Europe and nature in all forms on all continents.
Needs Wants photos of disasters, environmental, landscapes/scenics, wildlife, cities/urban, education, reli-

gious, adventure, travel, agriculture, business concepts, industry, political, science, technology/computers. Interested in everything that has to do with the development of countries in Asia, Africa and Latin America and from all over the world.

Specs Uses 35mm, 2¼×2¼ transparencies. Accepts images in digital format. Send via CD as TIFF or high-quality JPEG files at 300 dpi, A4 or bigger size. "Photofiles need to have IPTC information!"

Payments & Terms Pays 50% commission. Average price per image (to clients): $100-500. Enforces minimum prices. Offers volume discounts to customers; inquire about specific terms. Photographers can choose not to sell images on discount terms. Works with or without a signed contract; negotiable. Offers limited regional exclusivity. Statements issued quarterly. Payment made quarterly. Photographers allowed to review account records. "They can review bills to clients involved." Offers one-time rights. Informs photographers and allows them to negotiate when client requests all rights. Photo captions required; include country, city or region, description of the image.

Making Contact Submit portfolio or e-mail thumbnails (20KB files) for review. There is no minimum for initial submissions. Responds in 3 weeks. Market tips sheet available upon request.

Tips "We like to see high-quality pictures in all aspects of photography. So we'd rather see 50 good ones than 500 for us to select the 50 out of."

▣ ⊕ LINK PICTURE LIBRARY

33 Greyhound Rd., London W6 8NH United Kingdom. (44)(207)381-2433. E-mail: lib@linkpicturelibrary.com. Website: www.linkpicturelibrary.com. **Contact:** Orde Eliason. Has 40,000 photos in files. Clients include: businesses, book publishers, magazine publishers, newspapers. Specializes in Southern and Central Africa, Southeast Asia, China, India and Israel images.

Needs Wants photos of babies/children/teens, multicultural, cities/urban, religious, adventure, travel, business concepts, industry, military, political. Interested in documentary, historical/vintage. Especially interested in India and Africa.

Specs Uses 35mm transparencies. Accepts images in digital format. Send via CD, Zip, e-mail as TIFF, JPEG files at 300 dpi.

Payment & Terms Pays 50% commission for color photos. Average price per image (to clients): $120 minimum for b&w, color photos. Enforces minimum prices. Offers volume discounts to customers. Offers nonexclusive contract. Contracts renew automatically with additional submissions for 3 years. Statements issued semiannually. Payment made semiannually. Photographers allowed to review account records. Offers one-time rights. Photo captions required; include country, city location, subject detail.

Making Contact Send query letter with transparencies, stock list. Portfolio may be dropped off every Monday through Wednesday. Provide résumé, business card, self-promotion piece to be kept on file. Expects minimum initial submission of 100 images with quarterly submissions of at least 100 images. Responds in 2 weeks to samples; 1 week to portfolios. Responds only if interested, send nonreturnable samples.

Tips "Arrange your work in categories to view. Have all the work labeled. Provide contact details and supply SASE for returns."

▣ LONELY PLANET IMAGES

150 Linden St., Oakland CA 94607. (510)893-8555. Fax: (510)625-0306. E-mail: lpi@lonelyplanet.com.au. Website: www.lonelyplanetimages.com. **Contact:** Glenn Beanland, photo editor. Stock photo agency. Clients include: advertising agencies, public relations firms, book/encyclopedia publishers, magazine publishers, newspapers, calendar companies, greeting card companies, design firms.

• Lonely Planet Images's home office is located in Australia: 90 Maribyrong St., Footscray, Victoria 3011 Australia. (61)(38)379-8181. Fax: (61)(38)379-8182. E-mail: lpi@lonelyplanet.com.au.

Needs Wants photos of international travel destinations.

Specs Uses original color transparencies in all formats; digital images from 6MP and higher DSLRs.

Payment & Terms Pays 40-50% commission. Works with photographers on contract basis only. Offers image exclusive contract. Contract renews automatically. Model/property release preferred. Photo captions required.

Making Contact "Download submission guidelines from website—click on Photographers tab, then click on Prospective Photographers."

Tips "Photographers must be technically proficient, productive, and show interest and involvement in their work."

■ LUCKYPIX

1658 N. Milwaukee, #324, Chicago IL 60647. (773)235-2000. Fax: (773)235-2030. E-mail: info@luckypix.com. Website: www.luckypix.com. **Contact:** Michael Rastall, director of photography. Estab. 2001. Stock agency. Has 4,000 photos in files (adding constantly). Clients include: advertising agencies, businesses, book publishers, design companies, magazine publishers.

Needs Wants photos of babies/children/teens, multicultural, families, cities/urban, humor, travel, business concepts. Also needs unstaged, serendipitous photos.

Specs Uses 35mm, $2\frac{1}{4} \times 2\frac{1}{4}$, 4×5, 8×10 transparencies. Accepts images in digital format. Photos for review: upload to website. Final: CD as TIFF files.

Payment & Terms Pays 50% commission for b&w photos; 50% for color photos; 50% for film. Enforces minimum prices. Offers exclusivity by image and similars. Contracts renew automatically annually. Charges $10 if photographers want Luckypix to scan. Statements issued quarterly. Payment made quarterly. Photographers allowed to review account records. Offers one-time rights. Model/property release preferred. Photo captions preferred.

Making Contact Call or upload sample from website (preferred). Responds in 1 week. See website for guidelines.

Tips "Have fun shooting. Search the archives before deciding what pictures to send."

■ MAJOR LEAGUE BASEBALL PHOTOS

245 Park Ave., 30th Floor, New York NY 10022. Fax: (212)949-5699. **Contact:** Rich Pilling, director. Estab. 1994. Stock photo agency. Has over 1,000,000 photos in files. Clients include: advertising agencies, public relations firms, businesses, book/encyclopedia publishers, magazine publishers, newspapers, calendar companies, greeting card companies, postcard publishers and MLB licensees.

Needs Wants photos of any subject for major league baseball—action, feature, fans, stadiums, umpires, still life.

Specs Accepts images in digital format only. Send via CD.

Payment & Terms Pays 50% commission. Enforces minimum prices. Offers volume discounts to customers; inquire about specific terms. Discount sales terms not negotiable. Works with photographers on contract basis only. Offers exclusive contract only. Statements issued monthly. Payment made monthly. Photographers allowed to review account records. Offers one-time rights. Photo captions required.

Making Contact Arrange personal interview to show portfolio. Works with local freelancers on assignment only. Keeps samples on file. No minimum number of images expected with initial submission. Responds in 1-2 weeks. Photo guidelines available.

■ ⬆ MASTERFILE

175 Bloor St. E., South Tower, 2nd Floor, Toronto ON M4W 3R8 Canada. (800)387-9010. E-mail: portfolio@masterfile.com. Website: www.masterfile.com. General stock agency with over 500,000 images online. Clients include: advertising agencies, graphic designers, public relations firms, audiovisual firms, book/encyclopedia publishers, magazine publishers, newspapers, postcard publishers, calendar companies, greeting card companies, all media.

Specs Accepts transparencies, prints and digital files, in accordance with submission guidelines. Initial submissions—digital only.

Payment & Terms Pays photographers 40% royalties of amounts received by Masterfile. Contributor terms outlined in photographer's contract, which is image-exclusive. Photographer sales statements and royalty payments issued monthly.

Making Contact Refer to www.masterfile.com/info/artists/submissions.html for submission guidelines.

■ MICHELE MATTEI PHOTOGRAPHY

1714 Wilton Place, Los Angeles CA 90028. (323)462-6342. Fax: (323)462-7568. E-mail: michele@michelemattei.com. Website: www.michelemattei.com. **Contact:** Michele Mattei, director. Estab. 1974. Stock photo agency. Has "several thousand" photos in files. Clients include: book/encyclopedia publishers, magazine publishers, television, film.

Needs Wants photos of television, film, studio, celebrities, feature stories (sports, national and international interest events). Written information to accompany stories needed. "We do not wish to see fashion and greeting card-type scenics." Also wants environmental, architecture, cities/urban, health/fitness, science, technology/computers.

Payment & Terms Pays 50% commission for color and b&w photos. Offers one-time rights. Model release required. Photo captions required.

Making Contact Send query letter with résumé, samples, stock list.

Tips "Studio shots of celebrities, and home/family stories are frequently requested." In samples, looking for "marketability, high quality, recognizable personalities and current newsmaking material. We are interested mostly in celebrity photography. Written material on personality or event helps us to distribute material faster and more efficiently."

▣ ▨ ▧ MAXX IMAGES, INC.

711 W. 15th St., North Vancouver BC V7M 1T2 Canada. (604)985-2560. Fax: (604)985-2590. E-mail: newsubm issions@maxximages.com. Website: www.maxximages.com. **Contact:** Dave Maquignaz, president. Estab. 1994. Stock agency. Member of the Picture Archive Council of America (PACA). Has 250,000 photos in files. Has 350 hours of video footage. Clients include: advertising agencies, public relation firms, audiovisual firms, businesses, book publishers, magazine publishers, newspapers, calendar companies, postcard publishers, video production, graphic design studios.

Needs Wants photos of people, lifestyle, business, recreation, leisure.

Specs Uses all formats.

Making Contact Send e-mail. Review submission guidelines on website prior to contact.

▣ THE MEDICAL FILE INC.

279 East 44th St., 21st Floor, New York NY 10017. (212)883-0820 or (917)215-6301. E-mail: themedicalfile@g mail.com. Website: www.peterarnold.com. **Contact:** Barbara Gottlieb, president. Estab. 2005. Clients include: advertising agencies, public relations firms, businesses, book/encyclopedia publishers, magazine publishers, postcard companies, calendar companies and greeting card companies.

Needs Wants photos of any medically-oriented imagery including fitness and food in relation to healthcare.

Specs Accepts digital format images only on CD or DVD.

Payment & Terms Average price per image (for clients): $250 and up. Works on exclusive and nonexclusive contract basis. Contracts renew automatically with each submission for length of original contract. Payment made quarterly. Offers one-time rights. Informs photographers when clients request all rights or exclusivity. Model release required. Photo captions required.

Making Contact Arrange a personal interview to show portfolio. Submit portfolio for review. Tips sheet distributed as needed to contract photographers only.

Tips Wants to see "a cross-section of the style and subjects the photographer has in his/her library. Photographers should not photograph people *before* getting a model release. The day of the 'grab shot' is over."

▣ MEDICAL IMAGES INC.

40 Sharon Rd., P.O. Box 141, Lakeville CT 06039. Phone/fax: (860)435-8878. E-mail: medimag@ntplx.net. **Contact:** Anne Darden, president. Estab. 1990. Stock photo agency. Has 50,000 photos in files. Clients include: advertising agencies, public relations firms, corporate accounts, book/encyclopedia publishers, magazine publishers, newspapers.

Needs Wants medical and health-related material, including commercial-looking photography of generic doctor's office scenes, hospital scenarios and still life shots. Also, technical close-ups of surgical procedures, diseases, high-tech colorized diagnostic imaging, microphotography, nutrition, exercise and preventive medicine.

Specs Uses 8×10 glossy b&w prints; 35mm, 2¼×2¼, 4×5, 8×10 transparencies. Accepts images in digital format. Send via CD.

Payment & Terms Pays 50% commission for b&w and color photos. Average price per image (to clients): $150 minimum. Enforces minimum prices. Works with photographers with or without a contract. Offers nonexclusive contract. Contracts renew automatically. Statements issued bimonthly. Payment made bimonthly. "If client pays within same period, photographer gets check right away; otherwise, in next payment period." Photographer's accountant may review records with prior appointment. Offers one-time and electronic media rights. Model/property release preferred. Photo captions required; include medical procedures, diagnosis when applicable, whether model released or not, etc.

Making Contact Send query letter with stock list or telephone with list of subject matter. Responds in 2 weeks. Photo guidelines available. Market tips sheet distributed quarterly to contracted photographers.

Tips Looks for "quality of photograph—focus, exposure, composition, interesting angles; scientific value; and subject matter being right for our markets." Sees trend toward "more emphasis on editorial or realistic-

looking medical situations. Anything too 'canned' is much less marketable. Write and send some information about type (subject matter) of images and numbers available.''

▣ ▨ ⊕ MEDICAL ON LINE LTD.

2nd Floor, Patman House, 23-27 Electric Parade, George Lane, South Woodford, London E18 2LS United Kingdom. (44)(208)530-7589. Fax: (44)(208)989-7795. E-mail: info@mediscan.co.uk. Website: www.mediscan.co.uk. **Contact:** Tony Bright or Paula Willett. Estab. 2001. Picture library. Has over 1 million photos and over 2,000 hours of film/video footage on file. Subject matter includes medical personnel and environment, diseases and medical conditions, surgical procedures, microscopic, scientific, ultrasound/CT/MRI scans and x-rays. Online catalog on website. Clients include: advertising and design agencies, business-to-business, newspapers, public relations, book and magazine publishers in the healthcare, medical and science arenas.

Needs Photos of babies/children/teens/senior citizens; health/lifestyle/fitness/beauty; medicine, especially plastic surgery, rare medical conditions; model-released images; science, including microscopic imagery, botanical and natural history.

Specs Accepts negatives; 35mm and medium format transparencies; digital images (make contact before submitting samples).

Payment & Terms Pays up to 50% commission. Statements issued quarterly. Payment made quarterly. Model/property release required, where necessary.

Making Contact E-mail or call.

▣ ▨ MEGAPRESS IMAGES

1751 Richardson, Suite 2205, Montreal QC H3K 1G6 Canada. (514)279-9859. E-mail: info@megapress.ca. Website: www.megapress.ca. Estab. 1992. Stock photo agency. Has 500,000 photos in files. Has 2 branch offices. Clients include: book/encyclopedia publishers, magazine publishers, postcard publishers, calendar companies, greeting card companies, advertising agencies.

Needs Wants photos of people (babies/children/teens, couples, people at work, medical); animals including puppies in studio; industries; celebrities and general stock. Also needs families, parents, senior citizens, disasters, environmental, landscapes/scenics, wildlife, gardening, pets, religious, adventure, automobile, food/drink, health/fitness/beauty, sports, travel, business concepts, still life, science. "Looking only for the latest trends in photography and very high-quality images. A part of our market is Quebec's local French market.''

Specs Accepts images in digital format only. Send via CD, floppy disk, Zip as JPEG files at 300 dpi.

Payment & Terms Pays 50% commission for color photos. Average price per image (to client): $100. Enforces minimum prices. Will not negotiate below $60. Works with photographers with or without a contract. Statements issued semiannually. Payment made semiannually. Offers one-time rights. Model release required for people and controversial news. Photo captions required. Each slide must have the name of the photographer and the subject.

Making Contact Submit portfolio for review by registered mail or courier only. Does not keep samples on file; include SAE/IRC for return of material. Expects minimum initial submission of 250 images with periodic submission of at least 1,000 digital pictures per year. Make first contact by e-mail. Accepts digital submissions only.

Tips "Pictures must be very sharp. Work must be consistent. We also like photographers who are specialized in particular subjects. Megapress has merged with Reflexion Photo Agency and is now the leading agency when it comes to Canadian Tourism landscapes and nature.''

▣ MIDWESTOCK

9218 Metcalf, #145, Overland Park KS 66212. (816)474-0229. Fax: (888)474-0229. E-mail: info@midwestock.com. Website: www.midwestock.com. **Contact:** Suzana Roach-Bailes, director. Estab. 1991. Stock photo agency. Has over 200,000 photos in files. Clients include: advertising agencies, public relations firms, businesses, book/encyclopedia publishers, magazine publishers, newspapers, postcard publishers, calendar companies, greeting card companies.

Needs Distinct emphasis on ''Heartland'' and agricultural themes. Wants photos of families, landscapes/scenics, livestock, cities, rural, agriculture. Destinations in Midwest preferred. Agriculture images sought nationally and internationally.

Specs ''Agriculture and heartland themes are biggest sellers in all formats. We stock transparencies, digital files, and, for consistency, make our own scans for clients.''

Payment & Terms Pays 50% commission. Average price per image (to clients): $3 50 for color. Enforces

minimum price of $225, except in cases of reuse or volume purchase. Offers volume discounts to customers; inquire about specific terms. Works with photographers on contract basis only. "We negotiate with photographers on an individual basis." Prefers exclusivity, especially in agricultural subjects. Contracts renew automatically after 2 years and annually thereafter, unless notified in writing. Offers one-time and electronic media rights; negotiable. Model release required; property release preferred. Photo captions required.

Making Contact Send query e-mail with stock list. Request submission guidelines first (via e-mail). Expects minimum initial submission of 500 images in 35mm format (less if larger formats). Inquire if submitting digital files. Responds in 3 weeks.

Tips "We prefer photographers who are full-time professionals who already understand the value of upholding stock prices and trends in marketing and shooting stock. Visit our website, then e-mail us for submission guidelines."

🖳 MIRA

716 Iron Post Rd., Moorestown NJ 08057. (856)231-0594. E-mail: mira@mira.com. Website: www.mira.com or www.CreativeEyeCoop.com. "Mira is the stock photo agency of the Creative Eye Cooperative. Mira seeks premium rights-protected images and contributor/owners who are committed to helping build the Mira archive into a top-shelf resource that buyers just love to shop. Mira offers a broad and deep general collection of press ready images via state-of-the-art licensing technology.Customers are able to perform searches, obtain pricing, share lightboxes, view terms and condition, and download image files online. Mira sales and research support are also available via telephone, and we consider genuine customer care to be one of our distinguishing traits." Client industries include: advertising, publishing, corporate, marketing and education.

Making Contact "E-mail, call or visit our websites to learn more about participation in Mira."

🖳 MPTV (MOTION PICTURE AND TELEVISION PHOTO ARCHIVE)

16735 Saticoy St., Suite 109, Van Nuys CA 91406. (818)997-8292. Fax: (818)997-3998. E-mail: photo@mptv.net. Website: www.mptv.net. **Contact:** Ron Avery, president. Estab. 1988. Stock photo agency. Has over 1 million photos in files. Clients include: advertising agencies, book/encyclopedia publishers, magazine publishers, newspapers, postcard publishers, calendar companies, greeting card companies.

Needs Color shots of current stars and old TV and movie stills.

Specs Uses 8×10 b&w and/or color prints; 35mm, $2\frac{1}{4} \times 2\frac{1}{4}$, 4×5, 8×10 transparencies. Accepts images in digital format. Send via CD as TIFF, JPEG files.

Payment & Terms Buys photos/film outright. Pays 50% commission for b&w and color photos. Average price per image (to clients): $180-1,000 for b&w photos; $180-1,200 for color photos. Enforces strict minimum prices. Offers volume discounts to customers; terms specified in photographers' contracts. Works with photographers on contract basis only. Offers exclusive contract. Contracts renew automatically with additional submissions. Statements issued monthly. Payment made monthly. Photographers allowed to review account records. Rights negotiable; "whatever fits the job."

Making Contact Responds in 2 weeks.

🖳 🖼 NATURAL SELECTION STOCK PHOTOGRAPHY L.L.C.

1603 Golf Course Rd., Suite A, Rio Rancho NM 87124. (505)896-4362. Fax: (505)896-4367. E-mail: mail@nssp.com. Website: www.nssp.com. **Contact:** David L. Brown, manager. Estab. 1987. Stock photo agency. Has over 750,000 photos in files. Clients include: advertising agencies, public relations firms, businesses, book/encyclopedia publishers, magazine publishers, newspapers, postcard publishers, calendar companies, greeting card companies.

Needs Interested in photos of nature in all its diversity. Wants photos of disasters, environmental, landscapes/scenics, wildlife, pets, rural, adventure, travel, agriculture.

Specs Uses all formats.

Payment & Terms Pays 50% commission for color and b&w photos. Average price per image (to clients): $300-50,000 for b&w and color photos. Works with photographers on contract basis only. Offers nonexclusive contracts with image exclusivity. Contracts renew automatically with additional submissions for 3 years. Payment made monthly on fees collected. Offers one-time rights. "Informs photographer when client requests all rights." Model/property release required when appropriate. Photo captions required; include photographer's name, where image was taken and specific information as to what is in the picture.

Making Contact Send query letter with résumé of credits; include types of images on file, number of images, etc. Expects minimum initial submission of 200 images. Responds in 1 month.

Tips "All images must be completely captioned, properly sleeved, and of the utmost quality. High-quality digital images from Canon 1Ds or Nikon D2x cameras are welcomed."

🖥 🖼 911 PICTURES

60 Accabonac Rd., East Hampton NY 11937. (631)324-2061. Fax: (631)329-9264. E-mail: 911pix@optonline.net. Website: www.911pictures.com. **Contact:** Michael Heller, president. Estab. 1996. Stock agency. Has 3,100 photos in files. Clients include: advertising agencies, public relations firms, audiovisual firms, businesses, book publishers, magazine publishers, calendar companies, insurance companies, public safety training facilities.

Needs Wants photos of disaster services, public safety/emergency services, fire, police, EMS, rescue, hazmat. Interested in documentary.

Specs Uses 4×6 to 8×10 glossy, matte color and/or b&w prints; 35mm transparencies. Accepts images in digital format on CD at minimum 300 dpi, 8″ minimum short dimension. Images for review may be sent via e-mail, CD as BMP, GIF, JPEG files at 72 dpi.

Payment & Terms Pays 50% commission for b&w and color photos; 75% for film and videotape. Enforces minimum prices. Offers volume discounts to customers. Works with photographers on contract basis only. Offers nonexclusive contract. Charges any print fee (from negative or slide) or dupe fee (from slide). Statements issued/sale. Payment made/sale. Photographers allowed to review account records in cases of discrepancies only. Offers one-time rights. Informs photographers and allows them to negotiate when client requests all rights. Model release preferred. Photo captions preferred; include photographer's name, and a short caption as to what is occurring in photo.

Making Contact Send query letter with résumé, slides, prints, photocopies, tearsheets. "Photographers can also send e-mail with thumbnail (low-resolution) attachments." Does not keep samples on file; include SASE for return of material. Responds only if interested; send nonreturnable samples. Photo guidelines sheet free with SASE.

Tips "Keep in mind that there are hundreds of photographers shooting hundreds of fires, car accidents, rescues, etc., every day. Take the time to edit your own material, so that you are only sending in your best work. We are especially in need of hazmat, police and natural disaster images. At this time 911 Pictures is only soliciting work from those photographers who shoot professionally or who shoot public-safety on a regular basis. We are not interested in occasional submissions of one or two images."

🇳 🖥 🌐 NORDICPHOTOS

Klapparstigur 25-27, IS-101 Reykavik Iceland. (354)562-5900. Fax: (354)562-5901. E-mail: info@nordicphotos.com. Website: www.nordicphotos.com. **Contact:** Arnaldur Johnson, general manager. Estab. 2000. Stock agency. Also has location at Drottningatan 73B, S-111 36 Stockholm, Sweden; (46)(8)302500; fax: (46)(8)338875. Has 5 million photos in files. Clients include: advertising agencies, businesses, public relations firms, book publishers, magazine publishers.

Needs Wants photos of babies/children/teens, couples, families, parents, senior citizens, disasters, environmental, landscapes/scenics, wildlife, architecture, cities/urban, education, gardening, rural, adventure, entertainment, events, food/drink, health/fitness/beauty, performing arts, sports, travel, agriculture, business concepts, industry, medicine, technology/computers. Interested in alternative process, documentary.

Specs Uses glossy or matte color and/or b&w prints; 35mm, $2\frac{1}{4}\times2\frac{1}{4}$, 4×5, 8×10 transparencies. Accepts images in digital format. Send via CD, floppy disk, Zip, e-mail as TIFF, JPEG files at 300 dpi.

Payment & Terms Pays 55% commission for b&w photos; 55% for color photos. Average price per image (to clients): $150 for b&w or color photos. Negotiates fees below standard minimum prices. Offers volume discounts to customers. Discount sales terms not negotiable. Works with photographers on contract basis only. Contracts renew automatically with additional submissions. Statements issued automatically on the Internet. Payment made monthly. Photographers allowed to review account records. Model/property release preferred. Photo captions preferred.

Making Contact Contact through rep. Responds in 2 weeks. Catalog free.

🖥 📷 NORTHWEST PHOTOWORKS

P.O. Box 222, Chilliwack BC V2P 6J1 Canada. (877)640-3322. Fax: (604)608-3858. E-mail: info@nwpw.com. Website: www.nwpw.com. **Contact:** Nick Morley, president. Estab. 1998. Stock agency. Has over 100,000 photos in files. Clients include: advertising agencies, businesses, postcard publishers, public relations firms, book publishers, audiovisual firms, magazine publishers, greeting card companies.

Needs Wants photos of babies/children/teens, couples, multicultural, families, parents, senior citizens, disas-

ters, environmental, cities/urban, education, gardening, religious, adventure, entertainment, events, health/ fitness, sports, travel, agriculture, business concepts, industry, medicine, science, technology/computers. Interested in historical/vintage, seasonal.

Specs Accepts high-res digital images only. Contact for details.

Payment & Terms Pays 50% commission for b&w and color photos. Average price per image (to clients): $150 US for b&w and color photos. Offers volume discounts to customers. Terms specified in photographers' contracts. Works with photographers on contract basis only. Offers nonexclusive contract. Photographers allowed to review account records in cases of discrepancies only. Offers one-time/electronic media rights. Informs photographers and allows them to negotiate when client requests all rights. Model release required; property release preferred. Photo captions required.

Making Contact Send query letter with résumé, slides, stock list. Provide business card to be kept on file. Keeps samples on file. Expects minimum initial submission of more than 100 images with yearly submissions of at least 100-400 images. Responds in 2 months. Photo guidelines available on website. Market tips sheet available quarterly to affiliated photographers.

Tips "We are also interested in receiving submissions from new or lesser-known photographers. We look for compelling, professional-quality images. Industry, lifestyle, medical, science and technology images are always in demand. Accurate captions are required. We need more pictures of people—at work, at play—of all ages; must be model released."

NOVASTOCK

1306 Matthews Plantation Dr., Matthews NC 28105-2463. (888)894-8622. Fax: (704)841-8181. E-mail: Novastock@aol.com. Website: www.portfolios.com/novastock. **Contact:** Anne Clark, submission department. Estab. 1993. Stock agency. Clients include: advertising agencies, businesses, postcard publishers, public relations firms, book publishers, calendar companies, magazine publishers, greeting card companies and large international network of subagents.

Needs "We need commercial stock subjects like lifestyles, fitness, business, science, medical, family, etc. We also are looking for unique and unusual imagery. We have one photographer who burns, scratches and paints on his film." Wants photos of babies/children/teens, couples, multicultural, families, parents, senior citizens, disasters, environmental, wildlife, rural, adventure, health/fitness, travel, business concepts, military, science, technology/computers.

Specs "If you manipulate prints (e.g., hand coloring), submit first-class copy transparencies. We accept 35mm, $2^1/_4 \times 2^1/_4$ transparencies." Prefers images in digital format as follows: (1) Original digital camera files. (2) Digitally manipulated images in the 30-50 meg range. (3) Do not scan film. "When sending files for editing, please send small files only. Once we make our picks, you can supply larger files. Final large files should be uncompressed TIFF or JPEG saved at best-quality compression. NEVER sharpen or use contrast and saturation filters. Always flatten layers. Files and disks must be readable on Windows PC."

Payment & Terms Pays 50% commission for b&w and color photos. Price range per image: $100-50,000 for b&w and color photos. "We never charge the photographer for any expenses whatsoever." Works with photographers on contract basis only. "We need exclusivity only for images accepted, and similars." Photographer is allowed to market work not represented by Novastock. Statements and payments are made in the month following receipt of income from sales. Informs photographers and discusses with photographer when client requests all rights. Model/property release required. Photo captions required; include who, what and where. "Science and technology need detailed and accurate captions. Model releases must be cross-referenced with the appropriate images."

Making Contact Contact by e-mail or send query letter with digital files, slides, tearsheets, transparencies. Does not keep samples on file; include SASE for return of material or personal check to cover return costs. Expects minimum initial submission of 100 images. Responds in 1 week to submissions.

Tips "Film must be submitted in the following form: 35mm slides in 20-up sheets; $2^1/_4 \times 2^1/_4$ in individual acetate sleeves and then inserted in clear pages. Digital files on CD/DVD are fine. All images must be labeled with caption (if necessary) and marked with model release information and your name and copyright. We market agency material through more than 50 agencies in our international subagency network. The photographer is permitted to freely market nonsimilar work any way he/she wishes. If you are unsure if your work meets the highest level of professionalism as used in current advertising, please do not contact."

OKAPIA K.G.

Michael Grzimek & Co., Postfach 645, Röderbergweg 168, Frankfurt 60385 Germany. E-mail: okapia@t-online.de. Website: www.okapia.com. **Contact:** President. Stock photo agency and picture library. Has

700,000 photos in files. Clients include: ad agencies, book/encyclopedia publishers, magazine publishers, newspapers, postcard companies, calendar companies, greeting card companies, school book publishers.

Needs Wants photos of natural history, babies/children/teens, couples, families, parents, senior citizens, gardening, pets, adventure, health/fitness, travel, agriculture, industry, medical, science, technology/computers, general interest.

Specs Uses 35mm, $2^1/_4 \times 2^1/_4$, 4×5 transparencies. Accepts digital images. Send via CD, floppy disk as JPEG files at 355 dpi.

Payment & Terms Pays 50% commission for color photos. Average price per image (to clients): $60-120 for color photos. Enforces strict minimum prices. Offers volume discounts to customers. Discount sales terms not negotiable. Works with photographers on contract basis only. Offers nonexclusive contract, limited regional exclusivity and guaranteed subject exclusivity (within files). Contracts renew automatically for 1 year with additional submissions. Charges catalog insertion fee. Statements issued quarterly, semiannually or annually, depending on money photographers earn. Payment made quarterly, semiannually or annually with statement. Photographers allowed to review account records in cases of discrepancies only. Offers one-time, electronic media and agency promotion rights. Does not permit photographers to negotiate when client requests all rights. Model/property release preferred. Photo captions required.

Making Contact Send query letter with slides. Does not keep samples on file; include SASE for return of material. Expects minimum initial submission of 300 slides. Responds in 5 weeks. Photo guidelines free with SASE. Distributes tips sheets on request semiannually to photographers with statements.

Tips "We need every theme which can be photographed." For best results, "send pictures continuously."

N ▣ ▨ OMEGA NEWS GROUP/USA

P.O. Box 309, Lehighton PA 18235-0309. (610)377-6420. E-mail: omeganewsgroup@fast.net. **Contact:** Tony Rubel, managing editor. Stock photo agency and news/feature syndicate. Clients include: newspapers, magazines, book publishers, audiovisual producers, paper product companies (calendars, postcards, greeting cards), advertising agencies, businesses, PR firms.

Needs Wants photos of news, sports, features, celebrities, entertainment, events, essays, human interest, conflicts/wars and survivors, material from Ukraine. Interested in avant garde, documentary, fine art.

Specs Prefers transparencies, however, all formats accepted. For film/tape, send VHS for review.

Payment & Terms Pays 50% commission for b&w and color. Works with photographers on contract basis only. Offers nonexclusive contract. Offers one-time or electronic media rights. Model/property release preferred. Photo captions required.

Making Contact "Submit material for consideration digitally and we will get back to you." Submissions can be made on a trial and error basis.

Tips "Looking for quality, color saturation, clarity, comprehensive story material, imagination, uniqueness and bold self expression. Be creative."

▣ OMNI-PHOTO COMMUNICATIONS

10 E. 23rd St., New York NY 10010. Phone/fax: (212)995-0895. E-mail: info@omniphoto.com. Website: www.omniphoto.com. **Contact:** Mary Fran Loftus, president. Estab. 1979. Stock photo and art agency. Has 100,000 photos in files. Clients include: advertising agencies, public relations firms, businesses, book/encyclopedia/magazines/calendar/greeting card companies.

Needs Wants photos of babies/children/teens, couples, multicultural, families, senior citizens, environmental, wildlife, architecture, cities/urban, religious, rural, entertainment, food/drink, health/fitness, sports, travel, agriculture, industry, medicine.

Specs Accepts images in digital format. Low-resolution images (approximately 3×5 inches on DVD, CD-ROM or website portfolio review) accepted for review purposes only. 30- to 50-meg high-resolution JPEGs required for accepted digital images. All images must be Mac-readable and viewable in Photoshop.

Payment & Terms Pays 50% commission. Works with photographers on contract basis only. Offers limited regional exclusivity. Contracts renew automatically with additional submissions for 4 years. Charges catalog insertion fee. Statements issued with payment on a quarterly basis. Offers one-time rights. Informs photographers and allows them to negotiate when client requests all rights. Model/property release required. Photo captions required.

Making Contact Send query letter with samples. Send 100-200 transparencies in vinyl sheets, low-resolution images on CD-ROMs, or URLs with samples that are clear and easy to view. Photo guidelines free with SASE. "Please, no e-mail attachments."

Tips "We want spontaneous-looking, professional-quality photos of people interacting with each other. Have

carefully-thought-out backgrounds, props and composition, commanding use of color. Stock photographers must produce high-quality work at an abundant rate. Self-assignment is very important, as is a willingness to obtain model releases; caption thoroughly and make submissions regularly.''

N ▣ ⊕ ONASIA

30 Cecil St., Prudential Tower Level 15, Singapore 049712. (65)(662)655-4683. Fax: (65)(662)655-4682. E-mail: sales@onasia.com. Website: www.onasia.com. **Contact:** Peter Charlesworth or Yvan Cohen, managing directors. Stock agency, picture library, news/feature syndicate. Has 400,000 photos in files. Offices in Singapore and Bangkok. Representatives in Madrid, Tokyo and Paris. Clients include: advertising agencies, businesses, newspapers, book publishers, calendar companies, magazine publishers.

Needs Wants photos of babies/children/teens, multicultural, families, architecture, cities/urban, education, interiors/decorating, religious, rural, agriculture, industry, medicine, military, political, science, technology/computers, disasters, environmental, landscapes/scenics, wildlife, adventure, food/drink, health/fitness/beauty, performing arts, sports, travel, avant garde, documentary, fashion/glamour, historical/vintage, seasonal. ''We collect images from Asia only.''

Specs Uses 35mm transparencies. Accepts images in digital format. Send via CD, ZIP, e-mail, FTP as JPEG files at 300 dpi.

Payment & Terms Pays 50% commission for b&w and color photos. Offers volume discounts to customers. Terms specified in photographer contracts. Photographers can choose not to sell images on discount terms. Works with photographers on contract basis only. Offers nonexclusive contract or guaranteed subject exclusivity (within files). Contract remains in force unless terminated for cause. Statements issued monthly. Payment made monthly. Offers one-time rights, electronic media rights. Informs photographers and allows them to negotiate when a client requests all rights. Model/property release preferred. Photo captions required; include dates, location, country, description of image, including names where possible.

Making Contact E-mail query letter with JPEG samples at 72 dpi, link to photographer's website. Does not

OnAsia is a digital stock photography and assignment agency specializing in photography and photojournalism from Asia. Natalie Behring's image of a man feeding pigeons at the Garden Monastery in Mongolia is one of the images in their files.

keep samples on file; cannot return material. Expects minimum intitial submission of 50 images. Responds in 3 weeks to samples. Photo guidelines available by e-mail request.

Tips ''Provide a well-edited portfolio for initial evaluation. Ensure that subsequent submissions are tightly edited and submitted with full captions.''

☐ ONREQUEST IMAGES

1415 Western Ave., Suite 300, Seattle WA 98101. (877)202-5025. Fax: (206)774-1291. E-mail: photographer.m anager@onrequestimages.com. Website: www.onrequestimages.com. **Contact:** Photographer Manager. Estab. 2003. Stock agency. Member of the Picture Archive Council of America (PACA). ''OnRequest Images produces Custom Stock™ photography and Custom Stock Libraries™ for clients that include advertising and creative agencies and corporations.''

Needs Wants photos of action/sports, aerial, animals, architecture—interiors and exteriors, automotive, children, events/publicity, fashion, fine art, food/beverage, industry/transportation, landscapes, lifestyle, panoramic, portraiture, still life/product/tabletop, science/medicine, travel, underwater, wildlife.

Specs Accepts images in digital format as 16-bit, 48MB files at 300 dpi from ''11-megapixel camera or better.''

Payment/Terms Pays 50% commission for b&w or color photos. Model/property release required.

Making Contact Fill out an online application at www.onrequestimages.com/www/PhotographerJoin.aspx.

Tips ''OnRequest Images has customers who know what they need and are ready to buy. Why shoot stock without a customer, hoping it will sell someday, when you can shoot imagery you know customers want today? The company has shoots happening around the globe at any given time, so if you have an 11-megapixel camera or better, can produce 48MB, 16-bit, 300-dpi files and don't have any fear of short deadlines, On-Request Images would like to hear from you—and see your portfolio. See application form on our website.''

ℕ ☐ ⊕ OPCAO BRASIL IMAGENS

Largo do Machado, No. 54 GR. 605/606, Catete, Rio de Janeiro 22221-020 Brazil. Phone/fax: (55)(21)2556-3847. E-mail: opcao@opcaobrasil.com.br. Website: www.opcaobrasil.com.br. **Contact:** Ms. Graca Machado and Mr. Marcos Machado, directors. Estab. 1993. Has 600,000 photos in files. Clients include: advertising agencies, book publishers, magazine publishers, calendar companies, postcard publishers, publishing houses.

Needs Wants photos of babies/children/teens, couples, families, parents, wildlife, health/fitness, beauty, education, hobbies, sports, industry, medicine. ''We need photos of wild animals, mostly from the Brazilian fauna. We are looking for photographers who have images of people who live in tropical countries.''

Specs Uses 35mm, 4×5 transparencies. Accepts images in digital format.

Payment & Terms Pays 50% commission for b&w, color photos. Average price per image (to clients): $100-400 for b&w photos; $200 minimum for color photos. Negotiates fees below standard minimum prices only in case of renting, at least, 20 images. Offers volume discounts to customers. Works with photographers on contract basis only. Offers limited regional exclusivity. Contracts renew automatically with additional submissions for 3 years. Charges $200/image for catalog insertion. Statements issued quarterly. Payment made quarterly. Photographers allowed to review account records in cases of discrepancies only. Offers one-time rights, electronic media rights, agency promotion rights. Model release required; property release preferred. Photo captions required.

Making Contact Initial contact should be by e-mail or fax. Explain what kind of material you have. Provide business card, self-promotion piece to be kept on file. ''If not interested, we return the samples.'' Expects minimum initial submission of 200 images with quarterly submissions of at least 500 images. Responds in 1 month to samples.

Tips ''We need creative photos presenting the unique look of the photographer on active and healthy people in everyday life at home, at gyms, at work, etc., showing modern and up-to-date individuals. We are looking for photographers who have images of people with the characteristics of Latin-American citizens.''

☐ ⊕ ORION PRESS

1-13 Kanda-Jimbocho, Chiyoda-ku, Tokyo 101 Japan. (81)(3)3295-1424. Fax: (81)(3)3295-1430. E-mail: info @orionpress.co.jp. Website: www.orionpress.co.jp. **Contact:** Mr. Masa Takahashi. Estab. 1952. Stock photo agency. Member of the Picture Archive Council of America (PACA). Has 100,000 digital files and 700,000 photos in files. Has 3 branch offices in Osaka, Nagoya and Tokyo. Clients include: advertising agencies, public relations firms, businesses, book/encyclopedia publishers, magazine publishers, newspapers, postcard publishers, calendar companies, greeting card companies, and TV stations.

Needs Wants photos of babies/children/teens, celebrities, couples, multicultural, families, parents, senior

citizens, disasters, environmental, landscapes/scenics, wildlife, architecture, cities/urban, education, gardening, interiors/decorating, pets, religious, rural, adventure, automobiles, entertainment, events, food/drink, health/fitness, hobbies, humor, performing arts, sports, travel, agriculture, business concepts, medicine, military, political, industry, product shots/still life, science, technology/computers. Interested in documentary, erotic, fashion/glamour, fine art, historical/vintage, seasonal.

Specs Uses 35mm, 2¹⁄₄×2¹⁄₄ transparencies. Accepts images in digital format. Send via CD, FTP, e-mail as TIFF, JPEG files.

Payment & Terms Pays 60% commission for b&w and color photos. Average price per image (to clients): $120-500 for b&w photos; $200-800 for color photos. Enforces strict minimum prices. Offers volume discounts to customers; inquire about specific terms. Discount sales terms not negotiable. Works with photographers on contract basis only. Offers exclusive contract only. Contracts renew automatically with additional submissions for 2 years. Statements issued monthy. Payment made monthly. Photographers allowed to review account records. Offers one-time and electronic media rights. Model/property release required. Photo captions and keywords required.

Making Contact Send query letter with transparencies and SAE. Expects minimum initial submission of 100 images with periodic submissions of at least 200 images. Responds in 1 month. Photo guidelines and catalog free with SAE.

Ⓝ OUT OF THE BLUE

7350 S. Tamiami Trail, #227, Sarasota FL 34231. (941)966-4042. Fax: (941)966-8914. E-mail: outoftheblue.us @mac.com. Website: www.out-of-the-blue.us. Estab. 2003. **Contact:** Michael Woodward, president. Creative Director: Maureen May. "Where serendipity, creativity and commerce merge. We are a new division of Art Licensing International Inc., established in 1986. The new division specializes in creating 'art brands.' We are looking for photographic collections of concepts that we can license for product categories such as posters and prints, greeting cards, calendars, stationery, gift products, and for the home decor market."

Needs "We require collections of photography that have wide consumer appeal. CD presentations preferred, but photocopies/flyers are acceptable."

Making Contact Send examples on CD (JPEG files), color photocopies with SASE. E-mail presentations also accepted. Fine artists should send short bio. "Our general commision rate is 50% with no expenses to photographer as long as photographer can provide high-resolution scans if we agree to representation."

Tips "Our agency specializes in aiming to create full licensing programs so we can license art/photographs across a varied product range. We are therefore only interested in collections or groups of images or concepts that have commercial appeal. Photographers need to consider actual products when creating new art."

▢ ▨ 🌐 OXFORD SCIENTIFIC (OSF)

Oxford Scientific Films, Network House, Station Yard, Thame OX9 3UH United Kingdom. (44)(184)426-2370. Fax: (44)(184)426-2380. E-mail: creative@osf.co.uk. Website: www.osf.co.uk. **Contact:** Creative Director. Estab. 1968. Stock agency. Film unit, stills and film libraries. Has 350,000 photos, over 2 million feet of stock footage on 16mm, and 40,000 feet on 35mm. Clients include: advertising agencies, design companies, audiovisual firms, book/encyclopedia publishers, magazine and newspaper publishers, merchandising companies, multimedia publishers, film production companies.

Needs Wants photos of natural history: animals, plants, behavior, close-ups, life-histories, histology, embryology, electron microscopy, scenics, geology, weather, conservation, country practices, ecological techniques, pollution, special-effects, high-speed, time-lapse, landscapes, environmental, travel, sports, pets, domestic animals, wildlife, disasters, gardening, rural, agriculture, industry, medicine, science, technology/computers. Interested in seasonal.

Specs Uses 35mm and larger transparencies; 16 and 35mm film and videotapes. Accepts images in digital format. Send via CD, e-mail at 72 dpi for initial review; 300 dpi (RGB TIFF files) for final submission. Review guidelines for details.

Payment & Terms Pays 50% commission. Negotiates fees below stated minimums on bulk deals. Average price per image (to clients) $100-2,000 for b&w and color photos; $300-4,000 for film or videotape. Offers volume discounts to regular customers; inquire about specific terms. Discount sale terms not negotiable. Works with photographers on contract basis only; needs image exclusivity. Offers image-exclusive contract, limited regional exclusivity, guaranteed subject exclusivity. Contracts renew automatically every 2 years. There is a charge for taking on handling footage. Offers one-time, electronic media and agency promotion rights. Informs photographers and allows them to negotiate when client requests all rights. Model/property

release required. Photo captions required; include common name, Latin name, behavior, location and country, magnification where appropriate, if captive, if digitally manipulated.

Making Contact Submission guidelines available on website. Expects minimum initial submission of 100 images with quarterly submissions of at least 100 images. Interested in receiving high-quality, creative, inspiring work from both amateur and professional photographers. Responds in 1 month.

Tips "Contact via e-mail, phone or fax, or visit our website to obtain free submission guidelines." Prefers to see "good focus, composition, exposure, rare or unusual natural history subjects and behavioral and action shots, inspiring photography, strong images as well as creative shots. Read photographer's pack from website or e-mail/write to request a pack, giving brief outline of areas covered and specialties and size."

◼ PACIFIC STOCK

Koko Marina Center, 7192 Kalanianaole Hwy., Suite G-230, Honolulu HI 96825. (808)394-5100. Fax: (808)394-5200. E-mail: pics@pacificstock.com. Website: www.pacificstock.com. **Contact:** Barbara Brundage, owner/president. Member of Picture Archive Council of America (PACA). Has 150,000 photos in files; 10,000 digital images online. Clients include advertising agencies, public relations firms, audiovisual firms, businesses, book/encyclopedia publishers, magazine publishers, postcard companies, calendar companies, greeting card companies.

Needs "Pacific Stock is the *only* stock specializing exclusively in Pacific- and Asia-related photography." Locations include North American West Coast, Hawaii, Pacific Islands, Australia, New Zealand, Far East, etc. Subjects include: people (women, babies/children/teens, couples, multicultural, families, parents, senior citizens), culture, marine science, industrial, environmental, landscapes, wildlife, adventure, food/drink, health/fitness, sports, travel, agriculture, business concepts.

Specs Uses 35mm, $2^{1}/_{4} \times 2^{1}/_{4}$, 4×5 (all formats) transparencies. Accepts images in digital format. Send via CD as TIFF files (guidelines on website).

Payment & Terms Pays 50% commission for color photos. Average price per image (to clients): $250-550 for color photos. Works with photographers on contract basis only. Offers limited regional exclusivity. Statements issued monthly. Payment made monthly. Photographers allowed to review account records to verify sales figures. Offers one-time or first rights; additional rights with photographer's permission. Informs photographers and allows them to negotiate when client requests all rights. Model/property release required for all people and certain properties, i.e., homes and boats. Photo captions required; include: "who, what, where."

Making Contact Send query letter with résumé of credits, stock list. Responds in 2 weeks. Photo guidelines free with SASE. Tips sheet distributed quarterly to represented photographers; free with SASE to interested photographers.

Tips Looks for "highly edited shots, preferably captioned in archival slide pages. Photographer must be able to supply minimum of 1,000 slides (must be model-released) for initial entry and must make quarterly submissions of fresh material from Pacific and Asia area destinations and from areas outside Hawaii." Major trends to be aware of include "increased requests for 'assignment style' photography so it will be resellable as stock. The two general areas (subjects) requested are tourism usage and economic development." Looks for focus, composition and color. "As the Asia/Pacific region expands, more people are choosing to travel to various Asia/Pacific destinations while greater development occurs, i.e., tourism, construction, banking, trade, etc. Be interested in working with our agency to supply what is on our want lists."

◼ PAINET INC.

20 Eighth St. S., P.O. Box 431, New Rockford ND 58356. (701)947-5932 or (888)966-5932. Fax: (701)947-5933. E-mail: photogs@painetworks.com. Website: www.painetworks.com. **Contact:** S. Corporation, owner. Estab. 1985. Picture library. Has 323,000 digital photos in files. Clients include: advertising agencies, magazine publishers.

Needs "Anything and everything."

Specs "Refer to www.painetworks.com/scantips.html and www.painetworks.com/stock/sbmtphot.html for information on how to scan and submit images to Painet. You may view our standard contract at www.painetworks.com/contract.html."

Payment & Terms Pays 50% or 60% commission, depending on the size of the digital images submitted (see contract). Works with photographers with or without a contract. Offers nonexclusive contract. Payment made quarterly. Informs photographers and allows them to negotiate when client requests all rights. Provides buyer contact information to photographer by sending photographer copies of the original invoices on all orders of photographer's images.

Making Contact "To receive biweekly photo requests from our clients, send an e-mail message to addphotog @painetworks.com."

Tips "We have added an online search engine with 323,000 images. We welcome submissions from new photographers, since we add approximately 20,000 images quarterly. Painet markets color and b&w images electronically or by contact with the photographer. Because images and image descriptions are entered into a database from which searches are made, we encourage our photographers to include lengthy descriptions which improve the chances of finding their images during a database search. Photographers who provide us their e-mail address will receive a biweekly list of current photo requests from buyers. Photographers can then send matching images in JPEG format via e-mail, and we forward them to the buyer. When the buyer selects an image, we contact the photographer to upload a larger file (usually in TIFF format) to our FTP site. Instructions are provided on how to do this. The buyer then downloads the image file from our FTP site. Credit card payment is made in advance by the buyer. Photographer is paid on a quarterly basis."

PANORAMIC IMAGES

2302 Main St., Evanston IL 60202. (847)324-7000. Fax: (847)324-7004. E-mail: malvardo@panoramicimages. com. Website: www.panoramicimages.com. **Contact:** Michelle Alvardo, director of photography. Estab. 1987. Stock photo agency. Member of ASPP, NANPA and IAPP. Clients include: advertising agencies, magazine publishers, newspapers, design firms, graphic designers, corporate art consultants, postcard companies, calendar companies.

Needs Wants photos of lifestyles, environmental, landscapes/scenics, wildlife, architecture, cities/urban, gardening, interiors/decorating, rural, adventure, automobiles, health/fitness, sports, travel, business concepts, industry, medicine, military, science, technology/computers. Interested in alternative process, avant garde, documentary, fine art, historical/vintage, seasonal. Works only with *panoramic formats* (2:1 aspect ratio or greater). Subjects include: cityscapes/skylines, international travel, nature, tabletop, backgrounds, conceptual.

Specs Uses $2\frac{1}{4} \times 5$, $2\frac{1}{4} \times 7$, $2\frac{1}{4} \times 10$ (6×12cm, 6×17cm, 6×24cm). "$2\frac{1}{4}$ formats preferred; transparencies preferred; will accept negatives and scans. Call for digital submission guidelines. Will accept 70mm pans, 5×7, 4×10, 8×10 horizontals and verticals."

Payment & Terms Pays 40% commission for photos. Average price per image (to clients): $850. No chanrge for scanning, metadata or inclusion on website. Statements issued quarterly. Payment made quarterly. Offers one-time, electronic rights and limited exclusive usage. Model release preferred "and/or property release, if necessary." Photo captions required. Call for submission guidelines before submitting.

Making Contact Send e-mail with stock list or low-res scans/lightbox. Responds in 1-3 months. Specific want lists created for contributing photographers. Photographer's work is represented on full e-commerce website and distributed worldwide through image distribution partnerships with Getty Images, National Geographic Society Image Collection, Amana, Digital Vision, etc.

Tips Wants to see "well-exposed chromes or very high-res stitched pans. Panoramic views of well-known locations nationwide and worldwide. Also, generic beauty panoramics. PI has medium- and large-format films which allow us to provide drum scans to customers from 100MB to 2 gigs."

▣ ⊕ PANOS PICTURES

1 Honduras St., London EC1Y OTH United Kingdom. (440)(207)253-1424. Fax: (440)(207)253-2752. E-mail: pics@panos.co.uk. Website: www.panos.co.uk. **Contact:** Adrian Evans. Estab. 1986. Picture library. Member of the British Association of Picture Libraries and Agencies (BAPLA). Has 500,000 photos in files. Clients include: book publishers, magazine publishers, newspapers.

Needs Wants photos of multicultural, disasters, environmental, landscapes/scenics, wildlife, cities/urban, education, religious, rural, events, travel, agriculture, industry, medicine, military, political, technology/ computers. Interested in "documentary photography from developing world and Eastern Europe (i.e., everywhere except North America and Western Europe)."

Specs Uses 8×10 b&w prints; 35mm transparencies. Accepts images in digital format. Send via CD, Zip, e-mail as TIFF, JPEG files.

Payment & Terms Pays 50% commission for b&w and color photos. Average price per image (to clients): $100-5,000 minimum for b&w and color photos. Enforces strict minimum prices. Offers volume discounts to customers. Works with photographers with or without a contract. Offers nonexclusive contract. Contracts renew automatically with additional submissions. Statements issued quarterly. Photographers allowed to review account records in cases of discrepancies only. Offers one-time rights. Informs photographers and allows them to negotiate when a client requests all rights. Model release preferred. Photo captions required.

Making Contact Send query letter with stock list, tearsheets. Expects minimum initial submission of 500 images.

Tips When submitting work, photographers should have "good captions and edit their work tightly."

📷 🌐 PAPILIO NATURAL HISTORY LIBRARY

155 Station Rd., Herne Bay, Kent CT6 5QA United Kingdom. (44)(122)736-0996. E-mail: library@papiliophotos.com. Website: www.papiliophotos.com. **Contact:** Justine Pickett. Estab. 1984. Has 65,000 photos in files. Clients include: advertising agencies, book publishers, magazine publishers, newspapers, calendar companies, greeting card companies, postcard publishers.

Needs Wants photos of wildlife.

Specs Uses 35mm, medium-format transparencies, digital shot in camera as RAW and converted to TIFF for submission, minimum file size 17MB. See web page for further details or contact for a full information sheet about shooting and supplying digital photos.

Payment & Terms Works with photographers on contract basis only. Offers nonexclusive contract. Statements issued quarterly. Payment made quarterly. Offers one-time rights, electronic media rights. Photo captions required; include Latin names and behavioral information.

Making Contact Send query letter with résumé. Does not keep samples on file; include SASE for return of transparency material. Expects minimum initial submission of 150 images. Responds in 1 month to samples. Returns all unsuitable material with letter. Photo guidelines sheet free with SASE.

Tips "Contact first for information about digital. Supply transparencies in flat, clear plastic sheets for ease of viewing—not in boxes. Supply SASE or return postage. Supply full caption listing for all images. Wildlife photography is very competitive. Photographers are advised to send only top-quality images."

📷 PHOTO AGORA

3711 Hidden Meadow Lane, Keezletown VA 22832. (540)269-8283. Fax: (540)269-8283. E-mail: robert@photoagora.com. Website: www.photoagora.com. **Contact:** Robert Maust. Estab. 1972. Stock photo agency. Has 50,000 photos in files. Clients include: businesses, book/encyclopedia and textbook publishers, magazine publishers, calendar companies.

Needs Wants photos of families, children, students, Virginia, Africa and other third world areas, work situations, etc. Also needs babies/children/teens, couples, multicultural, parents, senior citizens, disasters, environmental, landscapes/scenics, wildlife, cities/urban, education, gardening, pets, religious, rural, health/fitness, travel, agriculture, industry, medicine, science, technology/computers.

Specs Uses 8×10 matte or glossy b&w prints; mounted transparencies of all formats; high-resolution digital images (ask for details).

Payment & Terms Pays 50% commission for b&w and color photos. Average price per image (to clients): $40 minimum for b&w photos; $100 minimum for color photos. Negotiates fees below standard minimum prices. Offers volume discounts to customers; inquire about specific terms. Photographers can choose not to sell images on discount terms. Works with photographers with or without a contract. Offers nonexclusive contract. Statements issued quarterly. Payment made quarterly. Photographers allowed to review account records. Offers one-time rights. Informs photographers and allows them to negotiate when client requests all rights. Model/property release preferred. Photo captions required; include location, important dates, scientific names, etc.

Making Contact Call, write or e-mail. No minimum number of images required in initial submission. Responds in 3 weeks. Photo guidelines free with SASE.

📰 📷 PHOTO ASSOCIATES NEWS SERVICE/PHOTO INTERNATIONAL

4607 Norborne Rd., Richmond VA 23234. (804)229-8129/571-3327859. Fax: (804)745-8639. E-mail: pans47@yahoo.com and photointernational2002@yahoo.com. **Contact:** Peter Heimsath, bureau manager. Estab. 1970. News/feature syndicate. Has 50,000 photos in files. Clients include: newspapers, magazines, newsletters, book publishers, story-specific clients.

Needs Wants photos for human interest features and immediate news for worldwide distribution. Celebrities, politicians, law enforcement, emergency preparedness.

Specs Uses b&w and/or color prints or digital images. Send via e-mail as JPEG files at 300 dpi.

Payment & Terms Pays $150-500 for color photos; $75-300 for b&w photos. Pays 50/50 on agency sales for distribution. Negotiates fees at standard prices depending on subject matter and need; reflects monies to be charged. Photographers can choose not to sell images on discount terms. Works with photographers with or without a contract. Statements issued monthly. Payment made "when client pays us. Photographers may

review records to verify sales, but don't make a habit of it. Must be a written request." Offers one-time rights. Informs photographer and allows them to negotiate when client requests all rights. Photo Associates News Service will negotiate when client requests all rights. Model/property release required on specific assignments. Photo captions required; include name of subject, when taken, where taken, competition and process instructions.

Making Contact "Inquire with specific interests. First, send us e-mail with attachments. We will review and notify within two weeks. Next step, submission of 50 images, then 100 every two months."

Tips "Put yourself on the opposite side of the camera, to grasp what the composition has to say. Are you satisfied with your material before you submit it? More and more companies seem to take the short route to achieve their visual goals. They don't want to spend real money to obtain a new approach to a possible old idea. Too many times, photographs lose their creativity because the process isn't thought out correctly. Show us something different."

PHOTO EDIT

235 E. Broadway St., Suite 1020, Long Beach CA 90802. (800)860-2098. Fax: (800)804-3707. E-mail: sales@photoeditinc.com. Website: www.photoeditinc.com. **Contact:** Leslye Borden or Liz Ely. Estab. 1987. Stock agency. 100% digital. 200,000 images online. Clients include: advertising agencies, businesses, public relations firms, book/textbook publishers, calendar companies, magazine/newspaper publishers.

Needs Digital images of babies/children/teens, couples, multicultural, families, parents, senior citizens, disasters, environment, cities/urban, education, religious, food/drink, health/fitness, hobbies, sports, travel, agriculture, business concepts, industry, medicine, political, science, technology/computers.

Specs Uses images in (raw, unmanipulated) digital format. Send via CD as TIFF or JPEG files at 300 dpi.

Payment & Terms Pays 50% commission for color images. Average price per image (to clients): $175 for color images. Enforces minimum prices. Enjoys preferred vendor status with many clients. Works with photographers on contract basis only. Offers nonexclusive contract. Contracts renew automatically with continuous submissions. Offers one-time rights. Informs photographers and allows them to negotiate when a client requests all rights. Model/property release preferred. Photo captions required.

Making Contact Send query letter by e-mail with images. Does not keep samples on file. Expects minimum initial submission of 1,000 edited images with quarterly submissions of new images. Responds immediately only if interested. Photo guidelines sheet available via e-mail.

Tips "Call to discuss interests, equipment, specialties, availability, etc."

PHOTO NETWORK

P.O. Box 317, Lititz PA 17543. (717)626-0296 or (800)622-2046. Fax: (717)626-0971. E-mail: info@heilmanphoto.com. Website: www.photonetworkstock.com or www.heilmanphoto.com. **Contact:** Sonia Wasco, president. Stock photo agency/library. Member of Picture Archive Council of America (PACA). Has more than 1 million photos in files. Clients include: agribusiness companies, ad agencies, textbook companies, graphic artists, public relations firms, newspapers, corporations, magazines, calendar companies, greeting card companies.

• Photo Network is now owned by Grant Heilman Photography.

Needs Wants photos of agriculture, families, couples, ethnics (all ages), animals, travel and lifestyles. Also wants photos of babies/children/teens, parents, senior citizens, disasters, environmental, wildlife, architecture, cities/urban, education, gardening, interiors/decorating, pets, religious, rural, adventure, automobiles, food/drink, health/fitness/beauty, hobbies, humor, sports, business concepts, industry, medicine, military, political, science, technology/computers. Special subject needs include people over age 55 enjoying life; medical shots (patients and professionals); children and domestic animals.

Specs Uses 35mm, $2\frac{1}{4} \times 2\frac{1}{4}$, 4×5 transparencies. Accepts images in digital format. Send via CD as JPEG files.

Payment & Terms Information available upon request.

Making Contact Send query letter with stock list. Send a sample of 200 images for review; include SASE for return of material. Responds in 1 month.

Tips Wants to see a portfolio "neat and well-organized and including a sampling of photographer's favorite photos." Looks for "clear, sharp focus, strong colors and good composition. We'd rather have many very good photos rather than one great piece of art. Would like to see photographers with a specialty or specialties and have it/them covered thoroughly. You need to supply new photos on a regular basis and be responsive to current trends in photo needs. Contract photographers are supplied with quarterly 'want' lists and information about current trends."

▣ PHOTO RESEARCHERS, INC.

60 E. 56th St., New York NY 10022. (212)758-3420. Fax: (212)355-0731. Website: www.photoresearchers.com. Stock agency. Has over 1 million photos and illustrations in files, with 100,000 images in a searchable online database. Clients include: advertising agencies; graphic designers; publishers of textbooks, encyclopedias, trade books, magazines, newspapers, calendars, greeting cards; foreign markets.

Needs Wants images of all aspects of science, astronomy, medicine, people (especially contemporary shots of teens, couples and seniors). Particularly needs model-released people, European wildlife, up-to-date travel and scientific subjects.

Specs Accepts any size transparencies. Prefers images in digital format.

Payment & Terms Rarely buys outright; works on 50% stock sales and 30% assignments. General price range (to clients): $150-7,500. Works with photographers on contract basis only. Offers limited regional exclusivity. Contracts renew automatically with additional submissions for 5 years (initial term; 1 year thereafter). Charges $15 for Web placement for transparencies. Photographers allowed to review account records upon reasonable notice during normal business hours. Statements issued monthly, bimonthly or quarterly, depending on volume. Informs photographers and allows them to negotiate when a client requests to buy all rights, but does not allow direct negotiation with customer. Model/property release required for advertising; preferred for editorial. Photo captions required; include who, what, where, when. Indicate model release.

Making Contact See "about representation" on website.

Tips "We seek the photographer who is highly imaginative or into a specialty (particularly in the scientific or medical fields) and who is dedicated to technical accuracy. We are looking for serious contributors who have many hundreds of images to offer for a first submission and who are able to contribute often."

▣ PHOTO RESOURCE HAWAII

111 Hekili St., #41, Kailua HI 96734. (808)599-7773. Fax: (808)235-5477. E-mail: stockphoto@hawaii.rr.com. Website: www.PhotoResourceHawaii.com. **Contact:** Tami Dawson, owner. Estab. 1983. Stock photo agency. Has website with electronic delivery of over 5,000 images. Clients include: ad agencies, audiovisual firms, businesses, book/encyclopedia publishers, magazine publishers, calendar companies, greeting card companies, postcard publishers.

Needs Photos of Hawaii and the South Pacific.

Specs Accepts images in digital format only, 18MB or larger.

Payment & Terms Pays 50% commission. Enforces minimum prices. Offers volume discounts to customers. Discount sales terms not negotiable. Works with photographers on contract basis only. Offers nonexclusive contract. Contracts renew automatically with additional submissions. Statements issued bimonthly. Payment made bimonthly. "Right-protected licensing only, no royalty-free." Model/property release preferred. Photo captions and keywording online required.

Making Contact Send query e-mail with samples. Expects minimum initial submission of 100 images with periodic submissions at least 5 times/year. Responds in 2 weeks.

▣ ▣ ⊕ PHOTO STOCK/GRANATAIMAGES.COM

95 Via Vallazze, Milan 20131 Italy. (39)(022)668-0702. Fax: (39)(022)668-1126. E-mail: peggy.granata@granataimages.com. Website: www.granataimages.com. **Contact:** Peggy Granata, manager. Estab. 1985. Stock agency. Member of CEPIC. Has 2 million photos in files and 200,000 images online. Clients include: advertising agencies, newspapers, book publishers, calendar companies, audiovisual firms, magazine publishers, production houses.

Needs Wants photos of celebrities, industry, people.

Specs Uses high-resolution digital files. Send via Zip, FTP, e-mail as TIFF, JPEG files.

Payment & Terms Pays 60% commission for color photos. Negotiates fees below stated minimums in cases of volume deals. Offers volume discounts to customers. Photographers can choose not to sell images on discount terms. Works with photographers on contract basis only. Offers exclusive contract only. Contracts renew automatically with additional submissions for 1 year. Statements issued monthly. Photographers allowed to review account records in cases of discrepancies only. Offers one-time rights. Model/property release preferred. Photo captions required; include location, country and any other relevant information.

Making Contact Send query letter with digital files.

Ⓝ ▣ ⊕ PHOTOBANK YOKOHAMA

6F IMAX Bldg., Onoe-cho, Naka-ku Yokohama-shi, Kanagawa 231-0015 Japan. (81)(45)212-3855. Fax: (81)(45)212-3839. E-mail: info@pby.jp. Website: www.pby.jp. **Contact:** Hitoshi Mochizuki, president. Estab.

1981. Stock agency. Member of the Picture Archive Council of America (PACA). Has 600,000 photos in files. Clients include: advertising agencies, public relations firms, businesses, book publishers, magazine publishers, calendar companies, greeting card companies, postcard publishers, department stores.

Needs Wants photos of babies/children/teens, celebrities, couples, families, disasters, environmental, landscapes/scenics, wildlife, cities/urban, gardening, interiors/decorating, pets, adventure, entertainment, health/fitness, hobbies, humor, performing arts, sports, business concepts, industry, medicine, political, product shots/still life, science, technology/computers. Interested in avant garde, fashion/glamour, fine art, seasonal.

Specs Uses 35mm, $2\frac{1}{4} \times 2\frac{1}{4}$, 4×5 transparencies. Accepts images in digital format. Send via CD, Zip, e-mail as TIFF, PICT, JPEG files at 200-400 dpi.

Payment & Terms Pays 50% commission for photos. Enforces minimum prices. Works with photographers on contract basis only. Offers nonexclusive contract. Contracts renew automatically with additional submissions for 1 year. Statements issued monthly. Payment made monthly. Photographers allowed to review account records. Offers one-time rights. Model release required; property release preferred. Photo captions required.

Making Contact Send transparencies. Portfolio may be dropped off Monday-Wednesday. Include SAE for return of material. Expects minimum initial submission of 50 images. Catalog available for $20 (includes cost and freight).

Tips "Please contact us by fax or e-mail."

🖼️ 🌐 PHOTOBANK-BANGKOK

Photobank-Singapore, 58/18 Soi Promsri 2, (Soi 49-19) Sukhumvit Rd., Klongton Nue, Wattana 10110 Bangkok. (66)(02)391-8185. Fax: (66)(02)391-4498. E-mail: cassio@loxinfo.co.th. Website: www.photobangkok.com. **Contact:** Alberto Cassio. Estab. 1975. Picture library. Has 550,000 photos in files. Clients include: advertising agencies, businesses, book publishers, audiovisual firms.

Needs Wants photos of babies/children/teens, couples, families, disasters, environmental, landscapes/scenics, wildlife, cities/urban, education, interiors/decorating, pets, adventure, food/drink, health/fitness/beauty, hobbies, sports, agriculture, business concepts, industry, medicine, product shots/still life, science, technology/computers. Interested in historical/vintage.

Specs Uses 35mm, $2\frac{1}{4} \times 2\frac{1}{4}$ transparencies; B copy videos.

Payment & Terms Pays 50% commission for color photos; 40% for videotape. Average price per image (to clients): $100-2,000 for photos; $200-3,000 for videotape. Enforces minimum prices. Offers volume discounts to customers. Works with photographers on contract basis only. Offers limited regional exclusivity. Contracts renew automatically with additional submissions. Statements issued quarterly. Photographers allowed to review account records in cases of discrepancies only. Offers one-time rights. Model release preferred. Photo captions required.

Making Contact Contact through rep. Expects minimum initial submission of 500 images with 6-month submissions of at least 200 images.

Tips "Set up an appointment and meet personally."

🖼️ PHOTOEDIT

235 Broadway, Suite 1020, Long Beach CA 90802. (800)860-2098. Fax: (800)804-3707. E-mail: sales@photoeditinc.com. Website: www.photoeditinc.com. **Contact:** Leslye Borden, president. Vice President: Elizabeth Ely. Estab. 1987. Stock photo agency. Member of Picture Archive Council of America (PACA). Has 500,000 photos. Clients include: textbook/encyclopedia publishers, magazine publishers.

Needs Photos of people—seniors, babies, couples, adults, teens, children, families, minorities, handicapped—ethnic a plus.

Specs Uses digital images only.

Payment & Terms Pays 50% commission for color photos. Average price per image (to clients): $200/quarter-page, textbook only; other sales higher. Works on contract basis only. Offers nonexclusive contract. Payments and statements issued quarterly; monthly if earnings over $1,000/month. Photographers are allowed to review account records. Offers one-time rights; limited time use. Consults photographer when client requests all rights. Model release preferred.

Making Contact Submit digital portfolio for review. Once accepted into agency, expects minimum initial submission of 1,000 images with additional submission of 1,000 images/year. Responds in 1 month. Photo guidelines available on website.

Tips In samples, looks for "drama, color, social relevance, inter-relationships, current (*not* dated material),

tight editing. We want photographers who have easy access to models of every ethnicity (not professional models) and who will shoot actively and on spec."

▣ ⊕ PHOTOLIBRARY.COM

Level 11, 54 Miller St., North Sydney 2090 NSW Australia. (61)(29)929-8511. Fax: (61)(29)923-2319. E-mail: creative@photolibrary.com. Website: www.photolibrary.com. **Contact:** Lucette Kenay. Estab. 1967. Stock agency. Has more than 700,000 high-res images on the Web. Clients include: advertising agencies, graphic designers, corporate, newspapers, postcard publishers, public relations firms, book publishers, calendar companies, magazine publishers, greeting card companies.

- This agency also has an office in the UK at 83-84 Long Acre, London WC2E 9NG. Phone: (44)(207)836-5591. Fax: (44)(207)379-4650; other offices in New Zealand, Singapore, Malaysia, Thailand, Phillipines. Other companies in The Photolibrary Group include OSF in Oxfordshire (UK), specializing in the natural world, and Garden Picture Library in London.

Needs "Contemporary imagery covering all subjects, especially model-released people in business and real life."

Specs Uses transparencies and negatives with prints. Digital specifications: 50-70 MB (see details on website).

Payment & Terms Pays 50% commission. Offers volume discounts to customers. Discount sales terms not negotiable. Offers guaranteed subject exclusivity. Statements issued quarterly. Photographers allowed to review account records. Offers one-time rights, electronic media rights, agency promotion rights. Model/property release required. Photo captions required; include date of skylines.

Making Contact "If you do not have a website to view, send an e-mail with low-res examples (72 dpi, under 100k) of approximately 50 images. You can also send low-res images on a CD to the address in Australia or the UK. All digital information and submission details are on the website. We prefer to see if the images are suitable before asking you to send transparencies."

▣ ⊕ PHOTOLIFE CORPORATION LTD.

2011 C C Wu Building, 302 Hennessy Rd., Wanchai Hong Kong. (852)(2)808-0012. Fax: (852)(2)808-0072. E-mail: edit@photolife.com.hk. Website: www.photolife.com.hk. **Contact:** Sarin Li, director of business development. Estab. 1994. Stock photo library. Has over 600,000 photos in files. Clients include: advertising agencies, newspapers, book publishers, calendar companies, magazine publishers, greeting card companies, corporations, production houses, graphic design firms.

Needs Wants contemporary images of babies/children/teens, celebrities, couples, families, wildlife, architecture, interiors/decorating, entertainment, events, performing arts, sports, travel, business concepts, industry, science, technology/computers, fashion/glamour.

Specs Uses 35mm, medium-format transparencies. Accepts images in digital format. Send low-res and high-res (30MB, minimum) data on CD or DVD as JPEG files at 300 dpi.

Payment & Terms Pays 50% commission for b&w and color photos. Average price per image (to clients): $105-1,550 for b&w photos; $105-10,000 for color photos. Offers volume discounts to customers; terms specified in photographers' contracts. Works with photographers on contract basis only. Contract can be initiated with minimum 300 selected images. Quarterly submissions needed. Informs photographers and allows them to negotiate when client requests all rights. Model release required; property release preferred. Photo captions required; include destination and country.

Making Contact Send sample of transparencies and stock list; include SAE/IRC for return of material. Expects minimum initial submission of 50 images.

Tips "Visit our website. Edit your work tightly. Send images that can keep up with current trends in advertising and print photography."

▣ PHOTOPHILE STOCK PHOTOGRAPHY

3109 W. 50th St., #112, Minneapolis MN 55410. (800)619-4PHOTO. E-mail: info@PhotophileStock.com. Website: www.PhotophileStock.com. **Contact:** Emily Schuette, owner. Clients include: advertising agencies, audiovisual firms, businesses, postcard and calendar producers, greeting card companies, textbook and travelbook publishers, editorial.

Needs Wants photos of lifestyle, vocations, sports, industry, business, medical, babies/children/teens, couples, multicultural/international, wildlife, architecture, cities/urban, education, interiors/decorating, animals/pets, religious, rural, events, food/drink, health/fitness, hobbies, humor, travel, agriculture, still life, science, sea life, digital illustrations.

Specs Uses digital formats only. Send website link or CD/DVD for review.

Payment & Terms Pays 50% commission when images sell. Works with photographers on contract basis only. Statements issued quarterly. Payment made quarterly. Informs photographers and allows them to negotiate when client requests all rights. Model/property release preferred. Photo captions required; "must be embedded in Photoshop Metadata or as a Microsoft Excel document with image number and caption in two separate columns"; include location or description of obscure subjects; travel photos should be captioned with complete destination information.

Making Contact E-mail website link or send CD/DVD for review. May also request FTP information to upload images for review. "Professionals only, please." Photographer must be continuously shooting to add new images to files.

Tips "Specialize, and shoot for the broadest possible sales potential. Get proper captions. Manage digital files for highest quality; sharp focus and good composition are important."

PHOTOSEARCH

P.O. Box 510332, Milwaukee WI 53203. (414)271-5777. **Contact:** Nicholas Patrinos, president. Estab. 1970. Stock photo agency. Has nearly 1 million photos in files. Has 2 branch offices. Clients include: ad agencies, public relations firms, audiovisual firms, businesses, book/encyclopedia publishers, magazine publishers, newspapers, postcard publishers, calendar companies, greeting card companies, network TV/nonprofit market (social services types).

Needs Interested in all types of photos.

Specs Uses 8×10 any finish b&w prints; 35mm, $2\frac{1}{4} \times 2\frac{1}{4}$, 4×5, 8×10 transparencies. Accepts images in digital format at high resolution.

Payment & Terms Buys photos; pays $150+/image. Commission varies for b&w and color photos. Offers volume discounts to customers; terms specified in photographer's contract. Photographers can choose not to sell images on discount terms. Works with photographers on contract basis only. Offers limited regional exclusivity, nonexclusive, guaranteed subject exclusivity contracts. Contracts renew automatically with additional submissions. Statements issued upon sale. Payment made immediately upon sale receipt from clients. Offers one-time, electronic media and agency promotion rights. Does not inform photographers or allow them to negotiate when client requests all rights. "This is pre-arranged and understood with the photographers." Model/property release required. Photo captions preferred; include basic specifics (i.e., place, date, etc.).

Making Contact Send query letter with stock list only initially. Keeps samples on file. Expects minimum initial submission of 250 images. Responds only if interested in 6 weeks or less. Photo guidelines given with contact only.

PHOTOTAKE, INC.

Editing and Submissions Dept., 224 W. 29th St., 9th Floor, New York NY 10001. (212)736-2525 or (800)542-3686. Fax: (212)736-1919. E-mail: yoav@phototakeusa.com. Website: www.phototakeusa.com. **Contact:** Yoav Levy, president. Stock photo agency; "fully computerized photo agency specializing in science and technology in stock and on assignment." Has 500,000 photos. Clients include: ad agencies, businesses, hospitals, newspapers, public relations and AV firms, book/encyclopedia and magazine publishers, and postcard, calendar and greeting card companies.

Needs General science and technology photographs, medical, high-tech, computer graphics, special effects for general purposes, health-oriented photographs, natural history, people and careers.

Specs Accepts digital previews of 500K; digital submissions of a resolution that scans at 50MB. Refer to guidelines for details.

Payment & Terms Pays 45-50% commission for b&w and color photos. Works on contract basis only. Offers guaranteed subject exclusivity. Contracts renew automatically with additional submissions. Statements issued quarterly. Payment made quarterly. Photographers allowed to review account records. Offers one-time or first rights (world rights in English language, etc.). Informs photographer when client requests all rights, but agency negotiates the sale. Model/property release required. Photo captions required.

Making Contact Send query letter with samples or with list of stock photo subjects via e-mail. Submit portfolio for review. Responds in 1 month. Photo guidelines available on website. Newsletter distributed quarterly to "all photographers that have contracted with us."

Tips Prefers to see "at least 100 color photos on general photojournalism or studio photography and at least 5 tearsheets—this, to evaluate photographer for assignment. If photographer has enough in medical, science, general technology photos, send these also for stock consideration." Using more "illustration type of photog-

raphy. Topics we currently see as hot are: general health, computers, news on science. Photographers should always look for new ways to illustrate concepts generally."

🖥 🖼 PHOTRI/MICROSTOCK, INC.

3701 S. George Mason Dr., Suite C2 North, Falls Church VA 22041. (703)931-8600 or (800)544-0385. Fax: (703)998-8407. E-mail: photri@erols.com. Website: www.microstock.com. **Contact:** William Howe, director. President: Jack Novak. Estab: 1980. Stock agency. Member of Picture Archive Council of America (PACA). Has 2 million photos in files. Clients include: book and encyclopedia publishers, advertising agencies, record companies, calendar companies, "various media for AV presentations."

Needs Wants photos of computer graphics, space, energy, people doing things, picture stories, babies/children/teens, families, senior citizens, architecture, cities/urban, pets, religious, automobiles, food/drink, humor, sports, travel, agriculture, business concepts, industry, medicine, military, science, technology/computers. Interested in documentary, fine art, historical/vintage, seasonal. Special needs include calendar and poster subjects. Needs ethnic mix in photos. Has sub-agents in 10 foreign countries interested in photos of USA in general.

Specs Uses glossy color and/or b&w prints; 35mm, $2\frac{1}{4} \times 2\frac{1}{4}$, 4×5, 8×10 transparencies. Accepts images in digital format. Send via CD as TIFF, JPEG files at 300 dpi.

Payment & Terms Seldom buys outright; pays 50% commission for b&w/color photos, film, videotape. Average price per image (to clients): $50-500 for b&w photos; $75-5,000 for color photos; $500 minimum for film and videotape. Negotiates fees below standard minimums. Offers volume discounts to customers; terms specified in photographers' contracts. Photographers can choose not to sell images on discount terms. Works with photographers with or without a contract. Offers nonexclusive contract. Contracts renew automatically with additional submissions. Charges 15% catalog insertion fee. Statements issued quarterly. Payment made quarterly. Photographers allowed to review records in cases of discrepancies only. Offers one-time, electronic media rights. Informs photographers and allows them to negotiate when client requests all rights. Model/property release preferred. Photo captions required.

Making Contact Call to arrange an appointment, e-mail URL link, or send query letter with tearsheets, transparencies, stock list, SASE. Expects initial submission of 60-300 color transparencies with full captions. Responds in 1 month. Photo guidelines free with SASE or on website. Catalog available for $5. Market tips sheet available.

Tips "Respond to current needs with good quality photos. Please send complete keyworded captions for each image in your submission. Good keywords are the key to good results in the marketplace."

🖥 🌐 PICTURE BOX BV

PXRS Unlimited, Krommenieërpad 38, 1521 HB Wormerveer The Netherlands. (31)(75)622-3022. Fax: (31)(75)640-3409. E-mail: info@picturebox.nl. Website: www.picturebox.nl. **Contact:** New Photographers Dept. Estab. 1985. Stock agency. Clients include: advertising agencies, businesses, newspapers, postcard publishers, public relations firms, book publishers, calendar companies, travel companies, audiovisual firms, magazine publishers, greeting card companies.

Needs Wants photos of babies/children/teens, couples, multicultural, families, parents, senior citizens, education, gardening, interiors/decorating, adventure, automobiles, entertainment, events, food/drink, health/fitness/beauty, hobbies, humor, performing arts, sports, travel, business concepts, medicine, science, technology/computers. Interested in historical/vintage.

Specs Accepts images in digital format. Send via CD, e-mail as JPEG files at 72 dpi.

Payment & Terms Pays commission. Offers volume discounts to customers. Discount sales terms not negotiable. Works with photographers on contract basis only. Offers exclusive contract only. Contracts renew automatically with additional submissions. Statements issued semiannually. Payment made semiannually. Photographers allowed to review account records. Offers one-time rights. Informs photographers and allows them to negotiate when client requests all rights. Model/property release required.

Making Contact Contact through rep. Send query letter with résumé, slides, photocopies, transparencies, stock list, SASE. Portfolio may be dropped off every weekday. Works with local freelancers only. Expects quarterly submissions of at least 50 images. Responds in 6 weeks. Photo guidelines available on website.

🖥 🌐 SYLVIA PITCHER PHOTO LIBRARY

75 Bristol Rd., Forest Gate, London E7 8HG United Kingdom. E-mail: SPphotolibrary@aol.com. Website: www.sylviapitcherphotos.com. **Contact:** Sylvia Pitcher. Estab. 1965. Picture library. Has 70,000 photos in files. Clients include: book publishers, magazine publishers, design consultants, record and TV companies.

Needs Wants photos of cities/urban, rural, entertainment, performing arts. Other specific photo needs: Musicians—blues, country, bluegrass, old time and jazz; relevant to the type of music (especially blues), e.g., recording studios, musicians' birth places, clubs. Please see website for good indication of needs.

Specs Uses 8×10 glossy color and/or b&w prints; 35mm, 2¼×2¼ transparencies. Accepts images in digital format. Send via CD.

Payment & Terms Pays 50% commission for b&w photos; 50% for color photos; 50% for film. Average price per image (to clients): $105-1,000 for b&w photos. Negotiates fees below stated minimum for budget CDs or multiple sale. Offers volume discounts to customers; terms specified in photographers' contracts. Photographers can choose not to sell images on discount terms, if specified at time of depositing work in library. Works with photographers with or without contract; negotiable. Offers nonexclusive contract. Contracts renew automatically with additional submissions for 3 years. Statements issued quarterly. Payment made when client's check has cleared. Offers one-time rights. Model/property release preferred. Photo captions required; include artist, place/venue, date taken.

Making Contact Send query letter with résumé, transparencies, stock list. Provide résumé, self-promotion piece to be kept on file. Expects minimum initial submission of 50 images with further submissions when available. Responds within 3 weeks.

▣ PIX INTERNATIONAL

P.O. Box 10159, Chicago IL 60610-2032. (773)472-7457. E-mail: pixintl@yahoo.com. Website: www.pixintl.com. **Contact:** Linda Matlow, president. Estab. 1976. Stock agency, news/feature syndicate. Has 200,000 photos in files. Clients include: advertising agencies, public relations firms, businesses, book publishers, magazine publishers, newspapers.

Needs Wants photos of celebrities, entertainment, performing arts.

Specs Accepts images in digital format only. Send via e-mail link to your website. "Do not e-mail any images. Do not send any unsolicited digital files. Make contact first to see if we're interested."

Payment & Terms Pays 50% commission for b&w or color photos, film. Average price per image (to clients): $75 minimum for b&w or color photos; $75-3,000 for film. Enforces minimum prices. Offers volume discounts to customers; terms specified in photographers' contracts. Discount sales terms not negotiable. Works with photographers with or without a contract; negotiable. Statements issued monthly. Payment made monthly. Photographers allowed to review account records in cases of discrepancies only. Offers one-time rights. Informs photographers and allows them to negotiate when client requests all rights. Model release not required for general editorial. Photo captions required; include who, what, when, where, why.

Making Contact "E-mail us your URL with thumbnail examples of your work that can be clicked for a larger viewable image." Responds in 2 weeks to samples, only if interested. Photo guidelines sheet free with SASE.

Tips "We are looking for razor-sharp images that stand up on their own without needing a long caption. Let us know by e-mail what types of photos you have, your experience, and cameras used. We do not take images from the lower-end consumer cameras—digital or film. They just don't look very good in publications. For photographers we do accept, we would only consider high-res 300-dpi at 6×9 or higher scans submitted on CDR."

▣ 🌐 PLANS, LTD. (Photo Libraries and News Services)

201 Kamako Bldg. #201, 1-8-9 Ohgi-gaya, Kamakura 248-0011 Japan. 81-467-23-2350. Fax: 81-467-23-2351. E-mail: yoshida@plans.jp. Website: www.plans.jp. **Contact:** Takashi Yoshida, president. Estab. 1982. Stock agency. Has 100,000 photos in files. Clients include: newspapers, book publishers, magazine publishers, advertising agencies.

Needs Wants editorial, historical/vintage, general stock photos, and Japanese Ukiyoe prints.

Specs Accepts images in digital format. Send via e-mail as JPEG files (as thumbnails at first, then 350 dpi if asked).

Payment & Terms Pays 45% commission for digital data. Average price per image (to clients): $120-1,000 for b&w or color photos. Negotiates fees below standard minimum prices. Offers volume discounts to customers. Discount sales terms not negotiable. Works with photographers with or without contract; negotiable. Offers nonexclusive contract. Contracts renew automatically with additional submissions. Statements issued monthly or every 6 months. Payment made monthly or every 6 months. Photographers allowed to review account records. Offers one-time rights, electronic media rights, agency promotion rights. Model release preferred. Photo captions required; include year, states, city.

Making Contact Send query e-mail with résumé, stock list. Does not keep samples on file. Responds only if interested; send digital data samples.

Tips "We need all kinds of photographs of the world. Photographers and archival photo owners should submit stock list including subjects, themes, when, where, color or b&w, format, total amount of stock, brief profile."

▣ PLANTSTOCK.COM

94-98 Nassau Ave., Suite 224, New York NY 11222. (212)252-3890. E-mail: photo@plantstock.com. Website: www.plantstock.com. **Contact:** Mathias McFarlane, photo editor. Estab. 2001. Stock agency. Has 10,000 photos in files. Clients include: advertising agencies, businesses, magazine publishers.

Needs Wants photos of environmental, landscapes/scenics, gardening, food/drink, health/fitness/beauty, agriculture, medicine. Also needs all types of culinary and medicinal herb imagery, including plants growing wild or being cultivated, as well as plants being harvested, prepared and used.

Specs Uses 8×10 glossy or matte color prints; 35mm transparencies. Accepts images in digital format. Send via CD, Zip as TIFF or JPEG files at 300 dpi.

Payment & Terms Pays 50% commission for color photos. Average price per image (to clients): $75-$1,200 for color photos. Enforces minimum prices. Offers volume discounts to customers. Terms specified in photographers' contracts. Discount sales terms not negotiable. Works with photographers with or without contract; negotiable. Offers nonexclusive contract. Contracts renew automatically with additional submissions for 1 year. Statements issued quarterly. Payment made quarterly. Photographers allowed to review account records. Offers one-time rights, electronic media rights. Informs photographers and allows them to negotiate when client requests all rights. Model/property release required. Photo captions required; include botanical name and common name of plant.

Making Contact Send query letter or e-mail with stock list. Provide business card to be kept on file. Expects minimum initial submission of 20 images with bimonthly submissions of at least 20 images. Responds in 2 weeks to samples, portfolios. Photo guidelines sheet free with SASE.

Tips "Accurately identify and label images with botanical name (most critical) and common name."

▣ ⊡ PONKAWONKA INC.

97 King High Ave., Toronto ON M3H 3B3 Canada. (416)638-2475. E-mail: contact@ponkawonka.com. Website: www.ponkawonka.com. **Contact:** Stephen Epstein. Estab. 2002. Stock agency. Has 60,000 photos in files. Clients include: advertising agencies, businesses, newspapers, public relations firms, book publishers, calendar companies, magazine publishers.

Needs Wants photos of religious events and holy places. Interested in avant garde, documentary, historical/vintage. "Interested in images of a religious or spiritual nature. Looking for photos of ritual, places of worship, families, religious leaders, ritual objects, historical, archaeological, anything religious, especially in North America."

Specs Accepts images in digital format. Send via CD or DVD as TIFF or JPEG files.

Payment & Terms Pays 50% commission for any images. Offers volume discounts to customers. Works with photographers on contract basis only. Charges only apply if negatives or transparencies have to be scanned. Statements issued quarterly. Payment made quarterly. Offers one-time rights. Informs photographers and allows them to negotiate when client requests all rights. Model/property release preferred. Photo captions required; include complete description and cutline for editorial images.

Making Contact Send query e-mail. Does not keep samples on file; cannot return material. Expects minimum initial submission of 150 images with annual submissions of at least 100 images. Responds only if interested; send 30-40 low-res samples by e-mail. Photo guidelines available on website.

Tips "We are always looking for good, quality images of religions of the world. We are also looking for photos of people, scenics and holy places of all religions. Send us sample images. Use Photoshop or a similar program to create a 'Web gallery' for us to view. If it looks promising, we will contact you for more images or offer a contract. Make sure the images are technically and esthetically sellable. Images must be well-exposed and large file size. We are an all-digital agency and expect scans to be high-quality files. Tell us if you are shooting digitally with a professional DSLR or if scanning from negatives with a professional slide scanner."

POSITIVE IMAGES

800 Broadway, Haverhill MA 01832. (978)556-9366. Fax: (978)556-9448. E-mail: pat@positiveimagesphoto.com. Website: www.agpix.com/positiveimages. **Contact:** Pat Bruno, owner. Stock photo agency. Member of ASPP, GWAA. Clients include advertising agencies, public relations firms, book/encyclopedia publishers, magazine publishers, greeting card companies, sales/promotion firms, design firms.

Needs Wants photos of garden/horticulture, fruits and vegetables, insects, plant damage, health, nutrition, herbs, healing, babies/children/teens, couples, senior citizens, environmental, landscapes/scenics, wildlife, cities/urban, education, pets, rural, events, food/drink, health/fitness, travel, agriculture—all suitable for advertising and editorial publication. Interested in seasonal.

Payment & Terms Pays 50% commission. Average price per image (to clients): $250. Works with photographers on contract basis only. Offers limited regional exclusivity. Payment made quarterly. Offers one-time and electronic media rights. "We never sell all rights."

Making Contact Send query letter. Call to schedule an appointment. Responds in a timely fashion.

Tips "We take on only one or two new photographers per year. We respond to everyone who contacts us and have a yearly portfolio review. Positive Images accepts only full-time working professionals who can contribute regular submissions. Our scenic nature files are overstocked, but we are always interested in garden photography, travel/tourism shots, as well as any images suitable for calendars and any new twists on standard topics."

N 📇 PURESTOCK

7660 Centurion Pkwy., Jacksonville FL 32256. (904)680-1990. E-mail: photoeditor@purestock.com. Website: www.purestock.com. The Purestock royalty-free brand is designed to provide the professional creative community with high-quality images at high resolution and very competitve pricing. Purestock offers CDs and single-image downloads in a wide range of categories including lifestyle, business, education and sports to distributors in over 100 countries.

Needs "We are focusing on collections of at least 200 images for inclusion on CDs in a variety of categories including lifestyle, business, education, medical, industry, etc."

Specs "We prefer digital files which are capable of being output at 80MB with minimal interpolation. File must be 300 dpi, RGB, TIFF at 8-bit color. We will also accept transparencies if digital files are not available."

Payment & Terms Statements issued monthly to contracted image providers. Model release required. Photo captions required.

Making Contact Submit a portfolio including a subject-focused collection of 300+ images. Photo guidelines available on website at www.purestock.com/submissions.asp.

Tips "Please review our website to see the style and quality of our imagery before submitting."

📇 🌐 RAILPHOTOLIBRARY.COM

(formerly Railways—Milepost 92½), Newton Harcourt, Leicester, Leicestershire LE8 9FH United Kingdom. (44)(116)259-2068. Fax: (44)(116)259-3001. E-mail: studio@railphotolibrary.com. Website: www.railphotolibrary.com. **Contact:** Colin Nash, picture library manager. Estab. 1969. Has 400,000 photos in files relating to railways worldwide. Clients include: advertising agencies, businesses, newspapers, postcard publishers, public relations firms, book publishers, calendar companies, audiovisual firms, magazine publishers, greeting card companies.

Needs Wants photos of railways.

Specs Uses digital images; glossy b&w prints; 35mm, $2\frac{1}{4} \times 2\frac{1}{4}$ transparencies.

Payment & Terms Buys photos, film or videotape outright depending on subject; negotiable. Pays 50% commission for b&w or color photos. Average price per image (to clients): $125 maximum for b&w or color photos. Works with photographers with or without a contract; negotiable. Statements issued quarterly. Photographers allowed to review account records in cases of discrepancies only. Photo captions preferred.

Making Contact Send query letter with slides, prints. Portfolio may be dropped off Monday through Saturday. Does not keep samples on file; include SAE/IRC for return of material. Unlimited initial submission. Responds in 2 weeks.

Tips "Submit well-composed pictures of all aspects of railways worldwide: past, present and future; captioned digital files, prints or slides. We are the world's leading railway picture library, and photographers to the railway industry."

📇 RAINBOW

61 Entrada, Santa Fe NM 87505. (505)820-3434. Fax: (505)820-6409. E-mail: rainbow@cybermesa.com. Website: www.rainbowimages.com. **Contact:** Coco McCoy, director. Library Manager: Julie West. Estab. 1976. Stock photo agency. Member of American Society of Picture Professionals. Has 100,000 photos in files "as back up for a rapidly growing digital library." Clients include: educational publishers, advertising agencies, public relations firms, design agencies, book/encyclopedia publishers, magazine publishers, calendar and notecard companies; 20% of sales come from overseas.

Needs Although Rainbow is a general coverage agency, it is known for its high-quality imagery in several areas such as the wonders of nature, photomicrography, people and cultures of the world, and unique shots of travel destinations. Also looking for graphically strong and colorful images in physics, biology and earth science concepts; active children, teenagers and elderly people. "Our rain forest file is growing but is never big enough!" Wants photos of wildlife, architecture, cities/urban, education, religion, adventure, entertainment, food/drink, health/fitness/beauty, humor, medicine, science. Interested in avant garde, documentary, fine art, historical/vintage, seasonal.

Specs Uses 35mm. Accepts images in digital format. Send via CD as JPEG files, "as long as TIFF files 50 MB and larger are available." Prefers photos shot with 5-megapixal and higher camera.

Payment & Terms Pays 50% commission. Contracts renew automatically with each submission; no time limit. Statements issued quarterly. Payment made quarterly. Photographers allowed to review account records to verify sales figures. Offers one-time rights. Informs photographers and allows them to negotiate when client requests all rights. Photo captions required for scientific photos or geographic locations, etc.; include simple description if not evident from photo; prefers both Latin and common names for plants and insects to make photos more valuable.

Making Contact Interested in receiving work from published photographers. "Photographers may e-mail, write or call us for photo guidelines or information. We may ask for CDs or an initial submission of 150-300 chromes." Arrange a personal interview to show portfolio, or send query letter with samples; include SASE for return of material. Responds in 2 weeks.

Tips "Write a short letter or e-mail describing your subject matter, with color photocopies or tearsheets of work (10 examples) and a minimum of 100 slides or CD with SASE or check to cover return mail. The best advice we can give is to encourage photographers to carefully edit their photos before sending. No agency wants to look at grey rocks backlit on a cloudy day! With no caption!" Looks for luminous images with either a concept illustrated or a mood conveyed by beauty or light. "Clear captions help our researchers choose wisely and ultimately improve sales. If you photograph people, model releases are important for advertising, calendars and notecards, greatly expanding your sales potential."

▣ RETNA LTD.

24 W. 25th St., 12th Floor, New York NY 10010. (212)255-0622. Fax: (212)255-1224. E-mail: nyc@retna.com. Website: www.retna.com. **Contact:** Kellie Mclaughlin. Estab. 1978. Member of the Picture Archive Council of America (PACA). Stock photo agency, assignment agency. Has more than 2 million photos in files. Clients include advertising agencies, public relations firms, book/encyclopedia publishers, magazine publishers, newspapers, record companies.

• Retna wires images worldwide to sub agents and domestically to editorial clients.

Needs Handles photos of musicians (pop, country, rock, jazz, contemporary, rap, R&B) and celebrities (movie, film, television and politicians). Covers New York, Milan and Paris fashion shows; has file on royals. Also uses events, sports. Interested in fashion/glamour, historical/vintage.

Specs Original material required. All formats accepted. Send digital images via CD, Zip, e-mail as TIFF, JPEG files at 300 dpi.

Payment & Terms Pays 50% commission for domestic sales. General price range (to clients): $200 and up. Works with photographers on contract basis only. Contracts renew automatically with additional submissions for 3 years. Statements issued monthly. Payment made monthly. Offers one-time rights; negotiable. When client requests all rights photographer will be consulted, but Retna will negotiate. Model/property release required. Photo captions required.

Making Contact Arrange a personal interview to show portfolio. Primarily concentrating on selling stock, but does assign on occasion. Does not publish "tips" sheets, but makes regular phone calls to photographers.

Tips "Wants to see a variety of celebrity studio or location shoots. Some music. Photography must be creative, innovative and of the highest aesthetic quality possible."

▣ REX USA LTD

160 Monmouth St., Red Bank NJ 07701. (732)576-1919. Fax: (732)576-1909. E-mail: chuck@rexusa.com. Website: www.rexusa.com. **Contact:** Charles Musse, manager. Estab. 1935. Stock photo agency, news/feature syndicate. Affiliated with Rex Features in London. Member of Picture Archive Council of America (PACA). Has 1.5 million photos. Clients include: advertising agencies, public relations firms, audiovisual firms, businesses, book/encyclopedia publishers, magazine publishers, newspapers, postcard companies, calendar companies, greeting card companies and TV, film and record companies.

Needs Wants primarily editorial material: celebrities, personalities (studio portraits, candid, paparazzi), hu-

man interest, news features, movie stills, glamour, historical, geographic, general stock, sports and scientific.
Specs Uses all sizes and finishes of b&w and color prints; 35mm, 2¼×2¼, 4×5, and 8×10 transparencies; b&w and color contact sheets; b&w and color negatives; VHS videotape.
Payment & Terms Pays 50-65% commission; payment varies depending on quality of subject matter and exclusivity. "We obtain highest possible prices, starting at $100-100,000 for one-time sale." Pays 50% commission for b&w and color photos. Works with or without contract. Offers nonexclusive contract. Statements issued monthly. Payment made monthly. Photographers allowed to review account records. Offers one-time, first and all rights. Informs photographers and allows them to negotiate when client requests all rights. Model release required. Photo captions required.
Making Contact Arrange a personal interview to show portfolio. Send query letter with samples. Send query letter with list of stock photo subjects. If mailing photos, send no more than 40; include SASE. Responds in 1-2 weeks.

�N 🖻 ⊘ ROMA STOCK

P.O. Box 50983, Pasadena CA 91115-0983. E-mail: romastock@SBCglobal.net. Website: www.eyecatchingimages.com. **Contact:** Robert Marien, owner. Estab. 1989. Stock photo agency. Has more than 150,000 photos in files. Clients include: advertising agencies, multimedia firms, corporations, graphic design and film/video production companies. International affiliations in Malaysia, Germany, Spain, France, Italy, England, Poland, Brazil, Japan, Argentina.

- RoMa Stock is not currently accepting submissions. Check website for updates.

Needs Looking for photographers with large collections of digital images only.
Specs Accepts images in digital format. Send on CD or Zip.
Payment & Terms Buys photos outright; pays $5-10 for b&w photos; $6-12 for color photos. Pays 40% commission for b&w and color photos, film and videotape. Average price per image (to clients): $50-1,000 for b&w and color photos, film and videotape. Offers volume discounts to customers; terms specified in photographers' contracts. Guaranteed subject exclusivity (within files). Contracts renew automatically with each submission (of 1,000 images) for 1 year. Statements issued with payment. Offers one-time rights, first rights. Informs photographer when client requests all rights for approval. Model/property release required for recognizable people and private places "and such photos should be marked with 'M.R.' or 'N.M.R.' respectively." Photo captions required for animals/plants; include common name, scientific name, habitat, photographer's name; for others include subject, location, photographer's name.
Making Contact Visit website for submission guidelines. Send query letter with résumé of credits, tearsheets, list of specialties. No unsolicited original work. Responds with tips sheet, agency profile and questionnaire for photographer with SASE.

🖻 ROBERTSTOCK

4203 Locust St., Philadelphia PA 19104. (800)786-6300. Fax: (800)786-1920. E-mail: sales@robertstock.com. Website: www.robertstock.com. **Contact:** Bob Roberts, president. Estab. 1920. Stock photo agency. Member of the Picture Archive Council of America (PACA). Has 2 million photos in files. Has 1 branch office. Clients include: advertising agencies, public relations firms, audiovisual firms, businesses, book/encyclopedia publishers, magazine publishers, newspapers, postcard publishers, calendar companies, greeting card companies.
Needs Uses images on all subjects in depth.
Specs Accepts images in digital format. Send via CD, Zip at 300 dpi, 30MB or higher.
Payment & Terms Pays 45-50% commission. Works with photographers with or without a contract; negotiable. Offers various contracts. Statements issued monthly. Payment made monthly. Payment sent with statement. Photographers allowed to review account records to verify sales figures "upon advance notice." Offers one-time rights. Informs photographers when client requests all rights. Model release required. Photo captions required.
Making Contact Send query letter with résumé of credits. Does not keep samples on file. Expects minimum initial submission of 250 images with quarterly submissions of 250 images. Responds in 1 month. Photo guidelines available.

🖻 🌐 SCIENCE PHOTO LIBRARY, LTD.

327-329 Harrow Rd., London W9 3RB United Kingdom. (44)(207)432-1100. Fax: (44)(207)286-8668. E-mail: picture.editing@sciencephoto.com. Website: www.sciencephoto.com. **Contact:** Rosemary Taylor, research director. Stock photo agency. Clients include: advertising agencies, public relations firms, audiovisual firms,

businesses, book/encyclopedia publishers, magazine publishers, newspapers, postcard companies, calendar companies, greeting card companies, electronic media.

Needs SPL specializes in all aspects of science, medicine and technology/computers. "Our interpretation of these areas is broad. We include earth sciences, landscape and sky pictures and animals. We have a major and continuing need for high-quality photographs showing science, technology and medicine *at work* : laboratories, high-technology equipment, computers, lasers, robots, surgery, hospitals, etc. We are especially keen to sign American freelance photographers who take a wide range of photographs in the fields of medicine and technology. We like to work closely with photographers, suggesting subject matter to them and developing photo features with them. We can only work with photographers who agree to our distributing their pictures throughout Europe, and preferably elsewhere. We duplicate selected pictures and syndicate them to our agents around the world."

Specs Uses color prints and 35mm, $2\frac{1}{4}\times2\frac{1}{4}$, 4×5, 6×7, 5×6 and 6×9 transparencies. Accepts images in digital format. Send via floppy disk, Zip, Jaz, e-mail as TIFF, JPEG files.

Payment & Terms Pays 50% commission for b&w and color photos. Average price per image (to clients): $80-1,000; varies according to use. Only discounts below minimum for volume or education. Offers volume discounts to customers; inquire about specific terms. Discount sales terms not negotiable. Works on contract basis only. Offers exclusivity; exceptions are made; subject to negotiation. Agreement made for 5 years; general continuation is assured unless otherwise advised. Statements issued quarterly. Payment made quarterly. Photographers allowed to review account records to verify sales figures; fully computerized accounts/commission handling system. Offers one-time and electronic media rights. Model release required. Photo captions required.

Making Contact Send query letter with samples or query with list of stock photo subjects. Send unsolicited photos by mail for consideration. Returns material submitted for review. Responds in 1 month. Photo guidelines available on website.

▣ SILVER IMAGE PHOTO AGENCY, INC.

4104 NW 70th Terrace, Gainesville FL 32606. (352)373-5771. Fax: (352)374-4074. E-mail: floridalink@aol.com. Website: www.silver-image.com. **Contact:** Carla Hotvedt, president/owner. Estab. 1988. Stock photo agency. Assignments in Florida/south Georgia. Has 150,000 photos in files. Clients include: public relations firms, book/encyclopedia publishers, magazine publishers, newspapers.

Needs Wants photos of Florida-based travel/tourism, Florida cityscapes and people.

Specs Uses 35mm transparencies. Accepts images in digital format. Send via CD, floppy disk, Zip, e-mail as JPEG files.

Payment & Terms Pays 50% commission for image licensing fees. Average price per image (to clients): $150-600. Works with photographers on contract basis only. Offers nonexclusive contract. Payment made monthly. Statements provided when payment is made. Photographers allowed to review account records. Offers one-time rights. Informs photographer and allows them to be involved when client requests all rights. Model release preferred. Photo captions required; include name, year shot, city, state, etc.

Making Contact Send query letter via e-mail only. Do not submit material unless first requested.

Tips "I will review a photographer's work to see if it rounds out our current inventory. Photographers should review our website to get a feel for our needs."

▣ SILVER VISIONS

P.O. Box 2679, Aspen CO 81612. (970)923-3137. E-mail: jjohnson@rof.net. Website: www.rof.net/yp/silverv ision. **Contact:** Joanne M. Johnson, owner. Estab. 1987. Stock photo agency. Has 10,000 photos. Clients include: book/encyclopedia publishers, magazine publishers, postcard companies, calendar companies, greeting card companies.

Needs Emphasizes lifestyles—people, families, children, couples involved in work, sports, family outings, pets, etc. Also scenics of mountains and deserts, horses, dogs, cats, cityscapes—Denver, Los Angeles, Chicago, Baltimore, New York City, San Francisco, Salt Lake City, capital cities of the USA.

Specs Uses 35mm, $2\frac{1}{4}\times2\frac{1}{4}$ or 4×5 transparencies. Accepts images in digital format. Send via CD, e-mail, floppy disk.

Payment & Terms Pays 40-50% commission for color photos. General price range: $35-750. Offers nonexclusive contract. Charges $15/each for entries in CD-ROM catalog. Statements issued semiannually. Payment made semiannually. Offers one-time rights and English language rights. Informs photographer and allows them to negotiate when client requests all rights. Model/property release required for pets, people, upscale homes. Photo captions required; include identification of locations, species.

Making Contact Send query letter with samples, SASE. Responds in 2 weeks. Photo guidelines free with SASE.

Tips Wants to see "emotional impact or design impact created by composition and lighting. Photos must evoke a universal human interest appeal. Sharpness and good exposures—needless to say." Sees growing demand for "minority groups, senior citizens, fitness."

SKISHOOT-OFFSHOOT

Hall Place, Upper Woodcott, Whitchurch, Hants RG28 7PY United Kingdom. (44)(1635)255527. Fax: (44)(1635)255528. E-mail: skishootsnow@aol.com. Website: www.skishoot.co.uk. Estab. 1986. Stock photo agency. Member of British Association of Picture Libraries and Agencies (BAPLA). Has over 300,000 photos in files. Clients include: advertising agencies, book publishers, magazine publishers, newspapers, greeting card companies, postcard publishers.

Needs Wants photos of skiing, snowboarding and other winter sports. Also photos of babies/children/teens, families, landscapes/scenics, cities/urban, rural, adventure, sports, travel. Interested in seasonal.

Specs Prefers CDs with high-resolution images or transparencies of any size.

Payment & Terms Pays 50% commission for color photos. Average price per image (to clients): $100-5,000 for color. Enforces strict minimum prices. BAPLA recommended rates are used. Offers volume discounts to customers. Photographers can choose not to sell images on discount terms. Works with photographers with or without a contract; negotiable. Offers limited regional exclusivity. Contracts renew automatically with additional submissions within originally agreed time period. Charges 50% of cost of dollar transfer fees from sterling. Statements issued quarterly. Payment made quarterly. Photographers allowed to review account records in cases of discrepancies only. Offers one-time rights. Informs photographers when a client requests all rights. Model release preferred for ski and snowboarding action models. Photo captions required; include location details.

Making Contact Send query letter with samples, stock list. Include SAE for return of material. Portfolio should include color. Works on assignment only. Expects minimum initial submission of 50 images. Responds in 1 month to samples.

Tips "We have now digitized our work so that we can send images to clients by modem. Label each transparency clearly or provide clear list that relates to transparencies sent."

SKYSCAN PHOTOLIBRARY

Oak House, Toddington, Cheltenham, Gloucestershire GL54 5BY United Kingdom. (44)(124)262-1357. Fax: (44)(124)262-1343. E-mail: info@skyscan.co.uk. Website: www.skyscan.co.uk. **Contact:** Brenda Marks, library manager. Estab. 1984. Picture library. Member of the British Association of Picture Libraries and Agencies (BAPLA) and the National Association of Aerial Photographic Libraries (NAPLIB). Has more than 130,000 photos in files. Clients include: advertising agencies, public relations firms, businesses, book publishers, magazine publishers, newspapers, calendar companies, postcard publishers.

Needs Wants "anything aerial! Air-to-ground; aviation; aerial sports. As well as holding images ourselves, we also wish to make contact with holders of other aerial collections worldwide to exchange information."

Specs Uses color and/or b&w prints; any format transparencies. Accepts images in digital format. Send via CD, e-mail.

Payment & Terms Pays 50% commission for b&w and color photos. Average price per image (to clients): $100 minimum. Enforces strict minimum prices. Offers volume discounts to customers. Photographers can choose not to sell images on discount terms. Works with photographers with or without a contract; negotiable. Offers guaranteed subject exclusivity (within files); negotiable to suit both parties. Statements issued quarterly. Payment made quarterly. Photographers allowed to review account records in cases of discrepancies only. Offers one-time, electronic media and agency promotion rights. Informs photographers and allows them to negotiate when a client requests all rights. Will inform photographers and act with photographer's agreement. Model/property release preferred for "air-to-ground of famous buildings (some now insist they have copyright to their building)." Photo captions required; include subject matter, date of photography, location, interesting features/notes.

Making Contact Send query letter or e-mail. Provide résumé, business card, self-promotion piece or tearsheets to be kept on file. Agency will contact photographer for portfolio review if interested. Portfolio should include color slides and transparencies. Does not keep samples on file; include SAE for return of material. No minimum submissions. Photo guidelines sheet free with SAE. Catalog free with SAE. Market tips sheet free quarterly to contributors only.

Tips "We see digital transfer of low-resolution images for layout purposes as essential to the future of stock

libraries, and we have invested heavily in suitable technology. Contact first by letter or e-mail with résumé of material held and subjects covered."

SOA PHOTO AGENCY

Lovells Farm, Dark Lane, Stoke St., Gregory TA3 6EU United Kingdom. (44)(207)870-6437. Fax: (44)1823-491-433. E-mail: info@pictureocean.net. Website: www.pictureocean.net. **Contact:** S. Oppenlander. Estab. 1992. Picture library. Has 125,000 photos in offline database. Clients include: advertising agencies, book publishers, magazine publishers, newspapers, greeting card companies, postcard publishers, TV.

Needs Wants photos of babies/children/teens, couples, multicultural, families, parents, senior citizens, environmental, landscapes/scenics, wildlife, architecture, cities/urban, gardening, pets, rural, food/drink, health/fitness/beauty, humor, sports, travel, agriculture, buildings, business concepts, industry, medicine, product shots/still life, science, technology/computers. Interested in alternative process, avant garde, documentary, fine art, historical/vintage, seasonal.

Specs Accepts only images in digital format. Send via CD/DVD as TIFF, JPEG files at 300 dpi minimum.

Payment & Terms Pays 50% commission. Average price per image (to clients): $125 minimum for b&w and color photos. Enforces minimum prices. Offers volume discounts to customers. Discount sales terms not negotiable. Works with photographers on contract basis only. Offers guaranteed subject exclusivity (within files). Statements issued quarterly. Payment made quarterly. Photographers allowed to review account records via an accountant. Offers one-time/electronic media rights. Model release required; property release preferred. Photo captions required.

Making Contact Send query e-mail with low-res samples. Keeps samples on file; provide business card, self-promotion piece. Expects minimum initial submission of 20 images with yearly submissions of at least 50 images. Responds in 6 weeks to samples. Photo guidelines available on request.

Tips "Only send us your best images in your specialized subject. Send a proper delivery note stating the number of pictures sent and a description. Pack CD/DVD properly (no floppy brown envelopes) in jiffy bags with strengtheners. Don't just turn up on our doorstep—make an appointment beforehand."

SOUTH BEACH PHOTO AGENCY

1521 Alton Rd., #48, Miami Beach FL 33139. (561)630-7841. Fax: (561)630-7849. E-mail: photographers@southbeachphoto.com. Website: www.southbeachphoto.com. **Contact:** Managing Director. Estab. 1996. Stock agency. Member of ASPP. Has 1 million photos in files. Clients include: public relations firms, book publishers, magazine publishers, newspapers.

Needs Wants photos of South Florida, Caribbean, Miami Beach, South Beach, celebrities, entertainment, events.

Specs Accepts digital images only.

Payment & Terms Buys photos outright. Pays 50% commission for digital images. Average price per image (to clients): $200 minimum for color photos. "We always work with client's budget." Offers volume discounts to customers; terms specified in photographers' contracts. Works with photographers with or without a contract; negotiable; depends on images. Statements issued monthly. Payment made monthly. Offers one-time rights. Informs photographers and allows them to negotiate when client requests all rights. Photo captions required; include who, what, when, where, how.

Making Contact Contact through rep or send query letter with résumé, promotional piece with samples, stock list. Does not keep samples on file; include SASE for return of material. Responds only if interested; send nonreturnable samples.

Tips "Be sure to caption photos completely."

SOVFOTO/EASTFOTO, INC.

150 W. 28th St., Suite 1404, New York NY 10001. (212)727-8170. Fax: (212)727-8228. E-mail: research@sovfoto.com. Website: http://sovfoto.com. **Contact:** Mr. Vanya Edwards, director; Meredith Brosnan, researcher. Estab. 1935. Stock photo agency. Has 1 million photos in files. Clients include: advertising firms, audiovisual firms, book/encyclopedia publishers, magazine publishers, newspapers.

Needs All subjects acceptable as long as they pertain to Russia, Eastern European countries, Central Asian countries or China.

Specs Uses b&w historical; color prints; 35mm transparencies. Accepts images in digital format. Send via CD as TIFF files.

Payment & Terms Pays 50% commission. Average price per image (to clients): $225-800 for b&w or color photos for editorial use. Statements issued quarterly. Payment made quarterly. Photographers allowed to

review account records to verify sales figures or account for various deductions. Offers one-time print, electronic media, and nonexclusive rights. Model/property release preferred. Photo captions required.

Making Contact Arrange personal interview to show portfolio. Send query letter with samples, stock list. Keeps samples on file. Expects minimum initial submission of 50-100 images. Responds in 2 weeks.

Tips Looks for "news and general interest photos (color) with human element."

SPECTRUM PHOTO

3127 W. 12 Mile Rd., Berkley MI 48072. (248)398-3630. **Contact:** Laszlo Regos, owner. Estab. 1990. Stock photo agency. Has 300,000 images in files. Clients include: ad agencies, public relations firms, businesses, magazine publishers, postcard publishers, calendar companies, display companies, architects, construction and real estate.

Needs Wants all subjects, but especially "high-tech, business, industry, lifestyles, food, landscapes and backgrounds."

Specs Uses 8×10 glossy b&w prints; 35mm, $2\frac{1}{4} \times 2\frac{1}{4}$, 4×5 transparencies, 70mm and panoramic. Accepts digital submissions.

Payment & Terms Pays 50% commission for b&w and color photos. General price range (to clients): $50-300 for b&w photos; $150-1,500 for color photos. Works with photographers on contract basis only. Offers limited regional exclusivity. Contracts renew automatically with each submission; time period not specified. Charges duping fee of 50%/image. Statements issued monthly. Payment made bimonthly. Photographers allowed to review account records to verify sales figures. Offers one-time and electronic media rights. Requires agency promotion rights. Informs photographer and permits negotiation when client requests all rights, with some conditions. Model/property release required. Photo captions required.

Making Contact Send query letter with 50-75 samples. Does not keep samples on file; include SASE for return of material. Responds in 3 weeks. Photo guidelines sheet free with SASE. Tips sheet available periodically to contracted photographers.

Tips Wants to see "creativity, technical excellence and marketability" in submitted images. "We have many requests for business-related images, high-tech, and lifestyle photos. Shoot as much as possible and send it to us."

SPECTRUM PICTURES

Ostrovni 16, 11000, Prague 1 Czech Republic. Phone/fax: (42)(023)333-1021. E-mail: spectrum@spectrumpic tures.com. Website: www.spectrumpictures.com. **Contact:** Martin Mraz, executive director. Estab. 1992. Stock agency and news/feature syndicate. Has 35,000 photos in files. Clients include: advertising agencies, audiovisual firms, businesses, book publishers, magazine publishers, newspapers, calendar companies.

Needs "We work mainly with pictures from Central and Eastern Europe and Eurasia." Wants photos of celebrities, children/teens, multicultural, families, parents, senior citizens, disasters, environmental, landscapes/scenics, wildlife, architecture/buildings, cities/urban, education, religious, rural, adventure, entertainment, events, health/fitness/beauty, humor, performing arts, travel, agriculture, business concepts, industry, medicine, military, political, science, technology/computers. Interested in alternative process, avant garde, documentary, fashion/glamour, fine art, historical/vintage, regional, seasonal.

Specs Uses digital images. Send via CD, e-mail, FTP as JPEG files.

Payment & Terms Pays 50% commission for b&w and color photos and film. Average price per image (to clients): $175-5,000 for b&w and color photos. Negotiates fees below standard minimum prices. Offers volume discounts to customers. Photographers can choose not to sell images on discount terms. Works with photographers with or without contract; negotiable. Offers nonexclusive contract. Contracts renew automatically with additional submissions. Payment made monthly. Photographers allowed to review account records in cases of discrepancies only. Offers one-time, electronic media, and agency promotion rights. Informs photographers and allows them to negotiate when client requests all rights. Photo captions required.

Making Contact Send query letter or e-mail with résumé, business card, self-promotion piece to be kept on file. Expects minimum initial submission of 50 images. Responds in 2 weeks. Responds only if interested; send nonreturnable samples.

Tips "Please e-mail before sending samples. We prefer that no one send original slides via mail. Send scanned low-resolution images on CD-ROM or via e-mail. Remember that we specialize in Eastern Europe, Central Europe, and Eurasia (Russia, Georgia, former Soviet countries). We are primarily a photojournalist agency, but we work with other clients as well."

THESPIRITSOURCE.COM

1310 Pendleton St., Cincinnati OH 45202. (513)241-7473. Fax: (513)241-7505. E-mail: mpwiggins@thespirits ource.com. Website: www.thespiritsource.com. **Contact:** Paula Wiggins, owner. Estab. 2003. Stock agency. Has 100 photos in files. Clients include: book publishers, magazine publishers, greeting card companies.

Needs Wants photos of multicultural, families, religious and spiritual symbolism. Specializes in religious/spiritual/inspirational work.

Specs Accepts images in digital format. Send via CD as TIFF or JPEG files at 300 dpi.

Payment & Terms Pays 50% commission for b&w or color photos. Enforces minimum prices. Works with photographers on contract basis only. Offers exclusive contract only. Contracts renew automatically with additional submissions for 3 years. Statements issued quarterly. Payment made quarterly. Photographers allowed to review account records in cases of discrepancies only. Offers one-time rights. Model/property release required. Photo captions preferred; include key words.

Making Contact Send query letter with images on a CD. Does not keep samples on file; include SASE for return of material. Expects minimum initial submission of 10 images. Responds in 2 weeks to samples.

Tips "Although photos of specifically religious imagery are needed, a photographer can interpret this broadly. We are a site specializing in quality, contemporary illustration and photography. No pious amateurs, please."

SPORTSLIGHT PHOTO

6 Berkshire Circle, Gt. Barrington MA 01230. (413)528-6524. E-mail: stock@sportslightphoto.com. Website: www.sportslightphoto.com. **Contact:** Roderick Beebe, director. Stock photo agency. Has 500,000 photos in files. Clients include: advertising agencies, public relations firms, corporations, book publishers, magazine publishers, newspapers, postcard companies, calendar companies, greeting card companies, design firms.

Needs "We specialize in every sport in the world. We deal primarily in the recreational sports such as skiing, golf, tennis, running, canoeing, etc., but are expanding into pro sports, and have needs for all pro sports, action and candid close-ups of top athletes. We also handle adventure-travel photos, e.g., rafting in Chile, trekking in Nepal, dogsledding in the Arctic, etc."

Specs Uses 35mm transparencies. Accepts images in digital format. Send via CD.

Payment & Terms Pays 50% commission. Average price per image (to clients): $100-6,000. Contract negotiable. Offers limited regional exclusivity. Contract is of indefinite length until either party (agency or photographer) seeks termination. Charges $5/image for duping fee; $3 for catalog and digital CD-ROM insertion promotions. Statements issued quarterly. Payment made quarterly. Photographers allowed to review account records to verify sales figures "when discrepancy occurs." Offers one-time rights, rights depend on client, sometimes exclusive rights for a period of time. Informs photographers and consults with them when client requests all rights. Model release required for corporate and advertising usage. (Obtain releases whenever possible.) Strong need for model-released "pro-type" sports. Photo captions required; include who, what, when, where, why.

Making Contact Interested in receiving work from newer and known photographers. Send query letter with list of stock photo subjects, "send samples *after* our response." SASE must be included. Cannot return unsolicited material. Responds in 2-4 weeks. Photo guidelines free with SASE.

Tips "We look for a range of sports subjects that shows photographer's grasp of the action, drama, color and intensity of sports, as well as capability of capturing great shots under all conditions in all sports. Want well-edited, perfect exposure and sharpness, good composition and lighting in all photos. Seeking photographers with strong interests in particular sports. Shoot variety of action, singles and groups, youths, male/female—all combinations; plus leisure, relaxing after tennis, lunch on the ski slope, golf's 19th hole, etc. Sports fashions change rapidly, so that is a factor. Art direction of photo shoots is important. Avoid brand names and minor flaws in the look of clothing. Attention to detail is very important. Shoot with concepts/ideas such as teamwork, determination, success, lifestyle, leisure, cooperation in mind. Clients look not only for individual sports but for photos to illustrate a mood or idea. There is a trend toward use of real-life action photos in advertising as opposed to the set-up slick ad look. More unusual shots are being used to express feelings, attitude, etc. New online digital catalog premiered June 2002."

TOM STACK & ASSOCIATES, INC.

98310 Overseas Hwy., Key Largo FL 33037. (305)852-5520. Fax: (305)852-5570. E-mail: tomstack@earthlink. net. **Contact:** Therisa Stack. Has 1.5 million photos in files. Clients include: advertising agencies, public relations firms, businesses, audiovisual firms, book publishers, magazine publishers, encyclopedia publishers, postcard companies, calendar companies, greeting card companies.

Needs Wants photos of wildlife, endangered species, marine-life, landscapes, foreign geography, people and

customs, children, sports, abstract/art and mood shots, plants and flowers, photomicrography, scientific research, current events and political figures, Native Americans, etc. Especially needs women in "men's" occupations; whales; solar heating; up-to-date transparencies of foreign countries and people; smaller mammals such as weasels, moles, shrews, fisher, marten, etc.; extremely rare endangered wildlife; wildlife behavior photos; current sports; lightning and tornadoes; hurricane damage; sharp images, dramatic and unusual angles and approach to composition, creative and original photography with impact. Especially needs photos on life science, flora and fauna and photomicrography. No run-of-the-mill travel or vacation shots. Special needs include photos of energy-related topics—solar and wind generators, recycling, nuclear power and coal burning plants, waste disposal and landfills, oil and gas drilling, supertankers, electric cars, geo-thermal energy.

Specs Uses 35mm transparencies. Accepts images in digital format. Send via CD, Zip as TIFF files.

Payment & Terms Pays 50-60% commission. Average price per image (to clients): $150-200 for color photos; as high as $7,000. Works with photographers on contract basis only. Contracts renew automatically with additional submissions for 3 years. Charges duping and catalog insertion fees. Statements issued quarterly. Payment made quarterly. Offers one-time and electronic media rights. Informs photographers and allows them to negotiate when client requests all rights. Model release preferred. Photo captions preferred.

Making Contact Send query letter with stock list, or send at least 800 transparencies for consideration. Include SASE or mailer for photos. Responds in 2 weeks. Photo guidelines free with SASE.

Tips "Strive to be original, creative and take an unusual approach to the commonplace; do it in a different and fresh way." Have "more action and behavioral requests for wildlife. We are large enough to market worldwide and yet small enough to be personable. Don't get lost in the 'New York' crunch—try us. Shoot quantity. We try harder to keep our photographers happy. We attempt to turn new submissions around within 2 weeks. We take on only the best so we can continue to give more effective service."

▣ STOCK CONNECTION, INC.

110 Frederick Ave., Suite A, Rockville MD 20850. (301)251-0720. Fax: (301)309-0941. E mail: photos@chd.com. Website: www.scphotos.com. **Contact:** Cheryl Pickerell, president. Stock photo agency. Member of the Picture Archive Council of America (PACA). Has 70,000 photos in files. Clients include advertising agencies, graphic design firms, businesses, postcard publishers, public relations firms, book publishers, calendar companies, audiovisual firms, magazine publishers, greeting card companies.

Needs "We handle many subject categories including people, lifestyles, sports, business, concepts, landscapes, scenics, wildlife. We will help photographers place their images into outlets where photo buyers can find them."

Specs Uses color and/or b&w prints; 35mm, $2^1/_4 \times 2^1/_4$, 4×5, 8×10 transparencies. Accepts images in digital format (JPEG or TIFF files no larger than 4MB for submission).

Payment & Terms Pays 65% commission. Average price per image (to client): $930. Enforces minimum prices. "We will only go below our minimum of $250 for certain editorial uses. We will turn away sales if a client is not willing to pay reasonable rates." Works with photographers on contract basis only. Offers nonexclusive contract. Contracts renew automatically with additional submissions for life of catalog. Photographers may cancel contract with 60 days written notice. Charges $15-23/image for scanning/keywording/placement. Statements issued monthly. Photographers allowed to review account records. Offers one-time rights and royalty-free. Informs photographers when a client requests all rights. Model/property release required. Photo captions required; include locations, nonobvious elements.

Making Contact See website for submission guidelines. Expects minimum initial submission of 100 images. Market tips sheet available for $3.

Tips "We market very heavily through Internet technology with excellent results. The cost to advertise images in this medium is so much less than in print catalogs of the past."

STOCK OPTIONS®

P.O. Box 1048, Fort Davis TX 79734. (432)426-2777. Fax: (432)426-2779. E-mail: stockoptions@overland.net. **Contact:** Karen Hughes, owner. Estab. 1985. Stock photo agency. Member of Picture Archive Council of America (PACA). Has 200,000 photos in files. Clients include: advertising agencies, public relations firms, audiovisual firms, corporations, book/encyclopedia and magazine publishers, newspapers, postcard companies, calendar companies, greeting card companies.

Needs Emphasizes the southern US. Files include Gulf Coast scenics, wildlife, fishing, festivals, food, industry, business, people, etc. Also western folklore and the Southwest.

Specs Uses 35mm, $2^1/_4 \times 2^1/_4$, 4×5 transparencies.

Payment & Terms Pays 50% commission for color photos. Average price per image (to client): $300-3,000. Works with photographers on contract basis only. Offers nonexclusive contract. Contracts renew automatically with each submission for 5 years from expiration date. When contract ends photographer must renew within 60 days. Charges catalog insertion fee of $300/image and marketing fee of $6/hour. Statements issued upon receipt of payment from client. Payment made immediately. Photographers allowed to review account records to verify sales figures. Offers one-time and electronic media rights. "We will inform photographers for their consent only when a client requests all rights, but we will handle all negotiations." Model/property release preferred for people, some properties, all models. Photo captions required; include subject and location.

Making Contact Interested in receiving work from full-time commercial photographers. Arrange a personal interview to show portfolio. Send query letter with stock list. Contact by phone and submit 200 sample photos. Tips sheet distributed annually to all photographers.

Tips Wants to see "clean, in-focus, relevant and current materials." Current stock requests include industry, environmental subjects, people in up-beat situations, minorities, food, cityscapes and rural scenics.

▣ ◩ ⊕ STOCK TRANSPARENCY SERVICES/STSIMAGES

225, Neha Industrial Estate, Off Dattapada Rd., Borivali (East), Mumbai 400 066 India. (91)(222)870-1586. Fax: (91)(222)870-1609. E-mail: info@stsimages.com. Website: www.stsimages.com. **Contact:** Mr. Pawan Tikku. Estab. 1993. Has over 200,000 photos in files. Has minimal reels of film/video footage. Clients include: advertising agencies, businesses, postcard publishers, public relations firms, book publishers, calendar companies, freelance web designers, audiovisual firms, magazine publishers, greeting card companies.

Needs Wants photos of babies/children/teens, celebrities, couples, multicultural, families, parents, senior citizens, disasters, environmental, landscapes/scenics, wildlife, architecture, cities/urban, education, gardening, interiors/decorating, pets, religious, rural, adventure, automobiles, entertainment, events, food/drink, health/fitness, hobbies, humor, performing arts, sports, travel, agriculture, business concepts, industry, medicine, military, political, product shots/still life, science, technology/computers. Interested in alternative process, avant garde, documentary, fashion/glamour, fine art, historical/vintage, seasonal. Also needs digital images, underwater images.

Specs Uses 10×12 glossy color prints; 35mm, 2¼×2¼, 4×5, 8×10 transparencies; 35mm film; Digi-Beta or Beta video. Accepts images in digital format. Send via DVD, CD, e-mail as TIFF, JPEG files at 300 dpi. Minimum file size 25MB, preferred 50MB or more.

Payment & Terms Pays 50% commission. Average price per image (to clients): $20 minimum for b&w or color photos, $50 minimum for film or videotape. Enforces minimum prices. Offers volume discounts to customers. Works with photographers on contract basis only. Offers exclusive contract, limited regional exclusivity. Contracts renew automatically with additional submissions for 3 years. No duping fee. No charges for catalog insertion. Statements issued quarterly. Payment made monthly. Photographers allowed to review account records. Offers royalty-free images as well as one-time rights, electronic media rights. Model release required; property release preferred. Photo captions required; include name, description, location.

Making Contact Send query letter with slides, prints. Portfolio may be dropped off every Saturday. Provide résumé, business card to be kept on file. Expects minimum initial submission of 200 images with regular submissions of at least some images. Responds in 1 month to queries. Photo guidelines sheet free with SASE. Catalog free with SASE. Market tips sheet available to regular contributors only; free with SASE.

Tips 1.) Strict self-editing of images for technical faults. 2.) Proper cataloging. 3.) All images should have the photographer's name on them. 4.) Digital images are welcome, should be minimum A4 size in 300 dpi. 5.) All digital images must contain necessary keyword and caption information within the "file info" section of the image file. 6.) Do not send duplicate images.

⊕ STOCKFILE

5 High St., Sunningdale, Berkshire SL5 0LX United Kingdom. (44)(134)487-2249. Fax: (44)(134)487-2263. E-mail: info@stockfile.co.uk. Website: www.stockfile.co.uk. **Contact:** Jill Behr, library manager. Estab. 1989. Stock photo agency. Member of British Association of Picture Libraries and Agencies (BAPLA). Has 50,000 photos in files. Clients include: advertising agencies, public relations firms, businesses, book publishers, magazine publishers, newspapers, calendar companies.

Needs Images of cycling and mountain biking worldwide.

Specs Uses 35mm transparencies.

Payment & Terms Pays 50% commission for color photos. Average price per image (to clients): $30-800 for color. Offers volume discounts to customers. Discount sales terms not negotiable. Works with photographers

with or without a contract, negotiable. Offers nonexclusive contract. Charges for marketing and administrative costs are "negotiable—no charges made without consultation." Statements issued semiannually; payments made semiannually. Photographers allowed to review account records in cases of discrepancies only. Offers one-time rights. Informs photographer and allows them to negotiate when client requests all rights. Model release preferred. Photo captions required; include location.

Making Contact Send query letter with stock list. Expects minimum initial submission of 50 images with annual submissions of at least 50 images. Responds only if interested; send nonreturnable samples. Photo guidelines sheet free with SAE. Market tips sheet not available.

Tips "Edit out unsharp or badly exposed pictures, and caption properly."

STOCKFOOD GMBH (THE FOOD IMAGE AGENCY)

Tumblingerstr. 32, 80337 Munich Germany. (49)(89)747-2020. Fax: (49)(89)721-1020. E-mail: petra.thierry@stockfood.com. Website: www.stockfood.com. **Contact:** Petra Thierry, manager, Photographers and Art Dept. Estab. 1979. Stock agency, picture library. Member of the Picture Archive Council of America (PACA). Has over 200,000 photos in files. Clients include: advertising agencies, businesses, newspapers, postcard publishers, public relations firms, book publishers, calendar companies, magazine publishers, greeting card companies.

Needs Wants photos of food/drink, health/fitness/food, wellness/spa, people eating and drinking, nice flowers and garden images, eating and drinking outside, tablesettings.

Specs Uses $2\frac{1}{4} \times 2\frac{1}{4}$, 4×5, 8×10 transparencies. Accepts images in digital format. Send via CD/DVD as TIFF files at 300 dpi, 20MB minimum (8.5 mio pixels).

Payment & Terms Pays 40% commission for color photos. Enforces minimum prices. Offers volume discounts to customers. Works with photographers on contract basis only. Offers limited regional exclusivity, guaranteed subject exclusivity (within files). Contracts renew automatically. Statements issued quarterly. Photographers allowed to review account records. Offers one-time rights. Model release required. Photo captions required.

Making Contact Send e-mail with examples of your work as JPEG files. Does not keep samples on file; include SASE for return of material sent by mail.

STOCKMEDIA.NET

(formerly International Color Stock, Inc.), Stock Media Corporation, 1123 Broadway, Suite 1006, New York NY 10010. (212)463-8300. E-mail: info@stockmedia.net. Website: www.stockmedia.net. **Contact:** Randy Taylor, CEO. Estab. 1998. Stock photo syndicate. Clients include: photographers, photo agencies, major publishers.

Needs "For photographers and stock photo agencies, we provide software and websites for e-commerce, image licensing, global rights control and fulfillment. We also serve as a conduit, passing top-grade, model-released production stock to foreign agencies." Currently promotes its images via the Internet at StockPhotoFinder.com, the stock photography search engine.

Specs Uses digital files only.

Payment & Terms Pays 60% commission. Works on contract basis only. Offers image exclusive contract only if distribution desired. Contracts renew automatically on annual basis. Statements are automated and displayed online. Payment made monthly. Photographers allowed to review account records to verify sales figures online at website or "upon reasonable notice, during normal business hours." Offers one-time rights. Requests agency promotion rights. Informs photographer and allows them to negotiate when client requests all rights. Model/property release required. Photo captions preferred; include "who, what, where, when, why and how."

Making Contact Send query letter with résumé of credits. Responds "only when photographer is of interest." Photo guidelines sheet available. Tips sheet not distributed.

Tips Has strong preference for experienced photographers. "For distribution, we deal only with top shooters seeking long-term success. If you have not been with a stock photo agency for several years, we would not be the right distribution channel for you."

STOCKYARD PHOTOS

1410 Hutchins St., Houston TX 77003. (713)520-0898. Fax: (713)227-0399. E-mail: jim@stockyard.com. Website: www.stockyard.com. **Contact:** Jim Olive. Estab. 1992. Stock agency. Has tens of thousands of photos in files. Clients include: advertising agencies, businesses, newspapers, postcard publishers, public relations

firms, book publishers, calendar companies, audiovisual firms, magazine publishers, greeting card companies, real estate firms, interior designers, retail catalogs.

Needs Needs photos relating to Houston, Texas, and the Gulf Coast.

Specs Uses 35mm transparencies. Accepts images in digital format. Send images via CD, Zip, e-mail as TIFF, BMP, GIF, JPEG, PSP files at any dpi.

Payment & Terms Average price per image (to clients): $250-1,500 for color photos. Offers volume discounts to customers. Photographers can choose not to sell images on discount terms.

◼ SUPERSTOCK INC.

7660 Centurion Pkwy., Jacksonville FL 32256. (904)565-0066. E-mail: photoeditor@superstock.com. Website: www.superstock.com. International stock photo agency represented in 104 countries. Extensive rights-managed contemporary, vintage, fine art collections, royalty-free collections and CDs available for use by clients. Clients include: advertising agencies, businesses, book and magazine publishers, newspapers, greeting card and calendar companies.

Needs SuperStock is looking for dynamic lifestyle, sports, business and travel imagery.

Specs Digital files must be a minimum of 35MB, 300 dpi, 8 bit color, RGB, TIFF format. May also submit small-, medium- and large-format transparencies and prints to be scanned in-house.

Payment & Terms Statements issued monthly to contracted image providers. Rights offered "vary, depending on client's request." Informs photographers when client requests all rights. Model release required. Photo captions required.

Making Contact Submit a portfolio including a minimum of 150 or a maximum of 300 images via CD, DVD, transparencies, or prints as your sample. If interested, you may e-mail photoeditor@superstock.com for FTP upload information. Photo guidelines on website at www.superstock.com/submissions.asp.

Tips "Please review our website to see the style and quality of our imagery before submitting."

◍ SWIFT IMAGERY

The Swift Group, The Old Farmhouse, Hexworthy, Yelverton Devon PL20 6SD United Kingdom. (44)(136)463-1101. Fax: (44)(136)463-1112. E-mail: info@theswiftgroup.co.uk. Website: www.theswiftgroup.co.uk. **Contact:** Rob Fleming. Estab. 1998. Has 250,000 photos in files. Clients include: businesses, book publishers, magazine publishers.

Needs Wants photos of multicultural, disasters, environmental, landscapes/scenics, wildlife, architecutre, cities/urban, pets, adventure, food/drink, travel.

Specs Uses 35mm, $2\frac{1}{4} \times 2\frac{1}{4}$ transparencies.

Payment & Terms Average price per image (to clients): $45 minimum for color photos. Enforces minimum prices. Offers volume discounts to customers. Terms specified in photographers' contracts. Discount sales terms not negotiable. Works with photographers on contract basis only. Offers nonexclusive contract. Statements issued monthly. Payment made quarterly. Photographers allowed to review in cases of discrepancies only. Offers one-time rights. Model release required. Photo captions required; include who, what, where.

Making Contact Send query letter with slides, stock list. Does not keep samples on file; include SASE for return of material. Expects minimum initial submission of 100 images with bimonthly submissions of at least 100 images. Responds in 2 weeks to samples, 1 month to portfolios. Photo guidelines sheet free with SASE.

Tips "Edit work before submission. Ensure each mount is captioned and has name on it. Group photographs by type and location."

◼ ◪ TAKE STOCK INC.

2343 Uxbridge Dr. NW, Calgary AB T2N 3Z8 Canada. (403)261-5815. E-mail: takestock@telusplanet.net. Estab. 1987. Stock photo agency. Clients include: advertising agencies, public relations firms, audiovisual firms, corporate, book/encyclopedia publishers, magazine publishers, newspapers, postcard publishers, calendar and greeting card companies, graphic designers, trade show display companies.

Needs Wants model-released people, lifestyle images (all ages), Asian people, Canadian images, arts/recreation, industry/occupation, business, high-tech, illustrations. Wants photos of couples, multicultural, families, senior citizens, gardening, rural, adventure, agriculture, technology/computers.

Specs Uses 35mm, medium- to large-format transparencies. Accepts digital images for review only.

Payment & Terms Pays 50% commission for b&w or color photos. General price range (to clients): $300-1,000 for b&w photos; $300-1,500 for color photos. Works with photographers on contract basis only. Offers limited regional exclusivity. Contracts renew automatically with additional submissions for 3 year terms. Charges 100% duping and catalog insertion fees. Statements issued every 2 months depending on sales.

Payment made every 2 months depending on sales. Photographers allowed to review account records to verify sales figures, "with written notice and at their expense." Offers one-time, exclusive and some multi-use rights; some buy-outs with photographer's permission. Model/property release required. Photo captions required.

Making Contact Send query letter with stock list. Responds in 3 weeks. Photo guidelines free with SAE/IRC. Tips sheet distributed every 2 months to photographers on file.

▣ ▨ ⊕ TANK INCORPORATED

Box 212, Shinjuku, Tokyo 163-8691 Japan. (81)(33)239-1431. Fax: (81)(33)230-3668. E-mail: max-tank@mx2 .nisiq.net. **Contact:** Max Seki, president. Has more than 500,000 images on slides and disks. Clients include: advertising agencies, encyclopedia/book publishers, magazine publishers and newspapers.

Needs "Women in various situations, families, special-effect and abstract, nudes, scenic, sports, animal, celebrities, flowers, picture stories with texts, humorous photos, etc."

Specs Uses color only. Accepts images in digital format. Send via CD, floppy disk, easy transfer as TIFF, JPEG files.

Payment & Terms Pays 60% commission. "We also handle videogramme for DVD production and TV broadcasting. As for video, we negotiate at case by case basis." General price range: $70-1,000. Works on contract basis only. Offers limited regional exclusivity within files. Contracts renew automatically with each submission for 3 years. Statements issued monthly. Payment made monthly; within 45 days. Photographers allowed to review account records to verify sales figures. Offers one-time rights. Informs photographer and allows them to negotiate when client requests all rights. Model/property release is required for glamour/nude sets. Photo captions required.

Making Contact Send query e-mail with samples, list of stock photo subjects. Responds in 1 month.

Tips "We need pictures or subjects that strike viewers. Paparazzi-oriented coverages are very much in demand. Stock photography business requires patience. Try to find some other subjects than your competitors. Keep a fresh mind to see saleable subjects." Remarks that "photographers should have the eyes of photo editor. Also, give a little background on these photos."

▣ ▨ TIMECAST PRODUCTIONS

2801 Poole Way, Carson City NV 89706. (775)883-6427. Fax: (775)883-6427. E-mail: timecast@mindspring.c om. Website: http://timecast.home.mindspring.com **Contact:** Edward Salas, owner. Estab. 1995. Stock photo and video agency. Has 5,000 photos, 150 hours of video footage. Produces documentary-style programs for television and DVD. Clients include: advertising agencies, nonprofit organizations, private companies, postcard publishers, public relations firms, book publishers, calendar companies, audiovisual firms, magazine publishers, greeting card companies, film and television production companies.

Needs Wants photos of environmental, landscapes/scenics, travel, historical. Most interested in photos and video footage shot in the state of Nevada. People, places, events, landscapes, scenic, historical.

Specs Accepts photos in digital format only. Send via CD as TIFF, PDF files at 300 dpi. Accepts video footage in DV format only.

Payment & Terms Pays 50% commission for b&w and color photos and video. Average price per photo (to clients): $300-1,000 for b&w or color photos; $25-300/second for video. Enforces minimum prices. Offers volume discounts to customers. Photographers/videographers can choose not to sell photos or video on discount terms. Works with photographers/videographers on contract basis only. Offers nonexclusive contract. Statements issued monthly. Payment made monthly. Photographers/videographers allowed to review account records. Offers one-time and electronic media rights. Informs photographers/videographers and allows them to negotiate when client requests all rights. Model, talent, and property releases required. Photo and video captions required.

Making Contact Send photos on CD-ROM in TIFF or EPS format; send video in DV format. Prefers photographers/videographers shooting in Nevada but will review other work from western US. Does not keep samples on file; include SASE for return of material. Expects minimum initial submission of 100 photos. Responds in 1 month to submissions.

▣ TOP STOCK

33855 LaPlata Lane, Pine CO 80470. (303)838-2203 or (800)333-5961. E-mail: info@all-digit-all.com. Website: http://all-digit-all.com/stock_images.htm. **Contact:** Tony Oswald, owner. Estab. 1985. Stock agency. Has 36,000 photos in files. Clients include: advertising agencies, public relations firms, book publishers, magazine publishers, calendar companies.

Needs Wants photos of sport fishing only.

Specs Uses color prints; 35mm, $2^{1}/_{4} \times 2^{1}/_{4}$, 4×5, 8×10 transparencies. Accepts images in digital format. Send via CD, Jaz, Zip as TIFF files at 350 dpi.

Payment & Terms Pays 50% commission for b&w or color photos. Average price per image (to clients): $100 minimum for b&w or color photos. Enforces minimum prices. Offers volume discounts to customers; terms specified in photographers' contracts. Photographers can choose not to sell images on discount terms. Works with photographers with or without a contract; negotiable. Contracts renew automatically with additional submissions for 2 years. Charges 50% filing fee. Statements issued quarterly. Payment made quarterly. Photographers allowed to review account records in cases of discrepancies only. Offers one-time rights. Informs photographers and allows them to negotiate when client requests all rights. Model release required; property release preferred. Photo captions required; include names of people, places.

Making Contact Send query letter with tearsheets. Does not keep samples on file; include SASE for return of material. Expects minimum initial submission of 100 images with monthly submissions of at least 25 images. Responds in 1 month. Photo guidelines sheet free with SASE.

Tips "Do not send images unless they are of sport fishing!"

⊘ ⊕ TRAVEL INK PHOTO LIBRARY

The Old Coach House, Goring-on-Thames, Reading, Berkshire RG8 9AR United Kingdom. (44)(149)187-3011. Fax: (44)(149)187-5558. E-mail: info@travel-ink.co.uk. Website: www.travel-ink.co.uk. Has 100,000 photos in files. Clients include: advertising agencies, businesses, newspapers, public relations firms, book publishers, calendar companies, audiovisual firms, magazine publishers, greeting card companies.

Needs Wants photos of multicultural, environmental, landscapes/scenics, wildlife, architecture, cities/urban, gardening, religious, rural, adventure, events, food/drink, health/fitness/beauty, hobbies, sports, travel, agriculture, buildings.

Specs Uses 35mm transparencies.

Payment & Terms Pays on a commission basis. Enforces minimum prices. Offers volume discounts to customers. Works with photographers on contract basis only. Offers exclusive contract only. Statements issued quarterly. Payment made quarterly. Photographers allowed to review account records. Offers one-time rights. Model/property release required. Photo captions required.

Making Contact Currently not accepting unsolicited submissions from new photographers.

TRAVELERSTOCK.COM

The Jackson Hole Stock Agency, P.O. Box 4980, Jackson WY 83001. (307)733-8319 or (800)865-7446. Fax: (307)733-3070. E-mail: latham@jhstock.com. Website: www.travelerstock.com. **Contact:** Latham Jenkins, president. Has over 5,000 photos in files. Clients include: advertising agencies, public relations firms, businesses, book publishers, magazine publishers.

Needs Wants photos of babies/children/teens, couples, families, landscapes/scenics, wildlife, adventure, sports, travel. "We specialize in mountain lifestyle images."

Specs Uses 35mm, $2^{1}/_{4} \times 2^{1}/_{4}$, 4×5 transparencies.

Payment & Terms Pays 50% commission for color photos. Works with photographers on contract basis only. Statements issued quarterly. Payment made quarterly. Photographers allowed to review account records. Model release required; property release preferred. Photo captions required.

Making Contact Send query letter with slides, transparencies. Provide self-promotion piece to be kept on file. Expects minimum initial submission of 20 images.

▣ ⊕ TRH PICTURES

Bradley's Close, 74-77 White Lion St., London N1 9PF United Kingdom. (44)(207)520-7647. Fax: (44)(207)520-7606. E-mail: sam@trhpictures.co.uk. Website: www.codyimages.com. **Contact:** Ted Nevill. Estab. 1982. Picture library. Has 100,000 photos in files. Clients include: advertising agencies, newspapers, book publishers, calendar companies, audiovisual firms, magazine publishers.

Needs Wants photos of historical/modern aviation, warfare, transport on land and sea, space.

Specs Uses color and/or b&w prints; 35mm, $2^{1}/_{4} \times 2^{1}/_{4}$, 4×5, 8×10 transparencies. Accepts images in ditigal format.

Payment & Terms Pays commission. Average price per image (to clients): $80 minimum. Offers volume discounts to customers. Discount sales terms not negotiable. Works with photographers with or without a contract; negotiable. Offers nonexclusive contract. Contracts renew automatically with additional submissions. Statements issued quarterly. Payment made quarterly. Photographers allowed to review account re-

cords. Offers one-time rights, electronic media rights. Informs photographers and allows them to negotiate when a client requests all rights. Model/property release preferred. Photo captions preferred.

Making Contact Send query letter with résumé, slides, prints, photocopies, transparencies, stock list. Provide résumé, business card, self-promotion piece to be kept on file. Expects minimum initial submission of 1,000 images. Responds in 1 month.

▣ ⊕ TROPIX PHOTO LIBRARY

44 Woodbines Ave., Kingston-Upon-Thames, Surrey KT1 2AY United Kingdom. (44)(208)546-0823. E-mail: photographers@tropix.co.uk. Website: www.tropix.co.uk. **Contact:** Veronica Birley, proprietor. Picture library specialist. Has 60,000 photos in files. Clients include: advertising agencies, book/encyclopedia publishers, magazine publishers, newspapers, government departments, design groups, travel companies, calendar/card companies.

Needs "Stunning images of the developing world, especially positive, upbeat and modern aspects: all people images to be accompanied by full model release. Full pictorial detail of cultures, societies, economies and destinations, as well as medicine, health, education, commerce, etc.—but every picture in brilliant color and imaginatively shot. Tropix only accepts stock shot in past 2 years. Please e-mail Tropix first to inquire if your own collection is of interest as many subjects are currently closed to new stock."

Specs Uses large digital files only, minimum 25MB when sent as TIFF files.

Payment & Terms Pays 50% commission for color photos. Average price per image (to clients): £60-500 for b&w and color photos. Offers guaranteed subject exclusivity. Charges cost of returning photographs by insured post, if required. Statements made quarterly with payment. Photographers allowed to have qualified auditor review account records to verify sales figures in the event of a dispute but not as routine procedure. Offers one-time, electronic media and agency promotion rights. Informs photographers when a client requests all rights, but agency handles negotiation. Model release always required. Photo captions required; accurate, detailed data, to be supplied on disk or by e-mail. "It is essential to follow guidelines available from agency."

Making Contact "E-mail Tropix with a detailed list of your photo subjects and destinations. Send no unsolicited photos or JPEGs, please." Transparencies/scans may be requested after initial communication by e-mail, if collection appears suitable. "When submitting images, only include those which are bright, exciting and technically perfect."

Tips Looks for "special interest topics, accurate and informative captioning, strong images and an understanding of and involvement with specific subject matters. Not less than 20 salable images per country photographed should be available." Digital images supplied to clients by e-mail or CD-ROM.

▣ ⊕ ULLSTEIN BILD

(formerly ullstein bilderdienst) Ullstein GmbH, Axel-Springer-Str. 65, 10888 Berlin Germany. E-mail: kontakt @ullsteinbild.de. Website: www.ullsteinbild.de. Estab. 1950. Stock agency, picture library and news/feature syndicate. Has approximately 12 million photos in files. Clients include: advertising agencies, public relations firms, audiovisual firms, businesses, book publishers, magazine publishers, newspapers, calendar companies, greeting card companies, postcard publishers, TV companies.

Needs Wants photos of babies/children/teens, celebrities, couples, multicultural, families, parents, senior citizens, wildlife, disasters, environmental, landscapes/scenics, architecture, cities/urban, education, pets, religious, rural, adventure, automobiles, entertainment, events, health/fitness, hobbies, humor, performing arts, sports, travel, agriculture, buildings, computers, industry, medicine, military, political, portraits, science, technology/computers. Interested in digital, documentary, fashion/glamour, historical/vintage, regional, seasonal. Other specific photo needs: German history.

Specs Accepts images in digital format *only*. Send via FTP, CD, e-mail, LEONARDO as TIFF, JPEG files at minimum 15MB decompressed.

Payment & Terms Pays on commission basis. Works with photographers on contract basis only. Offers nonexclusive contract for 5 years minimum. Statements issued monthly, quarterly, annually. Payment made monthly, quarterly, annually. Photographers allowed to review account records in cases of discrepancies only. Offers one-time rights. Photo captions required; include date, names, events, place.

Making Contact "Please contact us before sending pictures!"

UNICORN STOCK PHOTOS

524 Second Ave., Holdrege NE 68949. (308)995-4100. Fax: (308)995-4581. E-mail: info@unicorn-photos.com. Website: www.unicorn-photos.com. **Contact:** Larry Durfee, owner. Has over 500,000 photos in files. Clients

include: advertising agencies, corporate accounts, textbooks, magazines, calendar companies, religious publishers.

Needs Wants photos of ordinary people of all ages and races doing everyday things at home, school, work and play. Current skylines of all major cities, tourist attractions, historical, wildlife, seasonal/holiday and religious subjects. "We particularly need images showing two or more races represented in one photo and family scenes with BOTH parents. There is a need for more minority shots including Hispanics, Asians and African-Americans." Also wants babies/children/teens, couples, senior citizens, disasters, landscapes, gardening, pets, rural, adventure, automobiles, events, food/drink, health/fitness, hobbies, sports, travel, agriculture.

Specs Uses 35mm color slides.

Payment & Terms Pays 50% commission for color photos. Average price per image (to clients): $200 minimum for color photos. Works with photographers on contract basis only. Offers nonexclusive contract. Contracts renew automatically with additional submissions for 4 years. Charges $5 per image duping fee. Statements issued quarterly. Payment made quarterly. Informs photographers and allows them to negotiate when client requests all rights. Model release preferred; increases sales potential considerably. Photo captions required; include location, ages of people, dates on skylines.

Making Contact Write first for guidelines. "We are looking for professionals who understand this business and will provide a steady supply of top-quality images. At least 500 images are generally required to open a file. Contact us by e-mail."

Tips "We keep in close, personal contact with all our photographers. Our monthly newsletter is a very popular medium for doing this. Because UNICORN is in the Midwest, we have many requests for farming/gardening/agriculture/winter and general scenics of the Midwest."

▣ VIESTI ASSOCIATES, INC.

11399 CR 250, Durango CO 81301. (970)382-2600. Fax: (970)382-2700. E-mail: photos@viestiphoto.com. Website: www.viestiphoto.com. **Contact:** Joe Viesti, president. Estab. 1987. Stock photo agency. Has 30 affiliated foreign sub-agents. Clients include: advertising agencies, businesses, book/encyclopedia publishers, magazine publishers, calendar companies, greeting card companies, design firms.

Needs "We are a full-service agency."

Specs Uses analog or digital. "Digital requirements provided once review of artwork and contract is established. See photographers' info under 'About Us' on website for submission requirements."

Payment & Terms Pays 50% commission for images. Average price per image (to clients): $200-500 for b&w or color photos. "We negotiate fees above our competitors on a regular basis." Works with photographers on contract basis only. "Catalog photos are exclusive." Contract renews automatically for 5 years. Statements issued quarterly. "Payment is made quarterly after payment is received." Rights vary. Informs photographers and allows them to negotiate when client requests all rights. Model/property release preferred. Photo captions required.

Making Contact See above for making contact, submission requirements. Send no originals. Send dupes or tearsheets only with bio info and size of available stock; include return postage if return desired. Keeps samples on file. Expects minimum submissions of 500 edited images; 500 edited images per year is average. Submissions edited and returned usually within 1 week.

Tips There is an "increasing need for large quantities of images for interactive, multimedia and traditional clients. There is no need to sell work for lower prices to compete with low-ball competitors. Our clients regularly pay higher prices if they value the work."

▣ VIEWFINDERS

Bruce Forster Photography, Inc., 1325 NW Flanders St., Portland OR 97209. (503)417-1545. Fax: (503)274-7995. E-mail: studio@viewfindersnw.com. Website: www.viewfindersnw.com. **Contact:** Bruce Forster, owner. Estab. 1996. Stock agency. Member of the Picture Archive Council of America (PACA). Has 70,000 photos in files. Clients include: advertising agencies, public relations firms, businesses, book publishers, magazine publishers, design agencies.

Needs All images should come from the Pacific Northwest—Oregon, Washington, Northern California, British Columbia and/or Idaho. Wants photos of babies/children/teens, couples, multicultural, families, senior citizens, environmental, landscapes/scenics, architecture, cities/urban, education, gardening, adventure, entertainment, events, health/fitness, performing arts, sports, travel, agriculture, industry, medicine, science, technology/computers. Interested in alternative process, avant garde, documentary.

Specs Uses 35mm, 2¼×2¼, 4×5, 8×10 in original format. Accepts images in digital format. Send via CD as TIFF files at 300 dpi.

Payment & Terms Pays 50% commission for b&w and color photos. Works with photographers on contract basis only. Offers limited regional exclusivity. Statements issued monthly. Payment made monthly. Photographers allowed to review account records. Model/property release preferred. Photo captions required.

Making Contact Send query letter with résumé, stock list. Keeps samples on file; include self-promotion piece to be kept on file. Expects minimum initial submission of 100 images. Responds in 2 months.

Tips "Viewfinders is a regional agency specializing in imagery of the Pacific Northwest. Be prepared to make regular submissions. Please call or e-mail to discuss submission procedure."

▣ VIREO (Visual Resources for Ornithology)

The Academy of Natural Sciences, 1900 Benjamin Franklin Pkwy., Philadelphia PA 19103-1195. (215)299-1069. Fax: (215)299-1182. E-mail: vireo@acnatsci.org. Website: www.acnatsci.org/vireo. **Contact:** Doug Wechsler, director. Estab. 1979. Picture library. "We specialize in birds only." Has 120,000 photos in files. Clients include: advertising agencies, businesses, book publishers, magazine publishers, newspapers, calendar companies, CD-ROM publishers.

Needs "Wants high-quality photographs of birds from around the world with special emphasis on behavior. All photos must be related to birds or ornithology."

Specs Uses 35mm, 2¼×2¼ transparencies. Accepts images in digital format. See website for specs.

Payment & Terms Pays 50% commission for b&w and color photos. Average price per image (to clients): $125. Negotiates fees below stated minimums; "we deal with many small nonprofits as well as commercial clients." Offers volume discounts to customers. Discount sales terms negotiable. Works with photographers on contract basis only. Offers nonexclusive contract. Statements issued semiannually. Payment made semiannually. Offers one-time rights. Model release preferred when people are involved. Photo captions preferred; include date, location.

Making Contact Send query letter. To show portfolio, photographer should send 10 JPEGs. Follow up with a call. Responds in 1 month to queries.

Tips "Write describing the types of bird photographs you have, the type of equipment you use, and where you do most of your bird photography. You may also send us a Web link to a portfolio of your work. Edit work carefully."

VISAGES RPS, INC.

7750 Sunset Blvd., Los Angeles CA 90046. (323)650-8880. Fax: (323)436-0974. Website: www.visages.com. International syndication agency specializing in celebrity studio photographs, representing the work of Herb Ritts and others.

Needs Interested in working with photographers shooting celebrities for editorial projects.

Specs Uses 35mm, 2¼×2¼, 4×5 transparencies.

Payment & Terms Pays on commission. Offers exclusive contract only with limited regional exclusivity. Contracts renew automatically with additional submissions. Charges are negotiable. Statements issued monthly. Payment made monthly. Photographers allowed to review account records in cases of discrepancies only. Informs photographers and allows them to negotiate when client requests all rights. Model release required.

Making Contact Contact through rep. Portfolio may be dropped off every Monday. Provide self-promotion piece to be kept on file.

▣ ⊕ VISUAL & WRITTEN

Luis Bermejo 8, 7-B, 50009 Zaragoza Spain. (718)396-1860 (US number). E-mail: info@visual-and-written.com. Website: www.vwpics.com. **Contact:** Kike Calvo, director. Estab. 1997. Digital stock agency. Has 300,000 photos in files. Has branch office in New York: 35-36 76th St., Suite 628, New York NY 11372. Clients include: advertising agencies, businesses, newspapers, postcard publishers, public relations firms, book publishers, calendar companies, audiovisual firms, magazine publishers, greeting card companies, zoos, aquariums.

Needs Wants photos of babies/children/teens, celebrities, couples, multicultural, families, parents, senior citizens, disasters, environmental, landscapes/scenics, wildlife, architecture, cities/urban, education, pets, religious, rural, adventure, travel, agriculture, business concepts, industry, science, technology/computers. Interested in documentary, erotic, fashion/glamour, fine art. Also needs underwater imagery: reefs, sharks, whales, dolphins and colorful creatures, divers and anything related to oceans. Images that show the human impact on the environment.

Specs Uses 35mm transparencies. Accepts images in digital format. Send via CD, ZIP, e-mail at 300 dpi, 55MB minimum, scanned with a Nikon 4000 or similar scanner.

Payment & Terms Pays 50% commission for b&w photos; 50% for color photos. Enforces minimum prices. Works with photographers with or without contract; negotiable. Offers nonexclusive contract. Statements issued quarterly. Payment made quarterly. Any deductions are itemized. Offers one-time rights. Informs photographers and allows them to negotiate when client requests all rights. Model release required. Photo captions required. Photo essays should include location, Latin name, what, why, when, how, who.

Making Contact "The best way is to send a nonreturnable CD." Send query letter with résumé, tearsheets, stock list. Provide self-promotion piece to be kept on file. Expects minimum initial submission of 100 images with periodic submissions of at least 50 images. Responds in 1 month to samples; send nonreturnable samples. Photo guidelines sheet free with SASE.

Tips "Interested in reaching Spanish-speaking countries? We might be able to help you. We look for composition, color, and a unique approach. Images that have a mood or feeling. Tight, quality editing. We send a want list via e-mail. If you have a photo plus text article, we will help you translate it."

▣ ⊕ VISUAL PHOTO LIBRARY

4 Hasadnaot St., P.O. Box 12741, Hertzliya 46733 Israel. (09)955-0044. Fax: (09)955-7060. E-mail: visual@visual.co.il. Website: www.visual.co.il. **Contact:** Tammy Miller, sales manager. Estab. 1989. Stock agency. Member of the Picture Archive Council of America (PACA). Has 500,000 photos in files. Has 2 branch offices in Athens, Greece and Istanbul, Turkey. Clients include: advertising agencies, audiovisual firms, book publishers, magazine publishers, newspapers, calendar companies.

Needs Wants photos of the Holy Land, babies/children/teens, families, religious, food/drink, hobbies, humor, industry, still life, health/fitness, sports, business concepts, medicine.

Specs Uses 35mm, $2^1/_4 \times 2^1/_4$ transparencies; VHS PAL. Accepts images in digital format. Send via CD, e-mail as JPEG files at 72 dpi.

Payment & Terms Pays 50% commission for b&w and color photos, film, videotape. Average price per image (to clients): $100-10,000 for b&w and color photos; $800-3,000 for film/videotape. Offers volume discounts to customers. Discount sales terms not negotiable. Works with photographers with or without a contract; negotiable. Offers limited regional exclusivity. Contracts renew automatically with additional submissions. Charges $5 per image for duping fee. Charges $50 per image for catalog insertion. Statements issued monthly. Payment made monthly. Photographers allowed to review account records. Offers one-time, electronic media and agency promotion rights. Informs photographers and allows them to negotiate when client requests all rights. Model release required; property release preferred. Photo captions required.

Making Contact Send query letter with stock list.

▣ ⊕ VISUM

Lange Reihe 29, 20099 Hamburg Germany. (49)(40)284-0820. Fax: (49)(40)284-08240. E-mail: mail@visum.info. Website: www.visum.info. **Contact:** Lars Bauernschmitt or Alfred Buellesbach, managing directors. Estab. 1975. Stock agency. Has 1 million photos in files. Clients include: advertising agencies, public relations firms, businesses, book publishers, magazine publishers, newspapers.

Needs Wants journalistic features, photos of babies/children/teens, landscapes/scenics, architecture, cities/urban, education, adventure, food/drink, health/fitness, travel, agriculture, industry, science, technology/computers.

Specs Uses 35mm, $2^1/_4 \times 2^1/_4$ transparencies. Accepts images in digital format. Send via CD, e-mail as TIFF, JPEG files at 300 dpi (20-25MB).

Payment & Terms Pays 50% commission for b&w and color photos. "We use the fee recommendations of German Association of Photo-agencies (BVPA). Prices depend on type of market." Works with photographers on contract basis only. Offers limited regional exclusivity. Statements issued monthly. Payment made monthly. "A third party (lawyer, auditor . . .) who is required to maintain confidentiality by reason of his profession and who is instructed by the photographer may inspect the books and documents to check the statements of account." Offers one-time rights. Informs photographers and allows them to negotiate when client requests all rights. Photo captions required.

Making Contact "Send a fax for first contact." Send query letter with stock list. Keeps samples on file only after agreement.

Tips "Before submitting work, contact our editor; he will explain our demands. We want to avoid submissions that do not fit in our market."

▣ ⊕ WILDLIGHT PHOTO AGENCY

16 Charles St., Suite 14, Redfern NSW 2016 Australia. (61)(29)698-8077. Fax: (61)(29)698-2067. E-mail: images@wildlight.net. Website: www.wildlight.net. **Contact:** Manager. Estab. 1985. Picture library. Has 300,000 photos in files. Clients include: advertising agencies, public relations firms, audiovisual firms, businesses, book/encyclopedia publishers, magazine publishers, newspapers, postcard publishers, calendar companies, greeting card companies.

Needs Wants Australian photos of babies/children/teens, couples, multicultural, families, parents, senior citizens, disasters, environmental, landscapes/scenics, wildlife, architecture, cities/urban, education, gardening, interiors/decorating, pets, religious, rural, adventure, entertainment, events, food/drink, health/fitness, hobbies, humor, performing arts, sports, travel, agriculture, business concepts, industry, medicine, military, political, product shots/still life, science, technology/computers. Interested in documentary, seasonal.

Specs Accepts images in digital format only.

Payment & Terms Pays 45% commission for color photos. Works with photographers on contract basis only. Offers image exclusive contract within Australia. Statements issued quarterly. Payment made quarterly. Offers one-time rights. Model/property release required. Photo captions required.

Making Contact Send CD to show portfolio. Expects minimum initial submission of 500 images with periodic submissions of at least 100 images/quarter. Responds in 2-3 weeks. Photo guidelines available on website.

▣ WINDIGO IMAGES

Kezar, Inc., 11812 Wayzata Blvd., #122, Minnetonka MN 55305. (952)540-0606. Fax: (952)540-1018. E-mail: info@windigoimages.com. Website: www.windigoimages.com. **Contact:** Mitch Kezar, president/owner. Estab. 1982. Stock agency. Has 110,000 photos in files. Also sells fine art prints. Represents 92 photographers. Clients include: advertising agencies, businesses, newspapers, postcard publishers, public relations firms, book publishers, calendar companies, audiovisual firms, magazine publishers, greeting card companies.

Needs Wants photos of sports, camping, mountain biking, birding. "Windigo Images is the world's largest online collection of hunting and fishing stock photography. We seek high-quality images."

Specs Accepts images in digital format. Send via CD, e-mail as JPEG files at 72 dpi for initial consultation.

Payment & Terms Pays 50% commission for color photos. Offers volume discounts to customers; terms specified in photographers' contracts. Works with photographers on contract basis only. Offers nonexclusive contract. Statements issued monthly. Photographers allowed to review account records. Offers one-time, electronic media and agency promotion rights.

Making Contact Send query letter with résumé, stock list. Provide résumé, business card, self-promotion piece to be kept on file. Expects minimum initial submission of 100 images. Responds in 1 week.

Tips "Study the market and offer images that can compete in originality, composition, style and quality. Our clients are the best in the business, and we expect no less of our photographers."

▣ ⊕ WORLD RELIGIONS PHOTO LIBRARY

53A Crimsworth Rd., London SW8 4RJ United Kingdom. E-mail: co@worldreligions.co.uk. Website: www.worldreligions.co.uk. **Contact:** Christine Osborne. Has 50,000 photos in files. Clients include: book publishers, magazine publishers, newspapers.

Needs Religious images from anywhere in the world showing worship, rites of passage, sacred sites, shrines, food and places of pilgrimage. Especially Hispanic/Mexico and from South America. Also Kabbalah, Mormon, Jehovah's Witnesses, Moonies, Aum, cults and Shamans.

Specs Still accepts transparencies but prefers images in digital format. Send submissions on a CD as JPEGs, 500×300 at 72 dpi.

Payment & Terms Pays 50% commission. Offers volume discounts to customers. Works with photographers with or without a contract. Offers one-time rights. Model release preferred where possible. Photo captions required; include subject, place, date (if historic); descriptions are essential, no images will be considered without.

Making Contact Send query letter or e-mail. Call for portfolio appointment. Does not keep samples on file; include SASE for return of material. Expects minimum initial submission of 50 images. Responds in 2 weeks to samples. Photo guidelines free with SASE. Catalog available. Market tips sheet available to contract photographers.

Tips "Supply excellent captions and edit your submission very carefully."

Advertising, Design

& Related Markets

Advertising photography is always "commercial" in the sense that it is used to sell a product or service. Assignments from ad agencies and graphic design firms can be some of the most creative, exciting, and lucrative that you'll ever receive.

Prospective clients want to see your most creative work—not necessarily your advertising work. Mary Virginia Swanson, an expert in the field of licensing and marketing fine art photography, says that the portfolio you take to the Museum of Modern Art is also the portfolio that Nike would like to see. Your clients in advertising and design will certainly expect your work to show, at the least, your technical proficiency. They may also expect you to be able to develop a concept or to execute one of their concepts to their satisfaction. Of course, it depends on the client and their needs: Read the tips given in many of the listings on the following pages to learn what a particular client expects.

When you're beginning your career in advertising photography, it is usually easier to start close to home. That way, you can make appointments to show your portfolio to art directors. Meeting the photo buyers in person can show them that you are not only a great photographer

Regions

Important

- **Northeast & Midatlantic:** Connecticut, Delaware, Maine, Maryland, Massachusetts, New Hampshire, New Jersey, New York, Pennsylvania, Rhode Island, Vermont, Washington DC.

- **Midsouth & Southeast:** Alabama, Arkansas, Florida, Georgia, Louisiana, Mississippi, North Carolina, South Carolina, Tennessee, Virginia, West Virginia.

- **Midwest & North Central:** Illinois, Indiana, Iowa, Kentucky, Michigan, Minnesota, Nebraska, North Dakota, Ohio, South Dakota, Wisconsin.

- **South Central & West:** Arizona, California, Colorado, Hawaii, Kansas, Missouri, Nevada, New Mexico, Oklahoma, Texas, Utah.

- **Northwest & Canada:** Alaska, Canada, Idaho, Montana, Oregon, Washington, Wyoming.

but that you'll be easy to work with as well. This section is organized by region to make it easy to find agencies close to home.

When you're just starting out, you should also look closely at the agency descriptions at the beginning of each listing. Agencies with smaller annual billings and fewer employees are more likely to work with newcomers. On the flip side, if you have a sizable list of ad and design credits, larger firms may be more receptive to your work and be able to pay what you're worth.

Trade magazines such as *HOW*, *Print*, *Communication Arts* and *Graphis* are good places to start when learning about design firms. These magazines not only provide information about how designers operate, but they also explain how creatives use photography. For ad agencies, try *Adweek* and *Advertising Age*. These magazines are more business oriented, but they reveal facts about the top agencies and about specific successful campaigns. (See Publications on page 470 for ordering information.) The website of Advertising Photographer's of America (APA) contains information on business practices and standards for advertising photographers (www.apanational.org).

NORTHEAST & MIDATLANTIC

A.T. ASSOCIATES

63 Old Rutherford Ave., Charlestown MA 02129. (617)242-8595. Fax: (617)242-0697. **Contact:** Dan Kovacevic. Estab. 1980. Member of IDSA. Design firm. Approximate annual billing: $200,000. Number of employees: 3. Firm specializes in publication design, display design, packaging, signage and product. Types of clients: industrial, financial and retail. Examples of recent clients: real estate brochures (city scapes); and sales brochure (bikes/bikers).

Needs Works with 1 photographer/month. Uses photos for catalogs, packaging and signage. Reviews stock photos as needed. Model/property release preferred. Photo captions preferred.

Specs Uses 35mm, 4×5 transparencies, and film (specs vary). Accepts images in digital format.

Making Contact & Terms Works with local freelancers only. Provide résumé, business card, brochure, flier or tearsheets to be kept on file. Keeps samples on file. Cannot return material. Responds only if interested. Payment negotiable. Pays on receipt of invoice. Credit line sometimes given. Buys all rights; negotiable.

ADVERTEL, INC.

P.O. Box 18053, Pittsburgh PA 15236-0053. (412)344-4700, ext. 104. Fax: (412)344-4712. E-mail: info@advertel.com. Website: www.advertel.com. **Contact:** Dorota Grajewska. Estab. 1994. Member of MMTA (Multimedia Telecommunications Association). Specialized production house. Approximate annual billing: $500,000-1 million. Types of clients: all, including airlines, utility companies, manufacturers, distributors and retailers.

Needs Uses photos for direct mail, P-O-P displays, catalogs, signage and audiovisual. Subjects include: communications, telecommunications and business. Reviews stock photos. Model release preferred; property release required.

Audiovisual Needs Uses slides and printing and computer files.

Specs Uses 4×5 matte color and/or b&w prints; PCX, TIFF, JPEG files.

Making Contact & Terms Send query letter with stock list or with samples. Provide résumé, business card, brochure, flier or tearsheets to be kept on file. Works with local freelancers only. Keeps samples on file. Cannot return material. Response time varies; "I travel a lot." Payment negotiable. **Pays on receipt of invoice,** net 30 days. Rights negotiable.

Tips Looks for ability to mix media—video, print, color, b&w.

$ BOB BARRY ASSOCIATES

(610)353-7333. **Contact:** Bob Barry. Estab. 1964. Design firm. Approximate annual billing: $500,000. Number of employees: 5. Firm specializes in display design, magazine ads, collateral, packaging and signage. Types of clients: industrial, financial and nonprofit.

Needs Works with 2-3 photographers/month. Uses photos for annual reports, consumer and trade magazines, direct mail, P-O-P displays, catalogs, posters, packaging and signage. Subjects include: disasters, environmental, landscapes/scenics, wildlife, architecture, cities/urban, interiors/decorating, rural, adventure, automobiles, entertainment, events, food/drink, health/fitness, hobbies, humor, performing arts, sports, travel, medicine, military, science, technology. Interested in avant garde, documentary, erotic, fine art, historical/vintage. Reviews stock images of related subjects. Model release preferred for individual subjects.

Advertising

Specs Uses matte b&w and/or color prints, "very small to cyclorama (mural) size;" 35mm, $2\frac{1}{4} \times 2\frac{1}{4}$, 4×5, 8×10 transparencies.

Making Contact & Terms Provide résumé, business card, brochure, flier or tearsheets to be kept on file. Works on assignment only. Responds as needed; can be "days to months." Pays $50-150/hour; $600-1,200/day; other payment negotiable. Pays on variable basis, according to project. Credit lines sometimes given, depending upon "end use and client guidelines." Buys all rights; negotiable.

Tips Wants to see "creative use of subjects, color and lighting. Also, simplicity and clarity. Style should not be too arty." Sees trend toward more use of photos within the firm and in the design field in general. To break in, photographers should "understand the objective" they're trying to achieve. "Be creative within personal boundaries. Be my eyes and ears and help me to see things I've missed. Be available and prompt."

▣ CARLA SCHROEDER BURCHETT DESIGN CONCEPT

137 Main St., Unadilla NY 13849. (607)369-4709. **Contact:** Carla Burchett, owner. Estab. 1972. Member of Packaging Designers Council. Design firm. Number of employees: 2. Firm specializes in packaging. Types of clients: manufacturers, houses, parks. Example of recent project: Footlets (direct on package).

Needs Works with "very few" freelancers. Uses photos for posters, packaging and signage. Subjects include: environmental, landscapes/scenics, wildlife, pets, adventure, entertainment, events, health/fitness, hobbies, performing arts, travel, agriculture, business concepts, product shots/still life, technology/computers. Interested in reviewing stock photos of children and animals, as well as alternative process, avant garde, documentary, fine art, historical vintage. Model release required.

Specs Uses 35mm, 4×5 transparencies. Accepts images in digital format.

Making Contact & Terms Send unsolicited photos by mail for consideration. Works with local freelancers only. Keeps samples on file; include SASE for return of material. Responds same week if not interested. Payment negotiable. Credit line given. Buys first rights; negotiable.

$ $ $▣ ◲ HAMPTONDESIGN GROUP

417 Haines Mill Rd., Allentown PA 18104. (610)821-0963. Fax: (610)821-3008. E-mail: wendy@hamptondesigngroup.com. Website: www.hamptondesigngroup.com. **Contact:** Wendy Ronga, creative director. Estab. 1997. Member of Type Director Club, Society of Illustrators, Art Directors Club, Society for Publication Designers. Design firm. Approximate annual billing: $450,000. Number of employees: 3. Firm specializes in annual reports, magazine ads, publication design, collateral, direct mail. Types of clients: financial, publishing, nonprofit. Examples of recent clients: Conference for the Aging, Duke University/Templton Foundation (photo shoot/5 images); Religion and Science, UCSB University (9 images for conference brochure).

Needs Works with 2 photographers/month. Uses photos for billboards, brochures, catalogs, consumer magazines, direct mail, newspapers, posters, trade magazines. Subjects include: babies/children/teens, multicultural, senior citizens, environmental, landscapes/scenics, wildlife, pets, religious, health/fitness/beauty, business concepts, medicine, science. Interested in alternative process, avant garde, fine art, historical/vintage, seasonal. Model/property release required. Photo captions preferred.

Specs Uses glossy color and/or b&w prints; 35mm, $2\frac{1}{4} \times 2\frac{1}{4}$ transparencies. Accepts images in digital format. Send via CD as TIFF, EPS, JPEG files at 300 dpi.

Making Contact and Terms Send query letter. Keeps samples on file. Responds only if interested; send nonreturnable samples. Pays $150-1,500 for color photos; $75-1,000 for b&w photos. Pays extra for electronic usage of photos, varies depending on usage. Price is determined by size, how long the image is used and if it is on the home page. **Pays on recept of invoice.** Credit line given. Buys one-time rights, all rights, electronic rights; negotiable.

Tips "Use different angles and perspectives, a new way to view the same old boring subject. Try different films and processes."

Ⓝ $ $▣ ◲ IDEASCAPE, INC.

70 Northampton St., Suite 502, Boston MA 02118. (617)427-2716. Fax: (617)427-2717. E-mail: rl@ideascape.com. Website: www.ideascape.com. **Contact:** Ralph Lucier, creative director. Estab. 1990. Design firm. Approximate annual billing: $1 million. Number of employees: 4. Firm specializes in collateral, packaging. Types of clients: industrial, retail.

Needs Works with 1 photographer/month. Uses photos for brochures, catalogs, direct mail, trade magazines. Subjects include: architecture, interiors/decorating, food/drink, health/fitness/beauty, sports, travel, business concepts, medicine, product shots/still life, technology. Interested in fashion/glamour. Model release required; property release preferred.

Audiovisual Needs Uses film. Subjects include: product/still life, fashion/on figure.
Specs Accepts images in digital format. Send via CD.
Making Contact and Terms Send query letter. Provide business card, self-promotion to be kept on file. Responds only if interested; send nonreturnable samples. Credit line sometimes given.

$ $Ⓐ🖿🖼◐ MARSHAD TECHNOLOGY GROUP

76 Laight St., New York NY 10013. E-mail: neal@marshad.com. Website: http://marshad.com. **Contact:** Neal Marshad, owner. Estab. 1983. Video, motion picture and multimedia production house. Approximate annual billing: $9 million. Number of employees: 15. Types of clients: industrial, financial, retail.
Needs Buys 20-50 photos/year; offers 5-10 assignments/year. Freelancers used for cosmetics, food, travel. Subjects include: beauty, tabletop, architectural, landscapes/scenics, wildlife, entertainment, events, food/drink, performing arts, sports, travel, business concepts, product shots/still life. Interested in avant garde, documentary, fashion/glamour, fine art. Model release required; property release preferred. Photo captions preferred.
Audiovisual Needs Uses film, video, CD for multimedia DVDs.
Specs Uses DV. Accepts images in digital format. Send via CD as TIFF, JPEG files at 300 dpi.
Making Contact & Terms Works with local freelancers on assignment only. Provide résumé, business card, self-promotion piece or tearsheets to be kept on file. "No calls!" Pays $125-250 for b&w photos; $125-450 for color photos; $125-1,000 for videotape. Pays on usage. Credit line depends on client. Buys all rights; negotiable.

$🖿 MITCHELL STUDIOS DESIGN CONSULTANTS

1810-7 Front St., East Meadow NY 11554. (516)832-6230. Fax: (516)832-6232. E-mail: msdcdesign@aol.com. **Contact:** Steven E. Mitchell, principal. Estab. 1922. Design firm. Number of employees: 6. Firm specializes in packaging, display design. Types of clients: industrial and retail. Examples of projects: Lipton Cup-A-Soup, Thomas J. Lipton, Inc.; Colgate Toothpaste, Colgate Palmolive Co.; Chef Boy-Ar-Dee, American Home Foods—all 3 involved package design.
Needs Works with varying number of photographers/month. Uses photographs for direct mail, P-O-P displays, catalogs, posters, signage and package design. Subjects include: still life/product. Reviews stock photos of still life/people. Model release required. Property release preferred. Photo captions preferred.
Specs Uses all sizes and finishes of color and b&w prints; 35mm, 2¼×2¼, 4×5, 8×10 transparencies. Accepts images in digital format. Send via CD, SyQuest, floppy disk, Jaz, Zip as EPS files.
Making Contact & Terms Submit portfolio for review. Provide résumé, business card, brochure, flier or tearsheets to be kept on file. Cannot return material. Responds as needed. Pays $35-75/hour; $350-1,500/day; $500 and up/job. **Pays on receipt of invoice.** Credit line sometimes given depending on client approval. Buys all rights.
Tips In portfolio, looks for "ability to complete assignment." Sees a trend toward "tighter budgets." To break in with this firm, keep in touch regularly.

Ⓝ $ $Ⓐ◐ RUTH MORRISON ASSOCIATES

246 Brattle St., Cambridge MA 02138. (617)354-4536. Fax: (617)354-6943. **Contact:** Cindy Simon, account executive. Estab. 1972. PR firm. Types of clients: food, design, travel, general business.
Needs Uses photos for newspapers, consumer and trade magazines, posters and brochures.
Specs Specifications vary according to clients' needs. Typically uses b&w prints and transparencies.
Making Contact & Terms Provide résumé, business card, brochure, flier or tearsheets to be kept on file. Works with freelancers on assignment only. Responds "as needed." Pays $300-1,500. Credit line given whenever possible. Rights negotiable.

Ⓝ $ $🖿 🖼◐ MULLIN/ASHLEY ASSOCIATE

P.O. Box E, 11012 Worton Rd., Worton MD 21678. (410)778-2184. Fax: (410)778-6640. E-mail: mar@mullinas hley.com. Website: www.mullinashley.com. **Contact:** Marlayn King, creative director. Estab. 1978. Approximate annual billing: $2 million. Number of employees: 13. Firm specializes in collateral and interactive media. Types of clients: industrial, business to business, healthcare. Examples of recent clients: W.L. Gore & Associates, Nevamar of International Paper, Community Hospitals.
Needs Works with 3 photographers/month. Uses photos for brochures. Subjects include: business concepts, industry, product shots/still life, technology. Also needs industrial, business to business, healthcare on location. Model release required; property release preferred. Photo captions preferred.

Audiovisual Needs Works with 1 videographer/year. Uses for corporate capabilities, brochure, training and videos.

Specs Prefers images in digital format; also uses $2\frac{1}{4}\times2\frac{1}{4}$, 4×5 transparencies; high-8 video.

Making Contact and Terms Send query letter or e-mail with résumé, digital files or tearsheets. Provide résumé, business card, self-promotion piece to be kept on file. Responds only if interested; send nonreturnable samples. Pays $500-8,000 for b&w or color photos; depends on the project or assignment. Pays on receipt of invoice. Credit line sometimes given depending upon assignment.

$☐ NATIONAL BLACK CHILD DEVELOPMENT INSTITUTE

1101 15th St. NW, Suite 900, Washington DC 20005. (202)833-2220. Fax: (202)833-8222. Website: www.nbcd i.org. **Contact:** Vicki L. Davis, vice president. Estab. 1970.

Needs Uses photos in brochures, newsletters, annual reports and annual calendar. Candid action photos of black children and youth. Reviews stock photos. Model release required.

Specs Uses 5×7, 8×10 color and/or glossy b&w prints; color slides; b&w contact sheets. Accepts images in digital format. Send via CD.

Making Contact & Terms Send query letter with samples; include SASE for return of material. Pays $70 for cover photo and $20 for inside photos. Credit line given. Buys one-time rights.

Tips "Candid action photographs of one black child or youth or a small group of children or youths. Color photos selected are used in annual calendar and are placed beside an appropriate poem selected by organization. Therefore, photograph should communicate a message in an indirect way. Black & white photographs are used in quarterly newsletter and reports. Obtain sample of publications published by organization to see the type of photographs selected."

$ $☐ ☐ ☐ ☐ NOVUS

121 E. 24th St., 12th Floor, New York NY 10010. (212)473-1377. Fax: (212)505-3300. E-mail: novuscom@aol.c om. Website: www.novuscommunications.com. **Contact:** Robert Antonik, owner/president. Estab. 1988. Creative marketing and communications firm. Number of employees: 5. Firm specializes in advertising, annual reports, publication design, display design, multi-media, packaging, direct mail, signage and website, Internet and DVD development. Types of clients: industrial, financial, retail, health care, telecommunications, entertainment, nonprofit.

Needs Works with 1 photographer/month. Uses photos for annual reports, billboards, consumer and trade magazines, direct mail, P-O-P displays, catalogs, posters, packaging and signage. Subjects include: babies/ children/teens, couples, multicultural, families, parents, senior citizens, environmental, landscapes/scenics, wildlife, architecture, cities/urban, education, gardening, interiors/decorating, pets, religious, rural, adventure, automobiles, entertainment, events, food/drink, health/fitness, hobbies, humor, performing arts, sports, travel, agriculture, business concepts, industry, medicine, military, political, product shots/still life, science, technology/computers. Interested in alternative process, avant garde, documentary, fashion/glamour, fine art, historical/vintage, seasonal. Reviews stock photos. Model/property release required. Photo captions preferred.

Audiovisual Needs Uses film, videotape, DVD.

Specs Uses color and/or b&w prints; 35mm, $2\frac{1}{4}\times2\frac{1}{4}$, 4×5, 8×10 transparencies. Accepts images in digital format. Send via Zip, CD as TIFF, JPEG files.

Making Contact & Terms Arrange personal interview to show portfolio. Works on assignment only. Keeps samples on file. Cannot return material. Responds in 1-2 weeks. Pays $75-150 for b&w photos; $150-750 for color photos; $300-1,000 for film; $150-750 for videotape. Pays upon client's payment. Credit line given. Rights negotiable.

Tips "The marriage of photos with illustrations continues to be trendy. More illustrators and photographers are adding stock usage as part of their business. Send sample postcard; follow up with phone call."

$☐ ☐ POSEY SCHOOL OF DANCE, INC.

Box 254, Northport NY 11768. (631)757-2700. E-mail: EPosey@optonline.net. Website: www.poseyschool.c om. **Contact:** Elsa Posey, president. Estab. 1953. Sponsors a school of dance, art, music, drama, and a regional dance company. Uses photos for brochures, news releases and newspapers.

Needs Buys 10-12 photos/year; offers 4 assignments/year. Special subject needs include children dancing, ballet, modern dance, jazz/tap (theater dance) and classes including women and men. Interested in documentary, fine art, historical/vintage. Reviews stock photos. Model release required.

Specs Uses 8×10 glossy b&w prints. Accepts images in digital format. Send via CD, e-mail.

Making Contact & Terms "Call us." Responds in 1 week. Pays $25 for most photos, b&w or color. Credit line given if requested. Buys one-time rights; negotiable.

Tips "We are small but interested in quality (professional) work. Capture the joy of dance in a photo of children or adults. We prefer informal action photos, not posed pictures. We need photos of *real* dancers dancing. Call first. Be prepared to send photos on request."

N E ⊘ MIKE QUON/DESIGNATION INC.

543 River Rd., Fair Haven NJ 07704-3227. (732)212-9200. Fax: (732)212-9217. Website: www.quondesign.c om. **Contact:** Mike Quon, president/creative director. Design firm. Firm specializes in packaging, direct mail, signage, illustration. Types of clients: industrial, financial, retail, publishers, nonprofit.

Needs Works with 1-3 photographers/year. Uses photos for direct mail, P-O-P displays, packaging, signage. Model/property release preferred. Photo captions required; include company name.

Specs Uses color and/or b&w digital images.

Making Contact & Terms Submit portfolio for review by mail only. No drop-offs. "Please, do not call office. Contact through mail only." Keeps samples on file. Responds only if interested; send nonreturnable samples. Pays net 30 days. Credit line given when possible. Buys first rights, one-time rights; negotiable.

Tips Mike Quon says he is using more stock photography and less assignment work.

E JACK SCHECTERSON ASSOCIATES

5316 251 Place, Little Neck NY 11362. (718)225-3536. Fax: (718)423-3478. **Contact:** Jack Schecterson, principal. Estab. 1962. Design firm. Firm specializes in 2D and 3D visual marketing communications via: product, package, collateral and corporate graphic design. Types of clients: industrial, retail, publishing, consumer product manufacturers.

Needs "Depends on work in-house." Uses photos for packaging, P-O-P displays and corporate graphics, collateral. Reviews stock photos. Model/property release required. Photo captions preferred.

Specs Uses color and/or b&w prints; 35mm, 2¼×2¼, 4×5, 8×10 transparencies. Accepts images in digital format.

Making Contact & Terms Works with local freelancers on assignment. Responds in 3 weeks. Payment negotiable, "depends upon job." Credit line sometimes given. Buys all rights.

Tips Wants to see creative and unique images. "Contact by mail only. Send SASE for return of samples or leave samples for our files."

$ $ $E ⊠ SIMON DOES, LLC

146 Bank St., Suite 3A, New York NY 10014. (212)924-7725. Fax: (212)929-8905. E-mail: info@simondoes.c om. Website: www.simondoes.com. Estab. 1993. Member of AIGA, GAG. Design firm. Firm specializes in visual communication solutions, including annual reports, identity design, websites and collateral materials. Types of clients: industrial, financial, nonprofit, entertainment. Examples of recent clients: The ACLU, Children's Rights, MTV, Planned Parenthood of NYC, JP Morgan Chase.

Needs Works with 1 photographer every other month. Uses photos for billboards, brochures, direct mail, newspapers, P-O-P displays, posters, signage. Subjects include: babies/children/teens, couples, multicultural, senior citizens, education, events, humor, sports, business concepts, medicine. Interested in alternative process, avant garde, seasonal. Model/property release required.

Audiovisual Needs Uses any format for video and film.

Specs Uses any size prints. Accepts images in digital format. Send via Jaz, Zip, e-mail as TIFF, EPS files at 300 dpi.

Making Contact and Terms Send query letter with tearsheets. Provide self-promotion piece to be kept on file. Responds only if interested; send nonreturnable samples. Pays extra for electronic usage. Pays on publication. Credit line sometimes given depending upon client. Rights negotiable.

$ $E ⊠ MARTIN THOMAS, INC.

Advertising & Public Relations, 42 Riverside Dr., Barrington RI 02806. (401)245-8500. Fax: (866)899-2710. E-mail: contact@martinthomas.com. Website: www.martinthomas.com. **Contact:** Martin K. Pottle, president. Estab. 1987. Ad agency, PR firm. Approximate annual billing: $7 million. Number of employees: 5. Firm specializes in collateral. Types of clients: industrial and business-to-business. Examples of recent clients: NADCA Show Booth, Newspaper 4PM Corp. (color newspaper); Pennzoil-Quaker State "Rescue," PVC Container Corp. (magazine article); "Bausch & Lomb," GLS Corporation (magazine cover); "Soft Bottles," McKechnie (booth graphics); "Perfectly Clear," ICI Acrylics (brochure).

Lavoie Photography often lands assignments with the advertising firm Martin Thomas, Inc., who provides its industrial clients with advertising, marketing and PR services.

© Lavoie Photography

Needs Works with 3-5 photographers/month. Uses photos for trade magazines. Subjects include: location shots of equipment in plants and some studio. Model release required.

Audiovisual Needs Uses videotape for 5- to 7-minute capabilities or instructional videos.

Specs Uses 8×10 color and/or b&w prints; 35mm, 4×5 transparencies. Accepts images in digital format (call first). Send via CD, e-mail, floppy disk as GIF, JPEG files.

Making Contact & Terms Send stock list. Provide résumé, business card, brochure, flier or tearsheets to be kept on file. Send materials on pricing, experience. "No unsolicited portfolios will be accepted or reviewed." Cannot return material. Pays $1,000-1,500/day; $300-900 for b&w photos; $400-1,000 for color photos. Pays 30 days following receipt of invoice. Buys exclusive product rights; negotiable.

Tips To break in, demonstrate you "can be aggressive, innovative, realistic, and can work within our clients' parameters and budgets. Be responsive; be flexible."

$ $ 🅰 ▣ 🖼 TOBOL GROUP, INC.

14 Vanderventer Ave., Port Washington NY 11050. (516)767-8182. Fax: (516)767-8185. E-mail: mt@tobolgroup.com. Website: www.tobolgroup.com. **Contact:** Mitch Tobol, president. Estab. 1981. Ad agency/design studio. Types of clients: high-tech, industrial, business-to-business and consumer. Examples of recent clients: Weight Watchers (in-store promotion); Eutectic & Castolin; Mainco (trade ad); Light Alarms.

Needs Works with up to 2 photographers and videographers/month. Uses photos for billboards, consumer and trade magazines, direct mail, P-O-P displays, catalogs, posters, newspapers and audiovisual. Subjects are varied; mostly still-life photography. Reviews business-to-business and commercial video footage. Model release required.

Audiovisual Needs Uses videotape, DVD, CD.

Specs Uses 4×5, 8×10, 11×14 b&w prints; 35mm, 2¼×2¼, 4×5 transparencies; ½" videotape. Accepts images in digital format. Send via Zip, floppy disk, CD, SyQuest, optical, e-mail.

Making Contact & Terms Send query letter with samples; include SASE for return of material. Provide résumé, business card, brochure, flier or tearsheets to be kept on file; follow up with phone call. Works on assignment only. Responds in 3 weeks. Pays $100-10,000/job. Pays net 30 days. Credit line sometimes given, depending on client and price. Rights purchased depend on client.

Tips In freelancer's samples or demos, wants to see "the best—any style or subject as long as it is done well. Trend is photos or videos to be multi-functional. Show me your *best* and what you enjoy shooting. Get experience with existing company to make the transition from still photography to audiovisual."

$ $ ▣ ◯ WORCESTER POLYTECHNIC INSTITUTE

100 Institute Rd., Worcester MA 01609. (508)831-5609. Fax: (508)831-5604. E-mail: mwdorsey@wpi.edu. Website: www.wpi.edu. **Contact:** Michael Dorsey, director of communications. Estab. 1865. Publishes periodicals and promotional, recruiting and fund-raising printed materials. Photos used in brochures, newsletters, posters, audiovisual presentations, annual reports, catalogs, magazines, press releases and websites.

Needs On-campus, comprehensive and specific views of all elements of the WPI experience. Photos of students at over 20 global project sites.

Specs Prefers images in digital format, but will use 5×7 (minimum) glossy b&w and color prints; 35mm, 2¼×2¼, 4×5 transparencies; b&w contact sheets.

Making Contact & Terms Arrange a personal interview to show portfolio or query with website link. Provide résumé, business card, brochure, flier or tearsheets to be kept on file. "No phone calls." Responds in 6 weeks. Payment negotiable. Credit line given in some publications. Buys one-time or all rights; negotiable.

$ $ ◨ YASVIN DESIGNERS

P.O. Box 116, Hancock NH 03449. Estab. 1989. Member of NH Creative Club. Design firm. Number of employees: 3. Firm specializes in advertising, publication design and packaging. Types of clients: consumer, educational and nonprofit. Recent projects include work on annual reports, school view books, display graphics for trade shows, consumer packaging.

Needs Works with 2-5 photographers/month. Uses photos for advertising in consumer and trade magazines, P-O-P displays, catalogs, posters, packaging. Subject matter varies. Reviews stock photos. Model release required.

Specs Image specifications vary.

Making Contact & Terms Send query letter with résumé of credits, samples, SASE. Provide business card, brochure, flier or tearsheets to be kept on file. Response time varies. Payment negotiable. Buys first and all rights; negotiable.

Michael Havey works regularly for Yasvin Designers, mainly shooting people on location. Havey received $750 for one-time use of this photo, which appeared in a fundraising brochure. "Photographing people on location is all about composition and emotion," he says.

$ $ $☐ ☑ SPENCER ZAHN & ASSOCIATES

2015 Sansom St., Philadelphia PA 19103. (215)564-5979. Fax: (215)564-6285. **Contact:** Spencer Zahn, president. Estab. 1970. Member of GPCC. Marketing, advertising and design firm. Approximate annual billing: $5 million. Number of employees: 7. Firm specializes in direct mail, electronic collateral, print ads. Types of clients: financial and retail, automotive.

Needs Works with 1-3 photographers/month. Uses photos for billboards, consumer and trade magazines, direct mail, P-O-P displays, posters and signage. Subjects include: people, still life. Reviews stock photos. Model/property release required.

Specs Uses b&w and/or color prints and transparencies. Accepts images in digital format. Send via Zip, CD.

Making Contact & Terms Send query letter with résumé of credits, stock list, samples. Submit portfolio for review. Provide résumé, business card, brochure, flier or tearsheets to be kept on file. Keeps samples on file. Responds in 1 month. Pays on publication. Credit line sometimes given. Buys one time and/or all rights; negotiable.

MIDSOUTH & SOUTHEAST

$ $ AMBIT MARKETING COMMUNICATIONS

2455 E. Sunrise Blvd., #711, Ft. Lauderdale FL 33304. (954)568-2100. Fax: (954)568-2888. Website: www.am bitmarketing.com. Estab. 1977. Member of American Association of Advertising Agencies, American Advertising Federation, Public Relations Society of America. Ad agency. Firm specializes in ad campaigns, print collateral, direct mail.

ℕ Ⓐ 🖼 ◯ THE AMERICAN YOUTH PHILHARMONIC ORCHESTRAS

4026 Hummer Rd., Annandale VA 22003. (703)642-8051, ext. 25. Fax: (703)642-8054. **Contact:** Tomoko Azuma, general manager. Estab. 1964. Nonprofit organization that promotes and sponsors 4 youth orchestras. Photos used in newsletters, posters, audiovisual uses and other forms of promotion.

Needs Photographers usually donate their talents. Offers 8 assignments/year. Photos taken of orchestras, conductors and soloists. Photo captions preferred.

Audiovisual Needs Uses slides and videotape.

Specs Uses 5×7 glossy color and/or b&w prints.

Making Contact & Terms Arrange a personal interview to show portfolio. Works with local freelancers on assignment only. Keeps samples on file. Payment negotiable. "We're a résumé-builder, a nonprofit that can cover expenses but not service fees." **Pays on acceptance**. Credit line given. Rights negotiable.

$ $☐ ☑ BOB BOEBERITZ DESIGN

247 Charlotte St., Asheville NC 28801. (828)258-0316. E-mail: bobb@main.nc.us. Website: www.bobboeberitzd esign.com. **Contact:** Bob Boeberitz, owner. Estab. 1984. Member of American Advertising Federation, Asheville Freelance Network, Asheville Creative Services Group, National Academy of Recording Arts & Sciences, Public Relations Association of Western North Carolina. Graphic design studio. Approximate annual billing: $100,000. Number of employees: 1. Firm specializes in annual reports, collateral, direct mail, magazine ads, packaging, publication design, signage, websites. Types of clients: management consultants, retail, recording artists, mail-order firms, industrial, nonprofit, restaurants, hotels, book publishers. Examples of recent clients: product flyer, Quality America (1 stock image, 1 product photo); Billy Edd Wheeler CD, Sagittarius Records (back of CD montage).

Needs Works with 1 freelance photographer "every 6 months or so." Uses photos for consumer and trade magazines, direct mail, brochures, catalogs, posters. Subjects include: babies/children/teens, couples, multi-cultural, families, parents, senior citizens, environmental, landscapes/scenics, wildlife, architecture, cities/urban, education, pets, rural, adventure, entertainment, events, food/drink, health/fitness/beauty, hobbies, performing arts, sports, travel, business concepts, industry, medicine, product shots/still life, science, technology/computers; some location, some stock photos. Interested in fashion/glamour, seasonal. Model/property release required.

Specs Uses 8×10 glossy b&w prints; 35mm, 4×5 transparencies. Accepts images in digital format. Send via CD, Zip, floppy disk, e-mail as TIFF, BMP, JPEG, EPS, GIF files at 300 dpi.

Making Contact & Terms Provide résumé, business card, brochure, flier or tearsheets to be kept on file. Cannot return unsolicited material. Responds "when there is a need." Pays $50-150 for b&w photos; $50-500 for color photos; $50-100/hour; $350-1,000/day. Pays on per-job basis. Buys all rights; negotiable.

Tips "Send promotional piece to keep on file. Do not send anything that has to be returned. I usually look for a specific specialty; No photographer is good at everything. I also consider studio space and equipment. Show me something different, unusual, something that sets you apart from any average local photographer. If I'm going out of town for something, it has to be for something I can't get done locally. I keep and file direct mail pieces (especially postcards). If you want me to remember your website, send a postcard."

[N] [▢] [▨] BROWER, LOWE & HALL ADVERTISING, INC.

880 S. Pleasantburg Dr., P.O. Box 16179, Greenville SC 29606. (864)242-5350. Fax: (864)233-0893. E-mail: ebrower@blhadvertising.com. Website: www.blhadvertising.com. **Contact:** Ed Brower, president. Estab. 1945. Ad agency. Types of clients: consumer and business-to-business.

Needs Commissions 6 photographers/year; buys 50 photos/year. Uses photos for billboards, consumer and trade magazines, direct mail, newspapers, P-O-P displays, radio and TV. Model release required.

Audiovisual Needs Uses videotape; CD/DVD.

Specs Uses 8×10 b&w and/or color semigloss prints; digital.

Making Contact & Terms Arrange personal interview to show portfolio. Send query letter with list of stock photo subjects; will review unsolicited material. Include SASE. Responds in 2 weeks. Payment negotiable. Buys all rights; negotiable.

[A] [▨] [◉] STEVEN COHEN MOTION PICTURE PRODUCTION

1182 Coral Club Dr., Coral Springs FL 33071. (954)346-7370. **Contact:** Steven Cohen. Examples of productions: TV commercials, documentaries, 2nd unit feature films and 2nd unit TV series. Examples of recent clients: "Survivors of the Shoah," Visual History Foundation; "March of the Living," Southern Region 1998.

Needs Subjects include: babies/children/teens, celebrities, couples, families, parents, senior citizens, performing arts, sports, product shots/still life. Interested in documentary, historical/vintage. Model release required.

Audiovisual Needs Uses videotape.

Specs Uses 16mm, 35mm film; ½" VHS, Beta videotape, S/VHS videotape, DVCAM videotape.

Making Contact & Terms Send query letter with résumé. Provide business card, self-promotion piece or tearsheets to be kept on file. Works on assignment only. Cannot return material. Responds in 1 week. Payment negotiable. **Pays on acceptance** or publication. Credit line given. Buys all rights (work-for-hire).

$ [A] CREATIVE RESOURCES, INC.

2000 S. Dixie Highway, Suite 100-G, Miami FL 33133. Fax: (305)856-3151. **Contact:** Mac Seligman, chairman and CEO. Estab. 1970. PR firm. Handles clients in travel (hotels, resorts, airlines).

Needs Works with 1-2 photographers/month on assignment only. Buys 10-20 photos/year. Photos used in PR releases. Model release preferred.

Specs Uses 8×10 glossy prints; contact sheet OK. Also uses 35mm, 2¼×2¼ transparencies.

Making Contact & Terms Send query letter with résumé of credits. Provide résumé to be kept on file. No unsolicited material. Responds in 2 weeks. Pays $50 minimum/hour; $200 minimum/day; $100 for color photos; $50 for b&w photos. Negotiates payment based on client's budget. For assignments involving travel, pays $60-200/day plus expenses. **Pays on acceptance.** Buys all rights.

Tips Most interested in activity shots in locations near clients.

[▢] [▨] GOLD & ASSOCIATES, INC.

6000-C Sawgrass Village Circle, Ponte Vedra Beach FL 32082. (904)285-5669. Fax: (904)285-1579. **Contact:** Keith Gold, creative director. Estab. 1988. Marketing/design/advertising firm. Approximate annual billing: $50 million in capitalized billings. Multiple offices throughout Eastern US. Firm specializes in health care, publishing, tourism and entertainment industries. Examples of clients: State of Florida; Harcourt; Time-Warner; GEICO; The PGA Tour.

Needs Works with 1-4 photographers/month. Uses photos for print advertising, posters, brochures, direct mail, television spots, and packaging. Subjects vary. Reviews stock photos and reels. Tries to buy out images.

Audiovisual Needs Works with 1-2 filmmakers/month. Uses 35mm film; no video.

Specs Uses digital images.

Making Contact & Terms Contact through rep. Provide samples to be kept on file. Works with freelancers from across the US. Cannot return material. Only responds to "photographers being used." **Pays 50% on receipt of invoice, 50% on completion.** Credit line given only for original work where the photograph is the primary design element; never for spot or stock photos. Buys all rights worldwide.

$ $ A ☻ HACKMEISTER ADVERTISING & PUBLIC RELATIONS COMPANY

2631 E. Oakland Park Blvd., Suite 204, Ft. Lauderdale FL 33306. (954)568-2511. E-mail: hackmeisterad@aol.com. **Contact:** Richard Hackmeister, president. Estab. 1979. Ad agency and PR firm. Serves industrial, electronics manufacturers who sell to other businesses.

Needs Works with 1 photographer/month. Uses photos for trade magazines, direct mail, catalogs. Subjects include: electronic products. Model release required. Photo captions required.

Specs Uses 8×10 glossy color prints; 4×5 transparencies.

Making Contact & Terms "Call on telephone first." Does not return unsolicited material. Pays by the day; $200-2,000/job. Buys all rights.

Tips Looks for "good lighting on highly technical electronic products—creativity."

$ A 🖼 MIRACLE OF ALOE

5808 42nd St. E., Bradenton FL 34203. (941)727-0042. Fax: (941)753-5232. E-mail: catalogjfc@aol.com. Website: www.miracleofaloe.com. **Contact:** Jess F. Clarke, Jr., vice president. Estab. 1980. Manufacturers of aloe products for mail order buyers of healthcare products. Firm specializes in direct mail, magazine ads. Types of clients: retail, publishing.

Needs Works with 2 photographers/month. Uses testimonial photos and aloe vera plants. Model release preferred.

Audiovisual Needs Uses videotape.

Specs Uses 4×5 b&w and/or color prints; 35mm transparencies.

Making Contact & Terms Works on assignment only. Provide résumé, business card, self-promotion piece or tearsheets to be kept on file. Responds in 1 month. Pays $40-60/photo, $100-400 for videotape. **Pays on receipt of invoice.** Credit line given. Buys one-time rights.

Tips In freelancer's samples, looks for "older folks, head shots and nice white-haired ladies. Also show aloe vera plants in fields or pots; shoot scenes of southern Texas aloe farms. We need video photographers to do testimonials of aloe users all around the country for pending 30-minute infomercial."

N $ $ A 🖾 🖼 MYERS, MYERS & ADAMS ADVERTISING, INC.

938 N. Victoria Park Rd., Ft. Lauderdale FL 33304. (305)523-0202. Website: http://mmanda.com. **Contact:** Virginia Sours-Myers, creative director. Estab. 1986. Member of Ad Federation of Fort Lauderdale, Marine Industries Association. Ad agency. Approximate annual billing: $5 million. Number of employees: 7. Firm specializes in magazine ads, collateral. Types of clients: industrial, financial, retail, nonprofit, manufacturing, marine and health care. Examples of recent clients: MTM (direct mail campaign); Embassy Suites (newspaper ad); Marine Industries Association (corporate brochure); "Trade Show Colaterail," Penny Plate (trade show handout); "Vietech Yachts," Bounty (full-page ad).

Needs Works with 3-5 photographers, filmmakers and/or videographers/month. Uses photos for billboards, consumer and trade magazines, direct mail, P-O-P displays, catalogs, newspapers and audiovisual. Subjects include: marine, food, real estate, medical and fashion. Wants to see "all subjects" in stock images and footage.

Audiovisual Needs Uses photos/film/video for slide shows, film and videotape.

Specs Uses all sizes b&w and/or color prints; 35mm, $2\frac{1}{4} \times 2\frac{1}{4}$, 4×5 transparencies; 35mm film; 1", $\frac{3}{4}$", but to review need $\frac{1}{2}$". Accepts images in digital format. Send via CD as EPS files.

Making Contact & Terms Provide résumé, business card, brochure, flier or tearsheets to be kept on file. Works with freelancers on assignment basis only. Cannot return material. Responds as needed. Pays $50-200 for b&w photos; $50-800 for color photos; $100-900 for film; $50-250/hour; $200-1,200/day; $50-30,000/job. Credit line given sometimes, depending on usage. Buys all rights (work-for-hire) and 1 year's usage; negotiable.

Tips "We're not looking for arty-type photos or journalism. We need photographers who understand an advertising sense of photography: good solid images that sell the product." Sees trend in advertising toward "computer-enhanced impact and color effects. Send samples, tearsheets, and be patient. Please don't call us. If your work is good, we keep it on file, and as a style is needed, we will contact the photographer. Keep us updated with new work. Advertising is using a fair amount of audiovisual work. We use a lot of stills within our commercials. Make portfolio available to production houses."

A 🖾 ☻ MYRIAD PRODUCTIONS

P.O. Box 888886, Atlanta GA 30356. (678)417-0041. E-mail: myriad@mindspring.com. **Contact:** Ed Harris, president. Estab. 1965. Primarily involved with sports productions and events. Types of clients: publishing, nonprofit.

Needs Works with photographers on assignment-only basis. Uses photos for portraits, live-action and studio shots, special effects, advertising, illustrations, brochures, TV and film graphics, theatrical and production stills. Subjects include: celebrities, entertainment, sports. Model/property release required. Photo captions preferred; include name(s), location, date, description.

Specs Uses 8×10 b&w and/or color prints; 2¼×2¼ transparancies. Accepts images in digital format. Send via CD, floppy disk, Zip.

Making Contact & Terms Provide brochure, résumé or samples to be kept on file. Send material by mail for consideration. Cannot return material. Response time "depends on urgency of job or production." Payment negotiable. Credit line sometimes given. Buys all rights.

Tips "We look for an imaginative photographer; one who captures all the subtle nuances. Working with us depends almost entirely on the photographer's skill and creative sensitivity with the subject. All materials submitted will be placed on file and not returned, pending future assignments. Photographers should not send us their only prints, transparencies, etc., for this reason."

$ $ $ ☒ SIDES & ASSOCIATES

404 Eraste Landry Rd., Lafayette LA 70506. (337)233-6473. Fax: (337)233-6485. E-mail: larry@sides.com. **Contact:** Larry Sides, agency president. Estab. 1976. Member of AAAA, PRSA, Chamber of Commerce, Better Business Bureau. Ad agency. Number of employees: 13. Firm specializes in publication design, display design, signage, video and radio production. Types of clients: industrial, financial, retail, nonprofit. Examples of recent clients: Iberia Bank (brochures and newspaper); Episcopal School of Acadia VA (brochure, newspaper); Lafayette Consolicated Government (brochure).

Needs Works with 2 photographers/month. Uses photos for billboards, brochures, newspapers, P-O-P displays, posters, signage. Subjects include: setup shots of people. Reviews stock photos of everything. Model/property release required.

Audiovisual Needs Works with 2 filmmakers and 2 videographers/month. Uses slides and/or film or video for broadcast, TV, newspaper.

Specs Uses 35mm, 2¼×2¼, 4×5 transparencies.

Making Contact & Terms Provide résumé, business card, self-promotion piece or tearsheets to be kept on file. Works with local freelancers only. Responds only if interested; send nonreturnable samples. Payment determined by client and usage. Pays "when paid by our client." Rights negotiable.

$ ▣ ☒ ◯ SOUNDLIGHT

5438 Tennessee Ave., New Port Richey FL 34652. (727)842-6788. E-mail: keth@awakening healing.com. Website: www.SoundLight.org. **Contact:** Keth Luke. Estab. 1972. Approximate annual billing: $150,000. Number of employees: 2. Firm specializes in websites, direct mail, magazine ads, publication design. Types of clients: businesses, astrological and spiritual workshops, books, calendars, fashion, magazines, nonprofit, Web pages. Examples of recent clients: Sensual Women of Hawaii (calendars, post cards).

Needs Works with 1 freelance photographer every 4 months. Subjects include: teens, celebrities, couples, people in activities, landscapes/scenics, animals, religious, adventure, health/fitness/beauty, humor, medicine, science, spiritual, travel sites and activities, dance and models (glamour and nude). Interested in alternative process, avant garde, erotic, fine art. Reviews stock photos, slides, computer images. Model release preferred for models and advertising people. Photo captions preferred; include who, what, where.

Audiovisual Needs Uses freelance photographers for slide sets, multimedia productions, videotapes, websites.

Specs Uses 4×6 to 8×10 glossy color prints; 35mm color slides. Accepts images in digital format. Send via CD, floppy disk, e-mail as TIFF, GIF, JPEG files at 70-100 dpi.

Making Contact & Terms Send query letter with résumé, stock list. Provide prints, slides, business card, computer disk, CD, contact sheets, self-promotion piece or tearsheets to be kept on file. Works on assignment; sometimes buys stock model photos. May not return unsolicited material. Responds in 3 weeks. Pays $100 maximum for b&w and color photos; $10-1,800 for videotape; $10-100/hour; $50-750/day; $2,000 maximum/job; sometimes also pays in "trades." Pays on publication. Credit line sometimes given. Buys one-time, all rights; various negotiable rights depending on use.

Tips In portfolios or demos, looks for "unique lighting, style, emotional involvement; beautiful, artistic, sensual, erotic viewpoints." Sees trend toward "manipulated computer images. Send query about what you have to show, to see what we can use at that time."

☒ ☒ ▣ ☒ SOUTH CAROLINA FILM COMMISSION

1201 Main St., Suite 1600, Columbia SC 29201. (803)737-0490. Fax: (803)737-3104. Website: www.scfilmoffice.com. **Contact:** Jeff Monks. Types of clients: motion picture and television producers.

Needs Works with 8 photographers/month. Uses photos of South Carolina landscapes/architecture to recruit feature films/TV productions. Subjects include: location photos for feature films, TV projects, national commercials, print ads and catalogs.

Specs Uses 3×5 color prints; 35mm film. Accepts images in digital format. Send via CD as JPEG files.

Making Contact & Terms Submit portfolio by mail. Provide résumé, business card, self-promotion piece or tearsheets to be kept on file. Works with local freelancers on assignment only. Does not return unsolicited material. Payment negotiable. Pays per yearly contract, upon completion of assignment. Buys all rights.

Tips ''Experience working in the film/video industry is essential. Ability needed to identify and photograph suitable structures or settings to work as a movie location.''

MIDWEST & NORTH CENTRAL

$ [A] ▣ ⬚ BACHMAN DESIGN GROUP

6001 Memorial Dr., Dublin OH 43017. (614)793-9993. Fax: (614)793-1607. E-mail: thinksmart@bachmandesign.com. Website: www.bachmandesign.com. **Contact:** Bonnie Lattimer, lead graphic designer. Estab. 1988. Member of American Bankers Association, AIGA, Association of Professional Design Firms, Corporate Design Foundation, Bank Administration Institute, Bank Marketing Association, American Center of Design, Design Management Institute. Design firm. Approximate annual billing: $1 million. Number of employees: 8. Firm specializes in graphics and display design, collateral, merchandising. Types of clients: manufacturing, financial, retail. Examples of recent clients: S&G Manufacturing (catalog of products); HSBC Group (merchandising-lifestyle images); Westernbank (environments).

Needs Works with 1 photographer/month. Uses photos for P-O-P displays, posters. Subjects include: babies/children/teens, couples, multicultural, families, senior citizens, landscapes/scenics, cities/urban, humor, industry, product shots/still life, technology/computers, lifestyle. Reviews stock photos. Model/property release required. Photo captions preferred.

Specs Uses color and/or b&w prints; 2¼×2¼, 4×5 transparencies. Accepts images in digital format. Send via CD, SyQuest, Zip as TIFF, EPS, JPEG files.

Making Contact & Terms Send query letter with résumé of credits, samples. Provide résumé, business card, brochure, flier or tearsheets to be kept on file. Works on assignment only. Cannot return material. Responds in 2 weeks. Pays $50-150 for b&w or color photos. **Pays on receipt of invoice.** Credit line sometimes given depending on clients' needs/requests. Buys one-time, electronic and all rights; negotiable.

$ [A] BRAGAW PUBLIC RELATIONS SERVICES

800 E. Northwest Hwy., Suite 1040, Palatine IL 60074. (847)934-5580. Fax: (847)934-5596. **Contact:** Richard S. Bragaw. Estab. 1981. Member of Publicity Club of Chicago. PR firm. Number of employees: 3. Types of clients: professional service firms, high-tech entrepreneurs.

Needs Uses photos for trade magazines, direct mail, brochures, newspapers, newsletters/news releases. Subjects include: ''products and people.'' Model release preferred. Photo captions preferred.

Specs Uses 3×5, 5×7, 8×10 glossy prints.

Making Contact & Terms Provide résumé, business card, brochure, flier or tearsheets to be kept on file. Works with freelance photographers on assignment basis only. Pays $25-100 for b&w photos; $50-200 for color photos; $35-100/hour; $200-500/day; $100-1,000/job. **Pays on receipt of invoice.** Credit line ''possible.'' Buys all rights; negotiable.

Tips ''Execute an assignment well, at reasonable costs, with speedy delivery.''

[A] ▨ BRIGHT LIGHT PRODUCTIONS

602 Main St., Suite 810, Cincinnati OH 45202. (513)721-2574. Fax: (513)721-3329. **Contact:** Linda Spalazzi, president. Film and videotape firm. Types of clients: national, regional and local companies in the governmental, educational, industrial and commercial categories. Examples of recent clients: Procter & Gamble, US Grains Council and Convergys.

Needs Model/property release required. Photo captions preferred.

Audiovisual Needs Produces 16mm and 35mm films and videotape, including Betacam; 16mm and 35mm documentary, industrial, educational and commercial films.

Making Contact & Terms Provide résumé, flier and brochure to be kept on file. Call to arrange appointment or send query letter with résumé of credits. Works on assignment only. Pays $100 minimum/day for grip;

payment negotiable based on photographer's previous experience/reputation and day rate (10 hours). Pays within 30 days of completion of job. Buys all rights.

Tips Sample assignments include camera assistant, gaffer or grip. Wants to see sample reels or samples of still work. Looking for sensitivity to subject matter and lighting. ''Show a willingness to work hard. Every client wants us to work smarter and provide quality at a good value.''

N BVK/MCDONALD, INC.

250 W. Coventry Court, Milwaukee WI 53217. (414)228-1990. **Contact:** Theresa Graff, Brent Goral, Scott Krahn, Terri Burnesh, Kelly Ladwig, Mitch Markussen, Beki Clark-Gonzalez, art directors. Print Production: Rob Birdsall. Estab. 1984. Ad agency. Types of clients: travel, health care, financial, industrial, fashion. Examples of recent clients: Funjet Vacations, United Vacations, Aero Mexico Vacations, Time Warner Cable, Iowa Health System, Huffy Sports, Simplicity Manufacturing, Cousins Subs, Bonita Bay Group, Lee Island Tourism, Mount Carmel Health System, Intermountain Healthcare, Milwaukee Tool.

Needs Uses 5 photographers/month. Uses photos for billboards, consumer and trade magazines, direct mail, catalogs, posters and newspapers. Subjects include travel and health care. Interested in reviewing stock photos of travel scenes in Carribean, California, Nevada, Mexico and Florida. Model release required.

Specs Uses 35mm, $2^1/_4 \times 2^1/_4$, 4×5, 8×10 transparencies.

Making Contact & Terms Arrange a personal interview to show portfolio. Send query letter with website, résumé of credits or list of stock photo subjects. Provide résumé, business card, brochure, flier or tearsheets to be kept on file. Cannot return material. Payment negotiable. Buys all rights.

Tips Looks for ''primarily cover shots for travel brochures; ads selling Florida, the Caribbean, Mexico, California and Nevada destinations.''

$ $ $ 🖳 🖼 CARMICHAEL-LYNCH, INC.

800 Hennepin Ave., Minneapolis MN 55403. (612)334-6000. Fax: (612)334-6085. E-mail: sbossfebbo@clynch.com. Website: www.clynch.com. **Contact:** Sandy Boss Febbo, executive art producer. Art Producers: Bonnie Brown, Jill Kahn, Jenny Barnes, Andrea Mariash. Member of American Association of Advertising Agencies. Ad agency. Number of employees: 250. Firm specializes in collateral, direct mail, magazine ads, packaging. Types of clients: finance, healthcare, sports and recreation, beverage, outdoor recreational. Examples of recent clients: Harley-Davidson, Porsche, Northwest Airlines, American Standard.

Needs Uses many photographers/month. Uses photos for billboards, consumer and trade magazines, direct mail, P-O-P displays, brochures, posters, newspapers and other media as needs arise. Subjects include: environmental, landscapes/scenics, architecture, interiors/decorating, rural, adventure, automobiles, travel, product shots/still life. Model/property release required for all visually recognizable subjects.

Specs Uses all print formats. Accepts images in digital format. Send as TIFF, GIF, JPEG files at 72 dpi or higher.

Making Contact & Terms Submit portfolio for review. To show portfolio, call Andrea Mariash. Provide résumé, business card, brochure, flier or tearsheets to be kept on file. Payment negotiable. Pay depends on contract. Buys all, one-time or exclusive product rights, ''depending on agreement.''

Tips ''No 'babes on bikes'! In a portfolio we prefer to see the photographer's most creative work—not necessarily ads. Show only your most technically, artistically satisfying work.''

$ $ 🖳 🖉 DESIGN & MORE

1222 Cavell, Highland Park IL 60035. (847)831-4437. Fax: (847)831-4462. E-mail: burtdesignmore@sbcglobal.net. **Contact:** Burt Bentkover, principal creative director. Estab. 1989. Design and marketing firm. Approximate annual billing: $300,000. Number of employees: 2. Firm specializes in marketing communications, annual reports, collateral, display design, magazine ads, publication design, signage. Types of clients: foodservice and business-to-business, industrial, retail.

Needs Works with 1 freelancer/month. Uses photos for annual reports, consumer and trade magazines and sales brochures. Subjects include abstracts, food/drink. Interested in alternative process, avant garde. Reviews stock photos. Property release required.

Specs Uses 35mm, $2^1/_4 \times 2^1/_4$, 5×7 transparencies. Accepts images in digital format.

Making Contact & Terms Provide résumé, business card, brochure, flier or tearsheets to be kept on file. Never send originals. Responds in 2 weeks. Pays $500-2,000/day. Pays in 45 days. Cannot offer photo credit. Buys negotiable rights.

Tips Submit nonreturnable photos.

$ A ▣ ◪ IDEA BANK MARKETING

701 W. Second St., P.O. Box 2117, Hastings NE 68902. (402)463-0588. Fax: (402)463-2187. E-mail: mail@idea
bankmarketing.com. Website: www.ideabankmarketing.com. **Contact:** Sherma Jones, vice president/cre-
ative director. Estab. 1982. Member of Lincoln Ad Federation. Ad agency. Approximate annual billing: $1.5
million. Number of employees: 11. Types of clients: industrial, financial, tourism and retail.

Needs Works with 1-2 photographers/quarter. Uses photos for direct mail, catalogs, posters and newspapers.
Subjects include people and products. Reviews stock photos. Model release required; property release pre-
ferred.

Audiovisual Needs Works with 1 videographer/quarter. Uses slides and videotape for presentations.

Specs Uses digital images.

Making Contact & Terms Provide résumé, business card, brochure, flier or tearsheets to be kept on file.
Works with freelancers on assignment only. Responds in 2 weeks. Pays $75-125/hour; $650-1,000/day. **Pays
on acceptance** with receipt of invoice. Credit line sometimes given depending on client and project. Buys
all rights; negotiable.

▣ ◪ ◿ KINETIC CORPORATION

200 Distillery Commons, Suite 200, Louisville KY 40206. (502)719-9500. Fax: (502)719-9509. E-mail: info@th
eTechnologyAgency.com. Website: www.theTechnologyAgency.com. **Contact:** Tim Pitts, digital services
manager. Estab. 1968. Types of clients: industrial, financial, fashion, retail and food.

Needs Works with freelance photographers and/or videographers as needed. Uses photos for audiovisual
and print. Subjects include: location photography. Model and/or property release required.

Audiovisual Needs Uses photos for slides.

Specs Uses varied sizes and finishes of color and/or b&w prints; 35mm, $2\frac{1}{4} \times 2\frac{1}{4}$, 4×5, 8×10 transparencies
and negatives. Accepts images in digital format. Send via CD, Jaz, Zip as TIFF files.

Making Contact & Terms Provide résumé, business card, brochure, flier or tearsheets to be kept on file.
Works with local freelancers only. Responds only when interested. Payment negotiable. Pays within 30 days.
Buys all rights.

$ $ ▣ LOHRE & ASSOCIATES INC.

2330 Victory Pkwy., Suite 701, Cincinnati OH 45206. (513)961-1174. **Contact:** Charles R. Lohre, president.
Ad agency. Types of clients: industrial.

Needs Works with 1 photographer/month. Uses photos for trade magazines, direct mail, catalogs and prints.
Subjects include: machine-industrial themes and various eye-catchers.

Specs Uses high-res digital images.

Making Contact & Terms Send query letter with résumé of credits. Provide business card, brochure, flier or
tearsheets to be kept on file. Responds in 1 week. Pays $60 for b&w photos; $350 for color photos; $70/hour;
$600/day. Pays on publication. Buys all rights.

Tips Prefers to see "eye-catching and thought-provoking images/non-human. Need someone to take digital
photos on short notice in national plants."

O'CONNOR DESIGN WORKS

5 S. LaGrange Rd., LaGrange IL 60525. (708)354-4845. E-mail: info@OConnorDesignWorks.com. Website:
www.OConnorDesignWorks.com. **Contact:** Joseph O'Connor, principal. Estab. 1976. Design firm. Firm spe-
cializes in annual reports, publication design, direct mail and signage. Types of clients: industrial, financial
and nonprofit. Examples of recent clients: Methode Electronics; Stratos Lightwave Inc.

Needs Stock photos, CDs. Works with a various number of photographers/year. Uses photos for annual
reports and catalogs. Subject matter varies. Model release required; property release preferred. Photo captions
preferred.

Specs Uses 8×10 color and/or b&w prints; 35mm, $2\frac{1}{4} \times 2\frac{1}{4}$, 4×5 transparencies.

Making Contact & Terms Send unsolicited photos by mail for consideration. Provide résumé, business card,
brochure, flier or tearsheets to be kept on file. Sometimes returns material. Responds "as soon as we know
something." **Pays on receipt of invoice.** Credit line not given. Buys all rights; negotiable.

$ A ▣ ◿ QUALLY & COMPANY, INC.

2 E. Oak St., Suite 2903, Chicago IL 60611. **Contact:** Mike Iva, creative director. Ad agency. Types of clients:
new product development and launches.

Needs Uses photos for every media. "Subject matter varies, but it must always be a 'quality image' regardless of what it portrays." Model/property release required. Photo captions preferred.

Specs Uses b&w and color prints; 35mm, 4×5, 8×10 transparencies. Accepts images in digital format.

Making Contact & Terms Send query letter with photocopies, tearsheets. Provide résumé, business card, brochure, flier or tearsheets to be kept on file. Responds only if interested; send nonreturnable samples. Payment negotiable. Pays net 30 days from receipt of invoice. Credit line sometimes given, depending on client's cooperation. Rights purchased depend on circumstances.

ⓐ 🖼 STEVENS BARON ADVERTISING, INC.

1422 Euclid Ave., Suite 645, Cleveland OH 44115-1901. (216)621-6800. Fax: (216)621-6806. E-mail: ebaron@s tevensbaron.com. Website: www.stevensbaron.com. **Contact:** Edward Stevens, Sr., president. Incorporated 1973. Ad agency. Types of clients: food, industrial, electronics, telecommunications, building products, architectural. In particular, serves various manufacturers of tabletop and food service equipment.

Needs Uses 3-4 photographers/month. Uses photos for direct mail, catalogs, newspapers, consumer magazines, P-O-P displays, posters, trade magazines, brochures and signage. Subject matter varies. Model/property release required.

Audiovisual Needs Works with freelance filmmakers for AV presentations.

Making Contact & Terms Arrange a personal interview to show portfolio. Send query letter with list of stock photo subjects. Provide résumé, business card, brochure, flier or tearsheets to be kept on file. Works with freelancers on assignment only. Cannot return material. Payment negotiable. Payment "depends on the photographer." Pays on completion. Buys all rights; negotiable.

Tips Wants to see "food and equipment" photos and corporate photos (annual reports, etc.) in photographer's samples. "Samples not to be returned."

Ⓝ $ⓐ 🖵 🖼 VIDEO I-D, INC.

105 Muller Rd., Washington IL 61571. (309)444-4323. Fax: (309)444-4333. E-mail: videoid@videoid.com. Website: www.videoid.com. **Contact:** Sam B. Wagner, president. Number of employees: 10. Types of clients: health, education, industry, service, cable and broadcast.

Needs Works with 5 photographers/month to shoot slide sets, multimedia productions, films and videotapes. Subjects "vary from commercial to industrial—always high quality." Somewhat interested in stock photos/footage. Model release required.

Audiovisual Needs Uses film, videotape, DVD, DVD-Rom, CD-Rom.

Specs Uses 35mm transparencies; 16mm film; U-matic ¾" and 1" videotape, Beta SP. Accepts images in digital format ("inquire for file types"). Send via CD, e-mail, floppy disk, Zip, Jaz.

Making Contact & Terms Provide résumé, business card, self-promotion piece or tearsheets to be kept on file. "Also send video sample reel." Include SASE for return of material. Works with freelancers on assignment only. Responds in 3 weeks. Pays $10-65/hour; $160-650/day. Usually pays by the job; negotiable. **Pays on acceptance.** Credit line sometimes given. Buys all rights; negotiable.

Tips "Sample reel—indicate goal for specific pieces. Show good lighting and visualization skills. Show me you can communicate what I need to see, and have a willingness to put out effort to get top quality."

SOUTH CENTRAL & WEST

$🖵 BEAR ENTHUSIAST MARKETING GROUP

32121 Lindero Canyon Rd., Suite 200, Westlake Village CA 91361. (818)865-6464. Fax: (818)865-6499. E-mail: info@bearemg.com. Website: www.bearemg.com. **Contact:** Bruce Bear, president. Estab. 1961. Ad agency. Number of employees: 15. Firm specializes in display design, magazine ads, collateral, direct mail, packaging.

Needs Works with 3 photographers/month. Uses photos for brochures, catalogs, consumer magaiznes, direct mail, P-O-P displays, posters, trade magazines. Subjects include: fishing, hunting and outdoor scenes, wildlife, active lifestyle scenes. Model release preferred.

Specs Uses 35mm transparencies. Accepts images in digital format.

Making Contact and Terms Send query letter with stock list. Pays $151-300. **Pays on receipt of invoice.** Credit line sometimes given.

$ⓐ 🖵 ◎ BERSON, DEAN, STEVENS

P.O. Box 3997, Thousand Oaks CA 91359-3997. (818)713-0134. Fax: (818)713-0417. Website: www.BersonDe anStevens.com. **Contact:** Lori Berson, owner. Estab. 1981. Design firm. Number of employees: 3. Firm special-

izes in annual reports, display design, collateral, packaging and direct mail. Types of clients: industrial, financial, food and retail. Examples of recent clients: Dole Food Company; Charles Schwab & Co., Inc.

Needs Works with 4 photographers/month. Uses photos for billboards, trade magazines, direct mail, P-O-P displays, catalogs, posters, packaging and signage. Subjects include: product shots and food. Reviews stock photos. Model/property release required.

Specs Uses 35mm, $2\frac{1}{4} \times 2\frac{1}{4}$, 4×5, 8×10 transparencies. Accepts images in digital format. Send via CD, DVD as TIFF, EPS, JPEG files at 300 dpi.

Making Contact & Terms Provide résumé, business card, brochure, flier or tearsheets to be kept on file. Works on assignment only. Responds in 1-2 weeks. Payment negotable. Pays within 30 days after receipt of invoice. Credit line not given. Rights negotiable.

N $ A BETHUNE THEATREDANSE

8033 Sunset Blvd., #221, Los Angeles CA 90046. (323)874-0481. Fax: (323)851-2078. E-mail: zbethune@aol.com. Website: bethunetheatredanse.org. **Contact:** Amanda Lynne Porter, administrative director. Estab. 1979. Dance company.

Needs Works with 2-4 photographers/year. Uses photos for posters, newspapers, magazines. Photographers used to take shots of dance productions, dance outreach classes (disabled children's program) and performances, and graphics and scenic. Examples of uses: promotional pieces for the dance production ''Cradle of Fire'' and for a circus fundraiser performance (all shots in 35mm format). Reviews stock photos if they show an ability to capture a moment. Photo captions preferred; include company or name of subject, date, and equipment shown in photo.

Audiovisual Needs Uses slides and videotape. ''We are a multimedia company and use videos and slides within our productions. We also use video for archival purposes.'' Subject matter varies.

Specs Uses 8×10 color or b&w prints; 35mm transparencies and videotape.

Making Contact & Terms Provide résumé, business card, self-promotion piece or tearsheets to be kept on file. Cannot return material. Responds only when in need of work. Payment for each job is negotiated differently. Credit line sometimes given depending on usage. Buys all rights; negotiable. ''We are not always in control of newspapers or magazines that may use photos for articles.''

Tips ''We need to see an ability to see and understand the aesthetics of dance—its lines and depth of field. We also look for innovative approaches and a personal signature to each individual's work. Our productions work very much on a collaborative basis, and a videographer's talents and uniqueness are very important to each production. It is our preference to establish ongoing relationships with photographers and videographers.''

$ $ A BRAINWORKS DESIGN GROUP

5 Harris Court, Bldg. T, Suite A, Monterey CA 93940. (831)657-0650. Fax: (831)657-0750. E-mail: mail@brainwks.com. Website: www.brainwks.com. **Contact:** Al Kahn, president. Estab. 1986. Design firm. Approximate annual billing: $1-2 million. Number of employees: 8. Firm specializes in publication design and collateral. Types of clients: publishing, nonprofit.

Needs Works with 4 photographers/month. Uses photographs for direct mail, catalogs and posters. Subjects include: babies/children/teens, couples, environmental, education, entertainment, performing arts, sports, business concepts, science, technology/computers. Interested in avant garde, documentary. Wants conceptual images. Model release required.

Specs Uses 35mm, 4×5 transparencies. Accepts images in digital format. Send via CD.

Making Contact & Terms Arrange personal interview to show portfolio. Send unsolicited photos by mail for consideration. Works with freelancers on assignment only. Keeps samples on file. Cannot return material. Responds in 1 month. Pays $200-400 for b&w photos; $400-600 for color photos; $100-150/hour; $750-1,200/day; $2,500-4,000/job. **Pays on receipt of invoice.** Credit line sometimes given, depending on client. Buys first, one-time and all rights; negotiable.

A BRAMSON + ASSOCIATES

7400 Beverly Blvd., Los Angeles CA 90036. (323)938-3595. Fax: (323)938-0852. E-mail: gbramson@aol.com. **Contact:** Gene Bramson, principal. Estab. 1970. Ad agency. Approximate annual billing: $2 million. Number of employees: 7. Types of clients: industrial, financial, food, retail, health care. Examples of recent clients: Hypo Tears; 10 Lab Corporation; Chiron Vision.

Needs Works with 2-5 photographers/month. Uses photos for trade magazines, direct mail, catalogs, posters, newspapers, signage. Subject matter varies; includes babies/children/teens, couples, multicultural, families,

architecture, cities/urban, gardening, interiors/decorating, pets, automobiles, food/drink, health/fitness/beauty, business concepts, medicine, science. Interested in avant garde, documentary, erotic, fashion/glamour, historical/vintage. Reviews stock photos. Model/property release required. Photo captions preferred.

Audiovisual Needs Works with 1 videographer/month. Uses slides and/or videotape for industrial, product. **Specs** Uses 11×15 color and/or b&w prints; 35mm, $2\frac{1}{4}\times2\frac{1}{4}$, 4×5, 8×10 transparencies. Accepts images in digital format. Send via CD.

Making Contact & Terms Submit portfolio for review. Send unsolicited photos by mail for consideration; include SASE for return of material. Works with local freelancers on assignment only. Provide résumé, business card, brochure, flier or tearsheet to be kept on file. Responds in 3 weeks. Payment negotiable. **Pays on receipt of invoice**. Payment varies depending on budget for each project. Credit line not given. Buys one-time and all rights.

Tips "Innovative, crisp, dynamic, unique style—otherwise we'll stick with our photographers. If it's not great work, don't bother."

N $ $ 🖳 ⬚ DESIGN 2 MARKET

(formerly Yamaguma & Assoc./Design 2 Market), 909 Weddel Ct., Sunnyvale CA 94089. (408)744-6671. Fax: (408)744-6686. E-mail: info@design2marketinc.com. Website: www.design2marketinc.com. **Contact:** Antoinette Wardell, operations manager. Design firm. Number of employees: 5. Firm specializes in publication design, display design, magazine ads, collateral, packaging, direct mail and advertising. Types of clients: industrial, retail, nonprofit and technology. Examples of recent clients: "Silicon Valley Charity Ball" (invitation and posters); neoforma.com (advertising); SUN Microsystems (collateral); Polyism (packaging).

Needs Works with 6 photographers/month. Uses photos for trade magazines, direct mail, P-O-P displays, catalogs, posters, packaging and advertising. Subjects include: people, computers, equipment. Reviews stock photos. Model/property release required.

Specs Uses 35mm, $2\frac{1}{4}\times2\frac{1}{4}$, 4×5 transparencies. Accepts images in digital format. Send via CD as TIFF, EPS, PICT, JPEG files at 300 dpi minimum.

Making Contact & Terms Send unsolicited photos by mail for consideration. Include SASE for return of material. Provide résumé, business card, brochure, flier or tearsheets to be kept on file. Works on assignment and buys stock photos. Payment negotiable. Credit line sometimes given. Buys all rights.

A 🖳 DYKEMAN ASSOCIATES, INC.

4115 Rawlins, Dallas TX 75219. (214)528-2991. Fax: (214)528-0241. E-mail: adykeman@airmail.net. Website: www.dykemanassoc.com. **Contact:** Alice Dykeman, APR, Fellow-PRSA. Estab. 1974. Member of Public Relations Society of America. PR, advertising, video production firm. Firm specializes in collateral, direct mail, magazine ads, publication design. Types of clients: industrial, financial, sports, technology.

Needs Works with 4-5 photographers and/or videographers. Uses photos for publicity, billboards, consumer and trade magazines, direct mail, P-O-P displays, catalogs, posters, newspapers, signage, websites.

Audiovisual Needs "We produce and direct video. Just need crew with good equipment and people and ability to do their part."

Making Contact & Terms Arrange personal interview to show portfolio. Provide résumé, business card, brochure, flier or tearsheets to be kept on file. Works on assignment only. Cannot return material. Pays $800-1,200/day; $250-400/1-2 days. "Currently we work only with photographers who are willing to be part of our trade dollar network. Call if you don't understand this term." Pays 30 days after receipt of invoice.

Tips Reviews portfolios with current needs in mind. "If video, we would want to see examples. If for news story, we would need to see photojournalism capabilities. Show portfolio, state pricing; remember that either we or our clients will keep negatives or slide originals."

$ $ A 🖳 🖳 ⬚ FARNAM COMPANIES, INC.

301 W. Osborn, Phoenix AZ 85013-3997. (602)207-2129. Fax: (602)207-2193. E-mail: dkuykendall@mail.farnam.com. Website: www.farnam.com. **Contact:** Leslie Burger, creative director. Firm specializes in display design, magazine ads, packaging. Types of clients: retail.

• This company has an in-house ad agency called Charles Duff Advertising.

Needs Works with 2 photographers/month. Uses photos for direct mail, catalogs, consumer magazines, P-O-P displays, posters, AV presentations, trade magazines and brochures. Subject matter includes horses, dogs, cats, birds, farm scenes, ranch scenes, cowboys, cattle, horse shows, landscapes/scenics, gardening. Model release required.

Audiovisual Needs Uses film and videotape. Occasionally works with freelance filmmakers to produce educational horse health films and demonstrations of product use.

Specs Uses 35mm, $2\frac{1}{4} \times 2\frac{1}{4}$, 4×5 transparencies; 16mm and 35mm film and videotape. Accepts images in digital format. Send via CD, Zip.

Making Contact & Terms Send query letter with samples; include SASE for return of material. Provide résumé, business card, brochure, flier or tearsheets to be kept on file. Works with freelance photographers on assignment basis only. Pays $50-350 for color photos. Pays on publication. Credit line given whenever possible. Buys one-time rights.

Tips "Send me a number of good, reasonably priced for one-time use photos of dogs, horses or farm scenes. Better yet, send me good-quality dupes I can keep on file for *rush* use. When the dupes are in the file and I see them regularly, the ones I like stick in my mind and I find myself planning ways to use them. We are looking for original, dramatic work. We especially like to see horses, dogs, cats and cattle captured in artistic scenes or poses. All shots should show off quality animals with good conformation. We rarely use shots if people are shown and prefer animals in natural settings or in barns/stalls."

$ 🖂 🖼 📎 FRIEDENTAG PHOTOGRAPHICS

314 S. Niagara St., Denver CO 80224-1324. (303)333-0570. **Contact:** Harvey Friedentag, manager. Estab. 1957. AV firm. Approximate annual billing: $500,000. Number of employees: 3. Firm specializes in direct mail, annual reports, publication design, magazine ads. Types of clients: business, industry, financial, publishing, government, trade and union organizations. Produces slide sets, motion pictures and videotape. Examples of recent clients: Perry Realtors annual report (advertising, mailing); Lighting Unlimited catalog (illustrations).

Needs Works with 5-10 photographers/month on assignment only. Buys 1,000 photos and 25 films/year. Reviews stock photos of business, training, public relations, and industrial plants showing people and equipment or products in use. Other subjects include: agriculture, business concepts, industry, medicine, military, political, science, technology/computers. Interested in avant garde, documentary, erotic, fashion/glamour. Model release required.

Audiovisual Needs Uses freelance photos in color slide sets and motion pictures. No posed looks. Also produces mostly 16mm Ektachrome and some 16mm b&w; $\frac{3}{4}$" and VHS videotape. Length requirement: 3-30 minutes. Interested in stock footage on business, industry, education and unusual information. "No scenics, please!"

Specs Uses 8×10 glossy b&w and/or color prints; 35mm, $2\frac{1}{4} \times 2\frac{1}{4}$, 4×5 color transparencies. Accepts images in digital format. Send via CD, floppy disk as JPEG files.

Making Contact & Terms Send material by mail for consideration. Provide flier, business card, brochure and nonreturnable samples to show clients. Responds in 3 weeks. Pays $400/day for still; $600/day for motion picture plus expenses; $100 maximum for b&w photos; $200 maximum for color photos; $700 maximum for film; $700 maximum for videotape. **Pays on acceptance.** Buys rights as required by clients.

Tips "More imagination needed—be different; no scenics, pets or portraits, and above all, technical quality is a must. There are more opportunities now than ever, especially for new people. We are looking to strengthen our file of talent across the nation."

N $ $ 🖂 📎 GRAFICA

7053 Owensmouth Ave., Canoga Park CA 91303. (818)712-0071. Fax: (818)348-7582. E-mail: graficaeps@aol. com. Website: www.graficaeps.com. **Contact:** Larry Girardi, owner. Estab. 1974. Member of Adobe Authorized Imaging Center, Quark Service Alliance, Corel Approved Service Bureau. Design studio and service bureau. Approximate annual billing: $250,000. Number of employees: 5. Firm specializes in annual reports, magazine ads, direct mail, publication design, collateral design, video graphics-titling. Types of clients: high technology, industrial, retail, publishers, entertainment.

Needs Works with 1-2 photographers/month. Uses photos for annual reports, billboards, consumer and trade magazines, P-O-P displays, catalogs, posters, packaging. Subjects include: babies/children/teens, celebrities, couples, multicultural, families, parents, senior citizens, disasters, environmental, landscapes, scenics, wildlife, architecure, cities/urban, education, gardening, interiors/decorating, pets, religious, rural, adventure, automobiles, entertainment, events, food/drink, health/fitness, hobbies, humor, performing arts, sports, travel, agriculture, business concepts, industry, medicine, military, political, product shots/still life, science, technology/computers. Interested in alternative process, avant garde, documentary, erotic, fashion/glamour, fine art, historical/vintage, seasonal. Model release required; property release preferred.

Specs Uses 35mm, $2\frac{1}{4} \times 2\frac{1}{4}$, 4×5 transparencies. Accepts images in digital format. Send via CD, e-mail as JPEG files.

Making Contact & Terms Send query letter with samples. Provide résumé, business card, brochure, flier or tearsheets to be kept on file. Responds in 1-2 weeks. Pays $100-1,000 for b&w and color photos. Credit line sometimes given. Buys first, one-time, electronic and all rights; negotiable.

Tips "Send sample sheets (nonreturnable) for our files. We will contact when appropriate project arises."

$ 🅐 ▣ 🖾 ◙ GRAPHIC DESIGN CONCEPTS

15329 Yukon Ave., El Camino Village CA 90260-2452. (310)978-8922. **Contact:** C. Weinstein, president. Estab. 1980. Design firm. Number of employees: 10. Firm specializes in annual reports, collateral, publication design, display design, packaging, direct mail, signage. Types of clients: industrial, financial, retail, publishers, nonprofit. Examples of recent clients: Sign of Dove (brochures); Trust Financial (marketing materials).

Needs Works with 10 photographers/month. Uses photos for annual reports, billboards, consumer and trade magazines, direct mail, P-O-P displays, catalogs, posters, packaging, signage. Subjects include: babies/children/teens, celebrities, couples, multicultural, families, parents, senior citizens, disasters, environmental, landscapes/scenics, wildlife, architecture, cities/urban, gardening, interiors/decorating, pets, religious, rural, adventure, automobiles, entertainment, events, food/drink, health/fitness, hobbies, humor, performing arts, travel, sports, agriculture, business concepts, industry, medicine, military, political, product shots/still life, science, technology/computers, pictorial. Interested in alternative process, avant garde, documentary, erotic, fashion/glamour, fine art, historical/vintage, seasonal. Model/property release required for people, places, art. Photo captions required; include who, what, when, where.

Audiovisual Needs Uses film and videotape.

Specs Uses 8×10 glossy color and/or b&w prints; 35mm, 2¼×2¼, 4×5, 8×10 transparencies. Accepts images in digital format. Send via CD, floppy disk as TIFF, JPEG files at 300 dpi.

Making Contact & Terms Provide résumé, business card, brochure, flier or tearsheets to be kept on file. Works with freelancers on assignment only. Responds as needed. Pays $15 minimum/hour; $100 minimum/day; $100 minimum/job; $50 minimum for color photos; $25 minimum for b&w photos; $200 minimum for film; $200 minimum for videotape. **Pays on receipt of invoice.** Credit line sometimes given depending upon usage. Buys rights according to usage.

Tips In samples, looks for "composition, lighting, and styling." Sees trend toward "photos being digitized and manipulated by computer."

🅐 ▣ THE HITCHINS COMPANY

22756 Hartland St., Canoga Park CA 91307. (818)715-0510. Fax: (775)806-2687. E-mail: whitchins@socal.rr.com. **Contact:** W.E. Hitchins, president. Estab. 1985. Ad agency. Approximate annual billing: $300,000. Number of employees: 2. Firm specializes in: collateral, direct mail, magazine ads. Types of clients: industrial, retail (food), auctioneers. Examples of recent clients: Electronic Expediters (brochure showing products); Allan-Davis Enterprises (magazine ads).

Needs Uses photos for trade and consumer magazines, direct mail, newspapers. Model release required.

Specs Uses b&w and/or color prints. "Copy should be flexible for scanning." Accepts images in digital format. Send via CD, floppy disk, e-mail.

Making Contact & Terms Provide résumé, business card, brochure, flier or tearsheets to be kept on file. Works on assignment only. Cannot return material. Payment negotiable depending on job. **Pays on receipt of invoice** (30 days). Rights purchased negotiable; "varies as to project."

Tips Wants to see shots of people and products in samples.

🅝 LEVINSON ASSOCIATES

1440 Veteran Ave., Suite 650, Los Angeles CA 90024. (323)663-6940. Fax: (323)663-2820. E-mail: leviinc@aol.com. **Contact:** Jed Leland, Jr., assistant to president. Estab. 1969. PR firm. Types of clients: industrial, financial, entertainment. Examples of recent clients: Mystery Writers of America; MWA Annual Edgar Awards; Beyond Shelter; Temple Hospital; Health Care Industries, Inc. (sales brochure); *CAI Focus Magazine*; U4EA!; "Hello, Jerry," for Hollywood Press Club (national promotion), Moulin D'Or Recordings; Council On Natural Nutrition; G.B. Data Systems, Inc.

Needs Works with varying number of photographers/month. Uses photos for trade magazines and newspapers. Subjects vary. Model release required; property release preferred. Photo captions preferred.

Making Contact & Terms Works with local freelancers only. Keeps samples on file. Cannot return material. Payment negotiable. Buys all rights; negotiable.

$ $⬛ ▦ ⊘ LINEAR CYCLE PRODUCTIONS

Box 2608, Sepulveda CA 91393-2608. **Contact:** R. Borowy, production manager. Estab. 1980. Member of International United Photographer Publishers, Inc. Ad agency, PR firm. Approximate annual billing: $5 million. Number of employees: 20. Firm specializes in annual reports, display design, magazine ads, publication design, direct mail, packaging, signage. Types of clients: industrial, commercial, advertising, retail, publishing.

Needs Works with 7-10 photographers/month. Uses photos for billboards, consumer magazines, direct mail, P-O-P displays, posters, newspapers, audiovisual uses. Subjects include: candid photographs. Reviews stock photos, archival. Model/property release required. Photo captions required; include description of subject matter.

Audiovisual Needs Works with 8-12 filmmakers and 8-12 videographers/month. Uses slides and/or film or video for television/motion pictures. Subjects include: archival-humor material.

Specs Uses 8×10 color and/or b&w prints; 35mm, 8×10 transparencies; 16mm-35mm film; $\frac{1}{2}''$, $\frac{3}{4}''$, $1''$ videotape. Accepts images in digital format. Send via CD, floppy disk, Jaz as TIFF, GIF, JPEG files.

Making Contact & Terms Submit portfolio for review. Send query letter with résumé of credits, stock list. Provide résumé, business card, brochure, flier or tearsheets to be kept on file. Works with local freelancers on assignment and buys stock photos. Responds in 1 month. Pays $100-500 for b&w photos; $150-750 for color photos; $100-1,000/job. Prices paid depend on position. Pays on publication. Credit line given. Buys one-time rights; negotiable.

Tips "Send a good portfolio with color images. No sloppy pictures or portfolios! The better the portfolio is set up, the better the chances we would consider it, let alone look at it!" Seeing a trend toward "more archival/vintage and a lot of humor pieces."

$ $ $ $⊘ THE MILLER GROUP

1516 Bundy Dr., Suite 200, Los Angeles CA 90025. (310)442-0101. Fax: (310)442-0107. E-mail: sarah@millergroup.net. Website: www.millergroup.net. **Contact:** Sarah Milstein. Estab. 1990. Member of WSAAA. Approximate annual billing: $3.5 million. Number of employees: 6. Firm specializes in print advertising. Types of clients: consumer.

Needs Uses photos for billboards, brochures, consumer magazines, direct mail, newspapers. Model release required.

Making Contact and Terms Contact through rep or send query letter with photocopies. Provide self-promotion piece to be kept on file. Buys all rights; negotiable.

Tips "Please, no calls!"

Ⓝ $ $ $ $Ⓐ ⬛ POINTBLANK AGENCY

417 W. Arden Ave., Suite 105, Glendale CA 91203. E-mail: valn@pointblankagency.com. Website: www.pointblankagency.com. **Contact:** Valod Nazarian. Ad and design agency. Serves travel, high-technology and consumer-technology clients.

Needs Uses photos for trade show graphics, websites, consumer magazines, trade magazines, direct mail, P-O-P displays, newspapers. Subject matter of photography purchased includes: conceptual shots of people and table top (tight shots of electronics products). Model release required. Photo captions preferred.

Specs Uses 8×10 matte b&w and/or color prints; 35mm, $2\frac{1}{4} \times 2\frac{1}{4}$, 4×5, 8×10 transparencies. Accepts images in ditigal format. Send via CD, e-mail, floppy disk, or Zip.

Making Contact & Terms Arrange a personal interview to show portfolio. Provide résumé, business card, brochure, flier or tearsheets to be kept on file. Works on assignment basis only. Does not return unsolicited material. Responds in 3 weeks. Pays $100-5,000 for b&w photos; $100-8,000 for color photos; maximum $5,000/day; $200-2,000 for electronic usage (Web banners, etc.), depending on budget. **Pays on receipt of invoice.** Buys one-time, exclusive product, electronic and all rights (work-for-hire); negotiable.

Tips Prefers to see "originality, creativity, uniqueness, technical expertise" in work submitted. There is more use of "photo composites, dramatic lighting and more attention to detail" in photography.

$ $▦ ◔ RED HOTS ENTERTAINMENT

3105 Amigos Dr., Burbank CA 91504-1806. **Contact:** Chip Miller and Daniel Pomeroy, creative directors. Estab. 1987. Motion picture, music video, commercial and promotional trailer film production company. Number of employees: 12. Firm specializes in magazine ads. Types of clients: industrial, fashion, entertainment, publishing, motion picture, TV and music. Examples of recent clients: "History of Vegas," Player's

Network (broadcast); "Making of First Love," JWP/USA (MTV Broadcast); "The Sun Show," SSTV; "The Belly Twins Show."

Needs Works with 1-4 photographers/month. Uses freelancers for TV, music video, motion picture stills and production. Model release required; property release preferred. Photo captions preferred.

Audiovisual Needs Uses film and video.

Making Contact & Terms Provide business card, résumé, references, samples or tearsheets to be kept on file. Payment negotiable "based on project's budget." Rights negotiable.

Tips Wants to see a minimum of 2 pieces expressing range of studio, location, style and model-oriented work. Include samples of work published or commissioned for production.

$ A ⬛ 🖼 ⬛ SAN FRANCISCO CONSERVATORY OF MUSIC

1201 Ortega St., San Francisco CA 94122. (415)759-3452. Fax: (415)759-3488. E-mail: spc@sfcm.edu. Website: www.sfcm.edu. **Contact:** Steven Contreras, senior design manager. Estab. 1917. Provides publications about Conservatory programs, concerts and musicians.

Needs Offers 10-15 assignments/year. Uses photos for brochures, posters, newspapers, annual reports, catalogs, magazines and newsletters. Subjects include cities/urban, entertainment, performances, head shots, rehearsals, classrooms, candid student life, some environmental, instruments, operas, orchestras, ensembles, special events. Interested in fine art.

Audiovisual Needs Uses film or digital media.

Specs Uses digital files only.

Making Contact & Terms "Contact us only if you are experienced in photographing performing musicians." Knowledge of classical music helpful. Works with local freelancers only. Payment negotiable.

Tips "Send self-promo piece. We will call if interested."

$ $ $ STEVEN SESSIONS, INC.

5177 Richmond Ave, Suite 500, Houston TX 77056. (713)850-8450. Fax: (713)850-9324. Website: www.sessionsgroup.com. **Contact:** Steven Sessions, president. Estab. 1982. Design firm. Firm specializes in annual reports, packaging and publication design. Types of clients: industrial, financial, women's fashion, cosmetics, retail, publishers and nonprofit.

Needs Always works with freelancers. Uses photos for annual reports, consumer and trade magazines, P-O-P displays, catalogs and packaging. Subject matter varies according to need. Reviews stock photos. Model/property release preferred.

Specs Uses b&w and/or color transparencies, no preference for format or finish; 35mm, 2¼×2¼, 4×5, 8×10.

Making Contact & Terms Submit portfolio for review. Provide résumé, business card, brochure, flier or tearsheets to be kept on file. Responds in 2 weeks. Pays $1,800-5,000/day or more. Pays on receipt of invoice. Credit line possible. Sometimes buys all rights; negotiable.

A 🖼 VISUAL AID MARKETING/ASSOCIATION

Box 4502, Inglewood CA 90309-4502. (310)399-0696. **Contact:** Lee Clapp, manager. Estab. 1965. Ad agency. Number of employees: 3. Firm specializes in annual reports, display design, magazine ads, publication design, signage, collateral, direct mail, packaging. Types of clients: industrial, fashion, retail, publishing, food, travel hospitality.

Needs Works with 1-2 photographers/month. Uses photos for billboards, consumer and trade magazines, direct mail, P-O-P displays, catalogs, posters, newspapers, signage. Subjects include: celebrities, couples, multicultural, parents, senior citizens, disasters, environmental, landscapes/scenics, wildlife, architecture, cities/urban, pets, rural, adventure, automobiles, entertainment, events, food/drink, health/fitness/beauty, hobbies, humor, performing arts, sports, travel, business concepts, military, political, product shots/still life. Interested in avant garde, documentary, erotic, fashion/glamour, fine art, historical/vintage. Model/property release required for models and copyrighted printed matter. Photo captions required; include how, what, where, when, identity.

Audiovisual Needs Works with 1-2 filmmakers and 1-2 videographers/month. Uses film and videotape and slides for travel presentations.

Specs Uses 8×10 glossy color and/or b&w prints; 35mm, 2¼×2¼, 4×5, 8×10 transparencies; Ektachrome film; Beta/Cam videotape.

Making Contact & Terms Send query letter with résumé of credits, stock list. Works with local freelancers on assignment only. Provide résumé, business card, brochure, flier or tearsheets to be kept on file. Responds

in 2 weeks. Payment negotiable upon submission. **Pays on acceptance**, publication, or **receipt of invoice**. Credit line given depending upon client's wishes. Buys first and one-time rights; negotiable.

$ [A] [▣] [◿] DANA WHITE PRODUCTIONS, INC.

2623 29th St., Santa Monica CA 90405. (310)450-9101. E-mail: dwprods@aol.com. **Contact:** Dana White, president. Estab. 1977. Full-service audiovisual, multi-image, digital photography and design, video/film production studio. Types of clients: schools and community-based non-profit institutions, corporate, government, publishing, marketing/advertising, and art galleries. Examples of recent clients: Southern California Gas Company/South Coast AQMD (Clean Air Environmental Film Trailers in 300 LA-based motion picture theaters); Glencoe/McGraw-Hill (textbook photography and illustrations, slide shows); Pepperdine University (awards banquet presentations, fundraising, biographical tribute programs); US Forest Service (training programs); Venice Family Clinic (newsletter photography); Johnson & Higgins (brochure photography).

Needs Works with 2-3 photographers/month. Uses photos for catalogs, audiovisual, books. Subjects include: people, products, still life, event documentation, architecture. Interested in reviewing 35mm stock photos by appointment. Model release required for people and companies.

Audiovisual Needs Uses all AV formats including scanned and digital images for computer-based multimedia; 35mm slides for multi-image presentations using 1-9 projectors; and medium-format as needed.

Specs Uses color and/or b&w prints; 35mm, $2\frac{1}{4} \times 2\frac{1}{4}$ transparencies; digital images (minimum 6mp files).

Making Contact & Terms Arrange a personal interview to show portfolio and samples. "Please do not send originals." Works with freelancers on assignment only. Will assign certain work on spec. Do not submit unsolicited material. Cannot return material. **Pays when images are shot to White's satisfaction**—never delays until acceptance by client. Pays according to job: $25-100/hour, up to $750/day; $20-50/shot; or fixed fee based upon job complexity and priority of exposure. Hires according to work-for-hire and will share photo credit when possible.

Tips In freelancer's portfolio or demo, Mr. White wants to see "quality of composition, lighting, saturation, degree of difficulty, and importance of assignment. The trend seems to be toward more video, less AV. Clients are paying less and expecting more. To break in, freelancers should diversify, negotiate, be personable and flexible, go the distance to get and keep the job. Freelancers need to see themselves as hunters who are dependent upon their hunting skills for their livelihood. Don't get stuck in one-dimensional thinking. Think and perform as a team—service that benefits all sectors of the community and process."

NORTHWEST & CANADA

$ $ $ [A] [▣] [◿] [◿] DUCK SOUP GRAPHICS, INC.

21120 Terwillegar P.O., Edmonton AB T6R 2V4 Canada. (780)462-4760. Fax: (780)463-0924. **Contact:** William Doucette, creative director. Estab. 1980. Design firm. Approximate annual billing: $4.6 million. Number of employees: 7. Firm specializes in branding, annual reports, business collateral, magazine ads, publication design, corporate identity, packaging and direct mail. Types of clients: high-tech, industrial, government, institutional, financial, entertainment and retail.

Needs Works with 4-5 photographers/month. Uses photos for annual reports, billboards, consumer and trade magazines, direct mail, posters and packaging. Subjects include multicultural, families, environmental, landscapes/scenics, wildlife, architecture, cities/urban, rural, adventure, automobiles, entertainment, events, health/fitness, performing arts, sports, travel, agriculture, business concepts, industry, medicine, product shots/still life, science, technology. Interested in alternative process, avant garde, documentary, fashion/glamour, fine art, historical/vintage. Reviews stock photos. Model release required.

Specs Accepts images in digital format. Send via e-mail, CD, Zip as EPS files.

Making Contact & Terms Interested in seeing new, digital or traditional work. Provide résumé, business card, brochure, flier or tearsheets to be kept on file. Works on assignment only. Responds in 2 weeks. Pays $100-200/hour; $1,000-2,000/day; $1,000-15,000/job. **Pays on receipt of invoice.** Credit line given depending on number of photos in publication. Buys first rights; negotiable.

Tips "Call for an appointment or send samples by mail."

[N] $ [A] [▣] [◿] GIBSON ADVERTISING & DESIGN

P.O. Box 80407, Billings MT 59104. (406)248-3555. Fax: (406)248-9998. E-mail: mike@gibsonad.com. Website: www.gibsonad.com. **Contact:** Mike Curtis, account manager. Estab. 1984. Ad agency. Number of employees: 6. Types of clients: industrial, financial, retail, food, medical.

Needs Works with 1-3 freelance photographers and 1-2 videographers/month. Uses photos for direct mail, P-O-P displays, catalogs, posters, newspapers, signage and audiovisual. Subjects vary with job. Reviews stock photos. "We would like to see more Western photos." Model release required. Property release preferred.
Audiovisual Needs Uses slides and videotape.
Specs Uses color and b&w prints; 35mm, 2¼×2¼, 4×5, 8×10 transparencies; 16mm, VHS, Betacam videotape; and digital format.
Making Contact & Terms Send query letter with résumé of credits or samples. Provide résumé, business card, brochure, flier or tearsheets to be kept on file. Works with local freelancers on assignment only. Keeps samples on file. Cannot return material. Responds in 2 weeks. Pays $75-150/job; $150-250 for color photo; $75-150 for b&w photo; $100-150/hour for video. **Pays on receipt of invoice**, net 30 days. Credit line sometimes given. Buys one-time and electronic rights. Rights negotiable.

$ $ ▣ ☑ HENRY SCHMIDT DESIGN

14710 SE Lee Ave., Portland OR 97267-2631. (503)652-1114. E-mail: hank@hankink.com. Website: www.han kink.com. **Contact:** Hank Schmidt, president. Estab. 1976. Design firm. Approximate annual billing: $250,000. Number of employees: 2. Firm specializes in packaging, P-O-P display, catalog/sales literature. Types of clients: industrial, retail. Example of recent client: Marinco (marine products catalog).
Needs Works with 1-2 photographers/month. Uses photos for catalogs and packaging. Subjects include product shots/still life. Interested in fashion/glamour. Model/property release required.
Specs Uses digital photography for almost all projects. Send digital images via CD, e-mail as TIFF, JPEG files.
Making Contact & Terms Interested in receiving work from newer, lesser-known photographers. Send query letter with samples; include SASE for return of material. Provide résumé, business card, brochure, flier or tearsheets to be kept on file. Payment negotiable. **Pays on receipt of invoice**, net 30 days. Credit line sometimes given. Buys all rights.
Tips "I shoot with digital photographers almost exclusively. Images are stored on CD. Almost all photos are 'tuned up' in Photoshop."

Ａ ▣ 🖼 ☑ 🔀 WARNE MARKETING & COMMUNICATIONS

1300 Yonge St., Suite 502, Toronto ON M4T 1X3 Canada. (416)927-0881. Fax: (416)927-1676. E-mail: john@w arne.com. Website: www.warne.com. **Contact:** John Coljee, studio manager. Estab. 1979. Ad agency. Types of clients: business-to-business.
Needs Works with 4 photographers/month. Uses photos for trade magazines, direct mail, Internet, P-O-P displays, catalogs and posters. Subjects include: business concepts, science, technology/computers, in-plant photography and studio set-ups. Special subject needs include in-plant shots. Model release required.
Audiovisual Needs Uses PowerPoint and videotape.
Specs Uses digital images or transparencies.
Making Contact & Terms Send letter citing related experience plus 2 or 3 samples. Works on assignment only. Cannot return material. Responds in 2 weeks. Pays $1,000-1,500/day. Pays within 30 days. Buys all rights.
Tips In portfolio/samples, prefers to see industrial subjects and creative styles. "We look for lighting knowledge, composition and imagination."

Galleries

The popularity of photography as a collectible art form has improved the market for fine art photographs over the last decade. Collectors now recognize the investment value of prints by Ansel Adams, Irving Penn and Henri Cartier-Bresson, and therefore frequently turn to galleries for photographs to place in their private collections.

The gallery/fine art market can make money for many photographers. However, unlike commercial and editorial markets, galleries seldom generate quick income for artists. Galleries should be considered venues for important, thought-provoking imagery, rather than markets through which you can make a substantial living.

More than any other market, this area is filled with photographers who are interested in delivering a message. Many photography exhibits focus on one theme by a single artist. Group exhibits feature the work of several artists, and they often explore a theme from many perspectives, though not always. These group exhibits may be juried (i.e., the photographs in the exhibit were selected by a committee of judges who are knowledgeable about photography). Some group exhibits may also include other mediums such as painting, drawing, or sculpture. In any case, galleries want artists who can excite viewers and make them think about important subjects. They, of course, also hope that viewers will buy the photographs shown in their galleries.

As with picture buyers and art directors, gallery directors love to see strong, well-organized portfolios. Limit your portfolio to 20 top-notch images. When putting together your portfolio, focus on one overriding theme. A director wants to be certain you have enough quality work to carry an entire show. After the portfolio review, if the director likes your style, then you might discuss future projects or past work that you've done. Directors who see promise in your work, but don't think you're ready for a solo exhibition, may place your photographs in a group exhibition.

HOW GALLERIES OPERATE

In exchange for brokering images, a gallery often receives a commission of 40-50 percent. They usually exhibit work for a month, sometimes longer, and hold openings to kick off new shows. And they frequently provide pre-exhibition publicity. Some smaller galleries require exhibiting photographers to help with opening night reception expenses. Galleries also may require photographers to appear during the show or opening. Be certain that such policies are put in writing before you allow them to show your work.

Gallery directors who foresee a bright future for you might want exclusive rights to represent your work. This type of arrangement forces buyers to get your images directly from the gallery that represents you. Such contracts are quite common, usually limiting the exclusive

rights to specified distances. For example, a gallery in Tulsa, Oklahoma, may have exclusive rights to distribute your work within a 200-mile radius of the gallery. This would allow you to sign similar contracts with galleries outside the 200-mile range.

FIND THE RIGHT FIT

As you search for the perfect gallery, it's important to understand the different types of exhibition spaces and how they operate. The route you choose depends on your needs, the type of work you do, your long-term goals, and the audience you're trying to reach. (The following descriptions were provided by the editor of *Artist's & Graphic Designer's Market*.)

- **Retail or commercial galleries.** The goal of the retail gallery is to sell and promote artists while turning a profit. Retail galleries take a commission of 40-50 percent of all sales.
- **Co-op galleries.** Co-ops exist to sell and promote artists' work, but they are run by artists. Members exhibit their own work in exchange for a fee, which covers the gallery's overhead. Some co-ops also take a commission of 20-30 percent to cover expenses. Members share the responsibilities of gallery-sitting, sales, housekeeping and maintenance.
- **Rental galleries.** The rental gallery makes its profit primarily through renting space to artists and consequently may not take a commission on sales (or will take only a very small commission). Some rental spaces provide publicity for artists, while others do not. Showing in this type of gallery is risky. Rental galleries are sometimes thought of as "vanity galleries" and, consequently, they do not have the credibility other galleries enjoy.
- **Nonprofit galleries.** Nonprofit spaces will provide you with an opportunity to sell work and gain publicity, but will not market your work agressively, because their goals are not necessarily sales-oriented. Nonprofits normally take a commission of 20-30 percent.
- **Museums.** Don't approach museums unless you have already exhibited in galleries. The work in museums is by established artists and is usually donated by collectors or purchased through art dealers.
- **Art consultancies.** Generally, art consultants act as liaisons between fine artists and buyers. Most take a commission on sales (as would a gallery). Some maintain small gallery spaces and show work to clients by appointment.

If you've never exhibited your work in a traditional gallery space before, you may want to start with a less traditional kind of show. Alternative spaces are becoming a viable way to help the public see your work. Try bookstores (even large chains), restaurants, coffee shops, upscale home furnishings stores and boutiques. The art will help give their business a more pleasant, interesting environment at no cost to them, and you may generate a few fans or even a few sales.

Think carefully about what you take pictures of and what kinds of businesses might benefit from displaying them. If you shoot flowers and other plant life, perhaps you could approach a nursery about hanging your work in their sales office. If you shoot landscapes of exotic locations, maybe a travel agent would like to take you on. Think creatively and don't be afraid to approach a business person with a proposal. Just make sure the final agreement is spelled out in writing so there will be no misunderstandings, especially about who gets what money from sales.

COMPOSING AN ARTIST'S STATEMENT

When you approach a gallery about a solo exhibition, they will usually expect your body of work to be organized around a theme. To present your work and its theme to the public, the

gallery will expect you to write an artist's statement, a brief essay about how and why you make photographic images. There are several things to keep in mind when writing your statement:

1. Be brief. Most statements should be 100-300 words long. You shouldn't try to tell your life's story leading up to this moment.
2. Write as you speak. There is no reason to make up complicated motivations for your work if there aren't any. Just be honest about why you shoot the way you do.
3. Stay focused. Limit your thoughts to those that deal directly with the specific exhibit for which you're preparing.

Before you start writing your statement, consider your answers to the following questions:

1. Why do you make photographs (as opposed to using some other medium)?
2. What are your photographs about?
3. What are the subjects in your photographs?
4. What are you trying to communicate through your work?

ⓝ A.R.C. GALLERY

734 N. Milwaukee Ave., Chicago IL 60622. (312)733-2787. **Contact:** Carolyne King. Estab. 1973. Sponsors 5-8 exhibits/year. Average display time 1 month. Overall price range $100-1,200.
Exhibits Must send slides, résumé and statement to gallery for review. All styles considered. Contemporary fine art photography, documentary and journalism.
Making Contact & Terms Charges no commission.
Submissions Send material by mail for consideration; include SASE. Reviews transparencies. Responds in 1 month.
Tips Photographers "should have a consistent body of work. Show emerging and experimental work."

ADDISON/RIPLEY FINE ART

1670 Wisconsin Ave. NW, Washington DC 20007. (202)338-5180. Fax: (202)338-2341. E-mail: addisonrip@aol.com. Website: www.addisonripleyfineart.com. **Contact:** Christopher Addison, owner. Art consultancy, for-profit gallery. Estab. 1981. Approached by 100 artists/year; represents or exhibits 25 artists. Average display time 6 weeks. Gallery open Tuesday through Saturday from 11 to 6. Closed end of summer. Located in Georgetown in a large, open, light-filled gallery space. Overall price range $500-80,000. Most work sold at $2,500-10,000.
Exhibits Exhibits works of all media.
Making Contact & Terms Gallery provides insurance, promotion, contract. Accepted work should be framed, mounted, matted.
Submissions Mail portfolio for review. Send query letter with artist's statement, bio, photocopies, résumé, SASE. Responds in 1 month.
Tips "Submit organized, professional-looking materials."

ADIRONDACK LAKES CENTER FOR THE ARTS

Rt. 28, P.O. Box 205, Blue Mt. Lake NY 12812. (518)352-7715. Fax: (518)352-7333. E-mail: alca@telenet.net. **Contact:** Anisia Kelly, program director. Estab. 1967. Sponsors 15-20 exhibits/year. Average display time 1 month. Overall price range $100-2,000. Most work sold at $250.
Exhibits Exhibits photos of babies/children/teens, celebrities, couples, multicultural, families, parents, senior citizens, disasters, environmental, landscapes/scenics, wildlife, architecture, education, gardening, interiors/decorating, pets, religious, rural, adventure, automobiles, entertainment, events, food/drink, health/fitness, hobbies, humor, performing arts, sports, travel. Interested in contemporary Adirondack, nature photography, alternative process, avant garde, documentary, fashion/glamour, fine art, historical/vintage, seasonal.
Making Contact & Terms Charges 30% commission. "Pricing is determined by photographer. Payment made to photographer at end of exhibit." Accepted work should be framed, matted.
Submissions Send résumé, artist's statement, slides/photos. Deadline is first Monday in November.
Tips "Our gallery is open during all events taking place at the Arts Center, including concerts, films, workshops and theater productions. Guests for these events are often customers seeking images from our gallery

for their own collections or their places of business. Customers are often vacationers who have come to enjoy the natural beauty of the Adirondacks. For this reason, landscape and nature art sells well here.''

◪ AGORA GALLERY

415 W. Broadway, Suite 5S, New York NY 10012. (212)226-4151. Fax: (212)966-4380. E-mail: info@agora-gallery.com. Website: www.Agora-Gallery.com. **Contact:** Angela DiBello, director. For-profit gallery. Estab. 1984. Approached by 1,500 artists/year; represents or exhibits 100 artists. Sponsors 10 exhibits/year. Average display time 3 weeks. Gallery open Tuesday through Saturday from 12 to 6. Closed national holidays. Located in Soho between Prince and Spring; 2,000 sq. ft. of exhibition space, landmark building; elevator to gallery, exclusive gallery block. Also a location at 530 W. 25th St., 2nd Floor, New York NY 10001. Overall price range $550-10,000. Most work sold at $3,500-6,500.

Exhibits Interested in fine art.

Making Contact & Terms There is a representation fee. There is a 30% commission. Gallery provides insurance, promotion.

Submissions "Mail portfolio for review or upload to our website." See website for portfolio submission form if mailing a portfolio. Send artist's statement, bio, brochure, photographs, reviews if available, SASE. Responds in 3 weeks. Finds artists through word of mouth, submissions, portfolio reviews, art exhibits, referrals by other artists, website links.

Tips "Follow instructions!"

⊘ AKRON ART MUSEUM

70 E. Market St., Akron OH 44308. (330)376-9185. Fax: (330)376-1180. E-mail: mail@akronartmuseum.org. Website: www.akronartmuseum.org. **Contact:** Barbara Tannenbaum, chief curator. **"The Akron Art Museum is currently closed for expansion and will reopen in 2006."**

- This museum annually awards the Knight Purchase Award to a living artist working with photographic media.

Exhibits To exhibit, photographers must possess "a notable record of exhibitions, inclusion in publications, and/or a role in the historical development of photography. We also feature area photographers (northeast Ohio)." Interested in innovative works by contemporary photographers; any subject matter. Interested in alternative process, documentary, fine art, historical/vintage.

Making Contact & Terms Payment negotiable. Buys photography outright.

Submissions Will review slides, CD-ROMs and transparencies. Send material by mail with SASE for consideration. Responds in 2 months, "depending on our workload."

Tips "Prepare a professional-looking packet of materials including high-quality slides, and always send a SASE. Never send original prints."

ALASKA STATE MUSEUM

395 Whittier, Juneau AK 99801-1718. (907)465-2901. Fax: (907)465-2976. E-mail: bruce_kato@eed.state.ak.us. Website: www.museums.state.ak.us. **Contact:** Bruce Kato, chief curator. Museum. Estab. 1900. Approached by 40 artists/year. Sponsors 1 photography exhibit every 2 years. Average display time 10 weeks. Downtown location—3 galleries.

Exhibits Interested in historical and fine art.

Submissions Finds artists through portfolio reviews.

ALBANY CENTER GALLERIES

161 Washington Ave., Albany NY 12210. (518)462-4775. E-mail: albanycg1@capital.net. **Contact:** Sarah Martinez, executive director. Estab. 1977. Sponsors 1 exhibit/year. Show lasts 6 weeks. Sponsors opening; provides refreshments and hors d'oeuvres. Overall price range $100-1,000.

Exhibits Photographer must live within 75 miles of Albany for regular exhibit and within 100 miles for Photography Regional, which is held at the Albany Center Galleries on a rotating basis. Interested in all subjects.

Making Contact & Terms Charges 35% commission. Reviews transparencies. "Work must be framed and ready to hang." Send material by mail with SASE for consideration.

◪ THE ALBUQUERQUE MUSEUM OF ART & HISTORY

2000 Mountain Rd. NW, Albuquerque NM 87104. (505)243-7255. Fax: (505)764-6546. **Contact:** Douglas Fairchild, curator of art. Estab. 1967. Sponsors 5-7 exhibits/year. Average duration of exhibits 3-4 months.

Exhibits Considers art, historical and documentary photography for exhibition and purchase.
Submissions Submit portfolio of slides, photos, or disk for review. Responds in 2 months. Art related to Albuquerque, the state of NM, and the Southwest.

Ⓝ AMERICAN PRINT ALLIANCE

302 Larkspur Turn, Peachtree City GA 30269-2210. E-mail: director@printalliance.org. Website: www.printal liance.org. **Contact:** Carol Pulin, director. Nonprofit arts organization with online gallery and exhibitions, travelling exhibitions, and journal publication. Print Bin: a place on website that is like the unframed, shrink-wrapped prints in a bricks-and-mortar gallery's "print bin." Estab. 1992. Approached by hundreds of artists/year; represents dozens of artists/year. "We only exhibit original prints, artists' books and paperworks. Usually sponsors 2 travelling exhibits/year—all prints, paperworks and artists' books; photography within printmaking processes but not as a separate medium. Most exhibits travel for 2 years. Hours depend on the host gallery/museum/arts center. "We travel exhibits coast to coast and occasionally to Hawaii." Overall price range for Print Bin: $150-3,200; most work sold at $300-500.
Exhibits "We accept all styles, genres and subjects; the decisions are made on quality of work."
Making Contact & Terms Online gallery cost is $30-35/subscription plus $15 for the first image, $10 each additional image up to 5; Print Bin is free with subscription; subscribers have free entry to juried travelling exhibitions, but must pay for framing, shipping to and from our office. Gallery provides promotion.
Submissions Subscribe to journal, *Contemporary Impressions* (direct page is www.printalliance.org/alliance/al_subform.html), send one slide and signed permission form (see www.printalliance.org/gallery/printbin_info.html). Returns slide if requested with SASE. Usually does not respond to queries from non-subscribers. Files slides and permission forms. Finds artists through submissions to the gallery or Print Bin, and especially portfolio reviews at printmakers conferences. "Unfortunately, we don't have the staff for individual portfolio reviews, though we may—and often do—request additional images after seeing one work, often for journal articles. Generally about 100 images are reproduced per year in the journal."
Tips "See the Standard Forms area of our website (www.printalliance.org/library/li_forms.html) for correct labels on slides and much, much more about professional presentation."

AMERICAN SOCIETY OF ARTISTS, INC.

Box 1326, Palatine IL 60078. (847)991-4748 or (312)751-2500. E-mail: asoa@webtv.net. Website: www.ameri cansocietyofartists.org. **Contact:** Helen Del Valle, membership chairman.
Exhibits Members and nonmembers may exhibit. "Our members range from internationally known artists to unknown artists—quality of work is the important factor. We have about 25 shows throughout the year that accept photographic art."
Making Contact & Terms Accepted work should be framed, mounted or matted.
Submissions Send SASE and 5 slides/photos representative of your work, and request membership information and application. Responds in 2 weeks. Accepted members may participate in lecture and demonstration service. Member publication: *ASA Artisan.*

ARIZONA STATE UNIVERSITY ART MUSEUM

P.O. Box 872911, Tempe AZ 85287-2911. (480)965-2787. Fax: (480)965-5254. E-mail: asuartmusem@asu.e du. Website: http://asuartmuseum.asu.edu. **Contact:** Marilyn Zeitlin, director. Estab. 1950. The ASU Art Museum has 2 facilities and approximately 8 galleries of 2,500 square feet each; mounts over 20 exhibitions/year. Average display time 2-3 months.
Exhibits Work must be approved by curatorial staff as meeting museum criteria.
Making Contact & Terms Accepted work should be framed, mounted, matted.
Submissions Send query letter with samples and SASE. Responds "depending on when we can review work."

Ⓝ THE ART DIRECTORS CLUB

106 W. 29th St., New York NY 10001. (212)643-1440. Fax: (212)643-4266. E-mail: classifieds@adcglobal.org. Website: www.adcglobal.org. **Contact:** Myrna Davis, executive director. Estab. 1920. Sponsors 8-10 exhibits/year. Average display time 1 month.
Exhibits Exhibits photos of babies/children/teens, celebrities, couples, multicultural, families, parents, senior citizens, disasters, environmental, landscapes/scenics, wildlife, architecture, cities/urban, education, gardening, interiors/decorating, pets, religious, rural, adventure, automobiles, entertainment, events, food/drink, health/fitness/beauty, hobbies, humor, performing arts, sports, travel, agriculture, business concepts, industry, medicine, military, political, product shots/still life, science, technology/computers. Interested in

alternative process, avant garde, documentary, erotic, fashion, glamour, fine art, historical/vintage, seasonal. Must be a group show with theme and sponsorship. Interested in work for advertising, publication design, graphic design, new media.

Submissions Send query letter with samples. Cannot return material. Responds depending on review committee's schedule.

Ⓝ ART FORMS

16 Monmouth St., Red Bank NJ 07701. (732)530-4330. Fax: (732)530-9791. E-mail: artforms99@aol.com. **Contact:** Charlotte T. Scherer, director. Estab. 1985. Photography is exhibited all year long. Average display time 6 weeks. Overall price range $250-1,500.

Exhibits Work must be original. Interested in alternative process, avant garde, erotic, fine art.

Making Contact & Terms Charges 50% commission. Accepted work can be framed or unframed, mounted or unmounted, matted or unmatted. Requires exclusive representation locally.

Submissions Send query letter with samples, SASE. Responds in 1 month.

▣ 🖼 ART SOURCE L.A., INC.

West Coast office: 2801 Ocean Park Blvd., PMB 7, Santa Monica CA 90405. (310)452-4411. Fax: (310)452-0300. E-mail: info@artsourcela.com. Website: www.artsourcela.com. East Coast office: 12001 Montrose Park Place, North Bethesda MD 20852. (301)230-0023. Fax. (301)230-0025. E-mail: bonniek@artsourcela.com. **Contact:** Francine Ellman, president. Estab. 1980. Exhibitions vary. Overall price range $300-15,000. Most work sold at $1,000.

Exhibits Exhibits photos of multiculturual, environmental, landscapes/scenics, wildlife, architecture, cities/urban, gardening, interiors/decorating, rural, automobiles, food/drink, travel, technology/computers. Interes ted in alternative process, avant garde, fine art, historical/vintage, seasonal. "We do projects worldwide, putting together fine art for public spaces, hotels, restaurants, corporations, government, private collections." Interested in all types of quality work. "We use a lot of photography."

Making Contact & Terms Interested in receiving work from emerging and established photographers. Charges 50% commission. Accepted work should be mounted or matted.

Submissions Send a minimum of 20 slides, photographs or inkjet prints (laser copies not acceptable), clearly labeled with name, title and date of work; plus catalogs, brochures, résumé, price list, SASE. Responds in 2 months.

Tips "Show a consistent body of work, well marked and presented so it may be viewed to see its merits."

ART WITHOUT WALLS, INC.

P.O. Box 341, Sayville NY 11782. (631)567-9418. Fax: (631)567-9418. E-mail: artwithoutwalls@webtv.net. **Contact:** Sharon Lippman, executive director. Nonprofit gallery. Estab. 1985. Approached by 300 artists/year; represents or exhibits 100 artists. Sponsors 3 photography exhibits/year. Average display time 1 month. Gallery open daily from 9 to 5. Closed December 22 to January 5 and Easter week. Traveling exhibits in various public spaces. Overall price range $1,000-25,000. Most work sold at $3,000-5,000. "Price varies—especially if student work."

Exhibits Exhibits photos of celebrities, multicultural, families, parents, senior citizens, disasters, environmental, landscapes/scenics, wildlife, architecture, cities/urban, education, gardening, interiors/decorating, pets, rural, adventure, automobiles, entertainment, events, food/drink, health/fitness/beauty, hobbies, humor, performing arts, sports, travel, agriculture, medicine, political, product shots/still life, science, technology/computers. Interested in alternative process, avant garde, documentary, fashion/glamour, fine art, historical/vintage, seasonal.

Making Contact & Terms Artwork is accepted on consignment, and there is a 20% commission. Gallery provides promotion, contract. Accepted work should be framed, mounted, matted.

Submissions Mail portfolio for review. Send query letter with artist's statement, brochure, photographs, résumé, reviews, SASE, slides. Responds in 1 month. Finds artists through submissions, portfolio reviews, art exhibits.

Tips "Work should be properly framed with name, year, medium, title, size."

▣ 🌐 ART@NET INTERNATIONAL GALLERY

(617)495-7451 or (35)(989)844-8132. Fax: (35)(92)851-2838. E-mail: artnetg@yahoo.com. Website: www.de signbg.com. **Contact:** Yavor Shopov, director. For-profit Internet gallery. Estab. 1998. Approached by 100 artists/year; represents or exhibits 20 artists. Sponsors 5 photography exhibits/year. Display time permanent.

"Our gallery exists only on the Internet. Each artist has individual 'exhibition space' divided into separate thematic exhibitions along with bio and statement. Overall price range $150-55,000.

Exhibits Exhibits photos of multicultural, landscapes/scenics, wildlife, architecture, cities/urban, education, adventure, beauty, sports, travel, science, buildings. Interested in avant garde, erotic, fashion/glamour, fine art, seasonal.

Making Contact & Terms Artwork is accepted on consignment; there is a 10% commission and a rental fee for space of $1/image per month or $5/image per year. First 6 images are displayed free of rental fee. Gallery provides promotion. Accepted work should be matted.

Submission "We accept computer scans only; no slides, please. E-mail us attached scans, 900 × 1200 px (300 dpi for prints or 900 dpi for 36mm slides), as JPEG files for IBM computers." E-mail query letter with artist's statement, bio, résumé. Responds in 6 weeks. Finds artists through submissions, portfolio reviews, art exhibits, art fairs, referrals by other artists.

Tips "E-mail us a tightly edited selection of less than 20 scans of your best work. All work must force any person to look over it again and again. Main usage of all works exhibited in our gallery is for limited edition (photos) or original (paintings) wall decoration of offices and homes, so photos must have quality of paintings. We like to see strong artistic sense of mood, composition, light, color and strong graphic impact or expression of emotions. For us, only quality of work is important, so newer, lesser-known artists are welcome."

ARTLINK

437 E. Berry St., Suite 202, Fort Wayne IN 46802. (260)424-7195. Fax: (260)424-8453. E-mail: artlinkfw@juno. com. Website: http://artlinkfw.com. **Contact:** Betty Fishman, executive director. Nonprofit gallery. Estab. 1979. Approached by 300 artists/year. Sponsors 1 photography exhibit/year. Average display time 6 weeks. Gallery open Tuesday through Saturday from 12 to 5; Friday and Saturday evenings from 6 to 9; Sundays from 1 to 5. Located 2 blocks from downtown Fort Wayne. Overall price range $100-2,000. Most work sold at $250.

Making Contact & Terms Artwork is accepted on consignment, and there is a 35% commission. Gallery provides insurance. Accepted work should be framed.

Submissions Write to arrange an interview to show portfolio of slides. Mail portfolio for review. Send query letter with artist's statement, slides, SASE. Responds in 1 month. Finds artists through submissions, portfolio reviews, referrals by other artists.

ARTS IOWA CITY

129 E. Washington St., Suite 1, Iowa City IA 52245-3925. (319)337-7447. E-mail: members@artsiowacity.c om. Website: www.artsiowacity.com. **Contact:** LaDonna Wicklund, president. Nonprofit gallery. Estab. 1975. Approached by more than 65 artists/year; represents or exhibits more than 30 artists. Average display time 1 month. Mail gallery open limited hours; Saturdays 12 to 4. Several locations open during business hours include: AIC Jefferson Center & Gallery—129 E. Washington St.; satellite galleries at Starbucks Downtown, Salon Studios, Melrose Meadows, and other varying locations. Overall price range: $200-6,000. Most work sold at $500.

Exhibits Exhibits photos of landscapes/scenics, architecture, cities/urban, rural. Interested in fine art.

Making Contact & Terms Artwork is accepted on consignment and there is a 50% commission. Gallery provides insurance (in gallery, not during transit to/from gallery), promotion and contract. Accepted work should be framed, mounted and matted. "We represent artists who are members of Arts Iowa City; to be a member, one must pay a membership fee. Most members are from Iowa and surrounding states."

Submissions Call or write to arrange personal interview to show portfolio of photographs, slides and transparencies. Send query letter with artist's statement, bio, brochure, business card, photographs, résumé, reviews, slides and SASE. Responds to queries in 1 month. Finds artists through referrals by other artists, submissions and word of mouth.

Tips "We are a nonprofit gallery with limited staff. Most work is done by volunteers. Artists interested in submitting work should visit our website to gain a better understanding of the services we provide and to obtain membership and show proposal information. Please submit applications according to the guidelines on the website."

ARTS ON DOUGLAS

123 Douglas St., New Smyrna Beach FL 32168. (386)428-1133. Fax: (386)428-5008. Website: www.artsondou glas.net. **Contact:** Meghan Martin, gallery manager. For-profit gallery. Estab. 1996. Represents 57 Florida

artists and exhibits 8 artists/year. Average display time 1 month. Gallery open Tuesday through Friday from 11 to 6; Saturday from 10 to 2; by appointment. Located in 5,000 sq. ft. of exhibition space. Overall price range varies.

Exhibits Exhibits photos of environmental. Interested in alternative process, documentary, fine art.

Making Contact & Terms Artwork is accepted on consignment, and there is a 50% commission. Gallery provides insurance, promotion. Accepted work should be framed. Requires exclusive representation locally. Accepts only professional artists from Florida.

Submissions Call in advance to inquire about submissions/reviews. Send query letter with artist's statement, bio, brochure, résumé, reviews, slides, SASE. Finds artists through referrals by other artists.

ARTWORKS GALLERY

233 Pearl St., Hartford CT 06103. (860)247-3522. Fax: (860)548-0779. E-mail: info@artworksgallery.org. Website: www.artworksgallery.org. **Contact:** Diane Legere, executive director. Estab. 1976. Average display time 1 month. Overall price range $100-5,000. Most work sold at $500-800.

Exhibits Exhibits photos of disasters, environmental, landscapes/scenics, wildlife. Interested in contemporary work, alternative process, avant garde, documentary, erotic, fine art. "We have juried shows; members must be voted in after interview."

Making Contact & Terms There is a co-op membership fee plus a donation of time. There is a 30% commission.

Submissions Send for membership application. Include SASE. Responds in 1 month.

Tips "The more energy and equipment you put into the gallery, the more you get out of it. It's a great place to network and establish yourself."

ASIAN AMERICAN ARTS CENTRE

26 Bowery, 3rd Floor, New York NY 10013. (212)233-2154. E-mail: aaac@artspiral.org. Website: www.artspiral.org. **Contact:** Robert Lee, director. Estab. 1974. Average display time 6 weeks.

Exhibits Should be Asian American or significantly influenced by Asian culture and should be entered into the archive—a historical record of the presence of Asia in the US. Interested in "creative art pieces."

Making Contact & Terms Requests 30% "donation" on works sold. Sometimes buys photos outright.

Submissions To be considered, send dupes of slides, résumé, artist's statement, bio and online from to be entered into the archive. These will be kept for users of archive to review. Recent entries are reviewed once/year for the Art Centre's annual exhibition.

☒ ATLANTIC GALLERY

40 Wooster St., 4th Floor, New York NY 10013. (212)219-3183. Website: www.atlanticgallery.org. Cooperative gallery. Estab. 1974. Approached by 50 artists/year; represents or exhibits 40 artists. Average display time 3 weeks. Gallery open Tuesday through Saturday from 12 to 6. Closed August. Located in Soho. Overall price range $100-13,000. Most work sold at $1,500-5,000.

Exhibits Exhibits photos of multicultural, families, environmental, landscapes/scenics, wildlife, architecture, cities/urban, rural, performing arts, travel, product shots/still life, technology/computers. Interested in fine art.

Making Contact & Terms There is a co-op membership fee plus a donation of time. Accepts mostly artists from New York, Connecticut, Massachusetts, New Jersey.

Submissions Call or write to arrange a personal interview to show portfolio of slides. Send artist's statement, bio, brochure, SASE, slides. Responds in 1 month. Views slides monthly. Finds artists through word of mouth, submissions, art exhibits, referrals by other artists.

Tips "Submit an organized folder with slides, bio, and 3 pieces of actual work. If we respond with interest, we then review again."

AXIS GALLERY

453 W. 17th St., New York NY 10011. (212)741-2582. E-mail: axisgallery@aol.com. Website: www.axisgallery.com. **Contact:** Lisa Brittan, director. For-profit gallery. Estab. 1997. Approached by 40 African artists/year; represents or exhibits 30 artists. Gallery open Tuesday through Saturday from 11 to 6. Closed during summer. Located in Chelsea, 1,600 sq. ft. Overall price range $500-3,000.

Exhibits Interested in alternative process, avant garde, documentary, erotic, fine art, historical/vintage. Also interested in photojournalism, resistance.

Making Contact & Terms Artwork is accepted on consignment, and there is a 50% commission. Gallery provides insurance, promotion, contract. Accepts only artists from southern Africa.

Submissions Send query letter with photographs, résumé, reviews, SASE, slides. Responds in 3 months. Finds artists through word of mouth, submissions, portfolio reviews, art exhibits, referrals by other artists.

Tips "Send letter with SASE and materials listed above. Photographers should research galleries first to check if their work fits the gallery program. Avoid bulk mailings."

N BALZEKAS MUSEUM OF LITHUANIAN CULTURE ART GALLERY

6500 S. Pulaski Rd., Chicago IL 60629. (773)582-6500. Fax: (773)582-5133. Museum, museum retail shop, nonprofit gallery, rental gallery. Estab. 1966. Approached by 20 artists/year. Sponsors 2 photography exhibits/year. Average display time 6 weeks. Gallery open 7 days a week. Closed holidays. Overall price range $150-6,000. Most work sold at $545.

Exhibits Exhibits photos of babies/children/teens, celebrities, couples, multicultural, families, parents, senior citizens, disasters, environmental, landscapes/scenics, wildlife, architecture, cities/urban, education, gardening, interiors/decorating, pets, religious, rural, adventure, automobiles, entertainment, events, food/drink, health/fitness, hobbies, humor, performing arts, sports, travel, agriculture, buildings, business concepts, industry, medicine, military, political, product shots/still life, science, technology/computers. Interested in alternative process, avant garde, documentary, erotic, fashion/glamour, fine art, historical/vintage, seasonal.

Making Contact & Terms Artwork is accepted on consignment, and there is a 33½% commission. Gallery provides promotion. Accepted work should be framed.

Submissions Write to arrange personal interview to show portfolio. Responds in 2 months. Finds artists through word of mouth, art exhibits, referrals by other artists.

N BARRON ARTS CENTER

582 Rahway Ave., Woodbridge NJ 07095. (732)634-0413. Fax: (732)634-8633. **Contact:** Cynthia A. Knight, director. Estab. 1975. Overall price range $150-400. Most work sold at $175.

Making Contact & Terms Photography sold in gallery. Gallery takes 20% commission.

Submissions Reviews transparencies but prefers portfolio. Submit portfolio for review; include SASE for return. Responds "depending upon date of review, but generally within a month of receiving materials."

Tips "Make a professional presentation of work with all pieces matted or treated in a like manner. In terms of the market, we tend to hear that there are not enough galleries that will exhibit photography."

BELL STUDIO

3428 N. Southport Ave., Chicago IL 60657. Website: www.bellstudio.net. **Contact:** Paul Therieau, director. For-profit gallery. Estab. 2001. Approached by 60 artists/year; represents or exhibits 10 artists. Sponsors 3 photography exhibits/year. Average display time 6 weeks. Open all year; Monday through Friday from 12 to 7; weekends from 12 to 5. Located in brick storefront; 750 sq. ft. of exhibition space; high traffic. Overall price range: $150-3,500. Most work sold at $600.

Exhibits Interested in alternative process, avant garde, fine art.

Making Contact & Terms Artwork is accepted on consignment, and there is a 50% commission. Gallery provides insurance, promotion, contract. Accepted work should be framed. Requires exclusive representation locally.

Submissions Write to arrange personal interview to show portfolio; include bio and résumé. Responds to queries only if interested within 3 months. Finds artists through referrals by other artists, submissions, word of mouth.

Tips "Send SASE; type submission letter; include show history, résumé."

BENHAM STUDIO GALLERY

1216 First Ave., Seattle WA 98101. (206)622-2480. Fax: (206)622-6383. Website: www.benhamgallery.com. **Contact:** Marita Holdaway, owner. Estab. 1987. Sponsors 9 exhibits/year. Average display time 6 weeks. Overall price range $250-9,750. Most work sold at $500.

Exhibits Exhibits photos of multicultural, environmental, landscapes/scenics, architecture, cities/urban, religious, rural, humor. Interested in alternative process, avant garde, documentary, fine art.

Making Contact & Terms Submission guidelines available on website. Charges 50% commission.

Tips "Present 15-20 pieces of cohesive work in an easy to handle portfolio."

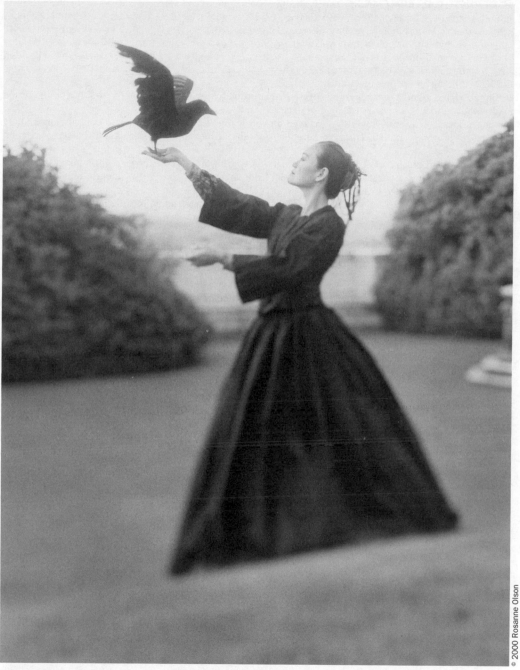

Rosanne Olson's "Equipoise" was exhibited by Benham Studio Gallery in Seattle. "This image was made for use in a poster for a theater production of *Jane Eyre*. It became the first in a series of photographs using the blackbird motif," says Olson.

N BENNETT GALLERIES AND COMPANY

5308 Kingston Pike, Knoxville TN 37919. (865)584-6791. Fax: (865)588-6130. Website: www.bennettgalleries .com. **Contact:** Marga Ingram, gallery director. For-profit gallery. Estab. 1985. Represents or exhibits 40 artists/year. Sponsors 1-2 photography exhibits/year. Average display time 1 month. Gallery open Monday through Saturday from 10 to 5:30. Conveniently located a few miles from downtown Knoxville in the Bearden area. The formal art gallery has over 2,000 sq. ft. and 20,000 sq. ft. of additional space. Overall price range $100-12,000. Most work sold at $400-600.

Exhibits Exhibits photos of landscapes/scenics, architecture, cities/urban, humor, sports, travel. Interested in alternative process, fine art, historical/vintage.

Making Contact & Terms Artwork is accepted on consignment, and there is a 50% commission. Gallery provides insurance, promotion, contract. Accepted work should be framed. Requires exclusive representation locally.

Submissions Mail portfolio for review. Send query letter with artist's statement, bio, photographs, SASE, CD. Responds only if interested within 1 month. Finds artists through word of mouth, submissions, art exhibits, referrals by other artists.

Tips "When submitting material to a gallery for review, the package should include information about the artist, neatly written or typed, photographic material and SASE if you want your materials back."

N BONNI BENRUBI GALLERY

41 E. 57th St. #13, New York NY 10022-1908. (212)517-3766. Fax: (212)288-7815. E-mail: benrubi@bonniben rubi.com. Website: www.bonnibenrubi.com. **Contact:** Thom Vogel, director. Estab. 1987. Sponsors 7-8 exhibits/year. Average display time 6 weeks. Overall price range $500-50,000.

Exhibits Interested in 19th- and 20th-century photography, mainly contemporary.

Making Contact & Terms Charges commission. Buys photos outright. Accepted work should be matted. Requires exclusive representation locally. No manipulated work.

Submissions Submit portfolio for review; include SASE. Responds in 2 weeks. "Portfolio review is the first Thursday of every month. Out-of-towners can send slides with SASE, and work will be returned."

N BERKSHIRE ARTISANS GALLERY

Lichtenstein Center for the Arts, 28 Renne Ave., Pittsfield MA 01201. (413)499-9348. Fax: (413)442-8043. E-mail: mwhilden@pittsfieldch.com. Website: www.pittsfield.com/artsculture.asp. **Contact:** Megan Whilden, artistic director. Estab. 1975. Sponsors 10 exhibits/year. Gallery open Wednesday through Saturday from 12 to 5. Overall price range $50-1,500.

Exhibits Professionalism in portfolio presentation, professionalism in printing photographs, professionalism.

Making Contact & Terms Charges 20% commission for sales. Will review transparencies of photographic work. Accepted work should be framed, mounted, matted.

Submissions "Photographer should send SASE with 20 slides or prints, résumé and statement by mail only to gallery."

Tips To break in, "Send portfolio, slides and SASE. We accept all art photography. Work must be professionally presented and framed. Send in by July 1 each year. Expect exhibition 2-3 years from submission date. We have a professional juror look at slide entries once a year (usually July-September). Expect that work to be tied up for 2-3 months in jury."

▣ MONA BERMAN FINE ARTS

78 Lyon St., New Haven CT 06511. (203)562-4720. E-mail: info@MonaBermanFineArts.com. Website: www. MonaBermanFineArts.com. **Contact:** Mona Berman, director. Estab. 1979. Sponsors 0-1 exhibit/year. Average display time 1 month. Overall price range $500-5,000.

●"We are art consultants serving corporations, architects and designers. We also have private clients. We hold very few exhibits; we mainly show work to our clients for consideration and sell a lot of photographs."

Exhibits "Photographers must have been represented by us for over 2 years. Interested in all except figurative, although we do use some portrait work."

Making Contact & Terms Charges 50% commission. "Payment to artist 30 days after receipt of payment from client." Interested in seeing unframed, unmounted, unmatted work only.

Submissions Accepts slides or digital images only. Send JPEGs or equivalent. Inquire about file format first via e-mail; "No calls, please." Submit portfolio (35mm slides only) or CD for review, or e-mail JPEGs. Send query letter with résumé, list of retail prices, SASE. Responds in 1 month.

Tips "Looking for new perspectives, new images, new ideas, excellent print quality, ability to print in *very*-large sizes, consistency of vision. Not too interested in digital prints."

N BETTCHER GALLERY-MIAMI

Soyka's 55th Street Station, 5582 NE Fourth Court, Miami FL 33137. (305)758-7556. Fax: (305)758-8297. E-mail: bettcher@aol.com. Website: www.bettchergallery.com. **Contact:** Cora Bettcher, president/director. Art consultancy; for-profit gallery. Estab. 1995. Approached by 400-500 artists/year; represents 40-50 artists/year. Sponsors 8 total exhibits/year. Average display time 6 weeks. Open Tuesday through Wednesday from 11 to 6; Thursday through Saturday from 1 to 11 p.m. Open all year. Overall price range: $500-50,000; most work sold at $5,000-15,000.

Exhibits Open to all subjects. Interested in various alternative processes.

Making Contact & Terms Retail price of the art set by the existing market (current, most recent exhibit or auction). Gallery provides contract.

Submissions Contact by e-mail. Responds to queries only if interested within 6 months.

Tips "Keep it clean and simple, and include retail prices."

BOOK BEAT GALLERY

26010 Greenfield, Oak Park MI 48237. (248)968-1190. Fax: (248)968-3102. E-mail: cary@thebookbeat.com. Website: www.thebookbeat.com. **Contact:** Cary Loren, director. Estab. 1982. Sponsors 6 exhibits/year. Average display time 6-8 weeks. Overall price range $300-5,000. Most work sold at $600.

Exhibits "Book Beat is a fine art and photography bookstore with a back-room gallery. Our inventory includes vintage work from 19th- to 20th-century rare books, issues of cameraworks, and artist books. Book Beat Gallery is looking for couragous and astonishing image makers. Artists with no boundries and an open mind are welcome to submit one slide sheet with statement, résumé and return postage. We are especially interested in photographers who have published book works or work with originals in the artist book format, and also those who work in 'dead media' and extinct processes."

Submissions Responds in 6 weeks.

BRUNNER GALLERY

215 N. Columbia, Covington LA 70433. (985)893-0444. Fax: (985)893-0070. E-mail: info@brunnergallery.com. Website: www.brunnergallery.com. **Contact:** Susan Brunner, director. For-profit gallery. Estab. 1997. Approached by 400 artists/year; represents or exhibits 45 artists. Sponsors 1 photography exhibit biannually. Average display time 1 month. Gallery open Tuesday through Friday from 10 to 5; Saturday from 1 to 5. Closed major holidays. Located 45 minutes from metropolitan New Orleans. Overall price range $200-10,000. Most work sold at $1,500-3,000.

Exhibits Exhibits photos of environmental, landscapes/scenics, architecture. Interested in avant garde, fine art.

Making Contact & Terms Artwork is accepted on consignment and there is a 50% commission. Artwork is bought outright for 90-100% of retail price; net 30 days. Gallery provides insurance, promotion, contract. Accepted work should be framed. Requires exclusive representation locally.

Submissions Write to arrange a personal interview to show portfolio of photographs, slides. Mail portfolio for review. Send query letter with artist's statement, bio, brochure, business card, photocopies, photographs, résumé, reviews, slides, SASE. Responds in 4 months as committee meets. Finds artists through word of mouth, submissions, portfolio reviews, art exhibits, art fairs.

N BUSINESS OF ART CENTER

513 Manitou Ave., Manitou Springs CO 80829. (719)685-1861. E-mail: businessofartcenter@usa.net. Website: www.passion4art.com/bac. Nonprofit gallery. Estab. 1988. Sponsors 6 photography exhibits/year. Average display time 1 month. Gallery open Tuesday through Saturday from 10 to 6. Shorter winter hours; please call. Overall price range $50-3,000. Most work sold at $300.

Exhibits Exhibits photos of environmental, landscapes/scenics, wildlife, gardening, rural, adventure, health/fitness, performing arts, travel. Interested in alternative process, avant garde, documentary, fashion/glamour, fine art.

Making Contact & Terms Artwork is accepted on consignment, and there is a 40% commission. Gallery provides insurance, promotion, contract. Accepted work should be framed. Accepts only artists from Colorado.

Submissions Write to arrange a personal interview to show portfolio. Send query letter with artist's statement, bio, slides. Finds artists through word of mouth, submissions, portfolio reviews, art exhibits, referrals by other artists.

THE CAMERA OBSCURA GALLERY

1309 Bannock St., Denver CO 80204. (303)623-4059. Fax: (303)623-4059. E-mail: info@CameraObscuraGallery.com. Website: www.CameraObscuraGallery.com. **Contact:** Hal Gould, owner/director. Estab. 1980. Approached by 350 artists/year; represents or exhibits 20 artists. Sponsors 7 photography exhibits/year. Open Tuesday through Saturday from 10 to 6; Sunday from 1 to 5. Overall price range $400-20,000. Most work sold at $600-3,500.

Exhibits Exhibits photos of environmental, landscapes/scenics, wildlife. Interested in fine art.

Making Contact & Terms Charges 50% commission. Write to arrange a personal interview to show portfolio of photographs. Send bio, brochure, résumé, reviews. Responds in 1 month. Finds artists by word of mouth, submissions, portfolio reviews, art exhibits, art fairs, referrals by other artists, reputation.

Tips "To make a professional gallery submission, provide a good representation of your finished work that is of exhibition quality. Slowly but surely we are experiencing a more sophisticated audience. The last few years have shown a tremendous increase in media reporting on photography-related events and personalities, exhibitions, artist profiles and market news."

[N] WILLIAM CAMPBELL CONTEMPORARY ART

4935 Byers Ave., Ft. Worth TX 76107. (817)737-9566. **Contact:** William Campbell, owner/director. Estab. 1974. Sponsors 8-10 exhibits/year. Average display time 5 weeks. Sponsors openings; provides announcements, press releases, installation of work, insurance, cost of exhibition. Overall price range $300-1,500.

Exhibits "Primarily interested in photography which has been altered or manipulated in some form."

Making Contact & Terms Charges 50% commission. Reviews transparencies. Accepted work should be mounted. Requires exclusive representation within metropolitan area.

Submissions Send slides and résumé by mail with SASE. Responds in 1 month.

CAPITOL ARTS ALLIANCE GALLERIES

416 E. Main St., Bowling Green KY 42101. E-mail: gallery@capitolarts.com. Website: www.capitolarts.com. **Contact:** Gallery Director. Nonprofit gallery. Approached by 30-40 artists/year; represents or exhibits 16-20 artists. Sponsors 1-2 photography exhibits/year. Average display time 1 month. Open 9 to 4; closed Christmas through New Year's day. Located adjacent to and in mezzanine of theater featuring chamber orchestra, community theatre and professional touring production.

Exhibits Interested in alternative process, avant garde, documentary, fine art.

Making Contact & Terms Artwork is accepted on consignment, and there is a 25% commission. Gallery provides promotion and contract. Accepted work should be framed. Accepts only artists within a 100-mile radius.

Submissions "Contact Capitol Arts to be added to 'call to artists list.' " Finds artists through submissions and word of mouth.

CAPITOL COMPLEX EXHIBITIONS

Florida Division of Cultural Affairs, Department of State, The Capitol, Tallahassee FL 32399-0250. (850)245-6470. Fax: (850)245-6492. E-mail: amccartney@dos.state.fl.us. Website: www.florida-arts.org. **Contact:** Allison McCartney. Average display time 3 months. Overall price range $200-1,000. Most work sold at $400.

Exhibits Exhibits photos of babies/children/teens, couples, multicultural, families, parents, senior citizens, landscapes/scenics, wildlife, architecture, cities/urban, gardening, adventure, entertainment, performing arts, agriculture. Interested in avant garde, fine art, historical/vintage. "The Capitol Complex Exhibitions Program is designed to showcase Florida artists and art organizations. Exhibition spaces include the Capitol Gallery (22nd floor), the Cabinet Meeting Room, the Old Capitol Gallery, the Secretary of State's Reception Room, the Governor's office and the Florida Supreme Court. Exhibitions are selected based on quality, diversity of medium, and regional representation."

Making Contact & Terms Does not charge commission. Accepted work should be framed.

Submissions Request an application; include SASE. Responds in 3 weeks. Only interested in Florida artists or arts organizations.

CENTER FOR CREATIVE PHOTOGRAPHY

University of Arizona, P.O. Box 210103, Tucson AZ 85721-0103. (520)621-7968. Fax: (520)621-9444. E-mail: oncenter@ccp.library.arizona.edu. Website: www.creativephotography.org. Museum, research center, print viewing, library, museum retail shop. Estab. 1975. Sponsors 6-8 photography exhibits/year. Average display time 3-4 months. Gallery open Monday through Friday from 9 to 5; weekends from 12 to 5. Closed most holidays. 5,500 sq. ft.

CENTER FOR EXPLORATORY AND PERCEPTUAL ART

617 Main St., Suite 201, Buffalo NY 14203. (716)856-2717. Fax: (716)270-0184. E-mail: info@cepagallery.com. Website: www.cepagallery.com. **Contact:** Lawrence Brose, executive director. Estab. 1974. "CEPA is an artist-run space dedicated to presenting photographically based work that is under-represented in traditional cultural institutions." The total gallery space is approximately 6,500 square feet. Sponsors 5-6 exhibits/year. Average display time 6 weeks. Call or see website for hours. Sponsors openings; reception with lecture. Overall price range $200-3,500.

- CEPA conducts an annual Emerging Artist Exhibition for its members. You must join the gallery in order to participate.

Exhibits Interested in political, digital, video, culturally diverse, contemporary and conceptual works. Extremely interested in exhibiting work of newer, lesser-known photographers.

Making Contact & Terms Accepted work should be framed or unframed, mounted or unmounted, matted or unmatted.

Submissions Send query letter with artist's statement, résumé. Accepts images in digital format. Send via CD, floppy disk, Zip as TIFF, PICT files. Include SASE for return of material. Responds in 3 months.

Tips "We review CD-ROM portfolios and encourage digital imagery. We will be showcasing work on our website."

THE CENTER FOR FINE ART PHOTOGRAPHY

The MOCA Building, 201 S. College Ave., Fort Collins CO 80524. (970)224-1010. E-mail: info@c4fap.org. Website: www.c4fap.org. **Contact:** Vered Galor, curator. Nonprofit gallery. Estab. 2005. Approached by 60 artists/year; represents or exhibits 6-8 artists in solo shows; 250-300 in juried group exhibitions. Sponsors 10 juried group exhibits, 6-8 solo exhibits/year. Average display time 4-5 weeks. Open Tuesday through Saturday from 12 to 5. "The gallery is located on the 3rd floor of the Fort Collins MOCA building. It consists of an 850-sq. ft. main gallery (for group exhibits) and a 440-sq. ft. solo gallery. Both galleries are used for annual International Exhibition." Overall price range $180-3,000. Most work sold at $150-500.

Exhibits Exhibits photos of babies/children/teens, celebrities, couples, multicultural, families, parents, senior citizens, architecture, cities/urban, interiors/decorating, rural, political, environmental, landscapes/scenics, wildlife, performing arts. Interested in alternative process, avant garde, documentary, erotic, fine art. "The Center features fine art photography that incorporates all processes, many styles and subjects. Considers all types of prints, traditional, digital and mixed media photography."

Making Contact & Terms Gallery provides insurance. Accepted work should be framed. Artwork is accepted through either juried calls for entry or from portfolio review.

Submissions Write to arrange personal interview to show portfolio of photographs, transparencies, slides. Send query letter with artist's statement, photographs, bio, slides, reviews. Prefers images on CD. Responds only if interested within 1 month. Finds artists through word of mouth, art exhibits, submissions, art fairs, portfolio reviews, referrals by other artists.

Tips "Only archival-quality work is seriously considered by art collectors. This includes both traditional and digital prints. A certificate of archival processing should accompany the work."

CENTER FOR MAINE CONTEMPORARY ART

162 Russell Ave., Rockport ME 04856. (207)236-2875. Fax: (207)236-2490. E-mail: info@artsmaine.org. Website: www.artsmaine.org. **Contact:** Bruce Brown, curator. Estab. 1952. Average display time 5 weeks.

Exhibits Photographer must live and work part of the year in Maine; work should be recent and not previously exhibited in the area.

Making Contact & Terms Charges 40% commission.

Submissions Accepts images in digital format. Send via CD, e-mail. Responds in approximately 2 months.

Tips "A photographer can request receipt of application for biennial juried exhibition, as well as apply for solo or group exhibitions."

CENTER FOR PHOTOGRAPHIC ART

Sunset Cultural Center, San Carlos & Ninth Ave., Suite 1, P.O. Box 1100, Carmel CA 93921. (831)625-5181. Fax: (831)625-5199. E-mail: info@photography.org. Website: www.photography.org. Estab. 1988. Nonprofit gallery. Sponsors 7-8 exhibits/year. Average display time 5-7 weeks.

Exhibits Interested in fine art photography.

Submissions Send query letter with slides, résumé, artist's statement, SASE.

Tips "Submit for exhibition consideration slides or transparencies accompanied by a concise bio and artist's statement."

☐ CENTER FOR PHOTOGRAPHY AT WOODSTOCK

59 Tinker St., Woodstock NY 12498. (845)679-9957. Fax: (845)679-6337. E-mail: info@cpw.org. Website: www.cpw.org. **Contact:** Ariel Shanberg, executive director. Program Director: Kate Menconeri. Alternative space, nonprofit arts and education center. Estab. 1977. Approached by more than 500 artists/year. Hosts 10 photography exhibits/year. Average display time 7 weeks. Gallery open Wednesday through Sunday from 12 to 5 year round.

Exhibits Interested in presenting all aspects of contemporary creative photography including digital media, film, video, and installation by emerging and under-recognized artists. " We host 5 group exhibitions and 5 solo exhibitions annually. Group exhibitions are curated by guest jurors, curators, and CPW staff. Solo exhibition artists are selected by CPW staff. Visit the exhibition archives on our website learn more."

Making Contact & Terms CPW hosts exhibition and opening reception; provides insurance, promotion, a percentage of shipping costs, installation and de-installation, and honoriaum for solo exhibition artists who give gallery talks. "We take 25% commission in exhibition-related sales." Accepted work should be framed and ready for hanging.

Submissions Send introductory letter with samples, résumé, artist's statement, SASE. Responds in 4 months. Finds artists through word of mouth, art exhibits, open calls, portfolio reviews, and referrals by other artists.

Tips "Please send 10-20 slides (labeled with your name, telephone number, image title, image media, size) or JPEGs on CD-ROM. Include a current résumé, statement, SASE for return. We are not responsible for unlabeled slides. We DO NOT welcome solicitations to visit websites. We DO advise artists to visit our website and become familiar with our offerings."

☒ ☐ CENTER GALLERY AT OLD CHURCH

561 Piermont Rd., Demarest NJ 07627. (201)767-7160. Fax: (201)767-0497. E-mail: gallery@occcartschool.org. Website: www.occcartschool.org. **Contact:** Paula Madawick, gallery director. Nonprofit gallery. Estab. 1974. Approached by 20-30 artists/year; 5 time slots available/year for individual, dual or group exhibits. Permanent annual exhibits are faculty, student, NJ Small Works Show, Select Faculty Exhibit, Voices of the World Exhibit, Pottery Show and Sale, and Photography Invitational every other year. Sponsors 12 total exhibits/year with 1 photography exhibit/year. Average display time 1 month. Open Monday through Friday from 9 to 5; call for weekend and evening hours; closed national and some religious holidays. Center Gallery is prominently situated in the front of the Art School at Old Church building, light and with an open feel, configured in an L-shape. Approximately 800 sq. ft. Overall price range: $50-4,000; most work sold at $500.

Exhibits Exhibits babies/children/teens, cities/urban, multicultural, political, still life, landscapes, scenics, wildlife, travel, rural. Interested in alternative process, avant garde, documentary, fine art.

Making Contact & Terms Charges 33⅓% commission. Gallery provides promotion and contract. Accepted work should be framed, mounted.

Submissions Call for information or visit website for submission details; slides and digital images on CD. Send query letter with artist's statement, bio, photographs, résumé, reviews, SASE, slides, CDs. Returns material with SASE. Responds to queries in 2 weeks. Finds artists through referrals by other artists, submissions, word of mouth, solicitations through professional periodicals.

Tips "Follow gallery guidelines available online or through phone contact."

THE CENTRAL BANK GALLERY

Box 1360, Lexington KY 40590. Fax: (606)253-6244. **Contact:** John G. Irvin, curator. Estab. 1987. Sponsors several exhibits/year. Average display time 3 weeks. "We pay for everything—invitations, receptions, and hanging. We give the photographer 100% of the proceeds." Overall price range $75-1,500.

Exhibits Interested in all types of photos. No nudes. Kentucky photographers only.

Making Contact & Terms Charges no commission.

Submissions Send query letter with telephone call. Responds same day.

Tips "We enjoy encouraging artists."

CHAPMAN FRIEDMAN GALLERY

624 W. Main St., Louisville KY 40202. E-mail: friedman@imagesol.com. Website: www.imagesol.com. **Contact:** Julius Friedman, owner. For-profit gallery. Estab. 1992. Approached by 100 or more artists/year. Represents or exhibits 25 artists. Sponsors 1 photography exhibit/year. Average display time 1 month. Open Wednesday through Saturday from 10 to 5. Closed August. Located downtown; approximately 3,500 sq. ft. with 15-foot ceilings and white walls. Overall price range: $75-10,000. Most work sold at more than $1,000.

Exhibits Exhibits photos of landscapes/scenics, architecture. Interested in alternative process, avant garde, erotic, fine art.

Making Contact & Terms Artwork is accepted on consignment, and there is a 50% commission. Gallery provides insurance, promotion and contract. Accepted work should be framed. Requires exclusive representation locally.

Submissions Send query letter with artist's statement, bio, brochure, photographs, résumé, slides and SASE. Responds to queries only if interested within 1 month. Finds artists through portfolio reviews and referrals by other artists.

▣ CLAMPART

531 W. 25th Street, New York NY 10001. E-mail: info@clampart.com. Website: www.clampart.com. **Contact:** Brian Clamp, director. For-profit gallery. Estab. 2000. Approached by 1,200 artists/year; represents or exhibits 15 artists. Sponsors 6 photography exhibits/year. Average display time 2 months. Open Tuesday through Saturday from 11 to 6; closed last 2 weeks of August. Located on the ground floor on Main Street in Chelsea. Small exhibition space. Overall price range: $300-50,000. Most work sold at $2,000.

Exhibits Exhibits photos of couples, disasters, environmental, landscapes/scenics, architecture, cities/urban, humor, performing arts, travel, science, technology/computers. Interested in alternative process, avant garde, documentary, erotic, fashion/glamour, fine art, historical/vintage.

Making Contact & Terms Artwork is accepted on consignment, and there is a 50% commission. Gallery provides insurance, promotion and contract. Accepted work should be framed, mounted and matted.

Submissions E-mail query letter with artist's statement, bio and JPEGs. Responds to queries in 2 weeks. Finds artists through portfolio reviews, submissions and referrals by other artists.

Tips "Include a bio and well-written artist's statement. Do not submit work to a gallery that does not handle the general kind of work you produce."

JOHN CLEARY GALLERY

2635 Colquitt, Houston TX 77098. (713)524-5070. E-mail: clearygallery@ev1.net. Website: www.johnclearyg allery.com. For-profit gallery. Estab. 1996. Average display time 5 weeks. Open Tuesday through Saturday from 10 to 5:30 and by appointment. Located in upper Kirby District of Houston, Texas. Overall price range $500-40,000. Most work sold at $1,000-2,500.

Exhibits Exhibits photos of babies/children/teens, celebrities, couples, multicultural, families, parents, senior citizens, landscapes/scenics, wildlife, architecture, cities/urban, education, pets, religious, rural, adventure, automobiles, entertainment, events, humor, performing arts, travel, agriculture, industry, military, political, portraits, product shots/still life, science, technology/computers. Interested in alternative process, documentary, fashion/glamour, fine art, historical/vintage.

Making Contact & Terms Artwork is bought outright or accepted on consignment with a 50% commission. Gallery provides insurance, promotion, contract.

Submissions Call to show portfolio of photographs. Finds artists through submissions, art exhibits.

STEPHEN COHEN GALLERY

7358 Beverly Blvd., Los Angeles CA 90036. (323)937-5525. Fax: (323)937-5523. E-mail: sc@stephencohengall ery.com. Website: www.stephencohengallery.com. Photography and photo-based art gallery. Estab. 1992. Represents 40 artists. Sponsors 6 exhibits/year. Average display time 2 months. Gallery open Tuesday through Saturday from 11 to 5. "We are a large, spacious gallery and are flexible in terms of types of shows we can mount." Overall price range $500-20,000. Most work sold at $2,000.

Exhibits All styles of photography and photo-based art.

Making Contact & Terms Charges 50% commission. Gallery provides insurance, promotion, contract. Requires exclusive representation locally.

Submissions Mail portfolio for review. Send query letter with artist's statement, bio, brochure, business card, photographs, résumé, reviews, SASE. Responds only if interested within 3 months. Finds artists through word of mouth, published work.

Tips "Photography is still the best bargain in 20th-century art. There are more people collecting photography now, increasingly sophisticated and knowledgeable people aware of the beauty and variety of the medium."

[N] CONCEPT ART GALLERY

1031 S. Braddock, Pittsburgh PA 15218. (412)242-9200. Fax: (412)242-7443. **Contact:** Sam Berkovitz, director. Estab. 1972. Examples of exhibits: "Home Earth Sky," by Seth Dickerman and "Idyllic Pittsburgh," 20th century photographs by Orlando Romig, Selden Davis, Luke Swank, Mark Perrot, Pam Bryan, Charles Biddle and others.

Exhibits Desires "interesting, mature work," work that stretches the bounds of what is perceived as typical photography.

Making Contact & Terms Payment negotiable. Reviews transparencies. Accepted work should be unmounted. Requires exclusive representation within metropolitan area. Send material by mail with SASE for consideration.

Tips "Mail portfolio with SASE for best results. Will arrange appointment with artist if interested."

CONTEMPORARY ARTS CENTER

900 Camp, New Orleans LA 70130. (504)528-3805. Fax: (504)528-3828. E-mail: drubin@cacno.org. Website: www.cacno.org. **Contact:** David S. Rubin, curator of visual arts. Alternative space, nonprofit gallery. Estab. 1976. Gallery open Tuesday through Sunday from 11 to 5. Closed Mardis Gras, Christmas, New Year's Day. Located in the central business district of New Orleans, renovated/converted warehouse.

Exhibits Interested in alternative process, avant garde, fine art. Cutting-edge contemporary preferred.

Terms Artwork is accepted on loan for curated exhibitions. CAC provides insurance and promotion. Accepted work should be framed. "The CAC is not a sales venue, but will refer inquiries." Receives 20% commission on items sold as a result of an exhibition.

Submissions Send query letter with bio, SASE, slides or CD. Responds in 4 months. Finds artists through word of mouth, submissions, art exhibits, art fairs, referrals by other artists, professional contacts, art periodicals.

Tips "Submit only 1 slide sheet with proper labels (title, date, media, dimensions) or CD-ROM with the same information."

THE CONTEMPORARY ARTS CENTER

44 E. Sixth St., Cincinnati OH 45202. (513)345-8400. Fax: (513)721-7418. Website: www.ContemporaryArtsCenter.org. **Contact:** Public Relations Coordinator. Nonprofit arts center. Sponsors 9 exhibits/year. Average display time 6-12 weeks. Sponsors openings; provides printed invitations, music, refreshments, cash bar.

Exhibits Photographer must be selected by the curator and approved by the board. Exhibits photos of multicultural, disasters, environmental, landscapes/scenics, gardening, technology/computers. Interested in avant garde, innovative photography, fine art.

Making Contact & Terms Photography sometimes sold in gallery. Charges 15% commission.

Submissions Send query with résumé, slides, SASE. Responds in 2 months.

CONTEMPORARY ARTS COLLECTIVE

101 E. Charleston Blvd., Suite 101, Las Vegas NV 89104. (702)382-3886. E-mail: info@caclv.lvcoxmail.com. Website: www.cac-lasvegas.org. **Contact:** Natalia Ortiz. Nonprofit gallery. Estab. 1989. Sponsors more than 9 exhibits/year. Average display time 1 month. Gallery open Tuesday through Saturday from 12 to 4. Closed Thanksgiving, Christmas, New Year's Day. 1,200 sq. ft. Overall price range $200-4,000. Most work sold at $400.

Exhibits Interested in alternative process, avant garde, documentary, fine art.

Making Contact & Terms Artwork is accepted through annual call for proposals of self-curated group shows, and there is a 20% requested donation. Gallery provides insurance, promotion, contract.

Submissions Finds artists through annual call for proposals, membership, word of mouth, submissions, portfolio reviews, art exhibits, art fairs, referrals by other artists and walk-ins. Check website for dates and submission guidelines.

Tips Submitted slides should be "well labeled and properly exposed with correct color balance. Cut-off for proposals is usually January."

CORPORATE ART SOURCE/CAS GALLERY

2960-F Zelda Rd., Montgomery AL 36106. (334)271-3772. Fax: (334)271-3772. Website: www.casgallery.c om. Art consultancy, for-profit gallery. Estab. 1990. Approached by 100 artists/year; represents or exhibits 50 artists. Sponsors 1 photography exhibit/year. Average display time 6 weeks. Gallery open Monday through Friday from 10 to 5:30; weekends from 11 to 3. Overall price range $200-20,000. Most work sold at $1,000.
Exhibits Exhibits photos of landscapes/scenics, architecture, rural. Interested in alternative process, avant garde, fine art, historical/vintage.
Making Contact & Terms Artwork is accepted on consignment, and there is a 50% commission. Gallery provides contract.
Submissions Mail portfolio for review. Send query letter. Responds only if interested within 6 weeks. Finds artists through submissions, portfolio reviews, art exhibits, art fairs, referrals by other artists.

PATRICIA CORREIA GALLERY

2525 Michigan Ave., Building E-2, Santa Monica CA 90404. (310)264-1760. Fax: (310)264-1762. E-mail: correia@earthlink.net. Website: www.correiagallery.com. **Contact:** Rae Anne, associate director. Estab. 1991. Average display time 5-6 weeks. Gallery open Tuesday through Saturday from 11 to 6 and by appointment. Closed Christmas, New Year's Day. The gallery is located at Bergamot Station—5 acres, 30 contemporary galleries. Patricia Correia Gallery is 3,000 sq. ft. Exhibits established contemporary artists that are Hispanic. Overall price range $500-200,000. Most work sold at $8,000.
Exhibits Contemporary.
Making Contact & Terms Gallery provides insurance, promotion, contract.
Submissions Call to ask for submission policy. Returns material with SASE. Responds in 6 months. Finds artists through referrals.
Tips Enclose résumé, slides with dimensions, media, retail price, cover letter, SASE. Visit gallery first and know their policies and the body of art they represent and exhibit.

⊠ ◯ CREALDÉ SCHOOL OF ART

600 St. Andrews Blvd., Winter Park FL 32792. (407)671-1886. Fax: (407)671-0311. **Contact:** Rick Lang, director of photography. ''The school's gallery has 8-10 exhibitions/year representing artists from regional/ national stature in all media. Anyone who would like to show here may send 20 slides, résumé, statement and return postage.''

THE DAYTON ART INSTITUTE

456 Belmonte Park N., Dayton OH 45405-4700. (937)223-5277. Fax: (937)223-3140. E-mail: info@daytonartin stitute.org. Website: www.daytonartinstitute.org. Museum. Estab. 1919. Galleries open Monday through Sunday from 10 to 4, Thursdays until 8.
Exhibits Interested in fine art.

SAMUEL DORSKY MUSEUM OF ART

SUNY New Paltz, 75 S. Manheim Blvd., New Paltz NY 12561. (845)257-3844. Fax: (845)257-3854. E-mail: tragern@newpaltz.edu. Website: www.newpaltz.edu/museum. **Contact:** Neil C. Trager, director. Museum. Estab. 1964. Sponsors ongoing photography exhibits throughout the year. Average display time 2 months. Museum open Wednesday through Saturday from 11 to 5; Sunday from 1 to 5. Closed holidays and school vacations.
Exhibits Interested in alternative process, avant garde, documentary, fine art, historical/vintage.
Submissions Send query letter with bio and SASE. Responds only if interested within 3 months. Finds artists through art exhibits.

▣ GEORGE EASTMAN HOUSE

900 East Ave., Rochester NY 14607. (716)271-3361. Fax: (716)271-3970. Website: www.eastmanhouse.org. **Contact:** Alison Nordstrom, curator of photographs. Museum. Estab. 1947. Approached by more than 400 artists/year. Sponsors more than 12 photography exhibits/year. Average display time 3 months. Gallery open Tuesday through Saturday from 10 to 5 (Thursday until 8); Sunday from 1 to 5. Closed Thanksgiving and Christmas. Museum has 7 galleries that host exhibitions, ranging from 50- to 300-print displays.
Exhibits GEH is a museum that exhibits the vast subjects, themes and processes of historical and contemporary photography.
Submissions See website for detailed information: http://eastmanhouse.org/inc/collections/submissions.a

sp. Mail portfolio for review. Send query letter with artist's statement, résumé, SASE, slides, digital prints. Responds in 3 months. Finds artists through word of mouth, art exhibits, referrals by other artists, books, catalogs, conferences, etc.

Tips "Consider as if you are applying for a job. You must have succinct, well-written documents; a well-selected number of visual treats that speak well with written document provided; an easel for reviewer to use."

N ▣ ETHERTON GALLERY

135 S. 6th Ave., Tucson AZ 85701. (520)624-7370. Fax: (520)792-4569. E-mail: ethertongallery@mindspring.com. Website: www.ethertongallery.com. **Contact:** Terry Etherton, director. Estab. 1981. Sponsors 10 exhibits/year. Average display time 6 weeks. Sponsors openings; provides wine and refreshments, publicity, etc. Overall price range $200-20,000.

● Etherton Gallery regularly purchases 19th-century, vintage, Western survey photographs and Native American portraits.

Exhibits Photographer must "have a high-quality, consistent body of work—be a working artist/photographer—no 'hobbyists' or weekend photographers." Interested in contemporary photography with emphasis on artists in Western and Southwestern US.

Making Contact & Terms Charges 50% commission. Occasionally buys photography outright. Accepted work should be matted or unmatted, unframed work. Please send portfolio by mail with SASE for consideration. Responds in 3 weeks.

Tips "You should be familiar with the photo art world and with my gallery and the work I show. Please limit submissions to 20, showing the best examples of your work in a presentable, professional format; slides or digital preferred."

N EVERSON MUSEUM OF ART

401 Harrison St., Syracuse NY 13202. (315)474-6064. Fax: (315)474-6943. E-mail: everson@everson.org. Website: www.everson.org. **Contact:** Debora Ryan, curator. Museum. Estab. 1897. Approached by many artists/year; represents or exhibits 16-20 artists. Sponsors 2-3 photography exhibits/year. Average display time 3 months. Gallery open Tuesday through Friday from 12 to 5; Saturday from 10 to 5; Sunday from 12 to 5. "The museum features four large galleries with twenty-four foot ceilings, track lighting and oak hardwood, a sculpture court, a children's gallery, a ceramic study center and five smaller gallery spaces."

Exhibits Photos of multicultural, environmental, landscapes/scenics, wildlife. Interested in alternative process, avant garde, documentary, fine art, historical/vintage.

Submissions Send query letter with artist's statement, bio, résumé, reviews, SASE, slides. Finds artists through submissions, portfolio reviews, art exhibits.

▣ FAHEY/KLEIN GALLERY

148 N. La Brea Ave., Los Angeles CA 90036. (323)934-2250. Fax: (323)934-4243. E-mail: fahey.klein@pobox.com. Website: www.faheykleingallery.com. **Contact:** David Fahey or Ken Devlin, co-owners. Estab. 1986. For-profit gallery. Approached by 200 artists/year; represents or exhibits 60 artists. Sponsors 10 exhibits/year. Average display time 5-6 weeks. Gallery open Tuesday through Saturday from 10 to 6. Closed on all major holidays. Sponsors openings; provides announcements and beverages served at reception. Overall price range $500-500,000. Most work sold at $2,500. Located in Hollywood; gallery features 2 exhibition spaces with extensive work in back presentation room.

Exhibits Must be established for a minimum of 5 years; preferably published. Interested in established work; babies/children/teens, celebrities, couples, multicultural, families, parents, senior citizens, landscapes/scenics, wildlife, arcitecture, entertainment, humor, performing arts, sports. Interested in alternative process, avant garde, documentary, erotic, fashion/glamour, fine art, historical/vintage.

Making Contact & Terms Artwork is accepted on consignment, and the commission is negotiated. Gallery provides insurance, promotion, contract. Accepted work should be unframed, unmounted and unmatted. Requires exclusive representation within metropolitan area.

Submissions Prefers website URLs for initial contact, or send material (CD, reproductions, no originals) by mail with SASE for consideration. Responds in 2 months. Finds artists through art fairs, exhibits, portfolio reviews, submissions, word of mouth, referrals by other artists.

Tips "Please be professional and organized. Have a comprehensive sample of innovative work. Interested in seeing mature work with resolved photographic ideas and viewing complete portfolios addressing one idea."

N FALKIRK CULTURAL CENTER

P.O. Box 151560, San Rafael CA 94915-1560. (415)485-3328. Fax: (415)485-3404. Website: www.falkirkcultur alcenter.org. Nonprofit gallery, national historic place (1888 Victorian) converted to multi-use cultural center. Approached by 500 artists/year; exhibits 300 artists. Sponsors 2 photography exhibits/year. Average display time 2 months. Gallery open Monday through Friday from 10 to 5; Thursday til 9; Saturday from 10 to 1.
Making Contact & Terms Gallery provides insurance. Accepts only artists from San Francisco Bay area, "especially Marin County since we are a community center."
Submissions Send query letter with artist's statement, bio, slides, résumé. Returns material with SASE. Finds artists through word of mouth, submissions, portfolio reviews, art exhibits, art fairs, referrals by other artists.

FAVA (Firelands Association for the Visual Arts)

New Union Center for the Arts, 39 S. Main St., Oberlin OH 44074. (440)774-7158. Fax: (440)775-1107. E-mail: favagallery@oberlin.net. **Contact:** Kyle Michalak, gallery director. Nonprofit gallery. Estab. 1979. Sponsors 1 photography exhibit/year. Average display time 1 month. Overall price range $75-3,000. Most work sold at $200.
Exhibits Open to all media, including photography. Sponsors 1 regional juried photo exhibit/year ("Six-State Photography"). Open to residents of Ohio, Kentucky, West Virginia, Pennsylvania, Indiana, Michigan. Deadline for applications: October. Send annual application for 6 invitational shows by mid-December of each year; include 15-20 slides, résumé, slide list. Exhibits a variety of subject matter and styles.
Making Contact & Terms Charges 30% commission. Accepted work should be framed or matted.
Submissions Send SASE for "Exhibition Opportunity" flier or Six-State Photo Show entry form.
Tips "As a nonprofit gallery, we do not represent artists except during the juried show. Present the work in a professional format; the work, frame and/or mounting should be clean, undamaged, and (in cases of more complicated work) well organized."

F8 FINE ART GALLERY

1137 W. Sixth St., Austin TX 78703. (512)480-0242. Fax: (512)480-0241. E-mail: amy@f8fineart.com. Website: www.f8fineart.com. **Contact:** Director. For-profit gallery. Estab. 2001. Approached by 250 artists/year; represents or exhibits 25 artists. Sponsors 12 photography and painting exhibits/year. Average display time 2 months. Gallery open Tuesday through Saturday 10 to 6. Overall photography price range $300-1,600. Most photography sold at $350.
Exhibits Exhibits photos of multicultural, landscapes/scenics, cities/urban, avant garde, erotic. Interested in traditional fine art photography only, no digital.
Making Contact & Terms Artwork is accepted on consignment, and there is a 50% commission. Gallery provides insurance, promotion, contract. Accepted work should be framed and matted.
Submissions Send query letter with artist's statement, bio, process, résumé, reviews, images on CD/website/slides; include SASE for return of material. See website for more information. Responds only if interested. Finds artists through submissions, art exhibits.
Tips "Give us all the information in a clean, well-organized form. Do not send original work. For exhibitions, we ask that all work be printed Archivally on fiber-based, museum-quality paper."

N FINE ARTS CENTER GALLERIES/UNIVERSITY OF R.I.

105 Upper College Rd., Kingston RI 02881-0820. (401)874-2627. Fax: (401)874-2007. E-mail: jtolnick@uri.e du. Website: www.uri.edu/artgalleries. Nonprofit galleries. Estab. 1968. Sponsors 4-6 photography exhibits/year. Average display time 1-3 months. There are 3 exhibition spaces: The Main and Photography Galleries, open Tuesday through Friday 12 to 4 and 1 to 4 on the weekends; and The Corridor Gallery, open 9 to 9 daily. Exhibitions are curated from a national palette and regularly reviewed in the local press. Unsolicited proposals (slides or CD with SASE) are reviewed as needed.

FLATFILE

217 N. Carpenter, Chicago IL 60607-2395. (312)491-1190. Fax: (312)491-1195. E-mail: info@flatfilegalleries.c om. Website: www.flatfilegalleries.com. **Contact:** Susan Aurinko, gallery director. For-profit gallery. Estab. 2000. Exhibits over 60 emerging and established international artists plus guest artists. Sponsors 10 photography exhibits/year. Average display time 4-5 weeks. Gallery open Tuesday through Saturday from 10:30 to 6. Closed between Christmas and New Year's. 2,300 sq. ft. plus a project room for video and photo-based installation. Overall price range $100-10,000. Most work sold at $400-800.
Exhibits Exhibits photos of multicultural, environmental, landscapes/scenics, architecture, rural, travel, still

life, nudes, abstracts, b&w/color, Polaroid transfers and assorted other processes such as platinum prints, gold-toned prints, etc. Interested in alternative process, avant garde, fine art, video, photobased installation.

Making Contact & Terms Artwork is accepted on consignment, and there is a 50% commission. Gallery provides insurance, promotion. Accepted work should be matted and/or framed. Requires exclusive representation locally, but encourages items to be shown in shows and museums and even promotes artists to other venues.

Submissions Mail portfolio for review or send query letter with artist's statement, photocopies, photographs, résumé, reviews, slides, SASE. Finds artists through word of mouth, submissions, portfolio reviews, referrals by other artists. "They find me." Portfolio reviews run 6-8 weeks.

Tips "I like to see the following: slides or thumbnail images; work prints, but must see fiber-based, finely printed piece to assess print quality; collateral materials, reviews, résumé, etc. No RC paper, only acid-free, archival work and matting will be accepted."

FOCAL POINT GALLERY

321 City Island Ave., New York NY 10464. (718)885-1403. Fax: (718)885-1451. Website: www.focalpointgalle ry.com. **Contact:** Ron Terner, photographer/director. Estab. 1974. Overall price range $75-1,500. Most work sold at $175.

Exhibits Open to all subjects, styles and capabilities. "I'm looking for the artist to show me a way of seeing I haven't seen before." Nudes and landscapes sell best. Interested in alternative process, avant garde, documentary, erotic, fine art.

Making Contact & Terms Charges 40% commission. Artist should call for information about exhibition policies.

Tips Sees trend toward more use of alternative processes. "The gallery is geared toward exposure—letting the public know what contemporary artists are doing—and is not concerned with whether it will sell. If the photographer is only interested in selling, this is not the gallery for him/her, but if the artist is concerned with people seeing the work and gaining feedback, this is the place. Most of the work shown at Focal Point Gallery is of lesser-known artists. Don't be discouraged if not accepted the first time. Continue to come back with new work when ready." Call for an appointment.

THE FRASER GALLERY

1054 31st St. NW, Washington DC 20007. Phone/fax: (202)298-6450. E-mail: info@thefrasergallery.com. Website: www.thefrasergallery.com. **Contact:** Catriona Fraser, director. Second location at 7700 Wisconsin Ave., Suite E, Bethesda MD 20814. (301)718-9651. Fax: (301)718-9652. Estab. 1996. Approached by 800 artists/year; represents 25 artists and/or exhibits 40 artists and sells the work of an additional 75 artists (Sothebys.com associate dealer). Sponsors 5 photography exhibits/year. Average display time 1 month. Washington, DC, gallery open Tuesday through Friday from 12 to 3; Saturday from 12 to 6. Closed Sunday and Monday except by appointment. Located in the center of Georgetown in a courtyard with 4 other galleries; 400 sq. ft. Second location opened in Bethesda, MD, in 2002; 1,600 sq. ft. Sponsors 6 photography exhibits/ year including a juried international photography competition. Bethesda gallery open Tuesday through Saturday from 11:30 to 6. Closed Sunday and Monday except by appointment. Overall price range $200-40,000. Most work sold at under $2,000.

Exhibits Exhibits photos of nudes, landscapes/scenics. Interested in figurative work, fine art.

Making Contact & Terms Artwork is accepted on consignment, and there is a 50% commission. Gallery provides insurance, promotion, contract. Accepted work should be framed, matted to full conservation standards. Requires exclusive representation locally.

Submissions Write to arrange personal interview to show portfolio of photographs, slides. Send query letter with bio, photographs, résumé, reviews, slides or CD-ROM, SASE. Responds in 1 month. Finds artists through submissions, portfolio reviews, art exhibits, art fairs.

Tips "Research the background of the gallery, and apply to galleries that show your style of work. All work should be framed or matted to full museum standards."

FREEPORT ARTS CENTER

121 N. Harlem Ave., Freeport IL 61032. (815)235-9755. Fax: (815)235-6015. E-mail: artscenter@aeroinc.net. **Contact:** Mary Fay Schoonover, director. Estab. 1976. Sponsors 10-12 exhibits/year. Average display time 2 months.

Exhibits All artists are eligible for solo or group shows. Exhibits photos of multicultural, families, senior

citizens, landscapes/scenics, architecture, cities/urban, gardening, rural, performing arts, travel, agriculture. Interested in fine art, historical/vintage.

Making Contact & Terms Charges 30% commission. Accepted work should be framed.

Submissions Send material by mail with SASE for consideration. Responds in 3 months.

N 🖼 GALERIAS PRINARDI

Condominio El Centro I 14-A Ave., Munoz Rivera #500, Hato Rey PR 00918. (787)763-5727. Fax: (787)763-0643. E-mail: prinardi@prinardi.com. Website: www.prinardi.com. **Contact:** Andrés Marrero, director. Art consultancy and for-profit gallery. Gallery open Monday through Friday from 10 to 6; Saturday from 11 to 4. Closed Sunday. Overall price range $3,000-25,000. Most work sold at $8,000.

Exhibits Exhibits photos of babies/children/teens, multicultural, landscapes/scenics, architecture, cities/urban, education, rural, performing arts, product shots/still life. Interested in avant garde, documentary, fine art, historical/vintage.

Making Contact & Terms Artwork is accepted on consignment, and there is a 40% or 50% commission, or it is bought outright for 100% of retail price; net 30 days.

Submissions Mail portfolio for review. Send query letter with artist's statement, bio, brochure, business card, photocopies, photographs, résumé, reviews, e-mail letter and digital photos. Responds to queries in 1 month. Finds artists through portfolio reviews, referrals by other artists, submissions.

THE GALLERIES DOWNTOWN

218 E. Washington St., Iowa City IA 52240. (319)338-4442. Fax: (319)338-3380. E-mail: info@thegalleriesdowntown.com. **Contact:** Benjamin Chait, director. For-profit gallery. Estab. 2003. Approached by 300 artists/year; represents or exhibits 30 artists. Average display time 3 months. Open all year; Monday through Friday from 11 to 6; weekends from 11 to 5. Located in a downtown building renovated to its original look of 1882 with 14-ft.-high molded ceiling and original 9-ft. front door. Professional museum lighting and Scamozzi-capped columns complete the elegant gallery. Overall price range: $50-4,000. Most work sold at $300.

Exhibits Exhibits photos of babies/children/teens, families, senior citizens, landscapes/scenics, architecture, cities/urban, rural.

Making Contact & Terms Artwork is accepted on consignment, and there is a 50% commission. Gallery provides insurance, promotion and contract. Accepted work should be framed. Requires exclusive representation locally.

Submissions Call, mail portfolio for review. Responds to queries in 2 weeks. Finds artists through art fairs, art exhibits, portfolio reviews and referrals by other artists.

N 🖼 GALLERY DENOVO

P.O. Box 7214, Ketchum ID 83340-7214. (208)726-8180. Fax: (208)726-1007. E-mail: info@gallerydenovo.com. Website: www.gallerydenovo.com. **Contact:** Robin Reiners, gallery director. For-profit gallery. Estab. 2002. Represents approximately 25 artists/year. Sponsors 9 exhibits/year. Average display time 1 month. Open Monday through Saturday from 10 to 6; Sunday from 12 to 5 (during winter and summer season); closed a week or two in late April/early May. Located in downtown Ketchum (in Sun Valley Area) along "gallery row." 1,000 sq. ft. of clean, contemporary gallery with crisp white walls and stained concrete floor. Three galleries are housed in this same building. Overall price range: $500-15,000; most work sold at $2,000-5,000.

Making Contact & Terms Artwork is accepted on consignment, and there is a 50% commission. Gallery provides insurance, promotion, contract.

Submissions E-mail with exhibition history, artist's statement and 3-5 images attached. Send query letter with SASE, artist's statement, bio, slides or CD of works. Return of material not guaranteed without SASE. Responds to queries only if interested within 1 month. Tries to respond to others, but receives so many queries that it is not guaranteed. Files interesting work that may fit in gallery at some other time. Finds artists mostly via art exhibits, but also referrals by other artists and art fairs.

Tips "Spell check! Be concise and organized with information, and look at the type of gallery and type of work that is shown to see if new work would fit into that gallery and what they tend to represent."

GALLERY 400, UNIVERSITY OF ILLINOIS AT CHICAGO

1240 W. Harrison St. (MC034), Chicago IL 60607. (312)996-6114. Fax: (312)355-3444. Website: http://gallery400.aa.uic.edu. **Contact:** Lorelei Stewart, director. Nonprofit gallery. Estab. 1983. Approached by 500 artists/

year; exhibits 80 artists. Sponsors 1 photography exhibit/year. Average display time 4-6 weeks. Gallery open Tuesday through Friday from 10 to 5; Saturday from 12 to 5.

Making Contact & Terms Gallery provides insurance, promotion.

Submissions Send query letter with SASE for guidelines. Responds in 5 months. Finds artists through word of mouth, art exhibits, referrals by other artists.

Tips "Please check our website for guidelines for proposing an exhibition."

N GALLERY M

2830 E. Third Ave., Denver CO 80206. (303)331-8400. Fax: (303)331-8522. E-mail: info@gallerym.com. Website: www.gallerym.com. **Contact:** Managing Partner. For-profit gallery. Estab. 1996. Sponsors 2 photography exhibits/year. Average display time 6-12 weeks for featured artist. Overall price range $265-5,000.

Exhibits Primarily social documentation and photojournalism.

Making Contact & Terms Gallery provides promotion. Requires exclusive regional representation.

Submissions Responds quarterly. Finds artists through referral only, "from our exhibiting gallery artists, dealers, museum curators and/or professionals." Offers online photographer program as an alternative to the referral process; visit www.gallerym.com/artists.cfm for more information.

N GALLERY NAGA

67 Newbury St., Boston MA 02116. (617)267-9060. Fax: (617)267-9040. E-mail: mail@gallerynaga.com. Website: www.gallerynaga.com. **Contact:** Arthur Dion, director. For-profit gallery. Estab. 1976. Approached by 150 artists/year; represents or exhibits 40 artists. Sponsors 2 photography exhibits/year. Average display time 1 month. Gallery open Tuesday through Saturday from 10 to 5:30. Overall price range $850-35,000. Most work sold at $2,000-3,000.

Exhibits Exhibits photos of landscapes/scenics, architecture, cities/urban.

Making Contact & Terms Charges 50% commission. Gallery provides insurance. Requires exclusive representation locally. Accepts only artists from New England/Boston.

Submissions Send query letter with artist's statement, résumé, bio, photocopies, slides, SASE. Responds in 6 months. Finds artists through submissions, portfolio reviews, art exhibits.

GALLERY OF ART, UNIVERSITY OF NORTHERN IOWA

Cedar Falls IA 50614-0362. (319)273-6134. E-mail: galleryofart@uni.edu. Website: www.uni.edu/artdept/gallery. Estab. 1976. Interested in all styles of high-quality contemporary art works. Sponsors 9 exhibits/year. Average display time 1 month. Open to the public.

Making Contact & Terms Work presented in lobby cases. "We do not often sell work; no commission is charged."

Submissions May arrange a personal interview to show portfolio, résumé and samples. Send material by mail for consideration or submit portfolio for review; include SASE for return of material. Response time varies.

▣ GALLERY 72

2709 Leavenworth, Omaha NE 68105-2399. (402)345-3347. Fax: (402)348-1203. E-mail: gallery72@novia.net. **Contact:** Robert D. Rogers, director. Estab. 1972. Represents or exhibits 6 artists. Sponsors 2 photography exhibits/year. Average display time 3-4 weeks. Gallery open Monday through Saturday from 10 to 5; Sunday from 12 to 5. One large room, one small room.

Exhibits Exhibits photos of senior citizens, landscapes/scenics, cities/urban, interiors/decorating, rural, performing arts, travel.

Making Contact & Terms Artwork is accepted on consignment, and there is a 50% commission. Gallery provides insurance, promotion. Requires exclusive representation locally. "No western art."

Submissions Call or write to arrange personal interview to show portfolio. Send query letter with artist's statement, brochure, photocopies, résumé. Accepts digital images. Finds artists through word of mouth, submissions, art exhibits.

GALLERY 218

207 E. Buffalo St., Suite 218, Milwaukee WI 53202. (414)643-1732. E-mail: info@gallery218.com. Website: www.gallery218.com. **Contact:** Judith Hooks, president. Estab. 1990. Sponsors 12 exhibits/year. Average display time 1 month. Sponsors openings. "If a group show, we make arrangements and all artists contribute.

If a solo show, artist provides everything." Overall price range $150-5,000. Most work sold at $350. Sponsors an international Elvis show in summer.

Exhibits Interested in alternative process, avant garde, abstract, fine art. Membership dues: $55/year. Artists help run the gallery. Group and solo shows. Photography is shown alongside fine arts painting, printmaking, sculpture, etc. Solo show after 1 year as a member.

Making Contact & Terms Charges 25% commission. There is an entry fee for each show. Fee covers the rent for 1 month. Accepted work must be framed.

Submissions Send SASE for an application. "This is a cooperative space. A fee is required."

Tips "Get involved in the process if the gallery will let you. We require artists to help promote their show so that they learn what and why certain things are required. Have inventory ready. Read and follow instructions on entry forms; be aware of deadlines. Attend openings for shows you are accepted into locally."

GALMAN LEPOW ASSOCIATES, INC

Unit 12, 1879 Old Cuthbert Rd., Cherry Hill NJ 08034. (856)354-0771. Fax: (856)428-7559. **Contact:** Elaine Galman and Judith Lepow, principals. Estab. 1979.

Submissions Send query letter with résumé, SASE. Visual imagery of work is helpful. Responds in 3 weeks.

Tips "We are corporate art consultants and use photography for our clients."

▣ SANDRA GERING GALLERY

534 W. 22nd St., New York NY 10011. (646)336-7183. Fax: (646)336-7185. E-mail: marianna@geringgallery.com. Website: www.geringgallery.com. **Contact:** Marianna Baer, director. For-profit gallery. Estab. 1991. Approached by 240 artists/year; represents or exhibits 12 artists. Sponsors 1 photography exhibit/year. Average display time 5 weeks. Gallery open Tuesday through Saturday from 10 to 6.

Exhibits Interested in alternative process, avant garde; digital, computer-based photography.

Making Contact & Terms Artwork is accepted on consignment.

Submissions E-mail with link to website or send postcard with image. Responds only if interested within 6 months. Finds artists through word of mouth, art exhibits, art fairs, referrals by other artists.

Tips "Most important is to research the galleries and *only* submit to those that are appropriate. Visit websites if you don't have access to galleries."

WELLINGTON B. GRAY GALLERY

Jenkins Fine Arts Center, East Carolina University, Greenville NC 27858. (252)328-6336. Fax: (252)328-6441. **Contact:** Gilbert Leebrick, director. Estab. 1978. Sponsors 6-8 exhibit/year. Average display time 4-6 weeks.

Exhibits For exhibit review, submit 20 slides, résumé, catalogs, etc., by November 15th annually. Exhibits are booked the next academic year. Work accepted must be framed or ready to hang. Interested in fine art photography.

Making Contact & Terms Charges 35% commission. Reviews transparencies. Accepted work should be framed for exhibitions; send slides for exhibit committee's review.

Submissions Send material by mail with SASE for consideration.

ℕ CARRIE HADDAD GALLERY

622 Warren St., Hudson NY 12534. (518)828-1915. Fax: (518)828-3341. E-mail: CarrieHaddadGallery@verizon.net. Website: www.carriehaddadgallery.com. **Contact:** Carrie Haddad, owner. Art consultancy, for-profit gallery. Estab. 1990. Approached by 50 artists/year; represents or exhibits 60 artists. Sponsors 8 photography exhibits/year. Average display time 5 weeks. Gallery open Thursday through Monday from 11 to 5. Overall price range $350-6,000. Most work sold at $1,000.

Exhibits Exhibits photos of nudes, landscapes/scenics, architecture, pets, rural, product shots/still life.

Making Contact & Terms Artwork is accepted on consignment, and there is a 50% commission. Gallery provides insurance, promotion. Requires exclusive representation locally.

Submissions Send query letter with bio, photocopies, photographs, price list, SASE. Responds in 1 month. Finds artists through word of mouth, submissions, art exhibits, referrals by other artists.

HALLWALLS CONTEMPORARY ARTS CENTER

341 Delaware Ave., Buffalo NY 14202. (716)854-1694. Fax: (716)854-1696. E-mail: john@hallwalls.org. Website: www.hallwalls.org. **Contact:** John Massier, visual arts curator. Nonprofit multimedia organization. Estab. 1974. Sponsors 10 exhibits/year. Average display time 6 weeks.

Exhibits "While we do not focus on the presentation of photography alone, we present innovative work by

contemporary photographers in the context of contemporary art as a whole. Sales are not our focus. If a work does sell, we suggest a donation of 15% of the purchase price." Interested in work that expands the boundaries of traditional photography. No limitations on type, style or subject matter.

Submissions Send material by mail for consideration. Work may be kept on file for additional review for 1 year.

Tips "We're looking for photographers with innovative work that challenges the boundaries of the medium."

THE HALSTED GALLERY INC.

P.O. Box 130, Bloomfield Hills MI 48303. (248)745-0062. Fax: (248)332-6776. **Contact:** Wendy or Thomas Halsted. Sponsors openings. Sponsors 5 exhibits/year. Average display time 2 months. Overall price range $500-25,000.

Exhibits Interested in 19th- and 20th-century photographs and out-of-print photography books.

Submissions Call to arrange a personal interview to show portfolio only. Prefers to see scans. Send no slides or samples. Unframed work only.

Tips This gallery has no limitations on subjects. Wants to see creativity, consistency, depth and emotional work.

N HEARST ART GALLERY, SAINT MARY'S COLLEGE

P.O. Box 5110, Moraga CA 94575. (925)631-4379. Fax: (925)376-5128. Website: gallery.stmarys-ca.edu. College gallery. Estab. 1931. Sponsors 1 photography exhibit/year. Gallery open Wednesday through Sunday from 11 to 4:30. Closed major holidays. 1,650 sq. ft. of exhibition space.

Exhibits Exhibits photos of multicultural, landscapes/scenics, religious, travel.

Submissions Send query letter (Attn: Registrar) with artist's statement, bio, résumé, slides, SASE. Finds artists through submissions, art exhibits, art fairs, referrals by other artists.

N HEMPHILL

1515 14th St. NW, Suite 300, Washington DC 20005. (202)234-5601. Fax: (202)234-5607. E-mail: gallery@hemphillfinearts.com. Website: www.hemphillfinearts.com. Art consultancy, for-profit gallery. Estab. 1993. Represents or exhibits 30 artists/year. Sponsors 2-3 photography exhibits/year. Average display time 6-8 weeks. Gallery open Tuesday through Saturday from 10 to 5. Overall price range $800-200,000. Most work sold at $3,000-9,000.

Exhibits Exhibits photos of landscapes/scenics, architecture, cities/urban, rural. Interested in alternative process, fine art, historical/vintage.

Making Contact & Terms HEMPHILL is not currently accepting artist submissions for consideration.

HENRY STREET SETTLEMENT/ABRONS ART CENTER

466 Grand St., New York NY 10002. (212)598-0400. Fax: (212)505-8329. E-mail: mdust@henrystreet.org. Website: www.henrystreet.org. **Contact:** Martin Dust, visual arts coordinator. Alternative space, nonprofit gallery, community center. Holds 9 solo photography exhibits/year. Gallery open Tuesday through Sunday from 10 to 6. Closed major holidays.

Exhibits Exhibits photos of multicultural, environmental, landscapes/scenics, architecture, cities/urban, rural. Interested in alternative process, avant garde, documentary, fine art, historical/vintage.

Making Contact & Terms Artwork is accepted on consignment, and there is a 20% commission. Gallery provides insurance, space, contract.

Submissions Send query letter with artist's statement, SASE. Finds artists through word of mouth, submissions, referrals by other artists.

HEUSER ART CENTER GALLERY & HARTMANN CENTER ART GALLERY

Bradley University, 1501 W. Bradley Ave., Peoria IL 61625. (309)677-2989. Fax: (309)677-3642. E-mail: payresmc@bradley.edu. Website: www.gcc.bradley.edu/art/. **Contact:** Pamela Ayres, director of galleries, exhibitions and collections. Alternative space, nonprofit gallery, educational. Estab. 1984. Approached by 260 artists/year; represents or exhibits 50 artists. Sponsors 1 photography exhibit/year. Average display time 4 to 6 weeks. Open Tuesday through Friday from 9 to 4; Thursday from 9 to 7; closed weekends and during Christmas, Thanksgiving, Fall and Spring breaks. Overall price range: $100-5,000. Most work sold at $300.

Exhibits Exhibits photos of babies/children/teens, celebrities, couples, multicultural, families, parents, senior citizens, disasters, environmental, landscapes/scenics, wildlife, architecture, cities/urban, education, rural, entertainment, events, performing arts, travel, agriculture, business concepts, industry, medicine, military,

political, product shots/still life, science, technology/computers. Interested in alternative process, avant garde, documentary, fashion/glamour, fine art, historical/vintage, large-format Polaroid. Has a digital photo juried exhibition—online catalog.

Making Contact & Terms Artwork is accepted on consignment, and there is a 35% commission. Gallery provides promotion and contract. Accepted work should be framed or glazed with Plexiglas. "We consider all professional artists."

Submissions Mail portfolio of 20 slides for review. Send query letter with artist's statement, bio, brochure, business card, photocopies, photographs, résumé, reviews, SASE, slides and CD. Queries are reviewed in January and artists are notified in June. Finds artists through art exhibits, portfolio reviews, referrals by other artists and critics, submissions and national calls.

Tips "No handwritten letters. Print or type slide labels. Send only 20 slides total."

HUNTSVILLE MUSEUM OF ART

300 S. Church St., Huntsville AL 35801. (256)535-4350. E-mail: info@hsvmuseum.org. Website: www.hsvmu seum.org. **Contact:** Peter J. Baldaia, chief curator. Estab. 1970. Sponsors 1-2 exhibits/year. Average display time 2-3 months.

Exhibits Must have professional track record and résumé, slides, critical reviews in package (for curatorial review). Regional connection preferred. No specific stylistic or thematic criteria. Interested in alternative process, avant garde, documentary, fine art, historical/vintage.

Making Contact & Terms Buys photos outright. Accepted work may be framed or unframed, mounted or unmounted, matted or unmatted.

Submissions Send material by mail with SASE for consideration. Responds in 3 months.

ICEBOX QUALITY FRAMING & GALLERY

1500 Jackson St. NE, Suite 443, Minneapolis MN 55413. (612)788-1790. Fax: (612)788-6947. E-mail: icebox@bitstream.net. Website: http://iceboxminnesota.com. **Contact:** Howard Christopherson. Exhibition, promotion and sales gallery. Estab. 1988. Represents photographers and fine artists in all media, predominantly but not solely Minnesota artists. Overall price range $200-1,500. Most work sold at $200-800.

Exhibits Exhibits photos of multicultural, environmental, landscapes/scenics, rural, adventure, travel and fine art photographs from "artists with serious, thought-provoking work who find it hard to fit in with the more commercial art gallery scene." Interested in alternative process, avant garde, documentary, erotic, historical/vintage. "A sole proprietorship alternative gallery, Icebox sponsors installations and exhibits in the gallery's new space in the Minneapolis Arts District."

Making Contact & Terms Charges 50% commission.

Submissions "Send letter of interest telling why and what you would like to exhibit at Icebox. Include slides and other appropriate materials for review. At first, send materials that can be kept at the gallery and updated as needed. Check website for more details about entry and gallery history."

Tips "We are also experienced with the out-of-town artist's needs."

ILLINOIS STATE MUSEUM CHICAGO GALLERY

100 W. Randolph, Suite 2-100, Chicago IL 60601. (312)814-5322. Fax: (312)814-3471. Website: www.museu m.state.il.us. **Contact:** Kent Smith, director. Assistant Administrator: Jane Stevens. Estab. 1985. Sponsors 2-3 exhibits/year. Average display time 2 months. Sponsors openings; provides refreshments at reception and sends out announcement cards for exhibitions.

Exhibits Must be an Illinois photographer. Interested in contemporary and historical/vintage, alternative process, fine art.

Submissions Send résumé, artist's statement, 10 slides, SASE. Responds in 6 months.

INDIANAPOLIS ART CENTER

820 E. 67th St., Indianapolis IN 46220. (317)255-2464. Fax: (317)254-0486. E-mail: exhibs@indplsartcenter.o rg. Website: www.indplsartcenter.org. **Contact:** David Kwasigroh, exhibitions curator. Estab. 1934. Sponsors 1-2 photography exhibits/year. Average display time 4-6 weeks. Overall price range $50-5,000. Most work sold at $500.

Exhibits Interested in alternative process, avant garde, documentary, fine art and very contemporary work, preferably unusual processes. Prefers artists who live within 250 miles of Indianapolis.

Making Contact & Terms Charges 35% commission. One-person show: $300 honorarium; 2-person show:

$200 honorarium; 3-person show: $100 honorarium; plus $0.32/mile travel stipend. Accepted work should be framed (or other finished-presentation formatted).

Submissions Send minimum of 20 slides with résumé, reviews, artist's statement and SASE between July 1 and December 31. No wildlife or landscape photography. Interesting color and mixed media work is appreciated.

Tips "We like photography with a very contemporary look that incorporates unusual processes and/or photography with mixed media. Submit excellent slides with a full résumé, a recent artist's statement, and reviews of past exhibitions or projects. Please, no glass-mounted slides. Always include a SASE for notification and return of materials, ensuring that correct return postage is on the envelope."

INSLEY ART GALLERY

427 Esplanade Ave., New Orleans LA 70116. (504)949-3512. Fax: (504)949-1909. E-mail: InsleyArtGallery@aol.com. Website: www.InsleyArt.com. **Contact:** Charlene Insley, owner. Retail gallery. Estab. 2004. Approached by 52 artists/year; represents or exhibits 5-8 artists. Sponsors 1 photography exhibit/year. Average display time 2 months. Open Tuesday through Friday from 12 to 5; 10-3 Saturdays. Located in historic building on the edge of the French Quarter. Overall price range $300-22,500. Most work sold at $2,000.

Making Contact & Terms Artwork is accepted on consignment, and there is a 30-50% commission. Gallery provides insurance, promotion and contract. Accepted work should be framed. Requires exclusive representation locally.

Submissions Call or write to arrange personal interview to show portfolio of photographs, slides and transparencies. Send query letter with bio, brochure and business card. Cannot return material. Responds only if interested within 2 months. Finds artists through referrals by other artists, submissions and portfolio reviews.

◼ INTERNATIONAL CENTER OF PHOTOGRAPHY

1133 Avenue of the Americas, New York NY 10036. (212)857-0000. Fax: (212)768-4688. E-mail: info@icp.org. Website: www.icp.org. **Contact:** Department of Exhibitions & Collections. Estab. 1974.

Submissions "Due to the volume of work submitted, we are only able to accept portfolios in the form of 35mm slides or CDs. All slides must be labeled on the front with a name, address, and a mark indicating the top of the slide. Slides should also be accompanied by a list of titles and dates. CDs must be labeled with a name and address. Submissions must be limited to one page of up to 20 slides or a CD of no more than 20 images. Portfolios of prints or of more than 20 images will not be accepted. Photographers may also wish to include the following information: cover letter, résumé or curriculum vitae, artist's statement and/or project description. ICP can only accept portfolio submissions via mail (or FedEx, etc.). Please include a SASE for the return of materials. ICP cannot return portfolios submitted without return postage."

INTERNATIONAL VISIONS GALLERY

2629 Connecticut Ave. NW, Washington DC 20008. (202)234-5112. Fax: (202)234-4206. E-mail: intvisions@aol.com. Website: www.inter-visions.com. **Contact:** Timothy Davis, owner/director. For-profit gallery. Estab. 1997. Approached by 60 artists/year; represents or exhibits 50 artists. Sponsors 1 photography exhibit/year. Average display time 4-6 weeks. Gallery open Wednesday through Saturday from 11 to 6. Located in the heart of Washington, DC; features 1,000 sq. ft. of exhibition space. Overall price range $1,000-8,000. Most work sold at $2,500.

Exhibits Exhibits photos of babies/children/teens, multicultural.

Making Contact & Terms Artwork is accepted on consignment, and there is a 50% commission. Gallery provides insurance, promotion, contract. Accepted work should be framed. Requires exclusive representation locally.

Submissions Call. Send query letter with artist's statement, bio, photocopies, résumé, SASE. Responds in 2 months. Finds artists through word of mouth, art exhibits, referrals by other artists.

ℕ ◼ JAMESON GALLERY & FRAME AND THE JAMESON ESTATE COLLECTION

305 Commercial St., Portland ME 04101. (207)772-5522. Fax: (207)774-7648. E-mail: art@jamesongallery.com. **Contact:** Martha Gilmartin, gallery director. Retail gallery, custom framing, restoration, appraisals, consultation. Estab. 1992. Represents 20+ artists/year. Mounts 6 shows/year. Average display time 3-4 weeks. Open all year; Monday-Saturday, 10-6. Located on the waterfront in the heart of the shopping district; 4,000 sq. ft. 50% of space for contemporary artists; 25% for frame shop; 25% for The Jameson Estate Collection dealing later 19th- and 20th-century paintings, drawings and photographs. Most work sold at $1,500 and up.

Exhibits B&w photography.

Making Contact & Terms Gallery provides insurance, promotion and contract; artist pays shipping costs. Prefers artwork unframed, but will judge on a case-by-case basis. Artist may buy framing contract with gallery.

Submissions Send CV and artist's statement, a sampling of images on a PC-compatible CD or zip of floppy disk and SASE if you would like the materials returned.

▣ JHB GALLERY

26 Grove St., Suite 4C, New York NY 10014-5329. (212)255-9286. Fax: (212)229-8998. E-mail: info@jhbgallery.com. Private art dealer and consultant. Estab. 1982. Gallery open by appointment only. Overall price range $1,000-20,000. Most work sold at $2,500-5,000.

Making Contact & Terms Artwork is accepted on consignment, and there is a 50% commission. Gallery provides promotion.

Submissions Send query letter with résumé, CD, slides, artist's statment, reviews, SASE. Finds artists through submissions, portfolio reviews, art exhibits, art fairs, referrals by other curators.

ⓝ KEARON-HEMPENSTALL GALLERY

536 Bergen Ave., Jersey City NJ 07304. (201)333-8855. Fax: (201)333-8488. E-mail: suzann@khgallery.com. Website: www.khgallery.com. **Contact:** Suzann McKiernan, director. Estab. 1980. Sponsors 1 exhibit/year. Average display time 1 month. Overall price range $150-400.

Exhibits Interested in color and b&w prints.

Making Contact & Terms Charges 50% commission. Reviews transparencies. Accepted work should be mounted, matted work only. Requires exclusive representation locally. Send material by mail for consideration. Include SASE, résumé, exhibition listing, artist's statement and price of sold work. Responds in 1 month.

Tips "Be professional: have a full portfolio; be energetic and willing to assist with sales of your work."

ⓝ KENT STATE UNIVERSITY SCHOOL OF ART GALLERY

KSU, 201 Art Building, Kent OH 44242. (330)672-7853. Fax: (330)672-9570. **Contact:** Fred T. Smith, director. Sponsors 1 exhibit/year. Average display time 3 weeks.

Exhibits Interested in all types, styles and subject matter of photography. Photographer must present quality work.

Making Contact & Terms Photography can be sold in gallery. Charges 20% commission. Buys photography outright.

Submissions Will review transparencies. Write a proposal and send with slides. Send material by mail for consideration; include SASE. Responds "usually in 4 months, but it depends on time submitted."

KENTUCKY MUSEUM OF ART AND CRAFT

(formerly Kentucky Museum of Arts & Design), 715 W. Main St., Louisville KY 40202. **Contact:** Brion Clinkingbeard. Nonprofit gallery, museum. Estab. 1981. Approached by 300 artists/year; represents or exhibits 100 artists. Sponsors 2 photography exhibits/year. Average display time 4-6 weeks. Open all year; Monday through Friday from 10 to 5; Saturday from 11 to 5. Three floors with a gallery on each floor. Overall price range: $50-40,000. Most work sold at $200.

Exhibits Exhibits photos of landscapes/scenics, performing arts, travel. Interested in alternative process, avant garde, documentary, fine art.

Terms Artwork is accepted on consignment, and there is a 50% commission. Gallery provides insurance, promotion and contract. Accepted work should be framed and matted.

Submissions Send query letter with artist's statement, bio, photocopies, photographs, slides and SASE. Responds to queries in 1 month. Finds artists through art fairs, art exhibits, portfolio reviews, referrals by other artists and submissions.

Tips "Clearly identify reason for wanting to work with KMAC. Show a level of professionalism and proven track record of exhibitions."

▣ ROBERT KLEIN GALLERY

38 Newbury St., Boston MA 02116. (617)267-7997. Fax: (617)267-5567. E-mail: inquiry@robertkleingallery.com. Website: www.robertkleingallery.com. **Contact:** Robert L. Klein, president. Estab. 1978. Sponsors 10 exhibits/year. Average display time 5 weeks. Overall price range $1,000-200,000.

Exhibits Must be established a minimum of 5 years; preferably published. Interested in fashion, documentary, nudes, portraiture, and work that has been fabricated to be photographs.

Making Contact & Terms Charges 50% commission. Buys photos outright. Accepted work should be unframed, unmmatted, unmounted. Requires exclusive representation locally.

Submissions "Send materials by e-mail or mail with SASE for consideration. Please allow *at least* 1 month for response."

ROBERT KOCH GALLERY

49 Geary St., San Francisco CA 94108. (415)421-0122. Fax: (415)421-6306. E-mail: info@kochgallery.com. Website: www.kochgallery.com. For-profit gallery. Estab. 1979. Sponsors 6-8 photography exhibits/year. Average display time 2 months. Gallery open Tuesday through Saturday from 10:30 to 5:30.

Making Contact & Terms Artwork is accepted on consignment. Gallery provides insurance, promotion, contract. Requires West Coast or national representation.

Submissions Finds artists through publicatons, art exhibits, art fairs, referrals by other artists and curators, collectors, critics.

Ⓝ ▣ PAUL KOPEIKIN GALLERY

6150 Wilshire Blvd., Los Angeles CA 90048. (323)937-0765. Fax: (323)937-5974. E-mail: info@PaulKopeikinG allery.com. Website: www.PaulKopeikinGallery.com. Estab. 1990. Sponsors 7-9 exhibits/year. Average display time 4-6 weeks.

Exhibits Must be highly professional. Quality and unique point of view also important. No restriction on type, style or subject.

Making Contact & Terms Charges 50% commission. Requires exclusive West Coast representation.

Submissions Submit CDs or digital prints and support material; include SASE. "Multimedia and painting also considered."

Tips "Don't waste people's time by showing work before you're ready to do so."

Ⓝ MARGEAUX KURTIE MODERN ART AT THE ART HOTEL

39 Yerba Buena, P.O. Box 39, Cerrillos NM 87010. (505)473-2250. E-mail: mkmamadrid@att.net. Website: www.mkmamadrid.com. **Contact:** Jill Alikas, director. For-profit gallery, art consultancy. Estab. 1996. Approached by 200 artists/year; represents or exhibits 13 artists. Sponsors 2 photography exhibits/year. Average display time 5 weeks. Gallery open Thursday through Tuesday from 11 to 5. Closed February. Located within a historic frontier village 35 miles outside of Santa Fe, 1,020 sq. ft. Overall price range $350-15,000. Most work sold at $2,800.

Exhibits Interested in avant garde, erotic, fine art.

Making Contact & Terms Artwork is accepted on consignment, and there is a 50% commission. Requires exclusive representation locally.

Submissions Website lists criteria for review process. Mail portfolio for review. Send query letter with artist's statement, bio, résumé, reviews, SASE, slides, $25 review fee, check payable to gallery. Finds artists through art fairs, art exhibits, portfolio reviews, referrals by other artists, submissions, word of mouth.

Ⓝ LA ART ASSOCIATION/GALLERY 825

825 N. La Cienega Blvd., Los Angeles CA 90069. (310)652-8272. Fax: (310)652-9251. Website: www.laaa.org. **Contact:** Peter Mays, executive director. Artistic Director: Sinead Finnerty. Estab. 1925. Sponsors 16 exhibits/ year. Average display time 4-5 weeks. Sponsors openings. Overall price range $200-5,000. Most work sold at $600.

● Also displays exhibitions at 825/LAAA Annex, 2525 Michigan Ave., E-2, Santa Monica CA 90404.

Exhibits Exhibits photography and work of all media. "Must go through membership screening conducted twice/year; contact the gallery for dates. Gallery offers group and solo shows." Interested in Southern Californian artists—all media and avant garde, alternative process, fine art. Has annual "open" juried show open to all southern California artists. Call for prospectus.

Making Contact & Terms Charges 33% commission. Works are limited to 100 lbs.

Submissions Submit 3 pieces during screening date. Responds immediately following screening. Call for screening dates.

Tips "Bring work produced in the last 2 years."

LANDING GALLERY

7956 Jericho Turnpike, Woodbury NY 11797. (516)364-2787. Fax: (516)364-2786. **Contact:** Bruce Busko, president. For-profit gallery. Estab. 1985. Approached by 40 artists/year; represents or exhibits 50 artists. Sponsors 1 photography exhibit/year. Average display time 2-3 months. Gallery open Monday through Friday from 10 to 6; weekends from 10 to 6. Closed Tuesdays. 3,000 sq. ft. on 2 floors with 19-foot ceilings. Overall price range $100-12,000. Most work sold at $1,500.

Exhibits Exhibits photos of landscapes/scenics, architecture, cities/urban, rural, adventure, automobiles, entertainment. Interested in alternative process, avant garde, erotic, fine art, historical/vintage. Seeking photos "with hand color or embellishment."

Making Contact & Terms Artwork is accepted on consignment, and there is a 50% commission. Gallery provides insurance, promotion, contract. Accepted work should be framed. Requires exclusive representation locally.

Submissions Call to show portfolio. Mail portfolio for review. Send query letter with artist's statement, bio, brochure, business card, photocopies, photographs, résumé, reviews, slides, SASE. Responds in 2 weeks. Finds artists through word of mouth, submissions, portfolio reviews, art exhibits, art fairs, referrals by other artists.

ᴺ ⊘ ELIZABETH LEACH GALLERY

417 NW 9th Ave., Portland OR 97209-3308. (503)224-0521. Fax: (503)224-0844. E-mail: art@elizabethleach.com. Website: www.elizabethleach.com. **Contact:** Molly Torgeson, assistant director. Sponsors 3-4 exhibits/year. Average display time 1 month. "The gallery has extended hours every first Thursday of the month for our openings." Overall price range $300-5,000.

Exhibits Photographers must meet museum conservation standards. Interested in "high-quality concept and fine craftmanship."

Making Contact & Terms Charges 50% commission. Accepted work should be framed or unframed, matted. Requires exclusive representation locally.

Submissions Not accepting submissions at this time.

▣ LEHIGH UNIVERSITY ART GALLERIES

420 E. Packer Ave., Bethlehem PA 18015. (610)758-3619. Fax: (610)758-4580. E-mail: rv02@lehigh.edu. Website: www.luag.org. **Contact:** Ricardo Viera, director/curator. Sponsors 5-8 exhibits/year. Average display time 6-12 weeks. Sponsors openings.

Exhibits Exhibits fine art/multicultural, Latin American. Interested in all types of works. The photographer should "preferably be an established professional."

Making Contact & Terms Reviews transparencies. Arrange a personal interview to show portfolio. Send query letter with SASE. Responds in 1 month.

Tips "Don't send more than 10 (top) slides, or CD."

DAVID LEONARDIS GALLERY

1346 N. Paulina St., Chicago IL 60622. (773)278-3058. E-mail: david@dlg-gallery.com. Website: www.dlg-gallery.com. **Contact:** David Leonardis, owner. For-profit gallery. Estab. 1992. Approached by 100 artists/year; represents or exhibits 12 artists. Average display time 30 days. Gallery open Tuesday through Saturday from 12 to 7; Sunday from 12 to 6. One big room, four big walls. Overall price range $50-5,000. Most work sold at $500.

Exhibits Exhibits photos of celebrities. Interested in fine art.

Making Contact & Terms Artwork is accepted on consignment, and there is a 50% commission. Gallery provides promotion. Accepted work should be framed. "Artists should be professional and easy to deal with." E-mail to arrange personal interview to show portfolio. Mail portfolio for review. Send query letter via e-mail. Responds only if interested. Finds artists through word of mouth, art exhibits, referrals by other artists.

ᴺ ▣ THE LIGHT FACTORY

345 N. College St., Charlotte NC 28202. E-mail: info@lightfactory.org. Website: www.lightfactory.org. **Contact:** Crista Cammaroto, artistic director. Nonprofit. Estab. 1972. Alternative visual arts organization. Open Monday through Friday from 10 to 6; Saturday from 12 to 5; Sunday from 1 to 5.

Exhibits Interested in light-generated media (photography, video, film, digital art). Exhibitions often push the limits of photography as an art form and address political, social or cultural issues.

Making Contact & Terms Artwork sold in the gallery. "Artists price their work." Charges 34% commission. Gallery provides insurance. "We do not represent artists, but present changing exhibitions." No permanent collection. Send query letter with résumé, slides/CDs, artist's statement, SASE. Responds in 4 months.

LIMITED EDITIONS & COLLECTIBLES

697 Haddon, Collingswood NJ 08108. (856)869-5228. E-mail: jdl697ltd@juno.com. Website: www.ltdedition s.net. **Contact:** John Daniel Lynch, Sr., owner. For-profit online gallery. Estab. 1997. Approached by 24 artists/year; represents or exhibits 70 artists. Sponsors 20 photography exhibits/year. Overall price range $100-3,000. Most work sold at $450.

Exhibits Exhibits photos of landscapes/scenics, wildlife, adventure, automobiles, entertainment, events, food/drink, health/fitness/beauty, hobbies, humor, performing arts, sports, travel. Interested in alternative process, documentary, erotic, fashion/glamour, historical/vintage, seasonal.

Making Contact & Terms Artwork is accepted on consignment, and there is a 30% commission. Gallery provides insurance, promotion, contract.

Submissions Call or write to show portfolio. Send query letter with bio, business card, résumé. Responds in 1 month. Finds artists through word of mouth, portfolio reviews, art exhibits, referrals by other artists.

▣ LONGVIEW MUSEUM OF FINE ARTS

215 E. Tyler St., P.O. Box 3484, Longview TX 75606. (903)753-8103. Fax: (903)753-8217. E-mail: lmfa@sbcglo bal.net. **Contact:** Renée Hawkins, director. Nonprofit museum. Estab. 1958. Sponsors 1 photography exhibit/ year. Average display time 6 weeks. Museum open Tuesday through Friday from 10 to 4; Saturday from 12 to 4. Large open gallery with hardwood floors, large doors, 14-foot ceilings, 15,000 sq. ft.

Exhibits Exhibits photos of architecture, landscapes/scenics, nudes, abstracts, sculpture.

Making Contact & Terms Gallery provides insurance. Accepted work should be ready to hang.

Submissions Mail portfolio for review. Send query letter with bio, list of gallery representation and résumé, as well as artist's statement with photographs, slides, CDs (preferred) and/or website address. Unsolicited portfolios are not returned.

Ⓝ MACNIDER ART MUSEUM

303 Second St. SE, Mason City IA 50401. (641)421-3666. Website: www.macniderart.org. **Contact:** Director. Nonprofit gallery. Estab. 1966. Represents or exhibits 1-10 artists. Sponsors 2-5 photography exhibits/year (one is competitive for the county). Average display time 2 months. Gallery open Tuesday and Thursday from 9 to 9; Wednesday, Friday, Saturday from 9 to 5; Sunday from 1 to 5. Closed Monday. Overall price range $50-2,500. Most work sold at $200.

Making Contact & Terms Artwork is accepted on consignment, and there is a 40% commission. Gallery provides insurance, promotion, contract. Accepted work should be framed.

Submissions Mail portfolio for review. Responds only if interested within 3 months. Finds artists through word of mouth, submissions, portfolio reviews, art exhibits, art fairs, referrals by other artists. Exhibition opportunities: exhibition in galleries, presence in museum shop on consignment or booth at Festival Art Market in June.

THE MAIN STREET GALLERY

105 Main St., P.O. Box 161, Groton NY 13073. (607)898-9010. Fax: (607)898-9010. Website: www.mainstreetg al.com. **Contact:** Adrienne Smith, director. For-profit gallery, art consultancy. Estab. 2003. Exhibits 15 artists. Sponsors 1 photography exhibit/year. Average display time 5-6 weeks. Open Thursday through Saturday from 12 to 7; Sunday from 1 to 5; closed January and February. Located in the village of Goton in the Finger Lakes Region of New York, 20 minutes from Ithaca; 900 sq. ft. Overall price range: $120-5,000.

Exhibits Interested in fine art.

Terms Artwork is accepted on consignment, and there is a 40% commission. Gallery provides insurance, promotion and contract. Accepted work should be framed, mounted and matted. Requires exclusive representation locally.

Submissions Write to arrange personal interview to show portfolio of photographs, slides. Send query letter with artist's statement, bio, brochure, photographs, résumé, reviews, slides and SASE. Responds to queries only if interested in 1 month. Finds artists through art exhibits, portfolio reviews, referrals by other artists, submissions and word of mouth.

Tips After submitting materials, the artist will set an appointment to talk over work. Artists should send in up-to-date résumé and artist's statement.

Galleries

N MANZANITA GALLERY

6525 Washington St., Yountville CA 94599. (707)945-0660. Fax: (510)724-9124. E-mail: hjlawton@manzan ita-ent.com. Website: www.manzanita-ent.com. **Contact:** Mike Radesky, Sales Manager. For-profit gallery. Estab. 2004. Approached by 50 artists/year; represents or exhibits 4 artists. Model release and property release are required. Average display time 3 months. Open Monday through Sunday from 10 to 5:30. Closed Thanksgiving, Christmas, New Year's Day. Located in the vintage 1870 Center, 830 sq. ft. dedicated to photography. Overall price range $125-1,500. Most work sold at $375.

Exhibits Exhibits photos of agriculture, disasters, environmental, landscapes/scenics, wildlife, travel. Interested in fine art.

Making Contact & Terms Artwork is accepted on consignment, and there is a 40% commission. Gallery provides insurance, promotion. Accepted work should be framed, mounted, matted.

Submissions Call or mail portfolio for review. Send query letter with artist's statement, bio. Responds in 1 month.

Tips "Guest artists are required to submit a minimum of 20 photographic prints (color or b&w) as examples of work to be displayed along with a 1- to 2-page bio. Guest artists have an opening night reception on 'Gallery Night,' the first Saturday of a given month."

MARLBORO GALLERY

Prince George's Community College, 301 Largo Rd., Largo MD 20772-2199. (301)322-0965. Fax: (301)808-0418. E-mail: tberault@pgcc.edu. Website: www.pgcc.edu. **Contact:** Tom Berault, gallery curator. Estab. 1976. Average display time 1 month. Overall price range $50-2,000. Most work sold at $75-350.

Exhibits Exhibits photos of celebrities, landscapes/scenics, wildlife, adventure, entertainment, events, travel. Interested in alternative process, avant garde, fine art. Not interested in commercial work. "We are looking for fine art photos; we need 10-20 to make assessment. Reviews are done every 6 months. We prefer to receive submissions February through April."

Making Contact & Terms Accepted work should be framed.

Submissions Send query letter with résumé, slides, photographs, artist statement, bio and SASE. Responds in 1 month.

Tips "Send examples of what you wish to display and explanations if photos do not meet normal standards (i.e., in focus, experimental subject matter)."

MATHIAS FINE ART

10 Mathias Dr., Trevett ME 04571. **Contact:** Cordula Mathias, president. Estab. 1992. Approached by 20-30 artists/year; represents or exhibits 15-20 artists. Average display time 2 months. Gallery open Wednesday through Sunday from 12 to 5:30 and by appointment. Mid-November through mid-May by appointment. 400 sq. ft.; combination of natural and artificial lighting. Overall price range $50-25,000. Most work sold at $800.

Exhibits Exhibits photos of environmental, landscapes/scenics. Interested in alternative process, avant garde, fine art, digital. Also interested in digitally enhanced chromogenic images.

Making Contact & Terms Artwork is accepted on consignment, and there is a 50% commission. Gallery provides promotion, contract. Accepted work should be framed, matted. Requires exclusive representation locally. Prefers artists who can deliver and pick-up. Send query letter with bio, photographs, résumé, reviews, slides, SASE. Responds in 4-6 weeks. Finds artists through word of mouth, submissions, portfolio reviews, art exhibits, referrals by other artists.

Tips "Photographers should have clearly labeled slides or photographs, well organized vita, informative artist's statement."

MORTON J. MAY FOUNDATION GALLERY—MARYVILLE UNIVERSITY

13550 Conway Rd., St. Louis MO 63141. (314)529-9940. E-mail: swt@maryville.edu. **Contact:** Steve Teczar, gallery director and art professor. Sponsors 1-3 exhibits/year. Average display time 1 month. Overall price range $400-1,200. Most work sold at $400.

Exhibits Must transcend student work, have a consistent aesthetic point of view or theme and be technically excellent. Interested in alternative process, avant garde, documentary, fine art, historical/vintage, and digital.

Making Contact & Terms Photographer is responsible for all shipping costs to and from gallery. Gallery takes no commission; photographer responsible for collecting fees. Accepted work should be framed or suitably presented.

Submissions Send material by mail with SASE for consideration. Responds in 4 months.

THE MAYANS GALLERY LTD.

601 Canyon Rd., Santa Fe NM 87501. (505)983-8068. Fax: (505)982-1999. E-mail: arte2@aol.com. Website: www.artnet.com/mayans.html. **Contact:** Ernesto Mayans, director. Estab. 1977. Publishes books, catalogs and portfolios. Overall price range $200-5,000.

Making Contact & Terms Charges 50% commission. Consigns. Requires exclusive representation within area.

Submissions Size limited to 11×20 maximum. Arrange a personal interview to show portfolio. Send query by mail with SASE for consideration. Responds in 2 weeks.

Tips "Please call before submitting."

MEADOW BROOK ART GALLERY

208 Wilson Hall/Oakland University, Rochester MI 48309-4401. (248)370-3005. Fax: (248)370-3005. E-mail: jaleow@oakland.edu. Website: www.oakland.edu/mbag. **Contact:** Dick Goody, director. Nonprofit gallery. Estab. 1962. Approached by 10 artists/year; represents 10-25 artists/year. Sponsors 3 exhibits/year. Average display time 4-5 weeks. Open Tuesday through Sunday from 12 to 5: evenings during theater performances from 7 to 9; weekends from 12 to 5: evenings during theater performances, 5:00-1st intermission. Closed June-August. Located on the campus of Oakland University. Exhibition space is approximately 2,350 sq. ft. of floor space; 301-ft. linear wall space, with 10-ft. 7-in. ceiling. The gallery is situated across the hall from the Meadow Brook Theatre. "We do not sell work, but do make available price lists for visitors with contact information noted for inquiries."

Exhibits Considers all styles and all types of prints and media.

Making Contact & Terms Charges no commission. Gallery provides insurance, promotion and contract. Accepted work should be framed, mounted, matted. No restrictions on representation; however, prefers emerging Detroit artists.

Submissions E-mail bio, education, artist's statement and JPEG images to director: goody@oakland.edu. Mail portfolio for review. Send query letter with artist's statement, bio, photocopies, résumé, slides. Returns material with SASE. Responds to queries in 1-2 months. Finds artists through referrals by other artists, word of mouth, art community, advisory board and other arts organizations.

MESA CONTEMPORARY ARTS

155 N. Center St., P.O. Box 1466, Mesa AZ 85211-1466. (480)644-2056. Fax: (480)644-2901. E-mail: patty.haberman@cityofmesa.org. Website: www.mesaarts.com. **Contact:** Curator. Not-for-profit art space. Estab. 1980. Sponsors 5 national juried exhibits/year. Average display time 4-6 weeks. Overall price range $250-5,000. Most work sold at $600.

Exhibits Exhibits photos of babies/children/teens, celebrities, couples, multicultural, families, parents, senior citizens, disasters, environmental, landscapes/scenics, wildlife, architecture, cities/urban, interiors/decorating, rural, adventure, automobiles, entertainment, events, performing arts, travel, industry, political, science, technology/computers. Interested in alternative process, avant garde, documentary, fine art, historical/vintage, seasonal, and contemporary photography as part of national juried exhibitions in any and all media.

Making Contact & Terms Charges $25 entry fee, 25% commission.

Submissions "Contact us to receive a current season prospectus, which includes information, guidelines and entry forms for all the exhibitions." Slides are reviewed by changing professional jurors. Must fit through a standard size door and be ready for hanging. National juried shows awards total $2,000. Responds in 1 month.

Tips "We do invitational or national juried exhibits only. Submit professional-quality slides."

THE MEXICAN MUSEUM

Fort Mason Center, Bldg. D, San Francisco CA 94123. (415)202-9700. Fax: (415)441-7683. Website: www.mexicanmuseum.org. **Contact:** Curator. Museum. Estab. 1975. Represents or exhibits 4 artists. Sponsors 1 photography exhibit every 3 years. Average display time 3 months. Gallery open Wednesday through Friday from 11 to 5; weekends from 11 to 5. Closed major holidays.

Exhibits Interested in fine art. Presents or sponsors only Latino artists.

Submissions Send query letter with artist's statement, bio, brochure, business card, photocopies, photographs, résumé, reviews, slides. Responds only if interested within 6 months.

R. MICHELSON GALLERIES

132 Main St., Northampton MA 01060. (413)586-3964. Fax: (413)587-9811. E-mail: RM@RMichelson.com. Website: www.RMichelson.com. **Contact:** Richard Michelson, owner and president. Estab. 1976. Sponsors

1 exhibit/year. Average display time 6 weeks. Sponsors openings. Overall price range $1,200-5,000.
Exhibits Interested in contemporary, landscape and/or figure work.
Making Contact & Terms Sometimes buys photos outright. Accepted work can be framed or unframed, mounted or unmounted, matted or unmatted. Requires exclusive representation locally. Not taking on new photographers at this time.

MILL BROOK GALLERY & SCULPTURE GARDEN

236 Hopkinton Rd., Concord NH 03301. (603)226-2046. E-mail: artsculpt@mindspring.com. Website: www.t hemillbrookgallery.com. For-profit gallery. Estab. 1996. Exhibits 70 artists. Sponsors 1 photography exhibit/ year. Average display time 6 weeks. Gallery open Tuesday through Saturday, April 1 to December 24, from 11 to 5. Open by appointment December 25 to March 31. Outdoor juried sculpture exhibit. Three rooms inside for exhibitions, 1,800 sq. ft. Overall price range $8-30,000. Most work sold at $500-1,000.
Making Contact & Terms Artwork is accepted on consignment, and there is a 50% commission. Gallery provides insurance, promotion, contract. Accepted work should be framed, matted.
Submissions Write to arrange a personal interview to show portfolio of photographs, slides. Send query letter with artist's statement, bio, photocopies, photographs, résumé, slides, SASE. Responds only if interested within 1 month. Finds artists through word of mouth, submissions, art exhibits, referrals by other artists.

PETER MILLER GALLERY

118 N. Peoria, Chicago IL 60607. (312)226-5291. Fax: (312)226-5441. E-mail: info@petermillergallery.com. Website: www.petermillergallery.com. **Contact:** Peter Miller and Natalie R. Domchenko, directors. Estab. 1979. Gallery is 3,500 sq. ft. with 12-foot ceilings. Overall price range $1,000-40,000. Most work sold at $5,000.
Exhibits Painting, sculpture, photography and new media.
Making Contact & Terms Charges 50% commission. Accepted work can be framed or unframed, mounted or unmounted, matted or unmatted. Requires exclusive representation locally.
Submissions Send 20 slides of your most recent work with SASE. Responds in 2 weeks.
Tips "We look for work we haven't seen before; i.e., new images and new approaches to the medium."

ⓝ MONTEREY MUSEUM OF ART

559 Pacific St., Monterey CA 93940. (831)372-5477. Fax: (831)372-5680. Website: www.montereyart.org. **Contact:** E. Michael Whittington, executive director. Estab. 1969. Sponsors 3-4 exhibits/year. Average display time approximately 10 weeks.
Exhibits Interested in all subjects.
Making Contact & Terms Accepted work should be framed.
Submissions Send slides by mail for consideration. Include SASE. Responds in 1 month.
Tips "Send 20 slides and résumé at any time to the attention of the museum director."

MULTIPLE EXPOSURES GALLERY

105 N. Union St., #312, Alexandria VA 22314-3217. (703)683-2205. E-mail: facph@starpower.net. Website: www.torpedofactory.org. **Contact:** Link Nicoll, president. Cooperative gallery. Estab. 1986. Represents or exhibits 14 artists. Sponsors 12 photography exhibits/year. Average display time 1 month. Gallery open Monday through Friday from 11 to 5; weekends from 11 to 5. Closed on 5 major holidays throughout the year. Located in Torpedo Factory Art Center; 10-foot walls with about 40 feet of running wall space; one bin for each artist's matted photos, up to 24×24 in size with space for 10-20 pieces.
Exhibits Exhibits photos of children, couples, multicultural, landscapes/scenics, architecture, beauty, cities/ urban, religious, rural, adventure, automobiles, events, travel, buildings. Interested in alternative process, documentary, fine art. Other specific subjects/processes: "We have on display roughly 300 images that run the gamut from platinum and older alternative processes through digital capture and output."
Making Contact & Terms There is a co-op membership fee, a time requirement, a rental fee and a 15% commission. Accepted work should be matted. Accepts only artists from Washington, DC, region. Accepts only photography. "Membership is by jury of active current members. Membership is limited to 14. Jurying for membership is only done when a space becomes available; on average, 1 member is brought in about every 2 years."
Submissions Send query letter with SASE to arrange a personal interview to show portfolio of photographs, slides. Responds in 2 months. Finds artists through word of mouth, referrals by other artists, ads in local art/photography publications.
Tips "Have a unified portfolio of images mounted and matted to archival standards."

MICHAEL MURPHY GALLERY INC.

2722 S. MacDill Ave., Tampa FL 33629. (813)902-1414. Fax: (813)835-5526. E-mail: mmurphy@michaelmurp hygallery.com. Website: www.michaelmurphygallery.com. **Contact:** Michael Murphy, owner. For-profit gallery. Estab. 1988. Approached by 100 artists/year; exhibits 35 artists. Sponsors 1 photography exhibit/year. Average display time 1 month. Open all year; Monday through Saturday from 10 to 6. Overall price range $500-15,000. Most work sold at less than $1,000.

Exhibits Exhibits photos of babies/children/teens, celebrities, couples, multicultural, families, parents, senior citizens, disasters, environmental, landscapes/scenics, wildlife, architecture, cities/urban, education, gardening, interiors/decorating, pets, religious, rural, agriculture, business concepts, industry, medicine, military, political, product shots/still life, science, technology/computers. Interested in alternative process, avant garde, documentary, erotic, fashion/glamour, fine art, historical/vintage, seasonal.

Making Contact & Terms Artwork is accepted on consignment, and there is a 50% commission. Accepted work should be framed. Requires exclusive representation locally.

Submissions Send query with artist's statement, bio, brochure, business card, photocopies, photographs, résumé, reviews, slides and SASE. Responds to queries only if interested in 1 month.

N MUSEO ITALOAMERICANO

Fort Mason Center, Building C, San Francisco CA 94123. (415)673-2200. Fax: (415)673-2292. E-mail: sfmuseo @sbcglobal.net. Website: www.museoitaloamericano.org. **Contact:** Amalie Veralli, administrator. Museum. Estab. 1978. Approached by 80 artists/year; exhibits 15 artists. Sponsors 1 photography exhibit/year (depending on the year). Average display time 2-3 months. Gallery open Wednesday through Sunday from 12 to 4; Monday and Tuesday by appointment. Closed major holidays. Gallery is located at Fort Mason Center, in Building C, in the San Francisco Marina District, with a beautiful view of the Golden Gate Bridge, Sausalito, Tiburon and Alcatraz. 3,500 sq. ft. of exhibition space.

Exhibits Exhibits photos of babies/children/teens, celebrities, couples, multicultural, families, parents, senior citizens, environmental, landscapes/scenics, architecture, cities/urban, education, religious, rural, entertainment, events, food/drink, hobbies, humor, performing arts, sports, travel, product shots/still life. Interested in alternative process, avant garde, documentary, fine art, historical/vintage.

Making Contact & Terms "The museum rarely sells pieces. If it does, it takes 20% of the sale." Museum provides insurance, promotion. Accepted work should be framed, mounted, matted. Accepts only Italian or Italian-American artists.

Submissions Call or write to arrange personal interview to show portfolio of photographs, slides, catalogs. Send query letter with artist's statement, bio, brochure, photographs, résumé, reviews, slides, SASE. Responds in 2 months. Finds artists through word of mouth, submissions.

Tips "Photographers should have good, quality reproduction of their work with slides, and clarity in writing their statements and résumés. Be concise."

N ▣ MUSEUM OF CONTEMPORARY PHOTOGRAPHY, COLUMBIA COLLEGE CHICAGO

600 S. Michigan Ave., Chicago IL 60605-1996. (312)663-5554. Fax: (312)344-8067. E-mail: mocp@colum.edu. Website: www.mocp.org. **Contact:** Rod Slemmons, director. Associate Director: Natasha Egan. Estab. 1984. "We offer our audience a wide range of provocative exhibitions in recognition of photography's roles within the expanded field of imagemaking." Sponsors 6 main exhibits and 4-6 smaller exhibits/year. Average display time 2 months.

Exhibits Exhibits photos of babies/children/teens, celebrities, couples, multicultural, families, parents, senior citizens, environmental, landscapes/scenics, architecture, cities/urban, rural, humor, performing arts, agriculture, medicine, political, science, technology/computers. Interested in alternative process, avant garde, documentary, fashion/glamour, fine art, photojournalism, commercial, technical/scientific, video. "All high-quality work considered."

Submissions Reviews portfolios, transparencies, images on CD. Interested in reviewing unframed work only, matted or unmatted. Submit portfolio for review; inlcude SASE. Responds in 1 month. No critical review offered.

Tips "Professional standards apply; only very high-quality work considered."

▣ ⊕ MYTHGALLERY.COM

B. Georgiou 37, Thessaloniki 54640 Greece. (30)(694)422-0890. E-mail: mythgallery@mythgallery.com. Website: www.mythgallery.com. **Contact:** Semitsoglou Ioannis, director. Online gallery. Estab. 2004.

Making Contact & Terms Artwork is accepted on consignment, and there is a 50% commission.

Submissions E-mail 5-25 JPEG files as attachments (approximately 100K), uniformly sized, and artist's bio. Responds in 3 weeks.

Tips "Visit website for submission guidelines. Acceptance of work is through review."

NEW MEXICO STATE UNIVERSITY ART GALLERY

MSC 3572, NMSU, P.O. Box 30001, Las Cruces NM 88001-8003. (505)646-2545. Fax: (506)646-8036. E-mail: artglry@nmsu.edu. Website: www.nmsu.edu/~artgal. **Contact:** Mary Anne Redding, director. Museum. Estab. 1969. Average display time 2-3 months. Gallery open Tuesday through Saturday from 10 to 5; Sunday from 12 to 5. Closed Christmas through New Year's Day and university holidays. Located on university campus, 3,900 sq. ft. of exhibit space.

Making Contact & Terms Artwork is accepted on consignment, and there is a 30% commission. Gallery provides insurance, promotion, contract. Accepted work should arrive ready to install.

Submissions Send query letter with artist's statement, bio, brochure, résumé, slides, SASE. Responds in 6 months.

NEXUS/FOUNDATION FOR TODAY'S ART

137 N. Second St., Philadelphia PA 19106. E-mail: info@nexusphiladelphia.org. Website: nexusphiladelphia. org. **Contact:** Nick Cassway, executive director. Alternative space; cooperative, nonprofit gallery. Estab. 1975. Approached by 40 artists/year; represents or exhibits 20 artists. Sponsors 2 photography exhibits/year. Average display time 1 month. Open Wednesday through Sunday from 12 to 6; closed July and August. Located in Old City, Philadelphia; 2 gallery spaces, approximately 750 sq. ft. each. Overall price range: $75-1,200. Most work sold at $200-400.

Exhibits Exhibits photos of multicultural, families, environmental, architecture, rural, entertainment, humor, performing arts, industry, political. Interested in alternative process, documentary, fine art.

Submissions Send query letter with artist's statement, bio, photocopies, photographs, slides, SASE. Finds artists through portfolio reviews, referrals by other artists, submissions, and juried reviews 2 times/year. "Please visit our website for submission dates."

Tips "Learn how to write a cohesive artist's statement."

ⓝ NICOLAYSEN ART MUSEUM & DISCOVERY CENTER

400 E. Collins Dr., Casper WY 82601. (307)235-5247. Fax: (307)235-0923. E-mail: info@thenic.org. Website: www.thenic.org. **Contact:** Holly Turner, executive director; Ben Mitchell, director of exhibitions and programming. Estab. 1967. Sponsors 10 exhibits/year. Average display time 3-4 months. Sponsors openings. Overall price range $250-1,500.

Exhibits Work must demonstrate artistic excellence and be appropriate to gallery's schedule. Interested in all subjects and media. ·

Making Contact & Terms Charges 40% commission.

Submissions Send material by mail for consideration (slides, résumé/CV, proposal); include SASE. Responds in 1 month.

NORTHWEST ART CENTER

500 University Ave. W., Minot ND 58707. (701)858-3264. Fax: (701)858-3894. E-mail: nac@minotstateu.edu. Website: www.misa.nodak.edu/nwac. **Contact:** Catherine Walker, director. Estab. 1976. Sponsors 18-20 exhibits/year. Average display time 1 month. Northwest Art Center consists of 2 galleries: Hartnett Hall Gallery and the Library Gallery. Overall price range $50-2,000. Most work sold at $800 or less.

Exhibits Exhibits photos of babies/children/teens, couples, multicultural, families, parents, senior citizens, disasters, environmental, landscapes/scenics, architecture, cities/urban, education, gardening, pets, religious, rural, adventure, entertainment, events, food/drink, health/fitness/beauty, hobbies, humor, performing arts, sports, travel, agriculture, military. Interested in alternative process, avant garde, documentary, fine art, historical/vintage.

Making Contact & Terms Charges 30% commission. Accepted work should be framed.

Submissions Send material by mail with SASE or e-mail for consideration. Responds within 3 months.

O.K. HARRIS WORKS OF ART

383 W. Broadway, New York NY 10012. (212)431-3600. Fax: (212)925-4797. E-mail: okharris@okharris.com. Website: www.okharris.com. **Contact:** Ivan C. Karp, director. Estab. 1969. Sponsors 3-8 exhibits/year. Aver-

age display time 1 month. Gallery open Tuesday through Saturday from 10 to 6. Closed August and from December 25 to January 1. Overall price range $350-3,000.

Exhibits Exhibits photos of cities/urban, events, rural. "The images should be startling or profoundly evocative. No rocks, dunes, weeds or nudes reclining on any of the above or seascapes." Interested in urban and industrial subjects, cogent photojournalism, documentary.

Making Contact & Terms Charges 50% commission. Accepted work should be matted and framed.

Submissions Appear in person, no appointment. Responds immediately.

Tips "Do not provide a descriptive text."

▣ ⊕ OXYGEN GALLERY

P.O. Box 50797, Thessaloniki 54014 Greece. (30)(694)425-7125. E-mail: info@oxygengallery.com. Website: www.oxygengallery.com. **Contact:** Giannis Angelou, owner. Online commercial gallery. Estab. 2004.

Exhibits Interested in concept and unusual images. Opportunities for additional portfolio showcases.

Making Contact & Terms Send query letter with résumé, credits, samples in digital media plus printed index. Charges 50% commission.

Submissions Submission guidelines provided on website. Accepts digital submissions only.

Tips "Study the images on the website and the information provided. We opt for a few very unique images rather than large numbers of images. Follow your most creative spirit."

THE PACKINGHOUSE GALLERY & PHOTOGRAPHY STUDIO

10900 Oakhurst Rd., Largo FL 33774-4539. (727)596-7822. Fax: (727)596-7822. E-mail: Lesley@packinghouse gallery.com. Website: www.packinghousegallery.com. **Contact:** Lesley Collins, founder. For-profit gallery. Estab. 2001. Approached by 30 artists/year; represents or exhibits 40 artists. Sponsors 4 photography exhibits/year. Average display time 12 weeks. Gallery open Monday through Saturday from 10 to 5. The gallery is 4,000 sq. ft. including the Nature Photography Gallery (1,900 sq. ft. by itself). Overall price range $25-1,200. Most work sold at $175-975.

Exhibits Exhibits photos of environmental, landscapes/scenics, wildlife, travel (mostly Florida). Interested in fine art photography.

Making Contact & Terms Artwork is accepted on consignment, and there is a 50% commission. Gallery provides promotion, contract. Accepted work should be framed, mounted, matted with archival materials.

Submissions Call/write to arrange personal interview to show portfolio of photographs, slides. Mail portfolio for review. Send query letter with bio, photographs, reviews, slides, SASE. Responds in 5 weeks. Finds artists through word of mouth, submissions, portfolio reviews, referrals by other artists.

▦ PALO ALTO ART CENTER

1313 Newell Rd., Palo Alto CA 94303. (650)329-2366. Fax: (650)326-6165. E-mail: artcenter@city.palo-alto.ca .us. Website: www.city.palo-alto.ca.us/artcenter. **Contact:** Exhibitions Dept. Estab. 1971. Average display time 1-3 months. Sponsors openings.

Exhibits Emphasis on art of the Bay Area. "Exhibit needs vary according to curatorial context." Seeks "imagery unique to individual artist. No standard policy. Photography may be integrated in group exhibits." Interested in alternative process, avant garde, fine art.

Submissions Send slides, bio, artist's statement, SASE.

▦ ROBERT PARDO GALLERY

121 E. 31st St., PH12C, New York NY 10016. (917)256-1282. Fax: (646)935-0009. E-mail: robertpardogallery@ yahoo.com. Website: www.robertpardogallery.com. **Contact:** Dr. Giovanna Federico. For-profit gallery. Estab. 1986. Approached by 500 artists/year; represents or exhibits 18 artists. Sponsors 3 photography exhibits/year. Average display time 4-5 weeks. Gallery open Tuesday through Saturday from 10 to 6. Closed August.

Exhibits Interested in avant garde, fashion/glamour, fine art.

Submissions Arrange personal interview to show portfolio of slides, transparencies. Responds in 1 month.

PENTIMENTI GALLERY

145 N. Second St., Philadelphia PA 19106. (215)625-9990. Fax: (215)625-8488. E-mail: mail@pentimenti.c om. Website: www.pentimenti.com. Commercial gallery. Estab. 1992. Average display time 6 weeks. Gallery open Tuesday by appointment; Wednesday through Friday from 12 to 5:15; Saturday from 12 to 5. Closed Christmas and New Year's Day. Located in the heart of Old City Cultural District in Philadelphia. Overall price range $500-10,000. Most work sold at $3,000.

Exhibits Exhibits photos of multicultural, families, environmental, landscapes/scenics, wildlife, architecture, cities/urban, gardening, entertainment, events. Interested in avant garde, documentary, fashion/glamour, fine art, historical/vintage.

Making Contact & Terms Artwork is accepted on consignment, and there is a 50% commission. Gallery provides insurance, promotion, contract. Accepted work should be framed, mounted, matted.

Submissions Send query letter with artist's statement, bio, brochure, photocopies, photographs, résumé, reviews, slides, SASE. Responds in 3 months. Finds artists through word of mouth, portfolio reviews, art fairs, referrals by other artists.

Ⓝ PETERS VALLEY CRAFT CENTER

19 Kuhn Rd., Layton NJ 07851. (973)948-5200. Fax: (973)948-0011. E-mail: pv@warwick.net. Website: www.pvcrafts.org. **Contact:** Jim Sittig, gallery manager. Estab. 1970. Approached by 50 artists/year; represents or exhibits 250 artists. Average display time 2 months. Gallery and store open year round; call for hours. Located in Delaware Water Gap National Recreation Area; 2 floors, approximately 3,000 sq. ft. Overall price range $1,000-3,000. Most work sold at $100-300.

Exhibits Exhibits photos of environmental, landscapes/scenics. Also interested in non-referential, mixed media, collage, non-silver printing.

Making Contact & Terms Artwork is accepted on consignment, and there is a 40% commission. Gallery provides insurance, promotion. Accepted work should be framed, mounted, matted.

Submissions Call or write to arrange a personal interview to show portfolio. Send query letter with artist's statement, bio, résumé, slides. Finds artists through submissions, art exhibits, art fairs, referrals by other artists.

Tips "Submissions must be neat and well-organized throughout."

Ⓝ PHILLIPS GALLERY

444 E. 200 S., Salt Lake City UT 84111. (801)364-8284. Fax: (801)364-8293. Website: www.phillips-gallery.com. **Contact:** Meri DeCaria, director/curator. Commercial gallery. Estab. 1965. Average display time 4 weeks. Sponsors openings; provides refreshments, advertisement, and half of mailing costs. Overall price range $300-2,000. Most work sold at $600.

Exhibits Must be actively pursuing photography. Accepts all types and styles.

Making Contact & Terms Charges 50% commission. Accepted work should be matted. Requires exclusive representation locally. Photographers must have Utah connection.

Submissions Submit portfolio for review; include SASE. Responds in 2 weeks.

PHOENIX GALLERY

210 11th Ave. at 25th St., Suite 902, New York NY 10001. (212)226-8711. Fax: (212)343-7303. E-mail: info@phoenix-gallery.com. Website: www.phoenix-gallery.com. **Contact:** Linda Handler, director. Estab. 1958. Sponsors 10-12 exhibits/year. Average display time 1 month. Overall price range $100-10,000. Most work sold at $3,000-8,000.

Exhibits "The gallery is an artist-run nonprofit organization; an artist has to be a member in order to exhibit in the gallery. There are 3 types of membership: active, inactive, and associate." Interested in all media; alternative process, documentary, fine art.

Making Contact & Terms Charges 25% commission.

Submissions Artists wishing to be considered for membership must submit an application form, slides and résumé. Call, e-mail or download membership application from website.

Tips "The gallery has a special exhibition space, The Project Room, where nonmembers can exhibit their work. If an artist is interested, he/she may send a proposal with art to the gallery. The space is free; the artist shares only in the cost of the reception with the other artists showing at that time."

Ⓝ ▣ PHOTO-EYE GALLERY

370 Garcia Street, Santa Fe NM 87504. E-mail: joslin@photoeye.com. Website: www.photoeye.com. **Contact:** Joslin Van Arsdale, associate gallery director. For-profit gallery. Represents or exhibits 5 artists. Average display time 2 months. Open Tuesday through Saturday from 10 to 5. "We have a physical gallery, photo-eye Santa Fe Gallery, located off of historic Canyon Road in a converted house with a front and back gallery space. We also have 2 online galleries, The Photographer's Showcase and Photo Bistro." Overall price range $200-4,500. Most work sold at $1,000.

Exhibits Exhibits photos of babies/children/teens, architecture, cities/urban, political, wildlife, adventure.

Interested in alternative process, avant garde, documentary, fine art. Exhibits contemporary photography only, all photographic processes.

Making Contact & Terms Gallery provides insurance, promotion, contract. Accepted work should be matted. Requires exclusive representation locally.

Submissions "We only accept digital files. All work should be submitted to the Photographer's Showcase." Responds in 2-4 weeks. Finds artists through art exhibits, word of mouth, art fairs, portfolio reviews, referrals by other artists.

Tips "Approach gallery in a professional, non-pushy way. Keep it short—in the end the work will speak for itself."

PHOTOGRAPHIC IMAGE GALLERY

79 SW Oak St ., Portland OR 97204. (503)224-3543. E-mail: staff@photographicimage.com. Website: www.ph otographicimage.com. **Contact:** Guy Swanson, director. Estab. 1984. Sponsors 12 exhibits/year. Average display time 1 month. Overall price range $400-5,000. Most work sold at $700.

Exhibits Contemporary photography.

Making Contact & Terms Charges 50% commission. Send résumé. Requires exclusive representation within metropolitan area.

PHOTOGRAPHIC RESOURCE CENTER

832 Commonwealth Ave., Boston MA 02215. (617)975-0600. Fax: (617)975-0606. E-mail: prc@bu.edu. Website: www.prcboston.org. **Contact:** Emily Grabian, programs coordinator. "The PRC is a nonprofit arts organization founded in 1976 to facilitate the study and dissemination of information relating to photography." Average display time 6-8 weeks. Open Tuesday, Wednesday and Friday from 10 to 6; Saturday and Sunday from 12 to 5; Thursday from 10 to 8. Closed major holidays. Located in the heart of Boston University. Gallery brings in nationally recognized artists to lecture to large audiences and host workshops on photography.

Exhibits Interested in contemporary and historical photography and mixed-media work incorporating photography.

Submissions Send query letter with artist's statement, bio, slides, résumé, reviews and SASE. Responds in 3 months "depending upon frequency of programming committee meetings." Finds artists through word of mouth, art exhibits and portfolio reviews.

Tips "Present a cohesive body of work."

▣ PHOTOGRAPHY ART

107 Myers Ave., Beckley WV 25801. (304)252-4060 Cell: (304)575-6491. Fax: (304)252-4060 (call before faxing). E-mail: bruceburgin@photographyart.com. Website: www.photographyart.com. **Contact:** Bruce Burgin, owner. Internet rental gallery. Estab. 2003. "Each artist deals directly with their customers. I do not charge commissions and do not keep records of sales."

Exhibits Exhibits photos of landscapes/scenics, wildlife. Interested in fine art.

Making Contact & Terms There is a rental fee for space. The rental fee covers 1 year. The standard gallery is $360 to exhibit 40 images with biographical and contact info for 1 year. No commission charged for sales. Artist deals directly with customer and receives 100% of any sale. Gallery provides promotion.

Submissions Internet sign-up. No portfolio required.

Tips "An artist should have high-quality digital scans. The digital images should be cropped to remove any unnecessary background or frames and sized according to the instructions provided with their Internet gallery. I recommend the artist add captions and anecdotes to the images in their gallery. This will give a visitor to your gallery a personal connection to you and your work."

THE PHOTOMEDIA CENTER

P.O. Box 8518, Erie PA 16505. (814)397-5308. E-mail: info@photomediacenter.org. Website: www.photomed iacenter.org. **Contact:** Eric Grignol, executive director. Nonprofit gallery. Estab. 2004. Sponsors 12 "new" photography exhibits/year. "Previously featured exhibits are archived online. We offer many opportunities for artists, including sales, networking, creative collaboration, and promotional resources; maintain an information board and slide registry for members; and hold an open annual juried show in the summer."

Exhibits Interested in alternative process, avant garde, documentary, fine art.

Making Contact & Terms Artwork is accepted on consignment, and there is a 25% commission. Gallery provides promotion. Prefers only artists working in photographic, digital, and new media.

Submissions "We have a general portfolio review call in the fall for the following year's exhibition schedule.

If after December 31, send query letter with artist's statement, bio, résumé, slides, SASE.'' Responds in 2-6 months. Finds artists through word of mouth, submissions, portfolio reviews, art exhibits, referrals by other artists.

Tips "We are looking for artists who have excellent technical skills, a strong sense of voice and cohesive body of work. Pay careful attention to our guidelines for submissions on our website. Label everything. Must include a SASE for reply.''

N PIERRO GALLERY OF SOUTH ORANGE

Baird Center, 5 Mead St., South Orange NJ 07079. (973)378-7755, ext. 3. Fax: (973)378-7833. E-mail: arts@southorange.org. Website: www.pierrogallery.org. **Contact:** Judy Wukitsch, director. Nonprofit gallery. Estab. 1994. Approached by 75-185 artists/year; represents or exhibits 25-50 artists. Average display time 7 weeks. Gallery open Wednesday through Thursday from 10 to 2 and 4 to 6; weekends from 1 to 4. Closed mid-December through mid-January; August. Overall price range $100-10,000. Most work sold at $800.

Exhibits Interested in fine art, "which can be inclusive of any subject matter.''

Making Contact & Terms Artwork is accepted on consignment, and there is a 15% commission. Gallery provides insurance, promotion, contract. Accepted work should be framed.

Submissions Mail portfolio for review; 3 portfolio reviews/year: January, June, October. Send query letter with artist's statement, résumé, slides. Responds in 2 months from review date. Finds artists through word of mouth, submissions, portfolio reviews, referrals by other artists.

N POLK MUSEUM OF ART

800 E. Palmetto St., Lakeland FL 33801-5529. (863)688-7743. Fax: (863)688-2611. E-mail: info@polkmuseumofart.org. Website: www.polkmuseumofart.org. **Contact:** Todd Behrens, curator of art. Museum. Estab. 1966. Approached by 75 artists/year; represents or exhibits 3 artists. Sponsors 1-3 photography exhibits/year. Galleries open Tuesday through Saturday from 10 to 5; Sunday from 1 to 5. Closed major holidays. Four different galleries of various sizes and configurations.

Exhibits Interested in alternative process, avant garde, documentary, fine art, historical/vintage.

Making Contact & Terms Museum provides insurance, promotion, contract. Accepted work should be framed.

Submissions Mail portfolio for review. Send query letter with artist's statement, bio, résumé, slides, SASE.

⊕ PRAXIS MÉXICO

Arquímedes 175 Colonia Polanco, Mexico D.F. 11570 Mexico. (525)254-8813. Fax: (525)255-5690. E-mail: info@praxismexico.com. Website: www.arte-mexico.com/praxismexico/. For-profit gallery. Estab. 1998. Sponsors 1 photography exhibit/year. Average display time 1 month. Open all year; Monday through Friday from 10 to 7:30; weekends from 10 to 3. Located in a basement with 2 exhibition spaces. Overall price range: $5,000-100,000.

Exhibits Interested in contemporary photos.

Making Contact & Terms Artwork is accepted on consignment, and there is a 50% commission; or artwork is bought outright, net 30 days. There is a co-op membership fee plus a donation of time. There is a 10% commission. Gallery provides promotion. Accepted work should be framed. Requires exclusive representation locally.

Submissions E-mail to arrange personal interview to show portfolio. Responds to queries in 1 month. Finds artists through art fairs and exhibits, portfolio reviews and referrals by other artists.

THE PRINT CENTER

1614 Latimer St., Philadelphia PA 19103. (215)735-6090. Fax: (215)735-5511. E-mail: info@printcenter.org. Website: www.printcenter.org. **Contact:** Ashley Peel Pinkham, assistant director. Nonprofit gallery and Gallery Store. Estab. 1915. Represents over 100 artists from around the world in Gallery Store. Sponsors 5 photography exhibits/year. Average display time 8-10 weeks. Gallery open Tuesday through Saturday from 11 to 5:30. Closed Christmas through January 4. Three galleries. Overall price range $45-4,000. Average price is $500.

Exhibits Exhibits contemporary prints and photographs of all processes.

Making Contact & Terms Charges 50% commission. Gallery provides insurance, promotion, contract. Artists must be printmakers or photographers.

Submissions Returns material with SASE. Responds in 3 months. Finds artists through membership in the

organization, word of mouth, submissions, portfolio reviews, art exhibits, art fairs and referrals by other artists (slides are submitted by our artist members for review by Program Committee and curator).

🅽 PUMP HOUSE CENTER FOR THE ARTS
P.O. Box 163, Chillicothe OH 45601-5613. (740)772-5783. Fax: (740)775-3956. E-mail: pumpart@bright.net. Website: www.bright.net/ ~ pumpart. **Contact:** Charles Wallace, executive director. Nonprofit gallery. Estab. 1986. Approached by 6 artists/year; represents or exhibits more than 50 artists. Average display time 6 weeks. Gallery open Tuesday through Friday from 11 to 4; weekends from 1 to 4. Closed Mondays and major holidays. Overall price range $150-600. Most work sold at $300.

Exhibits Exhibits photos of landscapes/scenics, wildlife, architecture, gardening, travel, agriculture. Interested in fine art, historical/vintage.

Making Contact & Terms Artwork is accepted on consignment, and there is a 30% commission. Gallery provides insurance, promotion. Accepted work should be framed, matted, wired for hanging. Call or stop in to show portfolio of photographs, slides. Send query letter with bio, photographs, slides, SASE. Responds in 1 month. Finds artists through word of mouth, submissions, portfolio reviews, art exhibits, art fairs, referrals by other artists.

Tips "All artwork must be original designs, framed, ready to hang (wired—no sawtooth hangers)."

🅽 QUEENS COLLEGE ART CENTER
Benjamin S. Rosenthal Library, Queens College, Flushing NY 11367-1597. (718)997-3770. Fax: (718)997-3753. E-mail: suzanna_simor@qc.edu. Website: www.qc.edu/Library/art/artcenter.html. **Contact:** Suzanna Simor, director. Curator: Alexandra de Luise. Estab. 1955. Average display time approximately 6 weeks. Sponsors openings. Photographer is responsible for providing/arranging refreshments and cleanup. Overall price range $100-500.

Exhibits Open to all types, styles, subject matter; decisive factor is quality.

Making Contact & Terms Charges 40% commission. Accepted work can be framed or unframed, mounted or unmounted, matted or unmatted.

Submissions Send query letter with résumé and samples, SASE. Responds in 1 month.

▣ 🔲 MARCIA RAFELMAN FINE ARTS
10 Clarendon Ave., Toronto ON M4V 1H9 Canada. (416)920-4468. Fax: (416)968-6715. E-mail: info@mrfinearts.com. Website: www.mrfinearts.com. **Contact:** Marcia Rafelman, president. Semi-private gallery. Estab. 1984. Average display time 1 month. Gallery is centrally located in Toronto; 2,000 sq. ft. on 2 floors. Overall price range $800-25,000. Most work sold at $1,500.

Exhibits Exhibits photos of environmental, landscapes. Interested in alternative process, documentary, fine art, historical/vintage.

Making Contact & Terms Charges 50% commission. Gallery provides insurance, promotion, contract. Requires exclusive representation locally.

Submissions Mail or e-mail portfolio for review; include bio, photographs, reviews. Responds only if interested within 2 weeks. Finds artists through word of mouth, submissions, art fairs, referrals by other artists.

Tips "We only accept work that is archival."

🅽 ROCHESTER CONTEMPORARY
137 East Ave., Rochester NY 14604. (585)461-2222. Fax: (585)461-2223. E-mail: info@rochestercontemporary.org. Website: www.rochestercontemporary.org. **Contact:** Elizabeth Switzer, director. Estab. 1977. Sponsors 10-12 exhibits/year. Average display time 4-6 weeks. Overall price range $100-500.

Making Contact & Terms Charges 25% commission.

Submissions Send slides, letter of inquiry, résumé and statement. Responds in 3 months.

SAN DIEGO ART INSTITUTE'S MUSEUM OF THE LIVING ARTIST
1439 El Prado, San Diego CA 92101. (619)236-0011. Fax: (619)236-1974. E-mail: admin@sandiego-art.org. Website: www.sandiego-art.org. **Contact:** Kerstin Robers, member associate. Art Director: K.D. Benton. Nonprofit gallery. Estab. 1941. Represents or exhibits 500 member artists. Overall price range $50-3,000. Most work sold at $700.

Exhibits Photos of babies/children/teens, couples, multicultural, families, parents, senior citizens, disasters, environmental, landscapes/scenics, wildlife, architecture, cities/urban, education, gardening, pets, rural, adventure, entertainment, events, food/drink, health/fitness/beauty, hobbies, humor, performing arts,

sports, travel, agriculture, political, product shots/still life, science, technology. Interested in alternative process, avant garde, documentary, erotic, fine art, historical/vintage, seasonal.

Making Contact & Terms Artwork is accepted on consignment, and there is a 40% commission. Membership fee: $125. Accepted work should be framed. Work must be carried in by hand for each monthly show except for annual international show, juried by slides.

Submissions Membership not required for submission in monthly juried shows, but fee required. Artists interested in membership should request membership packet. Finds artists through referrals by other artists.

Tips "All work submitted must go through jury process for each monthly exhibition. Work must be framed in professional manner. No glass; plexiglass or acrylic only."

SCHLUMBERGER GALLERY

P.O. Box 2864, Santa Rosa CA 95405. (707)544-8356. Fax: (707)538-1953. E-mail: sande@schlumberger.org. **Contact:** Sande Schlumberger. Estab. 1986. Art publisher/distributor and gallery. Publishes and distributes limited editions, posters, original paintings and sculpture. Specializes in decorative and museum-quality art and photographs.

Exhibits Interested in fine art.

Making Contact & Terms Send query letter with tearsheets and photographs. Samples are not filed and are returned by SASE if requested by artist. Publisher/distributor will contact artist for portfolio review if interested. Portfolio should include color photographs and transparencies. Negotiates payment. Offers advance when appropriate. Rights purchased vary according to project. Provides advertising, in-transit insurance, insurance while work is at firm, promotion, shipping to and from firm, written contract and shows. Finds artists through exhibits, referrals, submissions and "pure blind luck."

Tips "Strive for quality, clarity, clean lines and light. Bring spirit into your images. It translates!"

WILLIAM & FLORENCE SCHMIDT ART CENTER

Southwestern Illinois College, 2500 Carlyle Ave., Belleville IL 62221. E-mail: valerie.thaxton@swic.edu. Website: www.swicfoundation.com. **Contact:** Valerie Thaxton, executive director. Nonprofit gallery. Estab. 2001. Sponsors 2-3 photography exhibits/year. Average display time 6-8 weeks. Open Tuesday through Saturday from 11 to 5. Closed during college holidays.

Exhibits Exhibits photos of landscapes/scenics, architecture. Interested in fine art, historical/vintage.

Submissions Mail portfolio for review. Send query letter with artist's statement, bio and slides. Finds artists through art fairs and exhibits, portfolio reviews, referrals by other artists, submissions and word of mouth.

N SCHMIDT/DEAN SPRUCE

1710 Samson St., Philadelphia PA 19103. (215)569-9433. Fax: (215)569-9434. **Contact:** Christopher Schmidt, director. For-profit gallery. Estab. 1988. Sponsors 4 photography exhibits/year. Average display time 6 weeks. Gallery open Tuesday through Saturday from 10:30 to 6. August hours are Tuesday through Friday from 10:30 to 6. Overall price range $500-12,000.

Exhibits Interested in alternative process, documentary, fine art.

Making Contact & Terms Charges 50% commission. Gallery provides insurance, promotion. Accepted work should be framed, mounted, matted. Requires exclusive representation locally.

Submissions Call/write to arrange personal interview to show portfolio of slides. Send query letter with SASE. "Send 10 to 15 slides and a résumé that gives a sense of your working history. Include a SASE."

SELECT ART

4040 Avondale Ave., Suite 102, Dallas TX 75219. E-mail: selart@swbell.net. **Contact:** Paul Adelson, owner. Estab. 1986. Overall price range $250-900.

• This market deals fine art photography to corporations and sells to collectors.

Exhibits Wants photos of architectural pieces, landscapes, automobiles and buildings. Interested in fine art.

Making Contact & Terms Charges 50% commission. Accepted work should be unframed and matted.

Submissions Send slides by mail with SASE for consideration. Responds in 1 month.

Tips "Make sure the work you submit is fine art photography, not documentary/photojournalistic or commercial photography. No nudes. Label all slides. Include biographical information, pricing (state whether retail or wholesale). Photographers must be service oriented and send out slides or artwork when they say they will."

ℕ SHAPIRO GALLERY

760 Market St., Suite 248, San Francisco CA 94102. (415)398-6655. Fax: (415)398-0667. E-mail: info@shapiro gallery.net. **Contact:** Michael Shapiro, owner. Estab. 1980. Average display time 2 months. Sponsors openings. Overall price range: $500-200,000. Most work sold at $2,000-10,000.

Exhibits Interested in "all subjects and styles (particularly fine art). Superior printing and presentation will catch our attention."

Making Contact & Terms Artwork is accepted on consignment.

Submissions Weekly portfolio drop-off for viewing on Wednesdays. No personal interview or review is given.

Tips "Classic, traditional" work sells best.

ℕ PAUL SHARPE CONTEMPORARY ART

86 Walker Street, 6th Floor, New York NY 10013. Phone/fax: (646)613-1252. E-mail: paulsharpe1@msn.com. Website: www.paulsharpegallery.com. **Contact:** Paul Sharpe, director. Art gallery and consulting. Estab. 2000. Sponsors 8-10 exhibits/year lasting 1 month each (photography is included in various shows throughout the year). Open Wednesday through Saturday from 12 to 6. Closed the last 2 weeks of July and the month of August. 2,000-sq.-ft. gallery in a loft building in TriBeCa. Overall price range for photography: $1,000-50,000.

Making Contact & Terms There is a co-op membership fee plus a donation of time. Artwork is accepted on consignment and commission.

Submissions Interested artists should submit color copies of their work with a bio and artist's statement along with a SASE. Finds artists through referrals by other artists, word of mouth.

SICARDI GALLERY

2246 Richmond Ave., Houston TX 77098. (713)529-1313. Fax: (713)529-0443. E-mail: sicardi@sicardi.com. Website: www.sicardi.com. For-profit gallery. Estab. 1994. Approached by hundreds of artists/year; represents or exhibits 50 artists. Sponsors 4 photography exhibits/year. Average display time 1 month. Gallery open Tuesday through Friday from 10 to 6; Saturday from 11 to 5. Overall price range $500-20,000. Most work sold at $3,000.

Exhibits Interested in avant garde, fine art.

Making Contact & Terms Artwork is accepted on consignment, and there is a 50% commission. Gallery provides insurance, promotion. Accepted work should be framed. Requires exclusive representation locally. Accepts only artists from Latin America.

Submissions Mail portfolio for review. Responds only if interested within 2 months. Finds artists through portfolio reviews, art exhibits.

Tips "Include an organized portfolio with images from a body of work."

ℕ SOUTH DAKOTA ART MUSEUM

P.O. Box 2250, Medary Ave. at Harvey Dunn St., Brookings SD 57007. (605)688-5423. Fax: (605)688-4445. **Contact:** John Rychtarik, curator of exhibits. Museum. Estab. 1970. Sponsors 1-2 photography exhibits/year. Average display time 4 months. Gallery open Monday through Friday from 10 to 5; Saturday from 10 to 4; Sunday from 12 to 4. Closed state holidays. Six galleries offer 26,000 sq. ft. of exhibition space. Overall price range $200-6,000. Most work sold at $500.

Exhibits Interested in alternative process, documentary, fine art.

Making Contact & Terms Artwork is accepted on consignment, and there is a 30% commission. Gallery provides insurance, promotion. Accepted work should be framed.

Submissions Send query letter with artist's statement, bio, résumé, slides, SASE. Responds only if interested within 3 months. Finds artists through word of mouth, portfolio reviews, art exhibits, referrals by other artists.

ℕ ▢ 🌐 THE SPECIAL PHOTOGRAPHERS COMPANY

236 Westbourne Park Rd., London W11 1EL United Kingdom. (44)(207)721-3489. Fax: (44)(207)792-9112. E-mail: info@specialphotographers.com. Website: www.specialphotographers.com. **Contact:** Chris Kewbank, director. For-profit gallery. Estab. 1986. Approached by 350 artists/year; represents or exhibits 60 artists. Sponsors 6 photography exhibits/year. Average display time 8 weeks. Gallery open Tuesday through Thursday from 10 to 5:30; Friday from 10 to 3; Saturday from 11 to 5:30. Closed on UK bank holidays, last 2 weeks of August, and between Christmas and New Year. Overall price range $500-4,000. Most work sold at $1,000.

Exhibits Figurative work, florals, landscapes, portraits—any printing process that includes a photographic

technique. Exhibits photos of music (pop, rock, jazz), Hollywood, contemporary, celebrities, architecture, cities/urban, interiors/decorating, entertainment, still life. Interested in alternative process, avant garde, documentary, erotic, fashion/glamour, fine art, historical/vintage, seasonal.

Making Contact & Terms Charges 50% commission. Gallery provides insurance, promotion, contract.

Submissions E-mail website reference, portfolio or a few low-res JPEGs; or send query letter with artist's statement including previous exhibitions, sales, prices, etc., and SASE. Responds in 3 months. Finds artists through word of mouth, art exhibits, referrals by artists, college shows.

Tips "Make sure that any attached information is succinct and clear. An easy-to-handle folio is always more appealing. The art world is, it appears, more and more accepting of photography as a fine art medium. This can be seen by the fact that many fine art galleries are now dealing with photography and including the medium in their exhibition programs."

B.J. SPOKE GALLERY

299 Main St., Huntington NY 11743. (631)549-5106. E-mail: mgr@bjspokegallery.com. Website: www.bjspokegallery.com. **Contact:** Manager. Display time 1 month. Sponsors openings. Overall price range $300-2,500. **Exhibits** 12 monthly national/international juried competitions. Send for prospectus. Interested in "all styles and genres, photography as essay, as well as 'beyond' photography."

Making Contact & Terms Charges 30% commission. Photographer sets price.

Submissions Arrange a personal interview to show portfolio. Send query letter with SASE.

Tips Offers photography invitational alternate years. Curatorial fee: $75.

[N] STATE OF THE ART

120 W. State St., Ithaca NY 14850. (607)277-1626 or (607)277-4950. E-mail: gallery@soag.org. Website: www.soag.org. Cooperative gallery. Estab. 1989. Sponsors 1 photography exhibit/year. Average display time 1 month. Gallery open year round: Thursday from 12 to 6; Friday from 12 to 8; Saturday and Sunday from 12 to 5. Located in downtown Ithaca, 3 rooms about 13×25 sq. ft. each. Overall price range $100-6,000. Most work sold at $350-500.

Exhibits Exhibits photos of babies/children/teens, couples, multicultural, families, disasters, environmental, landscapes/scenics, wildlife, architecture, cities/urban, pets, rural, adventure, automobiles, performing arts, travel, agriculture, technology. Interested in alternative process, avant garde, fine art, computer-assisted photographic processes.

Making Contact & Terms There is a co-op membership fee plus a donation of time. There is a 10% commission for members. Gallery provides promotion, contract. Accepted work must be ready to hang. Write for membership application.

Tips Other exhibit opportunity: Annual Juried Photo Show in March. Application available on website in January.

STATE STREET GALLERY

1804 State St., La Crosse WI 54601. (608)782-0101. Fax: (608)791-6597. E-mail: ssg1804@yahoo.com. Website: www.statestreetartgallery.com. **Contact:** Ellen Kallies, president. Wholesale retail and trade gallery. Estab. 2000. Approached by 15 artists/year; exhibits 12-14/quarter in gallery. Average display time 4-6 months. Gallery open Tuesday through Saturday from 10 to 3. Located across from the University of Wisconsin/La Crosse. Overall price range $50-12,000. Most work sold at $175.

Exhibits Exhibits photos of environmental, landscapes/scenics, architecture, cities/urban, gardening, rural, travel, medicine. Interested in avant garde.

Making Contact & Terms Artwork is accepted on consignment, and there is a 40% commission. Gallery provides insurance, promotion, contract. Accepted work should be framed, matted.

Submissions Call or mail portfolio for review. Send query letter with artist's statement, photographs, slides, SASE. Responds in 1 month. Finds artists through word of mouth, art exhibits, art fairs, referrals by other artists.

Tips "Be organized, professional in presentation, flexible."

PHILIP J. STEELE GALLERY—ROCKY MOUNTAIN COLLEGE OF ART + DESIGN

1600 Pierce St., Lakewood CO 80214. (303)753-6046. Fax: (303)225-8610. E-mail: lspivak.rmcad.edu. Website: www.rmcad.edu. Nonprofit gallery. Estab. 1962. Approached by 25 artists/year; represents or exhibits 6-9 artists. Sponsors 1 photography exhibit/year. Average display time 1 month. Gallery open Monday through Saturday from 12 to 5. Closed major holidays.

Exhibits "No restrictions on subject matter."

Making Contact & Terms No fee or percentage taken. Gallery provides insurance, promotion. Accepted work should be framed.

Submissions Send query letter with artist's statement, bio, slides, résumé, reviews, SASE. Reviews in May, **deadline April 15**. Finds artists through word of mouth, submissions, referrals by other artists.

N SYNCHRONICITY FINE ARTS

106 W. 13th St., New York NY 10011. (646)230-8199. Fax: (646)230-8198. E-mail: synchspa@bestweb.net. Website: www.synchronicityspace.com. Nonprofit gallery. Estab. 1989. Approached by hundreds of artists/ year; represents or exhibits 12-16 artists. Sponsors 2-3 photography exhibits/year. Gallery open Tuesday through Saturday from noon to 6. Closed 2 weeks in August. Overall price range $1,500-10,000. Most work sold at $3,000.

Exhibits Exhibits photos of multicultural, environmental, landscapes/scenics, architecture, cities/urban, education, rural, events, agriculture, industry, medicine, political. Interested in avant garde, documentary, fine art, historical/vintage.

Making Contact & Terms Gallery provides insurance, promotion, contract. Accepted work should be framed, mounted, matted.

Submissions Write to arrange personal interview to show portfolio of photographs, transparencies, slides. Mail portfolio for review. Send query letter with photocopies, SASE, photographs, slides, résumé. Responds in 3 weeks. Finds artists through art exhibits, submissions, portfolio reviews, referrals by other artists.

N TALLI'S FINE ART

Pho-Tal Inc., 15 N. Summit St., Tenafly NJ 07670. (201)569-3199. Fax: (201)569-3392. E-mail: tal@photal.c om. Website: www.photal.com. **Contact:** Talli Rosner-Kozuch, owner. Alternative space, art consultancy, for-profit gallery, wholesale gallery. Estab. 1991. Approached by 38 artists/year; represents or exhibits 40 artists. Sponsors 12 photography exhibits/year. Average display time 1 month. Gallery open Monday through Sunday from 9 to 5. Closed holidays. Overall price range $200-3,000. Most work sold at $4,000.

Exhibits Exhibits photos of multicultural, architecture, cities/urban, education, gardening, interiors/decorating, pets, religious, rural, adventure, food/drink, travel, product shots/still life. Interested in alternative process, documentary, erotic, fine art, historical/vintage.

Making Contact & Terms Artwork is accepted on consignment, and there is a 50% commission. Accepted work should be framed, matted.

Submissions Write to arrange personal interview to show portfolio of slides. Send query letter with artist's statement, bio, brochure, business card, photocopies, résumé, slides, SASE. Responds in 2 months. Finds artists through word of mouth, submissions, portfolio reviews, art exhibits, art fairs, referrals by other artists.

N LILLIAN & COLEMAN TAUBE MUSEUM OF ART

P.O. Box 325, Minot ND 58702. (701)838-4445. E-mail: taube@ndak.net. **Contact:** Nancy Brown, executive director. Estab. 1970. Established nonprofit organization. Sponsors 1-2 photography exhibits/year. Average display time 4-6 weeks. Sponsors openings. "Museum is located at 2 North Main in a newly renovated historic landmark building with room to show 2 exhibits simultaneously." Overall price range $15-225. Most work sold at $40-100.

Exhibits Exhibits photos of babies/children/teens, couples, multicultural, families, parents, senior citizens, disasters, landscapes/scenics, wildlife, beauty, rural, travel, agriculture, buildings, military, portraits. Interested in avant garde, fine art.

Making Contact & Terms Charges 30% commission/member; 40%/nonmember. Submit portfolio along with a minimum of 6 examples of work in slide format for review. Responds in 3 months.

Tips "Wildlife, landscapes and floral pieces seem to be the trend in North Dakota. We get many slides to review for our photography exhibits each year. We also appreciate figurative, unusual and creative photography work. Do not send postcard photos."

TERCERA GALLERY

534 Ramona St., Palo Alto CA 94301. (650)322-5324. E-mail: pa@terceragallery.com. Website: www.tercerag allery.com. **Contact:** Michele Scott, director. For-profit gallery. Estab. 1989. Average display time 3 weeks. Open Tuesday through Saturday from 10 to 5:30.

Exhibits Interested in alternative process, avant garde.

Submissions Send query letter with résumé and slides. Finds artists through word of mouth, art exhibits and portfolio reviews.

JILL THAYER GALLERIES AT THE FOX

1700 20th St., Bakersfield CA 93301-4329. (661)328-9880. Fax: (661)631-9711. E-mail: jill@jillthayer.com. Website: www.jillthayer.com. **Contact:** Jill Thayer, director. For-profit gallery. Estab. 1994. Approached by 10 artists/year; represents or exhibits 20 artists. Sponsors 2 photography exhibits/year. Average display time 6 weeks. Gallery open Thursday from 1 to 4 or by appointment. Closed holidays. "Located at the historic Fox Theater, built in 1930. Renovated 400-sq.-ft. space featuring large windows, high ceilings, wood floor and bare-wire, halogen lighting system." Overall price range $250-10,000. Most work sold at $1,500.
Exhibits Environmental and fine art photography exhibited.
Making Contact & Terms Artwork is accepted on consignment with a 50% commission. Gallery shares promotion expenses with artist. Accepted work should be ready to install.
Submissions Send query letter with artist's statement, bio, résumé, reviews, slides, SASE. Responds only if interested within 1 month. Finds artists through submissions, portfolio reviews.
Tips "No color copies. Have a concise, professional, up-to-date vitae (listing of exhibitions and education/bio) and a slide sheet."

NATALIE AND JAMES THOMPSON ART GALLERY

School of Art & Design, San José State University, San José CA 95192-0089. (408)924-4723. Fax: (408)924-4326. E-mail: jfh@cruzio.com. Website: www.sjsu.edu. **Contact:** Jo Farb Hernandez, director. Nonprofit gallery. Approached by 100 artists/year. Sponsors 1-2 photography exhibits/year. Average display time 1 month. Gallery open Tuesday through Friday from 11 to 4; Tuesday evenings from 6 to 7:30.
Exhibits "We are open to all genres, aesthetics and techniques."
Making Contact & Terms "Works are not generally for sale." Gallery provides insurance, promotion. Accepted work should be framed and/or ready to hang.
Submissions Send query letter with artist's statement, bio, résumé, reviews, slides, SASE. Responds as soon as possible. Finds artists through word of mouth, submissions, portfolio reviews, art exhibits, art fairs, referrals by other artists.

THROCKMORTON FINE ART

145 E. 57th St., 3rd Floor, New York NY 10022. (212)223-1059. Fax: (212)223-1937. E-mail: throckmorton@earthlink.net. Website: www.throckmorton-nyc.com. **Contact:** Kraige Block, director. For-profit gallery. Estab. 1993. Approached by 50 artists/year; represents or exhibits 20 artists. Sponsors 5 photography exhibits/year. Average display time 2 months. Overall price range $1,000-10,000. Most work sold at $1,500.
Exhibits Exhibits photos of babies/children/teens, landscapes/scenics, architecture, cities/urban, rural. Interested in erotic, fine art, historical/vintage, Latin American photography.
Making Contact & Terms Charges 50% commission. Gallery provides insurance, promotion. Accepts only artists from Latin America.
Submissions Write to arrange personal interview to show portfolio of photographs/slides, or send query letter with artist's statement, bio, photocopies, slides, SASE. Responds in 3 weeks. Finds artists through word of mouth, portfolio reviews.
Tips "Present your work nice and clean."

TOUCHSTONE GALLERY

406 Seventh St. NW, Washington DC 20004-2217. (202)347-2787. E-mail: info@TouchstoneGallery.com. Website: www.TouchstoneGallery.com. **Contact:** Camille Mosley-Pasley, director. Cooperative rental gallery. Estab. 1976. Approached by 240 artists/year; represents or exhibits 35 artists. Sponsors 3 photography exhibits/year. Average display time 1 month. Open Wednesday through Friday from 11 to 5; weekends from 12 to 5. Closed Christmas through New Year's Day. Located in downtown Washington, DC, on gallery row. Large main gallery with several additional exhibition areas; high ceilings. Overall price range: $100-2,500. Most artwork sold at $600.
Exhibits Exhibits photos of landscapes/scenics, architecture, cities/urban, rural, automobiles. Interested in alternative process, avant garde, documentary, erotic, fine art, historical/vintage.
Making Contact & Terms There is a co-op membership fee plus a donation of time. There is a 40% commission. There is a rental fee for space; covers 1 month. Gallery provides contract. Accepted work should be framed and matted.

Submissions Call to arrange personal interview to show portfolio. Responds to queries in 1 month. Finds artists through referrals by other artists and word of mouth.

Tips "Visit website first. Read new member prospectus on the front page. Call with additional questions. Do not 'drop in' with slides or art. Do not show everything you do. Show 10-25 images that are cohesive in subject, style, and presentation."

UNION STREET GALLERY

1655 Union, Chicago Heights IL 60411. (708)754-2601. Fax: (708)754-8779. E-mail: bkleluga@aol.com. Website: www.unionstreetgallery.org. **Contact:** Karen Leluga, gallery administrator. Nonprofit gallery. Estab. 1995. Represents or exhibits more than 100 artists. "We offer group invitations and juried shows every year." Average display time 6 weeks. Gallery open Monday through Friday from 10 to 2 or by appointment. Overall price range $30-3,000. Most work sold at $300-600.

Submissions Write to arrange a personal interview to show portfolio of slides. Send query letter with artist's statement, brochure, résumé, slides, SASE. Finds artists through submissions, referrals by other artists, juried exhibits at the gallery. "To receive prospectus for all juried events, call, write or fax to be added to our mailing list. Artists interested in studio space or solo/group exhibitions should contact the gallery to request information packets."

UNIVERSITY ART GALLERY, NEW MEXICO STATE UNIVERSITY

Dept. 3572, P.O. Box 30001, Las Cruces NM 88003. (505)646-2545. Fax: (505)646-8036. E-mail: artglry@nmsu .edu. Website: www.nmsu.edu/~artgal. **Contact:** Mary Anne Redding, director. Estab. 1973. Sponsors 1 exhibit/year. Average display time 2 months. Overall price range $300-2,500.

Making Contact & Terms Buys photos outright. Arrange a personal interview to show portfolio. Submit portfolio for review. Send query letter with samples. Send material by mail with SASE by end of October for consideration. Responds in 3 months.

Tips Looks for "quality fine art photography. The gallery does mostly curated, thematic exhibitions. Very few one-person exhibitions."

[N] UNIVERSITY OF ALABAMA AT BIRMINGHAM

Visual Arts Gallery, 1530 Third Ave., S., Birmingham AL 35294-1260. (205)934-0815. Fax: (205)975-2836. **Contact:** Brett M. Levine, director/curator. Nonprofit university gallery. Sponsors 1-3 photography exhibits/ year. Average display time 3-4 weeks. Gallery open Monday through Thursday from 11 to 6; Fridays from 11 to 5; Saturdays from 1-5; closed Sundays. Closed major holidays and last 2 weeks of December. First floor of Humanities Building, a classroom and office building: 2 rooms with a total of 2,000 sq. ft. and 222 running feet.

Exhibits Exhibits photos of multicultural. Interested in alternative process, avant garde, fine art, historical/ vintage.

Making Contact & Terms Gallery provides insurance, promotion. Accepted work should be framed.

Submissions Write to arrange a personal interview to show portfolio of slides. Send query letter with artist's statement, bio, brochure, photographs, résumé, reviews, slides, SASE.

[N] UNIVERSITY OF MISSISSIPPI MUSEUMS

P.O. Box 1848, University MS 38677. (662)915-7073. Fax: (662)915-7035. E-mail: museums@olemiss.edu. Website: www.olemiss.edu. **Contact:** Albert Sperath, director. Museum. Estab. 1939. Approached by 5 artists/year; represents or exhibits 2 artists. Sponsors 1 photography exhibit/year. Average display time 3 months. Gallery open Tuesday through Saturday from 9:30 to 4:30; Sunday from 1 to 4. Closed Monday, 2 weeks for Christmas, other major holidays.

Exhibits Exhibits photos of multicultural, landscapes/scenics, wildlife. Interested in documentary, historical/ vintage.

Making Contact & Terms Artwork is bought outright. Gallery provides insurance. Accepted work should be framed. Accepts only artists from Mississippi, Tennessee, Alabama, Arkansas and Louisiana. Send query letter with artist's statement, bio, photographs, slides. Returns material with SASE. Responds in 3 months. Finds artists through word of mouth, submissions, referrals by other artists.

UNIVERSITY OF RICHMOND MUSEUMS

Richmond VA 23173. (804)289-8276. Fax: (804)287-1894. E-mail: rwaller@richmond.edu. Website: http://oncampus.richmond.edu/museums. **Contact:** Richard Waller, director. Estab. 1968. "University Museums

comprises Joel and Lila Harnett Museum of Art, Joel and Lila Harnett Print Study Center, and Lora Robins Gallery of Design from Nature.'' Sponsors 18-20 exhibits/year. Average display time 8-10 weeks.
Exhibits Interested in all subjects.
Making Contact & Terms Charges 10% commission. Work must be framed for exhibition.
Submissions Send query letter with résumé, samples. Send material by mail for consideration. Responds in 1 month.
Tips ''If possible, submit material that can be left on file and fits standard letter file. We are a nonprofit university museum interested in presenting contemporary art as well as historical exhibitions.''

UPSTREAM GALLERY

26 Main St., Dobbs Ferry NY 10522. (914)674-8548. E-mail: upstreamgallery@aol.com. Website: www.upstreamgallery.com. Cooperative gallery. Estab. 1990. Represents or exhibits 24 artists. Sponsors 1 photography exhibit/year. Average display time 1 month. Open all year; Thursday through Sunday from 12:30 to 5:30. Closed July and August. ''We have 2 store fronts, approximately 15×30 sq. ft. each.'' Overall price range: $300-2,000. Most work sold at $500.
Exhibits Exhibits photos of landscapes/scenics. Interested in fine art.
Terms There is a co-op membership fee plus a donation of time. There is a 10% commission. Gallery provides insurance. Accepted work should be framed, mounted and matted.
Submissions Write to arrange personal interview to show portfolio of photographs and slides. Send query letter with artist's statement, bio, brochure, business card, photographs, résumé, reviews, slides and SASE. Responds to queries only if interested within 2 months. Finds artists through referrals by other artists and submissions.

N̄ UPSTREAM PEOPLE GALLERY

(formerly Period Gallery), 5607 Howard St., Omaha NE 68106. (402)991-4741. E-mail: shows@upstreampeoplegallery.com. Website: www.upstreampeoplegallery.com. **Contact:** Larry Bradshaw, curator. For-profit Internet gallery. Estab. 1998. Approached by 13,000 artists/year; represents or exhibits 1,300 artists. Sponsors 4 photography exhibits/year. Average display time 1 or more years online. Virtual gallery open 24 hours daily. Overall price range $100-20,000. Most work sold at over $300.
Exhibits Exhibits photos of babies/children/teens, couples, multicultural, families, parents, senior citizens, disasters, environmental, landscapes/scenics, wildlife, gardening, interiors/decorating, pets, religious, adventure, automobiles, events, health/fitness/beauty, humor, performing arts, sports, travel, agriculture, military, political, product shots/still life, technology/computers. Interested in alternative process, avant garde, documentary, fine art, historical/vintage, seasonal.
Making Contact & Terms Artwork is accepted on consignment, and there is no commission. There is an entry fee for space; covers 1 or more years.
Submissions Mail portfolio of slides for review. Send query letter with artist's statement, bio, brochure (optional), résumé, reviews, slides, personal photo. Responds to queries in 1 week. Finds artists through art exhibits, portfolio reviews, referrals by other artists, submissions, word of mouth, Internet.

URBAN INSTITUTE FOR CONTEMPORARY ARTS

41 Sheldon Blvd. SE, Grand Rapids MI 49503. (616)454-7000. Fax: (616)459-9395. E-mail: jteunis@uica.org. Website: www.uica.org. **Contact:** Janet Teunis, visual arts program manager. Alternative space, nonprofit gallery. Estab. 1977. Approached by 250 artists/year; represents or exhibits 20 artists. Sponsors 3-4 photography exhibits/year. Average display time 6 weeks. Gallery open Tuesday through Saturday from 12 to 10; Sunday from 12 to 7. Closed Monday, the month of August, and the week of Christmas and New Year's.
Exhibits Interested in avant garde, fine art.
Making Contact & Terms Does not sell work. ''Artists may sell on their own. We do not take a commission.'' Gallery provides insurance, promotion, contract.
Submissions Send query letter with artist's statement, bio, résumé, reviews, slides, SASE. Finds artists through submissions.
Tips ''Get submission requirements at www.uica.org/visualArts.html under 'Apply for a Show.' ''

N̄ ▣ VERED GALLERY

68 Park Place, East Hampton NY 11937. (631)324-3303. **Contact:** Janet Lehr, vice president. Estab. 1977. Average display time 3 weeks. Sponsors openings.
Exhibits Interested in avant garde.

Making Contact & Terms Charges 50% commission. Reviews transparencies and JPEGs. Interested in slides or transparencies, then exhibition prints. Requires exclusive representation within metropolitan area.

Submissions Send query letter with résumé, SASE. Responds in 3 weeks.

VILLA JULIE COLLEGE GALLERY

1525 Greenspring Valley Rd., Stevenson MD 21153. (443)334-2163. Fax: (410)486-3552. Website: www.vjc.e du. **Contact:** Diane DiSalvo, director of cultural programs. College/university gallery. Estab. 1997. Approached by many artists/year; exhibits numerous artists. Sponsors at least 2 photography exhibits/year. Average display time 6 weeks. Gallery open Monday, Tuesday, Thursday, Friday from 11 to 5; Wednesday from 11 to 8; Saturday from 1 to 4. Two beautiful spaces.

Exhibits Interested in alternative process, avant garde, documentary, fine art, historical/vintage. "We are looking for artwork of substance by artists from the mid-Atlantic region."

Making Contact & Terms "We facilitate inquiries directly to the artist." Gallery provides insurance. Accepts artists from mid-Atlantic states only; emphasis on Baltimore artists.

Submissions Write to show portfolio of slides. Send artist's statement, bio, résumé, reviews, slides, SASE. Responds in 3 months. Finds artists through word of mouth, submissions, portfolio reviews, referrals by other artists.

Tips "Be clear, concise. Have good slides."

VILLA TERRACE DECORATIVE ARTS MUSEUM

2220 N. Terrace Ave., Milwaukee WI 53202. (414)271-3656. Fax: (414)271-3986. E-mail: shaberstroh@cavtm useums.org. Website: www.cavtmuseums.org. **Contact:** Sarah Haberstroh, manager of exhibitions & collections. Museum. Estab. 1965. Approached by 20 artists/year; represents or exhibits 6 artists. Sponsors 1-2 photography exhibits/year. Average display time 2 months. Open all year; Wednesday through Sunday from 1 to 5. Located in a historic home, featuring 2 galleries. Overall price range: $200-3,000. Most work sold at $300.

Exhibits Exhibits photos of landscapes/scenics, architecture, gardening, interiors/decorating. Interested in fine art, historical/vintage, gardens, Europe.

Terms Artwork is sold during run of an exhibition. There is a 30% commission. Museum provides insurance, promotion and contract. Accepted work should be framed. Prefers only decorative art.

Submissions Send query letter with artist's statement, bio, business card, résumé, reviews and slides. Responds to queries in 1 year. Finds artists through referrals by other artists, submissions and word of mouth.

Tips "All materials should be typed. Slides should be labeled and accompanied by a complete checklist."

VIRIDIAN ARTISTS, INC.

530 W. 25th St., #407, New York NY 10001. (212)414-4040. Fax: (212)414-4040. E-mail: info@viridianartists.c om. Website: www.viridianartists.com. **Contact:** Vernita Nemec, director. Estab. 1968. Sponsors 12-15 exhibits/year. Average display time 3 weeks. Overall price range $175-10,000. Most work sold at $1,500.

Exhibits Interested in eclectic work in all fine art media including photography, installation, painting, mixed media and sculpture. Interested in alternative process, avant garde, fine art.

Making Contact & Terms Charges 30% commission.

Submissions Will review transparencies only if submitted as part of membership application with SASE. Request membership application by phone or e-mail.

Tips "Opportunities for photographers in galleries are improving. Broad range of styles being shown in galleries. Photography is getting a large audience that is seemingly appreciative of technical and aesthetic abilities of the individual artists. Present a portfolio (regardless of format) that expresses a clear artistic and aesthetic focus that is unique, individual, and technically outstanding."

THE WAILOA CENTER GALLERY

P.O. Box 936, Hilo HI 96721. (808)933-0416. Fax: (808)933-0417. E-mail: wailoa@yahoo.com. **Contact:** Ms. Codie King, director. Estab. 1967. Sponsors 12 exhibits/year. Average display time 1 month.

Exhibits Photos must be submitted to director for approval. "All entries accepted must meet professional standards outlined in our pre-entry forms."

Making Contact & Terms Gallery receives 10% "donation" on works sold. No fee for exhibiting. Accepted work should be framed. "Photos must also be fully fitted for hanging. Expenses involved in shipping, insurance, etc., are the responsibility of the exhibitor."

Submissions Submit portfolio for review. Send query letter with résumé of credits, samples, SASE. Responds in 3 weeks.

Tips "The Wailoa Center Gallery is operated by the State of Hawaii, Department of Land and Natural Resources. We are unique in that there are no costs to the artist to exhibit here as far as rental or commissions are concerned. We welcome artists from anywhere in the world who would like to show their works in Hawaii. The gallery is also a visitor information center with thousands of people from all over the world visiting."

EDWARD WESTON FINE ART

P.O. Box 3098, Chatsworth CA 91313. (818)885-1044. Fax: (818)885-1021. **Contact:** Edward Weston, president. Estab. 1960. Approached by 50 artists/year; represents or exhibits 100 artists. Sponsors 10 photography exhibits/year. Average display time 4-6 weeks. Gallery open 7 days/week by appointment. Overall price range $50-75,000. Most work sold at $1,000.

Exhibits Exhibits photos of celebrities, disasters, entertainment, events, performing arts. Interested in avant garde, erotic, fashion/glamour, fine art.

Making Contact & Terms Artwork is accepted on consignment, and there is a 50% commission. Gallery provides contract. Accepted work should be framed, matted. Requires exclusive representation locally.

Submissions Write to arrange personal interview to show portfolio of photographs, transparencies. Mail slides for review. Send query letter with bio, brochure, business card, photocopies, photographs, reviews.

Tips "Be thorough and complete."

WHITE GALLERY—PORTLAND STATE UNIVERSITY

Box 751/SD, Portland OR 97207. (503)725-5656 or (800)547-8887. Fax: (503)725-4882. **Contact:** Nika Blasser, co-coordinator. Nonprofit gallery. Estab. 1969. Sponsors 1 show/month except December. Average display time 1 month. Sponsors openings. Overall price range $150-800.

Making Contact & Terms Charges 30% commission. Accepted work should be mounted, matted. "We prefer matted work that is 16×20."

Submissions Send artist's statement, résumé, 6-10 slides. Responds in 1 month.

Tips "Best time to submit is September-October of the year prior to the year show will be held. We are interested in high-quality original work. We are a nonprofit organization that is not sales-driven."

WOMEN & THEIR WORK GALLERY

1710 Lavaca St., Austin TX 78701. (512)477-1064. Fax: (512)477-1090. E-mail: wtw@texas.net. Website: www.womenandtheirwork.org. **Contact:** Kathryn Davidson, associate director. Alternative space, nonprofit gallery. Estab. 1978. Approached by more than 400 artists/year; represents or exhibits 8-9 one-person and several juried shows. Sponsors 1-2 photography exhibits/year. Average display time 5 weeks. Gallery open Monday through Friday from 9 to 5; Saturday from 12 to 4. Closed December 24 through January 2, and other major holidays. 2,000-sq.-ft. exhibition space. Overall price range $500-5,000. Most work sold at $800-1,000.

Exhibits Interested in alternative process, avant garde, fine art.

Making Contact & Terms "We select artists through a juried process and pay them to exhibit. We take 25% commission if something is sold." Gallery provides insurance, promotion, contract. Accepted work should be framed, mounted, matted. Texas women—all media in one-person shows only. All other artists, male or female, in juried show—once/year if member of Women & Their Work organization. Online Artist Slide Registry on website.

Submissions E-mail or call to show portfolio. Responds in 1 month. Finds artists through submissions, annual juried process.

Tips "Provide quality slides, typed résumé and a clear statement of artistic intent."

WOMEN'S CENTER ART GALLERY

UCSB, Bldg. 434, Santa Barbara CA 93106-7190. (805)893-3778. Fax: (805)893-3289. E-mail: artforwomen@mail2museum.com. Website: www.sa.ucsb.edu/women'scenter. **Contact:** Michelle Wiener, curator. Nonprofit gallery. Estab. 1973. Approached by 200 artists/year; represents or exhibits 50 artists. Sponsors 1 photography exhibit/year. Average display time 11 weeks. Gallery open Monday through Thursday from 10 to 7; Friday from 10 to 5. Closed UCSB campus holidays. Exhibition space is roughly 1,000 sq. ft. Overall price range $10-1,000. Most work sold at $300.

Exhibits Exhibits photos of babies/children/teens, couples, multicultural, families, parents, senior citizens,

disasters, environmental, landscapes/scenics, wildlife, architecture, cities/urban, education, interiors/decorating, religious, rural, adventure, entertainment, events, hobbies, humor, performing arts, sports, travel. Interested in alternative process, avant garde, documentary, erotic, fashion/glamour, fine art, historical/vintage, seasonal.

Making Contact & Terms Artwork is accepted on consignment, and there is no commission. Gallery provides insurance, promotion. Accepted work should be framed. Preference given to residents of Santa Barbara County.

Submissions Mail portfolio for review. Send query letter with artist's statement, bio, photocopies, photographs, résumé, slides, SASE. Responds only if interested within 3 months. Finds artists through word of mouth, portfolio reviews, art exhibits, e-mail and promotional calls to artists.

Tips "Complete your submission thoroughly and include a relevent statement pertaining to the specific exhibit."

WORLD FINE ART GALLERY

511 W. 25th St., #803, New York NY 10001-5501. (646)336-1677. Fax: (646)336-8644. E-mail: info@worldfinart.com. Website: www.worldfineart.com. **Contact:** O'Delle Abney, director. Cooperative gallery. Estab. 1992. Approached by 1,500 artists/year; represents or exhibits 50 artists. Average display time 1 month. Open Tuesday through Saturday from 12 to 6. Closed August. Located in Chelsea, NY; 1,000 sq. ft. Overall price range: $500-5,000. Most work sold at $1,500.

Exhibits Exhibits photos of landscapes/scenics, gardening. Interested in fine art.

Terms There is a rental fee for space; covers 1 month or 1 year. Gallery provides insurance, promotion and contract. Accepted work should be framed; must be considered suitable for exhibition.

Submissions Write to arrange personal interview to show portfolio, or e-mail JPEG images. Submission guidelines available on website at www.worldfineart.com/inforequest.html. Responds to queries in 1 week. Finds artists through the Internet.

Tips "Have website available for review."

YESHIVA UNIVERSITY MUSEUM

15 W. 16th St., New York NY 10011. (212)294-8330. Fax: (212)294-8335. E-mail: rmetzger@yum.cjh.org. Website: www.yumuseum.org. **Contact:** Sylvia A. Herskowitz, director. Estab. 1973. Sponsors 3-4 exhibits/year. Average display time 4-6 months. The museum occupies 4 galleries and several exhibition arcades. All galleries are handicapped accessible.

Exhibits Seeks "individual or group exhibits focusing on Jewish themes and interests; exhibition-ready work essential."

Making Contact & Terms Send color slide portfolio of 10-12 slides or photos, exhibition proposal, résumé with SASE for consideration. Reviews take place 3 times/year.

Tips "We exhibit contemporary art and photography based on Jewish themes. We look for excellent quality, individuality, and work that reveals a connection to Jewish identity and/or spirituality."

ZENITH GALLERY

413 Seventh St. NW, Washington DC 20004. (202)783-2963. Fax: (202)783-0050. E-mail: zenithga@erols.com. Website: www.zenithgallery.com. **Contact:** Margery E. Goldberg, owner/director. For-profit gallery. Estab. 1978. Open Tuesday through Friday from 11 to 6; Saturday from 12 to 7; Sunday from 12 to 5. Located in the heart of downtown Washington, DC—street level, 2,400 sq. ft., 3 exhibition rooms. Overall price range: $500-10,000.

Exhibits Exhibits photos of landscapes/scenics. Interested in avant garde, fine art.

Submissions Mail portfolio for review. Send query letter with artist's statement, bio, brochure, business card, photocopies, photographs, résumé, reviews, slides, SASE. Responds to queries only if interested within 1 year. Finds artists through art fairs and exhibits, portfolio reviews, referrals by other artists, submissions and word of mouth.

Contests

Whether you're a seasoned veteran or a newcomer still cutting your teeth, you should consider entering contests to see how your work compares to that of other photographers. The contests in this section range in scope from tiny juried county fairs to massive international competitions. When possible, we've included entry fees and other pertinent information in our limited space. Contact sponsors for entry forms and more details.

Once you receive rules and entry forms, pay particular attention to the sections describing rights. Some sponsors retain all rights to winning entries or even *submitted* images. Be wary of these. While you can benefit from the publicity and awards connected with winning prestigious competitions, you shouldn't unknowingly forfeit copyright. Granting limited rights for publicity is reasonable, but never assign rights of any kind without adequate financial compensation or a written agreement. If such terms are not stated in contest rules, ask sponsors for clarification.

If you're satisfied with the contest's copyright rules, check with contest officials to see what types of images won in previous years. By scrutinizing former winners you might notice a trend in judging that could help when choosing your entries. If you can't view the images, ask what styles and subject matter have been popular.

ALEXIA COMPETITION

Syracuse University Newhouse School, Syracuse NY 13244-2100. (315)443-2304. E-mail: dcsuther@syr.edu. Website: www.alexiafoundation.org. **Contact:** David Sutherland. Annual contest. Provides financial ability for students to study photojournalism in England and for professionals to produce a photo project promoting world peace and cultural understanding. Students win scholarships to study photojournalism at Syracuse University in London. A professional wins $15,000 cash grant. **February 1 student deadline**. **January 16 professional deadline**. Photographers should e-mail or see website for more information.

ANACORTES ARTS FESTIVAL

505 "O" Ave., Anacortes WA 98221. (360)293-6211. E-mail: info@anacortesartsfestival.com. Website: www.anacortesartsfestival.com. **Contact:** Mary Leone. Three-day festival, first full weekend in August. An invitational, juried fine art show with over 250 booths. Over $4,000 in prizes awarded for fine arts. Contest deadline and guidelines available on website.

ANNUAL JURIED PHOTO EXHIBITION

Perkins Center for the Arts, 395 Kings Hwy., Moorestown NJ 08057. (856)235-6488 or (800)387-5226. Fax: (856)235-6624. E-mail: create@perkinscenter.org. Website: www.perkinscenter.org. Regional juried photography exhibition. Past jurors include Merry Foresta, curator of photography at the Smithsonian American Art Museum; Katherine Ware, curator of photographs at the Philadelphia Museum of Art; and photographers Emmett Gowin and Vik Muniz. All work must be framed with wiring in back and hand-delivered to Perkins Center. Photographers should write, call or e-mail for prospectus in November.

APOGEE PHOTO MAGAZINE BIMONTHLY PHOTO CONTEST

11749 Zenobia Loop, Westminster CO 80031. (303)838-4848. Fax: (303)463-2885. E-mail: mfulks@apogeephoto.com. Website: www.apogeephoto.com. **Contact:** Michael Fulks, publisher. Bimonthly contest. Themes and prizes change with each contest. Photographers should see website (www.apogeephoto.com/contest.shtml) for more information.

APOGEE PHOTO MAGAZINE MONTHLY COVER PHOTO CONTEST

11749 Zenobia Loop, Westminster CO 80031. (303)838-4848. Fax: (303)463-2885. E-mail: mfulks@apogeephoto.com. Website: www.apogeephoto.com. **Contact:** Michael Fulks, publisher. Monthly contest. No theme; "We choose the best from all images received the previous month." Prizes change month-to-month. Photographers should see website (www.apogeephoto.com/POM_details.shtml) for more information.

ARC AWARDS

500 Executive Blvd., Ossining-on-Hudson NY 10562. (914)923-9400. Fax: (914)923-9484. E-mail: info@mercommawards.com. Website: www.mercommawards.com. Cost: $250 overall annual report; $215 other categories; $190 nonprofit organizations. Annual contest. The purpose of the contest is to honor outstanding achievement in annual reports. Major category for annual report photography—covers and interiors. "Best of Show" receives a personalized trophy. Grand Award winners receive personalized award plaques. Gold, silver, bronze and finalists receive a personalized award certificate. Every entrant receives complete judge score sheets and comments. **Early May deadline.** Photographers should write, call or e-mail for more information.

N ARTIST FELLOWSHIP GRANTS

% Oregon Arts Commission, 775 Summer St. NE, Salem OR 97310. (503)986-0082. Fax: (503)986-0260. E-mail: oregon.artscomm@state.or.us. Website: http://art.econ.state.or.us. A juried grant process offering cash awards to Oregon visual artists, in **odd-numbered years**.

N ARTIST FELLOWSHIPS/VIRGINIA COMMISSION FOR THE ARTS

223 Governor St., Richmond VA 23219-2010. (804)225-3132. Fax: (804)225-4327. E-mail: amy.krawczyk@arts.virginia.gov. Website: www.arts.virginia.gov. **Contact:** Amy Krawczyk, program coordinator. Applications accepted alternate years. The purpose of the Artist Fellowship program is to encourage significant development in the work of individual artists, to support the realization of specific artistic ideas, and to recognize the central contribution professional artists make to the creative environment of Virginia. Grant amounts are up to $5,000. Emerging and established artists are eligible. Open only to photographers who are legal residents

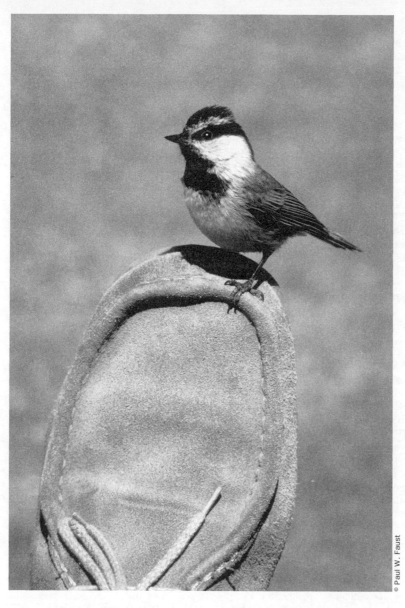

Paul Faust first made contact with *Apogee Photo Magazine* when he saw their listing in *Photographer's Market*. He sent them some sample images and articles and eventually became a regular contributor to the on-line magazine.

© Paul W. Faust

of Virginia and at least 18 years of age. Applications are available in June. See *Guidelines for Funding* and application forms on the website or write for more information.

ARTISTS ALPINE HOLIDAY

P.O. Box 167, Ouray CO 81427. (970)325-4372. **Contact:** Gary Wade, business director. Registration: DeAnn McDaniel. Cost: $20 first entry; $5 second entry; $5 third entry. Annual fine arts juried show. Cash awards for 1st, 2nd and 3rd prizes in all categories total $5,100. Best of Show: $1,000. Open to all skill levels. Photographers should write or call for more information.

ARTSLINK PROJECTS

435 Hudson Street, New York NY 10014. (212)643-1985, ext. 22. Fax: (212)643-1996. E-mail: al@cecartslink.org. Website: www.cecartslink.org. **Contact:** Tamalyn Miller. Cost: free. Annual travel grants. ArtsLink Proj-

ects accepts applications from individual artists, curators and nonprofit arts organizations who intend to undertake projects in Central Europe, Russia and Eurasia. Grants range from $2,500-10,000. Open to advanced photographers. **January deadline.** Photographers should e-mail or call for more information.

ASTRID AWARDS

500 Executive Blvd., Ossining-on-Hudson NY 10562. (914)923-9400. Fax: (914)923-9484. E-mail: info@mercommawards.com. Website: www.mercommawards.com. Cost: $230/entry (with discounts for multiple entries). Annual contest. The purpose of the contest is to honor outstanding achievement in design communications. Major category for photography, including books, brochures and publications. "Best of Show" receives a personalized trophy. Grand Award winners receive personalized award plaques. Gold, silver, bronze and finalists receive a personalized award certificate. Every entrant receives complete judge score sheets and comments. **January 31 deadline.** Photographers should write, call or e-mail for more information.

BANFF MOUNTAIN PHOTOGRAPHY COMPETITION

Box 1020, 107 Tunnel Mountain Dr., Banff AB T1L 1H5 Canada. (403)762-6347. Fax: (403)762-6277. E-mail: BanffMountainPhotos@banffcentre.ca. Website: www.BanffMountainFestivals.ca. **Contact:** Charla Sharp Tomlinson, competition coordinator. Annual contest. Up to 5 images (slides or prints) in each of 5 categories: Mountain Landscape, Mountain Adventure, Mountain Flora/Fauna, Mountain Culture and Mountain Environment. Entry form available on website. Approximately $8,500 in cash and prizes to be awarded. Open to all skill levels. Photographers should write, e-mail or fax for more information.

BEST OF COLLEGE PHOTOGRAPHY ANNUAL

Serbin Communications, 813 Reddick St., Santa Barbara CA 93103. (805)963-0439 or (800)876-6425. Fax: (805)965-0496. E-mail: admin@serbin.com. Website: www.serbin.com. Annual student contest. Winners and finalists have their photos published in the *Best of College Photography Annual.* See website for entry form.

BEST OF PHOTOGRAPHY ANNUAL CONTEST

Serbin Communications, 813 Reddick St., Santa Barbara CA 93103. (805)963-0439 or (800)876-6425. Fax: (805)965-0496. E-mail: admin@serbin.com. Website: www.serbin.com. Annual amateur contest. Winners and finalists have their photos published in the *Best of Photography Annual.* See website for entry form.

BETHESDA INTERNATIONAL PHOTOGRAPHY EXHIBITION

Fraser Gallery, 7700 Wisconsin Ave., Suite E, Bethesda MD 20814. (301)718-9651. Fax: (301)718-9652. E-mail: info@thefrasergallery.com. Website: www.thefrasergallery.com. **Contact:** Catriona Fraser, director. Cost: $25. Annual contest. Provides an exhibition opportunity in a highly respected art gallery. Over $1,000 in cash awards, a one-month solo exhibition for Best of Show winner, and group shows for other award winners. **February 4 deadline.** Photographers should send SASE for more information or print the prospectus and entry form from the website, www.thefrasergallery.com/photocomp.html.

CAMARGO FOUNDATION VISUAL ARTS FELLOWSHIP

400 Sibley St., 125 Park Square Court, St. Paul MN 55101-1928. (651)238-8805. E-mail: camargo@jeromefdn.org. Website: www.camargofoundation.org. **Contact:** U.S. Secretariat. Annual contest. Semester-long residencies awarded to visual artists and academics. Artists may work on a specific project, develop a body of work, etc. Fellows must live on-site at foundation headquarters for the duration of the term. One-semester residential grants (September-December or January-May). Each fellow receives a $3,500 stipend. Open to advanced photographers. **January 15 deadline.** Photographers should visit website for all necessary application and recommendation forms.

THE CENTER FOR FINE ART PHOTOGRAPHY

201 S. College Ave., Fort Collins CO 80524. (907)224-1010. E-mail: exhibitions@c4fap.org. Website: www.c4fap.org. **Contact:** Vered Galor, curator. Cost: typically $35 for first 3 entries; $10 for each additional entry. Contests held 10 times/year. "The Center's contests are designed to attract and exhibit quality fine art photography created by emerging and established artists working in traditional, digital and mixed media photography. The themes for each exhibition vary greatly. The themes, rules, details and entry forms for each Call for Entry are posted on the Center's website." All accepted work is exhibited in the Center gallery. Additionally, the Center offers monetary awards, scholarships, solo exhibitions and other awards. Awards are stated with each Call for Entry. Open to all skill levels. Photographers should see website for deadlines and more information.

COLLEGE PHOTOGRAPHER OF THE YEAR

109 Lee Hills Hall, Columbia MO 65211-1370. (573)882-4882. Fax: (573)884-4999. E-mail: info@cpoy.org. Website: www.cpoy.org. **Contact:** Angel Anderson, coordinator. Cost: $25. Annual contest to recognize excellent photography by currently enrolled college students. Portfolio winner receives a plaque, cash and products. Other category winners receive cash and film awards. Open to beginning and intermediate photographers. **Fall deadline.** Photographers should write, call or e-mail for more information.

FIFTYCROWS INTERNATIONAL FUND FOR DOCUMENTARY PHOTOGRAPHY

FiftyCrows, 49 Geary St., Suite 225, San Francisco CA 94108. (415)647-1100. Website: www.fiftycrows.org. Grants, career and distribution assistance to emerging and mid-career documentary photographers to help complete a long-term documentary project of social, political, ethical, environmental or economic importance. FiftyCrows maintains a by-appointment gallery and reference library, and creates short films about documentary photographers. To receive call-for-entry notification and updates, enter e-mail address in the sign-up area on the home page of the website.

N FIRELANDS ASSOCIATION FOR THE VISUAL ARTS

39 S. Main St., Oberlin OH 44074. (440)774-7158. E-mail: favagallery@oberlin.net. Website: www.favagallery .org. **Contact:** Betsy Manderen, executive director. Cost: $15/photographer; $12 for FAVA members. Annual juried photography contest for residents of Ohio, Kentucky, Indiana, Michigan, Pennsylvania and West Virginia. Both traditional and experimental techniques welcome. Photographers may submit up to 3 works completed in the last 3 years. **Annual entry deadline: March-April (date varies).** Photographers should call or e-mail for entry form.

GOLDEN LIGHT AWARDS

Maine Photographic Workshops, P.O. Box 200, 2 Central St., Rockport ME 04856. (207)236-8581. Fax: (207)236-2558. E-mail: info@theworkshops.com. Website: www.goldenlightawards.com. Annual competition for recently published photographic books. **October 4 deadline.** Photographers should call, fax or see website for more information.

N ⊕ HUMANITY PHOTO AWARD (HPA)

P.O. Box 8006, Beijing 100088 China. (86)(106)225-2175. E-mail: hpa@china-fpa.org. Website: www.china-fpa.org. **Contact:** Organizing Committee HPA. Cost: free. Biennial contest. Open to all skill levels. **HPA 2006 will launch on September 1, 2006.**

⊕ KRASZNA-KRAUSZ PHOTOGRAPHY AND MOVING IMAGE BOOK AWARDS

122 Fawnbrake Ave., London SE24 0BZ United Kingdom. E-mail: awards@k-k.org.uk. Website: www.k-k.org.uk. **Contact:** Andrea Livingstone, awards administrator. Awards made to encourage and recognize outstanding achievements in the writing and publishing of books on the art, history, practice and technology of photography and the moving image (film, television, video). **Entries from publishers only.** Announcement of winners in March every year.

LAKE SUPERIOR MAGAZINE AMATEUR PHOTO CONTEST

P.O. Box 16417, Duluth MN 55816-0417. (218)722-5002. Fax: (218)722-4096. E-mail: reader@lakesuperior.com. Website: www.lakesuperior.com. **Contact:** Konnie LeMay, editor. Annual contest. Photos must be taken in the Lake Superior region. Accepts up to 10 b&w and/or color images—prints no larger than $8\frac{1}{2} \times 10$, and transparencies. Digital images can be submitted as prints with accompanying CD. Grand Prize: $200 prize package to select Lake Superior region hotels and restaurants, plus a 1-year subscription and calendar. 1st Prize: $50 merchandise gift certificate plus 1-year subscription and calendar. 2nd Prize: 1-year subscription and calendar. Cover Prize: $125, image printed on magazine's cover, 1-year subscription and calendar. Open to all skill levels. **October 21 deadline.** Photographers should write, e-mail or see website for more information.

LARSON GALLERY JURIED PHOTOGRAPHY EXHIBITION

Yakima Valley Community College, P.O. Box 22520, Yakima WA 98907. (509)574-4875. Fax: (509)574-6826. E-mail: gallery@yvcc.edu. Website: www.yvcc.edu/larsongallery. **Contact:** Denise Olsen, assistant gallery director. Cost: $10/entry (limit 4 entries). National juried competition with approximately $3,500 in prize money. Held annually in April. **First jurying held in February.** Photographers should write, fax, e-mail or visit the website for prospectus.

Contests

LUMINESCENCE VII

Cookeville Camera Club, P.O. Box 999, Cookeville TN 38503. Website: www.cookevillecameraclub.com. **Contact:** Grady Deal, chairman. Cost: $7 per print; 4 prints for $25. Contest held annually. Purpose of contest: Enjoyment of sharing and exhibiting photos. Contest has 4 categories. Each photographer may enter 4 prints, but no more than 2 in a single category. No frames allowed, but each print must be mounted and matted. Minimum print size is 5×7, maximum mat size is 11×14. Best of Show receives $300, a plaque and a ribbon; 1st, 2nd and 3rd in each category receive medals and cash awards of $150, $75 and $50, respectively; 3 or more honorable mentions in each category receive $25 and a ribbon. Open to all skill levels. Entries judged by 3 persons—2 photographers and 1 artist from a different medium. **Deadline: June 17, 2006.** Photographers should write and send #10 SASE for more information.

MERCURY AWARDS

500 Executive Blvd., Ossining-on-Hudson NY 10562. (914)923-9400. Fax: (914)923-9484. E-mail: rwitt@merc ommawards.com. Website: www.mercommawards.com. **Contact:** Ms. Reni L. Witt, president. Cost: $190-250/entry (depending on category). Annual contest. The purpose of the contest is to honor outstanding achievement in public relations and corporate communications. Major category for photography, including ads, brochures, magazines, etc. "Best of Show" receives a personalized trophy. Grand Award winners receive award plaques (personalized). Gold, silver, bronze and finalists receive a personalized award certificate. All nominators receive complete judge score sheets and evaluation comments. **November 11 deadline.** Photographers should write, call or e-mail for more information.

THE MOBIUS ADVERTISING AWARDS

713 S. Pacific Coast Hwy., Suite A, Redondo Beach CA 90277-4233. (310)540-0959. Fax: (310)316-8905. E-mail: mobiusinfo@mobiusawards.com. Website: www.mobiusawards.com. **Contact:** Lee Gluckman, Jr., chairman. Annual international awards competition founded in 1971 for TV and radio commercials, print advertising, outdoor, specialty advertising, online, mixed media campaigns and package design. Student/spec work welcome. **October 1 deadline.** Awards presented in February each year in Los Angeles.

MYRON THE CAMERA BUG, "Photography's Official Mascot"™

(featuring The Foto Critters Family), % Educational Dept., 2106 Hoffnagle St., Philadelphia PA 19152-2409. E-mail: cambug8480@aol.com. **Contact:** Len Friedman, director. Sponsored by Luvable Characters EduTainment Workshop. Open to all photography students and educators. Photographers should e-mail for details.

NEW YORK STATE YOUTH MEDIA ARTS SHOWS

Media Arts Teachers Association, 910 Stuart Ave., Mamaroneck NY 10543. (315)469-8574. Website: www.emsc.n ysed.gov/nysssa/SMA/media.htm. **Contact:** Michael Witsch. Annual regional shows and exhibitions for still photo, film, videotape and computer arts. Co-sponsored by the New York State Media Arts Teachers Association and the State Education Department. Open to all New York State public and nonpublic secondary students.

NORTHERN COUNTIES INTERNATIONAL COLOUR SLIDE EXHIBITION

9 Cardigan Grove, Tynemouth, Tyne & Wear NE30 3HN United Kingdom. (44)(191)252-2870. E-mail: jane@h all-black.fsnet.co.uk. Website: www.ncpf.co.uk. **Contact:** Mrs. J.H. Black, honorary exhibition chairman, ARPS, Hon. PAGB, APSA. Judges 35mm slides—4 entries per person. Three categories: general, nature and photo travel. PSA and FIAP recognition and medals.

THE GORDON PARKS PHOTOGRAPHY COMPETITION

Fort Scott Community College, 2108 S. Horton, Fort Scott KS 66701-3140. (620)223-2700. Fax: (620)223-6530. E-mail: photocontest@fortscott.edu. Website: www.fortscott.edu. **Contact:** Kari West. Cost: $15 for each photo—maximum of 4 entries. Annual contest. Photos that reflect important themes in the life and works of Gordon Parks. Awards: $1,000 1st place, $500 2nd place, $250 3rd place. Open to all skill levels. Winners will be announced during the Gordon Parks Celebration of Culture & Diversity on the Fort Scott Community College campus in October. Photographers should send e-mail or write for more information.

THE PHOTO REVIEW ANNUAL PHOTOGRAPHY COMPETITION

140 E. Richardson Ave., Suite 301, Langhorne PA 19047. (215)891-0214. E-mail: info@photoreview.org. Website: www.photoreview.org. **Contact:** Stephen Perloff, editor. Cost: $25 for up to 3 prints or slides; $5 each for up to 2 additional prints or slides. National annual contest. All photographs—b&w, color, non-silver, computer-

manipulated, etc.—are eligible. Submit slides or prints (unmatted, unframed, 16×20 or smaller), or images on CD. All entries must be labeled. Awards $1,000 in cash prizes. All winners reproduced in summer issue of *Photo Review* magazine and exhibited at photography gallery of the University of Arts/Philadelphia. Open to all skill levels. **May 15 deadline**. Photographers should send SASE or see website for more information.

PHOTOGRAPHY NOW

% The Center for Photography at Woodstock, 59 Tinker St., Woodstock NY 12498. (845)679-9957. Fax: (845)679-6337. E-mail: info@cpw.org. Website: www.cpw.org. **Contact:** Kate Menconeri, CPW program director. Two annual contests: 1 for exhibitions, 1 for publication. Juried annually by renowned photographers, critics, museum and gallery curators. **Deadlines vary**. General submission is ongoing. Photographers must call or write for guidelines.

PHOTOSPIVA

Spiva Center for the Arts, 222 W. Third St., Joplin MO 64801. (417)623-0183. E-mail: jmueller@spivaarts.org. Website: www.spivaarts.org. **Contact:** Jo Mueller, director. National photography competition. $2,000 in awards. Photographers should send SASE for prospectus.

PICTURES OF THE YEAR INTERNATIONAL

109 Lee Hills Hall, Columbia MO 65211-1370. (573)882-4882. Fax: (573)884-4999. E-mail: info@poyi.org. Website: www.poyi.org. **Contact:** Angel Anderson, coordinator. Cost: $50/entrant. Annual contest to reward and recognize excellence in photojournalism. Over $20,000 in cash and product awards. Open to all skill levels. **January deadline.** Photographers should write, call or e-mail for more information.

RHODE ISLAND STATE COUNCIL ON THE ARTS FELLOWSHIPS

One Capitol Hill, 3rd Floor, Providence RI 02908. (401)222-3880. Fax: (401)222-3018. E-mail: Cristina@arts.ri.gov. Website: www.arts.ri.gov. **RI residents only!** Cost: free. Annual contest "to encourage the creative development of Rhode Island artists by enabling them to set aside time to pursue their work and achieve specific career goals." Awards $5,000 fellowship; $1,000 merit award. Open to advanced photographers. **April 1 deadline.** Photographers should send SASE, e-mail or see website for more information.

⊠ SEAS SCUBA EXPO PHOTO CONTEST

P.O. Box 472, Willow Spring NC 27592. (919)341-4524. Fax: (919)341-5740. E-mail: seas@nc.rr.com. Website: www.seas-expo.com. Annual contest. Photographers should see website for details.

W. EUGENE SMITH MEMORIAL FUND, INC.

% ICP, 1133 Avenue of the Americas, New York NY 10036. (212)857-0038. Fax: (212)768-4688. Website: www.smithfund.org. Annual contest. Promotes humanistic traditions of W. Eugene Smith. Grant of $30,000; secondary grant of $5,000. Open to photographers with a project in the tradition of W. Eugene Smith. Photographers should send SASE (60¢) for application information.

TAYLOR COUNTY FAIR PHOTO CONTEST

P.O. Box 613, Grafton WV 26354-0613. E-mail: hsw1@adelphia.net. **Contact:** Harry S. White, Jr., club president. Cost: $3/print (maximum of 10). Annual juried contest held in July/August. Color and b&w, all subject matter. All prints must be mounted or matted, with a minimum overall size of 8×10 and maximum overall size of 16×20. No framed prints or slides. No signed prints or mats. All prints must be identified on the back as follows: NAME, ADDRESS, PHONE NUMBER, TITLE, and entry number of print (e.g., 1 of 6). All entries must be delivered in a reusable container. Entrant's name, address and number of prints must appear on the outside of the container. Open to amateur photographers only.

⊠ U.S. INTERNATIONAL FILM AND VIDEO FESTIVAL

713 S. Pacific Coast Hwy., Suite A, Redondo Beach CA 90277-4233. (310)540-0959. Fax: (310)316-8905. E-mail: filmfestinfo@filmfestawards.com. Website: www.filmfestawards.com. **Contact:** Lee W. Gluckman, Jr., chairman. Annual international awards competition founded in 1968 for business, television, industrial, entertainment, documentary and informational film and video. **March 1 deadline.** Awards presented in early June each year in Los Angeles.

UNLIMITED EDITIONS INTERNATIONAL JURIED PHOTOGRAPHY COMPETITIONS

% Competition Chairman, P.O. Box 1509, Candler NC 28715-1509. (828)692-4638. E-mail: UltdEditionsIntl@aol.com. **Contact:** Gregory Hugh Leng, president/owner. Sponsors juried photography contests offering cash

and prizes. Also offers opportunity to sell work to Unlimited Editions. Photographers should send SASE for entry forms and information.

WHELDEN MEMORIAL LIBRARY PHOTO CONTEST
P.O. Box 147, West Barnstable MA 02668-0147. (508)362-3231. Fax: (508)362-8099. E-mail: ips3231@comcast.net. Website: www.whelden.org. **Contact:** Russ Kunze, contest manager. Cost: Amateur Division, $10/image; Snapshot Division, $5/image. All proceeds benefit the library. Biannual contest. Open format; snapshot up to and including 11×14. No framed prints accepted. Will return entries with SASE. Amateur Division: $100 1st Prize, $50 2nd Prize, $25 3rd Prize. Snapshot Division: $35 1st Prize, $25 2nd Prize, $15 3rd Prize. Open to all skill levels. **February/August deadlines**. Photographers should e-mail or see website for more information.

WRITERS' JOURNAL PHOTO CONTEST
Val-Tech Media, P.O. Box 394, Perham MN 56573. (218)346-7921. Fax: (218)346-7924. E-mail: writersjournal @writersjournal.com. Website: www.writersjournal.com. **Contact:** Leon Ogroske. Cost: $3/entry. No limit on number of entries. Photos can be of any subject matter, with or without people. Model releases must accompany all photos of people. 1st prize: $25; 2nd prize: $15; 3rd prize: $10; winners will be published in *Writers' Journal* magazine. **May 30/November 30 deadlines**. Photographers should send SASE for guidelines.

YOUR BEST SHOT
Popular Photography & Imaging, P.O. Box 1247, Teaneck NJ 07666. E-mail: rlazaroff@aol.com. Website: www.popphoto.com. Monthly photo contest; 3-page spread featuring 5 pictures: $300 1st place, $200 2nd place, $100 3rd place and 2 honorable mentions ($50 each). Photographers should e-mail for more information.

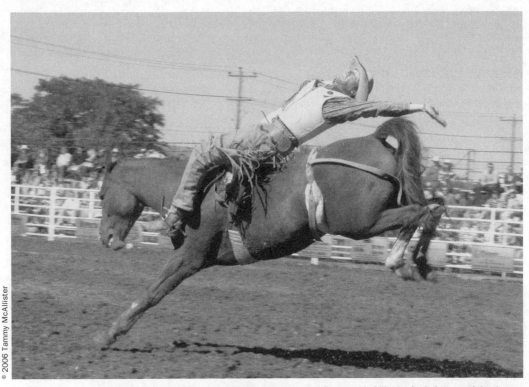

© 2006 Tammy McAllister

"I knew when I took this photo I had taken a really great shot," says Tammy McAllister. And she was right: It was a winner in the Whelden Memorial Library Photo Contest.

Photo Representatives

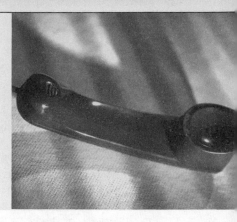

Many photographers are good at promoting themselves and seeking out new clients, and they actually enjoy that part of the business. Other photographers are not comfortable promoting themselves and would rather dedicate their time and energy solely to producing their photographs. Regardless of which camp you're in, you may need a photo rep.

Finding the rep who is right for you is vitally important. Think of your relationship with a rep as a partnership. Your goals should mesh. Treat your search for a rep much as you would your search for a client. Try to understand the rep's business, who they already represent, etc., before you approach them. Show you've done your homework.

When you sign with a photo rep, you basically hire someone to get your portfolio in front of art directors, make cold calls in search of new clients, and develop promotional ideas to market your talents. The main goal is to find assignment work for you with corporations, advertising firms, or design studios. And, unlike stock agencies or galleries, a photo rep is interested in marketing your talents rather than your images.

Most reps charge a 20- to 30-percent commission. They handle several photographers at one time, usually making certain that each shooter specializes in a different area. For example, a rep may have contracts to promote three different photographers—one who handles product shots, another who shoots interiors, and a third who photographs food.

DO YOU NEED A REP?

Before you decide to seek out a photo representative, consider these questions:

- Do you already have enough work, but want to expand your client base?
- Are you motivated to maximize your profits? Remember that a rep is interested in working with photographers who can do what is necessary to expand their business.
- Do you have a tightly edited portfolio with pieces showing the kind of work you want to do?
- Are you willing to do what it takes to help the rep promote you, including having a budget to help pay for self-promotional materials?
- Do you have a clear idea of where you want your career to go, but need assistance in getting there?
- Do you have a specialty or a unique style that makes you stand out?

If you answered yes to most of these questions, perhaps you would profit from the expertise of a rep. If you feel you are not ready for a rep or that you don't need one, but you still want some help, you might consider a consultation with an expert in marketing and/or self-promotion.

As you search for a rep, there are numerous points to consider. First, how established is the rep you plan to approach? Established reps have an edge over newcomers in that they know the territory. They've built up contacts in ad agencies, magazines and elsewhere. This is essential since most art directors and picture editors do not stay in their positions for long periods of time. Therefore, established reps will have an easier time helping you penetrate new markets.

If you decide to go with a new rep, consider paying an advance against commission in order to help the rep financially during an equitable trial period. Usually it takes a year to see returns on portfolio reviews and other marketing efforts, and a rep who is relying on income from sales might go hungry if he doesn't have a base income from which to live.

And whatever you agree upon, always have a written contract. Handshake deals won't cut it. You must know the tasks that each of you is required to complete, and having your roles discussed in a contract will guarantee there are no misunderstandings. For example, spell out in your contract what happens with clients that you had before hiring the rep. Most photographers refuse to pay commissions for these "house" accounts, unless the rep handles them completely and continues to bring in new clients.

Also, it's likely that some costs, such as promotional fees, will be shared. For example, freelancers often pay 75 percent of any advertising fees (such as sourcebook ads and direct mail pieces).

If you want to know more about a specific rep, or how reps operate, contact the Society of Photographers and Artists Representatives, 60 E. 42nd St., Suite 1166, New York NY 10165, (212)779-7464. SPAR sponsors educational programs and maintains a code of ethics to which all members must adhere.

AREP

P.O. Box 16576, Golden CO 80402. (720)320-4514. Fax: (720)489-3786. E-mail: christelle@aRep.biz. Website: www.aRep.biz. **Contact:** Christelle C. Newkirk, owner. Commercial photography, commercial illustration, digital composite representative. Estab. 1995. Represents 1 photographer, 1 illustrator and 1 digital composite artist. Agency specializes in exclusive partnership with artists in their respective field and style. Markets include advertising agencies, editorial/magazines, corporate/client direct, design firms, publishing/books. **Handles** Illustrators, copywriters. "No commercial photographers at this time, please."
Terms Rep receives 20% commission. Exclusive area representation required. Advertising costs paid by talent. For promotional purposes, talent must provide 1 portfolio (updated every year), website, direct mail pieces and leave-behinds.
How to Contact Send e-mail, query, tearsheets, bio, brochure or direct mail pieces. Responds only if interested within 1 week. To show portfolio, photographer should follow-up with call. Rep will contact photographer for portfolio review if interested.
Tips Finds new talent through referrals, source books.

ROBERT BACALL REPRESENTATIVES INC.

16 Penn Plaza, Suite 1754, New York NY 10001. (212)695-1729. E-mail: rob@bacall.com. Website: www.bacall.com. **Contact:** Robert Bacall. Commercial photography and artist representative. Estab. 1988. Represents 12 photographers. Agency specializes in digital, food, still life, fashion, beauty, kids, corporate, environmental, portrait, lifestyle, location, landscape. Markets include advertising agencies, corporations/clients direct, design firms, editorial/magazines, publishing/books, sales/promotion firms.
Terms Rep receives 30% commission. Exclusive area representation required. For promotional purposes, talent must provide portfolios, cases, tearsheets, prints, etc. Advertises in *Creative Black Book*, *The Workbook*, *Le Book*, *Alternative Pick*, *PDN-Photoserve*.
How to Contact Send query letter, direct mail flier/brochure. Responds only if interested. After initial contact, drop off or mail materials for review.
Tips "Seek representation when you feel your portfolio is unique and can bring in new business."

BERENDSEN & ASSOCIATES, INC.

2233 Kemper Lane, Cincinnati OH 45206. (513)861-1400. Fax: (513)861-6420. E-mail: bob@photographersrep.com. Website: http://photographersrep.com. **Contact:** Bob Berendsen. Commercial illustration, photography and graphic design representative. Estab. 1986. Represents 70 illustrators, 15 photographers, 25 Mac

designers/illustrators in the MacWindows Group Division. Agency specializes in "high-visibility consumer accounts." Markets include advertising agencies, corporations/clients direct, design firms, editorial/magazines, paper products/greeting cards, publishing/books, sales/promotion firms.

Handles Illustration, photography.

Terms Rep receives 30% commission. Charges "mostly for postage, but figures not available." No geographic restrictions. Advertising costs are split: 70% paid by talent; 30% paid by representative. For promotional purposes, "artist must co-op in our direct mail promotions, and sourcebooks are recommended. Portfolios are updated regularly." Advertises in *RSVP*, *Creative Illustration Book*, *The Ohio Source Book* and *American Showcase*.

How to Contact Send e-mail with no more than 6 JPEGs attached or send query letter, résumé, nonreturnable tearsheets, slides, photographs and photocopies. Follow up with a phone call.

Tips Obtains new talent "through recommendations from other professionals. Contact Bob Berendsen, president, for first meeting."

MARIANNE CAMPBELL ASSOCIATES

840 Fell St., San Francisco CA 94117. (415)433-0353. Fax: (415)433-0351. Website: www.MarianneCampbell. com. **Contact:** Marianne Campbell or Quinci Payne. Commercial photography representative. Estab. 1989. Member of APA, SPAR, Western Art Directors Club. Represents 5 photographers. Markets include advertising agencies, corporations/clients direct, design firms, editorial/magazines.

Handles Photography.

Terms Negotiated individually with each photographer.

How to Contact Send printed samples of work. Responds in 2 weeks, only if interested.

Tips Obtains new talent through recommendations from art directors and designers and outstanding promotional materials.

⬚N⬚ MARGE CASEY & ASSOCIATES

20 W. 22nd St., #1605, New York NY 10010. (212)929-3757. Fax: (212)929-8611. E-mail: info@margecasey.c om. Website: www.margecasey.com. **Contact:** Patrick Casey, partner. Represents photographers. Staff includes Elliot Abelson, production coordinator/partner; Patrick Casey, sales associate/photo agent/partner; Marge Casey, sales associate/photo agent/partner. Agency specializes in representing commercial photographers. Markets include advertising agencies, corporate/client direct, design firms, editorial/magazines, direct mail firms.

Will Handle Photography.

How to Contact Send brochure, promo cards. Responds only if interested. Portfolios may be dropped off every Monday through Friday. To show portfolio, photographer should follow up with call. Rep will contact photographer for portfolio review if interested.

Tips Finds new talent through submission, recommendations from other artists.

RANDY COLE REPRESENTS, LLC

24 W. 30th St., 5th Floor, New York NY 10001. (212)679-5933. Fax: (212)779-3697. E-mail: randy@randycole. com. Website: www.randycole.com. Commercial photography representative. Estab. 1989. Member of SPAR. Represents 8 photographers. Staff includes an assistant. Markets include advertising agencies, editorial/magazines, direct mail firms, corporate/client direct, design firms, publishing/books.

Handles Photography.

Terms Rep receives 25-30% commission; dependent upon specific negotiation. Advertises in *Creative Black Book*, *The Workbook*, other sourcebooks.

How to Contact Send promo piece and follow up with call. Portfolios may be dropped off; set up appointment.

Tips Finds new talent through submissions and referrals.

LINDA DE MORETA REPRESENTS

1839 Ninth St., Alameda CA 94501. (510)769-1421. Fax: (510)892-2955. E-mail: linda@lindareps.com. Website: www.lindareps.com. **Contact:** Linda de Moreta. Commercial photography and illustration representative; negotiation specialist for commissioned work and stock. Estab. 1988. Member of Graphic Artists' Guild. Represents 1 photographer, 8 illustrators, 2 lettering artists and 2 comp/storyboard artists. Markets include advertising agencies, design firms, corporations/client direct, editorial/magazines, paper products/greeting cards, publishing/books, sales/promotion firms.

Handles Photography, illustration, lettering/storyboards.

Terms Exclusive representation requirements and commission arrangements vary. Advertising costs are handled by individual agreement. Materials for promotional purposes vary with each artist. Advertises in *The Workbook*, *Directory of Illustration*, *RSVP*.

How to Contact E-mail or send direct mail flier/brochure, tearsheets or photocopies. "Please do *not* send original art. Include SASE for any items you wish returned." Responds to any inquiry in which there is an interest. Portfolios are individually developed for each artist.

Tips Obtains new talent primarily through client and artist referrals, some solicitation. "I look for a personal vision and style of photography or illustration and exceptional creativity, combined with professionalism, maturity, and commitment to career advancement."

FRANÇOISE DUBOIS/DUBOIS REPRESENTS

305 Newbury Lane, Newbury Park CA 91320. (805)376-9738. Fax: (805)376-9729. E-mail: fd@francoiseduboi s.com. Website: www.francoisedubois.com. **Contact:** Françoise Dubois, owner. Commercial photography representative and creative and marketing consultant. Represents 3 photographers. Staff includes Andrew Bernstein (sports and sports celebrities), Pam Francis (people, portraiture), Michael Dubois (still life/people) and Michael Baciu (photo impressionism). Agency specializes in commercial photography for advertising, editorial, creative, marketing consulting. Markets include advertising agencies, corporations/clients direct, design firms, editorial/magazines, publishing/books, sales/promotion firms.

Handles Photography.

Terms Rep receives 25% commission. Charges FedEx expenses (if not paid by advertising agency or other potential client). Exclusive area representation required. Advertising costs are paid by talent. For promotional purposes, talent must provide "3 portfolios, advertising in national sourcebook, and 3 or 4 direct mail pieces per year. All must carry my name and number." Advertises in *Creative Black Book*, *The Workbook*, *The Alternative Pick* and *Le Book*.

How to Contact Send tearsheets, bio and interesting direct mail promos. Responds only if interested in 2 months. Rep will contact photographer for portfolio review if interested. Portfolio should include "whatever format as long as it is consistent."

Tips "Do not look for a rep if your target market is too small a niche. Do not look for a rep if you're not somewhat established. Hire a consultant to help you design a consistent and unique portfolio and marketing strategy, and to make sure your strengths are made evident and you remain focused."

ⓝ JEAN GARDNER & ASSOCIATES

444 N. Larchmont Blvd., Suite 207, Los Angeles CA 90004. (323)464-2492. Fax: (323)465-7013. Website: www.jgaonline.com. **Contact:** Jean Gardner. Commercial photography representative. Estab. 1985. Member of APA. Represents 12 photographers. Staff includes Dominique Cole (sales rep) and Sherwin Taghdiri (sales rep). Agency specializes in photography. Markets include advertising agencies, design firms.

Handles Photography.

Terms Rep receives 25% commission. Charges shipping expenses. Exclusive representation required. No geographic restrictions. Advertising costs are paid by talent. For promotional purposes, talent must provide promos, advertising and a quality portfolio. Advertises in various source books.

How to Contact Send direct mail flier/brochure.

ⓝ MICHAEL GINSBURG & ASSOCIATES, INC.

240 E. 27th St., Suite 24E, New York NY 10016. (212)679-8881. Fax: (212)679-2053. E-mail: mg@michaelgins burg.com. Website: www.michaelginsburg.com. **Contact:** Michael Ginsburg. Commercial photography representative. Estab. 1978. Represents 9 photographers. Agency specializes in advertising and editorial photographers. Markets include advertising agencies, corporations/clients direct, design firms, editorial/magazines, sales/promotion firms.

Handles Photography.

Terms Rep receives 25% commission. Charges for messenger costs, FedEx expenses. Exclusive area representation required. Advertising costs are split: 75% paid by talent; 25% paid by representative. For promotional purposes, talent must provide a minimum of 5 portfolios—direct mail pieces 2 times per year—and at least 1 sourcebook per year. Advertises in *Creative Black Book*, source books and online source books.

How to Contact Send query letter, direct mail flier/brochure, or e-mail. Responds only if interested within 2 weeks. After initial contact, call for appointment to show portfolio of tearsheets, slides, photographs.

Tips Obtains new talent through personal referrals and solicitation.

BARBARA GORDON

165 E. 32nd St., New York NY 10016. (212)686-3514. Fax: (212)532-4302. **Contact:** Barbara Gordon. Commercial illustration and photography representative. Estab. 1969. Member of SPAR, Society of Illustrators, Graphic Artists Guild. Represents 9 illustrators and 1 photographer. "I represent only a small select group of people and therefore give a great deal of personal time and attention to each."

Terms Rep receives 25% commission. No geographic restrictions in continental US.

How to Contact Send direct mail flier/brochure. Responds in 2 weeks. After initial contact, drop off or mail appropriate materials for review. Portfolio should include tearsheets, slides, photographs; "if you want materials or promotion piece returned, include SASE."

Tips Obtains new talent through recommendations from others, solicitation, art conferences, etc. "I have obtained talent from all of the above. I do not care if an artist or photographer has been published or is experienced. I am essentially interested in people with a good, commercial style. Don't send résumés and don't call to give me a verbal description of your work. Send promotion pieces. *Never* send original art. If you want something back, include a SASE. Always label your slides in case they get separated from your cover letter. And always include a phone number where you can be reached."

CAROL GUENZI AGENTS, INC.

865 Delaware, Denver CO 80204-4533. (303)820-2599. Fax: (303)820-2598. E-mail: art@artagent.com. Website: www.artagent.com. **Contact:** Carol Guenzi. Commercial illustration, film and animation representative. Estab. 1984. Member of Art Directors Club of Denver, AIGA and ASMP. Represents 30 illustrators, 6 photographers, 6 computer multimedia designers. Agency specializes in a "wide selection of talent in all areas of visual communications." Markets include advertising agencies, corporations/clients direct, design firms, editorial/magazine, paper products/greeting cards, sales/promotions firms.

Handles Illustration, photography. Looking for "unique style application" and digital imaging.

Terms Rep receives 25-30% commission. Exclusive area representation required. Advertising costs are split: 70-75% paid by talent; 25-30% paid by representative. For promotional purposes, talent must provide "promotional material after 6 months, some restrictions on portfolios." Advertises in *Directory of Illustration*, *Black Book* and *The Workbook*.

How to Contact E-mail JPEGs, direct mail, tearsheets. Responds in 2-3 weeks, only if interested. After initial contact, call or e-mail for appointment or to drop off materials for review, depending on artist's location. Portfolio should include tearsheets, prints and samples.

Tips Obtains new talent through solicitation, art directors' referrals and active pursuit by individual. "Show your strongest style and have at least 12 samples of that style before introducing all your capabilities. Be prepared to add additional work to your portfolio to help round out your style. We do a large percentage of computer manipulation and accessing on network. All our portfolios are both electronic and prints."

KLIMT REPRESENTS

15 W. 72 St., 7-U, New York NY 10023. (212)799-2231. Fax: (212)799-2362. Commercial photography and illustration representative. Estab. 1980. Member of Society of Illustrators. Represents 1 photographer and 6 illustrators. Staff includes David Blattel (photo/computer), Ben Stahl, Ron Spears, Terry Herman, Shannon Maer, Fred Smith, Juan Moreno, and Tom Patrick (stylized illustration). Agency specializes in young adult book art. Markets include advertising agencies, corporate/client direct, interior decorators, private collectors.

Terms Rep receives 25% commission. Advertising costs are split: 75% paid by talent; 25% paid by representative. For promotional purposes, talent must provide all materials.

How to Contact Send query letter, tearsheets. Responds in 2 weeks. Rep will contact photographer for portfolio review if interested.

KORMAN + COMPANY

360 W. 34th St., Suite 8F, New York NY 10001. (212)402-2450. Fax: (212)504-9588. Website: www.kormanandcompany.com. Second office: 325 S. Berkeley, Pasadena CA 91107. (626)583-1442. **Contact:** Alison Korman, Cara Timko or Patricia Muzikar. Commercial photography representatives. Estab. 1984. Markets include advertising agencies, corporations/clients direct, editorial/magazines, publishing/books, music, celebrities, sports.

Handles Photography.

Terms Rep receives 25-30% commission. Exclusive area representation required. Advertises in trade directories and via e-mail/direct mail.

How to Contact Send promo by e-mail with link to website. Responds in 1 month if interested. After initial contact, e-mail for appointment or drop off/mail portfolio of tearsheets, photographs.

Tips "Research before seeking." Obtains new talent through "recommendations, seeing somebody's work out in the market and liking it. Be prepared to discuss your short-term and long-term goals and how you think a rep can help you achieve them."

JOAN KRAMER AND ASSOCIATES, INC.

10490 Wilshire Blvd., Suite 1701, Los Angeles CA 90024. (310)446-1866. Fax: (310)446-1856. **Contact:** Joan Kramer. Commercial photography representative and stock photo agency. Estab. 1971. Member of SPAR, ASMP, PACA. Represents 45 photographers. Agency specializes in model-released lifestyle. Markets include advertising agencies, design firms, publishing/books, sales/promotion firms, producers of TV commercials.
Handles Photography.
Terms Rep receives 50% commission. Advertising costs are split: 50% paid by talent; 50% paid by representative. Advertises in *Creative Black Book* and *The Workbook*.
How to Contact Send a query letter. Responds only if interested.
Tips Obtains new talent through recommendations from others.

⚇ CAROYL LABARGE REPRESENTING

5601 Santa Cruz Av., Richmond CA 94804. E-mail: lyorac@earthlinknet.com. Commercial photography representative in New York City market only. Estab. 1991. Represents 3 photographers and 1 fine artist. Agency specializes in still life. Markets include advertising agencies, corporations/clients direct, design firms, editorial/magazines, publishing/books, sales/promotion firms.
Handles Photography.
Terms Rep receives 25% commission. Photographer pays all expenses. For promotional purposes, talent must provide promo pieces.
How to Contact Send query letter, tearsheets. Responds within 1 week, only if interested. Rep will contact photographer for portfolio review if interested.
Tips Obtains new talent through references and magazines. "Contact me by direct mail only."

LEE + LOU PRODUCTIONS INC.

8522 National Blvd., #104, Culver City CA 90232. (310)287-1542. Fax: (310)287-1814. E-mail: leelou@earthlink.net. Website: www.leelou.com. Commercial illustration and photography representative, digital and traditional photo retouching. Estab. 1981. Represents 5 illustrators, 5 photographers, 3 film directors. Editorial company/music and sound design agency specializing in automotive. Markets include advertising agencies.
Handles Photography, commercial film.
Terms Rep receives 25% commission. Charges for shipping, entertainment. Exclusive area representation required. Advertising costs are paid by talent. For promotional purposes, talent must provide direct mail advertising material. Advertises in *Creative Black Book*, *The Workbook* and *Single Image*.
How to Contact Send direct mail flier/brochure, tearsheets. Responds in 1 week. After initial contact, call for appointment to show portfolio of photographs.
Tips Obtains new talent through recommendations from others, some solicitation.

THE BRUCE LEVIN GROUP

305 Seventh Ave., Suite 1101, New York NY 10001. (212)627-2281. Fax: (212)627-0095. E-mail: brucelevin@mac.com. Website: www.brucelevingroup.com. **Contact:** Bruce Levin, president. Commercial photography representative. Estab. 1983. Member of SPAR and ASMP. Represents 10 photographers. Agency specializes in advertising, editorial and catalog; heavy emphasis on fashion, lifestyle and computer graphics.
Handles Photography. Looking for photographers who are "young and college-educated."
Terms Rep receives 25% commission. Exclusive area representation required. Advertising costs are split: 75% paid by talent; 25% paid by representative. Advertises in *The Workbook* and other sourcebooks.
How to Contact Send brochure, photos; call. Portfolios may be dropped off every Monday through Friday.
Tips Obtains new talent through recommendations, research, word of mouth, solicitation.

MASLOV AGENT INTERNATIONAL

608 York St., San Francisco CA 94110. Website: http://maslov.com. **Contact:** Norman Maslov. Commercial photography representative. Estab. 1986. Member of APA. Represents 9 photographers. Markets include

advertising agencies, corporations/clients direct, design firms, editorial/magazines, paper products/greeting cards, publishing/books, private collections.
Handles Photography. Looking for "original work not derivative of other artists. Artist must have developed style."
Terms Rep receives 25% commission. Exclusive US national representation required. Advertising costs split varies. For promotional purposes, talent must provide 3-4 direct mail pieces/year. Advertises in *Archive*, *The Workbook*, *Alternative Pick*, *Klik* and *At Edge*.
How to Contact Send query letter, direct mail flier/brochure, tearsheets. Do not send original work. Responds in 2-3 weeks, only if interested. After initial contact, call to schedule an appointment, or drop off or mail materials for review.
Tips Obtains new talent through suggestions from art buyers and recommendations from designers, art directors, other agents, sourcebooks, and industry magazines. "We prefer to follow our own leads rather than receive unsolicited promotions and inquiries. It's best to have represented yourself for several years to know your strengths and be realistic about your marketplace. The same is true of having experience with direct mail pieces, developing client lists, and having a system of follow up. We want our talent to have experience with all this so they can properly value our contribution to their growth and success—otherwise that 25% becomes a burden and point of resentment. Enter your best work into competitions such as *Communication Arts* and *Graphis* photo annuals. Create a distinctive promotion mailer if your concepts and executions are strong."

MUNRO GOODMAN ARTISTS REPRESENTATIVES

630 N. State St., Chicago IL 60610. (312)321-1336. E-mail: steve@munrocampagna.com. Website: www.munrocampagna.com. **Contact:** Steve Munro, president. Commercial photography and illustration representative. Estab. 1987. Member of SPAR, CAR (Chicago Artist Representatives). Represents 2 photographers, 22 illustrators. Markets include advertising agencies, corporations/clients direct, design firms, publishing/books.
Handles Illustration, photography.
Terms Rep receives 25% commission. Exclusive area representation required. Advertising costs are split: 75% paid by talent; 25% paid by representative. For promotional purposes, talent must provide 2 portfolios, leave-behinds, several promos. Advertises in *American Showcase*, *Creative Black Book*, *The Workbook*, other sourcebooks.
How to Contact Send query letter, bio, tearsheets, SASE. Responds within 2 weeks, only if interested. After initial contact, write to schedule an appointment.
Tips Obtains new talent through recommendations, periodicals. "Do a little homework and target appropriate rep. Try to get a referral from an art buyer or art director."

MARIA PISCOPO

2973 Harbor Blvd., #341, Costa Mesa CA 92626-3912. Phone/fax: (888)713-0705. E-mail: maria@mpiscopo.com. Website: www.mpiscopo.com. **Contact:** Maria Piscopo. Commercial photography representative. Estab. 1978. Member of SPAR, Women in Photography, Society of Illustrative Photographers. Represents 4 photographers. Markets include advertising agencies, design firms, corporations.
Handles Photography. Looking for "unique, unusual styles; established photographers only."
Terms Rep receives 25% commission. Exclusive area representation required. No geographic restrictions. Advertising costs are split: 50% paid by talent; 50% paid by representative. For promotional purposes, talent must provide 3 traveling portfolios, leave-behinds and at least 6 new promo pieces per year. Plans Web, advertising and direct mail campaigns.
How to Contact Send query letter, bio, promo piece and SASE. Responds within 2 weeks, only if interested.
Tips Obtains new talent through personal referral and photo magazine articles. "Do lots of research. Be very businesslike, organized, professional and follow the above instructions!"

Ⓝ ALYSSA PIZER

13121 Garden Land Rd., Los Angeles CA 90049. (310)440-3930. Fax: (310)440-3830. **Contact:** Alyssa Pizer. Commercial photography representative. Estab. 1990. Member of APCA. Represents 8 photographers. Agency specializes in entertainment (movie posters, TV gallery, record/album); fashion (catalog, image campaign, department store, beauty and lifestyle awards). Markets include advertising agencies, corporations/clients direct, design firms, editorial/magazines, record companies, movie studios, TV networks, publicists.
Handles Photography. Established photographers only.
Terms Rep receives 25% commission. Photographer pays for FedEx and messenger charges. Talent pays

100% of advertising costs. For promotional purposes, talent must provide 10 portfolios, leave-behinds and quarterly promotional pieces.

How to Contact Send query letter or direct mail flier/brochure or e-mail website address to alyssapizer@earth link.net. Responds in a couple of days. After initial contact, call to schedule an appointment or drop off or mail materials for review.

Tips Obtains new talent through recommendations from clients.

TM ENTERPRISES

270 N. Canon Dr., Suite 2020, Beverly Hills CA 90210. E-mail: tmarquesusa@yahoo.com. **Contact:** Tony Marques. Commercial photography representative and photography broker. Estab. 1985. Member of Beverly Hills Chamber of Commerce. Represents 50 photographers. Agency specializes in photography of women only: high fashion, swimsuit, lingerie, glamour and fine (good taste) *Playboy*-style pictures, erotic. Markets include advertising agencies, corporations/clients direct, editorial/magazines, paper products/greeting cards, publishing/books, sales/promotion firms, medical magazines.

Handles Photography.

Terms Rep receives 50% commission. Advertising costs are paid by representative. "We promote the standard material the photographer has available, unless our clients request something else." Advertises in Europe, South and Central America, and magazines not known in the US.

How to Contact Send everything available. Responds in 2 days. After initial contact, drop off or mail appropriate materials for review. Portfolio should include slides, photographs, transparencies, printed work.

Tips Obtains new talent through worldwide famous fashion shows in Paris, Rome, London and Tokyo; by participating in well-known international beauty contests; recommendations from others. "Send your material clean and organized (neat). Do not borrow other photographers' work in order to get representation. Protect—always—yourself by copyrighting your material. Get releases from everybody who is in the picture (or who owns something in the picture)."

DOUG TRUPPE

121 E. 31st St., New York NY 10016. (212)685-1223. E-mail: doug@dougtruppe.com. **Contact:** Doug Truppe, president. Commercial photography representative. Estab. 1998. Member of SPAR, Art Directors Club. Represents 8 photographers. Agency specializes in lifestyle, food and children's photography. Markets include advertising agencies, corporate, design firms, editorial/magazines, publishing/books, direct mail firms.

Handles Photography. "Always looking for great commercial work." Established, working photographers only.

Terms Rep receives 25% commission. Exclusive area representation required. Advertising costs are paid by talent. For promotional purposes, talent must provide directory ad (at least 1 directory per year), direct mail promo cards every 3 months, website. Advertises in *The Workbook*.

How to Contact Send e-mail with website address. Responds within 1 month, only if interested. To show portfolio, photographer should follow up with call.

Tips Finds artists through recommendations from other artists, source books, art buyers. "Please be willing to show some new work every 6 months. Have 4-6 portfolios available for representative. Have website and be willing to do direct mail every 3 months. Be professional and organized."

Workshops & Photo Tours

© Barney Sellers

Taking a photography workshop or photo tour is one of the best ways to improve your photographic skills. There is no substitute for the hands-on experience and one-on-one instruction you can receive at a workshop. Besides, where else can you go and spend several days with people who share your passion for photography?

Photography is headed in a new direction. Digital imaging is here to stay and is becoming part of every photographer's life. Even if you haven't invested a lot of money into digital cameras, computers or software, you should understand what you're up against if you plan to succeed as a professional photographer. Taking a digital imaging workshop can help you on your way.

Outdoor and nature photography are perennial workshop favorites. Creativity is another popular workshop topic. You'll also find highly specialized workshops, such as underwater photography. Many photo tours specialize in a specific location and the great photo opportunities that location affords.

As you peruse these pages, take a good look at the quality of workshops and the skill level of photographers the sponsors want to attract. It is important to know if a workshop is for beginners, advanced amateurs or professionals. Information from a workshop organizer can help you make that determination.

These workshop listings contain only the basic information needed to make contact with sponsors, and a brief description of the styles or media covered in the programs. We also include information on costs when possible. Write or e-mail the workshop/photo tour sponsors for complete information.

A workshop or photo tour can be whatever the photographer wishes—a holiday from the normal working routine, or an exciting introduction to new skills and perspectives on the craft. Whatever you desire, you're sure to find in these pages a workshop or tour that fulfills your expectations.

ADOBE PHOTOSHOP WORKSHOP

Rochester Institute of Technology, 67 Lomb Memorial Dr., Rochester NY 14623-5603. (800)724-2536. Fax: (585)475-7000. E-mail: ptpd@rit.edu. Website: www.seminars.cias.rit.edu. **Contact:** Ken Posman, manager, Industry Education Programs. Cost: $895; includes lunch each day. Biannual workshop. "This hands-on workshop will teach you to use Photoshop's most advanced features to realize your creative visions." This workshop is intended for regular users of Photoshop who are comfortable with the latest application version and already use channels, layers, layer masks, clipping groups, adjustment layers and quick mask.

[N] AERIAL AND CREATIVE PHOTOGRAPHY WORKSHOPS

Hangar 23, Box 470455, San Francisco CA 94147. (415)771-2555. Fax: (707)769-7277. E-mail: workshops@ae rialarchives.com. Website: www.aerialarchives.com. **Contact:** Herb Lingl, director. Aerial and creative photography workshops in unique locations from helicopters, light planes and balloons.

AFRICAN PHOTO SAFARIS

7569 Mohawk St., Bonners Ferry ID 83805. (208)267-5586. Fax: (208)460-4259. E-mail: roselee647@imbris.n et. **Contact:** Brent Rosengrant. "Intense 21-day workshops and photo safaris limited to 4 photographers in a safari-equipped Land Rover. Regions explored include Etosha National Park, Namib Desert, the Skeleton Coast, Okovango Delta and Victoria Falls."

ALASKA'S SEAWOLF ADVENTURES

P.O. Box 97, Gustavus AK 99826. (907)723-9440. E-mail: seawolfadventures@earthlink.net. Website: www.s eawolf-adventures.com. **Contact:** Trip Coordinator. Cost: $1,750/5 days. "Photograph glaciers, whales, bears, wolves, incredible scenics, etc., while using the Seawolf, a 97-foot, 12-passenger expedition ship, as your base camp in the Glacier Bay area."

[N] ALDERMAN'S SLICKROCK ADVENTURES

19 W. Center St., Kanab UT 84741. (435)644-5981. E-mail: fotomd@xpressweb.com. Website: www.utahcam eras.com. **Contact:** Terry G. Alderman, master photographer. Cost: $80/day; 2 person minimum. Covers landscape photography of ghost towns, arches, petroglyphs and narrow canyons in the back country of Southern Utah and the Arizona Strip.

ANCHELL/PHOTOGRAPHY WORKSHOPS

P.O. Box 277, Crestone CO 81131-0277. (719)256-4157. Fax: (719)256-4158. E-mail: sanchell@ctellco.net. Website: www.steveanchell.com. **Contact:** Steve Anchell. Cost: $475-1,450. Workshops held throughout the year. Traditional forms of photography, film or digital, including large-format, studio lighting, darkroom, both color and b&w. Open to all skill levels. Photographers should write, call or e-mail for more information.

ANDERSON RANCH ARTS CENTER

P.O. Box 5598, Snowmass Village CO 81615. (970)923-3181. Fax: (970)923-3871. E-mail: info@andersonranc h.org. Website: www.andersonranch.org. Weekend to 3-week workshops run June through September in photography, digital imaging and creative studies. "Instructors are top artists from around the world. Classes are small, and the facilities have the highest-quality equipment." Program highlights include portrait and landscape photography; technical themes include photojournalism and advanced techniques. Offers field expeditions to the American Southwest and other locations around the globe.

ARIZONA HIGHWAYS PHOTO WORKSHOPS

Friends of Arizona Highways, P.O. Box 6106, Phoenix AZ 85005-6106. (888)790-7042. E-mail: Rnoll@azdot.g ov. Website: www.friendsofazhighways.com. **Contact:** Robyn Noll, director. Offers photo adventures to the American West's most spectacular locations with top professional photographers whose work routinely appears in *Arizona Highways* magazine.

ART NEW ENGLAND SUMMER WORKSHOPS @ BENNINGTON VT

(617)879-7175. E-mail: nmccarthy@massart.edu. Website: www.massartplus.org. **Contact:** Nancy McCarthy, coordinator. Weeklong workshops in August, run by Massachusetts College of Art. Areas of concentration include b&w, alternative processes, wet-plate collodion process, digital printing and many more. Photographers should call, e-mail or see website for more information.

ART WORKSHOPS IN GUATEMALA

4758 Lyndale Ave. S., Minneapolis MN 55419-5304. (612)825-0747. Fax: (612)825-6637. E-mail: info@artguat .org. Website: www.artguat.org. **Contact:** Liza Fourre, director. Cost: $2,095; includes tuition, air from US, lodging, breakfast, ground transport. Annual workshops held in Antigua, Guatemala. Workshops include Adventure Travel Photo with Steve Northup, Portraiture/Photographing the Soul of Indigenous Guatemala with Nance Ackerman, Photography/Capturing Guatemala's Light and Contrasts with David Wells, Travel Photography/Indigenous Peoples and Mayan Markets with Jackie Bell and Spirit of Place with Doug Beasley.

NOELLA BALLENGER & ASSOCIATES PHOTO WORKSHOPS

P.O. Box 457, La Canada CA 91012. (818)954-0933. Fax: (818)954-0910. E-mail: Noella1B@aol.com. Website: www.noellaballenger.com. **Contact:** Noella Ballenger. Travel and nature workshops/tours, west coast locations. Individual instruction in small groups emphasizes visual awareness, composition and problem-solving in the field. All formats and levels of expertise welcome. Call or write for information.

FRANK BALTHIS PHOTOGRAPHY WORKSHOPS

P.O. Box 255, Davenport CA 95017. (831)426-8205. E-mail: frankbalthis@yahoo.com. **Contact:** Frank S. Balthis, photographer/owner. Cost depends on the length of program and travel costs. "Workshops emphasize natural history, wildlife and travel photography, often providing opportunities to photograph marine mammals." Worldwide locations range from Baja California to Alaska. Frank Balthis runs a stock photo business and is the publisher of the Nature's Design line of cards and other publications.

Ⓝ BETTERPHOTO.COM ONLINE PHOTOGRAPHY COURSES

P.O. Box 2781, Redmond WA 98073. (425)246-9679. Fax: (425)898-9752. E-mail: heather@betterphoto.com. Website: www.betterphoto.com. **Contact:** Heather Young, customer service. Cost: Online courses including personal critiques cost $179-339 for 4- and 8-week sessions. Held 4 times/year. "Online courses are held every quarter, starting early October, January, April and July. We offer online photography courses from some of today's top professional photographers. Courses range in skill level from beginner to advanced and consist of inspiring weekly lessons and personal feedback on students' photos from the instructors. Our purpose at BetterPhoto is to provide honest answers for budding photographers. We provide free online newsletters, lively Q&A and photo discussions, a free monthly contest, helpful articles and online photography courses." Open to all skill levels. Photographers should see website for more information.

BIRDS AS ART/INSTRUCTIONAL PHOTO-TOURS

P.O. Box 7245, 805 Granada Dr., Indian Lake Estates FL 33855. (863)692-0906. E-mail: birdsasart@verizon.n et. Website: www.birdsasart.com. **Contact:** Arthur Morris, instructor. Cost: varies, approximately $300/day. The tours, which visit the top bird photography hot spots in North America, feature evening in-classroom lectures, breakfast and lunch, in-the-field instruction, 6 or more hours of photography, and most importantly, easily approachable yet free and wild subjects.

Ⓝ BLACK AND WHITE PHOTOGRAPHIC WORKSHOPS

P.O. Box 27555, Seattle WA 98165. (206)367-6864. Fax: (206)367-8102. E-mail: mark@bwphotoworkshops.c om. Website: www.bwphotoworkshops.com. **Contact:** Mark Griffith, director. Cost: $250-695. Lodging and food are not included in any workshop fee. Workshops on b&w photography, including the zone system, b&w print and photographing in various locations. Open to all formats. Call, e-mail or see website for information.

Ⓝ BLACKWELL PHOTOGRAPHY TOURS

8820 Burleigh Manor Dr. #101, Raleigh NC 27616-7932. (888)582-4895. Fax: (614)737-4960. E-mail: blackwellar t@nc.rr.com. Website: www.angelfire.com/art3/photo/main.html. **Contact:** Sharon Blackwell, owner. Cost: $495-5,000; does not include meals or lodging unless otherwise listed. Held monthly. Workshop offers instruction in the areas of nature, landscapes, people and architectural photography, focusing on techniques in creativity, exposure, film, lighting for digital and 35mm. Held in such scenic places as Yellowstone National Park, MT; Rocky Mountain National Park, CO; Wyoming; Washington; Bryce Canyon, UT; Monument Valley, AZ; Yosemite National Park, CA; Outer Banks, NC; Hill Country, TX; Grand Canyon, AZ; Mexico and Europe. Open to all skill levels. Photographers should write with SASE, call, e-mail or see website for more information.

BLUE PLANET PHOTOGRAPHY WORKSHOPS AND TOURS

201 N. Kings Rd., Suite 107, Nampa ID 83687. (208)466-9340. E-mail: inquire@blueplanetphoto.com. Website: www.blueplanetphoto.com. **Contact:** Mike Shipman, owner. Cost: varies depending on type and length of

workshop. Transportation and lodging during workshop usually included; meals included on some trips. Specific fees and options outlined in workshop materials. Wildlife biologist and award-winning professional photographer Mike Shipman conducts small group workshops/tours emphasizing individual expresssion and "vision-finding" by Breaking the Barriers to Creative Vision™. Workshops held in beautiful nontypical locations away from crowds and the more-often-photographed sites. Some workshops are semi-adventure-travel style, using alternative transportation such as hot air balloons, horseback, llama, and camping in remote areas. Group feedback sessions and film processing whenever possible. Workshops and tours held in Idaho, Alaska, British Columbia, Oregon, Montana, California, Wyoming, Florida, Arizona, New Zealand, Australia. Special workshops on emulsion transfer, emulsion lift and SX-70 manipulation also offered. Digital photographers welcome. Workshops and tours generally range from 2 to 12 days. Custom tours and workshops available upon request. Open to all skill levels. Photographers should write, call, e-mail or see website for more information.

HOWARD BOND WORKSHOPS

1095 Harold Circle, Ann Arbor MI 48103. (734)665-6597. **Contact:** Howard Bond, owner. Offers 1-day workshop: View Camera Techniques; and 2-day workshops: Zone System for All Formats, Refinements in B&W Printing, Unsharp Masking for Better Prints, and Dodging/Burning Masks. Call or visit www.apogeephoto. com/howard_bond.shtml for more details.

NANCY BROWN HANDS-ON WORKSHOPS

381 Mohawk Lane, Boca Raton FL 33487. (561)988-8992. Fax: (561)988-1791. E-mail: nbrown50@bellsouth.n et. Website: www.nancybrown.com. **Contact:** Nancy. Cost: $2,000. Offers one-on-one intensive workshops all year long in studio and on location in Florida. You work with Nancy, the models and the crew to create your images. Photographers should call, fax, e-mail or see website for more information.

🌐 BURREN COLLEGE OF ART WORKSHOPS

Burren College of Art, Newton Castle, Ballyvaughan, County Clare Ireland. (353)(65)707-7200. Fax: (353)(65)707-7201. E-mail: admin@burrencollege.ie. Website: www.burrencollege.com. **Contact:** Admissions Officer. "These workshops present unique opportunities to capture the qualities of Ireland's western landscape. The flora, prehistoric tombs, ancient abbeys and castles that abound in the Burren provide an unending wealth of subjects in an ever-changing light." Photographers should e-mail for more information.

🅽 CALIFORNIA PHOTOGRAPHIC WORKSHOPS

2500 N. Texas St., Fairfield CA 94533. (888)422-6606. E-mail: cpwschool@sbcglobal.net. Website: www.CP Wschool.com. **Contact:** James Inks. Five-day workshops on professional, digital, portrait, wedding and commercial photography at San Francisco Fishermans Wharf.

🅽 THE CAMERA, THE NEGATIVE, THE PRINT

6525 Washington St., Yountville CA 94599. (707)945-0160. Fax: (510)724-9124. E-mail: hjlawton@manzan ita-ent.com. Website: www.manzanita-ent.com. **Contact:** Mike Radesky, sales. Cost: $300 for 6-hour seminar. Held monthly. Each seminar is held in 3-hour sessions on Saturday or Sunday. Workshop held when 5 participants register. The limited student count allows for personal interaction with the instructor. The cost of each seminar includes a set of Ansel Adams' 3 books, which will be available prior to the seminar. Open to all skill levels. Photographers should write, send SASE, call, e-mail or see website for more information.

JOHN C. CAMPBELL FOLK SCHOOL

One Folk School Rd., Brasstown NC 28902. (800)365-5724 or (828)837-2775. Fax: (828)837-8637 Website: www.folkschool.org. Cost: $202-412 tuition; room and board available for additional fee. The Folk School offers weekend and weeklong courses in photography year round (b&w, color, wildlife and plants, image transfer, darkroom set-up, abstract landscapes). "Please call for free catalog."

CAPE COD NATURE PHOTOGRAPHY FIELD SCHOOL

P.O. Box 236, S. Wellfleet MA 02663. (508)349-2615. E-mail: mlowe@massaudubon.org. **Contact:** Melissa Lowe, program coordinator. Cost: $225-255. Three-day course on Cape Cod focusing on nature photography in a coastal setting. Sunrise, seal cruise, sunset, stars, wildflowers, shore birds featured. Taught by John Green. Sponsored by Massachusetts Audubon Society.

CAPE COD PHOTO WORKSHOPS
135 Oak Leaf Rd., P.O. Box 1618, N. Eastham MA 02651. (508)255-6808. E-mail: ccpw@capecod.net. Website: www.capecodphotoworkshops.com. **Contact:** Linda E. McCausland, director. 40 annual weekend or weeklong photography workshops for beginners to advanced students. Workshops run year round.

CENTER FOR PHOTOGRAPHY AT WOODSTOCK
59 Tinker St., Woodstock NY 12498. (845)679-9957. Fax: (845)679-6337. E-mail: info@cpw.org. Website: www.cpw.org. **Contact:** Ariel Shanberg, executive director. A not-for-profit arts and education organization dedicated to contemporary creative photography, founded in 1977. Programs in education, exhibition, publication, and services for artists. This includes year-round exhibitions, summer/fall Woodstock Photography Workshop and Lecture Series, artist residencies, *PHOTOGRAPHY Quarterly* magazine, annual call for entries, permanent print collection, slide registry, library, darkroom, fellowship, membership, portfolio review, film/video screenings, internships, gallery talks and more.

CATHY CHURCH PERSONAL UNDERWATER PHOTOGRAPHY COURSES
P.O. Box 479, GT, Grand Cayman, Cayman Islands. (345)949-7415. Fax: (345)949-9770. E-mail: cathy@cathychurch.com. Website: www.cathychurch.com. **Contact:** Cathy Church. Cost: $125/hour. Hotel/dive package available at Sunset House Hotel. Private and group lessons available for all levels throughout the year; classroom and shore diving can be arranged. Lessons available for professional photographers expanding to underwater work. Photographers should e-mail for more information.

CLICKERS & FLICKERS PHOTOGRAPHY NETWORK—LECTURES & WORKSHOPS
P.O. Box 60508, Pasadena CA 91116-6508. (626)794-7447. E-mail: photographer@ClickersAndFlickers.com. Website: www.ClickersAndFlickers.com. **Contact:** Dawn Stevens, organizer. Cost: depends on particular workshop. Monthly lectures, events and free activities for members. "Clickers & Flickers Photography Network, Inc., was created to provide people with an interest and passion for photography (cinematography, filmmaking, image making) the opportunity to meet others with similar interests for networking and camaraderie. It provides an environment in which photography issues, styles, techniques, enjoyment and appreciation can be discussed as well as experienced with people from many fields and levels of expertise (beginners, students, amateur, hobbyist, or professionals). We publish a bimonthly newsletter (18-22 pages) listing thousands of activities for photographers and lovers of images." Clickers & Flickers Photography Network, Inc., is a 20-year-old professional photography network association that promotes information and offers promotional marketing opportunities for photographers, cinematographers, individuals, organizations, businesses, events, publishers (including advertising or PR agencies). "C&F also provides referrals for photographers and cinematographers. If you are looking for the services of a photographer, we can help you. Our membership includes photographers and cinematographers who are skilled in the following types of photography: wedding, headshots, fine art, sports, events, products, news, glamour, fashion, macro, commercial, landscape, advertising, architectural, wildlife, candid, photojournalism, marquis gothic—fetish, aerial and underwater; using the following types of equipment: motion picture cameras (Imax, 70mm, 65mm, 35mm, 16mm, 8mm), steadicam systems, video, high-definition, digital, still photography—large-format, medium-format and 35mm." Open to all skill levels. Photographers should call or e-mail for more information.

COMMUNITY DARKROOM
713 Monroe Ave., Rochester NY 14607. (585)271-5920. E-mail: darkroom@geneseearts.org. Website: www.geneseearts.org. **Contact:** Sharon Turner, director. Associate Director: Marianne Pojman. Costs $65-200, depending on type and length of class. "We offer over 20 different photography classes for all ages on a quarterly basis. Classes include basic and intermediate camera and darkroom techniques; basic through intermediate photoshop on Mac computers; studio lighting; matting and framing; hand-coloring; alternative processes; night, sports and nature photography; and much, much more! Call for a free brochure."

THE CORPORATION OF YADDO RESIDENCIES
P.O. Box 395, Saratoga Springs NY 12866-0395. (518)584-0746. Fax: (518)584-1312. E-mail: yaddo@yaddo.org. Website: www.yaddo.org. **Contact:** Candace Wait, program director. No fee; room, board, and studio space are provided. Deadlines to apply are January 1 and August 1—residencies are offered year round. Yaddo is a working artists' community on a 400-acre estate in Saratoga Springs, New York. It offers residencies of 2 weeks to 2 months to creative artists in a variety of fields. The mission of Yaddo is to encourage artists to challenge themselves by offering a supportive environment and good working conditions. Open to advanced photographers. Photographers should write, send SASE (60¢ postage), call or e-mail for more information.

THE CORTONA CENTER OF PHOTOGRAPHY, ITALY

P.O. Box 550894, Atlanta GA 30355. (404)872-3264. E-mail: allen@cortonacenter.com. Website: www.corton acenter.com. **Contact:** Allen Matthews, director. Robin Davis and Allen Matthews lead a personal, small-group photography workshop in the ancient city of Cortona, Italy, centrally located in Tuscany, once the heart of the Renaissance. Dramatic landscapes; Etruscan relics; Roman, Medieval and Renaissance architecture; and the wonderful and photogenic people of Tuscany await. Photographers should write, e-mail or see website for more information.

CORY PHOTOGRAPHY WORKSHOPS

P.O. Box 42, Signal Mountain TN 37377. (423)886-1004. E-mail: tompatcory@aol.com. Website: hometown.a ol.com/tompatcory. **Contact:** Tom or Pat Cory. Small workshops/field trips (8-12 maximum participants) with some formal instruction, but mostly one-on-one instruction in the field. "Since we tailor this instruction to each individual's interests, our workshops are suitable for all experience levels. Participants are welcome to use film or digital cameras or even video. Our emphasis is on nature and travel photography. We spend the majority of our time in the field, exploring our location. Cost and length vary by workshop. Many of our workshop fees include single-occupancy lodging, and some also include home-cooked meals and snacks. We offer special prices for 2 people sharing the same room and, in some cases, special non-participant prices. Workshop locations vary from year to year but include the eastern Sierra of California, Colorado and Arches National Park, Olympic National Park, Acadia National Park, the Upper Peninsula of Michigan, Death Valley National Park, Smoky Mountain National Park, and Glacier National Park. We offer international workshops in Ireland, Scotland, Provence, Brittany, Tuscany, New Zealand, Costa Rica and Panama. We also offer a number of short workshops throughout the year in and around Chattanooga, Tennessee—individual instruction and custom-designed workshops for groups." Photographers should write, call, e-mail or see website for more information.

CREALDÉ SCHOOL OF ART

600 St. Andrews Blvd., Winter Park FL 32792. (407)671-1886. Website: www.crealde.org. **Contact:** Peter Schreyer, executive director. Director of Photography: Rick Lang. Cost: Membership fee begins at $35/individual. Offers classes covering traditional and digital photography; b&w darkroom techniques; landscape, portrait, documentary, travel, wildlife and abstract photography; and educational tours.

CREATIVE ARTS WORKSHOP

80 Audubon St., New Haven CT 06511. (203)562-4927. E-mail: hshapiro8@aol.com. **Contact:** Harold Shapiro, photography department head. Offers advanced workshops and exciting courses for beginning and serious photographers.

CYPRESS HILLS PHOTOGRAPHIC WORKSHOP

73 Read Ave., Regina SK S4T 6R1 Canada. (306)530-8888. Fax: (306)359-0622. E-mail: winverar@saskel.net. Website: www.ab-photo.com/chpw. **Contact:** Wayne Inverarity. Cost: $555 CDN before set date and $595 CDN after; partial workshop $345 CDN. Full workshop includes lodging, meals and ground transportation onsite, and film and processing for critique sessions. Five-day annual workshop held in June and August. Covers areas of participant interest and can include portrait, landscape, animal, macro and commercial.

BRUCE DALE PHOTOGRAPHIC WORKSHOPS

(formerly Discover the Southwest), Bruce Dale Photography. Website: www.brucedale.com. Bruce teaches throughout the world. Visit his website for current information on his workshops and lectures.

DAUPHIN ISLAND ART CENTER SCHOOL OF PHOTOGRAPHY

1406 Cadillac Ave., P.O. Box 699, Dauphin Island AL 36528. (800)861-5701. Fax: (251)861-5701. E-mail: photography@dauphinislandartcenter.com. Website: www.dauphinislandartcenter.com. Estab. 1984. **Contact:** Nick Colquitt, director. Cost: $495 per 3-day class (20% discount with 45-day advance registration). Annual workshops, seminars and safaris, cruises and tours for amateur and professional photographers. Open to all skill levels. Photographers should write, call or fax for more information. Free photography course catalog upon request. One-on-one instruction at no additional tuition (with mutually agreeable dates).

DAWSON COLLEGE CENTRE FOR IMAGING ARTS AND INFORMATION TECHNOLOGIES

4001 de Maisonneuve Blvd. W., Suite 2G.1, Montreal QC H3Z 3G4 Canada. (514)933-0047. Fax: (514)937-3832. E-mail: ciait@dawsoncollege.qc.ca. Website: www.dawsoncollege.qc.ca/ciait. **Contact:** Roula Kout-

soumbas. Cost: $90-595. Workshop subjects include imaging arts and technologies, computer animation, photography, digital imaging, desktop publishing, multimedia, and Web publishing and design.

THE JULIA DEAN PHOTO WORKSHOPS

3111 Ocean Front Walk, Suite 102, Marina Del Rey CA 90292. (310)821-0909. Fax: (310)821-0809. E-mail: julia@juliadean.com. Website: www.juliadean.com. **Contact:** Julia Dean, director. Photography workshops of all kinds held throughout the year. Open to all skill levels. Photographers should call, e-mail or see website for more information.

JOE ENGLANDER PHOTOGRAPHY WORKSHOPS & TOURS

P.O. Box 1261, Manchaca TX 78652. (512)922-8686. E-mail: info@englander-workshops.com. Website: www.englander-workshops.com. **Contact:** Joe Englander. Cost: $275-8,000. "Photographic instruction in beautiful locations throughout the world—all formats and media, color/b&w/digital darkroom instruction." Locations include Europe, Asia and the USA. See website for more information.

ROBERT FIELDS PHOTOGRAPHIC WORKSHOPS

P.O. Box 3516, Ventura CA 93006. (805)650-2770. E-mail: info@4fields.com. Website: www.4fields.com/photo/. **Contact:** Robert Fields, instructor. Cost: varies depending on location and duration; lodging included. Discounts available for groups. California photo workshops to Yosemite, Death Valley, Mono Lake, San Francisco, Morro Bay, Point Reyes, and Anza Borrego Desert. Both practical application and theory taught on location.

FINDING & KEEPING CLIENTS

2973 Harbor Blvd., Suite 341, Costa Mesa CA 92626-3912. Phone/fax: (888)713-0705. E-mail: maria@mpiscopo.com. Website: www.mpiscopo.com. **Contact:** Maria Piscopo, instructor. "How to find new photo assignment clients and get paid what you're worth! See website for schedule or send query via e-mail." Maria Piscopo is the author of *The Photographer's Guide to Marketing & Self Promotion*, 3rd edition (Allworth Press).

FINE ARTS WORK CENTER

24 Pearl St., Provincetown MA 02657. (508)487-9960, ext. 103. Fax: (508)487-8873. E-mail: workshops@fawc.org. Website: www.fawc.org. **Contact:** Dorothy Antczak, education coordinator. Cost: $480/week, $235/weekend (class); $500/week (housing). Weeklong and weekend workshops in visual arts, including photography, and creative writing. Open to all skill levels. Photographers should write, call or e-mail for more information.

FIRST LIGHT PHOTOGRAPHIC WORKSHOPS AND SAFARIS

P.O. Box 240, East Moriches NY 11940. (631)874-0500. E-mail: bill@firstlightphotography.com. Website: www.firstlightphotography.com. **Contact:** Bill Rudock, president. Photo workshops and safaris for all skill levels. Workshops are held on Long Island, all national parks, Africa and Australia.

FLORENCE PHOTOGRAPHY WORKSHOP

Washington University, St. Louis MO 63130. (314)935-6500. E-mail: sjstremb@art.wustl.edu. **Contact:** Stan Strembicki, professor. "Four-week intensive photographic study of urban and rural landscape of Florence and Tuscany, June 2006. Digital darkroom, field trips, housing available."

FOCUS ADVENTURES

P.O. Box 771640, Steamboat Springs CO 80477. Phone/fax: (970)879-2244. E-mail: focus22@excite.com. Website: www.focusadventures.com. **Contact:** Karen Gordon Schulman, owner. Workshops and photo tours emphasize the art of seeing and personal photographic vision. Summer workshops in Steamboat Springs, Colorado. Field trips to working ranches, the rodeo and wilderness areas. Fall workshops also in other areas of Colorado. Some women-only photo workshops. Customized private and small-group lessons available year round. International photo tours and workshops to various destinations including Ecuador, the Galápagos Islands and western Ireland. Karen is well known for her fine-art hand-colored images and teaches workshops in hand-coloring in various destinations year round.

FOTOFUSION

55 NE Second Ave., Delray Beach FL 33444. (561)276-9797. Fax: (561)276-9132. E-mail: info@fotofusion.org. Website: www.fotofusion.org. **Contact:** Fatima NeJame, executive director. America's foremost festival of

photography and digital imaging is held each January. Learn from more than 90 master photographers, picture editors, picture agencies, gallery directors and technical experts, over 5 days of field trips, seminars, lectures and Adobe Photoshop CS workshops. Open to all skill levels. Photographers should write, call or e-mail for more information.

FRANCE PHOTOGENIQUE/EUROPA PHOTOGENICA PHOTO TOURS TO EUROPE

3920 W. 231st Place, Torrance CA 90505. Phone/fax: (310)378-2821. E-mail: FraPhoto@aol.com. Website: www.francephotogenique.com. **Contact:** Barbara Van Zanten-Stolarski, owner. Cost: $2,000-3,500; includes most meals, transportation, hotel accommodation. Tuition provided for beginners/intermediate and advanced level. Workshops held in spring (2) and fall (2). Five- to 11-day photo tours of the most beautiful regions of Europe. Shoot landscapes, villages, churches, cathedrals, vineyards, outdoor markets, cafes and people in Paris, Provence, southwest France, England, Italy, Greece, etc. Open to all skill levels. Photographers should call or e-mail for more information.

N GALÁPAGOS TRAVEL

783 Rio Del Mar Blvd., Suite 49, Aptos CA 95003. (800)969-9014. E-mail: info@galapagostravel.com. Website: www.galapagostravel.com. Cost: $4,000; includes lodging and most meals. Landscape and wildlife photography tour of the islands with an emphasis on natural history. Three nights in a first-class hotel in Quito, Ecuador, and 10 or 14 nights aboard a yacht in the Galápagos. See website for more information.

N ☑ ANDRÉ GALLANT/FREEMAN PATTERSON PHOTO WORKSHOPS

Shampers Bluff NB Canada. (506)763-2189. E-mail: freepatt@nbnet.nb.ca. Website: www.freemanpatterson.com. Cost: $1,650 and HST 15% (Canadian) for 6-day course including accommodations and meals. All workshops are for anybody interested in photography and visual design, from the novice to the experienced amateur or professional. "Our experience has consistently been that a mixed group functions best and learns the most."

GERLACH NATURE PHOTOGRAPHY WORKSHOPS & TOURS

P.O. Box 259, Chatham MI 49816. (906)439-5991. E-mail: gina@gerlachnaturephoto.com. Website: www.gerlachnaturephoto.com. **Contact:** Gina Maki, office manager. Costs vary. Professional nature photographers John and Barbara Gerlach conduct intensive field workshops in the beautiful Upper Peninsula of Michigan in August and during October's fall color period. They lead a photo safari to the best game parks in Kenya during late-August/early-September every year. They also lead winter, summer and fall photo tours of Yellowstone National Park and conduct high-speed flash hummingbird photo workshops in British Columbia in late May. Photographers should see website for more information.

THE GLACIER INSTITUTE PHOTOGRAPHY WORKSHOPS

P.O. Box 1887, Kalispell MT 59903. (406)755-1211. Fax: (406)755-7154. Website: www.glacierinstitute.org. Cost: approximately $55-425 for uninstructed courses, $365 for instructed 3-day courses. Workshops sponsored in nature photography, landscape and photographic ethics. "All courses take place in and around beautiful Glacier National Park."

GLOBAL PRESERVATION PROJECTS

P.O. Box 30866, Santa Barbara CA 93130. (805)682-3398 or (805)455-2790. E-mail: TIMorse@aol.com. Website: www.GlobalPreservationProjects.com. **Contact:** Thomas I. Morse, director. Offers photographic workshops and expeditions promoting the preservation of environmental and historic treasures. Produces international photographic exhibitions and publications. Teaches digital imaging and Photoshop. Locations: ghost town of Bodie, Arches, Death Valley, Big Sur Coast, Point Reyes, Southwest, Colorado, New Mexico.

GOLDEN GATE SCHOOL OF PROFESSIONAL PHOTOGRAPHY

P.O. Box F, San Mateo CA 94402-0018. (650)548-0889. E-mail: ggs@goldengateschool.com. Website: www.goldengateschool.org. **Contact:** Julie Olson, director. Offers 1- to 6-day workshops in traditional and digital photography for professional and aspiring photographers in the San Francisco Bay Area.

N ◉ GREEK PHOTO WORKSHOPS

15 Thermopilon St., Thessaloniki, Analipsi 542 48 Greece. (30)(694)425-7125. Fax: (30)(231)085-5950. E-mail: info@greekphotoworkshops.com. Website: www.GreekPhotoWorkshops.com. **Contact:** Giannis

Agelou, owner. Mostly 7- to 9-day workshops: landscape, people, travel concepts, "The Stock Image," human figure/presence. Mostly digital shooting (open to shooting 35mm film—limited scanning capabilities). Variety of digital image post-shooting manipulation techniques demonstrated in detail (from classic to advanced, depending on workshop). Open to all skill levels (depending on workshop). Usually groups of 8-10 people. Custom workshops upon request; please inquire. Photographers should call, write, e-mail or visit website for information.

HALLMARK INSTITUTE OF PHOTOGRAPHY

P.O. Box 308, Turners Falls MA 01376. (413)863-2478. E-mail: info@hallmark.edu. Website: www.hallmark.edu. **Contact:** George J. Rosa III, president. Director of Admissions: Tammy Murphy. Tuition: $26,050. Offers an intensive 10-month resident program teaching the technical, artistic and business aspects of traditional and digital professional photography for the career-minded individual.

JOHN HART PORTRAIT SEMINARS

344 W. 72nd St., New York NY 10023. (212)873-6585. E-mail: johnharth@aol.com. Website: www.johnhartpics.com. One-on-one advanced portraiture seminars covering lighting and other techniques. John Hart is a New York University faculty member and author of *50 Portrait Lighting Techniques*, *Professional Headshots*, *Lighting For Action* and *Art of the Storyboard*.

HAWAII PHOTO SEMINARS

Changing Image Workshops, P.O. Box 280, Kualapuu, Molokai HI 96757. (808)567-6430. E-mail: hui@aloha.net. Website: www.huiho.org. **Contact:** Rik Cooke. Cost: $1,795; includes lodging, meals and ground transportation. 7-day landscape photography workshop for beginners to advanced photographers. Workshops taught by 2 *National Geographic* photographers and a multimedia producer.

HORIZONS TO GO

P.O. Box 634, Leverett MA 01054. (413)367 9200. Fax: (413)367-9522. E-mail: horizons@horizons-art.com. Website: www.horizons-art.com. **Contact:** Jane Sinauer, director. Artistic vacations and small-group travel: 1- and 2-week programs in Italy, Ireland, France, Scandinavia, The Netherlands, Mexico, Ecuador, Thailand, Vietnam, Cambodia and the American Southwest.

IN FOCUS WITH MICHELE BURGESS

20741 Catamaran Lane, Huntington Beach CA 92646. (714)536-6104. Fax: (714)536-6578. E-mail: maburg5820@aol.com. Website: www.infocustravel.com. **Contact:** Michele Burgess, president. Cost: $4,000-6,500. Offers overseas tours to photogenic areas with expert photography consultation at a leisurely pace and in small groups (maximum group size 20).

INTERNATIONAL CENTER OF PHOTOGRAPHY

1114 Avenue of the Americas, New York NY 10036. (212)857-0001. E-mail: education@icp.org. Website: www.icp.org. **Contact:** Donna Ruskin, education associate. "The cost of our weekend workshops range from $205 to $400 plus registration and lab fees. Our 5- and 10-week courses range from $295 to $650 plus registration and lab fees." ICP offers photography courses, lectures and workshops for all levels of experience—from intensive beginner classes to rigorous professional workshops.

INTERNATIONAL SUMMER ACADEMY OF FINE ARTS/PHOTOGRAPHY

P.O. Box 18, Salzburg 5010 Austria. (43)(66)284-2113. Fax: (43)(66)284-9638. E-mail: office@summeracademy.at. Website: www.summeracademy.at. **Contact:** Barbara Wally, director. Fine art workshops for intermediate to advanced photographers. Covers traditional and digital images. Emphasizes personal critiques and group discussions.

JIVIDEN'S "NATURALLY WILD" PHOTO ADVENTURES

P.O. Box 333, Chillicothe OH 45601. (800)866-8655 or (740)774-6243. Fax: (740)774-2272 (call first). E-mail: mail@imagesunique.com. Website: www.naturallywild.net. **Contact:** Jerry or Barbara Jividen. Cost: $149 and up depending on length and location. Workshops held throughout the year; please inquire. All workshops and photo tours feature comprehensive instruction, technical advice, pro tips and hands-on photography. Many workshops include lodging, meals, ground transportation, special permits and special "guest rates." Group sizes are small for more personal assistance and are normally led by 2 photography guides/certified

instructors. Subject emphasis is on photographing nature, wildlife and natural history. Supporting emphasis is on proper techniques, composition, exposure, lens and accessory use. Workshops range from 1-7 days in a variety of diverse North American locations. Open to all skill levels. Free information available upon request. Free quarterly journal by e-mail upon request. Photographers should write, call or e-mail for more information.

JORDAHL PHOTO WORKSHOPS

P.O. Box 3998, Hayward CA 94540. (510)785-7707. E-mail: kate@jordahlphoto.com. Website: www.jordahlp hoto.com. **Contact:** Kate or Geir Jordahl, directors. Cost: $150-700. Intensive 1- to 5-day workshops dedicated to inspiring creativity and community among women artists through critique, field sessions and exhibitions.

N ART KETCHUM HANDS-ON MODEL WORKSHOPS

2215 S. Michigan Ave., Chicago IL 60616. (773)478-9217. E-mail: ketch22@ix.netcom.com. Website: www.ar tketchum.com. **Contact:** Art Ketchum, owner. Cost: $125 for 1-day workshops in Chicago studio; $99 for repeaters; 2-day workshops in various cities around the US to be announced. Photographers should call, e-mail or visit website for more information.

WELDON LEE'S ROCKY MOUNTAIN PHOTO ADVENTURES

P.O. Box 487, Allenspark CO 80510-0487. Phone/fax: (303)747-2074. E-mail: wlee@RockyMountainPhotoAd ventures.com. Website: www.RockyMountainPhotoAdventures.com. **Contact:** Weldon Lee. Cost: $695-5,995; includes transportation and lodging. Workshops held monthly year round. Wildlife and landscape photography workshops featuring hands-on instruction with an emphasis on exposure, composition, and digital imaging. Participants are invited to bring a selection of images to be critiqued during the workshops. Photographers should write, call or e-mail for more information.

GEORGE LEPP DIGITAL WORKSHOPS

P.O. Box 6240, Los Osos CA 93412. (805)528-7385. Fax: (805)528-7387. E-mail: info@LeppPhoto.com. Website: www.LeppPhoto.com. **Contact:** Julie Corpuel, registrar. Offers small groups. New focus on digital tools to optimize photography. ''We are always stressing knowing one's equipment, maximizing gear, and seeing differently.''

N ◩ THE LIGHT FACTORY

Spirit Square, Suite 211, 345 N. College St., Charlotte NC 28202. (704)333-9755. E-mail: info@lightfactory.org. Website: www.lightfactory.org. **Contact:** Charles Thomas, director of education. The Light Factory is ''a nonprofit arts center dedicated to exhibition and education programs promoting the power of photography and film.'' Classes are offered throughout the year in SLR and digital photography and filmmaking.

N LIGHT WORK ARTIST-IN-RESIDENCE PROGRAM

316 Waverly Ave., Syracuse NY 13244. (315)443-1300. E-mail: info@lightwork.org. Website: www.lightwork .org. **Contact:** Jeffrey Hoone, director. Annual residency program for 12-15 photographers. Artists receive a $2,000 stipend, an apartment (in Syracuse) for one month, and 24-hour/day access to darkrooms. Their work is then published in Light Work's publication *Contact Sheet*.

C.C. LOCKWOOD WILDLIFE PHOTOGRAPHY WORKSHOP

P.O. Box 14876, Baton Rouge LA 70898. (225)769-4766. Fax: (225)767-3726. E-mail: cactusclyd@aol.com. Website: www.cclockwood.com. **Contact:** C.C. Lockwood, photographer. Cost: Lake Martin Spoonbill Rookery, $800; Atchafalaya Swamp, $290; Yellowstone, $2,695; Grand Canyon, $2,395. Workshop at Lake Martin is 3 days plus side trip into Atchafalaya, February and April. Each April and October, C.C. conducts a 2-day Atchafalaya Basin Swamp Wildlife Workshop. It includes lecture, canoe trip into the swamp, and critique session. Every other year, C.C. does a 7-day winter wildlife workshop in Yellowstone National Park. C.C. also leads an 8-day Grand Canyon raft trip photo workshop in August.

N HELEN LONGEST-SACCONE AND MARTY SACCONE

P.O. Box 220, Lubec ME 04652. (207)733-4201. Fax: (207)733-4202. E-mail: helen_marty@yahoo.com. Private creative vision photo workshops offered in Maine. Private digital imaging workshops, covering Photo Shop and digital cameras, offered in Maine.

▣ THE MACDOWELL COLONY

100 High St., Peterborough NH 03458. (603)924-3886. Fax: (603)924-9142. E-mail: admissions@macdowellcolony.org. Website: www.macdowellcolony.org. Founded in 1907 to provide creative artists with uninterrupted time and seclusion to work and enjoy the experience of living in a community of gifted artists. Residencies of up to 2 months for writers, composers, film/video makers, visual artists, architects and interdisciplinary artists. Artists in residence receive room, board and exclusive use of a studio. Average length of residency is 5 weeks. Ability to pay for residency is not a factor. There are no residency fees. Limited funds available for travel to and from the colony. Application deadlines: January 15: summer (June-September); April 15: fall/winter (October-January); September 15: winter/spring (February-May). Photographers should write, call or see website for application and guidelines. Questions should be directed to the admissions coordinator.

▣ THE MAINE PHOTOGRAPHIC WORKSHOPS

The International Film Workshops, Rockport College, Box 200, 2 Central St., Rockport ME 04856. (877)577-7700 or (207)236-8581. Fax: (207)236-2558. E-mail: info@TheWorkshops.com. Website: www.TheWorkshops.com. For over 30 years, the world's leading photography and film workshop center. More than 200 1-, 2- and 4-week workshops and master classes for working pros, serious amateurs, artists and college and high school students, in all areas of photography, filmmaking, video, television and digital media. Master Classes with renowned faculty including Eugene Richards, Arnold Newman, Joyce Tenneson and photographers from *Magnum* and *National Geographic*. Film faculty includes Academy Award-winning directors and cinematographers. Destination workshops in Tuscany, Italy; Paris and Provence, France; Oaxaca, Mexico; and the Island of Martha's Vineyard. Rockport College offers an Associate of Arts Degree, a Master of Fine Arts Degree and a 1-year Professional Certificate in film, photography and new media. Request current catalog by phone, fax or e-mail. See complete course listing on website.

WILLIAM MANNING PHOTOGRAPHY

6396 Birchdale Court, Cincinnati OH 45230. (513)624-8148. E-mail: william@williammanning.com. Website: www.williammanning.com. **Contact:** William Manning, director. Cost: $1,200-4,000. Offers small group tours. Four programs worldwide, with emphasis on landscapes, wildlife and culture.

▣ JOE & MARY ANN MCDONALD WILDLIFE PHOTOGRAPHY WORKSHOPS AND TOURS

73 Loht Rd., McClure PA 17841-9340. (717)543-6423. Fax: (717)543-6423. E-mail: hoothollow@acsworld.com. Website: www.hoothollow.com. **Contact:** Joe McDonald, owner. Cost: $1,200-8,500. Offers small groups, quality instruction with emphasis on nature and wildlife photography.

MID-AMERICA INSTITUTE OF PROFESSIONAL PHOTOGRAPHY

220 E. 2nd St., Ottumwa IA 52501. (641)683-7824. E-mail: MAIPP@maipp.com. Website: www.maipp.com. **Contact:** Charles Lee, registrar. Annual 5-day seminar covering professional photography. Open to beginning and advanced photographers.

▣ MIDWEST PHOTOGRAPHIC WORKSHOPS

28830 W. Eight Mile Rd., Farmington Hills MI 48336. (248)471-7299. E-mail: bryce@mpw.com. Website: www.mpw.com. **Contact:** Bryce Denison, owner. Cost: varies per workshop. "One-day weekend and weeklong photo workshops, small group sizes and hands-on shooting seminars by professional photographers/instructors on topics such as portraiture, landscapes, nudes, digital, nature, weddings, product advertising and photojournalism."

MISSOURI PHOTOJOURNALISM WORKSHOP

109 Lee Hills Hall, Columbia MO 65211. (573)882-4882. Fax: (573)884-4999. E-mail: info@mophotoworkshop.org. Website: www.mophotoworkshop.org. **Contact:** Angel Anderson, coordinator. Cost: $600. Workshop for photojournalists. Participants learn the fundamentals of documentary photo research, shooting, editing and layout.

MOUNTAIN WORKSHOPS

Western Kentucky University, MMTH 131, Bowling Green KY 42101. (502)745-6292. E-mail: mike.morse@wku.edu. **Contact:** Mike Morse, workshop director. Cost: $525 plus expenses. Annual weeklong documentary photojournalism workshop held in October. Open to intermediate and advanced shooters.

N NATURAL HABITAT ADVENTURES

2945 Center Green Court, Boulder CO 80301. (800)543-8917. E-mail: info@nathab.com. Website: www.natha b.com. Cost: $2,195-20,000; includes lodging, meals, ground transportation and expert expedition leaders. Guided photo tours for wildlife photographers. Tours last 5-27 days. Destinations include North America, Latin America, Canada, Galápagos Islands, Africa, the Pacific and Antarctica.

NATURAL TAPESTRIES

1208 State Rt. 18, Aliquippa PA 15001. (724)495-7493. Fax: (724)495-7370. E-mail: nancyrotenberg@aol.com. Website: www.naturaltapestries.com. **Contact:** Nancy Rotenberg and Michael Lustbader, owners. Cost: varies by workshop; $500-600 for weekend workshops in Pennsylvania. "We offer small groups with quality instruction and an emphasis on nature. Garden and macro workshops are held on our farm in Pennsylvania, and others are held in various locations in North America." Open to all skill levels. Photographers should call or e-mail for more information.

N NATURE PHOTOGRAPHY WORKSHOPS, GREAT SMOKY MOUNTAIN INSTITUTE AT TREMONT

Great Smoky Mountains National Park, 9275 Tremont Rd., Townsend TN 37882. (865)448-6709. E-mail: mail@gsmit.org. Website: www.gsmit.org. **Contact:** Registrar. Workshop instructors: Bill Lea, Will Clay and others. Cost: $350-500. Offers workshops in April and October emphasizing the use of natural light in creating quality scenic, wildflower and wildlife images.

N NEVERSINK PHOTO WORKSHOP

P.O. Box 641, Woodbourne NY 12788. (212)929-0008 or (845)434-0575. E-mail: lou@loujawitz.com. Website: www.loujawitz.com/neversink.html. **Contact:** Louis Jawitz, owner. Offers weekend workshops in scenic, travel, location and stock photography during the last 2 weeks of August in the Catskill Mountains. See website for more information.

NEW ENGLAND SCHOOL OF PHOTOGRAPHY

537 Commonwealth Ave., Boston MA 02215. (617)437-1868 or (800)676-3767. Fax: (617)437-0261. E-mail: info@nesop.com. Website: www.nesop.com. **Contact:** Academic Director. Instruction in professional and creative photography.

NEW JERSEY HERITAGE PHOTOGRAPHY WORKSHOPS

124 Diamond Hill Rd., Berkeley Heights NJ 07922. (908)790-8820. Fax: (908)790-0074. E-mail: nancyori@co mcast.net. Website: www.nancyoriphotography.com. **Contact:** Nancy Ori, director. Estab. 1990. Cost: $195-400. Workshops held every spring. Nancy Ori, well-known instructor, freelance photographer and fine art exhibitor of landscape and architecture photography, teaches how to use available light and proper metering techniques to document the man-made and natural environments of Cape May. A variety of film and digital workshops taught by guest instructors are available each year and are open to all skill levels, especially beginners. Topics include hand-coloring of photographs, creative camera techniques with Polaroid materials, intermediate and advanced digital, landscape and architecture with alternative cameras, environmental portraits with lighting techniques, street photography; as well as pastel, watercolor and oil painting workshops. All workshops include an historic walking tour of town, location shooting or painting, demonstrations and critiques. Scholarships available annually.

NEW JERSEY MEDIA CENTER LLC WORKSHOPS AND PRIVATE TUTORING

124 Diamond Hill Rd., Berkeley Heights NJ 07922. (908)790-8820. Fax: (908)790-0074. E-mail: nancyori@co mcast.net. Website: www.nancyoriworkshops.com. **Contact:** Nancy Ori, director. **1. Tuscany Photography Workshop** by Nancy Ori and Chip Forelli. Explore the Tuscan countryside, cities and small villages, with emphasis on architecture, documentary, portrait and landscape photography. The group will venture via private van to photograph in the cities of Florence, Pisa, Sienna, Arezzo and San Gimignano, and everywhere in between. Cost: $2,600; includes tuition, accommodations at a private estate, breakfasts and dinners. Open to all levels. Held October 14-21, 2006. **2. Private Photography and Darkroom Tutoring** with Nancy Ori in Berkeley Heights, NJ. This unique and personalized approach to learning photography is designed for the beginning or intermediate student who wants to expand his/her understanding of the craft and work more creatively with the camera, develop a portfolio, create an exhibit or learn darkroom techniques. The goal is to refine individual style while exploring the skills necessary to make expressive photographs. The content will be tailored to individual needs and interests. Cost: $300 for a total of 8 hours; $400 for the darkroom

sessions. **3. Capturing the Light of the Southwest**, a painting, sketching and photography workshop with Nancy Ori and Stan Sperlak, held every other year in October, will focus on the natural landscape and man-made structures of the area around Santa Fe and Taos. Participants can be at any level in their media. Stan Sperlak is a professional pastel painter and instructor. All will be encouraged to produce a substantial body of work worthy of portfolio or gallery presentation. Features special evening guest lecturers from the photography and painting community in the Santa Fe area. Artists should e-mail for more information. **4. Cape May Photography Workshops** are held annually in April and May. In 2006, a variety of subjects such as photojournalism, environmental portraiture, landscape, alternative cameras, Polaroid techniques, creative digital techniques, on-location wedding photography, large-format and how to photograph birds in the landscape will be offered by several well-known East Coast instructors. Open to all skill levels. Includes critiques, demonstrations, location shooting of Victorian architecture, gardens, seascapes and, in some cases, models in either film or digital. E-mail for dates, fees and more information. Workshops are either 3 or 4 days.

NEW MEXICO PHOTOGRAPHY FIELD SCHOOL

903 W. Alameda St., #204, Santa Fe NM 87501. (505)983-2934. E-mail: info@photofieldschool.com. Website: www.photofieldschool.com. **Contact:** Cindy Lane, associate director. "Since 1986, the New Mexico Field School has been unique in its offerings: hands-on photography workshops in the Southwest's canyons, hills, and villages; based in Santa Fe. Participants capture the light, color and texture that is the West. Workshops are for the novice to the experienced photographer; for anyone who wants to master photographic technique while exploring the enchanted land that is New Mexico. Field School director and instructor Craig Varjabedian has been teaching photography for 25 years. His photographs are known for their interpretations of light and place in the Southwest. His works are widely exhibited and collected. Joining the Field School as digital advisor is William Plunkett, landscape and nature photographer. Canon USA has made available EOS 10D cameras for students to try out. A catalog with workshop descriptions, instructors' bios, and Private Field and Darkroom workshop information is available upon request."

NIKON SCHOOL OF PHOTOGRAPHY

1300 Walt Whitman Rd., Melville NY 11747. (631)547-8666. Fax: (631)547-0309. Website: www.nikonschool.com. Weekend seminars traveling to 25 major cities in the US. **Intro to Digital SLR Photography**—Cost: $119; covers composition, exposure, downloading, viewing, basic editing and printing. **Next Steps in Digital Photography: Streamlined Workflow Technique**—Cost: $159; covers the benefits of RAW files, color management, advanced editing and printing techniques, and archiving of image files.

⬛ NORTHEAST PHOTO ADVENTURE SERIES WORKSHOPS

55 Bobwhite Dr., Glemont NY 12077. (518)432-9913. E-mail: images@peterfinger.com. Website: www.peterfinger.com/photoworkshops.html. **Contact:** Peter Finger, president. Cost: ranges from $95 for a weekend to $695 for a weeklong workshop. Offers over 20 weekend and weeklong photo workshops, held in various locations. Past workshops have included the coast of Maine, Acadia National Park, Great Smoky Mountains, Southern Vermont, White Mountains of New Hampshire, South Florida and the Islands of Georgia. "Small group instruction from dawn till dusk." Write for additional information.

NORTHERN EXPOSURES

4917 Evergreen Way #383, Everett WA 98203. (425)347-7650. Fax: (425)347-7650. E-mail: linmoore@msn.com. **Contact:** Linda Moore, director. Cost: $300-750 for 3- to 5-day workshops (US and western Canada); $175-400/day for tours in Canada. Offers 3- to 5-day intermediate to advanced nature photography workshops in several locations in Pacific Northwest and western Canada; spectacular settings including coast, alpine, badlands, desert and rain forest. Also, 1- to 2-week Canadian Wildlife and Wildlands Photo Adventures and nature photo tours to extraordinary remote wildlands of British Columbia, Alberta, Saskatchewan, Yukon and Northwest Territories.

⬛ ⬛ NORTHERN LIGHTS/CANADIAN BUSH/OIL MINE

Box 5242, Fort McMurray AB T9H 3G3 Canada. (780)743-0766. Fax: (780)743-0766. E-mail: info@wildernesscountry.com. Website: www.wildernesscountry.com. **Contact:** Chuck Graves, mentor/host. Cost: $1,000 for most meals, lodging, transportation, shows in Fort McMurray. Held during aurora borealis viewing, September-March; see website for specific dates. Purpose: to photograph northern lights, northern bush oil mine, birds, 4 seasons; also learn night photography. Open to all skill levels. Photographers should e-mail or see website for more information.

BOYD NORTON'S WILDERNESS PHOTOGRAPHY WORKSHOPS

P.O. Box 2605, Evergreen CO 80437-2605. (303)674-3009. Website: www.nscspro.com or www.wildernessph otography.com. **Contact:** Boyd Norton. Estab 1973. Emphasis on creativity, stock photography and publishing. Workshop locales include Tanzania, Borneo, Peru, Chile, Siberia, Mongolia, Italy, Galápagos Islands, Belize and Bhutan.

NYU TISCH SCHOOL OF THE ARTS

721 Broadway, 8th Floor, New York NY 10003. (212)998-1930. E-mail: photo.tsoa@nyu.edu. Website: www. photo.tisch.nyu.edu. **Contact:** Department of Photography and Imaging. Summer classes offered for credit and noncredit covering digital imaging, career development, basic to advanced photography, and darkroom techniques. Open to all skill levels.

OLYMPIC MOUNTAIN SCHOOL OF PHOTOGRAPHY

5114 Pt. Fosdick Dr., Mail Stop #EPMB57, Gig Harbor WA 98335. (253)858-4448. E-mail: info@cameraclass.c om. Website: www.cameraclass.com. **Contact:** Scott Bourne, executive director. Cost: ''We have classroom sessions starting at $59 and weeklong field workshops that cost anywhere between $595 and $1,295. Students are responsible for meals, lodging and transportation. We hold 15 events/year. We offer workshops 12 months/year. We are a nonprofit school with an emphasis on digital instruction; outdoor, wildlife, nature; and the business of photography.'' Open to all skill levels. Photographers should call or see website for more information.

OUTBACK RANCH OUTFITTERS

P.O. Box 269, Joseph OR 97846. (541)866-2029. E-mail: jonw@eoni.com. Website: www.oregonelkhunter.c om. **Contact:** Jon or Ken Wick, owners. Offers photography trips by horseback or river raft into Oregon wilderness areas.

⊕ STEVE OUTRAM'S TRAVEL PHOTOGRAPHY WORKSHOPS

D. Katsifarakis St., Galatas, Chania 73100 Crete, Greece. E-mail: mail@steveoutram.com. Website: www.stev eoutram.com. **Contact:** Steve Outram, workshop photographer. **Western Crete:** 9 days in the Venetian town of Chania, every May and October. **Lesvos:** 14 days on Greece's third-largest island, every October. **Zanzibar:** 14 days on this fascinating Indian Ocean island, every February and September. Learn how to take more than just picture postcard-type images on your travels. Workshops are limited to 8 people.

PALM BEACH PHOTOGRAPHIC CENTRE

55 NE Second Ave., Delray Beach FL 33444. (561)276-9797. Fax: (561)276-9132. E-mail: info@workshop.org. Website: www.workshop.org. **Contact:** Fatima NeJame, executive director. Cost: $75-1,300 depending on class. The center is an innovative learning facility offering 1- to 5-day seminars in photography and digital imaging year round. Also offered are travel workshops to Peru, Guatemala, Turkey, Ethiopia and India. Emphasis is on photographing the indigenous cultures of each country. Photographers should call for details.

RALPH PAONESSA PHOTOGRAPHY WORKSHOPS

509 W. Ward Ave., Suite B-108, Ridgecrest CA 93555-2542. (800)527-3455. E-mail: paonessa@rpphoto.com. Website: www.rpphoto.com. **Contact:** Ralph Paonessa, director. Cost: starting at $1,675; includes 1 week or more of lodging, meals and ground transport. Various workshops repeated annually. Nature, bird and landscape trips to Death Valley, Falkland Islands, Alaska, Costa Rica and many other locations. Open to all skill levels. Photographers should write, call or e-mail for more information.

PENINSULA ART SCHOOL PHOTOGRAPHY WORKSHOPS

P.O. Box 304, Fish Creek WI 54212. (920)868-3455. Fax: (920)868-9965. E-mail: staff@peninsulaartschool.c om. Website: www.peninsulaartschool.com. **Contact:** Programs Director. Cost: $125-400; meals and lodging not included. One- to 5-day workshops held year round. ''Peninsula Art School offers a full calendar of intensive photography workshops, featuring instruction by some of the region's top talent, including Zane Williams, Hank Erdmann, Dan Anderson and more. Peninsula Art School is located in beautiful Door County, Wisconsin—a popular destination for vacationers and artists alike.''

PETERS VALLEY CRAFT CENTER

19 Kuhn Rd., Layton NJ 07851. (973)948-5200. Fax: (973)948-0011. E-mail: pv@warwick.net. Website: www. pvcrafts.org. Offers workshops May, June, July, August and September; 3-6 days long. Offers instruction by

talented photographers as well as gifted teachers in a wide range of photographic disciplines. Also offers classes in blacksmithing/metals, ceramics, fibers, fine metals, weaving and woodworking. Located in northwest New Jersey in the Delaware Water Gap National Recreation Area, 70 miles west of New York City. Call for catalog or visit website.

PHOTO ADVENTURE TOURS

2035 Park St., Atlantic Beach NY 11509-1236. (516)371-0067 or (800)821-1221. Fax: (516)371-1352. E-mail: photoadventuretours@yahoo.com. **Contact:** Richard Libbey, manager. Offers photographic tours to Finland, Iceland, India, Nepal, Norway, Ireland, Mexico, South Africa and domestic locations such as New Mexico, Navajo Indian regions, Alaska, Albuquerque Balloon Fiesta and New York.

PHOTO ADVENTURES

701 Arnold Way, #6D, Half Moon Bay CA 94019. (650)712-0203. E-mail: joannordano@yahoo.com. **Contact:** Jo-Ann Ordano, instructor. Offers practical workshops covering creative and documentary photo techniques in California; nature subjects and night photography in San Francisco.

PHOTO EDITING WORKSHOP

Western Kentucky University, MMTH 131, Bowling Green KY 42101. (502)745-6292. E-mail: mike.morse@w ku.edu. **Contact:** Mike Morse, workshop director. Cost: $525. Weeklong picture-editing workshop. Participants will edit and produce a photo book using only digital technologies.

PHOTO EXPLORER TOURS

2506 Country Village, Ann Arbor MI 48103-6500. (800)315-4462 or (734)996-1440. E-mail: decoxphoto@aol.c om. Website: www.PhotoExplorerTours.com. **Contact:** Dennis Cox, director. Cost: $2,995-6,495; all-inclusive. Photographic explorations of China, South Africa, Bhutan, Turkey, Burma and Vietnam. "Founded in 1981 as China Photo Workshop Tours by award-winning travel photographer and China specialist Dennis Cox, Photo Explorer Tours has expanded its tours program since 1996. Working directly with carefully selected tour companies at each destination who understand the special needs of photographers, we keep our groups small, usually from 5 to 16 photographers, to ensure maximum flexibility for both planned and spontaneous photo opportunities." On most tours, individual instruction is available from professional photographer leading tour. Open to all skill levels. Photographers should write, call or e-mail for more information.

ⓝ PHOTO WORKSHOPS BY COMMERCIAL PHOTOGRAPHER SEAN ARBABI

(formerly How to Create Better Outdoor Images), 508 Old Farm Rd., Danville CA 94526-4134. Phone/fax: (925)855-8060. E-mail: workshops@seanarbabi.com. Website: www.seanarbabi.com/workshops.html. **Contact:** Sean Arbabi, photographer/instructor. Cost: $85-3,000 for workshops only; meals, lodging, airfare and other services are extra. Seasonal workshops held in spring, summer, fall, winter. Taught at locations including Pt. Reyes National Seashore, California's wine country, and the San Francisco Bay Area in Northern California. International photo workshops coming soon. Sean Arbabi teaches through PowerPoint computer presentations, field instruction and hands-on demonstrations. All levels of workshops are offered from beginner to advanced; subjects include digital photography, technical elements of exposure to composition, how to fine-tune your personal vision, equipment to pack and use, a philosophical approach to the art, as well as how to run a photography business.

ⓝ PHOTOCENTRAL

1099 E St., Hayward CA 94541. (510)881-6721. Fax: (510)881-6763. E-mail: geir@jordahlphoto.com. Website: www.photocentral.org. **Contact:** Geir and Kate Jordahl, coordinators. Cost: $50-300/workshop. PhotoCentral offers workshops for all photographers with an emphasis on small-group learning, development of vision, and balance of the technical and artistic approaches to photography. Special workshops include panoramic photography, infrared photography and hand-coloring. Workshops run 1-4 days and are offered year round.

PHOTOGRAPHIC ARTS WORKSHOPS

P.O. Box 1791, Granite Falls WA 98252. (360)691-4105. E-mail: photoartswkshps@aol.com. Website: www.b arnbaum.com. **Contact:** Bruce Barnbaum, director. Offers a wide range of workshops across the US, Mexico, Europe and Canada. Instructors include masters of digital images. Workshops feature instruction in composition, exposure, development, printing, photographic goals and philosophy. Includes reviews of student port-

folios. Sessions are intense, held in field, darkroom and classroom with various instructors. Ratio of students to instructors is always 8:1 or fewer, with detailed attention to problems students want solved. All camera formats, color and b&w.

PHOTOGRAPHIC CENTER NORTHWEST

900 12th Ave., Seattle WA 98122. (206)720-7222. E-mail: pcnw@pcnw.org. Website: www.pcnw.org. **Contact:** Daniel Mayer, interim executive director. Day and evening classes and workshops in fine art photography (b&w, color, digital) for photographers of all skill levels; accredited certificate program.

Ⓝ PHOTOGRAPHIC TECHNOLOGY AT DAYTONA BEACH COMMUNITY COLLEGE

DBCC-Photographic Technology, P.O. Box 2811, Daytona Beach FL 32120-2811. (386)506-3057. Fax: (386)506-3112. E-mail: holec@dbcc.edu. Website: www.dbcc.edu. **Contact:** Dawn Sealy, chair. Full-range professional photography coursework and periodic workshops available. Skills: commercial, editorial, fine art. Open to all. E-mail or call for more information.

PHOTOGRAPHS II

P.O. Box 4376, Carmel CA 93921. (831)624-6870. E-mail: rfremier@redshift.com. Website: www.starrsites.com/photos2. **Contact:** Roger Fremier. Cost: Starts at $2,945 for International Photography Retreats. Offers 4 programs/year. Previous locations include France, England, Spain and Japan.

Ⓝ PHOTOGRAPHY AT THE SUMMIT: JACKSON HOLE

Rich Clarkson & Associates LLC, 1099 18th St., Suite 1840, Denver CO 80202. (303)295-7770 or (800)745-3211. E-mail: bwilhelm@richclarkson.com. Website: www.photographyatthesummit.com. **Contact:** Brett Wilhelm, administrator. Annual workshops held in spring (April) and fall (October). Weeklong workshops with top journalistic, nature and illustrative photographers and editors. See website for more information.

Ⓖ PHOTOGRAPHY IN PROVENCE

La Chambre Claire, Rue du Petit Portail, Ansouis 84240 France. E-mail: andrew.squires@wanadoo.fr. Website: www.photographie.net/andrew/. **Contact:** Mr. Andrew Squires, M.A. Cost: $570; accommodations between $144-298. Annual workshop held from April to October. Theme: What to Photograph and Why? Designed for people who are looking for a subject and an approach they can call their own. Explore photography of the real world, the universe of human imagination, or simply let yourself discover what touches you. Explore Provence and photograph on location. Possibility to extend your stay and explore Provence if arranged in advance. Open to all skill levels. Photographers should send SASE, call or e-mail for more information.

POLAROID TRANSFER, SX-70 MANIPULATION & PHOTOSHOP WORKSHOPS

P.O. Box 723, Graton CA 95444. (707)829-5649. Fax: (707)824-8174. E-mail: kcarr@kathleencarr.com. Website: www.kathleencarr.com. **Contact:** Kathleen T. Carr. Cost: $75-90/day plus $20 for materials. Carr, author of *Polaroid Transfers* and *Polaroid Manipulations: A Complete Visual Guide to Creating SX-70, Transfer and Digital Prints* (Amphoto Books, 1997 and 2002), offers her expertise on the subjects for photographers of all skill levels. Includes hand-coloring. Programs last 1-7 days in various locations in California, Hawaii, Montana and other locales.

PRAGUE SUMMER SEMINARS

P.O. Box 1097, Metropolitan College, University of New Orleans, New Orleans LA 70148. (504)280-7318. E-mail: iziegler@uno.edu. Website: http://inst.uno.edu/prague. **Contact:** Irene Ziegler, program coordinator. Cost: $3,295; includes lodging. Challenging seminars, studio visits, excursions within Prague; field trips to Vienna, Austria, and Brno, Moravia; film and lecture series. Open to beginners and intermediate photographers. Photographers should call, e-mail or see website for more information.

PROFESSIONAL PHOTOGRAPHER'S SOCIETY OF NEW YORK PHOTO WORKSHOPS

121 Genesee St., Avon NY 14414. (716)226-8351. E-mail: miller12@rochester.rr.com. **Contact:** Lois Miller, director. Cost: $620. Weeklong, specialized, hands-on workshops for professional photographers in July.

Ⓖ PYRENEES EXPOSURES

19, rue Jean Bart, 66190 Collioure, France. E-mail: explorerimages@yahoo.com. Website: www.explorerimages.com. **Contact:** Martin N. Johansen, director. Cost: varies by workshop; starts at $250 for tuition; housing

and meals extra. Workshops held year round. Offers 3- to 5-day workshops and photo expeditions in the French and Spanish Pyrenees, including the Côte Vermeille, with emphasis on landscapes, wildlife and culture. Workshops and tours are limited to small groups. Open to all skill levels. Photographers should e-mail or see website for more information.

QUETICO PHOTO TOURS

P.O. Box 593, Atikokan ON P0T 1C0 Canada. (807)597-2621. E-mail: jdstradiotto@canoemail.com. Website: www.nwconx.net/ ~ jdstradi. **Contact:** John Stradiotto, owner/operator/instructor. Cost: $650 US; food and accommodation provided. Annual workshop/conference. Tours depart every Monday morning, May to October. "Demonstrations of 35mm nature photography skills, portrait photography and telephoto work will be undertaken as opportunities present themselves on the wilderness tour. Guests additionally enjoy the benefits of outdoor portraiture. We provide the support necessary for photographers to focus on observing nature and developing their abilities."

RAGDALE FOUNDATION

Application Request, 1260 North Green Bay Rd., Lake Forest IL 60045. (847)234-1063, ext. 206. E-mail: mosher@ragdale.org. Website: www.ragdale.org. **Contact:** Melissa Mosher, director of admissions. Cost: $30 application fee; $25/day residency fee (includes lodging and meals; dinner is prepared by the chef 6 nights/week). Ragdale is a nonprofit artists' community located 30 miles north of Chicago that supports emerging and established artists, writers and composers from all over the world. On the grounds of what was once Howard Van Doren Shaw's summer home, there are 12 private rooms for 8 writers, 3 visual artists and 1 composer. Residents are accomodated in 3 buildings, 2 of which were designed by Shaw. Residencies are 2 weeks to 2 months. Deadlines for the competitive application process are January 15 and June 1. Application and guidelines available via e-mail, SASE, phone or website.

JEFFREY RICH WILDLIFE PHOTOGRAPHY TOURS

P.O. Box 66, Millville CA 96062. (530)547-3480. E-mail: jrich@jeffrichphoto.com. Website: www.jeffrichphoto.com. **Contact:** Jeffrey Rich, owner. Leading wildlife photo tours in Alaska and western USA since 1990: bald eagles, whales, birds, Montana babies and predators, Brazil's Pantanal and Japan's winter wildlife. Photographers should call or e-mail for brochure.

ROCHESTER INSTITUTE OF TECHNOLOGY ADOBE PHOTOSHOP IMAGE RESTORATION AND RETOUCHING

67 Lomb Memorial Dr., Rochester NY 14623. (800)724-2536. Fax: (585)475-7000. E-mail: webmail@rit.edu. Website: www.seminars.cias.rit.edu. **Contact:** Ken Posman, program manager. Cost: $895. Usually held in mid-August. This learn-by-doing workshop demystifies the process for digitally restoring and retouching images in Photoshop. Intensive 3-day hands-on workshop designed for imaging professionals who have a solid working knowledge of Photoshop and want to improve their digital imaging skills for image restoration and retouching.

ROCHESTER INSTITUTE OF TECHNOLOGY DIGITAL PHOTOGRAPHY FOR PROFESSIONALS

67 Lomb Memorial Dr., Rochester NY 14623. (800)724-2536. Fax: (585)475-7000. E-mail: webmail@rit.edu. Website: www.seminars.cias.rit.edu. **Contact:** Ken Posman, program manager. Cost: $995. A 3-day, hands-on workshop to help experienced, professional photographers make the best possible pictures using the latest Kodak, Nikon, Olympus and other brands of digital cameras. Learn to apply proven image-handling techniques in the electronic darkroom and leave with a new repertoire of "tips and tricks" to attain customer-pleasing results. Photographers should see website for more information.

ROCKY MOUNTAIN FIELD SEMINARS

Rocky Mountain National Park, 1895 Fall River Rd., Estes Park CO 80517. (970)586-3262; (800)748-7002. Website: www.rmna.org. **Contact:** Kate Miller, seminar coordinator. Cost: $75-175. Daylong and weekend seminars covering photographic techniques for wildlife and scenics in Rocky Mountain National Park. Professional instructors include David Halpern, Perry Conway, Donald Mammoser, Glenn Randall and James Frank. Call for a free seminar catalog listing over 100 seminars.

ROCKY MOUNTAIN SCHOOL OF PHOTOGRAPHY

210 N. Higgins, Suite 101, Missoula MT 59802. (800)394-7677. Fax: (406) 721-9153. E-mail: rmsp@rmsp.com. Website: www.rmsp.com. **Contact:** Jeanne Chaput de Saintonge, co-director. Cost: $90-6,000. "RMSP offers

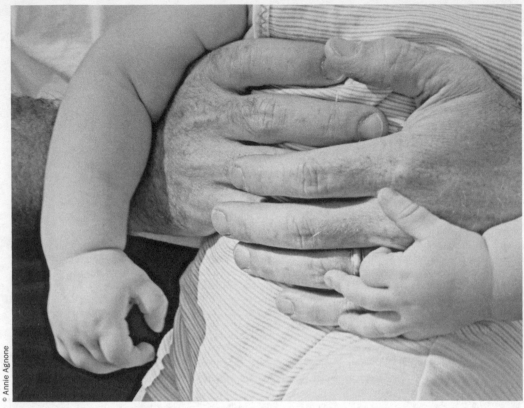

© Annie Agnone

In Tony O'Brien's "Seeing Light" workshop taught at Santa Fe Photographic Workshops, Annie Agnone learned to slow down and really look at things. "I learned to really work a situation, go in from different angles, not be afraid to get really close up, and be patient with a subject or lighting situation," she says. Agnone feels this image shows the intimacy and comfort between father and son better than the many shots she took of their faces.

professional career training in an 11-week 'Summer Intensive' program held each year in Missoula, Montana." Program courses include: basic and advanced color and b&w, studio and natural lighting, portraiture, marketing, stock, landscape, portfolio and others. Offers 7-day advanced training programs in nature, commercial, wedding, portraiture and documentary photography. "We also offer over 40 workshops year round, including field workshops and digital and b&w darkroom printing. Instructors include David Muench, David Middleton, Brenda Tharp, Alison Shaw, George DeWolfe, John Paul Caponigro and others."

SANTA FE WORKSHOPS

P.O. Box 9916, Santa Fe NM 87504-5916. (505)983-1400. E-mail: info@santafeworkshops.com. Website: www.santafeworkshops.com. **Contact:** Roberta Koska, registrar. Cost: $750-1,150 for tuition; lab fees, housing and meals extra; package prices for workshops in Mexico start at $2,250 and include ground transportation, most meals and accomodations. Over 120 weeklong workshops encompassing all levels of photography and more than 35 5-day digital lab workshops and 12 weeklong workshops in Mexico—all led by top professional photographers. The Workshops campus is located near the historic center of Santa Fe. Call or e-mail to request a free catalog.

BARNEY SELLERS OZARK PHOTOGRAPHY WORKSHOP/FIELD TRIP

40 Kyle St., Batesville AR 72501. (870)793-4552. E-mail: barneys@ipa.net. Website: www.barnsandruralscenes.com. **Contact:** Barney Sellers, conductor, retired photojournalist after 36 years with *The Commercial Appeal*, Memphis. Cost for 2-day trip: $100. Participants furnish own food, lodging, transportation and carpool.

Limited to 12 people. No slides shown. Fast-moving to improve alertness to light and outdoor subjects. Sellers also shoots.

SELLING YOUR PHOTOGRAPHY

2973 Harbor Blvd., #341, Costa Mesa CA 92626-3912. (888)713-0705. E-mail: maria@mpiscopo.com. Website: www.mpiscopo.com. **Contact:** Maria Piscopo. Cost: $25-100. One-day workshops cover techniques for marketing and selling photographs. Open to photographers of all skill levels. See website for dates and locations. Maria Piscopo is the author of *Photographer's Guide to Marketing & Self-Promotion*, 3rd edition (Allworth Press).

SELLPHOTOS.COM

Pine Lake Farm, 1910 35th Rd., Osceola WI 54020. (715)248-3800, ext. 25. Fax: (715)248-7394. E-mail: psi2@photosource.com. Website: www.photosource.com. **Contact:** Rohn Engh. Offers half-day workshops in major cities. Marketing critique of attendees' slides follows seminar.

JOHN SEXTON PHOTOGRAPHY WORKSHOPS

291 Los Agrinemsors, Carmel Valley CA 93924. (831)659-3130. Fax: (831)659-5509. E-mail: info@johnsexton.com. Website: www.johnsexton.com. **Contact:** Laura Bayless, administrative assistant. Director: John Sexton. Cost: $750-850. Offers a selection of intensive workshops with master photographers in scenic locations throughout the US. All workshops offer a combination of instruction in the aesthetic and technical considerations involved in making expressive prints.

BOB SHELL PHOTO WORKSHOPS

P.O. Box 808, Radford VA 24141. (540)639-4393. E-mail: bob@bobshell.com. Website: www.bobshell.com. **Contact:** Bob Shell, owner. Cost: $750 and up. Glamour and nude photography workshops in exciting locations with top models. Taught by Bob Shell, one of the world's top glamour/nude photographers and technical editor of *Digital Camera* magazine. Full details on website.

© Barney Sellers

Retired photojournalist Barney Sellers leads photo workshops in the Ozarks. "Autumn's Back Gate" was taken near the Buffalo National River area of Arkansas.

Workshops

⬛ SHENANDOAH PHOTOGRAPHIC WORKSHOPS

P.O. Box 54, Sperryville VA 22740. (703)937-5555. **Contact:** Frederick Figall, director. 3-day to 1-week photo workshops in the Virginia Blue Ridge foothills, held in summer and fall. Weekend workshops held year round in Washington, DC, area.

⬛ SINGING SANDS WORKSHOPS

156 Patillo Rd., Tecumseh ON N8N 2L9 Canada. (519)979-8662. E-mail: martel@wihcom.net. Website: www.singingsandsworkshops.com. **Contact:** Don Martel. Cost: $820; includes lodging/meals; film processing extra. Semiannual workshops held in June and October. Creative photo techniques in the rugged coastline of Georgian Bay and the flats of Lake Huron. Taught by Don Martel and James Sidney. Open to all skill levels. Photographers should send SASE, call, e-mail or see website for more information.

SOUTHEAST MUSEUM OF PHOTOGRAPHY AT DAYTONA BEACH COMMUNITY COLLEGE

1200 W. International Speedway Blvd., Daytona Beach FL 32114. (386)506-4475. Fax: (386)506-4487. Website: www.smponline.org. **Contact:** Kevin Miller, director. Photographic exhibitions, workshops and lecture series.

⬛ SPORTS PHOTOGRAPHY WORKSHOP: COLORADO SPRINGS

Rich Clarkson & Associates LLC, 1099 18th St., Suite 1840, Denver CO 80202. (303)295-7770 or (800)745-3211. E-mail: bwilhelm@richclarkson.com. Website: www.sportsphotographyworkshop.com. **Contact:** Brett Wilhelm, administrator. Annual workshop held in June. Weeklong workshop in sports photography at the U.S. Olympic Training Center with *Sports Illustrated* and *Allsport* photographers and editors. See website for more information.

SUMMIT PHOTOGRAPHIC WORKSHOPS

P.O. Box 67459, Scotts Valley CA 95067. (831)440-0124. E-mail: b-and-k@pacbell.net. Website: www.summitphotographic.com. **Contact:** Barbara Brundege, owner. Cost: $99-200 for workshops; $1,500-6,000 for tours. Offers several workshops per year, including nature and landscape photography; wildlife photography classes; photo tours from 5 days to 3 weeks; annual tour to Alaska. Open to all skill levels. Photographers should see website for more information.

SUPERIOR/GUNFLINT PHOTOGRAPHY WORKSHOPS

P.O. Box 19286, Minneapolis MN 55419. E-mail: photoworkshop@laynekennedy.com. **Contact:** Layne Kennedy, director. Cost: $300-1,300. Fee includes meals/lodging for all adventure-related workshops; lodging and meals for North Shore session are paid for by participants. Offers wilderness adventure photo workshops 3 times/year. Winter session includes driving your own dogsled team in northeastern Minnesota. Summer sessions include kayaking/camping trip in the Apostle Islands with first and last nights in lodges, and a new session along Minnesota's North Shore, at the famed North House Folk School, covering Lake Superior's north shore. All trips professionally guided. Workshops stress how to shoot effective and marketable magazine photos in a story-telling format. Write for details on session dates.

SYNERGISTIC VISIONS WORKSHOPS

P.O. Box 2585, Grand Junction CO 81502. Phone/fax: (970)245-6700. E-mail: steve@synvis.com. Website: www.synvis.com. **Contact:** Steve Traudt, director. Offers a variety of classes at Mesa State College (both film and digital), workshops and photo trips including Slot Canyons, Colorado Wildflowers, Bosque del Apache, Rock Art trips, Arches, Canyonlands and more. Customized private field trips in Colorado, New Mexico, Utah and Arizona. Open to all skill levels. Steve Traudt is the author of *Heliotrope—The Book* and creator of *Hyperfocal Card*. Also available are various instructional video and CD programs on slot canyons, macro and more. Call or write for brochures or visit website.

TAKE A PHOTOGRAPHIC JOURNEY OF A LIFETIME

(888)676-6468. E-mail: mcast@hfmus.com. Website: www.mentorseries.com. **Contact:** Michelle Cast. Workshops that build not only your skill as a photographer but your sense of the world around you. Enjoy many days of photo activities led by world-renown professional shooters, all experienced and charismatic photographers who will offer in-the-field advice, lectures, slide shows and reviews. "The chance of getting good photos is high because we have invested in getting great teachers and permits for private access to some cool places. Another exciting feature is the possibility of your photo credit in an upcoming issue of

Popular Photography & Imaging magazine. In each issue, the editors recap various photo treks around the world and showcase the images submitted by the attendees.'' Open to all skill levels. Photographers should call, e-mail or see website for more information.

TEXAS SCHOOL OF PROFESSIONAL PHOTOGRAPHY

1501 W. Fifth St., Plainview TX 79072. (806)296-2276. E-mail: ddickson@lonestarbbs.com. **Contact:** Don Dickson, director. Cost: $395-420. 25 different classes offered, including portrait, wedding, marketing, background painting and video.

TOUCH OF SUCCESS PHOTO SEMINARS

P.O. Box 1436, Dunnellon FL 34430. (352)867-0463. Website: www.touchofsuccess.com. **Contact:** Bill Thomas, director. Costs vary from $295-895 to $5,000 for safaris. Offers workshops on nature scenics, plants, wildlife, stalking, building rapport and communication, composition, subject selection, lighting, marketing and business management. Workshops held at various locations in the US. Photo safaris led into upper Amazon, Andes, Arctic, Alaska, Africa and Australia. Writer's workshops for photographers who wish to learn to write are also available. All workshops are conducted by author/photojournalist Bill Thomas. Photographers should see website for more information.

TRAVEL IMAGES

P.O. Box 4183, Boise ID 83711-4188. (800)325-8320. E-mail: phototours@travelimages.com. Website: www.travelimages.com. **Contact:** John Baker, owner/guide. Small group photo tours. Locations include US, Canada, Wales, Scotland, Ireland, England and New Zealand.

TRIP TO SOUTHERN INDIA

108 Madeira Blvd., Melville NY 11747. (631)367-8082. E-mail: nelbur@juno.com. **Contact:** Nelson Burack. Cost: $4,900. Annual workshop held in January. Concentrates on photographing all the exciting areas of southern India as well as Vanansi and the Taj Mahal. Open to all skill levels. Photographers should write with SASE, call or e-mail for more information.

N UNIVERSITY OF CALIFORNIA SANTA CRUZ EXTENSION PHOTOGRAPHY WORKSHOPS

1101 Pacific Ave., Suite 200, Santa Cruz CA 95060. (831)427-6620. E-mail: laitken@ucsc-extension.edu. Website: www.ucsc-extension.edu/photo. **Contact:** Photography Program. Ongoing program of workshops in photography throughout California and international study tours in photography. Call or write for details.

UNIVERSITY OF WISCONSIN SCHOOL OF THE ARTS AT RHINELANDER

715 Lowell Center, 610 Langdon St., Madison WI 53703. (608)263-3494. Fax: (608)262-1694. E-mail: kberigan @dcs.wisc.edu. Website: www.dcs.wisc.edu/lsa/soa. **Contact:** Kathy Berigan, coordinator. One-week multidisciplinary arts program held during July in northern Wisconsin.

JOSEPH VAN OS PHOTO SAFARIS, INC.

P.O. Box 655, Vashon Island WA 98070. (206)463-5383. Fax: (206)463-5484. E-mail: info@photosafaris.com. Website: www.photosafaris.com. **Contact:** Joseph Van Os, director. Offers over 50 different photo tours and workshops worldwide.

VIRGINIA CENTER FOR THE CREATIVE ARTS

154 San Angelo Dr., Amherst VA 24521. (434)946-7236. Fax: (434)946-7239. E-mail: vcca@vcca.com. Website: www.vcca.com. **Contact:** Sheila Gulley Pleasants, director of artists' services. Cost: $30/day suggested fee. Residencies available year round. A working retreat for writers, visual artists, composers, performance artists and filmmakers. Application and work samples required. Photographers should call or e-mail for more information.

VISION QUEST PHOTO WORKSHOP CENTER

2370 Hendon Ave., St. Paul MN 55108-1453. (651)644-1400. Fax: (651)644-2122. E-mail: doug@beasleyphotography.com. Website: www.beasleyphotography.com. **Contact:** Doug Beasley, director. Cost: $295-1,995; includes food and lodging. Annual workshops held May through November. Hands-on photo workshops that emphasize content, vision and creativity over technique or gimmicks. Workshops are held in a variety of locations such as Wisconsin, Oregon, Hawaii, Ireland, Norway and Guatemala. Open to all skill levels. Photographers should call or e-mail for more information.

VISUAL ARTISTRY & FIELD MENTORSHIP PHOTOGRAPHY WORKSHOP SERIES

6408 Bonnie Brae Rd., Eldersburg MD 21784. (410)552-4664. Fax: (410)552-3332. E-mail: tony@tonysweet.c om. Website: http://tonysweet.com. **Contact:** Tony Sweet. Cost: $850 for instruction; all other costs are the responsibility of participant. 5-day workshops, limit 10 participants. Formats: 35mm film; digital; xpan. Extensive personal attention and instructional slide shows. Post-workshop support and image critiques for 6 months after the workshop (for an additional fee). Frequent attendees discounts and inclement weather discounts on subsequent workshops. Dealer discounts available from major vendors. "The emphasis is to create in the participant a greater awareness of composition, subject selection, and artistic rendering of the natural world using the raw materials of nature: color, form and line." Open to intermediate and advanced photographers.

WILD WINGS PHOTO ADVENTURES

7284 Raccoon Rd., Manning SC 29102. (803)473-3414. E-mail: doug@totallyoutdoorspublishing.com. Website: www.douggardner.com. **Contact:** Doug Gardner, founder/instructor. Cost: $325 (meals, lodging, guide fees, instructors included). Annual workshops held various times throughout the year in North Carolina and South Carolina: Waterfowl (snow geese, tundra swans, ducks); Eastern Wild Turkeys, Wood Ducks, Osprey and Swamp Culture. "The purpose of Wild Wings Photo Adventures is to offer an action-packed, all-inclusive weekend of fun, fellowship, basic-to-advanced instruction on photography, as well as great opportunities to photograph 'wild' animals up-close. Students will learn valuable techniques in the field with internationally recognized wildlife photographer Doug Gardner. Excellent meals and lodging are included." Open to all skill levels. Photographers should call or e-mail for more information.

WILDERNESS ALASKA

P.O. Box 113063, Anchorage AK 99511. (907)345-3567. Fax: (907)345-3967. E-mail: macgill@alaska.net. Website: www.wildernessalaska.com. **Contact:** MacGill Adams. Offers custom photography trips featuring natural history and wildlife to small groups.

N WILDERNESS PHOTOGRAPHY EXPEDITIONS

402 S. Fifth, Livingston MT 59047. (406)222-2302. Website: tmurphywild.com. **Contact:** Tom Murphy, president. Offers programs in wildlife and landscape photography in Yellowstone National Park and special destinations.

ROBERT WINSLOW PHOTO, INC.

P.O. Box 334, Durango CO 81302-0334. (970)259-4143. Fax: (970)259-7748. E-mail: rwinslow@mydurango.n et. Website: www.agpix.com/robertwinslow. **Contact:** Robert Winslow, president. Cost: varies depending on workshop or tour. "We conduct wildlife model workshops in totally natural settings. We also arrange and lead custom wildlife and natural history photo tours to most destinations around the world."

N WOODSTOCK PHOTOGRAPHY WORKSHOPS

The Center for Photography at Woodstock, 59 Tinker St., Woodstock NY 12498. (845)679-9957. E-mail: info@cpw.org. Website: www.cpw.org. **Contact:** Kate Menconeci, CPW program director. Cost: $55-350. Offers annual lectures and workshops in all topics in photography from June through October. Faculty includes numerous top professionals in fine art, documentary and commercial photography. Topics include still life, landscape, portraiture, lighting, alternative processes and digital. Offers 1-, 2- and 4-day events. Free catalog available by request.

YELLOWSTONE ASSOCIATION INSTITUTE

P.O. Box 117, Yellowstone National Park WY 82190. (307)344-2294. Fax: (307)344-2485. E-mail: registrar@Y ellowstoneAssociation.org. Website: www.YellowstoneAssociation.org. **Contact:** Registrar. Offers workshops in nature and wildlife photography during the summer, fall and winter. Custom courses can be arranged. Photographers should see website for more information.

AIVARS ZAKIS PHOTOGRAPHER

21915 Faith Church Rd., Mason WI 54856. (715)765-4427. **Contact:** Aivars Zakis, photographer/owner. Cost: $450. Basic photographic knowledge is required for a 3-day intense course in nature close-up photography with 35mm, medium- or large-format cameras. Some of the subjects covered include lenses; exposure determination; lighting, including flash, films, accessories; and problem solving. "We do catalog, commercial; stock photography available."

Grants

State, Provincial & Regional

A rts councils in the United States and Canada provide assistance to artists (including photographers) in the form of fellowships or grants. These grants can be substantial and confer prestige upon recipients; however, **only state or province residents are eligible**. Because deadlines and available support vary annually, query first (with a SASE) or check Web sites for guidelines.

UNITED STATES ARTS AGENCIES

Alabama State Council on the Arts, 201 Monroe St., Montgomery AL 36130-1800. (334)242-4076. E-mail: staff@arts.alabama.gov. Website: www.arts.state.al.us.

Alaska State Council on the Arts, 411 W. Fourth Ave., Suite 1-E, Anchorage AK 99501-2343. (907)269-6610 or (888)278-7424. E-mail: aksca_info@eed.state.ak.us. Website: www.educ.state.ak.us/aksca.

Arizona Commission on the Arts, 417 W. Roosevelt, Phoenix AZ 85003. (602)255-5882. E-mail: info@ArizonaArts.org. Website: www.ArizonaArts.org.

Arkansas Arts Council, 1500 Tower Bldg., 323 Center St., Little Rock AR 72201. (501)324-9766. E-mail: info@arkansasarts.com. Website: www.arkansasarts.com.

California Arts Council, 1300 I St., Suite 930, Sacramento CA 95814. (916)322-6555 or (800)201-6201. Website: www.cac.ca.gov.

Colorado Council on the Arts, 1380 Lawrence St., Suite 1200, Denver CO 80204. (303)866-2723. E-mail: coloarts@state.co.us. Website: www.coloarts.state.co.us.

Connecticut Commission on Culture & Tourism, Arts Division, 1 Financial Plaza, 755 Main St., Hartford CT 06103. (860)256-2800. Website: www.cultureandtourism.org.

Delaware Division of the Arts, Carvel State Office Bldg., 820 N. French St., 4th Floor, Wilmington DE 19801. (302)577-8278 (New Castle County) or (302)739-5304 (Kent or Sussex Counties). E-mail: delarts@state.de.us. Website: www.artsdel.org.

District of Columbia Commission on the Arts & Humanities, 410 Eighth St. NW, 5th Floor, Washington DC 20004. (202)724-5613. E-mail: cah@dc.gov. Website: http://dcarts.dc.gov.

Florida Arts Council, Division of Cultural Affairs, Florida Dept. of State, 1001 DeSoto Park Dr., Tallahassee FL 32301. (850)245-6470. E-mail: info@florida-arts.org. Website: www.florida-arts.org.

Georgia Council for the Arts, 260 14th St. NW, Suite 401, Atlanta GA 30318. (404)685-2787. E-mail: gaarts@gaarts.org. Website: www.gaarts.org.

Guam Council on the Arts & Humanities Agency, P.O. Box 2950, Hagatna GU 96932. (671)475-4226. E-mail: kaha1@kuentos.guam.net. Website: www.guam.net/gov/kaha.

Hawaii State Foundation on Culture & the Arts, 250 S. Hotel St., 2nd Floor, Honolulu HI 96813. (808)586-0300. E-mail: ken.hamilton@hawaii.gov/sfca. Website: www.state.hi.us/sfca.

Idaho Commission on the Arts, 2410 N. Old Penitentiary Rd., Boise ID 83712. (208)334-2119 or (800)278-3863. E-mail: info@arts.idaho.gov. Website: www.arts.idaho.gov.

Illinois Arts Council, James R. Thompson Center, 100 W. Randolph, Suite 10-500, Chicago IL 60601. (312)814-6750. E-mail: info@arts.state.il.us. Website: www.state.il.us/agency/iac.

Indiana Arts Commission, 150 W. Market St., #618, Indianapolis IN 46204. (317)232-1268. E-mail: IndianaArtsCommission@iac.in.gov. Website: www.in.gov/arts.

Iowa Arts Council, 600 E. Locust, Des Moines IA 50319-0290. (515)281-6412. Website: www.iowaartscouncil.org.

Kansas Arts Commission, 700 SW Jackson, Suite 1004, Topeka KS 66603-3761. (785)296-3335. E-mail: KAC@arts.state.ks.us. Website: http://arts.state.ks.us.

Kentucky Arts Council, Old Capitol Annex, 300 W. Broadway, Frankfort KY 40601-1980. (502)564-3757 or (888)833-2787. E-mail: kyarts@ky.gov. Website: www.kyarts.org.

Louisiana Division of the Arts, P.O. Box 44247, Baton Rouge LA 70804-4247. (225)342-8180. E-mail: arts@crt.state.la.us. Website: www.crt.state.la.us/arts.

Maine Arts Commission, 25 State House Station, 193 State St., Augusta ME 04333-0025. (207)287-2724. E-mail: MaineArts.info@maine.gov. Website: www.mainearts.com.

Maryland State Arts Council, 175 W. Ostend St., Suite E, Baltimore MD 21230. (410)767-6555. E-mail: msac@msac.org. Website: www.msac.org.

Massachusetts Cultural Council, 10 St. James Ave., 3rd Floor, Boston MA 02116-3803. (617)727-3668. E-mail: web@art.state.ma.us. Website: www.massculturalcouncil.org.

Michigan Council for Arts & Cultural Affairs, 702 W. Kalamazoo St., P.O. Box 30705, Lansing MI 48909-8205. (517)241-4011. E-mail: artsinfo@michigan.gov. Website: www.michigan.gov/hal/0,1607,7-160-17445_19272---,00.html.

Minnesota State Arts Board, Park Square Court, 400 Sibley St., Suite 200, St. Paul MN 55101-1928. (651)215-1600 or (800)866-2787. E-mail: msab@arts.state.mn.us. Website: www.arts.state.mn.us.

Mississippi Arts Commission, 239 N. Lamar St., Suite 207, Jackson MS 39201. (601)359-6030. Website: www.arts.state.ms.us.

Missouri Arts Council, Wainwright State Office Complex, 111 N. Seventh St., Suite 105, St. Louis MO 63101-2188. (314)340-6845 or (866)407-4752. E-mail: moarts@ded.mo.gov. Website: www.missouriartscouncil.org.

Montana Arts Council, 316 N. Park Ave., Suite 252, Helena MT 59620-2201. (406)444-6430. E-mail: mac@mt.gov. Website: www.art.state.mt.us.

National Assembly of State Arts Agencies, 1029 Vermont Ave. NW, 2nd Floor, Washington DC 20005. (202)347-6352. E-mail: nasaa@nasaa-arts.org. Website: www.nasaa-arts.org.

Nebraska Arts Council, Joslyn Castle Carriage House, 3838 Davenport St., Omaha NE 68131. (402)595-2122 or (800)341-4067. Website: www.nebraskaartscouncil.org.

Nevada Arts Council, 716 N. Carson St., Suite A, Carson City NV 89701. (775)687-6680. E-mail: jcounsil@clan.lib.nv.us. Website: http://dmla.clan.lib.nv.us/docs/arts.

New Hampshire State Council on the Arts, 2½ Beacon St., 2nd Floor, Concord NH 03301-4974. (603)271-2789. Website: www.nh.gov/nharts.

New Jersey State Council on the Arts, 225 W. State St., P.O. Box 306, Trenton NJ 08625. (609)292-6130. Website: www.njartscouncil.org.

New Mexico Arts, Dept. of Cultural Affairs, P.O. Box 1450, Santa Fe NM 87504-1450. (505)827-6490 or (800)879-4278. Website: www.nmarts.org.

New York State Council on the Arts, 175 Varick St., New York NY 10014. (212)627-4455. Website: www.nysca.org.

North Carolina Arts Council, Dept. of Cultural Resources, Raleigh NC 27699-4632. (919)733-2111. E-mail: ncarts@ncmail.net. Website: www.ncarts.org.

North Dakota Council on the Arts, 1600 E. Century Ave., Suite 6, Bismarck ND 58503. (701)328-7590. E-mail: comserv@state.nd.us. Website: www.state.nd.us/arts.

Commonwealth Council for Arts and Culture, (Northern Mariana Islands), P.O. Box 5553, CHRB, Saipan MP 96950. (670)322-9982 or (670)322-9983. E-mail: galaidi@vzpacifica.net. Website: www.geocities.com/ccacarts/ccacwebsite.html.

Ohio Arts Council, 727 E. Main St., Columbus OH 43205-1796. (614)466-2613. Website: www.oac.state.oh.us.

Oklahoma Arts Council, P.O. Box 52001-2001, Oklahoma City OK 73152-2001. (405)521-2931. E-mail: okarts@arts.state.ok.gov. Website: www.arts.state.ok.us.

Oregon Arts Commission, 775 Summer St. NE, Suite 200, Salem OR 97301-1284. (503)986-0082. E-mail: oregon.artscomm@state.or.us. Website: www.oregonartscommission.org.

Pennsylvania Council on the Arts, Room 216, Finance Bldg., Harrisburg PA 17120. (717)787-6883. Website: www.pacouncilonthearts.org.

Institute of Puerto Rican Culture, P.O. Box 9024184, San Juan PR 00902-4184. (787)724-0700. E-mail: www@icp.gobierno.pr. Website: www.icp.gobierno.pr.

Rhode Island State Council on the Arts, One Capitol Hill, 3rd Floor, Providence RI 02908. (401)222-3880. E-mail: info@arts.ri.gov. Website: www.arts.ri.gov.

American Samoa Council on Culture, Arts and Humanities, P.O. Box 1540, Office of the Governor, Pago Pago AS 96799. (684)633-4347.

South Carolina Arts Commission, 1800 Gervais St., Columbia SC 29201. (803)734-8696. E-mail: goldstsa@arts.state.sc.us. Website: www.state.sc.us/arts.

South Dakota Arts Council, 800 Governors Dr., Pierre SD 57501. (605)773-3131. E-mail: sdac@state.sd.us. Website: www.state.sd.us/deca/sdarts.

Tennessee Arts Commission, Citizens Plaza Bldg., 401 Charlotte Ave., Nashville TN 37243-0780. (615)741-1701. Website: www.arts.state.tn.us.

Resources

Texas Commission on the Arts, P.O. Box 13406, Austin TX 78711-3406. (512)463-5535. E-mail: front.desk@arts.state.tx.us. Website: www.arts.state.tx.us.

Utah Arts Council, 617 E. South Temple, Salt Lake City UT 84102. (801)236-7555. Website: http://arts.utah.gov.

Vermont Arts Council, 136 State St., Drawer 33, Montpelier VT 05633-6001. (802)828-3291. E-mail: info@vermontartscouncil.org. Website: www.vermontartscouncil.org.

Virgin Islands Council on the Arts, 41-42 Norre Gade, St. Thomas VI 00802. (340)774-5984. E-mail: adagio@islands.vi. Website: http://vicouncilonarts.org.

Virginia Commission for the Arts, Lewis House, 223 Governor St., 2nd Floor, Richmond VA 23219. (804)225-3132. E-mail: arts@arts.virginia.gov. Website: www.arts.state.va.us.

Washington State Arts Commission, 711 Capitol Way S., Suite 600, P.O. Box 42675, Olympia WA 98504-2675. (360)753-3860. E-mail: info@arts.wa.gov. Website: www.arts.wa.gov.

West Virginia Commission on the Arts, The Cultural Center, 1900 Kanawha Blvd. E., Charleston WV 25305. (304)558-0240. Website: www.wvculture.org/arts.

Wisconsin Arts Board, 101 E. Wilson St., 1st Floor, Madison WI 53702. (608)266-0190. E-mail: artsboard@arts.state.wi.us. Website: www.arts.state.wi.us.

Wyoming Arts Council, 2320 Capitol Ave., Cheyenne WY 82002. (307)777-7742. E-mail: ebratt@state.wy.us. Website: http://wyoarts.state.wy.us.

CANADIAN PROVINCES ARTS AGENCIES

Alberta Foundation for the Arts, 901 Standard Life Centre, 10405 Jasper Ave., Edmonton AB T5J 4R7. Website: www.cd.gov.ab.ca/all_about_us/commissions/arts.

British Columbia Arts Council, P.O. Box 9819, Stn. Prov. Govt., Victoria BC V8W 9W3. (250)356-1718. E-mail: BCArtsCouncil@gems2.gov.bc.ca. Website: www.bcartscouncil.ca.

The Canada Council for the Arts, 350 Albert St., P.O. Box 1047, Ottawa ON K1P 5V8. (613)566-4414 or (800)263-558 (within Canada). Website: www.canadacouncil.ca.

Manitoba Arts Council, 525-93 Lombard Ave., Winnipeg MB R3B 3B1. (204)945-2237. E-mail: info@artscouncil.mb.ca. Website: www.artscouncil.mb.ca.

New Brunswick Arts Board (NBAB), 634 Queen St., Suite 300, Fredericton NB E3B 1C2. (866)460-2787. Website: www.artsnb.ca.

Newfoundland & Labrador Arts Council, P.O. Box 98, St. John's NL A1C 5H5. (709)726-2212 or (866)726-2212. E-mail: nlacmail@nfld.net. Website: www.nlac.nf.ca.

Nova Scotia Arts and Culture Partnership Council, Culture Division, 1800 Argyle St., Suite 402, Halifax NS B3J 2R5. (902)424-4442. E-mail: cultaffs@gov.ns.ca. Website: www.gov.ns.ca/dtc/culture.

Ontario Arts Council, 151 Bloor St. W., 5th Floor, Toronto ON M5S 1T6. (416)961-1660. E-mail: info@arts.on.ca. Website: www.arts.on.ca.

Prince Edward Island Council of the Arts, 115 Richmond St., Charlottetown PE C1A 1H7. (902)368-4410. E-mail: info@peiartscouncil.com. Website: www.peiartscouncil.com.

Quebec Council for Arts & Literature, 79 boul. René-Lévesque Est, 3e étage, Québéc QC

G1R 5N5. (418)643-1707 or (800)897-1707. E-mail: info@calq.gouv.qc.ca. Website: www.calq.gouv.qc.ca.

The Saskatchewan Arts Board, 2135 Broad St., Regina SK S4P 1Y6. (306)787-4056. E-mail: sab@artsboard.sk.ca. Website: www.artsboard.sk.ca.

Yukon Arts Section, Cultural Services Branch, Dept. of Tourism & Culture, Government of Yukon, Box 2703, Whitehorse YT Y1A 2C6. (867)667-8589. E-mail: arts@gov.yk.ca. Website: www.btc.gov.yk.ca/cultural/arts.

REGIONAL GRANTS AND AWARDS

The following opportunities are arranged by state since most of them grant money to artists in a particular geographic region. Because deadlines vary annually, check Web sites or call for the most up-to-date information. Note: not all states are listed; see the list of state and provincial arts agencies on page 461 for state-sponsored arts councils.

California

Flintridge Foundation Awards for Visual Artists, 1040 Lincoln Ave., Suite 100, Pasadena CA 91103. (626)449-0839 or (800)303-2139. Fax: (626)585-0011. Website: www.flintridgefoundation.org. *For artists in California, Oregon and Washington only.*

James D. Phelan Award in Photography, Kala Art Institute, Don Porcella, 1060 Heinz Ave., Berkeley CA 94710. (510)549-6914. Website: www.kala.org. *For artists born in California only.*

Connecticut

Martha Boschen Porter Fund, Inc., 145 White Hallow Rd., Sharon CT 06064. *For artists in northwestern Connecticut, western Massachusetts and adjacent areas of New York (except New York City).*

Idaho

Betty Bowen Memorial Award, % Seattle Art Museum, 100 University St., Seattle WA 98101. (206)654-3131. Website: www.seattleartmuseum.org/bettybowen/. *For artists in Washington, Oregon and Idaho only.*

Illinois

Illinois Arts Council, Artists Fellowship Program, James R. Thompson Center, 100 W. Randolph, Suite 10-500, Chicago IL 60601. (312)814-6750. Website: www.state.il.us/agency/iac/Guidelines/guidelines.htm. *For Illinois artists only.*

Kentucky

Kentucky Foundation for Women Grants Program, 1215 Heyburn Bldg., 332 W. Broadway, Louisville KY 40202. (502)562-0045. Website: www.kfw.org/grants.html. *For female artists living in Kentucky only.*

Massachusetts

See Martha Boschen Porter Fund, Inc., under Connecticut.

Minnesota

McKnight Photography Fellowships Program, University of Minnesota Dept. of Art, Regis Center for Art, E-201, 405 21st Ave. S., Minneapolis MN 55455. (612)626-9640. Website: www.mcknightphoto.umn.edu. *For Minnesota artists only.*

New York

A.I.R. Gallery Fellowship Program, 511 W. 25th St., Suite 301, New York NY 10001. (212)255-6651. E-mail: info@airnyc.org. Website: www.airnyc.org. *For female artists from New York City metro area only.*

Arts & Cultural Council for Greater Rochester, 277 N. Goodman St., Rochester NY 14607. (585)473-4000. Website: www.artsrochester.org.

Constance Saltonstall Foundation for the Arts Grants and Fellowships, P.O. Box 6607, Ithaca NY 14851 (include SASE). (607)277-4933. E-mail: info@saltonstall.org. Website: www.saltonstall.org. *For artists in the central and western counties of New York.*

New York Foundation for the Arts: Artists' Fellowships, 155 Avenue of the Americas, 14th Floor, New York NY 10013-1507. (212)366-6900, ext. 217. E-mail: nyfaafp@nyfa.org. Website: www.nyfa.org/artists_fellowships/. *For New York artists only.*

Oregon

See Flintridge Foundation Awards for Visual Artists, under California.

Pennsylvania

Leeway Foundation—Philadelphia, Pennsylvania Region, 123 S. Broad St., Suite 2040, Philadelphia PA 19109. (215)545-4078. E-mail: info@leeway.org. Website: www.leeway. org. *For female artists in Philadelphia only.*

Texas

Individual Artist Grant Program—Houston, Texas, Cultural Arts Council of Houston and Harris County, 3201 Allen Pkwy., Suite 250, Houston TX 77019-1800. (713)527-9330. E-mail: info@cachh.org. Website: www.cachh.org. *For Houston artists only.*

Washington

See Flintridge Foundation Awards for Visual Artists, under California.

Professional Organizations

Advertising Photographers of America, National, 28 E. Jackson, Bldg. #10-A855, Chicago IL 60604-2263. (800)272-6264. E-mail: office@apanational.com. Website: www.apanational.com.

Advertising Photographers of America, Atlanta, P.O. Box 20471, Atlanta GA 30325. (888)889-7190, ext. 50. E-mail: info@apaatlanta.com. Website: www.apaatlanta.com.

Advertising Photographers of America, Los Angeles, 5455 Wilshire Blvd., Suite 1709, Los Angeles CA 90036. (323)933-1631. Fax: (323)933-9209. E-mail: office@apa-la.org. Website: www.apa-la.org.

Advertising Photographers of America, Midwest, 28 E. Jackson, Bldg. #10-A855, Chicago IL 60604. (877)890-7375. E-mail: ceo@apa-m.com. Website: www.apamidwest.com.

Advertising Photographers of America, New York, 27 W. 20th St., Suite 601, New York NY 10011. (212)807-0399. Fax: (212)727-8120. E-mail: info@apany.com. Website: www.apany.com.

Advertising Photographers of America, San Diego, P.O. Box 84241, San Diego CA 92138. (619)417-2150. E-mail: membership@apasd.org. Website: www.apasd.org.

Advertising Photographers of America, San Francisco, 560 Fourth St., San Francisco CA 94107. (415)882-9780. Fax: (415)882-9781. E-mail: info@apasf.com. Website: www.apasf.com.

American Society of Media Photographers (ASMP), 150 N. Second St., Philadelphia PA 19106. (215)451-2767. Fax: (215)451-0880. Website: www.asmp.org.

American Society of Picture Professionals (ASPP), 409 S. Washington St., Alexandria VA 22314. Phone/fax: (703)299-0219. Website: www.aspp.com.

The Association of Photographers, 81 Leonard St., London EC2A 4QS United Kingdom. (44)(207)739-6669. Fax: (44)(207)739-8707. E-mail: general@aophoto.co.uk. Website: www.the-aop.org.

British Association of Picture Libraries and Agencies, 18 Vine Hill, London EC1R 5DZ United Kingdom. Phone: (44)(207)713-1780. Fax: (44)(207)713-1211. E-mail: enquiries@bapla.org.uk. Website: www.bapla.org.uk.

British Institute of Professional Photography (BIPP), Fox Talbot House, 2 Amwell End,

Ware, Hertsfordshire SG12 9HN United Kingdom. Phone: (44)(192)046-4011. Fax: (44)(192)048-7056. E-mail: info@bipp.com. Website: www.bipp.com

Canadian Association of Journalists, Algonquin College, 1385 Woodroffe Ave., B224, Ottawa ON K2G 1V8 Canada. (613)526-8061. Fax: (613)521-3904. E-mail: caj@igs.net. Website: www.eagle.ca/caj.

Canadian Association of Photographers & Illustrators in Communications, The Case Goods Building, Suite 302, 55 Mill St., Toronto ON M5A 3C4 Canada. (416)462-3677. Fax: (416)462-9570. E-mail: info@capic.org. Website: www.capic.org.

Canadian Association for Photographic Art, 31858 Hopedale Ave., Clearbrook BC V2T 2G7 Canada. (604)855-4848. Fax: (604)855-4824. E-mail: capa@capacanada.ca. Website: www.capacanada.ca.

The Center for Photography at Woodstock (CPW), 59 Tinker St., Woodstock NY 12498. (845)679-9957. Fax: (845)679-6337. E-mail: info@cpw.org. Website: www.cpw.org.

Evidence Photographers International Council (EPIC), 600 Main St., Honesdale PA 18431. (800)356-3742. E-mail: EPICheadquarters@verizon.net. Website: www.epic-photo.org.

International Association of Panoramic Photographers, 8855 Redwood St., Las Vegas NV 89139. (702)260-4608. E-mail: iappsecretary@aol.com. Website: www.panoramicassociation.org.

International Center of Photography (ICP), 1133 Avenue of the Americas at 43rd St., New York NY 10036. (212)857-0000. E-mail: info@icp.org. Website: www.icp.org.

The Light Factory (TLF), Spirit Square, Suite 211, 345 N. College St., Charlotte NC 28202. (704)333-9755. E-mail: info@lightfactory.org. Website: www.lightfactory.org.

National Press Photographers Association (NPPA), 3200 Croasdaile Dr., Suite 306, Durham NC 27705. (919)383-7246. Fax: (919)383-7261. E-mail: info@nppa.org. Website: www.nppa.org.

North American Nature Photography Association (NANPA), 10200 W. 44th Ave., Suite 304, Wheat Ridge CO 80033-2840. (303)422-8527. Fax: (303)422-8894. E-mail: info@nanpa.org. Website: www.nanpa.org.

Photo Marketing Association International, 3000 Picture Place, Jackson MI 49201. (517)788-8100. Fax: (517)788-8371. E-mail: PMA_Information_Central@pmai.org. Website: www.pmai.org.

Photographic Society of America (PSA), 3000 United Founders Blvd., Suite 103, Oklahoma City OK 73112-3940. (405)843-1437. Fax: (405)843-1438. E-mail: hq@psa-photo.org. Website: www.psa-photo.org.

Picture Archive Council of America (PACA). (949)460-4531. Fax: (949)460-4532. E-mail: pacnews@pacoffice.org. Website: www.stockindustry.org.

Professional Photographers of America (PPA), 229 Peachtree St. NE, Suite 2200, Atlanta GA 30303. (404)522-8600. Fax: (404)614-6400. E-mail: csc@ppa.com. Website: www.ppa.com.

Professional Photographers of Canada (PPOC), 371 Dundas St., Woodstock ON N4S 1B6 Canada. (519)537-2555. Fax: (519)537-5573. E-mail: ppoc@rogers.com. Website: www.ppoc.ca.

The Royal Photographic Society, Fenton House, 122 Wells Rd., Bath BA2 3AH United Kingdom. Phone: (44)(122)546-2841. Fax: (44)(122)544-8688. E-mail: reception@rps.org. Website: www.rps.org.

Society for Photographic Education, 126 Peabody, The School of Interdisciplinary Studies, Miami University, Oxford OH 45056. (513)529-8328. Fax: (513)529-9301. E-mail: speoffice @spenational.org. Website: www.spenational.org.

Society of Photographers and Artists Representatives (SPAR), 60 E. 42nd St., Suite 1166, New York NY 10165. E-mail: info@spar.org. Website: www.spar.org.

Volunteer Lawyers for the Arts, 1 E. 53rd St., 6th Floor, New York NY 10022. (212)319-2787, ext. 1. Fax: (212)752-6575. Website: www.vlany.org.

Wedding & Portrait Photographers International (WPPI), P.O. Box 2003, 1312 Lincoln Blvd., Santa Monica CA 90406. (310)451-0090. Fax: (310)395-9058. Website: www.wppio nline.com/index2.tml.

White House News Photographers' Association (WHNPA), 7119 Ben Franklin Station, Washington DC 20044-7119. Website: www.whnpa.org.

Resources

Publications

PERIODICALS

Advertising Age, Crain Communications, 711 Third Ave., New York NY 10017-4036. (212)210-0100. Website: www.adage.com. Weekly magazine covering marketing, media and advertising.

Adweek, VNU Business Publications, 770 Broadway, New York NY 10003. (646)654-5421. Fax: (646)654-5365. E-mail: info@adweek.com. Website: www.adweek.com. Weekly magazine covering advertising agencies.

AGPix Marketing Report, AG Editions, P.O. Box 31, Village Station, New York NY 10014. (800)727-9593. Fax: (646)349-2772. E-mail: office@agpix.com. Website: www.agpix.com. Market tips newsletter published monthly online and via e-mail.

American Photo, 1633 Broadway, 43rd Floor, New York NY 10019. (212)767-6000. Website: www.americanphotomag.com. Monthly magazine emphasizing the craft and philosophy of photography.

Art Calendar, P.O. Box 2675, Salisbury MD 21802. (410)749-9625. Fax: (410)749-9626. E-mail: info@ArtCalendar.com. Website: www.artcalendar.com. Monthly magazine listing galleries reviewing portfolios, juried shows, percent-for-art programs, scholarships and art colonies.

ASMP Bulletin, 150 N. Second St., Philadelphia PA 19106. (215)451-2767. Fax: (215)451-0880. Website: www.asmp.org. Newsletter of the American Society of Media Photographers published 5 times/year. Subscription with membership.

Communication Arts, 110 Constitution Dr., Menlo Park CA 94025. (650)326-6040. Fax: (650)326-1648. Website: www.commarts.com. Trade journal for visual communications.

Editor & Publisher, VNU Business Publications, 770 Broadway, New York NY 10003-9595. (800)336-4380 or (646)654-5270. Fax: (646)654-5370. Website: www.editorandpublisher.com. Monthly magazine covering latest developments in journalism and newspaper production. Publishes an annual directory issue listing syndicates and another directory listing newspapers.

Folio, Red 7 Media, LLC, 33 S. Main St., Norwalk CT 06854. (203)854-6730. Fax: (203)854-6735. Website: www.foliomag.com. Monthly magazine featuring trends in magazine circulation, production and editorial.

Graphis, 307 Fifth Ave., 10th Floor, New York NY 10016. (212)532-9387. Fax: (212)213-3229. E-mail: info@graphis.com. Website: www.graphis.com. Magazine for the visual arts. Starting with issue #357 (2006), *Graphis* will be split into 3 separate journals: design, advertising and photography.

HOW, F + W Publications, 4700 E. Galbraith Rd., Cincinnati OH 45236. (513)531-2690. Website: www.howdesign.com. Bimonthly magazine for the design industry.

News Photographer, 6677 Whitemarsh Valley Walk, Austin TX 78746-6367. (919)383-7246. Fax: (919)383-7261. E-mail: magazine@nppa.org. Website: www.nppa.org. Monthly news tabloid published by the National Press Photographers Association. Subscription with membership.

Outdoor Photographer, Werner Publishing, 12121 Wilshire Blvd., 12th Floor, Los Angeles CA 90025-1176. (310)820-1500. Fax: (310)826-5008. Website: www.outdoorphotographer.com. Monthly magazine emphasizing equipment and techniques for shooting in outdoor conditions.

Petersen's Photographic Magazine, Primedia, 261 Madison Ave., New York NY 10016. (212)886-3675. Website: www.photographic.com. Monthly how-to magazine for beginning and semi-professional photographers.

Photo District News, VNU Business Publications, 770 Broadway, 7th Floor, New York NY 10003. (646)654-5780. Fax: (646)654-5813. Website: www.pdn-pix.com. Monthly magazine for the professional photographer.

Photosource International, Pine Lake Farm, 1910 35th Rd., Osceola WI 54020-5602. (800)624-0266, ext. 21. E-mail: info@photosource.com. Website: www.photosource.com. This company publishes several helpful newsletters, including *PhotoLetter*, *PhotoDaily* and *PhotoStockNotes*.

Popular Photography & Imaging, Hachette Filipacchi Media, 1633 Broadway, New York NY 10019. (212)767-6000. Fax: (212)767-5602. Website: www.popphoto.com. Monthly magazine specializing in technical information for photography.

Print, F + W Publications, 4700 E. Galbraith Rd., Cincinnati OH 45236. (513)531-2690. E-mail: info@printmag.com. Website: www.printmag.com. Bimonthly magazine focusing on creative trends and technological advances in illustration, design, photography and printing.

Professional Photographer, Professional Photographers of America (PPA), 229 Peachtree St. NE, Suite 2200, Atlanta GA 30303. (404)522-8600. Fax: (404)614-6400. E-mail: csc@ppa.com. Website: www.ppa.com. Monthly magazine emphasizing technique and equipment for working photographers.

Publishers Weekly, Reed Business Information, 360 Park Ave. S., New York NY 10010. (646)746-6758. Fax: (646)746-6631. Website: www.publishersweekly.com. Weekly magazine covering industry trends and news in book publishing; includes book reviews and interviews.

Rangefinder, P.O. Box 1703, 1312 Lincoln Blvd., Santa Monica CA 90406. (310)451-8506. Fax: (310)395-9058. Website: www.rangefindermag.com. Monthly magazine covering photography technique, products and business practices.

Selling Stock, 110 Frederick Ave., Suite A, Rockville MD 20850. (301)251-0720. Fax: (301)309-0941. E-mail: sellingstock@chd.com. Website: www.pickphoto.com. Newsletter for stock photographers; includes coverage of trends in business practices such as pricing and contract terms.

Shutterbug, Primedia, 1419 Chaffee Dr., Suite 1, Titusville FL 32780. (321)269-3212. Fax: (321)225-3149. Website: www.shutterbug.net. Monthly magazine of photography news and equipment reviews.

Studio Photography and Design, Cygnus Business Media, 3 Huntington Quadrangle, Suite 301N, Melville NY 11747. (631)845-2700. Fax: (631)845-7109. Website: www.imaginginfo .com/spd/. Monthly magazine showcasing professional photographers. Also provides guides, tips and tutorials.

BOOKS & DIRECTORIES

Adweek Agency Directory, VNU Business Publications, 770 Broadway, New York NY 10003. (646)654-5421. E-mail: info@adweek.com. Website: www.adweek.com. Annual directory of advertising agencies in the U.S.

Adweek Brand Directory, VNU Business Publications, 770 Broadway, New York NY 10003. (646)654-5421. E-mail: info@adweek.com. Website: www.adweek.com. Directory listing top 2,000 brands, ranked by media spending.

AGPix Print, AG Editions, P.O. Box 31, Village Station, New York NY 10014. (800)727-9593. Fax: (646)349-2772. E-mail: office@agpix.com. Website: www.agpix.com. Directory of AGPix members listing their contact information and an index of their specialties.

ASMP Copyright Guide for Photographers, American Society of Media Photographers, 150 N. Second St., Philadelphia PA 19106. (215)451-2767. Fax: (215)451-0880. Website: www.asmp.org.

ASMP Professional Business Practices in Photography, 6th Edition, American Society of Media Photographers, 150 N. Second St., Philadelphia PA 19106. (215)451-2767. Fax: (215)451-0880. Website: www.asmp.org. Handbook covering all aspects of running a photography business.

Bacon's Media Directories, 332 S. Michigan Ave., Chicago IL 60604. (312)922-2400. Website: www.bacons.com.

The Big Picture: The Professional Photographer's Guide to Rights, Rates & Negotiation, by Lou Jacobs, Writer's Digest Books, F + W Publications, 4700 E. Galbraith Rd., Cincinnati OH 45236. (513)531-2690. Website: www.writersdigest.com. Essential information on understanding contracts, copyrights, pricing, licensing and negotiation.

Business and Legal Forms for Photographers, 3rd Edition, by Tad Crawford, Allworth Press, 10 E. 23 St., Suite 510, New York NY 10010. (212)777-8395. Fax: (212)777-8261. E-mail: PUB@allworth.com. Website: www.allworth.com. Negotiation book with 28 forms for photographers.

The Business of Commercial Photography, by Ira Wexler, Amphoto Books, Watson-Guptill Publications, 770 Broadway, New York NY 10003. (800)278-8477. E-mail: info@watsongu ptill.com. Website: http://amphotobooks.com. Comprehensive career guide including interviews with 30 leading commercial photographers.

The Business of Studio Photography, Revised Edition, by Edward R. Lilley, Allworth Press, 10 E. 23 St., Suite 510, New York NY 10010. (212)777-8395. Fax: (212)777-8261. E-mail: PUB@allworth.com. Website: www.allworth.com. A complete guide to starting and running a successful photography studio.

Children's Writers & Illustrator's Market, Writer's Digest Books, F + W Publications, 4700

E. Galbraith Rd., Cincinnati OH 45236. (513)531-2690. Website: www.writersdigest.com. Annual directory including photo needs of book publishers, magazines and multimedia producers in the children's publishing industry.

Creative Black Book, 740 Broadway, 2nd Floor, New York NY 10003. (800)841-1246. Fax: (212)673-4321. Website: www.blackbook.com. Sourcebook used by photo buyers to find photographers.

Direct Stock, P.O. Box 482, Cornwall NY 02518-0482. Fax: (845)497-5003. Website: www.directstock.com. Sourcebook used by photo buyers to find photographers.

Fresh Ideas in Promotion 2, by Betsy Newberry, North Light Books, F + W Publications, 4700 E. Galbraith Rd., Cincinnati OH 45236. (513)531-2690. Website: www.artistsnetwork .com/nlbooks. Idea book of self-promotions.

How to Shoot Stock Photos That Sell, 3rd Edition, by Michal Heron, Allworth Press, 10 E. 23 St., Suite 510, New York NY 10010. (212)777-8395. Fax: (212)777-8261. E-mail: PUB@allworth.com. Website: www.allworth.com. Comprehensive guide to producing, marketing and selling sock photos.

How You Can Make $25,000 a Year With Your Camera, by Larry Cribb, Writer's Digest Books, F + W Publications, 4700 E. Galbraith Rd., Cincinnati OH 45236. (513)531-2690. Website: www.writersdigest.com. Newly revised edition of the popular book on finding photo opportunities in your own hometown.

LA 411, 411 Publishing, 5700 Wilshire Blvd., Suite 120, Los Angeles CA 90036. (800)545-2411. Fax: (323)965-2052. Website: www.la411.com. Music industry guide, including record labels.

Legal Guide for the Visual Artist, 4th Edition, by Tad Crawford, Allworth Press, 10 E. 23 St., Suite 510, New York NY 10010. (212)777-8395. Fax: (212)777-8261. E-mail: PUB@allworth.com. Website: www.allworth.com. The author, an attorney, offers legal advice for artists and includes forms dealing with copyright, sales, taxes, etc.

Literary Market Place, Information Today, 143 Old Marlton Pike, Medford NJ 08055-8750. (800)300-9868. Fax: (609)654-4309. E-mail: custserv@infotoday.com. Website: www.info today.com or www.literarymarketplace.com. Directory that lists book publishers and other book publishing industry contacts.

Marketing Guidebook for Photographers, by Mary Virginia Swanson, available through her Web site (www.mvswanson.com) or by calling (520)742-6311.

Negotiating Stock Photo Prices, by Jim Pickerell and Cheryl Pickerell DiFrank, 110 Frederick Ave., Suite A, Rockville MD 20850. (301)251-0720. Fax: (301)309-0941. E-mail: sellingstock@chd.com. Website: www.pickphoto.com. Hardbound book that offers pricing guidelines for selling photos through stock photo agencies.

Newsletters in Print, Thomson Gale, 27500 Drake Rd., Farmington Hills MI 48331. (248)699-4253 or (800)877-GALE. Fax: (800)414-5043. E-mail: gale.galeord@thomson.com. Website: www.gale.com. Annual directory listing newsletters.

O'Dwyer's Directory of Public Relations Firms, J.R. O'Dwyer Company, 271 Madison Ave., #600, New York NY 10016. (212)679-2471. Fax: (212)683-2750. E-mail: john@odwyerpr.c om. Website: www.odwyerpr.com. Annual directory listing public relations firms, indexed by specialties.

Photo Portfolio Success, by John Kaplan, Writer's Digest Books, F + W Publications, 4700

E. Galbraith Rd., Cincinnati OH 45236. (513)531-2690. Website: www.writersdigest.com.

The Photographer's Guide to Marketing & Self-Promotion, 3rd Edition, by Maria Piscopo, Allworth Press, 10 E. 23 St., Suite 510, New York NY 10010. (212)777-8395. Fax: (212)777-8261. E-mail: PUB@allworth.com. Website: www.allworth.com. Marketing guide for photographers.

The Photographer's Internet Handbook, Revised Edition, by Joe Farace, Allworth Press, 10 E. 23 St., Suite 510, New York NY 10010. (212)777-8395. Fax: (212)777-8261. E-mail: PUB@allworth.com. Website: www.allworth.com. Covers the many ways photographers can use the Internet as a marketing and informational resource.

Photographer's Market Guide to Building Your Photography Business, by Vic Orenstein, Writer's Digest Books, F + W Publications, 4700 E. Galbraith Rd., Cincinnati OH 45236. (513)531-2690. Website: www.writersdigest.com. Practical advice for running a profitable photography business.

The Photographer's Market Guide to Photo Submission & Portfolio Formats, by Michael Willins, Writer's Digest Books, F + W Publications, 4700 E. Galbraith Rd., Cincinnati OH 45236. (513)531-2690. Website: www.writersdigest.com. A detailed, visual guide to making submissions and selling yourself as a photographer.

Pricing Photography: The Complete Guide to Assignment & Stock Prices, 3rd Edition, by Michal Heron and David MacTavish, Allworth Press, 10 E. 23 St., Suite 510, New York NY 10010. (212)777-8395. Fax: (212)777-8261. E-mail: PUB@allworth.com. Website: www.allworth.com.

Sell & Resell Your Photos, 5th Edition, by Rohn Engh, Writer's Digest Books, F + W Publications, 4700 E. Galbraith Rd., Cincinnati OH 45236. (513)531-2690. Website: www.writersdigest.com. Revised edition of the classic volume on marketing your own stock.

SellPhotos.com, by Rohn Engh, Writer's Digest Books, F + W Publications, 4700 E. Galbraith Rd., Cincinnati OH 45236. (513)531-2690. Website: www.writersdigest.com. A guide to establishing a stock photography business on the Internet.

Shooting & Selling Your Photos, by Jim Zuckerman, Writer's Digest Books, F + W Publications, 4700 E. Galbraith Rd., Cincinnati OH 45236. (513)531-2690. Website: www.writersdigest.com.

Songwriter's Market, Writer's Digest Books, F + W Publications, 4700 E. Galbraith Rd., Cincinnati OH 45236. (513)531-2690. Website: www.writersdigest.com. Annual directory listing record labels.

Standard Rate and Data Service (SRDS), 1700 Higgins Rd., Des Plains IL 60018-5605. (847)375-5000. Fax: (847)375-5001. Website: www.srds.com. Directory listing magazines and their advertising rates.

Workbook, Scott & Daughter Publishing, 940 N. Highland Ave., Los Angeles CA 90038. (800)547-2688. Fax: (323)856-4368. E-mail: press@workbook.com. Website: www.workbook.com. Numerous resources for the graphic arts industry.

Writer's Market, Writer's Digest Books, F + W Publications, 4700 E. Galbraith Rd., Cincinnati OH 45236. (513)531-2690. Website: www.writersdigest.com. Annual directory listing markets for freelance writers. Many listings include photo needs and payment rates.

Web Sites

PHOTOGRAPHY BUSINESS

The Alternative Pick http://altpick.com

Black Book www.blackbook.com

Copyright Website www.benedict.com

EP: Editorial Photographers www.editorialphoto.com

Photo News Network www.photonews.com

ShootSMARTER.com www.shootsmarter.com

Small Business Administration www.sba.gov

MAGAZINE AND BOOK PUBLISHING

AcqWeb http://acqweb.library.vanderbilt.edu

American Journalism Review's News Links http://newslink.org

Bookwire www.bookwire.com

STOCK PHOTOGRAPHY

Global Photographers Search www.photographers.com

PhotoSource International www.photosource.com

Stock Photo Price Calculator www.photographersindex.com/stockprice.htm

Selling Stock www.pickphoto.com

Stock Artists Alliance www.stockartistsalliance.org

The STOCKPHOTO Network www.stockphoto.net

ADVERTISING PHOTOGRAPHY

Advertising Age www.adage.com

Adweek, Mediaweek and Brandweek www.adweek.com

Communication Arts Magazine www.commarts.com

FINE ART PHOTOGRAPHY

The Art List www.theartlist.com

Art Support www.art-support.com

Art DEADLINES List www.xensei.com/adl

Photography in New York International www.photography-guide.com

PHOTOJOURNALISM

The Digital Journalist www.digitaljournalist.org

Foto8 www.foto8.com

National Press Photographers Association www.nppa.org

MAGAZINES

Afterimage www.vsw.org

Aperture www.aperture.org

Art Calendar www.artcalendar.com

Art on Paper www.artonpaper.com

Black and White Photography www.bandwmag.com

Blind Spot www.blindspot.com

British Journal of Photography www.bjphoto.co.uk

Camera Arts www.cameraarts.com

Lens Work www.lenswork.com

Photo District News www.pdnonline.com

Photograph Magazine www.photography-guide.com

Photo Insider www.photoinsider.com

The Photo Review, The Photography Collector, and The Photographic Art Market Magazines: www.photoreview.org

Shots Magazine www.afterimagegallery.com/shots.htm

View Camera www.viewcamera.com

E-ZINES

The following publications exist online only. Some offer opportunities for photographers to post their personal work.

Apogee Photo www.apogeephoto.com

American Photo Magazine www.americanphotomag.com

American Photography Museum www.photographymuseum.com

Art in Context www.artincontext.org

Art Business News www.artbusinessnews.com

Art Support www.art-support.com

Artist Register http://artistsregister.com

Digital Journalist www.digitaljournalist.org

Editorial Photographers www.editorialphoto.com

En Foco www.enfoco.org

Eye Caramba www.eyecaramba.com

Fotophile www.fotophile.com

Handheld Magazine www.handheldmagazine.com/index.html

Musarium www.musarium.com (formerly *Journal E*)

Fabfotos www.fabfotos.com

Foto8 www.foto8.com

Fire Storm www.firestorm.com

Nerve www.nerve.com/photography

One World Journeys www.oneworldjourneys.com/palmyra/html/index.html

PhotoArts www.photoarts.com

Pixel Press www.pixelpress.org

Talent Network www.photographynetwork.com

Photo Imaging Information Council www.takegreatpictures.com

Photo Links www.photolinks.com

Online Photo Workshops www.photoworkshop.com

Picture Projects www.pictureprojects.com

Sight Photo www.sightphoto.com

Zone Zero www.zonezero.com

TECHNICAL

About.com www.photography.about.com

FocalFix.com www.focalfix.com

Photo.net www.photo.net

The Pixel Foundry www.thepixelfoundry.com

Wilhelm Imaging Research www.wilhelm-research.com

DIGITAL

Adobe Tutorials www.adobe.com.au/products/tips/photoshop.html

Digital Photographers www.digitalphotographers.net

Digital Photography Review www.dpreview.com

Fred Miranda www.fredmiranda.com/forum/index.php

Imaging Resource www.imaging-resource.com

Lone Star Digital www.lonestardigital.com

The National Association of Photoshop Professionals www.photoshopuser.com

PC Photo Review www.pcphotoreview.com

Steve's Digicams www.steves-digicams.com

Resources

Portfolio Review Events

Portfolio review events provide photographers the opportunity to show their work to a variety of photo buyers including photo editors, publishers, art directors, gallery representatives, curators and collectors.

Art Director's Club, International Annual Awards Exhibition, New York City, www.adcglobal.org

Center for Photography at Woodstock, annual fall event, New York City, www.cpw.org

Festival of Light International Directory of Photography Festivals, an international collaboration of 16 countries and 22 photography festivals, www.festivaloflight.net

Fotofest, March, Houston TX, www.fotofest.org. Biennial—held in even-numbered years.

Fotofusion, January, Delray Beach FL, www.fotofusion.org

Photo LA, January, Los Angeles CA, www.photola.com

Photo San Francisco, July, San Francisco CA, www.photosanfrancisco.net

Photolucida March, Portland OR, www.photolucida.org. Biennial—held in odd-numbered years.

The Print Center, events held throughout the year, Philadelphia PA, www.printcenter.org

Review Santa Fe, July, Santa Fe NM, www.santafecenterofphotography.org. The only juried portfolio review event.

Rhubarb-Rhubarb, July, Birmingham UK, www.rhubarb-rhubarb.net

Society for Photographic Education National Conference, March, different location each year, www.spenational.org

Stock Photography Portals

These sites market and distribute images from multiple agencies and photographers.

AGPix www.agpix.com

Alamy www.alamy.com

Eureka Images www.eurekaimages.com

Find a Photographer www.asmp.org/findaphotographer

Image Pond Publishing www.imagepond.com

Independent Photography Network (IPNStock) www.ipnstock.com

Istockpro www.istockpro.com

Photoconnect www.photoconnect.net

PhotoExposure.com www.photoexposure.com

PhotoServe www.photoserve.com

PhotoSights www.photosights.com

PhotoSource International www.photosource.com

Portfolios.com www.portfolios.com

Shutterpoint Photography www.shutterpoint.com

Stock Artists Alliance www.stockartistsalliance.org

Veer www.veer.com

Workbook Stock www.workbook.com

Glossary

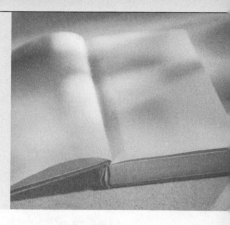

Absolute-released images. Any images for which signed model or property releases are on file and immediately available. For working with stock photo agencies that deal with advertising agencies, corporations and other commercial clients, such images are absolutely necessary to sell usage of images. Also see Model release, Property release.

Acceptance (payment on). The buyer pays for certain rights to publish a picture at the time it is accepted, prior to its publication.

Agency promotion rights. Stock agencies request these rights in order to reproduce a photographer's images in promotional materials such as catalogs, brochures and advertising.

Agent. A person who calls on potential buyers to present and sell existing work or obtain assignments for a client. A commission is usually charged. Such a person may also be called a *photographer's rep*.

All rights. A form of rights often confused with work for hire. Identical to a buyout, this typically applies when the client buys all rights or claim to ownership of copyright, usually for a lump sum payment. This entitles the client to unlimited, exclusive usage and usually with no further compensation to the creator. Unlike work for hire, the transfer of copyright is not permanent. A time limit can be negotiated, or the copyright ownership can run to the maximum of 35 years.

Alternative Processes. Printing processes that do not depend on the sensitivity of silver to form an image. These processes include cyanotype and platinum printing.

Archival. The storage and display of photographic negatives and prints in materials that are harmless to them and prevent fading and deterioration.

Artist's statement. A short essay, no more than a paragraph or two, describing a photographer's mission and creative process. Most galleries require photographers to provide an artist's statement.

Assign (designated recipient). A third-party person or business to which a client assigns or designates ownership of copyrights that the client purchased originally from a creator such as a photographer. This term commonly appears on model and property releases.

Assignment. A definite OK to take photos for a specific client with mutual understanding as to the provisions and terms involved.

Assignment of copyright, rights. The photographer transfers claim to ownership of copyright over to another party in a written contract signed by both parties.

Audiovisual (AV). Materials such as filmstrips, motion pictures and overhead transparencies which use audio backup for visual material.

Automatic renewal clause. In contracts with stock photo agencies, this clause works on the concept that every time the photographer delivers an image, the contract is automatically renewed for a specified number of years. The drawback is that a photographer can be

bound by the contract terms beyond the contract's termination and be blocked from marketing the same images to other clients for an extended period of time.

Avant garde. Photography that is innovative in form, style or subject matter.

Biannual. Occurring twice a year. Also see Semiannual.

Biennial. Occurring once every two years.

Bimonthly. Occurring once every two months.

Bio. A sentence or brief paragraph about a photographer's life and work, sometimes published along with photos.

Biweekly. Occurring once every two weeks.

Blurb. Written material appearing on a magazine's cover describing its contents.

Buyout. A form of work for hire where the client buys all rights or claim to ownership of copyright, usually for a lump sum payment. Also see All rights, Work for hire.

Caption. The words printed with a photo (usually directly beneath it), describing the scene or action.

CCD. Charged Coupled Device. A type of light detection device, made up of pixels, that generates an electrical signal in direct relation to how much light strikes the sensor.

CD-ROM. Compact disc read-only memory; non-erasable electronic medium used for digitized image and document storage and retrieval on computers.

Chrome. A color transparency, usually called a slide.

Cibachrome. A photo printing process that produces fade-resistant color prints directly from color slides.

Clips. See Tearsheet.

CMYK. Cyan, magenta, yellow and black—refers to four-color process printing.

Color Correction. Adjusting an image to compensate for digital input and output characteristics.

Commission. The fee (usually a percentage of the total price received for a picture) charged by a photo agency, agent or gallery for finding a buyer and attending to the details of billing, collecting, etc.

Composition. The visual arrangement of all elements in a photograph.

Compression. The process of reducing the size of a digital file, usually through software. This speeds processing, transmission times and reduces storage requirements.

Consumer publications. Magazines sold on newsstands and by subscription that cover information of general interest to the public, as opposed to trade magazines, which cover information specific to a particular trade or profession. See Trade magazine.

Contact Sheet. A sheet of negative-size images made by placing negatives in direct contact with the printing paper during exposure. They are used to view an entire roll of film on one piece of paper.

Contributor's copies. Copies of the issue of a magazine sent to photographers in which their work appears.

Copyright. The exclusive legal right to reproduce, publish and sell the matter and form of an artistic work.

Cover letter. A brief business letter introducing a photographer to a potential buyer. A cover letter may be used to sell stock images or solicit a portfolio review. Do not confuse cover letter with query letter.

C-print. Any enlargement printed from a negative.

Credit line. The byline of a photographer or organization that appears below or beside a published photo.

Cutline. See Caption.

Day rate. A minimum fee that many photographers charge for a day's work, whether a full day is spent on a shoot or not. Some photographers offer a half-day rate for projects involving up to a half-day of work.

Demo(s). A sample reel of film or sample videocassette that includes excerpts of a filmmaker's or videographer's production work for clients.

Density. The blackness of an image area on a negative or print. On a negative, the denser the black, the less light that can pass through.

Digital Camera. A filmless camera system that converts an image into a digital signal or file.

DPI. Dots per inch. The unit of measure used to describe the resolution of image files, scanners and output devices. How many pixels a device can produce in one inch.

Electronic Submission. A submission made by modem or on computer disk, CD-ROM or other removable media.

Emulsion. The light-sensitive layer of film or photographic paper.

Enlargement. An image that is larger than its negative, made by projecting the image of the negative onto sensitized paper.

Exclusive property rights. A type of exclusive rights in which the client owns the physical image, such as a print, slide, film reel or videotape. A good example is when a portrait is shot for a person to keep, while the photographer retains the copyright.

Exclusive rights. A type of rights in which the client purchases exclusive usage of the image for a negotiated time period, such as one, three or five years. May also be permanent. Also see All rights, Work for hire.

Fee-plus basis. An arrangement whereby a photographer is given a certain fee for an assignment—plus reimbursement for travel costs, model fees, props and other related expenses incurred in completing the assignment.

File Format. The particular way digital information is recorded. Common formats are TIFF and JPEG.

First rights. The photographer gives the purchaser the right to reproduce the work for the first time. The photographer agrees not to permit any publication of the work for a specified amount of time.

Format. The size or shape of a negative or print.

Four-color printing, four-color process. A printing process in which four primary printing inks are run in four separate passes on the press to create the visual effect of a full-color photo, as in magazines, posters and various other print media. Four separate negatives of the color photo—shot through filters—are placed indentically (stripped) and exposed onto printing plates, and the images are printed from the plates in four ink colors.

GIF. Graphics Interchange Format. A graphics file format common to the Internet.

Glossy. Printing paper with a great deal of surface sheen. The opposite of matte.

Hard Copy. Any kind of printed output, as opposed to display on a monitor.

Honorarium. Token payment—small amount of money and/or a credit line and copies of the publication.

Image Resolution. An indication of the amount of detail an image holds. Usually expressed as the dimension of the image in pixels and the color depth each pixel has. Example: a 640×480, 24-bit image has higher resolution than a 640×480, 16-bit image.

IRC. International Reply Coupon. IRCs are used with self-addressed envelopes instead of stamps when submitting material to buyers located outside a photographer's home country.

JPEG. Joint Photographic Experts Group. One of the more common digital compression methods that reduces file size without a great loss of detail.

Licensing/Leasing. A term used in reference to the repeated selling of one-time rights to a photo.

Matte. Printing paper with a dull, nonreflective surface. The opposite of glossy.

Model release. Written permission to use a person's photo in publications or for commercial use.

Ms, mss. Abbreviations for manuscript and manuscripts, respectively.

Multi-image. A type of slide show that uses more than one projector to create greater visual impact with the subject. In more sophisticated multi-image shows, the projectors can be programmed to run by computer for split-second timing and animated effects.

Multimedia. A generic term used by advertising, public relations and audiovisual firms to describe productions using more than one medium together—such as slides and full-motion, color video—to create a variety of visual effects.

News release. See Press release.

No right of reversion. A term in business contracts that specifies once a photographer sells the copyright to an image, a claim of ownership is surrendered. This may be unenforceable, though, in light of the 1989 Supreme Court decision on copyright law. Also see All rights, Work for hire.

On spec. Abbreviation for "on speculation." Also see Speculation.

One-time rights. The photographer sells the right to use a photo one time only in any medium. The rights transfer back to the photographer on request after the photo's use.

Page rate. An arrangement in which a photographer is paid at a standard rate per page in a publication.

Photo CD. A trademarked, Eastman Kodak-designed digital storage system for photographic images on a CD.

PICT. The saving format for bit-mapped and object-oriented images.

Picture Library. See Stock photo agency.

Pixels. The individual light-sensitive elements that make up a CCD array. Pixels respond in a linear fashion. Doubling the light intensity doubles the electrical output of the pixel.

Point-of-purchase, point-of-sale (P-O-P, P-O-S). A term used in the advertising industry to describe in-store marketing displays that promote a product. Typically, these highly-illustrated displays are placed near checkout lanes or counters, and offer tear-off discount coupons or trial samples of the product.

Portfolio. A group of photographs assembled to demonstrate a photographer's talent and abilities, often presented to buyers.

PPI. Pixels per inch. Often used interchangeably with DPI, PPI refers to the number of pixels per inch in an image. See DPI.

Press release. A form of publicity announcement that public relations agencies and corporate communications staff people send out to newspapers and TV stations to generate news coverage. Usually this is sent with accompanying photos or videotape materials.

Property release. Written permission to use a photo of private property or public or government facilities in publications or for commercial use.

Public domain. A photograph whose copyright term has expired is considered to be "in the public domain" and can be used for any purpose without payment.

Publication (payment on). The buyer does not pay for rights to publish a photo until it is actually published, as opposed to payment on acceptance.

Query. A letter of inquiry to a potential buyer soliciting interest in a possible photo assignment.

Rep. Trade jargon for sales representative. Also see Agent.

Resolution. The particular pixel density of an image, or the number of dots per inch a device is capable of recognizing or reproducing.

Résumé. A short written account of one's career, qualifications and accomplishments.

Royalty. A percentage payment made to a photographer/filmmaker for each copy of work sold.

R-print. Any enlargement made from a transparency.

SAE. Self-addressed envelope.

SASE. Self-addressed, stamped envelope. (Most buyers require a SASE if a photographer wishes unused photos returned to him, especially unsolicited materials.)

Self-assignment. Any project photographers shoot to show their abilities to prospective

clients. This can be used by beginning photographers who want to build a portfolio or by photographers wanting to make a transition into a new market.

Self-promotion piece. A printed piece photographers use for advertising and promoting their businesses. These pieces generally use one or more examples of the photographer's best work, and are professionally designed and printed to make the best impression.

Semiannual. Occurring twice a year. Also see Biannual.

Semigloss. A paper surface with a texture between glossy and matte, but closer to glossy.

Semimonthly. Occurring twice a month.

Serial rights. The photographer sells the right to use a photo in a periodical. Rights usually transfer back to the photographer on request after the photo's use.

Simultaneous submissions. Submission of the same photo or group of photos to more than one potential buyer at the same time.

Speculation. The photographer takes photos with no assurance that the buyer will either purchase them or reimburse expenses in any way, as opposed to taking photos on assignment.

Stock photo agency. A business that maintains a large collection of photos it makes available to a variety of clients such as advertising agencies, calendar firms and periodicals. Agencies usually retain 40-60 percent of the sales price they collect, and remit the balance to the photographers whose photo rights they've sold.

Stock photography. Primarily the selling of reprint rights to existing photographs rather than shooting on assignment for a client. Some stock photos are sold outright, but most are rented for a limited time period. Individuals can market and sell stock images to individual clients from their personal inventory, or stock photo agencies can market photographers' work for them. Many stock agencies hire photographers to shoot new work on assignment, which then becomes the inventory of the stock agency.

Subsidiary agent. In stock photography, this is a stock photo agency that handles marketing of stock images for a primary stock agency in certain US or foreign markets. These are usually affiliated with the primary agency by a contractual agreement rather than by direct ownership, as in the case of an agency that has its own branch offices.

SVHS. Abbreviation for Super VHS. Videotape that is a step above regular VHS tape. The number of lines of resolution in a SVHS picture is greater, thereby producing a sharper picture.

Tabloid. A newspaper about half the page size of an ordinary newspaper that contains many photos and news in condensed form.

Tearsheet. An actual sample of a published work from a publication.

TIFF. Tagged Image File Format. A common bitmap image format developed by Aldus.

Trade magazine. A publication devoted strictly to the interests of readers involved in a specific trade or profession, such as beekeepers, pilots or manicurists, and generally available only by subscription.

Transparency. Color film with a positive image, also referred to as a slide.

Unlimited use. A type of rights in which the client has total control over both how and how many times an image will be used. Also see All rights, Exclusive rights, Work for hire.

Unsolicited submission. A photograph or photographs sent through the mail that a buyer did not specifically ask to see.

Work for hire. Any work that is assigned by an employer who becomes the owner of the copyright. Stock images cannot be purchased under work-for-hire terms.

World rights. A type of rights in which the client buys usage of an image in the international marketplace. Also see All rights.

Worldwide exclusive rights. A form of world rights in which the client buys exclusive usage of an image in the international marketplace. Also see All rights.

Geographic Index

This index lists photo markets by the state in which they are located. It is often easier to begin marketing your work to companies close to home. You can also determine with which companies you can make appointments to show your portfolio, near home or when traveling.

COLORADO

CONNECTICUT

DELAWARE

DISTRICT OF COLUMBIA

GEORGIA
American Print Alliance 376
Aquarius 163
Atlanta Homes & Lifestyles 50
Atlanta Parent 50
Chattahoochee Review, The 67
Cortona Center of Photography,
 Italy, The 444
Deljou Art Group 247
Game & Fish Magazines 89
Georgia Backroads 90
KNOWAtlanta 105
Myriad Productions 358
North American Whitetail Maga-
 zine 116
OMM Fabricator 193
Professional Photographer 197

HAWAII
Hawaii Photo Seminars 447
Pacific Stock 318
Photo Resource Hawaii 322
Wailoa Center Gallery, The 420

IDAHO
African Photo Safaris 440
Appaloosa Journal 170
Blue Planet Photography Work-
 shops and Tours 441
Gallery DeNovo 393
Travel Images 459

ILLINOIS
A.R.C. Gallery 374
AIM Magazine 44
AKM Images, Inc. 270
American Bee Journal 169
American Planning Association
 208
American Society of Artists, Inc.
 376
Balzekas Museum of Lithuanian
 Culture Art Gallery 380
Bell Studio 380
Bragaw Public Relations Services
 360

Chef 174
Clavier 175
Collectible Automobile 71
Company Magazine 71
Complete Woman 72
Custom Medical Stock Photo 283
Design & More 361
Down Beat Magazine 80
Dynamic Graphics 247
El Restaurante Mexicano 178
Electrical Apparatus 179
Elks Magazine, The 81
Fire Chief 180
Flatfile 391
Freeport Arts Center 392
Gallant Greetings Corp. 248
Gallery 400, University of Illinois at
 Chicago 393
Grain Journal 182
Great Quotations Publishing Co.
 219
Heuser Art Center Gallery & Hart-
 mann Center Art Gallery 396
Human Kinetics Publishers 222
Illinois State Museum Chicago
 Gallery 397
Journal of Property Management
 186
Ketchum Hands-On Model Work-
 shops, Art 448
Lakeland Boating Magazine 106
Law and Order Magazine 187
Leonardis Gallery, David 401
Lion, The 106
Loyola Magazine 107
Luckypix 308
Lutheran, The 107
Marketing & Technology Group
 188
McGraw-Hill 225
Miller Gallery, Peter 405
Modern Baking 189
Munro Goodman Artists Represen-
 tatives 437

WASHINGTON

WEST VIRGINIA

WISCONSIN

WYOMING

International Index

This index lists photo markets located outside the United States. Most of the markets are located in Canada and the United Kingdom. To work with markets located outside your home country, you will have to be especially professional and patient.

CAYMAN ISLANDS

CZECH REPUBLIC

ECUADOR

FRANCE

GERMANY

GREECE

HONG KONG

Subject Index

This index can help you find buyers who are searching for the kinds of images you are producing. Consisting of markets from the Publications, Book Publishers, Greeting Cards, Posters & Related Products, Stock Photo Agencies, Advertising, Design & Related Markets, and Galleries sections, this index is broken down into 47 different subjects. If, for example, you shoot outdoor scenes and want to find out which markets purchase this material, turn to the categories Landscapes/Scenics and Environmental.

Adventure

Agriculture

Alternative Process

Subject Index

Architecture

Avant Garde

Babies/Children/Teens

Business Concepts

Celebrities

Cities/Urban

Couples

Disasters

Documentary

Entertainment

Environmental

Erotic

Events

Families

Subject Index

Fashion/Glamour

Fine Art

Food/Drink

Subject Index

Gardening

Health/Fitness/Beauty

Hobbies

Subject Index

Humor

Industry

Interiors/Decorating

Landscapes/Scenics

Medicine

Military

Multicultural

Parents

Performing Arts

Political

Product Shots/Still Life

Religious

Rural

Seasonal

Senior Citizens

Sports

Subject Index

Wildlife

General Index

This index lists every market appearing in the book; use it to find specific companies you wish to approach.

General Index

日本 / Ad. agency / Source
www. source. co. jp